A SHORT HISTORY OF ART

A SHORT HISTORY OF ART

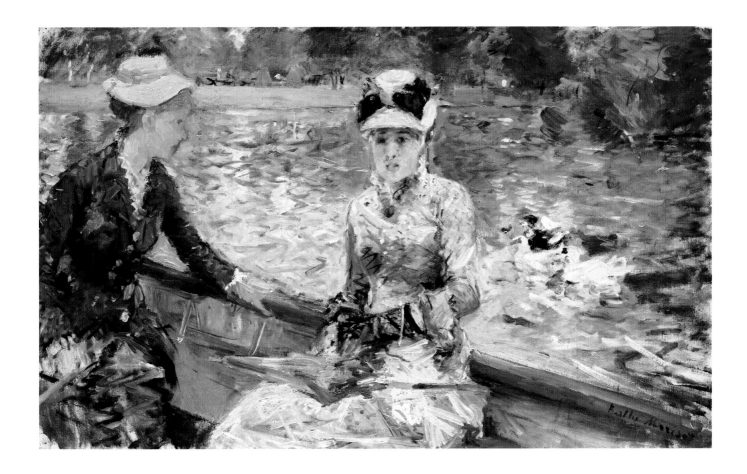

H.W. JANSON & ANTHONY F. JANSON

In collaboration with

FRIMA FOX HOFRICHTER JOSEPH JACOBS ANDREW STEWART

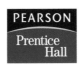

PEARSON

Prentice Hall

Prentice Hall, Upper Saddle River, New Jersey 07458

Library of Congress Cataloging-in-Publication Data

Janson, H. W. (Horst Woldemar)
 A short history of art / H. W. Janson & Anthony F. Janson.—7ᵗʰ ed.
 p. cm.
 Includes bibliographical references and index.
 ISBN 0-13-192731-0
 1. Art—History. I. Janson, Anthony F. II. Janson, H. W. (Horst Woldemar), History
of art for young people. III. Title.

N5300.J33 2006
709—dc22

 2004060091

Editor-in-Chief: *Sarah Touburg*
Editorial Assistant: *Sasha Anderson*
Editor-in-Chief, Development: *Rochelle Diogenes*
Senior Development Editor: *Roberta Meyer*
Sponsoring Editor: *Helen Ronan*
Media Project Manager: *Anita Castro*
Executive Marketing Manager: *Sheryl Adams*
Marketing Assistant: *Cherron Gardner*
AVP, Director of Production and Manufacturing: *Barbara Kittle*
Managing Editor: *Lisa Iarkowski*
Production Editor: *Barbara Taylor-Laino*
Production Assistant: *Marlene Gassler*
Manufacturing Manager: *Nick Sklitsis*
Manufacturing Buyer: *Sherry Lewis*
Creative Design Director: *Leslie Osher*
Art Director: *Kathryn Foot*
Interior and Cover Design: *Kathryn Foot*
Line Art Coordinator: *Mirella Signoretto*
Cartographer: *Cartographics*
Central Scanning Services: *Greg Harrison, Corin Skidds, Robert Uibelhoer, Ron Walko,*
 Shayle Keating, and Dennis Sheehan
Site Supervisor Central Scanning Services: *Joe Conti*
Photo Editing, Rights, and Reproduction: *Laurie Platt Winfrey, Fay Torres-Yap,*
 Barbara Nagelsmith, and Christian Peña, Carousel Research Inc.
Director, Image Resource Center: *Melinda Reo*
Manager, Rights and Permissions: *Zina Arabia*
Manager, Visual Research: *Beth Brenzel*
Manager, Cover Visual Research and Permissions: *Karen Sanatar*
Image Permission Coordinator: *Debbie Latronica*
Cover Image Coordinator: *Gladys Soto*
Copy Editor: *Kathy Pruno*
Proofreader: *Judy Winthrop*
Composition: *Seven World Wide*
Cover Printer: *Phoenix Color Corporation*
Printer/Binder: *R. R. Donnelley*
Cover Photo: *Morisot, Berthe* (1841–1895). *Summer's Day.* Oil (identified) on Canvas,
 45.7 × 75.2 cm. © National Gallery, London.

Credits and acknowledgments borrowed from other sources and reproduced, with
permission, in this textbook appear on the appropriate page within text or on the
credit pages in the back of this book.

Pearson Education Ltd. Pearson Education, Canada, Ltd.
Pearson Education Australia PTY, Limited Pearson Educación de Mexico, S.A. de C.V.
Pearson Education Singapore, Pte. Ltd. Pearson Education–Japan
Pearson Education North Asia Ltd. Pearson Education Malaysia, Pte. Ltd.

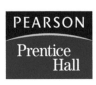

10 9 8 7 6 5 4 3 2 1
ISBN 0-13-192731-0

Contents in Brief

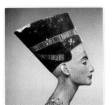
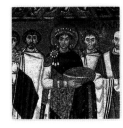
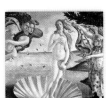
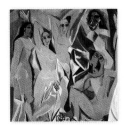

A SHORT HISTORY OF ART

by H.W. JANSON and ANTHONY JANSON

In collaboration with Frima Fox Hofrichter, Joseph Jacobs, and Andrew Stewart

The Janson name has long been synonymous with high quality reproductions, impeccable scholarship, and a gift for teaching generations of students and art enthusiasts. This new version of the book that was formerly known as A History of Art for Young People builds on the best of this tradition with the contributions of several scholars who made many critical improvements to the book.

Working closely with Anthony Janson, each contributor has added more contextual discussion to the narrative, without sacrificing the formal analysis that has characterized the Janson approach. The entire book has been carefully edited to achieve greater clarity, consistency, and objectivity.

We have appreciably increased the number of color illustrations throughout the book. 160 illustrations are new to this edition.

Other major features of this new edition include:

- The Introduction is completely new, with discussions such as "The Power of Art and the Impact of Context," and "Experiencing Art" in museums. It is designed to help stimulate interest in the study of art history and equip the reader with ways to look at art.
- The 20th Century chapters have been thoroughly reorganized and rewritten so that the material unfolds chronologically instead of by medium.
- New "Materials and Techniques" boxes explain key art practices or conventions across time.
- New "Cultural Context" boxes enrich the reader's understanding of works of art.
- Maps have been edited to better reflect the locations of key works of art.

Numerous smaller revisions have been made throughout the book, such as:

In Part One, The Ancient World, Andrew Stewart has greatly updated and enriched chapters 5 and 7, including new discussions of Greco-Roman naturalism, still-life painting, and Roman values and mores.

In Part Two, The Medieval World, Anthony Janson has given greater attention to San Lorenzo Maggiore, to help readers decipher the original structure from the later reworking in the 16th century. He has also added the Great Mosque at Cordova, in recognition of the influence of Islamic art on the Western Medieval world. The chronology of the Crusades has been clarified.

In Part Three, The Renaissance to Rococo: the Early Modern World, Frima Fox Hofrichter has infused the analysis of the period with exciting new discussions of social history as it relates to key works of art, incorporating issues of patronage, economics, social class, and gender identity. Major new works include Jan van Eyck's Ghent Altarpiece, along with a view of its reconstruction by Lotte Brand Philip, Raphael's Alba Madonna as well as his Portrait of Baldassare Castiglione, Bernini's Baldachino , Caravaggio's Musicians, and Fragonard's The Swing.

In Part Four, The Modern World, Joseph Jacobs has revised the introductions, focusing on the cultural and historical forces that influenced artists of these periods. The chapters on twentieth century art have been completely reorganized and rewritten so that the discussion flows chronologically instead of by medium. All of these changes are designed to show how historical forces molded aesthetic issues and to provide students with a methodological model for approaching art and art history.

Prentice Hall Art Team, Winter 2004

A SHORT HISTORY OF ART

Introduction

WHO WAS FREELOVE OLNEY SCOTT? HER PORTRAIT (FIG. I-1) shows us a refined-looking woman, born, we would guess, into an aristocratic family, used to servants and power. We have come to accept John Singleton Copley's portraits of colonial Bostonians, such as *Mrs. Joseph Scott*, as accurate depictions of his subjects and their lifestyles. But many, like Mrs. Scott, were not what they appear to be. Who was she? Let's take a closer look at the context in which the painting was made.

Copley is recognized as the first great American painter. Working in Boston from about 1754 to 1774, he became the most sought after portraitist of the period. Copley easily outstripped the meager competition, most of whom earned their living painting signs and coaches. After all, no successful British artist had any reason to come to America. The economically struggling colonies were not a strong market for art. Only occasionally was a portrait commissioned, and typically, artists were treated like craftsmen rather than intellectuals. Like most colonial portraitists, Copley was self-taught, learning his trade by looking at black-and-white prints of paintings by the European masters.

As we can see in *Mrs. Joseph Scott*, Copley was a master at painting textures, all the more astonishing when we realize that he had no one to teach him the tricks of the painter's trade. His illusions are so convincing, we think we are looking at real silk, ribbons, lace, pearls, skin, hair, and marble. Copley's contemporaries also marveled at his sleight of hand. No other colonial painter attained such a level of realism.

But is Copley just a "face painter," as portraitists were derogatorily called at the time, capturing only the resemblance of his sitter and her expensive accoutrements? And is this painting just a means to replicate the likeness of an individual in an era before the advent of photography? The answer to both questions is a resounding "no." Copley's job

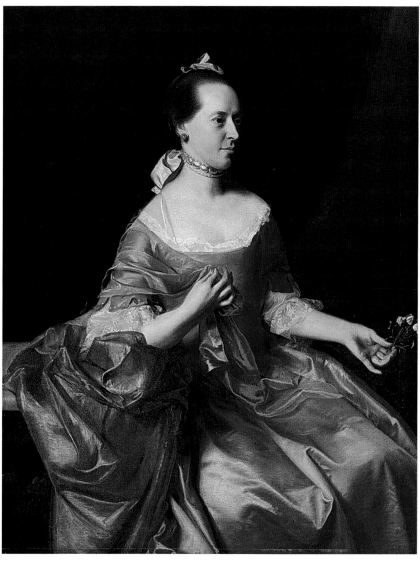

I-1 John Singleton Copley, *Mrs. Joseph Scott*. Oil on canvas, 69½" × 39½". Collection of The Newark Museum, Newark, New Jersey

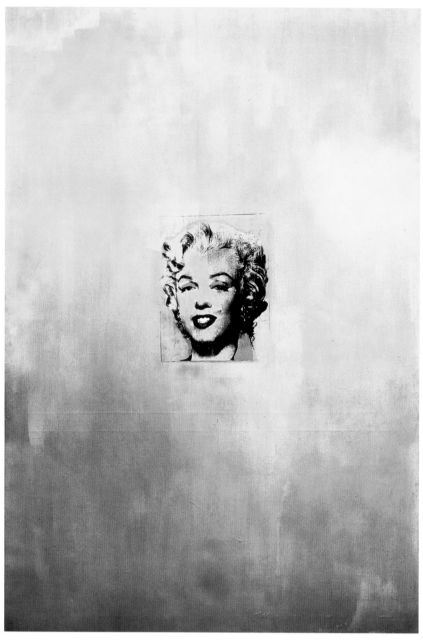

I-2 Andy Warhol. *Gold Marilyn Monroe*. 1962. Synthetic polymer paint, silk-screened, and oil on canvas, 6′11¼″ × 4′7″ (2.12 × 1.39 m). The Museum of Modern Art, New York Gift of Philip Johnson.

Source: ©2004 Andy Warhol Foundation for the Visual Arts/ARS, NY

Copley portraits. In other words, it was a studio prop, and the dress may have been as well. In fact, except for Mrs. Scott's face, the entire painting is a fiction designed to aggrandize the wife of a newly wealthy Boston merchant, who made a fortune selling provisions to the occupying British army. The Scotts were *nouveau riche* commoners, not titled aristocrats. By the middle of the eighteenth century, rich Bostonians wanted to distinguish themselves from others who were less successful. Now, after a century of trying to escape their British roots (from which many had fled to secure religious freedom), they sought to imitate the British aristocracy, even to the point of taking tea in the afternoon and owning English Spaniels, a breed that in England only aristocrats were permitted to own.

Mr. Scott commissioned this painting of his wife, as well as a portrait of himself, not just to record their features, but to show off the family's wealth. These pictures were extremely expensive and therefore status symbols, much like a Mercedes or a diamond ring from Tiffany's is today. The portraits were displayed in the public spaces of the house where they could be readily seen by visitors. Most likely they hung on either side of the mantle in the living room, or in the entrance hall. They were not intended as intimate affectionate resemblances destined for the bedroom. If patrons wanted cherished images of their loved ones, they would commission miniature portraits. These captured the likeness of the sitter in amazing detail and were often so small they could be encased in a locket that a woman would wear on a chain around her neck, or a gentleman would place in the inner breast pocket of his coat, close to the heart.

Let's move forward almost 200 years to look at a second image of a woman, Andy Warhol's *Gold Marilyn Monroe* (fig. I-2) of 1962, and explore the surprising stories it contains. In a sense, the painting can be considered a portrait, because it portrays the famous 1950s film star and sex symbol. Unlike *Mrs. Joseph Scott,* however, the painting was not commissioned, and instead was made to be exhibited in a commercial art gallery, where it could be purchased by a private collector for display in a home. Of course, Warhol hoped ultimately it would end up in a museum, something Copley never considered because they did not exist

was not just to make a faithful image of Mrs. Scott, but to portray her as a woman of impeccable character, limitless wealth, and aristocratic status. The flowers she holds are a symbol of fertility, faithfulness, and feminine grace, indicating that she is a good mother and wife, and a charming woman. Her expensive dress was imported from London, as was her necklace. Copley undoubtedly took her pose from one of the prints he had of British or French royalty.

Not only is Mrs. Scott's pose borrowed, but most likely her clothing is as well, for her necklace appears on three other women in

in his day. Because *Gold Marilyn Monroe* is not a commission, Warhol is not trying to flatter his subject. He is not even concerned about creating an illusionistic image; this image has no details and no sense of texture, as hair and flesh appear to be made of the same material—paint. Nor did Warhol painstakingly paint this picture. Instead he found a famous newspaper photograph of the film star and silkscreened it onto canvas, a process that involves first mechanically transferring the photograph onto a mesh screen and then pressing printing ink through the screen onto canvas. He then surrounded Marilyn's head with a field of broadly brushed gold paint.

Warhol's painting is a pastiche of the public image of Monroe as propagated by the mass media. He even imitates the sloppy, gritty look and feel of color newspaper reproductions of the period, for the colors were often misregistered, not aligning properly with the image. The Marilyn we are looking at is the impersonal celebrity of the media, supposedly glamorous with her lush red lipstick and bright blond hair but instead appearing pathetically tacky because of the garish color (blond hair becomes bright yellow) and grimy black ink. Her personality is impenetrable, reduced to a public smile. The painting was prompted, in part, by Monroe's recent suicide. This was the real Marilyn—a depressed, miserable person. Warhol has brilliantly expressed the indifference of the mass media that glorifies celebrities by saturating a celebrity-thirsty public with their likenesses, but tells us nothing meaningful about them and shows no concern for them. Marilyn Monroe's image is about promoting a product, much as the jazzy packaging of Brillo soap pads or Campbell's soup cans is designed to sell a product without telling us anything about the product itself. The packaging is just camouflage. Warhol floats Marilyn's face in a sea of gold paint, imitating icons of Christ and the Virgin Mary that traditionally encase these religious figures in a spiritual aura of golden, heavenly light (see fig. 8-13). But Warhol's revered Marilyn is sadly dwarfed in her celestial gold, adding to the tragedy of this powerful portrait, which so trenchantly comments on the enormous gulf existing between public image and private reality.

Copley and Warhol worked in very different times, which tremendously affected the look and meaning of their portraits. Because art always serves a purpose, it is impossible for any artist to make a work that does not represent a point of view and tell a story, sometimes many stories. As we will see, great artists tell great and powerful stories. We will find that an important key to unraveling these stories is understanding the context in which the work was made.

The Power of Art and the Impact of Context

In a sense, art is a form of propaganda, for it represents an individual's or group's point of view, and this view is often presented as truth or fact. For centuries, art was used by the church and the state to propagate the superiority of their powers. The *Alba Madonna* (see fig. I-16) was designed to proclaim the idealized, perfect state of existence attainable through Catholicism, and the *Arch of Titus* (fig. I-3) was erected to reinforce in the public's mind the military prowess of the Roman emperor, Titus. Even landscape paintings and still lifes of fruit, dead game, and flowers are loaded with messages and are far from simple attempts to capture the splendor and many moods of

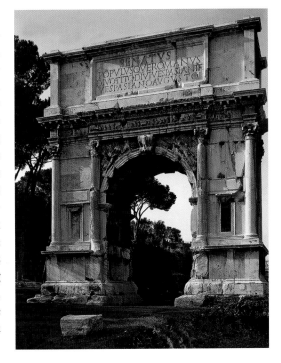

I-3 Arch of Titus, Forum Romanum, Rome, c. 81 CE., as restored.

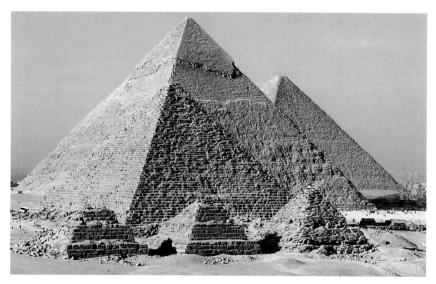

I-4 The Great Pyramids, Giza: (from left to right) of Menkaura (c. 2490–2472 B.C.), Khafra (c. 2520–2494 B.C.), and Khufu (c. 2551–2528 B.C.)

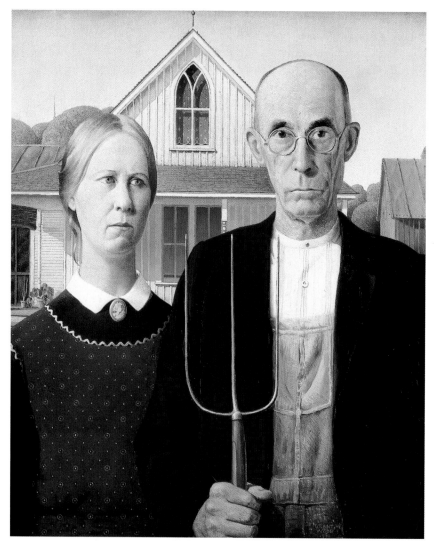

I-5 Grant Wood. American Gothic. 1930. Oil on board, 24⅞″ × 24⅞″ (74.3 × 62.4 cm). The Art Institute of Chicago, Friends of American Art Collection.

nature or show off the painter's finesse at creating a convincing illusionistic image.

Epitomizing the power of art is its ability to evoke entire historical periods. Say the words ancient Egypt and most people conjure up images of the pyramids (fig. I-4), the Sphinx, and flat stiff figures lined up sideways across the face of sandstone (see fig. 2-3). Or look at the power of Grant Wood's famous 1930 painting *American Gothic* (fig. I-5), which has led us to believe that humorless, austere, hardworking farmers dominated the American hinterlands at the time. The painting has virtually become an emblem of rural America.

American Gothic has also become a source of much sarcastic humor for later generations, which adapted the famous pitchfork-bearing farmer and sour-faced daughter for all kinds of agendas unrelated to the artist's message. Works of art are often appropriated to serve purposes quite different from those initially intended, with context heavily influencing the meaning of a work. The reaction of some New Yorkers to *The Holy Virgin Mary* (fig. I-6) by Chris Ofili reflects the power of art to provoke and spark debate, even outrage. The work appeared in an exhibition titled *Sensation: Young British Artists from the Saatchi Collection*, presented at the Brooklyn Museum in late 1999. Ofili, who is British of African descent, made an enormous picture using dots of paint, glitter, map pins, and collaged images of genitalia from popular magazines to depict a black Virgin Mary. Instead of hanging on the wall, this enormous painting rested on two large wads of elephant dung, which had been a signature of the artist's large canvases since 1991. Elephant dung is held scared in Zimbabwe, and for Ofili, a devout Catholic, who periodically attends Mass, the picture was about the elemental sacredness of the Virgin. The so-called pornographic images were intended to suggest procreation.

Many art historians, critics, and other viewers found the picture remarkably beautiful—glittering and shimmering with a delicate, ephemeral otherworldly aura. Many Catholics, however, were repulsed by Ofili's homage to the Virgin. Instead of viewing the work through Ofili's eyes, they placed the painting within the context of their own experience and beliefs. Consequently, they interpreted the dung and so-called pornography (and probably even a black Virgin,

although this was never mentioned) as sacrilegious. Within days of the opening of the exhibition, the painting had to be put behind a large Plexiglas barrier. One artist hurled horse manure at the facade of the Brooklyn Museum, claiming "I was expressing myself creatively"; another museum visitor sneaked behind the Plexiglas barrier and smeared the Virgin with white paint in order to hide her. But the greatest attack came from New York's Mayor Rudolph Giuliani, a Catholic, who was so outraged he tried to eliminate city funding for the museum. Ultimately, he failed, but only after a lengthy lawsuit by the museum. The public outrage at Ofili's work is one in a long tradition that probably goes back to the beginning of image making. Art has consistently provoked outrage, just as it has inspired pride, admiration, love, and respect, and the reason is simple: Art is never an empty container; rather, it is a vessel loaded with meaning, subject to multiple interpretations, and always representing someone's point of view.

Because the context for looking at art constantly changes, our interpretations and insights into art and entire periods evolve as well. For example, when the first edition of this book was published in 1971, women artists were not included, which was typical for textbooks of the time. America, like most of the world, was male-dominated and history was male-centric. Historically, women were expected to be wives and mothers, and to stay in the home and not have careers. They were not supposed to become artists, and the few known exceptions were not taken seriously by historians, who were mostly male. The feminist movement, beginning in the mid 1960s, overturned this restrictive perception of women. As a result, in the last 40 years, art historians—many of them women—have "rediscovered" countless women artists who had attained a degree of success in their day. Many of them were outstanding artists, held in high esteem during their lifetime, despite the enormous struggle to overcome powerful social and even family resistance against women becoming professional artists.

One of these lost women artists is the seventeenth-century Dutch painter Judith Leyster, a follower, if not a student, of Frans Hals. Over the centuries, all of Leyster's paintings were attributed to other artists,

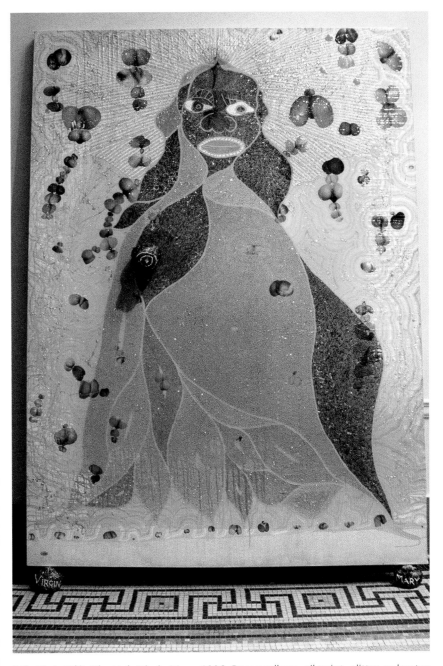

I-6 Chris Ofili. *The Holy Virgin Mary*. 1996. Paper collage, oil paint, glitter, polyester resin, map pins, and elephant dung on linen, 7'11" × 5'11⅝" (2.44 × 1.83m). The Saatchi Gallery, London.

including Hals and Gerrit van Honthorst. Or they were labeled "artist unknown." At the end of the nineteenth century, however, she was rediscovered through an analysis of her signature, documents, and style, and her paintings were gradually restored to her name. It was only with the feminist movement that she was elevated from a minor figure to one of the more accomplished painters of her generation, one important enough to be included in basic histories of art. The feminist movement provided a new context for evaluating art, one that had an interest in

rather than a denial of women's achievements and a study of issues relating to gender and how they appear in the arts.

A work like Leyster's c. 1633 *Self-Portrait* (fig I-7) is especially fascinating from this point of view. Because of its size and date, this may have been the painting the artist submitted as her presentation piece for admission into the local painters' guild, the Guild of St. Luke of Haarlem. Women were not encouraged to join the guild, which was a male preserve reinforcing the professional status of men. Nor did women artists generally take on students. Leyster bucked both restrictive traditions as she carved out a career for herself in a man's world. In her self-portrait, she presents herself as an artist, armed with many brushes, suggesting her deft control of the medium, which the presentation picture itself was meant to demonstrate. On the easel is a painting that is a segment of a genre scene of which several variations are known. We must remember that at this time, artists rarely showed themselves working at their easels, toiling with their hands. They wanted to separate themselves from mere artisans and laborers, presenting themselves as belonging to a higher class. As a woman defying male expectations, however, Leyster needed to clearly declare that she was indeed an artist. But she cleverly elevates her status by not dressing as

I-7 Judith Leyster, *Self-Portrait*. c. 1630. Oil on canvas, 29⅜" × 25⅝". National Gallery of Art (Gift of Mr. and Mrs. Robert Woods Bliss). ©2005 Board of Trustees, National Gallery of Art, Washington, D.C.

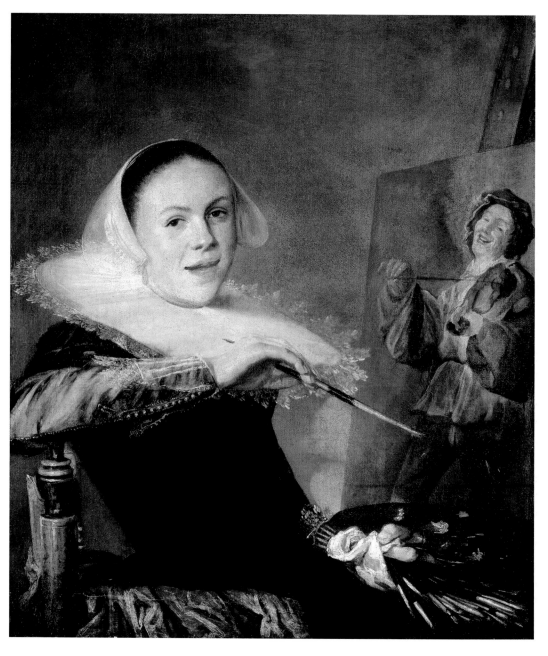

an artist would when painting. Instead, she appears as her patrons do in their portraits, well-dressed and well-off. Her mouth is open, in what is called a "speaking likeness" portrait, giving her a casual but self-assured animated quality, as she appears to converse on equal terms with a visitor, or with us. Leyster, along with Artemisia Gentileschi and Elizabeth Vigée-Lebrun who also appear in this book, was included in a major 1976 exhibition titled *Women Artists 1550-1950*, which appeared in Los Angeles and Brooklyn, New York and played a major role in establishing the importance of women artists.

What is Art?

Ask most people without a background in art and art history, What is art?, and they will respond with "an oil painting" or "a marble or bronze sculpture." Their criterion for quality is that it be beautiful, whatever that may be, although generally they define it as the degree to which a painting or sculpture is real looking or adheres to their notion of naturalistic. Technical finesse or craft is viewed as the highest attribute of art making, capable of inspiring awe and reverence. To debunk the myth that art is about technique and begin to get at what it is about, we return to Warhol's *Gold Marilyn Monroe*. The painting is rich with stories: we can talk about how it raises issues about the meaning of art, how it functions, and how it takes on value, both financial and aesthetic. Warhol even begs the question of the significance of technical finesse in art making, an issue raised by the fact that he may not have even touched this painting himself! We have already seen how he appropriated someone else's photograph of Marilyn Monroe, not even taking his own. Warhol then instructed his assistants to make the screens for the printing process. They also prepared the canvas, screened the image with the colors Warhol selected, and most likely painted the gold to Warhol's specifications, although we do not know this for sure.

By using assistants to make his work, Warhol is telling us that art is not about the artist's technical finesse, but about communicating an idea using visual language, even if the idea does not require the artist to actually make the art. The measuring stick for quality in art is the quality of the statement being made, or its philosophy, as well as the quality of the technical means for making this statement. Looking at *Gold Marilyn Monroe* in the flesh at New York's Museum of Modern Art is a powerful experience. Standing in front of this six-foot-high canvas, we cannot help but feel the empty glory of America's most famous symbol of female sexuality and stardom. Because the artist's vision, and not his touch, is the relevant issue for the making of this particular work, it is of no consequence that Warhol most likely never laid a hand to the canvas, except to sign the back. We will shortly see, however, that the artist's touch is often critical to the success of a work of art.

Warhol openly declared that his art was not about his technical ability when he called his midtown Manhattan studio "The Factory." He is telling us that art is a commodity, and he is manufacturing a product, even mass producing his product. The Factory churned out over a thousand, if not thousands, of paintings and prints of Marilyn Monroe based on the same newspaper photograph! All Warhol did for the most part was sign them, his signature reinforcing the importance people place on the signature itself as being an essential part of the work (ironically, most Old Master paintings, dating to the fourteenth through the eighteenth centuries, are not signed).

Actually, artists for centuries used assistants to help make their pictures. Peter Paul Rubens, an Antwerp painter working in the first half of the seventeenth century and one of the most famous artists of his day, had an enormous workshop that cranked out many of his pictures, especially the large works. His assistants were often artists specializing in flowers, animals, or clothing, for example, and many went on to become successful artists in their own right. Rubens would design the painting, and then assistants, trained in his style, would execute their individual parts. Rubens would then come in at the end and pull the painting together as needed. The price the client was willing to pay often determined how much Rubens himself participated in the actual painting of the picture, and many of his works were indeed made entirely by him. Rubens's brilliant flashy brushwork was in many respects critical to the making of the picture. Not only was his handling of paint considered superior to that of his

assistants, the very identity of his paintings, its very life so to speak, was linked to his unique genius of applying paint to canvas, almost as much as it was to his dramatic compositions. His brushwork complemented his subject matter; it even reinforced it. The two went hand in hand, as we'll see later in the Introduction and in Chapter 18.

Warhol was not the first artist to make art that intentionally raised the issue of what is art and how does it function. This distinction belongs to the humorous and brilliant Parisian Marcel Duchamp. In 1919, Duchamp took a roughly 8 x 4-inch reproduction of Leonardo da Vinci's *Mona Lisa* in the Louvre Museum in Paris and drew a moustache on the sitter's face (fig. I-8). Below he wrote the letters *L. H. O. O. Q.*, which when pronounced in French is *elle a chaud au cul*, which translates, "She has hot pants." Duchamp was poking fun at the public's fascination with the mysterious smile on the Mona Lisa, which had intrigued everyone for centuries and eluded suitable explanation. Duchamp irreverently provided one: she is sexually aroused, and she is gay. With the childish gesture of affixing a moustache to the Mona Lisa, Duchamp also attacked bourgeois reverence for Old Master

painting and the age-old esteem of oil painting representing the pinnacle of art.

Art, Duchamp is saying, can be made by merely placing ink drawing on a mass-produced reproduction. It is not strictly oil on canvas or cast bronze or chiseled marble sculpture. Artists can use any imaginable media in any way in order to express themselves. He is announcing that art is about ideas that are made visually, and not necessarily about craft. In this deceivingly whimsical work, which is rich with ideas, Duchamp is telling us that art is anything that someone wants to call art, which is not the same as saying it is good art. Furthermore, he is proclaiming art can be small, since *L. H. O. O. Q.* is a fraction of the size of its source, the *Mona Lisa*. By appropriating Leonardo's famous picture and interpreting it very differently from traditional readings (see pages 282–83), Duchamp suggests that the meaning of art is not fixed forever by the artist, that it can change and be assigned by viewers, writers, collectors, and museum curators, who can use it for their own purposes. Lastly, and this is certainly one of Duchamp's many wonderful contributions to art, he is telling us that art can be fun; it can defy conventional notions of beauty, and while intellectually engaging us in a most serious manner, it can also provide us with a smile, if not a good laugh.

ART AND AESTHETICS

L. H. O. O. Q. also raises the issue of aesthetics, which is the study of theories surrounding art, including what is beauty, and the meaning and purpose of art. Duchamp selected the *Mona Lisa* for "vandalizing" for many reasons, but one of them had to be that many people considered it the greatest and therefore the most beautiful painting ever made. Certainly, it was one of the most famous paintings in the world, if not the most famous. In 1919 most of those who held such a view had probably never seen it and only knew it from reproductions, probably no better than the one Duchamp used in *L. H. O. O. Q.!* And yet, they would describe the original painting as beautiful, but not Duchamp's comical version.

Duchamp called such altered found objects as *L. H. O. O. Q.* "assisted readymades" (for another example, see *Fountain*, fig. 26-2), and he was adamant when he claimed that these works had no aesthetic value whatsoever. They were not to be considered beautiful, and they were selected because they were aestheti-

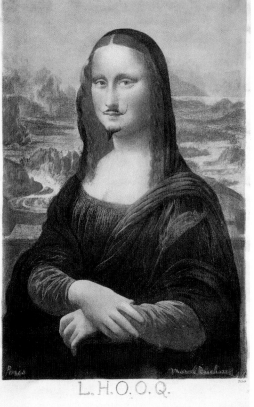

I-8 Marcel Duchamp, *Mona Lisa (L.H.O.O.Q.)* (1919) Rectified Readymade; pencil on a reproduction. 7″ × 4⅞″ Private collection c. 1998 Artists Rights Society (ARS). NY/ADAGP. Paris

Source: ©2004 Artists Rights Society (ARS), New York/ADAGP, Paris/Succession Marcel Duchamp

L. H.O.O.Q.

cally neutral. What interested Duchamp were the ideas that these objects embodied once they were declared art.

Despite his claim, Duchamp's assisted readymades can be perceived as beautiful, in ways, of course, that are quite different from Leonardo's *Mona Lisa*, but beautiful all the same. *L. H. O. O. Q.* has an aura about it, an aura of wit and ideas that are specific to Duchamp. As a result, this slightly altered cheap black-and-white reproduction is transformed into a compelling work of art, in a way that is very different from Leonardo's. As a result, the qualities that attract us to it, which we can describe as its beauty, could not be further from those of the *Mona Lisa*. Ultimately, beauty can be equated with quality.

Beauty is not just a pretty colorful picture or a perfectly formed, harmonious nude marble figure. Beauty resides in content and how successfully the content is made visual. This book is intended to suggest the many complex ways that quality, and thus beauty, appears in art. Some of the greatest and most beautiful paintings depict horrific scenes that many people could never find acceptable, nonetheless beautiful—scenes such as beheadings (see fig. 17-4), crucifixions (see fig. 16-1), death and despair (see figs. 22-5 and 22-6), emotional distress (see fig. 27-7), and the brutal massacre of innocent women and children (see fig. I-9). Like Duchamp's *L. H. O. O. Q.*, these works possess an aura that makes them powerful and riveting, despite the repulsiveness of the subject matter. They have quality, and to those who recognize and feel this quality, this makes these works beautiful. Others will continue to be repulsed and offended by them, or at best just be disinterested.

Illusionism and Meaning in Art

The Roman historian Pliny tells the story about the competition between the Greek painters Zeuxis and Parrhasius to see who could make the most illusionistic work. Zeuxis painted grapes so real that birds tried to eat them, but Parrhasius won the competition. He had painted a curtain covering a painting. So realistic was the work that Zeuxis asked him to pull back the curtain covering his painting only to discover that

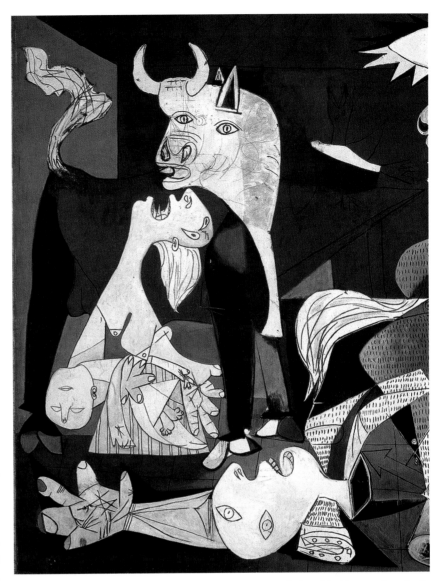

I-9 Pablo Picasso. Detail of *Guernica*. 1937. Oil on canvas, 11'6" × 25'8" (3.51 × 7.82 m). Museo Nacional Centro de Arte Reina Sofia, Madrid. On permanent loan from the Museo del Prado, Madrid.

Source: ©2004 Estate of Pablo Picasso/Artists Rights Society (ARS), NY

he *was* looking at the painting. The story of this competition is interesting, because despite a recurring emphasis on illusionism in art, the ability to create illusionistic effects and "fool the eye" is generally not what determines quality in art. As we discussed, quality in art comes from ideas *and* execution. Just being clever and fooling the eye is not enough.

A look at the sculpture of twentieth-century artist Duane Hanson shows us how illusionism can be put in the service of meaning to create a powerful work of art. Hanson's 1995 sculpture, *Man on a Lawn-mower* (fig. I-10), is a work that too often is appreciated only for its illusionistic qualities, while the real content goes unnoticed. Yet, it is the content, not the illusionism, that makes this sculpture so potent. Hanson began making his sculptures in the late

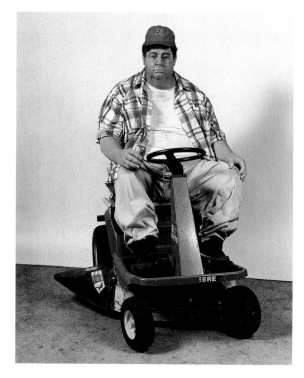

I-10 Duane Hanson, *Man on a Lawnmower,* 1995, Bronze poly-chromed with mower, life size. O'Hara Gallery, New York

Source: Art©Estate of Duane Hanson/Licensed by VAGA, New York

What is life about? The monotony of cutting grass, Hanson is saying. In this last work, made when he knew he was dying of cancer, Hanson captured what he perceived to be the emptiness of human existence and contemporary life. The illusionism of the sculpture makes this aura of alienation and lack of spirituality all the more palpable. This man is us, and this is our life, too. He embodies no poetry, nobility, or heroism. Our twentieth-century *Man on a Lawnmower* has no causes and beliefs to turn to as he confronts the down-to-earth reality of life and death.

Can a Mechanical Process Be Art?: Photography

The first edition of this book did not include photography, reflecting a prevailing attitude that photography, because it was largely a mechanical process, was not an art form. Now, three decades later, the artistic merit of photography seems self-evident. When it was invented in 1839, the art world largely dismissed it as a mechanical process with little artistic merit. Or it was perceived as not having sufficient aesthetic merit to be seen in the same lofty company with the twin peaks of art—painting and sculpture. It has struggled ever since to shed that stigma. Within the last 25 years, however, photography has been vindicated. Along with video and film, it has been elevated to an important medium used by today's artists. Pictures from the nineteenth and twentieth centuries that had interested only a handful of photography insiders suddenly became intensely sought after, with many museums rushing to establish photography departments and amass significant collections. In other words, it took well over 100 years for people to get beyond the stigma of the mechanical process to develop an eye for the quality and beauty of the medium.

1960s. He cast his figures in polyester resin, and then meticulously painted them. He then dressed them in real clothing, used real accessories (including wigs and artificial eyeballs), and placed them in real furniture. Most museum visitors are startled to discover his sculptures are not real, and many people have tried to interact with his characters, which include museum guards, tourists, shoppers, house painters, and female sunbathers.

But Hanson's art is more than just about a visual sleight of hand. He is also a realist and a moralist, and his art is filled with tragic social content. By realist, we mean that his sculpture is not limited to attractive, beautiful, and ennobling objects and situations but instead focuses on the base, coarse, crude, disgusting, and unseemly. In *Man on a Lawnmower,* we see an overweight man clutching a diet soda. He dwarfs the shabby riding mower he sits on. His T-shirt, baseball hat, pants, and sneakers are soiled. He is common and ordinary, and the entire sculpture is remarkably prosaic.

Man on a Lawnmower is a sad work. We see disillusionment in the man's eyes as he blankly stares off into space. The diet soda he holds suggests that he is trying to lose weight but is losing the battle. Grass-cutting is another metaphor for a losing battle, as the grass is going to grow back. This work also represents the banality of human existence.

We need only look at a 1972 photograph titled *Albuquerque* (fig. I-11) by Lee Friedlander to see how photography matches painting and sculpture in artistic merit. In *Albuquerque,* Friedlander portrays a modern America that is vacuous and lifeless, which he suggests is due to technology. How does he do this? The picture has a haunting emptiness. It has no people, and it is filled with strange empty spaces of walkway and

street that appear between the numerous objects that pop up everywhere. A hard, eerie geometry prevails, as seen in the strong verticals of the poles, buildings, hydrant, and wall. Cylinders, rectangles, and circles are everywhere. (Notice the many different rectangles on the background building, or the rectangles of the pavement bricks and the foreground wall.)

Despite the stillness and emptiness, the picture is busy and restless. The vertical poles and the strong vertical elements on the house and building establish a vibrant staccato rhythm. The energy of this rhythm is reinforced by the asymmetrical composition that has no focus or center, as well as by the powerful intersecting diagonals of the street and the foreground wall. (Note how the shadow of the fire hydrant runs parallel to the street.) Disturbing features appear throughout the composition. The street sign—which cannot be seen because it is cropped at the top of the print—casts a mysterious shadow on the wall. A pole visually cuts the dog in two, and the dog has been separated from his attribute, the fire hydrant, as well as from his absent owner. The fire hydrant, in turn, appears to be mounted incorrectly, because it sticks too far out of the ground. The car on the right has been brutally cropped, and a light pole seems to sprout strangely from its hood. The telephone pole in the center of the composition is crooked, as though it has been tilted by the force of the cropped car entering from outside the edge of the picture (of course, the car is parked and not moving). Why do we assume this empty, frenetic quality is human made? Because the work is dominated by the human made and by technology. We see telephone poles, electrical wires, crosswalk signs, an ugly machinelike modular apartment building, sleek automobiles, and a fire hydrant. Cropped in the lower left foreground is the steel cover to underground electrical wiring.

Everywhere, nature has been cemented over, and besides a few scraggly trees in the middle ground and distance, only the weeds surrounding the hydrant thrive. In this brilliant print, Friedlander captures his view of the essence of modern America: the way in which technology, a love of the artificial, and a fast fragmented lifestyle were spawning alienation and a disconnection with nature

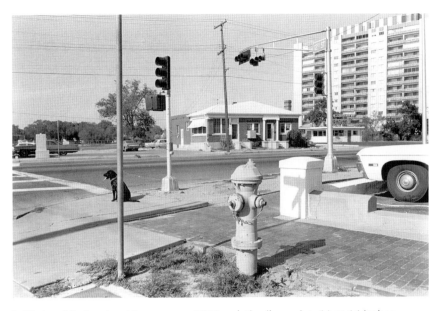

I-11 Lee Friedlander, *Albuquerque,* 1972, gelatin silver print, 11 × 14 inches
Source: ©Lee Friedlander

and spirituality. As important, he is telling us that modernization is making America homogeneous. The title tells us we are in Albuquerque, New Mexico, but without the title we are otherwise in Anywhere, U.S.A.

Friedlander did not just find this composition. He very carefully selected it and he very carefully made it. He not only needed the sun, he had to wait until it was in the right position (otherwise, the shadow of the fire hydrant would not align with the street). When framing the composition, he very meticulously incorporated a fragment of the utility cover in the left lower foreground, while axing a portion of the car on the right. Nor did the geometry of the picture just happen; he made it happen. Instead of a soft focus that would create an atmospheric blurry picture, he has used a deep focus that produces a sharp crisp image filled with detail, allowing, for example, the individual rectangular bricks in the pavement to be clearly seen. The strong white tones of the vertical rectangles of the apartment building, the foreground wall, and the utility box blocking the car on the left edge of the picture were probably carefully worked up in the darkroom, as was the rectangular columned doorway on the house. Friedlander has exposed the ugliness of modern America in this hard, cold, dry image, and because of the power of its message has created an extraordinarily beautiful work of art.

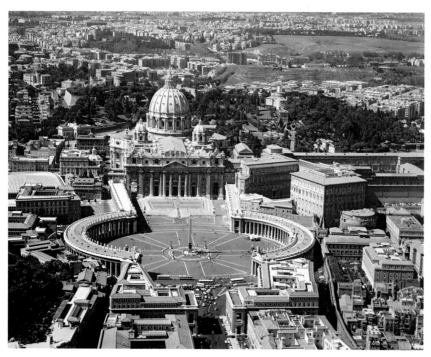

I-12 St. Peter's, Rome. Nave and facade by Carlo Maderno, 1607–15; colonnade by Gianlorenzo Bernini, designed 1657

Can Architecture Communicate Ideas?

An art form that is basically abstract and dedicated to structuring space in a functional way might be seen as hardly able to carry a message. And yet it does, especially in the hands of great architects. We see Gianlorenzo Bernini doing it in 1656 when he was asked by Pope Alexander XVII to design a large open space, or piazza, in front of St. Peter's cathedral in Rome. Bernini obliged, creating a space that was defined by a row of columns (a colonnade) resembling arms that appear to maternally embrace visitors, welcoming them into the bosom of the church (fig I-12). His form anthropomorphized the building by emphasizing the identification of the church with the Virgin Mary. At the same time, the French architect Claude Perrault was commissioned to design the East facade of King Louis XIV's palace, the Louvre in Paris (fig. I-13). To proclaim Louis's grandeur, he made the ground floor, where the day-to-day business of the court was carried out, a squat podium. The second floor, where Louis lived, was much higher and served as the main floor. Perrault articulated this elevated second story with a design that recalled Roman temples, thus associating Louis XIV with Imperial Rome and worldly power.

In our own era, an enormously wealthy businessman, Solomon R. Guggenheim indulged his passion for modern art by commissioning architect Frank Lloyd Wright to design a museum in New York City. One of the boldest architectural statements of the mid twentieth century, Wright's Solomon R. Guggenheim Museum is located on upper Fifth Avenue, overlooking Central Park (fig. I-14). The building, erected from 1956 to 1959, is radically different from the surrounding residential housing, thus immediately declaring that its function is different from theirs. As a matter of fact, the building is radically different from most anything built up until that time. We can say that the exterior announces that it is a museum, because it looks as much like a gigantic sculpture as a functional structure.

Wright conceived the Guggenheim in 1945, and his goal was to create an organic structure that deviated from the conventional static rectangular box filled with conventional static rectangular rooms. Beginning in the early twentieth century, Wright designed houses that related to the landscape and nature, both in structure and material (fig. 28-1). The structure of his buildings, whether domestic or commercial, reflects the very structure of nature, which he saw as a continuous expansion. His buildings radiate out from a central core or wrap around a central void, but in either case, they are

I-13 Claude Perrault. East front of the Louvre, Paris. 1667–70

meant to expand or grow like a leaf or crystal, with one form opening up into another.

The Guggenheim is based on a natural form. It is designed around a spiral ramp (fig. I-15), which is meant to evoke a spiral shell. The structure also recalls a ceramic vase: it is closed at the bottom and open at the top, and as it rises it widens, until it is capped by a light-filled glass roof. When referring to the Guggenheim, Wright often cited an old Chinese aphorism, "The reality of the vase is the space inside," and for the most part, the exhibition space is one enormous room formed by the spiral viewing ramp. Wright wanted visitors to take the elevator to the top of the ramp, and then slowly amble down its three percent grade, gently pulled by gravity. Because the ramp was relatively narrow, viewers could not get too far back from the art and were forced to have an intimate relationship with it. At the same time, they could look back across the open space of the room to see where they had gone, comparing the work in front of them to a segment of the exhibition presented on a sweeping distant arc. Or they could look ahead as well, to get a preview of where they were going. The building has a sense of continuity and mobility that Wright viewed as an organic experience, and looking down from the upper reaches of the ramp, we can see the undulation of the concave and convex forms that reflect the subtle eternal movement of nature. Wright even placed a pool on the ground floor, facing the light entering from the skylight high above.

Regardless of their size, no other museum has succeeded in creating a sense of open space and continuous movement as Wright did in the Guggenheim. Nor does any other museum have the same sense of communal spirit; at the Guggenheim everyone is united in one big room (see fig. I-15).

The Language of Art

As we have discussed, art is the visual expression of ideas. It has a message and makes statements. Like any language, it has a vocabulary. When discussing the Friedlander photograph, Wright's architecture, Hanson's sculpture, and the Copley and Warhol paintings, we actually touched on this vocabulary, because it is nearly impossible to talk about

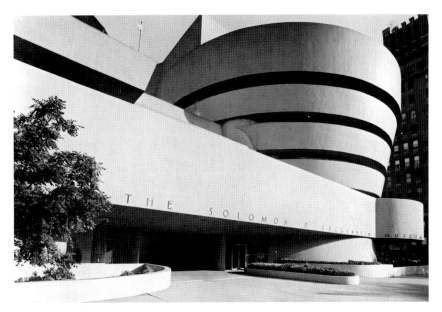

I-14 Frank Lloyd Wright. The Solomon R. Guggenheim Museum, New York. 1956–59. David Heald © The Solomon Guggenheim Foundation, New York
Source: @2004 Frank Lloyd Wright Foundation, Scottsdale, AZ/Artists Rights Society (ARS), NY

the messages in these works without describing how the artists brought them about. In the Friedlander photograph, for example, we discussed the artist's use of voids and harsh geometry, and how these devices had an impact on how we viewed the print's presentation of modern technology. Friedlander used both representational motifs and

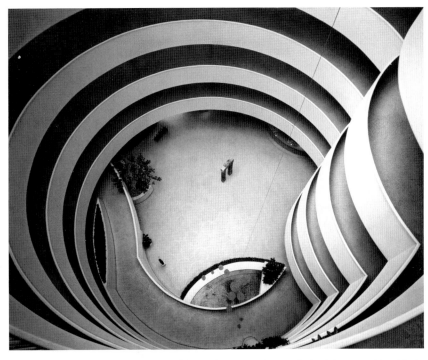

I-15 Frank Lloyd Wright. Interior of the Solomon R. Guggenheim Museum, New York. 1956–59. Robert Mates © The Solomon Guggenheim R. Foundation, New York
Source: @2004 Frank Lloyd Wright Foundation, Scottsdale, AZ/Artists Rights Society (ARS), NY

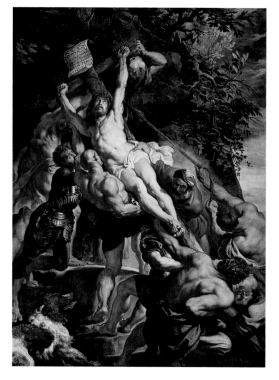

I-16 Raphael. *Alba Madonna.* Oil on panel, diameter 37¼″ (94 cm). National Gallery of Art, Washington, D.C.

abstract tools to tell his story. In painting, these abstract devices—line, color, composition, space, and form, for example—are also referred to as the formal qualities of the medium.

For most of the history of art, each period tends to share a similar vocabulary, or style. Each period has its own spirit, often called a *zeitgeist,* meaning the spirit of the time, and it employs a similar language to convey a similar message. Within this zeitgeist, there are regional variations, and within the regional variations, individual styles. But most art is contained within the broad period style that makes it instantly recognizable as being of its time.

We can see how this concept of style operates by comparing Raphael's (c. 1510) *Alba Madonna* (fig. I-16) with Peter Paul Rubens's 1609 *Raising of the Cross* (fig. I-17). Made roughly 100 years apart, the Raphael painting reflects a fifteenth- and early sixteenth-century view of Catholicism, whereas the Rubens painting supports a new, more fervent and emotional approach that characterizes the seventeenth century. The former period is called the Renaissance, the

latter the Baroque. What concerns us now, however, is not the labeling, but rather the different languages and messages of the two artists.

Raphael presents us with a harmonious view of the Catholic Church, as represented by John the Baptist, the Christ Child, and the Virgin Mary. The three figures are organized to form a stable pyramid with little sense of movement in this quiet scene. These sculpturesque monumental figures become frozen as they are aligned parallel to the picture plane. We can see this clearly in the crisp contour surrounding the group, but also in such passages as Christ's left arm and the Virgin's left shoulder and upper arm, as well as the outline of her headdress. Elements of the landscape follow the plane of the picture. Notice the buildings on the left, the earth immediately before them, and the flat silhouette of the grouping of some of the trees. Despite this planarity, each figure is volumetric, that is, round and three-dimensional. Raphael draws the rounded outline of each figure, and then bathes it in a soft dispersed light that gently models his forms, allowing shadow to make an arm or leg recede and light to pull it forward. Raphael's brush strokes are virtually imperceptible as they create his sculpturesque forms. Everything is solid, settled, and rational in this image. Even color has its assigned place, carefully contained in discreet areas to form solid building blocks of composition. Raphael has presented the Church as the embodiment of perfection—rock solid, rational, serene, harmonious, and comforting.

Rubens's *The Raising of the Cross* is anything but. His image is filled with dramatic movement as well as physical and emotional intensity. His composition is based on a pyramid as well. But now it is asymmetrical and unstable, pushed off to the right, creating unstable motion and action. Instead of running parallel to the picture plane, his composition moves in and out of the space. The plunging diagonal of the figure pulling up the cross in the lower right corner and Christ slanting backward set the tone for fierce spatial dynamics. This straining figure actually seems to be falling out of the composition into our space, drawing us into the scene. In contrast, Raphael's perfect heavenly world was hermetically sealed from us earth-bound sinners by his planar composition. Rubens's

I-17 Peter Paul Rubens. *The Raising of the Cross.* 1609–10. Center panel of a triptych, oil on panel, 15'1″ × 11'9⅝″ (4.57 × 3.60 m). Antwerp Cathedral

crowd of figures is composed of rippling muscles and undulating contours. A blast of light enters from the right dramatically highlighting Christ's torso and flickering throughout the image, causing our eye to jump from one light area to the next. Spots of strong color scattered here and there have the same effect. Although not obvious from our reproduction, Rubens's brushwork is bold and dramatic, causing the surface of the painting to ripple and be in constant flux. Nothing in this painting sits still.

Clearly, Rubens's sense of the world is quite different from Raphael's. As you will learn when studying the Baroque period, the political, social, scientific, and religious landscape changed enormously by the seventeenth century. Consequently, the language of art changed as well, reflecting fresh ways of perceiving the physical world, an increased religious fervor, and an unprecedented opulence that accompanied the rise of powerful monarchies. Throughout this book, we will be looking at how the language of art changes from one period to the next, as artists express changing views of the world. We'll also explore regional, nationalistic, and individual variations within each of these periods.

Experiencing Art

You will be astonished when you see first-hand much of the art in this book. No matter how accurate the reproductions in this book—or any other—are, they are just stand-ins for the actual objects. We hope you will visit some of the museums where the originals are displayed. But keep in mind that looking at art, absorbing its full impact takes time and repeated visits. Occasionally, you might do an in-depth reading of individual works. This would involve carefully perusing details and questioning why they are there.

Ideally, the museum will help you understand the art. Often, there are introductory text panels that tell you why the art has been presented together, and labels for individual works provide further information. Major temporary exhibitions generally have a catalogue, which adds yet another layer of interpretation. But text panels, labels, and catalogues generally reflect one person's reading of the art, and there are usually many other ways to approach or think about it.

Although the museum is an effective way to look at art and certainly the most efficient, art museums are relatively new. Indeed, before the nineteenth century, art was not made to be viewed in museums. Ultimately, art is everywhere: in galleries, corporate lobbies and offices, places of worship, and private homes. It can be found in public spaces, from subway stations and bus stops to plazas to such civic buildings as libraries, performing art centers, and city halls. University and college buildings are often filled with art, and the buildings themselves are art. The chair you are sitting in and the house and building you are reading this book in are also works of art, maybe not great art, but art all the same, as Duchamp told us. Even the clothes you are wearing are art. And everywhere you find art, it is telling you something and making a statement.

Art is not a luxury, as many people would have us believe, but an integral part of daily life. It has a major impact on us, even when we are not aware of it; we feel better about ourselves when we are in environments that are visually enriching and exciting. Most importantly, art stimulates us to think. Even when it provokes and outrages us, it broadens our experience by making us question our values, attitudes, and worldview. This book is an introduction to this fascinating field that is so intertwined with our lives. After reading it, you will find that the world will not look the same.

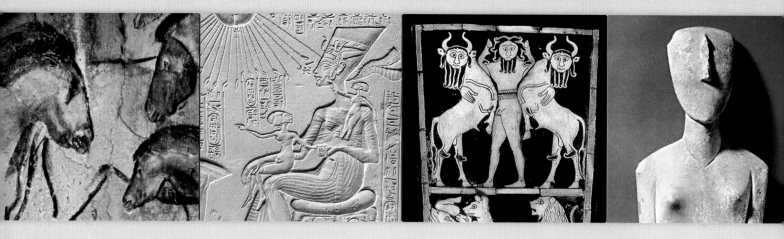

The Ancient World

Art history is more than a stream of art objects created over time. It is closely tied to history itself, that is, the recorded evidence of human events. We must therefore consider the *concept* of history. History, we are often told, began with the invention of writing by the "historic" civilizations of Mesopotamia and Egypt some 5,000 years ago. Without writing, the growth we have known would have been impossible. However, the development of writing seems to have taken place over a period of several hundred years—roughly between 3300 and 3000 B.C., with Mesopotamia in the lead—after the new societies were past their first stage. Thus "history" was well under way by the time writing could be used to record events.

The invention of writing serves as a landmark, for the lack of written records is one of the key differences between prehistoric and historic societies. But as soon as we ask why this is so, we face some intriguing problems. First of all, how valid is the distinction between "prehistoric" and "historic"? Does it merely reflect a difference in our *knowledge* of the past? (Thanks to the invention of writing, we know a great deal more about history than about prehistory.) Or was there a real change in the way things happened, and in the kinds of things that happened, after "history" began? Obviously, prehistory was far from uneventful. Yet the events of this period, decisive though they were, seem slow-paced and gradual when measured against the events of the last 5,000 years. The beginning of "history," then, means a sudden increase in the speed of events, a shift from low gear to high gear, as it were. It also means a change in the *kinds* of events. Historic societies literally make history. They not only bring forth "great individuals and

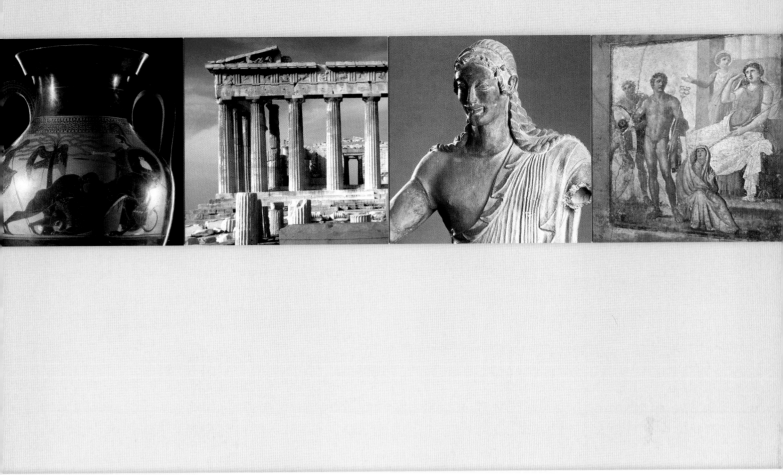

great deeds" (one definition of history) by demanding human effort on a large scale, but they make these achievements *memorable*. And for an event to be memorable, it must be more than "worth remembering." It must also occur quickly enough to be grasped by human memory, not spread over many centuries. Taken together, memorable events have caused the ever-quickening pace of change during the past five millenniums, which begin with what we call the ancient world.

This period was preceded by a vast prehistoric era of which we know almost nothing until the last Ice Age in Europe began to recede, from about 40,000 to 8000 B.C. (There had been at least three previous ice ages, alternating with periods of subtropical warmth, at intervals of about 25,000 years.) At the time, the climate between the Alps and Scandinavia resembled that of present-day Siberia or Alaska. Huge herds of reindeer and other large plant-eating animals roamed the plains and valleys, preyed upon by the ancestors of today's lions and tigers, as well as by our own ancestors. These people liked to live in caves or in the shelter of overhanging rocks. Many such sites have been found, mostly in Spain and in southern France. This phase of prehistory is known as the Old Stone Age, or Paleolithic era, because tools were made only from stone. Its way of life was adapted almost perfectly to the special conditions of the waning Ice Age, and it could not survive beyond them.

The Old Stone Age came to a close with what is termed the Neolithic Revolution, which ushered in the New Stone Age. And a revolution it was indeed, even though it was a period of transition that extended over several thousand years during the Mesolithic Age. It began in the "fertile crescent" of the Near East (an area covering what is now Turkey, Iraq,

Iran, Jordan, Israel, Lebanon, and Syria) sometime about 12,000–8000 B.C., with the first successful attempts to domesticate animals and food grains. The Neolithic came later to Europe but then spread much more rapidly.

The cultivation of regular food sources was one of the most decisive achievements in human history. People in Paleolithic societies had led the unsettled life of the hunter and food-gatherer, reaping wherever nature sowed. They were at the mercy of forces that they could neither understand nor control. But having learned how to ensure a food supply through their own efforts, they settled down in permanent villages. A new discipline and order entered their lives. There is, then, a very basic difference between the Neolithic and the Paleolithic, despite the fact that at first both still depended on stone for tools and weapons. The new way of life brought forth a number of new crafts and inventions long before the appearance of metals. Among them were pottery, weaving, and spinning, as well as basic methods of construction in wood, brick, and stone. When metallurgy in the form of copper finally appeared in southeastern Europe around 4500 B.C., at the beginning of the so-called Eneolithic era, it was as a direct outgrowth of the technology gained from pottery. Thus it did not in itself constitute a major advance; nor, surprisingly enough, did it have an immediate impact.

The Neolithic Revolution placed us on a level at which we might well have remained indefinitely. The forces of nature would never again challenge men and women as they had Paleolithic peoples. In a few places, however, the balance between humans and nature was upset by a new threat, one posed not by nature but by people themselves. Evidence of that threat can be seen in the earliest Neolithic fortifications, built almost 9,000 years ago in the Near East. What was the source of the human conflict that made these defenses necessary? Competition for grazing land among groups of herders or for arable soil among farming communities? The basic cause, we suspect, was that the Neolithic Revolution had been too successful. It had allowed population groups to grow beyond the available food supply. This situation might have been resolved in a number of ways. Constant warfare could have

reduced the population. Or the people could have united in larger and more disciplined social units for the sake of group efforts—such as building fortifications—that no loosely organized society could achieve on its own.

We do not know the outcome of the struggle in the region. (Future excavations may tell us how far the urbanizing process extended.) But about 3,000 years later, similar conflicts, on a larger scale, arose in the Nile Valley and again in the plains of the Tigris and Euphrates rivers. The pressures that forced the people in these regions to abandon Neolithic village life may well have been the same. These conflicts created enough pressure to produce the first civilizations. To be civilized, after all, means to live as a citizen, a town dweller. (The word civilization derives from the Latin term for city, civilis.) These new societies were organized into much larger units—cities and city-states—that were far more complex and efficient than had ever existed before. First in Mesopotamia and Egypt, somewhat later in neighboring areas, and in the Indus Valley and along the Yellow River in China, people would henceforth live in a more dynamic world. Their ability to survive was challenged not by the forces of nature but by human forces: by tensions and conflicts arising either within society or as the result of competition between societies. Efforts to cope with such forces have proved to be a far greater challenge than the earlier struggle with nature. The problems and pressures faced by historic societies thus are very different from those faced by peoples in the Paleolithic and Neolithic eras.

These momentous changes also spurred the development of new technologies in what we term the Bronze Age and the Iron Age, which, like the Neolithic, are stages, not distinct eras. People first began to cast bronze, an alloy of copper and tin, in the Middle East around 3500 B.C., at the same time that the earliest cities arose in Egypt and Mesopotamia. The smelting and forging of iron were invented about 2000–1500 B.C. by the Hittites, an Indo-European–speaking people who settled in Cappadocia (today's east central Turkey), a high plateau with abundant copper and iron ore. Indeed, it was the competition for mineral resources that helped create the conflicts that beset civilizations everywhere.

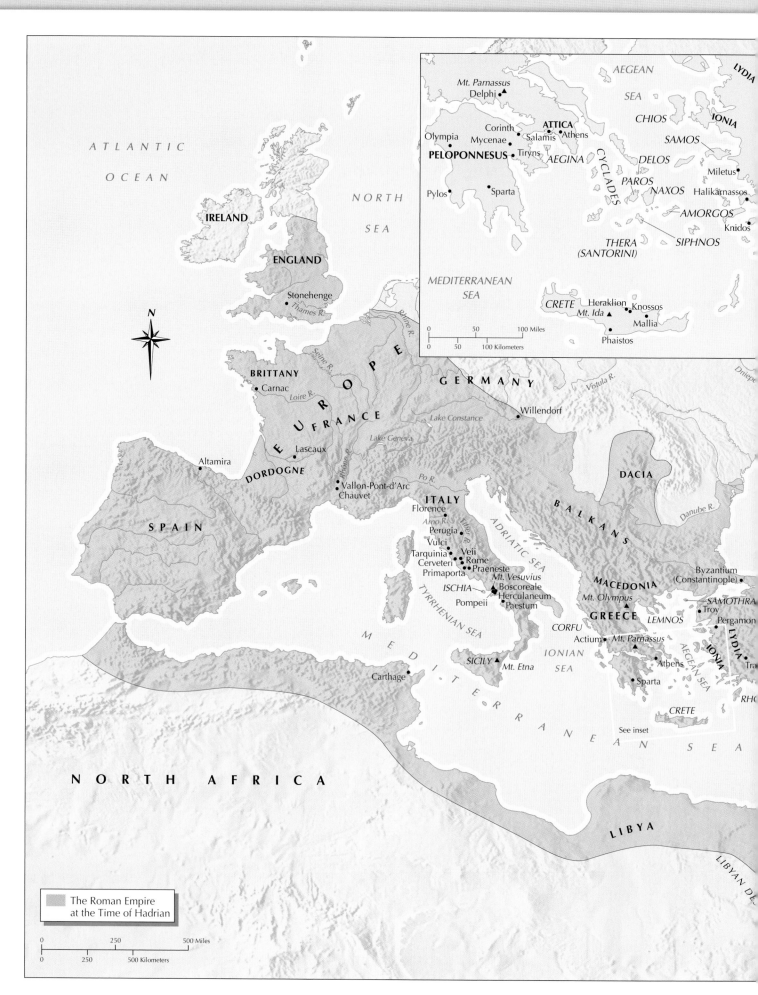

ATLANTIC
OCEAN

NORTH
SEA

IRELAND

ENGLAND

Stonehenge
Thames R.

N

BRITTANY
• Carnac

Loire R.

E U R O P E

FRANCE

DORDOGNE

Altamira •

• Lascaux

Vallon-Pont-d'Arc
Chauvet

SPAIN

Seine R.

Rhine R.

GERMANY

Lake Constance

Lake Geneva

Rhône R.

Po R.

Willendorf •

Vistula R.

Dniepr R.

DACIA

Danube R.

BALKANS

ITALY

Florence •
Arno R.
Perugia •
Vulci •
Tarquinia • Veii
Cerveteri • Rome
Primaporta • Praeneste

Tiber R.

ADRIATIC SEA

MACEDONIA

Mt. Olympus ▲

Byzantium
(Constantinople) •

ISCHIA
Mt. Vesuvius
Boscoreale
Herculaneum
Pompeii • Paestum

TYRRHENIAN SEA

GREECE

CORFU

Actium • Mt. Parnassus ▲

SAMOTHRA
Troy •
LEMNOS
Pergamon

LYDIA

IONIA

Tra

SICILY ▲ Mt. Etna

Carthage •

IONIAN
SEA

Athens •

Sparta •

AEGEAN SEA

RHO

M E D I T E R R A N E A N S E A

CRETE

See inset

N O R T H A F R I C A

LIBYA

LIBYAN DE

The Roman Empire
at the Time of Hadrian

0 250 500 Miles

0 250 500 Kilometers

Inset map

AEGEAN
SEA

LYDIA

Mt. Parnassus
Delphi • ▲

CHIOS

IONIA

Corinth
Olympia •
Mycenae •
Salamis
ATTICA
Athens

SAMOS

PELOPONNESUS
Tiryns •
AEGINA

DELOS

CYCLADES

Miletus •

Pylos •
• Sparta

PAROS
NAXOS

Halikarnassos •

AMORGOS

Knidos •

THERA
(SANTORINI)

SIPHNOS

MEDITERRANEAN
SEA

CRETE
Heraklion
Mt. Ida ▲ Knossos
Mallia

Phaistos

0 50 100 Miles

0 50 100 Kilometers

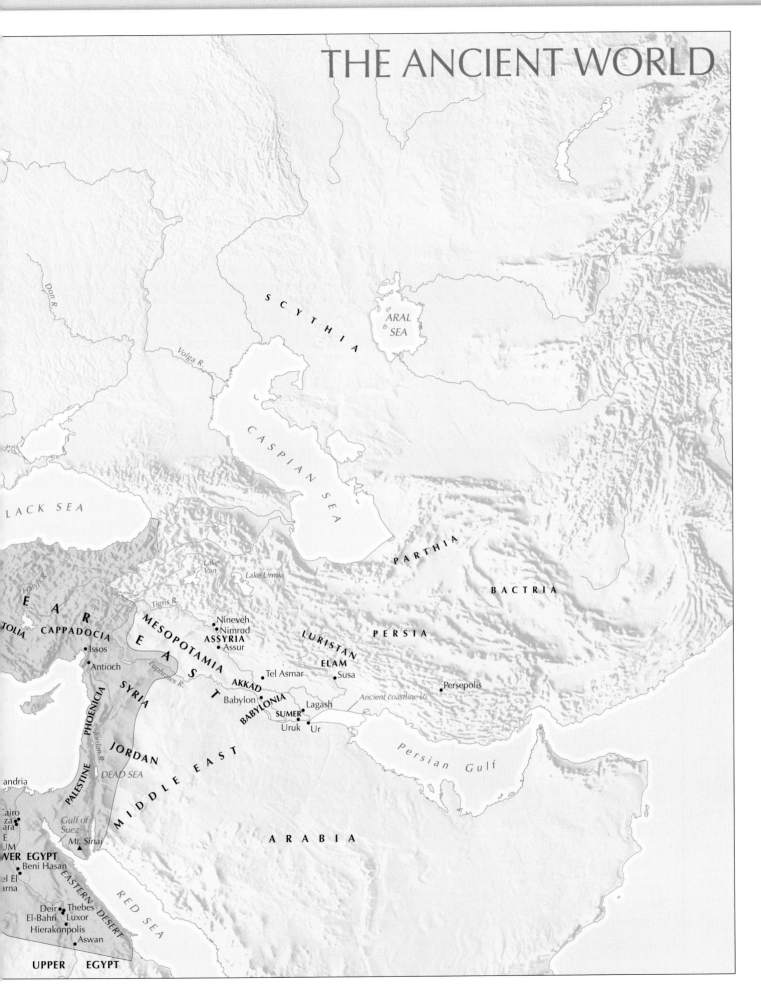

THE ANCIENT WORLD

Don R.

Volga R.

S C Y T H I A

ARAL SEA

C A S P I A N S E A

Halys R.

Lake Van

Lake Urmia

LACK SEA

PARTHIA

BACTRIA

E A R E A S T

TOLIA CAPPADOCIA

Tigris R.

M E S O P O T A M I A

Nineveh
Nimrud
ASSYRIA
Assur

LURISTAN
ELAM

PERSIA

Issos

Antioch

Euphrates R.

AKKAD

Tel Asmar

Susa

Persepolis

PHOENICIA

SYRIA

Babylon
BABYLONIA
SUMER
Uruk Ur

Lagash

Ancient coastline (?)

JORDAN

Jordan R.

PALESTINE

DEAD SEA

M I D D L E E A S T

P e r s i a n G u l f

andria

airo
za
ara
E
UM
WER EGYPT
Beni Hasan
el El
arna

Gulf of Suez

▲ *Mt. Sinai*

A R A B I A

EASTERN DESERT

RED SEA

Deir Thebes
El-Bahri Luxor
Hierakonpolis
Aswan

UPPER EGYPT

	4000–2000 B.C.	2000–1000 B.C.	1000–500 B.C.
POLITICAL HISTORY	Sumerians settle in lower Mesopotamia Early Dynastic period, Old Kingdom, Egypt (Dynasties 1–6), c. 3150–2190 Early dynastic period, Sumer, c. 4000–2340; Akkadian kings 2340–2180	Middle Kingdom, Egypt, c. 2040–1674 Hammurabi founds Babylonian dynasty c. 1760 Flowering of Minoan civilization c. 1700–1450 New Kingdom, Egypt, c. 1552–1069	Jerusalem capital of Palestine; rule of David; of Solomon (died 926) Assyrian Empire c. 1000–612 Persians conquer Babylon 539; Egypt 525 Romans revolt against Etruscans, set up Republic 510
RELIGION AND LITERATURE	Pictographic writing, Sumer, c. 3500 Hieroglyphic writing, Egypt, c. 3100 Cuneiform writing, Sumer, c. 2900 Divine kingship of the pharaoh Theocratic socialism in Sumer	Code of Hammurabi c. 1760 Monotheism of Akhenaten (ruled 1348–1336/35) *Book of the Dead*, first papyrus books, Dynasty 18	Hebrews accept monotheism Phoenicians develop alphabetic writing c. 1000; Greeks adopt it c. 800 First Olympian games 776 Homer (active c. 750–700), *Iliad* and *Odyssey* Zoroaster, Persian prophet (born c. 660) Aeschylus, Greek playwright (525–456)
SCIENCE AND TECHNOLOGY	Wheeled carts, Sumer, c. 3500–3000 Sailboats used on Nile c. 3500 Potter's wheel, Sumer, c. 3250 First bronze tools and weapons, Sumer	Bronze tools and weapons in Egypt Canal built from Nile to Red Sea Mathematics and astronomy flourish in Babylon under Hammurabi Hyksos bring horses and wheeled vehicles to Egypt c. 1725	Coinage invented in Lydia (Asia Minor) c. 700–650; soon adopted by Greeks Pythagoras, Greek philosopher (active c. 520)
PAINTING		*The Toreador Fresco,* Knossos, Crete (4-4) 4-4	Dipylon vase, Greece (5-1) Black-figure amphora by Psiax, Greece (5-3) Tomb of Hunting and Fishing, Tarquinia (6-2)
SCULPTURE	*Palette of King Narmer*, Egypt (2-1, 2-2) Statues from Abu Temple, Tell Asmar (3-3) Offering stand and harp, Ur (3-4, 3-5) *Menkaure and Queen Khameremebty*, Egypt (2-4) Female figure from Amorgos, Cycladic Islands (4-1) 2-4	Stela of Hammurabi, Susa (3-7) Head of Nefertiti, Egypt (2-13) Coffin of Tutankhamun, Egypt (2-14) Lion Gate, Mycenae (4-6)	Lion-hunt relief, Nimrud (3-8) *Kouros*, Greece (5-12) *Kore in Ionian Dress*, Greece (5-13) North frieze from Treasury of the Siphnians, Delphi (5-14) *Apollo*, Veii (6-5) 5-13
ARCHITECTURE	"White Temple" and ziggurat, Uruk (3-1, 3-2) Step Pyramid and funerary district of Zoser, Saqqara, by Imhotep (2-5, 2-6) Sphinx, Giza (2-9) Pyramids at Giza (2-7)	Stonehenge, England (1-5, 1-6) Palace of Minos, Knossos, Crete (4-2) Temple of Amun-Mut-Khonsu, Luxor (2-15) "Treasury of Atreus," Mycenae (4-5)	Ishtar Gate, Babylon (3-9) The Temple of Hera, Paestum (5-8)

Persian Wars in Greece 499–478

Periklean Age in Athens c. 460–429

Peloponnesian War, Sparta against Athens, 431–404

Alexander the Great (356–323) occupies Egypt 333; defeats Persians 331; conquers Near East

Rome dominates Asia Minor and Egypt, annexes Macedonia (and thereby Greece) 147

Julius Caesar dictator of Rome 49–44

Emperor Augustus (ruled 27 B.C.–14 A.D.)

Jewish rebellion against Rome 66–70; destruction of Jerusalem

Eruption of Mt. Vesuvius buries Pompeii, Herculaneum 79

Emperor Trajan (ruled 98–117) rules Roman Empire at its largest extent

Emperor Marcus Aurelius (ruled 161–80)

Shapur I (ruled 242–72), Sassanian king of Persia

Emperor Diocletian (ruled 284–305) divides Empire

Constantine the Great (ruled 324–37)

Sophocles, Greek playwright (496–406)

Euripides, Greek playwright (died 406)

Socrates, philosopher (died 399)

Plato, philosopher (427–347); founds Academy 386

Aristotle, philosopher (384–322)

Golden Age of Roman literature: Cicero, Catullus, Virgil, Horace, Ovid, Livy

Crucifixion of Jesus c. 30

Paul (died c. 65) spreads Christianity to Asia Minor and Greece

Persecution of Christians in Roman Empire 250–302

Christianity legalized by Edict of Milan 313; state religion 395

Augustine of Hippo (354–430), Jerome (c. 347–420)

Travels of Herodotus, Greek historian, c. 460–440

Hippokrates, Greek physician (born 469)

Books on geometry by Euclid (active c. 300–280)

Archimedes, physicist and inventor (287–212)

Invention of paper, China

Vitruvius's *De architectura*

Pliny the Elder (*Natural History*) dies in Pompeii 79

Seneca, Roman statesman

Ptolemy, Graeco-Egyptian geographer and astronomer (died 160)

Silk cultivation brought to eastern Mediterranean from China

Herakles Wrestling Antaios, red-figure krater, Greece (5-4)

Battle of Alexander and the Persians, Pompeian copy of Greek original (5-5)

Odyssey Landscapes, Rome (7-22)

Villa of the Mysteries, Pompeii (7-23)

House of the Vettii, Pompeii (7-21)

5-29

Portrait of a Boy, Faiyum, Egypt (7-25)

7-25

She-Wolf, Rome (6-6)

East pediment, Temple of Aphaia, Aegina (5-15)

Kritios Boy, Greece (5-16)

Zeus, Greece (5-17)

East pediment, Parthenon, Athens (5-21)

East frieze, Mausoleum, Halikarnassos (5-23)

Cinerary container, Etruria (6-3)

Dying Trumpeter, Greece (5-25)

Nike of Samothrace, Greece (5-28)

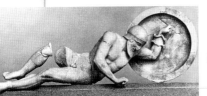

5-15

Roman Patrician, Rome (7-11)

Portrait Head, Delos (5-29)

Arch of Titus, Rome (7-17)

Column of Trajan, Rome (7-19)

Equestrian statue of Marcus Aurelius, Rome (7-13)

Philippus the Arab, Rome (7-15)

Colossal statue of Constantine the Great, Rome (7-16)

Palace, Persepolis (3-11)

Temple of Poseidon, Paestum (5-8)

Temples on Akropolis, Athens: Parthenon (5-9); Propylaia and Temple of Athena Nike (5-10)

Colosseum, Rome (7-5)

Pantheon, Rome (7-6, 7-7)

Basilica of Constantine, Rome (7-9, 7-10)

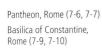

7-9

Prehistoric Art in Europe and North America

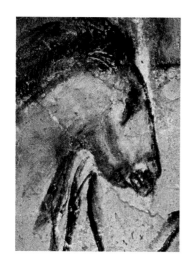

WHEN DID HUMAN BEINGS START CREATING WORKS of art? What prompted them to do so? What did these works of art look like? Every history of art must begin with these questions—and with the admission that we cannot answer them.

Our earliest known ancestors (called hominids) began to walk on two feet about four million years ago. (The chronology of paleontology is fluid and changes frequently, so that the dates given here are approximate.) Our species, *Homo sapiens*, also first emerged in Africa, some 250,000 years ago, during the Upper Paleolithic era (known as the Old Stone Age; see below), when it diverged from its nearest relatives, the Neanderthals. But the crucial evolutionary step came around 70,000 B.C. when, according to recent genetic analysis, people first developed the ability to speak. Speech is the necessary precondition, indeed the very foundation, of culture. Only 20,000 years later, a very short span in evolutionary terms, we find the first archaeological evidence of advanced tools, trade, and rudimentary art.

It is no accident that humans began to leave Africa around 50,000 B.C., about the same time that human culture emerged. This fact suggests competition for resources created by overpopulation—a pattern that has been repeated often since then. Although humans probably numbered no more than a hundred thousand or so, that number is astonishing, given that there were only about 15,000 breeding hominids a million years ago. People first crossed the Sinai Peninsula or the Red Sea, and then fanned out in all directions, to the Fertile Crescent (which stretches from Syria-Palestine in the west to the Euphrates and Tigris rivers in the east), up to Europe, across Asia and into India, China, and Southeast Asia. Eventu-ally they entered the Americas, probably across the Bering Strait, where they spread south and east. Some may also have crossed the Pacific in rafts, as they did in settling Australia and the numerous islands that dot that vast ocean.

Hominids must have used tools all along. After all, apes will pick up a stick to knock down a piece of fruit, or a stone to throw at an enemy. The *making* of tools is a more complex matter. It demands the ability to think of sticks as "fruit knockers" and stones as "bone crackers," not only when they are needed immediately for such purposes but at other times as well. The oldest manufactured tools, simple stone choppers, were probably made by hominids who lived in east Africa two million years ago.

Once humans were able to do this, they gradually found that some sticks and stones had a handier shape than others, and they put them aside for future use as tools because they had begun to connect *form* and *function*. The sticks, of course, have not survived, but a few of the stones have. These large pebbles or chunks of rock show the marks of repeated use for the same task, whatever that may have been. The next step was to try chipping away at these stones to improve their shape. With it we enter a phase of human development known as the Paleolithic period, or Old Stone Age, which in Europe lasted from about 40,000 to 8000 B.C. but began, as we have seen, much earlier in Africa.

Why the difference in time? Because Upper Paleolithic designates not a specific

era but a stage in cultural development, which varied by location as *Homo sapiens* spread across the world. During this time in Europe, *Homo sapiens* encountered earlier forms of humans, including Cro-Magnon man and Neanderthals. In many places they coexisted for thousands of years. (Cro-Magnon man endured until at least 40,000 years ago.) Whether they lived peaceably, and even mated, is still hotly debated. Eventually, however, these less developed species died out, unable to compete with the more intelligent and talented newcomers.

The Old Stone Age

CAVE ART

Chauvet The most striking works of Paleolithic art are the images of animals found on the rock surfaces of caves. In the Chauvet cave in southeastern France, we meet the earliest paintings known to us, which date from more than 30,000 years ago. Ferocious lions, panthers, rhinoceroses, bears, reindeer, and mammoths are depicted with extraordinary vividness, along with bulls, horses, birds, and occasionally humans. These paintings already show an assurance and refinement far removed from any humble beginnings. The horses seen in figure 1-1 amaze us by their forceful outlines and keenly observed features. Moreover, this artist (perhaps unintentionally) has invented something that is fundamental to all subsequent pictorial art and its offshoots (including engraving and sculpture in relief): the *plane*. Figure 1-1 shows three such planes, created by the overlapping of the animals' bodies. These are a foreground plane or **picture plane**, defined by the horse's head on the left and its two counterparts to the right; a *middle ground* plane, defined by the outlined body of the horse at center and the horse's head at top right; and an imagined or notional *background* plane, in front of which the animals all stand. Here and in other Paleolithic images, this planar system is not yet rigorously observed, perhaps because it was felt to be far less important than the act of creating the animals themselves. Notice,

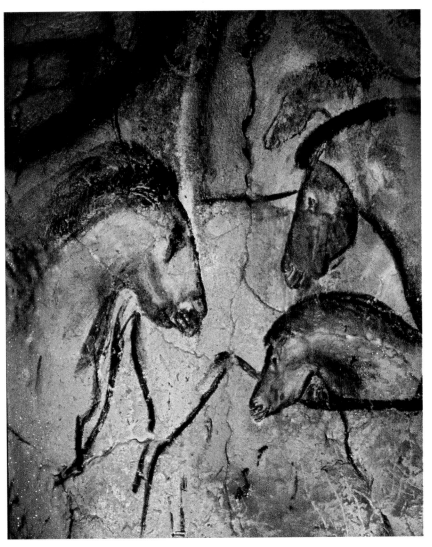

1-1 Cave paintings, Chauvet cave, Vallon-Pont-d'Arc, Ardèche gorge, France. C. 28,000 B.C.

for example, how in figure 1-1 the outlined belly of the horse at center cuts across the neck of the one at lower right.

It is hard to believe that such powerful, expressive, and sophisticated images came into being in a single, sudden burst. Were they preceded by thousands of years of development about which we know nothing at all?

Lascaux Based on differences among tools and other remains, scholars have divided later "cavemen" into several groups, each named after a specific site. Among these, the so-called AURIGNACIANS and MAGDALENIANS stand out for the gifted artists they produced and for the important role art must have played in their lives. One of the

The earliest Upper Paleolithic artists date to the AURIGNACIAN period and are best known for carved female statuettes such as the *"Venus" of Willendorf* (see fig. 1-3); some 130 of these have been found over a vast area from France to Siberia. The zenith of prehistoric art was reached during the MAGDALENIAN era, the last period of the Upper Paleolithic. Its masterpieces are the magnificent cave paintings of animals in the Périgord region of France, in the Pyrenees Mountains, and at Altamira in Spain.

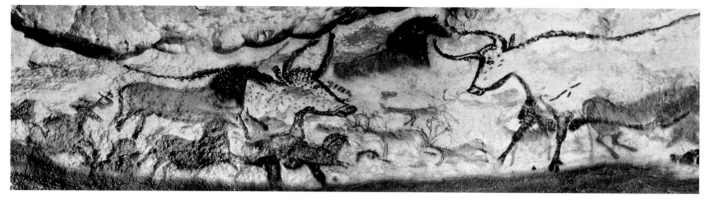

1-2 Cave paintings, Lascaux, Dordogne, France. c. 15,000–10,000 B.C.

This 30,000-year-old image of an owl in the Chauvet cave was made by pressing a flat-ended tool of some kind into the soft limestone surface of the cave wall, a process called **incising**. Most prehistoric incising produced chiseled lines that are narrower than those of this owl, but the process is the same.

major sites is at Lascaux, in the Dordogne region of France (fig. 1-2). As at Chauvet, bison, deer, horses, and cattle race across walls and ceiling. Some of them are outlined in black, others are filled in with bright earth colors, but all show the same uncanny sense of life. The style in both caves is essentially the same despite a gap of thousands of years—evidence of the stability of Paleolithic culture. Gone, however, are the fiercest beasts.

How did this amazing art survive intact over so many thousands of years? The question can be answered easily enough. The pictures never appear near the mouth of a cave, where they would be open to easy view and destruction. They are found only in dark recesses, as far from the entrance as possible. Some can be reached only by crawling on hands and knees. Often the path is so complex that one would soon be lost without an expert guide. In fact, the cave at Lascaux was discovered by chance in 1940 by some boys whose dog had fallen into a hole that led to the underground chamber.

What purpose did these images serve? Because they were hidden away to protect them from intruders, they must have been considered important. There can be little doubt that they were made as part of a ritual. But of what kind? The standard explanation is that they are a form of hunting magic. According to this theory, in "killing" the image of an animal (by throwing stones at it), people of the Old Stone Age thought they had killed its vital spirit. This later evolved into fertility magic, carried out deep in the bowels of the earth. But how are we to account for the presence at Chauvet of large

meat-eaters too dangerous to be hunted? Perhaps at first cavemen took on the identity of lions and bears to aid in the hunt. Although it cannot be disproved, this proposal is not completely satisfying, for it fails to explain many curious features of cave art.

There is growing agreement that cave paintings must embody a very early form of religion. If so, the creatures found in them have a spiritual meaning that makes them the distant ancestors of the animal divinities and their half-human, half-animal cousins we shall meet throughout the Near East and the Aegean. Indeed, how else are we to account for these later deities? Such an approach accords with animism—the belief that nature is filled with spirits—which thrived the world over in "primitive" societies that survived intact until recently.

Cave art is important as the earliest example of a long tradition found in civilizations everywhere: the urge to decorate walls and ceilings with **incised**, painted, or carved images that have a spiritual meaning. Because they were not constructed, caves such as Lascaux do not qualify as architecture (see below). Yet they served the same function as a church or temple. In that sense, they are the forerunners of the religious architecture featured throughout this book.

How did cave painting originate? In many cases the shape of an animal seems to have been suggested by the natural formation of the rock: its body coincided with a bump, or its contour followed a vein or crack. We all know how our imagination sometimes makes us see many sorts of images in clouds or blots. At first, Stone Age artists may have merely reinforced the outlines of

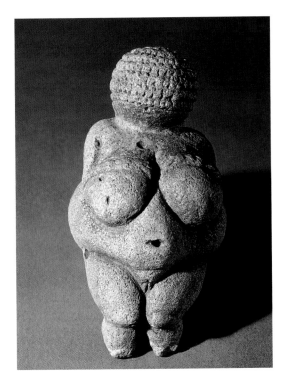

1-3 *"Venus" of Willendorf,* from Austria. c. 25,000–20,000 B.C. Limestone, height 4⅜" (11.1 cm). Naturhistorischesmuseum, Vienna

such images with a charred stick. It is tempting to think that those who were very good at finding such images were given a special status as artist-shamans. Then they were able to perfect their image hunting until they learned how to make images with little or no help from geology.

PORTABLE OBJECTS

Apart from large-scale cave art, the people of the Upper Paleolithic also produced small, hand-sized drawings and carvings in bone, horn, or stone, skillfully cut with flint tools. Some of these carvings suggest that they, too, may have stemmed from the perception of a chance resemblance. Earlier Stone Age people were content to collect pebbles in whose natural shape they saw some special quality. Echoes of this approach can sometimes be felt in later pieces. The so-called *Venus of Willendorf* (fig. 1-3), one of many such female figurines, has a roundness that recalls an egg-shaped "sacred pebble." Her navel, the central point of the design, is a natural cavity in the stone. Judging from the spiritual beliefs of the "preliterate" societies of modern times, scholars have often seen such carvings as fertility figures. Although

the idea is tempting, we cannot be sure that such beliefs existed in the Old Stone Age.

The New Stone Age

NEOLITHIC EUROPE

The art of the Old Stone Age in Europe as we know it represents the highest achievement of a culture that began to transform itself soon afterward. The change is marked by the rise of fired-clay pottery, which first appeared in the Near East about 6000 B.C. and eventually spread to Europe during the Mesolithic era, the transitional period between the last Ice Age and the Neolithic Age. Pottery, being breakable but durable, has survived in large numbers of fragments, known as sherds (or shards). Because the earliest sherds uncovered by archaeologists are so scattered, it is unclear whether pottery making at first arose independently in several places or was transmitted through direct contact. Over time, the patterns of distribution become clearer, with different forms making it possible to chart successive changes in culture. A great variety of clay vessels covered with abstract patterns have been found, along with stone tools of ever-greater technical refinement and beauty. But none of these items can be compared to the painting and sculpture of the Paleolithic Age.

Figurines There may be a vast chapter in the development of art that is largely lost because Neolithic artists worked mainly in wood or other impermanent materials. The shift from hunting to raising animals for food that occurred at this time must have been accompanied by profound changes in the people's view of themselves and the world—changes that were no doubt reflected in their art. Archaeologists have discovered many prehistoric sites in recent years, and as more are excavated and documented, patterns of development may arise that suggest answers.

Unfortunately, the tangible evidence of Neolithic settlements tells us very little about the spiritual life of the New Stone Age. Baked clay figurines, however, sometimes provide a tantalizing hint of Neolithic

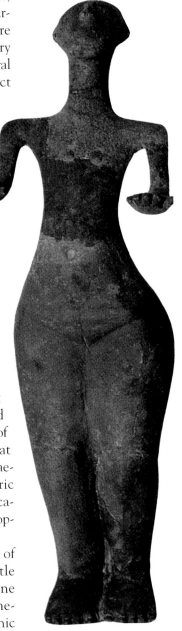

1-4 *Woman,* from Hluboké Masuvky, Moravia, Czech Republic. c. 3000 B.C. Clay, height 13" (33 cm). Vildomec Collection, Brno

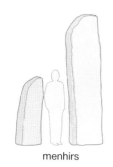
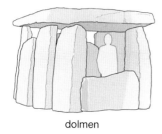

menhirs

dolmen

religious beliefs. The earliest European examples, produced in the Balkans but of Near Eastern type, still remind us of the *"Venus" of Willendorf* (see fig. 1-3). Yet one dating to about 3000 B.C. (fig. 1-4) has, despite her massive legs, an almost girlish figure, which lends her a surprisingly modern appearance. With arms and head raised in a gesture of worship, our statuette radiates a very human charm that is as irresistible now as the day she was made.

Menhirs, Dolmens, and Cromlechs

Long after the introduction of bronze about the beginning of the third millennium B.C., a sparse population in central and northern Europe continued to lead a simple tribal life in small village communities. Hence, there is no clear distinction from the Neolithic. Neolithic and Bronze Age Europe never reached the level of social organization necessary to produce the masonry construction found in New Stone Age sites in the Near East. Instead we find monumental stone structures of a different kind, first in France and Scandinavia and then in England. These structures are termed megalithic because they are made of huge blocks or boulders used either singly or placed upon each other without mortar. Even today these monuments, built about 4500–1500 B.C., have a superhuman air about them, as if they were the work of a race of giants.

The simplest are MENHIRS: upright slabs that served as grave markers. Sometimes they were arranged in rows, as at Carnac in northern France. Carnac features another type as well, known as DOLMENS. Originally underground, these are tombs perhaps built as "houses of the dead." Finally, there are the so-called Cromlechs, found only in the British Isles, which were the settings of religious rites. Many scholars believe that the huge effort required to construct them could be compelled only by religious faith—a faith that almost literally demanded the moving of mountains.

The last and most famous of the cromlechs is Stonehenge in southern England (figs. 1-5, 1-6). What we see today is the result of several distinct building campaigns, beginning in the New Stone Age and continuing into the early Bronze Age. During the first phase, from roughly 3500 to 2900 B.C., a nearly continuous circle (henge) was dug into the chalk ground. A silted ditch was added about 3300–2140 B.C., then the avenue down to the Avon River sometime from 2580 to 1890 B.C. The sandstone (sarsen) circle of evenly spaced trilithons, each consisting of two uprights (or posts) and a horizontal slab (or **lintel**), was erected during the early Bronze Age Wessex culture, between 2850 and 2200 B.C. These immense stones were evidently dragged from Marlbor-

1-5 Stonehenge, Salisbury Plain, Wiltshire, England. c. 2000 B.C. Diameter of circle 97′ (29.57 m)

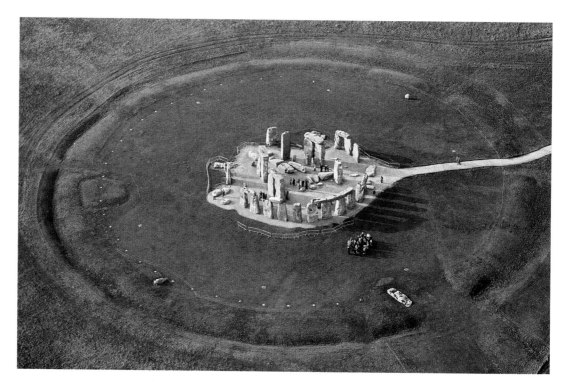

ough Downs, some 20 miles away—a feat as awesome as raising them. But it is far from clear whether the stones of the inner blue-stone circle and horseshoe, which date from several hundred years later (2480–1940 B.C.), were deposited by glaciers or carried by carts and rafts from the Preseli Mountains in Wales some 200 miles to the west. During the final phase, from 2030 to 1520 B.C., this arrangement was echoed in two similarly marked circles and a smaller horseshoe that enclose an altarlike stone at the center.

Why was Stonehenge built in the first place? The widely held belief that the so-called Heel Stone was positioned so that the sun would rise directly above it on the day of the summer solstice (when the sun is farthest from the equator) has long been shown to be incorrect. It appears that Stonehenge was originally aligned with the major and minor northern moonrises. Only later, as the earth's position continued subtly to shift in relation to the heavens, did the structure become oriented toward the sun: the Heel Stone and fallen "Slaughter Stone," along with other stones and the axis of the causeway, were rearranged in the direction of the midsummer sunrise.

Each of Stonehenge's building phases was linked to broader changes during the Neolithic and Bronze ages. Burial mounds, called barrows, and henges from as early as 3500 B.C. that have been found in Scandinavia and northern Britain reflect the changeover to a settled, agrarian way of life. The fact that they continued to be built until about 2000 B.C. testifies to a relatively stable Neolithic culture. However, the people who created the Wessex culture probably crossed the English Channel from Brittany in northwestern France, where megalithic horseshoes constructed along astronomical axes are far more common than in England. They brought with them Bronze Age technologies and ideas that must have seemed revolutionary to the local population, who initially put up a stiff resistance. At Stonehenge and elsewhere in southern England, these newcomers imposed their own traditions on established practices. In addition to erecting even larger cromlechs, they buried their leaders in barrows lined with boulders, making them, in effect, underground dolmens. Some of these tombs even have a rudimentary form of vaulting known as

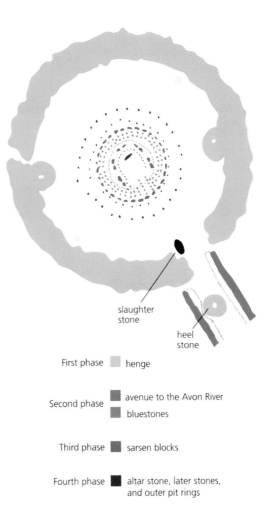

1-6 Diagram of original arrangement of stones at Stonehenge (after original drawing by Richard Tobias)

slaughter stone

heel stone

First phase █ henge

Second phase █ avenue to the Avon River

 █ bluestones

Third phase █ sarsen blocks

Fourth phase █ altar stone, later stones, and outer pit rings

corbeling, which is also found in Mycenaean "beehive" tombs (see fig. 4-5), as well as in certain Etruscan tombs (see chapter 6). Stonehenge was eventually abandoned about 1100 B.C. as part of another change that occurred during the late Bronze Age: the preference for cremation over inhumation burials.

By definition, menhirs and dolmens are monuments. Not only are they large, but they commemorate the dead. Whether they and cromlechs should be termed architecture is also a matter of definition. We tend to think of architecture in terms of enclosed interiors, but we also have landscape architects, who design gardens, parks, and playgrounds. Open-air theaters and sports stadiums are likewise thought of as architecture. To the ancient Greeks, who coined the term, *architecture* meant something higher (*archi*) than the usual construction or building, much as an archbishop ranks above a bishop. Architecture differed from practical, everyday building in scale, order, permanence, and purpose. A Greek would have viewed

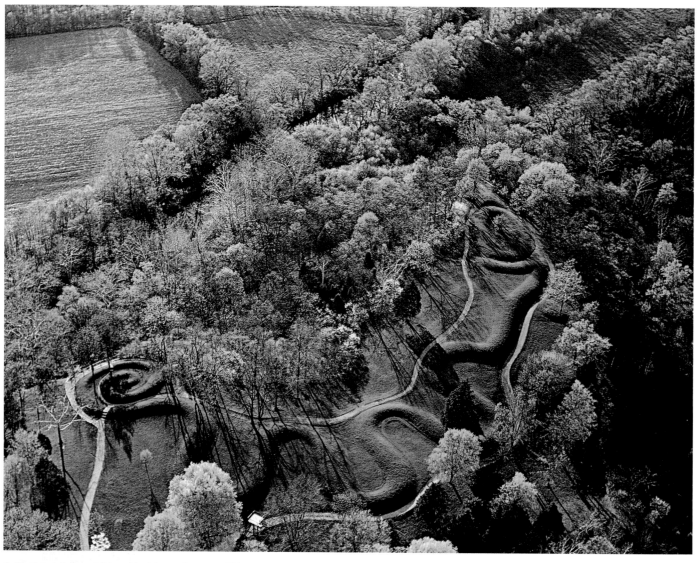

1-7 Great Serpent Mound, Adams County, Ohio. c. A.D. 1070 Length 1,400′ (426.72 m)

Carnac and Stonehenge as architecture, because their builders rearranged nature to serve as settings for human activities and to express shared beliefs. We, too, will be able to accept them as architecture once we understand that it is not necessary to *enclose* space in order to define it. If architecture is "the art of shaping space to human needs and aspirations," then Carnac and Stonehenge more than meet the test.

NEOLITHIC NORTH AMERICA

The "earth art" of the prehistoric Indians of North America, the so-called Mound Builders, may be usefully compared to the megalithic monuments of Europe. These mounds vary greatly in shape and purpose as well as in date, ranging from about 2000 B.C. to the time of Columbus. Of particular interest are the "effigy mounds" in the shape of animals, presumably the totems of the tribes that produced them. The most spectacular is the Great Serpent Mound (fig. 1-7), a snake some 1,400 feet long that slithers along the crest of a ridge by a small river in southern Ohio. The huge head, its center marked by a heap of stones that may once have been an altar, occupies the highest point. It appears that the natural formation of the terrain inspired this extraordinary work of landscape architecture, as mysterious and moving in its way as Stonehenge.

Egyptian Art

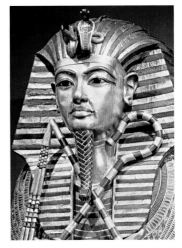

E GYPTIAN CIVILIZATION HAS LONG BEEN CONSIDERED THE MOST
rigid and conservative ever. Perhaps "enduring" and "continuous" are better terms for
it, although at first glance all Egyptian art between 3000 and 500 B.C. does have a cer-
tain sameness. The basic pattern of Egyptian institutions, beliefs, and artistic ideas was
formed during the first few centuries of that vast time span and was maintained until the end.
At times, however, this pattern experienced a series of severe crises that threatened its sur-
vival. Had it been as inflexible as supposed, Egyptian civilization would have collapsed at an
early date. Egyptian art alternates between conservatism and innovation, but is rarely static.
Moreover, its greatest achievements had a decisive influence on Greek and Roman art. Thus
we still feel ourselves linked to the Egypt of 5,000 years ago by a continuous tradition.

The Old Kingdom

DYNASTIES, THE PHARAOH, AND BELIEFS

Following ancient custom, modern scholars divide the history of Egypt into dynasties of rulers, beginning with the First Dynasty, shortly before 2900 B.C. (The dates of the earliest rulers are difficult to translate precisely into our calendar. This book uses the dating system of the Egyptologists John Baines and Jaromir Málek.) The transition from prehistory to the First Dynasty is called the Predynastic period. The next major period, known as the Old Kingdom, lasted from about 2650 B.C. until about 2150 B.C., the end of the Sixth Dynasty. This method of counting historic time by dynasties conveys both the strong Egyptian sense of continuity and the prime importance of the pharaoh (king), who was not only the supreme ruler but also a god.

The pharaoh transcended all people, for his kingship was not a privilege derived from a superhuman source but was absolute, divine. As the earthly embodiment of divine order, he had the task of maintaining the cults and rituals of the state religion, and thereby of persuading the gods constantly to reenact creation and to keep the world stable. By building temples and commissioning cult items (statues included), he performed acts of creation that strengthened order and banished chaos. These beliefs were central to Egyptian civilization and largely shaped the character of Egyptian art. We do not know the exact steps by which the early pharaohs established their claim to divinity, but we know their historic achievements. They molded the Nile Valley from the First Cataract (falls) at Aswan to the Delta into a single state, urbanized the region, and increased its fertility by regulating the river waters through dams and canals.

TOMB CULT

Nothing remains today of these vast public works, and very little has survived of ancient Egyptian palaces and cities. Our knowledge of early Egyptian civilization rests almost entirely on tombs and their contents. The survival of these structures is no accident, because they were built to last forever. Yet we must not make the mistake of concluding that the Egyptians viewed life on this earth mainly as a road to the grave. Their cult of

Major Periods In Ancient Egypt	
Before c. 2920 B.C.	Predynastic
c. 2920– 2469 B.C.	Early Dynastic (Dynasties 1, 2)
c. 2469– 2150 B.C.	Old Kingdom (Dynasties 3–6)
c. 2040– 1783 B.C.	Middle Kingdom (Dynasties 11, 12)
c. 1550– 1070 B.C.	New Kingdom (Dynasties 18–20)

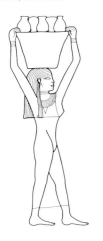

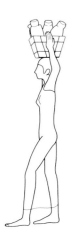

But he imposes a strict rule on himself. When the angle of vision changes, it must be by 90 degrees, as if sighting along the edges of a cube. Hence, only three views are possible: full face, strict profile, and vertically from above. In Egyptian court and elite art, any other position is non-canonical (see the sidebar on page 35) and is usually reserved for enemies and lower-class individuals. (Compare the rubbery figures of Narmer's fallen foes at the bottom of figure 2-1.) Moreover, the standing human figure does not have a single main profile. Instead, it has two different profiles, which must be combined for the sake of clarity. The method of doing this (which was to survive unchanged for 2,500 years) is shown in the large figure of Narmer in figure 2-1: eye and shoulders in frontal view, head and legs in profile.

This formula was worked out so as to show the pharaoh (and all those who move in the aura of his divinity) in the most complete way possible. And because the scenes describe solemn, timeless rituals, our artist could ignore the fact that this method of depicting the human body made movement and action hard to convey. In fact, the frozen quality of the image seems well suited to the divine nature of the pharaoh. Imposing order on the earth by his very presence, he banishes the forces of chaos wherever he appears.

Whenever any movement requiring some sort of effort or strain must be depicted, the Egyptian artist abandons the combined view, for such activities are always performed by underlings whose dignity does not have to be preserved. Thus in our palette the two animal trainers and the four men carrying standards are shown in strict profile, except for the eyes. The composite view seems to have been created specifically by artists working for the royal court to convey the majesty of the divine king. It never lost its sacred flavor, even in later times, when it had to serve other purposes as well.

Tomb of Ti Old Kingdom artists soon adopted this highly conventionalized style for the decoration of elite tombs. The hippopotamus hunt in figure 2-3, from the offering chambers of the architectural overseer Ti at Saqqara, is of special interest because of its landscape setting. Carved in low relief, it is essentially three-dimensional painting. The background is a papyrus thicket. The stems form a regular design that erupts in the top zone into an agitated scene of nesting birds menaced by small animals. The water in the lowest or foreground zone, indicated by a zigzag pattern, is equally crowded with struggling hippopotamuses and fish. All these, as well as the hunters in the first boat, are carefully observed and full of action. Only Ti himself, standing in the second boat, is immobile, as if he belonged to a different world. His pose is that of funerary portrait reliefs and statues (compare fig. 2-4). He towers above the other men since he is more important than they.

Ti's size also lifts him out of the context of the hunt. He does not direct it; he simply observes. His passive role is typical of the representations of the deceased in all such scenes from the Old Kingdom. It seems to be a way of conveying that the body is dead but the spirit is alive and aware of the pleasures of this world, although the man can no longer participate in them directly. We should also note that these scenes of daily life do not represent the dead man's favorite pastimes. If they did, he would be looking back, and such nostalgia is quite alien to the spirit of Old Kingdom tombs. It has been shown, in fact, that these scenes form a seasonal cycle, a sort of perpetual calendar of recurring human activities for the spirit of the deceased to watch year in and year out.

The hunt may have symbolic meaning as well. Osiris, the mythical founder of Egypt, was associated with the Nile and the underworld as the god of fertility, death, and resurrection. In ancient tradition, he was murdered and dismembered by his brother Seth, who sealed him in a casket that was cast into the Nile. Seth scattered his remains after Osiris's consort, Isis, retrieved the casket. She eventually recovered his parts and reassembled them into the first mummy, from which she conceived her son, Horus. Horus avenged his father's death by besting Seth in a series of contests lasting 80 years. As a result, Osiris became lord of the Underworld, Horus the ruler of the living, and Seth the god of chaos and evil who governed the

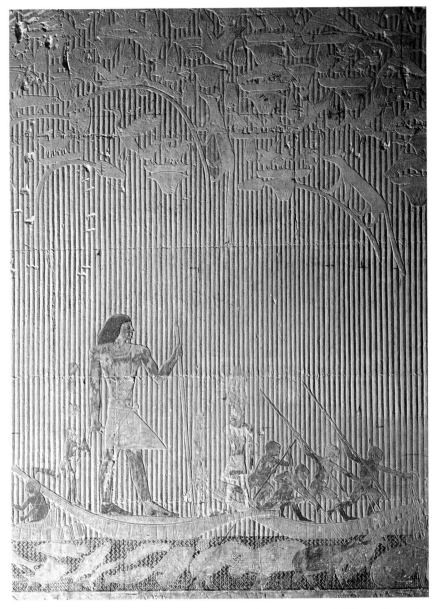

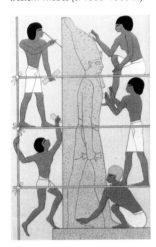

2-3 *Ti Watching a Hippopotamus Hunt,* Tomb of Ti, Saqqara. c. 2400 B.C. Painted limestone relief, height approx. 45" (114.3 cm)

deserts. The hippopotamus was viewed as a baneful animal that destroyed crops, and thus as the embodiment of Seth. In turn, the deceased may be likened to Osiris. Moreover, the papyrus thicket was where Isis hid Horus to protect him from Seth, so that it was seen as a place of rebirth, much like the tomb itself. Finally, the boat traditionally carried the ka through its eternal journey in the afterlife.

Scenes of daily life allowed Egyptian artists to exercise their formidable powers of observation. We often find astounding bits of realism in the description of plants and animals. Note, for example, the hippopota-mus in the lower right-hand corner, turning its head in fear and anger to face its attackers. This vivid portrayal is as delightful as it is unexpected. Even more remarkable is the variety of poses among the hunters—low-status folk unaffected by the rules that govern the figure of Ti. Eventually even the deceased will abandon his passive, timeless stance to participate in scenes of daily life (see fig. 2-12).

Portraits The "cubic" approach to the human form can be observed most strikingly in Egyptian **sculpture in the round,** such as the splendid group of King Menkaure and his

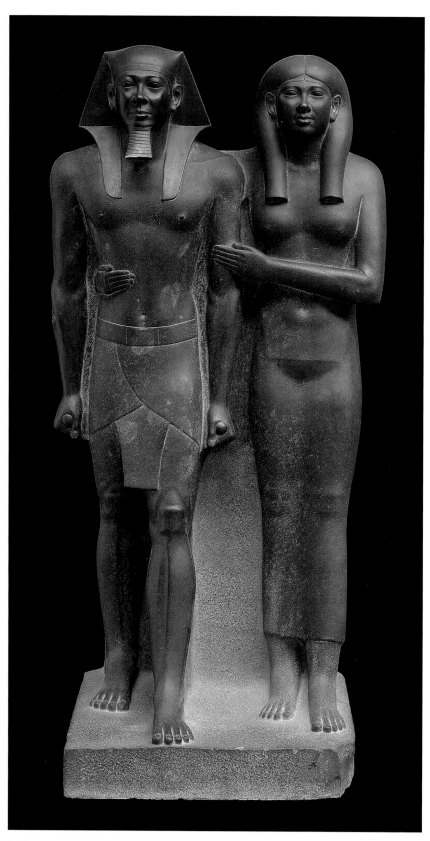

2-4 *King Menkaure (Mycerinus) and Queen Khamerernebty,* from Giza. c. 2480 B.C. Slate (graywacke), height 54¹/₂" (138.4 cm). Museum of Fine Arts, Boston

queen, Khamerernebty (fig. 2-4). These are idealized portraits. Because they were destined for display in open-fronted shrines, and were intended to "see" the rituals performed in front of them, all these figures are rigidly frontal, and stride forward with the left foot. Like the images of Narmer and Ti, they follow a canonical plan "spoken by the ancestors." After marking the surfaces of the rectangular block with a grid, the sculptor drew the front, top, and side views of the statue on the block, then worked inward until these views met. This approach automatically generated a body that was highly conventionalized and governed by a set of systematic, standardized proportions. Although the grid changed somewhat over the centuries, at any given time this CANON was uniformly respected in Egyptian royal and elite sculpture and painting. It encoded a worldview that was authoritative ("spoken by the ancestors"), timeless, infinitely replicable, and uniquely Egyptian. These beliefs both obligated the sculptor to reproduce the canon endlessly, but paradoxically also enabled him to achieve figures of overpowering three-dimensional monumentality—magnificent vessels for the ka to inhabit forever.

The pair allows us to compare the Egyptian ideals of male and female beauty as conveyed by one of the finest Old Kingdom sculptors. The artist knew not only how to contrast the structure of the two bodies but also how to emphasize the soft, swelling body of the queen through a thin, close-fitting gown. Like other Old Kingdom statues, the group was originally vividly colored and thus strikingly lifelike in appearance. Unfortunately, only a few vague blotches have survived, but according to the standard convention of Egyptian art, the king would have had a darker body color than the queen. Their eyes, too, would have been painted, and perhaps inlaid with shining quartz, to make them look as alive as possible and to emphasize the individuality of the faces.

ARCHITECTURE

When we speak of the Egyptians' attitude toward death and afterlife, we do not mean that of the average Egyptian. We are referring to the outlook of the small aristocratic elite clustered around the royal court. The tombs of this class of high officials, who were

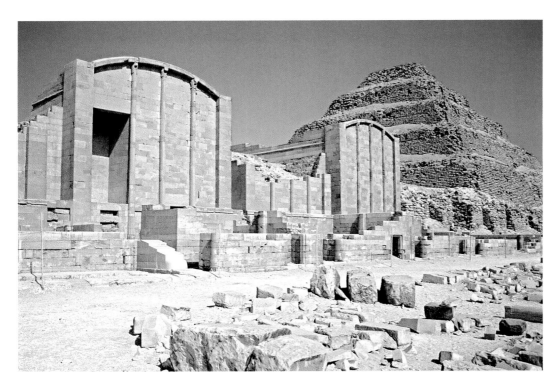

2-5 Imhotep. Step Pyramid of King Djoser, Saqqara. c. 2630–2611 B.C.

often relatives of the royal family, are usually found near the pharaohs'. Their shape and contents emulate the tombs of the kings. We still have a great deal to learn about the origin and significance of Egyptian tombs, but the concept of afterlife we find in the so-called private tombs initially seems to have applied only to the privileged few because of their association with the pharaohs. Ordinary mortals could look forward only to a shadowy afterlife in the underground realm of the dead.

As early as the Fourth Dynasty, wealthy individuals built tombs imitating royal examples, complete with paintings and reliefs, cut into the bedrock near Giza. The standard marker for these tombs was the **mastaba** (the word comes from the Arabic for "bench" because of their shape): a squarish mound faced with brick or stone built above the burial chamber, which was deep underground and linked to the mound by a shaft. The mastaba housed a chapel for offerings to the ka and a secret cubicle for the statue of the deceased (see fig. 2-8).

Pyramids　Royal mastabas became quite large as early as the First Dynasty, and their exteriors sometimes resembled that of a royal palace. During the Third Dynasty, they developed into step pyramids. The best known (and probably the first) is that of King Djoser (fig. 2-5), which consists of five square, solid platforms superimposed upon a traditional mastaba. This step pyramid's functions were mortuary, commemorative, religious, and "political": in addition to housing the pharaoh's body in death, it declared his supreme power and divine status in life. Its height and shape suggest Mesopotamian **ziggurats** (see fig. 3-1). It, too, was perhaps intended to bridge the gap with the heavens by serving as the "stairway" and "jumping-off" point for Djoser to ascend to the heavens and fulfill his cosmological role as a god.

Pyramids were not isolated structures in the middle of the desert; they were part of vast funerary districts, with temples and other buildings that were the scene of great religious celebrations during the pharaoh's lifetime as well as after. The funerary district around the Step Pyramid of Djoser is both the earliest and the first built entirely of stone, which had been used sparingly before that time. Enough of it has survived for us to see why its creator, Imhotep, came to be revered as the founder of Egyptian culture. He was both vizier (overseer) to the king and high priest of the sun god Ra. Imhotep is the first artist whose name has been recorded in history, as well as the first in a long line of Egyptian architects that are known to us.

The Egyptian CANON of proportions basically divided the standing human figure into 18 units, the seated figure into 14. Artists achieved precision through the use of a system of grids drawn on the stone, which were removed as the carving progressed. A similar system was used on two-dimensional works.

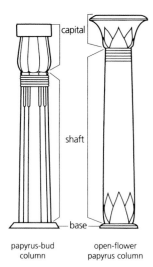

papyrus-bud column open-flower papyrus column

Imhotep's achievement is impressive not only for its scale but also for its highly structured organization, which embodies the mission of the pharaoh to perfection. The funerary district proclaims Djoser king of both Upper and Lower Egypt, in that there are two of everything, including north and south "palaces" (or shrines) and a second tomb. The east courtyard was used for ritual purposes during the pharaoh's coronation. In accordance with Egyptian beliefs about creation and the pharaoh's duty to reenact it, this ceremony was to be restaged there as part of the Sed festival to celebrate his jubilee 30 years later. (Unfortunately for Djoser, though, his reign lasted only 19 years.) Imhotep must have had a remarkable intellect as well as outstanding ability—he was renowned as an astronomer and later deified as a healer. In this regard he set a precedent for the great architects who followed in his footsteps. In that they too address the important ideas and issues of their time, today's architects are his direct descendants.

Columns Egyptian architecture had begun with structures made of mud bricks, wood, reeds, and other light materials. Although Imhotep used cut stone masonry, his architectural forms reflected shapes and devices developed for these less enduring materials. Thus, we find **columns** of several kinds—always **engaged** (set into the wall rather than **freestanding**)—which echo the bundles of reeds or the wooden supports that were set into mud-brick walls to strengthen them. But the very fact that they no longer had their original function made it possible for Imhotep and his fellow architects to make them serve a new, expressive purpose.

The idea that architectural forms can express anything may seem hard to grasp at first. We tend to assume that unless these forms have a clear-cut structural role, such as supporting or enclosing, they are mere decoration. But the slender, tapered, fluted columns in figure 2-5, or the papyrus-shaped half-columns in figure 2-6, do not simply decorate the walls to which they are attached. They interpret them and give them life. Their proportions, the feeling of strength and resilience they convey, their spacing, the degree to which they project—all share in this task.

We shall learn more about the expressive role of columns when we discuss Greek architecture, which took over the Egyptian stone column and developed it further. For the time being, let us note another factor that may enter into their design: announcing the symbolic purpose of the building. The papyrus half-columns in figure 2-6 are linked with Lower Egypt (compare the papyrus plants in fig. 2-3); hence they appear in the North "Palace" of Djoser's funerary district. The South Palace has columns of a different shape, which is linked with Upper Egypt.

The Pyramids at Giza Djoser's successors adapted the step pyramid to the smooth-sided shape that is familiar to us, a process that took several generations. The development of the pyramid reaches its climax during the Fourth Dynasty in the three **monumental** Pyramids at Giza (fig. 2-7). They are made of huge blocks of stone, some weighing as much as several hundred tons. Most of these blocks were quarried nearby, as were the ramps used to roll them in place, although the granite used for the tomb chambers had to be ferried down the Nile River. All of these originally had an outer casing of carefully **dressed**, fine white limestone, which has disappeared except near the top of the Pyramid of Khafre. The top of each was also covered with a thin layer of gold. The three differ slightly from one another in scale, as well as in some details, but the basic features are shown in the section of Khufu's pyramid (fig. 2-8). The burial chamber is near the center of the structure rather than below ground, as in the Step Pyramid of Djoser. This placement was a vain attempt to safeguard the chamber from robbers.

2-6 Papyrus-shaped half-columns, North Palace, funerary district of King Djoser, Saqqara

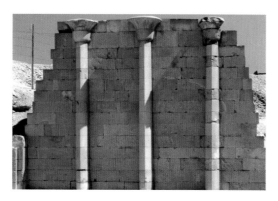

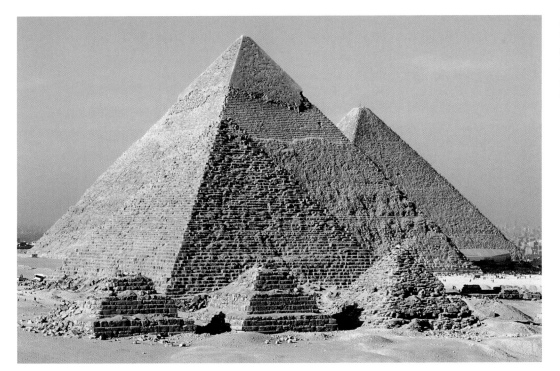

The pyramid evidently was identified with the pharaoh's "father," the sun god Ra, and perhaps served as the sun's final resting place. According to a recent theory, the three pyramids at Giza are arranged in the same formation as the stars in the constellation Orion, which was identified with the god Osiris. One of the so-called air shafts in the king's chamber of the Pyramid of Khufu pointed to the polar stars in the north, which are always visible; in ancient times the other lined up with Orion, which could be seen in the southern sky after an absence of some two months (the position of Orion has since changed). The shaft thus served as a kind of "escape hatch" that allowed the pharaoh to

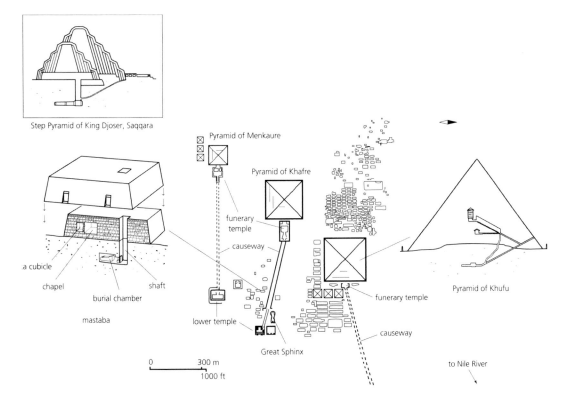

Step Pyramid of King Djoser, Saqqara

Pyramid of Menkaure

Pyramid of Khafre

funerary temple

causeway

a cubicle

chapel shaft

burial chamber

mastaba lower temple

Great Sphinx

funerary temple

Pyramid of Khufu

causeway

to Nile River

0 300 m
1000 ft

2-8 Plan of necropolis at Giza with sections of Pyramid of Khufu and mastaba, and with inset of Step Pyramid of Djoser at Saqqara

take his place as a star in the cosmos. Another hidden shaft in the queen's chamber was aligned with the star of Isis (Sirius). It seems to have been used in the ritual of fertilization and rebirth described in the Egyptian Book of the Dead. The proposal, although controversial, is tantalizing, for it helps to explain many puzzling features of the pyramids in terms of Egyptian cosmology, which equated the living pharaoh with Horus and the dead one with Osiris.

Clustered about the three Great Pyramids are several smaller ones and a large number of mastabas for members of the royal family and high officials (see fig. 2-8). The unified funerary district of Djoser has given way to a simpler arrangement. Adjoining each of the Great Pyramids to the east is a mortuary temple, where the pharaoh's body was brought for embalming and last rites. From there a causeway leads to a second temple at a lower level, in the Nile Valley, about a third of a mile away. This arrangement represents the final step in the evolution of kingship in Egypt. It links the

pharaoh to the eternal cosmic order by connecting him, in both physical and ritual terms, to the Nile River, whose annual cycles give life to Egypt and dictate its rhythm to this very day.

Next to the valley temple of the Pyramid of Khafre stands the Great *Sphinx*, which was carved from the living rock (fig. 2-9). (Sphinx is an ancient Greek word for "strangler"; it was probably derived from the Egyptian *shesep ankh*, meaning "living image.") It is an even more impressive symbol of divine kingship than the pyramids themselves. The royal head rising from the body of the lion reaches a height of 65 feet. Damage inflicted during Islamic times has obscured the details of the face, and parts of the top of the head are missing. Despite its location the Great Sphinx bears, in all probability, the features not of Khafre but of Khufu.

The statue can be regarded as a colossal guardian figure in the guise of the lion god Ruty. (Lions became associated with the pharaoh, perhaps through hunting, as early as the Predynastic period, when they were still

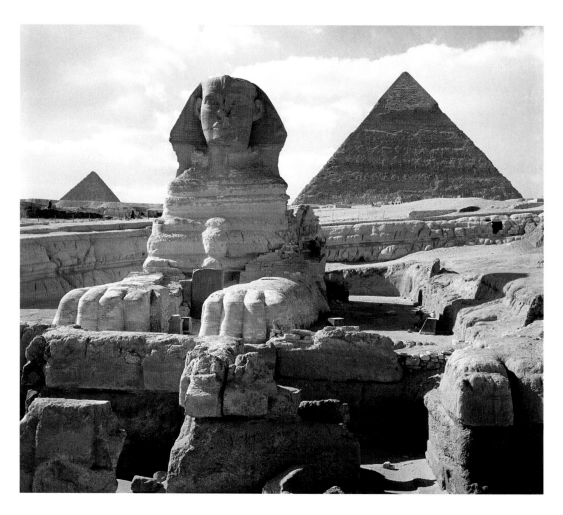

2-9 The Great Sphinx, Giza. c. 2551–2528 B.C. Sandstone, height 65′ (19.81 m)

plentiful. The sphinx in its original form was a griffin and destroyer of the enemy.) Its awesome majesty is such that the Great Sphinx could be considered an image of the sun god a thousand years later, when the lion became the personification of Ra. It acquired this connection through its nearness to the temple of the solar deity Harmakhis, which lies just before it.

The pyramids of Giza mark the high point of pharaonic power. After the end of the Fourth Dynasty, less than two centuries later, pyramids on such a scale were never attempted again, although more modest ones continued to be built. The world has always marveled at the sheer size of the Great Pyramids as well as at the technical accomplishment they represent. To design and build them required both enormous skill and a strong grasp of geometry. Egyptian mathematics seems to have been based on practical problem-solving rather than abstract numbers. Despite this limitation, which precluded the development of the formulas that underlie higher mathematics, it was possible to calculate the volume of a pyramid, for example, by using a complex sequence of steps to arrive at the correct answer. The ingenious methods used to construct the pyramids are even more remarkable given the simple tools and measuring devices available to the builders. Much of the work was done with stone tools, such as chisels and axes, although some metal ones were also used.

The pyramids have come to be seen as symbols of slave labor, with thousands of men forced by cruel masters to work at their construction. Such a picture may not be entirely just. Records show that much of the labor was paid for and that shelter, clothing, food, and drink were often furnished. It may be closer to the truth to view these monuments as vast public works that provided a livelihood for a good part of the population. As such, they required a considerable administrative apparatus to attend to every detail. According to a recent theory, there were two main classes of workers: a relatively small permanent group of skilled artisans, who lived in a village nearby, and a much larger one of as many as 2,000 temporary laborers drawn from around the country, who performed obligatory service to the state for a fixed period. The latter, perhaps organized according to their home regions, were

housed in long, narrow barracks just deep enough to sleep in. At the same time, criminals, prisoners of war, and others were forced to work on the pyramids.

Even under the best conditions, however, the labor was hard and dangerous, as the injuries to those buried in the local cemetery attest.

The Middle Kingdom

After the collapse of centralized pharaonic power at the end of the Sixth Dynasty, Egypt entered a period of intermittent political disturbance that was to last almost 700 years. During much of this time, power was in the hands of local or regional overlords, who revived the old rivalry between Upper and Lower Egypt. Many dynasties followed one another in rapid succession. Only two, the Eleventh and Twelfth, which make up the Middle Kingdom (c. 2040–1783 B.C.), interest us here. During this period a series of able rulers, beginning with Montuhotep II, the king who reunited Egypt about 2000 B.C., managed to prevail against the provincial nobility. However, the authority of the Middle Kingdom pharaohs tended to be personal rather than institutional. Once broken, the spell of divine kingship never regained its old effectiveness. Soon after the

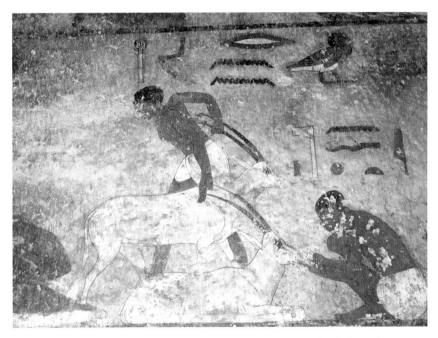

2-10 *Feeding the Oryxes*. Detail of a wall painting at the Tomb of Khnumhotep, Beni Hasan. c. 1890 B.C.

close of the Twelfth Dynasty the weakened country was taken over by the Hyksos (the term essentially meant "foreign ruler"), a group of western Asiatic peoples of somewhat mysterious origin who had evidently been living in Egypt for some time. They seized the Delta area and ruled it for 150 years until their defeat by King Ahmose of Thebes about 1550 B.C.

TOMB DECORATIONS

During these unsettled times, Egyptian artists began to experiment, even though they continued to look back to the Old Kingdom. Some relaxation of the rules appears in Middle Kingdom painting and relief sculpture, whose scenes featuring nonelite figures often depart markedly from convention. This loosening is most evident in the tombs of local princes at Beni Hasan. Because they were carved into the living rock, these tombs have survived better than most Middle Kingdom monuments. The **mural** *Feeding the Oryxes* (fig. 2-10) comes from one of these rock-cut tombs, that of Khnumhotep. (As the emblem of the prince's domain, the oryx antelope seems to have been a sort of honored pet in his household.) According to the standards of Old Kingdom art, all the figures ought to stand on the same line or **groundline**, representing the ground. If not, the second oryx and its attendant ought to be placed above the first (a system known as vertical recession).

Instead, the painter employs a secondary groundline only slightly higher than the primary one. This has the effect of creating a notional **ground plane**, relating the two groups in a way that is similar to normal appearances. This interest in spatial effects can also be seen in the experimental **foreshortening** of the shoulders of the two attendants. If we cover up the hieroglyphic signs, which emphasize the flatness of the wall, we can "read" the depth with surprising ease.

The New Kingdom

The 500 years after the Hyksos were expelled, which make up the Eighteenth, Nineteenth, and Twentieth dynasties, represent the third and final flowering of pharaonic Egypt. Once again united under strong kings, the country extended its frontiers far to the east, into Palestine and Syria; hence this period is known as the Empire as well as the New Kingdom. Its art covers a wide range of styles and quality, from rigid conservatism to brilliant inventiveness, massive ostentation to delicate refinement. These different strands are interwoven into fabric so complex that, as with the art of imperial Rome 1,500 years later, it is difficult to come up with a representative sampling of New Kingdom art that adequately conveys its flavor and variety.

THE TEMPLE OF QUEEN HATSHEPSUT

The climactic period of the New Kingdom extended from about 1500 B.C. to the end of the reign of Ramses III in 1163 B.C. It was an era of tremendous architectural projects, centering on Thebes, the region most responsible for the return of prosperity and stability. Monumental architecture was first marked by the revival of Middle Kingdom architectural forms to signify royal power. Thus the memorial temple of Queen HATSHEPSUT (fig. 2-11), built about 1460 B.C. against the rocky cliffs of Deir el-Bahri, imitates Montuhotep II's funerary temple of more than 500 years earlier (to the left in fig. 2-11), which now lies in ruins. Hatshepsut's temple is, however, very much larger. (A third temple, built somewhat later by her nephew, Thutmose III, was sandwiched between them and was not unearthed until 1961.)

2-11 Temple of Queen Hatshepsut, Deir el-Bahri. c. 1473–1458 B.C.

The worshiper is led toward the holy of holies—a small chamber driven deep into the rock—through three large courts on ascending levels, which are linked by ramps flanked by long rows of columns or **colonnades**. Together they form a processional road similar to those at Giza, but with the mountain instead of a pyramid at the end. The ramps and colonnades echo the crags of the cliff behind them. This magnificent union of architecture and nature makes Hatshepsut's temple the rival of any of the Old Kingdom monuments.

The temple complex was dedicated to Amun-Ra and several other deities. During the New Kingdom, divine kingship was asserted by claiming the god Amun as the father of the reigning monarch. By fusing his identity with that of the sun god Ra, Amun became the supreme deity, ruling the lesser gods much as the pharaoh dominated the provincial nobility.

AKHENATEN

Over time the priests of Amun gained such wealth and power that they posed a threat to royal authority. The pharaoh could maintain his position only with their consent. Amenhotep IV, the most remarkable figure of the Eighteenth Dynasty, tried to defeat them by proclaiming his faith in a single god, the sun disk Aten, whose cult had been promoted by his father, Amenhotep III. He changed his name to Akhenaten ("Effective for the Aten"), closed the Amun temples, and moved the capital to central Egypt, near the modern Tell el'Amarna. However, his attempt to place himself at the head of a new faith did not outlast his reign (1353–1335 B.C.).

Of the great projects built by Akhenaten almost nothing remains above ground. He must have been a revolutionary not only in his religious beliefs but in his artistic tastes as well. Through his choice of masters, he fostered a new style. Known as the Amarna style, it can be seen at its best in a sunken relief portrait of Akhenaten and his family (fig. 2-12). The intimate domestic scene suggests that the relief was meant to serve as a shrine in a private household. The life-giving rays of the sun help to unify the composition and identify the royal couple as the living counterparts of the Aten. Representing the male and female principles of the universe, they too have given birth, in a continuous process of creation, to three children.

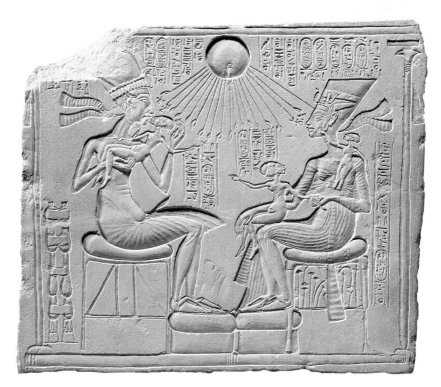

2-12 *Akhenaten and His Family.* c. 1353–1335 B.C. Limestone, 12¾ × 15¼" (32.5 × 38.7 cm). Staatliche Museen zu Berlin, Ägyptisches Museum

At first glance, the treatment of the royal family seems like a brutal caricature. Yet in reality, their androgynous forms, elongated proportions, oddly haggard features, and emphatic outlines constitute a new ideal that proclaims the couple's divine status. As one Egyptologist has justly remarked, this is not merely a pretty picture of family life at the palace, but a religious icon that encodes a statement of belief.

The scene's composition is completely canonical, and its execution is remarkably skillful. The sculptor has chosen the **sunken relief** format often used in Egyptian temple sculpture. The deeply cut contours etch the figures onto the face of the block, and thus directly relate them to this emphatically defined foreground or **picture plane**. Within these etched outlines, the sculptor separates the scene's complex overlapping planes with surprising ease. What distinguishes it—and the Amarna style in general—is not greater realism so much as a new sense of purpose that enlivens the traditional immobility of Egyptian art. Not only the contours but the shapes, too, seem more pliable. That this was a conscious choice, not merely an exaggeration of their anatomy, can be seen in the way the features of Akhenaten's queen, Nefertiti,

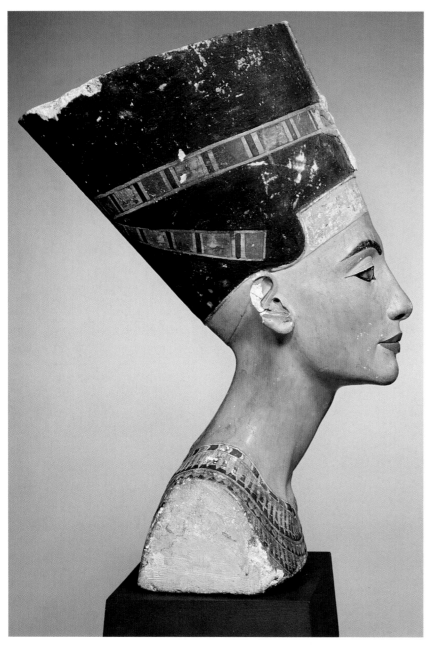

2-13 *Queen Nefertiti.* c. 1348–1335 B.C. Limestone, height 19″ (48.3 cm). Staatliche Museen zu Berlin, Ägyptisches Museum

opments earlier in the Eighteenth Dynasty. The process was already highly evolved under Akhenaten's father, Amenhotep III. Indeed, the new ideal can already be seen emerging in certain portraits of Hatshepsut. The famous bust of Nefertiti (fig. 2-13) does not abandon that style. Rather, it relaxes the forms for the sake of a more elegant effect, reminding us that her name means "the beautiful one has arrived." Its perfection comes from a command of geometry that is at once precise—the face is completely symmetrical—and wonderfully subtle. Strangely enough, the bust remained unfinished (the left eye lacks the inlay of the right). It was abandoned with a nearly identical head in the workshop of the royal sculptor Thutmose when he moved back from Amarna to Memphis after Akhenaten's death.

Thutmose, like Imhotep before him, must have been a great genius—court records call him the "king's favorite and master of the works"—one who could give visible form to Akhenaten's ideas. He is not the first Egyptian artist known to us by name, but he is the first we can identify with a personal style. Thutmose was the last of several sculptors in succession who were mainly responsible for the Amarna style. This union of powerful patron and sympathetic artist is rare. We will not see it again until we come to Periklean Athens (see pages 83–84).

TUTANKHAMUN

Akhenaten's successor, Smenkhkara, died soon after becoming pharaoh. The throne then passed to Tutankhamun, who was only about nine or ten years old at the time. Tutankhamun, who may have been Akhenaten's nephew, was married to his daughter Ankhesenpaaten; he died at the age of 18, perhaps of tuberculosis. (There is no solid evidence to support the popular conspiracy theories that he was murdered.) He owes his fame entirely to the fact that his is the only pharaonic tomb that has been found in our times with most of its contents intact. The immense value of the objects makes it easy to understand why grave robbing has been practiced in Egypt ever since the Old Kingdom. Tutankhamun's gold coffin alone weighs 250 pounds. Even more impressive is the exquisite workmanship of its cover (fig. 2-14), with its rich play of colored inlays against the polished gold surfaces. Its stern

have been subtly altered to resemble his (compare fig. 2-13). The same must be true of the egg-shaped skulls of the three princesses, one of them still an infant. These are not simply a genetic oddity, but imply life and (further) creativity. The seemingly playful gestures, so appealing to modern eyes, are intended to ward off evil spirits and protect the household from harm. The informal, tender poses nonetheless defy all earlier conventions of pharaonic dignity and suggest a new view of humanity.

Despite its unique qualities, the Amarna revolution was partly an outgrowth of devel-

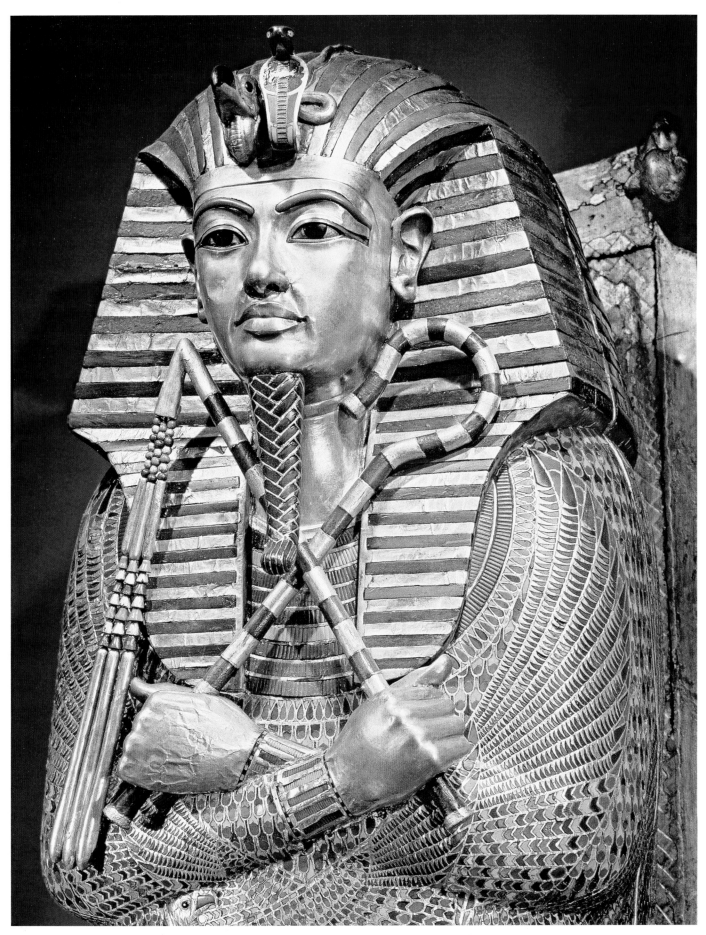

2-14 Cover of the middle coffin of Tutankhamen. c. 1327 B.C. Gilded and inlaid wood, height 80¼"
(204 cm). Egyptian Museum, Cairo

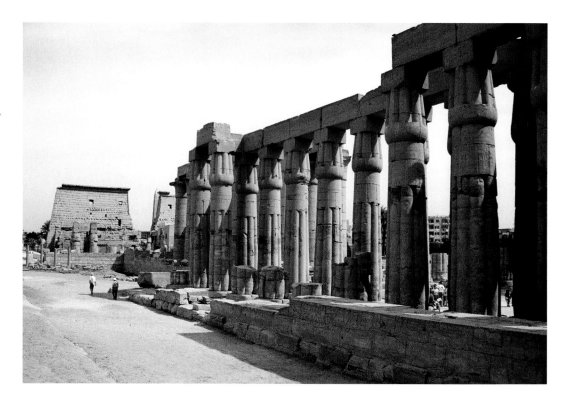

2-15 Court and pylon of Ramses II and colonnade and court of Amenhotep III, temple complex of Amun-Mut-Khonsu, Luxor. c. 1290–1224 and 1391–1353 B.C., respectively

A simple space-spanning construction device is the post-and-lintel combination. The wider the distance spanned (and the less the "give" of the spanning material), the closer the uprights (posts) have to be. Egyptians used stone columns for posts; the weight of the rigid stone lintels forced the builders to place the columns close together.

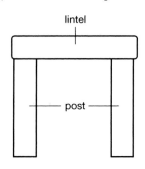

orthodoxy signals a rejection of the Amarna style and a return to ancestral tradition.

RAMSES II: THE TEMPLES AT LUXOR AND KARNAK

The old religion was restored by Tutan-khamun and his successors. These New Kingdom rulers devoted an ever-greater share of their architectural energies to building huge temples of Amun. The cult's center was Thebes, which included Karnak and Luxor on the east bank of the Nile and Deir el-Bahri on the west bank. Beyond lay the Valley of the Kings to the north and the Valley of the Queens to the south. Vast temple complexes at Karnak and Luxor that had been begun during the Middle Kingdom were greatly enlarged during the Nineteenth Dynasty.

At Luxor, Amenhotep III had replaced an earlier temple with a huge new one. It was completed by Ramses II, the greatest of the New Kingdom pharaohs, who built on an unprecedented scale. The complex (fig. 2-15) is typical of later Egyptian temples. The **facade** (the side that faces a public way, at the far left in our illustration) consists of two massive walls, with sloping sides, that flank the entrance. This gateway, or **pylon**, leads to a series of courts and pillared halls. Beyond it is the temple itself, a series of symmetrically arranged halls and chapels. They shield the holy of holies: a rectangular shrine for Amun's sacred boat (not completed until 325 B.C., under Alexander the Great) and a square room with four columns containing a colossal statue of the god. The temple was regarded as the actual house of the god. The cult statue, as his physical embodiment, was bathed, anointed, clothed, and fed by priests in elaborate daily rituals.

The temple's design rests on a principle of exclusion. The entire complex was enclosed by high walls that shut off the outside world. Except for the pylon, such a structure is designed to be seen from within. Ordinary worshipers were confined to the courts and could only marvel at the forest of columns that screened the dark recesses of the sanctuary. The elite could penetrate further, but only the king and priests of Amun could enter the holy of holies. The columns had to be closely spaced, for they supported the stone **lintels**, or horizontal members, of the ceiling, which were necessarily short to keep them from breaking under their own weight. Yet the architect has consciously exploited this condition by making the columns far heavier than they need be. The

viewer feels almost crushed by their sheer mass. The effect is certainly impressive, but it is also somewhat coarse when compared with earlier masterpieces of Egyptian architecture. We need only compare the papyrus columns of the colonnade of Amenhotep III with their remote ancestors in Djoser's North Palace (see fig. 2-6) in order to see how radically Imhotep's vision has been transformed.

As an expression of pharaonic power, the temples at Luxor and Karnak are without equal—perhaps justifiably, for the Ramesside period, as the Nineteenth and Twentieth dynasties are known, represents the height of Egyptian power. About 1070 B.C., less than a century after Ramses III died, the country entered a long period of political instability and fragmentation. During this period, Egypt was reunited only for brief intervals, sometimes under expansionist pharaohs who sought to reconquer some of the former Egyptian empire in the Levant. The last of these dynasties, the Twenty-Sixth, was toppled by the Persians in 525 B.C.

The final phase of ancient Egypt belongs to the Greeks and the Romans. Alexander the Great conquered the country in 331 B.C. and founded the city of Alexandria at the mouth of the Nile Delta. He did not, however, neglect or spurn the traditional Egyptian cults, and his patronage of a magnificent shrine at Luxor for the sacred boat of Amun both followed ancient custom and set a precedent for his successors. In 304, his general Ptolemy became king, founding a dynasty that lasted until the Romans conquered Egypt nearly 300 years later. Alexandria became the leading center of Greek culture, but in Egypt proper; the traditional art forms continued to flourish under Ptolemaic and Roman patronage. New forms of art emerged as well, such as the encaustic portraits on mummy cases (see fig. 7-25).

Ancient Near Eastern Art

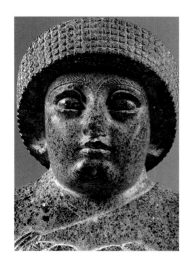

T IS AN ASTONISHING FACT THAT CIVILIZATION EMERGED IN several places at about the same time. Around 3000 B.C., when Egypt was being united under pharaonic rule, another great civilization arose in Mesopotamia, the "land between the rivers." Indeed, the latter may well claim to have developed first. And for close to 3,000 years these two regions retained their distinct characters, even though they had contact with each other from the beginning and their destinies were interwoven in many ways. The pressures that forced the people of both regions to abandon Neolithic village life may well have been the same.

Mesopotamia is a largely arid plain, but there is written evidence that at the dawn of civilization it was covered with lush vegetation created by irrigation. Unlike the Nile River Valley, a narrow, fertile strip protected by deserts on either side, the valley of the Tigris and Euphrates rivers is a wide, shallow trough crisscrossed by the two rivers and their tributaries. Having few natural defenses, it is easily entered from any direction.

Thus the facts of geography tended to discourage the idea of uniting the entire area under a single head. Rulers who had this ambition did not appear, so far as we know, until about a thousand years after the beginning of Mesopotamian civilization, and they succeeded in carrying it out only for brief periods and at the cost of almost continuous warfare. As a result, the history of ancient Mesopotamia has no underlying theme of the sort that divine kingship provides for Egypt. It is a mixture of local rivalries, many languages, foreign incursions, and the sudden upsurge and collapse of military power. Against this background, the continuity of the region's cultural traditions is remarkable. This common heritage was largely created by the founders of Mesopotamian civilization, whom we call Sumerians, after Sumer, the region in which they lived, near the junction of the Tigris and Euphrates rivers.

Sumerian Art

The origin of the Sumerians remains obscure. Their language is not related to any other known tongue. Sometime before 4000 B.C., they came to southern MESOPOTAMIA from Iran. There, within the next thousand years, they founded a number of city-states. They also developed a distinctive form of writing in CUNEIFORM (wedge-shaped) characters on clay tablets. This phase, which corresponds to the Predynastic period in Egypt, is called "protoliterate"; it leads to the early dynastic period, from about 3000 to 2340 B.C. (The chronology used here is by J. A. Brinkman.)

Archaeological Conditions The first evidence of Bronze Age culture is seen in Sumer about 4000 B.C. Unfortunately, the archaeological remains of Sumerian civilization are less impressive than those of ancient Egypt. Because there was no stone for building, the Sumerians used mud brick and wood, so that little is left of their structures but the foundations. Nor did they initially share the Egyptians' concern with the afterlife, although some rich early dynastic tombs, in the shape of vaulted underground chambers, have been found in the city of Ur that are clearly intended to provide for the needs of the deceased. Our knowledge of Sumerian civilization thus depends more heavily on

Major Civilizations in the Ancient Near East	
c. 4000–2340 B.C.	Sumerian
c. 1792–1595 B.C.	Babylonian
c. 1000–612 B.C.	Assyrian
c. 612–539 B.C.	Neo-Babylonian
c. 559–331 B.C.	Persian

chance fragments, including vast numbers of inscribed clay tablets, brought to light by excavation. Yet we have learned enough to form a general picture of this vigorous, inventive, and disciplined people.

Religion Each Sumerian city-state had its own local god, who was regarded as its "king" and owner. It also had a human ruler—the steward of the "king"—who led the people in serving the deity; in effect, he was a priest-king, who was vested with the responsibility for bringing peace and abundance to his people. The local god, in return, was expected to speak for the city-state among the other gods, who controlled the forces of nature, such as wind and weather, water, fertility, and the heavenly bodies. The idea of divine ownership was not a pious fiction. Sumerians believed that the god owned not only the territory of the city-state but also the labor of the population and its products. All these were subject to his commands, which were transmitted to the people by his human steward, the ruler. The result was a system that has been dubbed "theocratic socialism," a planned society administered from the temple. The temple controlled the supply of labor and resources for communal projects such as the building of dikes and irrigation ditches, and it collected and distributed much of the harvest. Detailed written records were required to carry out so many duties. Hence it is no surprise that early Sumerian texts deal largely with economic and administrative rather than religious matters, although writing was a priestly privilege.

ARCHITECTURE

The role of the temple as the center of both spiritual and physical life can be seen in the layout of Sumerian cities. The houses were clustered around a sacred area that was a vast architectural complex containing not only shrines but workshops, storehouses, and scribes' quarters as well. In their midst, on a raised platform, stood the temple of the local god. Perhaps reflecting the Sumerians' origin in the mountainous north, these platforms, known as **ziggurats**, soon reached considerable heights. They can be compared to the pyramids of Egypt in the immense effort

required to build them and in their effect as landmarks that tower above the plain.

The most famous ziggurat, the biblical Tower of Babel, has been destroyed, but a much earlier example, built shortly before 3000 B.C. (and thus several centuries before the first pyramids), survives at Warka, the site of the Sumerian city of Uruk (called Erech in the Bible). The city, nearly a square mile in extent, housed as many as 40,000 people. At its center were two public spaces: the sizable E-anna ("the temple of heaven") precinct of temples and palaces dedicated to Inanna, the goddess of heaven; and the Anu district, dominated by the ziggurat, devoted to the sky god An. The ziggurat, 40 feet high, has sloping sides reinforced by brick masonry. Stairs and ramps lead up to the platform on which stands the sanctuary, called the "White Temple" because of its whitewashed brick exterior (figs. 3-1, 3-2, page 50). Its heavy walls, with regularly spaced projections and recesses, are well enough preserved to suggest the original appearance of the structure. The main room, or the **cella**, where sacrifices were made before the statue of the god, is characteristic of Sumerian architecture: it consists of a narrow hall that runs the length of the temple and is flanked by smaller chambers. Its main entrance is on the southwest side, rather than on the side facing the stairs or on one of the narrow sides of the temple, as one might expect. To

Apparently independent of one another, the earliest civilizations arose along four great rivers during the fourth millennium B.C. Egyptian civilization is found in the northeast corner of the continent of Africa, nourished by the Nile River. MESOPOTAMIA is the area encompassed by present-day Iraq and its immediate neighbors, drained by the Tigris and Euphrates rivers. In roughly what is Pakistan today, drained by the Indus River, were the Indus Valley civilizations, and in west-central China, civilizations arose along the Yellow River.

CUNEIFORM characters were made by pressing a stylus into damp clay. The stylus, usually fashioned from a reed, was shaped on both ends. One end was wedge-shaped; the other end was pointed, rounded, or flat-tipped. The pointed end was used to draw lines and make punch marks. The tablets were then sun-dried or baked.

3-1 Remains of the "White Temple" on its ziggurat, Uruk (Warka), Iraq. c. 3500–3000 B.C.

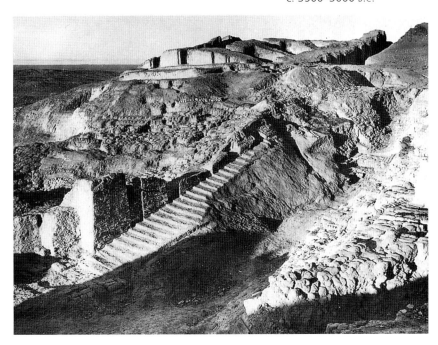

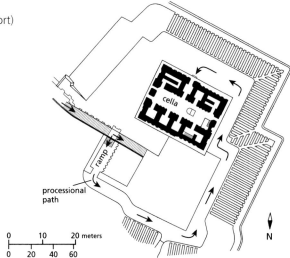

3-2 Plan of the "White Temple" (after H. Frankfort)

0 10 20 meters
0 20 40 60

N

understand why this is the case, we must view the ziggurat and temple as a whole. The entire complex is planned in such a way that the worshiper, starting at the bottom of the stairs on the east side, must go around as many corners as possible before reaching the cella. In other words, the path is a sort of angular spiral that increases one's sense of anticipation with every twist and turn.

Uruk reached its height of power in the early third millennium B.C., probably under Gilgamesh, the hero of the most famous

Mesopotamian story, who ruled Uruk around 2750 B.C. However, a shift in the course of the Euphrates caused the city's rapid decline, and it is rarely mentioned again. Nevertheless, this "bent-axis approach" is a basic feature of Mesopotamian religious architecture, in contrast to the straight, single axis of Egyptian temples (see fig. 2-15). During the following 2,500 years, it was elaborated into ever taller ziggurats rising in multiple stages. These were generally erected by the priest-king in his role as royal builder. What was the inspiration behind these structures? Certainly not the kind of pride attributed to the builders of the Tower of Babel in the Old Testament. Rather, they reflect the belief that mountaintops are the dwelling places of the gods. The Sumerians felt they could provide a fitting home for a god only by creating their own artificial mountains.

SCULPTURE

The image of the god to whom the White Temple was dedicated—probably Anu, the god of the sky—is lost, but excavations of other temples have yielded stone statuary. A group of figures from Tell Asmar, in modern Iraq (fig. 3-3), shows the geometric and

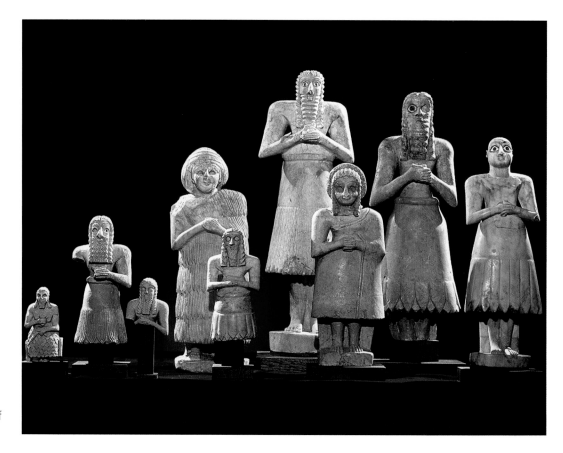

3-3 Statues, from the Abu Temple, Tell Asmar, Iraq. c. 2700–2500 B.C. Marble, height of tallest figure approx. 30" (76.2 cm). Iraq Museum, Baghdad, and The Oriental Institute Museum of The University of Chicago

expressive aspects of sculpture from the early dynastic period. The entire group must have stood in the cella of a temple, contemporary with the pyramid of King Djoser; this temple was dedicated to Abu, the god of vegetation. Although the two tallest figures may represent Abu and a mother goddess, it is more likely that all are **votive** statues of priests and worshipers, offered to the god as dedications. Despite the difference in size, all make the same gesture, with hands clasped in eternal worship. They communicate with the god through their enormous eyes, which convey the sense of awe the Sumerians felt before the often terrifying gods they worshiped. Their stare is emphasized by colored inlays, which are still in place.

The concept of representation had a very direct meaning for the Sumerians: the gods were believed to be present in their images, and the statues of the worshipers served as stand-ins for the persons they portrayed, offering prayers or transmitting messages to the god. Yet none of them attempts to achieve a real likeness. Bodies as well as faces are highly simplified so as not to distract attention from the eyes, "the windows of the soul." If Egyptian sculpture was based on the cube, Sumerian forms were derived from the cone and cylinder. Arms and legs have the roundness of pipes, and the long skirts are as smoothly curved as if they had been turned on a lathe.

The simplification of the Tell Asmar statues is characteristic of the carver, who works by cutting forms out of a solid block. A far more naturalistic style is found in Sumerian sculpture that was made not by subtraction but by addition; such works are either **modeled** in soft materials for **casting** in bronze (see page 105) or put together from varied substances such as wood, gold leaf, and lapis lazuli. Some **assemblages** of the latter kind, roughly contemporary with the Tell Asmar figures, have been found in the tombs at Ur mentioned earlier. They include the fascinating object shown in figure 3-4 of a ram rearing up against a flowering tree. The marvelously alive animal, which originally formed the base of an offering stand now missing but known from cylinder seals, has an almost demonic quality as it gazes from between the branches of the symbolic tree. And well it might, for it

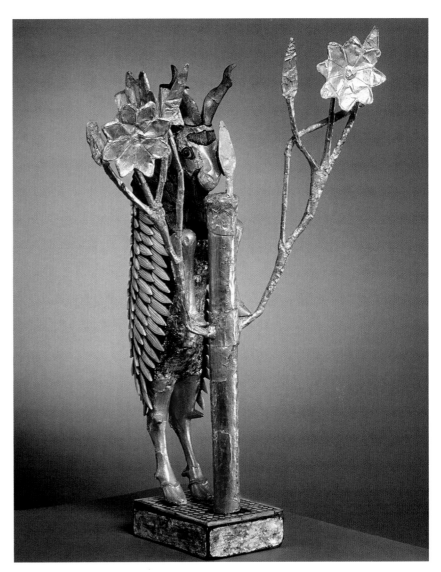

3-4 *Ram and Tree.* Offering stand from Ur (Muqaiyir), Iraq. c. 2600 B.C. Wood, gold, and lapis lazuli, height 20″ (50.8 cm). University of Pennsylvania Museum, Philadelphia

is sacred to the god Tammuz (Dumuzi) and thus embodies the male principle in nature. Here the awesome power of Mesopotamian gods and goddesses is given forceful visual expression.

Such an association of animals with deities is a carryover from prehistoric times (see page 26). We find it not only in Mesopotamia but in Egypt as well (compare the falcon of Horus in fig. 2-1). What distinguishes the sacred animals of the Sumerians is the active part they play in mythology. Much of this lore has not come down to us in written form, but we catch glimpses of it in pictorial representations such as those on an inlaid panel from a

This c. 1750 B.C. Babylonian deed of sale graphically shows the impressions made by the stylus in the soft clay.

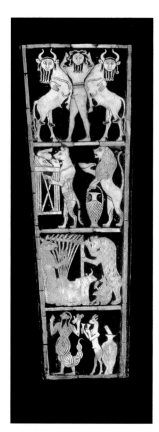

3-5 Inlay panel from the soundbox of a harp, from Ur (Muqaiyir), Iraq. c. 2600 B.C. Shell and bitumen, 12¼ × 4½″ (31.1 × 11.3 cm). University of Pennsylvania Museum, Philadelphia

The FABLE is a very old literary form in which animals play human characters. Fables may be in verse or in narrative, but either way they are moralizing allegorical commentaries on human behavior and are often highly satirical. The two greatest fabulists are AESOP, a semi-legendary Greek said to have lived in the sixth century B.C., and JEAN DE LA FONTAINE, a seventeenth-century French writer of twelve books containing 230 fables, many of which derive from Aesop's. The word *fabulous*, meaning "of an astonishing or exaggerated nature," derives from *fable*.

harp (fig. 3-5), which, like the offering stand, was recovered at Ur. The hero embracing two human-headed bulls in the top compartment was such a popular subject that its design has become a rigidly symmetrical formula. His beard denotes his divine status. He may be the god Baal, who is usually seen with two bulls, or perhaps the hero Gilgamesh, who is variously described as a wild bull and a man of battle, with a black beard and dark, bison eyes. The other sections, however, show animals performing human tasks in surprisingly lively fashion. The wolf and the lion carry food and drink to an unseen banquet, and the ass, bear, and deer provide music. (The bull-headed harp is the same type as the instrument to which our panel was attached.) At the bottom, a scorpion-man—associated with the mountains of sunrise and sunset and thus with clear funerary overtones—and a goat carry objects they have taken from a large vessel.

The artist who created these scenes was far less constrained by rules than Egyptian artists were. Even though these figures, too, are arranged in registers that serve as **groundlines**, the artist has no fear of overlapping forms or **foreshortened** shoulders. But we must be careful not to mistake the intent. What strikes us as delightfully humorous was most likely meant to be viewed seriously. Given the funerary context, these beasts are probably part of the final banquet before the descent into the underworld. Although ultimately derived from Iranian art of the fourth millennium B.C., they may be viewed as the earliest known ancestors of the animal FABLE that flourished in the West from AESOP to LA FONTAINE. The ass with the harp and the hero between two animals survived as fixed images; we meet them again almost 4,000 years later in medieval sculpture.

UR

Toward the end of the early dynastic period, the theocratic socialism of the Sumerian city-states began to decay. The local "stewards of the god" became ruling kings. The more ambitious tried to enlarge their domains by conquering their neighbors. At the same time, the Semitic-speaking inhabitants of northern Mesopotamia drifted south in ever-larger waves, until they outnumbered the Sumerians in many places. Although these newer arrivals adopted many features of Sumerian civilization, they were less bound to the tradition of the city-state. Sargon of Akkad (his name means "true king," even though he usurped the throne of the northern city of Kish before founding Akkad) openly proclaimed his ambition to rule the entire earth. Sargon succeeded in conquering Sumer, as well as northern Syria and Elam, about 2334 B.C. He also combined the Sumerian and Akkadian gods and goddesses in a new pantheon. His goal was to unite the country and break down the traditional link between cities and their local gods. The rule of the Akkadian kings came to an end when tribesmen from the northeast descended into the Mesopotamian plain and gained control of it for more than half a century. They were driven out in 2112 B.C. by King Urnammu of Ur (the modern Muqaiyir), who reestablished a united realm that was to last a hundred years.

During the period of foreign dominance, Lagash (the modern Telloh), one of the lesser Sumerian city-states, managed to remain independent. Its ruler, Gudea, who lived at about the same time as Urnammu, took care to reserve the title of king for Lagash's city-god, Ningursu, and to promote his cult by an ambitious rebuilding of his temple. Nothing remains of the temple, but Gudea had numerous statues of himself placed in the shrines of Lagash. (Some 20 examples, all of the same general type, have been found so far.) However devoted he was to the Sumerian city-state, Gudea seems to have inherited the Akkadian kings' sense of personal importance, although he prided himself on his relations with the gods rather than on his secular power.

The statue of Gudea in figure 3-6 tells us much about how he viewed himself. He dedicated it to Geshtinanna, the goddess of poetry and the interpreter of dreams, for it was in a dream that Ningursu ordered Gudea to build a temple when the Tigris failed to rise. Since early times, one of the king's principal roles was to build temples and irrigation canals; the gods often commanded these projects in dreams. So Gudea helped to build

the ziggurat with his own hands. He not only laid out the temple according to the design revealed to him by Enki, the god of building, but also helped make and carry the mud bricks. (A second statue shows him seated with the diagram of the temple or **ground plan** on his lap). Gudea had to follow the process scrupulously to ensure the ziggurat's sanctity, or risk incurring the gods' anger. His effort was rewarded, because his statue was an offering to Geshtinanna for her role in helping to end the drought. Gudea is holding a vase from which flow two streams of life-giving water that represent the Tigris and Euphrates rivers. This attribute, which was reserved for water goddesses and female votive figures, may also allude to the king's role in providing irrigation canals as well as attesting to his benevolent rule, and subtly proclaims his divine status.

Because the statue conforms to the same general type as others of Gudea, we may speak of a Canon of forms for the first time in Mesopotamian art. (*Canon* means "rule"; see page 35.) Such consistency was probably inspired by Egyptian sculpture, which was based on set proportions. Moreover, the statue is carved of diorite, a hard, imported stone first used several hundred years earlier by the Egyptians (see fig. 2-4), whose sculpture must have inspired Gudea to choose it. Here the material has been worked to a high finish that invites a play of light upon the features. Despite the apparent debt to Egypt, the figure contrasts with sculptures such as those in figures 2-4. The Sumerian carver has followed tradition by rounding off all the corners to emphasize the cylindrical quality of the forms, although Gudea's fleshy roundness is far removed from the geometric simplicity of the Tell Asmar statues. Equally characteristic is the muscular tension in the bare arm and shoulder, compared with the passive, relaxed limbs of Egyptian sculpture.

BABYLON

The late third and the early second millennium B.C. was a time of turmoil in Mesopotamia. It gave rise to the city-states of Isin and Larsa, which rivaled Ur, and several others. Central power collapsed about 2025 B.C., and stability was regained only in

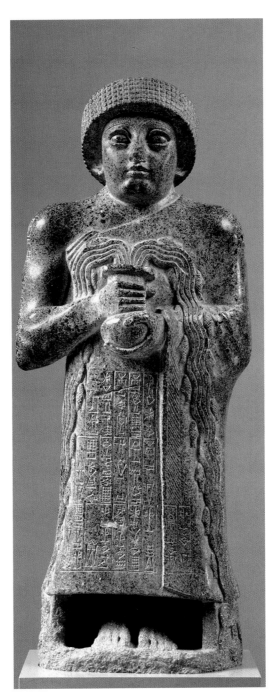

3-6 *Gudea*, from Lagash (Telloh), Iraq. c. 2120 B.C. Diorite, height 29″ (73.7 cm). Musée du Louvre, Paris

1792 B.C, when Babylon assumed the role formerly played by Akkad and Ur. Hammurabi (ruled 1792–1750 B.C.), the founder of the Babylonian dynasty, is by far the greatest figure of the age. Combining military prowess with a deep respect for Sumerian tradition, he saw himself as "the favorite shepherd" of the sun god Shamash, whose mission was "to cause justice to prevail in the land." Under him and his successors, Babylon became the cultural center of Sumer. The city was to retain this prestige for more

than a thousand years after its political power had waned.

Hammurabi's greatest achievement is his LAW CODE. Justly famous as one of the earliest uniform written bodies of law, it is strikingly rational and humane. This code was engraved on a tall diorite **stela**, or stone slab, that is crowned by a scene showing Hammurabi meeting the enthroned Shamash (fig. 3-7). Flames spurt from the sun god's shoulders, and he holds the ring and rod of kingship, which here probably stand for justice as well. Hammurabi's right arm is raised in a gesture of address, as if he were reporting his work to the god. The image recalls a type of "introduction scene" in Mesopotamian art: an individual, his hand raised in prayer, is led by a goddess before a seated deity who bestows his blessing or, if it be an enthroned king, his office. Hammurabi is, then, a suppliant, but in this case he appears without the benefit—or need—of a divine intercessor. Hence, his relationship to the god is unusually direct.

Although this scene was carved four centuries after the Gudea statues, it is closely related to them in both style and technique. It is also very different from Egyptian low reliefs like those illustrated in figs. 2-2, 2-3, and 2-12. The relief here is so high that the two figures almost give the impression of statues sliced in half. Yet perhaps because he instinctively felt that this could sever the connection between figure and background, the sculptor has taken care to compose their limbs and drapery in a complex series of gradually receding planes, subtly reuniting the two. He has also carved the eyes in the round, so that Hammurabi and Shamash gaze at each other with an immediacy that is unique in works of this kind. In this respect they recall the statues from Tell Asmar (see fig. 3-3), whose enormous eyes indicate an attempt to establish the same rapport between humans and gods in an earlier phase of Sumerian civilization.

ASSYRIA

Babylon was overthrown in 1595 B.C. by the Hittites, an INDO-EUROPEAN tribe that had entered Asia Minor (present-day Asian Turkey) from southern Russia in the late third millennium B.C. and settled on the rocky plateau of Anatolia. The Hittite empire reached its height between 1400 and 1200 B.C., when it ruled most of Turkey and Syria. Its greatest king, Suppiluliuma I (ruled c. 1380/40–c. 1320 B.C.), established diplomatic relations with the Egyptian pharaohs Akhenaten and Tutankhamen (see pages 43–46), and expanded into northern Mesopotamia. Meanwhile, in north-central Mesopotamia, the kingdom of Assur began to push southward, and Babylon was occupied by the Kassites from the

3-7 Upper part of stela inscribed with the Law Code of Hammurabi, from Susa (Shush), Iran. c. 1760 B.C. Diorite, height of stela approx. 7′ (2.13 m); height of relief 28″ (71.1 cm). Musée du Louvre, Paris

northwest, who eventually rose to great heights under Nebuchadnezzar I (ruled 1125–1104 B.C.). Borrowing from the art of Ur and Babylon, this Kassite dynasty established a revised canon of forms and new standard of skill that soon reached the Assyrians, who conquered southern Mesopotamia shortly thereafter.

Assur is located on the upper course of the Tigris. Under a series of able rulers who also had contact with the Amarna pharaohs, the Assyrian empire gradually expanded. In time it ruled not only Mesopotamia proper but the surrounding regions as well. At the height of its power, from about 1000 to 612 B.C., it stretched from the Sinai Peninsula to Armenia. Around 670 B.C. the Assyrians even successfully invaded Lower Egypt.

The Assyrians, it has been said, were to the Sumerians what the Romans were to the Greeks. Assyrian civilization drew on the achievements of the south but adapted them to fit its own distinct character. The temples and ziggurats they built were based on Sumerian models, while the palaces of their kings grew to unprecedented size and magnificence. Although the Assyrians, like the Sumerians, built in brick, they liked to line gateways and the lower walls of interiors with reliefs of limestone (which was easier to obtain in northern Mesopotamia). These low-relief panels were devoted to glorifying the power of the king, either by detailed depictions of his military conquests or by showing the sovereign as a successful lion hunter. Both types of scenes derive from Egyptian art, but the Assyrian sculptor developed new techniques to meet the demands of pictorial storytelling.

As in Egypt, the royal lion hunts were more like ritual combats than actual hunts: the animals were released from cages into a square formed by troops with shields. Almost from the beginning, lion, as well as bull, hunting had been an important duty of Mesopotamian rulers as the "shepherds" of the communal flocks. The earliest depiction, from Uruk, is contemporary with the White Temple (fig. 3-1). Hunting scenes came to signify the role of the ruler in defeating the king of beasts, mastering the forces of nature, bringing order to chaos, and helping to control the eternal cycle of life and death.

These scenes mark the apex of Assyrian art. In figure 3-8, the lion attacking the royal chariot from the rear is clearly the hero of the scene. Of magnificent strength and courage, the wounded animal seems to embody all the dramatic emotion of combat. The dying lion on the right is equally impressive in its agony—so different from the way the Egyptian artist had interpreted a hunted hippopotamus (see fig. 2-3). Yet in reading them, we must not forget that their prime purpose is not to stir our sympathy for the vanquished animals, but to glorify the victorious king. Besting such a worthy opponent merely magnifies his power.

THE NEO-BABYLONIANS

The Assyrian empire came to an end in 612 B.C., when its capital, Nineveh, fell to the Medes and Babylonians. Under the

INDO-EUROPEAN describes the world's largest language group, or linguistic family. It takes its name from the area where the original language arose sometime before 2000 B.C.—that encompassed by Europe and India and the lands in between. The term denotes only a linguistic group, not ethnic or cultural divisions. Not all peoples living in this area speak an Indo-European language. Vocabulary and grammar structure are the common elements. The subfamilies include Anatolian, Baltic, Celtic, Germanic (which contains English), Italic, Greek, Slavic, Indo-Iranian, and several other smaller language groups.

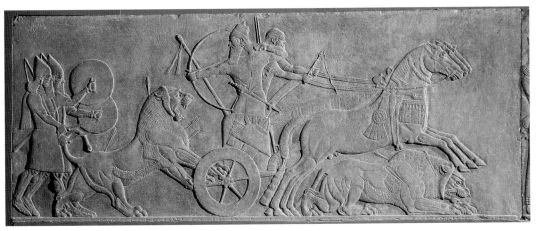

3-8 *Ashurnasirpal II Killing Lions,* from the Palace of Ashurnasirpal II, Calah (Nimrud), Iraq. c. 850 B.C. Limestone, 3'3" × 8'4" (1 × 2.54 m). The British Museum, London

Chaldean dynasty Babylon experienced a final brief flowering between 612 and 539 B.C., before it was conquered by the Persians. The best known of these Neo-Babylonian rulers was Nebuchadnezzar II (ruled 604–c. 561 B.C.), the builder of the Tower of Babel and the famous HANGING GARDENS, who put a stop to Egyptian advances in the Levant.

Whereas the Assyrians had employed carved stone slabs to decorate their structures, the Neo-Babylonians (who were farther removed from the quarries) substituted baked and **glazed** brick. This technique, too, had been developed in Assyria. Now, however, it was used on a far greater scale, both for surface ornament and for reliefs. Its distinctive effect is evident in the Ishtar Gate of Nebuchadnezzar's sacred precinct in Babylon, which has been rebuilt in Berlin from the thousands of glazed bricks that covered its surface (fig. 3-9). The procession of bulls, dragons, and other animals of molded brick within a framework of vividly colored ornamental bands has an elegance and refinement that remind us again of that special genius of ancient Mesopotamian art for the portrayal of animals.

Persian Art

Persia, the mountain-fringed high plateau to the east of Mesopotamia, takes its name from the people who occupied Babylon in 539 B.C. (see the discussion of the Achaemenids below). Today the country is called Iran, its older and more suitable name. Iran has been inhabited since prehistoric times and was a gateway for tribes migrating from the Asiatic steppes in the north as well as from India in the east. The new arrivals would settle down for a while, dominating or mingling with the local population, until the next wave of immigrants forced them to move on—to Mesopotamia, Asia Minor, or southern Russia.

ANIMAL STYLE

Not much is known about the movements of these nomadic tribes; the information we have is vague. Because they left no permanent structures or records, we can trace their wanderings only by careful study of the articles they buried with their dead. These objects, made of wood, bone, or metal, are a distinct kind of portable art called nomad's gear. They include weapons, bridles, buckles, and other articles of adornment, as well as cups, bowls, and the like. Found over a vast area, from Siberia to Central Europe, from Iran to Scandinavia, such articles have in common not only their ornamental design but also a set of forms known as the **animal style**. This style's main feature, as the name suggests, is the decorative use of animal motifs in abstract and imaginative ways.

One of the sources of the animal style appears to be ancient Iran, where it suddenly

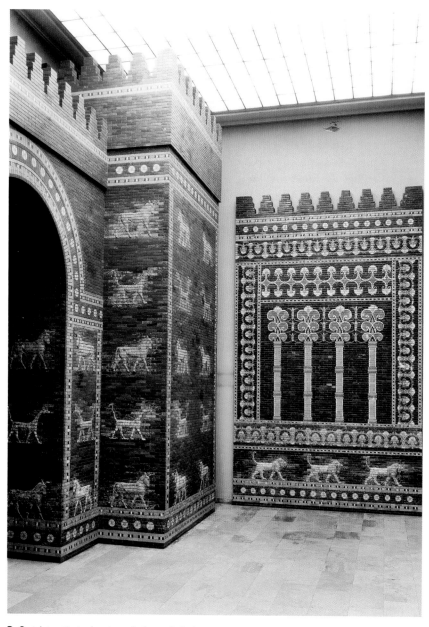

3-9 Ishtar Gate (restored), from Babylon, Iraq. c. 575 B.C. Glazed brick. Staatliche Museen zu Berlin, Preussischer Kulturbesitz, Vorderasiatisches Museum

reappeared in the tenth to seventh centuries B.C. Although the exact origin and date of most objects are by no means certain, the remains of the gold belt in figure 3-10 are probably from Ziwiye in the northwestern part of the country. Here the animal style is at its finest—and most puzzling. The kneeling ibex is a descendant of those on prehistoric pottery from western Iran. But what are we to make of the other creatures? The stag, which is not native to the region, is a motif transported from the steppes of Central Asia by the Scythians. The alternating rows of ibexes and stags are enclosed in a pattern of abstract lion heads; this pattern was native to Urartu (the biblical Ararat) in eastern Turkey, which was conquered by Sargon II of Assyria in 714 B.C. Similar belts of bronze have also been found in Urartian tombs.

The SCYTHIANS belonged to a group of nomadic Indo-European tribes, including the Medes and the Persians, that began to filter into Iran soon after 1000 B.C. The animal style of the Scythians merged with that of the Luristan region in western Iran during the late eighth century B.C. These tribes, however, were makers of bronze. Although goldsmithing was of ancient origin and widely diffused, it was probably the Phoenicians who translated the animal style into gold. (A pectoral, or breastplate, from the same hoard as our belt depicts Phoenician deities in a similar fashion.) These seafaring traders, based in Canaan (present-day Lebanon and Palestine), began to range throughout the Mediterranean in the fourteenth century B.C.

Eventually, they established colonies on Cyprus and founded the great city of Carthage in North Africa. Their maritime trading network helped to spread their unique culture, which was a blend of everything they came in contact with, throughout the Mediterranean, and provided a measure of stability that lasted nearly six centuries.

The seventh century B.C. was a time of intense contact between East and West. These cultural exchanges gave rise to the Orientalizing style in Greece (see pages 71–72), which in turn contributed new motifs to the Near East. The Phoenicians played a key role in this process. They were superb craftsmen in various metals, including gold, who made use of motifs derived

from their travels. Their settlements on Cyprus soon became centers of silver- and goldsmithing and borrowed styles and motifs liberally from elsewhere. Whether Phoenician (as seems likely) or Cypriot, the artist who created our gold belt has brought together the elements of the animal style into a masterful design and fashioned it with impressive skill.

THE ACHAEMENIDS

The Near East long remained a vast melting pot. After the mid sixth century B.C., however, the entire region came under the sway of the Persians. After overthrowing the king of the Medes, Cyrus the Great (Kyros II, ruled 550–530/29 B.C.) conquered Babylon in 538 B.C. and then Phoenicia. Along with the title "king of Babylon," he assumed the ambitions of the Assyrian rulers. The empire Cyrus founded continued to expand under his successors. Egypt as well as Asia Minor fell to them, while mainland Greece escaped by a narrow margin. At its height, under Darius I (ruled 521–486 B.C.) and his son Xerxes (ruled 485–465 B.C.), the Persian empire was far larger than the Egyptian and Assyrian empires combined. This huge domain endured for two centuries, and during most of its life it was ruled both efficiently and humanely. Within a single generation, the formerly nomadic Persians not only settled down and learned how to administer an empire but also developed a highly original monumental art to express the grandeur of their rule.

Despite their genius for adaptation, the Persians retained their own religious beliefs, which were drawn from the prophecies of ZOROASTER. This faith was based on the

The SCYTHIANS spoke an Indo-European language and had no written language. They were at their peak in the eighth to fourth centuries B.C. Nomads and fearless riders, the Scythians originated in western Siberia and migrated to southern Russia in the first millennium B.C. Scythian gold jewelry and ornaments are renowned for their intricacy and imaginative design.

ZOROASTER was a prophet and religious teacher born about 628 B.C. in northwestern Persia. His name derives from the Persian *Zarathustra*, meaning "camel driver." Interestingly, the sixth century B.C. saw the birth of three other great religions: Taoism (China), Confucianism (China), and Buddhism (India)—each because of the appearance of a great religious teacher.

dualism of Good and Evil, embodied in Ahuramazda (Light) and Ahriman (Darkness). Because the cult of Ahuramazda centered on fire altars in the open air, the Persians had no religious architecture. Their palaces, on the other hand, were huge and impressive. The most ambitious of these, at Persepolis, was begun by Darius I in 518 B.C. Assyrian traditions are the strongest single element throughout the vast complex, which consisted of a great number of rooms, halls, and courts on a raised platform. Yet they do not determine the character of the building, for they have been combined with borrowings from every cor-

ner of the empire to create a new, uniquely Persian style.

Columns are used on a grand scale at Persepolis. The Audience Hall of Darius and Xerxes, a room 250 feet square, had a wooden ceiling supported by 36 columns 40 feet tall, a few of which are still standing (fig. 3-11). It resembles a huge nomadic tent translated into stone. The massed columns also recall Egyptian architecture, however (compare fig. 2-15), as does the ornamental detail of the bases and capitals. The slender, fluted shafts of the columns are derived from the Ionian Greeks of Asia Minor. These Greek settlers were also sub-

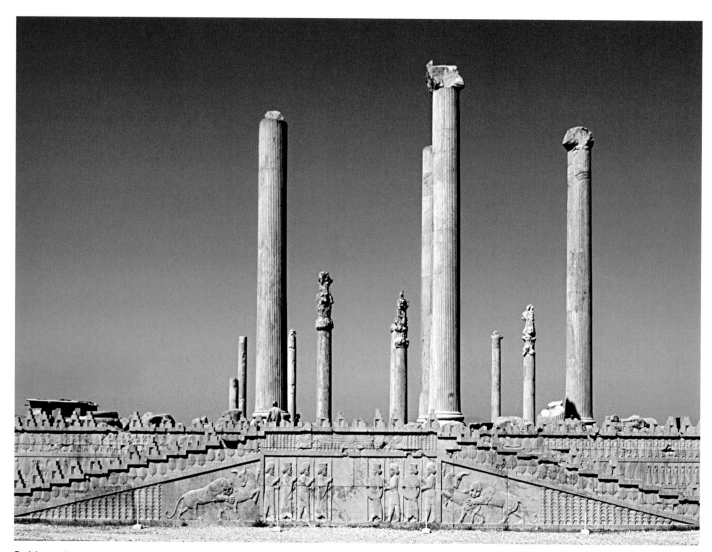

3-11 Audience Hall of Darius and Xerxes, Persepolis, Iran. c. 500 B.C.

ject to Persia and supplied artists to the Persian court.

The double stairway leading up to the Audience Hall is decorated with long rows of marching figures in low relief, marshaled in superimposed registers, Egyptian style. Their repetitive, ceremonial character defers to the architectural setting in a way that is typical of all Persian sculpture. Yet even here, we discover that the Assyro-Babylonian heritage has been softened and refined by its Ionian Greek carvers. This imperial Persian style continued without major change until the end of the Persian empire. Uniting all the empire's major representational traditions, it was the perfect vehicle for expressing the majesty of the Achaemenid kings and the universality, power, and tranquillity of their rule. As a result, change was not only unnecessary but actually undesirable.

Mesopotamia, like Egypt, eventually became part of the Greek and Roman world, although it retained many aspects of its ancient culture. Alexander the Great (356–323 B.C.) destroyed the Persian empire in 331 B.C. After his death eight years later, his realm was divided among his generals.

short order at Knossos, Phaistos, and Mallia, and then others at Hagia Triada and Chania. Little is left of this sudden spurt of large-scale building.

The three early palaces were all destroyed around 1800–1700 B.C., evidently by earthquakes. Almost immediately, new and even larger structures were built on their ruins, and Minoan civilization began to reach its zenith. An Egyptian-style "temple tomb" near Knossos and a large group of Minoan-style frescoes in the eastern Nile Delta tell us that the Egyptians and Minoans were in close contact. After a century or so, probably in 1628 B.C., the volcano on the nearby island of Thera (the modern Santorini), exploded in a catastrophic eruption. Whatever damage it may have caused on Crete, Minoan civilization continued to flourish until around 1450 B.C., when all the palaces

except for Knossos were destroyed, either by earthquake once more, or by human violence. Knossos was then occupied by the Mycenaeans, who introduced the Greek language, and from then on ruled most of the island.

ARCHITECTURE

The "new" palaces are our main source of information about Minoan architecture. The one at Knossos, called the Palace of MINOS, was the most ambitious. Arranged around a huge central court, it covered a large area and contained so many rooms that it survived in Greek legend as the LABYRINTH of the MINOTAUR. The palace has been carefully excavated and partly restored (fig. 4-2). There was no striving for a unified effect, and the exterior was modest compared with those of Assyrian and Persian

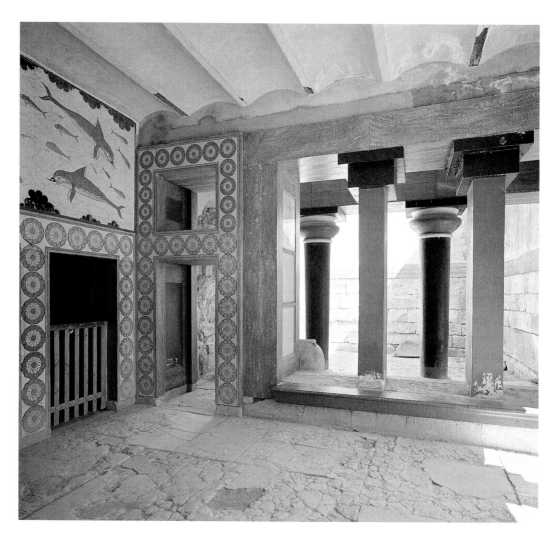

4-2 The so-called Queen's Megaron, Palace of Minos, Knossos, Crete. C. 1700–1300 B.C.

palaces (see fig. 3-11). The individual units are often small and the ceilings often low, so that even those parts of the structure that were several stories high must have seemed quite squat.

Nevertheless, the numerous colonnaded terraces or **porticoes**, staircases, and air shafts must have given the palace an open, airy look. Some of the interiors, with richly decorated walls, still retain their elegant appearance (see fig. 4-2, though much is restored). Some of the rooms have a strikingly modern look, largely due to the practice of including multiple screen doors with large internal windows or *transoms* above them. One could shut the doors for privacy and leave the transoms open to allow a through draft. The masonry construction, reinforced with timber for stability and earthquake safety, is excellent; the columns were always of wood. Although none of the columns has survived, we know their form from paintings and sculptures. They had a smooth **shaft** tapering downward and were topped by a wide, cushion-shaped **capital**. The origins of this type of column, which in some contexts could also serve as a religious symbol, remain a mystery.

Who were the rulers that built these palaces? We do not know their names or deeds, except for the legendary Minos, but the archaeological evidence suggests that they were not warriors. No fortifications have been found anywhere in Minoan Crete, and military themes are almost unknown in Minoan art. Nor is there any hint that they were priest-kings like those of Egypt or Mesopotamia, although they may have presided at religious festivals and their palaces certainly were centers of religious life. However, the only parts that can be identified as places of worship are small chapels, which suggests that religious ceremonies took place either in the central court or at outlying shrines, upon which at least two of the palaces are aligned.

The many storerooms, workshops, and "offices" at Knossos indicate that the palace was not only a royal residence but also a center of administration, industry, and commerce. Shipping and trade were a major part of Minoan economic life, to judge from elaborate harbor constructions and from Cretan artifacts found in Egypt and elsewhere. Perhaps, then, we should think of the king as

the head of a merchant aristocracy, but just how much power he had and how far it extended are still unclear.

SCULPTURE

The religious life of Minoan Crete centered on certain sacred places, such as caves or groves. Some of its chief deities were female, akin to the mother and fertility goddesses we have met before. Because the Minoans had no temples, we are not surprised to find that they lacked large cult statues. Several statuettes from Knossos of snake handlers, dated about 1750 B.C., present serious problems of interpretation: all have been tampered with in varying degrees, so that their appearance is misleading. Unfortunately, the head of our example (fig. 4-3) was missing when the statuette was found, and the present one is modern; the beret and the feline that sits on it were found in the same deposit, but may belong to another figure. Thus it is unclear whether such statuettes represent goddesses or, as we believe, their votaries, although they are closely related in type to similar figures in frescoes.

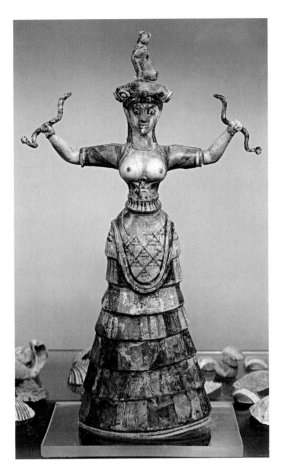

4-3 *"Snake Priestess,"* from the palace complex, Knossos. c. 1750 B.C. Faience, height 11⅝" (29.5 cm). The head is restored and the beret and feline it wears may not belong to this figure. Archaeological Museum, Iraklion, Crete

Made of faience (a vitreous paste), they wear striking, gaily painted costumes presumably of linen and flax. Snakes are associated with earth deities and male fertility in many ancient religions, just as the startlingly bared breasts of this statuette radiate fecundity. The style of this "*Snake Priestess*" hints at a foreign source: the voluptuous bosom and the conical quality of the figure suggest a kinship—indirect, perhaps through Syria—with Mesopotamian art (compare fig. 3-3).

PAINTING

After the earlier palaces were destroyed, there was an explosive increase in wealth and a remarkable outpouring of creative energy that produced most of what we have in Minoan art and architecture. The most surprising achievement of this sudden flowering is mural painting. Unfortunately, the murals that covered the walls of the new palaces have survived mainly in fragments; we rarely have a complete composition left, let alone the design of an entire wall.

Marine life (as seen in the fish-and-dolphin fresco in figure 4-2) was a favorite subject of Minoan painting after 1700 B.C. The floating world of Minoan wall painting was an imaginative creation so rich and original that its influence can be felt throughout Minoan art during the era of the new palaces. Instead of permanence and stability we find a passion for rhythmic movement, and the forms themselves have an oddly weightless quality. They seem to float, or sway, in a world without gravity. It is as if the scenes took place underwater, even though a great many show animals and birds among luxuriant vegetation.

We sense this quality even in *The Toreador Fresco*, the most dynamic Minoan mural recovered so far (fig. 4-4). (The darker patches are the original fragments on which the restoration is based.) The conventional title should not mislead us. What we see here is not a bullfight but a ritual in which the performers vault lithely over the back of the animal. Two of the slim-waisted athletes are young women, distinguished (as in Egyptian

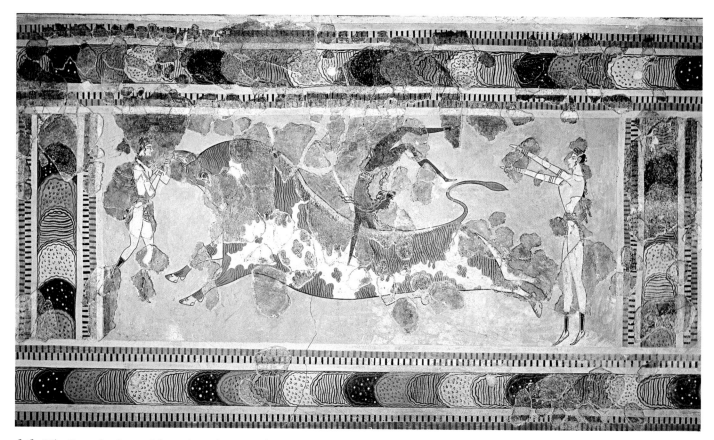

4-4 *"The Toreador Fresco,"* from the palace complex, Knossos. Original c. 1500 B.C.; restored. Height including upper border approx. 24¹/₂" (62.3 cm). Archaeological Museum, Iraklion, Crete

art) mainly by their white skin, and performing topless.

The bull was a sacred animal to the Minoans, and bull-vaulting occupied an important place in their religious life. The ceremony, which must have taken many lives, perhaps took place in the great central courts of the palaces, observed by throngs of spectators in the porticoes and on the balconies around. The scene recalls the Greek legend of the 14 youths and maidens sent annually from Athens to be sacrificed to the Minotaur, a half-animal, half-human creature, but eventually rescued by the hero Theseus.

The three figures may either show different phases of the same action, undertaken by the sexes in turn, or a "snapshot" of a single jump. The two are not mutually exclusive and indeed most ancient artists probably never thought to distinguish them. Instead, the painter's first priority was evidently to stress the performers' fluid movement and effortless domination of the huge, unpredictable creature. His fresco deftly idealizes this almost unbelievably dangerous ritual, transforming it into a harmonious, playful game where the performers behave like dolphins frolicking in the Cretan sea.

Mycenaean Art

Along the southeastern shores of the Greek mainland, dating from about 1700–1200 B.C., there were a number of settlements similar in many ways to those of Minoan Crete. They, too, for example, were grouped around palaces. Their inhabitants have come to be called Mycenaeans, after Mycenae, the most important of these settlements. Because the works of art excavated there often showed a strikingly Minoan character, the Mycenaeans were thought to have come from Crete. Scholars now agree that they were the descendants of the earliest Greeks, who had entered the country somewhat before 2000 B.C.

For some 400 years, these people led a pastoral life in their new homeland. Their modest tombs contained only simple pottery and a few bronze weapons. Around 1700 B.C., however, they suddenly began to bury their dead in deep shaft graves. A lit-

tle later, the burials were in conical stone chambers, known as beehive tombs. This trend reached its height about 1300 B.C. in structures such as the one shown in figure 4-5. Such tombs were built of concentric layers of precisely cut stone blocks that taper inward toward the highest point. (This method of spanning space is called **corbeling**.) The discoverer of this tomb thought it far too ambitious to have been used for that purpose and named it the Treasury of ATREUS. Burial places as elaborate as this can be matched only in Egypt during the same period.

The great monuments of Mycenaean architecture were all built between 1400 B.C. and 1200 B.C. Apart from such details as decorative motifs or the shape of the columns, Mycenaean architecture owes little to the Minoan tradition. The palaces were hilltop fortresses surrounded by defensive walls of huge, irregularly shaped stone blocks. This type of construction, unknown in Crete, was similar to the fortifications of the contemporary Hittite centers of Asia Minor (modern Turkey). The so-called Lion Gate at Mycenae (fig. 4-6) is the most impressive remnant of these massive ramparts, which inspired such awe in the Greeks of later times that they were regarded as the work of the Cyclopes, a mythical race of one-eyed giants. Even the Treasury of Atreus, although built of smaller and more precisely shaped blocks, has a Cyclopean **lintel** (see fig. 4-5).

The stone relief over the doorway of the Lion Gate is another departure from the Minoan tradition. The two lions (or perhaps lionesses) flanking a symbolic Minoan column have a grim, **heraldic** majesty. Their heads, now lost, were added in another—probably precious—material. Their function as guardians of the gate, their tense, muscular bodies, and their symmetrical design again suggest contact with the Hittites, who often employed such beasts to protect their citadels and palaces. We may at this point recall Homer's ILIAD and ODYSSEY, which recount the events of the TROJAN WAR and its aftermath, which brought the Mycenaeans to Asia Minor around 1300 B.C. Yet archaeologists have shown that the Mycenaeans had begun to cross the Aegean, for trade or war, much earlier than that.

In Greek legend, ATREUS was the ancestor of the royal family of Mycenae.

Corbeling as a space-spanning device relies on the downward pressure of overlapped layers of stone to lock in the projecting ends.

corbel arch

corbel vault

The TROJAN WAR was a half-legendary conflict fought between a number of the Greek city-states and Troy, a city on the northwest coast of Asia Minor (modern Turkey). Homer's epic poem the *ILIAD* describes events that took place during the last year of the war, and the *ODYSSEY* recounts the ten-year homeward voyage of one of the Greek kings, Odysseus (Roman Ulysses), after the conflict. These poems—part history and part myth—developed gradually within the oral tradition of Greek poetry for centuries before there was a written Greek language and were passed down from one generation of poets to another. Archaeological discoveries have confirmed the accuracy of many of the details of Homer's narrative.

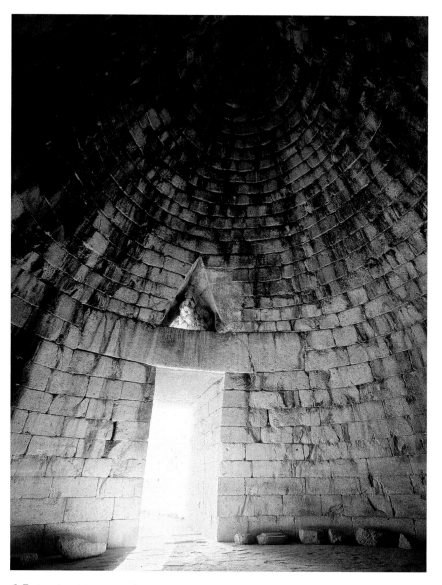

4-5 Interior, "Treasury of Atreus," Mycenae. c. 1300–1250 B.C.

The most important room in a Mycenaean palace was the megaron. This rectangular hall typically had a hearth at the center and a roof supported by four columns. It was entered through a porch and vestibule. This design is basically an enlarged version of the simple houses of earlier generations; it even appears at Troy in the third millennium B.C. There may have been a rich decorative scheme of wall paintings and ornamental carvings to stress its dignity as the king's residence. The paintings on walls and objects recovered at Mycenae often have a Near Eastern flavor that recalls much earlier art at such cities as Mari.

Mycenaean civilization was thus remarkably dynamic. Its sudden rise to wealth and power around 1700 B.C. may be due to the raiding and mercenary activities of its warrior elite, perhaps ranging as far afield as Egypt. Its art was energized by close contacts with Crete, beginning with the importation of Minoan artifacts and then artisans, who trained locals to work in this style. Around 1450 B.C. the Mycenaeans began to expand abroad, dominating Crete and establishing a dynasty at Knossos. Soon, other Mycenaean palaces sprang up at Tiryns, Athens, Thebes, Pylos, and elsewhere, and Mycenaean settlements appeared in the Cyclades and in Asia Minor, where contacts with the Hittites were apparently not always friendly. These ventures inspired the composition of the two greatest poems in the Greek language,

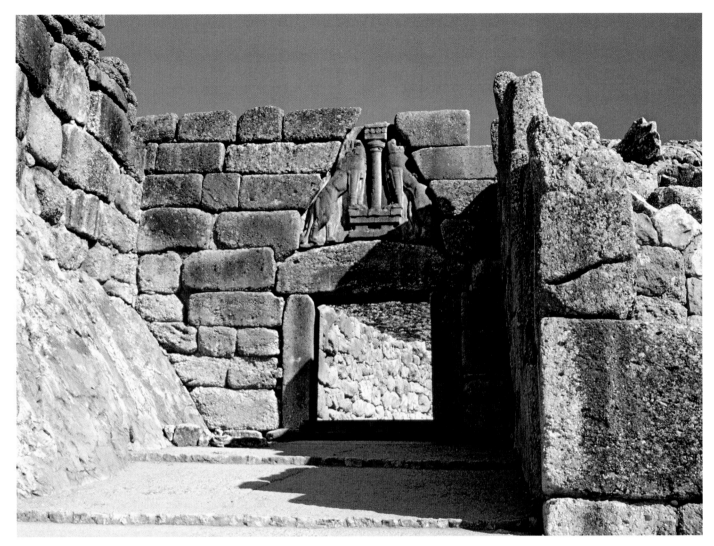

4-6 The Lion Gate, Mycenae. c. 1250 B.C.

the founding texts of European literature, Homer's *Iliad* and *Odyssey*. And when Mycenaean civilization at last collapsed in the chaos of the Dark Age (c. 1150–950 B.C.), some of its products such as the megaron lived on, to be taken up by the new, even more dynamic Greek civilization that arose from its ruins.

Greek Art

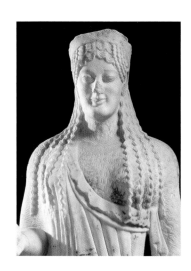

B ECAUSE OF THE VAST GAPS IN TIME AND CULTURE FROM THE present, the works of art we've seen so far seem alien, no matter how fascinating they may be. Greek architecture, sculpture, and painting, by contrast, are immediately recognizable as the direct ancestors of our own, although they owe a great deal to their predecessors. A Greek temple reminds us of the bank around the corner, a Greek statue brings to mind countless other statues that we have seen somewhere, and a Greek coin seems as close as the change in our pockets. But the tradition linking us with the ancient Greeks can be a handicap as well as an advantage. Sometimes our familiarity with these latter by-products blinds us to the uniqueness of the Greeks' own original contributions.

Another complication in the study of Greek art arises from the fact that we have three separate, and sometimes conflicting, sources of information on the subject. There are, first of all, the surviving monuments themselves, a reliable but often inadequate source. Then we have Roman copies that tell us something about important works that would otherwise be lost to us entirely. These copies, however, pose a problem. Some are of such high quality that we cannot be sure that they really are copies at all. Others make us wonder how closely they follow their model—especially if we have several copies, all slightly different, of the same lost original.

Finally, there are the literary sources. The Greeks were the first people in history to write at length about their own art, and their accounts were eagerly collected and paraphrased into Latin by the Romans, who handed them down to us. From them we learn what the Greeks themselves considered their most important achievements in architecture, sculpture, and painting. This written testimony has helped us to identify some celebrated artists and monuments, but much of it deals with works of which no visible trace remains today, whereas other works, which do survive and which strike us as among the greatest masterpieces of their time, are not mentioned at all. To reconcile the literary evidence with that of the copies and originals, and to weave these strands into a coherent picture is a difficult task, despite the enormous amount of work that has been done since the beginnings of archaeological scholarship some 250 years ago.

One of the most vexing problems is that the Greeks never had a term for art as we understand it. Art was one of the crafts, which were not everyday chores like plowing or spinning, but part of a large class of skilled occupations that included medicine, music, and divination, among others. (The name of the mythical first artist, Daidalos, was derived from the same root term for all finely crafted objects, *daidal-*.) Yet the Greeks made a distinction even here: poets and musicians were inspired by the Muses and doctors by Apollo, but the artist-craftsperson's "gifts" of wisdom and all skill-at-hand, and Hephaistos, the deformed god of the forge and the husband of Aphrodite, goddess of love.

This is not to say that the early Greeks did not admire what we would call artistic qualities; on the contrary, real artistry was distinguished from purely manual skill (*techne,* technique) by *sophia* (wisdom), which guides it. Especially prized was the ability to produce a lively appearance and to induce awe

(*thauma*) in the beholder. Moreover, like their Egyptian and Near Eastern predecessors, the Greeks prized fine artisanship and rich materials, which certified an object's value as a gift, a votive offering, and the like, as much as they prized this lifelike quality. For such brilliantly crafted objects both were "wonders" in their own right and eloquently affirmed the social status, wealth, power, and good taste of those who commissioned them.

In Greece, artists and artisans were free men or very occasionally women (as we know from texts and from depictions on Greek vases) who took orders from a variety of different people, although slaves were regularly employed on building sites and in sculptors' and potters' workshops. The elite always looked down on craftspeople, because working with one's hands and working for others were both considered slavish. As the biographer Plutarch snobbishly remarked, "just because you admire a particular work doesn't mean that you give its maker the time of day." These attitudes persisted into the twentieth century and still resonate today.

The Greeks

Who were the Greeks? In the last chapter, we met the Mycenaeans, who entered Greece about 2100 B.C. Other Greek-speaking tribes entered the peninsula from the north toward 1100 B.C. These newcomers absorbed the Mycenaeans and gradually spread to the Aegean Islands and Asia Minor. During the following centuries they created what we now call Greek civilization. In the eighth century B.C., they also spread westward, founding settlements in Sicily and southern Italy, and in the seventh they colonized the Black Sea.

Despite a strong sense of kinship based on language and common beliefs, which were expressed in such traditions as the four great Panhellenic (all-Greek) festivals, the Greeks remained divided into small city-states. This pattern was largely a response to the geography of Greece, whose mountain ranges, narrow valleys, and jagged coastline made political unification difficult. The intense rivalry of these states and the competitiveness of their citizens spurred the growth of ideas, institutions, and even the development of Greek art.

Our own thinking about government uses many terms of Greek origin that reflect the evolution of the city-state. They include *monarchy* (from *monarches*, sole ruler), *aristocracy* (from *aristokratia*, rule of the best), *tyranny* (from *tyrannos*, despot), *oligarchy* (from *oligoi*, a small ruling elite), *democracy* (from *demos*, the people, and *kratos*, rule), and, most important, *politics* (derived from *polites*, the citizen of the *polis*, or city-state).

In the end, however, the Greeks paid dearly for their divisiveness. They engaged in constant warfare involving shifting alliances and banded together only reluctantly when threatened by their common enemies, the Persians and later the Macedonians. The Persians conquered the Greeks of Asia Minor in the late sixth century. They invaded the Greek mainland in 490 B.C. under Darius I, only to be repulsed at the Battle of Marathon by a much smaller contingent of Athenians. They invaded again ten years later under Darius's son, Xerxes I, who sent a vast force. At first everything went his way. After defeating Leonidas and his 300 Spartans at Thermopylai, the Persians took Athens, whose citizens had already left except for a few die-hard defenders of the Akropolis, which was sacked. Yet the Greek alliance eventually repelled the invasion, and Athens then ushered most of the Aegean cities into an anti-Persian alliance that under the leadership of Perikles (c. 495–429 B.C.) soon became an Athenian empire. Greece was now divided into two armed camps, the Athenian and the Spartan. After a quarter-century of intermittent conflict, the two powers clashed head-on in the Peloponnesian War (431–404 B.C.). This war ended Athenian dominance and weakened the major Greek powers, enabling Philip II of Macedon and his son, Alexander the Great, to defeat them piecemeal in the late fourth century B.C.

Painting

GEOMETRIC STYLE

The formative phase of Greek civilization covers about 400 years, from about 1100 to 700 B.C. We know little about the first three centuries of this period, but after about 800 B.C. the Greeks rapidly emerge into the full light of history. The earliest

specific dates that have come down to us are from that time. The main ones are the founding of the OLYMPIC GAMES in 776 B.C., the starting point of Greek chronology, as well as slightly later dates for the founding of various colonies abroad. Also during that time the first post-Mycenaean style in the arts, the so-called Geometric, developed. We know it only from painted pottery and small-scale sculpture. (Monumental architecture and sculpture in stone did not appear until the seventh century B.C.) The two arts are closely related. The pottery was often adorned with the same kinds of figures found in sculpture, which was made of clay or bronze. These bronzes leave little doubt that the technique of **casting** had survived the Mycenaean collapse.

Greek potters soon developed a considerable variety of vessel types or shapes. Each type was well adapted to its function, which was reflected in its form. As a result, each shape presented unique challenges to painters, and some became specialists at decorating certain types of vases. Their "paint" was actually a refined clay solution applied before firing; a series of chemical changes during the firing process created the separate colors we see today. Because both the mak-

ing and the decoration of vases required considerable expertise, these were usually separate professions, but the finest painters were sometimes potters as well.

At first, Geometric pottery was decorated only with **abstract** designs—triangles, checkers, concentric circles, and so on—but toward 800 B.C. humans and animals began to appear. In the most mature examples these figures are grouped into elaborate scenes. The one shown here (fig. 5-1), from the Dipylon cemetery at Athens, belongs to a group of very large vases that served as grave monuments. Its bottom has holes through which liquid offerings could filter down to the dead below. On the body of the vase we see the dead man lying in state, flanked by figures who are tearing their hair in mourning. Below is a funeral procession of chariots and warriors on foot.

This vase makes no reference to an afterlife. Its purpose is to commemorate the dead. Here lies a worthy man, it tells us, who was mourned by many and had a splendid funeral. Did the Greeks, then, have no concept of a hereafter? They did, but to them the realm of the dead was a colorless, ill-defined region where ghosts led a feeble and passive existence without making any demands on the living. When the warrior Odysseus conjures up the ghost of Achilles in Homer's *Odyssey*, all the dead hero can do is mourn his own death: "Don't speak to me about death so soothingly, Odysseus. I'd prefer to be working the earth, hired out to a poor man . . . than to lord it over all the wasted dead." Although the Greeks marked and tended their graves, and even poured liquid offerings over them, they did so in a spirit of pious remembrance, rather than to satisfy the physical needs of the deceased. Clearly, they had abandoned the elaborate burial customs of the Mycenaeans. Nor is the Geometric style an outgrowth of the Mycenaean tradition. It is a fresh, in some ways primitive, start.

Given the limited repertory of shapes, the artist who painted our vase has achieved a remarkably varied effect. The width, density, and spacing of the bands are subtly related to the structure of the vessel. Interest in representation is limited, however. The figures or groups, repeated at regular intervals, are highly stylized and arranged side-by-side since the silhouette style cannot accom-

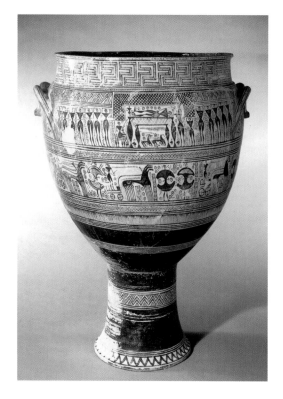

5-1 *Dipylon Vase*, from the Dipylon cemetery, Athens, c. 750 B.C. Height 40¹/₂″ (102.9 cm). The Metropolitan Museum of Art, New York. Rogers Fund, 1914

modate overlapping. Stripped to their essentials, they are naked, and merge into the overall decorative pattern, so that their size varies according to the area to be filled. Organic and geometric elements coexist, and often it is hard to distinguish between them. Lozenges indicate legs, whether of a man, a chair, or a bier. Circles with dots represent human heads. The chevrons, boxed triangles, and other motifs inserted between the figures maintain the overall half-tone effect of the decoration.

Geometric pottery has been found not only in Greece but in Italy and the Near East as well. This wide distribution signals that Greek traders had begun to roam the Mediterranean by the eighth century B.C. They soon adapted the Phoenician alphabet to their own use, as we know from inscriptions on these same vases. The greatest Greek achievements of this era, however, are the two Homeric epics, the *Iliad* and the *Odyssey*. The scenes on Geometric vases barely hint at the narrative power of these poems. If our knowledge of eighth-century Greece were based on the visual arts alone, we would think of it as a far simpler and more provin-cial society than the literary evidence suggests.

There is a paradox here. The arts do not necessarily develop at the same pace and at the same time. Indeed, during this period Greek civilization was perhaps so verbal that painting and sculpture played a less important role than they would in later centuries. Moreover, the Geometric style was highly formulaic, and its figure scenes were mostly funerary in nature. Vivid narrative—the representation of heroic myths and legends—demanded more than it could provide. The dam finally burst by 700 B.C.: new motifs flooded in and Greek art entered another phase, which we call Orientalizing.

ORIENTALIZING STYLE

As its name implies, the new style looks to Egypt and the Near East. Spurred by increasing trade with these regions, Greek art absorbed a host of Near Eastern motifs and ideas between about 725 and 650 B.C., and was profoundly transformed in the process. Whereas earlier Greek art is Aegean in flavor, the Orientalizing phase has a new monumentality and variety. Its wild exuberance reflects the efforts of painters and sculptors to master the new motifs that came in waves, like immigrants from afar. The later development of Greek art is unthinkable without this vital period of experiment.

Some of the subjects and motifs that we think of as typically Greek were, in fact, derived from Mesopotamia and Egypt, where their long history reaches back to the dawn of Near Eastern civilization. Another major source was contemporary Syria, home to a crude but vigorous blend of Hittite and Assyrian art. Greek traders were active in northern Syria, at the port of Al Mina at the mouth of the Orontes River. So were Etruscans and Phoenicians, who also played an intermediary role as both artists and traders (see page 104). It was the blend of the novelties encountered in these ventures, with Geometric discipline and the distinctive Greek temperament—individual, inquisitive, intellectualizing, and contentious—that soon gave rise to what we think of as Greek art proper.

The change becomes evident if we compare the large **amphora** (a vase for storing wine or oil) from Eleusis (fig. 5-2) with the *Dipylon Krater* of about a hundred years

Major Periods of Greek Art
c. 900–725 B.C.	Geometric
c. 725–650 B.C.	Orientalizing
c. 650–480 B.C.	Archaic
c. 480–400 B.C.	Classical
c. 400–325 B.C.	Late Classical
c. 325–30 B.C.	Hellenistic

Some common Greek vessel forms

amphora

krater

hydria

lekythos

oinochoe

kylix

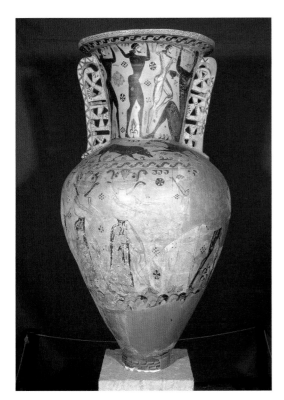

5-2 *The Blinding of Polyphemos* and *The Gorgons Chasing Perseus,* on a Proto-Attic amphora. c. 675–650 B.C. Height 56" (142.2 cm). Archaeological Museum, Eleusis

earlier (see fig. 5-1). Geometric ornament is now confined to the foot, handles, and lip, whereas new, curvilinear motifs—such as spirals, interlacing bands, palmettes, and rosettes—appear everywhere. On the vessel's shoulder is a frieze of fighting animals, derived from Near Eastern art. The major areas, however, are given over to narrative, and storytelling now dominates the vase.

The Greek myths and legends provided a vast source of subjects for narrative painting. Tales imported from the Near East merged with others featuring the Olympian gods and a whole array of purely Greek heroes (see Cultural Context, pages 73 and 74). They represent a comprehensive attempt to understand the world in all its baffling complexity. The Greek interest in heroes and their deeds helps to explain the appeal of oriental lions and monsters to the Greek imagination. These terrifying creatures embodied the unknown forces that the hero faced. This fascination can be seen on the Eleusis amphora (fig. 5-2). The figures have gained so much in size and vividness that the decorative patterns scattered among them no longer interfere with their actions. Ornament is now both separate and secondary, as the focus turns toward figural representation—to the activities of heroes, gods, and monsters.

The neck of the Eleusis amphora shows the blinding of the giant, one-eyed Cyclops Polyphemos, a son of Poseidon, by Odysseus and his companions, whom the giant had imprisoned. The story, recounted in the *Odyssey* but undoubtedly popular as a folktale, is portrayed with directness and dramatic force. These men have an expressive vigor that makes them seem thoroughly alive. The slaying of another monstrous creature is depicted on the belly of the vase, which has been so badly damaged that only two figures have survived intact. They are GORGONS, sisters of the snake-haired MEDUSA, whom PERSEUS (partly seen fleeing at far right) killed with the aid of the goddess ATHENA. The goddess herself stands at center right, dressed in white and carrying a spear or scepter, protecting the hero from the Gorgons' wrath. Throughout, we can see an interest in human anatomy that goes far beyond the limits of the Geometric style. Two technical advances opened the way for this development: outline draw-

ing and incision (scratching in details with a needle or *burin*). These techniques allow the painter to create overlappings and interior lines, and thus to explore details of hair, anatomy, dress, and so on.

In these pictures the men are naked and the women are clothed—even the Gorgons. This convention, which establishes the powerful, muscular, nude body as the "default setting" for men and the veiled and thereby regulated one as the "default setting" for women, now became normative, and survived in Western art until the twentieth century (see, for example, figs. 13-10, 22-22). The artist may add items of clothing or armor to the male body, as appropriate, but to strip a woman either partially or completely now marks her as somehow "other"—the monstrous Gorgon (fig. 5-2) with her crudely bared leg, the rape victim (fig. 5-18), or the totally naked love goddess herself (fig. 5-23).

ARCHAIC STYLE

The Orientalizing period was a time of transition, in contrast to the stable Geometric style. As artists assimilated these new elements from the East, another style emerged, as well defined as the Geometric but much greater in range: the **Archaic,** which lasted from the later seventh century to about 480 B.C., the time of the momentous Greek victories over the Persians. During the Archaic period, we see the unfolding of the artistic genius of Greece, not only in vase painting but also in architecture and sculpture. Although Archaic art lacks the measure and restraint of the Classical style of the later fifth century (see page 77), it has such freshness that many people consider it the most vital phase of Greek art.

Black-Figure Technique Archaic vases are generally smaller than the big Geometric funerary ones, because they no longer served as grave monuments (which were now made of stone). Their painted decoration, however, shows a far greater range of subjects. Scenes from myth, legend, and everyday life appear in endless variety, and the artistic level is often very high, especially among Athenian vases. From the early sixth century, some of the finest vases bear the signatures of the artists who made them, both potters and painters. Appar-

Used almost continuously throughout Western art, the Greek vocabulary of ornamental motifs is vast, highly adaptable, and very durable.

guilloche

palmette

rosette

acanthus

meander

egg-and-dart

In Greek myth, MEDUSA and her sister GORGONS (see fig. 5-2) were so powerful that anyone looking directly at their faces would be turned to stone. PERSEUS, a favorite mythical hero, is most often shown in art as the one who beheaded MEDUSA. ATHENA was the goddess of war, intelligence, and wisdom.

ALL EARLY CIVILIZATIONS AND PRELITERATE CULTURES HAD CREATION MYTHS TO EXPLAIN the origin of the universe and humanity's place in it. Over time, these myths evolved into complex cycles that represent a comprehensive attempt to understand the world. The Greek gods and goddesses, though immortal, behaved in very human ways. They quarreled, and had children with each other's spouses and often with mortals as well. They were sometimes threatened and even overthrown by their own children. The principal Greek gods and goddesses, with their Roman counterparts in parentheses, are given below.

ZEUS (Jupiter): son of Kronos and Rhea; god of sky and weather, and king of the Olympian deities (see fig. 5-17). After killing Kronos, Zeus married his sister HERA (Juno) and divided the universe by lot with his brothers: POSEIDON (Neptune) was allotted the sea, and HADES (Pluto), was allotted the Underworld, which he ruled with his queen PERSEPHONE (Proserpina).

Zeus and Hera had several children:

ARES (Mars), the god of war

HEBE, the goddess of youth

HEPHAISTOS (Vulcan), the lame god of metalwork and the forge

Zeus also had numerous children through his love affairs with other goddesses and with mortal women, including:

ATHENA (Minerva), goddess of crafts, including war, and thus of intelligence and wisdom. A protector of heroes (see fig. 5-3), she became the patron goddess of Athens, an honor she won in a contest with Poseidon. Her gift to the city was an olive tree, which she caused to sprout on the Akropolis.

APHRODITE (Venus), the goddess of love, beauty, and female fertility (see fig. 5-24). She married Hephaistos, but had many affairs. Her children were HARMONIA, EROS, and ANTEROS (with Ares), HERMAPHRODITOS (with Hermes), PRIAPOS (with Dionysos), and AENEAS (with the Trojan prince Anchises).

APOLLON (Apollo), with his twin sister ARTEMIS, god of the stringed lyre and bow, who therefore both presided over the civilized pursuits of music and poetry, and shot down transgressors (see fig. 5-14); a paragon of male beauty, he was also the god of prophecy and medicine.

ARTEMIS (Diana), with her twin brother, APOLLO, virgin goddess of the hunt and the protector of young girls. She was also sometimes considered a moon goddess with SELENE.

DIONYSOS (Bacchus), the god of altered states, particularly that induced by wine. Opposite in temperament to Apollo, Dionysos was raised on Mount Nysa, where he invented winemaking; he married the princess Ariadne (see fig. 7-23, page 131) after the hero Theseus abandoned her on Naxos. His followers, the goatish satyrs and their female companions, the nymphs and humans who were known as maenads (bacchantes), were given to orgiastic excess (see fig. 7-23, page 131). Yet there was another, more temperate side to Dionysos's character. As the god of fertility, he was also a god of vegetation, as well as of peace, hospitality, and the theater.

HERMES (Mercury), the messenger of the gods (see fig. 7-21, p. 129), conductor of souls to Hades, and the god of travelers and commerce.

ently these artisans not only took pride in their work but also were striving to market a personal style. Some of the painters have so distinctive a style that it can be recognized even without a signature. Archaic vase painting thus introduces us to the first clearly defined *personalities* in the history of art. (Signatures occur in Archaic sculpture and architecture as well, but they are much rarer and thus much less helpful in identifying the personalities of individual masters.)

Archaic Greek painting was, of course, not confined to vases. There were murals and panels, too. Almost nothing has survived of them, but because all Archaic painting was essentially drawing filled in with solid, flat color, murals could not have looked much different from vase pictures. According to the literary sources, Greek wall painting did not come into its own until about 475–450 B.C., after the Persian wars. During this period artists gradually discovered how to model figures and objects through shading and how to create a strong sense of spatial depth. From that time on, vase painting became a lesser art, because these advances were beyond its limited technical means; by the end of the fifth century its decline was obvious. Thus the great age of vase painting was the Archaic era. Until about 475 B.C., the best vase painters apparently enjoyed as much prestige as other artists. Whether or not their work directly reflects the lost wall paintings, it deserves to be viewed as a major achievement.

The difference between Orientalizing and Archaic vase painting is one of artistic discipline. In the Eleusis amphora (see fig. 5-2), the figures are shown partly as solid silhouettes, partly in outline, and as a combination of both; some details such as beards and toes are incised. Toward the end of the seventh century, Athenian vase painters adopted the **black-figure** style, in which the entire design is silhouetted in black against the reddish clay and all internal details are incised; white and purple may be added on top of the black to make certain areas stand out. This technique favors a layered, two-dimensional effect that complements the curvature of the vase and reminds us that the picture is not a kind of window in its surface but part of the wall of a container.

Herakles wrestling the Nemean lion, on an amphora attributed to the painter Psiax (fig. 5-3), is the direct outgrowth of the forceful Orientalizing style of the blinding of Polyphemos in the Eleusis amphora. It reminds us of the hero on the soundbox of the harp from Ur (see fig. 3-5). Both show a man facing unknown forces in the form of terrifying creatures. The lion also serves to underscore the hero's might and courage against demonic powers. The scene on Psiax's amphora is all grimness and violence. The two heavy bodies are locked in combat,

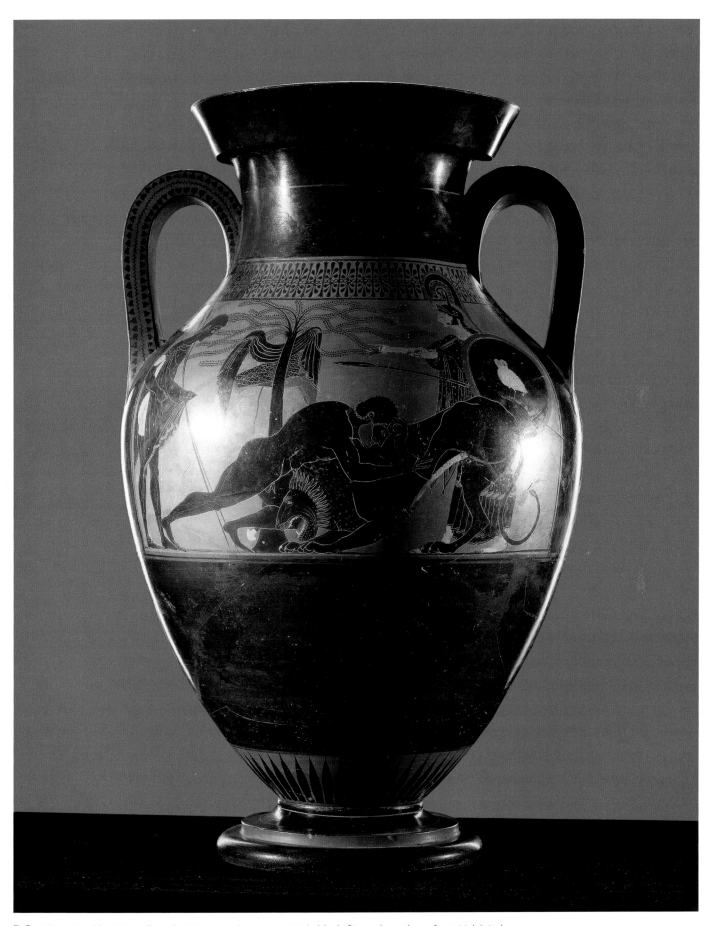

5-3 Psiax. *Herakles Strangling the Nemean Lion,* on an Attic black-figured amphora from Vulci, Italy.
c. 525 B.C. Height 19¹/₂″ (49.5 cm). Museo Civico dell'Età Cristiana, Brescia

SPEAKING OF

Classical, classical, and classic

In art history, *Classical* spelled with a capital C refers specifically to Greek civilization between about 480 and 330 B.C. The term *classical* refers to the entire ancient Greek and Roman period and its creations. In the Western tradition, classical has also come to mean that which is moderate, balanced, excellent, and enduring. Thus, for example, serious European music is often called "classical music." The word *classic* is used to describe and signify something of lasting excellence and importance, such as Shakespeare's *Hamlet,* or a top-rank sporting event, such as a golf classic.

so that they almost merge into a single unit. Lines and colors have been added with utmost economy to avoid breaking up the massive expanse of black. Yet the interlocked figures show such a wealth of anatomical knowledge and skillful foreshortening that they give an illusion of existing in the round. (Note the way the abdomen and shoulders of Herakles are rendered.) Only in such details as the eye of Herakles do we still find the traditional combination of front and profile views.

Red-Figure Technique Psiax evidently felt that the silhouette-like black-figure technique made foreshortening unduly difficult, for in some of his vases he tried the reverse procedure, leaving the figures red and filling in the background. This **red-figure** technique gradually replaced the older method toward 500 B.C. We can see its advantages in figure 5-4, a **krater** for mixing wine of about 510 B.C. signed by Euphronios and showing Herakles wrestling the giant Antaios. Interior lines are not

incised but were applied by squeezing a bladder with a nozzle like a cake-icer, or by freely drawing them with the brush. As a result, the artist depends far less on the profile view than before. Instead, he uses interior line to show boldly foreshortened and overlapping limbs, precise details of costume (note the pleated dresses of the women), and intense facial expressions. He is so fascinated by these new effects that he has made the figures as large as possible. They almost seem to burst from the field of the vase! No wonder some of the pioneers of red-figure painting also turned to mural and panel painting.

The heightened naturalism made possible by the new technique allowed the artist to explore a new world of feeling as well. Euphronios takes care to show even subtle differences in appearance between Herakles and Antaios to make clear the distinction in their character or *ethos.* By contrast, the outcome is never in doubt in Psiax's amphora, as can be seen from the composition and from the gesture of Athena, goddess of heroes (see

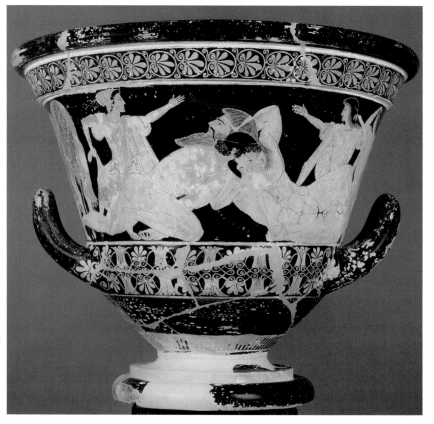

5-4 Euphronios. *Herakles Wrestling Antaios,* on an Attic red-figured krater. c. 510 B.C. Height 19" (48 cm). Musée du Louvre, Paris

fig. 5-3). And whereas Psiax's lion roars in rage, Euphronios makes us feel the suffering, not just the pain, of the shaggy Antaios, who clearly will lose out to the neatly coiffed Herakles. He also depicts the fear of the mortal women on either side, who support the combatants but cannot protect them. For the first time we see sympathy for the vanquished as victim.

The Symposium These richly decorated vases were associated with wine. They were reserved for special occasions, the most important of which was the symposium (*symposion*), an exclusive drinking party for men and another import from the Near East. The participants reclined on couches around the edges of a room; slaves brought the wine in an amphora (e.g., fig. 5-3) and mixed it with water in a krater (e.g., fig. 5-4) set in the middle of the room. A master of ceremonies directed the proceedings and filled the drinkers' cups. Music, poetry, storytelling, and word games accompanied the festivities. The event often ended in dancing and lovemaking, which is frequently depicted on drinking cups. There was also a serious side to symposia, as described by Plato and Xenophon, which centered on debates about politics, ethics, and morality.

CLASSICAL STYLE

According to literary sources, Greek mural painters of the Classical period, which began about 480 B.C., achieved major breakthroughs in creating an illusion of spatial depth or **perspective**, scenes of real dramatic power, and vigorous studies of human character and emotion. Unfortunately, the only surviving Classical Greek murals are to be found in several late fourth-century Macedonian tombs, including that of Philip II at Vergina, discovered in 1976 and subsequent years. From the mid-fifth century on, the impact of this new kind of painting gradually transformed vase painting into a minor art. Only occasionally did vase painters try to reproduce these large-scale compositions, and the results were seldom successful.

Greek painting reached its peak in the fourth century B.C. with the invention of the **picture**, for display on an easel or a wall.

Among the most accomplished painters mentioned by the Roman writer PLINY THE ELDER are Parrhasios of Ephesos, who "first gave proportion to painting . . . and was supreme in painting contour lines—the most subtle aspect of painting," and Zeuxis of Herakleia, a master of shading and color modeling. Pliny also discusses Apelles of Kos, Alexander the Great's favorite artist and the most famous painter of his day, who was celebrated for his grace and his invention of luster (the glint of light on a raindrop or a spear blade), and Nikomachos of Athens, who was renowned for his rapid brush. Unfortunately, not a single original picture of theirs survives to verify these claims directly.

Roman frescoes and mosaics give us some idea of what late classical Greek painting looked like, but such evidence is not always reliable (see page 132). According to Pliny, at the end of the fourth century B.C. Philoxenos of Eretria painted one of the victories of ALEXANDER THE GREAT over King Darius III and his Persians. The same subject is shown in an exceptionally large and technically masterful floor **mosaic** from a Pompeian house of about 100 B.C. (fig. 5-5). The scene depicts Darius and the fleeing Persians on the right, and, in the badly damaged left-hand portion, Alexander on his favorite horse, Boukephalas.

Although there is no special reason to link this mosaic with Pliny's account (several other such paintings are recorded), it is surely an excellent copy of an early Hellenistic painting of c. 330–300 B.C. The picture follows the four-color scheme (yellow, red, black, and white) widely used at that time. The crowding, the air of frantic excitement, the powerfully modeled and foreshortened forms, the clearly delineated **ground plane** (see page 42) and the precise shadows make the scene far more complicated and dramatic than any other work of Greek art from the period. Although Greek artists had produced historical scenes before, most notably to celebrate the Persian defeats of 490 and 480 B.C., we know little about them. With its dramatic confrontation of the intense, implacable Alexander and the hapless Darius, this picture explores a new world: the clash of civilizations and the triumphs and

There were two Plinys: PLINY THE ELDER (23/24–79 A.D.) and his nephew and adopted son, Pliny the Younger (c. 61–c. 112). Pliny the Elder served several Roman emperors as a military officer. In midlife, he took up writing, producing an encyclopedia that contains a history of art organized by materials—bronze, earth, and stone. This text is a prime source for our knowledge of Greek sculpture and painting. Pliny the Younger left numerous letters, including a detailed description of his villa and another of his uncle's death during the eruption of Mount Vesuvius.

Philip II (382–336 B.C.), king of Macedon—modern Macedonia—was a military genius who, by the time of his assassination, had humbled the major powers of mainland Greece and had cajoled all the Greek states except Sparta into an anti-Persian alliance. His son, ALEXANDER THE GREAT (356–323 B.C.), was already an accomplished general at the age of 18 and succeeded his father two years later. He invaded Persia in 334 and within ten years created an empire that reached the Indus Valley. He founded many cities in the conquered territories that all bore his own name. He died suddenly in his capital, Babylon (see fig. 3-9) when he was just 33. His empire disintegrated into several independent kingdoms after his death.

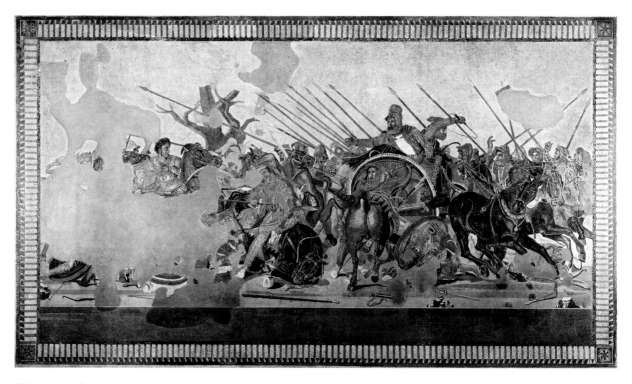

5-5 *Battle of Alexander and the Persians.* C. 100 B.C. Mosaic copy from Pompeii of a Hellenistic painting of c. 330–300 B.C. 8′10″ × 16′9¹⁄₂″ (2.71 × 5.12 m). Museo Archeologico Nazionale, Naples

tragedies of men of awesome power and seemingly limitless resources. In effect, its realism turns us into eyewitnesses of these events. All this is a far cry from the small, squabbling Greek city-states, black- and red-figure vases, and mythology (figs. 5-3 and 5-4).

Temples

A handful of shrines to the gods are known from Mycenaean Greece and the subsequent Dark Age (c. 1150–950 B.C.), but the creation of large, free-standing temples is an achievement of the Late Geometric period: the eighth century B.C. The earliest temples were made of mudbrick and wood on rough-hewn stone foundations, but from c. 600 B.C. cut stone was normally used throughout, except for the roof. Essentially a weather-proof statue box, the temple was intended to house the statue of the deity worshiped there and any offerings made to him or her that were either perishable (like clothes) or vulnerable to theft (like jewelry). The cult rituals themselves, however, were usually not performed inside the temple. Instead, they centered on an altar placed in front of it, on which the priests of

the cult made sacrifice, facing the rising sun. Greek temple architecture is one of their most important legacies to Western art.

TEMPLE PLANS

The textbook Greek temple is often around or just over 100 feet long (see Temple Plans: Reading Architectural Drawings, and fig. 5-6). Its nucleus is the **cella** or naos (the room that housed the statue of the deity), and the porch (pronaos) with its two columns (columns in antis) flanked by **pilasters** (antae). Sometimes a second, dummy porch was added behind the cella, to make the design more symmetrical. This central unit is often surrounded by a **colonnade**, called the **peristyle** (smaller temples such as that illustrated in fig. 5-10 were given a colonnade only at front and back, and the smallest dispensed with it altogether). A textbook peristyle consists of six columns at front and back, and from 12 to 14 along the sides (the corner columns are counted twice). Some large Doric temples like the Parthenon (see fig. 5-9) increased this number to 8 by 17 columns, and the very largest temples of Ionian Greece even had double colonnades. In most Greek temples the entrance faces east, toward its altar and the rising sun. This orien-

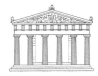
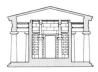
tation reaches back to Stonehenge (see fig. 1-6) and is continued in Christian basilicas (see pages 144–45), which also face east but were entered from the west.

ORDERS

Since Roman times, the Greek achievement in architecture has been identified with the three Classical **orders**: Doric, Ionic, and Corinthian. Actually, there are only two, for the Corinthian is a variant of the Ionic. The Doric is so named because its home is southern Greece, settled by Dorian Greeks. It is somewhat older and more sharply defined than the Ionic, which developed on the Aegean Islands and the coast of Asia Minor.

What do we mean by an architectural "order"? Essentially, it is a distinct and consistent architectural *style*. The term is used only for Greek architecture and its descendants; and rightly so, for no other Western architectural system produced anything like it. Perhaps the simplest way to make this point is to note that there is no such thing as "the Egyptian temple" or "the Gothic

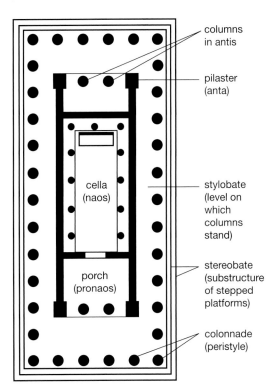

5-6 Ground plan of a typical Greek peripteral temple

columns in antis

pilaster (anta)

cella (naos)

stylobate (level on which columns stand)

porch (pronaos)

stereobate (substructure of stepped platforms)

colonnade (peristyle)

church." The individual buildings, however much they may have in common, are so varied that we cannot say that they represent a consistent type. But "the Doric temple" is a real, distinct, and instantly recognizable entity that forms in our minds as we study the monuments themselves.

We must not think of these abstractions as a series of rules against which to measure the degree of perfection of any given Doric or Ionic building. Instead, they were sets of generally accepted conventions, ensuring that the elements of the two orders remained extraordinarily constant in kind, in number, and in their relation to one another. As a result, Doric and Ionic temples all belong to the same easily recognized families, just as kouros and kore statues do (see pages 87–88). And like these statues, each temple is governed by a structural logic that makes it look stable and satisfying because of the precise arrangement of its parts; it shows an internal consistency, harmony, and balance that gives it a uniquely organic unity. Nor is the similarity a coincidence. According to the Roman architect Vitruvius, no doubt basing himself on Greek sources, "Without symmetry and proportion there can be no principles in the design of any temple; that is, if there is no precise relation between its members, as in the case of a well-shaped man. [Like the face] the other bodily members have also their measured ratios, such as the great painters and master sculptors employed for attainment of great and boundless fame." A Greek temple is an abstract sculpture in a landscape.

A faith in ratio can be found throughout Greek philosophy beginning with the Pythagoreans, who believed that like musical harmony, the harmony of the universe could be expressed in mathematical terms. The Greeks were not the first to explore proportions, of course; the Egyptians had done so earlier. But the Greeks explored them more systematically, thanks to their passion for abstract numbers. They were able to devise the formulas required for solving complex problems, something that was beyond the grasp of the Egyptians, who remained wedded to a practical approach. There is considerable evidence that the Greeks of Asia Minor gained their theoretical bent from Mesopotamia. Once they had acquired this taste for mathematics, the Greeks never lost it, and applied it, as we will see, to sculpture as well as architecture, and even to painting. Plato, too, made numbers the basis of his doctrine of ideal forms and acknowledged that beauty was based on proportion, though he seems to have had little use for art.

The Greek orders necessarily place a premium on design as an essential precondition of architecture (as opposed to mere building). This is consistent with the Greek reverence for geometry and mathematics, for *order* in its most fundamental sense. Yet, as we have seen, the term *architecture* derives from *tekton*, meaning carpenter. Initially, then, it was one of the crafts as defined at the beginning of this chapter. Inscriptions attest that architectural design, no matter how much expertise it required, was valued, at least financially, no more than any other form of masonry. Indeed, purely decorative carvings sometimes commanded higher prices. It is nevertheless significant that Greek and Roman writers recorded only the names of the architects, not the stonemasons. Thus we must think of the Greek architect as something more than a chief mason or clerk of the works, even if he was not accorded the same exalted status as today.

In the end, Greek architects' greatest achievement was more than the creation of beautiful buildings. At times, their temples seem to be almost alive. They achieved this triumph chiefly by expressing the structural forces active in the buildings themselves. In the Classical period, expressions of force and counterforce in both Doric and Ionic temples were proportioned so exactly that their opposition produced the effect of a perfect balance of forces and a harmony of sizes and shapes. This is the real reason why, in so many periods of Western history, the Greek orders have been considered the only true basis for good architecture. They are so satisfying both visually and psychologically that (it was thought) they could not be surpassed.

THE DORIC ORDER

The term **Doric order** refers to the standard parts, and their arrangement, found on the exterior of any Doric temple, such as figure 5-8. The diagram in figure 5-7 shows the order in detail. Many of these terms have

become part of our general architectural vocabulary. They remind us that analytical thinking, in architecture as in countless other fields, began with the Greeks.

Let us look first at the three main divisions: the stepped platform (consisting of the stereobate and stylobate), the column, and the **entablature**. The **Doric column** consists of the **shaft**, marked by 20 shallow vertical grooves known as **flutes**, and the **capital**, which is made up of the flaring, cushion-like **echinus** and a square element called the **abacus**. All these bear a strict ratio to each other, though columns became slimmer and capitals smaller and more compact over time. The entablature, which includes all the horizontal elements that rest on the columns, is the most complex of the three major units. It is subdivided into the **architrave** (a row of stone lintels resting directly on the capitals); the **frieze**, made up of grooved **triglyphs** and flat or sculpted **metopes**; and a projecting horizontal cornice, or geison, topped by a gutter (sima). The architrave in turn supports the triangular **pediment** and the roof elements (raking cornice and raking sima).

The entire structure is built of cut stone blocks fitted together without mortar. Limestone was preferred because it was abundant, easily cut, and easily stuccoed. Marble temples were rare. Naturally, the blocks had to be shaped with great precision to achieve smooth joints, which were then secured by iron clamps. Dovetail or L-shaped cuttings were made in the adjoining upper surfaces of the blocks, filled with molten lead, and the clamps sunk into them. Columns, with very rare exceptions, were composed of sections called **drums**, each secured with iron dowels to the one below it. The shaft was fluted after the entire column was assembled and in position. The roof was made of terracotta tiles supported by wooden rafters, and wooden beams were used for the ceiling, so the threat of fire was constant.

How did the Doric order originate? What factors shaped it? Our answers are incomplete, for we have almost no remains from the time when the system was invented. The earliest stone temples were probably built north of Mycenae near Corinth, the leading cultural center of Greece during the seventh century B.C. From there the idea spread across the isthmus that connects the Peloponnesos

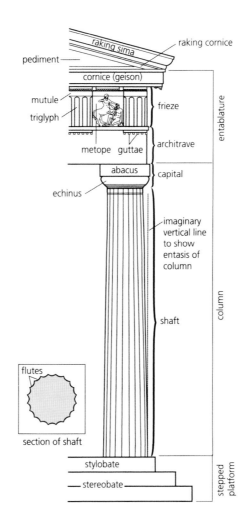

to the mainland and up the coast to Delphi and Corfu, then rapidly throughout the Hellenic world. Soon after, the first Greek architects become known to us by name, signaling the importance of this architectural revolution. The oldest surviving temples show that the main features of the Doric order were already well established around 600 B.C. But how they developed, individually and in combination, and why they coalesced into a system so quickly, remain puzzles to which we have few reliable clues.

The early Greek builders in stone seem to have drawn on three sources of inspiration: Mycenae, Egypt, and contemporary Greek architecture in wood and mudbrick. Of the three, Mycenae is the most obvious, although probably not the most important. The central unit of the Greek temple, the cella and its porch, is clearly derived from the megaron, the main hall of the Mycenaean palace, either through tradition or by way of revival. There is something oddly symbolic about the fact that the Mycenaean royal hall should have been converted into the dwelling place

of the Greek gods. The entire Mycenaean era had become part of Greek mythology, as attested by the Homeric epics, and the walls of the Mycenaean fortresses were thought to be the work of mythical giants, the Cyclopes. The awe the Greeks felt toward these remains also helps us to understand the link between the Lion Gate relief at Mycenae (see fig. 4-6) and the sculptured pediments on Doric temples. Finally, the flaring, cushion-like capital of the Minoan-Mycenaean column is much closer to the Doric echinus and abacus than is any Egyptian capital. Doric columns, on the other hand, taper upward, not downward like Minoan-Mycenaean ones, and this points to Egypt.

In Egypt, an obvious place to start is the funerary district of Djoser at Saqqara (see fig. 2-6) with its faceted columns (or rather half-columns). They look somewhat like the typical Doric shaft, but are more than 2,000 years older. Nevertheless, the very notion that temples should be built of stone and have large numbers of columns must have come from Egypt. Moreover, the Greeks must have learned many of their stonecutting and masonry techniques from the Egyptians, together with their knowledge of architectural ornament and the geometry needed to lay out temples and to fit the parts together. It is true, of course, that the Egyptian temple is meant to be seen from the inside, whereas the Greek temple is designed so that the exterior matters most. A peripteral temple (that is, one surrounded by a colonnade) might be viewed as the columned court of an Egyptian sanctuary turned inside out, but essentially it is a new idea, a radical break with tradition. Unfortunately, we cannot say just how the Greeks went about all this, or exactly what they borrowed, technically and artistically, although they surely owed more to the Egyptians than to the Minoans and Mycenaeans.

Finally, we need to consider a third factor: To what extent did the Doric order reflect earlier, local wooden structures? The earliest Greek temples were modest huts little larger than a standard Greek house but divided into two rooms, one in front for the temple (cult) statue and one in back for storage. The first large-scale Greek temple so far excavated, the Temple of Hera on Samos, dating from the eighth century, was originally nothing more than a 100-foot long mudbrick hall on a stone foundation. A row of posts down the middle supported the wooden roof and a wooden cult statue stood slightly off center at the end. Sometime later it received a portico (porch) complete with a peristyle of wooden columns on stone bases.

These early temples offer little support for the idea that the Doric order sprang directly from wood prototypes. Nevertheless, at the very start, Doric architects certainly imitated in stone some features of wooden temples, if only because these features were deemed necessary to identify a building as a temple. Thus the triglyphs may be derived from the ends of ceiling beams decorated with three grooves and secured with wooden pegs. The shape of these pegs is echoed in the **guttae**. Metopes evolved out of the boards that filled in the gaps between the triglyphs to keep the rain out. Likewise, **mutules** (flat projecting blocks) imitate the rafter ends of wooden roofs. When Greek architects incorporated these wooden forms into the Doric order, however, they did not simply petrify them, as it were. They thoroughly reworked them so that little or nothing remained of their original structural function: the ceiling beams, for example, were no longer placed at frieze level but one course higher, in sockets cut into the triglyphs' upper surfaces.

Paestum We can see the evolution of temples in two examples located near the southern Italian town of Paestum, where the Greek colony of Poseidonia flourished during the Archaic period (fig. 5-8). They are both dedicated to the goddess Hera, wife of Zeus; however, the Temple of Hera II (foreground) was built almost a century after the Temple of Hera I (the so-called Basilica). Both temples are Doric, but there are striking differences in their proportions. The Temple of Hera I seems low and sprawling—and not just because so much of the entablature is missing—whereas the Temple of Hera II looks tall and compact. Part of the difference is psychological and is produced by the outline of the columns. Those in the Temple of Hera I are more strongly curved and are tapered to a relatively narrow top. This swelling effect, known as **entasis**, makes one feel that the columns bulge with the strain of supporting the superstructure and that their slender tops, although aided by the widely flaring, cushion-like capitals, are just barely up to the task. The sense of strain has been

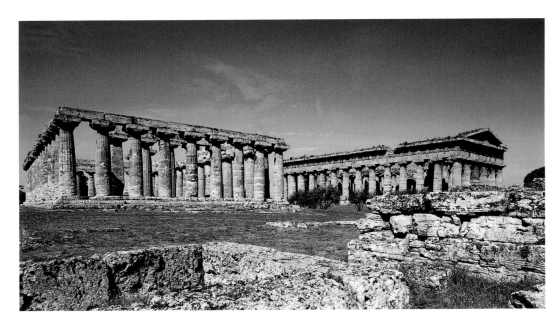

5-8 The Temple of Hera I, c. 550 B.C., and the Temple of Hera II, c. 460 B.C., Paestum, Italy

explained on the grounds that Archaic architects were not fully familiar with their new materials and engineering procedures. Such a view, however, judges the building by the standards of later temples and overlooks the expressive vitality of the building—the vitality we also sense in a living body.

In the Temple of Hera II the exaggerated curvatures have been modified, the columns are taller, and the capitals more compact. These changes, combined with a slightly wider column spacing, literally as well as expressively brings the stresses between supports and weight into more harmonious balance.

The Parthenon In 480 B.C., shortly before their defeat by the Greeks, the Persians destroyed the temples and statues on the Akropolis (literally, "high city"), the sacred hill above Athens, which had been fortified since Mycenaean times. The rebuilding of the Akropolis under the leadership of PERIKLES during the later fifth century, when Athens was at the height of its power, was the most ambitious enterprise in the history of Greek architecture. Individually and collectively, these structures exemplify the Classical phase of Greek art in full maturity. This achievement is all the more surprising in light of the fact that, by today's standards, Athens was only a modest city, never with more than about 100,000 inhabitants.

The greatest temple, and the only one completed before the Peloponnesian War began in 431 B.C., is the Parthenon (fig. 5-9), dedicated to the virgin goddess Athena, the patron deity in whose honor Athens was named. Inside was a colossal cult statue of Athena by Pheidias. The architects Iktinos, Kallikrates, and Karpion erected the Parthenon in 448–438 B.C., an amazingly brief span of time for such a huge project (its pediments, fig. 5-21, took five years longer). Built of gleaming white marble on the most prominent site along the southern flank of the Akropolis, it dominates the entire city and the surrounding countryside, a brilliant landmark against the backdrop of mountains to the north.

To meet the huge expense of building the largest and most lavish temple on the Greek mainland, Perikles used funds that had been collected from states allied with Athens for mutual defense against the Persians. He argued that the danger was no longer real and that Athens, the chief victim and victor of the Persian wars in 480–479 B.C., was justified in using the money to rebuild what the Persians had destroyed. Not everyone agreed. Perikles's political enemies reproached him for adorning the city "like a harlot with precious stones, statues, and temples costing a thousand talents." His act also increased the allies' resentment against Athens' growing power, indirectly contributing to the disastrous outcome of the Peloponnesian War.

If we contrast the Parthenon, the embodiment of Classical Doric architecture, with the Temple of Hera II at Paestum (see fig. 5-8, right), we can make several interesting observations. Despite the Parthenon's greater

The preeminent politician of Classical Greece was the Athenian PERIKLES (c. 495–429 B.C.; often Latinized to Pericles). During his 33-year ascendancy, from 462 to 429 B.C., Athens became the center of a wealthy empire, a highly progressive democratic society, and a vibrant hub of art and architecture.

5-9 Iktinos, Kallikrates, and Karpion. The Parthenon (view of the east facade), Akropolis, Athens. 448–432 B.C.

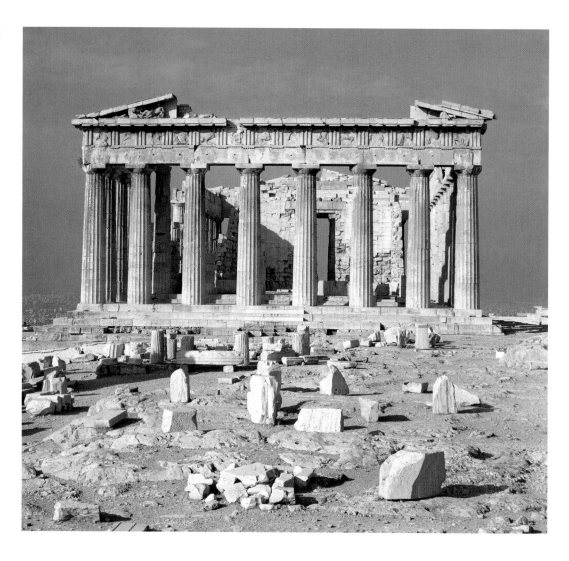

■ Marcus VITRUVIUS Pollio (active 46–27 B.C.) was an architect for Julius Caesar. His lasting fame, however, rests on the fact that his ten-book treatise on classical architecture, *De architectura*, is the only such work to survive from antiquity. Based heavily on Greek architectural treatises, it is our most important written source of information about Greek architecture. From the fifteenth century to the present, architects have pored over translations of Vitruvius to learn about classical principles of proportion, the Greek orders, and other matters of architectural theory and practice—often interpreting them with wide latitude.

size, it seems far less massive. Instead, it creates an impression of festive, balanced grace within the austere scheme of the Doric order. This effect is achieved by using shining white marble throughout, and readjusting the proportions once more. The entablature is even lighter and the cornice less obtrusive. The columns themselves are more slender still, their taper and swelling (entasis) are far less pronounced, and their capitals are smaller and less flaring; yet the column spacing is wider. The load they carry appears to have decreased, and as a result they seem to fulfill their task with a new sense of ease.

These and other intentional departures from the strict geometric regularity of the design are features of the Classical Doric style that can be seen in the Parthenon better than anywhere else. For example, the stepped platform and entablature are slightly curved, so that their centers are an inch or two higher than their ends. Similarly, the columns lean inward somewhat;

the spaces between the corner ones and their neighbors are smaller than the standard interval used for the colonnade as a whole; and every capital of the colonnade is slightly distorted to fit the curving architrave. Such adjustments were made for aesthetic reasons. They give us visual reassurance that the points of greatest stress are supported and are provided with a counterstress as well, and infuse the massive structure with elasticity and life.

The labor and expertise required to produce these refinements, indeed to build the Parthenon at all, were simply staggering. Many elements weigh over five tons, and the capitals and architraves almost ten tons. In only ten years, tens of thousands of marble blocks, from the 506 drums of the outer colonnade to the 8,957 marble roof-tiles, had to be quarried, hauled the dozen miles to the Akropolis, and finished to tolerances so fine that they exceed any in use today. For example, every platform block and every column

drum had to be cut on the bias to accommodate the curvature of the stylobate and the inward lean and taper of the columns; no right angles were possible and no two stones could be identical. Yet every angle is true; the platform's joints are so tight (less than one ten thousandth of an inch across) that a 60-power microscope cannot penetrate them; and the joining surfaces of the drums, totaling over one thousand, deviate from the flat by less than a thousandth of an inch. The masons accomplished all this without the aid of accurate rulers, protractors, or other precision measuring instruments.

Such great technical skill, nevertheless, doesn't account fully for the Parthenon's remarkable visual power, which has never been surpassed. The Roman architect VITRUVIUS records that Iktinos based his design on carefully considered proportions. The ratio of the distance between the column axes and their lower diameters (9:4) was used throughout the building. But accurate measurements reveal them to be anything but simple or rigid. There are many subtle adjustments, which

give the temple its surprisingly organic quality. In this respect its design closely parallels the underlying principles of Classical sculpture (see pages 91–98). Indeed, with its sculpture in place the Parthenon must have seemed animated with the same inner life that informs the pediment figures, such as the *Three Goddesses* (see fig. 5-21).

The Propylaea While the Parthenon was still in progress, Perikles persuaded the Athenians to agree to another costly project. This was the monumental entry gate at the western end of the Akropolis, called the Propylaea (fig. 5-10, left and center). It was begun in 437 B.C. under the architect Mnesikles, who completed the main part in five years; the rest had to be abandoned because of the Peloponnesian War. Again, the entire structure was built of marble and featured proportions and refinements similar to those of the Parthenon. It is fascinating to see how the elements of a Doric temple have been adapted to a totally different task, on an irregular and steeply rising site. Mnesikles's design not only

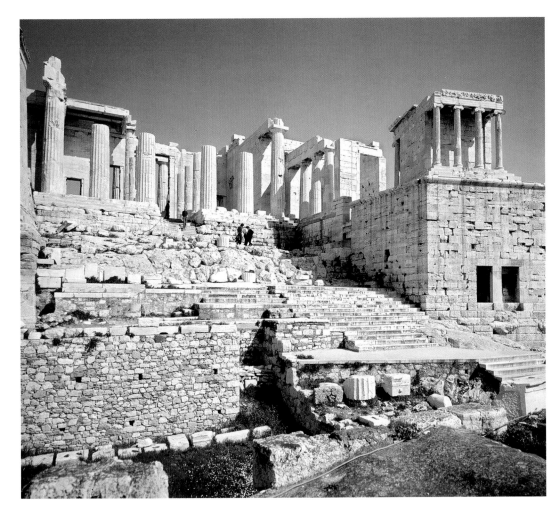

5-10 Mnesikles. The Propylaea, 437–432 B.C. (left and center), with the Temple of Athena Nike, 427–424 B.C. (right). Akropolis (view from the west), Athens

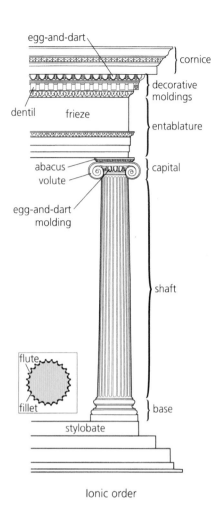

egg-and-dart

cornice

decorative moldings

dentil frieze

entablature

abacus

volute

capital

egg-and-dart molding

shaft

flute

fillet

base

stylobate

Ionic order

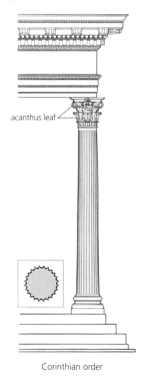

The third major classical order, the Corinthian, is the most elaborate. The acanthus-leaf motif is distinctive of the Corinthian capital.

acanthus leaf

Corinthian order

fits the difficult terrain but also transforms it from a rough passage among rocks into a splendid entrance to the sacred precinct.

THE IONIC ORDER

Next to the Propylaea is the elegant little Temple of Athena Nike (fig. 5-10, right), which was probably built between 427 and 424 B.C. It has the slenderer proportions and the scroll capitals of the **Ionic order**. This order first appeared about a half-century after the Doric. Unfortunately, though, of the huge Ionic temples that were erected in Archaic times—the Temple of Hera at Samos, built around 575 B.C. by Theodoros of Samos according to Vitruvius, and the Temple of Artemis at Ephesos, designed some 15 years later by Chersiphron and his son Metagenes— little has survived. Indeed, they were so huge that their architects even surrounded them with a double ring of columns—the earliest such double-colonnaded or *dipteral* temples that we know of. Athens, with its strong Aegean orientation, had been open to this eastern Greek style of building from the mid-

sixth century on. In fact, the finest surviving examples of the Ionic order are on the Akropolis. In pre-Classical times, however, the only Ionic structures on the Greek mainland had been the small treasuries built by eastern Greek states at Delphi in their regional styles. Thus, when Athenian architects first used the Ionic order, they thought of it as suitable only for small temples with simple plans.

The Ionic order (fig. 5-11) always remained more flexible than the Doric. Its entablature lacks the latter's alternating triglyphs and metopes, but whereas east Greek Ionic simply substituted for these an elaborately molded cornice, Athenian Ionic added a continuous frieze, which was often sculptured (see fig. 5-11). But its most striking feature is the **Ionic column**, which differs fundamentally from the Doric. It rests on an ornate rounded base that is sometimes set on a square plinth. The shaft is more slender, and there is less tapering and little or no apparent swelling of the columns (entasis) (see page 82). The capital now includes a large double scroll, or **volute**, below the abacus, which projects strongly beyond the width of the shaft.

When we turn from a diagram to an actual building, it becomes clear that the Ionic column is very different in character from the Doric column. The Doric column consists of two parts; the Ionic, of three (see figs. 5-7 and 5-11). It is also lighter and more graceful. It lacks the muscular quality of its mainland cousin. (Vitruvius, in fact, calls the Doric order masculine and best suited to male divinities and the Ionic order feminine and best suited to female ones). It evokes a growing plant, something like a formalized palm tree. If we trace the early relatives of these plantlike columns back to their point of origin, we would find ourselves at Saqqara in Egypt. There we see not only "proto-Doric" supports but also the papyrus half-columns of figure 2-6, with their flaring capitals. Perhaps the form of the Ionic column, too, had its ultimate source in Egypt. But instead of reaching Greece by sea, as we suppose the proto-Doric column did, it perhaps traveled a slow and tortuous path by land through Syria and Asia Minor.

Sculpture

The new motifs that distinguish the Orientalizing style from the Geometric in vase paint-

ing—fighting animals, winged monsters, scenes of combat—had reached Greece mainly through ivory carvings and metalwork imported from Phoenicia and Syria. Enough such objects, incorporating Mesopotamian as well as Egyptian motifs, have been found on Greek soil to establish the connection. However, they do not help us to explain the rise of monumental sculpture in stone about 650 B.C. All surviving Greek sculpture from the Geometric period consists of simple clay or bronze figurines of animals and warriors only a few inches high, though later sources often mention primitive wooden temple (cult) statues that are now lost.

So how did the Greeks suddenly develop a taste for monumental stone sculpture? Like their new interest in monumental architecture, it must have resulted from renewed contact with Egypt. We know that a colony of Greeks existed in Egypt at the time. In 664 B.C., an armed band of Greeks was driven by a storm into the Nile Delta and helped Psamtik conquer his rivals, oust the Assyrians, and reunify Egypt under his rule. He then allowed them to found a colony there. But how did Greek artists master stone carving so quickly? The oldest surviving Greek stone sculpture and architecture show that the Egyptian tradition had already been absorbed and Hellenized, although the link with Egypt is still clearly visible.

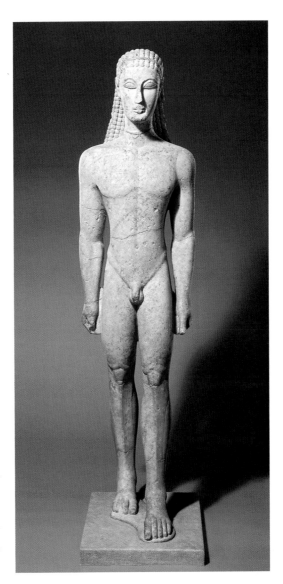

5-12 *Kouros (Standing Youth).* c. 580 B.C. Marble, height 6'1½" (1.88 m). The Metropolitan Museum of Art, New York. Fletcher Fund, 1932

ARCHAIC STYLE

Let us compare a very early Greek statue of a nude youth of about 600 B.C., called a **kouros** (fig. 5-12), with the Egyptian statue of Menkaure (see fig. 2-4). The similarities are certainly striking. We note the block-conscious, foursquare character of both; the slim, broad-shouldered silhouette of the figures; the position of their arms; their clenched fists; the way they stand with the left leg forward; the emphatic rendering of the kneecaps; and the formalized, wiglike treatment of the hair. The two were both planned using a grid drawn on the stone; indeed, the Greek statue uses a late version of this Egyptian grid invented around 700 B.C. And, like Egyptian sculpture, it was originally painted, as were all Greek statues. Yet judged by Egyptian standards, it seems somewhat primitive: rigid, oversimplified, and awkward. It reduces the naturalistic modeling of Menkaure to a series of patterns that bring the undulant volumes and muscles of the human body to order.

But the kouros also has virtues that cannot be measured in Egyptian terms. First, it is truly **freestanding**. In fact, it is the earliest large stone image of the human form in the entire history of art of which this can be said. Egyptian carvers had never cared to liberate such figures completely from the stone. Their statues remain immersed in it to some degree, so that the empty spaces between the forms always remain partly filled. There are never any holes in Egyptian stone figures, which essentially resemble ultra-high reliefs. The Greek sculptor, in contrast, does not mind holes: The arms are separated from the torso and the legs from each other, and the carver goes to great lengths to cut away all the rest of the stone. (The only exceptions are the bridges between the fists and the thighs.) Apparently, the Greeks felt that the stone

must be transformed; it is a representational resource that cannot be allowed to remain inert or neutral.

This is not a question of technique but of artistic intention. The liberation of the figure gives our kouros a character quite different from that of Egyptian statues. While the latter seem becalmed by a spell that has released them from every strain for all time to come, the Greek image is tense and full of hidden life. The direct stare of his huge eyes offers the most telling contrast to the gentle, faraway gaze of the Egyptian figures. And he is completely naked except for a choker, revealing his body in all its youthful glory to every passer-by. Something beyond mere convention is clearly at work here. During this time, it was becoming common for Greek men to exercise and compete in ath-

letic games while naked. Homoeroticism, too, was becoming increasingly prevalent. By the end of the Archaic period it would spread far beyond the elite (see page 95).

The **kore**, as the Greek female statue type is called, is more varied than the kouros. Always clothed, it poses a different problem: how to relate body and drapery. It is also more likely to reflect changing habits or local differences of dress. The kore in figure 5-13 was carved almost a century after our kouros. Although found on the Akropolis, she wears two fashionably Ionian garments: A light, symmetrical, linen gown or *chiton* that covers but does not conceal the solidly rounded shapes beneath, and a heavy, asymmetrical, woolen cloak or *himation* that forms a highly differentiated, ornate layer over it. Both garments are brightly painted, and like the anatomy of the kouros, their folds are highly stylized, as the sculptor seeks meaningful patterns within the complex, shifting play of cloth and body. Most noteworthy of all is the strong face, whose mannish features are softened somewhat by the characteristic smile and the soft auburn tresses that fall to the shoulders and discreetly model the breasts.

Whom do these figures represent? The general names of *kore* ("maiden") and *kouros* ("youth") are modern, noncommittal terms that gloss over the difficulty of identifying them further. As it happens, figure 5-12 was a grave marker and figure 5-13 a votive to Athena, offering her an apple. Yet although they both stand for particular individuals, each could fulfil the function of the other, and neither is a portrait in any meaningful sense. Instead, they are generic images of "life's jeweled springtime," as an Archaic poet put it, intended, respectively, to console a dead man and his relatives, and to delight a divinity and her worshipers. Not surprisingly, both types were produced in large numbers throughout the Archaic period, and the general outlines of the kouros, at least, remained remarkably constant, paralleling the consistency we have noted in Doric temple architecture. This lack of differentiation seems part of the essential character of the figures. They are neither gods nor mortals but something in between, an ideal of youth, beauty, vitality, and happiness shared by mortal and immortal alike, just as the heroes of the Homeric epics dwell in the realms of both history and mythology.

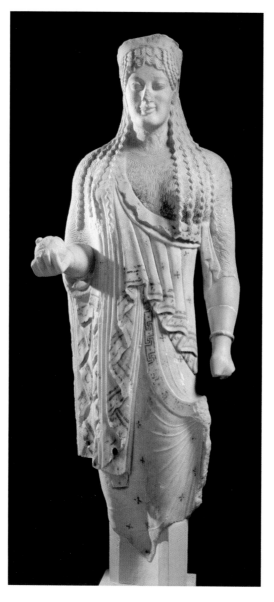

5-13 *Kore in Ionian Dress.* c. 520 B.C. Marble, height 5'1" (155 cm). Akropolis Museum, Athens

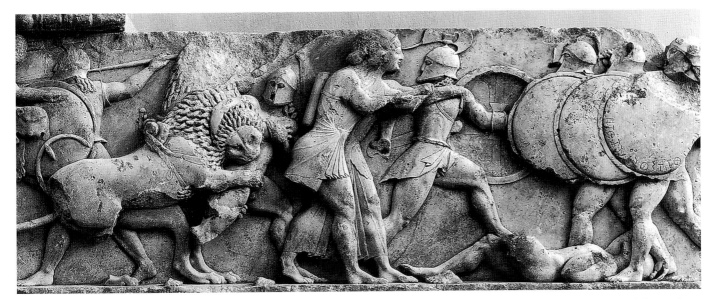

5-14 *Battle of the Gods and Giants,* from the north frieze of the Treasury of the Siphnians, Delphi. c. 530 B.C. Marble, height 26" (66 cm). Archaeological Museum, Delphi

Architectural Sculpture

It is a striking feature of Greek temples and other religious buildings that they were designed with sculpture in mind almost as soon as they began to be built of stone. Indeed, early Greek architects such as Theodoros of Samos were often sculptors. Thus to a Greek, a temple would have seemed "undressed" without sculpture, which was usually designed at the same time as the structure itself. Architecture and sculpture became so closely linked that Greek architecture is highly sculptural and, as we have seen, itself takes on something of the quality of a living organism. The sculpture, in turn, plays an important role in bringing the structure to life.

In this way, the Greeks fell heir to the age-old tradition of architectural sculpture. The Egyptians had been covering walls and columns with reliefs since the Old Kingdom, but these carvings were so shallow (for example, fig. 2-3) that they did not break the continuity of the surface and had no weight or volume of their own. They were related to their architectural setting only in the same limited sense as wall paintings (with which they were, in practice, interchangeable). This is also true of the reliefs on Assyrian, Babylonian, and Persian buildings (for example, figs. 3-8 and 3-11).

In the Near East, however, there was another kind of architectural sculpture, which apparently began with the Hittites: the guardian monsters protruding from the blocks that framed the gateways of fortresses and palaces. This tradition must have inspired, perhaps indirectly, the Lion Gate at Mycenae (see fig. 4-6). We must nevertheless note one important feature that distinguishes the Mycenaean guardian figures from their predecessors. Although they are carved in high relief on a huge slab, the slab is thin and light compared to the enormous blocks around it. In building the gate, the Mycenaean architect left an empty triangular space above the lintel, for fear that the weight of the wall above would break it. That space was then filled with the lightweight relief panel. Here we have a new kind of architectural sculpture: a work integrated with the structure yet also a separate entity rather than a modified wall surface or block.

The Greeks followed the Mycenaean example. In their temples, stone sculpture is confined to the pediment, between the ceiling and the sloping sides of the roof, and to the zone immediately below it (the metopes in Doric temples and the frieze in Ionic architecture). Otherwise there were few places that the Greeks deemed suitable for architectural sculpture. They might put freestanding figures or akroteria (often of terracotta) above the ends and the center of the pediment to break the severity of its outline. The Ionians would also sometimes support the roof of a porch with female statues (called **caryatids**) instead of columns, an idea evidently derived from Syria.

The Greeks retained the narrative wealth of Egyptian reliefs. The *Battle of the Gods and Giants* (fig. 5-14), part of a frieze from the TREASURY OF THE SIPHNIANS at

The TREASURY OF THE SIPH-NIANS is one of 20 treasuries built by various Greek cities within the walls of the sacred precinct at DELPHI, the god Apollo's main sanctuary. These small, rectangular buildings, fronted with two columns *in antis* and often decorated with sculpture, were commissioned by cities as receptacles for their more precious offerings to the god. The other major buildings inside the sacred precincts were altars and temples. In the late sixth century B.C., when this treasury was built, Siphnos, one of the Cyclades islands, was extremely rich from its gold and silver mines.

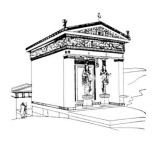

DELPHI, is executed in very high relief, with deep undercutting. At the far left, two lions (who pull the chariot of the mother goddess Cybele) are tearing apart an anguished giant. In front of them, Apollo and Artemis advance together, shooting their arrows. A dead giant, stripped of his armor, lies at their feet, while three others enter in formation from the right. The sculptor has taken full advantage of the spatial possibilities offered by working in high relief. The projecting ledge at the bottom of the frieze, originally painted brown, creates a stage on which figures can be placed in depth, and a similarly painted strip, now all but effaced, continued this ground plane a few inches up the background behind the figures. The arms and legs of the combatants nearest the viewer are carved completely in the round. In the second and third planes, the forms become shallower, and those farthest removed from us even penetrate the background—like the shield of the fleeing giant at center. The result is a condensed but convincing space that permits a more dramatic relationship between the figures than we have ever seen before in narrative reliefs. Compared with older examples (such as figs. 2-3 and 3-8), the Greek sculptor has indeed conquered a

new dimension here, not only in the physical but also in the expressive sense.

Meanwhile, in pedimental sculpture, relief was soon abandoned altogether. Instead, we find statues arranged in complex dramatic sequences designed to fit the triangular frame. The most ambitious groups of this kind in Archaic art were the pediments of the Temple of Aphaia at Aegina, which was built around 490. The original east pediment was apparently demolished after the defeat of the Persians at Salamis in 480 B.C., and the present one substituted. It shows the first sack of Troy by Herakles, who had completed his Twelve Labors, and Telamon, king of Salamis, who had fled Aegina after he and Peleus killed their half-brother. The subject attests to the important role played by Aeginetan heroes in this battle and the second siege of Troy (recounted in the *Iliad* and depicted on the west pediment)—and, by extension, at Salamis, where their navy helped win the day. This elevation of a contemporary victory to a universal plane through mythological analogy was typical of the Greek mentality.

The east pediment brings us to the final stage in the evolution of Archaic sculpture.

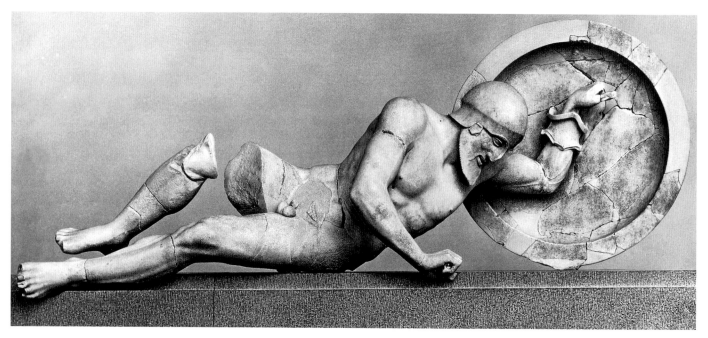

5-15 *Dying Warrior,* from the east pediment of the Temple of Aphaia, Aegina. c. 475 B.C. Marble, length 6' (1.83 m). Staatliche Antikensammlungen und Glyptothek, Munich

The figures were found in pieces on the ground. Among the most impressive is the fallen warrior from the left-hand corner (fig. 5-15), who has just plucked an arrow (rendered in bronze and now lost) from his chest. His lean, muscular body seems marvelously functional and lithe. That in itself, however, does not explain his great beauty, much as we may admire the artist's command of the human form in action. What really moves us is his nobility of spirit in the agony of dying, as his eyes close and his hand begins to slip from his shield. This man, we sense, is suffering—or carrying out—what fate has decreed. This sense of extraordinary dignity and resolve is communicated to us in the very feel of the magnificently firm shapes of which he is composed.

CLASSICAL STYLE

Sometimes things that seem simple are the hardest ones to achieve. Greek sculptors of the late Archaic period were skilled at representing in reliefs battle scenes full of struggling, running figures. To introduce the same freedom of movement into freestanding statues was a far greater challenge. Not only did it run counter to the conservative tradition of the kouroi and korai (figs. 5-12 and 13), but also the sculptors had to be sure to safeguard their all-around balance, self-sufficiency, and monumentality.

Kouroi walk, but it took more than a century after our kouros was made before the Greeks discovered the secret to making a figure stand "at ease." The *Kritios Boy* (fig. 5-16), named after the Athenian sculptor to whom it has been attributed, is the first known statue that "stands" in the full sense of the term. This is simply a matter of allowing the weight of the body to shift onto one leg from equal distribution on both legs (as is the case with the kouros, even though one foot is in front of the other. The resulting stance, called **contrapposto** (or counterpoise) because it balances weight-bearing and free, tensed and relaxed, brings about all kinds of subtle displacements. The bending of the relaxed knee creates a slight swivel of the pelvis, a compensating curvature of the spine, an adjusting tilt of the shoulders, and a slight

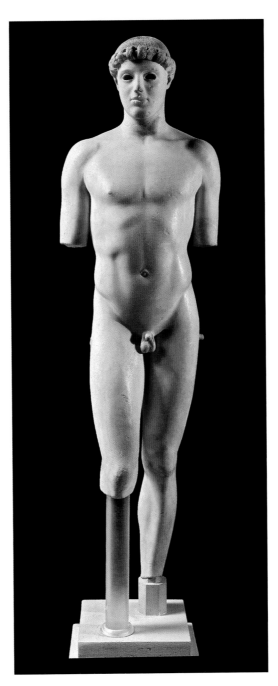

turn of the head. (All of these elements of the *contrapposto* stance are clearly visible in fig. 5-18).

Like the refinements of the Parthenon, these variations have nothing to do with the statue's ability to stand erect. Rather, they make it seem more alive. No longer a mere mechanism, a "robot made by Daidalos," it has become an organism. In repose, it will still seem capable of movement; in motion, of maintaining its stability. The

The *Zeus* (fig. 5-17) is one of the earliest surviving Greek statues that was made by the indirect lost-wax process. This technique enables sculptors to create spatially freer forms than they can in stone. Projecting limbs are made separately and soldered onto the torso, and no longer need be supported by unsightly struts. Compare, for example, the freely outstretched arms of the *Zeus* (fig. 5-17) with the strut extending from hip to drapery on the *Knidian Aphrodite* (fig. 5-24).

The Egyptians, Minoans, and early Greeks had often made statuettes of solid bronze using the *direct* lost-wax process. The technique was simple. The sculptor modeled his figure in wax; covered it with clay to form a mold; heated out the wax; melted copper and tin in the ratio of 9 parts to 1 in a crucible; and poured this alloy into the space left by the "lost wax" in the clay mold. Yet because figures made in this way were solid, the method had severe limitations. A solid-cast, life-size statue would have been prohibitively expensive, incredibly heavy, and prone to developing unsightly bubbles and cracks as the alloy cooled. So from the eighth through the sixth centuries B.C. the Greeks developed the indirect lost-wax method, which allowed statues to be cast hollow and at any scale.

First, the sculptor shaped a core of clay into the basic form of the intended metal statue. He then covered the clay core with a layer of wax to the thickness

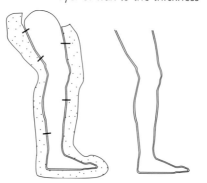

of the final metal casting, and carved the details of the statue carefully in the wax. The figure was then sectioned into its component parts—head, torso, limbs, and so on. For each part, a heavy outer layer of clay was applied over the wax and secured to the inner core with metal pegs. The package was then heated to melt the wax, which ran out. Molten metal—usually bronze, but sometimes silver or gold—was then poured into the space left by this "lost wax." When the molten metal cooled, the outer and inner molds were broken away, leaving a metal casting—the statue's head, torso, arm, or whatever. The sculptor then soldered these individual sections together to create the statue. He completed the work by polishing the surface, chiseling details such as strands of hair and skin folds, and inlaying features such as eyes, teeth, lips, nipples, and dress patterns in ivory, stone, glass, copper, or precious metal.

entire figure seems so alive that the Archaic smile, the "sign of life," is no longer needed. It has given way to a pensive expression. In a sense, once the Greek statue was free to move, it became free to think, not merely to act. The two—movement and thought—are inseparable aspects of Greek Classicism. Together they imply thoughtful ethical choice before taking action, and with it a new philosophical outlook that culminates in the *Doryphoros* (see fig. 5-18). The forms, moreover, display a new naturalism, simplicity, and proportional harmony that together provided the basis for the strong idealization characteristic of all subsequent Greek art.

Once these principles had been established, the problem of showing large, freestanding statues in motion no longer presented serious difficulties. Such figures, most of them made of hollow-cast bronze, are the most important achievement of the early phase of Classicism (see Materials and Techniques: The Indirect Lost-wax Process). For bronze has a much greater tensile strength than marble, and action figures made of this material do not require reinforcing with unsightly struts. The finest such statue to survive (fig. 5-17) was recovered from the sea near the coast of Greece: a magnificent nude bronze Zeus, almost seven feet tall, hurling his thunderbolt (now lost) at some unseen enemy. This statue takes the discoveries of the *Kritios Boy* one stage further. Its physique is a mature version of the *Boy*'s, powerfully defined and as massive and authoritative as the facade of a Doric temple. The pose is that of an athlete, yet it is

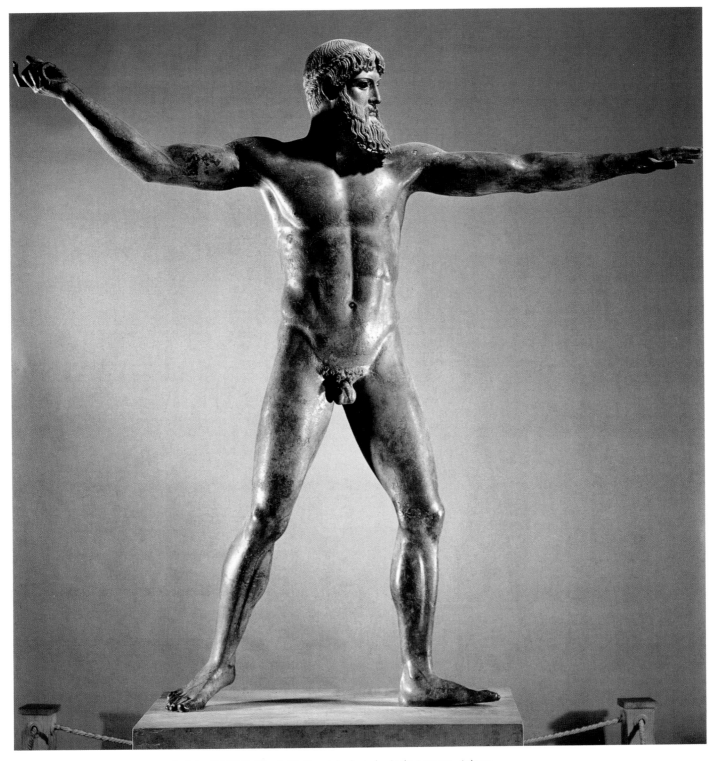

5-17 *Zeus.* c. 460 B.C. Bronze, height 6'10" (2.08 m). National Archaeological Museum, Athens

not so much the arrested moment in a continuous motion as the awe-inspir-ing gesture that reveals the god's cosmic power. Hurling a weapon becomes a divine attribute rather than an act aimed at a specific foe in the heat of battle.

Within half a century, the new articulation of the body that appears in the *Kritios Boy* and the *Zeus* reached its full development in the mature Classical style. The most famous nude male of that time, the bronze *Doryphoros (Spear Bearer)* by Polykleitos of Argos in the

5-18 *Doryphoros (Spear Bearer).* Modern bronze reconstruction by Georg Roemer of the original of c. 440 B.C. by Polykleitos. Marble, height 6'6" (2 m). Formerly in Munich, destroyed in 1944

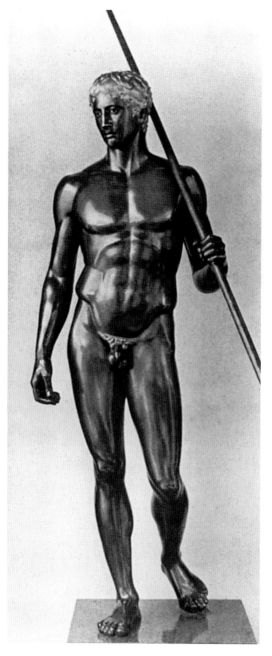

S P E A K I N G O F

Canon

Kanon (canon) in ancient Greek meant "rule" or "measure." In art history, the canon has come to mean the large body of artworks that, together, have been judged the central, most defining works of the Western tradition. (This book is centered on that canon.) The term also means a normative or ideal ratio of proportions, usually based on a unit of measure. This is why Polykleitos called the treatise that he wrote to accompany his *Doryphoros* (see fig. 5-18), the *Kanon. Canon* also describes the central and normative works in the fields of music, religion, and law; in the Catholic Church; and in cultural fields that parallel art history, such as literature.

Peloponnese (fig. 5-18), is known to us largely through Roman marble copies, which convey little of the beauty and power of the original. This is why we illustrate a modern reconstruction, painstakingly created by the German sculptor Georg Roemer from a composite of several Roman copies.

Still, it is instructive to compare this work with its two predecessors. Everything is a harmony of complementary opposites. The awesome physique is similar to that of the *Zeus,* but now the tense and relaxed limbs, and the major and minor muscles, are more sharply and clearly differentiated. The turn of the head, barely hinted at in the *Kritios Boy,* is

now pronounced, locking in the pose as the eye travels up the statue's proper left side and down its right. The figure's superhuman poise, precise anatomical details, and above all its harmonious proportions made it renowned as the embodiment of the Classical ideal of beauty. The ideal here must be understood in a dual sense: as a perfect model—the perfect citizen warrior—and as a sculptural prototype. To this end, following the precedent of the architects, Polykleitos accompanied his bronze with an explanatory treatise, a manifesto entitled the *Kanon* or "Rule." Soon the *Doryphoros* became known simply by this name.

The *Kanon* began with the statement that "Perfection comes about little by little through many numbers," and in it Polykleitos expounded a proportional system that embraced the entire male body from top to toe, relating every part mathematically to all the other parts and to the whole. Only paraphrases of the treatise survive, so the precise details of this system are lost, but it is clear that the *Doryphoros* was the very embodiment of mathematical and anatomical perfection. Yet it was more than an academic exercise. Polykleitos's faith in numbers also had a moral dimension often found in Classical Greek philosophy from the Pythagoreans to Plato. Harmonious proportions were equated with the good in an absolute sense—with moral as well as physical perfection.

As we have seen, the *Kanon* embraced not only an ideal of perfect proportion but also one of perfectly ordered movement. Both were basic aspects of Greek aesthetics, derived from music and dance. To the Greeks, deportment reflected character and feeling, which revealed the inner person and, with it, one's *arete* (excellence or virtue) or lack of it (see Cultural Context: Greek Heroes and Civic Values, page 74). The *Doryphoros,* then, is meant to instruct the viewer. His "mobile repose" and measured gait alert us to the measured self-knowledge required of the perfect citizen-warrior. His lowered gaze signals the need for modesty before the world and the gods.

This kind of sculpture appeals to both the mind and the eye, so that human and divine beauty become one. Indeed, the ideal Polykleitan body and its *contrapposto* were also used for the gods (see fig. 5-17 on page 93), and Polykleitos himself was even criticized for failing to do justice to their majesty. For his system, aiming at absolute perfection across the board,

tended to level the distinctions between humans and gods. The poet Pindar expressed the problem this way: Although "we are somehow like the gods in our great mind and form," what really separates humans from gods is power. Solving this problem would be the task of another High Classical sculptor, Pheidias, and his successors.

The Male Nude and Its Audience There can be little doubt that the Classical male nude was also intended to exert a sexual appeal—not primarily to female viewers as we might suppose, although they might well have enjoyed its attractions too, but to other men. Much has been made of Greek homosexuality, which was perhaps rooted in warrior bonding, but was institutionalized in Athens, Sparta, and elsewhere in very different ways and for very different reasons. Of course, if the Greeks had been exclusively homosexual, they would have soon died off! Their keen interest in erotic heterosexuality appears in many Greek vases, and one of the best-known comedies of the playwright Aristophanes centers on the war between the sexes. In the play, *Lysistrata*, the women of Athens decide to withhold sex until their men agree to a series of social and political demands. Yet even though the Greeks were predominantly heterosexual, the homoerotic intent of the male nude in Greek, and especially Athenian, art is inescapable. How strongly it was present at the beginnings of Greek art is debatable, but from the *Kritios Boy* on (see fig. 5-16), the soft flesh and youthful forms are subtly, yet pervasively sensual. Both Classical literature and art clearly show that the attraction was of older men to adolescent youths, and sometimes to young boys as well.

CLASSICAL ARCHITECTURAL SCULPTURE

Classical Greek temples often carried architectural sculpture, and great efforts were made to integrate it harmoniously with the building's structure. Solving the problem of movement in freestanding statues helped to liberate architectural sculpture as well, endowing it with a new spaciousness, fluidity, and balance. Individual figures often echo the subtle eroticism of their freestanding counterparts, and sometimes flaunt it in the context of an explicitly moralizing tale.

The Pediments of the Temple of Zeus The greatest sculptural ensemble of the generation after the Persian Wars is the pair of pediments of the Temple of Zeus at Olympia. The temple, begun around 470 B.C., was funded by booty from a local war. In the west pediment we see the LAPITHS defeat the CENTAURS (fig. 5-19). At the center of the composition stands Apollo. His commanding figure is part of the drama and yet rises above it. His outstretched right arm and the strong turn of his head show his active role. He wills the victory over the bestial Centaurs but, as befits a god, does not physically help to achieve it. Still, there is a tenseness in this powerful body that makes its outward calm even more impressive.

The forms themselves are massive and simple, with soft contours and undulating surfaces. To the left of Apollo, we see another

The mythical story of the LAPITHS' fight with the CENTAURS is first mentioned in Homer's *Odyssey*. Half-man, half-horse, Centaurs were the offspring of the Lapith king Ixion and a phantom of Hera, whom he had tried to rape (see the picture in fig. 7-21). As half-brothers of the Lapiths, the Centaurs were invited to the wedding of the Lapith king and his bride. In the story, the Centaurs were driven crazy by wine and tried to rape the bride and female guests (see fig. 5-19). Helped by the king's friend Theseus, the Lapiths fought and subdued the attacking Centaurs. To the Greek mind, their defeat signaled the need for the rational side of human nature to prevail over the irrational side. Centaurs appear in other myths, including an attack on Herakles.

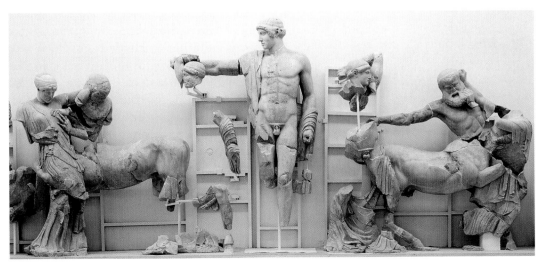

5-19 *Battle of the Lapiths and Centaurs,* from the west pediment of the Temple of Zeus, Olympia. c. 460 B.C. Marble, height of central Apollo 10'2" (3.1 m). Archaeological Museum, Olympia

tour-de-force in the Centaur king, Eurytion, who has seized Hippodameia, the bride of the Lapiths' king. No Archaic artist would have known how to combine the two into a group so compact, so full of interlocking movements. Late Archaic sculptors of friezes and pediments had already tackled scenes of strenuous action (see fig. 5-14 and 5-15), but now the passionate struggle is expressed not only through overt violence but through the emotions mirrored in the face of the Centaur. His bestiality contrasts vividly with the slight expression of disgust on Hippodameia's face, even as the Centaur gropes her naked breast.

The sculptures of the pediment make a clear moral distinction between the bestial Centaurs and the human Lapiths, who share Apollo's nobility. But it is Apollo, the god of self-control and rationality (see box, page 73, who is the real hero. In general, the pediment stands for the victory of humanity's rational and moral sides over its animal nature. It thus celebrates the triumph of Greek civilization over barbarism as a whole—and the Greek victory over the Persians in particular. (Perhaps it also served as a gentle reminder to visitors at the Olympic games to behave in a dignified manner.)

The *Dying Niobid* The pedimental figures we have seen so far, although technically carved in the round, are not freestanding. Instead, they are a kind of super-relief, designed to be seen against a background and from one direction only. By contrast, the *Dying Niobid* (fig. 5-20), a work of the 440s, is so three-dimensional and self-contained that we would hardly suspect she was carved for the pediment of a Doric temple. According to legend, Niobe had humiliated the mother of Apollo and Artemis by boasting of her seven sons and seven daughters. In revenge, the two gods killed all of Niobe's children. Our Niobid ("child of Niobe") has been shot in the back while running. Her strength broken, she sinks to the ground while trying to extract the fatal arrow. The violent movement of her arms has made her garment slip off. Her nudity is thus a dramatic device, emphasizing her helplessness in the face of divine wrath, rather than a necessary part of the story.

The *Niobid* is the earliest known large female nude in Greek art. The artist clearly enjoyed displaying a beautiful female body in the kind of strenuous action that previously had been reserved for the male nude. Still, we must not misread his intent. It was not a detached interest in the physical aspect of the event alone but the desire to unite motion and emotion and thus to make the viewer experience the suffering of this victim of a cruel fate. In the *Niobid*, human feeling is for the first time expressed as eloquently in the features as in the rest of the figure. A glance at the wounded warrior from Aegina (see fig. 5-15) will show us how differently the agony of death had been conceived only half a century before. What separates the *Niobid* from the world of Archaic art is summed up in the Greek word *pathos*. *Pathos* means suffering, but particularly suffering conveyed with nobility and restraint, so that it touches rather than horrifies us. Late Archaic art may approach it now and then, yet its full force can be felt only in Classical works such as the *Dying Niobid*.

The Parthenon Sculptures and the "Pheidian Style" The largest, as well as the finest, group of Classical sculptures that has come down to us consists of the remains of the marble decoration of the Parthenon. Unfortunately, it is in battered and frag-

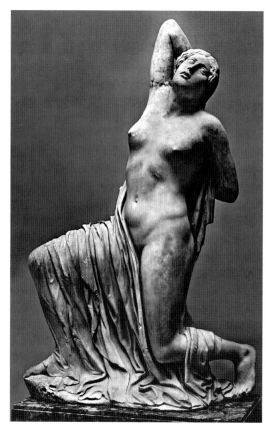

5-20 *Dying Niobid.* c. 440 B.C. Marble, height 59" (1.50 m). Museo delle Terme, Rome

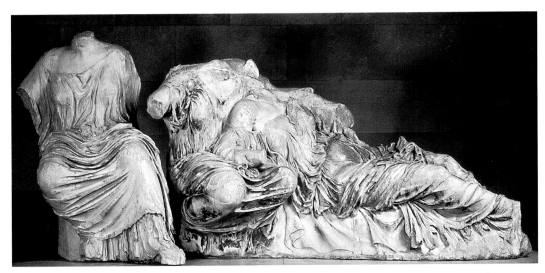

5-21 *Three Goddesses,* from the east pediment of the Parthenon. 438–432 B.C. Marble, over-life-size. The British Museum, London

mentary condition. In 1687 an explosion destroyed many of the sculptures, and between 1801 and 1803 Lord Elgin, the British ambassador to Turkey (which ruled Greece until 1827), removed many of those that remained and sent them to Britain. These works, known as the Elgin Marbles, are housed today in the British Museum. The centers of both pediments are gone, and of the figures in the corners only those from the east pediment are well enough preserved to convey something of the quality of the whole. They represent various deities, most in sitting or reclining poses, witnessing the birth of Athena from the head of Zeus (fig. 5-21). (The west pediment portrayed the struggle of Athena and Poseidon for Athens.)

Here we marvel at the ease of movement even in repose. There is no violence nor pathos—indeed, no specific action of any kind, only a deeply felt poetry of being. We find it in the soft fullness of the three goddesses, enveloped in thin drapery that seems to share the qualities of a liquid as it flows around the forms underneath and unites them in one continuous action. These figures are so freely conceived in depth that they create their own space. In fact, we find it hard to imagine them "shelved" upon the pediment. Evidently so did the sculptors who achieved such lifelike figures: the sculptural decoration of later buildings tended to be placed in areas where the figures would seem less boxed in and be more readily visible.

In keeping with the Classical commitment to portraying *ethos,* or character, this "wet-look" drapery is most evident in the right-hand, reclining figure, who is probably Aphrodite. Her body, the site of her desirability, is both lusciously revealed and tantalizingly veiled by its clinging folds. These sculptures have long been associated with the name of Pheidias, who, according to the Greek biographer Plutarch, oversaw all the artistic projects authored by Perikles. Pheidias was famous for the colossal gold-and-ivory statue of Athena that he made for the cella of the Parthenon, an equally large bronze Athena that stood on the Akropolis facing the Propylaea, and a colossal gold-and-ivory Zeus for the Temple of Zeus at Olympia. None of these works survives, and the small-scale Roman copies do little to convey their awesome grandeur. The admiration they aroused was due apparently to their size, the cost and richness of their materials, the complexity of their iconography, and (as in the Aphrodite, fig. 5-21, right) their subtle accommodation of style to subject. Indeed, the same critics who censured Polykleitos for not properly distinguishing gods and men praised Pheidias for this very virtue, noting that his work "seemed to have added something to the traditional religion, to such an extent is the majesty of the work equal to the majesty of the god." In short, Pheidias was a genius, comparable to the Egyptian architect Imhotep (see page 37).

The Parthenon undoubtedly employed a large number of carvers, because its two huge pediments, 92 carved metopes, and 520-foot frieze were executed in only 15 years (447–432 B.C.). The term *Pheidian style* is

nevertheless convenient, for it conveys an ideal that was not merely artistic but extended to life itself: it denotes a distinctive attitude in which the gods are aware of, yet aloof from, human affairs as they fulfill their cosmic roles. This outlook came to be widely shared among Greek philosophers, especially in the fourth century B.C.

FOURTH-CENTURY SCULPTURE

The "Pheidian" style, so harmonious in both feeling and form, was the creation of a particular historical moment, a crossroads in the history of art. Although it did not long survive the onset of the Peloponnesian War, its achievements resonated for centuries. In a profound sense, all later Greek art is either indebted to it or reacts against it.

Unfortunately, there is no single word, like *Archaic* or *Classical*, that we can use to designate this third and final phase in the development of Greek art, which lasted from about 400 to the first century B.C. The 70-year span between the end of the Peloponnesian War and the rise of Alexander the Great is often

called *Late Classical*. The remaining three centuries are labeled *Hellenistic*, a term that was coined to describe the spread of Greek civilization southeastward to Asia Minor, Syria, Mesopotamia, Egypt, and the borders of India. It was natural to expect that the conquests of Alexander between 334 and 323 B.C. would bring about an artistic revolution. However, the history of style is not always in tune with political history. Although the center of Greek thought shifted to Alexandria, Hellenistic art is the direct outgrowth of developments that occurred not at the time of Alexander but during the preceding 50 years.

The contrast between Classical and Late Classical art is strikingly demonstrated by the only project of the fourth century that corresponds to the Parthenon in size and ambition. It is not a temple but a huge tomb designed by Satyros and Pytheos of Priene and erected about 360 B.C. at Halikarnassos in Asia Minor by Maussolos, the ruler of Karia, and his widow, Artemisia. From his name comes the term *mausoleum* (the Latin form of *Maussolleion*), used for outsized funerary monuments. The structure itself has been destroyed, but its dimensions and general appearance are known from the accounts of Pliny the Elder and Vitruvius. Scholars have undertaken a variety of reconstructions on the basis of these ancient descriptions and the excavated remains, which include much sculpture as well as numerous architectural fragments.

The drawing in figure 5-22, based on new evidence revealed by a Danish excavation begun in 1966, is not an exact reconstruction. We know from Pliny, however, that the rectangular building was 440 feet in circumference and rose to a height of 140 feet, excluding the sculpture and its pedestal at the top. The tall base supported an Ionic order 40 feet tall surmounted by a large stepped pyramid. Atop it stood an enormous quadriga (four-horse chariot). Its lavish sculptural program included several friezes, extended freestanding groups, and numerous portraits of Maussolos's ancestors. Other subjects included battles with AMAZONS, Centaurs, and Persians; hunts, sacrifices, and audience scenes; and a frieze of racing chariots. But with so much lost, the placement of the sculpture on the building is fiercely controversial.

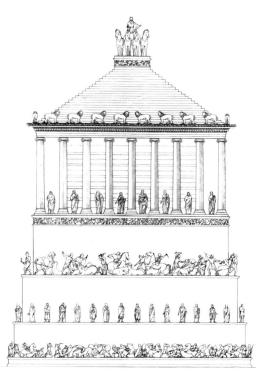

5-22 Pytheos and Satyros. The Mausoleum at Halikarnassos, c. 360–351 B.C. Reconstruction by Peter Jackson

The Mausoleum's commemorative character, based on the idea of life as a heroic-style contest, is entirely Greek. Yet we immediately notice the un-Greek way in which it has been carried out. The vast size of the tomb and the pyramid form are derived from Egypt. They imply an exaltation of the ruler far beyond ordinary human status. Maussolos also took the view of himself as a divinely ordained sovereign from the Persians, whom he had served as a satrap; they in turn had inherited it from the Assyrians and Egyptians. (Friezes of figures paying homage to the ruler are found at the Audience Hall of Darius and Xerxes at Persepolis; see fig. 3-11.) However, he seems to have wanted to glorify his personality as much as his office. With its multiple levels of sculpture and a pyramid instead of pediments above the colonnade, the ensemble must have struck his contemporaries as both intriguingly daring and uncomfortably bombastic.

According to Pliny, a different master, chosen from among the best of the time, did the sculpture on each of the four sides of the monument. Bryaxis was responsible for the north side, Timotheos the south, Leochares the west, and Skopas, the most famous, the main one on the east. Skopas's dynamic style has been recognized in some parts of the Amazon frieze, such as the portion in figure 5-23. The Parthenon style can still be felt here, but its harmony and rhythmic flow have been qualified by an un-Classical violence, physical as well as emotional, which is conveyed through strained movements and passionate expressions. (Deep-set eyes are a hallmark of Skopas's style.) His sweeping, impulsive gestures require a lot of elbow-room. What the composition lacks in continuity, it more than makes up for in bold innovation (note, for instance, the Amazon seated backward on her horse) and heightened expressiveness. In a sense, Skopas turned back as well—to the scenes of violent action so popular in the Archaic period. We recognize an ancestor of this scene in the Siphnian *Battle of the Gods and Giants* (see fig. 5-14).

In most instances, unfortunately, the best-known works of the Greek sculptors of the fourth century B.C. have been lost. Indeed, we do not have a single undisputed original work by any of the great virtuosi of the time—only copies are preserved. Such is the case with Praxiteles' most famous statue, a marble Aphrodite of about 340 B.C. (fig. 5-24). This work was purchased by the city of Knidos, while a clothed version was acquired, so Pliny tells us, by the island of Kos. The *Knidian Aphrodite* achieved such fame that she is often referred to in ancient literature as a synonym for female perfection. (According to one account, Praxiteles' mistress, Phryne, posed for the statue.) She was to have countless descendants in Hellenistic and Roman art. Gradually rediscovered in the fourteenth and fifteenth centuries, these statues alerted Italian Renaissance painters to the expressive power of the female nude,

The AMAZONS, a mythical nation of powerful women warriors, daughters of the god Ares, were said to live somewhere in Asia Minor. In legend, they invaded Greece and repeatedly engaged the Greeks in battle but always lost to them. From very early, these battles were popular subjects in Greek art and are seen from the seventh century B.C. through the Hellenistic era (see fig. 5-23).

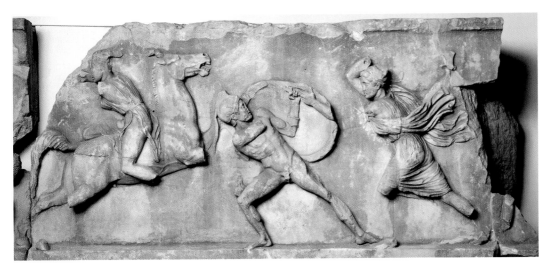

5-23 Skopas (?). *Battle of the Greeks and Amazons*, from the east frieze of the Mausoleum, Halikarnassos. c. 360–351 B.C. Marble, height 35" (88.9 cm). The British Museum, London

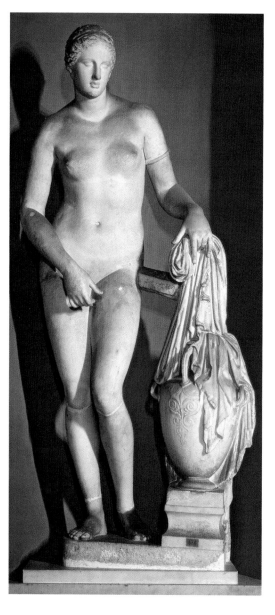

5-24 *Knidian Aphrodite.* Roman copy after an original of c. 340 B.C. by Praxiteles. Marble, height 6'8" (2 m). Musei Vaticani, Museo Pio Clementino, Gabinetto della Venere, Città del Vaticano, Rome

◻ The CELTS first appear in the second millennium B.C. in southwestern Germany and eastern France (called Gaul by the Romans), and eventually ranged over a wide territory. They spoke Indo-European dialects, were skilled in the art of smelting iron, and raided and conquered other peoples in Europe and Asia Minor well into the third century B.C. They dominated Iron Age culture in Europe until displaced by the Germans in the east and subdued by the Romans in the west. Greek and Roman writers noted that Celtic warriors were tall, light-skinned, well muscled, and ferocious; the front ranks often fought naked (see fig. 5-25).

and reignited a fascination with it that shows no signs of abating.

Though the Knidia's beauty was famous, the copies give little sign of it. They do, however, hint at some key innovations. Chief among these are the graceful S-curve of the goddess's body, which counters the *contrapposto* of the pose (the body's natural response to the pull of gravity) and thus distances it somewhat from everyday reality; and the purely feminine physique and face (earlier attempts such as those in figs. 5-13 and 5-20 had tended to resemble mutated men). But the Knidia's reputation rested at least as much on the fact that she was (so far as we know) the first completely nude monumental cult statue of a goddess in Greek art. She was placed in an open-air shrine in such a way that the viewer "discovered" her in the midst of bathing; yet through

her pose and expression she maintains a modesty so chaste that it could not fail to disarm even the sternest critic.

HELLENISTIC SCULPTURE

We know little about the development of Greek sculpture during the first hundred years of the Hellenistic era. Even after that, only a small fraction of the many works that have survived can be firmly dated. Moreover, Greek sculpture was now being produced throughout such a vast territory that the interplay of local and international currents must have formed a complex pattern, of which we can trace only isolated strands. Nevertheless, we can see sharp differences between Hellenistic and Classical sculpture. Hellenistic sculpture is generally both more realistic and more expressive. At times, experiments with drapery and pose achieved effects that can be quite contrived, even contorted. These changes should be seen as a valid, even necessary, attempt to extend the subject matter and dynamic range of Greek art for new patrons and new contexts.

For example, this dramatic conception is found in the sculpture groups dedicated by King Attalos I of Pergamon (a city in northwestern Asia Minor) between about 230 and 200 B.C. These works celebrated his victories over the CELTS, who had invaded Greece and Asia Minor in the early third century. The famous *Dying Celtic Trumpeter* (fig. 5-25), another Roman copy after an original bronze, is often attributed to Epigonos of Pergamon. Over six feet tall, the trumpeter has been fatally wounded in the chest as, naked, he led his fellow warriors into battle, and has collapsed upon his shield and broken trumpet. The sculptor must have known the Celts well, for the ethnic type is carefully rendered in the leathery body, the distinctive facial structure, and the bristly moustache and shock of hair. The torque around the neck is also specifically Celtic.

Although the trumpeter's agony seems much more realistic in comparison with, say, the warrior of the Aegina pediments (see fig. 5-15), it still has a great deal of dignity and pathos. "He knew how to die, barbarian though he was," is the idea conveyed by the statue. Yet we also sense something else, an animal quality never seen before in Greek battle monuments. Hellenistic artists knew that barbarians came in two types: the sophisticated (see fig. 5-5) and the savage.

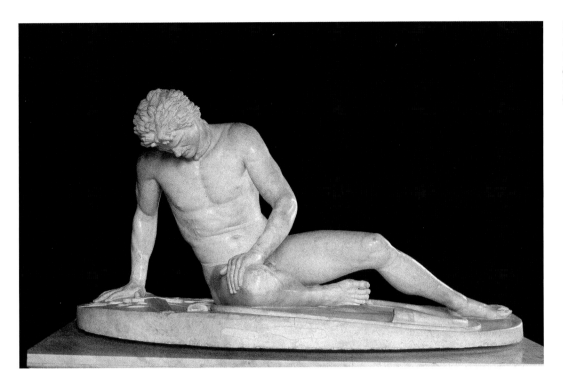

5-25 Epigonos of Pergamon (?). *Dying Trumpeter.* Roman copy after a bronze original of c. 220 B.C. Marble, life-size. Museo Capitolino, Rome

Hated and feared for their ferocity and cruelty, the Celts belonged firmly in the latter camp. Whereas in 490 and 480 a Persian victory would have brought tyranny, theirs would have brought chaos. Perhaps this is why the sculptor has put so much thought into describing this Celt's death which, as we witness it here, is a very concrete physical process. No longer able to move his legs, he puts all his waning strength into his arms, as if to force his failing body up from the earth that soon will claim it.

Several decades later, we find a second sculptural style flourishing at Pergamon: the Hellenistic baroque. About 165 B.C., Eumenes II, the son and successor of Attalos I, had an enormous altar built at Pergamon to commemorate his victories—now as an ally of Rome—over King Antiochos the Great of Syria and his allies (including, again, the hated Gauls) in 192–166. His reward, handed him by the victorious Romans, was much of the western part of the Seleucid empire. A large part of the sculptural decoration has been recovered by excavation, and the entire west front of the altar has been reconstructed in Berlin (fig. 5-26). Its boldest feature is the frieze that rings the podium, which is 400 feet long and over 7 feet tall (fig. 5-27). The huge figures, cut so deep that they seem almost detached from the background, have the scale and weight of pedimental statues, but are now freed from the confining triangular frame and placed in a frieze. This unique blend of two

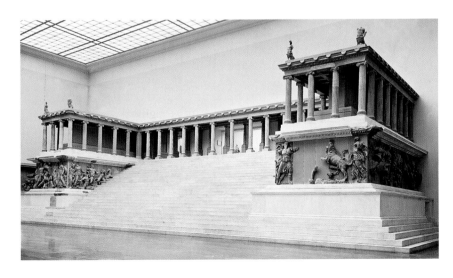

5-26 Reconstructed west front of the altar from Pergamon. c. 166–156 B.C. Marble. Staatliche Museen zu Berlin, Antikensammlung, Pergamonmuseum

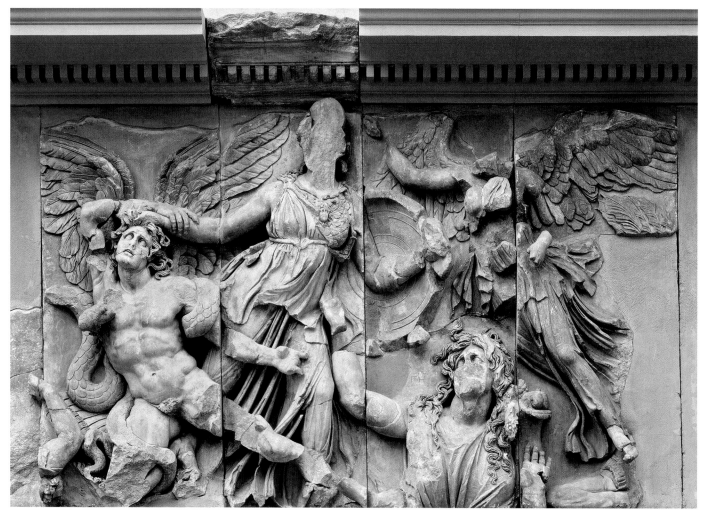

5-27 *Athena and Alkyoneos,* from the east side of the Great Frieze of the Great Altar of Pergamon. c. 170 B.C. Marble, height 7′6″ (2.29 m). Pergamonmuseum, Berlin

traditions brings the development of Greek architectural sculpture to a thundering climax. The carving of the frieze has tremendous dramatic force. The muscular bodies rush at each other, and the high relief creates strong accents of light and dark. The beating wings and windblown garments are almost overwhelming in their dynamism. A writhing movement pervades the entire design, down to the last lock of hair, linking the figures in a single continuous rhythm. This sense of unity restrains the violence of the struggle and keeps it—but just barely—from exploding its architectural frame.

The subject, the battle of the gods and giants, is a traditional one for Ionic friezes. (We saw it before on the Siphnian Treasury, fig. 5-14.) Yet the Pergamenes gave it a novel twist. It both raises Eumenes' successes to cosmic significance and promotes Pergamon as a new Athens. The patron goddess of both cities was Athena, who has a prominent

place in the great frieze. Such translations of history into mythology had been common in Greek art for a long time. But to place Eumenes in analogy with the gods themselves implies an exaltation of the ruler that is thoroughly Hellenistic.

Equally dramatic is the great *Nike of Samothrace* (fig. 5-28). This sculpture may commemorate a naval victory gained by the island of Rhodes over Antiochos the Great in the same war that Eumenes commemorated with his Great Altar. The goddess has just landed on the prow of a warship. A powerful head-wind still beats at her body and outspread wings. The invisible force of onrushing air here becomes a tangible reality. It not only balances the forward movement of the figure but also shapes every fold of the wonderfully animated drapery. As a result, there is an active relationship between the statue and the space around it such as we have never seen before. By comparison, all earlier examples of

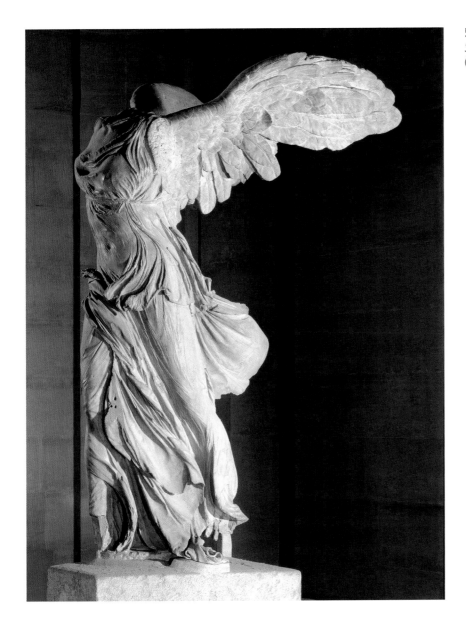

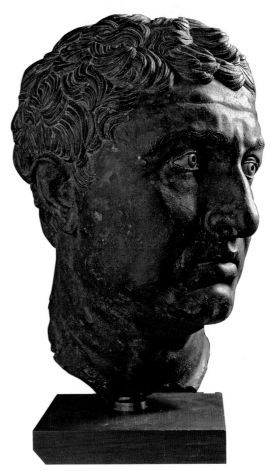

5-28 Pythokritos of Rhodes (?). *Nike of Samothrace*. c. 190 B.C. Marble, height 8′ (2.44 m). Musée du Louvre, Paris

5-29 Portrait head, from Delos. c. 100 B.C. Bronze, height 12³/₄″ (32.4 cm). National Archaeological Museum, Athens

active drapery seem somewhat inert. This is true even of the three goddesses from the Parthenon (see fig. 5-21), whose "wet-look" drapery responds not to the atmosphere around it but to an inner impulse that is independent of motion. Nor shall we see its like again for a long time to come. The *Nike of Samothrace* deserves her fame as the greatest surviving masterpiece of Hellenistic sculpture.

Individual likenesses were rare in Classical art, which sought the general and typical in humanity. But in the mid fourth century, portraiture became a major branch of Greek sculpture, and it continued to flourish in Hellenistic times. Its achievements, however, are known to us only indirectly, for the most part through Roman copies. One of the few originals is a vivid bronze head from Delos (fig. 5-29) that was once part of a full-length statue,

dating from around 100 B.C. The man's identity is not known, though he may have been a local politician. Whoever he was, we get an intensely private view of him that captures the character of the age, for his likeness has been fused with a distinctive Hellenistic type (compare the face of Alkyoneus in fig. 5-27). The fluid modeling of the somewhat flabby features, the uncertain mouth, and the unhappy eyes under furrowed brows reveal a careworn individual beset by doubts and fears—a very human, unheroic personality. There are echoes of pathos in these features, but it is a pathos translated into psychological terms. This kind of anxiety had certainly existed earlier in the Greek world, just as it does today. Yet it is significant that it was registered in Greek portraiture only when Greek independence was about to come to an end, under Rome.

CHAPTER
6 Etruscan Art

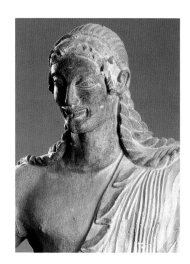

T HE ITALIAN PENINSULA DID NOT EMERGE INTO THE LIGHT of history until fairly late. The Bronze Age, which dawned first in Mesopotamia about 3500 B.C., came to an end in the Italian peninsula only around 1000 B.C. At that time, an early Iron Age culture was established near present-day Bologna. The Etruscans absorbed and succeeded those settlers in the eighth century B.C., just as the Greeks began to settle along the western shores of Italy and in Sicily.

The Etruscans had strong cultural links both with Asia Minor and the ancient Near East. Yet they also show many traits that are not found anywhere else. The sudden flowering of Etruscan civilization resulted in large part from contacts with Greece. For example, the Etruscans borrowed their alphabet from the Greeks around 700 B.C. Nevertheless, their language is unique. The only Etruscan writings that have come down to us are brief funerary inscriptions and a few somewhat longer texts relating to religious ritual. However, Roman authors tell us that a rich Etruscan literature once existed. In fact, we would know little about the Etruscans at first hand were it not for their tombs and sanctuaries. The tombs were left alone when the Romans destroyed or rebuilt the Etruscan cities, and so have survived intact until modern times; the sanctuaries have been revealed by archaeologists largely during the past 50 years.

In the sixth century B.C. the Etruscans reached the height of their power. Their cities rivaled those of the Greeks; their fleet dominated the western Mediterranean and protected a commercial empire that competed with the Greeks and Phoenicians; and their territory extended as far as Naples in the south and the lower Po Valley in the north. But the Etruscans, like the Greeks, never formed a unified nation. They were no more than a loose federation of quarrelsome city-

states and were slow to unite against a common enemy. Rome expelled its Etruscan kings in 510 B.C., and just over 30 years later, the fleet of the Greek colony of Syracuse defeated the Etruscan navy. Finally, during the later fifth and fourth centuries one Etruscan city after another fell to the Romans. By 270 B.C., all of them had lost their independence, although many continued to prosper under Roman rule, judging by the richness of their third- and second-century tombs and temples.

The flowering of Etruscan civilization, then, coincides with the Archaic age in Greece. During this period, especially in the late sixth and early fifth centuries B.C., Etruscan art showed its greatest vigor. Archaic Greek models displaced the former Near Eastern ones. (Many of the finest Greek vases have been found in Etruscan tombs of that time.) But Etruscan artists did not simply imitate Greek art. Working in a very different cultural setting, they retained their own clear-cut identity.

Tombs and Their Decoration

EARLY FUNERARY BELIEFS
We might expect the Etruscan CULT OF THE DEAD to have waned under Greek influence, but, in fact, Etruscan tombs grew

■ About 700 B.C. Etruscans began to build tombs of stone. These imitated the interiors of dwellings, and were covered by great conical mounds of earth. Cinerary urns, which had formerly been simple pottery vessels, gradually took on human shape (see below). The frequent depictions of funerary meals in Etruscan art as well as the gold and other precious objects found in the tombs are evidence of a CULT OF THE DEAD.

more elaborate as the skills of the sculptor and painter increased. The deceased could be shown full-length, reclining on the lids of sarcophagi shaped like couches, as if they were participants in a festive event similar to the Greek symposium (see page 77). The Etruscans, however, made such feasts into family affairs instead of restricting them to men. (When women do appear in Greek banquet scenes or symposia, they are courtesans, prostitutes, or slaves.)

In figure 6-1, a husband and wife recline side by side, an Archaic smile on their lips, so that they seem gay and majestic at the same time. He may have held an egg in his right hand, and a drinking cup in his left; she perhaps held a perfume vase and a piece of fruit. The entire work is of **terra-cotta** (clay molded and then baked until very hard), and was once painted in bright colors. The rounded forms reveal the Etruscan sculptor's preference for **modeling** in soft materials, in contrast to the Greek love of stone carving. There is less formal discipline here but an extraordinary directness and vivacity that are characteristic of Etruscan art.

We do not know exactly what ideas the Archaic Etruscans held about the afterlife. Effigies such as our reclining couple, which for the first time in history show the deceased as alive and enjoying themselves, suggest that they regarded the tomb as a home not only for the body but also for the soul. (In contrast, the Egyptians thought that the soul roamed freely, so their funerary statues were "inanimate.") How else are we to understand the purpose of the wonderfully rich array of murals in these tombs? Because nothing of the sort has survived in Greek territory, they are uniquely important not only as an Etruscan achievement but also as a possible reflection of Greek wall painting.

The Tomb of Hunting and Fishing

Perhaps the most remarkable murals are found in the Tomb of Hunting and Fishing at

Modeled sculpture, as in figure 6-5 (page 109), is additive in the sense that the basic form is built up from a raw material such as clay (below left), and then finished by carving and smoothing the details (below right). In large-scale work, supports or armatures are incorporated into the figure to stabilize the forms.

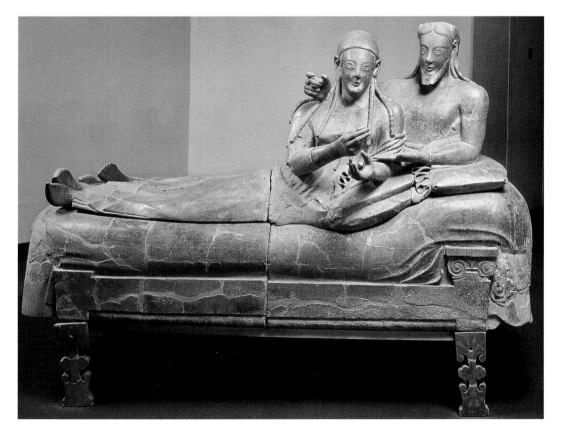

6-1 Sarcophagus, from Cerveteri. c. 520 B.C. Terra-cotta, length 6'7" (2 m). Museo Nazionale di Villa Giulia, Rome

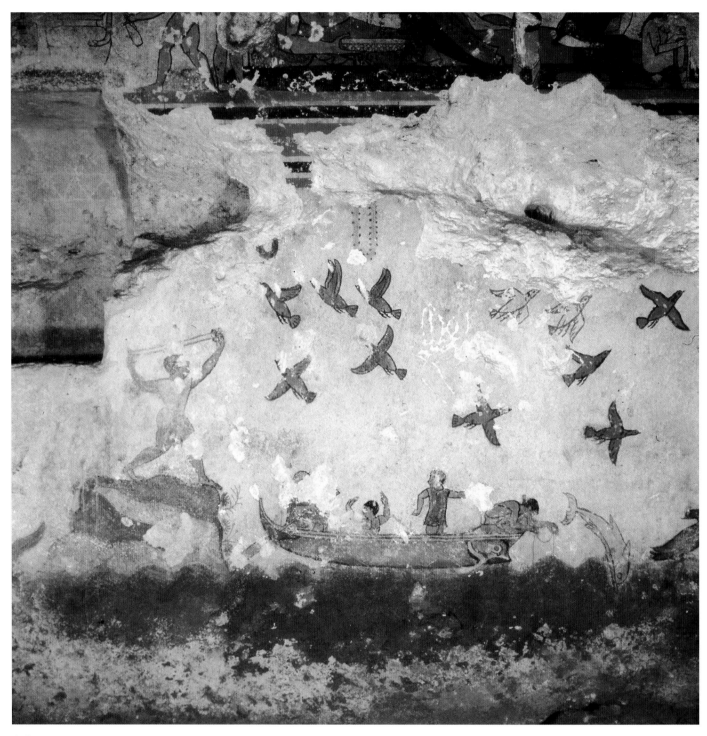

6-2 Tomb of Hunting and Fishing, Tarquinia, Italy. c. 520 B.C.

Tarquinia of about 520 B.C. Figure 6-2 shows a marine panorama at one end of the low chamber. In this vast expanse of water and sky, the fishermen seem to play only an incidental part. There is no evidence that any Greek Archaic artist knew how to place human figures in a natural setting as effectively as the Etruscan painter did. Could the mural have been inspired by Egyptian scenes of hunting in the marshes, such as the one in figure 2-3? They seem the most likely precedent for our subject. If so, the Etruscan artist has brought the scene to life, just as the reclining couple in figure 6-1 has been brought to life compared with Egyptian funerary statues.

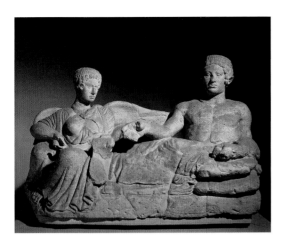

6-3 *Youth and Demon of Death.* Cinerary container. Early fourth century B.C. Stone, length 47" (119.4 cm). Museo Archeològico Nazionale, Florence

The free, rhythmic movement of birds and dolphins also reminds us of Minoan painting of a thousand years earlier (see fig. 4-2). So far as we know, the Minoans were the only people before the Etruscans to paint murals devoted solely to landscape. Yet because their palaces and the frescoes that decorated them were all destroyed long before the Etruscans came on the scene, the resemblance must be coincidental. Independent invention seems the only solution.

Despite the air of enchantment, the scene has ominous overtones. The giant hunter with a slingshot, from whom the birds flee in all directions, is very likely a demon of death. This theme of life and death is continued in the niche above, where a couple on a couch enjoy a last meal. (By contrast, paintings of the final supper found at the entrances to Egyptian tombs show only the deceased seated at a table.) Thus the purpose of the mural is essentially commemorative, ushering the deceased into the next life.

The man and woman in the mural are flanked by a musician and servants, one of whom is drawing wine from a large mixing bowl, or **krater**, while another is making wreaths. From the Greeks, the Etruscans adopted the cult of DIONYSOS, whom they called Fufluns or Pachies (from Bacchus, his other Greek name). Besides being the god of wine, he was the god of vegetation and, therefore, of death and resurrection, like Osiris. In this context, for example, the couple may be seen as counterparts to Bacchus and Ariadne (known as Ariatha to the Etruscans), who were symbols of regeneration.

LATER FUNERARY BELIEFS

During the fifth century, the Etruscan view of the hereafter apparently became a good deal more complex and less festive. We notice the change immediately if we compare the figures in figure 6-3, an ash-chest made of soft local stone soon after 400 B.C., with the couple in figure 6-1. The woman now sits at the foot of the couch, but she is not the wife of the young man. Her wings show that she is a death-demon or Lasa, and she unrolls the scroll of his destiny. The young man is pointing to it as if to say, "Behold, my time has come." The thoughtful, melancholy air of the two **carved** figures may be due, to some extent, to the influence of Classical Greek art, which pervades the style of this work. A new mood of uncertainty and regret is felt. Human destiny is in the hands of inexorable supernatural forces. Death is now the great divide rather than a continuation, albeit on a different plane, of life on earth. In later tombs, the demons of death gain an even more fearful aspect. Other, more terrifying demons enter the scene. Often they are shown battling against benevolent spirits for possession of the soul of the deceased—a prefiguration of the Last Judgment in medieval art (see fig. 10-14).

Temples

Only the stone foundations of Etruscan temples have survived, because the buildings themselves were mostly built of wood. Their design bears a general resemblance to Greek temples (see fig. 5-8). Nevertheless, they

The festivals of DIONYSOS (Bacchus) were often marked by orgiastic revels and animal sacrifice. From their music, dancing, and singing came the dithyramb, the ultimate source of Greek drama. Known to the Etruscans as Fufluns or Pachies, Dionysos is represented as an effeminate youth, an old man, or a figure with animal-like characteristics.

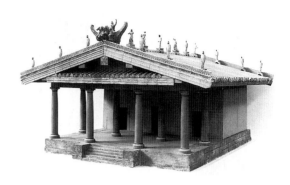

6-4 Reconstruction of an Etruscan temple, as described by the Roman architectural historian Vitruvius. Museo delle Antichità Etrusche e Italiche, Università di Roma

have several distinctive features, some of which were later adopted by the Romans. The entire structure (fig. 6-4) rests on a tall base, or **podium**, that is no wider than the cella and has steps only on the south side. The steps lead to a deep porch, supported by two rows of four columns each, and to the cella beyond. The columns have bases and cushion-like capitals that look like simplified versions of Doric and Ionic ones (see figs. 5-7 and 5-11, respectively). The Romans later adopted this style along with the three Greek orders and called it the Tuscan order. Because Etruscan religion was dominated by three gods who were the predecessors of the Roman Juno, Jupiter, and Minerva, the cella is often subdivided into three compartments. The shape of Etruscan temples, then, must have been squat and squarish compared to the graceful lines of Greek ones and was more closely linked with domestic architecture.

Sculpture

Apollo **from Veii** The Etruscan temple provided no place for stone sculpture. The decoration usually consisted of terra-cotta plaques that covered the architrave and the edges of the roof. Only after 400 B.C. do we occasionally find large-scale terra-cotta groups designed to fill the pediment above the porch. We do know of one earlier attempt—and an astonishingly bold one—to find a place for monumental sculpture on the exterior of an Etruscan temple. The so-called Temple of Apollo at Veii, not far north of Rome, was a structure of

the standard type. However, it had four life-size terra-cotta statues on the ridge of its roof (similar examples appear in the reconstruction model, fig. 6-4). They formed a dramatic group of the sort we might expect in Greek pedimental sculpture: the contest of Hercules and Apollo for the sacred hind (female deer), in the presence of other deities.

The best preserved of these figures is the Apollo (fig. 6-5), acknowledged to be the masterpiece of Etruscan Archaic sculpture. The tall, elongated body, revealed beneath the ornamental folds of the drapery; the sinewy, muscular legs; the hurried, purposeful stride—all these possess an expressive force that has no counterpart in freestanding Greek statues of the same date.

She-Wolf According to Roman tradition, the last Etruscan king of Rome called on a master from Veii to make the terra-cotta image of Jupiter for the temple on the Capitoline Hill. This image has been lost, but an even more famous one, cast in bronze, still exists (fig. 6-6). According to a myth, two brothers, Romulus and Remus, founded Rome in 753 B.C. After being abandoned, the story goes, the brothers were nourished by a she-wolf. (The two babes beneath this wolf are Renaissance additions, but representations of the scene on Roman coins and relief sculpture indicate that the restorer's intuition was correct.) The she-wolf has strong links with Etruscan mythology, in which wolves seem to have played an important part from early times. The wonderful ferocity of expression, the physical power of

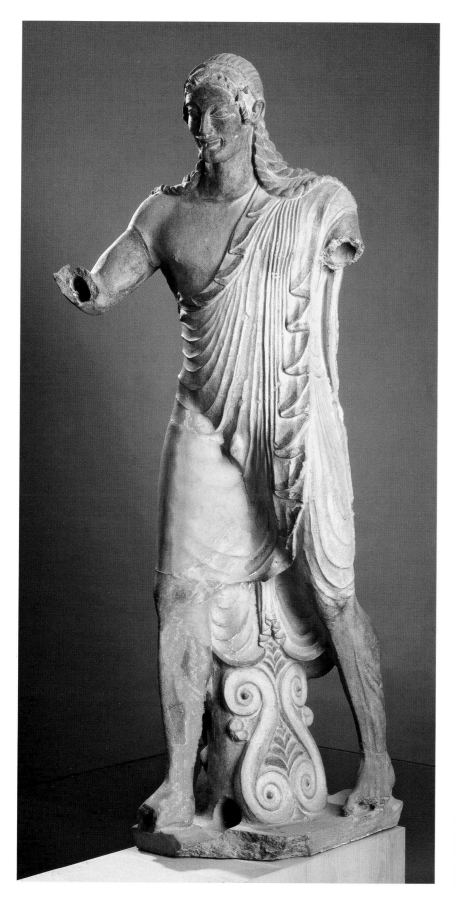

6-5 Apollo, from Veii. c. 510 B.C. Terra-cotta, height 5'9" (1.75 m). Museo Nazionale di Villa Giulia, Rome

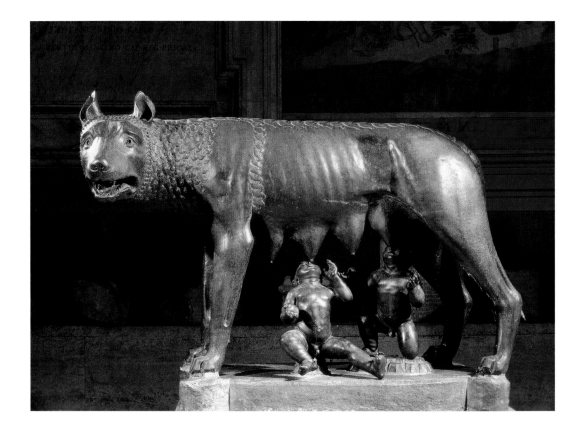

6-6 *She-Wolf.* c. 500 B.C. Bronze, height 33¹/₂″ (85 cm). Museo Capitolino, Rome. The two babies are Renaissance additions.

the body and legs, and the assertive surface modeling betray the same awesome quality sensed in the Apollo from Veii.

City Architecture

According to Roman writers, the Etruscans were masters of architectural engineering, town planning, and surveying. There is little doubt that the Romans learned a good deal from them. Roman temples certainly retained many Etruscan features. In town planning and surveying, too, the Etruscans have a good claim to priority over the Greeks. The Etruscans began using arches in the fourth century B.C. and also taught the Romans how to build fortifications, bridges, drainage systems, and aqueducts. Nevertheless, we cannot say exactly how much the Etruscans contributed to Roman architecture, because very few Etruscan or early Roman buildings are still standing.

Roman Art

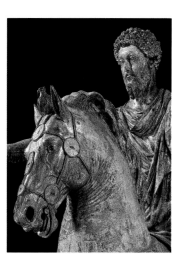

ROMAN CIVILIZATION IS FAR MORE ACCESSIBLE TO US THAN any other civilization of the ancient world. We know a great deal about its history, thanks to its vast literary legacy, ranging from the high culture of historiography, oratory, philosophy, and poetry to inscriptions recording events both momentous and ordinary. The Romans also built vast numbers of monuments throughout their empire. Yet there are few questions more difficult to answer than "What is Roman art?" The Roman genius, so clearly recognizable in everything else, is much harder to distinguish when we ask whether there was a characteristic Roman style in the fine arts.

Why is this so? The most obvious reason is the Romans' admiration for Greek art. They imported Greek originals by the thousands and had them copied in even greater numbers. In addition, their own works were clearly based on Greek sources, and many of their artists, from Republican times (510–31 B.C.) to the end of the empire (31 B.C.–A.D. 410), were of Greek origin. Actually, the Greek names of these artists do not mean much: most of them, it seems, were fully Romanized.

Roman authors tell us a good deal about the development of Greek art as it was described in Greek writings on the subject. They also discuss Roman art during the early days of the Republic, of which almost no trace survives today. However, they show little concern with the art of their own time. And, except for Vitruvius, whose treatise on architecture is of great importance for later eras (see page 84), the Romans never developed a rich literature on the history and theory of their art such as the Greeks had.

Indeed, some prominent Romans even viewed their own art as degenerate compared with the extraordinary achievements of the Greeks. This attitude also prevailed among scholars until not very long ago. Roman art, they claimed, is Greek art in its final phase—

Greek art under Roman rule. There could be, then, no such thing as Roman style, only Roman subject matter. Yet the fact remains that, as a whole, Roman art looks distinctly different from Greek art. Otherwise the "problem" would not have arisen. If we insist on judging Roman art by Greek standards, it will seem inferior. If, on the other hand, we interpret it as responding to different circumstances and expressing different aims, we can see it in a more positive light.

Rome, after all, was no mere outgrowth of Greece. According to legend, the Romans were descended from Trojan refugees led to Italy by the hero Aeneas. Rome itself was founded supposedly in 753 B.C. by Romulus, who chose the site after slaying his brother, Remus (see fig. 6-6), although in fact it had been inhabited for about 250 years. Rome expanded rapidly during the following two centuries under a series of kings, some of whom probably came from the nearby Sabine Mountains. This openness was to become a hallmark of Roman civilization as a whole. In fact, Rome was ruled by an Etruscan dynasty for about a century, until 510 B.C., when the last one was overthrown as a despot and the Roman Republic was established. The Etruscan kings built the first defensive wall around the seven hills, drained the swampy plain of

the FORUM, and built the original temple on the CAPITOLINE Hill, thus making a city out of what had been little more than a group of villages consisting of primitive huts. Equally important, they established the foundations for its future greatness by providing Rome with its early institutions and introducing the latest techniques of warfare. This fusion of Etruscan and native traditions made Roman civilization quite distinct from that of the Greeks.

Under the Republic, two magistrates called *consuls* replaced the king. They were advised by the Senate, made up of patricians (aristocrats) who monopolized power and resources, although in theory the people were sovereign. A series of popular uprisings lasting over 200 years, from 494 to 287 B.C., ended with the plebeians (ordinary citizens) being granted the right to run for high office and to pass laws in their own assembly. Rome and its allies, the Latin League, conquered southern Etruria in 396 B.C. Six years later, Rome itself was sacked by the Gauls, who failed to take the Capitol and left after receiving a large ransom.

Recovery was swift: the Latin cities soon lost their independence, and by 275 B.C. Rome ruled most of Italy, the Greek colonies included. It soon launched the first of the three Punic (Latin for "Phoenician") Wars against the north African city of Carthage, which ended with the latter's utter defeat and destruction in 146 B.C. Meanwhile, the Romans had turned eastward, and by the mid first century B.C. they had succeeded in bringing all of Greece and Asia Minor under their direct or indirect control.

This rapid expansion of Roman power, and the wealth and personal ambition that it generated, strained the Republic to the limit. After a brief civil war, Sulla emerged as dictator in 82 B.C.—an ominous precedent. In 49 B.C. Julius Caesar followed suit, but was murdered a mere five years later. His nephew and heir, Octavius, gradually vanquished his rivals and, after defeating Antonius and Queen Cleopatra of Egypt in 31 B.C. Octavius became undisputed ruler of the Roman world. Proclaimed Augustus Caesar and Father of the Nation by the Senate in 27 B.C. (see fig. 7–12), he gave Rome a much-needed period of peace and prosperity. After his death in A.D. 14, Augustus was revered as the architect of a new world order: the Roman Empire. Yet his rise to power set the precedent for the battles of succession that afflicted the empire until its end in the fifth century A.D..

In the Roman Empire, national and regional traditions coexisted with trends set by the capital, the city of Rome. From the very start, Roman society was remarkably tolerant of this kind of diversity. As long as the provincials did not threaten the security of the state or challenge the supremacy and divine mission of the Emperor, they were not forced to change their ways. Instead, they were put into a fairly low-temperature melting pot. A governor was installed, law and order were imposed, and respect for the symbols of Roman rule was demanded. At the same time, their gods, politicians, intellectuals, and businessmen were hospitably received in the capital, and eventually they themselves were given Roman citizenship. Roman civilization and Roman art were thus enriched not only by Greek culture but also, to a lesser extent, by Etruscan, Egyptian, and Near Eastern culture too. All this made for a complex, open society that was simultaneously both uniform and diverse.

Under such conditions, we cannot expect Roman art to show a consistent style, such as we found in Egypt, or the clear-cut evolution that distinguishes the art of Greece. Its development consists of a set of tendencies and preferences that may exist side by side, even within a single monument, none of which is necessarily dominant. The "Roman-ness" of Roman art must be found in this complex pattern rather than in a single, consistent quality of form—and that is precisely its strength.

Architecture

Although the originality of Roman sculpture and painting has been questioned, there is no such doubt about Roman architecture, which is a creative feat of extraordinary importance. From the very start, its growth reflected a distinctly Roman way of public and private life. Greek models, although much admired, could not accommodate the sheer numbers of people in large public

buildings required by the empire. And when it came to supplying citizens with everything they needed, from water to entertainment on a grand scale, new forms had to be invented, and cheaper materials and quicker methods had to be used.

ARCHES AND CONCRETE

We cannot imagine the growth of Roman architecture without the **arch** and the **vault** systems derived from it: the **barrel vault** (a half-cylinder); the **groin vault** (two barrel vaults that intersect at right angles); and the **dome**. True arches are constructed of wedge-shaped blocks, called **voussoirs**, each pointing toward the center of the semicircular opening. Such an arch is strong and (when properly buttressed) self-sustaining, in contrast to the "false" arch made up of horizontal courses of masonry or brickwork (like the opening above the lintel of the Lioness Gate at Mycenae, fig. 4-6). The true arch, as well as its extension, the barrel vault, had been discovered in Egypt as early as about 2700 B.C. But the Egyptians had used it mainly in underground tombs and in utilitarian buildings, never in temples. Apparently they did not think it was suited to monumental architecture. In Mesopotamia and Israel the true arch was used for city gates and perhaps elsewhere as well, but to what extent we cannot determine for lack of preserved examples. The Greeks knew the principle of the true arch from the fifth century on, but they confined its use to underground structures or simple gateways and refused to combine it with the architectural orders. The Etruscans began using it in the fourth century, and from them, the idea passed to Rome.

No less vital to Roman architecture was concrete, a mixture of mortar and gravel with rubble (small pieces of building stone and brick). Concrete construction had been invented in the Near East more than a thousand years earlier, but the Romans made it their chief building technique. Concrete offers many advantages: it is strong, lighter than stone, cheap, and adaptable. Concrete made possible the vast architectural works that are the chief reminders of "the grandeur that was Rome." Similar structures, made of multiple stones had required heavy buttressing to counter strong lateral thrusts. But with concrete, once the mixture had set, arches, vaults, and domes were essentially monolithic. Consequently, the lateral thrusts were greatly reduced, and architects could dispense with heavy butressing, creating much wider spans. The Romans hid the raw concrete surface by adding a facing of brick, stone, or marble, or by covering it with smooth plaster. Today this decorative skin has disappeared from most Roman buildings, leaving the concrete core exposed and depriving these ruins of the appeal that those of Greece have for us.

SANCTUARY OF FORTUNA PRIMIGENIA

Roman buildings characteristically speak to us through their massive size and bold conception. The oldest monument in which these qualities are fully seen is the Sanctuary of Fortuna Primigenia at Praeneste (modern Palestrina), in the foothills of the Apennines east of Rome (figs. 7-1,

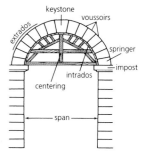

Arches were constructed of stone or brick over a temporary wooden scaffold, called centering. Roman arches are semicircular, as opposed to later Gothic arches, which are pointed. In building the arch, the last stone laid is the keystone, which locks in the other arch stones (**voussoirs**) before the centering can be removed. The outside curve of the arch is the extrados, the inside curve the intrados.

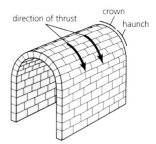

Built on the principle of the semicircular arch, the **barrel vault** may be thought of as a continuous arch (see fig. 7-3). This vaulting is very heavy and exerts enormous pressure (thrust) both outward and downward. Barrel vaulting, therefore, is usually supported by heavy walls and/or buttresses.

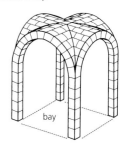

Also called the square vault, the **groin vault** was much favored in Roman architecture. The area enclosed within the four corner piers is called a bay.

7-1 Sanctuary of Fortuna Primigenia, Praeneste (Palestrina). Late second century B.C.

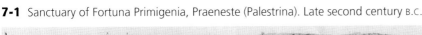

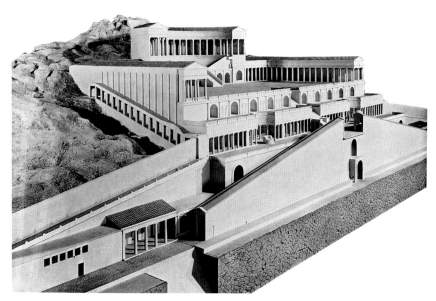

7-2 Model of the Sanctuary of Fortuna Primigenia, Praeneste (Palestrina). Palestrina, Palazzo Barberini

A.D., it has been reconstructed in model form (fig. 7-2) using material found in the archaeological excavation of the site. The comparison gives us some idea of how difficult it is to comprehend Roman architecture once its elaborate stone facing has disappeared, leaving only the raw concrete core behind.

Marching up the hillside in a series of interlinked terraces, the entire massive structure was built of stone-faced concrete. The terraces were approached by two ramps supporting an unusual, sloping Doric colonnade. The first terrace carried an Ionic colonnade punctuated by two semicircular, barrel-vaulted recesses, and the second featured ten arched niches framed by engaged columns and entablatures. Unfortunately, the barrel-vaulted Ionic colonnade survives only in one of the recesses (fig. 7-3), though its fragments still litter the site. Staircases lead up from these terraces to a great colonnaded court, a semicircular theater crowned by a Corinthian colonnade roofed with a double barrel vault, and finally a round temple, whose form perhaps symbolized the goddess's universal reach.

What makes the Palestrina sanctuary so imposing is not merely its scale but

7-2, 7-3), dating from the late second century B.C. Here, in what was once an important Etruscan stronghold, a cult had thrived since early times, dedicated to Fortuna (Fate) as a mother deity and combined with a famous oracle through which the deity spoke to her devotees. Converted into a Renaissance palace in the sixteenth century

7-3 Barrel-vaulted recess in the Sanctuary of Fortuna at Praeneste

The first three levels of the Colosseum facade have engaged columns flanking the open ends of barrel vaults. A statue probably stood within each opening. The highest level is decorated with pilasters, between which cartouches and tablets with inscriptions once hung.

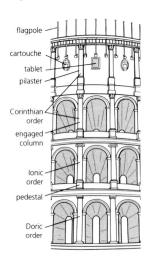

flagpole

cartouche

tablet

pilaster

Corinthian order

engaged column

Ionic order

pedestal

Doric order

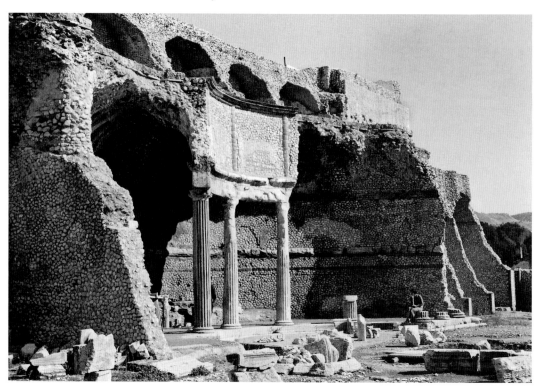

the superb way it fits the site. An entire hillside, comparable to the Akropolis of Athens in its commanding position, has been transformed. The architectural forms seem to grow out of the rock, as if human beings had simply completed a design laid out by nature itself. Such a molding of open spaces had never been possible, or even desired, in the Classical Greek world. The only comparable projects are to be found in Egypt (see the Temple of Queen Hatshepsut, fig. 2-11). Like Hatshepsut's temple, the entire complex is rigidly symmetrical. It dominates both the visitor and the countryside around, and is directly aligned with the great temple to Jupiter, Juno, and Minerva on the Capitoline Hill at Rome, 20 miles away. All this gives it an authoritarian air that in the context of Roman second-century imperialism can hardly be accidental.

THE COLOSSEUM

The combination of colonnade, arch, and vault, as we saw at Palestrina, was essential to Roman monumental architecture. It testifies not only to the high caliber of Roman engineering but also to the sense of discipline, order, and permanence that inspired these efforts. It is these qualities, one may argue, that underlie all Roman architecture and define its unique character. They impress us again in the Colosseum, the huge amphitheater for gladiatorial games in the center of Rome (figs. 7-4, 7-5). Completed in A.D. 80, it was funded by spoils from the emperor Titus's victory over the Jews, which was also commemorated the next year by his triumphal arch (see fig. 7-17).

At the Colosseum's inauguration, hundreds of pairs of gladiators fought, but these were not the only attraction. For this was the "world theater" where the empire came to watch myth, history, and current events bloodily restaged before its eyes. It was the world turned outside in, where Rome's enemies were corralled and turned into objects of sport for the baying crowd. In this particular festival, condemned criminals were paraded and then thrown to the lions, male and female hunters battled a menagerie of wild beasts in an artificial forest, a series of Greek mythological tales were bloodily reenacted, and (in a dramatic climax) the

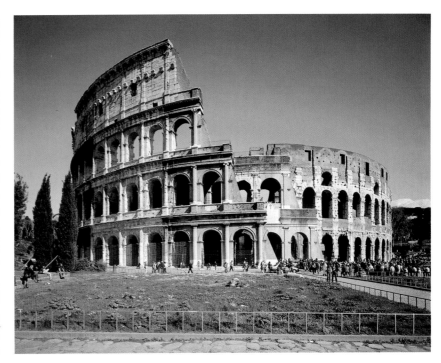

7-4 The Colosseum, Rome, 72–80 A.D.

7-5 The Colosseum, Rome. 72–80 A.D. (aerial view)

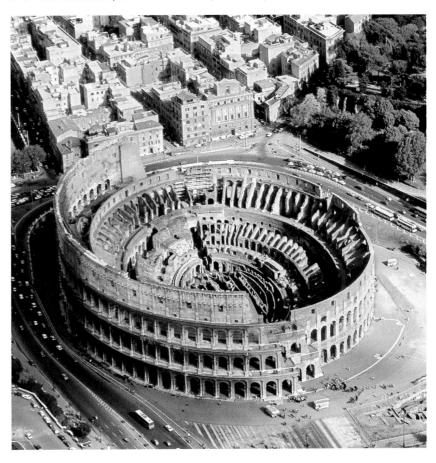

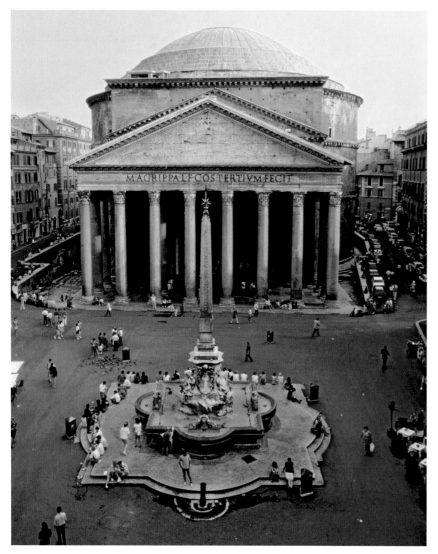

7-6 The Pantheon, Rome. 118–125 A.D.

clothes and accentuates it in cut stone. There is a fine balance between vertical and horizontal elements in the framework of engaged columns and entablatures that contains the endless series of arches. The three Classical orders are superimposed according to their "weight": Doric, the oldest and most severe, on the ground floor, followed by Ionic and Corinthian. The lightening of the proportions, however, is barely noticeable, for the Roman versions of the orders are almost alike. In this building they have become structurally superfluous, yet they still serve a practical function. It is through them that the building acquires the dignity and authority of tradition, and its enormous facade is related to a human scale.

THE PANTHEON

Arches, vaults, and concrete permitted the Romans to create huge, uninterrupted interior spaces for the first time in the history of architecture. The potential of all three was explored especially in the great baths, or THERMAE, which were major centers of social life in imperial Rome. The experience gained there could then be applied to more traditional building types, sometimes with revolutionary results.

Unfortunately, despite their social and architectural importance, none of these *thermae* is sufficiently well preserved to merit inclusion in this book. But perhaps the most striking example of the ways in which their great domed and vaulted interior spaces influenced other building types is the famous **Pantheon** in Rome (fig. 7-6). This large round temple of the early second century A.D. is one of the best preserved, as well as the most impressive, of all Roman structures. Although the inscription on its facade honors Marcus Agrippa, who built a predecessor on the site in 27 B.C., it was actually erected by the emperor Hadrian, who modestly allowed the long-dead Agrippa to take the credit. As its name suggests, it was dedicated to all the gods—more precisely, to the seven planetary gods. There had been round temples long before this time (see fig. 7-2), but they are so different from the Pantheon that it could not have been derived from them, and precedents elsewhere are few and much less imposing.

Public bathing facilities existed in other ancient civilizations, but none compared with those built by the Romans. Their *THERMAE* ranged from the great imperial baths in the capital to smaller local examples. Each had a *frigidarium* (cold bath), *tepidarium* (warm bath), and *caldarium* (hot bath), as well as a *natatio* (swimming pool) and small "plunge baths." The imperial baths built by Caracalla and Diocletian were massive complexes with richly decorated interiors.

arena was flooded so that mermaids could frolic and warships duel before the astonished multitude.

The Colosseum proclaims its imperial mission with truly majestic splendor. In terms of sheer mass, it is one of the largest single buildings anywhere: it could hold more than 50,000 spectators. The concrete core, with its miles of stairways and barrel- and groin-vaulted corridors, is an outstanding feat of engineering, designed to ensure the smooth flow of traffic to and from the tiers of seats and the arena. An aqueduct supplied water for flooding the arena, and an array of underfloor cells and cages held the gladiators, criminals, and wild beasts. The exterior, dignified and monumental, reflects the interior of the structure but

On the outside, a deep Corinthian porch, once approached via a rectangular, colonnaded forecourt, all but hides the temple proper: a plain cylindrical **drum** or rotunda surmounted by a gently curved dome. The junction of these two elements seems abrupt, but because the surrounding ground level has risen substantially since antiquity, we no longer see the building as it was meant to be seen, raised high on a podium. Moreover, it seems that the original design called for 60-foot Egyptian granite columns instead of the 48-foot ones now in place. These would have hidden the rotunda even more effectively, but after some were lost at sea the rest were diverted to other building projects.

The heavy plainness of the exterior wall suggests that the architects did not have an easy time with the problem of supporting the huge dome. Nothing on the outside, however, gives any hint of the interior. Indeed, its airiness and elegance are completely different from what the conventional porch and stolid rotunda would lead us to expect. The impact of the interior—awe-inspiring and harmonious at the same time—is impossible to convey in photographs. Even the painting in figure 7-7 fails to do it justice.

The dome is a true hemisphere of ingenious design. The interlocking ribs form a structural cage that permits the use of relatively lightweight **coffers** (recessed panels) arranged in five rings. The height from the floor to the oculus (eye) at the top is 143 feet, which is also the diameter of the dome's base and the interior. The dome and drum are likewise of equal heights, so that all the proportions are in exact balance (fig. 7-8). The weight of the dome is concentrated on the eight solid sections of wall. (The sculptures of the seven planetary gods date from the Baroque era.) Between these eight piers are seven niches, screened by columns that give the effect of an open space behind the supports, and top-lit by the windows in the wall above them. We thus feel that the wall is less massive and the dome much lighter than they actually are. The columns, the colored marble paneling of the wall surfaces, and the floor remain largely as they were in

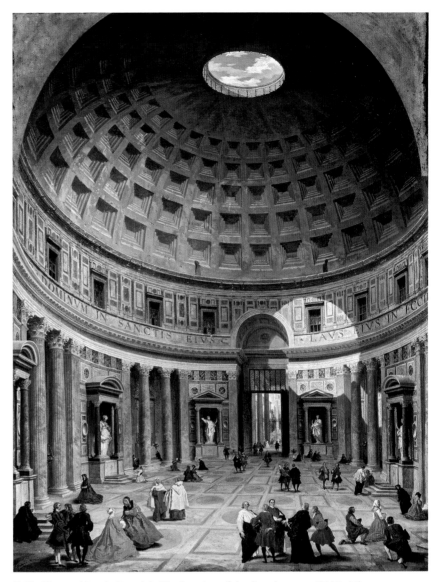

7-7 Giovanni Paolo Pannini. *The Interior of the Pantheon.* c. 1740. Oil on canvas, 50½ × 39″ (128.2 × 99.1 cm). National Gallery of Art, Washington, D.C. Samuel H. Kress Collection

Roman times. However, the coffers were originally overlaid with a thin layer of gold. One Roman writer compares this golden canopy to the Dome of Heaven, and we are not surprised to learn that Hadrian, supreme ruler of the known world, held audiences under it.

BASILICA OF CONSTANTINE

The Basilica of Constantine (it was actually begun by Constantine's predecessor, Maxentius) is an even more direct example of how

7-8 Section and plan of the Pantheon

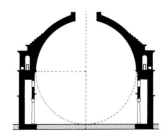

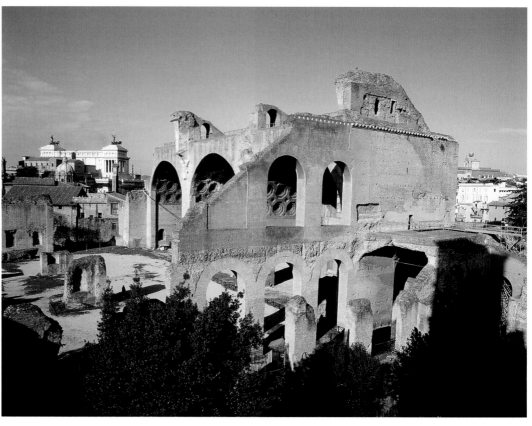

7-9 The Basilica of Maxentius and Constantine, Rome. c. 307–320 A.D.

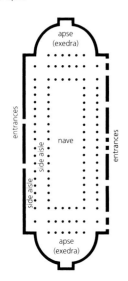

There was no standard form for the Roman **basilica**. This basilica plan shows a basilica with a nave, two side aisles, and an exedra or apse.

apse
(exedra)

entrances

side aisle
side aisle
nave

entrances

apse
(exedra)

thermae were transformed in new types of buildings. **Basilicas**, halls used for a variety of civic purposes, had first been developed in Hellenistic Greece during the third century B.C. (In ancient Greek, *basilica* meant "royal building," from *basileus*, "king.") They never conformed to a single type but varied from region to region. The basilica, whose origins can be traced back to 184 B.C., eventually became a standard feature of every major Roman town. One of their chief functions was to provide a dignified setting for the courts of law that dispensed justice in the name of the emperor. These basilicas had wooden ceilings instead of masonry vaults, for reasons of convenience and tradition rather than necessity. Thus they were often destroyed by fire. The Basilica of Constantine, by contrast, was derived from the main halls of the public baths built by two earlier emperors, Caracalla and Diocletian. However, it is built on an even grander scale and

was the largest roofed interior in all of Rome. Today only the north **aisle**, consisting of three huge barrel-vaulted compartments, is still standing (fig. 7-9).

The Basilica of Constantine was entered through the **narthex** at the east end (fig. 7-10). At the opposite end was a semicircular niche, called an **apse**, where the colossal statue of Constantine was found (see fig. 7-16). Inheriting this statue from Maxentius, Constantine left it in place, had it recut to represent himself, and modified the building by adding a second entrance to the south and a second apse opposite it where he could sit as emperor. Three groin vaults covered the center space, or **nave**, and rose a good deal higher than the aisles. Since a groin vault, like a canopy, has its weight and thrust concentrated at the four corners, the upper walls of the nave could be pierced by large windows (called the **clerestory**). As a result, the interior of the basilica must have had

a light and airy quality despite its enormous size.

The Basilica of Constantine was a daring attempt to create a new, vaulted type of basilica. But despite its obvious advantages, it remains unique in fourth-century Rome. The Christian basilicas that succeeded it (see fig. 8-2) were modeled on the older, wooden-roofed type, perhaps because the resources and expertise needed to build the new, vaulted one vanished with Rome's precipitate decline in the later fourth century. Not until 700 years later did vaulted basilican churches become common in western Europe.

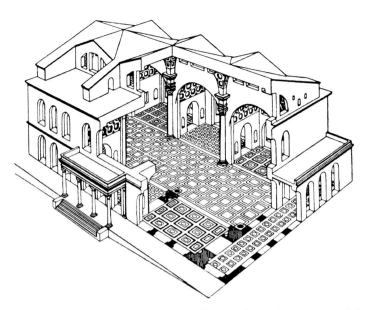

7-10 Reconstruction drawing of the Basilica of Maxentius and Constantine (after Huelsen)

Sculpture

The question "Is there such a thing as a Roman style?" centered largely on sculpture, and for good reason. Even if we discount the importing and copying of Greek originals, the reputation of the Romans as imitators seems to be borne out by large numbers of works that are probably based on Greek models. Although the Roman demand for sculpture was tremendous, much of it may be attributed to a taste for antiquities (see figs. 5–24 and 5–25, both of them copies found in Rome) and for sumptuous interior decoration—for creating an *ambience*. Yet other kinds of sculpture had important political and social functions in ancient Rome. We will consider two such genres: portraiture and narrative relief.

PORTRAITS

We know from literary accounts that the Senate honored Rome's great political and military leaders by putting their portraits on public display. This custom began in Republican times and was to continue until the end of the empire many hundred years later. It probably arose from the Greek practice of placing votive statues of athletes and other important individuals in sanctuaries such as the Akropolis, Delphi, and Olympia (see fig. 5-16)—a practice that was gradually secularized during the Classical and Hellenistic periods (see fig. 5-29). Unfortunately, the first 300 years of this Roman tradition are a closed book. Not a single Roman portrait has come to light that can be securely dated before the first century B.C. How were those early statues related to

Etruscan or Greek sculpture? Did they have any specifically Roman qualities? Were they individual likenesses, or were their subjects identified only by pose, costume, attributes, and inscriptions?

We can first glimpse a clearly Roman portrait style only around 100 B.C. It parallels an ancient custom. When the male head of the family died, he was honored with a wax portrait, which was then preserved in a special shrine or family altar. At funerals, these ancestral images were carried in the procession, and masks were even made from them for chosen participants to wear, in order to create a living parade of the family's illustrious ancestors. Such mimicry may have fostered a desire among the Roman elite for similarly true-to-life portraits in bronze and marble.

Ancestor Portraits Such display is certainly the purpose of the statue in figure 7-11. It shows an unknown Roman holding two busts of his ancestors, presumably his father and grandfather; his own head, missing when the statue was found, has been replaced by another that is nevertheless stylistically and physiognomically appropriate. The impressive heads of the two ancestors are marble copies of the lost-wax originals. (Differences in style and in the shape

Major Roman Emperors	
Augustus	31 B.C.–A.D. 14
Titus	79–81
Trajan	98–117
Hadrian	117–138
Marcus Aurelius	161–180
Septimius Severus	193–211
Caracalla	211–117
Diocletian	284–305
Constantine	306–337

ORIGINALLY A NATION OF PEASANT FARMERS, THE ROMANS PRIDED THEMSELVES ON THEIR connection to the land and to rural values. The ideal Roman was exemplified by Cincinnatus, a patrician and consul in 460 B.C., who immediately returned to his farm when his term ended. Two years later, after a military disaster, the Senate recalled him from the plough and appointed him dictator; within two weeks he raised an army, defeated the enemy, triumphed, resigned his office, and returned to his plough again. This stern devotion to duty (*fides*), steadfastness (*constantia*), dignity (*dignitas*), austerity, modesty, and courage—all summed up by the Latin word *gravitas* (weightiness of character, gravity, seriousness)—is obsessively emphasized in the portraiture of the Roman republican elite (see fig. 7-11).

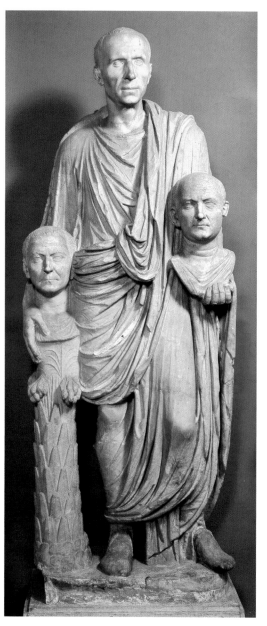

7-11 *A Roman Patrician with Busts of His Ancestors.* Late first century B.C. Marble, life-size. Museo Capitolino, Rome

of the bust indicate that the model for the head on the left was made about 30 years before the model for the one on the right.) The somber faces and grave demeanor of these dutiful Romans are strangely affecting and project a spirit of patriarchal dignity that was probably not present in the original wax portraits. Thus the process of translating ancestor portraits into bronze and marble not only made the images permanent but monumentalized them in the spiritual sense as well.

What mattered, however, was the face itself, not the style of the artist who recorded it. For that reason, these portraits have a serious, prosaic quality. The positive value accorded to this serious demeanor becomes clear when we compare the right-hand ancestral head in our group with the Hellenistic portrait from Delos in figure 5-29. It would be hard to imagine a greater contrast. Both are persuasive likenesses, yet they seem worlds apart. Whereas the Hellenistic head impresses us with its grasp of the sitter's psychology, the Roman bust may strike us at first glance as no more than a detailed record of the face's topography, in which the sitter's character appears only incidentally. This style is often called "verist," a term derived from the Latin *verus*, meaning "true," but documentary realism is only part of the story. The features are true to life, no doubt, but the carver has emphasized them selectively to bring out a specifically Roman personality: stern, rugged, devoted to duty (see Cultural Context: Roman Values). It is a father

image of daunting authority, and the facial details are like individual biographical data that distinguish it from others.

Augustus from Primaporta

As we approach the reign of the emperor AUGUSTUS (27 B.C.–A.D. 14), we find a new trend in Roman portraiture, which reaches its climax in the images of Augustus himself. At first glance, we may not be certain whether his statue from Primaporta (fig. 7-12) represents a god or a human being. This doubt is entirely appropriate, for the figure is meant to suggest both. Here we meet a concept familiar to us from Egypt and the ancient Near East: the godlike, even divine ruler. It had entered the Greek world in the fourth century B.C. Alexander the Great adopted it, as did his successors, who modeled themselves after him. They, in turn, transmitted it to Julius Caesar and the Roman emperors, who at first encouraged the worship of themselves in the eastern provinces, where belief in a divine ruler was a tradition.

The idea of giving the emperor the divine stature appropriate to his godlike status, authority, and power soon became official policy. Although Augustus did not carry it as far as later emperors, the Primaporta statue clearly shows him enveloped in an air of divinity. Its bare feet may indicate Augustus's heroic or even godlike status. Myth and reality are blended in order to glorify the emperor. The little Cupid on a dolphin serves both to support the heavy marble figure and to remind us of the claim that the Julian family was descended from the goddess Venus.

Still, despite its heroic, idealized body, which is clearly derived from the *Doryphoros* of Polykleitos (see fig. 5-18), the sculpture has an unmistakably Roman flavor. The emperor reaches out toward us as if to address us in person. His costume, including the rich allegorical program on the breastplate, has a concreteness of surface texture that conveys the actual touch of cloth, metal, and leather. His head is now somewhat idealized, or better yet "Hellenized." Small details are omitted, and the focus on the eyes gives it something of an inspired look. Even so, the face is a definite, individual likeness, as we know from many other portraits of Augus-

tus. All Romans would have recognized it immediately, for they knew it from coins and countless other representations.

Although it was found in the villa of Augustus's wife, Livia, the Primaporta statue may be a contemporary copy of a lost bronze original. The breastplate illustrates Augustus's diplomatic triumph over the Parthians in 20 B.C., when he recovered

AUGUSTUS (63 B.C.–A.D. 14; see fig. 7-12), was the first Roman emperor. During his long reign, he returned Rome to a form of constitutional rule, instituted a massive building program, and promoted peace and prosperity at home. His foreign policy was cautiously expansionist, provided that the cost in treasure and lives could be kept low. Augustus was awarded the title *Pater Patriae* (Father of His Country) by the Roman Senate and People.

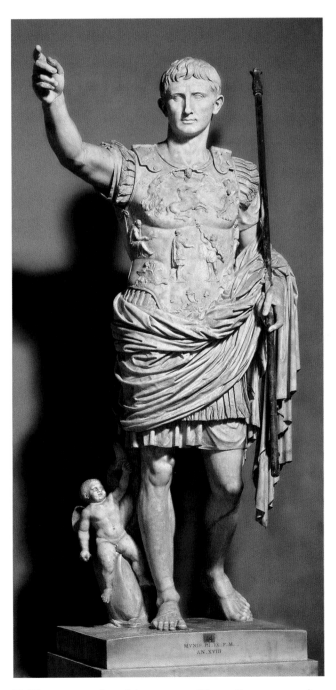

7-12 *Augustus from Primaporta.* c. 20 A.D.. Roman copy of a Roman original of c. 15 B.C. Marble, height 6′ 8″ (2.03 m). Musei Vaticani, Braccio Nuovo, Rome

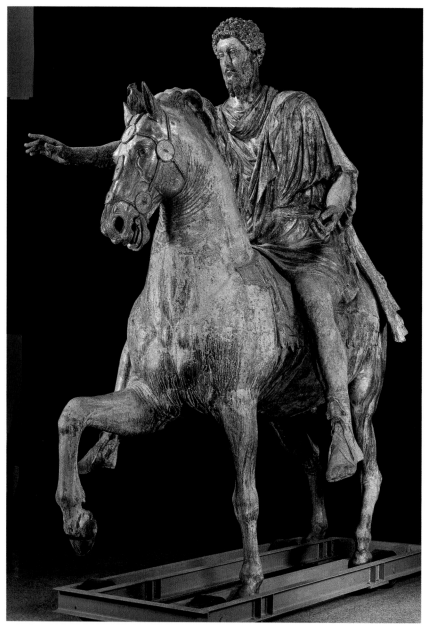

7-13 *Equestrian Statue of Marcus Aurelius.* A.D. 161–80. Bronze, over-life-size. Formerly in the Piazza del Campidoglio, Rome; now in the Museo Capitolino

fore, to find a strongly classicizing trend, often of a peculiarly cool, formal sort, in the sculpture of the second century A.D., especially during the reigns of Hadrian and MARCUS AURELIUS, both of them private men deeply immersed in Greek culture. We can sense this quality in the famous equestrian bronze statue of Marcus Aurelius (fig. 7-13), which is notable not only as the only intact survivor from antiquity of this class of monument but also as one of the few Roman statues that remained on public view throughout the Middle Ages. Such images, showing the mounted emperor as the all-conquering lord of the earth, had been an established tradition ever since Julius Caesar permitted an equestrian statue of himself to be erected in the forum that he built. Marcus Aurelius, too, was meant to be seen as ever victorious. According to medieval accounts, a small figure of a bound barbarian chieftain once crouched beneath the horse's right front leg. The powerful and spirited horse expresses this martial spirit. But the emperor himself is a model of STOIC calm. Addressing us like Augustus, but without weapons or armor, Marcus Aurelius appears as a bringer of peace rather than a military hero, for this is how he saw himself and his reign.

Portrait Heads and Busts A portrait of Marcus Aurelius's wife, Faustina the Younger (fig. 7-14), is cast in the same neoclassical mold as those of her husband. Although it is a clear likeness, her features have been subtly idealized in accordance with Greek sculpture, and even her hairdo is perfectly symmetrical. In this way, the bust acclaims Faustina as a model of Roman womanhood. Roman empresses served as a model for other women and often determined matters of taste in fashion. Besides bearing the emperor several children, Faustina accompanied him on his military campaigns, which earned her the title Mother of the Camps. Her life embodied the feminine virtues that were important to the Romans, for which her husband later consecrated her a goddess (*diva*): devotion to home and family, affection, respect, and piety, as well as beauty, grace, fertility, and chastity. The tunic and cloak worn by Faustina are signs of modesty befitting a Roman matron.

Emperor MARCUS AURELIUS (121–80 A.D.; see fig. 7-13), a scholar and philosopher, was constantly forced to repress rebellions and incursions by "barbarian" peoples such as the Britons, Moors, Germans, and Parthians. His domestic policies were generally humane. His *Meditations* are imbued with STOIC philosophy. Stoicism expressed the ideas of the fourth century Greek philosopher, Zeno. Emotions were considered false and deceiving; impassive detachment was its highest virtue. Sacrifice and hardship were to be endured for the sake of moral principle.

the legionary standards lost in Roman defeats in 53 and 36. Characteristically, however, the event is shown as an allegory. The presence of gods and goddesses raises it to cosmic significance, while the symbolic aspects of the work proclaim that this triumph, which Augustus viewed as pivotal, began a new era of peace and plenty.

Equestrian Monuments Augustus still conformed to Roman republican custom by being clean-shaven. Some later emperors, in contrast, adopted the Greek fashion of wearing beards as an outward sign of culture and refinement. It is not surprising, there-

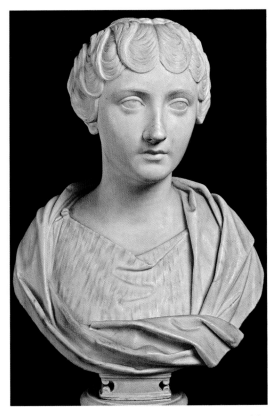

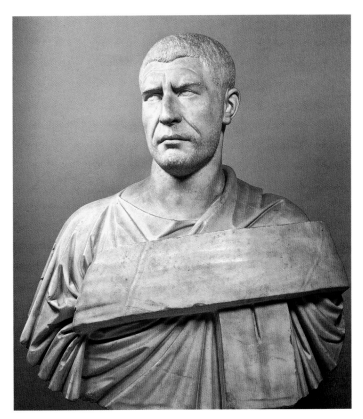

7-14 *Faustina the Younger.* C. A.D. 147–48. Marble, height 23⅝″ (60 cm). Museo Capitolino, Rome

7-15 *Philippus the Arab.* A.D. 244–49. Marble, life-size. Musei Vaticani, Braccio Nuovo, Città del Vaticano, Rome

The reign of Marcus Aurelius was the calm before the storm. A period of chaos ensued under his decadent son Commodus, who was finally murdered in A.D. 192. The reforms of the short-lived Severan dynasty (A.D. 193–235) gave way to almost constant crisis, which plagued the Roman Empire for the remainder of the third century. Barbarians penetrated the frontiers while internal conflicts undermined the emperor's authority. Retaining the throne became a matter of naked force, succession by murder a regular event. These "soldier emperors," often hailing from the outlying provinces of the realm, supplanted one another with sometimes dizzying speed.

The portraits of some of these men, such as Philippus the Arab (fig. 7-15), who reigned from A.D. 244 to 249 and presided over the thousandth anniversary of the founding of Rome, are among the most powerful likenesses in all of art. Their realism is as exact as that of Republican portraiture, but its aim is expressive rather than documentary. A gifted and conscien-

tious administrator, Philip soon found himself overwhelmed by military problems. Appointing a subordinate to deal with a rebellion and a simultaneous Gothic invasion across the Danube, he lost the army's confidence and was defeated and killed in a brief civil war. Like the "Worried Man" from Delos (fig. 5-29), his portrait reveals a careworn individual beset by the burdens of the world. We are struck, first of all, by the way expression centers on the eyes, which seem to gaze out at some unseen threat. The engraved outline of the iris and the hollowed-out pupils, devices that appear gradually in later Roman portraiture (compare fig. 7-13), serve to fix the direction of the glance. The hair, too, is rendered in unclassical fashion, as a military crewcut. Finally, the sculptor has replaced the full beard by a stubble that results from roughing up the surfaces of the jaw and mouth with short chisel strokes.

It is tempting to interpret all this negatively, as a dark psychological study of human fear and suspicion, even cruelty. Yet although to our eyes the image's stark,

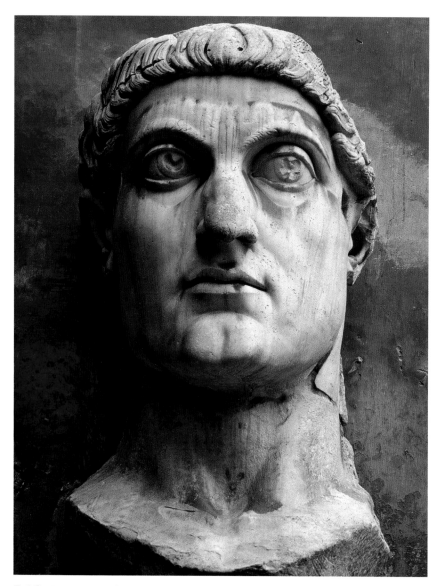

7-16 *Constantine the Great.* Recut shortly after A.D. 312 from a portrait of his predecessor Maxentius. Marble, height 8′ (2.44 m). Palazzo dei Conservatori, Rome

penetrating realism may inadvertently betray such feelings, like all ancient portraits it was not a freelance work but a paid commission—in this case from the emperor or his subjects. It was intended to be positive, to flatter the sitter, by showing him as mentally and physically prepared to handle the stresses and strains of ruling this increasingly unstable and uncertain world.

We enter a different universe with the head of Constantine the Great, the first Christian emperor and reorganizer of the Roman state (fig. 7-16). Its face is not a true portrait. In fact, the head is one of several fragments of the huge statue from the apse of Constantine's basilica (see fig. 7-9). Originally intended to represent Maxentius, in 312 it was commandeered and remodeled by Constantine—just like the basilica itself. Unlike the *Augustus of Primaporta* (see fig. 7-12) and other full-length imperial portraits, which generally show the ruler standing, this one followed a tradition that depicted him seated like Jupiter, with his torso bare and a mantle draped across his legs, in imitation of Pheidias's great cult statue of Zeus at Olympia (see page 93). It probably held an orb in its left hand and a cross-scepter, called a *labarum*, in its right. After Constantine's conversion, this imperial device, originally a Roman military standard, became a Christian symbol through the addition of the Chi Rho insignia within a wreath. (Chi and rho are the first two letters of Christ's name in Greek.) So although pagans would see nothing untoward in this colossal semi-divine image, Christians could interpret it as representing a Christian ruler of the world.

The head alone is eight feet tall. Everything is so out of proportion to ourselves that we feel crushed by its size. An image more of imperial majesty than of a living, breathing man, it was clearly intended to give the viewer the impression of being in the presence of truly superhuman power. The massive, immobile features, particularly the huge eyes that stare out with hypnotic intensity, reinforce this impression. All in all, the colossal head conveys little of Constantine's appearance, but it does tell us a great deal about his view of himself and his exalted office.

NARRATIVE RELIEFS

Imperial art was not confined to portraiture. The emperors also commemorated their achievements in narrative reliefs on MONUMENTAL ALTARS, TRIUMPHAL ARCHES, and columns. Similar scenes are familiar to us from the ancient Near East (see figs. 3-7 and 3-8) but not from Greece. Classical Greek sculpture commemorated historical events—that is, events that occurred only once, at a specific time and place—only rarely. A victory over the Persians, for instance, was normally commemorated in mythical guise, by a combat of Lap-

iths and Centaurs, Greeks and Amazons, or Gods and Giants (see figs. 5-19 and 5-23). This attitude persisted in Hellenistic times, although not quite as absolutely. When the kings of Pergamon celebrated their victories over the Celts, the latter were represented faithfully (see fig. 5-25), but mythical battles were sometimes added for good measure, and the Great Altar reverts to myth alone (see fig. 5-27).

Greek painters, on the other hand, had shown historical subjects such as the Battle of Marathon as early as the mid fifth century B.C., although we do not know how specific these pictures were in detail. As we have seen, the Alexander mosaic from Pompeii (see fig. 5-5) probably reflects a famous Hellenistic painting of about 315 B.C. depicting the defeat of the Persian king Darius at Issos. Historic events had been portrayed in Rome, too, from the third century B.C. on. A victorious military leader would have his deeds painted on panels that were carried in his triumphal procession or shown in public places. These pictures seem to have had the ephemeral status of posters advertising the hero's achievements; none has survived. During the last century of the Republic such images began to take on a more monumental and permanent form. They were

no longer painted, but carved and attached to structures intended to last indefinitely. They proved a ready tool for glorifying Roman successes, and the emperors used them on a large scale.

Arch of Titus Roman high relief carving reached its maturity in the two large narrative panels on the triumphal arch erected by the Senate in A.D. 81 to commemorate the victories of the emperor Titus. Like others of its kind, the Arch of Titus (fig. 7-17) was really a glorified statue base, supporting a gilded bronze chariot group bearing an image of the victorious emperor. It spans the entrance to the Roman forum, and the two relief panels flank the visitor walking beneath it. One of them (fig. 7-18) shows part of the procession celebrating the conquest of Jerusalem in A.D. 70. The booty includes a seven-branched Jewish menorah (candlestick) and other sacred objects. The movement of a crowd of figures

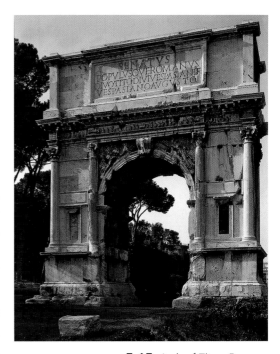

7-17 Arch of Titus, Forum Romanum, Rome, C. A.D. 81, as restored. 15.4 m high by 13.5 m wide.

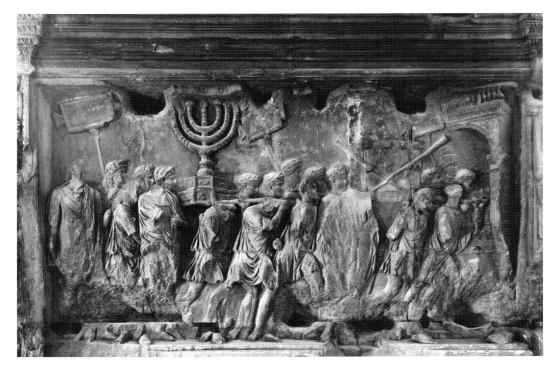

7-18 *Spoils from the Temple in Jerusalem.* Relief in passageway, Arch of Titus, Rome. A.D. 81. Marble, height 7'10" (2.39 m)

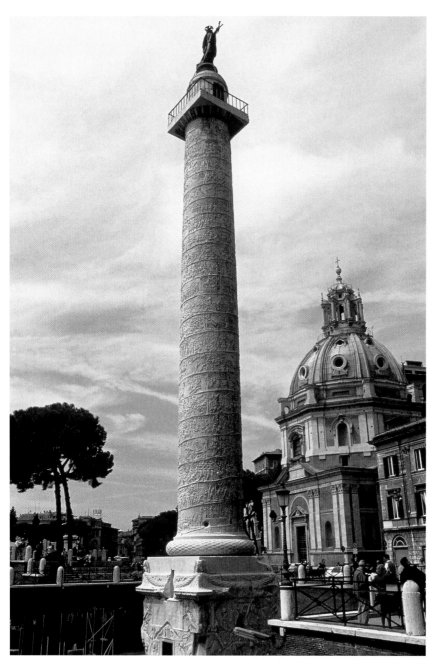

7-19 Column of Trajan, Rome. General view

Column of Trajan In the Column of Trajan (fig. 7-19) we can clearly see the conflict between the documentary purposes of imperial art—to portray the victories of the emperor—and the desire to treat space in a realistic way. The column was erected between A.D. 106 and 113 to celebrate the emperor Trajan's victorious campaigns against the Dacians (the inhabitants of what is now Romania); a colossal bronze statue of him stood on top of it. Freestanding columns had been used in this way from Archaic times on, but never so grandiosely. Trajan's is distinguished not only by its sheer height (125 feet, including the base) but also by the continuous spiral band of low relief (fig. 7-20), which recounts in epic length the history of the Dacian wars. The base served as a burial chamber for Trajan's ashes. The design is often credited to Apollodoros of Damascus, who served as Trajan's military architect during the wars and designed the great forum in which the column stood.

If we could unwind the relief band on the column, it would be 656 feet long, more than the combined length all of the friezes of the Mausoleum at Halikarnassos (see fig. 5-23). In terms of the number of figures and the density of the narrative, too, our relief is by far the most ambitious **frieze** composition up to that time. It is also the most frustrating, for viewers must "run around in circles like a circus horse" (as one scholar put it) if they want to follow the narrative. Moreover, although the reliefs almost certainly were painted, details above the fourth or fifth spiral can hardly be seen without binoculars. One wonders for whose benefit this elaborate pictorial account was intended. In Roman times, the monument formed the center of a small court flanked by libraries at least two stories tall within the Forum of Trajan, but even that arrangement does not answer our question.

At any rate, the spiral frieze was a new and demanding framework for historical narrative, which imposed a number of difficult conditions upon the sculptor. There could be no inscriptions, so the pictorial account had to be very clear. The spatial setting of each episode, therefore, had to be worked out with great care. Visual continuity had to be

in depth is conveyed with striking success, despite the damaged surface. Emerging on the left from the background, the procession passes in front of us, hurrying us along with it. It then turns away and disappears through a triumphal arch, which is placed obliquely to the background plane so that only the nearer half is actually visible—a radical but effective compositional device. So the relief both transports us back to Titus's real triumph of A.D. 71 and fosters the fiction that the arch it embellishes played a key part in it.

preserved without destroying the coherence of each scene. And the carving had to be much shallower than in reliefs such as those on the Arch of Titus. Otherwise, the projecting parts would disrupt the column's outline and their shadows would make the scenes unreadable from below.

Figure 7-20 shows that the designer has solved these problems with great success, but at a price. He has tilted the ground plane sharply upward, creating a space that is far deeper and more accommodating than in figures 5-14, 5-27, and 7-18, for example. The figures are viewed straight on, and the buildings either straight on or obliquely from above. Landscape and buildings are drastically reduced in scale, and thus become "stage sets," props that function as a kind of shorthand for reality (although there is great realism of detail). These devices had already been used in some Assyrian narrative reliefs and in Classical Greek painting. Here they appear once more. Yet despite the testimony of literary sources that Greek Classical painters made great strides in treating illusionistic space (see pages 77-78), there is no direct evidence that they did so in the manner found here. Seen in this light, the Roman conquest of landscape and architectural space is a striking achievement, even though it appears peculiar to our eyes. This method of pictorial description was to become dominant in another 200 years, at the dawn of medieval art. In this respect, this frieze foretells both the end of one era and the beginning of the next.

Painting

We know infinitely less about Roman painting than we do about Roman architecture or sculpture. Almost all the surviving works are wall paintings, and most of these come from Pompeii, Herculaneum, and other towns buried by the eruption of Mount Vesuvius in 79 A.D., or from Rome and its environs. Their dates cover a span of less than 200 years, from the end of the second century B.C. to the late first century A.D. After that time Roman painting seems to have declined. And because we have only a few Greek wall paintings in

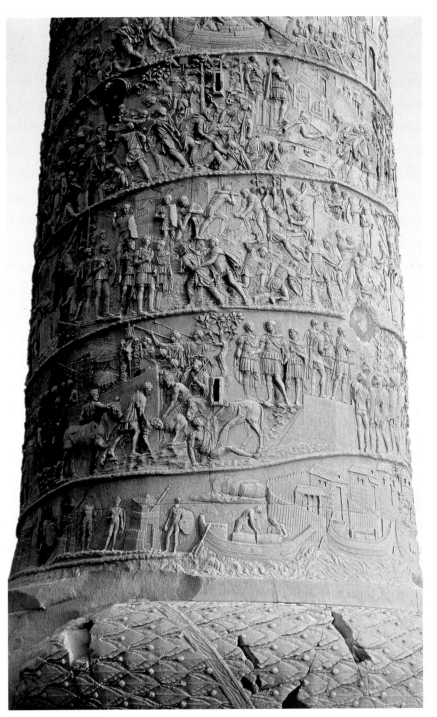

7-20 *The Roman Army Invades Dacia.* Lower portion of the Column of Trajan, Rome. A.D. 106–13. Marble, height of relief band approx. 50" (127 cm)

Macedonian tombs from Alexander's time, it is far more difficult to single out the Roman element in painting than in sculpture or architecture.

Who were these painters? From the few inscriptions, we know that some of them at least were Greek, like many architects and sculptors. But others must have been Italians and Romans. Most were of modest ability, local residents of Pompeii and its neighbors, although some must have been itinerants imported from Rome who painted a few major commissions before moving on. Although a few of them ran shops with teams of artists, most worked alone or with an assistant or two. Essentially high-end interior decorators, they produced large-scale decorative schemes, often for entire rooms (see fig. 7-21) or suites of rooms. Into these they then inserted copies or free adaptations of major masterpieces, selected from pattern books, or (on occasion) new compositions, particularly landscapes, still-lifes, and mythological scenes. The finest of these have a startling originality that cannot be explained simply in terms of some lost, presumably Greek, source.

ROMAN ILLUSIONISM

Vitruvius, writing around 20 B.C., describes three phases or styles of Roman wall painting, and archaeologists have added a fourth, ending with the eruption of Vesuvius and the destruction of Pompeii and Herculaneum (our best sources for painted walls) in A.D. 79. However, the differences among them are not always clear, and there seems to have been considerable overlap among them. Elements of all four occur in the Ixion Room of the House of the Vettii at Pompeii, which was frescoed around A.D. 70 (fig. 7-21).

The earliest style, known at Pompeii and Herculaneum from the later second century B.C., was already widespread in the Hellenistic world, because examples of it have also been found in the eastern Mediterranean. Unfortunately, it is not very informative for us, as it consists entirely of imitations of colored marble paneling. In figure 7-21 it decorates the very bottom section or *dado* of the wall. About 80 B.C., this so-called First Style began to be displaced by a far more ambitious Second Style that opens up the flat surface of the wall—the **picture plane**—by means of

illusionistic architectural perspectives and "window effects," including landscapes and figures. In figure 7-21, such windows appear in the middle section of the wall, whereas the upper section opens out completely into a large-scale architectural vista, whose centralized perspective anticipates the **scientific perspective** of the Renaissance by almost 1,400 years (see fig. 12-5 and Materials and Techniques: Perspective, page 272).

Next, around 20 B.C., a Third Style reasserts the wall's solidity and impermeability again. It uses broad expanses of intense color, against which large Greek-style panel paintings are "hung," and often turns the framing architectural elements into bizarre fantasies. In figure 7-21 a Greek-style picture of the Punishment of Ixion (who had tried to rape the goddess Hera) is "hung" against the large red panel, and a sketch of the god Bacchus (Dionysos) and a maenad floats against the large white one. Both are framed by spindly, metallic columns supporting a narrow, fanciful cornice. Finally, from around A.D. 60 to the eruption of A.D. 79 a Fourth Style partially opens up the wall again, blending elements of all three of its predecessors into a dazzling kaleidoscope of pictorial illusion. Fig. 7-21 illustrates this climactic point in the sequence.

This artist is clearly a master of composition, color, modeling, and texture. He has composed each wall of the rectangular room around the large red panel with its mythological scene (the corresponding panel to the Ixion one is just visible at fig. 7-21's extreme left-hand edge). He has then flanked these large panels by architectural vistas and (because the left-hand wall is longer than the right) has filled up the extra space between these and the corners with two white-on-red panels, of which only the Bacchus panel is visible in this illustration. His frames alternate between strongly three-dimensional (the richly decorated columns, moldings, and garlands) and (in the white panel) completely flat. These framed panels set off the architectural perspectives, which are flooded with light to convey a sense of open space. But we quickly realize that the painter has no interest in representing spatial depth systematically. We are never intended to enter this architectural maze. Like a promised land, it remains forever beyond us.

SPEAKING OF

wall painting, mural, and fresco

Wall painting is a very broad descriptive term for painting in any medium on a wall-like surface, from those on caves and rock-cut tombs to those on modern buildings. A *mural* is a painted image made on or attached to a particular wall, such as the painting cycle in the Villa of the Mysteries (see fig. 7-22). *Fresco* is a specific wall-painting technique favored in Italy from Roman times through the eighteenth century. In true (*buon*) fresco, the artist paints with water-borne colored pigments directly on fresh, still-damp plaster, working in small sections and producing a stable, long-lasting image. Dry (*secco*) fresco, in which the pigments are painted on dry plaster, is far less durable than true fresco and was used mostly for details.

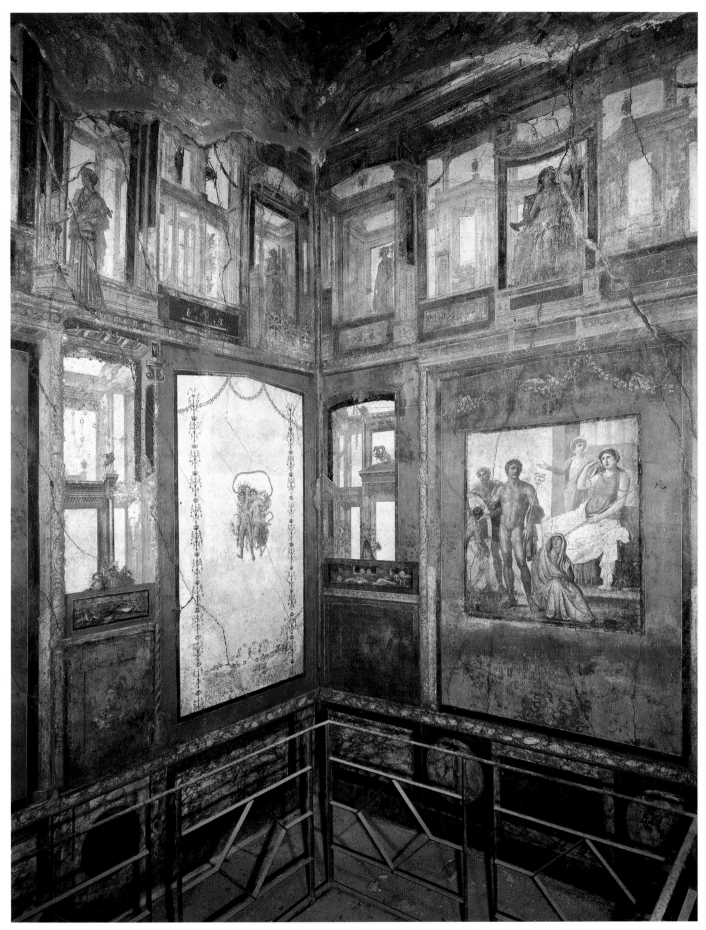

7-21 The Ixion Room, House of the Vettii, Pompeii. A.D. 63–79. The panel picture shows Ixion being bound to a wheel in punishment for attempting to rape Zeus's wife, the goddess Hera.

7-22 *The Laestrygonians Hurling Rocks at the Fleet of Odysseus.* Wall painting from the Odyssey frieze in a house on the Esquiline Hill, Rome. Late first century B.C. Biblioteca Apostolica Vaticana, Città del Vaticano, Rome

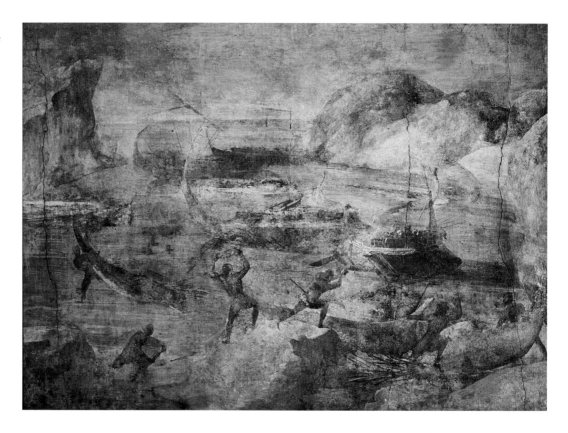

Odyssey Landscapes In some contexts, particularly along the walls of long corridors, landscape friezes were used instead of architectural vistas. We see this very clearly in the Odyssey Landscapes (fig. 7-22) that adorned a Roman villa of the late first century B.C. Inspired by Homer's *Odyssey* and illustrating the adventures of Odysseus (Ulysses) on his way home from Troy, the continuous stretch of landscape was divided into eight compartments. Vitruvius tells us that such cycles were common in first-century Rome. However, the narrative has some gaps in it and the inscriptions are in Greek, not Latin. So the painter probably adapted the scenes from a larger, originally Hellenistic composition and wrestled them into this window-frame format.

In the adventure with the Laestrygonians (fig. 7-22), the bluish tones create a feeling of light-filled space that envelops all the forms in this warm Mediterranean fairyland, including the figures. These, in turn, now play a much less commanding role than in most Greek and Roman painting (compare figs. 5-1 through 5-5, 7-21 and 7-22). This anonymous painter is a master of perspective. He both gradually diminishes the size of his figures as the scene recedes from the eye and shifts his palette from warm colors to cold. (This technique, known as **atmospheric perspective,** would be reinvented 1,500 years later by the great Italian Renaissance artists, Masaccio and Leonardo; see chapter 12.) One of the most consistently realized landscapes to have survived from antiquity, the Odyssey frieze achieves a unity that is not merely structural but poetic.

Villa of the Mysteries The great cycle of murals in one of the rooms in the Villa of the Mysteries just outside Pompeii (fig. 7-23) dates from the mid first century B.C., when the Second Style was at its height. The subject is unique and (despite a few defects) the frieze has a grandeur and coherence that are rare in Roman painting. While in Pompeii, the painter picked up a few other commissions, the only others known by the same hand.

First Style marbling frames the composition at top and bottom. The statuesque figures stand on a narrow ledge or **ground plane** of green against a regular pattern of red panels separated by strips of black. In effect, the artist has created a kind of extended stage on which the figures perform their enigmatic ritual. Who are they, and what is the meaning of the cycle? Many details remain puzzling, but the

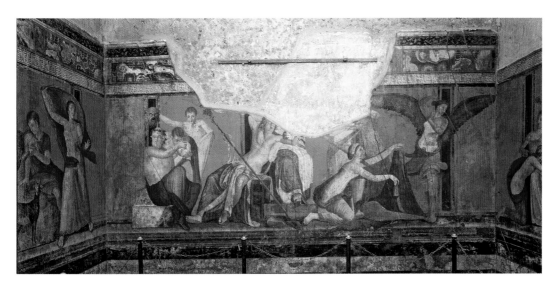

7-23 *Scenes of a Dionysiac Mystery Cult.* Mural frieze. c. 50 B.C. Villa of the Mysteries, Pompeii

frieze as a whole depicts various rites of the Bacchic (Dionysiac) mysteries, a semisecret cult of very ancient origin that had been brought to Italy from Greece. As part of a girl's initiation into womanhood or her preparation for marriage, the rituals are performed in the presence of Bacchus and his wife Ariadne (seen in the center of the rear wall), accompanied by SATYRS and SILENI. Thus human and mythical reality tend to merge into one. As a result all the figures have certain qualities in common: their dignified bearing and expression, the firmness of body and drapery, and the rapt intensity with which they participate in the drama of the ritual.

Still-Life Paintings Although the Greeks had painted still-lifes, the earliest ones that survive are from the Roman period. Among the many different items depicted, one group stands out: displays of food and drink. Vitruvius tells us that these were called *xenia*, or "guest-gifts," and were intended to make visitors feel welcome in the home. Many Roman examples, like that of figure 7-24, take the form of imaginary niches or cupboards so that the objects, which are often displayed on two levels, seem to be easily within reach. In the *Still-Life with Peaches and Glass Jar* (fig. 7-24), the textures and reflections are so carefully observed that we feel in the presence of the very objects themselves. However, the shadows cast by the peaches and the angle of the reflections in the water are not consistent with each other, and the viewpoints from which the fruit and jar are seen are different.

As in the reliefs of Trajan's Column (fig. 7-20), each part of the composition is conceived separately. Here, though, the painter's aim is perhaps to emphasize that the offering is quite spontaneous and casual, a hospitable tidbit awaiting any visitor who happens along. Not

In Greek mythology, SATYRS were phallic, goatish beings of the woods and hills. Although similar to satyrs, SILENI were older, usually bald, and always bearded.

7-24 *Still-Life with Peaches and Glass Jar.* Wall painting from Herculaneum, c. 50 A.D. Museo Nazionale Archeologico, Naples

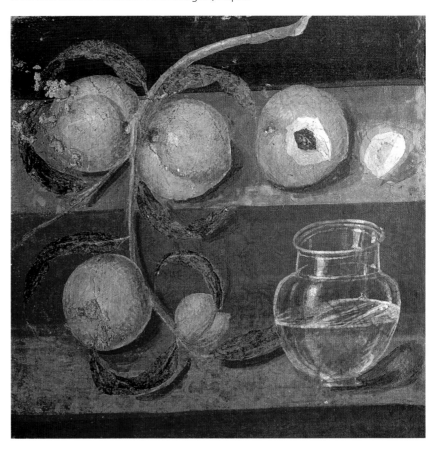

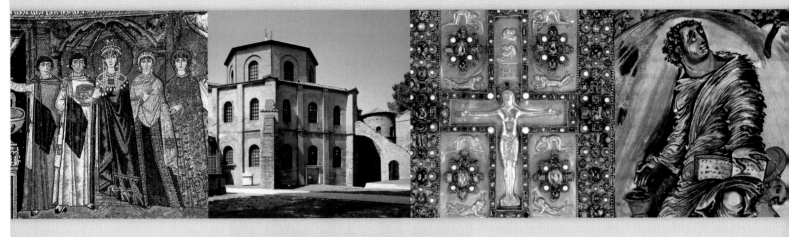

PART

2 The Middle Ages

e tend to think of the great Western civilizations of the past in terms of the monuments that have come to symbolize them: the pyramids of Egypt, the ziggurats of Babylon, the Parthenon of Athens, the Colosseum of Rome. The Middle Ages would be represented by a Gothic cathedral—Notre-Dame in Paris or Chartres in France, perhaps, or Salisbury Cathedral in England. We have many to choose from, but whichever one we pick, it will be well north of the Alps (albeit in an area that was once part of the Roman Empire). And if we were to spill a bucket of water in front of the cathedral of our choice, this water would eventually make its way to the English Channel rather than to the Mediterranean sea. Here, then, we have perhaps the most important single fact about the Middle Ages. The center of gravity of European civilization has shifted to what had been the northern boundaries of the Roman

world. The Mediterranean, which for so many centuries bound together all the lands along its shores, has become a border zone.

How did this dramatic shift come about? In A.D. 323 Constantine the Great made a fateful decision, the consequences of which are still felt today. He resolved to move the capital of the Roman Empire to the Greek town of Byzantium, which came to be known as Constantinople and today as Istanbul. Six years later, after a major building campaign, the transfer was officially completed. In taking this step, the emperor acknowledged the growing strategic and economic importance of the eastern provinces. The new capital also symbolized the new Christian basis of the Roman state, since it was in the heart of the most fully converted part of the empire. Constantine could hardly have foreseen that moving the seat of imperial power would split the empire. Less than 75 years later, in 395, the divi-

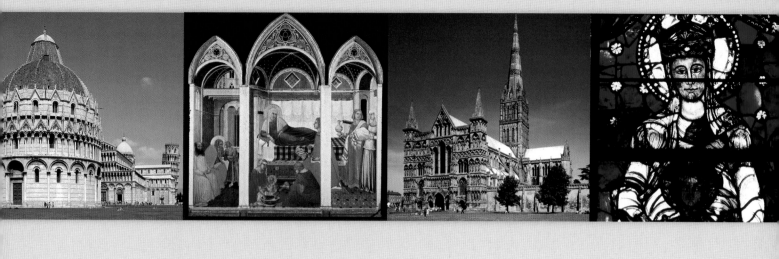

sion of the realm into the Eastern and Western empires was complete. Eventually that separation led to a religious split as well.

By the end of the fifth century, the bishop of Rome, who derived his authority from St. Peter, regained independence from the emperor. He then reasserted his claim as the pope, the head of the Christian Church. This claim to supremacy, however, was soon disputed by his Eastern counterpart, the patriarch of Constantinople. Differences in doctrine began to emerge and eventually the division of Christendom into a Western, or Catholic, and an Eastern, or Orthodox, Church became all but final. The differences between them went very deep. Roman Catholicism maintained its independence from state authority and became an international institution, reflecting its character as the Universal Church. The Orthodox Church, on the other hand, was based on the union of spiritual and secular authority in the person of the emperor, who appointed the patriarch. It thus remained dependent on the power of the State, requiring a double allegiance from the faithful. This tradition did not die even with the fall of Constantinople to the Ottoman Turks. The czars of Russia claimed the mantle of the Byzantine emperors, Moscow became "the third Rome," and the Russian Orthodox Church was as closely tied to the State as the Byzantine church had been.

Under Justinian (ruled 527–565), the Eastern, or Byzantine, Empire reached new power and stability after riots in 532 nearly deposed him. In contrast, the Latin West soon fell prey to invading Germanic peoples: Visigoths, Vandals, Franks, Ostrogoths, and Lombards. By the end of the sixth century, the last vestige of centralized authority had disappeared, even though the emperors at Constantinople did not give up their claim to the western provinces. Yet these invaders, once they had settled in their new lands, accepted the framework

of late Roman, Christian civilization, however imperfectly. The local kingdoms they founded—the Vandals in North Africa, the Visigoths in Spain, the Franks in Gaul, the Ostrogoths and Lombards in Italy—were all Mediterranean-oriented, provincial states on the edges of the Byzantine Empire. They were subject to the pull of the empire's military, commercial, and cultural power. As late as 630, after the Byzantine armies had recovered Syria, Palestine, and Egypt from the Sassanid Persians, the reconquest of the western provinces remained a serious possibility as well. Ten years later, the chance had ceased to exist, for an unforeseen new force—Islam—had made itself felt in the East.

Under the banner of Islam, the Arabs overran the African and Near Eastern parts of the empire. By 732, a century after Muhammad's death, they had absorbed Spain and threatened to conquer southwestern France as well. In the eleventh century, the Turks occupied much of Asia Minor. Meanwhile the last Byzantine lands in the West (in southern Italy) fell to the Normans, from northwestern France. The Eastern Empire, with its domain reduced to the Balkan peninsula, including Greece, held on until 1453, when the Turks conquered Constantinople.

In the East, Islam created a new civilization stretching to the Indus Valley (now Pakistan). That civilization reached its highest point far more rapidly than did that of the medieval West. Baghdad, on the Tigris, was the most important city of Islam in the eighth century. Its splendor rivaled that of Byzantium. Islamic art, learning, and crafts were to have great influence on the European Middle Ages, from arabesque ornament, the manufacture of paper, and Arabic numerals to the transmission of Greek philosophy and science through the writings of Arab scholars. (The English language records this debt in words such as algebra.)

This rapid advance of Islam had a tremendous impact. The Byzantine Empire, deprived of its western Mediterranean bases, focused on keeping Islam at bay in the East and retained only a precarious foothold in the West. The European shore of the western Mediterranean, from the Pyrenees to Naples, was exposed to Arabic raiders from North Africa and Spain. Western Europe was thus forced to develop its own resources—political, economic, and spiritual.

The process was slow and difficult, however. The early medieval world was in a state of constant turmoil and therefore presents a continually shifting picture. Not even the Frankish kingdom, which was ruled by the Merovingian dynasty from about 500 to 751 (when it was overthrown by the Carolingian king Pepin III) was able to impose lasting order. As the only international organization of any sort, Christianity

was of critical importance in promoting a measure of stability. Yet it, too, was divided between the papacy, whose influence was limited, and the monastic orders that spread quickly throughout Europe but remained largely independent of the Church in Rome.

This rapid spread of Christianity, like that of Islam, cannot be explained simply in institutional terms, for the Church did not perfectly embody Christian ideals. Moreover, its success was hardly guaranteed. In fact, its position was often precarious under Constantine's Latin successors. Instead, Christianity must have been extremely persuasive, in spiritual as well as moral terms, to the masses of people who heard its message. There is no other way to explain the rapid conversion of northern Europe. (Heathen gods were as terrifying as those of the ancient Near East, reflecting the violent life of a warrior society.)

Church and State gradually discovered that they could not live without each other. What was needed, however, was an alliance between a strong secular power and a united church. This link was forged when the Catholic Church, which had now gained the allegiance of the religious orders, broke its last ties with the East and turned for support to the Germanic north. There the leadership of Pepin III's son Charlemagne and his descendants—the Carolingian dynasty—made the Frankish kingdom into the leading power during the second half of the eighth century. Charlemagne usurped the territory of his brother, Carloman, from his heirs. He then conquered most of Europe from the North Sea to Spain and as far south as Lombardy. When Pope Leo III appealed to him for help in 799, Charlemagne went to Rome, where on Christmas Day 800, the pope gave him the title of emperor—something that Charlemagne neither sought nor wanted.

In placing himself and all of Western Christianity under the protection of the king of the Franks and Lombards, Leo not only solemnized the new order of things, but also tried to assert his authority over the newly created Catholic emperor. He claimed that the emperor's legitimacy depended on the pope, based on the forged Donation of Constantine. (Before then it had been the other way around: the emperor in Constantinople had ratified the newly elected pope.) Charlemagne did not subordinate himself to the pope, but this dualism of spiritual and political authority, of Church and State, was to distinguish the West from both the Orthodox East and the Islamic South. Its outward symbol was the fact that although the emperor was crowned in Rome, he did not live there. Charlemagne built his capital at the center of his power, in Aachen, located in what is now Germany and close to France, Belgium, and the Netherlands.

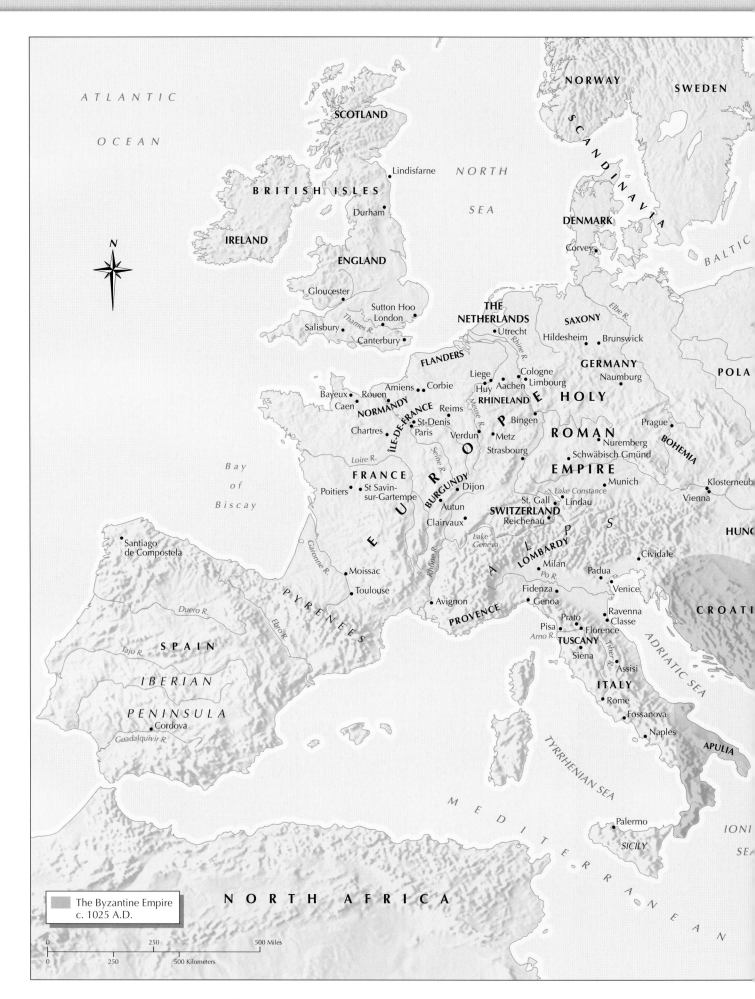

ATLANTIC

OCEAN

NORTH

SEA

SCOTLAND

Lindisfarne

BRITISH ISLES

Durham

IRELAND

N

ENGLAND

Gloucester

Sutton Hoo

Salisbury

London

Thames R.

Canterbury

Bay

of

Biscay

Santiago
de Compostela

Garonne R.

Moissac

Toulouse

PYRENEES

SPAIN

Duero R.

IBERIAN

Tajo R.

Ebro R.

PENINSULA

Cordova

Guadalquivir R.

NORWAY

SWEDEN

SCANDINAVIA

DENMARK

Corvey

BALTIC

THE
NETHERLANDS

SAXONY

Elbe R.

Utrecht

Hildesheim

Brunswick

FLANDERS

GERMANY

Rhine R.

Liege

Cologne

Naumburg

POLA

Bayeux

Amiens

Corbie

Huy

Aachen

Limbourg

Rouen

RHINELAND

E

HOLY

Caen

NORMANDY

Reims

Bingen

Prague

Meuse R.

Chartres

ÎLE-DE-FRANCE

St-Denis

Verdun

Metz

P

ROMAN

BOHEMIA

Paris

Nuremberg

Loire R.

Strasbourg

Schwäbisch Gmünd

EMPIRE

Klosterneub

Seine R.

O

Munich

FRANCE

Vienna

Poitiers

St Savin-
sur-Gartempe

BURGUNDY

Dijon

R

St. Gall

Lindau

HUNG

Autun

SWITZERLAND

Avignon

Clairvaux

Reichenau

E

U

Lake
Geneva

Lake Constance

Rhône R.

A

L

P

S

Cividale

LOMBARDY

Milan

Padua

Po R.

Fidenza

Venice

PROVENCE

Genoa

Ravenna

CROATI

Prato

Classe

Pisa

Florence

Arno R.

TUSCANY

Siena

Assisi

ADRIATIC SEA

TYRRHENIAN SEA

ITALY

Rome

Fossanova

Naples

APULIA

MEDITERRANEAN

Palermo

IONI

SICILY

SEA

N

NORTH AFRICA

The Byzantine Empire
c. 1025 A.D.

0 250 500 Miles

0 250 500 Kilometers

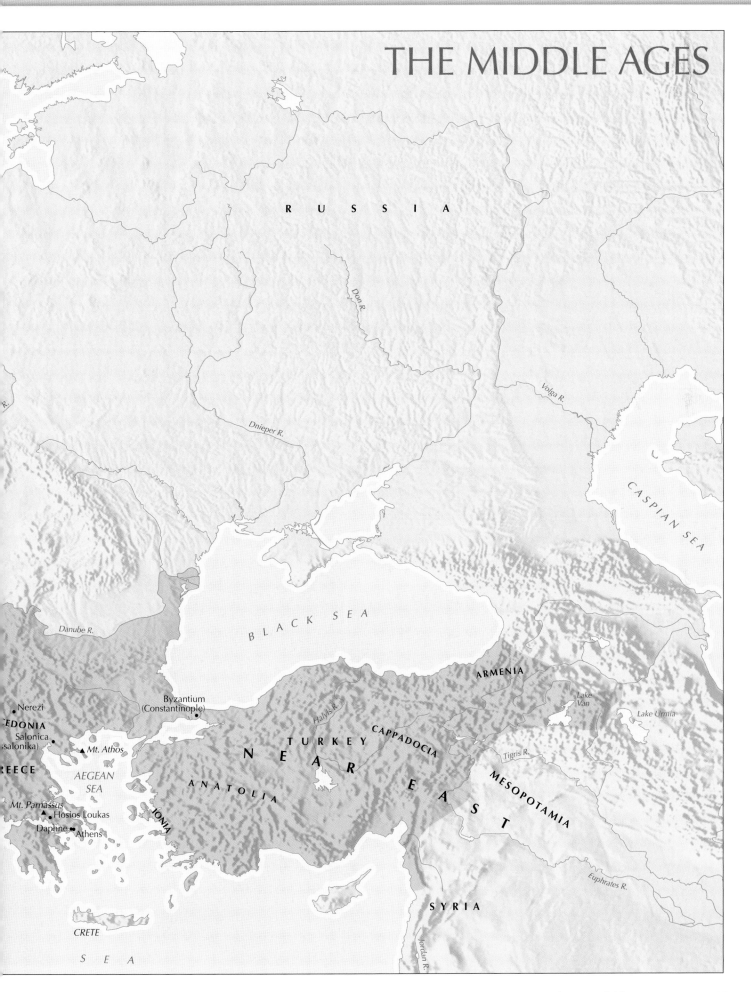

RUSSIA

Don R.

Volga R.

Dnieper R.

CASPIAN SEA

R.

Danube R.

BLACK SEA

ARMENIA

Lake Van

Lake Urmia

Nerezi

Byzantium (Constantinople)

ΞEDONIA

Salonica (ssalonika)

▲ Mt. Athos

ЯEECE

AEGEAN SEA

TURKEY

Halyls R.

CAPPADOCIA

N E A R

Tigris R.

MESOPOTAMIA

ANATOLIA

E A S T

Mt. Parnassus

▲ Hosios Loukas

IONIA

Daphne Athens

Euphrates R.

SYRIA

CRETE

Jordan R.

SEA

The Middle Ages
400–1400

	400–700	700–900	900–1100
POLITICAL HISTORY	Roman Empire split into Eastern and Western branches 395 Rome sacked by Visigoths 410 Fall of the Western Roman Empire 476 "Golden Age" of Justinian 527–65 Muhammad (570–632) Byzantium loses Near Eastern and African provinces to Muslims (642–732)	Muslims invade Spain 711–18; defeated by Franks, Battle of Tours 732 Independent Muslim state established in Spain 756 Charlemagne (ruled 768–814) crowned Holy Roman Emperor 800 Alfred the Great (ruled 871–99?), Anglo-Saxon king of England	Otto I crowned Holy Roman Emperor 962 Otto II (ruled 973–83) defeated by Muslims in southern Italy Normans arrive in Italy 1016 William the Conqueror defeats Harold at Battle of Hastings 1066 Reconquest of Spain from Muslims begins 1085 First Crusade (1095–99) takes Jerusalem
RELIGION AND LITERATURE	Patrick (died c. 461) founds Church in Ireland 432 Split between Eastern and Western Churches begins 451 Isidore of Seville, encyclopedist (died 636) Koran 652	*Beowulf*, English epic, early 8th cent. Iconoclastic Controversy 726–843 Carolingian revival of Latin classics Earliest printed book, China, 868	Cluniac monastic order founded 910 Conversion of Russia to Orthodox Church c. 990 College of Cardinals formed to elect pope 1059 Cistercian order founded 1098 *Chanson de Roland*, French epic, c. 1098
SCIENCE AND TECHNOLOGY	Papermaking introduced into Near East from China Stirrup introduced into western Europe c. 600	Earliest documented church organ, Aachen, 822 Horse collar adopted in western Europe, makes horses efficient draft animals	Earliest application of waterpower to industry Leif Ericsson sails to North America 1002
PAINTING	Catacomb of SS. Pietro e Marcellino, Rome (8-1) Mosaics, Sta. Maria Maggiore, Rome (8-4) *Vienna Genesis* (8-5) Mosaics, S. Apollinare in Classe and S. Vitale, Ravenna (8-3, 8-9, 8-10) *Lindisfame Gospels* (9-2) 8-10	*Gospel Book of Charlemagne* (9-6) *Gospel Book of Archbishop Ebbo of Reims* (9-7)	*Gospel Book of Otto III* (9-12) Mosaics, Daphné (8-16) *Bayeux Tapestry* (10-18) 9-9
SCULPTURE	*Sarcophagus of Junius Bassus*, Rome (8-6) *Archangel Michael*, diptych leaf (8-14) Sutton Hoo ship-burial treasure (9-1) 8-14	*Crucifixion* (plaque from a book cover?) (9-3) Oseberg ship burial (9-1) Crucifixion relief, cover of *Lindau Gospels* (9-8)	*Gero Crucifix*, Cologne Cathedral (9-9) Bronze doors of Bishop Bernward, Hildesheim (9-12) *Apostle*, St-Sernin, Toulouse (10-11)
ARCHITECTURE	S. Vitale, Ravenna (8-7, 8-8) Hagia Sophia, Istanbul (8-11, 8-12) S. Apollinare in Classe, Ravenna (8-2, 8-3)	Palace Chapel of Charlemagne, Aachen (9-4)	St. Michael's, Hildesheim (9-10, 9-11) Pisa Cathedral complex (10-9) Baptistery, Florence (10-10) St-Étienne, Caen (10-5) St-Sernin, Toulouse (10-1–10-2, 10-3) Durham Cathedral (10-6)

1100–1200	1200–1300	1300–1400
King Henry II founds Plantagenet line in England 1154 Frederick Barbarossa (ruled 1155–90) titles himself "Holy Roman Emperor," tries to dominate Italy	Fourth Crusade (1202–4) conquers Constantinople Magna Carta limits power of English kings 1215 Louis IX (ruled 1226–70), king of France Philip IV (ruled 1285–1314), king of France	Exile of papacy in Avignon 1309–76 Hundred Years' War between England and France begins 1337 Black Death throughout Europe 1347–50
Rise of universities (Bologna, Paris, Oxford); faculties of law, medicine, theology Pierre Abélard, French philosopher and teacher (1079–1142) Flowering of French vernacular literature (epics, fables, *chansons*); age of the troubadours	St. Dominic (1170–1221) founds Dominican order; Inquisition established to combat heresy St. Francis of Assisi (died 1226) St. Thomas Aquinas, Italian scholastic philosopher (died 1274) Dante Alighieri, Italian poet (1265–1321)	John Wycliffe (died 1384) challenges Church doctrine; translates Bible into English Petrarch, first humanist (1304–1374) *Canterbury Tales* by Chaucer c. 1387 *Decameron* by Boccaccio 1387
Earliest manufacture of paper in Europe, by Muslims in Spain Earliest use of magnetic compass for navigation Earliest documented windmill in Europe 1180	Marco Polo travels to China and India c. 1275–93 Arabic (actually Indian) numerals introduced in Europe First documented use of spinning wheel in Europe 1298	First large-scale production of paper in Italy and Germany Large-scale production of gunpowder; earliest known use of cannon 1326 Earliest cast iron in Europe
 9-13	Stained glass *Notre Dame de la Belle Verrière*, Chartres Cathedral (11-27) *Psalter of St. Louis* (11-29) *Madonna Enthroned*, icon (8-18) 11-9	Arena Chapel frescoes, Padua, by Giotto (11-30) *Maestà Altarpiece*, Siena, by Duccio (11-29) *Good Government* fresco, Palazzo Pubblico, Siena, by Ambrogio Lorenzetti (11-34) *Road to Calvary*, by Simone Martini (11-32) *Birth of the Virgin* triptych, Siena, by Pietro Lorenzetti (11-33) *Death of the Virgin*, by Bohemian Master (11-36) Altar wings, Dijon, by Melchior Broederlam (11-37)
South portal, St-Pierre, Moissac (10-12) Baptismal font, St-Barthélemy, Liège, by Renier of Huy (10-15) *Last Judgment* tympanum, Autun Cathedral, by Giselbertus (10-14) West portals, Chartres Cathedral (11-15, 11-16) *Klostemeuburg Altarpiece*, by Nicholas of Verdun (10-20)	 West portal, Reims Cathedral (11-9) Choir screen, Naumburg Cathedral (11-21) Pulpit, Baptistery, Pisa, by Nicola Pisano (11-24)	*Roettgen Pietà*, Bonn (11-22) Pulpit, Pisa Cathedral, by Giovanni Pisano (11-25) *Moses Well*, Dijon, by Claus Sluter (11-23) 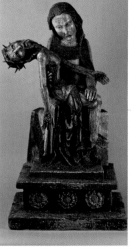
St-Denis, Paris (11-1) Nôtre-Dame, Paris (11-2–11-6) Chartres Cathedral (11-7, 11-8) Reims Cathedral (11-9)	Salisbury Cathedral (11-10) Sta. Croce, Florence (11-14)	Gloucester Cathedral (11-11) 11-22

CHAPTER

8

Early Christian and Byzantine Art

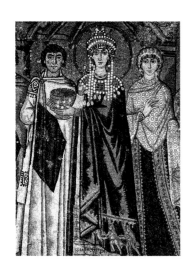

I N THE THIRD CENTURY A.D. THE ROMAN EMPIRE WAS COLLAPSING and widespread social turmoil resulted in a profound spiritual crisis. Religions that had been developing in the southeastern provinces and border regions of the Roman world began to spread. These cults stemmed from ancient traditions in the Egyptian, Persian, and Semitic cultures. Over time, they had absorbed Greek influences and also had influenced one another. Included among these Near Eastern faiths were Mithraism, Manichaeism, Gnosticism, Judaism, and Christianity. Central to all of these religions was a claim to being "the true faith," an emphasis on revealed truth, the hope of salvation, a chief prophet or messiah, a belief in a cosmic struggle of good against evil, a ritual of purification or initiation (such as baptism), and the duty to seek converts among unbelievers. The last faith of this type to develop was Islam, which was founded in the seventh century and continues to dominate the Near East to this day.

It is difficult to trace the growth of these religions under Roman rule. Many of them were underground movements that have left few tangible remains or texts. This is true of early Christianity. The Gospels of Mark, Matthew, Luke, and John were probably written in the later first century. They present somewhat varying views of Jesus and his teachings. In part, these reflect differences of opinion regarding doctrine that were held by St. Peter, the first bishop of Rome, and St. Paul, the most important of the early converts and a tireless recruiter for the faith. Peter, chosen by Jesus as the first bishop of the church, was conservative in all matters relating to dogma, whereas Paul was a new kind of Christian who represented the "church militant," willing to rewrite the basic articles of faith in order to win converts and spread the religion everywhere.

For the first three centuries after Christ, Christian congregations were reluctant to worship in public. Like those of other "mystery" religions of the time, they met in small numbers and usually in secret to avoid persecution. Thus their simple services took place

in the houses of wealthy members. They made use of altars that were portable; there were few implements or vestments (special clothing worn by those who conducted the services). From Judaea, the new Christian faith spread first to the Greek-speaking communities, notably Alexandria, then eventually reached the Latin world by the end of the second century.

Even before it was declared a lawful religion in 261 by the emperor Gallienus, Christianity was rarely persecuted. It suffered chiefly under the emperors Nero and Diocletian. In 309 Galerius, who succeeded Diocletian, issued a proclamation of tolerance for the faith. Though nearly one-third of Rome was Christian, the new faith had little standing until the conversion of Constantine the Great in 312. The famous story of Constantine's conversion begins on the eve of the battle against his rival Maxentius at the Milvian Bridge, over the Tiber River in Rome. According to the emperor's recounting of the event, there appeared in the sky the sign of the cross with the inscription, "In this sign, conquer." The next night, Christ

came to Constantine in a dream with a sign (most likely, the CHI RHO monogram) and commanded him to copy it. He had the insignia inscribed on his helmet and on the military standards of his soldiers. After his victory, Constantine accepted the faith, although he was baptized only on his deathbed. The next year, 313, he issued the Edict of Milan, which proclaimed freedom of religion throughout his empire.

Although Constantine never made Christianity the official state religion, it enjoyed a special status under his rule. The emperor promoted it and helped shape its theology. Unlike the pagan emperors, Constantine could not be deified, but he did claim that his authority was granted by God. Thus he placed himself at the head of the Church as well as of the State. In doing so, he adapted an ancient tradition: the divine kingship of Egypt and the Near East. Although there is no doubt that Constantine's faith was sincere, he did set a pattern for future Christian rulers by employing religion for his own personal and imperial ends.

Early Christian Art

We do not know when or where the first Christian works of art were produced. None of the surviving examples can be dated earlier than about A.D. 200. In fact, we know little about Christian art before the fourth-century reign of Constantine the Great. The painted decorations of the Roman CATACOMBS, the underground burial places of the Christians, are the only sizable body of artwork to survive, but these are merely one of several kinds of Christian art that may have existed. Rome was not the only center of faith in the early days of Christianity. Older and larger Christian communities existed in the great cities of North Africa and the Near East, such as Alexandria and Antioch. They had probably developed separate artistic traditions of their own, but few traces remain because the area has witnessed so much war and destruction in succeeding centuries. There is enough evidence, however, to indicate that the new faiths also gave birth to a new style in art, and that this style blended Greek and Roman (called Graeco-Roman) and Near Eastern (or Orientalizing) elements.

CATACOMBS

The catacomb paintings tell us a good deal about the spirit of the communities that sponsored them. The burial rite and the safeguarding of the tomb were of vital concern to the early Christians, whose faith rested on the hope of eternal life in heaven. In the painted ceiling in figure 8-1, the imagery clearly expresses this otherworldly outlook. The forms still resemble those found in pre-Christian Roman murals. The division of the ceiling into compartments is a simplified echo of the architectural schemes that are found in Pompeian painting (see fig. 7-21). The modeling of the figures, as well as the landscape settings, are also descended from Roman designs. The catacomb painter, however, has little interest in the original meaning of the forms, because they now are used to convey a new, symbolic content. The geometric framework shares in this task, for the great circle suggests the dome of heaven, inscribed with the Cross, the basic symbol of the faith. In the central medallion, or circle, we see a youthful shepherd, with a sheep on his shoulders, in a pose that can be traced back as far as Greek Archaic art. He stands for Christ the Savior, the Good Shepherd who gives his life for his flock.

The semicircular compartments tell the story of Jonah. On the left he is cast from the ship, and on the right he emerges from the whale. At the bottom he is safe again on dry land, meditating upon the mercy of the Lord. This Old Testament miracle, often juxtaposed with those of the New Testament, enjoyed great favor in Early Christian art as proof of the Lord's power to rescue the faithful from the jaws of death. The standing figures with their hands raised in prayer (known as orants) may represent members of the Church. The entire scheme, however small in scale and unimpressive in execution it may seem, has a consistency and clarity that set it apart from its non-Christian ancestors. In the ceiling of the catacomb of SS. Pietro e Marcellino, we have at least the promise of a monumental new form.

ARCHITECTURE

Constantine's decision to make Christianity a favored religion of the Roman Empire had a profound impact on Christian art. Before then, the Church (ecclesia) was simply the

The CHI RHO sign, a monogram of Christ, is composed of the first two Greek letters of Christos: chi (x) and rho (p). It is also called the Chrismon or the Christogram.

Rome's vast network of CATACOMBS, dug into the tufa (porous rock) hills outside the city, preserves frescoes from about the third to the sixth century. Most of the epitaphs, or tomb inscriptions, are in Greek rather than Latin—a reflection of the low social standing of the majority of early Christians. Among the Christian symbols found on the walls are anchors (symbolizing hope), fish (the Last Supper), doves (peace), the Good Shepherd (Christ), and depictions of Noah and Jonah.

SPEAKING OF

pagans, infidels, heathens, and heretics

To early Christians and Muslims, all believers in polytheistic religions were called infidels, or unbelievers. In Early Christian Rome and during the Middle Ages, unbelievers were known either as pagans ("unenlightened ones," from the Latin paganus, "country dweller") or heathens (those who were not Christian, Jewish, or Muslim). Although, strictly speaking, the words PAGAN and HEATHEN are synonyms, the former is often—including in this book—reserved for classical antiquity, the latter for northern Europe. Heretics, by contrast, are the faithful who hold opinions contrary to orthodox doctrine.

8-1 Painted ceiling, Catacomb of SS. Pietro e Marcellino, Rome. Fourth century

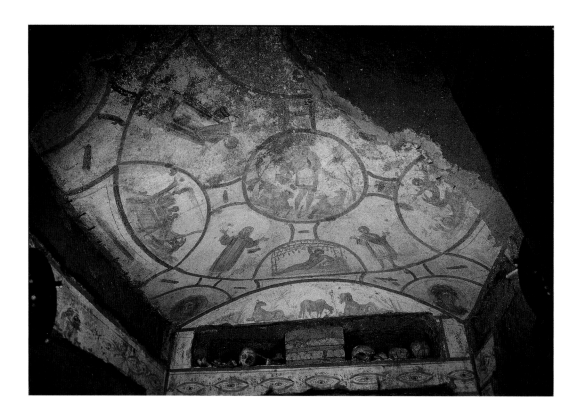

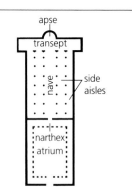

This plan for Old St. Peter's in Rome has two features not present in S. Apollinare in Classe (see **fig. 8-2**): a transept and an atrium forecourt.

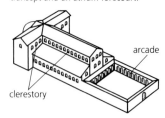

The oblique view shows clearly the rows of clerestory windows in the transept and nave and reveals the open arches (arcades) around the inside of the atrium.

congregation that met away from the public eye. (The Greek word *ekklesia* originally meant "the assembly of citizens.") Now, almost overnight, an impressive setting had to be created for the faith, so that the Church might be visible to all. To do so, however, involved rethinking the meaning of the Church itself. It now needed a public space for services and ceremonies. To meet the challenge, Church leaders adapted existing types to new ends. Constantine devoted the full resources of his office to this task, and within a few years an astonishing number of large, imperially sponsored churches were built, not only in Rome but also in Constantinople, the Holy Land, and other major centers.

The most important structures were of a new type, called the basilica, which evolved into the basic model for the development of church architecture across western Europe. The Early Christian basilica, as we know it, owes its essential character to the imperial basilicas built after about A.D. 225 (see pages 118–19). The Roman basilica already had been adapted by pagan cults and by Judaism. It was a suitable model for Constantinian churches, because it combined the spacious interior, needed to accommodate a large congregation, with imperial associations that proclaimed the privileged status of Christianity. But a church had to be more than an assembly hall. In addition to serving as a meeting place for the faithful, it was the sacred House of God, literally the Heavenly Jerusalem. As such, it was the Christian successor to the temples of old. To express this function, the Roman basilica, used for civic functions, had to be redesigned. The plan of the Early Christian basilica was given a new focus, the altar, which was placed in front of the semicircular apse at the eastern end of the nave. The entrances, which in earlier basilicas usually had been on the flanks, were shifted to the western end. The Early Christian basilica thus was arranged along a single, longitudinal axis that is indebted to the layout of Greek temples.

Unfortunately, none of the early Christian basilicas has survived in its original form. But a good deal is known about the greatest Constantinian church, Old St. Peter's in Rome, both from original documents and from drawings recording its appearance (see the diagrams at the left). (It was torn down and replaced by the present church in the sixteenth and seventeenth centuries; see figs. 13-14 and 17-8). Old St. Peter's, begun as early as 319 and finished by 329, was built on the Vatican hill next to a pagan burial

Much of Western art deals with biblical persons and celestial beings. Their names appear in titles of paintings and sculpture and in discussions of subject matter. The following is a brief guide to some of the most commonly encountered persons and beings in Christian art.

PATRIARCHS. Literally, heads of families or rulers of tribes. The Old Testament patriarchs are Abraham, Isaac, Jacob, and Jacob's 12 sons. Patriarch may also refer to the bishops of the five chief bishoprics of Christendom: Alexandria, Antioch, Constantinople, Jerusalem, and Rome.

PROPHETS. In Christian art, prophets usually refer to the Old Testament figures whose writings were seen to foretell the coming of Christ. The so-called major prophets are Isaiah, Jeremiah, and Ezekiel. The minor prophets are Hosea, Joel, Amos, Obadiah, Jonah, Micah, Nahum, Habakkuk, Zephaniah, Haggai, Zechariah, and Malachi.

TRINITY. Central to Christian belief is the doctrine that One God exists in Three Persons: Father, Son (Jesus Christ), and Holy Spirit. The Holy Spirit is often represented as a dove.

HOLY FAMILY. The infant Jesus, his mother, Mary (also called the Virgin or the Virgin Mary), and his foster father, Joseph, constitute the Holy Family. Sometimes Mary's mother, St. Anne, appears with them.

JOHN THE BAPTIST. The precursor of Jesus Christ, John is regarded by Christians as the last prophet before the coming of the Messiah, Jesus. John baptized his followers in the name of the coming Messiah; he recognized Jesus as that Messiah when he saw the Holy Spirit descend on Jesus when he came to John to be baptized.

EVANGELISTS. There are four: Matthew, John, Mark, and Luke—each an author of one of the Gospels. The first two were among Jesus's 12 apostles. The latter two wrote in the second half of the first century.

APOSTLES. The apostles are the 12 disciples Jesus asked to convert nations to his faith. They are Peter (Simon Peter), Andrew, James the Greater, John, Philip, Bartholomew, Matthew, Thomas, James the Less, Jude (or Thaddaeus), Simon the Canaanite, and Judas Iscariot. After Judas betrayed Jesus, his place was taken by Matthias. St. Paul (though not a disciple) is also considered an apostle.

DISCIPLES. See APOSTLES.

ANGELS and ARCHANGELS. Beings of a spiritual nature, angels are spoken of in the Old and New Testaments as having been created by God to be heavenly messengers between God and human beings, heaven and earth. Mentioned first by the apostle Paul, archangels, unlike angels, have names: Michael, Gabriel, and Raphael.

SAINTS. Persons are declared saints only after death. The pope acknowledges sainthood by canonization, a process based on meeting rigid criteria of authentic miracles and beatitude, or blessed character. At the same time, the pope ordains a public cult of the new saint throughout the Catholic church. A similar process is followed in the Orthodox church.

MARTYRS. Originally, martyrs (witnesses) referred to all the apostles. Later, it signified those persecuted for their faith. Still later, the term was reserved for those who died in the name of Christ.

ground. It was built directly over the grave of St. Peter, and thus served mainly as a **martyrium** of the apostle. (*Martyr* originally meant "witness" in Greek and only later came to denote someone willing to die for faith.) Old St. Peter's, which was covered by a wooden roof, had a long nave lit by clerestory windows and flanked by aisles. As in several early Christian basilicas, the apse is at the west end of the church, facing east, perhaps in imitation of Greek examples. The building included a **transept**, a separate compartment of space placed at right angles to the nave and aisles to form a cross. The plan also shows the entrance hall (**narthex**) and the colonnaded court (**atrium**).

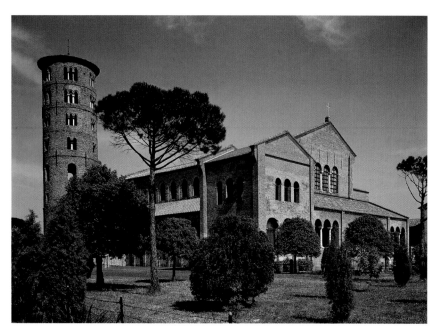

8-2 S. Apollinare in Classe, near Ravenna. 533–49

S. Apollinare in Classe The sixth-century Church of S. Apollinare in Classe, near Ravenna (figs. 8-2, 8-3), is the best preserved of the Early Christian basilicas. (S. Apollinarus was the first bishop of Ravenna; Classe is the seaport of Ravenna, which originally was a naval station on the Adriatic.) Our view, taken from the west, shows the narthex but not the atrium, which was torn down long ago. The church is similar in plan to Old St. Peter's, except that it has a single aisle on each side of the nave and the transept was omitted, as it was in many early churches. (The round bell tower, or **campanile**, is a medieval addition.)

S. Apollinare in Classe shows another essential aspect of Early Christian religious architecture, that is, the contrast between exterior and interior. The plain brick exterior is merely a shell, shaped to reflect the space it encloses—the opposite of the Classical temple. This restrained treatment of the exterior gives way to the utmost richness as we enter the church proper. Having left the everyday world behind, we find ourselves in a shimmering realm of light and color where precious marble surfaces and the brilliant glitter of **mosaics** evoke the spiritual splendor of the Kingdom of God. The steady rhythm of the nave **arcade** (the series of arches and their supports) pulls us toward the great "triumphal" arch at the eastern end, which frames the altar and the vaulted apse beyond.

MOSAICS

The rapid, large-scale growth of Christian architecture had a revolutionary effect on other forms of Early Christian art. Suddenly, huge wall surfaces had to be covered with images worthy of their monumental framework. Who was equal to this challenge? Certainly not the humble artists who had decorated the catacombs. As with the architects of the new basilicas, masters of great ability were probably recruited by officials of the empire. Unfortunately, very little of the decoration of fourth-century churches has survived, and so it is not possible to trace its history in any detail.

Out of this process emerged a great new art form, the Early Christian wall mosaic. To a large extent, it replaced the older and cheaper medium of mural painting. Mosaics—designs composed of small pieces of colored material (such as stone or glass) set in plaster—had been used by the Sumerians as early as the third millennium B.C. to decorate architectural surfaces. The Hellenistic Greeks and the Romans, using small cubes of marble called **tesserae**, had refined the technique to such a high level that paintings could be copied (e.g., *Battle of Alexander and the Persians* see fig. 5-5). But these were mostly floor mosaics, and the color scale, although rich in gradations, lacked brilliance, because it was limited to the natural colors of marble. The Romans also produced wall mosaics, but these were for special purposes and were limited in scale.

The extensive and complex wall mosaics of Early Christian art, therefore, are without precedent. The same is true of their material. They consist of tesserae made of colored glass. The Romans had known about this technique but never fully exploited it. Glass tesserae offered colors of a far greater range and intensity than marble tesserae, but they lacked the fine gradations in tone needed to imitate painted pictures. Moreover, the shiny (and slightly irregular) faces of glass tesserae act as tiny reflectors, so that the overall effect is that of a glittering, immaterial screen rather than of a solid, continuous

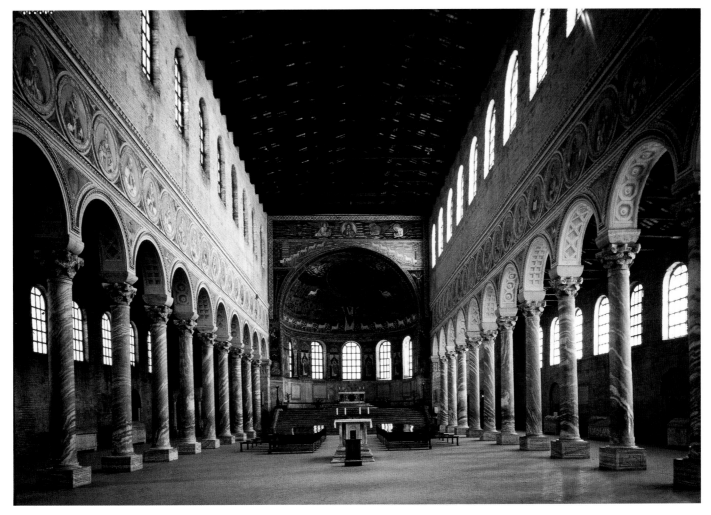

8-3 Interior (view toward the apse), S. Apollinare in Classe

surface. All these qualities made glass mosaic the ideal material for the new architectural aesthetic of Early Christian basilicas. The brilliant color, including the frequent use of gold, and the severe geometric order of the images in a mosaic cycle such as that of S. Apollinare in Classe—all fit the spiritual context of these interiors to perfection. One might say, in fact, that Early Christian churches demand mosaics the way Greek temples demand architectural sculpture.

Early Sources The challenge of inventing a body of Christian imagery produced an extraordinary creative outpouring. By A.D. 500 the process was largely complete. It took less than two centuries after Christianity had been officially sanctioned to lay the foundation for a new artistic tradition—a remarkably short time indeed! The evolution of Christian imagery was interwoven with the

development of religious architecture. The earliest church decorations probably consisted of ornamental designs in marble, plaster, stucco, or even gold. Soon, however, great picture cycles of subjects selected from the Old and New Testaments were spread over the nave walls, the triumphal arch, and the apse; these were executed first in painting, then in mosaic. Much of the initial development of these pictorial wall decorations seems to have occurred during the fifth century A.D.

These cycles must have drawn on sources that reflected the whole range of Graeco-Roman painting as well as the art of Christian centers. Paintings in an Orientalizing style may have decorated the walls of Christian places of worship in Syria and Palestine. Moreover, during the first or second century A.D., Alexandria, the home of a large Jewish colony, may have produced illustrations of

SPEAKING OF

saints

In English, the abbreviations for SAINT and SAINTS are ST. and STS. Saints in Italian are S. (SAN, male saint), STA. (SANTA, female saint), and SS. (SANTI, male or male and female saints). It is quite permissible to use simply S. for any category. In French, SAINT is expressed without a period and always hyphenated with the name of the person, as in St-Denis: ST- (SAINT, male), STE- (SAINTE, female), and STS- (SAINTS, all plural forms).

the Old Testament in a style akin to that of Pompeian murals. We meet echoes of such scenes in Christian art later on, but we cannot be sure when or where they originated, or by what paths they entered the Christian tradition. The importance of Judaic sources for Early Christian art is hardly surprising: the new faith also incorporated many aspects of the Jewish service into its own liturgy. These included hymns, which later formed the basis of medieval chants.

Sta. Maria Maggiore

As we have seen, Roman mural painting used illusionistic devices to suggest a reality beyond the surface of the wall. Early Christian mosaics also denied the flatness of the wall surface, but their goal was to achieve an "illusion of unreality," a luminous realm filled with celestial beings or symbols. In Early Christian narrative scenes we see the illusionistic tradition of ancient painting being transformed by new content.

The Parting of Lot and Abraham (fig. 8-4) is a scene from the oldest and most impor-

tant surviving mosaic cycle of this kind. It was created in about 432–40 in the church of Sta. Maria Maggiore in Rome. In the left half of the scene, Abraham, his son Isaac, and the rest of his family depart for the land of Canaan. On the right, Lot and his clan, including his two small daughters, turn toward the city of Sodom. The task of the artist who designed the panel was similar to that of the sculptors of the Column of Trajan (see fig. 7-19, 7-20) Both needed to condense complex actions into a form that could be read at a distance. In fact, many of the same "shorthand" devices used on the column are employed in the mosaic. These include the formulas for house, tree, and city, as well as the trick of showing a crowd of people as a "grape-cluster of heads."

In the Trajanic reliefs, these devices could be used only to the extent that they allowed the artist to re-create actual historical events. The mosaics in Sta. Maria Maggiore, by contrast, depict the history of salvation. They begin with Old Testament scenes along the nave (in this instance from Genesis 13) and end with the life of Jesus as the Messiah on the arch across the nave. The scheme is not only a historical cycle but a symbolic program that presents a higher reality—the Word of God. Hence the artist need not be concerned with the details of historical narrative. Glances and gestures are more important than movement or three-dimensional form. The symmetrical composition of the scene with Lot and Abraham has a gap in the center that makes clear the significance of this parting. The way of righteousness is represented by Abraham, the way of evil by the city of Sodom, which was destroyed by the Lord.

ROLL, BOOK, AND ILLUSTRATION

From what sources did the designers of mosaic cycles such as those at Sta. Maria Maggiore derive their compositions? They were certainly not the first to depict scenes from the Bible (see Cultural Context: Versions of the Bible, page 149) in extensive fashion. For certain subjects, they could have found models among the catacomb murals, but some prototypes may also have come from illustrated manuscripts. Because they were portable, manuscripts

8-4 *The Parting of Lot and Abraham.* Mosaic in Sta. Maria Maggiore, Rome. c. 432–40

The word *bible* is derived from the Greek word for "books," because it was originally a compilation of a number of sacred texts. Over time, the books of the Bible came to be regarded as a unit, and thus the Bible is now generally considered a single book.

There is considerable disagreement between Christians and Jews, and among various Christian and Jewish sects, over which books should be considered canonical—that is, accepted as legitimate parts of the biblical canon, the standard list of authentic texts. However, every version of the Bible includes the Hebrew TORAH, or the Law (also called the PENTATEUCH, or Books of Moses), as the first five books. Also universally accepted by both Jews and Christians are the books known as the Prophets (which include texts of Jewish history as well as prophecy). There are also a number of other books known simply as the Writings, which include history, poetry (the Psalms and the Song of Songs), prophecy, and even folktales, some universally accepted, some accepted by one group, and some accepted by virtually no one. Books of doubtful authenticity are known as APOCRYPHAL BOOKS, or simply Apocrypha, from a Greek word meaning "obscure." The Jewish Bible or Hebrew Canon—the books that are accepted as authentic Jewish scripture—was agreed upon by Jewish scholars sometime before the beginning of the Christian era.

The Christian Bible is divided into two major sections, the OLD TESTAMENT and the NEW TESTAMENT. The Old Testament contains many, but not all, of the Jewish scriptures, whereas the New Testament, originally written in Greek, is specifically Christian. It contains four GOSPELS— each written in the first century A.D. by one of the Early Christian missionaries known as the four EVANGELISTS, Mark, Matthew, Luke, and John. The Gospels tell, from slightly different points of view, the story of the life and teachings of Jesus of Nazareth. They are followed by the EPISTLES, letters written by Paul and a few other Christian missionaries to various congregations of the Church. The final book is the APOCALYPSE, by John the Divine, also called the Book of Revelation, which foretells the end of the world.

Jerome (342–420), the foremost scholar of the early Church, selected the books considered canonical for the Christian Bible from a large body of Early Christian writings. It was because of his energetic advocacy that the Church accepted the Hebrew scriptures as representing the Word of God as much as the Christian texts, and therefore worthy to be included in the Bible. Jerome then translated the books he had chosen from Hebrew and Greek into Latin, the spoken language of Italy in his time. This Latin translation of the Bible was—and is—known as the VULGATE because it was written in the vernacular (Latin *vulgaris*) language. The Vulgate remained the Church's primary text for the Bible for more than a thousand years. It was regarded with such reverence that in the fourteenth century, when early humanists first translated it into the vernacular languages of their time, they were sometimes suspected of heresy for doing so. The writings rejected for inclusion in the New Testament by Jerome are known as Christian Apocrypha. Although not canonical, some of these books, such as the Life of Mary and the Gospel of James, were nevertheless used by artists and playwrights during the Middle Ages as sources for stories to illustrate and dramatize.

were assigned an important role in disseminating religious imagery.

Because it was founded on the Word of God as revealed in Holy Writ, the early Christian Church must have sponsored the duplicating of sacred text on a large scale. Every copy was handled with a reverence quite unlike the treatment of any book in Graeco-Roman civilization. But when did these copies become works of pictorial art as well? And what did the earliest Christian text illustrations look like?

Because books are frail things, we have only indirect evidence of their history in the

ancient world. It begins in Egypt with the discovery of a suitable and convenient surface for writing. Paperlike but more brittle, the material was derived from the papyrus plant (see pages 34–5). Books of papyrus were made in the form of rolls throughout antiquity. Not until the second century B.C., in late Hellenistic times, did a better substance become available. This was parchment, or **vellum** (thin, bleached animal hide), which is far more durable than papyrus. It was strong enough to be creased without breaking and thus made possible the kind of bound book we know today, technically called a codex, which appeared sometime in the late first century A.D.

Between the second and fourth centuries A.D., the vellum codex gradually replaced the roll. This change must have had an important effect on text illustration. As long as the roll form prevailed, illustrations seem to have been mostly line drawings, because layers of pigment would soon have cracked and come off in the process of rolling and unrolling. Only the vellum codex permitted the use of rich colors, including gold. Hence, it would make book illustration—or, as we usually say, manuscript **illumination**—the small-scale counterpart of murals, mosaics, and panel paintings. There can be little doubt that the earliest illuminations, whether Christian, Jewish, or classical, were strongly influenced by the illusionism of Hellenistic-Roman painting of the sort we met at Pompeii. Some questions are still unanswered: When, where, and at what pace did book illumination develop? Were most early subjects biblical, mythological, or historical? How much of a carryover was there from roll to codex?

Vienna Genesis The oldest illustrated Bible manuscripts discovered thus far appear to date from the early sixth century, except for one fragment of five leaves that is probably a hundred or so years earlier. They contain echoes of the Graeco-Roman style, which has been adapted to religious narrative. The most important example is the *Vienna Genesis* (fig. 8-5). This Greek translation of the first book of the Bible achieves a sumptuous effect not unlike that of the mosaics we have seen. It is written in silver (now turned black) on vellum and adorned with brilliantly colored **miniatures** (small color illustrations). Our page shows a number of scenes from the story of Jacob. (In the center foreground, for example, we see him wrestling with the angel, then receiving the angel's blessing.) The picture thus does not show a single event but a whole sequence. The scenes are strung out along a single U-shaped path, so that progression in space becomes progression in time. This method, known as continuous narration, has a history going back as far as ancient Egypt and Mesopotamia and thus gives our story of Jacob a Near Eastern flavor. The appearance of continuous narration in miniatures such as that shown in figure 8-5 may reflect earlier illustrations made for books in roll form: our picture certainly does look like a frieze turned back upon itself.

8-5 Page with *Jacob Wrestling the Angel*, from the *Vienna Genesis*. Early sixth century. Tempera and silver on dyed vellum, 13¼ × 9½″ (33.7 × 24.1 cm). Österreichische Nationalbibliothek, Vienna

For manuscript illustration, the continuous method makes the most economical use of space. The painter can pack a maximum of narrative content into the area at his disposal. Our artist seems to have thought of his picture as a running account to be read like lines of text rather than as a window that required a frame. The painted forms are placed directly on the purple background that holds the letters, making the entire page a unified field.

SCULPTURE

Compared with painting and architecture, sculpture was less significant in Early Christian art. The biblical prohibition of graven (carved) images in the Second Commandment was thought to apply particularly to large cult statues, the idols that were worshiped in pagan temples. To escape the taint of idolatry, therefore, religious sculpture had to avoid life-size representations of the human figure. It thus developed away from the spatial depth and massive scale of Graeco-Roman sculpture toward small-scale forms and lacelike surface decoration.

The earliest works of Christian sculpture are marble coffins, or **sarcophagi**. These evolved from the pagan examples that replaced cinerary urns in Roman society toward the middle of the second century,

when belief in an afterlife arose as part of a major change in the attitude toward death. From the middle of the third century on, these stone coffins were also made for the more important members of the Christian Church. Before the time of Constantine, they were decorated mainly with themes that are familiar from catacomb murals—the Good Shepherd, Jonah and the Whale, and so forth—but within a framework borrowed from pagan art. Not until the mid fourth century do we find a much broader range of subjects and forms.

Sarcophagus of Junius Bassus The finest Early Christian sarcophagus is the richly carved example made for Junius Bassus, a prefect of Rome who died in 359 (fig. 8-6). Its colonnaded front, divided into ten square compartments, shows a mixture of Old and New Testament scenes. In the upper row we see (left to right) the Sacrifice of Isaac, St. Peter Taken Prisoner, Christ Enthroned between Sts. Peter and Paul, and Christ before Pontius Pilate (two compartments). In the lower row are the Misery of Job, the Temptation of Adam and Eve, Christ's Entry into Jerusalem, Daniel in the Lions' Den, and St. Paul Led to His Martyrdom. The choice of scenes from Jesus' life, which may seem somewhat strange to the modern viewer, is

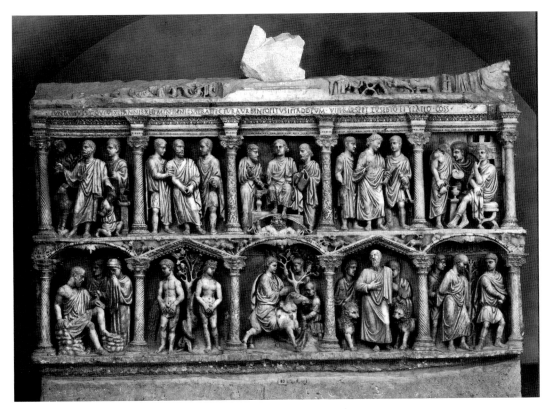

8-6 *Sarcophagus of Junius Bassus.* c. 359. Marble, 3'10½" × 8' (1.18 × 2.44 m). Museo Storico del Capitolino di San Pietro, Rome

characteristic of the Early Christian way of thinking, which stressed his divine rather than his human nature. Hence there is only a limited reference to his suffering and death.

Christ appears before Pilate as a youthful, long-haired philosopher expounding the true wisdom (note the scroll). The martyrdom of the two apostles, Peter and Paul, is shown in the same discreet fashion. The two central scenes are devoted to Jesus (see Cultural Context: The Life of Jesus, pages 154–155). Enthroned above Jupiter as the personification of the heavens, he dispenses the Law to Sts. Peter and Paul. Below, he enters Jerusalem as Conquering Savior. Adam and Eve, the original sinners, symbolize the burden of guilt redeemed by Christ. The Sacrifice of Isaac is an Old Testament prefiguration, or foreseeing, of Christ's death and resurrection. Job and Daniel carry the same message as Jonah in the catacomb painting (see fig. 8-1): they fortify the hope of salvation. The figures in their deeply recessed niches still recall the statuesque dignity of the Greek and Roman tradition. (Compare Eve to the *Knidian Aphrodite* of Praxiteles, fig. 5-24.) Yet beneath this classicism there is a kinship to the style of Constantinian sculpture in the doll-like figures and large heads. The events and figures are no longer intended to tell their own story but to call to mind a symbolic meaning that unites them. Hence these scenes, which might be expected to call for dramatic action, are depicted in a passive and restrained manner.

Byzantine Art

It is the religious, even more than the political, separation of East and West that makes it impossible to discuss the development of Christian art in the Roman Empire under a single heading. *Early Christian* does not, strictly speaking, designate a style. It refers, rather, to any work of art produced by or for Christians during the time prior to the splitting off of the Orthodox Church— roughly, the first five centuries after Christ. *Byzantine*, on the other hand, designates not only the art of the eastern Roman Empire with its center in Constantinople but a specific culture and a quality of style as well. Hence, the terms are by no means equivalents.

There is no clear-cut line between Early Christian and Byzantine art. Some argue that a Byzantine style (that is, a style linked to the imperial court of Constantinople) can be seen in Early Christian art as early as the beginning of the fourth century, soon after the division of the empire. However, we have avoided making this distinction. East Roman and West Roman—or, as some scholars prefer to call them, Eastern and Western Christian—characteristics are difficult to separate before the sixth century. Until that time, both areas contributed to the development of Early Christian art, but as the West declined, the leadership tended to shift to the East. Keep in mind also that in the Eastern, or Orthodox Church, the emperor was at the center of power because it was he who selected the patriarch, or leader of the Church. This process of consolidating leadership and power was completed during the reign of Justinian, who ruled the Eastern Empire from 527 to 565. Constantinople not only reasserted its political dominance but became the artistic capital as well. Justinian himself was a man of strongly Latin, or Western, orientation, and he almost succeeded in reuniting the Constantinian domain. The monuments he sponsored have a grandeur that justifies the claim that his era was a golden age. In addition, they display an inner unity of style that links them more strongly with the future development of Byzantine art than with the art of the past. The political and religious break between East and West became an artistic separation as well. In western Europe, Celtic and Germanic peoples fell heir to the civilization of late antiquity of which Early Christian art had been a part. They transformed it into the life and culture of the Middle Ages. The East, in contrast, experienced no such disruption or transformation. Late antiquity lived on in the Byzantine Empire, although the Greek and oriental elements came increasingly to the fore at the expense of the Roman heritage. A sense of tradition, of continuity with the past, was central to the development of Byzantine art.

EARLY BYZANTINE ART

The finest of the Early Byzantine monuments (A.D. 526–726) survive not in Constantinople, where much has been destroyed, but in the town of Ravenna in Italy. Ravenna had become the capital of the West

Roman emperors in 402. Then, at the end of the century, Theodoric, king of the Ostrogoths, whose tastes were patterned after those of Constantinople made it his capital. Under Justinian, Ravenna became the main stronghold of Byzantine rule in Italy.

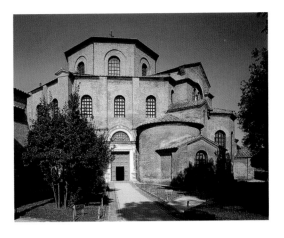

S. Vitale, Ravenna The most important church of that time, S. Vitale (figs. 8-7, 8-8), was begun in 526, just before Theodoric's death, but it was built chiefly in 540–47 under the sponsorship of Bishop Maximianus, who also consecrated S. Apollinare in Classe two years later. Dedicated to a little-known martyr whose body had been rediscovered at Bologna, S. Vitale functioned as a martyrium, or consecrated building erected over the place where the remains of a martyr are buried. The type of structure is derived mainly from Constantinople. Its plan shows only the barest remnants of the longitudinal axis of the Early Christian basilica. Toward the east is a cross-vaulted compartment for the altar, backed by an apse. On the other side is a narthex, whose odd, nonsymmetrical placement has never been fully explained. Otherwise the plan is octagonal with a domed central space that makes it a descendant of Roman baths. (The design of the Pantheon

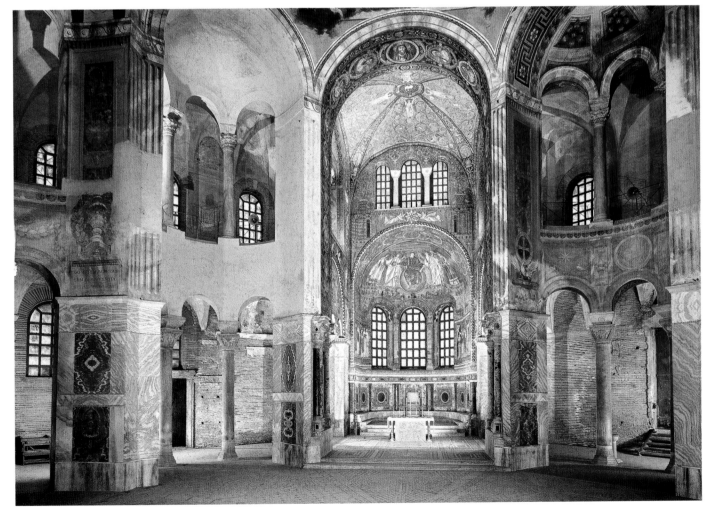

8-8 Interior (view from the apse), S. Vitale

was derived from that source as well; see fig. 7-6.) The intervening development from these previous styles to the plan seen in San Vitale seems to have taken place in the East, where domed churches of various kinds had been built during the previous century.

When we recall S. Apollinare in Classe (see figs. 8-2 and 8-3), built at the same time on a straightforward basilican plan with funds from the same donor, we are struck by the differences found in San Vitale. How did it happen that the East

Passion Cycle

The Passion (from *passio*, Latin for "suffering") cycle relates Jesus's death, resurrection from the dead, and ascension to heaven.

ENTRY INTO JERUSALEM. Welcomed by crowds as the Messiah, Jesus triumphantly rides an ass into the city of Jerusalem.

LAST SUPPER. At the Passover seder, Jesus tells his disciples of his impending death and lays the foundation for the Christian rite of the Eucharist: the taking of bread and wine in remembrance of Christ. (Strictly speaking, Jesus is called Jesus until he leaves his earthly physical form, after which he is called Christ.)

JESUS WASHING THE DISCIPLES'S FEET. Following the Last Supper, Jesus washes the feet of his disciples to demonstrate humility.

AGONY IN THE GARDEN. In Gethsemane, the disciples sleep while Jesus wrestles with his mortal dread of suffering and dying.

BETRAYAL (ARREST). The disciple Judas Iscariot takes money to identify Jesus to Roman soldiers. Jesus is arrested.

DENIAL OF PETER. As Jesus predicted, Peter, waiting outside the high priest's palace, denies knowing Jesus three times as Jesus is being questioned by the high priest, Caiaphas.

JESUS BEFORE PILATE. Jesus is questioned by the Roman governor Pontius Pilate regarding whether he calls himself King of the Jews. Jesus does not answer. Pilate reluctantly condemns him.

FLAGELLATION (SCOURGING). Jesus is whipped by Roman soldiers.

JESUS CROWNED WITH THORNS (THE MOCKING OF CHRIST). Pilate's soldiers mock Jesus by dressing him in robes, crowning him with thorns, and calling him King of the Jews.

CARRYING OF THE CROSS (ROAD TO CALVARY). Jesus carries the wooden cross on which he will be executed from Pilate's house to the hill of Golgotha, "the place of the skull."

CRUCIFIXION. Jesus is nailed to the Cross by his hands and feet, and dies after great physical suffering.

DESCENT FROM THE CROSS (DEPOSITION). Jesus's followers lower his body from the Cross and wrap it for burial. Also present are the Virgin, the apostle John, and in some accounts Mary Magdalen.

LAMENTATION (PIETÀ or VESPERBILD). The grief-stricken followers gather around Jesus' body. In the Pietà, his body lies in the lap of the Virgin.

ENTOMBMENT. The Virgin and others place the wrapped body in a sarcophagus, or rock tomb.

DESCENT INTO LIMBO (HARROWING OF HELL or ANASTASIS in the Orthodox Church). Christ descends to hell, or limbo, to free deserving souls who have not heard the Christian message—the prophets of the Old Testament, the kings of Israel, and Adam and Eve.

RESURRECTION. Christ rises from the dead on the third day after his entombment.

THE MARYS AT THE TOMB. As terrified soldiers look on, Christ's female followers (the Virgin Mary, Mary Magdalen, and Mary, mother of the apostle James) discover the empty tomb.

NOLI ME TANGERE, Supper at Emmaus, and the Doubting of Thomas. In three episodes during the 40 days between his resurrection and ascent into heaven, Christ tells Mary Magdalen not to touch him *(Noli me tangere)*, shares a supper with his disciples at Emmaus, and invites the apostle Thomas to touch the lance wound in his side.

ASCENSION. As his disciples watch, Christ is taken into heaven from the Mount of Olives.

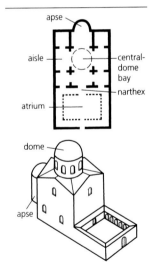

A **central-plan church** may be in the form of a square (as in this generalized plan of an Early Christian structure), a polygon, or a Greek cross, with its four "arms" intersecting at the crossing. The dome sits over the central bay.

The verticality of central-plan buildings is distinctive. Otherwise, central-plan churches share elements with basilica-plan churches: narthex, nave, aisles, crossing (under the dome), and apse. Not every Early Christian and Byzantine church had an atrium.

favored a type of church building so unlike the basilica? A number of reasons—practical, religious, and political—have been suggested, but we do not know for sure what caused this turn of events. After all, the design of the basilica had been backed by the authority of Constantine; yet it was Constantine who built the first **central-plan churches** in Constantinople, thereby helping to establish the preference for the type in the East. In any case, domed, central-plan churches were to dominate the

world of Orthodox Christianity as thoroughly as the basilican plan dominated the architecture of the medieval West.

S. Vitale is notable for its rich sense of space. The circular nave is ringed by an aisle, or **ambulatory**. Below the clerestory, this central space turns into a series of semicircular niches that penetrate into the aisle and thus link it to the nave in a new way. The aisle itself has a second story, known as the **gallery**, and this area may have been reserved for women. A new economy in the construction of the vaulting permits large windows on every level of the church, and these flood the interior with light. The complexity of the interior of S. Vitale is fully matched by its lavish decoration.

S. Vitale's link with the Byzantine court can be seen in the two famous mosaics flanking the altar (figs. 8-9, 8-10). These depict Justinian and his empress, Theodora, accompanied by officials, the local clergy, and ladies-in-waiting, about to enter the church from the atrium at the beginning of the Byzantine liturgy. Although they did not attend the actual event, the royal couple are shown as present at the consecration of S. Vitale. The purpose is to demonstrate their authority over Church and State, as well as their support for

Bishop Maximianus, who at first was unpopular with the citizens of Ravenna. In these large panels, whose design was most likely a product of the imperial workshop, we find an ideal of beauty that is extraordinarily different from the squat, large-headed figures we have encountered in the art of the fourth and fifth centuries (see fig. 8-4).

Despite a few glimpses of this new ideal of beauty in previous works (see fig. 8-1), only now do we see it complete. The figures are tall and slim, with tiny feet, small almond-shaped faces dominated by huge eyes, and bodies that seem to be capable only of ceremonial gestures and the display of magnificent costumes. There is no hint of movement or change. The dimensions of time and earthly space have given way to an eternal present in the golden setting of heaven. Hence the solemn, frontal images seem to belong to a celestial rather than a secular court. This union of political and spiritual authority reflects the "divine kingship" of the Byzantine emperor. Justinian and Theodora are portrayed as analogous to Christ and the Virgin. Justinian is flanked by 12 companions—the equivalent of the 12 apostles. (Six are soldiers, crowded behind a shield with the monogram of Christ.) The embroidery on the

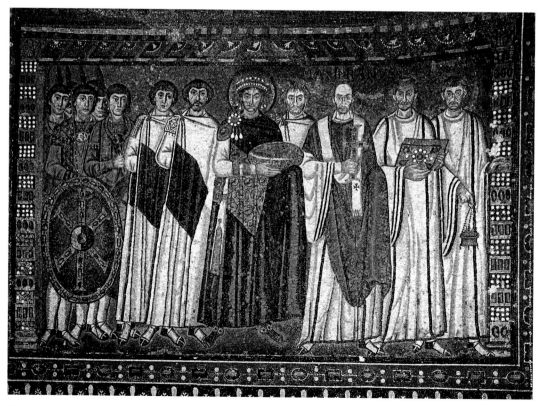

8-9 *Emperor Justinian and His Attendants.* Mosaic in S. Vitale. c. 547

hem of Theodora's mantle shows the three Magi carrying their gifts to Mary and the newborn King. Its exact meaning is not clear: it may refer to the Eucharist, the awaited Second Coming of Christ, or, more likely, the royal couple as donors of the church.

Justinian, Theodora, and the other main figures were surely meant to be individual likenesses. Their features are differentiated to some degree—especially those of Maximianus and Julianus Argentarius, the banker who underwrote the building. But the ideal has molded the faces as well as the bodies, so that they all resemble one another. We shall meet the same large, dark eyes under curved brows, the same small mouths and long, narrow noses countless times from now on in Byzantine art. Turning

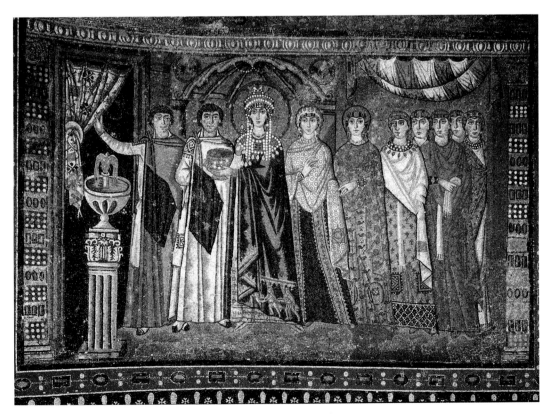

8-10 *Empress Theodora and Her Attendants.* Mosaic in S. Vitale. c. 547

from these mosaics back to the interior space of S. Vitale (see fig. 8-8), we come to realize that it, too, shares the quality of dematerialized, soaring slenderness that we saw in the courtly figures.

Hagia Sophia, Istanbul Among the surviving monuments of Justinian's reign in Constantinople, the most important by far is Hagia Sophia (Church of Holy Wisdom). The architectural masterpiece of its era, Hagia Sophia is one of the great creative triumphs of any age (figs. 8-11, 8-12). The first church, begun by Constantine II and finished in 360, was destroyed during rioting in 404. Its replacement, built by Theodosius II within a decade, suffered the same fate in the riots of 532 that almost deposed Justinian, who immediately rebuilt it. Completed in only five years, Hagia Sophia achieved such fame that, unlike other buildings of the time, the names of the architects are recorded: Anthemius of Tralles, an expert in geometry and the theory of statics and kinetics, and Isidorus of Miletus, who taught physics and wrote on vaulting techniques. The dome collapsed in the earthquake of 558, and a new, taller one was built in four years from a new design by Isidorus's nephew. After the

Turkish conquest in 1453, the church became a mosque (the four minarets and extra buttresses were added then), and much of the mosaic decoration was hidden under whitewash. Some of the mosaics were uncovered in the twentieth century, after the building was turned into a museum.

The design of Hagia Sophia presents a unique combination of elements. It has the longitudinal axis of an Early Christian basilica, but the central feature of the nave is a vast, square space crowned by a huge dome. At either end are half-domes, so that the nave has the form of a great ellipse. Attached to the half-domes are semicircular niches with open arcades, similar to those in S. Vitale. One might say, then, that the domed central space of Hagia Sophia has been inserted between the two halves of a divided central-plan church. The dome rests on four arches that carry its weight to large vertical elements, called **piers**, at the corners of the square. Thus the walls below the arches have no supporting function at all. The transition from the square formed by the arches to the circular rim of the dome is achieved by spherical triangles called **pendentives**. Hence we speak of the entire unit as a dome on pendentives. This device, along with a new technique for building

8-11 Anthemius of Tralles and Isidorus of Miletus. Hagia Sophia, Istanbul. 532–37

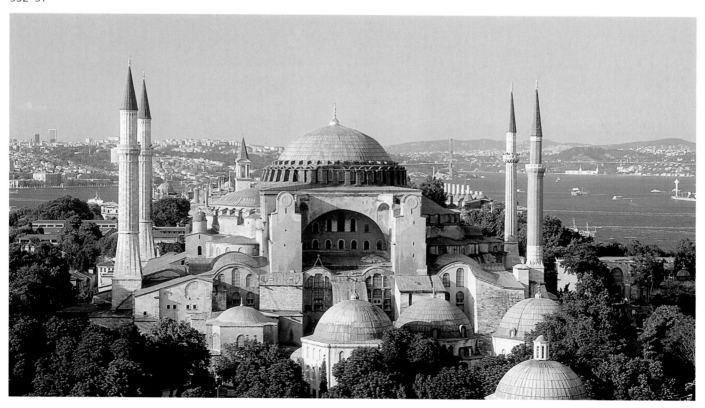

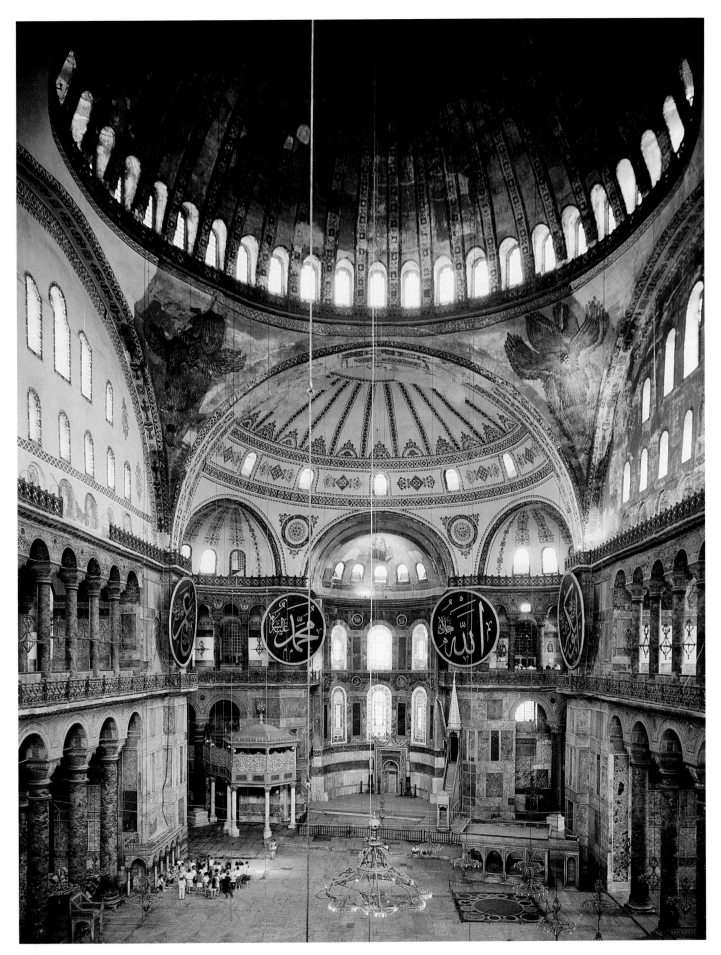

8-12 Interior, Hagia Sophia

domes using thin bricks embedded in mortar, permits the construction of taller, lighter, and more economical domes than the older method (seen in the Pantheon, fig. 7-6 and S. Vitale, fig. 8-7) of placing the dome on a round or polygonal base. Where or when the dome on pendentives was invented we do not know. Hagia Sophia is the earliest case we have of its use on a monumental scale, and it had a lasting impact. It became a basic feature of Byzantine architecture and, somewhat later, of Western architecture as well.

There is another element that entered into the design of Hagia Sophia. The plan, the support system of the main piers, and the huge scale of the whole recall the Basilica of Constantine (see figs. 7-9 and 7-10), the most ambitious achievement of imperial Roman vaulted architecture. The Basilica also was the greatest monument associated with Constantine, a ruler for whom Justinian had particular admiration. The massive exterior of Hagia Sophia, firmly planted upon the earth like a great mound, rises by stages to a height of 184 feet—41 feet higher than the Pantheon—and therefore its dome, although somewhat smaller in diameter (112 feet), stands out far more boldly. The dome improves on the Pantheon's, to which it is obviously indebted: the thinnest of ribs radiate from an oculus, which has been closed in, while the extremely lightweight construction made it possible to dispense altogether with the rings used in the Pantheon and permitted the insertion of a row of windows around the base. Hagia Sophia thus unites East and West, past and future, in a single overpowering synthesis.

Once we are inside, all sense of weight disappears, as if the material, solid aspects of the structure had been banished to the outside. Nothing remains but a space that inflates, like so many sails, the apsidal recesses, the pendentives, and the dome itself. Here the architectural aesthetic we saw taking shape in Early Christian architecture has achieved a new dimension. Even more than before, light plays a key role. The dome seems to float—"like the radiant heavens," according to a contemporary description—because it rests upon the closely spaced row of windows. The nave walls are pierced by so many openings that they have the transparency of lace curtains. The golden glitter of the mosaics must have completed the "illu-

sion of unreality." Its purpose is clear. As Procopius, the court historian to Justinian, wrote: "Whenever one enters this church to pray, he understands at once that it is not by any human power or skill, but by the influence of God, that this work has been so finely turned. And so his mind is lifted up toward God and exalted, feeling that He cannot be far away, but must especially love to dwell in this place that He has chosen."

Icons During the first six centuries of Christianity, relics (physical remains and objects associated with saints) were a principle focus of veneration by the faithful. In the late sixth century, ICONS began to compete with relics as objects of personal, then public, veneration. Icons are paintings of Christ, the Enthroned Madonna, or saints. From the beginning they were considered "portraits," and understandably so, for such pictures had developed in Early Christian times out of Graeco-Roman portrait panels. One of the chief arguments in their favor was the claim that Christ had appeared with the Virgin to St. Luke and permitted him to paint their portrait. It also was believed that other portraits of Christ or of the Virgin had miraculously appeared on earth by divine command. These "true" sacred images were considered to have been the sources for the later, human-made ones. Little is known about their origins, but they no doubt developed in part from pagan icons, since both first appeared about 200 A.D.

Of the few early examples that have survived, the most revealing is the *Madonna and Child Enthroned between Saints and Angels* (fig. 8-13). Like late Roman murals (see pages 129–31), it incorporates several styles. Its link with Graeco-Roman portraiture is clear not only from the use of encaustic, but also from the gradations of light and shade in the Madonna's face, which is similar in treatment to that of the little boy in our Faiyum portrait (see fig. 7-25). The Madonna (another name for the Virgin Mary) is flanked by two warrior saints, probably Theodore on the left and George (or Demetrios?) to the right, who recall the stiff figures that accompany Justinian in S. Vitale (see fig. 8-9). Typical of early icons, however, their heads are too massive for their doll-like bodies. Behind them are two angels who most recall Roman art; although

As transportable panel paintings, Christian ICONS (from the Greek *eikon,* "image") could be venerated by the public on special occasions, carried in processions, and even brought into battle as a means of seeking divine protection. Among the most common subjects found on early icons are the Christ Pantokrater ("All-Sovereign"), the Theotokos ("God-Bearer," an image of the Virgin), and the Deesis ("Entreaty," Christ flanked by the Virgin and St. John the Baptist).

their lumpy features show that classicism is no longer a living tradition. Clearly these figures are quotations from different sources, indicating that the painting marks an early stage in the development of icons. Yet it is typical of the conservative icon tradition that the artist has tried to remain faithful to his sources.

This icon is particularly noteworthy because it is the earliest representation we have of the Christ Child with his mother, Mary. The motif itself most likely was taken from the cult of the god, Isis, which was popular in Egypt at the time of the Faiyum portraits. The regal Christ Child probably evolved from images of the Greek god Dionysos depicted as an infant. We note the stiff formality of the pose. To the Byzantines, the Madonna was the regal mother, or bearer, of god (Theotokos), whereas Jesus is no mere infant but god in human form (Logos). Only later did Mary acquire a gentle maternal presence that is so familiar in western European art (compare fig. 12-17).

Icons functioned as living images to instruct and inspire the worshiper. As in antiquity, the actual figure—be it Christ, Mary, a saint, or an angel—was thought to reside in the image. For this reason, it was believed that icons were able to work miracles and to intercede on behalf of the faithful. In describing an icon of the archangel Michael, the sixth-century poet Agathias writes: "The wax remarkably has represented the invisible. . . . The viewer can directly venerate the archangel [and] trembles as if in his actual presence. The eyes encourage deep thoughts; through art and its colors the innermost prayer of the viewer is passed to the image."

Classicism Classicizing tendencies seem to have recurred in Early Christian sculpture from the mid fourth through the sixth century. Their causes have been explained in various ways. During this period paganism still had many important followers, who may have fostered such revivals as a kind of rearguard action. Recent converts (including Junius Bassus, who was not baptized until shortly before his death) often remained loyal to values of the past. Some Church leaders also sought to reconcile Christianity with the heritage of classical antiquity. They did so with good reason: early Christian the-ology depended a great deal on Greek and Roman philosophers, not only more recent thinkers such as Plotinus but also Plato, Aristotle, and their predecessors. The imperial courts, both East and West, remained aware of their links with pre-Christian times. They collected large numbers of original Greek works and Roman copies, so that they became centers for classicizing tendencies. Whatever its roots in any given case, classicism remained important during this time of transition.

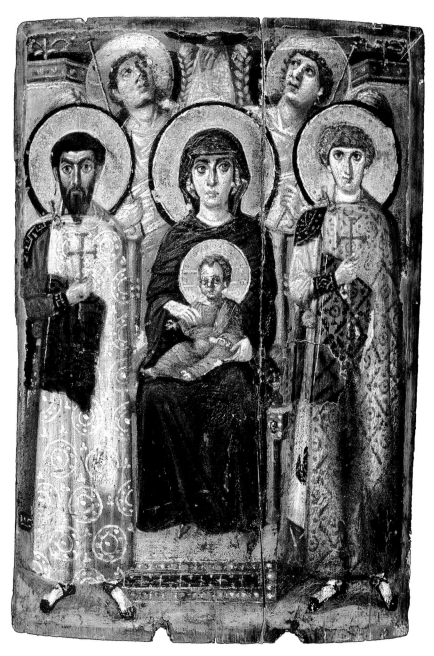

8-13 *Madonna and Child Enthroned between Saints and Angels.* Late sixth century. Encaustic on panel, 27 × 19³/₈" (68.6 × 49.2 cm). Monastery of St. Catherine, Mount Sinai, Egypt

Ivory Diptychs The lingering classical tradition is found especially in a category of objects whose artistic importance far exceeds their physical size: ivory panels and other small-scale reliefs in precious materials. Designed for private ownership, and meant to be enjoyed at close range, they often mirror a collector's taste. Such a refined aesthetic sense is not found among the large works sponsored by Church or State. The ivory panel in figure 8-14 was made about 525–50 in the eastern Roman Empire. It is one of two panels that would have been hinged together to form what is known as a **diptych**. The panel shows a classicism that has become an eloquent vehicle for Christian content. The majestic archangel is a descendant of the winged Victories of Graeco-Roman art, down to the rich drapery (see fig. 5-28). He may have been paired with a panel showing Justinian. (The Greek inscription above has the prayer, "Receive these gifts, and having learned the cause . . .," which would probably have continued on the missing leaf with a plea to forgive the owner's sins.) The power the angel heralds is not of this world, nor does he inhabit an earthly space. The niche against which he appears has lost all three-dimensional reality. Its relationship to him is purely symbolic and ornamental, so that he seems to hover rather than to stand. (Notice the position of the feet on the steps.) It is this disembodied quality, conveyed through harmonious forms, that makes his presence so compelling.

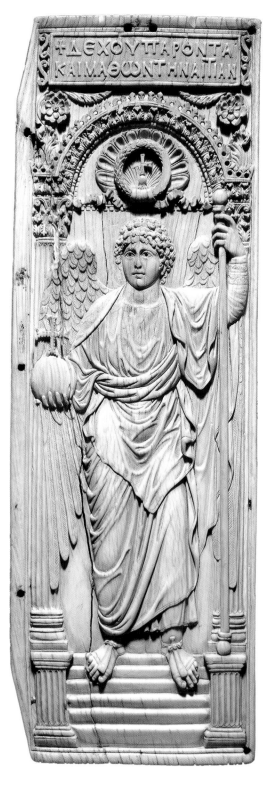

8-14 *The Archangel Michael.* Leaf of a diptych. c. 525–50. Ivory, 17 × 5¹/₂" (43.2 × 14 cm). The British Museum, London

MIDDLE BYZANTINE ART

Iconoclastic Controversy After the age of Justinian, the development of Byzantine art and architecture was disrupted by the ICONOCLASTIC Controversy, which began with a declaration, or edict, by Emperor Leo III in 726 prohibiting religious images. The conflict raged for more than a hundred years between two hostile groups. The image-destroyers (Iconoclasts), led by the emperor and supported mainly in the eastern provinces, insisted on a literal interpretation of the biblical ban against graven images as a potential means of falling into idolatry. They wanted to restrict religious art to abstract symbols and plant or animal forms. Their opponents, the Iconophiles, were led by the monks and centered in the western provinces, where the imperial edict was not very effective. Over time, the strongest argument in favor of retaining icons was that, because Christ and his image are inseparable, the honor given to the image is transferred to him.

The roots of the argument went very deep. On the plane of theology, they involved the basic issue of the relationship between the human and the divine in the person of Christ. Moreover, icons had come

to replace the Eucharist as the focus of lay devotion. This was because in Orthodox churches a screen with icons hanging on it separated the Eucharistic altar from the worshipers, who were therefore unable to view the service and naturally focused on the icons instead. Socially and politically, the conflict was a power struggle between Church and State, which in theory were united in the figure of the emperor. It came during a low point in Byzantine power, when the empire had been greatly reduced in size by the rise of Islam. The controversy also caused an irreparable break between Catholicism and the Orthodox faith, although the two churches remained officially united until 1054, when the pope excommunicated the Eastern patriarch for heresy.

If Leo's edict had been enforced throughout the empire, it might well have dealt Byzantine religious art a fatal blow. It did succeed in greatly reducing the production of sacred images, but failed to wipe it out entirely. Hence there was a fairly rapid recovery after the victory of the Iconophiles in 843 under the empress Theodora. A new period, which we now call Middle Byzantine, was ushered in with the reign of Basil I the Macedonian (r. 867–886) and lasted through the eleventh century. We know little about how the Byzantine artistic tradition managed to survive from the early eighth to the mid ninth century, but survive it did.

Mosaics The Byzantine empire never produced another architectural structure to match the scale of Hagia Sophia. The churches built after the Iconoclastic Controversy were initially modest in size and monastic in spirit. Most were built for small groups of monks living in isolated areas, although later monasteries erected in Constantinople under imperial patronage were much larger and served social purposes by operating schools and hospitals.

The most important of these later churches was the Nea (New Church), completed by Basil I in Constantinople by 880, which established the basic character of Middle Byzantine architecture. It was at this time that Middle Byzantine imagery was also defined in the mosaics of the Nea and the decorations Basil added to Constantine's Church of the Holy Apostles in Constantinople (both now destroyed). A logical order governs the distribution of subjects throughout the interiors of churches from this period. Most often, the subjects were organized approximately along the lines of the 12 Great Feasts of the Orthodox church, which celebrate major events from the lives of Jesus and Mary. Taken together, they illustrate the Orthodox belief in the Incarnation as the redemption of original sin and the triumph over death.

Byzantine art had managed somehow to preserve biblical subjects from Early Christian times. By the eleventh century the narrative and pictorial potential of these subjects was being thoroughly explored, along with a wider range of themes and feelings. The Nativity in the monastery of Hosios Loukas (fig. 8-15) is more complex than previous depictions of this scene. Instead of focusing simply on the Virgin and Child, the mosaicist uses continuous narrative. The scene includes not only midwives bathing the newborn infant but also a host of angels, the Adoration of the Magi, and the Annunciation to the Shepherds. The great variety of poses and expressions lends a heightened sense of drama to the scene. Despite its abstract rendering, the mountainous landscape shows a new interest in illusionistic space as well.

SPEAKING OF

iconoclasm

The term *ICONOCLASM* derives from two Greek words meaning "to break an image." It refers to a prohibition against the religious use of images—not all images per se. At the root of all iconoclastic movements is the fear that images will be worshiped.

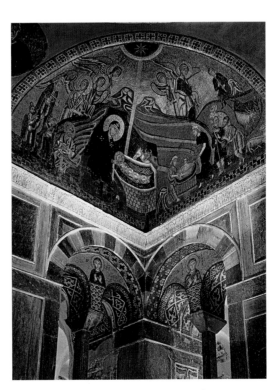

8-15 *Nativity.* Mosaic in Monastery of Hosios Loukas, Thessaly, Greece. c. 1030–40

During the Middle Byzantine period there was a revival of classical learning, literature, and art. Much of it occurred in the early tenth century under Constantine VII, who was emperor in name only for most of his life and consequently turned to classical scholarship and art. This renewed interest helps to explain the reappearance of Late Classical motifs in Middle Byzantine art. More often, however, classicism is merged with the spiritualized ideal of human beauty we saw in the art of Justinian's reign.

The *Crucifixion* mosaic in the Greek monastery church at Daphne (fig. 8-16) enjoys special fame. Its classical qualities are deeply felt, yet they are also completely Christian. There is no attempt to create a realistic spatial setting, but the composition has a balance and clarity that are truly monumental. Classical, too, is the heroic nudity of Christ, which emphasizes the Incarnation of the Logos, or God in human form. The statuesque dignity of the figures makes them seem extraordinarily organic and graceful compared to those of the Justinian mosaics at S. Vitale (see figs. 8-9 and 8-10).

The most important aspect of these figures' classical heritage, however, is emotional rather than physical. The gestures and facial expressions convey a restrained and noble suffering of the kind we first met in Greek art of the fifth century B.C.. Early Christian art, which stressed the Savior's divine wisdom and power rather than his **Passion** (see page 155), had been quite devoid of this quality. In earlier times, the Crucifixion was depicted only rarely and without pathos, although with the same simplicity found here. We cannot say when and where this human interpretation of the Savior first appeared. But it seems to have developed in the wake of the Iconoclastic Controversy and reached its height during the Ducas and Comnene dynasties, which ruled Byzantium from the middle of the eleventh through the late twelfth century. There are, to be sure, a few earlier examples of it, but none of them appeals to the emotions of the viewer so powerfully as the Daphne *Crucifixion*. To have introduced this compassionate view of Christ into sacred art was perhaps the greatest achievement of Middle Byzantine art.

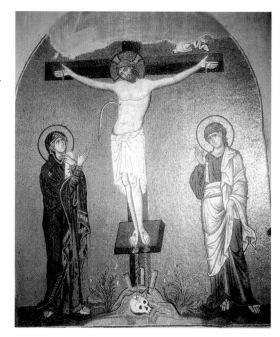

8-16 *Crucifixion.* Mosaic in Monastery Church, Daphne, Greece. Early twelfth century

Murals The emphasis on human emotions reaches its climax in the paintings at the church of St. Panteleimon in Nerezi, Macedonia. Built by members of the Byzantine royal family, it was decorated by a team of artists from Constantinople. From the beginning of Byzantine art in the sixth century, mural painting had served as a less expensive alternative to mosaic, which was preferred whenever possible. The two were closely linked, however, because the figures and scenes of a mosaic were laid out in paint on fresh plaster each day before the tesserae were added. Thus the best painters participated fully in the new style and, in some cases, introduced innovations of their own. The artist responsible for the *Lamentation* (fig. 8-17) was a great master who expanded on the recent evolution toward expressing emotion in religious imagery. The gentle sadness of the Daphne *Crucifixion* has been replaced by a grief of almost unbearable intensity. The style remains the same, but its expressive qualities have been emphasized by subtle adjustments in the proportions and features. The subject seems to have been invented recently, for it does not occur in earlier Byzantine art. Its origins, even more than those of the Daphne *Crucifixion*, lie in classical art. Yet nothing prepares us for the Virgin's anguish as she clasps her dead son or the deep sorrow of St. John holding Christ's lifeless

hand. We have entered a new realm of religious feeling that was to be explored further in the West.

LATE BYZANTINE PAINTING

Beginning in the eleventh century, there was a series of four crusades sponsored by Christian leaders in the West. These military expeditions had as their goal the elimination of Muslim power in the region of the Near and Middle East. In 1204 Byzantium suffered an almost fatal defeat when the armies of the Fourth Crusade captured and sacked the city of Constantinople, instead of warring against the Muslim Turks. For more than 50 years, the core of the Eastern Empire remained in Western hands. Byzantium, however, survived this catastrophe. In 1261 it regained its independence under the Palaeologue dynasty, and the fourteenth century saw a last flowering of Byzantine painting. The empire came to an end with the Turkish conquest of Constantinople in 1453.

Icons The Crusades decisively changed the course of Byzantine art by bringing contact with the West. The impact can be seen in the *Madonna Enthroned* (fig. 8-18), which unites elements of both, so that its author-

ship has been much debated. Because of the veneration in which they were held, icons had to conform to strict rules, with fixed patterns repeated over and over again. As a result, most of them are noteworthy more for exacting craftsmanship than for artistic inventiveness. Although painted at the end of the thirteenth century, our example reflects a much earlier type. There are echoes of Middle Byzantine art in the graceful pose, the play of drapery folds, the tender melancholy of the Virgin's face. But these elements have become abstract, reflecting a new taste and style. The elaborate throne, which looks like a miniature replica of the Colosseum (see fig. 7-4), no longer functions as a three-dimensional object, despite the foreshortening. The highlights on the drapery resemble sunbursts, in contrast to the soft shading of hands and faces. The total effect is neither flat nor spatial but transparent: the shapes look as if they were lit from behind. Indeed, the gold background and highlights are so brilliant that even the shadows never seem wholly opaque. This all-pervading radiance, we will recall, first appears in Early Christian mosaics. Panels such as this may therefore be viewed as the aesthetic equivalent of mosaics, and not simply as the descendants

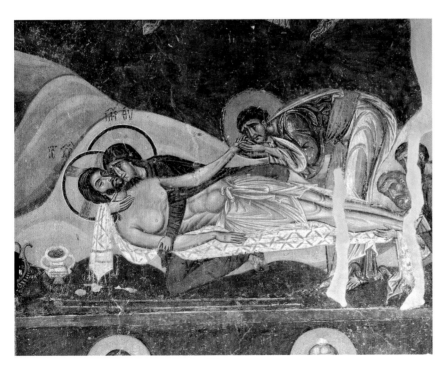

8-17 *Lamentation*. Fresco in the Church of St. Panteleimon, Nerezi, Republic of Macedonia. 1164

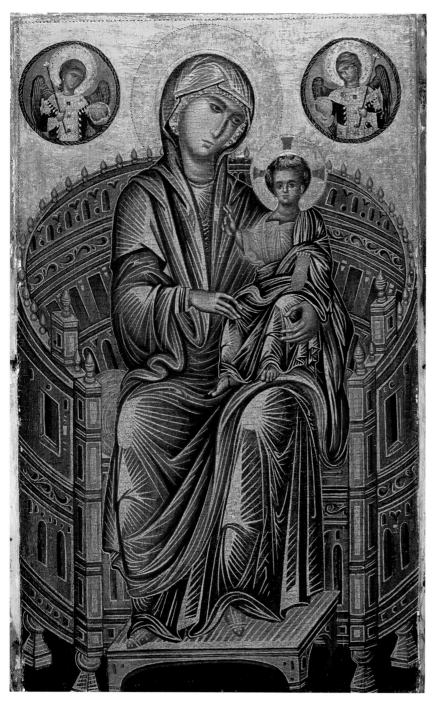

8-18 *Madonna Enthroned.* Late thirteenth century. Tempera on panel, 32⅛ × 19⅜" (81.6 × 49.3 cm). National Gallery of Art, Washington, D.C.

Andrew W. Mellon Collection

pean control. Our painter might even have visited Italy or been active there, perhaps in Rome or Tuscany, where a neo-Byzantine style was well established (see chapter 11). Whatever position we adopt points to a profound shift in the relation between the two traditions: after 600 years of borrowing from Byzantium, Western art for the first time began to contribute something in return.

Mosaics and Murals The finest surviving cycles of Late Byzantine mosaics and murals are found in Istanbul's Kariye Camii, the former Church of the Savior in the Chora Monastery. (*Chora* means "land" or "place"; *Camii* denotes a mosque, although the site is now a museum.) They represent the climax of the humanism that emerged in Middle Byzantine art. Because of the greatly reduced resources in the latter years of the empire, murals often took the place of mosaics, but at Kariye Camii they exist on an even footing.

Figure 8-19 shows the *Anastasis* (from a Greek term meaning both "to rise" and "to raise"), which is part of the frescoes in the burial chapel attached to Kariye Camii. The scene depicts the traditional Byzantine image of this subject, which Western Christians call Christ's Descent into Limbo, or the Harrowing of Hell, to rescue souls. Surrounded by a radiant **mandorla** (large oval signifying holiness), the Savior has vanquished Satan and battered down the gates of hell. (Note the bound Satan at his feet, in the midst of a profusion of hardware; the two kings to the left are the Old Testament figures, David and Solomon.) What amazes us about the central group of Christ raising Adam and Eve from the dead is its dramatic force, a quality we would not expect from what we have seen of Byzantine art so far. Christ here moves with extraordinary physical energy, tearing Adam and Eve from their graves, so that they appear to fly through the air—a magnificently expressive image of divine triumph. Such dynamism had been unknown in the earlier Byzantine tradition. This style, which was related to slightly earlier developments in manuscript painting, was indeed revolutionary. Coming in the fourteenth century, it indicates that 800 years after Justinian, when the subject first appeared, Byzantine art still had all its creative powers.

of the panel-painting tradition. In fact, some of the most precious Byzantine icons are miniature mosaics attached to panels, and our artist may have been trained as a mosaicist rather than as a painter.

The style, then, is Late Byzantine. It seems likely that this master was a Byzantine artist who may have worked either for a Western patron or in a Byzantine center under Euro-

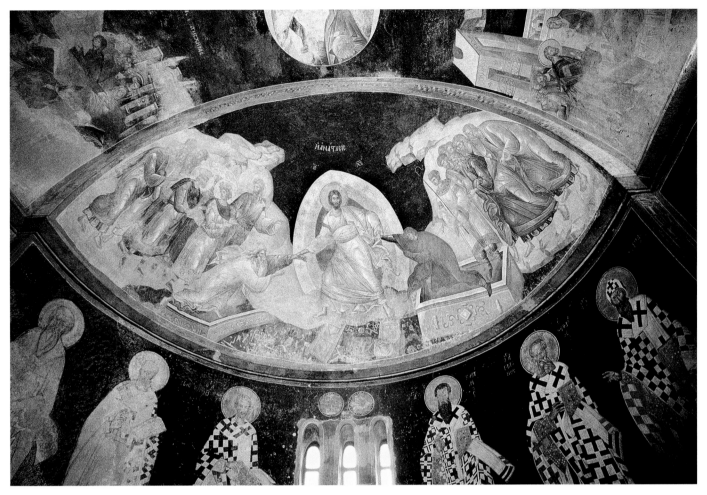

8-19 *Anastasis.* Fresco in Kariye Camii (Church of the Savior in Chora), Istanbul. c. 1310–20

The resurrection miracles depicted on either side of the *Anastasis* show the growing Byzantine fascination with storytelling. *The Raising of the Widow's Son*, on the far left, uses a landscape style that had flourished in sixth-century secular mosaics and had been all but lost. The architectural illusionism in *The Raising of the Daughter of Jairus*, to the right, is familiar to us from Pompeian paint-ing (e.g., Ixion Room, see fig. 7-21), which was recovered in manuscripts of the classical revival during the tenth century. More important than such details is the way the settings have been incorporated to complete these lively narratives. We shall not meet their equal in the West until the time of Duccio and Giotto, who were clearly influenced by Late Byzantine art.

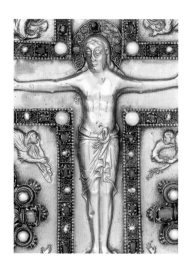

ONCE ESTABLISHED, THE LABELS USED FOR HISTORICAL periods are almost impossible to change, even though they may no longer be suitable. The humanists who coined the term *Middle Ages* thought of the entire thousand years from the fifth to the fifteenth century as an age of darkness: an empty interval between classical antiquity and its rebirth in their own time, the Renaissance in Europe. Since then, our view of this period has altered completely. We now think of it as a time of great cultural change and creative activity. During the 200 years between the death of Justinian and the reign of the new emperor of the West, Charlemagne, the center of gravity of European civilization shifted northward from the Mediterranean Sea. At the same time, the economic, political, and spiritual framework of the Middle Ages began to take shape. These two centuries also gave rise to some important artistic achievements.

Celtic-Germanic Style

The first of these achievements was the Celtic-Germanic style, which was a result of the widespread migrations that took place after the fall of the Roman Empire. The Celts, who had settled the area later known to the Romans as Gaul (southwestern Germany and eastern France) during the second millennium B.C., spread across much of Europe and into Asia Minor, where they battled the Greeks (see page 100). Pressed by neighboring Germanic peoples who originated in the Baltic region, they crossed the English Channel in the fourth century B.C. and colonized Britain and Ireland. There they were joined in the fifth century by the Angles and Saxons from today's Denmark and northern Germany. In 376 the Huns, who had advanced beyond the Black Sea from Central Asia, became a serious threat to Europe. They pushed the Germanic Visigoths westward into the Roman Empire from the Danube. Then under Attila (d. 453) the Huns invaded Gaul in 451 before attacking Rome a year later. These Germanic peoples from the east carried with them, in the form of nomads' gear, the ancient and widespread artistic tradition known as the animal style (see pages 56-57). We have seen an early example of it in the gold belt from Ziwiye (see fig. 3-10). The animal style, with its combination of abstract and organic shapes, of strict control and imaginative freedom, merged with the intricate ornamental metalwork for which the Celts were noted. Out of this union came Celtic-Germanic art.

An excellent example of this "heathen" style is the gold-and-enamel purse cover (fig. 9-1) from the SHIP BURIAL at Sutton Hoo of an East Anglian king. On it are four pairs of symmetrical motifs. Each has its own distinctive character, an indication that the purse was assembled from different sources. One motif, the standing man between facing animals, has a very long history. Though we first saw it in Mesopotamian art more than 3,200 years earlier (see fig. 3-5) its origins are even older. The eagles pouncing on ducks bring to mind similar pairings of carnivore and victim in ancient bronzes. The design above them, at the center, is of more recent origin. It consists of fighting animals whose tails, legs, and jaws are elongated into bands

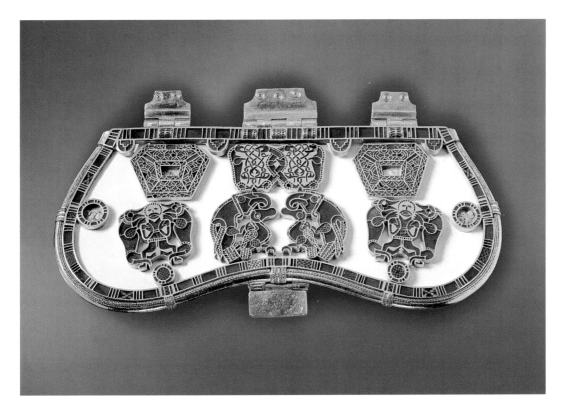

9-1 Purse cover, from the Sutton Hoo ship burial. 625–33. Gold with garnets and enamels, length 8″ (20.3 cm). The British Museum, London

that form a complex interweaving pattern. The fourth, on the top left and right, uses interlacing bands as an ornamental device. This motif occurs in Roman and Early Christian art, especially along the southern shore of the Mediterranean. However, the combination of these bands with the animal style, as shown here, seems to be an invention of Celtic-Germanic art that dates not much before the time of our purse cover.

Hiberno-Saxon Style

During the early Middle Ages, the Irish (Hibernians) were the spiritual and cultural leaders of western Europe. In fact, the period from 600 to 800 deserves to be called the Golden Age of Ireland. Unlike their English neighbors, the Irish had never been part of the Roman Empire. Thus the missionaries who carried the Gospel to them from England in the fifth century found a Celtic society that was barbarian by Roman standards. The Irish readily accepted Christianity, which brought them into contact with Mediterranean civilization. However, they adapted what they had received in a spirit of vigorous local independence.

Because it was essentially urban, the institutional framework of the Roman Church was poorly suited to the rural Irish way of life. Irish Christians preferred to follow the example of the desert saints of Egypt and the Near East, who had left the temptations of the city to seek spiritual perfection in the solitude of the wilderness, where groups of them founded the earliest monasteries (see Cultural Context: Monasticism and Christian Monastic Orders, pages 190-191). Irish monasteries, unlike their Egyptian models, soon became centers of learning and the arts. They sent monks to preach to the heathens and to found monasteries not only in northern Britain but also on the European mainland, from present-day France to Austria. These Irish monks speeded the conversion of Scotland, northern France, the Netherlands, and Germany to Christianity. Further, they made the monastery a cultural center throughout the European countryside. Irish influence was felt within medieval civilization for several hundred years.

MANUSCRIPTS AND BOOK COVERS

To spread the Gospel, the Irish monasteries had to produce copies of the Bible and other Christian books in large numbers. Their SCRIPTORIA (writing workshops) also became artistic centers. A manuscript containing the Word of God was looked upon as a

SHIP BURIALS originated among the Scandinavians early in the first millennium A.D. The deceased was placed in the center of the ship and surrounded by grave goods (weapons, armor, and jewelry); the ship was then either buried intact beneath a mound of earth or burned before burial. Whether symbols of the soul's journey or of social status, ship burials such as those at Oseberg in Norway and Ladby in Denmark are valuable resources of material culture.

The monks working in the medieval SCRIPTORIA were adept at all aspects of manuscript production, from parchment preparation to binding. At first, the copying and illumination of the texts probably were performed by the same individual, but later each of these tasks was executed by a specialist. The scriptorium itself could be a large room with benches and tables or a series of individual carrels.

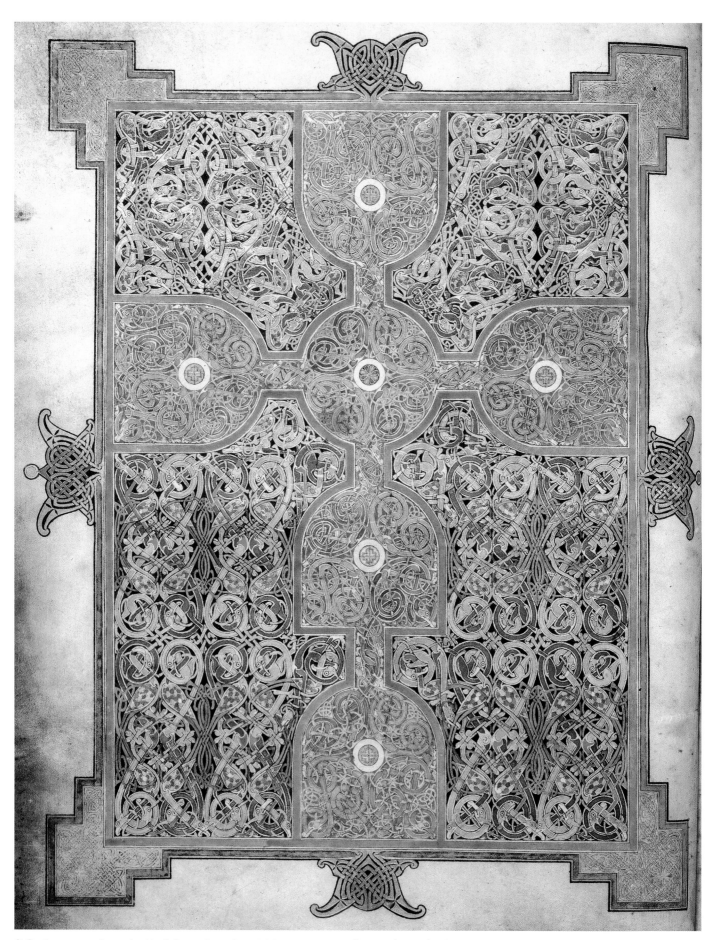

9-2 Cross page from the *Lindisfarne Gospels.* c. 700. Tempera on vellum, 13½ × 9¼" (34.3 × 23.5 cm).
The British Library, London

sacred object whose beauty should reflect the importance of its contents. Irish monks must have known Early Christian illuminated manuscripts, but here, too, they developed an independent tradition instead of simply copying their models. Although pictures illustrating biblical events held little interest for them, they devoted much effort to abstract decoration. The finest of their manuscripts belong to the Hiberno-Saxon style—a Christian form that evolved from heathen Celtic-Germanic art and flourished in the monasteries founded by Irishmen in Saxon England.

Thanks to a later colophon (inscription), we know a great deal about the origin of the *Lindisfarne Gospels,* including the names of the translator and the scribe, who presumably painted the illuminations as well. The Cross page (fig. 9-2) is a creation of breathtaking complexity. Working with the precision of a jeweler, the miniaturist has poured into the geometric frame an animal interlace so dense and yet so full of movement that the fighting beasts on the Sutton Hoo purse cover seem simple in comparison. It is as if these biting and clawing monsters had been subdued by the power of the Cross. To achieve this effect, our artist has had to work within a severe discipline by exactly following the "rules of the game." These rules demand, for instance, that organic and geometric shapes must be kept separate. Within the animal compartments, every line must turn out to be part of an animal's body. There are other rules concerning symmetry, mirror-image effects, and repetitions of shapes and colors. Only by working these out by intense observation can we enter into the spirit of this mazelike world.

Of the images in Early Christian manuscripts, the Hiberno-Saxon illuminators retained only the symbols of the four evangelists, because they could be readily translated into their ornamental style. These symbols—the man (St. Matthew), the lion (St. Mark), the ox (St. Luke), and the eagle (St. John)—were derived from the Revelation of St. John the Divine and assigned to the evangelists by St. Augustine (354–430). This lack of interest in the human figure persisted for some time among Celtic and Germanic artists. The bronze plaque of the Crucifixion (fig. 9-3), probably made for a book cover, emphasizes flat patterns, even when dealing with the image of a man. Although

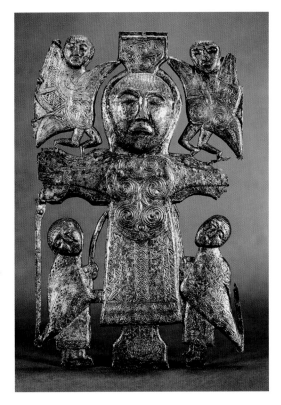

the composition is Early Christian in origin, the artist has treated the human frame as a series of ornamental compartments. The figure of Jesus is disembodied in the most literal sense: the head, arms, and feet are all separate elements joined to a central pattern of whorls, zigzags, and interlacing bands. Most fascinating of all are the faces: they hardly differ from those found on Celtic bronzes of fully 1,200 years earlier! Clearly, there is a wide gulf between the Celtic-Germanic and the Mediterranean traditions, a gulf that the Irish artist who modeled the Crucifixion saw no need to bridge. The situation was much the same in the rest of Europe during the early Middle Ages. There was not a renewal of interest in depicting the human figure until Carolingian artists began to look back to the Byzantine tradition and its roots in classical art.

Carolingian Art

The cultural achievements of CHARLEMAGNE'S reign have proved far more lasting than his empire, which began to fall apart even before his death. Indeed, this very page is printed in letters whose shapes are derived from the script in Carolingian manuscripts. The fact that these letters are known today

9-3 *Crucifixion.* Plaque from a book cover (?). Eighth century. Bronze, height 8¼" (21 cm). National Museum of Ireland, Dublin

Matthew, a man

Mark, a lion

Luke, an ox

John, an eagle

Each of the four evangelists has a symbol, or icon. Their identities were immediately recognizable by Christians until comparatively recent times—though their appearance varied greatly according to period. Often but not always the symbols were winged.

CHARLEMAGNE (742–814), king of the Franks, conquered the Saxons and the Lombards and fought the Arabs in Spain before being crowned Emperor of the West in 800 by Pope Leo III. Besides his accomplishments in the fields of art, architecture, and education, he vigorously promoted agriculture, manufacture, and commerce. After his death, he was declared "blessed" by the Church and even became a figure of legend, appearing, for instance, in the *Chanson de Roland.*

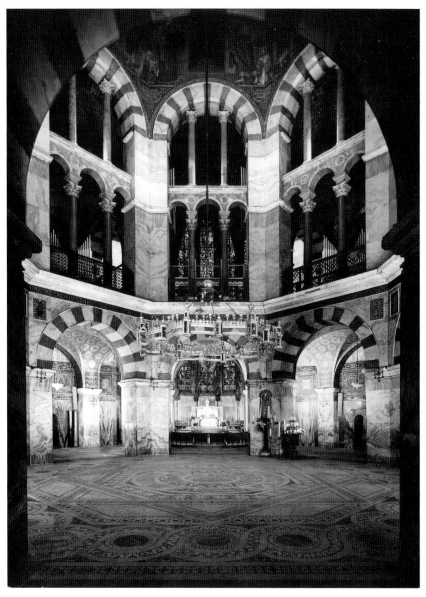

9-4 Odo of Metz. Interior, Palace Chapel of Charlemagne, Aachen. 792–805

of York, the most learned scholar of the day, to restore ancient Roman learning and to establish a system of schools at every cathedral and monastery. The emperor, who could read but not write, took an active hand in this renewal. He wanted to model his rule after the empire under Constantine and Justinian—not their pagan predecessors. To a great extent he succeeded. Thus the "Carolingian revival" may be termed the first, and in some ways most important, phase of a fusion of the Celtic-Germanic spirit with the heritage of the Mediterranean world.

ARCHITECTURE

The achievement of Charlemagne's famous Palace Chapel (fig. 9-4), is all the more spectacular when seen in the light of this fusion. On his visits to Italy, beginning with his son Pepin's baptism by Pope Hadrian in 781, Charlemagne had become familiar with the monuments of the Constantinian era in Rome and with those of the reign of Justinian in Ravenna. He felt that his new capital at Aachen (the site was chosen for its mineral baths) must convey the majesty of empire through buildings of an equally imposing kind. To signify Charlemagne's position as a Christian ruler, his palace complex was modeled on the Lateran Palace in Rome, which had been given by Constantine to the pope. Charlemagne's palace included a basilica, the Royal Hall, which was linked to the Palace Chapel. The chapel itself was inspired in equal measure by the Lateran baptistery and S. Vitale (see figs. 8-7 and 8-8). To construct such a building on Northern soil was a difficult undertaking. It was supervised by Einhard, Charlemagne's trusted adviser and biographer. Columns and bronze gratings had to be imported from Italy, and expert stonemasons must have been hard to find.

The design is by Odo of Metz (probably the earliest architect north of the Alps known to us by name). It is by no means a mere echo of S. Vitale but a fresh reinterpretation. The piers and vaults have an impressive massiveness, whereas the sense of individual geometric spaces that make up the interior is very different from the fluid space of the earlier structure. These features, which are found in French buildings of the previous century, are a distinctly Northern

as "Roman" rather than Carolingian recalls another aspect of the cultural reforms sponsored by Charlemagne: the collecting and copying of ancient Roman literary texts. The oldest surviving texts of many classical Latin authors are found in Carolingian manuscripts, which, until not long ago, were mistakenly considered Roman. Hence their lettering, too, was called Roman.

This interest in preserving the classics was part of a larger reform program to improve the education of the court and the clergy. Charlemagne's goals were to improve the administration of his realm and the teaching of Christian truths. He summoned the best minds to his court, including Alcuin

■ WHAT IS AN ARCHITECT AND WHO IS A MASTER? ■

The word *architect* derives from the Greek term for "master builder" and was defined in its modern sense of "designer and theoretician" by the Roman writer Vitruvius during the first century B.C. During the Middle Ages, it came to have different meanings. In the course of the eighth century, the distinction between design and construction, theory and practice, became increasingly blurred. As a result, the term nearly disappeared in Northern Europe by the tenth century and was replaced by a new more specific vocabulary that related to the building trades, which were strictly separated under the guild system. When it was used, the term *architect* could apply not only to masons, carpenters, and even roofers but also to the person who commissioned or supervised a building.

Not until about 1260 did Thomas Aquinas revive Aristotle's definition of *architect* as the person of intellect who leads or conducts, as opposed to the artisan who makes. Within a century the term was used by the Italian humanist Petrarch to designate the artist in charge of a project.

In the Middle Ages, the word *master* (Latin, *magister*) was a title conferred by a trade organization, or **guild**, on a member who had achieved the highest level of skill in the guild's profession or craft. In each city, trade guilds virtually controlled commercial life by establishing quality standards, setting prices, defining the limits of each guild's activity, and overseeing the admission of new members. The earliest guilds were formed in the eleventh century by merchants. Soon, however, craftsmen also organized themselves in similar professional societies, which continued to be powerful well into the sixteenth century. Most guilds admitted only men, but some, such as the painters' guild of Bruges, occasionally admitted women as well. Guild membership established a certain level of social status for townspeople, who were not nobility, clerics (people in religious life), or peasantry.

A boy would begin as an apprentice to a master in his chosen guild and after many years might advance to the rank of journeyman. In most guilds this meant that he was then a full member of the organization, capable of working without direction, and entitled to receive full wages for his work. Once he became a master, the highest rank, he could direct the work of apprentices and manage his own workshop, hiring journeymen to work with him.

In architecture, the master mason, who was sometimes called the master builder, generally designed the building, that is, acted in the role of architect. In church-building campaigns, there were teams of masons, carpenters (joiners), metalworkers, and glaziers (glassworkers) who labored under the direction of the master builder.

variant of Roman architecture. Odo's scheme for the western entrance, now largely obscured by later additions and rebuilding, featured a monumental structure known as a **westwork** (from the German *Westwerk*). Although contemporary documents say very little about its function, the westwork seems to have been used initially as a royal loge or chapel. The best-preserved westwork from the Carolingian era is seen on the abbey church at Corvey (fig. 9-5), which was built in 873–85. Except for the upper stories, which date from about 1146, the westwork retains much of its original appearance. Even without these additions, it

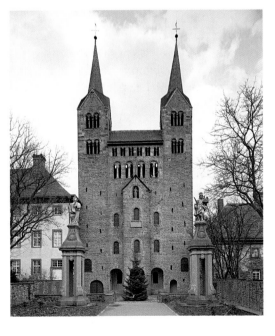

9-5 Facade, Abbey Church, Corvey, Westphalia, Germany. 873–85, with later additions

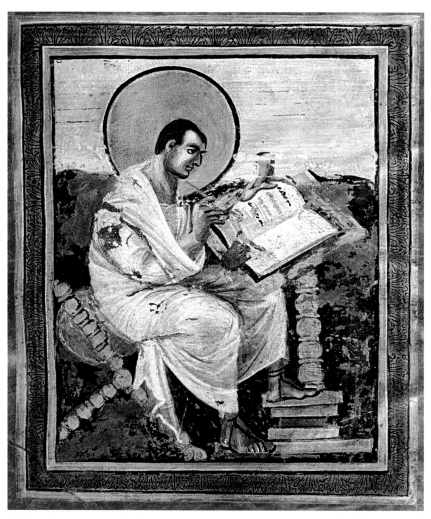

9-6 *St. Matthew,* from the *Gospel Book of Charlemagne.* c. 800–810. Ink and colors on vellum, 13 × 10″ (33 × 25.4 cm). Kunsthistorisches Museum, Vienna

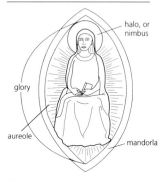

The HALO (or nimbus) represents light radiating around the head of a saint or divinity. The *aureole* is light around the body, and the *glory* is all the light—both the halo and aureole. The *mandorla* is the almond-shaped form that encloses the image of a saint and is also symbolic of the radiant light of holiness.

provided a suitably regal entrance. It is impressive not only because of its height but also because of its plain surfaces, which show the understated power of Carolingian architecture at its finest. The clear geometry and powerful masses of the front face, or **facade**, have a wonderful simplicity that is continued inside the church.

MANUSCRIPTS AND BOOK COVERS

The fine arts were an important part of Charlemagne's cultural program from the very start. We know from literary sources that Carolingian churches contained murals, mosaics, and relief sculpture, but these have disappeared almost entirely. Illuminated manuscripts, carved ivories, and goldsmiths' work, on the other hand, have survived in considerable numbers. They

demonstrate the impact of the Carolingian revival even more strikingly than the architectural remains of the period. The former Imperial Treasury in Vienna contains a Gospel Book said to have been found in the tomb of Charlemagne and, in any case, closely linked with his court at Aachen. Looking at the picture of the evangelist Matthew from that manuscript (fig. 9-6), we can hardly believe that such a work could have been executed in northern Europe about the year 800. Were it not for the large golden HALO, the *St. Matthew* might almost be mistaken for the portrait of a classical author. Whether Byzantine, Italian, or Frankish, the artist clearly knew the Roman tradition of painting, down to the acanthus ornament on the wide frame, which emphasizes the "window" treatment of the picture.

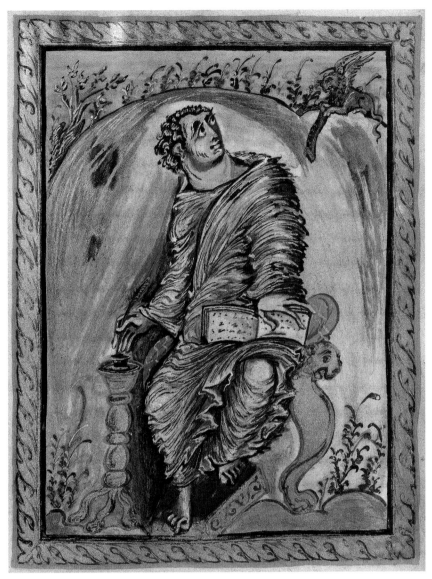

9-7 *St. Mark,* from the *Gospel Book of Archbishop Ebbo of Reims.* 816–35. Ink and colors on vellum, 10¼ × 8¼" (26 × 20.8 cm). Bibliothèque Municipale, Épernay, France

The *St. Matthew* represents the first and most conservative phase of the Carolingian revival. It is comparable to a copy of the text of a classical work of literature. More typical of the revival is a miniature of St. Mark painted some three decades later for the *Gospel Book of Archbishop Ebbo of Reims* (fig. 9-7), which shows the classical model translated into a Carolingian idiom. It must have been based on an evangelist's portrait of the same style as the *St. Matthew,* but now the picture is filled with a vibrant energy that sets everything into motion. The drapery swirls about the figure, the hills heave upward, and the vegetation seems to be tossed about by a whirlwind. Even the acanthus pattern on the frame has a flamelike character. Although Matthew resembled a Roman author setting down his thoughts, Mark is here seized with the frenzy of divine inspiration, a vehicle for recording the Word of God. His gaze is fixed not upon his book but upon his symbol (the winged lion with a scroll), which transmits the sacred text. This dependence on the Word, so powerfully expressed here, characterizes the contrast between classical and medieval images of humanity. But the means of expression—the dynamism of line that distinguishes our miniature—recalls the passionate movement that we have previously seen in the ornamentation of Irish manuscripts (see fig. 9-2).

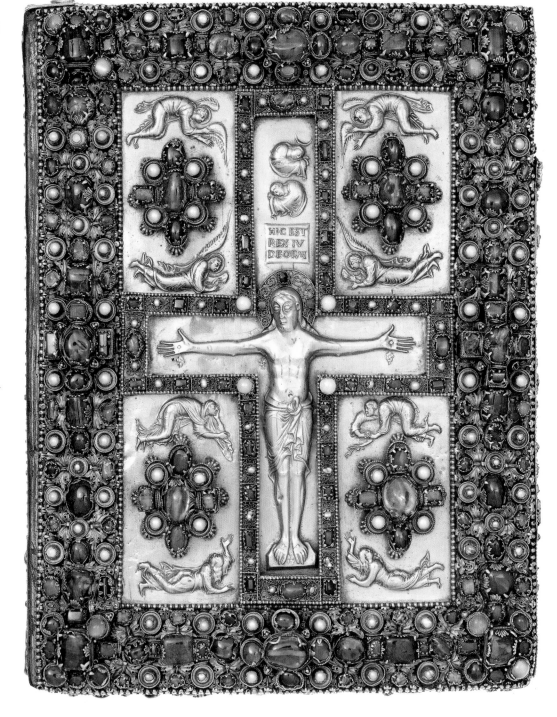

9-8 Front cover of binding, *Lindau Gospels*. c. 870. Gold and jewels, 13¾ × 10½″ (34.9 × 26.7 cm). The Pierpont Morgan Library, New York

Latin cross

Greek cross

papal cross

Tau, Egyptian, or St. Anthony's cross

Celtic cross

These five types of crosses are among those most often seen in Western art, though many variants exist.

The style of the Reims school can still be felt in the reliefs on the front cover of the *Lindau Gospels* (fig. 9- 8). This masterpiece of the goldsmith's art, made in the third quarter of the ninth century, shows how splendidly the Celtic-Germanic metalwork tradition was adapted to the Carolingian revival. The clusters of semiprecious stones are not mounted directly on the gold ground. Instead, they are raised on claw feet or arcaded turrets, so that the light can penetrate from beneath them to bring out their full brilliance. The crucified Jesus betrays no hint of pain or death. He seems to stand rather than to hang, his arms spread out in a solemn gesture. To endow him with the signs of human suffering was not yet conceivable for the Carolingian artists, even though the means were at hand, as we can see from the expressions of grief among the small figures found in the surrounding compartments.

Ottonian Art

Upon the death of Charlemagne's son, Louis I, in 843, the empire built by Charlemagne was divided into three parts by his grandsons. This division greatly weakened the power of the domain. Additionally, during his reign, Charlemagne had tried to impose unified rule by placing his friends in positions of power throughout the realm, but they became increasingly independent over time. During the late ninth and early tenth centuries this loose arrangement gave way to the decentralized political and social system known today as feudalism, in France and Germany, where it had deep historical roots. Knights (originally cavalry officers) held fiefs, or feuds, as their land was called. In return, they gave military and other service to their lords, to whom they were linked through a complex system of personal bonds—termed vassalage—that extended all the way to the king. The land itself was worked by the large class of generally downtrodden peasants (serfs and esnes), who were utterly powerless.

The Carolingians finally became so weak that Continental Europe once again lay exposed. The Muslims attacked in the south. Slavs and Magyars advanced from the east, and Vikings from Scandinavia ravaged the north and west. The Vikings (the Norse ancestors of today's Danes and Norwegians) had been raiding Ireland and Britain by sea from the late eighth century on. Now they invaded northwestern France and occupied the area that ever since has been called Normandy. They soon adopted Christianity and Carolingian civilization, and their leaders were recognized as dukes nominally subject to the king of France. During the eleventh century, the Normans played a major role in shaping the political and cultural destiny of Europe. The duke of Normandy, William the Conqueror, became king of England following the invasion of 1066, and other Norman nobles expelled the Arabs from Sicily and the Byzantines from southern Italy and Sicily.

In Germany, the center of political power shifted north to Saxony after the death of the last Carolingian monarch in 911. Beginning with Henry I, the Saxon kings (919–1024) reestablished an effective central government. The greatest of them, Otto I, also revived the imperial ambitions of Charlemagne. After marrying the widow of a Lombard king, he extended his rule over most of Italy. Otto's successors were unable to maintain their claim to sovereignty south of the Alps, though they did continue to wield tremendous political power in the North and to hold the title of Holy Roman Emperor.

SCULPTURE

During the Ottonian period, from the mid tenth century to the beginning of the eleventh, Germany was the leading nation of Europe, artistically as well as politically. German achievements in both areas began as revivals of Carolingian traditions but soon developed characteristics that reflected a new outlook. The change is brought home to us if we compare the Christ on the cover of the *Lindau Gospels* (fig. 9-8) with the *Gero Crucifix* (fig. 9-9) in the Cathedral at Cologne.

9-9 *The Gero Crucifix.* c. 975–1000. Wood, height 6′2″ (1.88 m). Cologne Cathedral

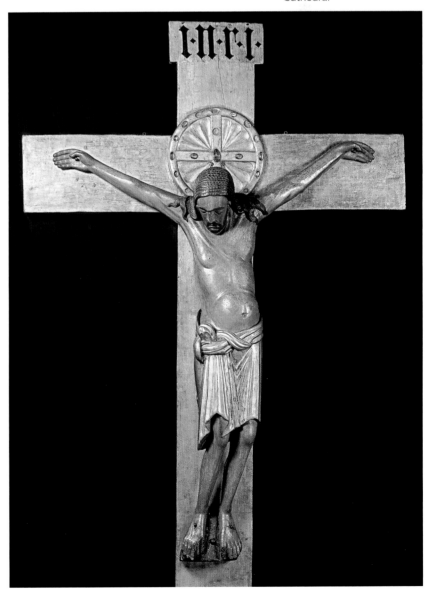

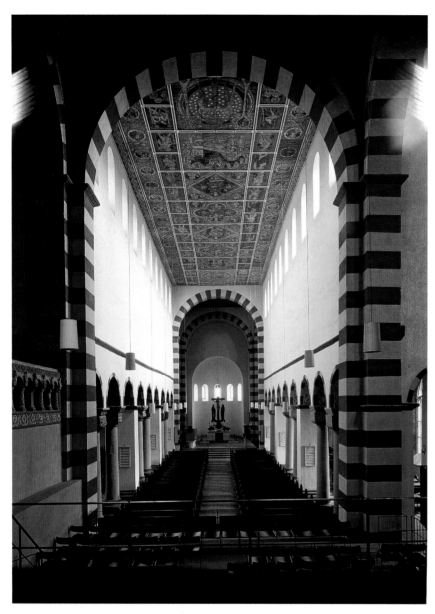

9-10 Interior, Hildesheim Cathedral (Abbey Church of St. Michael), 1001–33. View toward the apse, after restoration of 1950–60

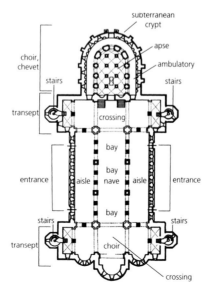

9-11 Reconstructed plan, Hildesheim Cathedral

(It was carved for Archbishop Gero of that city.) The two works are separated by little more than a hundred years, but the contrast between them suggests a far greater span. In the *Gero Crucifix* we meet an image of the crucified Savior that is new to Western art. It is monumental in scale, carved in powerfully rounded forms, and filled with deep concern for the sufferings of the Lord. Particularly striking is the forward bulge of the heavy body, which makes the physical strain on the arms and shoulders seem almost unbearable. The face, with its deeply incised, angular features, has turned into a mask of agony, from which all life has fled.

How did the Ottonian sculptor arrive at this bold conception? The *Gero Crucifix* was clearly influenced by Middle Byzantine art, which had created the compassionate view of Christ on the Cross (see fig. 8-16). Byzantine influence was strong in Germany at the time, for Otto II had married a Byzantine princess, thereby linking the two imperial courts. Yet, that source alone is not enough to explain the results. It remained for the Ottonian artist to translate the Byzantine image into large-scale sculptural terms and to replace its gentle pathos with the expressive, or emotion-filled, realism that has been the main strength of German art ever since.

ARCHITECTURE

Judged in terms of surviving works, the most ambitious patron of architecture and art in the Ottonian age was Bernward, who became bishop of Hildesheim after having been court chaplain and a tutor of Otto III. His chief monument is the Benedictine abbey church, St. Michael's (figs. 9-10, 9-11). The plan is remarkable for its symmetry. There are not only two **choirs** (space for clergy and singers set off from nave by steps) and side entrances, but also two identical transepts, each with a crossing tower and stair turrets. The supports of the nave arcade, instead of being uniform, consist of pairs of columns separated by square piers. This alternating system divides the arcade into three equal units, called **bays**, of three openings each.

The western choir, as reconstructed in our plan, is especially interesting. Its floor was raised above the level of the rest of the church to make room for a half-subterranean basement chapel, or **crypt**. The crypt (apparently a special sanctuary of St. Michael) could be

entered both from the transept and from the west. It was roofed by **groin vaults** resting on two rows of columns, and its walls were pierced by arched openings that linked it with the U-shaped corridor, or **ambulatory**, wrapped around it. This ambulatory must have been visible above ground, where it enriched the exterior of the choir, because there were windows in its outer wall. Such crypts with ambulatories, usually housing the venerated tomb of a saint, had been introduced into Western church architecture during Carolingian times. But the Bernwardian design stands out for its large scale and its careful integration with the rest of the building. The exterior as well as the choirs of Bernward's church have been disfigured by rebuilding. However, the restoration of the interior of the nave (fig. 9-10), with its great expanse of wall space between arcade and clerestory, retains the majestic feeling of the original design. (The capitals of the columns date from the original structure, the Bernwardian western choir from the twelfth century, and the painted wooden ceiling from the thirteenth.)

METALWORK

We can gauge the importance Bernward himself attached to the crypt at St. Michael's from the fact that he commissioned a pair of richly sculptured bronze doors that were probably meant for the two entrances leading from the transept to the ambulatory. They were finished in 1015, the year the crypt was consecrated. According to his biographer, Thangmar of Heidelberg, Bernward excelled in the arts and crafts. The idea for the doors may have come to him as a result of his visit to Rome, where he could have seen ancient Roman (and perhaps Byzantine) bronze examples. Bernward's, however, differ from earlier ones: they are divided into broad horizontal fields rather than vertical panels, and each field contains a biblical scene in high relief. The subjects, taken from Genesis (left door) and the Life of Christ (right door), depict the origin and redemption of sin.

Our detail (fig. 9-12) shows Adam and Eve after the Fall. Below it, in inlaid letters notable for their classical Roman character, is

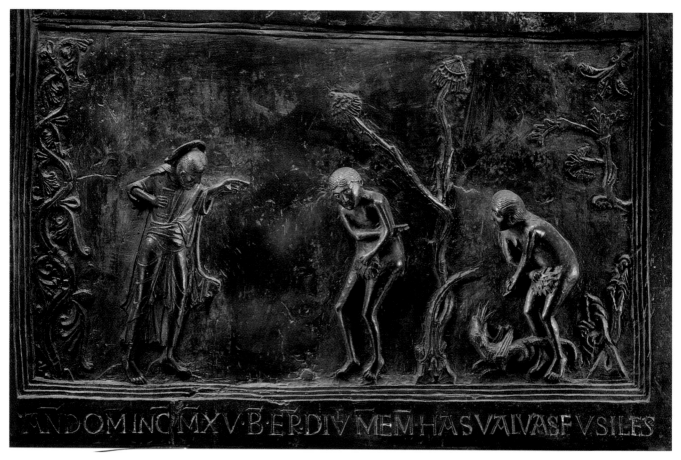

9-12 *Adam and Eve Reproached by the Lord,* from the Doors of Bishop Bernward, Hildesheim Cathedral. 1015. Bronze, approx. 23 × 43" (58.3 × 109.3 cm)

part of the inscription, with the date and Bernward's name. The figures here have none of the monumental spirit of the *Gero Crucifix* (fig. 9-9). They seem far smaller than they actually are, so that one might mistake them for a piece of goldsmith's work such as the *Lindau Gospels* cover (compare fig. 9-8). The composition must have been derived from an illuminated manuscript, because similar scenes are found in medieval Bibles. Even the references to vegetation have a good deal of the twisting movement we recall from Irish miniatures. Yet this is no mere imitation. The story is conveyed with splendid directness and expressive force. The accusing finger of the Lord, seen against a great void of surface, is the focal point of the drama. It points to a cringing Adam, who passes the blame to his mate, while Eve, in turn, passes it to the serpent at her feet.

MANUSCRIPTS

The same intensity is found in Ottonian manuscript painting. Here Carolingian and Byzantine elements are blended into a new style of extraordinary scope and power. The most important center of manuscript illumination at that time was the Reichenau Monastery, located on an island in Lake Constance, on the borders of modern-day Germany and Switzerland. Perhaps its finest achievement—and one of the great masterpieces of medieval art—is the *Gospel Book of Otto III*.

The scene of Jesus washing the feet of St. Peter (fig. 9-13) contains strong echoes of ancient painting, transmitted through Byzantine art. (The same subject is found among the mosaics at Hosios Loukas.) The soft pastel hues of the background recall the illusionism of Graeco-Roman landscapes (see fig. 7-20), and the architectural frame around Jesus is a late descendant of the kind of architectural perspectives we saw in the House of the Vettii (see fig. 7-21). The Ottonian artist has put these elements to a new use. What was once an architectural vista now becomes the Heavenly City, the House of the Lord filled with golden celestial space as against the atmospheric earthly space outside.

The figures also have been transformed. In ancient art, this composition had been used to depict a doctor treating a patient.

Now St. Peter takes the place of the patient and Jesus that of the physician. (Jesus is still represented as a beardless young philosopher.) As a result, the emphasis has shifted from physical to spiritual action. This new kind of action not only is conveyed through glances and gestures, but also governs the scale of things. Jesus and St. Peter, the most animated figures, are larger than the rest, and Jesus' "active" arm is longer than his "passive" one. The eight apostles, who merely watch, have been compressed into a tiny space, so that we see little more than their eyes and hands. Even the fanlike Early Christian crowd from which this group is derived (see fig. 8-4) is less disembodied. The scene straddles two eras. On the one hand, the nearly perfect blend of Western and Byzantine elements represents the culmination of the early medieval manuscript tradition. On the other, the expressive distortions, such as the elongated arms, look forward to Romanesque art, which incorporated them in heightened form.

Islamic Spain

At the same time that Charlemagne lived and ruled in Northern Europe, much of Spain came under the control of Muslims. Islamic rule was maintained, with only a brief interruption, from 750, when the last of the Ummayid dynasty moved from Baghdad to Cordova, until 1492, when they were expelled by Ferdinand II (1452–1516) of Aragon and Isabella I (1451–1504) of Castile.

Upon the death of the prophet Muhammad (born c. 570) in 632, he was succeeded by four caliphs ("successors"). They are recognized by Sunni Muslims, who make up some 90 percent of the faith. However, Shiites recognize Muhammad's nephew, Ali (c. 600–661), as his true successor, setting up a bitter division that continues to this day.

Upon Ali's death, Muawiya (d. 680) became caliph through force of arms, and established the Ummayid dynasty, with its capital in Damascus, Syria, until it was overthrown in 750. Only Abd Ar-Rahman (d. 732) escaped the massacre of the Ummayids. He immigrated to Spain where he established the emirate (later caliphate)

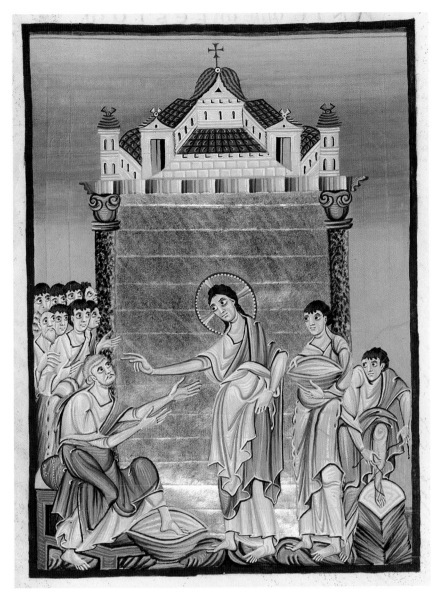

9-13 *Jesus Washing the Feet of Peter,* from the *Gospel Book of Otto III.* c. 1000. Tempera on vellum, 13 × 9³/₈″ (33 × 23.8 cm). Staatsbibliothek, Munich

of Cordova, which conquered most of the southern Iberian peninsula. At about the same time that Otto I reigned in the north, the Cordovan caliphate reached its zenith under Abd al-Rahman II (891–961) and his son al-Hakam (914–976).

ISLAM began with seminomadic tribes who absorbed aspects of every civilization they conquered. This is not to say that Islamic art and architecture is a hodge-podge of unrelated elements. On the contrary, only those parts consistent with Islamic doctrine were used. The result was a distinctive style that is immediately recognizable. Moreover, by incorporating components of earlier civi-

lizations, Islam proclaimed itself their legitimate heirs and successors. Nowhere is this truer than in the caliphate of Cordova.

The caliphate's finest achievement was the great mosque at Cordova. Each ruler expanded on the basic plan, which utilized Roman as well as Islamic models. Like all mosques, it has a large courtyard and a covered prayer hall, which are loosely descended from Muhammad's own house. Because the hall consisted of a series of adjacent "naves" arranged in rows across a prayer wall (**qibla**) with four niches (**mihrabs**), it could readily be extended almost indefinitely in both length and width.

ISLAM is practiced by Muslims. Islam has but one God, Allah, who revealed himself in the seventh century A.D. to a historical figure, the prophet Muhammad. (Muslims regard Old Testament prophets and Jesus as predecessors to Muhammad.) The Koran is the text of God's revelations to Muhammad. Because the representation of people and animals is discouraged. Islamic art is highly decorative and incorporates much calligraphy into designs.

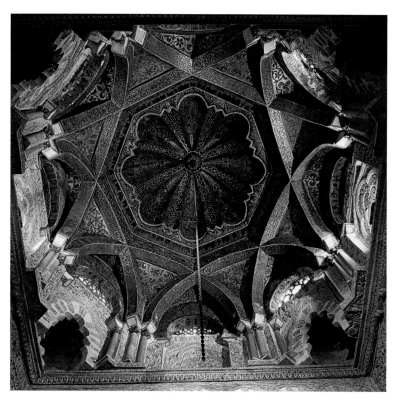

9-14 Cordova, Great Mosque, dome in front of mihrab, 961–76

The unique quality of Cordovan Islamic art under Abd al-Rahamn II can be seen in the **cupola**, or rounded vault, of the dome he commissioned opposite one of the mihrabs (fig. 9-14). It is essentially a Roman cupola in the general shape of a **baldacchino** (canopy-like structure). With its lavish use of gold, it recalls the traditional dome of heaven from Early Christian and Byzantine art—an association reinforced by the elaborate mosaic work, which was commanded from the Byzantine emperor and which further recalls the dome mosaic of Charlemagne's chapel at Aachen. These imperial associations were entirely appropriate to the caliph, who was both earthly ruler and religious leader. The ornamental vegetal motifs decorating the arches are characteristic of mature Islamic architecture, which derived it from Persian, as well as Byzantine, art. Unique to Islam is the system of ribs creating the eight-point star. Like the elaborate stuccowork of the horseshoe-shaped arches below, it is essentially decorative: its supporting function is minimal at best. Not until much later was the load-bearing potential realized by Guarino Guarini (see chapter 17). Like so much other Cordovan art and architecture, the cupola was the product of Muslim, Byzantine, and local Spanish artisans working together to create an entirely new entity that is dazzling in its novelty, no matter how great its debt may be to earlier sources.

Romanesque Art

U P TO THIS POINT, ALMOST ALL OF OUR CHAPTER HEADINGS
and subheadings might serve equally well for a general history of Western civiliza-
tion. Some are based on technology (for example, the Old Stone Age), others on
geography, ethnology, or religion. Whatever the source, scholars have borrowed the terms
from other fields to designate artistic styles. There are only two important exceptions:
Archaic and *Classical* are mainly stylistic terms. They refer to qualities of form rather than to
the setting in which these forms were created. Why don't we have more terms of this sort?
We do, as we shall see, but only for the art of the past 900 years.

Initially the history of art was viewed as
an evolution of styles. It began with the
belief that all ancient art evolved toward a
single climax: Greek art from the age of
Perikles to that of Alexander the Great. This
style was called *Classical* (that is, perfect).
Everything that came before was labeled
Archaic, to indicate that it was still old-
fashioned and tradition-bound—it was not
yet Classical but striving in the right direc-
tion. The style of post-Classical times, on
the other hand, did not deserve a special
term, because it had no positive qualities of
its own—it was merely an echo or a decline
of Classical art.

The early historians of medieval art fol-
lowed a similar pattern. To them, the great
climax was the Gothic style, from the thir-
teenth century to the fifteenth. For what-
ever was not yet Gothic they adopted the
label *Romanesque*, which was first intro-
duced in 1871. In doing so, they were think-
ing mainly of architecture. Pre-Gothic
churches, they noted, were round-arched,
solid, and heavy, compared with the pointed
arches and the soaring lightness of Gothic
structures. It was somewhat like the heavy
style of ancient Roman building, and
Romanesque was meant to convey just that
quality. The term is actually rather mislead-
ing. Originally, Romanesque was applied

only to a small group of modest churches in
northern Italy, southern France, and north-
ern Spain. These structures were part of a
regional revival about 950–1060 of the Early
Christian style under Constantine and Jus-
tinian. They do show late Roman traits,
although the effect is rather superficial. The
same vocabulary, moreover, also was used on
the facades of Ottonian churches of the
same time. Soon, however, the style name
was applied to all European art of the
mid tenth through the twelfth century.
Romanesque art is amazing in its diversity
and inventiveness. It bespeaks a new spirit
that is expressed most fully in monumental
architecture.

The Romanesque, unlike the court-
based art of the Carolingian and Ottonian
periods, sprang up all over western Europe at
about the same time. It consists of a large
variety of regional styles, without a central
origin, distinct yet closely related in many
ways. In this respect, the Romanesque
resembles the art of the early Middle Ages
rather than the court styles that had pre-
ceded it. Its sources, however, include those
styles, along with many other, less clearly
traceable ones. Late Classical, Early Christ-
ian, and Byzantine elements can be found,
as well as some Islamic influence and the
Celtic-Germanic heritage.

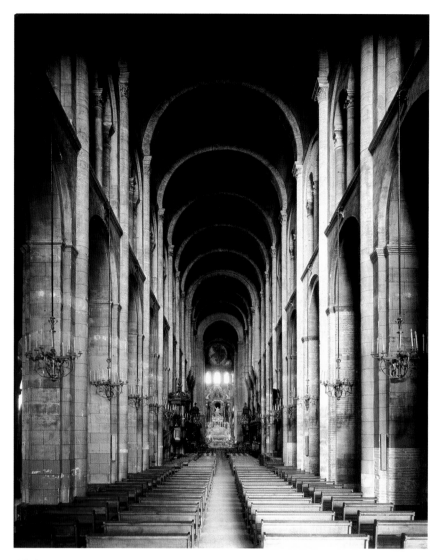

10-3 Nave and choir, St-Sernin

We do not mean to suggest that the architect set out to achieve this effect. Beauty and engineering were inseparable. Vaulting the nave to eliminate the fire hazard of a wooden roof not only was a practical aim, but also provided a challenge to make the House of the Lord grander. Because a vault becomes more difficult to sustain the farther it is from the ground, every resource had to be strained to make the nave as tall as possible. However, for safety's sake there is no clerestory to light the nave. Instead, galleries were built over the inner aisles in the hope that enough light would filter through them into the central space. The galleries also serve to help relieve the pressure of the nave vault. St-Sernin reminds us that architecture, like politics, is "the art of the possible." Its success, here as elsewhere, is measured by the degree to which the architect has explored the limits of what seemed possible, both structurally and aesthetically, under those particular conditions.

BURGUNDY AND WESTERN FRANCE

The builders of St-Sernin would have been the first to admit that their answer to the problem of supporting the weight of the nave vault while allowing enough light to enter the church was not the final one. The architects of Burgundy, in central France, arrived at a more elegant solution, which can be seen in the Cathedral of Autun (fig. 10-4). The cathedral was dedicated to Lazarus, the dead man revived by Christ and whose bones it came to house. It was begun by Bishop Étienne de Bagé of the Cluniac order (see Cultural Context: Monasticism and Christian Monastic Orders, pages 190-191) and was consecrated in 1132. Here the galleries have been replaced by a clerestory, which allows far more light than galleries could provide, and a narrow "blind" arcade, which no longer admits any light, because it isn't needed. As a result, the arches and supports of the arcade are simply attached to the wall, so that they serve a decorative rather than a functional purpose. This kind of arcade is called a **triforium,** because it has three openings per bay. This three-

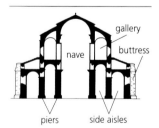

Seen in section, the physics of St-Sernin are quite apparent. The walls of the nave and the aisles transfer the weight downward through the piers and outward to the lowest side walls, where it is buttressed.

to a remarkable degree. Yet the forces expressed in the nave of St-Sernin are no longer the physical, muscular forces of Graeco-Roman architecture but spiritual forces of the kind we have seen governing the human body in Carolingian and Ottonian miniatures. To a Roman viewer, the half-columns running the entire height of the nave wall would appear just as unnaturally drawn out as the arm of Jesus in figure 9-13. The columns seem to be driven upward by some tremendous, unseen pressure, as if hastening to meet the transverse arches that subdivide the barrel vault of the nave. Their insistently repeated rhythm propels us toward the eastern end of the church, with its light-filled apse and ambulatory (now obscured by a huge altar of later date).

story elevation was made possible by the use of the pointed arch for the nave vault. The pointed arch probably reached France from Islamic architecture, where it had been used for some time. By eliminating the center part of the round arch, which responds the most to the pull of gravity, the two halves of a pointed arch brace each other. This type of arch thus exerts less outward pressure than the semicircular arch. It can therefore be made as steep as possible, and its walls can be pierced as well. (For reasons of harmony, the pointed arch also appears in the nave arcade, where it is not needed for further support.) The advances that grew out of this discovery were to make possible the soaring churches of the Gothic period (see, for example, figs. 11-3 and 11-7). Like St-Sernin, Autun comes close to straining the limits of the possible. The upper part of the nave wall shows a slight outward lean under the pressure of the vault—a warning against any further attempts to increase the height of the clerestory or to enlarge the windows.

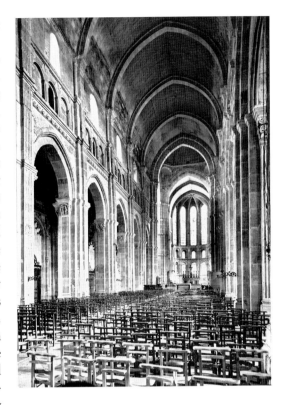

10-4 Nave wall, Autun Cathedral. c. 1120–32

NORMANDY AND ENGLAND

The duchy of Normandy, farther north, had been ruled by a series of weak Carolingians before being ceded to the Danes by the aptly named Charles the Simple in 911. By the middle of the eleventh century, however, it had developed into the most dynamic force in Europe under the Capetian dynasty, which was established when Hugh Capet was elected king in 987 and which ruled France for almost 350 years. Although it came late, Christianity was strongly supported by the Norman dukes and barons, who were active in promoting monastic reform and who founded numerous abbeys. Thus Normandy soon became a cultural center of international importance. The architecture of southern France merged with local traditions to produce a new Norman school that evolved in an entirely different direction.

The westwork of St-Étienne (fig. 10-5), the abbey church founded at Caen by William the Conqueror a year or two after his invasion of England in 1066 (see page 198), proclaims this an imperial church. Its closest ancestors are Carolingian churches built under royal patronage, such as Corvey

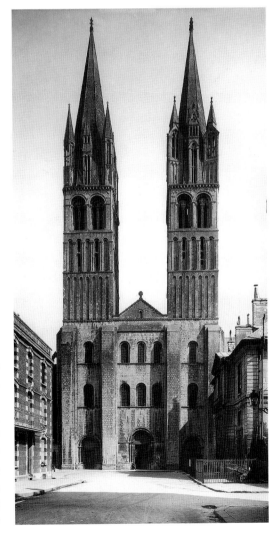

10-5 West facade, St-Étienne, Caen. Begun 1068

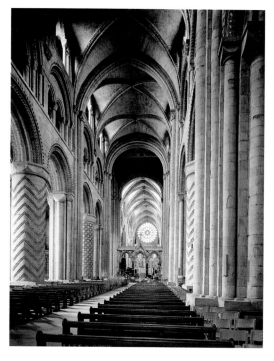

10-6 Nave (looking east), Durham Cathedral. 1093–1130

10-7 Plan of Durham Cathedral (after Conant)

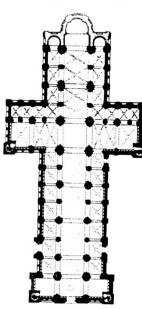

(see fig. 9-5). Like its predecessors, it has a minimum of decoration. Four huge buttresses divide the front of the church into three vertical sections. The vertical thrust continues in the two towers, whose height would be impressive even without the tall Early Gothic helmets. St-Étienne is cool and composed: its refined proportions are meant to be appreciated by the mind rather than the eye.

The thinking that went into Norman architecture is responsible for the next great breakthrough in structural engineering, which took place in England, where William started to build as well. Durham Cathedral (fig. 10-6), begun in 1093, is among the largest churches of medieval Europe. It has a nave one-third wider than St-Sernin's, and its overall length (400 feet) is also greater. The nave may have been designed to be vaulted from the start. The vault over its eastern end had been completed by 1107, a remarkably short time, and the rest of the nave was finished by 1130. The choir was heavily damaged by a fire and was rebuilt in 1174–84, so that the vault is very different from the nave's (see fig. 10-7). This nave vault is of great interest. As the earliest systematic use of a ribbed groin vault over a three-story nave, it marks a basic advance beyond the solution we saw at Autun.

The aisles, which we can glimpse through the arcade, consist of the usual groin-vaulted compartments approaching a square. The bays of the nave, separated by strong transverse arches, are oblong and groin-vaulted in such a way that the **ribs** form a double-X design. As we can see from the ground plan (fig. 10-7), the vault thus is divided into seven sections rather than the usual four. Because the nave bays are twice as long as the aisle bays, the transverse arches occur only at the odd-numbered piers of the nave arcade. The piers therefore alternate in size. The larger ones are of compound shape (that is, bundles of column and pilaster shafts attached to a square or oblong core), while the others are cylindrical.

The easiest way to visualize the origin of this system is to imagine that the architect started out by designing a barrel-vaulted nave, with galleries over the aisles and without a clerestory, as at St-Sernin, but with the transverse arches spaced more widely. The realization suddenly dawned that putting groin vaults over the nave as well as the aisles would gain a semicircular area at the ends of each transverse vault that could be broken through to make a clerestory, because it had no essential supporting functions (fig. 10-8). Each nave bay is intersected by two transverse barrel vaults of oval shape, so that it contains a pair of Siamese-twin groin vaults that divide it into seven compartments. The outward thrust and weight of the whole vault are concentrated at six securely anchored points on the gallery level. The ribs were needed to provide a stable skeleton for the groin vault, so that the curved surfaces between them could be filled in with masonry of minimum thickness. Thus both weight and thrust were reduced. We do not know whether this ingenious scheme was actually invented at Durham, but it could not have been devised much earlier, for it is still in an experimental stage. Although the transverse arches at the crossing are round, those to the west of it are slightly pointed, indicating an ongoing search for improvements.

This system had other advantages as well. From an aesthetic standpoint, the nave at Durham is among the finest in all Romanesque architecture. The wonderful sturdiness of the alternating piers makes a splendid contrast with the dramatically lit, sail-like surfaces of the vault. This light-

weight, flexible system for covering broad expanses of great height with fireproof vaulting, while retaining the ample lighting of a clerestory, marks the culmination of the Romanesque and the dawn of the Gothic.

ITALY

We might have expected central Italy, particularly the area of Tuscany, which had been part of the heartland of the Roman Empire, to have produced the noblest Romanesque of them all, because surviving classical originals were close at hand. However, a number of factors prevented this development. All of the rulers who sought to revive "the grandeur that was Rome," with themselves in the role of emperor, were in northern Europe. The spiritual authority of the pope, reinforced by large territorial holdings, made imperial ambitions in Italy difficult to achieve. New centers of prosperity and commerce, whether arising from seaborne trade or local industries, tended to consolidate a number of small principalities. They competed among themselves or aligned themselves from time to time with the pope or the German emperor if it seemed politically profitable. Lacking the urge to re-create the old empire, and having Early Christian buildings as readily accessible as classical

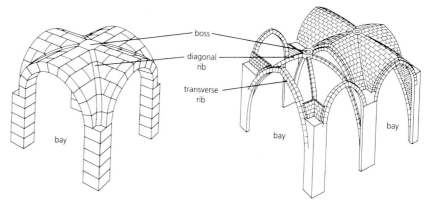

10-8 Rib vaults (after Acland)

Roman ones, the Tuscans were content to continue basically Early Christian forms. Yet they enlivened these structures with decorative features inspired by pagan architecture.

The most famous monument of the Tuscan Romanesque owes its fame to an accident. Because of poor foundations, the Leaning Tower of Pisa, designed by the sculptor Bonanno Pisano (active 1174–86), began to tilt even before it was completed. The tower is the **campanile** (or bell tower) of the Pisa Cathedral complex, which includes the church itself and the circular, domed baptistery to the west (fig. 10-9). This ensemble, built on an open site north

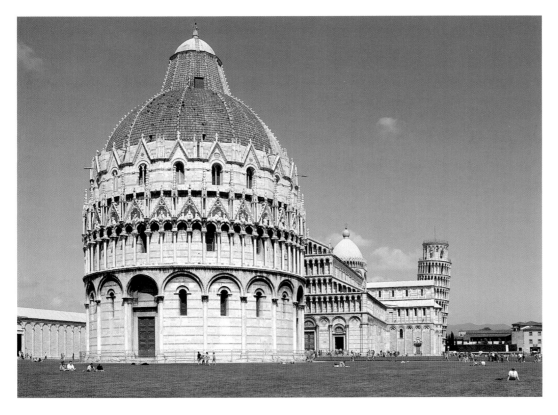

10-9 Pisa Baptistery, Cathedral, and Campanile (view from the west). 1053–1272

People of many times, places, and religious faiths have renounced the world and devoted themselves entirely to a spiritual way of life. Some have chosen to live alone as hermits, often in isolated places, where they have led harsh, ascetic existences. Others have come together in religious communities known as MONASTERIES to share their faith and religious observance. Hermits have been especially characteristic of Hinduism, whereas the monastic life has been more common in Buddhism. Among the Jews of the first century B.C., there were both hermits, or ANCHORITES (John the Baptist was one of these), and a kind of monasticism practiced by a sect known as the Essenes. Both forms are found in Christianity throughout most of its history as well. Their basis can be found in Scripture. On the one hand, Jesus urged his followers to give up all earthly possessions as the road to salvation. On the other, the book of Acts in the Bible records that the disciples came together in their faith after the Crucifixion.

The earliest form of a devoted religious calling practiced by Christians was the hermit's life. It was chosen by a number of pious men and women who lived alone in the Egyptian desert in the second and third centuries A.D. This way of life was to remain fundamental to the Eastern Church, especially in Syria. But early on, communities emerged when colonies of disciples—both men and women—gathered around the most revered of the hermits, such as St. Anthony (fourth century), who achieved such fame as a holy man that he was pursued by people asking him to act as a divine intercessor on their behalf.

Monasteries soon came to assume great importance in early Christian life. (They included communities for women, which are often called convents or nunneries.) The earliest known monastery was founded by Pachomius along the Nile about 320 and blossomed into a community of nine monasteries and two nunneries by the time of his death a quarter-century later. Similar ones quickly followed in Syria, where monachism (monasticism) flourished until the 638 conquest by the Arabs. Syrian monasteries were for the most part sites along pilgrimage routes leading to the great monastery at Telanessa (present-day Qal'at Sim'an), where Simeon Stylites (born 390) spent the last 30 years of his long life atop a tall column in almost ceaseless prayer.

Eastern monasticism was founded by Basil the Great (c. 330–379), bishop of Caesarea in Asia Minor. Basil's rule established the basic characteristics of Christian monasticism: poverty, chastity, and humility. It emphasized prayer, scriptural reading, and work, not only within the monastery but also for the good of laypeople in the world beyond its walls; as a result, monasticism now assumed a social role.

The most important figure in Western monasticism was Benedict of Nursia (c. 480–c. 553), the founder of the abbey at Monte Cassino in southern Italy. His rule, which was patterned after Basil's, divided the monk's day into periods of private prayer, communal ritual,

of the city, reflects the wealth and pride of the city-republic of Pisa.

Tuscany remained conscious of its classical heritage throughout the Middle Ages. If we compare Pisa Cathedral with S. Apollinare in Classe and St-Sernin in Toulouse (see figs. 8-2 and 10-2), we see that it is closely related to the latter in its scale and shape. However, the essential features are still much as we see them in S. Apollinare. The basic plan of Pisa Cathedral is that of an Early Christian basilica, but it has been

and labor; it also required a moderate form of communal life, which was strictly governed. This was the beginning of the BENEDICTINE order, the first of the great monastic orders (or societies) of the Western church. The Benedictines thrived with the strong support of Pope Gregory the Great, himself a former monk, who codified the Western liturgy and the forms of Gregorian chant.

Because of their organization and continuity, monasteries were considered ideal seats of learning and administration under the Frankish kings of the eighth century. They were supported even more strongly by Charlemagne and his heirs, who gave them land, money, and royal protection. As a result, they became rich and powerful, even exercising influence on international affairs. Monasteries and convents provided a place for the younger children of the nobility, and even talented members of the lower classes, to pursue challenging, creative, and useful lives as teachers, nurses, writers, and artists—opportunities that generally would have been closed to them in secular life. Although they had considerable independence at first, the various orders eventually gave their loyalty to Gregory. They thereby became a major source of power for the papacy in return for its protection. Through these ties, Church and State over time became linked institutionally to their mutual benefit, thereby promoting greater stability. Besides the Benedictines, the other important monastic orders of the West included the Cluniacs, the Cistercians, the Carthusians, the Franciscans, and the Dominicans.

The CLUNIAC order (named after its original monastery at Cluny, in France) was founded as a renewal of the original Benedictine rule in 909 by Berno of Baume. CISTERCIAN monasteries were deliberately located in remote places, where the monks would come into minimal contact with the outside world, and the rules of daily life were particularly strict. In keeping with this austerity, the order developed an architectural style known as Cistercian Gothic, recognizable by its geometric simplicity and lack of ornamentation (see pages 210 and 212-14).

The CARTHUSIAN order was founded by Bruno, an Italian monk, in 1084. Carthusians are in effect hermits, each monk or nun living alone in a separate cell, vowed to silence and devoted to prayer and meditation. Because of the extreme austerity and piety of this order, several powerful dukes in the fourteenth and fifteenth centuries established Carthusian houses (charterhouses; French, *chartreuses*), so that the monks could pray perpetually for the souls of the dukes after they died.

The FRANCISCAN order was founded in 1209 by St. Francis of Assisi (c. 1181–1226) as a preaching community. Francis, who was perhaps the most saintly character since Early Christian times, insisted on a life of complete poverty, not only for the members personally but for the order as a whole. Franciscan monks and nuns were originally MENDICANTS—that is, they begged for a living. This rule was revised in the fourteenth century.

The DOMINICAN order was established in 1220 by St. Dominic (c. 1170–1221), a Spanish monk who had been a member of the Cistercians. Besides preaching, the Dominicans devoted themselves to the study of theology. They were considered the most intellectual of the religious orders in the late Middle Ages and the Early Renaissance.

transformed into a Latin cross by the addition of transept arms that resemble small basilicas with apses of their own. The crossing is marked by a dome.

The only deliberate revival of the antique Roman style in Tuscan architecture was in the use of a multicolored marble "skin" on the exteriors of churches. Little of this is left in Rome because much of it was literally "lifted" to decorate later buildings. However, the interior of the Pantheon still gives us some idea of it (see fig. 7-7). We can

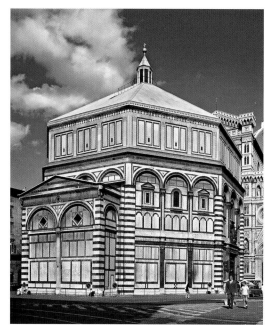

10-10 Baptistery of S. Giovanni, Florence. c. 1060–1150

10-11 Apostle. c. 1090. Stone. St-Sernin, Toulouse

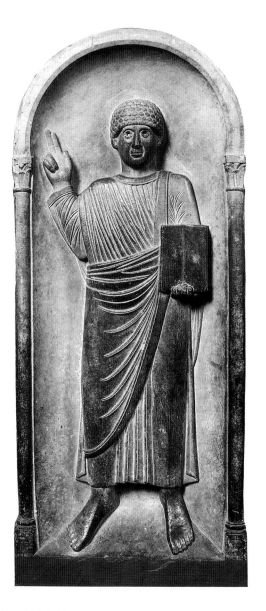

recognize the desire to emulate such marble inlay in the baptistery opposite Florence Cathedral (fig. 10-10). The green-and-white marble paneling follows severe geometric lines, and the blind arcades are extraordinarily classical in proportion and detail. The entire building, in fact, has such a classical air that a few hundred years later, the Florentines believed it to have been originally a temple of Mars. Even today the debate over its date has not been settled completely. (Parts of the facade may actually date from the Early Renaissance.) We shall return to the Baptistery of S. Giovanni a number of times (see chapters 11 and 12), because it was to be of great importance in the Renaissance.

Sculpture

The revival of **monumental** stone sculpture is even more surprising than the architectural achievements of the Romanesque era. Neither Carolingian nor Ottonian art had shown any tendencies in this direction. Freestanding statues all but disappeared from Western art after the fifth century. Stone relief survived only in the form of architectural ornament or surface decoration, with the depth of the carving kept to a minimum. Thus the only continuous sculptural tradition in early medieval art was that of sculpture-in-miniature: small reliefs, and occasional statuettes, in metal or ivory. In works such as the bronze doors of Bishop Bernward (see fig. 9-12), Ottonian art had enlarged the scale of this tradition but not its spirit. Moreover, its truly large-scale sculptural efforts, such as the impressive *Gero Crucifix* (see fig. 9-9), were limited almost entirely to wood.

SOUTHWESTERN FRANCE

Toward the end of the eleventh century, the situation had changed dramatically. We do not know exactly when and where the revival of stone sculpture began, but the earliest surviving examples are found in southwestern France and northern Spain, along the pilgrimage roads leading to Santiago de Compostela. Thus, as in Romanesque architecture, the rapid development of stone sculpture shortly before 1100 coincides with the growth of religious fervor in the decades before the First Crusade. Architectural sculpture, espe-

cially on the exterior of a church, is meant to appeal to the lay worshiper rather than to the members of a closed monastic community.

St-Sernin at Toulouse contains several important examples probably carved about 1090, including the *Apostle* in figure 10-11. (This panel is now in the ambulatory; its original location is not certain, but it may have decorated the front of an altar.) Where have we seen its like before? The solidity of the forms has a strongly classical air, indicating that our artist must have had a close look at late Roman sculpture, of which there are numerous remains in southern France. But the solemn frontality of the figure and its placement in the architectural frame show that the design must be derived from a Byzantine source, probably an ivory panel descended from the Archangel Michael in figure 8-14. In enlarging such a miniature, the carver of our relief has also reinflated it. The niche is a real cavity, the hair a round, close-fitting cap, the body severe and block-like. Our *Apostle* has, in fact, much the same dignity and directness as the sculpture of Archaic Greece (see fig. 5-12 and 5-13).

The figure, which is somewhat more than half-life-size, was not meant to be viewed only at close range. Its impressive bulk and weight "carry" over a considerable distance. This emphasis on massive volume hints at what may have been the main impulse behind the revival of large-scale sculpture. A stone-carved image, being tangible and three-dimensional, is far more "real" than a painted one. To the mind of a cleric steeped in abstract theology, this might seem irrelevant or even dangerous. For unsophisticated lay worshipers, however, any large sculpture had something of the quality of an idol, and it was this quality that gave it such great appeal.

Another important early center of Romanesque sculpture was the abbey at Moissac, farther north of Toulouse along the Garonne River. In figure 10-12, we see the magnificent **trumeau** (the center post supporting the lintel) and the western **jamb** (the side of the doorway) of the south portal. (Elements of a typical Romanesque portal are shown in figure 10-13.) Both have a scalloped profile—apparently a bit of Moorish influence. The shafts of the half-columns applied to the jambs and trumeau also follow this pattern, as if they had been squeezed from a giant pastry tube.

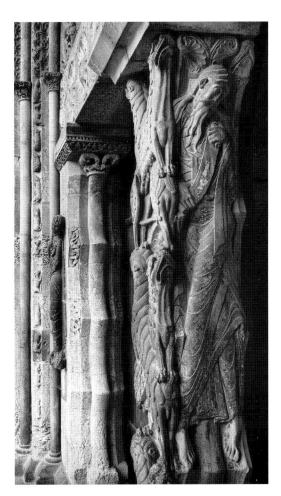

10-12 Portion of south portal, St-Pierre, Moissac. Early twelfth century

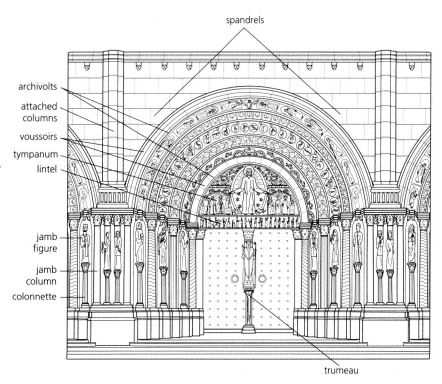

10-13 Romanesque portal ensembles

Human and animal forms are treated with the same flexibility, so that the spidery prophet on the side of the trumeau seems perfectly adapted to his precarious perch. (Notice how he, too, has been fitted into the scalloped outline.) He even remains free to cross his legs in a dancelike movement and to turn his head toward the interior of the church as he unfurls his scroll.

But what of the crossed lions that form a symmetrical zigzag on the face of the trumeau—do they have a meaning? So far as we know, they simply "animate" the shaft, just as the interlacing beasts of Irish miniatures (from which they are descended) enliven the compartments they inhabit. In manuscript illumination, this tradition had never died out. Our sculpture has undoubtedly been influenced by it, just as the agitated movement of the prophet originated in miniature painting (see fig. 9-7). The crossed lions reflect another source as well. We can trace them through textiles to Persian metalwork (although not in this towerlike formation). They descend ultimately from the confronted animals of ancient Near Eastern art (see fig. 3-5). Yet we cannot fully account for their presence at Moissac in terms of their effectiveness as ornament alone. They belong to an extensive family of savage or monstrous creatures in Romanesque art that retain their demonlike vitality even though they are forced, like our lions, to perform a supporting function. Their purpose is thus not only decorative but expressive as well. They embody dark forces that have been domesticated into guardian figures or banished to a position that holds them fixed for all eternity, however much they may snarl in protest. The south portal at Moissac shows a richness of invention that St. Bernard of Clairvaux condemned in a letter of 1127 to Abbot William of St-Thierry concerning the sculpture of the monastery at Cluny: "In the cloister under the eyes of the brethren who read there, what profit is there in those ridiculous monsters, in that marvelous and deformed beauty, in that beautiful deformity? . . . So many and so marvelous are the varieties of shapes on every hand, that we are even more tempted to read in the marble than in our books, and to spend the whole day wondering at these things rather than in meditating on the law of God." The pictorial representation of Christian themes was often justified by a famous saying,

"*Quod legentibus scriptura, hoc idiotis . . . pictura.*" Translated freely, it means that painting conveys the Word of God to the unlettered. Although he did not object specifically to the teaching role of art, St. Bernard had little use for monastic church decoration. He would surely have disapproved of the Moissac portal's excesses, which were clearly meant to appeal to the eye—as his grudging admiration for the cloister at Cluny attests.

BURGUNDY

The **tympanum** (the semicircular zone, or **lunette,** above the lintel) of the main portal of Romanesque churches usually holds a composition centering on the Enthroned Christ. Most often it shows the Apocalyptic Vision, or the Last Judgment, the most awesome scene in Christian art. At Autun Cathedral this subject has been visualized with extraordinary force by Giselbertus (fig. 10-14), who probably based his imagery on a contemporary account rather than on the Revelation of St. John the Divine. The apostles, at the viewer's left, observe the weighing of souls, shown at the right. Four angels in the corners sound the trumpets of the Apocalypse. At the bottom, the dead rise from their graves in fear and trembling; some are already beset by snakes or gripped by huge, clawlike hands. Above, their fate quite literally hangs in the balance, with devils yanking at one end of the scales and angels at the other. The saved souls cling like children to the angels for protection before their ascent to the Heavenly Jerusalem (far left), while the condemned, seized by grinning devils, are cast into the mouth of hell (far right). These devils betray the same nightmarish imagination we saw in the Romanesque animal world. Although human in general outline, they have birdlike legs, furry thighs, tails, pointed ears, and savage mouths. No visitor, having "read in the marble" here (to quote St. Bernard of Clairvaux), could fail to enter the church in a chastened spirit.

The emergence of distinct artistic personalities in the twelfth century is rarely acknowledged, perhaps because it contradicts the widespread notion that all medieval art is anonymous. Giselbertus is not the only or even the earliest case. He is one of several Romanesque sculptors who are known to us by name, and not by accident. Their highly individual styles made theirs the first names

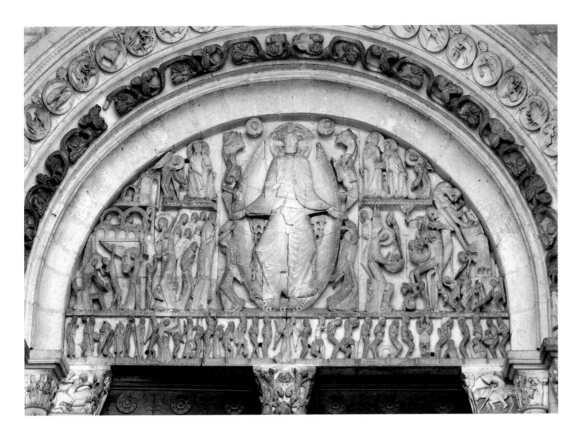

10-14 Giselbertus. *Last Judgment*, west tympanum, Autun Cathedral. c. 1130–35

worthy of being recorded since Odo of Metz more than 300 years earlier.

THE MEUSE VALLEY

The revival of individuality also took place in the valley of the Meuse River, which runs from northeastern France into Belgium and Holland. This region had been the home of the classicizing Reims style in Carolingian times (see figs. 9-7 and 9-8), and an awareness of classical sources pervades its art (called Mosan) during the Romanesque period. Here again the revival of individuality is linked with the influence of ancient art, although this influence did not lead to works on a monumental scale.

Mosan Romanesque sculptors excelled in metalwork. The baptismal font of 1107–18 in Liège (fig. 10-15) was done by the earliest artist of the region whose name we know: Renier of Huy. The vessel rests on 12 oxen (symbols of the 12 apostles), like Solomon's basin in the Temple at Jerusalem as described in the Bible. The reliefs make an instructive contrast with those of Bernward's doors (see fig. 9-12), because they are about the same height. Instead of the rough expressive power of the Ottonian panel, we find here a harmonious balance of design, a subtle control of the sculptured surfaces, and

an understanding of organic structure that, in medieval terms, are amazingly classical. The figure seen from the back (beyond the tree on the left), with its graceful movement and Greek-looking drapery, might almost be taken for an ancient work. The scene was, in fact, adapted from Byzantine art, which helps to explain its classical quality.

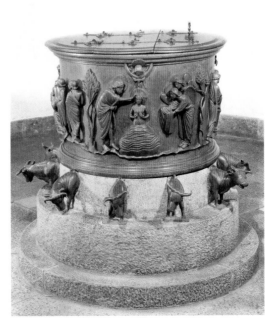

10-15 Renier of Huy. Baptismal font. 1107–18. Bronze, height 25" (63.5 cm). St-Barthélemy, Liège

ITALY

The French style quickly became international, but was modified through interaction with local tradition. We see this process in the work of Benedetto Antelami, the greatest sculptor of Italian Romanesque art. Unlike Giselbertus, Antelami was at heart a monumental sculptor, not a relief carver. His *King David* (fig. 10-16), from the facade of Fidenza Cathedral in the north Italian region of Lombardy, approaches the ideal of the self-sufficient statue more closely than any medieval work we have seen so far. The *Apostle* from St-Sernin is one of a series of figures, all of them fixed to their niches. Antelami's *David*, by contrast, stands physically free and even shows an attempt to recapture the classical *contrapposto*. To be sure, he would look awkward if placed on a pedestal in isolation; he demands the architectural framework for which he was made, but certainly to a far lesser extent than do other Romanesque statues. Nor is he subject to the group discipline of a series. His only companion is a second niche statue on the other side of the portal, which is likewise lost in thought. Such expressiveness, new to Romanesque sculpture, is characteristic of Antelami's work. We shall meet it again in the statues of Donatello (see chapter 12). The *King David* is an extraordinary achievement, especially if we consider that less than a hundred years separate it from the beginnings of the sculptural revival.

10-16 Benedetto Antelami. *King David.* c. 1180–90. West facade, Fidenza Cathedral, Italy

Painting and Metalwork

Unlike architecture and sculpture, Romanesque painting shows no revolutionary developments that set it apart from Carolingian or Ottonian art. Nor does it look more "Roman" than Carolingian or Ottonian painting. This does not mean, however, that in the eleventh and twelfth centuries painting was any less important than it had been during the earlier Middle Ages. The lack of dramatic change merely emphasizes the greater continuity of the pictorial tradition, especially in manuscript illumination. Nevertheless, soon after the year 1000 we find the beginnings of a painting style that corresponds to—and often anticipates—the monumental qualities of Romanesque sculpture.

THE CHANNEL REGION

Although Romanesque painting, like architecture and sculpture, developed a wide variety of regional styles throughout western Europe, its greatest achievements emerged from the monastic scriptoria of northern France, Belgium, and southern England. The works produced in this area are so closely

related in style that it is at times impossible to be sure on which side of the English Channel a given manuscript originated. Thus the style of the miniature of St. John (fig. 10-17) has been linked with both Cambrai, France, and Canterbury, England. Here the abstract linear draftsmanship of earlier medieval manuscripts (see fig. 9-7) has been influenced by Byzantine art, but without losing its energetic rhythm. (Note the ropelike loops of drapery, whose origin can be traced back to such works as the *Crucifixion* at Daphne in figure 8-16 and even further, to the ivory leaf in figure 8-14.) The masterful control of every contour, both in the main figure and in the frame, unites the varied elements of the composition into a coherent

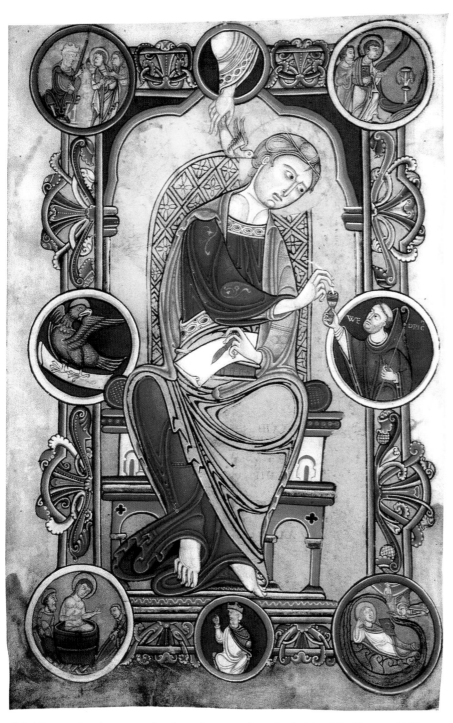

10-17 *St. John the Evangelist,* from the *Gospel Book of Abbot Wedricus.* c. 1147. Tempera on vellum, 14 × 9¹/₂″ (35.5 × 24 cm). Société Archéologique et Historique, Avesnes-sur-Helpe, France

whole. This quality of line betrays its ultimate source, the Celtic-Germanic heritage.

If we compare our miniature with the Cross page from the *Lindisfarne Gospels* (see fig. 9-2), we realize how much the interlacing patterns of the early Middle Ages have contributed to the design of the St. John page. The drapery folds and the clusters of floral ornament have an impulsive yet disciplined aliveness that echoes the intertwined, snakelike monsters of the animal style, even though the foliage is derived from the classical acanthus and the human figures are based on Carolingian and Byzantine models. The unity of the page is conveyed not only by the forms but by the content as well. St. John "inhabits" the frame in such a way that we could not remove him from it without cutting off his ink supply (offered by the donor of the manuscript, Abbot Wedricus), his source of inspiration (the dove of the Holy Spirit held in the hand of God), or his symbol (the eagle). The other medallions show various scenes taken from the saint's life.

The linearity and the simple, closed contours of this painting style lend themselves readily to changes in scale and to other mediums (murals, tapestries, stained-glass windows, sculptured reliefs). The *Bayeux Tapestry* is an embroidered frieze 230 feet long, illustrating WILLIAM THE CONQUEROR'S invasion of England. Embroidery was an art in which medieval women were involved and it is probable that women helped create this work. In our detail (fig. 10-18) depicting the Battle of Hastings, the designer has integrated narrative and ornament with complete ease. The main

scene is framed by two border strips. The upper tier with birds and animals is purely decorative, but the lower one is full of dead warriors and horses and thus forms part of the story. Although it does not use the pictorial devices of classical painting, such as foreshortening and overlapping (see fig. 5-5), the tapestry gives us a vivid and detailed account of warfare in the eleventh century. The massed forms of the Graeco-Roman scene are gone, replaced by a new kind of individualism that makes each figure a potential hero, whether by force or by cunning. (Note how the soldier who has fallen from the horse with its hind legs in the air is, in turn, toppling his foe by yanking at the saddle girth of his mount.)

SOUTHWESTERN FRANCE

The firm outlines and strong sense of pattern found in the English Channel region are equally characteristic of Romanesque wall painting in southwestern France. *The Building of the Tower of Babel* (fig. 10-19) is part of the most impressive surviving cycle, which appears on the nave vault of the church at St-Savin-sur-Gartempe and depicts scenes of the Old Testament. It is an intensely dramatic design, crowded with strenuous action. The Lord himself, on the far left, participates directly in the narrative as he addresses the builders of the huge structure. He is counterbalanced, on the right, by the giant Nimrod, the leader of the enterprise, who frantically hands blocks of stone to the masons atop the tower, so that the entire scene becomes a great test of strength between God and human. The heavy, dark contours and the

10-18 *The Battle of Hastings.* Detail of the *Bayeux Tapestry.* c. 1073–83. Wool embroidery on linen, height 20" (50.7 cm). Centre Guillaume le Conquérant, Bayeux, France

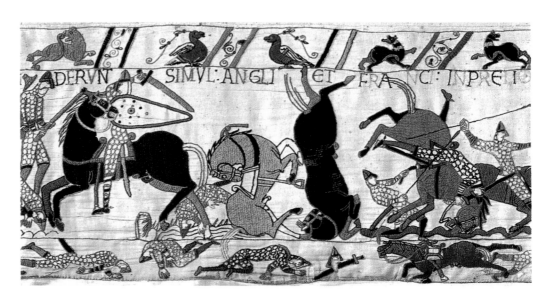

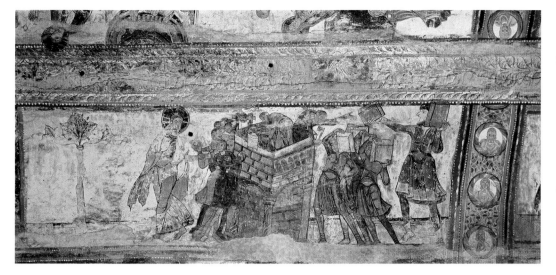

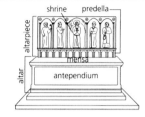

Altars are tables or sometimes low stones that are the focal point of religious worship, often the site of sacrificial rites. They have been found at most Neolithic sites and are virtually universal. The Christian altar traditionally is a narrow stone "table" that contains bone fragments of a martyr within it (Protestants do not have this requirement) and a prescribed set of liturgical objects used in the rite of Eucharist on the top surface (the mensa). The altar frontal (antependium) may be plain or decorated.

An ALTARPIECE is not an altar, but is placed behind or at the back of the altar table. Early altarpieces were wingless, with painted or carved images in the shrine section and more images in the predella zone below the shrine. Winged altarpieces were developed in the twelfth century. Wings allow the imagery to change according to the Church calendar.

emphatic play of gestures make the composition easily readable from the floor below. Yet the same qualities occur in the illuminated manuscripts of the region, which can be equally monumental despite their small scale.

THE MEUSE VALLEY

Soon after the middle of the twelfth century, there was an important change in Romanesque painting on both sides of the English Channel under the influence of metalwork. That the new style should have originated in this way is not as strange as it might seem, for its essential qualities are sculptural rather than pictorial. Metalwork includes not only cast or **embossed** sculpture, but also **engraving** (embellishing metal surfaces with incised pictures), **enameling** (fusing colored glass to metal), and goldsmithing. It had been a highly developed art in the Meuse Valley area since Carolingian times, when the techniques had been derived from Byzantium. Its greatest practitioner after Renier of Huy was Nicholas of Verdun, in whose work the classicizing, three-dimensional style of draftsmanship reaches full maturity.

An ALTARPIECE at Klosterneuburg that Nicholas completed in 1181 for provost Wernher consists of numerous engraved and enameled plaques laid out side by side like a series of manuscript illuminations from the Old and New Testaments. Originally this work took the form of a pulpit, but after a fire in 1330 it was rearranged as an altarpiece. *The Crossing of the Red Sea* (fig. 10-20) has a sumptuousness that recalls, on a miniature scale, the glittering play of light across mosaics (compare fig. 8-4). Here we meet the pictorial

counterpart of the classicism that we saw earlier in the baptismal font of Renier of Huy at Liège (see fig. 10-15). The lines again describe three-dimensional forms instead of abstract patterns. The figures, clothed in "wet" draperies familiar to us from Classical statues, have achieved such a high degree of organic structure and freedom of movement that we tend to think of them as forerunners of Gothic art (see chapter 11) rather than as the final phase of the Romanesque. Whatever we choose to call it, the style of the *Klosterneuburg Altarpiece* had a profound impact on both painting and sculpture during the next 50 years (see figs. 11-18 and 11-31).

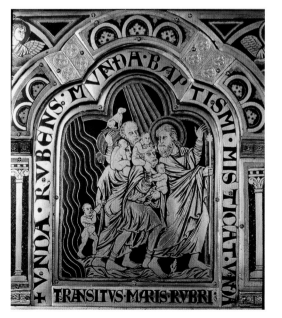

10-20 Nicholas of Verdun. *The Crossing of the Red Sea*, from the *Klosterneuburg Altarpiece*. 1181. Enamel on gold plaque, height 5½" (14 cm). Klosterneuburg Abbey, Austria

The late tenth through the twelfth century witnessed the unprecedented rise of women, first as patrons of art and then as artists. This remarkable development began with the Ottonian dynasty, which forged an alliance with the Church by placing members of the family in prominent positions. Thus Mathilde, Otto I's granddaughter, became abbess of the Holy Trinity convent at Essen in 974. Later, the sister, daughters, and granddaughter of Otto II also served as abbesses of major convents. Hardly less important, though not of royal blood, were Hrosvitha, canoness at the monastery of Gandersheim, who was the first woman dramatist we know of, and the two abbesses of Niedermünster, both named Uota. They paved the way for Herrad of Hohenberg (died 1195), author of *The Garden of Delights,* an encyclopedia of knowledge and history compiled for the education of her nuns.

Most remarkable of all was the Benedictine abbess Hildegard of Bingen (1098–1179). Among the most

Page with self-portrait of the nun, Guda, Book of Homilies, from Germany. Early 12th century. Ink on parchment. Stadt-und Universitäts-Bibliothek, Germany. MS. Barth. 42, folio 110V.

brilliant women in history, she corresponded with leaders throughout Europe. Hildegard composed almost 80 vocal works that rank with the finest of the day. She also wrote some 13 books on theology, medicine, and science. Hildegard is known above all for her books of visions, which made her one of the great spiritual voices of her day. Although one, *Scivias* (To Know the Ways of God), is now available only in facsimile (it was destroyed in 1945) and the other, *Liber divinorum operum* (The Book of Divine Works), in a later reproduction, it seems likely that the originals were executed under her direct supervision by nuns in her convent on the Rhine.

That there were women artists from the twelfth century on is certain, although we know only a few of their names. In one instance, an initial in a manuscript includes a nun bearing a scroll inscribed, "Guda, the sinful woman, wrote and illuminated this book"; another book depicts Claricia, evidently a lay artist, swinging as carefree as any child from the letter Q she has decorated. Without these author portraits, we might never suspect the involvement of women illuminators.

Equally revolutionary is the new expressiveness of the scene. All the figures, even the little dog perched on the bag carried by one of the men, are united through the exchange of glances and gestures within the tightly knit composition. Not since late Roman times have we seen such concentrated drama, although its intensity is unique to medieval art (compare fig. 8-4). Indeed, the astonishing humanity of Nicholas of Verdun's art is linked to an appreciation of the beauty of ancient works of art, as well as to a new regard for classical literature and mythology.

Gothic Art

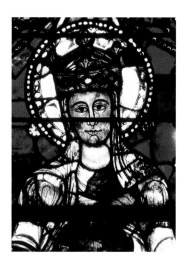

W E TEND TO THINK OF EVENTS AS UNFOLDING IN TIME, YET we are not as aware of their unfolding in terms of place. The Gothic era cannot be defined by means of time alone—we must consider its geographic range as well. At the start, about 1140, its area of influence was small indeed. It included only the province known as the Île-de-France (Paris and vicinity), the royal domain of the French kings. A hundred years later, most of Europe had adopted the Gothic style, from Sicily to Iceland. Around 1450, the Gothic area began to shrink. (It no longer included Italy.) By about 1550, it had disappeared almost entirely.

The term *Gothic* was first coined for architecture, and it is in architecture that the characteristics of the style are most easily recognized, although we also speak of Gothic sculpture and painting. For a century—from about 1150 to 1250, during the Age of the Great Cathedrals—architecture played the dominant role. Gothic sculpture was at first severely architectural in spirit but became less and less so after 1200; its greatest achievements are between the years 1220 and 1420. Painting, in turn, reached a peak between 1300 and 1350 in central Italy. North of the Alps, it became the leading art form from about 1400 on. Thus, in surveying the Gothic era as a whole, we find a gradual shift of emphasis from architectural to pictorial qualities. Early Gothic sculpture and painting reflect the discipline of their monumental architectural setting, whereas Late Gothic architecture and sculpture strive for "picturesque" effects.

Overlying this broad pattern is another one: international diffusion as opposed to regional independence. As mentioned, Gothic art originally spread from the Île-de-France to the rest of France and then all of Europe, where it came to be known as *opus modernum* or *opus francigenum* ("modern work" or "French work"). In the course of the thirteenth century, the new style gradually lost its imported flavor, and regional variety began to appear. Toward the middle of the fourteenth century, there was a growing tendency for these regional styles to influence each other until an "International Gothic" style prevailed almost everywhere about 1400. Shortly thereafter, this unity broke apart. Italy, with Florence in the lead, created a radically new art, that of the Early Renaissance. North of the Alps, Flanders took the lead in the development of Late Gothic painting and sculpture. Finally, a century later the Italian Renaissance became the basis of another international style.

This development roughly parallels what happened in the political arena. Supported by shifting alliances with the papacy, the kings of France and England emerged as the leading powers at the expense of the Germans in the early thirteenth century, which was generally a time of peace and prosperity. Under these ideal conditions the new Franciscan and Dominican orders were established (see pages 190–91), and Catholicism found its greatest intellect, St. Thomas Aquinas, since St. Augustine and St. Jerome some 850 years earlier. After 1290, however, the balance of power quickly broke down. Finally, in 1305 the French pope Clement V moved the papacy to Avignon, where it remained for more than 70 years during what the humanist Petrarch called "the Babylon Captivity of the Papacy."

Architecture

FRANCE

Abbey Church of St-Denis We can pinpoint the origin of the Gothic style with uncommon accuracy. It was born between 1137 and 1144 in the rebuilding by Abbot Suger of the royal Abbey Church of St-Denis, just outside the city of Paris. To understand how Gothic architecture arose at this particular spot, we must examine the relationship among St-Denis, Suger, and the French monarchy. The kings of France derived their authority from the Carolingian tradition, although they belonged to the Capetian line (see page 187). However, their power was eclipsed by that of the nobles, who, in theory, were their vassals. The only area the kings ruled directly was the Île-de-France, and their authority was often challenged even there. Not until the early twelfth century did royal power begin to expand. As chief adviser to Louis VI, Abbot Suger helped to shape this process. It was he who forged the alliance between the monarchy and the Church. This union brought the bishops of France (and the cities under their authority) to the king's side; the king, in turn, supported the papacy in its struggle against the German emperors.

SPEAKING OF

Early Gothic, High Gothic, Classic High Gothic, International Gothic, and International Style

The first three of these terms are descriptive of styles, not time periods (the points of difference among them are explored in the text). *High Gothic* and *Classic High Gothic* creations can and do appear in the same place and at the same time, as do a number of other overlapping styles. *International Gothic* refers to the spread of the French High Gothic style outward from the Île-de-France to all of Europe, and *International Style* describes the lyrical, courtly painting and sculpture that flourished about 1400 throughout Europe.

11-1 Ambulatory, Abbey Church of St-Denis, Paris. 1140–44

Suger also engaged in "spiritual politics." By giving the monarchy religious significance and glorifying it as the strong right arm of justice, he sought to rally the nation behind the king. The abbey of St-Denis was a key element in his plan. The church, founded in the late eighth century, enjoyed a dual prestige: it was both the shrine of St-Denis, the Apostle of France and protector of the realm, and the chief memorial of the Carolingian dynasty. Both Charlemagne and his father, Pepin, had been consecrated as kings there. It was also the burial place of Charles Martel, Pepin, and Charles the Bald. Suger wanted to make the abbey the spiritual center of France, a pilgrimage church that would outshine all others and provide a focal point for religious as well as patriotic emotion. To achieve this goal, the old structure had to be enlarged and rebuilt. The great abbot himself wrote two accounts of the church and its rebuilding, which tell us a great deal, although they are incomplete. Unfortunately, the west facade of the present church is badly mutilated, and the choir at the east end, which Suger saw as the most important part of the church, retains its original appearance only in the ambulatory (fig. 11-1).

The ambulatory and radiating chapels surrounding the **arcaded apse** are familiar elements from the Romanesque pilgrimage choir (compare fig. 10-1), but they have been integrated in a new way. Instead of being separate, the **chapels** are merged to form, in effect, a second ambulatory. Ribbed groin vaulting based on the pointed arch is used throughout. (In the Romanesque pilgrimage choir, only the ambulatory had been groin-vaulted.) As a result, the entire apse is held together by a new kind of geometric order. It consists of seven nearly identical wedge-shaped units fanning out from the center of the apse. (The central chapel, dedicated to the Virgin, and its neighbors on either side are slightly larger, presumably because of their greater importance.) We experience this double ambulatory not as a series of individual compartments but as a continuous (though articulated) space, whose shape is outlined for us by the network of slender arches, ribs, and columns that sustains the vaults.

What distinguishes this interior from earlier ones is its lightness, in both senses of the

word. The architectural forms seem graceful, almost weightless, compared with the massive solidity of the Romanesque. In addition, the windows have been enlarged to the point that they are no longer openings cut into a wall—they themselves become translucent walls. What makes this abundance of light possible? The outward pressure of the vaults is contained by heavy buttresses jutting out between the chapels. (For the structural system of Gothic architecture, see fig. 11-5.) No wonder, then, that the interior appears so airy, because the heaviest parts of the structural skeleton are outside. The impression would be even more striking if we could see all of Suger's choir, for the upper part of the apse, rising above the double ambulatory, had very large, tall windows. The effect, from the nave, must have been similar to that of the somewhat later choir of Notre-Dame in Paris (see fig. 11-3).

Suger and Gothic Architecture In describing Suger's choir, we have also described the essentials of Gothic architecture. Yet none of the elements that make up its design is really new. The pilgrimage choir plan, the pointed arch, and the ribbed groin vault can be found in regional schools of the French and Anglo-Norman Romanesque. However, they were never combined in the same building until St-Denis. Because the Île-de-France had not developed a Romanesque tradition of its own, Suger (as he himself tells us) had to bring together artisans from many different regions for his project. Yet we must not conclude that Gothic architecture was merely a synthesis of Romanesque traits. Otherwise, we would be hard-pressed to explain the new spirit that strikes us so forcibly at St-Denis with its two key points of emphasis, geometric planning and a quest for luminosity. Suger's account of the rebuilding of his church stresses both of these features as the highest values achieved in the new structure. He believes that "harmony" (that is, the perfect relationship among parts in terms of mathematical proportions or ratios) is the source of all beauty, because it exemplifies the laws by which divine reason made the universe. Thus, it is suggested, the "miraculous" light that floods the choir through the "most sacred" windows becomes the Light Divine, a revelation of the spirit of God.

Suger was not a scholar but a man of action who was conventional in his thinking. He probably consulted the contemporary theologian Hugh of St-Victor, who was steeped in Dionysian thought (see Cultural Context: Dionysian Theology and the Abbey of St-Denis, page 204), especially for the most obscure part of his program at the west end of the church. This does not mean that Suger's own writings are simply a justification after the fact. On the contrary, he clearly knew his own mind. What, then, was he trying to achieve? For Suger, the material realm was the stepping-stone for spiritual contemplation. Thus the actual experience of dark, jewel-like light filtering through the stained-glass windows and disembodying the material world lies at the heart of Suger's mystical intent: to be transported, in his words, to "some strange region of the universe which neither exists entirely in the slime of earth nor entirely in the purity of Heaven."

Suger and the Medieval Architect The success of the choir design at St-Denis is proved not only by its inherent qualities but also by its extraordinary impact. Every visitor, it seems, was overwhelmed by the achievement, and within a few decades the new style had spread far beyond the Île-de-France. The how and why of Suger's success are a good deal more difficult to explain. They involve a controversy we have met several times before—that of form versus function. To those who take the side of functionalism, Gothic architecture was the result of advances in engineering, which made it possible to build more efficient vaults, to concentrate their thrust at a few critical points, and thus to eliminate the solid walls of the Romanesque church. Suger, they argue, was fortunate in having an architect who understood the principles of ribbed groin vaulting better than anybody else at that time. The functionalists maintain that if the abbot chose to interpret the resulting structure as symbolic of Dionysian theology, he was simply expressing his enthusiasm in the abstract language of the churchman; thus, his account does not help us to understand the origin of the new style.

As the integration of its parts suggests, the choir of St-Denis is more rationally planned and constructed than any Romanesque church. The pointed arch (which can be

"stretched" to reach any desired height regardless of the width of its base) has become an integral part of the ribbed groin vault. As a result, these vaults are no longer restricted to square or near-square compartments. They have a new flexibility that allows them to cover areas of almost any shape (such as the trapezoids and pentagons of the ambulatory). The buttressing of the vaults, too, is more fully understood than before.

How could Suger's ideas have led to these technical advances unless he had been professionally trained as an architect? Actually, architectural training in the modern sense did not exist at the time, and in any event we know that Suger had no such background. Can the abbot then claim any credit for the style of what he so proudly calls "his" new church? Oddly enough, there is no contradiction here. To the medieval mind, the overall leader of the project, not the master builder responsible for its construction, was the "architect." As Suger's account makes abundantly clear, he shared this view, which is why he remains so silent about his helper.

Perhaps this is a chicken-and-egg question. The function of a church, after all, is not merely to enclose a maximum of space with a minimum of material but also to convey the religious ideas that lie behind it. For the master who built the choir of St-Denis, the technical problems of vaulting must have been intertwined with such ideas, as well as with issues of form—beauty, harmony, and the like. As a matter of fact, the design includes elements that express function without actually performing it, for example, the slender shafts (called **responds**) that give the illusion of carrying the weight of the vaults to the church floor.

To know what concepts to convey, the medieval architect needed the guidance of religious authority. At a minimum, such guidance might be a simple directive to follow some established model. In Suger's case, however, it amounted to a more active role. It seems that he began with one master builder at the west end but was disappointed with the result and had it torn down. This fact not only shows that Suger was actively involved in the design process but also confirms his position as the architect of St-Denis in the medieval sense. Suger's views, and not simply his design preferences, no doubt guided his choice of a second master of Norman background who would translate his ideas into the kind of structure he wanted. This great artist must have been singularly responsive to the abbot's objectives. Together, they created the Gothic style. We have seen this kind of close collaboration between patron and architect before: it occurred between Djoser and Imhotep (see page 37) Perikles and Pheidias (see page 83), just as it does today.

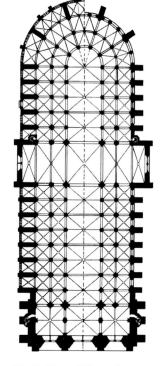

11-2 Plan of Notre-Dame, Paris. 1163–c. 1250

Constructing St-Denis Building St-Denis was an expensive and complex task that required the combined resources of Church and State. Suger used stone from quarries near Pontoise (northwest of Paris) for the ambulatory columns and lumber from the forest of Yveline for the roof. Both had to be transported by land and river over great distances, a slow and costly process. The master builder probably employed several hundred stonemasons and two or three times that many laborers. He was aided by advances in technology spurred by warfare. Especially important were better cranes powered by windlasses or treadwheels that used counterweights and double pulleys for greater efficiency. These devices were easily put up and taken down, allowing for lighter scaffolding suspended from the wall instead of resting on the ground. Such developments made possible the construction techniques that were essential to building the new rib vaults.

Notre-Dame, Paris Despite the crucial importance of St-Denis, the future of Gothic architecture lay in the towns rather than in such rural monastic communities. There had been a vigorous revival of urban life, we will recall, since the early eleventh century. This movement continued at a rapid pace, and the growth of the cities was felt not only economically and politically but in countless other ways as well. Their bishops and clergy rose to new importance, and cathedral schools and universities took the place of monasteries as centers of learning. The artistic efforts of the age culminated in the great cathedral churches.

Notre-Dame ("Our Lady," the Virgin Mary) at Paris, begun in 1163, reflects the main features of Suger's St-Denis more directly than does any other church (figs. 11-2– 11-5). The plan (fig. 11-2), with its emphasis on the long axis, is extraordinarily compact and unified compared to that of the major Romanesque churches. The double ambulatory of the choir continues directly into the aisles, and the stubby transept barely exceeds the width of the facade. The six-part nave vaults over squarish bays, although not identical with the "Siamese-twin" groin vaulting in Durham Cathedral (see fig. 10-6), continue the kind of structural experimentation that was begun by the Norman Romanesque.

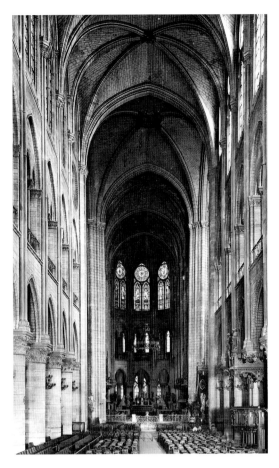

11-3 Nave and choir, Notre-Dame, Paris

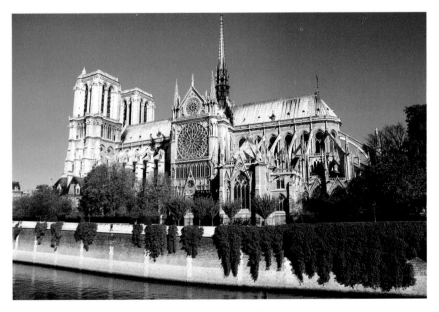

11-4 Notre-Dame, Paris (view from the southeast)

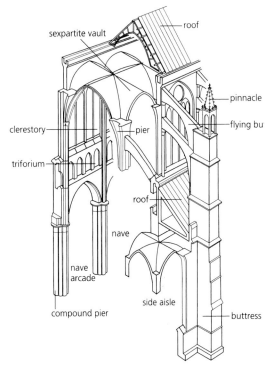

11-5 Axonometric projection of a High Gothic cathedral (after Acland)

sexpartite vault

roof

pinnacle

clerestory

pier

flying bu

triforium

roof

nave

nave
arcade

side aisle

compound pier

buttress

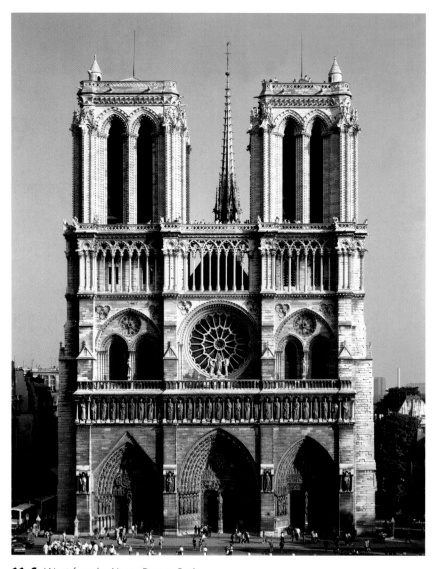

11-6 West facade, Notre-Dame, Paris

Inside (fig. 11-3) we find other echoes of the Norman Romanesque in the galleries above the inner aisles and the columns of the nave arcade. Here the pointed ribbed arches, pioneered in the western bays of the nave at Durham, are used throughout the building. Yet the large clerestory windows and the light and slender forms make the nave walls seem thin and create the weightless effect that we associate with Gothic interiors. The vertical emphasis of the interior is also Gothic. It depends less on the actual proportions of the nave—some Romanesque naves are equally tall relative to their width—than on the constant accenting of the verticals and the apparent ease with which the sense of height is attained. By contrast, Romanesque interiors (such as that in fig. 10-3) emphasize the great effort required in supporting the weight of the vaults.

In Notre-Dame, as in Suger's choir, the buttresses (the "heavy bones" of the structural skeleton) cannot be seen from the inside. (The plan shows them as massive blocks of masonry that stick out from the building like a row of teeth.) Above the aisles, these piers turn into **flying buttresses**—arched bridges that reach upward to the critical spots between the clerestory windows where the outward thrust of the nave vault is concentrated (fig. 11-4). This method of anchoring vaults, characteristic of Gothic architecture, certainly owed its origin to functional considerations (fig. 11-5). Yet even the flying buttress soon became aesthetically important. Besides actually providing support, the shape of a flying buttress could be designed so that it also expressed the *idea* of support in a variety of ways.

The most monumental aspect of the exterior of Notre-Dame is the west facade (fig. 11-6). It retains its original appearance, except for the sculpture, which was badly damaged during the French Revolution and is for the most part restored. The design reflects that of St-Denis, which was in turn derived from Norman Romanesque facades. If we compare Notre-Dame with St-Étienne at Caen (see fig. 10-5), we see that they share some basic features. These include the **pier buttresses** that reinforce the corners of the towers and divide the facade into three main parts, the placing of the portals, and the three-story arrangement. The rich sculptural

decoration, however, recalls the facades of southwestern France (see fig. 10-12) and the carved portals of Burgundy (see fig. 10-14). At the same time, the cubic solidity of the facade of St-Étienne (see fig. 10-5) has been dissolved. Lacelike arcades and huge portals and windows break down the continuity of the wall surfaces, so that the total effect of Notre-Dame's facade is that of a weightless openwork screen.

How rapidly this tendency advanced during the first half of the thirteenth century can be seen by comparing the west front of Notre-Dame with the somewhat later facade of the south transept, visible in the center of figure 11-4. In the west facade, the **rose window** (round window decorated with stained glass) in the center is still deeply recessed. As a result, the **tracery**, or ornamental stonework, that subdivides the opening is clearly set off against the surrounding wall. On the transept, we can no longer distinguish the rose window from its frame, because a network of tracery covers the entire area.

Much more important are the qualities that distinguish Notre-Dame's facade from its Romanesque ancestors. Foremost among these is the way all the details have been integrated into a coherent whole. Here the meaning of Suger's emphasis on harmony, geometric order, and proportion becomes even more evident than in St-Denis itself. The same formal discipline can be seen in the sculpture, which no longer shows the spontaneous (and often uncontrolled) growth so typical of the Romanesque. Instead, it has been assigned a precise role within the architectural framework.

Chartres Cathedral It was about 1145 when the bishop of Chartres, who befriended Abbot Suger and shared his ideas, began to rebuild his cathedral in the new style. In 1194 a fire destroyed all but the west facade, which provided the main entrance, and the east crypt. A second rebuilding was begun that year, and as the result of a huge campaign, it was largely complete within the astonishingly brief span of 26 years.

Designed one generation after the nave of Notre-Dame in Paris, the rebuilt nave (fig. 11-7) is the first masterpiece of the mature, or High Gothic, style. The openings of the pointed nave arcade are taller

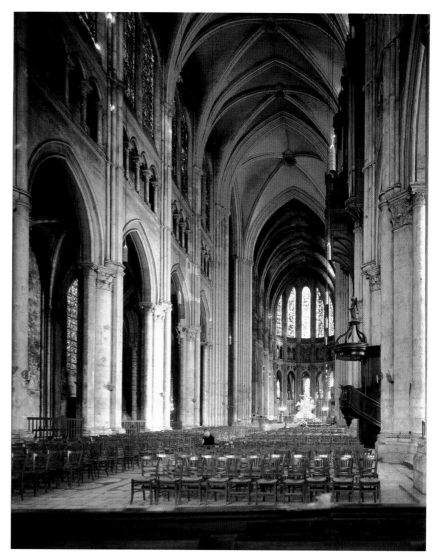

11-7 Nave and choir, Chartres Cathedral. 1145–1220

and narrower (see fig. 11-3) than in Early Gothic churches. They are joined to a clerestory of the same height by a short triforium screening the galleries, which have been reduced to a narrow wall. Responds have been added to the columnar supports to stress the continuity of the vertical lines and guide our eye upward to the quadripartite vaults, which appear as delicately formed webs stretched across the slender ribs. Because there are so few walls, the vast interior space appears at first to lack clear boundaries. The cathedral is made to seem even larger because sounds within it have a sense of being disembodied. The effect is so striking that it may well have been planned from the beginning with music in mind—both antiphonal choirs and large pipe organs had been in use for more than two centuries in some parts of Europe.

11-8 Triforium wall of the nave, Chartres Cathedral

An alternating sequence of round and octagonal piers extends down the nave toward the apse, where the liturgy is performed. Beneath the apse is the crypt, which houses Chartres's most important possession: remnants of a robe said to have been worn by the Virgin Mary, to whom the cathedral is dedicated. The relic, which miraculously survived the great fire of 1194, drew pilgrims from all over Europe. To provide room for large numbers of visitors without disturbing worshipers, there is a wide aisle running the length of the nave and around the transept. It is joined at the choir by a second aisle, forming an ambulatory that connects the apsidal chapels.

Alone among all the major Gothic cathedrals, Chartres still retains most of its more than 180 original stained-glass windows. The magic of the jewel-like light from the clerestory is unforgettable to anyone who has experienced it (fig. 11-8). The windows admit far less light than one might expect. They act mainly as diffusing filters that change the quality of daylight, giving it the poetic and symbolic values so highly praised by Abbot Suger. The sensation of ethereal light dissolves the physical solidity of the church and, hence, the distinction between the earthly and the divine realms. The "miraculous light" creates the intensely mystical experience that lies at the heart of Gothic spirituality. (The aisles are darker because the stained-glass

windows on the outer walls, though relatively large, are located at ground level, where they let in less light.)

The High Gothic style defined at Chartres reached its climax a generation later. Breathtaking height became the dominant aim, both technically and aesthetically. Skeletal construction was carried to its most precarious limits. The inner logic of the system forcefully manifested itself in the varied shapes of the vaults, taut and thin as membranes, and in the expanded window area, so that the entire wall above the nave arcade became a clerestory.

Reims Cathedral The same emphasis on verticality and translucency can be traced in the development of the High Gothic facade. The most famous of these, at Reims Cathedral (fig. 11-9), makes an instructive contrast with the west facade of Notre-Dame in Paris, even though its basic design was conceived only about 30 years later. The two share many elements (as the coronation cathedral of the kings of France, Reims was closely linked to Paris), but in the later structure they have been reshaped into a very different ensemble. The portals, instead of being recessed, project forward as porches, with triangular canopies and windows in place of tympanums above the doorways. The gallery of royal statues, which in Paris forms a horizontal band between the first and second stories, has been raised until it merges with the third-story arcade. Every detail except the rose window has become taller and narrower than before. Pinnacles everywhere accentuate the restless upward movement. The sculptural decoration, by far the most lavish of its kind (see fig. 11-19), no longer remains in clearly marked-off zones. It has now spread to so many new perches, not only on the facade but on the flanks as well, that the exterior almost seems crammed with an overabundance of compartments for statues.

Secular Architecture Because our account of medieval architecture is mainly concerned with the development of style, we have confined our attention to religious structures, the most ambitious as well as the most representative efforts of the age. Nonreligious, or secular, building reflects the same general trends, but these are often obscured by the

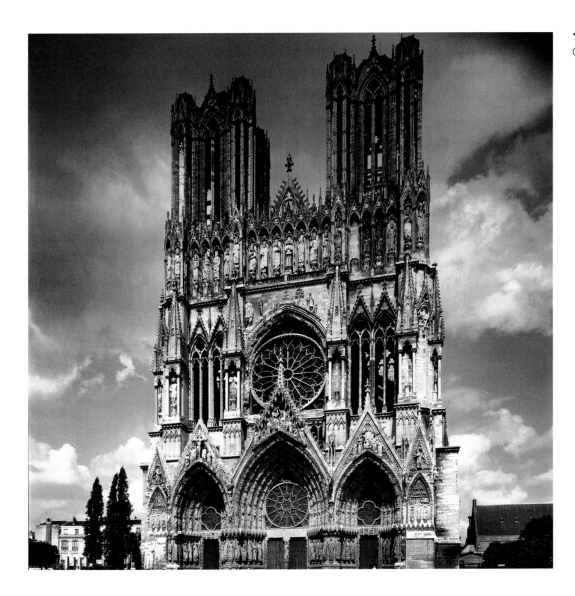

diversity of types, ranging from bridges and fortifications to royal palaces, from barns to town halls. Moreover, social, economic, and practical factors were more important here than in church design, so that the useful life of the buildings is apt to be much briefer and their chances of surviving lower. (Fortifications, for example, are often made obsolete by even minor advances in the technology of warfare.) As a result, our knowledge of secular structures of the pre-Gothic Middle Ages is fragmentary. Most of the surviving examples from Gothic times belong to the second half of the period. This fact, however, is significant in itself: nonreligious architecture, both private and public, became far more elaborate during the fourteenth and fifteenth centuries than it had been before.

The history of the Louvre in Paris provides a striking example. The original building, erected about 1200, followed the functional plan of the castles of that time. It consisted mainly of a stout tower (the donjon or keep) surrounded by a heavy wall. In the 1360s, King Charles V had a new one built as a royal residence. Although this second Louvre, too, has now disappeared, we know what it looked like from a miniature painted in the early fifteenth century (see fig. 11-38). There is still a defensive outer wall, but the structure behind it is much more like a palace than a fortress. Symmetrically laid out around a square court, it provided comfortable quarters for the royal household (note the countless chimneys), as well as lavishly decorated halls for state occasions.

International Gothic Architecture The High Gothic cathedrals of France represent a concentrated effort rarely seen before or since then. They are truly national monuments.

Their huge cost was borne by donations collected all over the country and from all classes of society. They are the tangible expression of the merging of religious and patriotic fervor that had been the goal of Abbot Suger. By the middle of the thirteenth century, this wave of enthusiasm had passed its crest. Work on the vast structures begun during the first half of the century now proceeded at a slower pace. New projects were fewer and generally far less ambitious. As a result, the highly organized teams of masons and sculptors that had formed at the sites of the great cathedrals during the preceding decades gradually broke up into smaller units.

The "royal French style of the Paris region" evoked an enthusiastic response abroad. Even more remarkable was its ability to adapt itself to a variety of local conditions. In fact, the Gothic monuments of England and Germany have become objects of intense national pride, and critics in both countries have claimed Gothic as a native style. A number of factors contributed to the rapid spread of Gothic art. Among these were the skill of French architects and stone carvers and the prestige of French centers of learning, such as the Cathedral School of Chartres and the University of Paris. Also important was the influence of the Cistercians, the reformed monastic order (see Cultural Context: Monasticism and Christian Monastic Orders, pages 190–91). Still, one wonders whether any of these explanations really go to the heart of the matter. The basic reason for the spread of Gothic art seems to have been the persuasive power of the style itself. It kindled the imagination and aroused religious feeling even among people far removed from the cultural climate of the Île-de-France.

ENGLAND

Salisbury Cathedral That England was especially receptive to the new style is not surprising. Yet the English Gothic did not grow directly from the Anglo-Norman Romanesque. Rather, it emerged from the Gothic of the Île-de-France (introduced in 1175 by the French architect who rebuilt the choir of Canterbury Cathedral) and from that of the Cis-

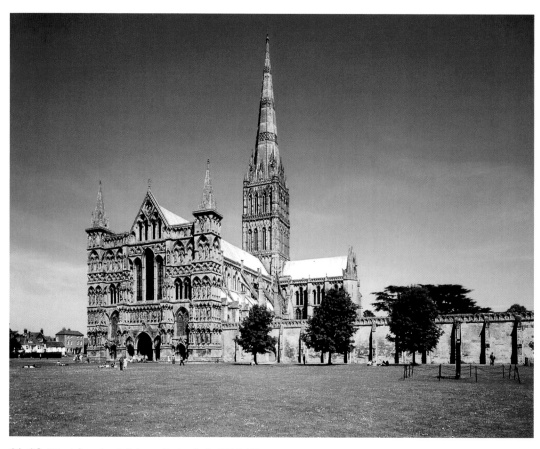

11-10 West facade, Salisbury Cathedral. 1220–70

tercians. Within less than 50 years, it developed a well-defined character of its own, known as the Early English style, which dominated the second quarter of the thirteenth century. Although there was a great deal of building activity during those decades, most of it consisted of additions to Anglo-Norman structures. Many English cathedrals had been begun about the same time as Durham (see fig. 10-6), but remained unfinished. They were now completed or enlarged. As a result, we find few churches that are designed in the Early English style throughout.

Among cathedrals, only Salisbury meets this requirement (fig. 11-10). We see immediately how different the exterior is from its counterparts in France—and how futile it would be to judge it by French Gothic standards. Compactness and verticality have given way to a long, low, sprawling look. (The crossing tower, which provides a dramatic unifying accent, was built a century later than the rest and is much taller than originally planned.) Because height is not the main goal, flying buttresses are used only as an afterthought. The west facade has become a screen wall, wider than the church itself and divided into horizontal bands of ornament and statuary, and the towers have shrunk to stubby turrets.

Gloucester Cathedral English Gothic rapidly developed toward a more pronounced verticality. The choir of Gloucester Cathedral (fig. 11-11) is a striking example of the English Late Gothic, also called the Perpendicular style. The name certainly fits, because we now find the dominant vertical accent that is absent in the Early English style. (Note the responds running in an unbroken line from the vault to the floor.) In this respect Perpendicular Gothic is much more akin to French sources, but it includes so many features we have come to know as English that it would look out of place on the Continent. The repetition of small uniform tracery panels recalls the bands of statuary on the west facade at Salisbury. The square end simulates the apses of earlier English churches, and the upward curve of the vault is as steep as in those buildings (see, for example, fig. 10-6). The ribs of the vaults, on the other hand, have taken on a new role. They have been multiplied until

they form an ornamental network that screens the boundaries between the bays and thus makes the entire vault look like one continuous surface. This effect, in turn, emphasizes the unity of the interior space. Such elaboration of the "classic" four-part vault is characteristic of the so-called Flamboyant style on the Continent as well (see page 332), but the English started it earlier and carried it to greater lengths.

GERMANY

Hall Churches In Germany, Gothic architecture took root a good deal more slowly than in England. Until the mid thirteenth century, the Romanesque tradition, with its persistent Ottonian elements, remained dominant, despite the growing acceptance of Early Gothic features. From about 1250 on, however, the High Gothic of the Île-de-France had a strong impact on the Rhineland. Especially characteristic of German Gothic is the hall church, or *Hallenkirche*. Such churches, with aisles and nave of the same height, stem from Romanesque architecture. Although also found in France, the type was favored in Germany, where its artistic possibilities were explored fully. Heiligenkreuz (Holy Cross) in Schwäbish Gmünd

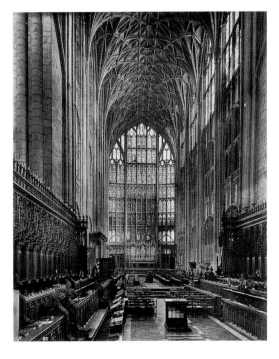

11-11 Choir, Gloucester Cathedral. 1332–57

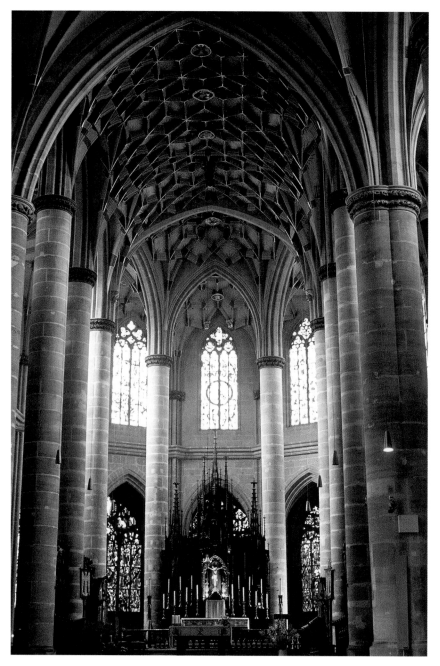

11-12 Choir, Heiligenkreuz, Schwäbish Gmünd, Germany. After 1351

(fig. 11-12) is one of many examples from central Germany. The space has a fluidity and expansiveness that enfold us as if we were standing under a huge canopy. There is no clear sense of direction to guide us. And the unbroken lines of the pillars, formed by bundles of shafts that diverge as they turn into lacy ribs covering the vaults, seem to echo the continuous movement that we feel in the space itself.

ITALY

Italian Gothic architecture stands apart from that of the rest of Europe. Judged by the stan-dards of the Île-de-France, we find it difficult to apply the term *Gothic* to these buildings. Yet the Gothic in Italy produced beautiful and impressive structures that cannot be viewed simply as continuations of the local Roman-esque. Rather, they are a blend of Gothic qual-ities and Mediterranean tradition. It was the Cistercians, rather than the cathedral builders of the Île-de-France, who provided the chief models for Italian architects. As early as the end of the twelfth century, Cistercian abbeys sprang up in both northern and central Italy, their designs patterned directly after those of the order's French monasteries.

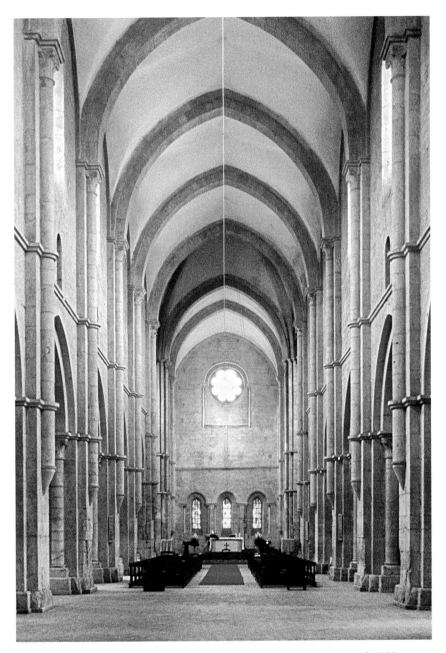

11-13 Nave and choir, Abbey Church of Fossanova, Italy. Consecrated 1208

Abbey Church, Fossanova In keeping with St. Bernard's ideals, Cistercian abbey churches were of a distinctive, severe type. Decoration of any sort was held to a minimum, and a square choir took the place of apse, ambulatory, and radiating chapels. For that very reason, however, Cistercian architects put special emphasis on harmonious proportions and exact craftsmanship. Their "anti-Romanesque" outlook (see page 194) also led them to adopt certain basic features of the Gothic style (such as the pointed arch), even though Cistercian churches remained strongly Romanesque in appearance. During the latter half of the twelfth century, as the reform movement gathered momentum, this austere Cistercian Gothic came to be known throughout western Europe.

One of the finest buildings is at Fossanova, some 60 miles south of Rome, which was consecrated in 1208 (fig. 11-13). Without knowing its location, we would be hard put to decide where to place it on a map—it might as well be Burgundian or English. The plain interior is in keeping with the ideal of austerity prescribed by St. Bernard. The finely proportioned interior resembles those of Cistercian abbeys of the French Romanesque and Gothic eras. The

groin vaults, although based on the pointed arch, have no diagonal ribs. The windows are small, and the architectural detail retains a good deal of Romanesque solidity. Still, the flavor of the whole is unmistakably Gothic.

Sta. Croce, Florence Churches such as the one at Fossanova made a deep impression upon the Franciscans, the monastic order founded by St. Francis of Assisi in the early thirteenth century (see Cultural Context: Monasticism and Christian Monastic Orders, pages 190–91). As mendicant friars dedicated to poverty, simplicity, and humil-

ity, they were the spiritual kin of St. Bernard. The severe beauty of Cistercian Gothic must have seemed to express an ideal closely related to theirs. Thus, from the first, their churches reflected Cistercian influence and were pivotal in establishing Gothic architecture in Italy.

Sta. Croce in Florence, begun about a century after Fossanova, may well claim to be the greatest of all Franciscan structures (fig. 11-14). Reputed to be by the sculptor Arnolfo di Cambio (c. 1245–1310), it is also a masterpiece of Gothic architecture, even though it has wooden ceilings instead of groin vaults, except in the choir. There

11-14 Nave and choir, Sta. Croce, Florence. Begun c. 1295

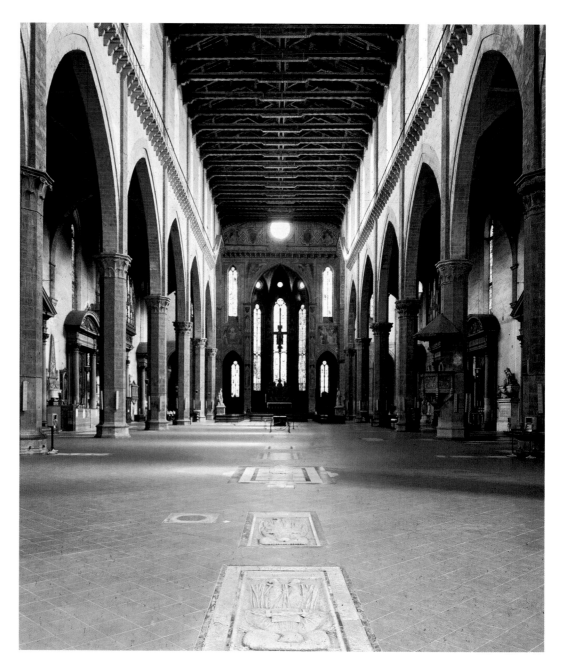

can be no doubt that this was a matter of deliberate choice, rather than of technical or economic necessity. The decision was made not simply on the basis of local practice. (Wooden ceilings had been a feature of the Tuscan Romanesque.) It may also have sprung from a desire to evoke the simplicity of Early Christian basilicas and to link Franciscan poverty with the traditions of the early Church. Because the wooden ceiling does not require buttresses, there are none. The walls thus provide continuous surfaces. Indeed, Sta. Croce owes part of its fame to its murals.

Why, then, do we speak of Sta. Croce as Gothic? Surely the use of the pointed arch is not enough to justify the term. Yet the interior creates an effect fundamentally different from that of either Early Christian or Romanesque architecture. The nave walls have the weightless, "transparent" quality we saw in Northern Gothic churches, and the dramatic massing of windows at the eastern end conveys the dominant role of light as forcefully as Abbot Suger's choir at St-Denis. Judged in terms of its emotional impact, Sta. Croce is Gothic beyond doubt. It is also profoundly Franciscan—and Florentine—in its monumental simplicity.

Sculpture

FRANCE

Abbot Suger must have attached considerable importance to the sculptural decoration of St-Denis, although his story of the rebuilding of the church does not discuss it at length. The three portals of his west facade were far larger and more richly carved than those of Norman Romanesque churches. Unhappily, the trumeau figure of St-Denis and the jamb statue-columns were removed when the central portal was enlarged in 1770–71; worse still, the heads of the remaining figures were attacked by a mob during the French Revolution (1789–1799), and the metal doors melted down. As a result of these ravages and a series of clumsy restorations undertaken during the eighteenth and nineteenth centuries, we can gain only a general view of Suger's ideas about the role of sculpture within the total context of the structure he had envisioned.

Chartres Cathedral Suger's ideas paved the way for the splendid west portals of Chartres Cathedral (fig. 11-15), which were begun about 1145 under the influence of

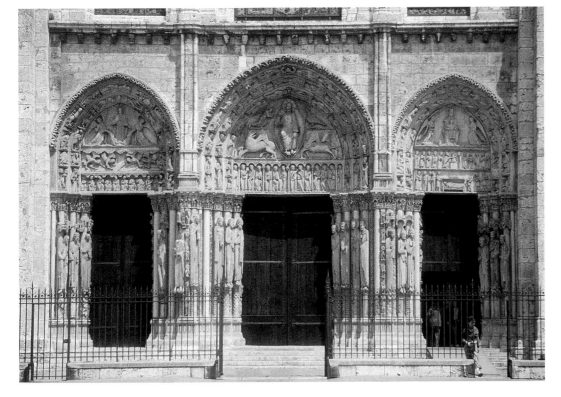

11-15 West portal, Chartres Cathedral. c. 1145–70

St-Denis, but were even more ambitious. They may well be the oldest full-fledged example of Early Gothic sculpture. The work involved several sculptors (at least three hands have been distinguished). However, only Rogerus signed his name; yet this inscription is not particularly revealing, for it does not help us to identify a recognizable artistic personality.

Comparing them with a Romanesque portal (see fig. 10-13), we are impressed with a new sense of order. It is as if all the figures, conscious of their responsibility to the architectural framework, had suddenly come to attention. The dense crowding and frantic movement of Romanesque sculpture have given way to symmetry and clarity. The fig-

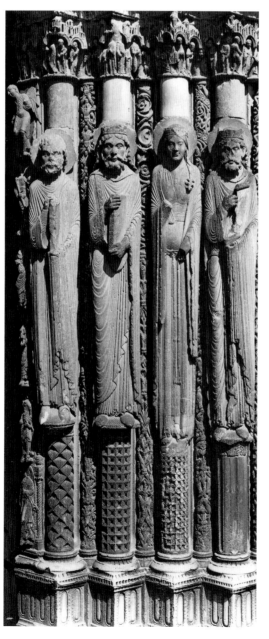

11-16 Jamb statues, west portal, Chartres Cathedral

ures on the lintels, **archivolts** (molded band framing an arch or tympanum), and tympanums are no longer entangled (see fig. 10-12), but stand out as separate entities. Consequently, when compared to earlier portals, the design does not lose its clarity or impact when viewed from a distance.

Especially striking is the novel treatment of the jambs (fig. 11-16), which are lined with tall figures attached to columns. Such figures had occurred on the jambs or trumeaux of Romanesque portals, but they were reliefs carved into or protruding from the masonry of the doorway. The Chartres jamb figures, in contrast, are essentially statues, each with its own axis. They could, in theory at least, be detached from their supports. Here, then, we witness a development of truly revolutionary importance: the first step toward the reconquest of monumental sculpture in the round since the end of classical antiquity. (Only Benedetto Antelami, we will recall, had made such an attempt during the Romanesque era; see fig. 10-16.) Apparently this step could be taken only by borrowing the cylindrical shape of the column for the human figure, with the result that these statues seem more abstract than their Romanesque predecessors. Yet they will not retain their immobility and unnatural proportions for long. The very fact that they are round gives them a stronger presence than anything in Romanesque sculpture, and their heads show a gentle, human quality that bespeaks the fundamentally realistic trend of Gothic sculpture.

Realism is, of course, a relative term whose meaning varies according to circumstances. On the Chartres west portals, it appears to spring from a reaction against the fantastic and demoniacal aspects of Romanesque art. This response may be seen in the solemn spirit of the figures and their increased physical bulk (compare the Christ of the center tympanum in fig. 11-15 with that at Autun, fig. 10-14). It also appears in the tightly woven symbolism that underlies all of the sculpted images (called a **program**). Although an understanding of the subtler aspects of this program requires a knowledge of the theology of the Chartres Cathedral School, its main elements can be readily understood.

The jamb statues form a continuous sequence linking all three portals. Together

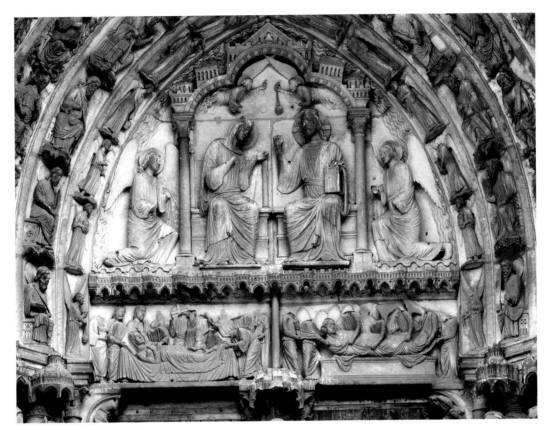

11-17 *Coronation of the Virgin* (tympanum) and *Dormition and Assumption of the Virgin* (lintel), north transept portal, Chartres Cathedral. c. 1230

they represent the prophets, kings, and queens of the Bible. Their purpose is to acclaim the rulers of France as the spiritual descendants of Old Testament royalty and to stress the harmony of spiritual and secular rule, of priests (or bishops) and kings—ideals put forward by Abbot Suger. Christ himself is enthroned above the main doorway as Judge and Ruler of the universe. He is flanked by the symbols of the four evangelists, with the apostles below and the 24 elders of the Apocalypse in the outer two archivolts. The right-hand tympanum shows Christ's incarnation: the Birth, the Presentation in the Temple, and the Infant Christ on the lap of the Virgin, who also stands for the Church. In the outer two archivolts above are representations of the liberal arts as human wisdom paying homage to the divine wisdom of Christ. Finally, in the left-hand tympanum, we see the timeless Heavenly Christ (the Christ of the Ascension) framed by the ever-repeating cycle of the year: the signs of the zodiac and their earthly counterparts, the labors of the 12 months.

When Chartres Cathedral was rebuilt after the fire of 1194, the so-called Royal Portals of the west facade must have seemed small and old-fashioned in relation to the rest of the new structure. Perhaps for that reason, the two transept facades each received three large portals preceded by deep porches. The north transept (fig. 11-17) is devoted to the Virgin. She had already appeared over the right portal of the west facade in her traditional guise as the Mother of God seated on the Throne of Divine Wisdom. Her new prominence reflects the growing importance of the cult of the Virgin, which had been actively promoted by the Church since the Romanesque period. The growth of Mariology, as it is known, was linked to a new emphasis on divine love, which was embraced by the faithful as part of the more human view that became increasingly popular during the Gothic era. The cult of the Virgin received special emphasis about 1204, when Chartres, which is dedicated to her, received the head of her mother, St. Anne, as a relic.

The north tympanum shows events associated with the Feast of the Assumption (celebrated on August 15), when Mary was transported to heaven. They are the Death (Dormition), Assumption, and Coronation of the Virgin, which, along with the Annunciation, became the most frequently depicted subjects relating to her life. The

11-22 *Roettgen Pietà.* Early fourteenth century. Wood, height 34½" (87.6 cm). Rheinisches Landesmuseum, Bonn

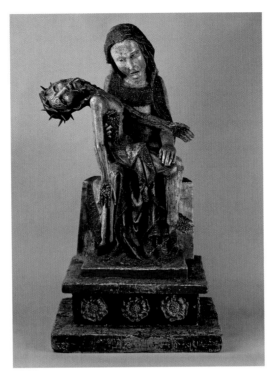

The *Roettgen Pietà* (fig. 11-22), named for the town it comes from, is carved of wood and vividly painted. Like most such groups, this large cult statue was meant to be placed on an altar. The style, like the subject, expresses the emotional fervor of an intensely religious period, which emphasized a personal relationship with God as part of the tide of mysticism that swept fourteenth-century Europe. Realism here has become purely a means of expression to enhance the work's impact. The faces convey unbearable pain and grief; the wounds are exaggerated grotesquely; and the bodies and limbs have become puppetlike in their thinness and rigidity. The purpose of the work clearly is to arouse so overwhelming a sense of horror and pity that the faithful will share in Jesus' suffering and identify their own feelings with those of the grief-stricken Mother of God. The ultimate goal of this emotional bond is a spiritual transformation that comprehends the central mystery of God in human form through compassion (which means "to suffer with").

At a glance, our Pietà would seem to have little in common with *The Virgin of Paris* (see fig. 11-20), which dates from the same period. Yet they share a lean, "deflated" quality of form and a strong emotional appeal to the viewer. Both features characterize the art of Northern Europe from the late thirteenth century to the mid fourteenth. Only after 1350 do we again find an interest in weight and volume, coupled with a renewed desire to explore tangible reality as part of a change in religious sensibility.

INTERNATIONAL STYLE SCULPTURE IN THE NORTH

Sluter The climax of the new trend toward realism came about 1400, during the period of the International Style (see pages 238–41). Its greatest representative was Claus Sluter, a sculptor of Netherlandish origin working at Dijon for Philip the Bold, the duke of Burgundy. Much of Sluter's work belongs to a category that, for lack of a better term, we will label church furniture. It includes tombs, pulpits, and the like, which combine large-scale sculpture with a small-scale architectural setting. The most impressive of these is *The Moses Well* at the Carthusian monastery near Dijon known as the Chartreuse de Champmol (fig. 11-23).

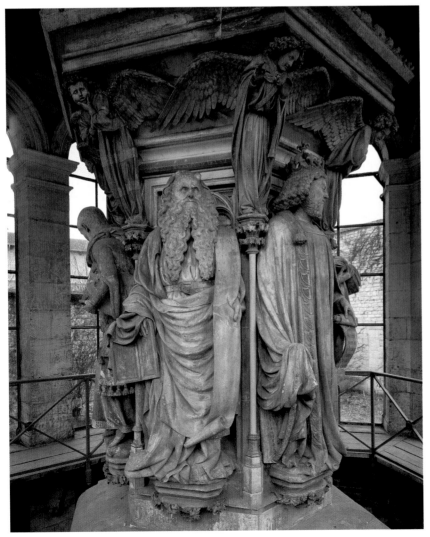

11-23 Claus Sluter. *The Moses Well.* 1395–1406. Stone, height of figures approx. 6' (1.88 m). Chartreuse de Champmol, Dijon

This symbolic well surrounded by statues of Old Testament prophets was at one time surmounted by a crucifix. Heavy draped garments envelop the majestic Moses like an ample shell. The swelling forms seem to reach out into the surrounding space as if trying to capture as much of it as possible. (Note the outward curve of the scroll, which reads: "The children of Israel do not listen to me.") The effect must have been enhanced greatly by the **polychromy** (painted color) added by the artist Jean Malouel, which has largely disappeared. At first glance, Moses seems to look forward to the Renaissance. Only when we look more closely do we realize that Sluter remains firmly tied to the Gothic.

What strikes us is the precise and masterful realism of every detail, from the particulars of the costume to the texture of the wrinkled skin. The head has all the individuality of a portrait. Nor is this impression misleading: Sluter left us two splendid examples in the heads of the duke and duchess of Burgundy on the Chartreuse portal. It is this attachment to the specific that distinguishes his realism from that of the thirteenth century.

ITALY

We have left a discussion of Italian Gothic sculpture to the last, for here, as in Gothic architecture, Italy stands apart from the rest of Europe. The earliest Gothic sculpture there was probably produced in the extreme south, in Apulia and Sicily. This region was ruled during the thirteenth century by the German emperor Frederick II, who employed Frenchmen and Germans along with native artists at his court. Few of the works Frederick sponsored have survived, but there is evidence that he favored a strongly classical style derived from the sculpture of the Chartres transept portals and the *Visitation* group at Reims (see fig. 11-19). This style not only provided a fitting visual language for a ruler who saw himself as the heir of the Caesars, it also blended easily with the classical tendencies in Italian Romanesque sculpture (see fig. 10-16).

Nicola Pisano Such was the background of Nicola Pisano (c. 1220/5–1284), who went to Tuscany from southern Italy about

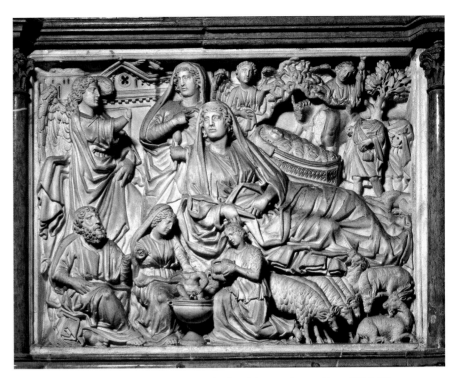

11-24 Nicola Pisano. *The Nativity.* Detail of pulpit, Baptistery, Pisa. 1259–60. Marble, 33½ × 44½" (85 × 113 cm)

1250, the year of Frederick II's death. Ten years later he completed the marble pulpit in the Baptistery of Pisa Cathedral. Pisano has been described as "the greatest—and in a sense the last—of medieval classicists." The classical flavor in reliefs such as the *Nativity* (fig. 11-24), is so strong that the Gothic elements are at first hard to detect, but they are there nonetheless. The most striking Gothic quality is the human feeling. The dense crowding of figures, however, has no counterpart in Northern Gothic sculpture. The panel also shows the Annunciation and the shepherds in the fields receiving the glad tidings of the birth of Christ. The treatment of the relief as a shallow box filled almost to the bursting point with solid, convex shapes shows that Nicola Pisano must have been thoroughly familiar with Roman and Early Christian sarcophagi (compare fig. 8-6).

Giovanni Pisano Half a century later, Nicola's son Giovanni (1245/50–after 1314), who was an equally gifted sculptor, carved a marble pulpit for Pisa Cathedral. (It has two inscriptions by the artist praising his own ability but bemoaning the hostility to his work.) This pulpit, too, includes a Nativity

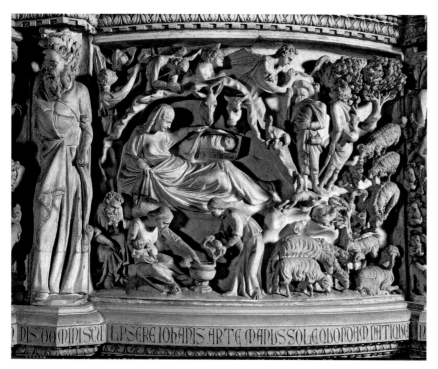

11-25 Giovanni Pisano. *The Nativity.* Detail of pulpit, Pisa Cathedral. 1302–10. Marble, 34⅜ × 43" (87.2 × 109.2 cm)

(fig. 11-25). Both panels have much in common, as we might expect, yet they also present a sharp—and instructive—contrast. Giovanni's slender, swaying figures, with their smoothly flowing draperies, recall neither classical antiquity nor the *Visitation* group at Reims. Instead, they reflect the elegant style of the royal court at Paris, which had become the standard Gothic formula during the later thirteenth century (compare fig. 11-19, left pair). And with this change came a new treatment of relief. To Giovanni Pisano, space is as important as form. The figures are no longer tightly packed together. They are now placed far enough apart to let us see the landscape setting, and each figure has its own pocket of space. Whereas Nicola's *Nativity* strikes us as a sequence of bulging, rounded masses, Giovanni's appears to be made up mainly of cavities and shadows. Giovanni Pisano, then, follows the same trend toward disembodiment that we saw north of the Alps around 1300, only he does so in a more limited way.

Tomb Sculpture Italian Gothic church facades generally did not attempt to rival those of the French cathedrals. The French Gothic portal, with its jamb statues and richly carved tympanum, never found favor in the south. Instead, we often find a survival of Romanesque traditions of architectural sculpture, such as statues in niches or small-scale reliefs on wall surfaces (see fig. 10-16). Italian Gothic sculpture excelled in the field that we have called church furniture—pulpits, screens, shrines, and tombs.

The late thirteenth century saw the development of a new kind of tomb for leaders of the Catholic church. Its origins lie in French royal tombs, but the type spread quickly to Italy. There it was given definitive form by Arnolfo di Cambio (see page 214), who had been an assistant to Nicola Pisano. A characteristic example is the elaborate tomb by an unknown sculptor in the Bardi Chapel, Sta. Croce (see fig. 11-35, foreground), which, although somewhat later, is still very much in Arnolfo's style. With its large pinnacle and three-lobed, or **trefoil**, cutout, it is like a High Gothic portal in miniature. Thus the tomb is far closer to French architecture (compare fig. 11-9) than is the church itself (see fig. 11-14). Like others of its class, it is set inside a shallow niche, so that sculpture and architecture become one. Here the traditional carved effigy figure has been replaced by a painting of the deceased rising from the grave (see page 236).

INTERNATIONAL STYLE SCULPTURE IN THE SOUTH

Ghiberti During the later fourteenth century, Italy was especially open to artistic influences from across the Alps, not only in architecture but in sculpture as well. These crosscurrents gave rise to the International Style about 1400. The outstanding representative of this style in Italian sculpture was Lorenzo Ghiberti (c. 1381–1455), a Florentine who as a youth must have had close contact with French art. We first meet him in 1401–2, when he won a competition, later described in his *Commentaries*, for a pair of richly decorated bronze doors for the Baptistery of S. Giovanni in Florence (see fig. 10-10). (It took him more than two decades to complete these doors, which fill the north portal of the building.) Each of the competing artists had to submit a trial relief, in a Gothic **quatrefoil** (four-lobed) frame, depicting the Sacrifice of Isaac.

When we enter buildings such as Chartres, the sheer mass of stained-glass windows immediately causes us to consider their spectacular overall characteristics: light, size, and color. When we begin to understand the process by which they were created, however, it is the painstaking work and detail that captures the imagination.

A window such as *Notre Dame de la Belle Verrière* (fig. 11-27) consists of hundreds of small pieces of tinted glass bound together by strips of lead. The maximum size of these pieces was limited by the methods of medieval glass manufacture. The design was not "painted on glass," rather, the window was painted *with* glass. The colored glass was produced by adding metal oxides to molten silicate. Hot iron cutting tools were used to shape or cut the individual pieces that made up a window. It was assembled in somewhat the same way as one would put together a mosaic or a jigsaw puzzle, out of odd-shaped fragments cut to fit the contours of the forms.

(See diagrams for more detail about this process.) Only the finer details, such as eyes, hair, and drapery folds, were added by painting—or drawing—in black or gray on the glass surfaces.

These windows were created at enormous expense. At Chartres, this cost was borne by a whole range of people. The largest and most complex were the rose windows, and these were financed through the patronage of the aristocracy. Lesser nobility and clergy helped with the cost of smaller windows. In the margins of these fields of colored glass we see bakers, weavers, carpenters, and other tradespeople. These scenes were once thought to represent the members of the guilds that sponsored the windows. Recent scholarship suggests that these scenes were part of the overall planned symbolic imagery of the windows. The trades people, in fact, had not yet been permitted to form guilds and contributed to the cathedral construction not through donations, but by means of an assessed time.

The stained-glass artist first drew the design on a large, flat surface, then cut pieces of colored glass to match the drawn sections.

The individual pieces of glass were enclosed by channeled strips of lead.

The lead strips between the individual glass pieces were always an important part of the design.

Ghiberti's panel (fig. 11-26) strikes us first of all with the perfection of its craftsmanship, which reflects his training as a goldsmith. The silky shimmer of the surfaces and the wealth of detail make it easy to understand why this entry was awarded the prize. If the composition seems somewhat lacking in dramatic force, that is characteristic of Ghiberti's calm, lyrical temper, which suited the taste of the period. Indeed, his figures, in their softly draped garments, have an air of courtly elegance even when they engage in acts of violence.

However much his work may owe to French influence, Ghiberti shows himself to be thoroughly Italian in one respect: his admiration for ancient sculpture, which can be seen in the beautiful nude torso of Isaac. Here he revives a tradition of classicism that had reached its highest point in Nicola

11-26 Lorenzo Ghiberti. *The Sacrifice of Isaac.* 1401–2. Gilt bronze, 21 × 17" (53.3 × 43.2 cm). Museo Nazionale del Bargello, Florence

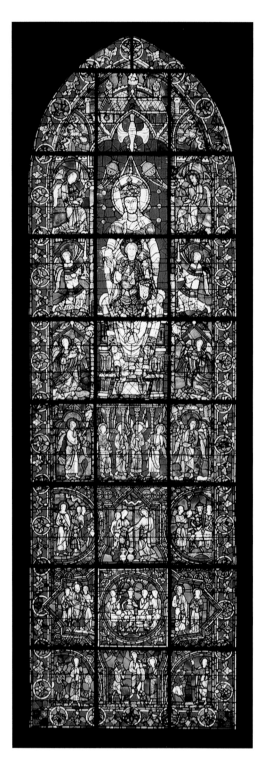

so that the angel in the upper right-hand corner seems to hover in midair. This pictorial quality relates Ghiberti's work to the painting of the International Style, where we find a similar concern with spatial depth and atmosphere (see pages 238-41). Although not a revolutionary himself, he prepares the ground for the momentous changes that will take place in Florentine art during the second decade of the fifteenth century, at the beginning of the Early Renaissance.

Painting

FRANCE

Stained Glass Although Gothic architecture and sculpture began dramatically at St-Denis and at Chartres, Gothic painting developed at a rather slow pace in its early stages. The architectural style sponsored by Abbot Suger gave birth to a new conception of monumental sculpture almost at once, but it did not demand any radical change in painting. To be sure, Suger's account of the rebuilding of his church emphasizes the miraculous effect of stained-glass windows, with their "continuous light." Stained glass was thus an integral element of Gothic architecture from the very beginning. Yet the technique of stained-glass painting had already been perfected in Romanesque times, and the style of stained-glass designs (especially single figures) sometimes remained surprisingly Romanesque for nearly another hundred years. Nevertheless, the "many masters from different regions" whom Suger assembled to execute the choir windows at St-Denis faced a larger task and a more complex pictorial program than ever before.

During the next half-century, from about 1150 to 1200, as Gothic structures became ever more skeletal and clerestory windows grew to huge size, stained glass displaced manuscript illumination as the leading form of painting. Since the production of stained glass was so closely linked with the great cathedral workshops, the designers were influenced more and more by architectural sculpture. The majestic *Notre Dame de la Belle Verrière* (fig. 11-27) at Chartres Cathedral is the finest early example of this process. The design—which still betrays its Byzantine ancestry (see fig. 8-14)—recalls the relief on the west portal of the church (see fig. 11-15, right hand door)

Pisano but had gradually died out during the fourteenth century. But Ghiberti is also the heir of Giovanni Pisano. In Giovanni's *Nativity* panel (see fig. 11-25) we noted a new emphasis on the spatial setting. Ghiberti's trial relief carries this tendency a good deal further and achieves a far more natural sense of recession. For the first time since classical antiquity, we experience the background of the panel not as a flat surface but as empty space from which the sculpted forms emerge,

but lacks its sculptural qualities. Instead, the stained glass dissolves the group into a weightless mass that hovers effortlessly in indeterminate space.

The stained-glass workers who filled the windows of the great Gothic cathedrals had to face difficulties arising from the enormous scale of their work. No Romanesque painter had ever been called upon to cover areas so vast or so firmly bound into an architectural framework. The task required a degree of orderly planning that had no precedent in medieval painting. Only architects and stonemasons knew how to deal with this problem, and it was their methods that the stained-glass workers borrowed in mapping out their own designs. As we recall from our discussion of the apse of St-Denis (see pages 202-03), Gothic architectural design uses a system of geometric relationships to establish numerical harmony. The same rules could be used to control the design of stained-glass windows or even of an individual figure.

The period 1200–1250 might be termed the golden age of stained glass. After that, as architectural activity declined and the demand for stained glass began to slacken, manuscript illumination gradually regained its former position of leadership. By then, however, miniature painting had been thoroughly influenced by both stained glass and stone sculpture, the artistic pacemakers of the first half of the century.

Illuminated Manuscripts The change of style can be seen in figure 11-28, from a Psalter done about 1260 for King Louis IX (St. Louis) of France. The scene illustrates I Samuel 11:2, in which Nahash the Ammonite threatens the Jews at Jabesh. We first notice the careful symmetry of the framework, with its flat, ornamented panels. Equally symmetrical is the architectural setting, which is remarkably similar to the choir screen by the Naumburg Master (see fig. 11-21).

Against this two-dimensional background, the figures stand out in relief by their smooth and skillful modeling. But their sculptural quality stops short at the outer contours, which are defined by heavy, dark lines rather like the lead strips in stained-glass windows. The figures themselves show all the features of the elegant style originated about 20 years earlier by the sculptors of the royal court: graceful gestures, swaying poses,

11-28 *Nahash the Ammonite Threatening the Jews at Jabesh,* from the *Psalter of St. Louis.* c. 1260. 5 × 3¹/₂″ (12.7 × 8.9 cm). Bibliothèque Nationale, Paris

smiling faces, and neatly waved strands of hair (compare *The Virgin of Paris,* fig. 11-20). Our miniature thus exemplifies the subtle and refined taste that made the court art of Paris the standard for all Europe. Of the expressive energy of Romanesque painting, we find not a trace (see fig. 10-19).

ITALY

Italian painting at the end of the thirteenth century produced an outpouring of creative energy as spectacular, and as far-reaching in its impact on the future, as the rise of the Gothic cathedral in France. As we inquire into the conditions that made it possible, we find that it arose from the same "old-fashioned" attitudes we met in Italian Gothic architecture and sculpture.

Medieval Italy, although strongly influenced by Northern art from Carolingian times on, had maintained contact with Byzantine civilization. As a result, panel painting, mosaic, and murals—mediums that had never taken firm root north of the Alps—were kept alive on Italian soil, though barely. Indeed, a new wave of influences from Byzantine art, which enjoyed a resurgence during the thirteenth century, overwhelmed the Romanesque elements in Italian painting at the very time when stained glass became the dominant pictorial medium in France.

There is a certain irony in the fact that this neo-Byzantine style appeared soon after the conquest of Constantinople by the armies of the Fourth Crusade in 1204. (One thinks of the way Greek art had once captured the taste of the Romans.) Pisa, whose navy made it a power in the eastern Mediterranean, was the first to develop a school of painting based on this "Greek manner," as the Italians called it. In some cases it was transplanted by Byzantine artists who had fled Constantinople during the Crusades. The painter and biographer, Giorgio Vasari (1511–1574), wrote that in the mid-thirteenth century, "Some Greek painters were summoned to Florence by the government of the city for no other purpose than the revival of painting in their midst, since that art was not so much debased as altogether lost."

There may be more truth to this statement than is often acknowledged. Byzantine art had preserved the tradition of Early Christian narrative scenes virtually intact. When transmitted back to the West, the result was an explosion of subjects and designs that essentially had been lost for nearly 700 years. Many of them, of course, had been visible all along in the mosaics of Rome and Ravenna. There had also been successive waves of Byzantine influence throughout the early Middle Ages and the Romanesque period. Nevertheless, these sources lay dormant, so to speak, until interest in them was reawakened through closer relations with Constantinople, which enabled Italian painters to absorb Byzantine art far more thoroughly than ever before. During this same period, we recall, Italian architects and sculptors took a different course: untouched by the Greek manner, they were assimilating the Gothic style. Eventually, toward 1300, Gothic influence spilled over into painting as well, and its

interaction with the neo-Byzantine produced the revolutionary new style.

Duccio The most important painter in the Greek manner was Duccio (Duccio di Buoninsegna, c. 1255–before 1319), of Siena. The back of his great altarpiece for Siena Cathedral, the *Maestà* (Majesty), includes numerous small panels with scenes from the lives of Jesus and the Virgin. Among these, the most mature works of Duccio's career, is *Christ Entering Jerusalem* (fig. 11-29). The composition, which goes back to Early Christian times (see fig. 8-6), is based directly on a Byzantine example that was fully developed by the late tenth century. In Duccio's hands, the Greek manner has become unfrozen. The rigid, angular draperies have given way to an undulating softness. The abstract shading-in-reverse with lines of gold is kept to a minimum (see fig. 8-18). The bodies, faces, and hands are beginning to swell with three-dimensional life. Clearly, the heritage of Graeco-Roman illusionism that had always been part of the Byzantine tradition, however submerged, is asserting itself once more. But there is also a half-hidden Gothic element here. We sense it in the fluency of the drapery, the appealing naturalness of the figures, and the tender glances by which they communicate with one another. The chief source of this Gothic influence must have been Giovanni Pisano (see page 223–24), who was in Siena from 1285 to 1295 as the sculptor-architect in charge of the cathedral facade.

Here, the cross-fertilization of Gothic and Byzantine elements has given rise to a development of fundamental importance: a new kind of picture space. In *Christ Entering Jerusalem*, the architecture has a space-creating function. Ancient painters and their Byzantine successors had been unable to achieve such a space. Their architectural settings always stay behind the figures, so that their indoor scenes tend to look as if they were taking place in an open-air theater, on a stage without a roof. Duccio's figures, in contrast, inhabit a space that is created and defined by the architecture. Northern Gothic painters, too, had tried to produce architectural settings, but they could do so only by flattening them out completely (as in the *Psalter of St. Louis*, fig. 11-28).

Because they were trained in the Greek manner, the Italian painters of Duccio's

generation learned enough of the devices of Graeco-Roman illusionism (see fig. 7-19) to let them render such an architectural framework without draining it of three-dimensionality. Duccio, however, is not interested simply in space for its own sake. The architecture is used to integrate the figures within the drama more convincingly than ever before. The diagonal movement into depth is conveyed not by the figures, which have the same scale throughout, but by the walls on either side of the road leading to the city, by the gate that frames the welcoming crowd, and by the structures beyond. Whatever the shortcomings of Duccio's perspective, his architecture is able to contain and enclose. For that reason, it seems more understandable than similar views in ancient or Byzantine art (compare figs. 7-20 and 8-15).

Giotto In Giotto (Giotto di Bondone, 1267–1336/7) we meet an artist of far bolder and more dramatic temper. Ten to 15 years younger than Duccio, Giotto was by instinct a wall painter rather than a panel painter. Thus he was less close to the Greek manner from the start, despite his probable apprenticeship under another painter in the Greek manner, Cimabue. The art of Giotto is so daringly original that its sources are far more difficult to trace than those of Duccio's style. Apart from his knowledge of the Greek manner, the young Giotto seems to have been familiar with the work of the neo-Byzantine masters of Rome. In Rome, too, Giotto must have become acquainted with Early Christian and ancient Roman mural painting. Classical sculpture likewise seems to have left an impression on him. More fundamental, however, was the influence of late medieval Italian sculptors, especially Nicola and Giovanni Pisano. It was through them that Giotto came in contact with Northern Gothic art. The latter remains the most important of all the elements that entered into Giotto's style. Indeed, Northern works such as those in figure 11-18 and figure 11-21 are almost certainly the ultimate source of the emotional quality in his work.

Of Giotto's surviving murals, those in the Arena Chapel in Padua, painted in 1305–6, are the best preserved as well as the most characteristic. Devoted mainly to events from the life of Christ, they are arranged in three tiers of

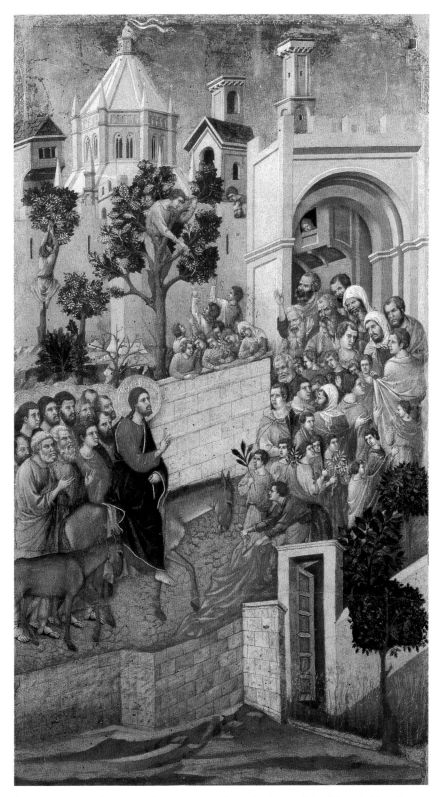

11-29 Duccio. *Christ Entering Jerusalem,* from the back of the *Maestà Altarpiece.* 1308–11. Tempera on panel, 40½ × 21⅛" (103 × 53.7 cm). Museo dell'Opera del Duomo, Siena

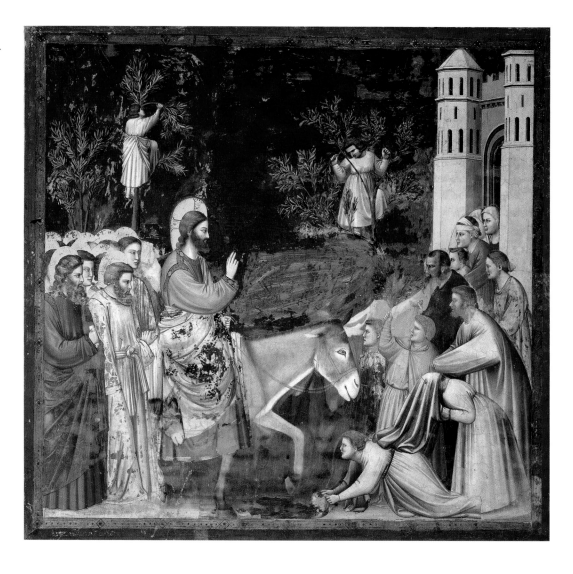

11-30 Giotto. *Christ Entering Jerusalem.* 1305–6. Fresco in the Arena (Scrovegni) Chapel, Padua

Italian painting of the thirteenth and fourteenth century was dominated by fresco and tempera. FRESCO is a wall painting technique that was known in antiquity. Pigment is mixed with water and applied to a surface of wet plaster. The pigment bonds permanently with the plaster. The TEMPERA used in Italy at this period was a mixture of pigment and an emulsion of egg yolk and water. It was applied to wood panels which were first prepared with a coat of gesso (ground plaster or chalk and glue) and underpainted in green or brown.

narrative scenes that culminate in a Last Judgment at the west end of the chapel. Giotto depicts many of the same subjects that we find on the reverse of Duccio's *Maestà,* including *Christ Entering Jerusalem* (fig. 11-30). But while Duccio has enriched the traditional scheme, spatially as well as narratively, Giotto simplifies it. The two versions have much in common, because both ultimately derive from Byzantine sources. Giotto's painting, however, suggests the example of Byzantine mosaics done on Italian soil during the twelfth century. The action proceeds parallel to the **picture plane.** (The picture plane is the theoretical plane suggested by the actual surface of a painting, drawing, or relief.) Landscape, architecture, and figures have been reduced to a minimum. The austerity of Giotto's art is emphasized by the sober medium of FRESCO painting, with its limited range and intensity of tones. By contrast, Duccio's picture, which is executed in egg TEMPERA on gold ground, has a jewel-like brilliance and sparkling colors.

Yet Giotto's work has far more impact: it makes us feel so close to the event that we have a sense of being direct participants rather than distant observers.

How does the artist achieve this extraordinary effect? He does so, first of all, by having the entire scene take place in the foreground. Even more important, he presents it in such a way that the viewer's eye level falls within the lower half of the picture. Thus we can imagine ourselves standing on the same surface, or **ground plane,** as the figures, even though we actually see them from well below. In contrast, Duccio makes us survey the scene from above in "bird's-eye" perspective. The effects of Giotto's choice of viewpoint are far-reaching. *Choice* implies conscious awareness—in this case, awareness of a relationship in space between the beholder and the picture. Duccio does not yet treat his picture space as continuous with the viewer's, and so we have the feeling of floating above the scene. With the notable exception of the Villa of the

Mysteries (see fig. 7-23), ancient painting rarely tells us where we stand as Giotto does. Above all, he gives his forms such a strong three-dimensional reality that they seem as solid and tangible as sculpture in the round.

Giotto uses the figures, not the architecture and landscape, to create the picture space. As a result, his space is more limited than Duccio's. Its depth extends no further than the combined volumes of the overlapping bodies in the picture—but within its limits it is much more persuasive. To Giotto's contemporaries, the tactile quality of his art must have seemed a near-miracle. It was this quality that made them praise him as equal, or even superior, to the greatest of the ancient painters. His forms looked so lifelike that they could be mistaken for reality itself. Equally significant are the stories linking Giotto with the claim that painting is superior to sculpture. This was not an idle boast, as it turned out, for Giotto does indeed mark the start of what might be called the era of painting in Western art. The symbolic turning point is the year 1334, when he was appointed head of the Florence Cathedral workshop, an honor that until then had been reserved for architects or sculptors.

Giotto's aim was not simply to transplant Gothic statuary into painting. By creating a radically new kind of picture space, he had also sharpened his awareness of the picture surface. When we look at a work by Duccio (or his ancient and medieval predecessors), we tend to do so in installments, as it were. Our glance travels from detail to detail until we have surveyed the entire area. Giotto, on the contrary, invites us to see the whole at one glance. His large, simple forms, the strong grouping of his figures, and the limited depth of his "stage" give his scenes an inner coherence never found before. Notice how dramatically the massed verticals of the "block" of apostles on the left are contrasted with the upward slope formed by the welcoming crowd on the right, and how Jesus, alone in the center, bridges the gulf between the two groups. The more we study the composition, the more we come to realize its majestic firmness and clarity. Thus the artist has rephrased the traditional pattern of Christ's Entry into Jerusalem to stress the solemnity of the event as the triumphal procession of the Prince of Peace.

Giotto's achievement as a master of design does not fully emerge from any single work. Only if we examine a number of scenes from the Arena fresco cycle do we see how closely each composition is attuned to the emotional content of the subject. *The Lamentation* (fig. 11-31) was clearly inspired

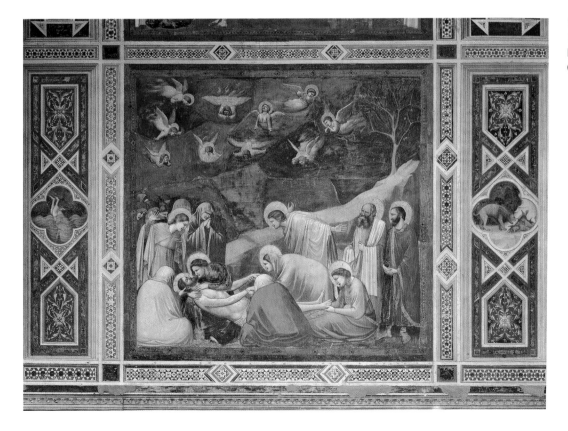

11-31 Giotto. *The Lamentation*. 1305–6. Fresco in the Arena (Scrovegni) Chapel, Padua

by a Byzantine example similar to the Nerezi fresco (see fig. 8-17), which was known in Italy early on. The differences, however, are as important as the similarities. In its muted expression this *Lamentation* is closer to the Gothic *Death of the Virgin* on Strasbourg Cathedral (see fig. 11-18) than it is to the anguish conveyed so vividly by the Byzantine painter. The tragic mood, found also in religious texts of the era, is brought home to us by the formal rhythm of the design as much as by the gestures and expressions of the participants. The low center of gravity and the hunched figures convey the somber quality of the scene and arouse our compassion even before we have grasped the meaning of the event. With extraordinary boldness, Giotto sets off the frozen grief of the human mourners against the frantic movement of the weeping angels among the clouds. It is as if the figures on the ground were restrained by their obligation to maintain the stability of the composition, whereas the angels, small and weightless as birds, do not share this duty.

Once again the impact of the drama is heightened by the simple setting. The descending slope of the hill acts as a unifying element. At the same time, it directs our glance toward the heads of Christ and the Virgin, which are the focal point of the scene. Even the tree has a twin function. Its barrenness and isolation suggest that all of nature shares in the sorrow over the Savior's death. Yet it also carries a more precise symbolic message: it alludes (as does DANTE in a passage in *The Divine Comedy*) to the Tree of Knowledge, which the sin of Adam and Eve had caused to wither and which was to be restored to life through the sacrificial death of Christ.

Simone Martini Few artists in the history of art equal Giotto as an innovator. His very greatness, however, tended to dwarf the next generation of Florentine painters. Their contemporaries in Siena were more fortunate in this respect, because Duccio never had the same overpowering impact. As a result, it was they, not the Florentines, who took the next decisive step in the development of Italian Gothic painting. Perhaps the most distinguished of Duccio's disciples was Simone Martini (c. 1284–1344), who spent the last years of his life in Avignon, the town in southern France that served as the residence of the popes during most of the fourteenth century.

The Road to Calvary (fig. 11-32), originally part of a small altar, was probably painted in Avignon about 1340, as it was commissioned by Philip the Bold of Burgundy for the Chartreuse de Champmol. In its sparkling colors, and especially in its architectural background, the panel still echoes the art of Duccio (compare fig. 11-29). However, the vigorous modeling of the figures, as well as their dramatic gestures and expressions, shows the influence of Giotto. Although Simone Martini is little concerned with spatial clarity, he is an acute observer. The sheer variety of costumes and physical types and the wealth of human activity provide a sense of down-to-earth reality very different from both the lyricism of Duccio and the grandeur of Giotto.

Pietro and Ambrogio Lorenzetti This closeness to everyday life also can be seen in the work of the brothers Pietro and Ambrogio Lorenzetti (both died 1348). But it appears on a more monumental scale and is coupled with a keen interest in problems of space. The boldest spatial experiment is Pietro's *Birth of the Virgin* (fig. 11-33). In this triptych of 1342, the painted architecture has been related so closely to the real architecture of the frame that the two are seen as a single system. Moreover, the chamber where the birth takes place occupies two panels and continues unbroken behind the column that divides the center from the right wing. The left wing represents an anteroom, which leads to a large and only partially seen space that suggests the interior of a Gothic church.

What Pietro Lorenzetti achieved here is the outcome of a development that began three decades earlier in the work of Duccio. The painting surface takes on the quality of a transparent window through which—not on which—we perceive the same kind of space we know from daily experience. Duccio's work alone does not explain Pietro's astonishing breakthrough. His achievement became possible, rather, through a combination of the architectural picture space of Duccio and the sculptural picture space of Giotto.

The same approach enabled Ambrogio Lorenzetti to unfold a view of the entire

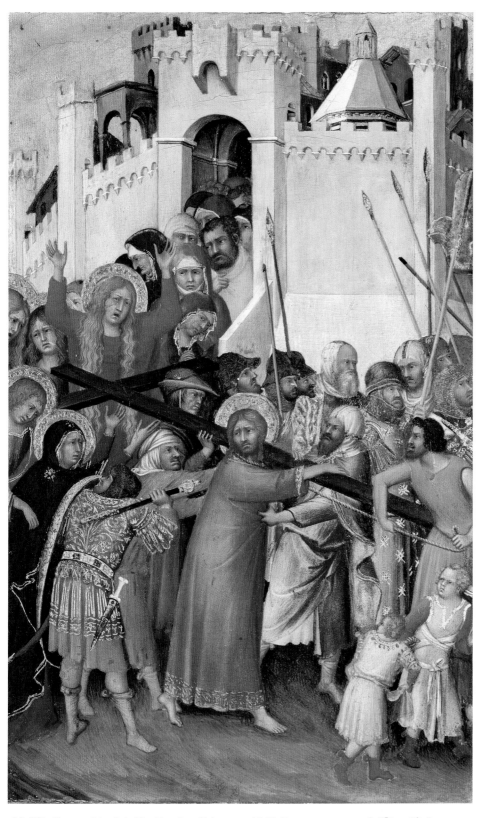

11-32 Simone Martini. *The Road to Calvary.* c. 1340. Tempera on panel, 9⅞ × 6⅛″ (25 × 15.5 cm). Musée du Louvre, Paris

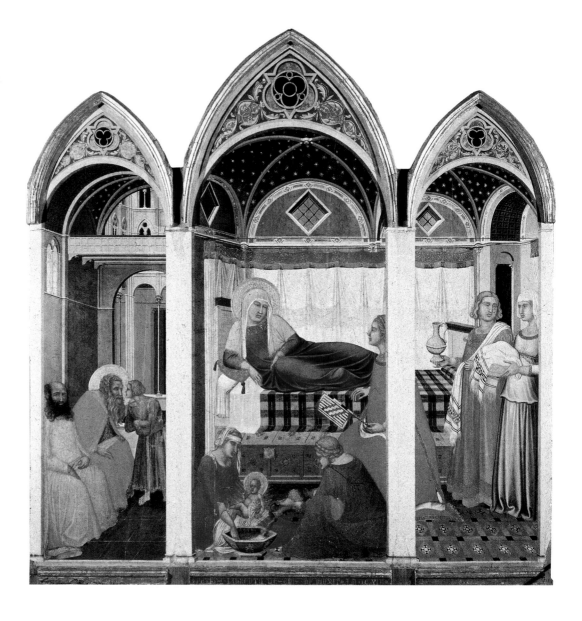

11-33 Pietro Lorenzetti. *Birth of the Virgin.* 1342. Tempera on panel, 6′1¹/₂″ × 5′11¹/₂″ (1.88 × 1.82 m). Museo dell'Opera del Duomo, Siena

town before our eyes in his frescoes of 1338–40 in the Siena city hall (fig. 11-34). We are struck by the distance that separates this precise "portrait" of Siena from Duccio's Jerusalem (see fig. 11-29). Ambrogio's mural is part of an allegorical program depicting the contrast of good and bad government. For example, the inscription under *Good Government* praises Justice and the many benefits that derive from her. To the right on the far wall we see the Commune of Siena guided by Faith, Hope, and Charity and flanked by a host of other symbolic figures. To show the life of a well-ordered city-state, the artist had to fill the streets and houses of *Good Government in the City* with teeming activity. The bustling crowd gives the architectural vista its striking reality by introducing the human scale. On the right, outside the city walls, the other *Good Government* fresco provides a view of the Sienese countryside (not visible in fig. 11-34), fringed by distant mountains—the first true landscape since ancient Roman times.

The Black Death The first four decades of the fourteenth century in Florence and Siena had been a period of political stability and economic expansion, as well as of great artistic achievement. In the 1340s both cities suffered a series of catastrophes whose echoes were to be felt for many years. Banks and merchants went bankrupt by the score in both cities, internal upheavals shook the governments, and there were repeated crop failures. Then, in 1348, the epidemic of bubonic plague—the Black Death—that swept Europe wiped out more than half the population of the two cities. The plague was spread by hungry, flea-infested rats that

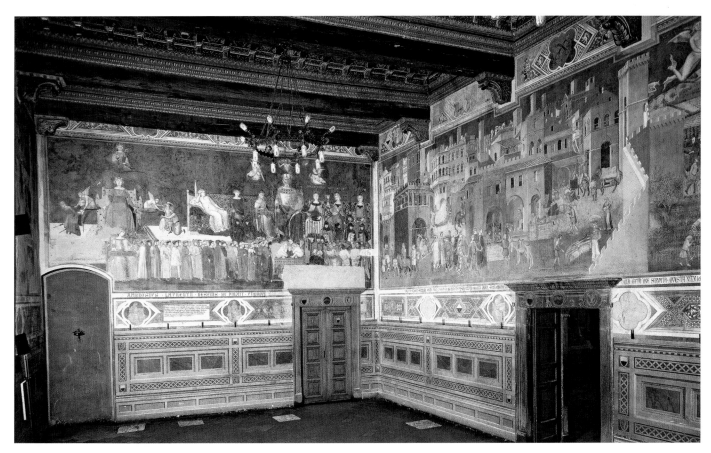

11-34 Ambrogio Lorenzetti. *The Commune of Siena* (left), *Good Government in the City,* and portion of *Good Government in the Country* (right). 1338–40. Frescoes in the Sala della Pace, Palazzo Pubblico, Siena

swarmed into cities from the barren countryside in search of food. This was simply the most spectacular outbreak, which continued almost unabated in northern Italy until the end of the fifteenth century and broke out eight times again in Florence. Still, by 1400 stability had been restored throughout most of the peninsula. As a result of the 1348 epidemic, there was a severe decline in the ranks of painters and sculptors (including Pietro and Ambrogio Lorenzetti, both of whom, it seems, died in 1348). Those artists who survived found it difficult to make a living.

Popular reactions to these events were mixed. Many people saw them as signs of divine wrath, warnings to a sinful humanity to forsake the pleasures of this earth. In such people the Black Death aroused a mood of otherworldly exaltation. To others, such as the merry company in BOCCACCIO'S *Decameron*, the fear of death intensified the desire to enjoy life while there was still time.

Maso di Banco, Taddeo Gaddi The artists who reached maturity around 1340

were not as innovative as the earlier painters we have discussed, but neither were they blind followers. At their best, they expressed the somber mood of the time with memorable intensity. The heritage of Giotto can be seen in the tombs made about this time for members of the Bardi family, leading bankers of Florence. The tombs are located in Sta. Croce, Florence, and were painted by two of Giotto's foremost pupils (fig. 11-35). The larger of the two, probably by Maso di Banco (active 1341–46), shows the dead man rising from his marble sarcophagus to receive a personal Last Judgment from the risen Christ. The scene, with its eerie landscape and majestic Jesus, retains some of Giotto's grandeur without being simply derivative (compare fig. 11-30). The ensemble is among the first to combine painting and sculpture. The result is a mixture of temporal and visionary reality that expresses the hope—indeed, the expectation—of salvation and life after death.

The same theme is repeated in the tomb to the right by Taddeo Gaddi (1295/1300–1366).

Giovanni BOCCACCIO (1313–1375) began his career as an author in Naples but moved in 1341 to Florence, where he became a friend of the poet and humanist, Petrarch. A diplomat and scholar of the "new learning," Boccaccio wrote his classic, *The Decameron*, from 1348 to 1353. This collection of 100 witty and sometimes bawdy tales greatly influenced later writers such as Geoffrey Chaucer, William Shakespeare, and John Keats.

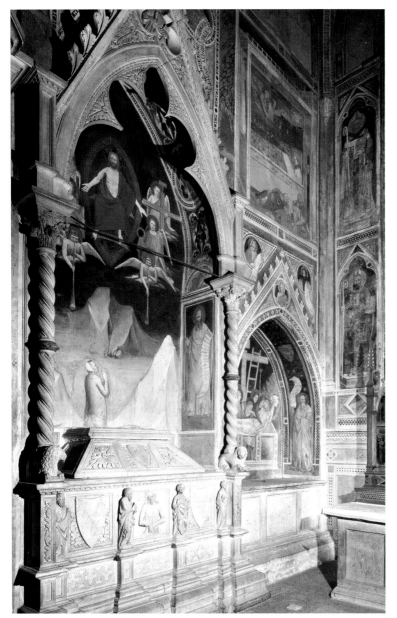

11-35 Maso di Banco (attributed to) (left) and Taddeo Gaddi (right). Tombs of members of the Bardi family. c. 1335–45 and c. 1335–41. Bardi di Vernio Chapel, Sta. Croce, Florence

The deceased is painted on the side of the sarcophagus receiving the body of Jesus above her own sepulchre. The message is clear: by bearing witness to the Entombment, she shall rise again, just as Christ did. This tomb, like the other, incorporates the image, widespread at the time, of Jesus as the Man of Sorrows, whose suffering redeems humanity's sins and offers the promise of eternal life. Despite the debt to Giotto's *Lamentation* (see fig. 11-31), Taddeo has begun to feel the influence of the Lorenzetti, which was soon seen in the work of Maso and other Florentine artists as well.

PAINTING NORTH OF THE ALPS

What happened to Gothic painting north of the Alps during the latter half of the fourteenth century was determined in large part by the influence of the great Italians. Sometimes this influence was transmitted by Italian artists who were active on Northern soil. An example is Simone Martini, who worked at the palace of the popes near Avignon.

One gateway of Italian influence was the city of Prague, the capital of Bohemia, thanks to Emperor Charles IV (1316–1378), the most remarkable ruler since Charlemagne. Charles had received an excellent education in Paris at the French court. He returned to Prague and in 1346 succeeded his father as king of Bohemia. With the support and intervention of Pope Clement VI, Charles was named Holy Roman Emperor by the German Electors at Aachen in 1349. This title was confirmed by coronations in Milan and Rome six years later. Like Charlemagne before him, Charles wanted to make his capital a center of learning. In 1348 he established a university along the lines of that in Paris, which attracted many of the best minds from throughout Europe. He also became a patron of the arts and founded an artists' guild. Prague soon became a cultural center second only to Paris itself. Charles was also impressed by the art he saw during his two visits to Italy. (He is known to have commissioned works by several Italian painters.) It therefore is not surprising that the *Death of the Virgin* (fig. 11-36), done by a Bohemian master about 1355–60, brings to mind the works of the great Sienese painters. The carefully defined architectural interior shows its descent from such works as Pietro Lorenzetti's *Birth of the Virgin* (see fig. 11-33), but it lacks the spaciousness of its Italian models. Also Italian is the vigorous modeling of the heads and the overlapping of the figures, which reinforces the three-dimensional quality of the design but raises the awkward question of what to do with the halos. Finally, the rich color recalls that of Simone Martini (see fig. 11-32). Still, the Bohemian master's picture is not just an echo of Italian painting. The gestures and facial expressions convey a restrained, yet intense emotion that represents the finest heritage of Northern Gothic art. In this

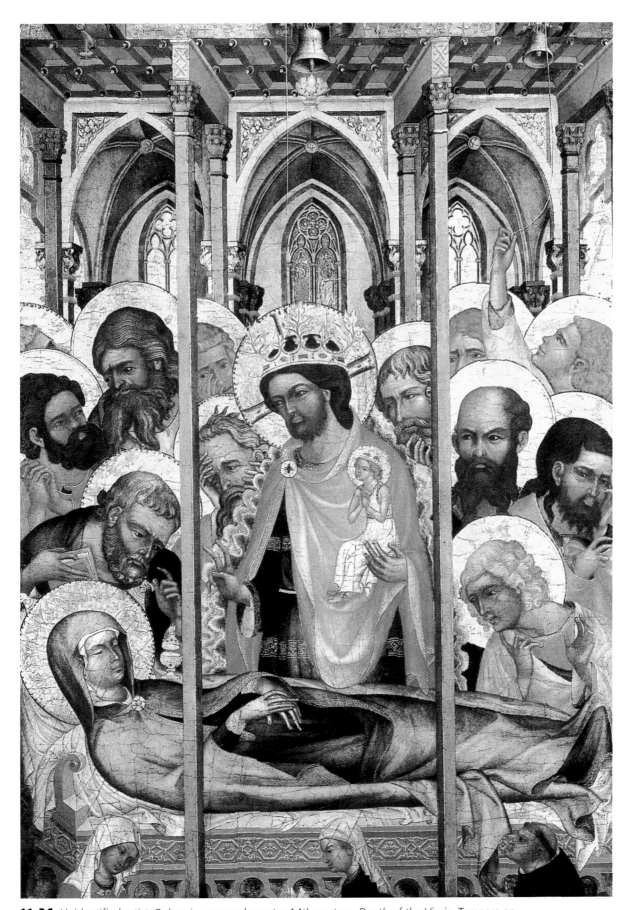

11-36 Unidentified artist, Bohemian, second quarter 14th century, *Death of the Virgin.* Tempera on panel, 39⅜ × 28" (100 × 71.1 cm). Museum of Fine Arts, Boston

William Francis Warden Fund; Seth K. Sweetser Fund, The Henry C. and Martha B. Angell Collection, Juliana Cheney Edwards Collection. Gift of Martin Brimmer, and Gift of Reverend and Mrs. Frederick Frothingham; by exchange 50.2716

Photograph © 2004 Museum of Fine Arts, Boston

respect, our panel is far more akin to the *Death of the Virgin* at Strasbourg Cathedral (see fig. 11-18) than to any Italian work except Giotto's, which shares the same characteristic (compare fig. 11-31).

INTERNATIONAL STYLE PAINTING

Broederlam Around 1400 the merging of Northern and Italian traditions gave rise to a single dominant style throughout western Europe. This International Style was not confined to painting—we have used the same term for the sculpture of the period—but painters clearly were the major force in its development. Among the most important was Melchior Broederlam (active c. 1387–1409), a Fleming who worked for the court of the duke of Burgundy in Dijon, where he would have known Simone Martini's *Road to Calvary* (see fig. 11-32). Figure 11-37 shows the panels of a pair of shutters for an altar shrine that Broederlam painted in 1394–99 for the Chartreuse de Champmol. (The interior consists of an elaborately carved relief by Jacques de Baerze showing the Adoration of the Magi, the Crucifixion, and the Entombment.) Each wing is really two pictures within one frame. Landscape and architecture stand abruptly side by side, even though the artist has tried to suggest that the scene extends around the building.

Compared with paintings by Pietro and Ambrogio Lorenzetti, Broederlam's picture space seems naive in many ways. The architecture looks like a doll's house, although it is derived from Duccio (see fig. 11-29) and the Lorenzettis (see figs. 11-33 and 11-34), whereas the details of the landscape, which remind us of the background in Ghiberti's trial relief (see fig. 11-26), are out of scale with the figures. Yet the panels convey a far stronger feeling of depth than we have found in any previous Northern work, thanks to the subtlety of the modeling. The softly rounded shapes and the dark, velvety shadows create a sense of light and air that more than makes up for any shortcomings of scale or perspective. This soft, pictorial quality is a hallmark of the International

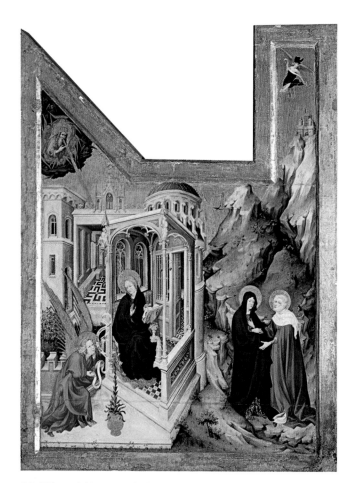
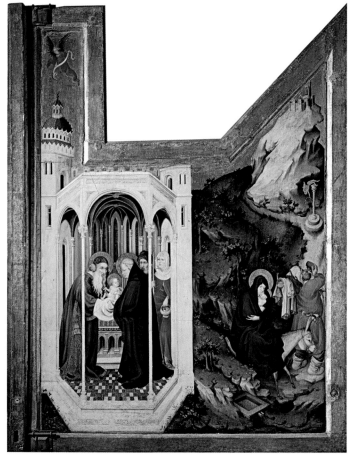

11-37 Melchior Broederlam. *Annunciation and Visitation; Presentation in the Temple and Flight into Egypt.* 1394–99. Tempera on panel, each 65 × 49¼" (167 × 125 cm). Musée des Beaux-Arts, Dijon

Style. It appears as well in the ample, loosely draped garments with their fluid, curving lines and edges, which remind us of Sluter and Ghiberti (see figs. 11-23 and 11-26).

Broederlam's panels also show another feature of the International Style: its "realism of particulars." It is the same kind of realism we first saw in Gothic sculpture. In the left panel we find it in the carefully rendered foliage and flowers of the enclosed garden to the left, and in the contrast between the Gothic chamber and the Romanesque temple. We see it as well in the right panel: in the delightful donkey (obviously drawn from life) and in the rustic figure of St. Joseph, who looks and behaves like a simple peasant and thus helps to emphasize the delicate, aristocratic beauty of the Virgin. This painstaking detail gives Broederlam's work the flavor of an enlarged miniature rather than of a large-scale painting, even though the panels are more than five feet tall.

The expansion of subject matter during the period of the International Style was linked to a comparable growth in symbolism. In the left panel, for example, the lily signifies Mary's virginity, as does the enclosed garden next to her. The contrasting Romanesque and Gothic buildings stand for the Old and New Testaments, respectively. This development paves the way for the elaboration of symbolic meaning that occurs 25 years later in works by Robert Campin and Jan van Eyck (see chapter 15).

The Limbourg Brothers Despite the growing importance of panel painting, book illumination remained the leading form of painting in Northern Europe during the International Style. Manuscript painting reached its height in the luxurious BOOK OF HOURS known as *Les Très Riches Heures du Duc de Berry* (The Very Rich Hours of the Duke of Berry). This volume was produced for the brother of the king of France, a man of far from admirable character but, nonetheless, the most lavish art patron of his day. The artists were Pol de Limbourg and his two brothers, Herman and Jean. (All died in 1416, most likely of the plague.) The three were from Flanders and were introduced to the court by their uncle, Jean Malouel, the artist who had applied the polychromy to Sluter's *Moses Well* (see fig. 11-23). They must have visited Italy, for their work includes numerous motifs and whole compositions borrowed from the great masters of Tuscany.

The most remarkable pages of *Les Très Riches Heures* are those of the calendar, which depict the annual cycle of human and natural life. Such cycles, originally consisting of 12 single figures each performing an appropriate seasonal activity, were an established tradition in medieval art. The Limbourg brothers, however, integrated these elements into a series of panoramas of human life in nature.

The illustration for the month of October (fig. 11-38) shows the sowing of winter

Developed in the fourteenth century, the BOOK OF HOURS was a prayer book for laypersons that contained psalms and devotional meditations chosen to suit the various seasons, months, days of the week, and hours of the day. Many of these small, portable books are masterpieces of luxurious illumination, especially those made for royal or aristocratic patrons.

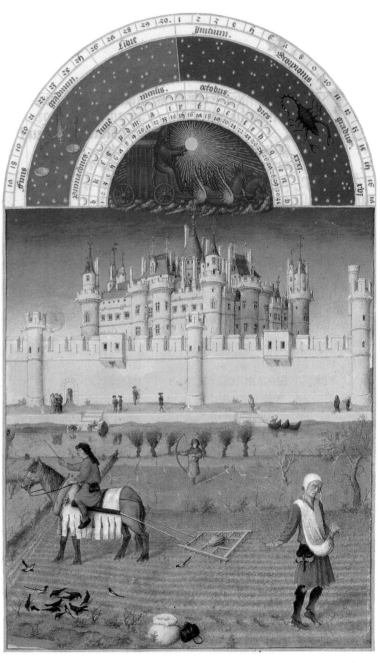

11-38 The Limbourg Brothers. *October,* from *Les Très Riches Heures du Duc de Berry.* 1413–16. 8⅞ × 5³⁄₈″ (22.5 × 13.7 cm). Musée Condé, Chantilly

grain. It is a bright, sunny day, and the figures—for the first time since classical antiquity—cast visible shadows on the ground. There is a wealth of realistic detail, such as the scarecrow in the middle distance and the footprints of the sower in the soil of the freshly plowed field. The sower is memorable in many ways. His tattered clothing, his unhappy air, go beyond mere description.

Peasants were often caricatured in Gothic art, but the portrayal here is surprisingly sympathetic, as it is throughout this book of hours. The figure is meant to arouse our compassion for the miserable lot of the peasantry in contrast to the life of the aristocracy, symbolized by the castle on the far bank of the river. (The castle, we recall, is a "portrait" of the Gothic Louvre; see page 209.)

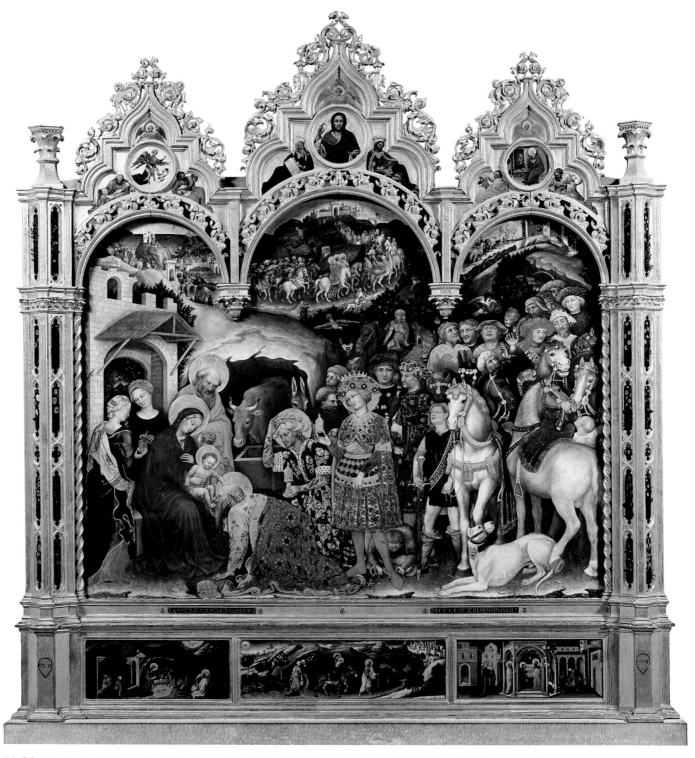

11-39 Gentile da Fabriano. *The Adoration of the Magi*. 1423. Tempera on panel, 9'10¹/₈" × 9'3" (3 × 2.88 m). Galleria degli Uffizi, Florence

Here, then, Gothic art transcends its "realism of particulars" to produce an encompassing vision of life that reflects the Limbourg brothers' knowledge of Italian art, as a glance at Ambrogio Lorenzetti's *Good Government* frescoes (see fig. 11-34) attests.

Gentile da Fabriano Italy was also affected by the International Style, although it gave more than it received. The altarpiece with the three Magi and their train (fig. 11-39) by Gentile da Fabriano (c. 1370–1427), the greatest Italian painter of the International Style, shows that he knew the work of the Limbourg brothers. The costumes here are as colorful, the draperies as ample and softly rounded, as in Northern painting. The Holy Family, on the left, seems almost in danger of being overwhelmed by the festive pageant pouring down from the hills in the distance. The foreground includes more than a dozen marvelously observed animals, not only the familiar ones but leopards, camels, and monkeys. (Such creatures were eagerly collected by the princes of the period, many of whom kept private zoos.) The eastern background of the Magi is emphasized by the Mongolian facial cast of some of their companions. It is not these exotic touches, however, that mark this as the work of an Italian master, but something else—a greater sense of weight, of physical substance, than we find in Northern painting of the International Style.

Despite his love of detail, Gentile clearly is not a manuscript illuminator but a painter used to working on a large scale. The panels decorating the base, or **predella**, of the altarpiece have a monumentality that belies their small size. Gentile was thoroughly familiar with Sienese art. Thus the *Flight into Egypt* in the center panel is indebted to Ambrogio Lorenzetti's frescoes in the Siena city hall (see fig. 11-34), while the *Presentation in the Temple* to the right is based on another scene by the same artist. Nevertheless, Gentile could achieve the delicate pictorial effects of a miniaturist when he wanted to. Although he was not the first artist to depict it, the night scene in the *Nativity* to the left, which was partly based on the vision received by the fourteenth-century Swedish princess St. Bridget in Bethlehem, has a remarkable poetic intimacy that shows the refinement that characterizes International Style art at its best.

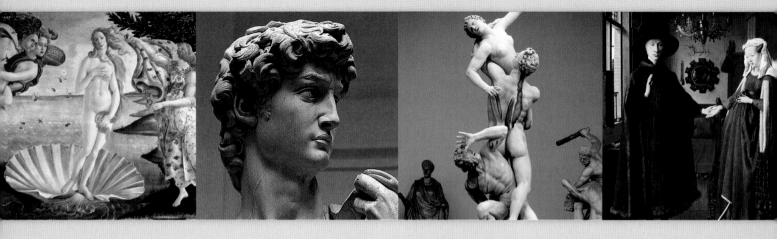

PART 3

The Renaissance through the Rococo: The Early Modern World

ecall that the transition from classical antiquity to the Middle Ages was marked by the rise of both Christianity and Islam. No comparable cultural shifts set off the Middle Ages from the Renaissance. The fifteenth and sixteenth centuries, to be sure, witnessed far-reaching developments: the fall of Constantinople and the Turkish conquest of southeastern Europe; the journeys of exploration that led to the founding of overseas empires in the New World, in Africa and Asia, with the subsequent rivalry of Spain and England as the foremost colonial powers; and the deep spiritual crises of the Reformation and Counter-Reformation. But none of these events, however great their effects, brought about the new era. By the time they happened, the Renaissance was well under way.

Views on the origins of the Renaissance abound, but most experts agree that the Renaissance began when people realized they were no longer living in the Middle Ages. This is not as simple as it may seem. The Renaissance was the first period in history to be aware of its own existence and to coin a label for itself. Medieval people did not think they belonged to an age distinct from classical antiquity. The past, to them, consisted simply of "B.C." and "A.D.," the era "under the Law" (that is, of the Old Testament) and the era "of Grace" (that is, after the birth of Jesus). From their point of view, then, history was made in Heaven rather than on earth. The Renaissance, and the Early Modern World, by contrast, divided the past not according to the divine plan of salvation, but on the basis of human achievements. It saw classical antiquity as the era when civilization had reached the peak of its creative powers, an era that ended abruptly when barbarian invaders destroyed the Roman Empire. During the thousand-year interval of "darkness" that followed,

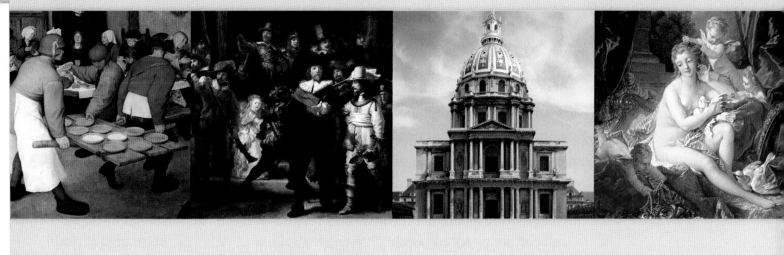

little was accomplished, scholars once believed, but now, at last, this "time in-between" or "Middle Age" had been superseded by a revival of all those arts and sciences that had flourished in classical antiquity. The present, the "New Age," could thus be fittingly labeled a "rebirth"—*rinascita* in Italian (from the Latin *renascere*, "to be reborn"), renaissance in French and, by adoption, in English.

We can trace this revolutionary view of history back to the 1330s, in the writings of the Italian poet Francesco Petrarca, the first of the great individuals who made the Renaissance. Petrarch, as we call him, thought of the new era mainly as a "revival of the classics," limited to the restoration of Latin and Greek to their former purity and the return to the original texts of ancient authors. During the next two centuries, this concept of the rebirth of antiquity grew to embrace almost the entire range of cultural endeavor, includ-ing the visual arts. The latter, in fact, came to play a particularly important part in shaping the Renaissance, for reasons that we will explore later.

Individualism—a new self-awareness and self-assurance—enabled Petrarch to proclaim, against all established authority, his own conviction that the "age of faith" was actually an era of darkness, whereas the "benighted pagans" of antiquity really represented the most enlightened stage of history. Such readiness to question traditional beliefs and practices was to become profoundly characteristic of the Renaissance as a whole. Humanism, to Petrarch, meant a belief in the importance of what we still call "the humanities" or "humane letters" (rather than divine letters, or the study of Scripture): the pursuit of learning in languages, literature, history, and philosophy for its own end, in a secular rather than a religious framework.

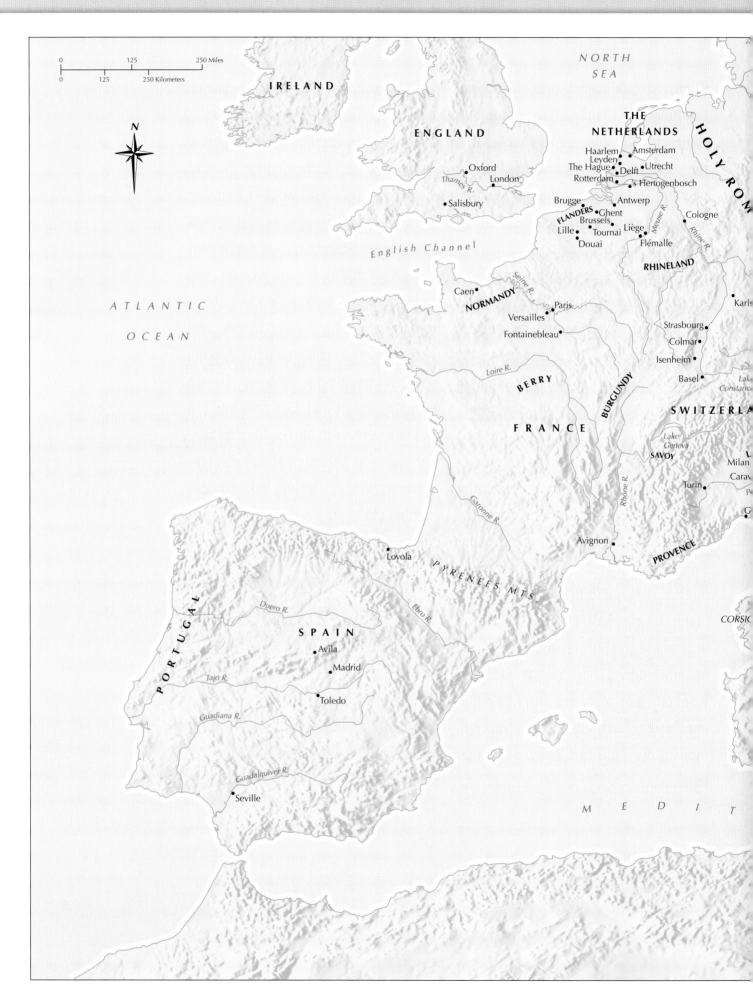

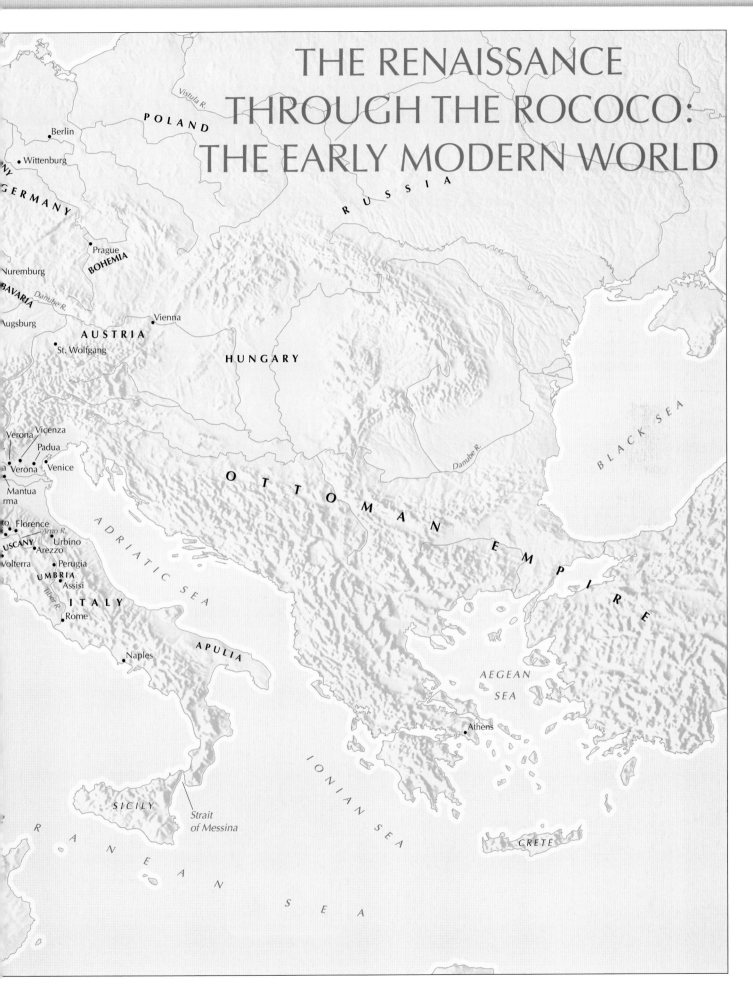

THE RENAISSANCE
THROUGH THE ROCOCO:
THE EARLY MODERN WORLD

The Renaissance through the Rococo: The Early Modern World

	1400–1450	1450–1500	1500–1550
POLITICAL HISTORY	Great Papal Schism (since 1378) settled 1417; pope returns to Rome Cosimo de' Medici leading citizen of Florence 1434–64	Hapsburg rule of Holy Roman Empire begins 1452 Constantinople falls to Turks 1453 Lorenzo de' Medici virtual ruler of Florence 1469–92 Ferdinand and Isabella unite Spain 1469 Spain and Portugal divide southern New World 1493–94 Charles VIII of France invades Italy 1494–99	Charles V of Spain elected Holy Roman Emperor 1519; Sack of Rome 1527 Hernando Cortés wins Aztec Empire in Mexico for Spain 1519; Francisco Pizarro conquers Peru 1532 Henry VIII of England (ruled 1509–47) founds Anglican Church 1534 Peace of Augsburg (1555) lets each German prince decide religion of his subjects
RELIGION AND LITERATURE	Leonardo Bruni (c. 1374–1444), *History of Florence* Leone Battista Alberti (1404–1472), *On Architecture; On Painting* Jan Hus, Czech reformer, burned at stake for heresy 1415; Joan of Arc burned at stake for heresy and sorcery 1431 Council of Florence attempts to reunite Catholic and Orthodox faiths 1439	Marsilio Ficino (1433–1499), Italian Neoplatonic philosopher Pius II, humanist pope (ruled 1458–64) Savonarola virtual ruler of Florence 1494; burned at stake for heresy 1498	Erasmus of Rotterdam's *Manual of a Christian Knight* 1503 Thomas More's *Utopia* 1516 Martin Luther (1483–1546) posts 95 Theses 1517; excommunicated 1521 Machiavelli's *Prince* 1532 Ignatius of Loyola founds Jesuit order 1534 John Calvin's *Institutes of the Christian Religion* 1536
SCIENCE AND TECHNOLOGY	Prince Henry the Navigator of Portugal (1394–1460) promotes geographic exploration Gutenberg credited with invention of printing with movable type 1446–50	Bartolomeu Diaz rounds Cape of Good Hope 1488 Christopher Columbus discovers America 1492 Vasco da Gama reaches India, returns to Lisbon 1497–99	Vasco de Balboa sights Pacific Ocean 1513 First circumnavigation of the globe, by Ferdinand Magellan and crew 1520–22 Copernicus (1473–1543) refutes geocentric view of universe 16-8
PAINTING	Masaccio, *Holy Trinity* fresco (12-14) Robert Campin, *Mérode Altarpiece* (15-1) Jan van Eyck, *Arnolfini Betrothal* (15-5, 15-6) Rogier van der Weyden, *Descent from the Cross* (15-7) 12-14	Piero della Francesca, Arezzo frescoes (12-18) Mantegna, *St. Sebastian* (12-23) Hugo van der Goes, *Portinari Altarpiece* (15-8) Botticelli, *Birth of Venus* (12-21) Perugino, *Delivery of the Keys* (12-22) Leonardo, *Virgin of the Rocks* (13-1) Giovanni Bellini, *Saint Francis in Ecstasy* (12-24) Leonardo, *Last Supper* (13-2)	Bosch, *Garden of Delights* (15-9) Leonardo, *Mona Lisa* (13-3) Giorgione, *The Tempest* (13-19) Michelangelo, Sistine Chapel, Rome (13-9–13-12) Grünewald, *Isenheim Altarpiece* (16-1, 16-2) Raphael, *School of Athens* (13-16) Dürer, *Four Horsemen* (16-3) Holbein, *Erasmus of Rotterdam* (16-8) Pontormo, *Deposition* (14-2) Altdorfer, *Battle of Issus* (16-7) Parmigianino, *Madonna with the Long Neck* (14-3)
SCULPTURE	Donatello, *St. George* (12-2); *David* (12-3) Ghiberti, "Gates of Paradise," Baptistery, Florence (12-5) Donatello, Equestrian statue of Gattamelata, Padua (12-4)	Pollaiuolo, *Hercules and Antaeus* (12-7) Verrocchio, *Doubting of Thomas* (12-8)	Michelangelo, *David* (13-7); Tomb of Giuliano de' Medici, Florence (13-13)
ARCHITECTURE	Brunelleschi begins career as architect 1419; Florence Cathedral dome (12-9); S. Lorenzo, Florence (12-10, 12-11)	Alberti, S. Andrea, Mantua (12-12) Giuliano da Sangallo, Sta. Maria delle Carceri, Prato (12-13) 12-13	Bramante, design for St. Peter's, Rome (13-5) Michelangelo becomes architect of St. Peter's, Rome, 1546 (13-14)

1400–1750

1550–1625	1625–1700	1700–1750
Ivan the Terrible of Russia (ruled 1547–84)	Thirty Years' War 1618–48	Peter the Great (ruled 1682–1725) westernizes Russia, defeats Sweden
Charles V retires 1556; son Philip II becomes king of Spain, Netherlands, New World	Cardinal Richelieu consolidates power of Louis XIII, 1624–42	Robert Walpole first prime minister of England 1721–42
Elizabeth I of England (ruled 1558–1603)	Charles I of England beheaded 1649; Commonwealth under Cromwell 1649–53; Charles II restores English monarchy 1660	Frederick the Great of Prussia defeats Austria 1740–45
Netherlands revolt against Spain 1586		Seven Years' War (1756–63): England and Prussia vs. Austria and France, called French and Indian War in America; French defeated in Battle of Quebec 1769
Spanish Armada defeated by English 1588	Frederick William, the Great Elector (ruled 1640–88), establishes power of Prussia	
Edict of Nantes establishes religious toleration in France 1598	Louis XIV absolute ruler of France (ruled 1661–1715)	Catherine the Great (ruled 1762–96) extends Russian power to Black Sea
Jamestown, Virginia, founded 1607; Plymouth, Massachusetts, 1620	Glorious Revolution against James II of England 1688; Bill of Rights	
Montaigne (1533–1592), French essayist	René Descartes (1596–1650), French mathematician and philosopher	Daniel Defoe's *Robinson Crusoe* 1719
Council of Trent for Catholic reform 1545–63	Molière (1622–1673), French dramatist	Jonathan Swift's *Gulliver's Travels* 1726
Giorgio Vasari's *Lives* 1564	Blaise Pascal (1623–1662), French scientist and philosopher	Wesley brothers found Methodism 1738
William Shakespeare (1564–1616), English dramatist	Spinoza (1632–1677), Dutch philosopher	Voltaire (1698–1778), French author
Miguel de Cervantes's *Don Quixote* 1605–16	John Milton's *Paradise Lost* 1667	Diderot's *Encyclopédie* 1751–72
John Donne (1572–1631), English poet	John Bunyan's *Pilgrim's Progress* 1678	Samuel Johnson's *Dictionary* 1755
King James Bible 1611	John Locke's *Essay Concerning Human Understanding* 1690	Edmund Burke (1729–1797), English reformer
		Jean-Jacques Rousseau (1712–1778), French philosopher and writer
Johannes Kepler establishes planetary system 1609–19	William Harvey describes circulation of the blood 1628	Carolus Linnaeus (1707–1778), Swedish botanist
Galileo (1564–1642) invents telescope 1609; establishes scientific method	Isaac Newton (1642–1727), theory of gravity 1687	James Watt patents steam engine 1769
		Priestley discovers oxygen 1774
		Coke-fed blast furnaces for iron smelting perfected c. 1760–75
		Benjamin Franklin's experiments with electricity c. 1750

18-13

Bruegel, *Return of the Hunters* (16-12)	Hals, *Jolly Toper* (18-9)	Watteau, *Pilgrimage to Cythera* (20-3)
Titian, *Christ Crowned with Thorns* (13-23)	Pietro da Cortona, Palazzo Barberini ceiling (17-7)	Chardin, *Back from the Market* (20-6)
Veronese, *Christ in the House of Levi* (14-8)	Van Dyck, *Portrait of Charles I Hunting* (18-6)	Hogarth, *Rake's Progress* (20-8)
El Greco, *Burial of Count Orgaz* (14-10)	Rembrandt, *The Night Watch* (18-12)	Tiepolo, Würzburg ceiling fresco (20-12)
Tintoretto, *Last Supper* (14-9)	Poussin, *Abduction of the Sabine Women* (19-2)	Boucher, *Toilet of Venus* (20-4)
Caravaggio, *Calling of Saint Matthew* (17-1)	Lorraine, *Pastoral Landscape* (19-3)	Reynolds, *Sarah Siddons as the Tragic Muse* (20-10)
Annibale Carracci, Farnese Gallery ceiling (17-5)	Velázquez, *Maids of Honor* (17-21)	
Rubens, *Marie de' Medici, Queen of France, Landing in Marseilles* (18-3)	Rembrandt, *Self-Portrait* (18-13)	
Artemisia Gentileschi, *Judith and Her Maidservant with the Head of Holofernes* (17-4)	Vermeer, *The Letter* (18-19)	
Giovanni Bologna, *Abduction of the Sabine Woman*, Florence (14-12)	Bernini, Cornaro Chapel, Rome (17-16, 17-17)	
Bernini, *David* (17-15)	Puget, *Milo of Crotona* (19-12)	
	Coysevox, *Charles Lebrun* (19-11)	

14-12

19-12

20-11

Palladio, Villa Rotonda, Vicenza (14-14)	Bernini's colonnade, St. Peter's, Rome (17-9)	Fischer von Erlach, St. Charles Borromaeus, Vienna (20-11)
Della Porta, Facade of Il Gesù, Rome (14-15)	Borromini, S. Carlo alle Quattro Fontane, Rome (17-11, 17-12)	Neumann, *The Kaisersaal, Residenz, Würzburg.* (20-12)
Maderno, Nave and facade of St. Peter's, Rome (17-9)	Perrault, East front of Louvre, Paris (19-5)	Burlington and Kent, Chiswick House, London (21-9)
	Hardouin-Mansart and Le Vau, Palace of Versailles (19-6); with Coysevox, Salon de la Guerre (19-7)	

CHAPTER 12

The Early Renaissance in Italy

A NUMBER OF REASONS HELP TO EXPLAIN WHY THE EARLY
Renaissance was born in Florence at the beginning of the fifteenth century, rather
than in some other place or at some other time. Around 1400, Florence's indepen-
dence was threatened by Gian Galeazzo Visconti, the powerful duke of Milan, who was try-
ing to bring all of Italy under his rule. Florence put up a vigorous defense against Milan on
three fronts: military, diplomatic, and intellectual. Of these, the intellectual was by no means
the least important. The duke was admired by some as a new Caesar, bringing peace and
order to the country. In opposition, Florence proclaimed itself the champion of freedom
against unchecked tyranny. This propaganda war was waged by humanists on both sides, but
the Florentines gave by far the better account of themselves. After all, the native Florentine
Petrarch was the central literary figure of the fourteenth century. The humanists' writings,
such as *Praise of the City of Florence* (1402–3) by Leonardo Bruni (see fig. 12-6), gave new
focus to Petrarch's ideal of a rebirth of the classics. Speaking as a citizen of a free republic,
Bruni asks why, among all the states of Italy, Florence alone had been able to defy the supe-
rior power of Milan. He finds the answer in her institutions, her cultural achievements, her
geographical situation, the spirit of her people, and her descent from the city-states of
ancient Etruria. Florence, he concludes, has taken on the same role of political and intellec-
tual leadership as Athens had during the Persian Wars.

This "rebirth" of the legacy of the
ancient past is known as the Renaissance.
The patriotic pride, the call to greatness
that can be seen in this image of Florence as
the "new Athens" must have aroused a deep
response throughout the city. The Floren-
tines embarked on an ambitious campaign
to finish the great artistic works begun a
century before at the time of Giotto. The
competition of 1401–2 for the bronze doors
of the Baptistery of S. Giovanni (see fig. 11-
26) marked the opening of the era.

At the same time, another major program
continued the sculptural decoration of Flo-
rence Cathedral and debate resumed over
how to build its dome, the largest and most

difficult project of all. The artistic campaign,
in enthusiasm and cost, was comparable to
that of rebuilding the Akropolis in Athens.
The huge investment was not a guarantee in
itself of artistic quality, but it provided an
excellent opportunity for the emergence of
creative talent and a new style worthy of the
"new Athens."

From the start, the visual arts were
viewed as central to the rebirth of the Flo-
rentine spirit. Throughout most of antiquity
and the Middle Ages, they had been classed
with the crafts, or "mechanical arts." It can-
not be by chance that the first statement
claiming a place for them among the liberal
arts since antiquity occurs about 1400 in the

writings of the Florentine chronicler Filippo Villani; this position was solidified by Alberti's treatise on painting (see page 263). A century later, this idea was acknowledged throughout most of the Western world. What does it imply?

The liberal arts were defined by a tradition going back to Plato. They comprised the intellectual disciplines necessary for a "gentleman's" education: mathematics (including musical theory), dialectics (logical disputation), grammar, rhetoric (the art of persuasion), and philosophy. The fine arts were initially excluded because they were "handiwork" and lacked a theoretical basis. During the early fourth century B.C., however, they were included in the liberal arts (see page 77). When Renaissance artists gained admission to the select group of humanists, they were viewed as people of ideas rather than mere manipulators of materials. Works of art came to be viewed more and more as the visible records of creative minds. This meant that they need not—indeed, should not—be judged only by the standards of craftsmanship. Soon anything that bore the imprint of a great master was eagerly collected: drawings, sketches, fragments, and unfinished pieces as well as finished works.

The outlook of artists changed as well. Now in the company of scholars and poets, they themselves often became learned and literary. They might write poems, autobiographies, or theoretical treatises. Another outgrowth of their new social status was that artists' personalities tended to develop in either of two contrasting ways. One was the person of the world, self-controlled, at ease in aristocratic society. The other was the solitary genius, secretive, subject to fits of melancholy, and likely to be in conflict with the patrons who commissioned their work. If the courtier enjoyed wealth and success, he was nevertheless expected to serve—and thus to be subservient. The solitary genius, by contrast, maintained his freedom, often by playing his patrons off against each other.

It is remarkable how quickly this modern view of art and artists took root in Early Renaissance Florence. Much of the reason can be found in the figure of Cosimo de' Medici, who treated artists as equals and

friends, not mere laborers. The Medici were bankers (they made their fortune running the Vatican bank), who engaged artists as collaborators. They were inherently sympathetic to the humanist ideal of the learned and cultivated man. (It did not yet extend fully to women.) However, this idea was not accepted immediately everywhere, nor did it apply equally to all artists. England, for example, was slow to grant artists special status, and women in general were denied the training and opportunities available to men.

In addition to humanism and historical forces, individual genius played a decisive role in the birth of Renaissance art. It began with three men of exceptional ability—Filippo Brunelleschi, Donatello, and Masaccio. It is hardly a coincidence that these men knew one another. Moreover, they all faced the same task: to reconcile classical form with Christian content. They needed to find ways to express the most deeply held traditions of Christianity in the artistic tradition of classical Greece and Rome. Each approached this problem in a unique way. Thanks to them, Florentine art retained leadership of the movement during the first half of the fifteenth century, which is often thought of as the heroic age of the Early Renaissance. To trace its beginnings, we turn first to sculpture, because the sculptors had earlier and more plentiful opportunities to meet the challenge of the "new Athens."

Sculpture

The artistic campaign began with the competition for the Baptistery doors, and for some time it consisted mainly of sculptural projects. Ghiberti's trial relief (see fig. 11-26) of *The Sacrifice of Isaac* does not differ greatly from the International Gothic; nor do the doors themselves, even though it took another 20 years to complete them. Only in the torso of Isaac can Ghiberti's admiration for ancient art be linked with the classicism of the Florentine humanists. Similar examples can be found in other Florentine sculpture around 1400. But such instances, isolated and small in scale, merely recapture what Nicola Pisano had done a century before (see fig. 11-24).

12-1 Nanni di Banco. *Four Saints (Quattro Coronati)*. c. 1410–14. Marble, about life-size. Or San Michele, Florence

Nanni di Banco A decade later this medieval classicism was surpassed by a somewhat younger artist, Nanni di Banco (c. 1384–1421). The *Four Saints (Quattro Coronati)* (fig. 12-1), which he made about 1410–14 for one of the niches on the exterior of the Florentine church Or San Michele, should be compared with the Reims *Visitation* (see fig. 11-19, right pair) 200 years earlier. The saints represent four Christian sculptors who were executed for not carving the statue of a pagan god ordered by the Roman emperor Diocletian, a story that was later merged with one about four martyrs who refused to worship in the god's temple. The subject raises the importance of artists, and sculptors in particular, in the history of the Church. The figures in both groups are about life-size, yet Nanni's give the impression of being a good deal larger than those at Reims. Their monumental quality was well beyond the range of medieval sculpture, even though Nanni depended less directly on ancient models. Only the heads of the second and third of the *Coronati* directly recall Roman sculpture—specifically, the portrait heads of the third century A.D. (see fig. 7-15), and each figure stands in the classical Greek **contrapposto** posture (see page 91 and fig. 5-18). Nanni clearly was impressed by their realism and their tormented expressions. His ability to retain these qualities shows a new attitude toward ancient art, one that unites classical form and content instead of separating them as medieval classicists had done.

Donatello Early Renaissance art re-established an attitude toward the human body similar to that of classical antiquity. Donatello (Donato de Betto di Bardi, 1386–1466), the greatest sculptor of his time, played a particularly important role in forming this new approach. Among the founders of the new style, he alone lived well past the middle of the century. (He was born only a few years after Nanni and outlived him by 45 years.) Together with Nanni, Donatello spent his early career working on commissions for Florence Cathedral and Or San Michele after completing his apprenticeship under Ghiberti. They often faced the same artistic problems and influenced

each other, although their personalities had little in common.

St. George Their different approaches can be seen by comparing Nanni's *Quattro Coronati* with Donatello's *St. George* (fig. 12-2). Both are located in Gothic niches, but Nanni's figures, like Antelami's *King David* (see fig. 10-16), cannot be divorced from the architectural setting. Instead, they still seem attached, like jamb statues, to the pilasters behind them. The figure of St. George, however, would lose none of its authority if it were removed from the niche. Perfectly balanced, it could stand by itself, like the statues of antiquity. Donatello has recaptured the full meaning of the classical *contrapposto*, the central achievement of Greek sculpture. Yet, unlike the *Coronati*, *St. George* is not at all classical in appearance—that is, ancient motifs are not quoted as they are in Nanni's figures. Perhaps "classic" is a better word for him. Donatello treats the human body as a clearly defined structure capable of movement. Although encased in armor, the saint's body and limbs are not rigid. His stance, with the weight placed on the forward leg, conveys his readiness for combat. (The right hand originally held a lance or sword.) The controlled energy of his body is reflected in his eyes, which seem to scan the horizon for the enemy. Here St. George is portrayed both as an Early Renaissance version of the Christian soldier and also as the proud defender of the "new Athens."

Below *St. George*'s niche is a relief panel showing the hero's best-known exploit, the slaying of a dragon. (The maiden on the right is the princess whom George had come to free.) Here Donatello devised a new kind of relief that is shallow (called *schiacciato*, "squashed") yet creates an illusion of infinite depth. This had been achieved to some degree in Greek and Roman reliefs, as well as by Ghiberti (compare with figs. 5-14, 7-18, and 11-26). In all these cases, however, the actual carved depth is roughly proportional to the apparent depth of the space represented. The forms in the front plane are in very high relief, whereas more distant ones become progressively lower, seemingly immersed in the background. Donatello takes an entirely different approach. Behind

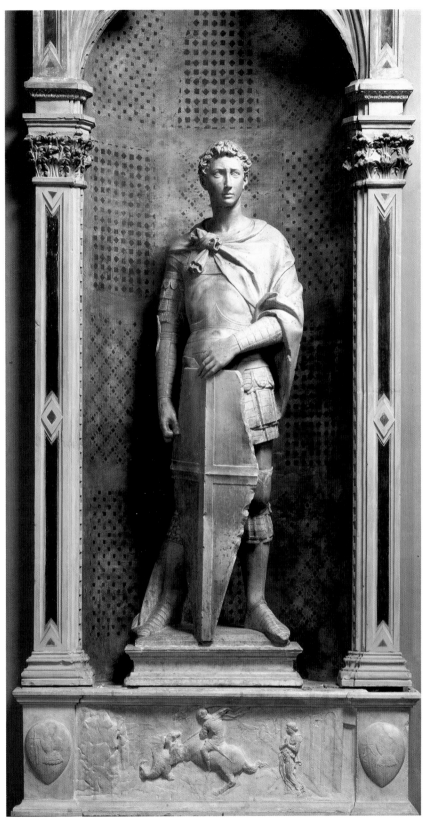

12-2 Donatello. *St. George* tabernacle, from Or San Michele, Florence. c. 1415–17. Marble, height of statue 6'10" (2.08 m). Museo Nazionale del Bargello, Florence

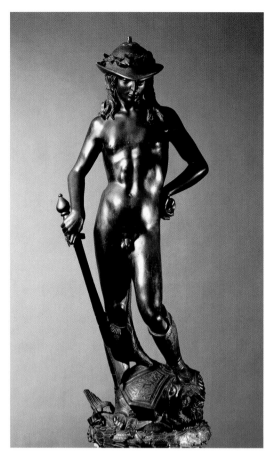

12-3 Donatello. *David.* c. 1425–30. Bronze, height 62¹/₂″ (158.8 cm). Museo Nazionale del Bargello, Florence

the figures, the landscape consists of delicate surface modulations that cause the marble to catch light from varying angles. Every tiny ripple has a descriptive power that is much greater than its real depth. The sculptor's chisel, like a painter's brush, becomes a tool for creating shades of light and dark. Yet Donatello cannot have borrowed his effects from any landscape painting, for no painter at the time had achieved so unified and atmospheric a view of nature. In creating pictorial effects, sculptors remained far in advance of most painters until well past midcentury.

David Donatello had learned the technique of bronze sculpture as a youth by working under Ghiberti on the first Baptistery doors. By the 1420s, he began to rival his former teacher in that medium. His bronze *David* (fig. 12-3) is the first **freestanding** (sculpted in the round, not attached to architecture) life-size nude statue since antiquity. In the Middle Ages

it would have been condemned as an idol, and even in Donatello's day people must have felt uneasy about it, because for many years it remained the only work of its kind. The statue evidently was meant for an open space. It probably stood on top of a column in the garden of Cosimo de' Medici, the most powerful figure in Florence, where it would have been visible from every side.

The key to the meaning of the statue is the helmet of Goliath, with its visor and wings. This form was derived from depictions of the Roman wind god Zephyr, an evil figure who killed the young boy Hyacinth. We may assume that the helmet is a reference to the dukes of Milan, who were again warring against Florence in the mid 1420s. The statue thus is a patriotic public monument identifying DAVID—weak but favored by the Lord—with Florence, and GOLIATH with Milan. David's nudity may be a reference to the classical origin of Florence; his wreathed hat, the opposite of Goliath's helmet, perhaps represents peace versus war.

Donatello chose to model an adolescent boy, not a full-grown youth like the athletes of Greece, so that the figure lacks their swelling muscles. Nor is the torso articulated according to the classical pattern (compare figs. 5-16 and 5-18). Rather, it is softly sensuous. *David* resembles an ancient statue mainly in its *contrapposto.* If the figure has a classical appearance, the reason lies in its expression, not in its anatomy. The lowered gaze signifies humility, which triumphs over the sinful pride of Goliath. It was inspired by classical examples, which equate it with modesty and virtue (compare fig. 5-18). As in ancient statues, however, the body speaks to us more eloquently than the face, which by Donatello's standards strangely lacks individuality.

Gattamelata In 1443 Donatello was invited to Padua to produce his largest freestanding work in bronze: the equestrian monument of Gattamelata (fig. 12-4). This statue, which honors the recently deceased commander of the Venetian armies, is still in its original position on a tall pedestal near the facade of the church dedicated to St. Anthony of Padua. Like the mounted Mar-

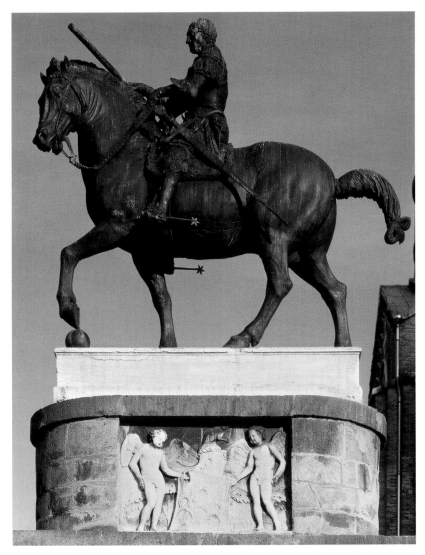

12-4 Donatello. *Equestrian Monument of Gattamelata.* 1445–50. Bronze, approx. 11 × 13′ (3.35 × 3.96 m). Piazza del Santo, Padua

cus Aurelius in Rome (see fig. 7-13), the *Gattamelata* is impressive in scale and reflects a sense of balance and dignity. The horse, a heavyset animal fit to carry a man in full armor, is so large that the rider must dominate it by authority rather than by force. But the *Gattamelata* is not the self-glorifying statue of a sovereign; it is a monument authorized by the Republic of Venice to commemorate a great *condottiere* (an elite mercenary leader; "condot" is a contract). His real name was Erasmo da Narni (Gattamelata means "honeycat"). Donatello therefore has united the ideal with the real. The armor combines modern construction with classical detail; the head is that of an individual, yet it displays a truly Roman nobility of character.

Lorenzo Ghiberti Donatello's only serious rival was his former teacher, Lorenzo Ghiberti. After the great success of his first doors for the Florence Baptistery, Ghiberti was commissioned to do a second pair, which are so beautiful that they were soon dubbed the *"Gates of Paradise."* Each contains ten large reliefs in simple square frames, which create a larger field than the 28 small panels in quatrefoil frames of the earlier doors. The style reveals the influence of Donatello and other pioneers of the Early Renaissance. The only remnants of the Gothic are seen in the graceful classicism of the figures, which reminds us of the International Style.

The *"Gates of Paradise"* show the pictorialism found in many Renaissance reliefs. The hint of spatial depth we saw in *The Sacrifice of*

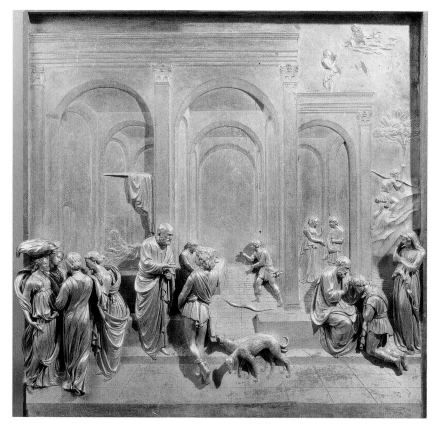

12-5 Lorenzo Ghiberti. *The Story of Jacob and Esau,* panel of the *"Gates of Paradise."* c. 1435. Gilt bronze, 31¼" (79.4 cm) square. Baptistery of S. Giovanni, Florence

12-6 Bernardo Rossellino. Tomb of Leonardo Bruni. c. 1445–50. Marble, height to top of arch 20′ (6.10 m). Sta. Croce, Florence

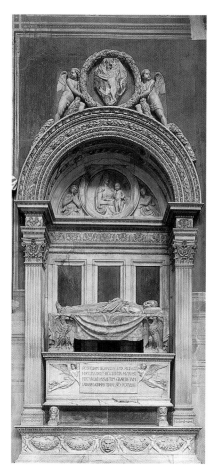

Isaac (see fig. 11-26) has grown in *The Story of Jacob and Esau* (fig. 12-5) into a complete setting that goes back as far as the eye can reach. We can imagine the figures leaving the scene, for the deep space of this relief does not require their presence. Ghiberti's spacious hall is a fine example of Early Renaissance architectural design. It is also an example of a picture space using Brunelleschi's **scientific perspective** (see Materials & Techniques: Perspective, page 272), which assumes an ideal vantage point in which the viewer's eye is on a line perpendicular to the center of the panel. From this point we see archways through archways. The floor is inscribed with a checkerboard grid to better create the sense of depth. The new pictorial space allows Ghiberti to present his story in continuous narrative with unprecedented coherence, as if all seven episodes of this story were taking place simultaneously (compare fig. 8-5).

Bernardo Rossellino After Donatello left for Padua in 1443, there was a shortage of marble sculptors in Florence. By the time he returned ten years later, this gap had been filled by a group of men, most still in their twenties, from the hill towns north and east of Florence that had long supplied the city with stonemasons and carvers. Taking advantage of the unusual opportunities open to them, the most gifted of these developed into artists of considerable importance. The oldest, Bernardo Rossellino (1409–1464), seems to have begun as a sculptor and architect in Arezzo. He came to Florence about 1436 but received no major commissions until eight years later, when he was asked to design the tomb of Leonardo Bruni (fig. 12-6). This great humanist and statesman had played a vital part in the city's affairs since the beginning of the century (see page 250). He was secretary to the papal chancery beginning in 1405, as well as chancellor of Florence from 1427 until his death. He was also the state historian of the city, and used original sources to document his *Twelve Books of the Histories of the Florentine People,* so that he was one of the first historians in the modern sense of the term. When he died in 1444, he received a grand funeral "in the manner of the ancients." His monument was probably ordered by the city government. Because Bruni had been born in Arezzo, his native town also wished to

honor him and may have helped obtain the commission for Bernardo.

Although Bruni's is not the earliest Renaissance tomb, it is the first to express fully the spirit of the era. The references to antiquity contain many echoes of Bruni's funeral: the deceased lies on a bier supported by Roman eagles, his head wreathed in laurel and his right hand resting on a book (presumably his own *History of Florence*, rather than a prayer book). The monument is a fitting tribute to the man who, more than any other, had helped establish the historical perspective of the Florentine Early Renaissance. On the sarcophagus, two winged GENIUS figures hold an inscription that is very different from those on medieval tombs. Instead of recording the name, rank, and age of the deceased and the date of his death, it refers only to his achievements: "At Leonardo's passing, history grieves, eloquence is mute, and it is said that the MUSES, Greek and Latin alike, cannot hold back their tears." The religious aspect of the tomb is confined to the lunette, where the Madonna is adored by angels.

The monument may be viewed as an attempt to reconcile two contrasting attitudes toward death: the retrospective, commemorative outlook of the ancients and the Christian concern with afterlife and salvation. Bernardo's design, adapted from Gothic tombs (see fig. 11-35), is well suited to this task. Consequently, all the tombs, tabernacles, and reliefs of the Madonna produced in Florence between 1450 and 1480 owe much to it. The Bruni monument balances architecture and sculpture within a compact framework. The architectural quality is not surprising: after Brunelleschi's death, Rossellino became one of the leading architects in Florence. The two pilasters supporting a round arch resting on a strongly accented architrave recall the work of Leone Battista Alberti, who employed this motif often (see fig. 12-12). Although Bernardo may have used it for aesthetic reasons, he may also have meant it to symbolize the gateway between one life and the next. Perhaps he even wanted us to associate the motif with the Pantheon, the "temple of the immortals" for both pagans and Christians. (Once dedicated to all the gods of the Roman world, the Pantheon had been rededicated to all the martyrs when it had became a Christian church. In the High Renaissance the building was to house the tombs of another breed of immortals: famous artists such as Raphael.)

Antonio del Pollaiuolo By 1450, the great civic art campaign had come to an end in Florence, and artists had to depend mainly on private commissions. This put the sculptors at a disadvantage because of the high cost of making their work. Because there were few commissions for monuments, they created pieces of moderate size and price, such as bronze statuettes. The collecting of sculpture, common in ancient times, had stopped during the Middle Ages. The taste of kings, feudal lords, and others who could afford to collect for their own pleasure ran to gems, jewelry, goldsmith's work, illuminated manuscripts, and precious fabrics. The habit resumed in fifteenth-century Italy as part of the "revival of antiquity." Humanists and artists first collected ancient sculpture, especially small bronzes, of which there were many. Before long, artists began to cater to the demand by creating portrait busts and small bronzes "in the manner of the ancients."

A fine example of this kind is *Hercules and Antaios* (fig. 12-7) by Antonio del Pollaiuolo (1431–1498). Pollaiuolo's style was

The Latin word GENIUS ("begetter") originally referred to the guardian spirit of the male head of a Roman household. It was later extended to peoples and places, as in the *genius populi Romani* ("genius of the Roman people"). In art and literature, the term came to be applied to figures personifying or embodying particular qualities, conditions, or attributes; it is generally capitalized when used this way. In modern times, *genius* most commonly denotes great intellectual or artistic talent or a person who possesses it.

Patron goddesses of intellectual and creative endeavors, the MUSES were nine mythical daughters of Zeus and the goddess of memory, Mnemosyne. They were Klio, history; Kalliope, epic poetry; Erato, love poetry; Euterpe, lyric poetry; Melpomene, tragedy; Polyhymnia, songs and poetry for the gods; Thalia, comedy; Terpsichore, choral songs and dance; and Urania, astronomy.

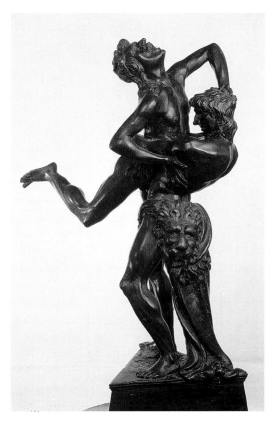

12-7 Antonio del Pollaiuolo. *Hercules and Antaios.* c. 1475. Bronze, height with base 18" (45.8 cm). Museo Nazionale del Bargello, Florence

very different from that of the marble carvers discussed above. Trained as a goldsmith and metalworker, probably in the Ghiberti workshop, he was deeply impressed by the late style of Donatello, as well as by ancient art. From these sources, he developed the distinctive style that appears in our statuette.

Pollaiuolo was a painter and engraver as well as a bronze sculptor, and we know that about 1465 he did a closely related picture of HERCULES and ANTAIOS for the Medici, who also owned the statuette. (The painting has been lost, but the design is preserved in a smaller copy.) Here, for the first time, a sculptural group has been given the pictorial quality that could be seen in reliefs since the early years of the Renaissance. To create a freestanding group of two struggling figures, even on a small scale, was a daring idea. There is no precedent for this design among earlier statuary groups, ancient or Renaissance. Even bolder is the centrifugal force that can be felt in this composition. Limbs seem to move

outward in every direction. We see the full complexity of their movements only when we view the statuette from all sides. Despite its violent action, the group is in perfect balance. To stress the central axis, Pollaiuolo in effect grafted the upper part of Antaeus onto the lower part of Hercules.

Andrea del Verrocchio Although Pollaiuolo made two bronze tombs for St. Peter's in Rome during the late years of his career, he never had a chance to create a large-scale freestanding statue. For such works we must turn to Andrea del Verrocchio (1435–1488), the greatest sculptor of his day and the only one to share some of Donatello's range and ambition. A modeler as well as a carver—we have works of his in marble, terra-cotta, silver, and bronze—he combined elements from Rossellino and Pollaiuolo into a unique style. He was also a respected painter and the teacher of Leonardo da Vinci.

■ ANTAIOS was a mythical Greek giant, a wrestler who was invincible as long as he could renew his powers by touching his mother, the earth. HERCULES (Herakles), greatest of the mythical Greek heroes (see pages 74–76), was Antaeus's undoing: he held him off the ground and crushed him.

Like *Hercules and Antaeus* by Pollaiuolo, Verrocchio's *Doubting of Thomas* (fig. 12-8) is closely related to a painting: a Baptism of Christ, painted with the assistance of the young Leonardo. The result is a pictorialism unique in monumental sculpture of the Early Renaissance. In contrast to the *Quattro Coronati* of Nanni di Banco (see fig. 12-1), the subject is a narrative. Christ lifts his arm to allow St. Thomas to touch, even put his finger in, Christ's side-wound, thus allaying Thomas's doubts as to who is before him. The upper part of Thomas moves forward to Christ, but one leg remains outside the niche, suggesting his hesitancy. In fact, Verrocchio's group does not quite fit its niche on Or San Michele, for it replaced a figure by Donatello that had been moved. Hence the statues have no backs, so that they can fit in the shallow tabernacle, which acts as a foil rather than as a container.

Although the biblical text is inscribed on the drapery, the drama is conveyed by the eloquent poses and bold exchange of gestures between Christ and Thomas. It is heightened by the active drapery, with its deep folds, which echo the contrasting states of mind. *The Doubting of Thomas* is of great importance in the history of sculpture. The work was admired for its great beauty, especially the head of Christ, which was to inspire Michelangelo. For Leonardo it served as a model of figures whose actions express the passions of the mind. Later it stimulated the sculpture of Bernini (compare fig. 17-14).

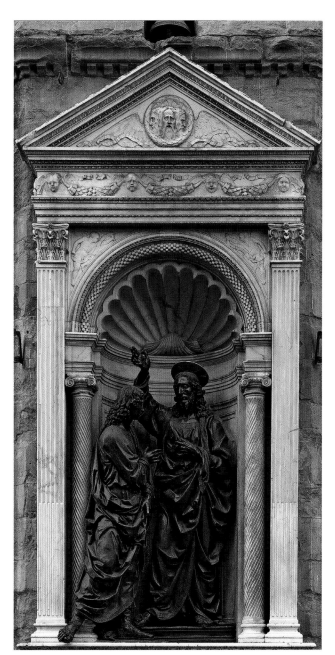

12-8 Andrea del Verrocchio. *The Doubting of Thomas.* 1465–83. Bronze, life-size. Or San Michele, Florence

Architecture

Because of its public nature, architecture occupied a position of special importance during the Renaissance. Magnificent buildings of the finest materials and designs conferred prestige to city-states, which strived to outdo each other in splendor without imitating another's example. Thus it was architects who were the first to free themselves from the lowly status of craft and manual labor, and to establish themselves as intellectuals, even though many of them began their careers as stone masons. Architects were often civil and military engineers as well, which made their services especially valuable.

Filippo Brunelleschi Donatello did not create the Early Renaissance style in sculpture all by himself. The new architecture, in contrast, owed its existence to one person, Filippo Brunelleschi (1377–1446), who was arguably the central figure in Early Renaissance art. Ten years older than Donatello, he, too, had begun his career as a sculptor. After losing the competition for the first Baptistery doors to Ghiberti, he certainly went to Rome with Donatello. There he studied ancient structures and seems to have been the first person to take exact measurements of them. His discovery of scientific perspective (see

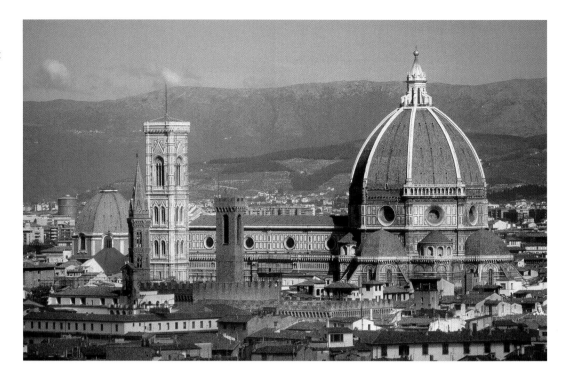

12-9 Florence Cathedral (Sta. Maria del Fiore). Begun by Arnolfo di Cambio, 1296; dome by Filippo Brunelleschi, 1420–36

Materials & Techniques: Perspective, page 272) may have grown out of his search for an accurate way of recording their appearance. We do not know what else Brunelleschi did during this period, but between 1417 and 1419 he again competed with Ghiberti, this time for the job of building the Florence Cathedral dome.

Florence Cathedral, begun in 1296, was planned from the beginning as a landmark to civic pride towering above the city (fig. 12-9). The most striking feature of Florence Cathedral, the vast octagonal dome, presented a task so overwhelming it was not completed until 1436 and only through innovations by Brunelleschi.

Because the dome had been designed half a century earlier by a committee of leading painters and sculptors, only details could be changed. Nevertheless, Brunelleschi's proposals, although contrary to traditional practice, so impressed the authorities that this time he won—thanks in part to a model he built with the help of Donatello and Nanni di Banco. Thus the dome may be viewed as the first work of postmedieval architecture, as an engineering feat if not for style.

Brunelleschi's main achievement was to build the dome in two separate shells. These make use of a skeletal system inspired by the coffered dome of the Pantheon (see fig. 7-7). The two are ingeniously linked so as to rein-force each other, rather than forming a solid mass. Because the weight of the structure was lightened, Brunelleschi could dispense with the massive and costly wooden truss-work required by the older method of construction. Instead of having building materials carried up on ramps to the required level, he designed hoisting machines. His entire scheme reflects a bold, analytical mind that was willing to discard traditional solutions if better ones could be devised.

In 1419, while he was working out the final plans for the dome, Brunelleschi received his first opportunity to create buildings entirely of his own design. It came from the head of the Medici family, one of the leading merchants and bankers of Florence, who commissioned him to add a **sacristy** (a room near the main altar where vessels and vestments are kept) to the Romanesque church of S. Lorenzo. His plans for this structure (which was to serve also as a burial chapel for the Medici) were so successful that he was asked to develop a new design for the entire church. (He had to take into account the choir, which had already been started by the prior of San Lorenzo.) The construction, begun in 1421, was often interrupted, so that the interior was not completed until 1469, more than 20 years after the architect's death. (The exterior remains unfinished to this day.) Nevertheless, the building in its present form

is essentially what Brunelleschi had envisioned about 1420, and represents the first full statement of his architectural aims (figs. 12-10 and 12-11).

At first glance, the plan may not seem very novel. Its general arrangement recalls that of Cistercian Gothic churches, and the unvaulted nave and transept link it to Sta. Croce (see fig. 11-14). What distinguishes it is a new emphasis on symmetry and regularity. The entire design consists of square units. Four large squares form the choir, the crossing, and the arms of the transept. Four more are combined into the nave. Other squares, one-fourth the size of the large ones, make up the aisles and the chapels attached to the transept. (The oblong chapels outside the aisles were not part of the original design but were added sometime after 1442.)

As we study the plan, we see that Brunelleschi must have decided to make the floor area of the choir equal to four of the small square units. The nave and transept thus would be twice as wide as the aisles or chapels. In other words, Brunelleschi conceived S. Lorenzo as a grouping of "space blocks," the larger ones being simple multiples of a standard unit. (He was not concerned with the thickness of the walls between these compartments, so that the transept arms are slightly longer than they are wide, and the length of the nave is not four but four and one-half times its width.) Once we understand this, we realize how revolutionary he was. His clearly defined space compartments were a radical change from the Gothic architect's way of thinking. The difference is one of consistency. Despite Abbot Suger's emphasis on harmonious ratios, Gothic churches such as Notre-Dame in Paris (see fig. 11-2) never applied a systematic set of proportions throughout, even though groin-vaulting encouraged the development of uniform modules.

In the interior, static order has replaced the flowing spatial movement of Gothic examples. S. Lorenzo does not sweep us off our feet. It does not even draw us forward after we have entered; we are content to remain near the door. From there our view seems to take in the entire structure, almost as if we were looking at a demonstration of scientific perspective (compare fig. 12-5). The effect recalls the "old-fashioned" Tuscan Romanesque, such as the Baptistery of

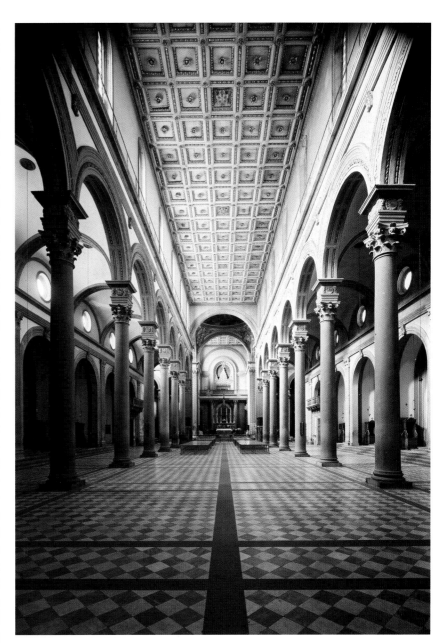

12-10 Filippo Brunelleschi. S. Lorenzo, Florence. 1421–69

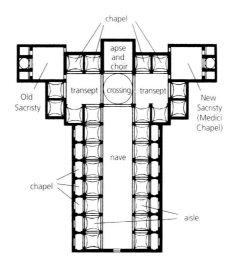

12-11 Plan of S. Lorenzo

S. Giovanni in Florence (see fig. 10-10), as well as Early Christian basilicas. These monuments, to Brunelleschi, exemplified the church architecture of classical antiquity. (The Baptistery was even thought to have once been a classical temple.) They inspired his use of round arches and columns, rather than piers, in the nave arcade. Yet these earlier buildings lack the lightness and precise articulation of S. Lorenzo. Their columns are larger and more closely spaced, tending to screen off the aisles from the nave. Only the arcade of the Florentine Baptistery is as gracefully proportioned as that of S. Lorenzo, but it is a blind arcade, without any supporting function.

Clearly, then, Brunelleschi did not revive the architectural forms of the ancients out of mere enthusiasm. The very quality that attracted him to them—their inflexibility—must have seemed their chief drawback from the medieval point of view. Unlike a medieval column, a classical column is strictly defined; its details and proportions can be varied only within narrow limits. The classical round arch, unlike any other arch (horseshoe, pointed, and so forth), has only one possible shape, a semicircle. The classical architrave, profiles, and ornaments are all subject to similarly strict rules. This is not to say that classical forms are completely rigid. If they were, they could not have persisted to the fourth century A.D. But the discipline of the Greek orders, which can be felt even in the most original Roman buildings, demands regularity and discourages arbitrary departures from the norm.

Without such "standardized" forms, Brunelleschi would have been unable to define his "space blocks" so clearly. With remarkable logic, he emphasizes the edges or "seams" of the units without disrupting their rhythmic sequence. To take one noteworthy example, consider the vaulting of the aisles. The transverse arches rest on pilasters attached to the outer wall (corresponding to the columns of the nave arcade), but between arch and pilaster there is a continuous architrave linking all the bays. We would expect these bays to be covered by unribbed groin vaults. Instead, we find a new kind of vault whose curved surface is formed from the upper part of a hemispherical dome. (Its radius equals half the diagonal of the square compartment.) Avoiding the ribs and even the groins, Brunelleschi has created a "one-piece" vault, strikingly simple and regular, in which each bay is a distinct unit.

At this point we may ask: if the new architecture consists of separate elements added together, be they spaces, columns, or vaults, how do they relate to one another? What makes the interior of S. Lorenzo seem so fully integrated? There is indeed a principle that accounts for the balanced nature of the design. For Brunelleschi, the secret of good architecture was to give the "right" proportions—that is, proportional ratios expressed in simple whole numbers—to all the major measurements of a building. The ancients had possessed this secret, he believed, and he tried to discover it when he measured their monuments. What he found, and exactly how he applied it, we do not know for sure. He may have been the first to discover what would be stated a few decades later in Leone Battista Alberti's *Treatise on Architecture:* the mathematical ratios that determine musical harmony must also govern architecture, for they recur throughout the universe and thus are divine in origin.

Similar ideas, derived from the theories of the Greek philosopher Pythagoras, had been current during the Middle Ages, but they had never before been expressed so directly and simply. When Gothic architects "borrowed" the ratios of musical theory, they did so far less consistently. But even Brunelleschi's faith in harmonious proportions did not tell him how to allot these ratios to the parts of any given building. It left him many alternatives, and his choice was necessarily subjective. We may say, in fact, that the main reason S. Lorenzo strikes us as the product of a great mind is the individual sense of proportion that can be found in every detail.

In the revival of classical forms, Renaissance architecture found a standard vocabulary. The theory of harmonious proportions gave it a syntax that had been mostly absent in medieval architecture. This relative lack of flexibility should be viewed as an advantage. To take our linguistic analogy further, we may draw a parallel between the "unclassical" flexibility of medieval architecture, expressed in numerous regional styles, and the equally "unclassical" attitude toward language that prevailed at the time, as found in its barbarized Latin and regional vernaculars, the ancestors of today's Western languages. The

revival of Latin and Greek in the Renaissance did not stunt these languages. On the contrary, it made them much more stable, precise, and articulate, so that before long Latin lost its dominant position as the language of intellectual discourse. It is not by chance that we can read Renaissance literature in Italian, French, English, or German without much trouble, whereas texts of a century or two earlier can often be understood only by scholars. Similarly, the revival of classical forms and proportions enabled Brunelleschi to transform the architectural "vernacular" of his region into a stable, precise, and clear system. The principles on which his buildings were based soon spread to the rest of Italy and later to all of Northern Europe.

Leone Battista Alberti In architecture, the death of Brunelleschi in 1446 brought to the fore Leone Battista Alberti (1404–1472). Highly educated in mathematics, classical literature, and philosophy, Alberti was both a humanist and a person of the world. After receiving his degree in canon law at the University of Bologna in 1428, he entered the papal court in Rome and spent the rest of his career working for the Church.

Until he was 40, Alberti seems to have been interested in the fine arts only as an antiquarian and theorist. He studied the monuments of ancient Rome, albeit casually at first, and wrote the first Renaissance treatises on sculpture and painting. He also began a third treatise, far more exhaustive than the others, on architecture—the first of its kind since Vitruvius's, on which it is modeled (see page 85). After about 1430, he was close to the leading artists of his day. (*On Painting* is dedicated to Brunelleschi and refers to "our dear friend" Donatello.) Alberti began to practice architecture as a dilettante, but in time he became a professional of outstanding ability.

Alberti devoted much of his career to resolving a fundamental issue of Renaissance architecture: how to apply a classical system to the exterior of a nonclassical structure. Whether Brunelleschi ever coped with this problem is hard to say. In any case, most of Alberti's work for the Church consisted of remodeling projects, which hampered his goal of superimposing a classical temple front on the traditional basilican church facade. Only toward the end of his career did he achieve

this seemingly impossible feat: in the majestic facade of S. Andrea at Mantua (fig. 12-12), his last work, designed in 1470 at the behest of Lodovico Gonzaga, duke of Mantua.

Alberti superimposed a **triumphal-arch** motif (see page 124) with a huge center niche on a classical temple front and projected this combination onto the wall. The arch supported by pilasters is derived in turn from the doorway to the Pantheon (see fig. 7-6). These are clearly set off from their surroundings, and their flatness emphasizes the primacy of the wall surface. The pilasters are of two sizes. The smaller ones support the arch over the central niche, and the larger ones are linked with the unbroken architrave and the strongly outlined pediment. The latter form what is known as a **colossal order** (meaning that it is more than one story high). Extending across all three stories of the facade, it balances the horizontal and vertical elements of the design. So intent was Alberti on creating a unified facade that he inscribed the entire design within a square, even though it is much lower than the nave of the church. (The effect of the west wall protruding above the pediment is more disturbing in photographs than at street level, where it can hardly be seen.) Although the facade is distinct from the main body of the structure, it

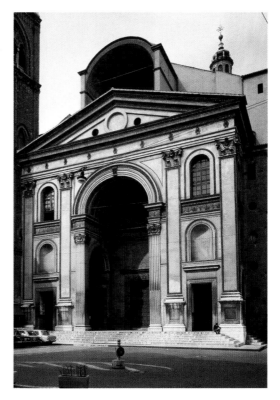

12-12 Leone Battista Alberti. S. Andrea, Mantua. Designed 1470

offers a "preview" of the interior, where the same colossal order, the same proportions, and the same triumphal-arch motif reappear on the walls of the nave.

Because it occupies the site of an older basilican church (note the Gothic campanile next to the facade), S. Andrea does not conform to the ideal shape of sacred buildings as defined in Alberti's *Treatise on Architecture*. There he explains that the plan of such structures should be either circular or derived from the circle (square, hexagon, octagon, and so forth). The justification is that the circle is the perfect, as well as the most natural, figure and therefore a direct image of divine reason. Alberti's ideal church must have such a harmonious design that it would be a revelation of God and would arouse pious contemplation in the worshiper. It should stand alone,

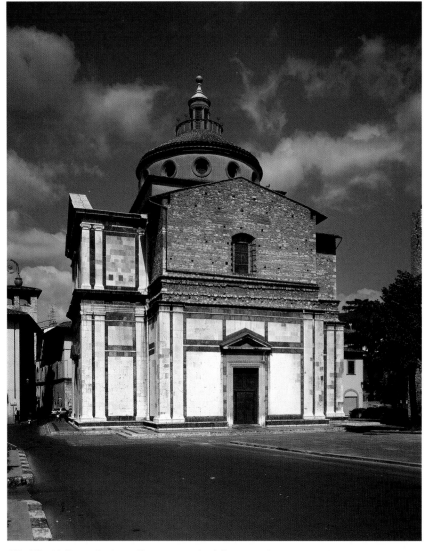

12-13 Giuliano da Sangallo. Sta. Maria delle Carceri, Prato. Begun 1485

above its surroundings. Light should enter through openings placed high, for only the sky should be seen through them. The fact that such a structure was not well suited to Catholic ritual meant little to Alberti. A church, he believed, must embody "divine proportion," which could be attained only by the central plan (see page 155). This claim rests, of course, on Alberti's faith in the God-given validity of mathematical proportions. He took to heart Vitruvius's belief that architecture must employ the same principles of symmetry and proportion as a "well-shaped man." (In support of this rule, Vitruvius pointed out that a man with arms and legs outstretched fits into a circle or square.) How could Alberti reconcile his belief in the central plan with historical evidence? After all, the standard form of both ancient temples and Christian churches was longitudinal. But, he reasoned, the basilican church plan became traditional only because the early Christians worshiped in private Roman basilicas. Because pagan basilicas were associated with the dispensing of justice (which originates from God), he granted that their shape had some relationship to sacred architecture. However, because they could not rival the sublime beauty of the temple, their purpose must have been human rather than divine.

In speaking of temples, Alberti relied entirely on the Pantheon (see figs. 7-6 and 7-7) and other round structures that he mistook for temples. Moreover, he asked, had not the early Christians themselves acknowledged the sacred nature of these structures by converting them to their own use? Here he could point not only to the Pantheon itself (which had been used as a church ever since the early Middle Ages) but also the Baptistery in Florence (then thought to be a former temple of Mars).

Giuliano da Sangallo Toward the end of the century, after Alberti's treatise became widely known, the central-plan church gained wide acceptance. Between 1500 and 1525 it reigned supreme in High Renaissance architecture. It is no coincidence that Sta. Maria delle Carceri in Prato (fig. 12-13) was begun in 1485, the date of the first printed edition of the treatise. Its architect, Giuliano da Sangallo (c. 1443–1516), who was employed as a military engineer, must have been an admirer of Brunelleschi, as we can

tell from the vocabulary. The basic shape of his structure, however, conforms to Alberti's ideal. Except for the dome, the entire church would fit neatly inside a cube; its height (up to the **drum**) equals its length and width. By cutting into the corners of this cube, Giuliano has formed a Greek cross (a plan he preferred for its symbolic value). The arms are **barrel-vaulted**, and the dome rests on these vaults. Yet the drum does not quite touch the supporting arches, so that the dome seems to hover weightlessly, like the pendentive domes of Byzantine architecture (compare fig. 8-12). There can be no doubt that Giuliano wanted his dome to accord with the age-old tradition of the Dome of Heaven. The single round opening in the center and the 12 on the perimeter clearly refer to Christ and the apostles.

Painting

Masaccio Early Renaissance painting did not appear until the early 1420s. The new style was launched by a young genius named Masaccio (Tommaso di Giovanni di Simone Guidi, 1401–1428), who was only 21 years old at the time and who died just six years later. The fact that the Early Renaissance was already well established in sculpture and architecture made Masaccio's task easier than it would have been otherwise. The artist's achievement was quite remarkable nevertheless.

Trinity Masaccio's first mature work is a fresco of 1425 in Sta. Maria Novella (fig. 12-14) depicting the Holy Trinity in the company of the Virgin, St. John the Evangelist, and two donors who kneel on either side. The lowest section, which is linked with a tomb below, shows a skeleton lying on a sarcophagus. The inscription (in Italian) reads as follows: "What you are, I once was; what I am, you will become."

Masaccio's style completely abandons the lyrical grace of the International Gothic of Gentile da Fabriano's *The Adoration of the Magi* (see fig. 11-39). Instead we seem to plunge into a new environment, one that brings to mind not the style of the recent past but the art of Giotto and his school, with its large scale, severe composition, and sculptural volume (compare figs. 11-30,

11-31, and 11-35). Masaccio's allegiance to Giotto was only a starting point, however. For Giotto, body and drapery form a single unit, as if both had the same substance. In contrast, Masaccio's figures, like Donatello's, are "clothed nudes," whose drapery falls like real fabric. The Christ still follows the example set by Duccio's *Maestà* altarpiece (see fig. 11-29), but the nearly sculptural treatment recalls an early *Crucifixion* by Brunelleschi that translates the same model into three dimensions. Like Donatello and Brunelleschi, Masaccio had a thorough knowledge of anatomy, not seen since Roman art. They may well have initiated the modern practice of dissecting cadavers to study the inner workings of the human body.

Alberti, in his treatise *On Painting*, 1435, explains this new view of painting: "I first draw a rectangle of right angles, where I am

Plan of floor and ceiling derived from the painting

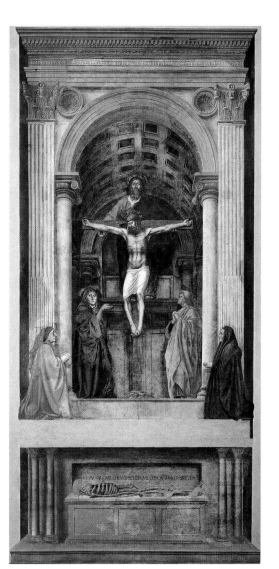

Masaccio's one-point scientific perspective creates a rational picture space—the illusion that the figures are standing in a coffered, barrel-vaulted niche just above our eye.

12-14 Masaccio. *The Holy Trinity with the Virgin, St. John, and Two Donors.* 1425. Fresco in Sta. Maria Novella, Florence

to paint, which I treat just like an open window through which I might look at what will be painted there. . . ." The up-to-date setting reveals the artist's understanding of Brunelleschi's new architecture and of scientific perspective. For the first time in history, we are given all the data needed to measure the depth of a painted interior, to draw its plan, and to duplicate the structure in three dimensions. It is, in short, the earliest example of a rational space in painting. This barrel-vaulted chamber is not a shallow niche, but a deep space in which the figures could move freely if they so wished. As in Ghiberti's relief panel *The Story of Jacob and Esau* (see fig. 12-5), the picture space is independent of the figures. They inhabit the space, but they do not create it. Take away the architecture and you take away the figures' space. We could go even further and say that scientific perspective depends on this particular kind of architecture, so different from the Gothic.

First we note that all the lines perpendicular to the picture plane converge toward a point below the foot of the Cross, on the platform that supports the kneeling donors. To see the fresco correctly, we must face this point, which is at normal eye level, somewhat more than five feet above the floor of the church. The figures within the chamber are five feet tall, slightly less than life-size, whereas the donors, who are closer to us, are fully life-size. The framework therefore is "life-size," too, because it is directly behind the donors. The distance between the pilasters equals the span of the barrel vault, seven feet. The circumference of the arc over this span is 11 feet. That arc is subdivided by eight square coffers and nine ridges, the coffers being one foot wide and the ridges four inches wide. If we apply these data to the length of the barrel vault (it consists of seven coffers, the nearest of which is hidden behind the entrance arch), we find that the vaulted area is nine feet deep.

We can now draw a complete floor and ceiling plan. However, the position of God the Father is puzzling at first. His arms support the Cross, close to the front plane, while his feet rest on a ledge attached to a wall. How far back is this surface? If it is the rear wall of the chamber, God would seem to be exempt from the laws of perspective. But unless the artist made a gross error in his calculations, this cannot be so. Hence Masaccio must have intended to locate the ledge directly behind the Cross. The strong shadow that St. John casts on the wall beneath the ledge bears this out. What, then, is God standing on? It is likely that he is standing on the tomb of Christ, which is placed at a right angle to the wall and measures five and a half feet high by four feet wide and six or seven feet deep.

We realize, then, that *The Holy Trinity* is a restatement of the promise of eternal life in the Bardi chapel frescoes by Maso di Banco and Taddeo Gaddi (see fig. 11-35), as well as a reminder, a *memento mori,* of one's earthly mortality (in the words of the inscription). Instead of combining painting with actual tomb sculpture, Masaccio has created an illusion that is far more convincing. This is so even though the niche is treated as a separate realm that the viewer, like the two donors, cannot enter. The rational pictorial space plays a key role in other ways as well. For Masaccio, as for Brunelleschi, it must have been a symbol of the universe ruled by divine reason. This attitude further explains the quiet atmosphere, the calm gesture of the Virgin as she points to the Cross, and the solemn grandeur of God the Father as he holds it effortlessly. The fervent hope of salvation portrayed in the Bardi chapel (note the prayerful poses of the deceased) is presented here as a certitude based on reason as well as faith. Such, indeed, was the purpose of Renaissance humanism, in which the artist now assumed a position comparable to that of a philosopher.

Brancacci Chapel The largest group of Masaccio's works to come down to us are frescoes in the Brancacci Chapel in Sta. Maria del Carmine, Florence (fig. 12-15), which are devoted to the life of St. Peter. The most famous of the Brancacci frescoes is *The Tribute Money,* located in the upper tier. It depicts the story in the Gospel of Matthew (17:24–27) as a continuous narrative. In the center, Christ instructs Peter to catch a fish, whose mouth will contain the tribute money for the tax collector. On the far left, in the distance, Peter takes the coin from the fish's mouth, and on the right he gives it to the tax collector. Because the lower edge of this

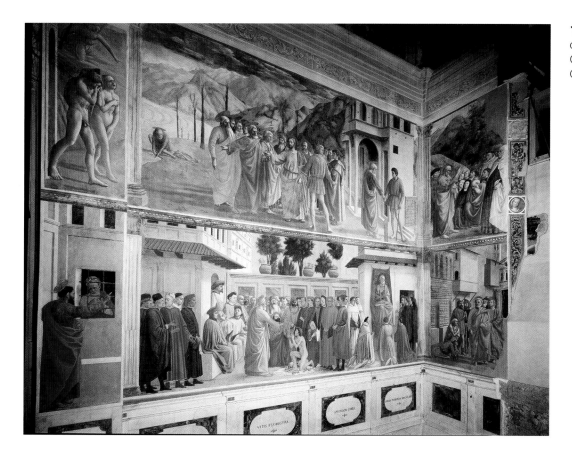

scene is almost 14 feet above the floor of the chapel, the artist could not assume an ideal vantage point. Instead, we must imagine that we are looking directly at the central vanishing point, which is located behind the head of Christ. Oddly enough, this feat is so easy that we take note of it only if we stop to analyze it.

If we could see *The Tribute Money* from the top of a ladder, the illusion of reality would not improve very much, because it does not depend mainly on scientific perspective. Masaccio controls the flow of light (which comes from the right, where the window of the chapel is located) and also uses **atmospheric perspective** (see page 272) in the subtle tones of the landscape. We now recall Donatello's use of such a setting a decade earlier in his small relief of St. George (compare fig. 12-2).

The figures in *The Tribute Money*, even more than those in the *Trinity* fresco, display Masaccio's ability to merge the weight and volume of Giotto's figures with the new functional view of body and drapery. All stand in balanced *contrapposto*. Fine vertical lines scratched in the plaster establish the axis of each figure from the head to the heel

of the engaged leg. In accord with this dignified approach, the figures seem rather static. The narrative is conveyed by intense glances and a few strong gestures, rather than by physical movement. But in *The Expulsion from Paradise*, just to the left, Masaccio proves that he can show the human body in motion. The tall, narrow format leaves little room for a spatial setting. The gate of paradise is barely indicated, and in the background are a few shadowy, barren slopes. Yet the soft, atmospheric modeling, and especially the forward-moving angel, boldly foreshortened, convey a sense of unlimited space. Masaccio's grief-stricken Adam and Eve, though hardly dependent on ancient models, are striking representations of the beauty and power of the nude human form.

Fra Angelico Masaccio died too young (he was only 27) to be the founder of a school, and his style was too bold to be taken up immediately by his contemporaries. His slightly older contemporary, Fra Angelico (Guido di Pietro, c. 1400–1455), was a friar who rose to a high position within his order. We sense his reverential

SPEAKING OF

school, school of, and follower of

Art historians use the word *school* in several ways. Some master artists developed a following of people who worked in their presence, consciously emulating the style of the master. Similarly, artists who worked in the same time, place, and style sometimes are considered to be a school, such as those during the nineteenth century who painted at Barbizon. *School of* is used to identify an unknown artist clearly working under the influence of a major figure, and *follower of* suggests a second-generation artist whose work continues the style of the named master.

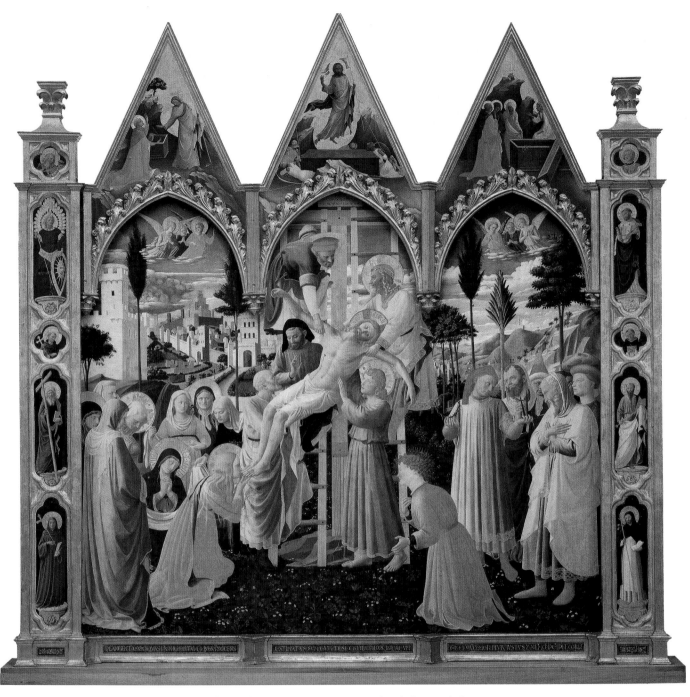

12-16 Fra Angelico. *The Deposition.* Probably early 1440s. Tempera on panel, 9'1¼" × 9'4¼" (2.75 × 2.85 m). Museo di S. Marco, Florence

attitude in the large *Deposition* (fig. 12-16), which was probably done for the same chapel as Gentile da Fabriano's *Adoration of the Magi* (see fig. 11-39). Fra Angelico took over the commission from Gentile's contemporary Lorenzo Monaco. Lorenzo was responsible for the paintings in the frame and the triangular pinnacles, but died before he could complete the altar. *The Deposition* may date anywhere from about 1435 to the early 1440s, for Fra Angelico, like Ghiberti, developed slowly, and his mature style underwent very little change.

This painting is an object of devotion. Fra Angelico retains Masaccio's dignity, directness, and spatial order. Thus Fra Angelico's dead Christ is the true heir of the monumental figure in Masaccio's *Trinity*. Yet Fra Angelico's art is something

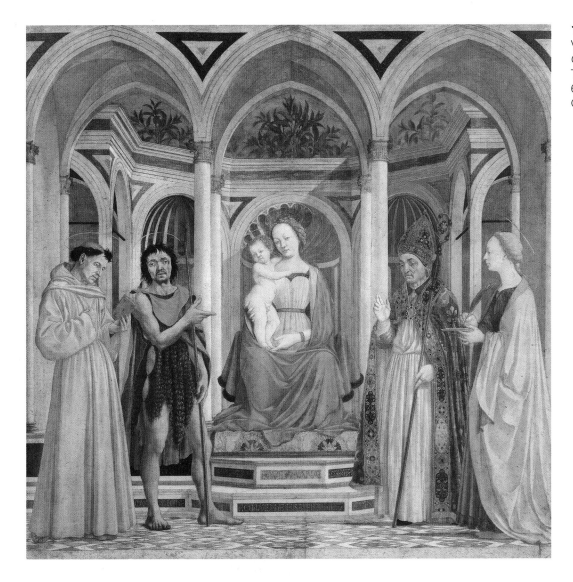

12-17 Domenico Veneziano. *Madonna and Child with Saints*. c. 1455. Tempera on panel, 6′10″ × 7′ (2.08 × 2.13 m). Galleria degli Uffizi, Florence

of a paradox. It combines Gothic piety with Renaissance grandeur in an atmosphere of calm contemplation. The setting spreads behind the figures like a tapestry. The landscape, with the town in the distance, harks back to the *Good Government* by Ambrogio Lorenzetti (see fig. 11-34). The artist also shows his awareness of the achievements of Northerners such as the Limbourg brothers (compare fig. 11-38): he evokes a brilliant sunlit day with striking success. Yet the scene does not seem at all Gothic. This light fills the landscape with a sense of wonderment at God's creation, an effect that is wholly Renaissance in spirit. We shall meet it again in the work of Giovanni Bellini, which it anticipates in another respect: the beautiful yet uninhabited city in the distance is surely the Heavenly Jerusalem (see fig. 12-24), a counter-

part to the actual earthly city, Jerusalem. At the same time, the bright, enamel-like hues, though remnants of the International Style, look forward to the colorism of Domenico Veneziano.

Domenico Veneziano In 1439 Domenico Veneziano, a gifted painter from Venice, settled in Florence. We can only guess at his age, training, and previous work. (He was probably born about 1410 and died in 1461.) He must, however, have been in sympathy with the spirit of Early Renaissance art, for he quickly became an important artist in his new home. His *Madonna and Child with Saints* (fig. 12-17) is one of the earliest examples of a new kind of altar panel, called a *sacra conversazione* ("sacred conversation"). An enthroned Madonna is framed by architecture and flanked by

saints, who may converse with her, with the beholder, or among themselves.

Looking at Domenico's panel, we can understand the appeal of the *sacra conversazione*. The architecture and the space it defines are clear and tangible, yet elevated above the everyday world. The figures, while echoing the formality of their setting, are linked with each other by a fully human awareness. We are admitted to their presence, but they do not invite us to join them. Like spectators in a theater, we are not allowed "on stage."

The basic elements of our panel were already present in Masaccio's *Holy Trinity* fresco. Domenico must have studied it carefully, for his St. John looks at us while pointing toward the Madonna, repeating the glance and gesture of Masaccio's Virgin. Domenico's perspective setting is worthy of the earlier master, although the slender proportions and colored inlays of his architecture are more decorative. His figures, too, are as balanced and dignified as Masaccio's, but without the same weight and bulk. The slim, sinewy bodies of the male saints, with their highly individualized, expressive faces, show Donatello's influence.

Unlike Masaccio, Domenico treats color as an integral part of his work, and the *sacra conversazione* is as noteworthy for its palette as for its composition. The blond tonality—its harmony of pink, light green, and white set off by spots of red, blue, and yellow—reconciles the brightness of Gothic panel painting with perspective space and natural light. A *sacra conversazione* is usually an indoor scene, but this one takes place in a kind of **loggia** (a covered open-air arcade) with sunlight streaming in from the right, as we can tell from the cast shadow behind the Madonna. The surfaces reflect the light so strongly that even the shadowed areas glow with color. Masaccio had achieved a similar quality of light in one of his oil paintings, which Domenico surely knew. In this *sacra conversazione*, the technique has been applied to a more complex set of forms and merged with Domenico's exquisite color sense. The influence of its distinctive tonality can be seen throughout Florentine painting during the second half of the century.

Piero della Francesca When Domenico Veneziano settled in Florence, he had a young assistant from southeastern Tuscany named Piero della Francesca (c. 1420–1492). Piero became his most important disciple and one of the great artists of the Early Renaissance. Surprisingly, however, he left Florence after a few years, never to return, and spent his career near Arezzo in the market town Borgo Sansepulcro, then part of the papal states, although he executed a number of works for Federico da Montefeltro (1422–1482), the duke of Urbino. The Florentines seem to have viewed his work as provincial and old-fashioned, and from their point of view they were right. Piero's style, even more than Domenico's, reflected the aims of Masaccio. Piero retained his allegiance to the founder of Italian Renaissance painting throughout his long career, even while Florentine taste developed in a different direction in the years after 1450.

Piero's most impressive work is the fresco cycle in the choir of S. Francesco in Arezzo, painted from about 1452 to 1459. Its many scenes depict the legend of the True Cross: the story of the Cross used for Christ's crucifixion, which had been rediscovered in 216 by St. Helena, mother of Constantine the Great. The section in figure 12-18 shows the empress Helena discovering the True Cross and the two crosses of the thieves who died beside Jesus. (All three had been hidden by enemies of the Faith.) On the left, they are being lifted out of the ground; on the right, the True Cross is identified by its power to bring a dead youth back to life.

Piero's link with Domenico is apparent in his colors. The tonality of this fresco, although less luminous than in Domenico's *sacra conversazione*, is similarly blond and evokes morning sunlight in much the same way. Because the light enters the scene at a low angle, in a direction almost parallel to the picture plane, it defines every shape and lends drama to the narrative. But Piero's figures have an austere grandeur that recalls Masaccio, or even Giotto, more than Domenico. These men and women seem to belong to a lost heroic race, beautiful and strong—and silent. Their inner life is conveyed by glances and gestures, not by facial expressions. They have a gravity that makes them seem akin to Greek sculpture of the Severe style (see figs. 5-17 and 5-19).

How did Piero arrive at these images? They were born of his passion for perspec-

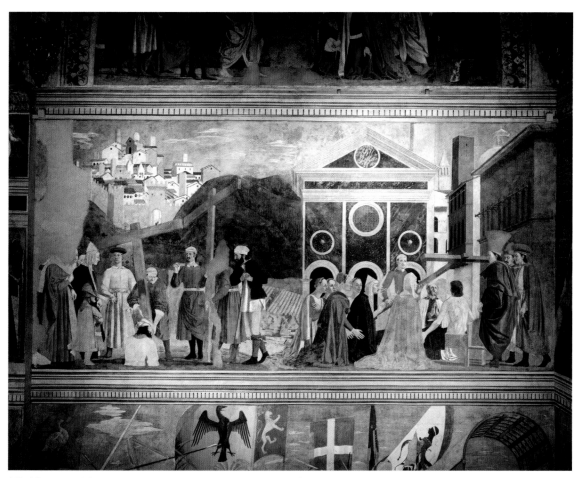

12-18 Piero della Francesca. *The Discovery and Proving of the True Cross.* c. 1455. Fresco in S. Francesco, Arezzo

tive. More than any other artist of his day, Piero believed in scientific perspective as the basis of painting. In a mathematical treatise that was the first of its kind, he showed how it applied to stereometric (scientifically measured) bodies and architectural shapes, as well as to the human form.

We see these stereometric forms in his *Baptism of Christ* (fig. 12-19), which may have been the center section of an altarpiece. Piero transforms Christ's solid, white, smoothly almost cylinder-like body into an ethereal vision, but one firmly standing on this earth. He stands as an ideal figure in *contrapposto.* The verticality of his form is strengthened by the tree to the left and in contrast to the three androgynous angels. The intense blue of the sky pales as it reaches the horizon and is an example of aerial or atmospheric perspective, so that we view the horizon as in a greater distance. The strong light from the right emphasizes the painting's starkness.

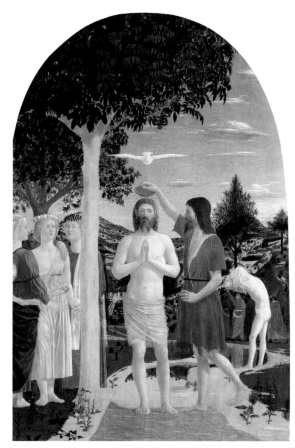

12-19 Piero della Francesca. *Baptism of Christ.* c. 1452. Tempera on panel 65³/₄″ × 45²/₃″ (1.67 × 1.16 m). The National Gallery, London

Perspective is a way of making a two-dimensional surface appear to be three dimensional. That is, it helps us to understand and see depth. Artists use this technique in painting, print, drawing, and relief sculpture. There are two general ways to do this: through scientific perspective or atmospheric perspective.

Scientific perspective is a term that can be used interchangeably with linear perspective. They are the same. The architect and sculptor, Brunelleschi, may have invented scientific perspective, which is based on mathematical principles. Alberti was the first to write about it. Scientific perspective expects that the observer has a single, fixed viewpoint; the viewer's focus is on a single spot, known as the **vanishing point**. The lines that converge and direct our focus to that vanishing point are known as orthogonals. Sometimes, we can see those orthogonals as drawn by the artist and other times they are not visible; they may have been used by the artist to establish perspective, but there are no actual drawn lines on the painted or printed surface. We can see the orthogonals in Pietro Perugino's *The Delivery of the Keys* (fig. 12-22), which recede from the center foreground to the door of the church in the background and can imagine them across the walls in Leonardo's *Last Supper* (see fig. 13-2), focusing our attention at their vanishing point, Christ's head.

Atmospheric or aerial perspective is a method of showing depth through the use of color. The decrease in intensity of color (at a horizon line) to a light blue or gray tone, suggests a greater depth at the lightest point. We perceive the colors of greater intensity (as a deeper blue in the sky) as closer to us and see this principle at work at the horizon in Piero's *Baptism of Christ* (fig. 12-19) and in numerous examples. Atmospheric perspective is more subtle than scientific. It is also easier to execute and, therefore, more widely used.

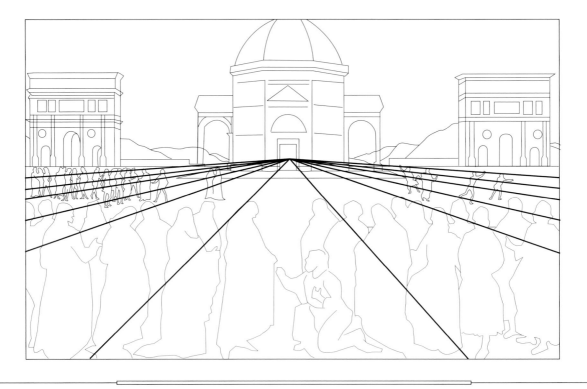

Although Christ was baptized in the Jordan River, seen flowing in the center, the landscape is really a Tuscan one. Winding down the road from the right, four figures in exotic costumes with flat-top cylindrical hats approach. These figures have been tentatively identified as the Magi (despite their number) or as Jews, who do not recognize the miracles that are unfolding in the foreground. Plants on both sides of the Jordan have been identified as medicinal, protecting against toothaches (buttercups), or snakebites (clover), among several others, as baptism itself is a form of healing for ultimate salvation. But the entire work is a grave study of the Baptism, and one devoid of emotion.

This scientific or mathematical outlook appears in all of Piero's work. When he drew a head, an arm, or a piece of drapery, he saw them as variations or compounds of spheres, cylinders, cones, cubes, and pyramids. Thus he endowed the visible world with some of the clarity and permanence of stereometric bodies. Medieval artists, in contrast, built natural forms on geometric scaffolds (see fig. 11-27). We may regard Piero as the earliest ancestor of the abstract artists of our own time, for they, too, simplify natural forms. It is not surprising that Piero's fame is greater today than ever before. But in the second half of the fifteenth century, Florentine taste would turn in a new direction.

Sandro Botticelli The new direction in Florentine painting, a dynamic linear style, reached its highpoint in the final quarter of the century, in the art of Sandro Botticelli (1444/5–1510). One of the pioneers of Italian Renaissance portraiture, Botticelli became the favorite painter of the Medici circle—the group of nobles, scholars, and poets surrounding Lorenzo the Magnificent, the head of the family, and for all practical purposes, the real ruler of the city.

The dynamic linear style of Botticelli, one that gives way to graceful movement, rather than by the statuesque immobility of Piero or Masaccio is conveyed by the windblown hair of his *Idealized Portrait of a Lady (The So-Called "Simonetta Vespucci")* (fig. 12-20). The young woman has been identified as Simonetta Vespucci (c.1453–1476, née Cattaneo) of a noble Genoese family and the secret love of Giuliano de' Medici (1453–1478). The portrait would have been painted a few years after her death, still extolling her virtue and beauty. She wears a white gown symbolizing chastity (part of the concept of courtly love) set against a dark background, emphasizing the linearity of form. The intricate, careful weaving of ribbons and pearls plaited in her hair (known as *vespaio*, and may be a pun on the name Vespucci) is contrasted to her wispy, wind-swept look and the casualness this suggests. The combination reveals a softer, breathless beauty, who wears a pendant bearing the subject of Apollo and Marsyas. Jewelry of this subject, mounted by Ghiberti, was in the Medici collection and may be the one seen here. The elegant portrait, seen in profile, is typical of fifteenth-century portraits

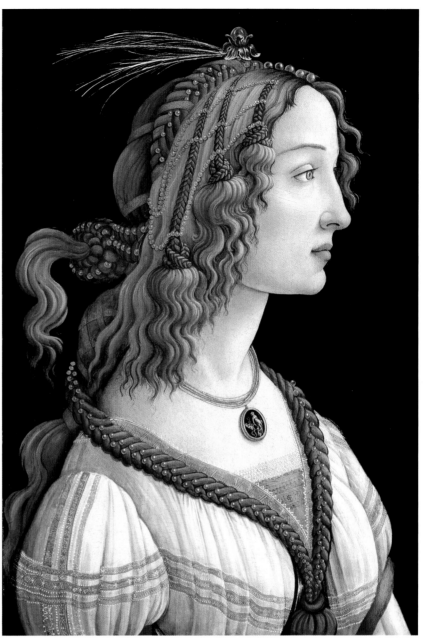

12-20 Sandro Botticelli. *Idealized Portrait of a Lady (The So-Called "Simonetta Vespucci")*. c. 1483–86. Tempera on poplar, 20³/₄″ × 13³/₄″ (82 × 54 cm.). Gemäldegalerie, Staedel Kunstinstitut, Frankfurt am Main

and reminiscent of both ancient and Renaissance coins. But the popularity of profile portraits at the end of the fifteenth century was primarily confined to images of women. It was a chivalric response to the concept of courtly love and the possibility of gazing unabashedly at a woman who (by nature of her being in profile) would not notice us, nor need to avert her eyes. Courtly love was one of chastity and presumed innocence—a love without physical contact (although that may not have truly been the case). It would have been important that the object of desire (Simonetta, in this

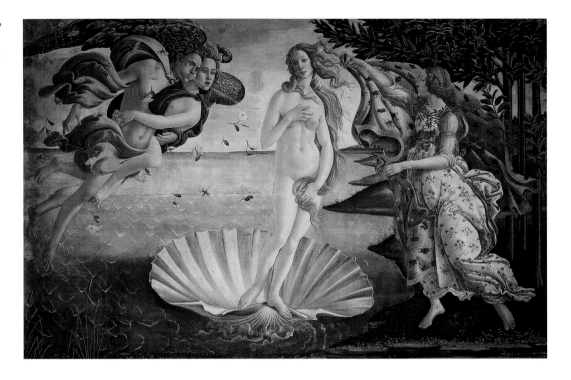

12-21 Sandro Botticelli. *The Birth of Venus.* c. 1480. Tempera on canvas, 5'8⁷⁄₈" × 9'1⁷⁄₈" (1.75 × 2.79 m). Galleria degli Uffizi, Florence

case) neither encourage the attention or even acknowledge it.

Botticelli painted his most famous picture, *The Birth of Venus* (fig. 12-21), for the young prince Lorenzo de' Medici. (It once hung in his summer villa.) The shallow modeling and the emphasis on outline produce an effect of low relief rather than of solid, three-dimensional shapes. We note, too, a lack of concern with deep space. The grove at the right, for example, functions as an ornamental screen. Bodies are elongated and drained of all weight; indeed, they seem to float even when they touch the ground in strong contrast to the solid, weighted forms of Piero (see fig. 12-18). *The Birth of Venus* seems to deny the basic values of the founders of Early Renaissance art, with their emphasis on individualism, but the very nudity and grace of the central figure stakes a claim on the Renaissance ideal. The bodies, however ethereal, remain voluptuous. They are genuine nudes, with full freedom of movement.

Botticelli's Venus is derived from a variant of the *Knidian Aphrodite* by Praxiteles (see fig. 5-24). The subject itself was inspired by the Homeric "Hymn to Aphrodite," which begins: "I shall sing of beautiful Aphrodite . . . who is obeyed by the flowery sea-girt land of Cyprus, whither soft Zephyr and the breeze wafted her in soft foam over the waves. Gently the golden-filleted Horae received her, and clad her in divine gar-

ments." (See Cultural Context: The Greek Gods and Goddesses, page 73.) Yet no single literary source accounts for the pictorial conception. It also owes something as well to Ovid and especially the humanist poet Angelo Poliziano (1454–1494), who was, like Botticelli, a member of the Medici circle and almost certainly advised him on the painting, as he undoubtedly did on others.

Neoplatonism The subject of *The Birth of Venus* is clearly meant to be serious, even solemn. How could such images be justified in Christian terms without both the artist and his patron being accused of neopaganism? To answer this question we must consider the meaning of the picture as well as the use of classical subjects in Early Renaissance art.

During the Middle Ages, classical form had become divorced from classical subject matter. Artists could draw upon ancient poses, gestures, expressions, and types only by changing the identity of their sources: Orpheus turned into Adam, Hercules was now Samson. When medieval artists wanted to represent the pagan gods, they based their pictures on literary descriptions rather than visual models. This was the situation, by and large, until the mid fifteenth century.

By mid fifteenth century an argument could be made for fusing the Christian faith with ancient mythology, rather than merely to relating them. Strongly influenced by the

Greek philosopher, PLATO, these Neoplatonists enjoyed great prestige during the late fifteenth century and after. Foremost among them was Marsilio Ficino, who was also a priest. He believed that the life of the universe, including human life, was linked to God by a spiritual circuit continuously ascending and descending, so that all revelation—whether from the Bible, Plato, or classical myths—was one. He also proclaimed that beauty, love, and beatitude, being phases of this same circuit, were one. Thus Neoplatonists could speak of both the "celestial Venus" (the nude Venus born of the sea, as in our picture) and the Virgin Mary as sources of "divine love" (meaning the recognition of divine beauty).

The celestial Venus, according to Ficino, dwells purely in the sphere of Mind. Her twin, the ordinary Venus, gives rise to "human love." Of her Ficino wrote to the Medici prince: "Venus . . . is a nymph of excellent comeliness, born of heaven and more than others beloved by God all highest. Her soul and mind are Love and Charity, her eyes Dignity and Magnanimity, the hands Liberality and Magnificence, the feet Comeliness and Modesty. The whole, then, is Temperance and Honesty, Charm and Splendor. Oh, what exquisite beauty! . . . a nymph of such nobility has been wholly given into your hands! If you were to unite with her in wedlock and claim her as yours she would make all your years sweet." In both form and content, this passage follows odes to the Virgin composed by medieval Church fathers.

Once we know that Botticelli's picture has this quasi-religious meaning, it seems less surprising that the wind god Zephyr and the breeze goddess Aura on the left look so much like angels. It also makes sense that the **Hora** on the right, personifying Spring, who welcomes Venus ashore, recalls the relationship of St. John to the Savior in Piero's *Baptism of Christ* (fig. 12-19). As baptism is a "rebirth in God," so the birth of Venus evokes the hope for "rebirth," from which the Renaissance takes its name.

Neoplatonic philosophy and its expression in art were obviously too complex to become popular outside the select and highly educated circle of its devotees. In 1494 the suspicions of ordinary people were aroused by the friar Girolamo Savonarola, who attacked the "cult of paganism." He is usually portrayed unsympathetically as a book-burning firebrand whose sermons gained him a huge following, who was ultimately (and unjustly) burned at the stake as a heretic in 1498. Botticelli himself was perhaps a follower of Savonarola and reportedly burned a number of his own "pagan" pictures. In his last works, Botticelli returned to traditional religious themes but with no essential change in style. He seems to have stopped painting entirely after 1500, even though the apocalyptic destruction of the world predicted by Savonarola at the millennium-and-a-half was not fulfilled.

Pietro Perugino Rome, long neglected during the papal exile in Avignon (see page 201), once more became a major artistic center in the later fifteenth century. As the papacy regained power on Italian soil, the popes began to beautify both the Vatican and the city, in the belief that the monuments of Christian Rome must outshine those of the pagan past. The most ambitious pictorial project of those years was the decoration of the walls of the recently completed Sistine Chapel for Pope Sixtus IV (see fig. 13-9). Begun around 1481–82, this large cycle consists of events from the life of Moses (left wall) and Christ (right wall), representing the old and new covenants. The artists include most of the important painters of central Italy, among them Botticelli and Ghirlandaio. If the Sistine murals do not, on the whole, present their best work, it is because these mostly young artists had little experience in monumental fresco painting, for which there had been few opportunities since the 1450s.

There is, however, one notable exception: *The Delivery of the Keys* (fig. 12-22, see Materials & Techniques: Perspective, page 272) by Pietro Perugino (c. 1450–1523) is this artist's finest achievement. Born near Perugia in Umbria (the region southeast of Tuscany), Perugino maintained close ties with Florence. Early in his career he was strongly influenced by Verrocchio, as can be seen in the statuesque balance and solidity of his figures (compare fig. 12-8). The symmetrical design conveys the importance of the subject. The authority of St. Peter as the first pope, as well as of all those who followed him, rests on his having received the keys to the Kingdom of Heaven from Christ himself, in the same way that the Christian church in the background is built on the rock that is Peter. A number of

One of the most creative and influential philosophers of all time, PLATO (c. 428–c. 347 B.C.) was an aristocratic Athenian, a pupil of Socrates, and founder of the Academy, on the outskirts of Athens. (Aristotle was Plato's outstanding student.) Plato's writings are in the form of dialogues, and the ideas characterized as "Platonic thought" are those that rely on his theory of Forms, or Ideas. Expressed very simply, Plato distinguishes two levels of awareness: opinion—based on information received by the senses and experiences—and genuine knowledge, which is derived from reason and is universal and infallible. In Platonic thinking, the objects conceived by reason exist in a pure form in an Idea realm.

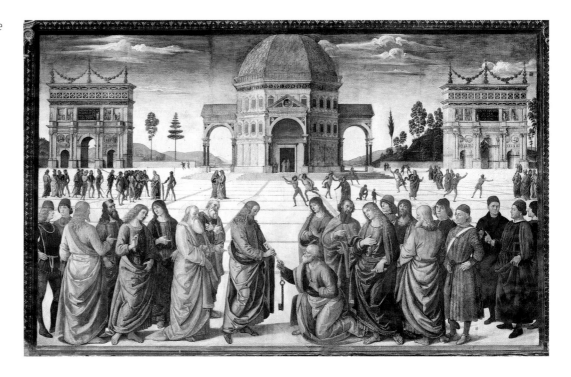

12-22 Pietro Perugino. *The Delivery of the Keys.* 1482. Fresco in the Sistine Chapel, the Vatican, Rome

Perugino's contempraries, with highly individualized features, witness the solemn event.

Equally striking is the vast expanse of the background. To the left, in the middle distance, is the moment when Jesus says, "Render to Caesar what is Caesar's"; to the right, the stoning of Christ. The inscriptions on the two Roman triumphal arches (modeled on the Arch of Constantine in Rome) favorably compare Sixtus IV to Solomon, who built the Temple of Jerusalem, where the Ark of the Covenant was later housed. The pair of arches flank a domed structure representing the ideal church of Alberti's *Treatise on Architecture*. Also Albertian is the mathematically exact perspective, which lends the view its spatial clarity. (To simplify the scheme, however, the squares are far larger than those recommended by Alberti for such a piazza.) This scene, so rational and intelligible in its construction, nevertheless achieves a stunning visionary effect. Despite its novel spatial qualities, Perugino's fresco in many respects continues the tradition of Piero della Francesca, who spent much of his later life working for Umbrian clients, notably the duke of Urbino. Also from Urbino, shortly before 1500, Perugino received a pupil whose fame would soon outshine his own: Raphael.

Andrea Mantegna In northern Italy, the International Style in painting and sculpture lingered until midcentury, and architecture long retained a strongly Gothic flavor. As a result, there were hardly any major achievements in these fields. Between 1450 and 1500, however, a great painting tradition was born in Venice and its territories that was to flourish for the next three centuries. The Republic of Venice, although more oligarchic and oriented toward the East, had many ties with Florence. Hence it is not surprising that Venice, rather than Milan, became the center of Early Renaissance art in northern Italy.

Florentine masters had been carrying the new style to Venice and nearby Padua since the 1420s. Yet their presence had little effect until shortly before 1450. At that time, Andrea Mantegna (1431–1506) emerged as an independent master. He was trained by a minor Paduan painter, but his early career was shaped by his impressions of Florentine works, and, we may assume, by contact with Donatello. Next to Masaccio, he is the most important painter of the Early Renaissance. He, too, was a young genius, able to carry out commissions of his own by age 17. In the next decade he reached artistic maturity, and during the next half-century (he died at the age of 75) he broadened the range of his art, without abandoning the style he had developed in the 1450s. He nevertheless preferred to work in Padua and then Mantua, where in 1459 he became court painter to Ludovico Gonzaga

(d. 1478), with whom he developed a uniquely close relationship and became a member of the duke's inner circle; this arrangement continued under Francesco II (1466–1519), who became duke six years after his father's death.

The *St. Sebastian* panel reproduced in figure 12-23 is set among classical ruins. (In the foreground, to the left of the saint, we also find the artist's signature in Greek.) Here Mantegna's devotion to the visible remains of antiquity, almost like an archaeologist's, shows his close association with the learned humanists at the University of Padua, who had the same devotion to ancient literature. No Florentine painter or sculptor of the time could have conveyed such an attitude to him. The saint looks more like a statue than a living body. The tense figure, muscular and firm, is derived from Donatello. Mantegna was much concerned with light and color. We see an atmospheric landscape and a deep blue sky dotted with soft white clouds. The scene is bathed in warm late-afternoon sunlight, which creates a melancholy mood and makes the pathos of the dying saint even more poignant. The background shows the influence, direct or indirect, of the Van Eycks (compare fig. 15-2, left). And, in fact, some works of the great Flemish masters had reached Florence as well as Venice between 1430 and 1450. They created the interest in light-filled landscapes that became such an important part of Venetian painting.

Giovanni Bellini In the painting of Giovanni Bellini (c. 1431–1516), Mantegna's brother-in-law, we can trace the further impact of the Flemish tradition in the South. Bellini was slow to mature. His finest pictures, such as *St. Francis in Ecstasy* (fig. 12-24), date from the last decades of the century or even later. Bellini's contours are less brittle than Mantegna's, his colors softer and the light more glowing. He also shares the concern of the great Flemings for every detail and its symbolism. Unlike the Northerners, however, he can define the viewer's spatial relationship to the landscape. The rock formations of the foreground are clear and firm, like architecture rendered by scientific perspective.

The subject is unique. The scene is treated as the equivalent of Moses and the burning bush in the book of Exodus. When the patriarch of the Jews came to the mountain of God, an angel appeared to him in a

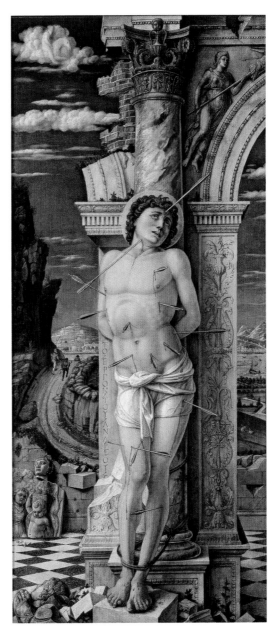

12-23 Andrea Mantegna. *St. Sebastian.* c. 1455–60. Tempera on panel, 26¾″ × 11⅞″ (68 × 30.6 cm). Kunsthistorisches Museum, Vienna

flame of fire out of a bush that was not consumed and from which the Lord commanded him to remove his shoes, because he was on holy ground (see also page 327). It was then that God promised to deliver the Jews out of the hands of the Egyptians and into the land of milk and honey. Here, the saint has left his wooden pattens behind and looks up ecstatically to the sky.

The painting is often thought to show Francis receiving the stigmata (the wounds of Christ) on the Feast of the Holy Cross in 1224, when a crucified seraph appeared to him on Mount Alverna; however, the marks on his hands and feet are barely visible and have clearly healed. Instead, it most likely "illustrates" the Hymn of the Sun, which

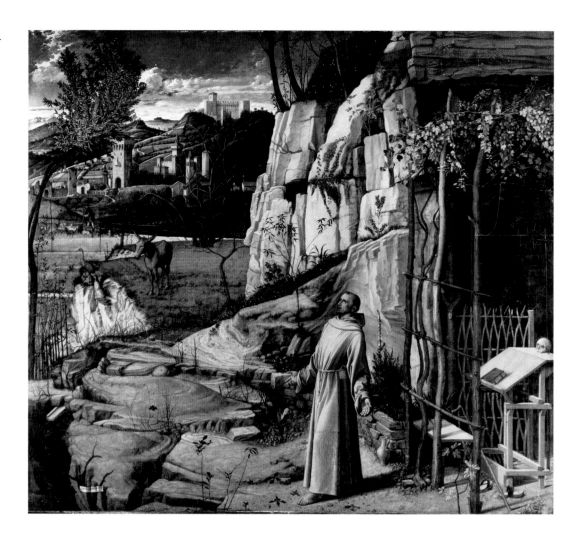

Francis composed the next year, after his annual fast at a hermitage near his hometown of Assisi. During that time he could not bear the sight of light and was plagued by mice. The monk finally emerged from his cell after the Lord assured him that he would enter the Kingdom of Heaven.

For Francis, "Brother Sun, who gives the day . . . and . . . is beautiful and radiant with great splendor" was a symbol of the Lord. What he sees, however, is not the sun itself, which is obscured by a cloud, but God revealed as the light divine. This miraculous light is so intense that it illuminates the entire scene. Even the lone tree at the left, a counterpart to the burning bush, bends in response to it, as if moved by a powerful, unseen force.

In the background is a magnificent expanse of Italian countryside. Yet this is no ordinary landscape. It represents the Heavenly Jerusalem, inspired by the Revelation of St. John the Divine. The city remains empty until Judgment Day, when it will receive the souls of the blessed. It lies across the river, separated from the everyday world by the bridge to the left. Behind looms Mount Zion, where the Lord dwells. How, then, shall we enter the gate to paradise, shown as a large tower? For Francis, the road to salvation lay in the ascetic life, symbolized by the cave, which also links him to St. Jerome, the first great hermit saint. The donkey stands for St. Francis, who referred to his body as Brother Ass, which must be disciplined. The other animals—the heron, bittern, and rabbit—are, like monks, solitary creatures in Christian lore.

The symbolism does not by itself explain the picture. More important is the treatment of the landscape. Francis is so small compared to the setting that he seems almost incidental. Yet his mystic rapture before the beauty of the visible world guides our own response to the view that is spread out before us, which is ample and intimate at the same time. Francis believed that the Lord had created nature for the benefit of humanity. Bellini clearly shares his reverence for God's handiwork, as expressed in the Hymn of the Sun, which begins, "Be praised, my Lord, with all Your creatures."

The High Renaissance in Italy

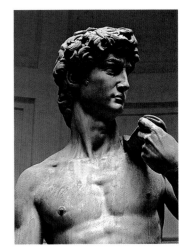

T USED TO BE TAKEN FOR GRANTED THAT THE HIGH RENAISSANCE followed the Early Renaissance as inevitably as night follows day. The great masters of the sixteenth century—Leonardo, Bramante, Michelangelo, Raphael, Giorgione, Titian—were thought to have shared the ideals of their predecessors, but to have expressed them so completely that their names became synonyms for perfection. They represented the climax, the classic phase, of Renaissance art, just as Phidias had brought the art of ancient Greece to its highest point. This view could also explain why these two classic phases, although 2,000 years apart, were so short. If art is assumed to develop along the pattern of a ballistic curve, its highest point cannot last more than a moment.

In some basic respects, the High Renaissance was indeed the culmination of the Early Renaissance. In others, however, it was a major departure. Certainly the tendency to view artists as geniuses, rather than simply as artisans, was never stronger than during the first half of the sixteenth century. Plato's concept of genius—the spirit that enters poets and causes them to compose in a "divine frenzy"—had been broadened by Marsilio Ficino and his fellow Neoplatonists to include architects, sculptors, and painters. For Giorgio Vasari, geniuses were set apart by "grace," in the sense of both divine grace (a gift from God) and gracefulness (which reflected it). To him, this concept, which was the hallmark of the successful courtier, had moral and spiritual significance, inspired in part by Dante's *Inferno*. Building further on Petrarch's scheme of history (see page 136), Vasari saw the High Renaissance as superior even to antiquity, because it belonged to the era of Christian grace. Thus, in his *Lives of the Painters* (1550–68), he praises the "gracious," virtuous personalities of Michelangelo, Leonardo, and Raphael as a way of accounting for their talent. Grace also

served to justify his assessment of Michelangelo as the greatest artist of all time. This view remains with us to this day, although Michelangelo's character was far from admirable in some respects.

What set these artists apart was the inspiration guiding their efforts, which was worthy of being called "divine," "immortal," and "creative." (Before 1500, creating, as distinct from making, was the privilege of God alone.) To Vasari, the painters and sculptors of the Early Renaissance, like those of the Late Gothic, had learned only to imitate nature. The geniuses of the High Renaissance, in contrast, had conquered nature by ennobling or transcending it. In actual fact, the High Renaissance remained thoroughly grounded in nature. Its achievement lay in the creation of a new classicism.

Faith in the divine origin of inspiration led artists to rely on subjective standards of truth and beauty. Whereas Early Renaissance artists felt bound by what they believed to be universal rules, such as the numerical ratios of musical harmony and the laws of scientific perspective, their High Renaissance successors were less concerned with rational order than with visual

effectiveness. They evolved a new drama and a new rhetoric to engage the emotions of the beholder, whether sanctioned or not by classical precedent. Indeed, the works of the great masters of the High Renaissance soon became classics in their own right, with an authority equal to that of the most famous monuments of antiquity. At the same time, this cult of the genius had a profound effect on the artists themselves. It spurred them to ambitious goals and prompted their patrons to support those projects. Because these ambitions often went beyond what was humanly possible, they were apt to be limited by external as well as internal difficulties. Artists were thus left with a sense of having been defeated by malevolent fate.

Here we face a contradiction: if the creations of genius are viewed as unique by definition, they cannot be successfully imitated by lesser artists, however worthy they may seem of emulation. Unlike the founders of the Early Renaissance, the leading artists of the High Renaissance did not set the pace for a broadly based "period style" that could be practiced on every level of quality. The High Renaissance produced surprisingly few minor masters. It died with those who had created it, or even before. Of the six great personalities mentioned above, only Michelangelo and Titian lived beyond 1520.

Most of the key monuments of the High Renaissance were produced between 1495 and 1520. Conditions after that date were less favorable to the High Renaissance style than those of the first two decades of the sixteenth century. Its harmonious grandeur was an inherently unstable balance of conflicting elements. Only these components, not the balance itself, could be transmitted to the artists who reached maturity after 1520. Yet, for most of the next 300 years, the great masters of the early sixteenth century loomed so large that the achievements of their predecessors seemed to belong to a forgotten era. Even when the art of the fourteenth and fifteenth centuries was finally rediscovered, people still saw the High Renaissance as the turning point and referred to all painters before Raphael as "the Primitives."

LEONARDO DA VINCI

The distinction of being the earliest High Renaissance master belongs to Leonardo da Vinci (1452–1519). He was trained in Florence by Verrocchio. Conditions there must not have suited him, however. At the age of 30 Leonardo went to work for the duke of Milan, the ruthless Ludovico Sforza (1452–1508), second son of Francesco Sforza.

The Virgin of the Rocks Leonardo did few paintings in Milan. He was occupied mainly with military and other engineering projects but soon after arriving, Leonardo painted *The Virgin of the Rocks* (fig. 13-1).

13-1 Leonardo da Vinci. *The Virgin of the Rocks.* c. 1485. Oil on panel transferred to canvas, 6′3″ × 3′7½″ (1.91 × 1.11 m). Musée du Louvre, Paris

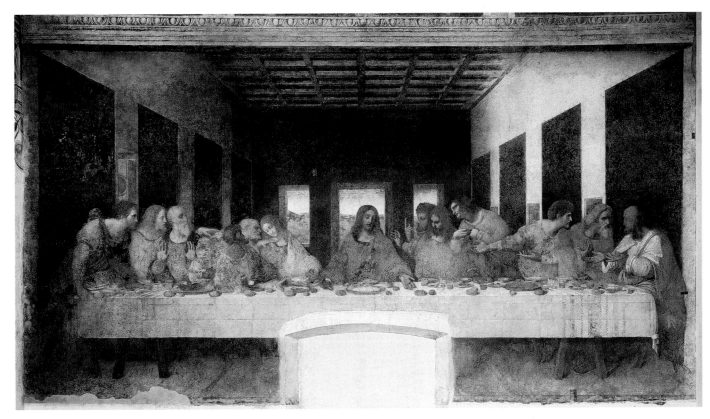

13-2 Leonardo da Vinci. *The Last Supper.* c. 1495–98. Tempera, 15′2″ × 28′10″ (4.62 × 8.79 m). Mural in Sta. Maria delle Grazie, Milan

The figures emerge from the semidarkness of the grotto, enveloped in a moist atmosphere that delicately veils their forms. This fine haze, called **sfumato**, is more pronounced than similar effects in Flemish and Venetian painting. It lends an unusual warmth and intimacy to the scene. It also creates a remote, dreamlike quality and makes the picture seem a poetic vision rather than an image of reality. In his NOTEBOOKS Leonardo had much to say about the relationship between art and literature. His argument, called the *Paragone* (comparison of the arts), was rooted in Horace's statement that poetry is like painting (*ut pictura poesis*); however, Leonardo forcefully presents his belief that the painter is superior to the poet. The subject—the infant St. John adoring the Christ Child in the presence of the Virgin and an angel—is entirely new in art. The story of their meeting is one of the many legends that arose to satisfy curiosity about the "hidden" early life of Jesus, which is hardly mentioned in the Bible. (According to a similar legend, St. John, about whom equally little is known, spent his childhood in the wilderness; hence he is shown wearing a hair shirt.)

The treatment of the scene is mysterious in many ways. The secluded setting, the pool in front, and the carefully rendered plant life hint at levels of meaning that are hard to define. How are we to interpret the relationships among the four figures, expressed in their gestures? Protective, pointing, blessing, they convey with infinite tenderness the wonderment of St. John's recognition of Christ as the Savior. The gap between these hands and St. John makes the exchange all the more telling. Although present in *The Doubting of Thomas* by Leonardo's teacher, Verrocchio (see fig. 12-8), the elegant gestures and refined features are the first example of that High Renaissance "grace" signifying a spiritual state of being.

The Last Supper Despite its originality, *The Virgin of the Rocks* does not yet differ clearly in conception from Early Renaissance art. Leonardo's *Last Supper*, of a dozen years later, was the first full statement of the ideals of High Renaissance painting (fig. 13-2). It was commissioned for the refectory (dining hall)

In the early 1490s, during his stay at the court of Ludovico Sforza in Milan, Leonardo made a meticulous record of his wide-ranging studies in more than 1,000 pages of NOTEBOOKS, today preserved in 31 volumes. Written backward in mirror writing, the notebooks treat four main themes—painting, architecture, mechanics, and human anatomy—and reveal the range and depth of the artist's prodigious mind. Among the devices anticipated by Leonardo but not built until centuries later were flying machines (including the helicopter), bicycles, submarines, missile launchers, and parachutes.

of the convent at Santa Maria della Grazie, where duke Ludovico dined weekly with the court's leading theologian. Unfortunately, the famous mural began to deteriorate a few years after its completion. The artist, dissatisfied with the limitations of the traditional fresco technique, experimented in an oil-tempera medium in plaster that did not adhere well to the wall. We thus need some effort to imagine its original splendor, even though the painting was recently restored. Yet what remains is more than sufficient to account for its tremendous impact. Viewing the composition as a whole, we are struck at once by its balanced stability. Only afterward do we realize that Leonardo achieved this balance by the reconciliation of competing, even conflicting, aims that no previous artist had attempted.

As we know from preparatory drawings, Leonardo began with the figure composition. Hence the architecture had merely a supporting role from the start, so that it is the very opposite of the rational pictorial space of the Early Renaissance. His perspective is an ideal one. The painting, high up the refectory wall, assumes a vantage point some 15 feet above the floor and 30 feet back. This position is clearly impossible, yet we readily accept it. The central vanishing point, which governs our view of the interior, is located behind the head of Jesus in the exact middle of the picture and therefore becomes charged with symbolic significance. Equally plain is the symbolic function of the main opening in the back wall: it acts as the architectural equivalent of a halo. We thus tend to see the perspective framework of the scene almost entirely in relation to the figures, rather than as something preexisting. We can easily test how vital this relationship is by covering the upper third of the picture. The composition then takes on the character of a **frieze**; the grouping of the apostles is less clear; and the calm triangular shape of Jesus becomes passive, instead of acting as a physical and spiritual force. At the same time, the perspective system helps to "lock" the composition in place, giving the scene an eternal quality without making it look static.

The Savior has presumably just spoken the fateful words, "One of you shall betray me." The disciples are asking, "Lord, is it I?" We see nothing that contradicts this interpretation. But to view the scene as just one moment in a psychological drama does not do justice to Leonardo's aims, which went well beyond a literal rendering of the biblical narrative. He crowded the disciples together on the far side of the table, in a space too small for so many people. He clearly wanted to condense his subject, both physically (by the compact, monumental grouping of the figures) and spiritually (by presenting many levels of meaning at one time). Thus Jesus' gesture is one of submission to the divine will, and of offering. It is a hint at his main act at the Last Supper, the institution of the **Eucharist**, in which bread and wine become his body and blood through **transubstantiation**.

The apostles do not simply react to Jesus' words. Each reveals his own personality, his own relationship to Christ. (Note that Judas is no longer segregated from the rest; his defiant profile sets him apart well enough.) Leonardo has carefully calculated each pose and expression so that the drama unfolds across the picture plane. The figures exemplify what the artist wrote in one of his notebooks, that the highest and most difficult aim of painting is to depict "the intention of man's soul" through gestures and movements of the limbs—a statement to be interpreted as referring not to momentary emotional states but to the inner life as a whole.

Mona Lisa In 1499 the duchy of Milan fell to the French, and Leonardo returned to Florence where he was active mainly as an engineer and surveyor. He did execute one painting (known to us only through copies), *The Battle of Anghiari*, for the City of Florence. In 1506, however, he returned to Milan at the request of the French. There he painted the *Mona Lisa* (fig. 13-3). Here the sfumato of *The Virgin of the Rocks* is so perfected that it seemed miraculous to the artist's contemporaries. The forms are built from layers of glazes so thin that the panel appears to glow with a gentle light from within. But the fame of the *Mona Lisa* comes not from this subtlety alone. Even more intriguing is the sitter's personality. Why, among all the smiling faces ever painted, has this one been singled out as "mysterious"? Perhaps the reason is that, as a portrait, the picture does not fit our expectations. The features are too individual for Leonardo to have simply depicted an ideal type, yet they are so idealized that they blur the sitter's character. Once again the artist has brought two opposites into harmonious balance. The smile also may be

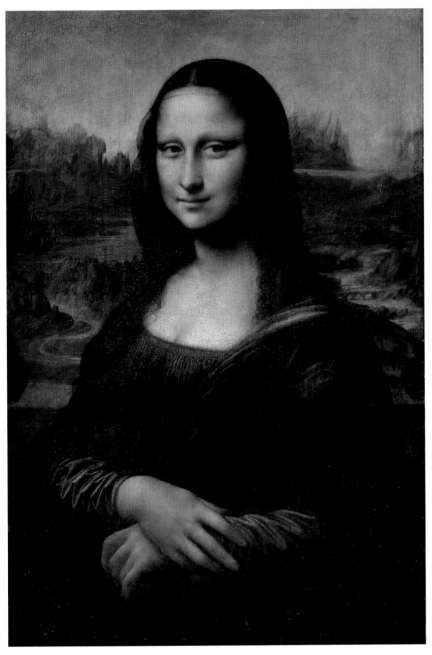

13-3 Leonardo da Vinci. *Mona Lisa*. c. 1503–5. Oil on panel, 30¼ × 21″ (76.8 × 53.5 cm). Musée du Louvre, Paris

read in two ways: as the echo of a momentary mood and as a timeless, symbolic expression akin to the "Archaic smile" of the Greeks (see fig. 5-13). The boldness of *Mona Lisa* both looking out to us and smiling must have been even more startling in its time, after a lengthy period of many painted portraits of women in profile (see fig. 12-20) who are the subject of our gaze, but do not engage us themselves.

The *Mona Lisa* seemingly embodies a maternal tenderness that was the essence of womanhood to Leonardo. The soft fleshiness of the *Mona Lisa* is in contrast to Botticelli's elegant, courtly Simonetta (fig. 12-20). Even

Leonardo's landscape, made up mainly of rocks and water, suggests elemental generative forces. Who was the sitter for this, the most famous portrait in the world? Her identity long remained a mystery, but we now know that she was the wife of a Florentine merchant and was born in 1479 and was dead before 1556. This is not the only painting of the *Mona Lisa*: Leonardo also painted a nude version that once belonged to the king of France, and there are numerous copies by followers.

Architecture Leonardo devoted himself more and more to his scientific interests. Art

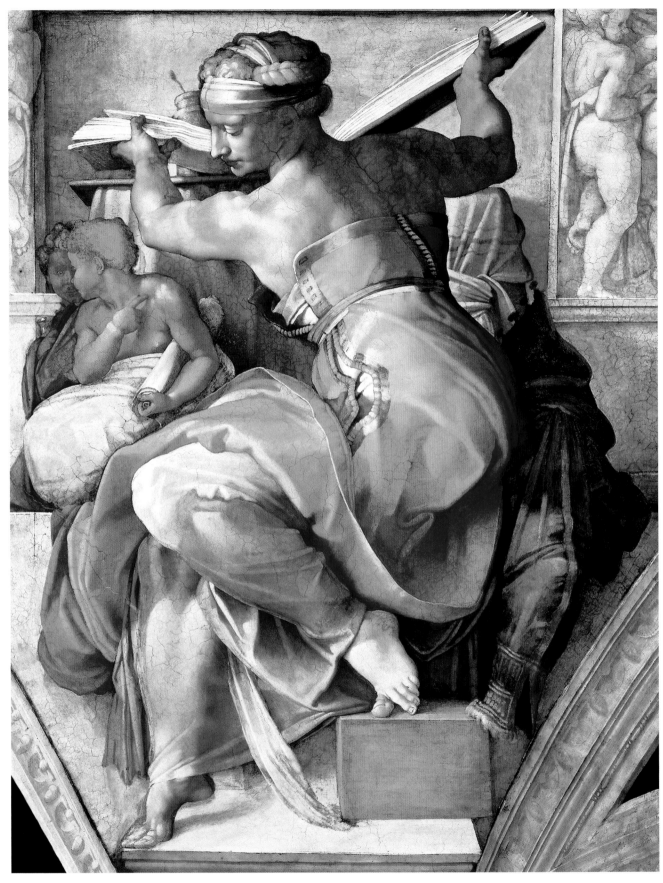

13-11 Michelangelo. *Libyan Sibyl,* detail of the Sistine Ceiling. 1508–12.

Last Judgment (fig. 13-12), which illustrates Matthew 24:29–31. Here the agony has become essentially spiritual, as expressed through violent physical contortions within the turbulent atmosphere. The blessed and damned alike huddle together in tight clumps, pleading for mercy before a wrathful God. The only trace of classicism is the Apollo-like figure of the Lord. Straddling a cloud just below him is the apostle Bartholomew, holding a human skin to represent his martyrdom by flaying. The face on that skin, however, is not the saint's but Michelangelo's own. In this grim self-portrait, so well hidden that it was recognized only in modern times, the artist has left his personal confession of guilt and unworthiness.

The Medici Chapel The time between the Sistine ceiling and *The Last Judgment* coincides with the papacies of Leo X (1513–21) and Clement VII (1523–34). Both were members of the Medici family and preferred to employ Michelangelo in Florence. His activities centered on the Medici church of S. Lorenzo. A century after Brunelleschi's design for the sacristy (see page 260), Leo X decided to build a matching structure, the New Sacristy. It was to house the tombs of Lorenzo the Magnificent, Lorenzo's brother Giuliano, and two younger members of the family, also named Lorenzo and Giuliano. Michelangelo worked on the project for 14 years and managed to complete the architecture and two of the tombs, those for the lesser Lorenzo and Giuliano (fig. 13-13); these tombs are nearly mirror-images of each other. The New Sacristy was thus conceived as an architectural-sculptural ensemble. It is the only one of the artist's works in which the statues remain in the setting intended for them, although their exact placement is problematic. Michelangelo's plans for the Medici tombs underwent many changes while the work was under way. Other figures and reliefs were designed but never executed. The present state of the monuments can hardly be Michelangelo's desired solution, but the design process was

13-12 Michelangelo. *The Last Judgment.* 1534–41. Detail of fresco in the Sistine Chapel

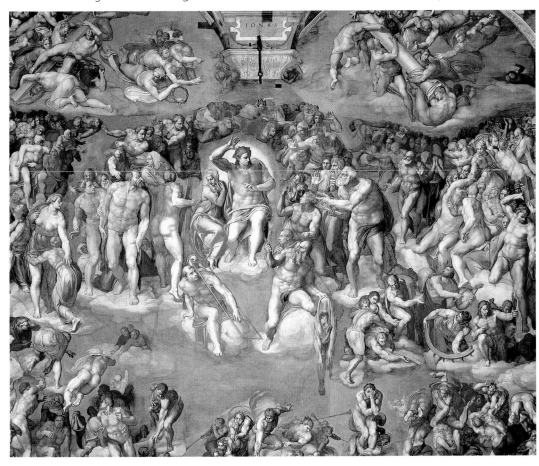

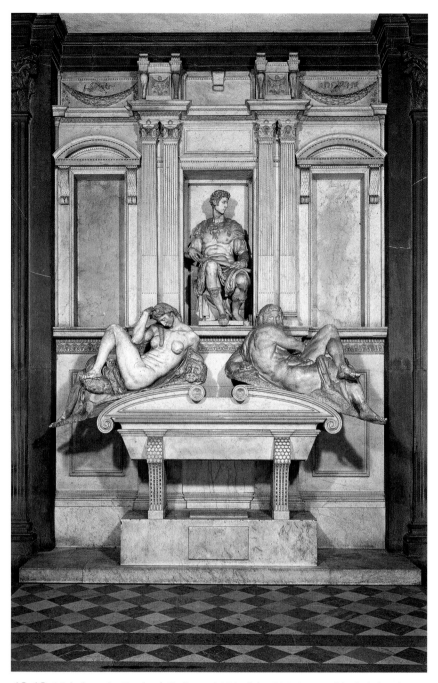

13-13 Michelangelo. Tomb of Giuliano de' Medici. 1524–34. Marble, height of central figure 71″ (1.81 m). New Sacristy, S. Lorenzo, Florence

halted when the artist left permanently for Rome in 1534.

The tomb of Giuliano remains an imposing visual unit, although the niche is too narrow and shallow to accommodate the seated figure comfortably. The triangle of statues is held in place by a network of verticals and horizontals whose slender, sharp-edged forms heighten the roundness and weight of the sculpture. The design still shows some kinship with such Early Renais-sance tombs as that of Leonardo Bruni (see fig. 12-6), but the differences are more important. There is no inscription, and the effigy has been replaced by two allegorical figures—Day on the right and Night on the left. What is the meaning of this group? Some lines penned on one of Michelangelo's drawings suggest an answer: "Day and Night speak, and say: We with our swift course have brought the Duke Giuliano to death. . . . It is only just that the Duke takes revenge

[for] he has taken the light from us; and with his closed eyes has locked ours shut, which no longer shine on earth."

Giuliano, the ideal image of the prince, is in classical military garb and bears no resemblance to the deceased Medici, who had been brutally murdered in 1478 (see Cultural Context: Medici and Artistic Patronage, page 258). ("A thousand years from now, nobody will know what he looked like," Michelangelo is said to have remarked.) Originally the base of each tomb was to have included a pair of river gods. The reclining figures, themselves derived from ancient river gods (compare fig. 23-5), embody action-in-repose more dramatically than any other works by Michelangelo. They contrast sharply in mood. In the brooding menace of Day, whose face was left deliberately unfinished, and in the disturbed slumber of Night, the dualism of body and soul is expressed with unforgettable grandeur.

St. Peter's The construction of St. Peter's progressed so slowly that in 1514, when Bramante died, only the four crossing piers had actually been built. For the next three decades the campaign was carried on hesitantly by architects trained under Bramante, who modified his design in a number of ways. A new and decisive phase in the history of the church began only in 1546, when Michelangelo took over. Ironically, the two men had been such bitter enemies that Michelangelo left Rome in anger when the commission for St. Peter's was given to Bramante; upon the latter's death, his friend Raphael (see page 294), another rival of Michelangelo, was put in charge of the project. Michelangelo replaced the architect Antonio da Sangallo the Younger (nephew of Giuliano da Sangallo; see pages 264–65), whose peculiar design for the church (known in a wooden model) would have completely recast Bramante's.

The present appearance of St. Peter's (fig. 13-14) was largely shaped by Michelangelo's ideas. He simplified Bramante's complex plan without changing its centralized character. He also redesigned the exterior. Unlike Bramante's many-layered elevation (see fig. 13-5), Michelangelo's uses a **colossal order** of pilasters to emphasize the compact body of the structure, thus setting off the dome more dramatically. We have encountered the colossal order before, on the facade of Alberti's S. Andrea (see fig. 12-12), but it was Michelangelo who welded it into a fully coherent system. The same desire for compactness and organic unity led him to simplify the interior. He brought the complex spatial sequences of Bramante's plan (see fig. 13-5) into one cross-and-square. He further defined the main axis by modifying the exterior of the eastern apse and adding a portico to it; this part of his design was never carried out. The dome, however, reflects Michelangelo's ideas in every important respect, although it was largely built after his death and has a steeper pitch.

Bramante had planned his dome as a stepped hemisphere above a narrow drum, which would have seemed to press down on the church. Michelangelo's plan, in contrast, has a powerful thrust that draws energy upward from the main body of the structure. This effect is created by the high drum, the strongly projecting buttresses accented by

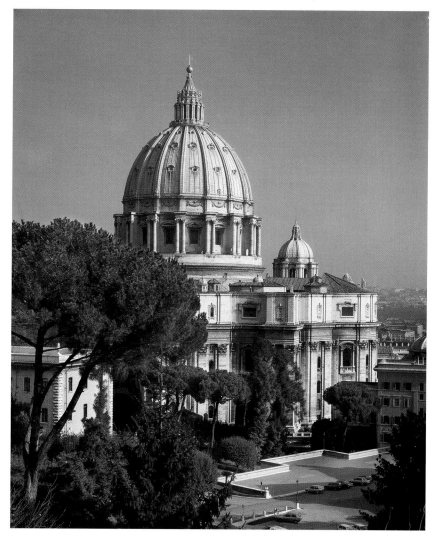

13-14 Michelangelo. St. Peter's (view from the west), Rome. 1546–64. Dome completed by Giacomo della Porta, 1590

Painter, architect, and historiographer GIORGIO VASARI (1511–1574) defined Italian Renaissance art with his publication in 1550 of the history of Italian art from Cimabue (c. 1240–1302?) through Michelangelo; in 1568 he published an expanded and corrected edition of the work. *The Lives of the Most Excellent Italian Architects, Painters, and Sculptors,* known as the *Lives,* gives a mass of anecdotal biographical information about Florentine artists and accords Florence most of the credit for the Renaissance. More significantly, Vasari's view that the goal of art should be the faithful imitation of nature expressed a value judgment favoring classical and Renaissance art that endured for centuries.

double columns, the ribs, the raised curve of the cupola, and the tall lantern. Michelangelo borrowed not only the double-shell construction but also the Gothic profile from the Florence Cathedral dome (see fig. 12-9), yet the effect is very different. The smooth planes of Brunelleschi's dome give no hint of the internal stresses. Michelangelo, however, gives a sculptured shape to these forces and relates it to the rest of the building. The impulse of the paired colossal pilasters below is taken up by the double columns of the drum, continues in the ribs, and culminates in the lantern. The logic of this design is so persuasive that almost all domes built between 1600 and 1900 were influenced by it.

Michelangelo's magnificent assurance in handling such projects as St. Peter's seems to belie his portrayal of himself as a limp skin in *The Last Judgment.* It is indeed difficult to reconcile these contrasting aspects of his personality. Perhaps toward the end of his life he found greater fulfillment in architecture than in shaping human bodies, for we have no finished sculpture from his hand after 1545, when he at last completed the Tomb of Julius II, albeit in heavily modified form. Much of his final two decades were devoted to poetry and drawings of a religious and Neoplatonic sort that are highly personal in content. The statues undertaken for his own purposes, including a Pietà intended for his tomb that he mutilated and partly reworked, show him groping for new forms, as if his earlier work had become meaningless to him.

RAPHAEL

If Michelangelo exemplifies the solitary genius, then Raphael of Urbino (Raffaello Sanzio, 1483–1520) belongs to the opposite type: the artist as a man of the world. As a result, the two were natural antagonists. The contrast between them was as clear to their contemporaries as it is to us. Although each had his defenders, they enjoyed equal fame. Thanks to GIORGIO VASARI, Michelangelo's chief partisan, as well as to the authors of historical novels and fictionalized biographies, Michelangelo still fascinates people. Today Raphael is usually discussed only by historians of art, although his life, too, was the subject

of a fanciful account. The younger artist's career seems too much a success story, his work too marked by effortless grace, to match the tragic heroism of Michelangelo. Raphael also appears to have been less of an innovator than Leonardo, Bramante, and Michelangelo, whose achievements were basic to his. Nevertheless, he is the central painter of the High Renaissance. Our conception of the entire style rests more on his work than on any other artist's. Raphael had a unique genius for synthesis that enabled him to merge the qualities of Leonardo and Michelangelo. Thus his art is lyric and dramatic, pictorially rich and sculpturally solid.

Alba Madonna These characteristics can be seen in his *Alba Madonna* (fig. 13-15), of about 1509 (known by the name of its owners of the seventeenth and eighteenth centuries, the Dukes of Alba). It is one of the most perfect examples within the High Renaissance of compositional balance, simplicity, serenity, and sculpturesque figures in a **tondo**, or round format. The figures, the Madonna, Christ Child, and the child St. John the Baptist, are arranged in a triangular composition, with the shadow of the group forming the lower plane creating an equilateral triangle inscribed in a circle, and the horizon line seems to bisect the circle. Typical of most of Raphael's Madonna and Child paintings, the group is set outdoors as if on a clear spring or summer day. This is in contrast to Leonardo's *Virgin of the Rocks* (fig. 13-1) set in a dark and mysterious grotto. The mystery of the scene is peeled away here to reveal the clarity of Raphael's work. The large figure of the Virgin owes a debt to Michelangelo. And we see this master's influence as well in other works by Raphael.

Stanza della Segnatura In 1508, at the time Michelangelo began to paint the Sistine ceiling, Julius II summoned Raphael from Florence at the suggestion of Bramante, who also came from Urbino. At first Raphael mined ideas he had developed under his teacher Perugino, but Rome transformed him as an artist, just as it had Bramante, and he underwent an astonishing growth. The results can be seen in the Stanza della Segnatura, the first in a series of rooms he was

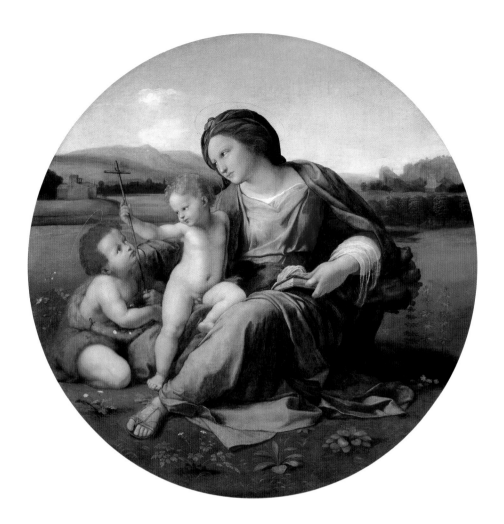

13-15 Raphael. *Alba Madonna.* Oil on panel, diameter 37¼″ (94 cm). National Gallery of Art, Washington, D.C., Andrew Mellon Collection

called on to decorate at the Vatican Palace. The Stanza housed Julius II's personal library; only later did the tribunal of the seal (segnatura), presided over by Pope Paul III, meet there to dispense canon and civil law.

Raphael's cycle of frescoes on its walls and ceiling refers to the four domains of learning: theology, philosophy, law, and the arts. The program is derived in part from the Franciscan St. Bonaventure, who sought to reconcile reason and faith, and from St. Thomas Aquinas, the Dominican chiefly responsible for reviving Aristotelian philosophy. The Stanza represents a summation of High Renaissance humanism, for it attempts to unify all understanding into one grand scheme. Raphael probably had a team of scholars and theologians as advisers; yet the design is his alone.

Of all the frescoes in the Stanza della Segnatura, *The School of Athens* (fig. 13-16) has long been acknowledged as Raphael's masterpiece and the perfect embodiment of the classical spirit of the High Renaissance. Its subject is "the Athenian school of thought," a group of famous Greek philosophers gathered around Plato and Aristotle, each in a characteristic pose or activity. Raphael must have already looked at the Sistine ceiling, then nearing completion. He owes to Michelangelo the expressive energy, physical power, and dramatic grouping of his figures. Yet Raphael has not simply borrowed Michelangelo's gestures and poses. He has absorbed them into his own style and thus given them a different meaning.

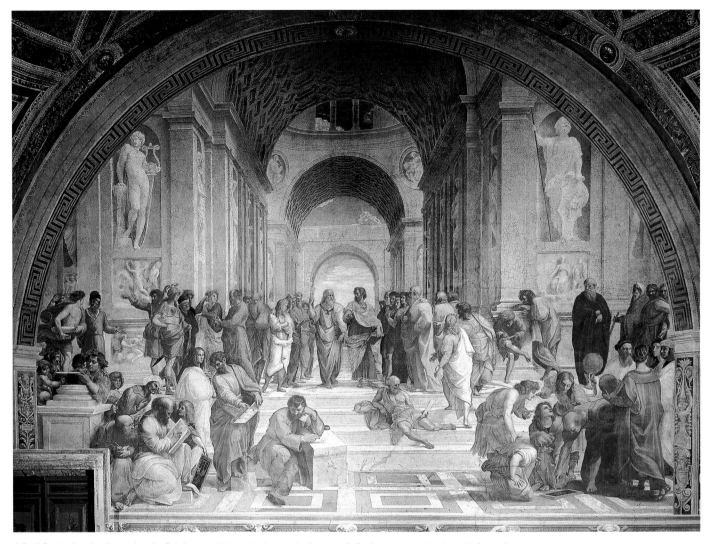

13-16 Raphael. *The School of Athens.* 1510–11. Fresco in Stanza della Segnatura, Vatican Palace, Rome

Body and spirit, action and emotion, are now balanced harmoniously, and all members of this great assembly play their roles with magnificent, purposeful clarity. The total conception of *The School of Athens* suggests the spirit of Leonardo's *Last Supper* (see fig. 13-2) rather than the Sistine ceiling. Raphael makes each philosopher reveal "the intention of his soul." He further distinguishes the relations among individuals and groups, and links them in a formal rhythm. (The artist worked out the poses in a series of drawings, many from life.) Also in the spirit of Leonardo is the symmetrical design, as well as the interdependence of the figures and their architectural setting.

Raphael's building is more central to the composition than the hall of *The Last Supper*. With its lofty dome, barrel vault, and colossal statuary, it is classical in spirit, yet Christian in meaning. The building is in the shape of a simplified Greek cross to suggest the harmony of pagan philosophy and Christian theology. Inspired by Bramante, who, as Vasari informs us, helped Raphael with the architecture, it seems like an advance view of the new St. Peter's. (Raphael developed into a skilled architect in his own right and, as we have seen, succeeded Bramante at St. Peter's.) The dimensions and overall ground plan of the structure can be determined with considerable accuracy. This geometric precision, along with the spatial grandeur of the work as a whole, brings to a climax the tradition begun by Masaccio (see fig. 12-14). It was transmitted to Raphael by Perugino, who had inherited it from Piero della Francesca. What is new is the active role played by the architecture in creating narrative space. This innovation was of fundamental importance and had a profound impact on the course of painting far beyond the sixteenth century.

The identity of most of the figures is not certain, but we can be sure that many incorporate portraits of Raphael's friends and patrons. At center stage, Plato (whose face resembles Leonardo's) is holding his book of cosmology and numerology. *Timaeus,* which provided the basis for much of the Neoplatonism that came to pervade Christianity. To Plato's proper left (the "sinister," or inferior side) his pupil Aristotle grasps a volume of his *Ethics,* which, like his science, is grounded in what is knowable in the material world. The tomes explain why one is pointing to the heavens, the other to the earth. Thus stand reconciled the two most important Greek philosophers, whose seemingly opposite approaches were deemed complementary by many Renaissance humanists.

To Plato's right (his "good" side) is his mentor, Socrates, in a purple robe, who was already viewed as a precursor of Jesus because he died for his beliefs (see fig. 21-2). Raphael borrowed the features of Bramante for the head of Euclid, seen drawing or measuring two overlapping triangles with a pair of compasses in the foreground to the lower right. The diagram must be a reference to the Star of David. It also forms the plan for the arrangement of the figures in the fresco. Seated on the other side is the bearded mathematician, Pythagoras, who believed in a rational universe based on harmonious proportions, the foundation for much of Greek philosophy. He has his sets of numbers and harmonic ratios arranged on a pair of inverted tables that each achieve a total of the divine number ten. They refer in turn to the two tablets with the Ten Commandments held by Moses. Despite their rivalry, Raphael added Michelangelo at the last minute as the brooding Greek philosopher, Heraclitus, writing on the steps. Vasari also states that the figure wearing a black hat at the extreme right is a self-portrait of Raphael. The man next to him is probably his teacher, Perugino. The inclusion of so many artists among, as well as in the guise of, famous philosophers is testimony to their recently acquired—and hard-won—status as members of the learned community.

Galatea Raphael rarely set so splendid a stage again. To create pictorial space, he relied increasingly on the movement of human figures rather than perspective vistas. In the *Galatea* of 1513 (fig. 13-17), the subject is again classical: the beautiful nymph GALATEA belongs to Greek mythology. Like the verse by Angelo Poliziano that inspired it, the painting celebrates the lighthearted, sensuous aspect of antiquity, in contrast to *The School of Athens.* While the latter presents an ideal view of the antique past, *Galatea* captures its pagan spirit as if it were a living force. The composition recalls Botticelli's *Birth of Venus* (see fig. 12-21), a picture Raphael knew from his Florentine days, which shares a debt to Poliziano. Yet the very resemblance emphasizes their profound differences. Raphael's statuesque, full-bodied figures suggest the influence of Michelangelo as well as Raphael's careful study of ancient Roman sculpture (he was later appointed

In Greek mythology, the sea nymph GALATEA was vainly pursued by the ugly, one-eyed giant (Cyclopean) shepherd, Polyphemos. The Cyclops crushed Galatea's lover, Acis, by hurling stones, whereupon Galatea turned Acis's blood into a river.

13-17 Raphael. *Galatea.* 1513. Fresco in Villa Farnesina, Rome

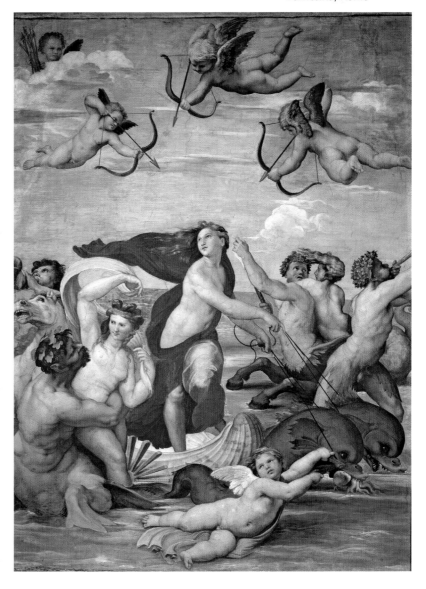

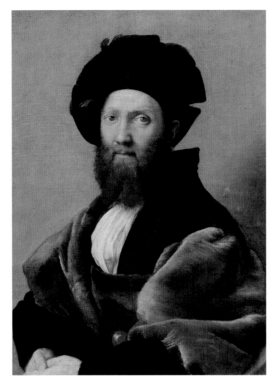

13-18 Raphael. *Baldassare Castiglione.* c. 1515. Canvas, 31⅓″ × 26″ (82 × 66 cm). The Louvre, Paris

superintendent of antiquities for all of Rome). They take on a dynamic spiral movement from the vigorous *contrapposto* of Galatea. In Botticelli's picture, the movement is not generated by the figures but imposed on them by the decorative, linear design, so that it remains on the surface of the canvas.

Baldassare Castiglione Raphael's development as a portraitist, however, owes a debt to Leonardo and his compositional innovations, as we see in his painting of Baldassare Castiglione (1478–1529) of 1514–15. An accomplished writer and diplomat to several courts, Castiglione was a collector of art and antiquities and had specific views on painting and drawing, which he outlined in his *Book of the Courtier*, published in 1528. Most notably, the book was a treatise on the proper etiquette and the intellectual and physical abilities of the aristocrat. Describing the characteristics of the ideal courtier, or Renaissance man, Castiglione writes:

> . . . besides his noble birth, I would wish the courtier [be] endowed by nature not only with talent and beauty of countenance and person, but with that certain grace, which we call an 'air' . . . [yet] to avoid affectation in every way possible.

His ideas on etiquette ranged from the way a courtier should approach dancing in public (with dignity) and in private (where quick movement is permitted) to the type of clothing that should be worn (sober and restrained, nothing foolish, the color black is recommended).

Raphael's portrait of Baldassare Castiglione (fig. 13-18) gives us a glimpse of how the author of *The Courtier* embodied the modesty, dignity, and grace that he commends in his treatise. Yet the painting cannot be fully appreciated without also understanding it as both a quote and correction of Leonardo's *Mona Lisa* (fig. 13.3). Castiglione is shown in a similar half-length, three-quarter view facing out to us, with his hands folded in complete composure, as a simplified version of the complex *Mona Lisa*. The composition is basically triangular topped with a rounded cap (covering Castiglione's bald head) and is both plain and luxurious. The colors are solid, subtle, and yet rich in texture, and the neutral background avoids

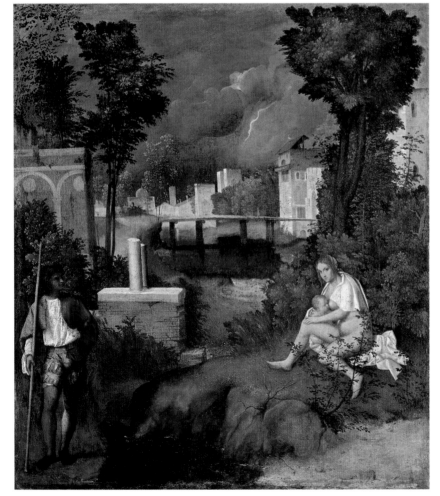

13-19 Giorgione. *The Tempest.* c. 1505. Oil on canvas, 31¼ × 28¾″ (79.5 × 73 cm). Galleria dell'Accademia, Venice

the mysterious, winding, complicated landscape of Leonardo's *Mona Lisa*. Raphael's use of **chiaroscuro** rather than sfumato clarifies the figure rather than obscuring it, thus making the painting clearer and the figure more accessible. This painting and other portraits by Raphael would influence Titian, and even Rembrandt and Velazquez.

GIORGIONE

The distinction between Early and High Renaissance art, so marked in Florence and Rome, is far less sharp in Venice. Giorgione (Giorgione da Castelfranco, 1478–1510), the first Venetian painter to belong to the new era, left the orbit of Giovanni Bellini only during the final years of his short career. Among his few mature works, *The Tempest* (fig. 13-19) is both the most unusual and the most enigmatic. There have been many attempts to explain this image. The most persuasive one is that the painting depicts Adam and Eve after the Fall. Their fate as decreed by God, whose voice is represented by the lightning bolt, is that man shall till the ground from which he was taken and that woman shall bring forth children in sorrow. Adam, dressed in Venetian costume, is seen resting from his labors. Eve, whose draped nudity signifies shame and carnal knowledge, suckles Cain, her firstborn son. In the distance is a bridge over the river surrounding the city of the Earthly Paradise, from which they have been expelled. Barely visible near the rock at river's edge is a snake, signifying the Temptation. The broken columns stand for death, the ultimate punishment of original sin.

The Tempest was probably commissioned by the merchant Gabriele Vendramin, one of Venice's greatest patrons of the arts, who owned the picture when it was first recorded in 1530. It certainly reflects the taste for humanist allegories in Venetian painting, whose subjects are often obscured, as here, by static poses and alien settings. The iconography does not tell us the whole story of *The Tempest*, however. It is the landscape, rather than Giorgione's figures, that interprets the scene for us. Belonging themselves to nature, Adam and Eve are passive victims of the thunderstorm that seems about to engulf them. The contrast to Bellini's *St. Francis in Ecstasy* (see fig. 12-24) is striking. Bellini's landscape is meant to be seen through the eyes of the saint, as a piece of God's creation. Despite its biblical subject, the mood in *The Tempest* is subtly, pervasively pagan. The scene is like an enchanted idyll, a dream of pastoral beauty soon to be swept away. In the past, only poets had captured this air of nostalgic reverie. Now, it entered the repertory of the artist. Indeed, the painting is very similar in mood to *Arcadia* by Jacopo Sannazaro, a poem about unrequited love that was popular in Giorgione's day. Thus *The Tempest* initiates what was to become an important new tradition.

TITIAN

Giorgione died before he could fully explore the sensuous, lyrical world he had created in *The Tempest*. This task was taken up by Titian (Tiziano Vecellio, 1488/90–1576), who was influenced first by Bellini and then by Giorgione. An artist of incomparable ability, Titian was to dominate Venetian painting for the next half-century.

Bacchanal Titian's *Bacchanal* of about 1518 (fig. 13-20) is frankly pagan, inspired by an ancient author's description of such a

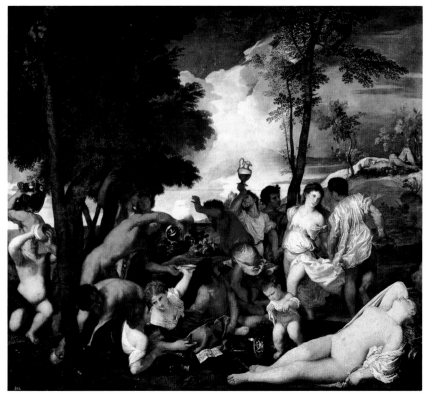

13-20 Titian. *Bacchanal*. c. 1518. Oil on canvas, 5′ 8⅞″ × 6′ 4″ (1.75 × 1.93 m). Museo del Prado, Madrid.

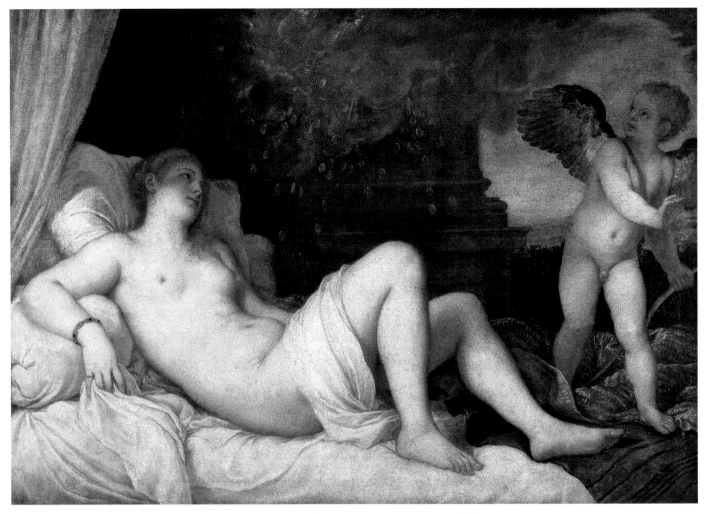

13-21 Titian. *Danaë.* c. 1544–46. Oil on canvas, 7¼ × 67¾″ (120 × 172 cm). Museo e Gallerie Nazionale di Capodimonte, Naples

revel. The landscape, rich in contrasts of cool and warm tones, has all the poetry of Giorgione, but the figures are of another breed. Active and muscular, they move with a joyous freedom that recalls Raphael's *Galatea* (see fig. 13-17). By this time, many of Michelangelo's and Raphael's compositions had been engraved (see fig. 23-4), and from these reproductions Titian became familiar with the Roman High Renaissance. A number of the figures in his Bacchanal also reflect the influence of classical art. Titian's approach to antiquity, however, is very different from Raphael's. He visualizes the realm of classical myths as part of the natural world, inhabited not by animated statues but by beings of flesh and blood. The figures of the *Bacchanal* are idealized just enough to persuade us that they belong to a long-lost Golden Age. They invite us to share their blissful state in a way that makes the *Galatea* seem cold and remote by comparison.

Danaë Danaë (fig. 13-21), painted during a long stay in Rome in the middle of Titian's career, is a masterful display of the painterly use of sonorous color. (The scene, taken from a story in Ovid's *Metamorphoses*, depicts Jupiter in the guise of a gold shower seducing the young woman, who had been locked in a tower by her father to keep all suitors away.) The figure shows the impact of Michelangelo's *Night* on the Tomb of Giuliano de' Medici (see fig. 13-13), which Titian probably knew from an engraving. After seeing the canvas in the artist's studio, Michelangelo is said to have praised Titian's coloring

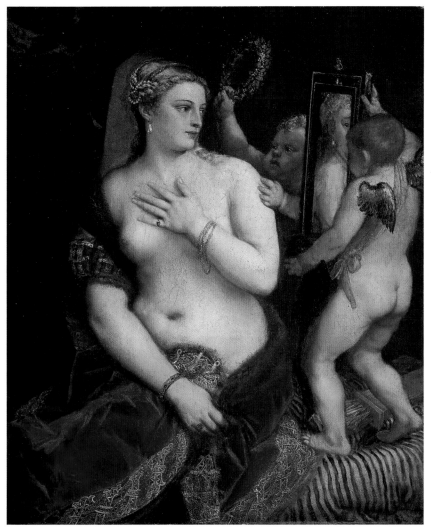

13-22 Titian. *Venus with a Mirror.* c. 1553–55. Oil on canvas, 49 × 41½"
(124.5 × 105.5 cm). National Gallery of Art, Washington, D.C.
Andrew W. Mellon Collection

and style but criticized his design. We can readily understand Michelangelo's discomfort, for Titian has rephrased his sculpture in utterly sensuous terms.

Venus with a Mirror Sensuality is defined by Titan's *Venus with a Mirror* (fig. 13-22). Venus's half-nude body faces us as she turns her own face to a mirror held by two winged CUPIDS who precariously balance themselves on the cushioned bed. Venus wears pearls from the ocean she has risen from in her hair and in her ears. Precious bracelets and rings adorn her wrists and fingers. The embroidered velvet and fur cape wrapped around her arm and lower torso emphasize the sensuality of textures while she conceals her private parts with her hands in the same gesture we see in classical statuary (see, for example, fig. 5-24).

Titian, like Michelangelo, made detailed drawings for his figures. Although he presumably worked out the essential features of his compositions in preliminary drawings, none has survived. Nor, it seems, did he transfer the design onto the canvas. Instead, he worked directly on the surface and made adjustments as he went along.

Ever since Michelangelo and Titian, the merits of **line** versus **color**—of *disegno* and *colore*—have been the subject of intense debate. The role of color rests mainly on its sensuous and emotional appeal, in contrast to the more intellectual quality of line.

Shown as a naked and winged child (looking often like a chubby baby), CUPID is the Roman equivalent of the Greeks' Eros, child of Aphrodite and Ares, who is shown with a bow and sheaf of arrows. Cupid, also called Amor, and Eros are the personifications of love in all its many manifestations, from blissful to tormented and from erotic to platonic.

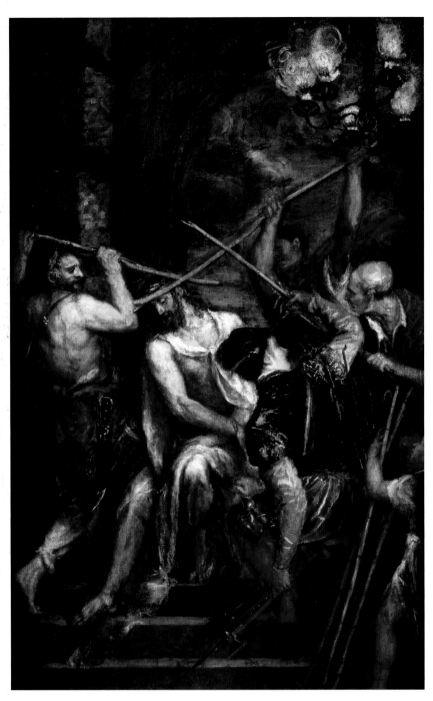

Titian thus stands at the head of the coloristic tradition that descends through Rubens, Delacroix, and Van Gogh to the Expressionists of the twentieth century.

Late Works A change of pictorial technique is no mere surface phenomenon. It always indicates a change in the aim of the artist. This correspondence of form and technique is especially clear in *Christ Crowned with Thorns* (fig. 13-23), the most awesome work of Titian's old age. To what does this canvas owe its power? Surely not only to its large scale or dramatic composition, although these are contributing factors. (The painting is a variant of one the artist had made a quarter-century earlier that is less successful.) The answer lies in Titian's technique. The shapes emerging from the semidarkness now consist wholly of light and color. Despite the heavy **impasto**, the shimmering surfaces have lost every trace of material solidity and seem translucent, as if aglow from within. The violent action has been miraculously suspended. What lingers in our minds is the mood of serenity arising from deep religious feeling rather than the drama. As a result, we contemplate not Jesus' physical suffering but its purpose: the redemption and salvation of humanity. In this regard, the painting is the very opposite of a German *Andachtsbild*. In its ethereality, *Christ Crowned with Thorns* reflects a widespread visionary tendency that was shared by other late-sixteenth-century Venetian artists. We shall meet it again in the work of Tintoretto and El Greco.

13-23 Titian. *Christ Crowned with Thorns.* c. 1570. Oil on canvas, 9'2" × 6' (2.79 × 1.83 m). Alte Pinakothek, Munich

The Late Renaissance in Italy

A RT HISTORIANS HAVE YET TO AGREE ON A NAME FOR THE 80 years separating the High Renaissance from the Baroque. We have run into this difficulty before, in dealing with the problem of Late Classical versus Hellenistic art. Any label implies that the period has only a single style. This interval, however, was a time of crisis that gave rise to a number of competing tendencies rather than a main ideal. In fact, there is no clear dividing line between them, and we often find several trends in the work of a single artist, which adds to the complexity of the age. Because there was no single style in the years 1520 to 1600, why should this span be thought of as a period at all? What was its relation to the two eras that it separates? The term *Late Renaissance*, which used to be common, is controversial. It implies a period of decline from the peak attained by the High Renaissance and a transition to the great next phase, the Baroque, that followed. Yet we have no truly satisfactory alternative. Until one is found, we have chosen to retain *Late Renaissance* as a matter of convenience, but with the understanding that it is the rich diversity that gives this epoch its peculiar flavor. We look in vain for an underlying unity, be it historical, social, cultural, or religious. The one common denominator we find is a tidal wave of change on all fronts that reshaped Europe.

The great voyages of discovery that took place during the High Renaissance—Columbus's landing in the New World in 1492, Amerigo Vespucci's exploration of South America seven years later, and Magellan's voyage around the world beginning in 1519—had far-reaching consequences. The most immediate effect was the rise of the major European colonial powers, which vied with each other for commercial supremacy around the world. The Spanish, then the Portuguese, quickly established themselves in the Americas; Mexico was conquered by Hernán Cortés in 1519–21, Peru by Francisco Pizarro during the next decade. By 1585 Sir Walter Raleigh had founded the first English settlement in North America; the French soon followed with outposts of their own. An unexpected effect was the explosion of knowledge as explorers brought back a host of natural and artistic wonders never before seen in Europe. Avid collectors formed *Kunst und Wunderkammern* (literally, "art and wonder rooms") to display exotic treasures from every corner of the earth. As Europeans struggled to absorb the new discoveries into old categories of thought, the science inherited from ancient Greece and Rome was largely discarded by 1650 in favor of the new body of learning.

Painting

MANNERISM IN FLORENCE AND ROME

Among the trends in art in the wake of the High Renaissance, Mannerism is the most significant, as well as the most problematic.

The original meaning of the term was narrow and derogatory. It referred to a group of mid-sixteenth-century painters in Rome and Florence whose "artificial" style (*maniera*) was derived from certain aspects of the work of Raphael and Michelangelo. This phase has since been recognized as part of a wider movement that had begun about 1520. Keyed to a sophisticated taste, early Mannerism had appealed to a small circle of aristocratic patrons such as Cosimo I, the grand duke of Tuscany, and Francis I, the king of France. The style soon became international as a number of events—including the plague of 1522, the Sack of Rome by Spanish forces in 1527, and the conquest of Florence three years later—drove many artists abroad, where most of the style's next phase developed.

This new phase, High Mannerism, was the assertion of a purely aesthetic ideal. Through formulaic abstraction, it became a style of utmost refinement that emphasized grace, variety, and virtuoso display at the expense of content, clarity, and unity. This taste for affected elegance and bizarre conceits appealed to a small but sophisticated audience. In a larger sense, however, Mannerism signaled a fundamental shift in Italian culture. In part it resulted from the High Renaissance quest for originality as a projection of the individual's character, which had given artists license to explore their imaginations freely. Although this investigation of new modes was ultimately beneficial, the Mannerist style itself came to be regarded by many as decadent, and no wonder: given such subjective freedom, it produced extreme personalities who today seem the most "modern" of all sixteenth-century painters.

The formalism of High Mannerist art was part of a wider movement that placed inner vision, however private or fantastic, above the twin standards of nature and the ancients. Hence the definition of Mannerism has sometimes been expanded to include the later style of Michelangelo, who would acknowledge no artistic authority higher than his own genius. Mannerism is often viewed as a reaction against the ideal created by the High Renaissance as well. Except for a brief early phase, however, Mannerism did not consciously reject the tradition from which it stemmed. The subjectivity inherent in its aesthetic was unclassical, but it was not deliberately anticlassical, save for its most extreme forms. Even more important than Mannerism's anticlassicism is its insistent antinaturalism.

The relation of Mannerism to religious trends was equally ambiguous. Although a deep reverence is found in many works by the first generation of painters, the extreme worldliness of the second generation was inherently opposed to both the Reformation, with its stern morality, and the Counter-Reformation, which demanded strict adherence to doctrine. After midcentury there was nonetheless a "Counter-Mannerist" trend, centering on Bronzino and Vasari (see below), which adapted the vocabulary of Mannerism for Counter-Reformation ends. The result was an arid style geared solely to supporting the Church and its dogma. These "official" Counter-Reformation images were given a strong physical presence to convey their theological messages as clearly as possible.

The Counter-Reformation had a well-founded concern over the proliferation of images that were unsupported by the Bible or traditional doctrine. Worse still were images that might be deemed disrespectful or even sacrilegious. However, commentators were not always in agreement about what was permissible. As the Catholic church sought to define itself against the Protestant Reformation, religious imagery nevertheless became increasingly standardized. Much of the reason can be found in the INQUISITION, a medieval institution that was revived in Italy in 1542 after a lapse of several hundred years and established separately in Spain in 1478 to enforce religious orthodoxy. Yet, these visual sermons also reflect a sincere response to Catholic reform. Indeed, the sculptor and architect Bartolomeo Ammanati renounced the nude statues he had produced early in his career. At the same time, however, the subjective freedom of Mannerism was valued for its visionary power as part of a larger shift in religious sentiment toward mysticism, especially in northern Italy.

Rosso Fiorentino The first signs of discord in the High Renaissance appear shortly before 1520 in Florence. Art had been left in

The INQUISITION began as a papal judicial process in the twelfth century, was codified in 1231 with the institution of excommunication, and was formalized in 1542 by Pope Paul III as the Holy Office. In Spain in 1478, it independently became an instrument of the State and was not abolished until 1834. In all its forms, its purpose was to rid the Catholic church of heresy. At its fairest, the process was just and merciful; at its worst, the Inquisition was pure political terrorism.

the hands of a younger generation that could refine but not further develop the styles of the great masters who had spent their early careers there. Having absorbed the lessons of the leading artists for the most part at one remove, the first generation of Mannerists was free to apply High Renaissance formulas to a new style divorced from its previous content. Although this early phase of Mannerism may be a reflection of the growing turmoil in Italy, its highly personal spirituality is almost certainly the legacy of Savonarola.

The first full expression of the new attitude is *The Descent from the Cross* (fig. 14-1) painted by Rosso Fiorentino (1495–1540), the most eccentric of the first-generation Mannerists. It was commissioned in 1521 by the Company of the Cross of the Day, a confraternity of flagellants, in the Tuscan city of Volterra. Although it looks back in part to Early Renaissance art, nothing has prepared us for the shocking impact of the spidery forms spread out against the dark sky. The figures are agitated yet rigid, as if frozen by a sudden icy blast. Even the draperies have brittle, sharp-edged planes. The acid colors and the light, brilliant but unreal, reinforce the nightmarish effect of the scene. Here is clearly a full-scale revolt against the classical balance of High Renaissance art—a profoundly disquieting, willful, visionary style that indicates a deep inner anxiety. Amid the violent activity the limp, astonishingly serene figure of Christ appears to hover almost effortlessly. We are, then, meant to experience the painting on two levels: as something akin to an *Andachtsbild*, with its intense

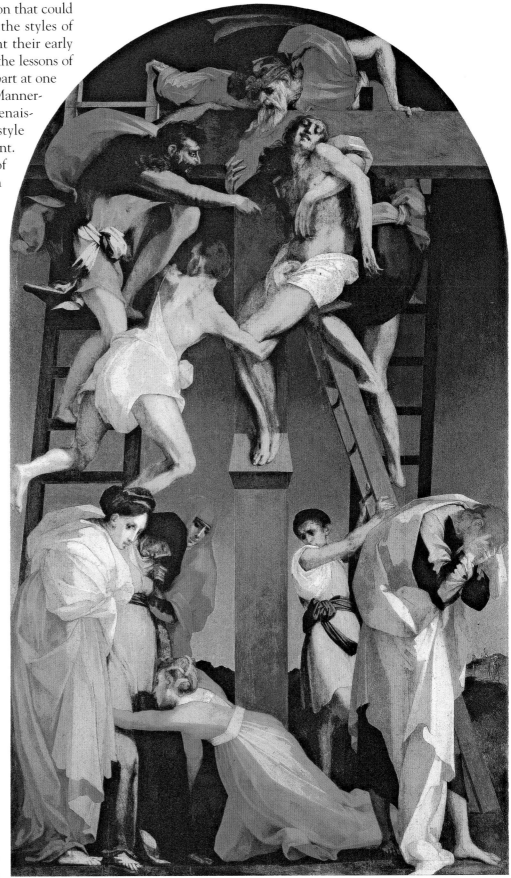

14-1 Rosso Fiorentino. *The Descent from the Cross.* 1521. Oil on panel, 11′ × 6′5¹⁄₂″ (3.35 × 1.97 m). Pinacoteca Communale, Volterra

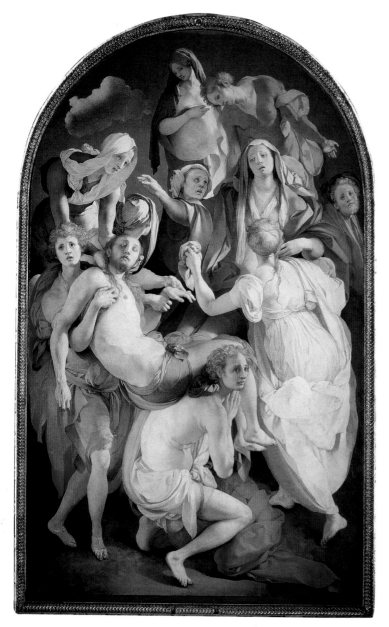

14-2 Jacopo da Pontormo. *The Deposition.* c. 1526–28. Oil on panel, 10′3″ × 6′4″ (3.12 × 1.93 m). Sta. Felicità, Florence

and for whom he pleased. He would shut himself up in his quarters for weeks on end and refuse to see even his closest friends. His *Deposition* (fig. 14-2) is a reflection of his character. It contrasts sharply with Rosso's *Descent from the Cross* but is no less disturbing. Unlike Rosso's elongated forms, Pontormo's have a nearly classical beauty and sculptural solidity inspired by Michelangelo, who is known to have admired his art. Yet the figures are confined to a stage so claustrophobic as to cause acute discomfort in the viewer. The very implausibility of the image, however, makes it convincing in spiritual terms. Indeed, this visionary quality is essential to its meaning, which is conveyed by formal means alone.

We have entered a world of innermost contemplation in which every pictorial element responds to a purely subjective impulse. Everything is subordinate to the play of graceful rhythms created by the tightly interlocking forms. These patterns unify the surface and give the work a poignancy unlike any we have seen. Although they seem to act together, the mourners are lost in a grief too personal to share with one another—or us. In this hushed atmosphere, anguish is transformed into a lyrical expression of exquisite sensitivity. The entire scene is as haunted as Pontormo's self-portrait just to the right of the swooning Madonna. The artist, moodily gazing into space, seems to shrink from the outer world—as if scarred by the trauma of some half-remembered experience—and into one of his own invention.

Parmigianino　The first phase of Mannerism was soon replaced by one less openly anticlassical, less charged with subjective emotion, but equally far removed from the confident, stable world of the High Renaissance. *The Madonna with the Long Neck* (fig. 14-3) reflects the strange imagination of Parmigianino (Girolamo Francesco Maria Mazzuoli, 1503–1540). Vasari informs us that the artist, as he neared the end of his brief career, became "a bearded, long-haired, neglected, and almost savage or wild man." This, his most famous work, was painted after he had returned to his native Parma from a stay of

emotion, and as an object of devotion, like an icon. As such, it accords with Savonarola's urging of continuous, "inflamed" contemplation of the meaning of the crucified Christ and his role in the salvation of humanity. Thus this *Descent from the Cross* was especially appropriate to the religious order that commissioned it.

Jacopo da Pontormo　Jacopo da Pontormo (1494–1556/7), a friend of Rosso, had an equally strange temperament. Introspective, headstrong, and shy, he worked only when

several years in Rome. He had been deeply impressed with the rhythmic grace of Raphael's art, but here he has transformed the older artist's figures into a remarkable new breed.

The limbs, elongated and ivory-smooth, move with effortless languor and embody an ideal of beauty as remote from nature as any Byzantine figure. The pose of the Christ Child balanced precariously on the Madonna's lap echoes that of a Pietà (compare fig. 11-22), which shows that he is already aware of his mission to redeem original sin through his death. Although sometimes also found in Byzantine icons, this unusual device evidently is Parmigianino's own invention and helps to explain the setting, which is not as arbitrary as it may seem. The gigantic column, representing the gateway to heaven, is a symbol often associated with the Madonna. It refers both to eternal life and to the Immaculate Conception. It may also refer to the flagellation of Jesus during the Passion, thus reminding us of his sacrifice, which the tiny figure of a prophet foretells on his scroll. Visually the column serves to disrupt our perception of the pictorial space, which is strangely disjointed. Parmigianino seems determined to prevent us from judging anything in this picture by the standards of ordinary experience. Here we approach the "artificial" style for which the term *Mannerism* was coined. *The Madonna with the Long Neck* is a vision of unearthly perfection, with a cold elegance that is no less compelling than the violence in Rosso's *Descent*.

Agnolo Bronzino High Mannerism is identified with the second generation of artists who surrounded Agnolo Bronzino (1503–1572) and his contemporaries. They transformed the styles of Rosso, Pontormo, and Parmigianino into one of cool perfection that filtered out the intensely individual outlooks of those artists. As a result, the High Mannerists produced few masterpieces. In their best works, however, formal beauty becomes the aesthetic counterpart to obscure, even perverse thought.

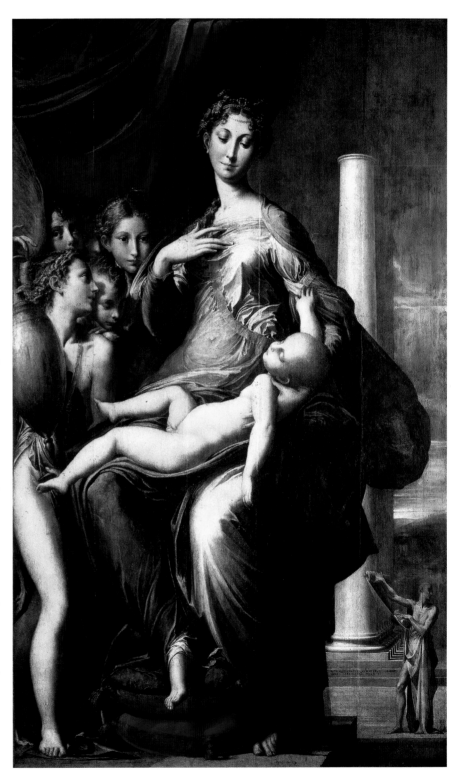

14-3 Parmigianino. *The Madonna with the Long Neck.* c. 1535. Oil on panel, 7'1" × 4'44" (2.16 × 1.32 m). Galleria degli Uffizi, Florence

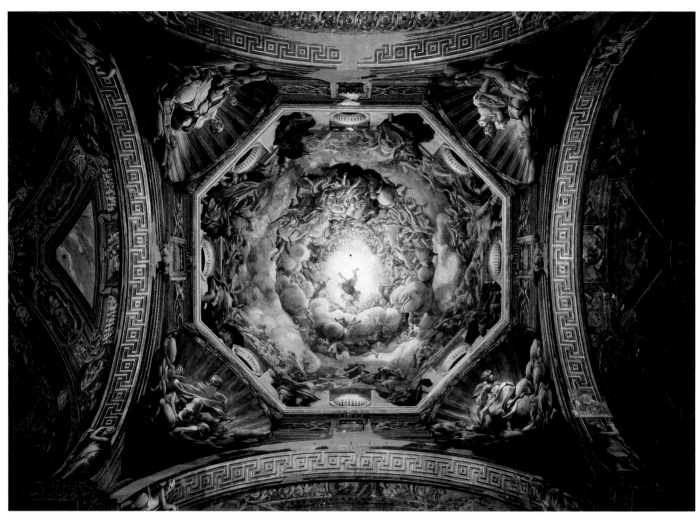

14-6 Correggio. *The Assumption of the Virgin.* c. 1525. Portion of fresco in the dome of Parma Cathedral

JUPITER is a Roman counterpart to the Greek god Zeus, who fell in love with IO. To disguise Io so that his wife, Hera (Juno in Roman mythology), would not be jealous, Zeus turned Io into a white heifer. Hera suspected Io's real identity and demanded the heifer as a gift from Jupiter. Correggio's painting shows the moment before Io was transformed—when Jupiter made himself into a cloud for an amorous visit.

first Leonardo and the Venetians, then Michelangelo and Raphael. But their ideal of classical balance did not attract him for long. Correggio's work applies North Italian realism with the imaginative freedom of the Mannerists. (Surprisingly, we do not find any hint of his fellow townsman Parmigianino in his style.) His largest work, the fresco of *The Assumption of the Virgin* in the dome of Parma Cathedral (fig. 14-6), is a masterpiece of illusionistic perspective. In transporting us into the heavens, it is the very opposite of Savoldo's painting. Correggio here initiates an entirely new kind of visionary representation in which heaven and earth are joined visually and spiritually. Although not the first to execute an illusionistic dome painting— that honor belongs to Mantegna, from whom he got the idea—he was the first to apply it to a religious subject. Also new are the figures themselves. They move with such exhilarat-

ing ease that the force of gravity seems not to exist for them, and they frankly delight in their weightless condition. These are healthy, energetic beings of flesh and blood, reflecting the influence of Titian, not the disembodied spirits so often found in Mannerist art.

There was little difference between spiritual and physical rapture for Correggio, who thereby established an important precedent for Baroque artists such as Gianlorenzo Bernini (see pages 364–66). We can see this relationship by comparing *The Assumption of the Virgin* with his *Jupiter and Io* (fig. 14-7), part of a series depicting the loves of the classical gods. The nymph IO, swooning in the embrace of a cloudlike JUPITER, is the direct kin of the jubilant angels in the fresco. The use of **sfumato**, combined with a Venetian sense of color and texture, produces a frank sensuality that far exceeds Titian's in his *Bacchanal* (see fig. 13-20).

Like Savoldo, Correggio had no immediate successors, nor did he have any lasting influence on the art of his century, but toward 1580 his work began to be appreciated by Federico Barocci (1528?–1612) and Annibale Carracci (see pages 359–61). Like Savoldo's, Correggio's paintings embody so many features that later characterized the Baroque that his style has been labeled Proto-Baroque; such a term, however, hardly does justice to Correggio's highly individual qualities. For the next century and a half he was admired as the equal of Raphael and Michelangelo, while the Mannerists, so important before, were largely forgotten.

VENICE

Paolo Veronese In the work of Paolo Veronese (Paolo Caliari, 1528–1588), who was born and trained in Verona, North Italian realism takes on the splendor of a pageant. *The Feast in the House of Levi* (fig. 14-8) avoids all reference to the supernatural. The symmetrical composition harks back to paintings by Leonardo and Raphael, while the festive mood of the scene reflects examples by Titian of the 1520s. At first glance the picture looks like a High Renaissance work born 50 years too late. Missing, however, is the ideal conception of humanity that underlies the High Renaissance. Veronese paints a sumptuous banquet, a true feast for the eyes, but not "the intention of man's soul."

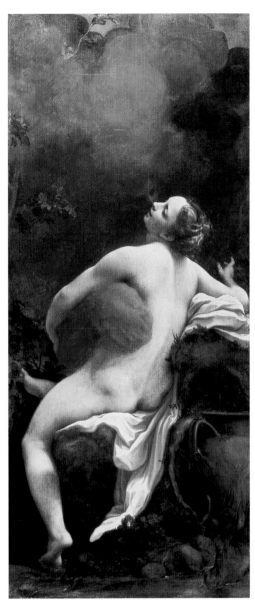

14-7 Correggio. *Jupiter and Io.* c. 1532. Oil on canvas, 64½ × 27³/₄" (163.8 × 70.5 cm). Kunsthistorisches Museum, Vienna

14-8 Paolo Veronese. *The Feast in the House of Levi.* 1573. Oil on canvas, 18'2" × 42' (5.54 × 12.8 m). Galleria dell'Accademia, Venice

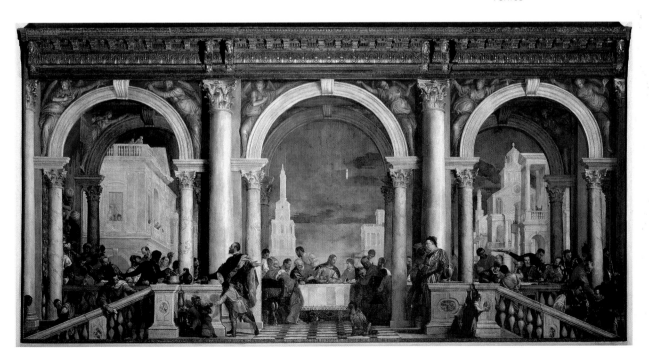

We are not even sure which event from the life of Jesus he originally meant to depict. He gave the painting its present title only after he had been summoned by the religious tribunal of the Inquisition on the charge of filling his picture with "buffoons, drunkards, Germans, dwarfs, and similar vulgarities" unsuited to its sacred character. Veronese's reply is of great interest. He responds to the Tribunal that he put the buffoons, drunkards, Germans, and dwarfs (note the grouping) "outside of the place of the supper . . . especially as those figures . . . are outside of the place where Our Lord is depicted." The picture, then, has a pointed message entirely in keeping with the Counter-Reformation in the wake of the Council of Trent. To Italians, Germans were barbarians, despite the close ties between Venice's territories and their German trading partners. Germany was also the home of the Reformation, as well as the seat of the Holy Roman Empire, which laid claim to Lombardy. Thus, they were no better than drunkards and buffoons, and clearly belonged to the unjust who were unfit to sit in the same space as the Lord. (Note the Moors fighting at the left edge of the painting!) The Inquisition, of course, considered only the impropriety of Veronese's art, which violated the concept of decorum and overlooked its meaning.

The account of this trial shows that the tribunal thought the painting represented the Last Supper, but Veronese's testimony never made clear whether it was the Last Supper or the Supper in the House of Simon. To him this distinction made little difference. In the end, he settled on a convenient third title, *The Feast in the House of Levi*, which permitted him to leave the offending incidents in place. He argued that they were no more objectionable than the nudity of Jesus and the Heavenly Host in Michelangelo's *Last Judgment*. Nevertheless, the tribunal failed to see the analogy, on the grounds that "in the *Last Judgment* it was not necessary to paint garments, and there is nothing in those figures that is not spiritual."

Veronese's refusal to admit the justice of the Inquisition's charge, his insistence on his right to include directly observed details, however "improper," and his indifference to the subject of the picture spring from an attitude so extroverted that it was not widely accepted until the nineteenth century. The painter's domain, Veronese seems to say, is the entire visible world, and here he acknowledges no authority other than his senses. Although tame by Mannerist standards, the presentation is supremely theatrical, from the vast, stagelike space to the lavish costumes, which hardly differ from those in Venetian productions of the day. This is not merely theatrical display, however, but religious pageantry on a grand scale.

Jacopo Tintoretto Veronese and Jacopo Tintoretto (1518–1594) both found favor with the public. They certainly looked at each other's work, but the differences in their styles are readily apparent if we compare Veronese's *The Feast in the House of Levi* to Tintoretto's *Last Supper* (fig. 14-9), his final and most spectacular major painting. Tintoretto reportedly wanted "to paint like Titian and to design like Michelangelo," but his relationship to those two masters, although real enough, was as peculiar as Parmigianino's was to Raphael. Tintoretto fully assimilated the influence of Mannerism into his personal style in order to heighten the visionary effects seen in Titian's late work (see fig. 13-23).

The Last Supper seems to deny in every possible way the classic values of Leonardo's version (see fig. 13-2), painted almost exactly a century before, which still underlie Veronese's picture. Christ, to be sure, is at the center of the composition, but his small figure in the middle distance is distinguished mainly by the brilliant halo. Tintoretto barely hints at the human drama of Judas's betrayal, so important to Leonardo. Judas can be seen isolated on the near side of the table across from Christ, but his role is so insignificant that he could almost be mistaken for an attendant. The table is now placed at a sharp angle to the picture plane in exaggerated perspective. This arrangement was designed to relate the scene to the space of the **chancel** of the Benedictine monastery church S. Giorgio Maggiore in Venice, for which it was commissioned. There it was seen on the wall by the friars as they knelt at the altar rail to receive Communion, so that it receded less sharply than when viewed head on.

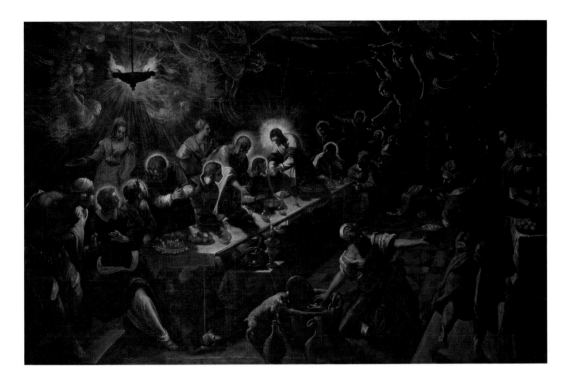

14-9 Jacopo Tintoretto. *The Last Supper.* 1592–94. Oil on canvas, 12′ × 18′8″ (3.66 × 5.69 m). S. Giorgio Maggiore, Venice

Tintoretto has gone to great lengths to give the event an everyday setting, cluttering the scene with attendants, containers of food and drink, and domestic animals. There are also celestial attendants who converge upon Christ just as he offers his body and blood, in the form of bread and wine, to the disciples. The smoke from the blazing oil lamp miraculously turns into clouds of angels, blurring the distinction between the natural and the supernatural and turning the scene into a magnificently orchestrated vision. The artist's main concern has been to make visible the miracle of the Eucharist —the transubstantiation of earthly into divine food—in both real and symbolic terms. The central importance of this institution to Catholic doctrine was forcefully reasserted during the Counter-Reformation. The painting was especially appropriate for its location in S. Giorgio Maggiore, which played a prominent role in the early reform movement.

El Greco If we can call Tintoretto a Mannerist only with hesitation, there can be no such doubt about Domenikos Theotocopoulos (1541–1614), called El Greco, even though his work, too, falls outside the mainstream of that tradition. He came from Crete, which was then under Venetian rule. There he must have been trained by an artist still working in the Byzantine tradition. (El Greco never forgot his Byzantine background. Until the very end of his career, he signed his pictures in Greek.) Soon after 1560 he arrived in Venice and quickly absorbed the lessons of Titian, Tintoretto, and other artists. A decade later, in Rome, he came to know the art of Raphael, Michelangelo, and the Mannerists from central Italy. In 1576/7 El Greco went to Spain and settled in Toledo for the rest of his life. He became a member of the leading intellectual circles of the city, then a major center of learning as well as the seat of Catholic reform in Spain. Although it provides the context of his work, Counter-Reformation theology does not account for the exalted emotionalism that informs his painting. The spiritual tenor of El Greco's mature work was primarily a response to mysticism, which was especially intense in Spain. Contemporary Spanish painting, however, was too provincial to affect him. His style had already been formed before he arrived in Toledo.

The largest and most splendid of El Greco's major commissions, and the only one for a public chapel, is *The Burial of Count Orgaz*

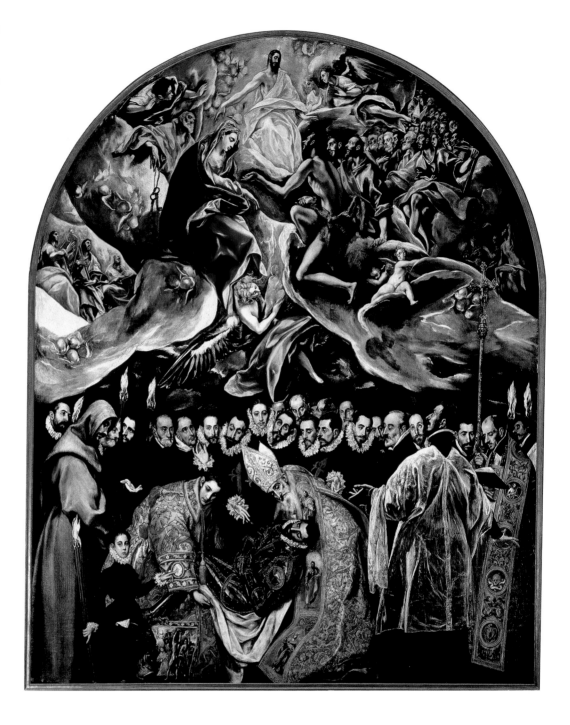

14-10 El Greco. *The Burial of Count Orgaz.* 1586. Oil on canvas, 16′ × 11′0″ (4.88 × 3.61 m). Sto. Tomé, Toledo, Spain

(fig. 14-10) in the church of Sto. Tomé. The program, which was given at the time of the commission, emphasizes the traditional role of good works in salvation and of the saints as intercessors with heaven. This huge canvas honors a medieval benefactor so pious that St. Stephan and St. Augustine miraculously appeared at his funeral and lowered the body into its grave. The burial took place in 1323, but El Greco presents it as a contemporary event and even portrays many of the local nobility and clergy among the attendants. The

dazzling display of color and texture in the armor and vestments could hardly have been surpassed by Titian himself. Above, the count's soul (a small, cloudlike figure like the angels in Tintoretto's *Last Supper*) is carried to heaven by an angel. The celestial assembly in the upper half of the picture is painted very differently from the group in the lower half: every form—clouds, limbs, draperies—takes part in the sweeping, flamelike movement toward the figure of Christ. The painting is close in its unearthly spirit and style to Rosso's

Descent from the Cross (see fig. 14-1). Here, even more than in Tintoretto's art, the entire range of Mannerism fuses into a single ecstatic vision.

The full meaning of the work becomes clear only when we see it in its original setting (fig. 14-11). Like a huge window, it fills one entire wall of its chapel. The bottom of the canvas is six feet above the floor, and as the chapel is only about 18 feet deep, we must look sharply upward to see the upper half of the picture. The violent foreshortening is calculated to achieve an illusion of boundless space above, whereas the figures in the lower foreground appear as on a stage. (Their feet are cut off by the molding just below the picture.) The large stone plaque set into the wall also belongs to the ensemble. It represents the front of the sarcophagus into which the two saints lower the body of the count and therefore explains the action in the picture. The viewer, then, perceives three levels of reality. The first is the grave itself, supposedly set into the wall at eye level and closed by an actual stone slab; the second is the reenactment of the miraculous burial; and the third is the vision of celestial glory witnessed by some of the participants. El Greco's task here was similar to Masaccio's in his *Trinity* mural (see fig. 12-14). But whereas Masaccio constructed the illusion of reality through a rational pictorial space that appears continuous with ours, El Greco summons an apparition that remains separate from its architectural surroundings.

El Greco has created a spiritual counterpart to his imagination. Every passage is alive with his fervent religiosity, which is felt as a nervous exaltation occurring as the dreamlike vision is conjured up. This kind of mysticism is very similar in character to that found in the *Spiritual Exercises* of Ignatius of Loyola, the founder of the Jesuits, although his teachings are based on a long tradition that achieved a new popularity after 1490. St. Ignatius sought to make visions so real that they would seem to appear before the very eyes of the faithful. Such mysticism could be achieved only through strenuous devotion. That effort is mirrored in the intensity of El Greco's work, which fully retains a feeling of intense spiritual struggle.

14-11 Chapel with *The Burial of Count Orgaz*. Sto. Tomé, Toledo, Spain

Sculpture

Italian sculptors of the later sixteenth century failed to match the achievements of the painters. Perhaps Michelangelo's overpowering personality discouraged new talent in this field, but there was also a lack of major commissions outside of portraiture, as we can tell from the considerable number of small bronzes that were made during this period. In any case, the most interesting sculpture of this period was produced outside of Italy. After the death of Michelangelo in 1564, even the leading sculptor in Florence was a Northerner.

Giovanni Bologna A number of Italians artists, including Rosso Fiorentino, were employed by Francis I at Fontainebleau and, as a result, Mannerism became the dominant style in sixteenth-century France. (See a discussion of the impact of these artists in France, chapter 16). The influence of the Italians went far beyond the royal court. It reached Jean de Bologne (1529–1608), a gifted young sculptor from Douai in northern France, who went to Italy about 1555 for further training. He stayed and, under the

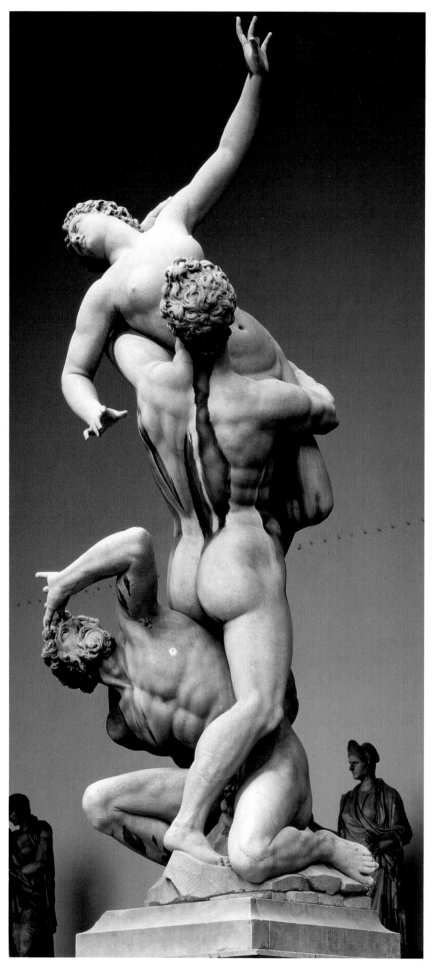

Italianized name of Giovanni Bologna, became the most important sculptor in Florence during the last third of the century. His over-life-size marble group, *The Abduction of the Sabine Woman* (fig. 14-12), was especially admired and still has its place of honor near the Palazzo Vecchio.

The subject, drawn from the legends of ancient Rome, seems an odd choice for statuary. According to the story, the city's founders, an adventurous band of men from across the sea, tried in vain to find wives among their neighbors, the Sabines. Finally, they resorted to a trick. Having invited the entire Sabine tribe into Rome for a festival, they attacked them, took the women away by force, and thus ensured the future of their stock. Actually, the artist designed the group with no specific subject in mind. It was meant to demonstrate his ability while he was a student at the Academy of Design, founded by Vasari in 1562 under the patronage of Cosimo I de' Medici. Bologna chose what seemed to him the most difficult feat: three contrasting figures united in a single action. When asked to identify the figures, the artist proposed Andromeda, but another member of the Academy, Raffaello Borghini, suggested *The Abduction of the Sabine Woman* as the most suitable title.

Here, then, is another artist who is non-committal about subject matter, although his motive was different from Veronese's. Like Cellini, Bologna wished to display his virtuosity. His task was to carve in marble, on a massive scale, a sculptural composition that was to be seen from all sides. This had previously been attempted only in bronze and on a much smaller scale (see fig. 12-7). He has solved this formal problem brilliantly, but at the cost of removing his group from the world of human experience. These figures, spiraling upward as if confined inside a tall, narrow cylinder, perform their well-rehearsed exercise with ease. But, unlike much Hellenistic sculpture (compare fig. 5-27), they lack emotional meaning. We admire their discipline but find no trace of pathos.

14-12 Giovanni Bologna. *The Abduction of the Sabine Woman.* Completed 1583. Marble, height 13′6″ (4.11 m). Loggia dei Lanzi, Florence

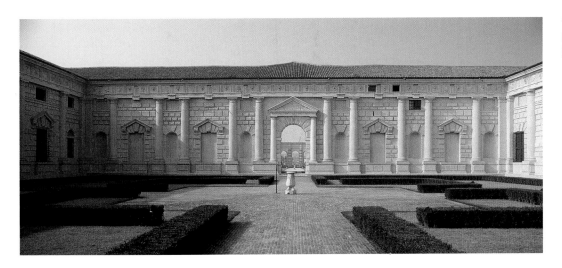

Architecture

The term *Mannerism* was first coined to describe painting. We have had no difficulty in applying it to sculpture. But can it be usefully extended to architecture as well? And if so, what qualities must we look for? These questions have proved difficult to answer. The reasons are all the more puzzling, because the important Mannerist architects were leading painters and sculptors. Yet today only a few buildings are generally considered to be Mannerist.

MANNERISM

Giulio Romano The main example is the Palazzo del Te in Mantua by Giulio Romano (c. 1499–1546), Raphael's chief assistant, who had been summoned to the Gonzaga court by Baldassare Castiglione (see *Baldassare Castiglione*, fig. 13-18), where he became a member of the duke's inner circle. The courtyard facade (fig. 14-13) features unusually squat proportions and coarse **rustication**. The massive **keystones** of the windows have been "squeezed" up by the force of the triangular lintels. The effect is an absurd impossibility. There are no true arches except over the central doorway, which is surmounted by a pediment in violation of classical canon. Even more bizarre is how the **triglyph** midway between each pair of columns "slips" downward in defiance of all logic and accepted practice, thereby creating the sense that the frieze might collapse before our eyes. Finally, the intervals between the portals and pilasters are unequal, so that they "collide" at the corners, as one historian has aptly noted. The entire fantasy was enhanced by colored decoration that no longer exists.

The reliance on eccentric gestures that depart from Renaissance norms does not in itself define Mannerism as an architectural period style. What, then, are the qualities we must look for? Above all, form is divorced from content for the sake of surface effect. The emphasis is instead on picturesque devices, especially encrusted decoration, with the occasional distortion of form and novel, even illogical rearrangement of space. Thus Mannerist architecture lacks a consistent integration of elements.

CLASSICISM

Andrea Palladio Most later sixteenth-century architecture can hardly be called Mannerist at all. Andrea Palladio (1508–1580), next to Michelangelo the most important architect of the century, belongs to the tradition of the humanist and theoretician Leone Battista Alberti (see pages 263–64). Although Palladio's career centered on his native Vicenza, a town near Venice, his buildings and theoretical writings brought him international renown. Palladio believed that architecture had to be governed by reason and by certain rules that were exemplified by the buildings of the ancients. He thus shared Alberti's basic outlook and faith in the cosmic significance of numerical ratios. The two differed in how each related theory and practice, however. With Alberti, this relationship had been

flexible, whereas Palladio believed quite literally in practicing what he preached. This view stemmed in part from the fact that he had begun his career as a stonemason and sculptor before entering the humanist circles of Count Giangiorgio Trissino of Vicenza at the age of 30. As a result, his treatise *THE FOUR BOOKS OF ARCHITECTURE* (1570) is more practical than Alberti's, which helps to explain its huge success, while his buildings are linked more directly with his theories. It has even been said that Palladio designed only what was, in his view, sanctioned by ancient precedent. Indeed, the usual term for both Palladio's work and theoretical attitude is *classicistic*. This term denotes a conscious striving for classic qualities, although the results are not necessarily classical in style.

Much of Palladio's architecture consists of town houses and country villas. The Villa Rotonda (fig. 14-14), one of Palladio's finest buildings, perfectly illustrates the meaning of his classicism. This country residence, built near Vicenza for Paolo Almerico, consists of a square block surmounted by a dome, with identical porches in the shape of temple fronts on all four sides. Alberti had defined the ideal church as a symmetrical, centralized

design of this sort. Palladio adapted the same principles for the ideal country house. As he tells us in the second book of his treatise, his design takes advantage of the pleasing views offered in every direction by the site.

How could Palladio justify such a secular context for the solemn motif of the temple front? Like Alberti, he interpreted the historical evidence in a selective fashion. He was convinced, on the basis of Vitruvius and Pliny, that Roman private houses had porticoes like these. (Excavations have since proved him wrong.) But Palladio's use of the temple front here is not mere antiquarianism. He regarded this feature as both legitimate and essential for decorum—namely, appropriateness, beauty, harmony, and utility—befitting the houses of "great men." This concept, embedded in the social outlook of the later sixteenth century, was similar to that introduced in theater by Julius Caesar Scaliger and Lodovico Castelvetro. Beautifully correlated with the walls behind and the surrounding vistas, the porches of the Villa Rotonda give the structure an air of serene dignity and festive grace that is enhanced by Lorenzo Vicentino's sculptures.

RELIGIOUS ARCHITECTURE

Giacomo Della Porta The problem of how to fit a classical facade onto a basilican church remained the greatest challenge faced by Italian architects. Alberti's compromise at S. Andrea in Mantua (see fig. 12-12) was too singular to provide a guideline for later architects. Palladio also had great difficulty solving this puzzle. The most widely accepted solution was the facade of Il Gesù (Jesus) in Rome by Giacomo della Porta (c. 1540–1602), who had assisted Michelangelo at St. Peter's and was still using his architectural vocabulary (fig. 14-15). Because it was the mother church of the Jesuits, its design must have been closely supervised so as to conform to the aims of that militant order. We may therefore view it as the architectural embodiment of the spirit of the Counter-Reformation. Indeed, the planning of the structure began in 1550, only five years after the Council of Trent was

14-14 Andrea Palladio. Villa Rotonda, Vicenza. c. 1567–70

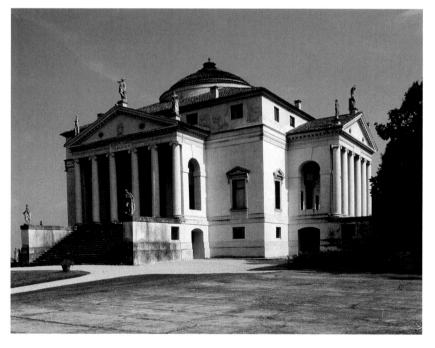

first convened (see page 312). Michelangelo himself once promised a design, but apparently never furnished it. The present plan by Giacomo Vignola (1507–1573), another former assistant of Michelangelo, was adopted in 1568.

Despite its originality, the facade of Il Gesù is not entirely new. The paired pilasters and broken **architrave** on the lower story are clearly derived from the **colossal order** on the exterior of St. Peter's (compare fig. 13-14), and small wonder: it was Della Porta who completed Michelangelo's dome. In the upper story the same pattern recurs on a somewhat smaller scale, with four instead of six pairs of supports. The difference in width is bridged by two scroll-shaped buttresses, which hide the roofline. This device, taken from the facade of S. Maria Novella in Florence by Alberti, forms a graceful transition to the large pediment crowning the facade, which retains the classic proportions of Renaissance architecture. (The height equals the width.)

What is fundamentally new here is the integration of all the parts into a single whole. Della Porta, freed from classicistic scruples by his allegiance to Michelangelo, gave the same vertical rhythm to both stories of the facade. This rhythm is obeyed by all the horizontal members. (Note the broken **entablature**.) In turn, the horizontal divisions determine the size of the vertical members; hence no colossal order. Equally important is the sculptural treatment of the facade, also inspired by Michelangelo, which places greater emphasis on the main portal. Its double frame—two pediments resting on coupled pilasters and columns—projects beyond the rest of the facade and gives strong focus to the entire design. Not since Gothic architecture has the entrance to a church received such a dramatic concentration of features. The total effect is remarkably theatrical, in the best sense of the term.

What are we to call the style of Il Gesù? Obviously, it has little in common with Palladio. The label *Mannerist* will not serve us either. As we shall see, the design of Il Gesù became basic to Baroque architecture. As with the paintings of Savoldo and Correggio, we may call it Proto-Baroque, which suggests both its great importance for the future and its special place in relation to the past.

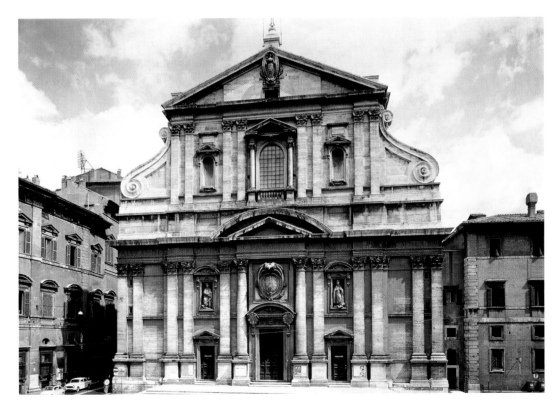

14-15 Giacomo della Porta. Facade of Il Gesù, Rome. c. 1575–84

The Renaissance in the North: Fifteenth Century

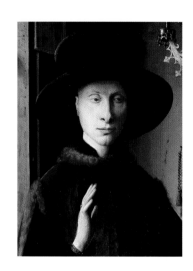

MANY SCHOLARS TREAT FIFTEENTH-CENTURY NORTHERN painting as the counterpart of the Early Renaissance in Italy and with good reason, as it had an impact that went far beyond its own region. In Italy, Flemish artists were admired as much as the leading Italian artists. To Italian eyes, their work was clearly postmedieval, and its intense realism had a marked influence on Early Renaissance painting. Should we, then, think of the Renaissance as a unified style? Or should we view it as an attitude that was embodied in several styles?

The Italians, as we have already seen, associated the exact imitation of nature in painting with a "return to the classics." When Boccaccio praised Giotto's imitation of nature, he could not know how many aspects of reality Giotto and his contemporaries had failed to investigate. These, we recall, were further explored later by the painters of the International Style, however tentatively. To go beyond Gothic realism required a second revolution, which began in Italy and in the Netherlands about 1420. We must think of two events, linked by a common aim—the conquest of the visible world—yet sharply divided in almost every other way.

There are still many unanswered questions about the Northern revolution and its relation to the Renaissance as a whole. In contrast to the Early Renaissance, which started in Florence under very specific circumstances, we do not yet know why the new style emerged in Flanders around 1420, although, as we shall see below, the cultural and commercial circumstances were favorable for fostering a new artistic climate. Italian Renaissance art, moreover, made very little impression north of the Alps during the fifteenth century. Not until the final decades did humanism become an important force in Northern thought, which it then changed

decisively. Nor do we find a strong interest in the art of classical antiquity before that time. Rather, the artistic and cultural environment of Northern painters clearly remained rooted in the Gothic tradition.

We have, in fact, no satisfactory name for Northern fifteenth-century art as a whole. Whatever we choose to call the style, we shall find that it has some justification. For the sake of convenience, scholars often use the label *Late Gothic*. The term hardly does justice to the special character of the new Flemish painting. It does suggest the continuity with the worldview of the late Middle Ages. Netherlandish art, unlike the Italian Renaissance, did not entirely reject the International Style. Instead, Northern painters took it as their point of departure, so that the break with the past was less abrupt than in the South. Despite its great importance, their work may be seen as the final phase of Gothic painting. The term *Late Gothic* also reminds us that fifteenth-century architecture and sculpture outside Italy were an outgrowth of the Gothic.

The best argument for considering this period the Early Renaissance in the North lies outside art. The North, especially Burgundy (which included modern-day Burgundy, as well as Flanders, roughly today's Belgium and the Netherlands), was in many ways more

advanced commercially and even culturally. It was linked by a better system of roads and rivers for transporting goods, thanks in part to the development of the pilgrimage routes, and thus was wealthier. Political power came to be concentrated in France, Spain, and England. In comparison, Italy was a minor player subject to these outside forces.

Netherlandish Painting

Robert Campin The first, and perhaps most decisive, phase of the pictorial revolution in FLANDERS can be seen in the work of an artist formerly known as the Master of Flémalle (after the fragments of a large altar from Flémalle), who was undoubtedly Robert Campin (c. 1378–1444), the foremost painter of Tournai. We can trace his career in documents from 1406 to his death in 1444, although it declined after his conviction in 1428 for adultery, which was a criminal offense at that time. His finest work is the *Mérode*

Altarpiece (fig. 15-1), which he must have painted soon after 1425. If we compare it to the Franco-Flemish pictures of the International Style (see fig. 11-37), we see that it falls within the same tradition. Yet we also recognize in it a new pictorial experience.

Here, for the first time, we have the sense of actually looking through the surface of the panel into a world that has all the essential features of everyday reality: unlimited depth, stability, continuity, and completeness. The painters of the International Style, even at their most daring, had never aimed at such consistency, and their commitment to reality was far from absolute. Their pictures have the enchanting quality of fairy tales. The scale and relationship of things can be shifted at will, and fact and fancy mingle without conflict. Campin, in contrast, has tried to tell the truth, the whole truth, and nothing but the truth. To be sure, he does not yet do it with total ease. His objects, overly **foreshortened**, tend to jostle each other in space. But he defines every last detail of every object to make it as concrete

Originally a county (ruled by counts), FLANDERS was a cultural and political entity for many centuries (its original lands are now parts of Belgium, France, and the Netherlands). It was fought over and controlled by a succession of counts, dukes, and kings of France, Burgundy, and Flanders itself. Ghent and Bruges were two of its most important cities. Holland was a county to the north of Flanders, whose history parallels that of Flanders in being subject to outside rule for much of its history. Holland was absorbed into the Netherlands when it was officially formed as a kingdom in 1648. Belgium is a relatively modern entity, a kingdom created in 1839.

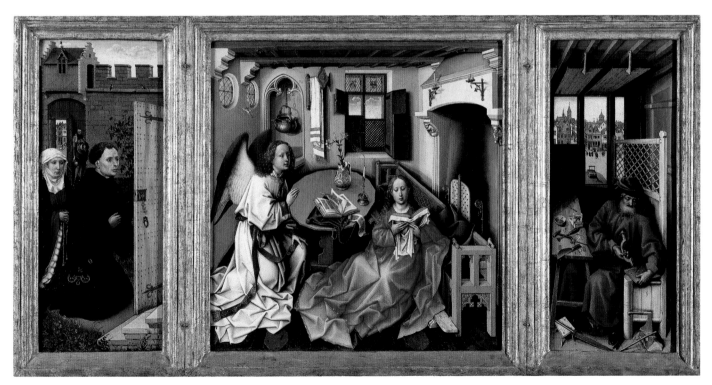

15-1 Robert Campin and Assistant. *The Annunciation Triptych,* Altarpiece, c. 1425, South Netherlandish; Made in Tournai, Oil on wood; Overall (open), 25⅜ × 46⅜" (64.5 × 117.8 cm). The Metropolitan Museum of Art

as possible: its shape and size; its color, material, hardness, and surface textures; and its way of responding to light. The artist even distinguishes between the diffused light, which creates soft shadows and delicate gradations of brightness, and the direct light entering through the two round windows, which produces the twin shadows sharply outlined in the upper part of the center panel and the twin reflections on the brass vessel and candlestick.

The *Mérode Altarpiece* transports us from the aristocratic world of the International Style to the household of a Flemish burgher. The central room has a beamed ceiling, a fireplace and screen, shuttered windows, a gothic niche, a simple curved table, candlesticks, and an earthenware pitcher. The setting is not a medieval church and nor is it Bethlehem. Setting this biblical scene in a contemporary Flemish house would make it more appealing, more accessible to the patrons who kneel outside the door in the left wing. Their name was Engelbrecht, which means "Angel Brings," and may have suggested this very theme—the Angel is bringing the word of the Lord. This is the earliest Annunciation in panel painting that occurs in a fully equipped domestic interior. It is also the first to honor Joseph, the humble carpenter, by showing him at work next door.

This bold departure from tradition forced our artist to confront a problem that no one had faced before. He needed to transfer supernatural events from symbolic settings to an everyday environment without making them look either trivial or out of place. He met this challenge by the method known as "disguised symbolism," which means that almost any detail within the picture, however casual, may carry a symbolic message. We saw its beginnings during the International Style in the *Annunciation* by Melchior Broederlam (see fig. 11-37), but his symbolism seems simple compared with the many hidden meanings in the *Mérode Altarpiece*.

The flowers, for example, are associated with the Virgin. In the left wing the roses denote her charity and the violets her humility, and in the center panel the lilies symbolize her chastity. The shiny water basin and the towel on its rack are not just household equipment. They are further attributes of

Mary as the "vessel most clean" and the "well of living waters." Perhaps the most intriguing symbol of this sort is the candle next to the vase of lilies. It has been extinguished only moments before, as we can tell from the glowing wick and the curl of smoke. But why had it been lit in broad daylight, and what made the flame go out? Has the divine radiance of the Lord's presence overcome the material light? Or did the flame of the candle itself represent the divine light, now extinguished to show that God has become human, that in Jesus "the Word was made flesh"?

Clearly, the entire range of medieval symbolism not only survives in our picture but has been expanded. It is nevertheless so completely immersed in the world of everyday appearances that we often wonder whether a given detail carries a symbolic meaning. Scholars long speculated, for instance, about the boxlike object on Joseph's workbench (and a similar one on the ledge outside the open window). Finally they were identified as mousetraps that convey a specific theological message. According to St. AUGUSTINE, God had to appear on earth in human form so as to fool Satan: "The Cross of the Lord was the devil's mousetrap."

Because it takes much scholarly ingenuity to explain this sort of iconography, we tend to think of the *Mérode Altarpiece* and similar pictures as puzzles. We can still enjoy them without knowing all their symbolism. But what about the patrons for whom these works were painted? Did they understand the meaning of every detail? They would have had no trouble with the well-established symbols in our picture, such as the flowers, and they probably knew the significance of the water basin. The message of the extinguished candle and the mousetrap could not have been common knowledge even among the well educated, however.

These two symbols—and we can hardly doubt that they are symbols—appear for the first time in the *Mérode Altarpiece*. They must be unusual, too, for St. Joseph with the mousetrap has been found in only one other picture, and the freshly extinguished candle does not occur elsewhere, so far as we know. It seems that Campin introduced them into the visual arts, yet hardly any artists adopted

them despite his great influence. If the candle and the mousetrap were difficult to understand even in the fifteenth century, why are they in our picture at all? Was the artist told to put them in by an exceptionally educated patron? This would be possible if it were the only case of its kind, but because there are many instances of equally subtle or obscure symbolism in fifteenth-century Northern painting, it seems more likely that the initiative came from the artists rather than from their patrons.

Campin either was a man of unusual learning or had contact with theologians or scholars who could supply him with references that suggested the symbolic meanings of things such as the extinguished candle and the mousetrap. In other words, the artist did not simply continue the symbolic tradition of medieval art within the framework of the new realistic style. He enlarged and enriched it by his own efforts. To him, even more than Broederlam, realism and symbolism were interrelated. We might say that Campin needed a growing symbolic repertory because it encouraged him to explore features of the visible world that had not been depicted before, such as a candle just after it has been blown out or the interior of a carpenter's shop, which provided the setting for the mousetraps. For him to paint everyday reality, he had to "sanctify" it with spiritual significance.

This reverence for the physical world as a mirror of divine truths helps us to understand why in the *Mérode* panels the smallest details are rendered with the same attention as the sacred figures. The disguised symbolism of Campin and later painters was not grafted onto the new realistic style. It was ingrained in the creative process. Their Italian contemporaries must have sensed this, for they praised both the realism and the "piety" of the Flemish masters.

Campin's distinctive **tonality** makes the *Mérode* Annunciation stand out from earlier panel paintings. The jewel-like brightness of the older works, their patterns of brilliant hues and lavish use of gold, have given way to a color scheme far less decorative but much more flexible and nuanced. The muted greens and the bluish or brownish grays show a new subtlety, and the scale of intermediate shades is smoother and has a wider range. These effects are essential to the realistic style of Campin. They were made possible by the use of oil.

Tempera and Oil Techniques The basic medium of medieval panel painting had been **tempera**, in which the finely ground pigments were mixed ("tempered") with diluted egg yolk to produce a tough, quick-drying coat of colors that cannot be blended smoothly. Oil, a viscous, slow-drying medium, could produce a vast variety of effects, from thin, translucent films (called **glazes**) to a thick layer of creamy, heavy-bodied paint (called **impasto**). The **tones** could also yield the continuous scale of **hues** necessary for rendering three-dimensional effects, including rich, velvety dark shades previously unknown. **Oil painting** offers another unique advantage over egg tempera, **encaustic**, and **fresco**: oils give artists the unprecedented ability to change their minds almost at will. Without oil, the Flemish artists' conquest of visible reality would have been much more limited. Although oil was not unfamiliar to medieval artists, it was Campin and his contemporaries who discovered its artistic possibilities. Thus, from the technical point of view, too, they deserve to be called the founders of modern painting, for oil has been the painter's basic medium ever since.

Jan and Hubert van Eyck The full possibilities of oil were not discovered all at once, nor by any one artist. The great contribution was made by Jan van Eyck (c. 1390–1441), a somewhat younger and much more famous artist who was long thought to have "invented" oil painting. We know a good deal about Jan's life and career. Born about 1390, he worked in Holland from 1422 to 1424, in Lille from 1425 to 1429, and thereafter in Bruges, where he died in 1441. Both a townsman and a court painter, he was highly esteemed by Duke Philip the Good of Burgundy, who occasionally sent him on diplomatic errands. After 1432, we can follow Jan's career through a number of signed and dated pictures. His older brother Hubert remains a shadowy figure, however. But their lives come together in one remarkable painting. The most extraordinary altarpiece of the fifteenth century, *The Adoration of the Lamb*,

15-2 Jan and Hubert van Eyck. *Ghent Altarpiece* (open). Completed 1432. Oil on panel, 11'3" × 14'5" (3.4 × 4.4 m). Cathedral of St. Bavo, Ghent, Belgium

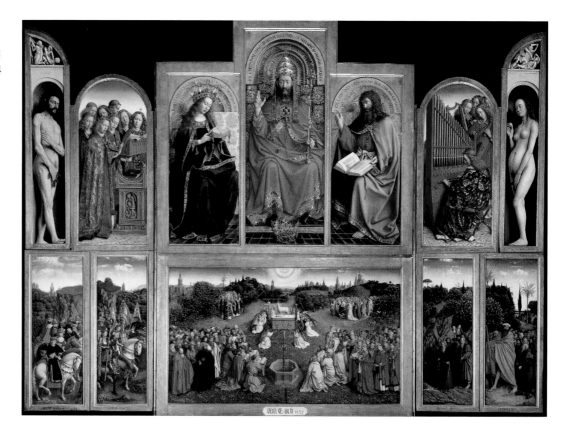

15-3 *Ghent Altarpiece* (closed). Cathedral of St. Bavo, Ghent, Belgium

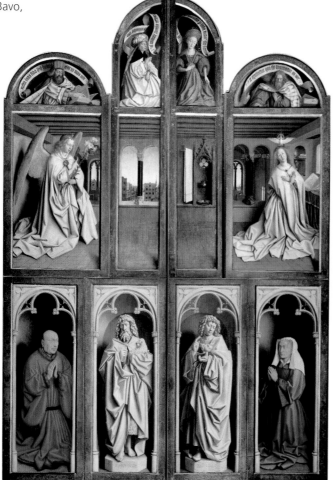

(figs. 15-2, 15-3), known as the *Ghent Altarpiece* from its location in the Cathedral of St. Bavo in Ghent. It is a sumptuous, spectacular, and complex work, famous both for its intense detail and overall program. It was praised even by contemporary viewers, and the German artist Albrecht Dürer (see page 340) mentioned it in his diary in 1521 while he traveled through Flanders. It drew all this attention for several reasons: its technical achievement in the use of oil paints and their use in imitation of pearls, gold, rubies, and brocades; the ornately garbed figures of Mary, St. John the Baptist, and God; the bold nude, near life-size figures of Adam and Eve; and the very size of the altarpiece of 20 painted panels, which today measure over 15 feet high and 11 feet wide and which may have been (with its elaborate frame) more than twice this size in the fifteenth century.

The original paintings may have been engaged in an elaborate Gothic frame, such as one reconstructed by the art historian Lotte Brand Philip (fig. 15-4), who also suggests, based on an inscription of 1432, that the artist Jan van Eyck executed the paintings we see today and that his brother, Hubert van Eyck, created its extravagant frame (a project that would have been com-

pleted first, coinciding with his death in 1426). Indeed, such architectural/sculptural masterpieces embodying painted altarpieces can be seen somewhat later in Michael Pacher's *St. Wolfgang Altarpiece*, 1471 (fig. 15-12), and Grünewald's *Isenheim Altarpiece* (fig. 16-1) of c.1515, as well as in copies or versions of the Ghent work. The possible reconstruction of this ensemble (fig. 15-4) suggests how the paintings may have "worked" when the altarpiece was closed.

The main theme of the altarpiece is the Adoration of the Lamb, seen in the center panel when the altarpiece is open. The lamb, a symbol of the sacrificed Christ, stands on an altar, bleeding into a chalice; directly above him in the same panel is the dove of the Holy Spirit. The lamb is surrounded by prophets and hermits and, in panels to the left, right, and above, singing and music-making angels. At the lowest point is a fountain, symbolizing the fountain of life and a baptismal font, which provides the gateway to Christian salvation. The landscape of the lamb is seen in *aerial* or **atmospheric perspective** (see page 272) with the lightest sky deep in the horizon behind the lamb and the richer blue at the top edge of the painting. Above the lamb is the dove, the Holy Spirit, sent down by God the Father (although this figure is also described as Christ) in the painting above. There are many inscriptions throughout the painting that deepen its meaning. For example, as God looks out to us with the power of his omnipresence, above him are the words: "This is God, the Almighty by reason of His divine majesty." The images of Adam and Eve, which at first seem puzzling, actually make complete sense in this program. It was their sin that must be redeemed by the new Adam, who is Christ.

When the altarpiece is closed, we view four painted architectural niches, the donors Jodocus Vijd and Elisabeth Borluut, who kneel at either side of the altarpiece and clasp their hands in prayer, and beside them, statues of St. John the Baptist and St. John the Evangelist. The saints are painted in **grisaille**, that is, in grays to simulate sculpture (we see this, too, in the "sculptural" niches of Adam and Eve on the interior). This concept was common in Northern altarpieces so that they would indeed appear more somber closed, and even more glorious with a blaze of color when opened. Above the four niches is an

15-4 *Reconstruction of Ghent Altarpiece* (closed), by Lotte Brand Philip

Annunciation scene and at the highest level sibyls and prophets who foretell the coming of Christ. The Annunciation here is also in a domestic interior, although not as detailed or perhaps as cozy as the *Mérode Altarpiece* (fig. 15-1). Because we don't know when the *Mérode* was actually executed, or when this was begun, it is unclear who influenced whom. But with two artists producing Flemish interiors for the Annunciation, a trend was created. However, here the Archangel Gabriel and the Virgin actually "speak" with words inscribed on the painting—from Luke 1:28 and 1:38. The Angel says "Hail, you who are highly favored, The Lord is with you," and Mary responds with: "Behold the handmaiden of the Lord." But Mary's acceptance is written upside down, so only the Holy Spirit, above her, and the Lord can read these words. The Annunciation on the outer wings acts as an announcement for what will come in the open version: the Heavenly Jerusalem, and the multitudes who pay homage to Christ, the Lamb.

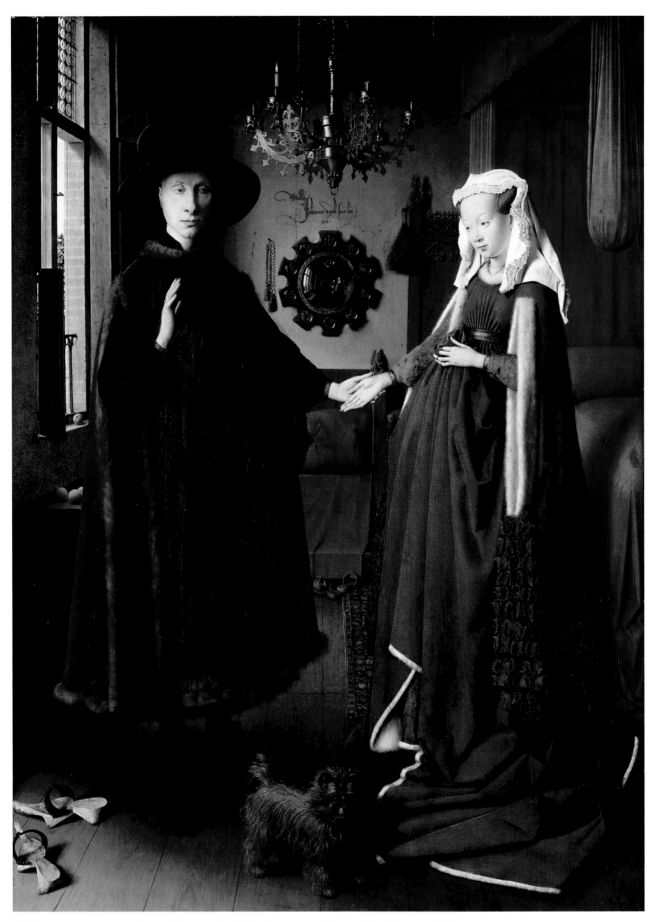

15-5 Jan van Eyck. *The Arnolfini Betrothal.* 1434. Oil on panel, 33 × 22¹/₂″ (83.8 × 57.2 cm). The National Gallery, London

It is a magnificent public spectacle, and the technical achievements raised it to the highest level. There can be no doubt that Van Eyck used the oil medium with extraordinary refinement. By alternating opaque and translucent layers of paint, he was able to give his pictures a soft, glowing color that has never been equaled, probably because it depends as much on individual sensibilities as it does on skillful craftsmanship.

The Flemish cities of Tournai, Ghent, and Bruges, where the new style of painting flourished, rivaled those of Italy as centers of international banking and trade. Their foreign residents included many Italian businessmen. Jan van Eyck painted the portrait in figure 15-5 to celebrate the alliance of two families that were active in Bruges and Paris. It probably shows the betrothal of Giovanni Arnolfini and Giovanna Cenami in the main room of the bride's house, rather than an exchange of marriage vows in the privacy of the bridal chamber, as usually thought. The furnishings may be her dowry, the goods a bride brought to a marriage. The young couple touch hands as he raises his right hand in solemn oath. (In accordance with Northern custom, the actual wedding no doubt took place later in front of a church, when the young couple's right hands were joined in holy matrimony.) But their touching is hardly an embrace. They seem devoid of emotion, which suggests that this painting represents some formal or legal document. They seem to be quite alone, but in the mirror behind them is the reflection of two other people who have entered the room (fig. 15-6). One of them is presumably the bride's father, who by tradition gives her to the groom. The other must be the artist, because the words above the mirror, in florid lettering, tell us that "Johannes de eyck fuit hic" (Jan van Eyck was here) in the year 1434.

Jan's role, then, is that of a witness to the engagement, which also entailed a legal and financial contract between the two families. The picture claims to show exactly what he saw. Given its secular nature, we may wonder whether the picture is filled with the same sort of disguised symbolism as the *Mérode Altarpiece*. Or does the realism serve simply as an accurate record of the event and its domestic setting? The elaborate bed, the main piece of furniture in the well-appointed living room of the day, was used not for sleep-ing but for greeting new mothers and paying final respects to the dead. May it not also refer to the physical consummation of marriage? Have the couple taken off their shoes merely as a matter of custom, or to remind us that they are standing on "holy ground"? (For the origin of the theme, see page 49). By the same token, is the little dog a beloved pet, or an emblem of fidelity? (In Latin, *fides* is the root for the words *dog*, *fidelity*, and *betrothal*.) The other furnishings of the room pose similar questions. What is the role of the single candle in the chandelier, burning in broad daylight (compare page 322)? And is the convex mirror, whose frame is decorated with scenes from the Passion, not also a Vanitas symbol (see fig. 18-16)? Jan was so intrigued by its visual effects that he included it in two other paintings as well.

In the end, we are forced to conclude that here, too, the natural world contains the world of the spirit so completely that the two become one. As our detail of the mirror shows, the young couple are too far from the doorway to have removed their shoes simply out of habit. The mirror and its carved decorations convey a moral message: to think of spiritual values, not simply to enjoy the worldly pleasures represented by the luxurious interior. Nor can the placement of the dog directly below the mirror and squarely between the man and woman be simply a coincidence. As a sacrament, matrimony was holy and binding in a spiritual, not just a legal, sense. Yet, in questioning the traditional reading, we are reminded not to overinterpret the symbolic meaning of an image to the point where it

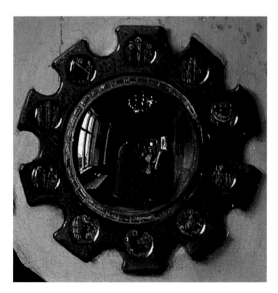

15-6 Jan van Eyck. Detail of *The Arnolfini Betrothal*

would have been hopelessly obscure even to the artist's contemporaries.

Rogier van der Weyden In the work of Jan van Eyck, the exploration of the reality made visible by light and color reached a level that was not to be surpassed for another two centuries. Rogier van der Weyden (1399/1400–1464), the third great master of early Flemish painting, set himself a different but equally important task: to recapture the emotional drama and pathos of the Gothic past within the framework of the new style. We see this greater expressive immediacy in his early masterpiece, *Descent from the Cross* (fig. 15-7), which dates from about 1435. Here the modeling is sculpturally precise, with angular drapery folds recalling those of Rogier's teacher, Robert Campin. The soft half-shadows and rich colors show his knowledge of Jan van Eyck, with whom he may also have been in contact. Yet Rogier is far more than a follower of the two older artists.

Whatever he owes to them (and it is clearly a great deal) he uses for his own purposes. The external event of lowering Jesus' body from the Cross concerns him less than the world of human feeling: "the inner desires and emotions . . . whether sorrow, anger, or gladness," in the words of an early account. The visible world in turn becomes a means toward that same end. Rogier's art has been well described as "at once physically barer and spiritually richer than Jan van Eyck's." Judged for its expressive content, this *Descent* could well be called a *Lamentation*. The Virgin's swoon echoes the pose and expression of her son. So intense are her pain and grief that they inspire the same compassion in the viewer. Rogier has staged his scene in a shallow niche or shrine, not against a landscape. This bold device gives him a double advantage in heightening the effect of the tragic event. It focuses the viewer's attention on the foreground and allows the artist to mold the figures into a coherent group. It seems fitting that Rogier treats his figures as if they were colored statues, for the source of these grief-stricken gestures and faces is in sculpture rather than in painting. The panel descends from the Strasbourg *Death of the Virgin* (see fig. 11-18), to which it is very similar in both composition and mood.

Truly "Late Gothic," Rogier's art never departs from the spirit of the Middle Ages. Yet visually it belongs just as clearly to the new era, so that the past is restated in con-

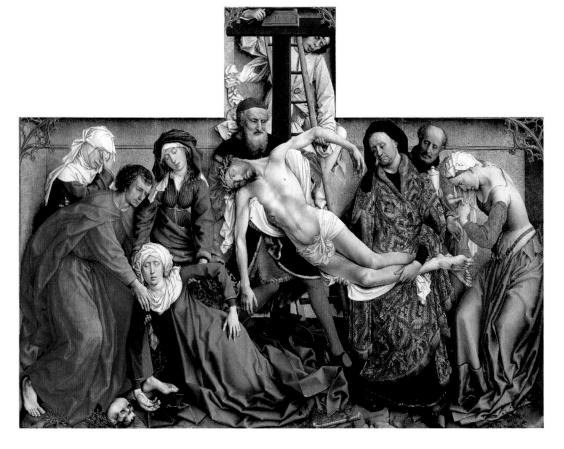

15-7 Rogier van der Weyden. *Descent from the Cross*. c. 1435. Oil on panel, 7'2⅝" × 8'7⅛" (2.20 × 2.62 m). Museo del Prado, Madrid

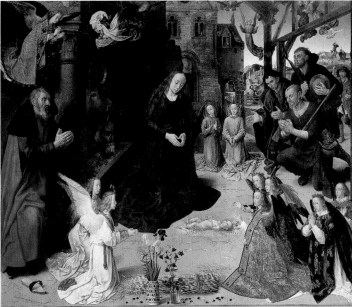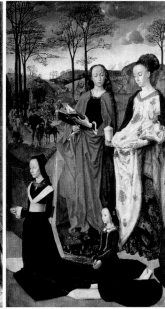

15-8 Hugo van der Goes. *Portinari Altarpiece* (open). c. 1476. Tempera and oil on panel, center 8'3¹/₂" × 10' (2.53 × 3.05 m); wings each 8'3¹/₂" × 4'7¹/₂" (2.53 × 1.41 m). Galleria degli Uffizi, Florence

temporary terms. Thus Rogier was accessible to people who retained a medieval outlook. No wonder he set an example for countless other artists. When he died in 1464, after 30 years as the foremost painter of Brussels, his influence was supreme throughout Europe north of the Alps. Its impact continued to be felt almost everywhere outside Italy, in painting as well as sculpture, until the end of the fifteenth century.

Hugo van der Goes Few of the artists who followed Rogier van der Weyden escaped from his shadow. To them his paintings offered a choice between intense drama and delicate restraint. The vast majority chose the latter, and their work is marked by a fragile charm. The most dynamic of Rogier's disciples was Hugo van der Goes (c. 1440–1482), an unhappy genius whose tragic end suggests an unstable personality. After a spectacular rise to fame in the cosmopolitan atmosphere of Bruges, he decided to enter a monastery as a lay brother in 1475, when he was about 35 years old. He continued to paint for some time, but increasing fits of depression drove him to the verge of suicide, and seven years later he was dead.

The huge altarpiece commissioned in 1475 by Tommaso Portinari, an agent of the Medici in Bruges, is Hugo's most ambitious work (fig. 15-8). There is a tension between the artist's devotion to the natural world and his concern with the supernatural that suggests a nervous and restless personality. Hugo has rendered a wonderfully spacious and atmospheric landscape with a wealth of precise detail. Yet the difference in the size of the figures seems to contradict this realism. In the wings, the kneeling members of the Portinari family are dwarfed by their patron saints, whose gigantic size marks them as beings of a higher order. The latter figures are not meant to be larger than life, however. They share the same huge scale with Joseph, the Virgin Mary, and the shepherds of the Nativity in the center panel, whose height is normal in relation to the architecture and to the ox and ass. The angels are on the same scale as the donors, and thus appear abnormally small.

This change of scale stands outside the logic of everyday experience found in the setting that the artist has provided for his figures. Although it originated with Rogier van der Weyden and has a clear symbolic purpose, Hugo exploited this variation for expressive effect. There is another striking contrast between the hushed awe of the shepherds and the ritual solemnity of all the other figures. These field hands, gazing in breathless wonder at the newborn Child, react to the miracle of the Nativity with a wide-eyed directness new to Flemish art. Perhaps the most important aspect of this commission is that the painting

was brought to Florence in 1483. And so, for generations, Italian painters would see Northern art (altarpieces, landscape, portraits, images of saints) through this work.

Hieronymus Bosch During the last quarter of the fifteenth century, there were no painters in Flanders comparable to Hugo van der Goes, and the most original artists appeared farther north, in Holland. One of these, Hieronymus Bosch (c. 1450–1516), appeals to our interest in the world of fantasy. Little is known about him except that he came from a family of painters named Van Aken, spent his life in the provincial town of Hertogenbosch, and died, an old man, in 1516. His work, full of weird and seemingly irrational imagery, has proved difficult to interpret.

Bosch's most famous work, the TRIPTYCH known as *The Garden of Delights* (fig. 15-9), is the richest and most puzzling of all. The key to its understanding may be the text on the grisaille exterior of the closed altarpiece panels. There Bosch painted a globelike sphere with a strange moonscape representing the beginning of time. A small figure of God is accompanied by Psalm 33: "He spoke, and it came to be; He commanded and it stood forth." Thus the world opened. And when the altarpiece opens

we see the Garden of Eden on the left wing, the times of Noah in the center, when people were without law, and on the right wing, the payment for their excesses, in Hell.

On the left, in the Garden of Eden, the Lord introduces Adam to the newly created Eve. They have not yet sinned. They are new together and suggest optimism, al-though some of the creatures in the Garden hint at evil inclinations. The airy landscape is filled with animals, including such exotic creatures as an elephant and a giraffe, as well as sinister hybrid monsters. The center panel is populated with countless nude men and women engaged in a variety of strange acts. They parade around a circular basin on the backs of all sorts of beasts. Many frolic in pools of water. Most of them are linked with huge birds, fruit, flowers, or marine animals. Only a few are openly engaged in lovemaking, but there can be no doubt that the birds, fruit, and the like are thinly disguised symbols of carnal desire. The delights in this "garden" are an unending repetition of the original sin of Adam and Eve, which dooms us in our life on earth to be prisoners of our appetites. They are the children of the descendants of Adam and Eve, and in sixteenth-century prints such themes are entitled "Thus it was in the days of Noah," where the

15-9 Hieronymus Bosch. *The Garden of Delights.* c. 1510–15. Oil on panel, center 7'2½" × 6'4¾" (2.20 × 1.95 m); wings each 7'2½" × 3'2" (2.20 m × 96.5 cm). Museo del Prado, Madrid

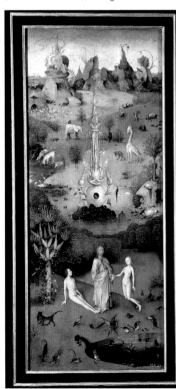
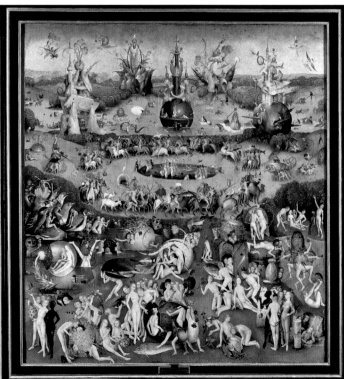
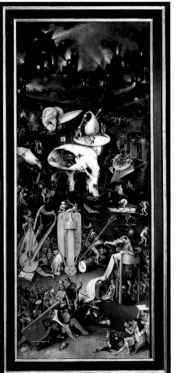

earthly delights are consumed. The right wing, a nightmarish scene of burning ruins and instruments of torture, surely represents Hell. Here people are repaid for their wanton lustfulness in physically painful terms, often of sexual and humiliating torture.

There is much more to this complex painting filled with imagery. We also know that the shapes of the fountains and many other forms were taken from treatises on Astrology and Alchemy, which Bosch would have known through his father-in-law, a well-to-do pharmacist. In the context of *The Garden of Delights* they represent earthly knowledge, which is the corruption of spiritual knowledge, just as earthly love is the sinful opposite of divine love.

French Painting

After about 1430, the new realism of the Flemish masters began to spread into France and Germany. By the middle of the century, its influence prevailed everywhere in Northern Europe, from Spain to the Baltic. Among the countless artists (including many whose names are not known) who turned out provincial versions of Netherlandish painting, only a few were gifted enough to impress us with a distinctive personality.

Jean Fouquet In France, the leading painter was Jean Fouquet (c. 1420–1481) of Tours. As the result of a lengthy visit to Italy around 1445, soon after he had completed his training, Fouquet's work blends Flemish and Early Renaissance elements, although it remains basically Northern. The *Melun Diptych* is his most famous work. Because of the stark boldness of the depiction of a mother prior to nursing on the right wing (not an unusual theme, just stunningly presented), it is difficult at first to reconcile that these two panels are diptychs. They are and their reconciliation comes in understanding them separately, showing Fouquet's mastery as a portraitist. In the left wing (fig. 15-10), *Étienne Chevalier and St. Stephen*, the head of St. Stephen seems no less individual than that of the donor, Étienne Chevalier. Italian influence can be seen in the style of the architecture and, less directly, in the statuesque solidity of the two figures. According to an old tradition, the Madonna in the right wing (fig. 15-11) is also a portrait: of Agnes

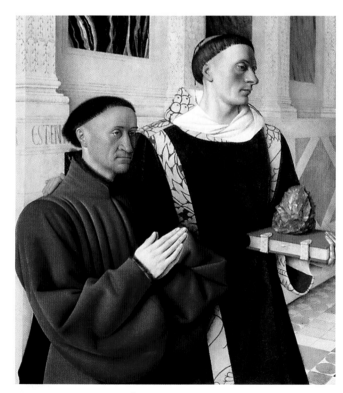

15-10 Jean Fouquet. *Étienne Chevalier and St. Stephen,* left wing of the *Melun Diptych.* c. 1450. Oil on panel, 36½ × 33½″ (92.7 × 85 cm). Staatliche Museen zu Berlin, Gemäldegalerie

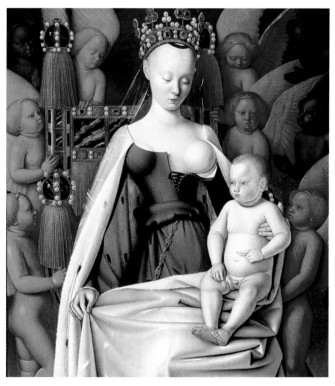

15-11 Jean Fouquet. *Madonna and Child,* right wing of the *Melun Diptych.* c. 1450. Oil on panel, 36⅝ × 33½″ (93 × 85 cm). Koninklijk Museum voor SchoneKunsten (Musée Royal des Beaux-Arts), Antwerp

The term FLAMBOYANT style is used to characterize the last phase of Gothic architecture in France, ranging from the late fourteenth to the early sixteenth century. The most common feature of the style is a sinuous tracery with flamelike shapes, but it is also characterized by wide arches, flattened arcades, and star-patterned rib vaults.

Sorel, Charles VII's mistress. If so, it presents an idealized image of courtly beauty, as befits the Queen of Heaven, seen wearing a crown amid a choir of angels. (Her bared, ample breast signifies the lactating Mary who nurtures the infant Jesus.) Chevalier, the king's secretary and lord treasurer served as executor of Sorel's estate upon her death in 1450, when our diptych may have been painted. He was rumored to have been in love with her, and once presented her with a large diamond ring, symbol of betrothal, before a tournament.

The pearls in the right panel have special significance. Charles had a passion for them, but they also have religious meaning. In Revelation, they are reserved for the twelfth and final gate of heaven, and serve to remind the viewer that the Madonna is also the gate to heaven.

In this altarpiece we see the beginnings of the tendency toward intellectual clarity and visual abstraction that were to become distinctive to French art. This emphasis even extends to the background. The treatment of space is very different in the two panels, not out of disregard for visual perspective but in order to distinguish between the temporal and spiritual realms. Thus each half of the diptych is a self-contained world. In turn, pictorial space for Fouquet exists independently of the viewer's "real" space.

Fifteenth-Century Sculpture

If we had to describe fifteenth-century art north of the Alps in a single phrase, we might label it "the first century of panel painting." Panel painting was so dominant in the period between 1420 and 1500 that its standards apply to manuscript illumination, stained glass, and even sculpture. After the later thirteenth century, we will recall, the emphasis had shifted from architectural sculpture to the more intimate scale of devotional images, tombs, pulpits, and the like. Claus Sluter, whose art is so impressive in weight and volume (see fig. 11-23), had briefly recaptured the monu-

mental spirit of the High Gothic. However, he had no real successors, although echoes of his style can be felt in French art for the next 50 years. It was the influence of Campin and Rogier van der Weyden that ended the International Style in the sculpture of Northern Europe. The carvers, who quite often were also painters, reproduced the style of these artists in stone or wood until about 1500.

Michael Pacher The most important works of the fifteenth-century carvers are wooden altar shrines, often large in size and intricate in detail. Such shrines were especially popular in the Germanic countries. One of the richest examples is the *St. Wolfgang Altarpiece* (fig. 15-12) by the Tyrolean sculptor and painter Michael Pacher (c. 1435–1498). Its lavishly gilt and colored forms make a dazzling spectacle as they emerge from the shadows under FLAMBOYANT canopies. The reconstruction of *The Adoration of the Lamb* altarpiece by Jan and Hubert van Eyck is another example of this multimedia extravaganza. We enjoy it, but in pictorial rather than sculptural terms. We have no sense of volume, either positive or negative. The figures and setting in the central panel, showing the Coronation of the Virgin, seem to melt into a pattern of twisting lines that permits only the heads to stand out as separate elements.

Surprisingly, when we turn to the paintings of scenes from the life of the Virgin on the interior of the wings, we enter a different realm, one that already commands the vocabulary of the Northern Renaissance. Here the artist provides a deep space in scientific perspective that takes the viewer's vantage point into account, so that the upper panels are represented slightly from below. The figures, strongly modeled by the clear light, seem far more "sculptural" than the carved ones, even though they are a good deal smaller. It is as if Pacher the sculptor felt unable to compete with Pacher the painter in rendering three-dimensional bodies and therefore chose to treat the Coronation of the Virgin in pictorial terms, by extracting the maximum of drama from contrasts of light and shade.

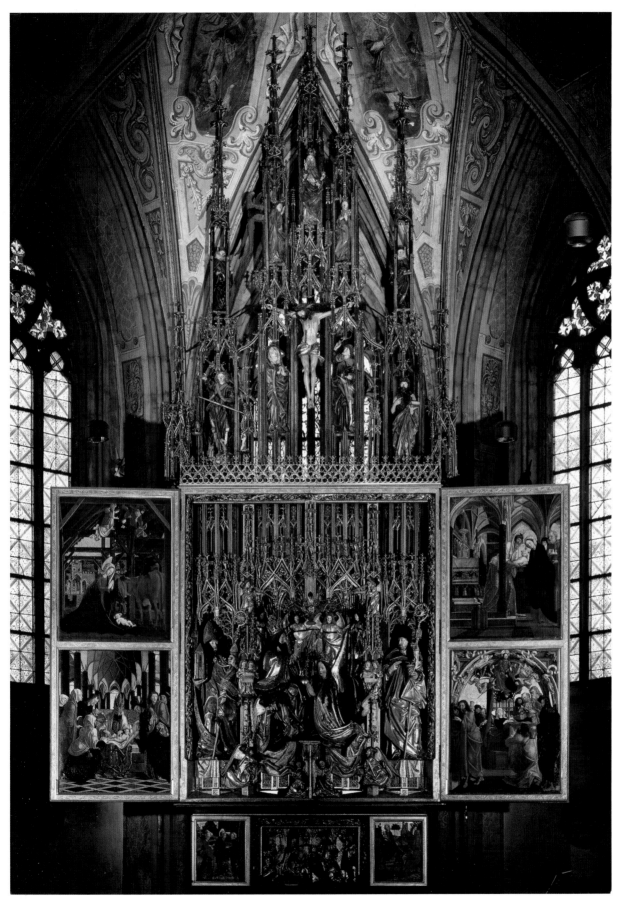

15-12 Michael Pacher. *St. Wolfgang Altarpiece.* 1471–81. Carved wood, figures about life-size; wings, oil on panel. Church of St. Wolfgang, Austria

Printmaking primarily is used to make multiple copies of an image. In each of the printmaking techniques—woodcuts, engraving, etching—the artist works on a block or plate and then covers the surface

St. Dorothy. c. 1420. Woodcut, 10⅝ × 7½" (27 × 19.1 cm). Saaliche Graphische Sammlung, Munich

with paper to print it. Throughout the process, the artist must keep in mind that the resulting image will be a reverse of the original design. Typically, the artist begins with a drawing and a plan for the project.

Making a woodcut is a fairly simple method for achieving a simple design. The artist cuts away and removes wood that will not be inked. The wood left in high relief receives the ink and becomes the positive image of the print. (Potato cuts or linoleum cuts are made in the same way.) The designs for early woodcuts were probably furnished by painters or sculptors. The actual carving of the woodblocks, however, was done by specially trained artisans, who also produced woodblocks for textile prints. As a result, early woodcuts, such as *St. Dorothy* (see illustration), have a flat ornamental pattern. Masters of the sixteenth century, remarkably, executed quite intricate woodcuts with this

technique. Dürer's *Four Horsemen of the Apocalypse* (fig. 16-3) is an extraordinary example of the fine detail achieved. The white space in the image corresponds to the cut-away areas of the block, and the inked lines and shapes are created by the fine wood ridges. Unfortunately, the pressure of the press on the wood block often dulled the ridges and even split the blocks. This meant that there were limitations to the reproductive quality of woodcuts.

Engraving is an example of a process known as intaglio (the cutting or incising of an image into a metal plate so that the ink is held below the surface of the plate). Deep cuts are made (engraved) in the metal with a tool called a burin. The plate is inked, and the ink gathers in the grooves made by the cuts. The artist wipes the surface clean, so the only ink remaining on the plate is in the grooves. A damp sheet of paper is placed over the plate, cushioned with blankets, and then rolled through a press. (The paper is damp so that it is soft and better able to pick up the ink.)

Etching also is a form of intaglio printing. In this process the artist uses acid to help make (etch) cuts in the metal plate. To begin, the metal plate is coated with a waxy substance. Instead of gouging to create grooves directly in the metal, the artist will lightly "draw" on the plate with a stylus, or needle, thereby removing the coating and revealing the metal beneath (see illustration). Next the plate is placed in an acid bath and the revealed metal will react to the acid, which will burn the area deeply. The plate is removed, wiped off, and covered in ink. Then

burin

etching needle

drawing on a wax-coated etching plate

that is wiped off, leaving ink only in the grooves. Like engraving, dampened paper covers the plate and is rolled through a press. Because the acid continues to burn the metal, the etched lines may be uneven, and depending on the length of time in the bath, the grooves can be very deep. So with etching, the actual creation is much like drawing, but the finished process includes an element of chance.

The range of blacks was explored further by the use of **drypoint**. Drypoint is the process of picking out the metal (see illustration of tool) and leaving the burr, the metal displaced by the needle, on the plate, which will then gather up the ink. This process has the possibility of creating areas of higher black density, as in Rembrandt's *One Hundred Guilder* print (fig. 18-14). Drypoint is often used in combination with etching and engraving.

Another option for creating greater tone is to only partially wipe the plate. This results in an overall dark tone to the print and creates dramatic effects of light and dark. In some cases, Rembrandt seems hardly to have wiped the plate at all, keeping it inked and only selectively wiping it.

In each of the above processes, changes are possible. The initial print is called a state. In each case, after printing one example, the artist can make a change. That second printing, using the same plate or block, is called a second state. There can be many states for a single print. The block or plate is therefore quite valuable and can be used many years later, even after the artist's death, by family members or other owners to provide income. Sometimes the artist will deface the plate (called "striking" it) to prevent anyone else from using it.

drypoint needles

The Graphic Arts

PRINTING AND ENGRAVING

Although printing was accomplished by the Chinese a thousand years ago, it did not have an impact on Western art until the late fifteenth century, with the invention of movable type and access to paper. The development of printmaking had a profound effect on Western civilization. Our earliest printed books in the modern sense were produced in the Rhineland soon after 1450. (It is not certain whether Johannes Gutenberg deserves the priority long claimed for him.) The new technique quickly spread all over Europe and developed into an industry, ushering in the era of increased literacy. Printed pictures were equally important. Without them the printed book could not have replaced the work of the medieval scribe and illuminator so quickly and completely. The pictorial and the literary aspects of printing, then, were closely linked from the start.

The idea of printing pictorial designs from blocks of wood onto paper is first found in Northern Europe at the very end of the fourteenth century. Many of the oldest surviving examples of such prints, called **woodcuts**, are German, others are Flemish, and some may be French, but all show the qualities of the International Style. Despite their appeal to modern eyes, fifteenth-century woodcuts were popular art, on a level that did not attract artists of great ability until shortly before 1500. A single woodblock yielded thousands of copies, to be sold for a few pennies apiece, so that for the first time in history anyone could own pictures (see Materials and Techniques: Early Printmaking, page 334).

The technique of **engraving** was developed in classical antiquity and continued to be practiced throughout the Middle Ages. Thus, no new skill was required to engrave a plate that was to serve as the matrix for a paper print. Engraving began in the Upper Rhine region, and early German and Netherlandish prints are the most important of the fifteenth century. Because engraving requires skill in cutting into metal, many early printmakers were silversmiths and goldsmiths or came from families that practiced this craft. This is true

even for Dürer, the leading printmaker of the sixteenth century (see pages 340-41), whose father was a goldsmith. Metal plates were more durable than woodblocks, so could be used more successfully for making multiple images that would be sold and distributed throughout Europe. Engravings appealed to a smaller and more sophisticated public. Individual hands can be distinguished almost from the beginning, dates and initials appear soon after, and we know the names of most of the important engravers of the last third of the fifteenth century.

Martin Schongauer Martin Schongauer (c. 1430–1491) was the first printmaker whom we also know as a painter, and the first to gain international fame. Schongauer might be called the Rogier van der Weyden of engraving. After learning the goldsmith's craft in his father's shop, he must have spent considerable time in Flanders, for he shows a thorough knowledge of Rogier's art. His prints are filled with motifs and expressive devices that reveal a deep affinity to the great Fleming. Yet Schongauer was a highly original artist in his own right. His finest engravings have a complex design, spatial depth, and rich texture that make them equivalent to panel paintings. In fact, lesser artists often found inspiration in them for large-scale pictures. They were also copied by other printmakers.

The Temptation of St. Anthony (fig. 15-13), one of Schongauer's most famous works, masterfully combines intense expressiveness and formal precision, violent movement and ornamental stability. Schongauer was not surpassed by any later engraver in his range of tonal values, the rhythmic beauty of his engraved line, and his ability to render every conceivable kind of surface—spiky, scaly, leathery, furry—by varying the burin's attack upon the plate. Although he remained fifteenth century in spirit, Schongauer paved the way for Albrecht Dürer, who was to become the greatest representative of the sixteenth-century Renaissance in the North (see pages 340–41). Indeed, Dürer hoped to become a member of Schongauer's workshop, but he did not arrive in Colmar until shortly after the older artist's death.

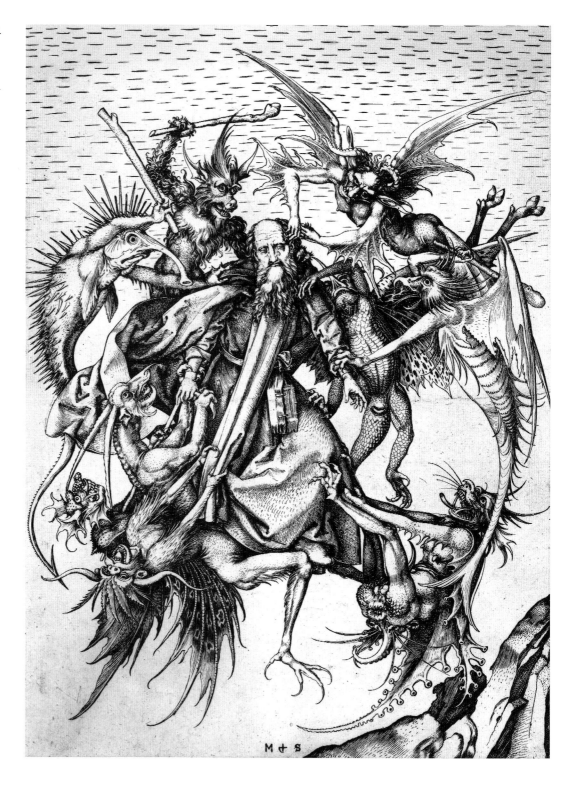

The Renaissance in the North: Sixteenth Century

TALIAN FORMS AND IDEAS, AS WE HAVE SEEN, HAD LITTLE

influence on fifteenth-century artists north of the Alps, particularly in Germany, the

Netherlands, and France. Since the time of Robert Campin and the Van Eycks northern

artists had looked to Flanders, rather than to Tuscany, for leadership. This relative isolation

ended suddenly toward the year 1500. As if a dam had burst, Italian influence flowed north-

ward in an ever-wider stream, as artists themselves traveled south and brought ideas, draw-

ings, and prints of Italian art back home.

Germany

It was in Germany, the home of the Reforma-tion, where the first major stylistic develop-ments took place during the first quarter of the century (see Cultural Context: The Reforma-tion, page 339). Between 1475 and 1500, Germany had produced such important artists as Michael Pacher and Martin Schongauer (see figs. 15-12 and 15-13), but they hardly prepare us for the extraordinary burst of cre-ative energy that was to follow. This period was as brief and brilliant as the Italian High Renaissance. The range of its achievements can be measured by the contrasting personali-ties of its greatest artists: Matthias Grünewald and Albrecht Dürer. Both died in 1528, proba-bly at about the same age, although we know only Dürer's birth date (1471). Dürer quickly became internationally famous, whereas Grünewald, who was born about 1470–80, remained so obscure that his real name, Mathis Gothart Nithart, was discovered only at the end of the nineteenth century.

Grünewald Grünewald's main work, the *Isenheim Altarpiece*, was long believed to be by Dürer. It was painted between about 1509/10 and 1515 for the monastery church of the Order of St. Anthony at Isenheim, in Alsace, not far from the former abbey that now houses it in the city of Colmar. It was intended as a program of salvation for the inmates of the

hospital of the monastery, which treated those with "St. Anthony's fire" and other diseases. This magnificent altarpiece is unique in Northern Renaissance art: it is fully the equal of the Sistine ceiling in its ambitious program and its ability to overwhelm us.

There are two sets of movable wings, which provide three stages, or "views." The first of these, when all the wings are closed, shows the Crucifixion in the center panel (fig. 16-1)—the most impressive ever painted. Christ's skin is covered with sores and pustules similar to those experienced by patients in the hospital. In one respect it is very medieval. Jesus's terrible agony and the desperate grief of the Virgin, St. John, and Mary Magdalen recall the older German **Andachtsbild** (see fig. 11-22). But the body on the Cross, with its twisted limbs, its many wounds, its streams of blood, is on a heroic scale that raises it beyond the human and thus reveals the two natures of Christ. The same message is conveyed by the flanking figures. The three mourn Jesus's death as a man, John the Baptist, on the right, calmly points to him as the Savior foretold in the Bible he holds. Behind him is water, which refers both to the waters of baptism and the hydrotherapy, which was one of the cures in the hospital. The Baptist, in fact, was not a historic witness to the Crucifixion, as he had already died. But here he appears. Through Christ, he lives again. Even the background

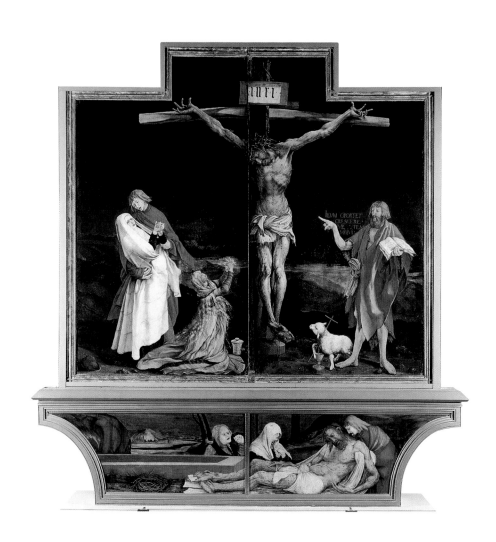

fully closed

half closed

fully open

suggests this duality. Golgotha here is not a hill outside Jerusalem, but a mountain towering above lesser peaks. The crucifixion, lifted from its familiar setting, becomes a lonely event silhouetted against a ghostly landscape and a blue-black sky. Darkness is over the land, in accordance with the Gospel, yet light bathes the foreground with the force of revelation. This union of time and eternity, of reality and symbolism, gives Grünewald's *Crucifixion* its awesome grandeur.

When the outer wings are opened, the mood of the *Isenheim Altarpiece* changes dramatically (fig. 16-2), although the theme of salvation and healing remains. All three scenes in this second view—*The*

16-1 Matthias Grünewald. *The Crucifixion,* from the *Isenheim Altarpiece* (fully closed, central section). c. 1509/10–15. Oil on panel, 8′10″ × 10′1″ (2.69 × 3.07 m). Musée Unterlinden, Colmar, France

16-2 Matthias Grünewald. *The Annunciation, The Madonna and Child with Angels,* and *The Resurrection,* from the *Isenheim Altarpiece* (half closed). c. 1510–15. Oil on panel, each wing 8′10″ × 4′8″ (2.69 × 1.42 m); center panel 8′10″ × 11′2¹/₂″ (2.69 × 3.42 m)

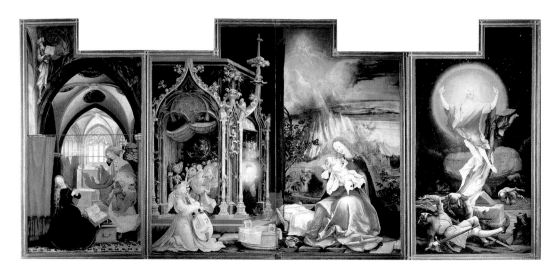

IN OCTOBER 1517 MARTIN LUTHER NAILED A LIST OF GRIEVANCES TO THE CHURCH DOOR at Wittenberg Castle, and the Protestant Reformation was launched. Luther had been an Augustinian friar before becoming a professor of theology at the University of Wittenberg. Now, in his broadside against the Catholic Church—a list of 95 theses—Luther attacked the Church's practice of selling "indulgences," which promised individuals salvation and the redemption of their sins. More fundamentally, the theses were a wholesale attack on Catholic dogma. For Luther, the Bible and natural reason were the sole sources of religious authority. Salvation, he claimed, was freely given by God. The intervention of clerics and saints, therefore, was unnecessary. Luther's revolutionary scheme transferred authority from the pope to the conscience of each Bible reader.

Studying the Bible required literacy, and now both girls and boys were required to read. The invention of the printing press enhanced Protestantism's spread, as grievances against the Church could be quickly reproduced and circulated. The implications of the Reformation were enormous for the liturgy, for social life, and for art. The teaching and reading of scripture became the focus of the liturgy, replacing the celebration of the mass before altarpieces. Images of saints and even (especially) Mary were outlawed. Iconoclasm (the actual destruction of images) reached a frenzy in 1566, as altarpieces and religious sculpture were destroyed by Protestants. Religious painting still existed—for underground Catholic Churches, but also for some Protestants—as people were reluctant to give up such imagery. Secular art, however, increased. Protestantism saw the growth of portraiture and the development of landscape, still life, and genre painting, as we will see throughout this chapter.

The Reformation would also foster social changes. Luther, who was married, promoted the concept of a married clergy. The idea of a clergy that had sex encouraged a new way of thinking, not just about the clergy, but about the power of women. In addition, Protestant thinking would influence ideas about raising children and the proper way to dress.

The Catholic Church would change as well. Luther's complaints spurred reforms beginning in the late sixteenth century and continuing into the seventeenth. This Counter-Reformation would have its own effects on European art and life (see chapters 17–19).

Annunciation, *The Madonna and Child with Angels*, and *The Resurrection*—celebrate events as jubilant as *The Crucifixion* is solemn. Most striking in comparison with fifteenth-century painting is the sense of movement found throughout these panels. Everything twists and turns as if it had a life of its own. The angel of *The Annunciation* enters the room like a gust of wind that blows the Virgin backward, and the Risen Christ leaps from his grave with explosive force healed of all the wounds seen in his Crucifixion. This vibrant energy is matched by the ecstatic vision of heavenly glory in celebration of Jesus' birth, seen behind the Madonna and Child, who are the most tender and lyrical in all of Northern art. The altarpiece opens yet a third time to reveal painted panels of the Temptation of St. Anthony (this subject is also seen in Schon-gauer, fig. 15-13) and St. Paul the Hermit flanking painted wood sculptures of saints, the donor, and a scene of the Last Supper.

In contrast to the brittle contours and angular drapery of fifteenth-century art, Grünewald's forms are soft and fleshy. His light and color show a similar change. He employs the resources of Flemish art with extraordinary boldness and flexibility. The range of his color scale is matched only by the Venetians. Indeed, his use of colored light has no parallel at that time. Grünewald achieved unsurpassed miracles through light in the luminous angels of *The Madonna and Child*, the apparition of God the father and the heavenly host above the Madonna, and the rainbow-hued radiance of the spectacular Risen Christ.

How much did Grünewald owe to Italian art? Nothing at all, we are first tempted to

say. Yet he must have learned from the Renaissance in more ways than one. His knowledge of perspective (note the low horizons) and the vigor of his figures cannot be explained by the fifteenth-century Northern tradition alone, and at times his pictures show architectural details of Southern origin.

Perhaps the most important effect of the Renaissance on him, however, was psychological. We know little about his career, but he apparently did not lead the settled life of an artisan-painter controlled by GUILD rules. Like Leonardo, he was also an architect, an engineer, something of a courtier, and an entrepreneur. Moreover, he worked for many different patrons and stayed nowhere for very long. He was in sympathy with Martin Luther even though as a painter he depended on Catholic patronage. In a word, Grünewald seems to have shared the free, individualistic spirit of Italian Renaissance artists. The daring of his pictorial vision likewise suggests that he relied on his own abilities. The Renaissance, then, had a liberating influence on him but did not change the basic cast of his imagination. Instead, it helped him to heighten the expressive aspects of fifteenth-century painting in a uniquely intense and individual style.

Albrecht Dürer For Albrecht Dürer, the Renaissance held a richer meaning. Attracted to Italian art while still a young journeyman, he visited Venice in 1494/5 and returned to his native Nuremberg with a new view of the world and the artist's place in it. (He was to go again in 1505.) To him, the unbridled fantasy of Grünewald's art was "a wild, unpruned tree" (a phrase he used for painters who worked by rules of thumb, without theoretical foundations) that needed the discipline of the objective, rational standards of the Renaissance. Taking the Italian view that the fine arts belong among the liberal arts, he also adopted the ideal of the artist as a gentleman and humanistic scholar. By cultivating his artistic and intellectual interests, Dürer incorporated an unprecedented variety of subjects and techniques. And as the greatest printmaker of the time, he had a wide influence on sixteenth-century art through his woodcuts and engravings, which circulated widely in Europe.

Dürer's large and magnificent woodcut of *The Four Horsemen of the Apocalypse* (fig. 16-3) is one of fifteen woodcuts (plus the title page) executed by him for the Apocalypse from the Book of Revelation. The illustrations did not follow the text (published in both German and Latin) but were independent images. This print revolutionized woodcut technique, revealing a vitality and intricacy that heretofore could not be imagined in this new medium (see Materials & Techniques: Early Printmaking, page 334). Dürer enhanced the simple woodcut technique by using HATCHING and SHADING. These subtleties marked the emergence of printmaking as an important medium.

The Four Horsemen represent Death as stirringly described by John (Revelation 6:1–2), "Saying with a voice like thunder

16-3 Albrecht Dürer. *The Four Horsemen of the Apocalypse*. c. 1497–98. Woodcut, 15½ × 11⅛" (39.3 × 28.3 cm). The Metropolitan Museum of Art, New York

Gift of Junius S. Morgan, 1919

'Come and See' and I looked and behold, a white horse." The first horse is described as having a rider with a bow and crown (seen in the rear of the print), the second with a sword, the third with scales, and the fourth with death himself, as each would kill with "sword, with hunger, with death and by the beasts of the earth" (Revelation 6:8), as they trampled the people before them. It is a compelling and dynamic work expressing speed and mystery.

Dürer was the first artist to be fascinated by his own image. In this respect he was more of a Renaissance personality than any Italian artist. His earliest known work, a drawing made at 13, is a self-portrait, and he continued to produce images of himself throughout his career. Most impressive, and uniquely revealing, is the panel of 1500 (fig. 16-4). In pictorial terms, it belongs to the Flemish tradition, but the solemn pose and the idealization of the features have an authority that is beyond the range of ordinary portraits. The picture looks, in fact, like a secularized icon, for it is patterned after images of Christ. It reflects not so much Dürer's vanity as the seriousness with which he viewed his mission as an artistic reformer.

The didactic aspect of Dürer's art is clearest in the engraving *Adam and Eve* of 1504 (fig. 16-5). Here the biblical subject serves as a pre-

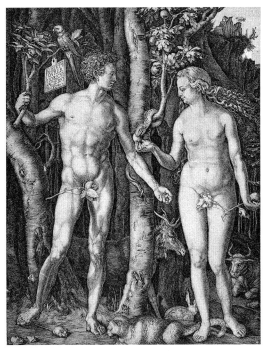

16-5 Albrecht Dürer. *Adam and Eve*. 1504. Engraving, 9⅞ × 7½" (25.2 × 19.1 cm). Los Angeles County Museum of Art
Art Museum Council Fund

text for the display of two ideal nudes: Apollo and Venus in a Northern forest (compare figs. 5-19 and 5-24). No wonder they look somewhat out of place. Unlike the picturesque setting and the animals in it, Adam and Eve are not observed from life. Instead, they are constructed according to what Dürer believed to be perfect proportions. For the first time, both the form and the substance of the Italian Renaissance enter Northern art, but adapted to the unique cultural climate of Germany. That is why Dürer's ideal male and female figures, although very different from classical examples, were to become models in their own right to countless Northern artists.

Dürer's own convictions were essentially those of Christian humanism. They made him an early and enthusiastic follower of Martin Luther, although, like Grünewald, he continued to work for Catholic patrons. Most of Dürer's religious paintings were done before the onset of the Reformation (see Cultural Context: The Reformation, page 339), and his hope for a monumental art embodying the Protestant faith was not fulfilled.

Lucas Cranach the Elder Other German painters, notably Lucas Cranach the Elder (1472–1553), tried to cast Luther's doctrines

HATCHING and SHADING are two methods of creating dark areas and enhancing an illusion of three-dimensionality in drawings and prints. Individual hatch lines often taper from thin to thick. To intensify darkness, hatch lines may be superimposed at angles, which is called cross-hatching. Shading can be achieved through many means; it is the simple manipulation of light and dark areas to model an object.

hatching and cross-hatching

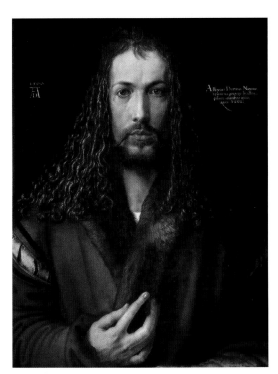

shading

16-4 Albrecht Dürer. *Self-Portrait*. 1500. Oil on panel, 26¼ × 19¼" (66.7 × 49 cm). Alte Pinakothek, Munich

into visual form but created no viable tradition. On his way to Vienna around 1500, Cranach probably visited Dürer in Nuremberg. In any event, he fell under the influence of Dürer's work, which he turned to for inspiration throughout his career. In 1504 Cranach left Vienna for Wittenberg, then a center of humanist learning. There he became court painter to Frederick the Wise of Saxony, who also commissioned works by Dürer, as well as a close friend of Martin Luther, who became a godfather to one of his children. Like Grünewald and Dürer, Cranach relied on

Catholic patronage. Some of his altars have a Protestant content but, ironically, they lack the fervor of those he painted before his conversion. Efforts to embody Luther's doctrines in art were doomed, because the spiritual leaders of the Reformation looked upon religious images with indifference or, more often, hostility—even though Luther himself seems to have tolerated them.

Cranach is best remembered today for his delightfully incongruous mythological scenes, his portraits, and his portraits in historical guise, such as his *Judith with the Head*

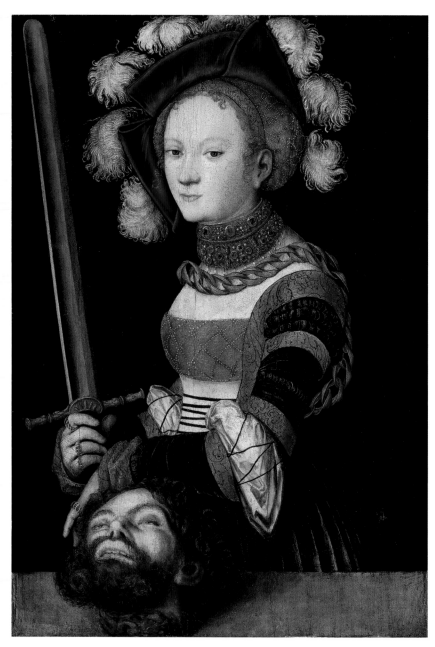

16-6 Lucas Cranach the Elder. *Judith with the Head of Holofernes.* c.1530. Oil on panel, 35¼ × 24⅜" (89.5 × 61.9 cm). The Metropolitan Museum of Art, New York

of Holofernes (fig. 16-6). The theme of Judith with the Head of Holofernes was popular in the Renaissance (there are examples by both Donatello and Botticelli) but even more so in the Reformation period, when the roles and images of women were being re-examined. The Apocryphal story of the Jewish widow Judith who saves her people by traveling with her maid to the tent of the Assyrian General Holofernes, getting him drunk, and cutting off his head with his own sword, yields parallels to the story of David and Goliath—might conquered by virtue and innocence. However, with the theme of Judith, the victor was not always seen positively, but with some suspicion as her triumph was one of deceit: the unspoken promise of sexual activity was never realized.

Other stories of women, Eve offering Adam the apple in the Garden, Lot's Daughters, Delilah orchestrating Samson's haircut and loss of power, together with the story of Judith, formed the basis of a theme known as the Power of Women. Images of these related themes appear in numerous prints of this period. One artist even called these "Women's Tricks of the Old Testament." Lucas Cranach's *Judith with the Head of Holofernes* should be seen in this light. It is one of several similar works by him that all show Judith not as a Biblical heroine but as a well-dressed Saxon Princess with the bloody decapitated head of Holofernes in her hand. Although the Book of Judith does indicate that the widow put on festive attire and jewels for her meeting with Holofernes, the image appears as somewhat startling. While the theme and the painting undoubtedly indicate the power and ingenuity of Judith to save her people, the contemporary costume suggests contemporary issues. As the Reformed Church allowed the marriage of its clergy, in contrast to the celibate clergy of the Catholic Church, the potential power and influence of women was viewed with suspicion. Judith was seen as an example of a sexual temptress who would make the object of her beguiling ways pay the ultimate price.

Albrecht Altdorfer We could not possibly identify the subject of Albrecht Altdorfer's *Battle of Issus* (fig. 16-7), Alexander's victory over Darius, without the text on the tablet suspended in the sky, the inscriptions on the banners (they were probably written by the Regensburg court humanist Aventinus), and the label on Darius's fleeing chariot. Altdorfer has tried to follow ancient descriptions of the actual number and kind of combatants in the battle. In doing so, he adopts a bird's-eye view, traditional in Northern landscapes (compare fig. 15-9), so that the two leaders are lost in the antlike mass of their own armies. (Compare the depiction of the same subject in a Hellenistic mosaic, fig. 5-5.)

However, the soldiers' armor and the fortified town in the distance are unmistakably of the sixteenth century. The picture commemorates a battle that took place in 1529, the year this panel was painted. At that time the Turks tried unsuccessfully to invade Vienna after gaining control over much of eastern Europe. (They were to threaten the city repeatedly for another 250 years.) Neither the Hapsburg emperor Charles V nor Suleiman the Magnificent, the Turkish sultan, was present at this battle. Yet the painting acclaims Charles a new Alexander in his victory over Suleiman, who, like Darius, became the ruler of a vast empire.

To suggest its importance, Altdorfer treats the event as an allegory. The sun triumphantly breaks through the clouds of the spectacular sky and "defeats" the moon, which represents the Turkish Crescent. The celestial drama above a vast Alpine landscape, correlated with the human contest below, raises the scene to the cosmic level. This turbulent sky is strikingly similar to the vision of the Heavenly Host above the Virgin and Child in the *Isenheim Altarpiece* (see fig. 16-2) by Grünewald, who influenced Altdorfer earlier in his career. He was also greatly influenced by the fantastic landscapes of Cranach, who played a critical role in the formation of the Danube School. Altdorfer, too, was an architect and was thoroughly familiar with scientific perspective and with Italian Renaissance style. However, his paintings show the same "unruly" imagination as the work of the older painter. But Altdorfer is unlike Grünewald in treating the human figure with ironic intent by making it incidental to the setting. Tiny figures like the soldiers of *The Battle of Issus* also appear in his other late pictures, and he

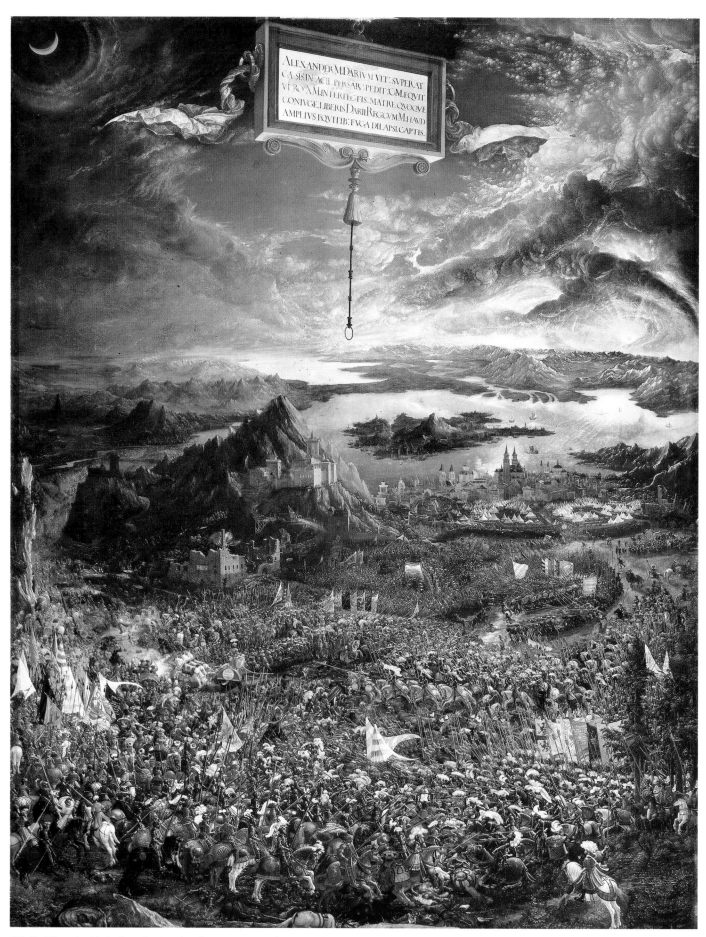

16-7 Albrecht Altdorfer. *The Battle of Issus*. 1529. Oil on panel, 62 × 47" (157.5 × 119.5 cm). Alte Pinakothek, Munich

painted at least one landscape with no figures at all—the first "pure" landscape we know of since antiquity.

Hans Holbein the Younger Gifted though they were, Cranach and Altdorfer both evaded the main challenge of the Renaissance so bravely faced, if not always mastered, by Dürer: the human image. Their miniature-like style set the pace for dozens of lesser masters. Perhaps the rapid decline of German art after Dürer's death was due to lack of ambition among artists and patrons alike. The career of Hans Holbein the Younger (1497–1543), the one painter of whom this is not true, confirms the general rule. The son of an important artist, he was born and raised in Augsburg, a center of international commerce in southern Germany that was particularly open to Renaissance ideas, but he left at the age of 18 with his brother to seek work in Switzerland. Thanks in large part to the help of humanist patrons, he was well established in Basel by 1520 as a decorator, portraitist, and designer of woodcuts. Holbein took Dürer as his point of departure, but almost from the beginning his religious paintings and portraits show a keen interest in the Italian Renaissance, especially the latest tendencies from Venice and Rome.

Holbein's likeness of ERASMUS of Rotterdam (fig. 16-8), painted soon after the famous author had settled in Basel, gives us a truly memorable image, at once intimate and monumental. This kind of profile view had been popular during the Early Renaissance and was adopted by Dürer late in his career. Here it is combined with a characteristically Northern emphasis on tangible reality to convey the sitter's personality in a way that is nonetheless in keeping with High Renaissance concepts. The very ideal of the scholar, this doctor of humane letters has a calm rationality that lends him an intellectual authority formerly reserved for Doctors of the Church. The similarity is intentional. Erasmus took as his model St. Jerome, who translated the Bible into Latin (the Vulgate). In his biography of the saint, Erasmus praises him as "the best scholar, writer and expositor," who was "equally and completely at home in all literature, both sacred and profane" and "had the whole of Scripture by heart."

Holbein spent 1523–24 traveling in France, apparently with the intention of offering his services to Francis I. When he returned two years later, Basel was in the throes of the Reformation. Hoping that he would obtain commissions at the court of HENRY VIII, Holbein then went to England. He brought with him the portrait of Erasmus as a gift to the humanist Thomas More, who became his first patron in London. (Erasmus, in a letter recommending him to More, wrote: "Here [in Basel] the arts are out in the cold.") Ironically, Henry had More beheaded in 1525 for refusing to consent to the Act of Supremacy, which made the king the head of the Church of England.

Dutch writer and scholar Desiderius ERASMUS (1466?–1536) was Northern Europe's leading humanist: he applied classical studies and scholarship to Christian learning. One of his most influential works was the 1503 *Manual of a Christian Knight*, which was a plea for and a guide to living according to simple Christian ethics. Regarded now as a precursor to the Protestant Reformation, Erasmus in fact remained a Catholic at the barricades in a humanistic war against ignorance and superstition.

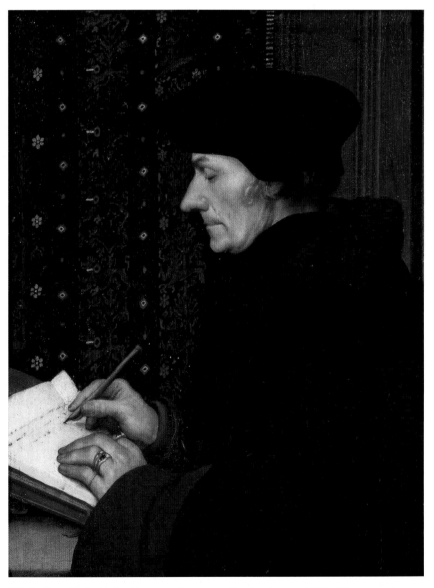

16-8 Hans Holbein the Younger. *Erasmus of Rotterdam*. c. 1523. Oil on panel, 16½ × 12½″ (41.9 × 31.8 cm). Musée du Louvre, Paris

When Holbein returned to Basel in 1528, he saw Protestant mobs destroying religious images as "idols"; reluctantly, he abandoned Catholicism. Despite the entreaties of the city council, he left for London four years later and visited Basel only once more, in 1538, while traveling on the Continent as court painter to Henry VIII. The city council made a last attempt to keep Holbein at home, but he had become an artist of international fame to whom Basel now seemed provincial indeed.

Holbein's style, too, had gained an international flavor. His portrait of Henry VIII (fig. 16-9) has the rigid frontality of Dürer's self-portrait (see fig. 16-4), but its purpose is to convey the almost divine authority of the absolute ruler. The king's physical bulk creates an overpowering sense of his ruthless,

commanding personality as his upper body completely fills the picture plane. Holbein not only painted the royal costumes and jewels, but also designed them. He may have been responsible for this ornate costume, with its lavish display of gems, many of them confiscated from the Catholic church when the king created the Church of England.

The immobile pose, the air of unapproachability, and the precisely rendered costume and jewels show the impact of court portraits that Holbein could have seen on his travels. The type originated in Mannerist portraiture between 1525 and 1550, then spread quickly to other regions as the embodiment of a new aristocratic ideal. Although portraitists in France during the reign of Francis I, such as Jean Clouet (active 1516–40/41), were largely of Flemish origin,

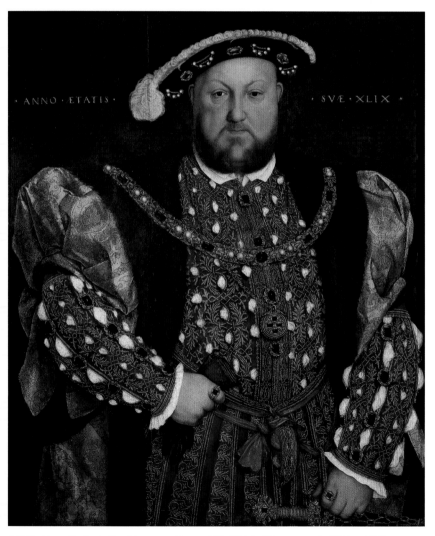

16-9 Hans Holbein the Younger. *Henry VIII*. 1540. Oil on panel, 32½ × 29" (82.6 × 73.7 cm). Palazzo Barberini, Galleria Nazionale d'Arte Antica, Rome

the French court was especially hospitable to Italian artists and influences, and imported large numbers of paintings by the leading Italian masters. (For Francis I as a patron of Italian Mannerists, see page 315.) Holbein's pictures molded British taste in aristocratic portraiture for decades, but he had no English disciples of real talent. The Elizabethan genius was more literary and musical than visual, and the English demand for portraits in the later sixteenth century continued to be filled largely by visiting foreign artists.

The Netherlands

The Netherlands in the sixteenth century had the most turbulent history of any country north of the Alps. When the Reformation began, it was part of the empire of the Hapsburgs under Charles V, who was also king of Spain. Protestantism quickly gained strength in the Netherlands, and attempts to suppress it led to revolt against foreign rule. After a bloody struggle, the northern provinces (today's Holland) emerged at the end of the century as an independent state. The southern ones (roughly corresponding to modern Belgium) remained in Spanish hands and were a Catholic stronghold.

The religious and political strife might have had catastrophic effects on the arts, but this, astonishingly, did not happen. The art of the period did not equal that of the fifteenth century in brilliance, nor did it produce any pioneers of the Northern Renaissance comparable to Dürer and Holbein. This region absorbed Italian elements more slowly than Germany, but more steadily and systematically, so that instead of a few isolated peaks we find a continuous range of achievement. Between 1550 and 1600, its most troubled time, the Netherlands produced all the major painters of Northern Europe, who in turn paved the way for the great Dutch and Flemish masters of the next century.

Still Life, Landscape, and Genre After 1550, narrative painting was increasingly replaced by secular themes: landscape, **still life**, and **genre** (scenes of everyday life). The process was gradual—it began around 1500 and was not complete until a hundred years later—and was shaped less by the genius of individual artists than by the need to cater to popular taste as Church commissions became scarcer. Protestant iconoclastic zeal was particularly widespread in the Netherlands. Under Calvin's instruction, sculpture, frescoes, and stained glass gave way to clear windows and to whitewashed walls. Still life, landscape, and genre had been part of the Flemish tradition since Campin and the Van Eycks. In the *Mérode Altarpiece* (see fig. 15-1) we recall the objects grouped on the Virgin's table and the scene of Joseph in his workshop. We may also think of the outdoor setting of the Van Eyck central scene, *The Adoration of the Lamb*, the *Ghent Altarpiece* (see fig. 15-2). But these elements were subordinate to the devotional purpose of the whole and were often governed by the principle of disguised symbolism. Now they gained a new independence and grew in importance, until the religious subject could even be relegated to the background.

Joachim Patinir We see the beginnings of this approach in the paintings of Joachim Patinir (c. 1485–1524). *Landscape with St. Jerome Removing the Thorn from the Lion's Paw* (fig. 16-10) shows that he is the heir of

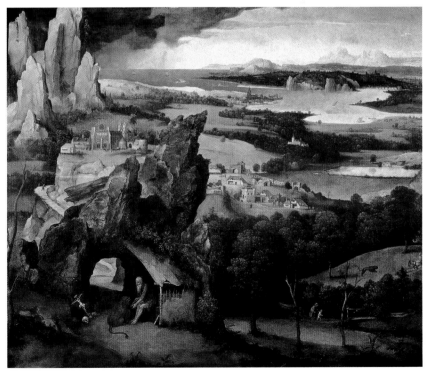

16-10 Joachim Patinir. *Landscape with St. Jerome Removing the Thorn from the Lion's Paw.* c. 1520. Oil on panel, 29⅛ × 35⅞" (74 × 91 cm). Museo del Prado, Madrid

Bosch in both his treatment of nature and his choice of subject, but without the strange demonic overtones of *The Garden of Delights* (see fig. 15-9). Although the landscape dominates the scene, the figures are central to both its composition and subject. The landscape has been constructed around the hermit in his cave, which could exist happily in another setting, whereas the picture would be incomplete without it.

The painting is an allegory of the pilgrimage of life. It contrasts the way of the world with the road to salvation through ascetic withdrawal. (Note the two pilgrims wending their way up the hill to the right, past the lion hunt, which they do not notice.) The church on the mountain represents the Heavenly Jerusalem, which can be reached only by passing through the hermit's cave (compare fig. 12-24). Like Bosch, Patinir is ambivalent toward his subject. The vista in the background, with its well-kept fields and its tidy villages, is enchanting in its own right. Yet, he seems to tell us, these temptations should not distract us from the path of righteousness.

Pieter Aertsen Pieter Aertsen (1508/9–1575) is remembered today mainly as a pioneer of still lifes, which were also painted by his nephew, Joachim Beuckelaer (c. 1534–1573/4). However, Aertsen, whose early works are sometimes reminiscent of Patinir's, seems to have first done such pieces as a sideline, until he saw many of his altarpieces destroyed by iconoclasts (see Cultural Context: The Reformation, page 339).

The Meat Stall (fig. 16-11), done a few years before he moved from Antwerp to Amsterdam, seems at first glance to be a purely secular picture. The tiny, distant figures are almost blotted out by the food in the foreground. There seems little interest in selection or formal arrangement. The artist, who lived near the city's meat market, extols its virtues. The objects of carnivorous delight, piled in heaps or strung from poles, are meant to overwhelm us with their sensuous reality.

The still life so dominates the picture that it seems independent of the religious subject in the background. Yet the latter is not merely a pretext for the painting; it must be important to the scene's meaning. In the distance to the left we see the Virgin on the Flight into Egypt giving bread to the poor, who are ignored by the worshipers lined up for church. To the right is a tavern scene with the Prodigal Son, who will later repent his sins and return to his forgiving father. The stall has a variety of Christian symbols, many of them disguised, some of them obvious, such as the two pairs of crossed fish, which signify the Crucifixion.

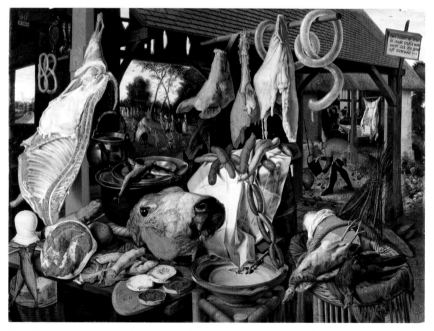

16-11 Pieter Aertsen. *The Meat Stall*. 1551. Oil on panel, 48⅜ × 65¾" (122.9 × 167 cm). Uppsala University, Sweden, University Art Collections

This "inverted" perspective was a favorite device of Aertsen's younger contemporary Pieter Bruegel the Elder and typical of Northern Mannerists, who treated it with ironic purpose in their landscapes. Aertsen belonged to the same tradition. It was an outgrowth of Northern humanist literature, whose greatest representative was Erasmus of Rotterdam (see fig. 16-8). *The Meat Stall* is, then, a moralizing sermon on gluttony, charity, and faith, possibly relating to Lent, the time of fasting before Easter when meat and fish were traditionally forbidden. Not until around 1600 was this vision displaced as part of a larger change in worldview. Only then did it no longer prove necessary to include religious or historical scenes in still lifes and landscapes.

Bruegel the Elder Pieter Bruegel the Elder (1525/30–1569), the only genius among these Netherlandish painters, explored landscape, peasant life, and MORAL ALLEGORY. Although his career was spent in Antwerp and Brussels, he may have been born near Hertogenbosch, the home of Hieronymus Bosch. Certainly Bosch's paintings impressed him deeply, and in many ways his work is just as puzzling. What were his religious convictions, his political sympathies? We know little about him, but his interest in folk customs and the daily life of humble people seems to have sprung from a complex philosophical outlook. Bruegel was highly educated, the friend of humanists, who, with wealthy merchants, were his main clients, although he was also patronized by the Hapsburg court. He apparently never worked for the Church, and when he dealt with religious subjects he did so in a strangely ambiguous way.

Bruegel's attitude toward Italian art is also hard to define. A trip to the South in 1552–53 took him to Rome, Naples, and the Strait of Messina, but the famous monuments admired by other Northerners seem not to have interested him. He returned instead with a sheaf of magnificent landscape drawings, especially Alpine views. He was probably much impressed by landscape painting in Venice, above all its integration of figures and scenery and the progression in space from foreground to background (see figs. 13-19 and 13-20).

Out of this experience came the sweeping landscapes of Bruegel's mature style. *The Return of the Hunters* (fig. 16-12) is one of a

Allegory is used to convey symbolic meaning in literary and artistic mediums. Religious allegory uses extended metaphor, parable (a biblical metaphor, usually in narrative form in the New Testament), or fable to teach a lesson. Thus, MORAL ALLEGORY delivers a moral lesson in disguised form. Bruegel's work often makes use of this device.

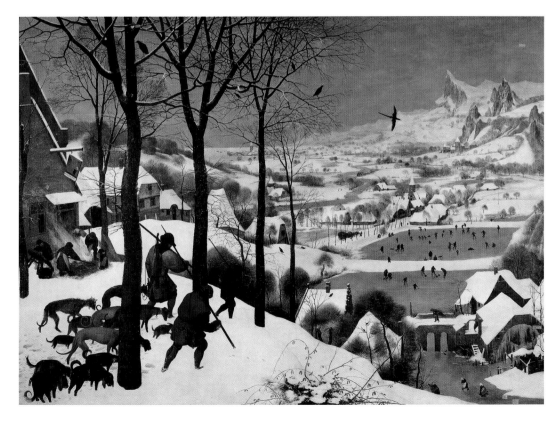

16-12 Pieter Bruegel the Elder. *The Return of the Hunters*. 1565. Oil on panel, 46½ × 63¾″ (118.1 × 161.9 cm). Kunsthistorisches Museum, Vienna

set depicting the months. (He typically composed in series.) Such scenes, we recall, had begun with medieval calendar illustrations, and Bruegel's still shows its descent from *Les Très Riches Heures du Duc de Berry* (see fig. 11-38). Now, however, nature is more than a setting for human activities. It is the main subject of the picture. The seasonal tasks of men and women are incidental to the majestic annual cycle of death and rebirth that is the rhythm of the cosmos.

Peasant Wedding (fig. 16-13) is Bruegel's most memorable scene of peasant life and festivity. One can hardly imagine Jan van Eyck's *Arnolfini Betrothal* (see fig. 15-5) culminating with a wedding in a setting such as this, amidst this crowd and with its main course of the feast, a modest gruel. The guests are stolid, crude folk, heavy-bodied and slow, yet their very clumsiness gives them a strange gravity that commands our respect. Painted in flat colors with little modeling and no cast shadows, the figures nonetheless have a weight and solidity that remind us of Giotto. Their plain clothes of solid colors contrast starkly with the brocades, patterns, and pearls we have seen in painting of the court. Space is created in

assured perspective, and the composition is as monumental and balanced as that of any Italian master. Why, we wonder, did Bruegel endow this commonplace ceremony with the solemnity of a biblical event? It is because he saw in the life of these rural people the natural condition of humanity. We know from his biographer, Karel van Mander, that Bruegel and his patron Hans Franckert often disguised themselves as peasants and joined in their revelries, so that Bruegel could draw them from life. Van Mander wrote that Bruegel represented peasants "naturally, as they really were, betraying their boorishness in the way they walked, danced, stood still, or moved." In Bruegel's hands, they become types whose follies he knew at first hand, yet whose dignity ultimately remains intact. For him, Everyman occupies an important place in the scheme of things.

France

France conquered Milan, militarily, in 1499, and chose to acquire her fame, artistically, when King Francis I invited Leonardo to Fontainebleau before luring several of the

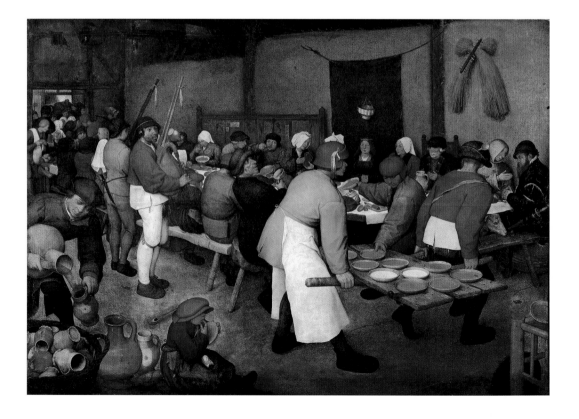

16-13 Pieter Bruegel the Elder. *Peasant Wedding*. c. 1565. Oil on panel, 44⅞ × 64⅛" (114 × 162.9 cm). Kunsthistorisches Museum, Vienna

leading Mannerists—including Rosso Fiorentino (see pages 304-06) and, as we shall see, Francesco Primaticcio and Benvenuto Cellini—to France. As a result, France began to assimilate Italian art and architecture somewhat earlier than the other countries and was the first to achieve an integrated Renaissance style.

Francesco Primaticcio Francesco Primaticcio (1504–1570) arrived at Fontainebleau in early 1532 after working under Raphael's chief assistant, Giulio Romano, in Mantua (see fig. 14-13) Almost nothing survives of the rooms he decorated for the king and queen before 1540, when he was sent by

Francis I to Rome to acquire works of art. Upon his return a year later, he replaced Rosso Fiorentino, who had died in the meantime, as the chief designer at Fontainebleau. His style now shows the influence of Parmigianino, which is clearly seen in his most important surviving work, the decorations for the Room of the Duchesse d'Éstampes (fig. 16-14). Primaticcio follows Rosso's general scheme of embedding paintings in a luxuriously sculptured stucco framework, which nearly swallows them, but the figures are subtly elongated and show an ease that contrasts sharply with Rosso's often tense poses and complex compositions (compare fig. 14-1).

16-14 Francesco Primaticcio. *Stucco Figures*. c. 1541–45. Room of the Duchesse d'Éstampes, Château of Fontainebleau, France.

Benvenuto Cellini's AUTOBIOGRAPHY, written between 1558 and 1567, is a valuable (if somewhat exaggerated) account of social, political, and ecclesiastical life, especially in sixteenth-century Florence, where Cellini lived from 1545 onward. It was first translated into English in 1960.

Counterpart to the English fortified castle, the French CHÂTEAU (plural, châteaux) was a securely fortified residence and stronghold for French nobility and large landholders in the late Middle Ages and Renaissance. In the sixteenth century, châteaux were less heavily fortified—a moat was usually enough—and were outfitted with gardens and decorative secondary structures.

The entire room is devoted to Alexander the Great. The scene in figure 16-14 shows Apelles painting the abduction of Campaspe by Alexander, who gave his favorite concubine to the artist when he fell in love with her. Such a heady mixture of violence and eroticism appealed greatly to the Mannerists. Yet the story was interpreted as a gesture of uncommon respect and nobility by the Roman historian Pliny, which justified the subject. The image also draws a parallel between Alexander and Francis I and between Campaspe and the Duchesse, the king's mistress, who had taken Primaticcio under her wing. Although the treatment of the border in the etching differs considerably from the original stucco, prints after Primaticcio's elegant designs spread throughout Europe, so that they were often imitated.

Benvenuto Cellini Primaticcio's only rival at the court of Francis I in 1540–45 was Benvenuto Cellini (1500–1571), a Florentine goldsmith and sculptor who owes much of his fame to his colorful AUTOBIOGRAPHY. The gold saltcellar (fig. 16-15) Cellini made for the king of France while working at Fontainebleau is his only important work in precious metal that has survived; alas, it was stolen from the Vienna museum in 2003. The piece displays the virtues and limitations of his art. The main function of this lavish object is clearly as a conversation piece. Because salt comes from the sea and pepper from the land, the boat-shaped salt container is protected by Neptune. The pepper, in a tiny triumphal arch, is watched over by a personification of Earth. On the base are figures representing the four seasons and the four parts of the day.

The saltcellar reflects the cosmic significance of the Medici tombs (compare fig. 13-13). But on this miniature scale Cellini's program turns into playful fancy. Cellini wants to impress us with his ingenuity and skill. Earth, he wrote, is "fashioned like a woman with all the beauty of form, the grace and charm, of which my art was capable." The allegorical significance of the design is simply a pretext for this display of virtuosity.

Pierre Lescot In 1546 Francis I decided to replace the Gothic royal castle, the Louvre (see fig. 11-38), with a new palace on the old site. The project had barely begun at the time of his death, but his architect, Pierre Lescot (c. 1515–1578), continued it under Henry II and quadrupled the size of the court. This enlarged scheme was not completed for more than a century. Lescot built only the southern half of the court's west side (fig. 16-16), which represents its "classic" phase. The term is well justified. Whereas earlier buildings were derived from the Early Renaissance, Lescot drew on the work of Bramante and his successors. Lescot's design is classic in another sense. It is the finest surviving example of Northern Renaissance architecture.

The details of Lescot's facade do indeed have a surprising classical purity, yet we would not think it an Italian building. Its distinctive quality comes not from a superficial use of Renaissance forms but from a genuine synthesis of the traditional French CHÂTEAU with the Italian palazzo. The superimposed classical orders, the pedi-

16-15 Benvenuto Cellini. *Saltcellar of Francis I.* c. 1543. Gold with enamel, 10¼ × 13⅛" (26 × 33.3 cm). Kunsthistorisches Museum, Vienna

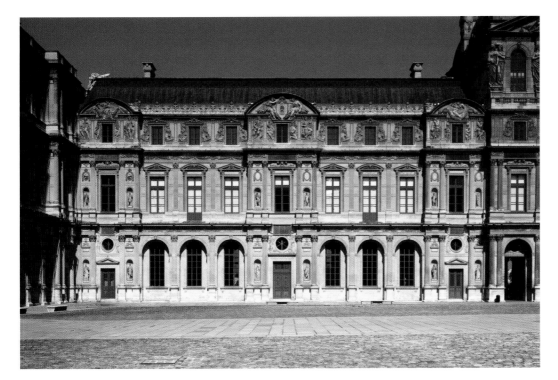

mented window frames, and the arcade on the ground floor are Italian. But the continuity of the facade is broken by three projecting pavilions that have taken the place of the château turrets. The high-pitched roof is also French. The vertical accents thus overcome the horizontal ones. (Note the broken architraves.) This effect is heightened by the tall, narrow windows, which descend from the Gothic. The solution devised by Lescot proved to be so satisfying that the need for a purer classicism was not felt until the completion of the Louvre 120 years later under Louis XIV (see fig. 19-5).

CHAPTER 17

The Baroque in Italy and Spain

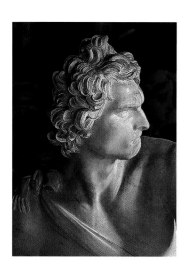

WHAT IS BAROQUE? LIKE MANNERISM, THE TERM WAS originally coined to disparage the style it designates. It meant "irregular, contorted, grotesque." Even today, art historians disagree over its meaning and whether the Baroque forms a distinct period between the Renaissance and the modern era. Most agree, though, that for the Catholic Church, Baroque art was a form of visual persuasion. Paintings, sculpture, and architecture carried the Church's message to the faithful. Such works might also persuade those who had been influenced by the Reformation, and had converted to Protestantism, to return to the fold (see Cultural Context: The Counter-Reformation, page 358).

The Baroque was a time of contradictions and paradoxes. Painting and sculpture of the period can be beautiful, sensuous, and stirring, and its architecture, enveloping and awe-inspiring. At the same time, there was an interest in secular tastes and everyday life. Still lifes and genre scenes often carried a moral message, but they also depicted the pleasure and sensuality found in the small things of life. In such works we can glimpse ordinary people in their relationships with each other, with their children, and with shopkeepers and tradespeople. We also see artists with names (as opposed to the anonymity of the medieval world) struggling with issues of status and wealth. During this period, too, curiosity about foreign cultures grew. Explorations in the Americas brought knowledge about people, plants, and animals never seen in Europe. The pious made pilgrimages to distant lands, and the travels of the simply curious made for an exuberant internationalism. These similarities to our own time explain why this time period, together with the Renaissance, is now more commonly referred to as the "Early Modern" period.

The new style was not specifically Italian, even though it was born in Rome during the final years of the sixteenth century. Nor was it confined to religious art. Baroque elements quickly entered the Protestant North, where they were applied primarily to secular subjects. In fact, the seventeenth century has been called the Golden Age of painting in France, Holland, Flanders, and Spain, despite the fact that each of these countries was at war.

This conflict, the Thirty Years' War (1618–48), was fueled by the ambitions of the kings of France, who sought to dominate Europe, and by those of the Hapsburgs, who ruled not only Austria and Spain but also the Netherlands, Bohemia, and Hungary. Although fought largely in Germany, the war eventually engulfed nearly all of Europe. After the Treaty of Westphalia ended the war and formally granted their freedom, the United Provinces—as the independent Netherlands was known—entered into a series of battles with England and France that lasted until 1679.

In addition to understanding the important connections between art and religion and art and politics, the Baroque era also demands that we acknowledge the essential relationship between the art and science of the period. The complex metaphysics of the humanists, which gave everything religious meaning, was replaced by a new physics. The

354 PART THREE The Renaissance through the Rococo: The Early Modern World

change began with Nicholas Copernicus, Johannes Kepler, and Galileo Galilei, and culminated in Descartes and Isaac Newton. Their cosmology broke the ties between sensory perception and science. By placing the sun, not the earth (and humanity), at the center of the universe, it contradicted what our eyes (and common sense) tell us: that the sun revolves around the earth. Scientists now defined underlying relationships in mathematical and geometrical terms as part of the simple, orderly system of mechanics. Not only was the seventeenth century's worldview fundamentally different from what had preceded it, but its understanding of visual reality was forever changed by the new science, thanks to the invention of the microscope and the telescope. Thus we may say that the Baroque literally saw with new eyes.

In the end, Baroque art was influenced by (rather than being the result of) religious, political, and intellectual developments. Let us therefore think of it as one among other basic features that distinguish the period: the strengthened Catholic faith, the absolutist state, and the new science. These factors are combined in volatile mixtures that give the Baroque its fascinating variety. Such diversity was well suited to express the expanding view of life. What ultimately unites this complex era is a reevaluation of humanity and its relation to the universe. Central to this image is the new psychology of the Baroque. Philosophers gave greater prominence to human passion, which encompassed a wider range of emotions and social levels than ever before. The scientific revolution leading up to Newton's unified mechanics responded to the same view, which presumes a more active role for people's ability to understand and affect the world around them. Remarkably, the Baroque remained an age of great religious faith, however divided it may have been in its loyalties. The interplay of passion, intellect, and spirituality may be seen as forming a dialogue that has never been truly resolved.

Painting in Italy

Around 1600 Rome became the fountainhead of the Baroque, as it had of the High Renaissance a century before, by attracting artists from other regions, especially northern Italy, the birthplace of the Counter-Reformation. The papacy patronized art on a large scale, with the aim of making Rome the most beautiful city of the Christian world "for the greater glory of God and the Church" (see Cultural Context: The Counter-Reformation, page 358). This campaign had begun as early as 1585, but the artists then on hand were Late Mannerists with little talent. Nevertheless, it soon attracted ambitious young artists, especially from northern Italy. It was they who created the new style.

Caravaggio Foremost among them was a painter of genius, Michelangelo Merisi (1571–1610), called Caravaggio after his birthplace near Milan. His first important religious commission was for a series of three monumental canvases devoted to St. Matthew that he painted for the Contarelli chapel in S. Luigi dei Francesi from about 1599 to 1602. As decorations they perform the same function that fresco cycles had in the Renaissance. The main image, *The Calling of St. Matthew* (fig. 17-1), is remote from both Mannerism and the High Renaissance. Its only ancestor is the "North Italian realism" of artists such as Savoldo (see fig. 14-5), and it embodies much the same Counter-Reformation mentality. But Caravaggio's realism is of a new and radical kind. According to contemporary accounts, Caravaggio painted directly on the canvas, as had Titian, but he worked from the live model. He depicted the world he knew, so that his canvases are filled with ordinary people. Indeed, his pictures are surprisingly autobiographical at times.

Never have we seen a sacred subject depicted so entirely in terms of contemporary lowlife. Matthew, the tax gatherer, sits with some armed men (who must be his agents) in a common Roman tavern as two figures approach from the right. (The setting and costumes must have been very familiar to Caravaggio. He moved in a circle of young toughs in a working-class neighborhood and carried a sword himself. Highly argumentative, he was often in trouble and even killed a friend in a duel over a ball game, so that he fled to Naples and eventually Malta.) The arrivals are poor people whose bare feet and simple garments contrast strongly with the colorful costumes of Matthew and his companions.

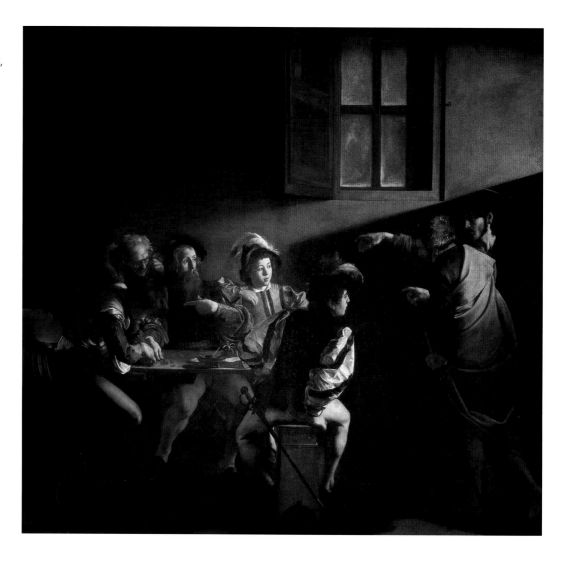

17-1 Caravaggio. *The Calling of St. Matthew.* c. 1599–1602. Oil on canvas, 11'1" × 11'5" (3.38 × 3.48 m). Contarelli Chapel, S. Luigi dei Francesi, Rome

For Caravaggio, however, naturalism is not an end in itself but a means of conveying profoundly religious content. Why do we sense a religious quality in this scene and not mistake it for an everyday event? The answer is that Caravaggio's North Italian realism is wedded to elements derived from his study of Renaissance art in Rome, which gives the scene its surprising dignity. His style, in other words, is classical, without being classicizing. The composition, for example, is spread across the picture surface, and its forms are sharply highlighted, much as in a relief (see fig. 7-17). What identifies one of the figures as Christ? It is surely not his halo, the only supernatural feature in the picture, which is an inconspicuous gold band that we might well overlook. Our eyes fasten instead upon his commanding gesture, borrowed from Michelangelo's *Creation of Adam* (see fig. 13-10), which "bridges" the gap between the two groups and is echoed by Matthew, who points questioningly at himself.

Most decisive is the beam of sunlight above Jesus. It illuminates his face and hand in the gloomy interior, thus carrying his call across to Matthew. This strong beam of light in the dark background is known as a **tenebristic** effect, or **tenebrism**. Without this light, so natural yet so charged with meaning, the picture would lose its power to make us aware of the divine presence. Caravaggio gives direct form to an attitude shared by certain saints of the Counter-Reformation: that the mysteries of faith are revealed not by speculation but through an inward experience that is open to all people. What separates the Baroque from the later Counter-Reformation is the externalization of the mystic vision, which appears to us complete, without any signs of the spiritual struggle that characterizes El Greco's art (see pages 313-15).

Caravaggio's paintings have a "lay Christianity" that spoke powerfully to all. Stripped of its religious context, the men seated at the table would seem like figures in a genre scene.

Indeed, Caravaggio's painting would be a source for similar secular scenes. Likewise, fanciful costumes, with slashed sleeves and feathered berets, will appear in the works of Caravaggio's followers. Figures seen in half-length (that is, the upper half, behind the table) will also be a common element in other works by Caravaggio and his followers.

Caravaggio's realism can also be seen in his disturbing *David with the Head of Goliath* (fig. 17-2). The youthful David is seen as if emerging from darkness, lit by a strong tenebristic light. His left arm is extended as far away from him as possible, foreshortened into our space holding the hair of the grotesque, open-mouthed and open-eyed, head of Goliath. David looks at the head somewhat mournfully, even regretfully. Contemporary sources indicate that the grotesque head is a self-portrait of Caravaggio. Shown as the villain rather than the hero in this biblical story, it turns our expectations of artist's identity upside down.

We see Caravaggio in other examples of self-portraits, but in these cases as a young man in sensual and erotic circumstances, seducing and soliciting, as in *The Musicians* with four androgynous, seminude youths (fig. 17-3). The musicians are half-length, but life-size; their blushed cheeks and full mouths suggest erotic, sensual pleasures, with each other and in offering themselves to the viewer. That viewer (the patron) was probably the Cardinal del Monte, who commissioned other paintings of similar subjects.

The lute, the violin, and music sheets surrounding these half-draped men, and even the grapes being plucked on the side, suggest a contemporary, homoerotic bacchanal. The subject may be disturbing or unsettling, but this is part of the sensuality and passion–both physical and erotic–that is part of the Baroque. In Italy, Caravaggio's work was praised by artists and connoisseurs, but the ordinary people for whom it was intended resented meeting their own kind in these paintings. Conservative critics, moreover, regarded Caravaggio as lacking decorum—the propriety and reverence demanded of religious subjects. For these reasons, Caravaggism largely ran its course by 1630, when it was absorbed into other Baroque tendencies.

Artemisia Gentileschi Most artists had fathers who were also artists. And this was

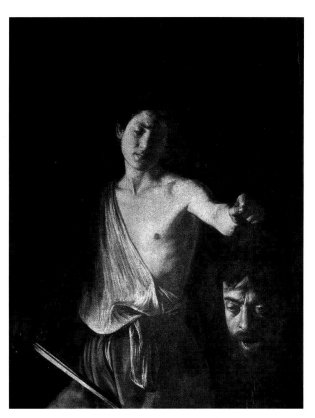

17-2 Caravaggio. *David with the Head of Goliath.* 1607 or 1609/10. Oil on canvas, 49¼ × 39⅜" (125.1 × 100 cm). Galleria Borghese, Rome

17-3 Caravaggio. *The Musicians.* c. 1595. Oil on canvas, 36¼ × 46⅝" (92.1 × 118.4 cm). The Metropolitan Museum of Art, New York
Rogers Fund, 1952

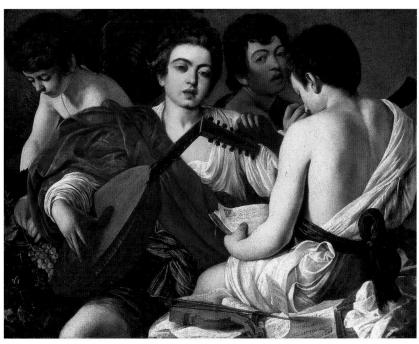

THE COUNTER-REFORMATION, ALSO KNOWN AS CATHOLIC REFORM, WAS A MOVEMENT that began in the mid sixteenth century and was created specifically to counter the attacks of the Protestant Reformation and to allow the Church of Rome to both reform and reaffirm itself.

These reforms were officially executed through the Council of Trent, which convened between 1545 and 1563 and clarified every aspect of liturgy and doctrine (including the role of art) contested by the Protestant Church. The Council affirmed the role of Mary, the nature of the Eucharist, and other hotly contested points of divergence. It renewed the devotion to martyrs and developed the concept of the guardian angel. (Accordingly, loin-cloths were painted on nude figures of Michelangelo's Last Judgment, fig. 13-9).

The Jesuit Order, founded by Ignatius Loyola and recognized by the Church in 1540, had the particular mission of defending and supporting the pope. The Church sought to gain Catholics abroad, having lost so many in Europe to the Protestant Church. Through their missionary work in the East and in the Americas (aimed at converting native peoples to Catholicism), the Jesuits were central to the Reform. Although the Council and the founding of the Jesuits date to the sixteenth century, their impact was greatest in the seventeenth century. In 1622, both Loyola and Francis Xavier (also one of the first Jesuits, he was instrumental in carrying Christianity to India and Japan) became saints. In that same year, the mystic Teresa of Avila (fig. 17-16) and Filippo Neri also achieved sainthood. Charles Borromeo, who was instrumental in the Council of Trent, had already become a saint. With these new seventeenth-century saints, who were nearly contemporary figures, new imagery, ideas, and a revitalization of the Church were possible. Art, with these exemplary figures as its subject (see fig. 17-16), abounded and was used to spread the teachings of the saints and the Church. The worldly and spiritual splendor of the Church flourished by means of extensive building programs and elaborate commissions to furnish the churches (see fig. 17-9).

true for most of the few women artists of the seventeenth century as well. Artemisia Gentileschi (1593–c. 1653) was born in Rome, the daughter of Caravaggio's follower Orazio Gentileschi, and became one of the leading painters of her day. She took great pride in her work but found the way difficult for a woman artist. In a letter of 1649, she wrote that "people have cheated me" and tells that she had submitted a drawing to a patron only to have him commission "another painter to do the painting using my work. If I were a man, I can't imagine it would have turned out so. . . ." Her characteristic subjects are heroines: Bathsheba, the tragic object of King David's passion, and Judith, who saved her people by beheading the Assyrian general Holofernes (see also Cranach, fig. 16-6). Both themes were popular during the Baroque era, which delighted in erotic and violent scenes. Gentileschi's frequent depictions of these biblical heroines (she often showed herself in the lead role) suggest an ambivalence toward men that was rooted in her turbulent life. (Gentileschi was raped by her teacher, who was acquitted in a jury trial.)

While Gentileschi's early paintings of Judith take her father's and Caravaggio's work as their points of departure, our example (fig. 17-4) is a fully mature, independent large work. The inner drama is hers alone, and it is no less powerful for its restraint. Rather than the beheading itself, the artist shows the instant after. Momentarily distracted, Judith gestures theatrically as her servant stuffs Holofernes's head into a sack. The object of their attention remains hidden from view, heightening the air of suspense and intrigue. The hushed, candlelit atmosphere creates a mood of

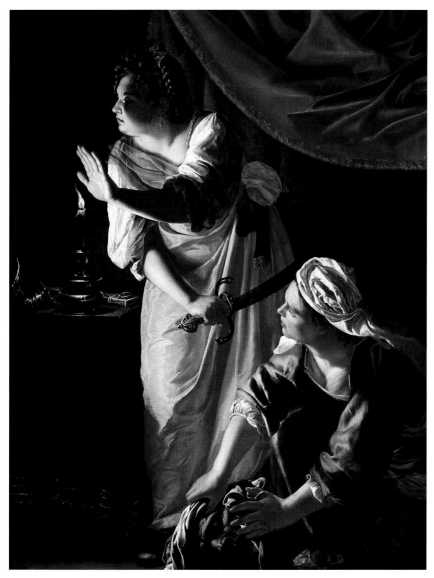

17-4 Artemisia Gentileschi. *Judith and Her Maidservant with the Head of Holofernes.* c. 1625. Oil on canvas, 72½ × 55¾" (184.2 × 141.6 cm). The Detroit Institute of Arts

Gift of Leslie H. Green

mystery that conveys Judith's complex emotions with unsurpassed understanding. Gentileschi's rich palette was to have a strong influence on painting in Naples, where she settled in 1631.

Annibale Carracci The conservative wishes of everyday people in Italy were met by artists who were less radical, and less talented, than Caravaggio. They took their lead instead from Annibale Carracci (1560–1609), who also had recently arrived in Rome. Annibale came from Bologna, where in the 1580s he and two other members of his family had evolved an anti-

Mannerist style based on North Italian realism and Venetian art. He was a reformer rather than a revolutionary. As with Caravaggio, who admired him, his experience of Roman classicism transformed his art. He, too, felt that art must return to nature, but his approach emphasized a revival of the classics, which to him meant the art of antiquity. Annibale also sought to emulate Raphael, Michelangelo, Titian, and Correggio. At his best, he was able to fuse these diverse elements, although their union always remained somewhat unstable.

Between 1597 and 1604 Annibale produced a vast ceiling fresco in the GALLERY

■ A GALLERY is a long, rectangular space that usually functions as a passageway or corridor. From the Renaissance onward, galleries in palaces, public buildings, and stately houses would be heavily decorated, frequently with paintings and works of sculpture. From this practice, the word *gallery* came to mean an independent space devoted to the exhibition of works of art. In churches, a gallery is a low story above the nave, often arcaded.

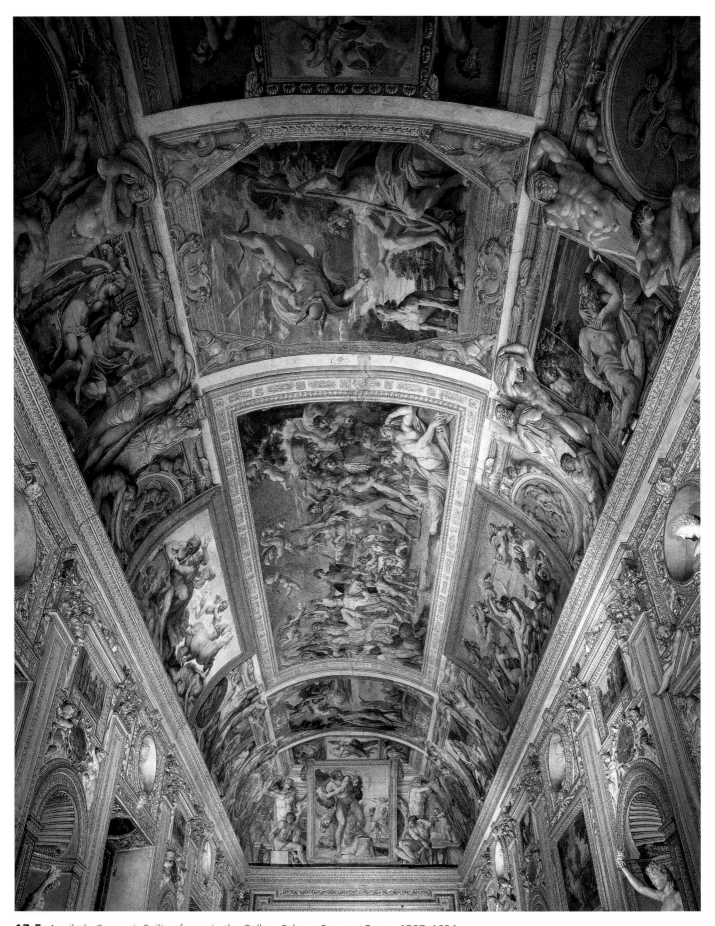

17-5 Annibale Carracci. Ceiling fresco in the Gallery, Palazzo Farnese, Rome. 1597–1604

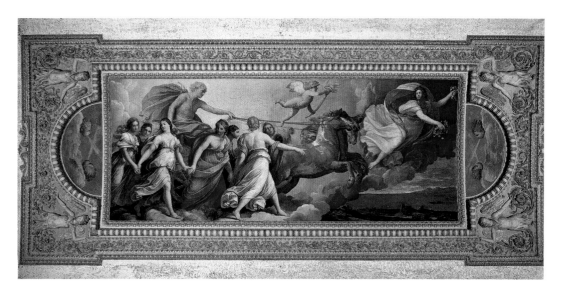

of the Farnese Palace (fig. 17-5), his most ambitious work, which soon became so famous that it ranked behind only the murals of Michelangelo and Raphael. Commissioned to celebrate a wedding in the Farnese family, it wears its humanist subject, the Loves of the Classical Gods, lightly. The narrative scenes, like those of the Sistine ceiling, are surrounded by painted architecture, simulated sculpture, and nude youths. But the fresco does not rely solely on Michelangelo's masterpiece. The style of the main panels recalls Raphael's *Galatea* (see fig. 13-17), with a strong debt to Titian (compare the *Bacchanal*, fig. 13-20). The whole is held together by an illusionistic scheme that reflects Annibale's knowledge of Correggio (see fig. 14-6) and Veronese. Carefully foreshortened and lit from below (as we can judge from the shadows), the nude youths and the simulated sculpture and architecture appear real. Against this background the mythologies are presented as simulated easel pictures, a solution adopted from Raphael. Each of these levels of reality is handled with consummate skill, and the entire ceiling has an exuberance that sets it apart from both Mannerism and High Renaissance art.

Guido Reni and Guercino To artists who were inspired by it, the Farnese Gallery seemed to offer two alternatives. Using the Raphaelesque style of the mythological panels, they could arrive at a deliberate, "official" classicism, or they could take their cue from the illusionism of the framework. The approach varied according to personal style and the specific site. Among the earliest

examples of the first alternative is the ceiling fresco *Aurora* (fig. 17-6) by Guido Reni (1575–1642), which shows Apollo in his chariot (the Sun) led by Aurora (Dawn). Here grace becomes the pursuit of perfect beauty. The relieflike design would seem little more than a pallid reflection of High Renaissance art were it not for the glowing color and dramatic light, which give it an emotional force that the figures alone could never achieve. This style is called Baroque classicism to distinguish it from all earlier forms of classicism, no matter how much it may be indebted to them.

The *Aurora* ceiling (fig. 17-7) painted less than ten years later by Guercino

17-7 Guercino. *Aurora.* 1621–23. Ceiling fresco in the Villa Ludovisi, Rome

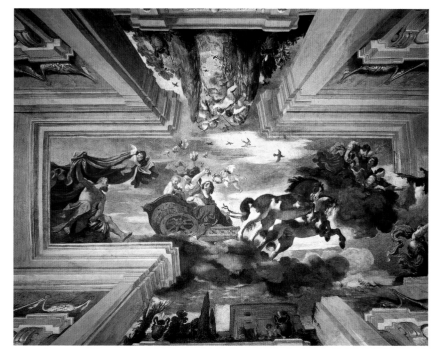

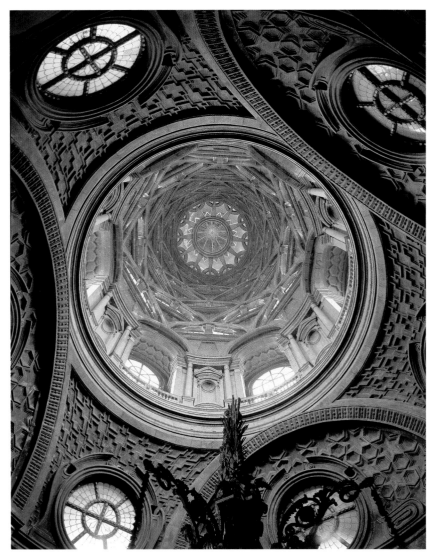

17-14 Guarino Guarini. Dome of the Chapel of the Holy Shroud, Turin Cathedral. 1668–94

Assumption of the Virgin (fig. 14-6). A concentric structure of alternating rings of light and shadow enhances the illusion of great depth and features brilliant light at its center. However, the objective harmony of the Renaissance has become subjective, a compelling experience of the infinite. If Borromini's style at times suggests a fusion of Gothic and Renaissance, Guarini takes the next step. In his writings, he contrasts the "muscular" architecture of the ancients with the effect of Gothic churches, which appear to stand only by means of some kind of miracle, and he expresses equal admiration for both. This attitude corresponds exactly to his own practice. Guarini and Borromini were obsessed with originality and were willing to break architectural rules to achieve it. By using the most advanced mathematical techniques of his day, Guarini achieved wonders even greater than those of the seemingly weightless Gothic structures. He thus helped to pave the way for Soufflot and the rationalist movement in the next century.

Sculpture in Italy

Gianlorenzo Bernini We have already encountered Gianlorenzo Bernini as an architect. It is now time to consider him as a sculptor, although the two aspects are never far apart in his work, as we have seen in the *Baldachino* (fig. 17-10). He was trained by his father, Pietro Bernini (1562–1629), a sculptor of considerable ability who worked in Florence, Naples, and Rome. Thus his work was a direct outgrowth of Mannerist sculpture in many ways, but this does not explain his revolutionary qualities.

As in the colonnade for St. Peter's (see fig. 17-9), we can often see a strong relationship between Bernini's sculpture and that of antiquity. If we compare Bernini's *David* (fig. 17-15) with Michelangelo's (see fig. 13-7) and ask which is closer to the Pergamon frieze (see fig. 5-27), our vote must go to Bernini. His figure shares with Hellenistic works that unison of body and spirit, of motion and emotion, which Michelangelo so consciously avoids. This does not mean that Michelangelo is more classical than Bernini. It shows, rather, that

the dome of the Chapel of the Holy Shroud (fig. 17-14), a round structure attached to Turin Cathedral, consists of familiar Borrominian motifs, yet it ushers us into a realm of pure illusion completely unlike anything by the earlier architect. Here the surface has disappeared in a maze of ribs, inspired by Moorish architecture, which Guarini had studied while working in Messina, Sicily, during 1660–62. As a result, we find ourselves staring into a huge kaleidoscope. Above this seemingly infinite funnel of space hovers the dove of the Holy Spirit within a 12-pointed star.

Guarini's dome retains the symbolic meaning of the Dome of Heaven (see figs. 7-6 and 12-13). It repeats architecturally what Correggio achieved in painting in his

both the Baroque and the High Renaissance were inspired by different aspects of ancient art.

Bernini's *David* is in no sense an echo of Hellenistic art. In part, what makes it Baroque is the implied presence of Goliath. Unlike earlier statues of David, including Donatello's (see fig. 12-3), Bernini's is conceived not as a self-contained figure but as half of a pair, his entire action focused on his adversary. Did Bernini, we wonder, plan a statue of Goliath to complete the group? He never did, nor did he need to. His David tells us clearly enough where he sees the enemy. Consequently, the space between David and his invisible opponent is charged with energy—it "belongs" to the statue.

The *David* shows us just what distinguishes Baroque sculpture from that of the two preceding centuries: its new, active relationship with the surrounding space. It rejects self-sufficiency in favor of the illusion of a presence or force implied by the action of the statue. Bernini presents us with "the moment" of action—not just the contemplation of it as in Michelangelo's work or after it, as in Donatello's. The Baroque often suggests a heightened vitality and energy. Because they so often present an "invisible complement" (like the Goliath of Bernini's *David*), Baroque statues attempt pictorial effects that were traditionally outside the province of sculpture. Such a charging of space with energy is, in fact, a key feature of Baroque art. Caravaggio had achieved it in his *St. Matthew* (fig. 17-1), with the aid of a sharply focused beam of light. Indeed, Baroque art does not make a clear-cut distinction between sculpture and painting. The two may even be combined with architecture to form a compound illusion, like that of the stage.

Bernini had a passionate interest in the theater and was an innovative scene designer. A contemporary wrote that Bernini "gave a public opera wherein he painted the scenes, cut the statues, invented the engines, composed the music, writ the comedy, and built the theatre." Thus he was at his best when he could merge architecture, sculpture, and painting. His masterpiece in this vein is the Cornaro Chapel in the church of Sta. Maria della Vittoria, containing the famous group called *The Ecstasy of St. Teresa*

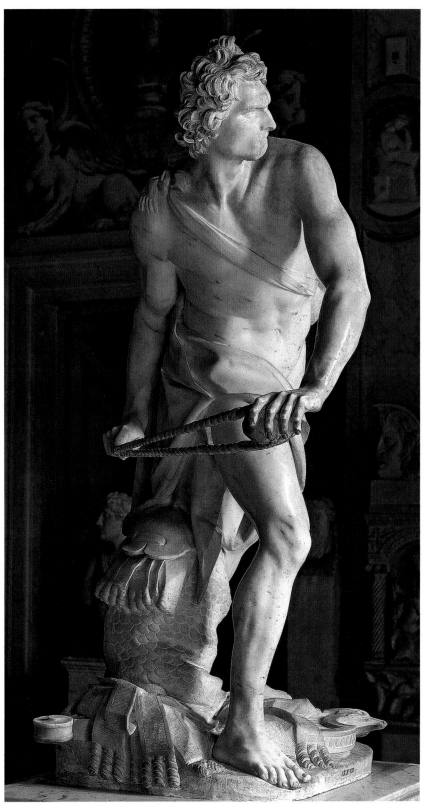

17-15 Gianlorenzo Bernini. *David*. 1623. Marble, life-size. Galleria Borghese, Rome

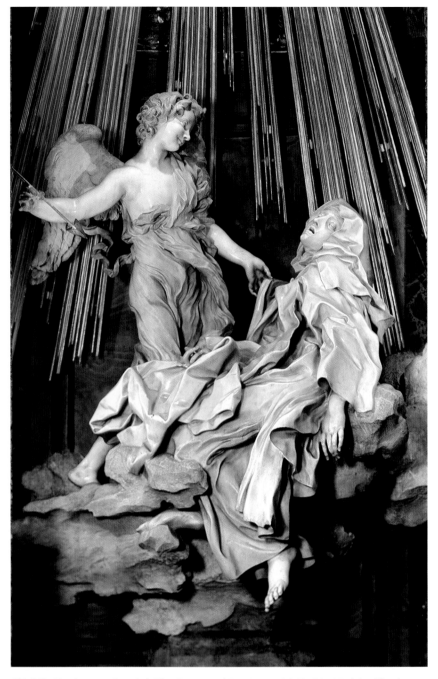

17-16 Gianlorenzo Bernini. *The Ecstasy of St. Teresa.* 1645–52. Marble, life-size.
Cornaro Chapel, Sta. Maria della Vittoria, Rome

(fig. 17-16). ST. TERESA OF AVILA, one of
the great saints of the Counter-Reformation
and only newly canonized in 1622 (see
Cultural Context: Counter-Reformation,
page 358), had described how an angel
pierced her heart with a flaming golden
arrow: "The pain was so great that I
screamed aloud; but at the same time I felt
such infinite sweetness that I wished the
pain to last forever. It was not physical but
psychic pain, although it affected the body as
well to some degree. It was the sweetest
caressing of the soul by God."

Bernini has made this visionary experi-
ence as sensuously real as Correggio's *Jupiter
and Io* (see fig. 14-7). In a different context,

the angel could be Cupid, and the saint's ecstasy is palpable. The two figures on their floating cloud are lit from a hidden window above, so that they seem almost dematerialized. The viewer thus experiences them as visionary. The "invisible complement" here, less specific than David's but equally important, is the force that carries the figures toward heaven and causes the turbulence of their drapery. Its divine nature is suggested by the golden rays, which come from a source high above the altar. In an illusionistic fresco by Guidobaldo Abbatini on the vault of the chapel, the glory of the heavens is revealed as a dazzling burst of light from which tumble clouds of jubilant angels (fig. 17-17). This celestial "explosion" gives force to the thrusts of the angel's arrow and makes the ecstasy of the saint fully believable.

To complete the illusion, Bernini even provides a built-in audience for his "stage." On the sides of the chapel are balconies resembling theater boxes that contain marble figures, depicting members of the Cornaro family, who also witness the vision. Their space and ours are the same and thus are part of everyday reality, whereas the saint's ecstasy, which is in a strongly framed niche, occupies a space that is real but beyond our reach, for it is intended as a divine realm.

It would be easy to dismiss *The Ecstasy of St. Teresa* as a theatrical display, but Bernini also was a devout Catholic who believed (as did Michelangelo) that he was inspired directly by God. Like the *SPIRITUAL EXERCISES* of Ignatius of Loyola, which Bernini practiced, his religious sculpture is intended to help the viewer identify with miraculous events through a vivid appeal to the senses. Theatricality in the service of faith was basic to the Counter-Reformation, which often referred to the Church as sacred theater and the theater of human life.

Bernini was steeped in Renaissance humanism. Central to his sculpture is the role of gesture and expression in arousing emotion. Although these devices were also important to the Renaissance (compare Leonardo), Bernini uses them with a freedom that seems anticlassical. However, he essentially followed the concept of decorum

17-17 *The Cornaro Chapel.* Eighteenth-century painting of the chapel. Staatliches Museum, Schwerin, Germany

(which also explains why his *David* is not completely nude), and he planned his effects carefully, by varying them in accordance with his subject (see page 369). Unlike the Frenchman Nicolas Poussin (whom he respected, as he did Annibale Carracci), Bernini did this for the sake of expressive impact rather than conceptual clarity. The approaches of the two artists were diametrically opposed as well. For Bernini, antique art served as no more than a point of departure for his own inventiveness, whereas for Poussin it served as a standard of comparison. It is nevertheless characteristic of the Baroque that Bernini's theories should be far more orthodox than his art. Thus he often sided with the classicists against his fellow High Baroque artists, especially Pietro da Cortona, who, like Raphael before him, made an important contribution to architecture and was a rival in that sphere.

Alessandro Algardi It is no less ironic that Cortona was the closest friend of the sculptor Alessandro Algardi (1598–1654), who is regarded as the leading classical sculptor of the Italian Baroque and the only serious rival to Bernini in ability. His main

Ignatius of Loyola (Iñigo de Oñaz y Loyola, 1491–1556) was an influential Catholic teacher, founder of the Jesuit order (see page 358), and eventually a saint and patron of spiritual retreats. His SPIRITUAL EXERCISES is a manual for contemplation of the meaning of life as well as a source of pragmatic advice on how to live a spiritual life in the service and honor of God. It is used as a model for many Roman Catholic retreats and missions.

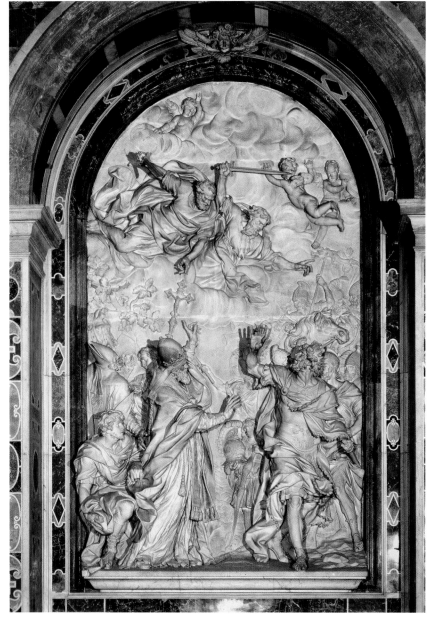

17-18 Alessandro Algardi. *The Meeting of Pope Leo I and Attila.* 1646. Marble, 28'1¾" × 16'2½" (8.58 × 4.94 m). St. Peter's, the Vatican, Rome

umphs, and the victory is spiritual rather than military.

The commission was given for a sculpture because water condensation caused by the location in an old doorway of St. Peter's made a painting impossible. Never before had an Italian sculptor attempted such a large relief—it stands more than 28 feet high. The problems posed by translating a pictorial conception (it had been treated by Raphael in one of the Vatican Stanze) into a relief on this gigantic scale were formidable. If Algardi has not succeeded in resolving every detail, his achievement is stupendous nonetheless. By varying the depth of the carving, he nearly convinces us that the scene takes place in the same space as ours. The foreground figures are in such high relief that they seem detached from the background. To accentuate the effect, the stage on which they are standing projects several feet beyond its surrounding niche. Thus Attila seems to rush out toward us in fear and astonishment as he flees the vision of the two apostles defending the faith. The result is surprisingly persuasive in both visual and expressive terms.

Such illusionism is, of course, quintessentially Baroque. So is the intense drama, which is heightened by the twisting poses and theatrical gestures of the figures. Algardi was obviously touched by Bernini's genius. Strangely enough, the relief is partly a throwback to an Assumption of the Virgin of 1606–10 in Sta. Maria Maggiore by Bernini's father, Pietro. Only in his observance of the three traditional levels of relief carving (low, middle, and high, instead of continuously variable depth), his preference for frontal poses, and his restraint in dealing with the violent action can Algardi be called a classicist, and then purely in a relative sense. Clearly, we must not draw the distinction between the High Baroque and Baroque classicism too sharply in sculpture any more than in painting.

Painting in Spain

During the sixteenth century, at the height of its political and economic power, Spain had produced great saints and writers but, strangely enough, no artists of the first rank.

contribution is *The Meeting of Pope Leo I and Attila* (fig. 17-18), done while he replaced Bernini at St. Peter's during the papacy of Innocent X. It introduced a new kind of high relief that soon became widely popular. The scene depicts the defeat of the Huns under Attila during a threatened attack on Rome in 452, a fateful event in the early history of Christianity, when its very survival was at stake. The subject revives one that is familiar to us from antiquity: the victory over barbarian forces (compare fig. 5-19). But now it is the Church, not civilization, that tri-

Nor did El Greco's presence stimulate native talent. The reason is that the Catholic Church, the main source of patronage in Spain, was extremely conservative, whereas the Spanish court and most of the aristocracy preferred to employ foreign painters and held native artists in low esteem. Thus the main influences came from Italy and Flanders, which was ruled by Spain. And with Spain ruling parts of Italy, Caravaggio became a dominant force in Spanish art.

Jusepe Ribera Caravaggio's style lived on in Naples, then under Spanish rule. His main disciple in that city was the Spaniard Jusepe Ribera (1591–1652). Ribera settled there after having seen Caravaggio's paintings in Rome. Especially popular were Ribera's paintings of saints, prophets, and ancient beggar-philosophers. Their asceticism appealed strongly to the otherworldliness of Spanish Catholicism. Such pictures also reflected the learned humanism of the Spanish nobility, who were the artist's main patrons. Most of Ribera's figures are middle-aged or elderly men who possess the unique blend of inner strength and intensity seen in *St. Jerome and the Angel of Judgment* (fig. 17-19), his masterpiece in this vein. The fervent characterization owes its expressive force to both the dramatic composition, inspired by Caravaggio, and the raking light, which gives the figure a powerful presence by heightening the realism and emphasizing the vigorous surface textures.

Francisco de Zurbarán Seville was the home of the leading Spanish Baroque painters before 1640. Francisco de Zurbarán (1598–1664) stands out among them for his quiet intensity. His most important works were done for monastic orders and are filled with an ascetic piety that is uniquely Spanish. *St. Serapion* (fig. 17-20) shows an early member of the Mercedarians (Order of Mercy) who was brutally murdered by pirates in 1240 but canonized only a hundred years after this picture was painted. The canvas was placed as a devotional image in the funerary chapel of the order, which was originally dedicated to self-sacrifice.

The painting will remind us of Caravaggio. Zurbarán's saint is shown as a life-size three-quarter-length figure and fills the

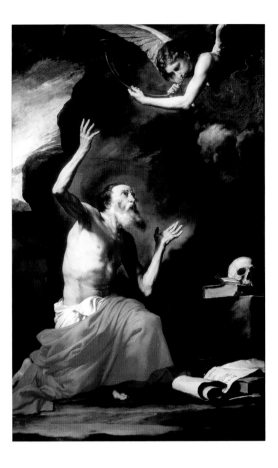

17-19 Jusepe Ribera. *St. Jerome and the Angel of Judgment.* 1626. Oil on canvas, 8′7⅛″ × 5′4½″ (2.62 × 1.64 m). Museo e Gallerie Nazionali di Capodimonte, Naples

17-20 Francisco de Zurbarán. *St. Serapion.* 1628. Oil on canvas, 47½× 41″ (120.7 × 104.1 cm). Wadsworth Atheneum, Hartford, Connecticut

Ella Gallup Sumner and Mary Catlin Sumner Collection

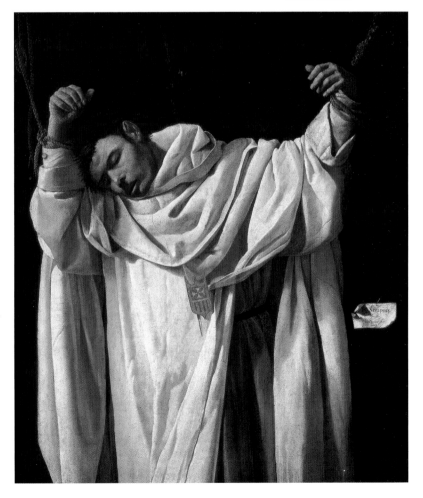

picture plane. The strong contrast between the white habit and the dark background gives the figure a heightened visual and expressive presence, so that the viewer contemplates the slain monk with a mixture of compassion and awe. Here pictorial and spiritual purity become one. The stillness creates a reverential mood that complements the stark realism. As a result, we identify with the strength of St. Serapion's faith rather than with his physical suffering. The absence of pathos is what makes this image deeply moving.

Diego Velázquez During his early years in Seville, Diego Velázquez (1599–1660) painted in a style similar to Caravaggio's. His interests at that time centered on scenes of people eating and drinking rather than religious themes. In the late 1620s Velázquez was appointed court painter to Philip IV, whose reign from 1621 to 1665 was the great age of painting in Spain. Much of the credit must go to the duke of Olivares, who largely restored Spain's fortunes and supported an ambitious program of artistic patronage to proclaim the monarchy's greatness. Upon moving to Madrid, Velázquez quickly displaced the mediocre Florentines who had enjoyed the favor of Philip III and his minister, the duke of Lerma. A skilled courtier, the artist soon became a favorite of the king, whom he served as chamberlain. Velázquez spent most of the rest of his life in Madrid painting mainly portraits of the royal family. His trip to Rome for the jubilee year of 1650 was no doubt taken as a result of conversations with the Flemish painter Peter Paul Rubens many years before.

During his visit to the Spanish court on a diplomatic mission in 1628, Rubens (see pages 378-81) helped Velázquez to discover the beauty of the many Titians in the king's collection, from which Velázquez developed a new fluency and richness. *The Maids of Honor* (fig. 17-21) shows Velázquez's mature style at its fullest. Commissioned by the king, it is both a group portrait and a genre scene and depicts Velázquez himself at work on a huge canvas. In the center is the Princess Margarita, who has just posed for him, among her playmates and maids of honor. In fact, the vanishing point is directly between her eyes, so that everything literally centers on her. The faces of her parents, king Philip IV and queen Maria Anna, appear in the mirror on the back wall. They have just stepped into the room, to see the scene as we do. Yet their position also suggests a slightly different vantage point than ours, and indeed there are several throughout the picture. In this way, the artist perhaps intended to include the viewer in the scene by implication, even though it was clearly painted for the king and hung in the office of his summer quarters at the Alcázar Palace.

Antonio Palomino, the first to discuss *The Maids of Honor,* wrote ". . . the name of Velázquez will live from century to century, as long as that of the most excellent and beautiful Margarita, in whose shadow his image is immortalized." Thanks to Palomino, we know the identity of every person. Through the presence of the princess, king, and queen, the canvas commemorates Velázquez's position as royal painter and his aspiration to the knighthood in the Order of Santiago. This is a papal military order to which he gained admission only with great difficulty years after the painting was executed. He wears the red cross of the Order (added to the painting after the artist's death).

Velázquez had struggled for status at court since his arrival. Even though the usual family investigations (almost 150 friends and relatives were interviewed) assisted his claim to nobility, the very nature of his profession worked against him. "Working with his hands" conveyed on Velazquez the very antithesis of noble status. Only by papal dispensation was he accepted.

The painting then is a response to personal ambition; it is a claim for both the nobility of the act of painting and that of the artist himself. The presence of the king and queen affirm his status. The Spanish court had already honored Titian and Rubens (although not to the same order), and the high regard of Titian and Rubens as models had a great impact on Velázquez, as did their painterly style.

The painting reveals Velázquez's fascination with light as fundamental to vision. The artist challenges us to match the mirror image against the paintings on the same

wall and against the "picture" of the man in the open doorway. Although the side lighting and strong contrasts of light and dark still suggest the influence of Caravaggio, Velázquez's technique is far more subtle. The glowing colors have a Venetian richness, but the brushwork is even freer and sketchier than Titian's. Velázquez explored the optical qualities of light more fully than any other painter of his time. His aim is to represent the movement of light itself and the infinite range of its effects on form and color. For Velázquez, as for Jan Vermeer in Holland (see page 396), light *creates* the visible world.

Bartolomé Esteban Murillo The work of Bartolomé Esteban Murillo (1617–1682), Zurbarán's successor as the leading painter in Seville, is the most cosmopolitan, as well as the most accessible, of any Spanish Baroque artist. For that reason, he had countless

17-21 Diego Velázquez. *The Maids of Honor.* 1656. Oil on canvas, 10′5″ × 9′ (3.18 × 2.74 m). Museo del Prado, Madrid

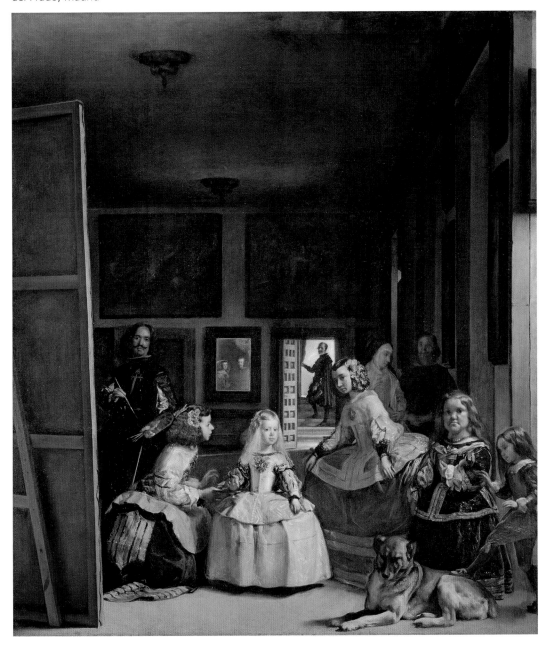

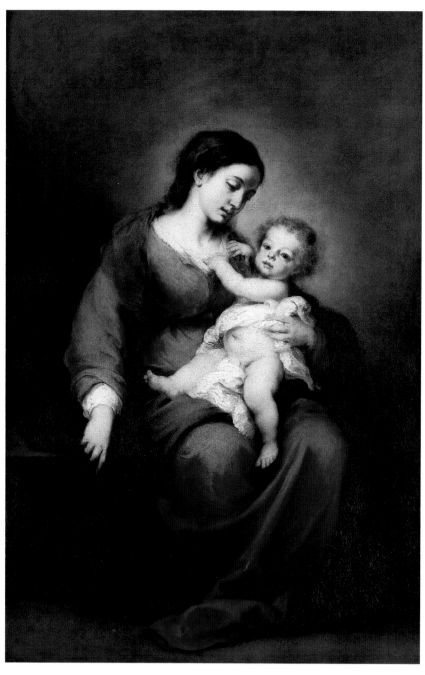

followers, whose pale imitations obscure his real achievement. He learned as much from Northern artists, including Rubens and Rembrandt, as he did from Italians such as Reni and Guercino. His *Virgin and Child* (fig. 17-22) unites these influences in an image that nevertheless retains an unmistakably Spanish character. The haunting expressiveness of the faces has a gentle pathos that is more emotionally appealing than Zurbarán's austere pietism. This human warmth reflects a basic change in religious outlook. It is also an attempt to inject new life into standard devotional images that had been reduced to formulas in the hands of lesser artists. The extraordinary sophistication of Murillo's brushwork and the subtlety of his color show the influence of Velázquez. There is a debt as well to the great Flemish Baroque painters Peter Paul Rubens and Anthony van Dyck.

17-22 Bartolomé Esteban Murillo. *Virgin and Child.* c. 1675–80. Oil on canvas, 65¼ × 43" (165.7 × 109.2 cm). The Metropolitan Museum of Art, New York
Rogers Fund, 1943

The Baroque in Flanders and Holland

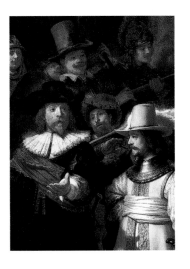

THE NORTHERN COUNTRIES OF FLANDERS (MODERN BELGIUM and part of France) and Holland may not appear so different from each other today, but in the seventeenth century, they were sharply divided by religion, government, and indeed their art. In 1581 the six northern provinces of the Netherlands, led by William the Silent of Nassau, declared their independence from Spain, capping a rebellion that had begun 15 years earlier against Catholicism and the attempt by Philip II to curtail local power. Spain soon recovered the southern Netherlands, called Flanders (now divided between France and Belgium). After a long struggle the United Provinces (today's Holland) gained their autonomy, which was recognized by the truce declared in 1609. Although hostilities broke out again in 1621, the freedom of the Dutch was never again seriously in doubt; it was finally ratified by the Treaty of Münster, which ended the Thirty Years' War in 1648.

The division of the Netherlands had very different consequences for the economy, social structure, culture, and religion of the north and the south. After being sacked by Spanish troops in 1576, Antwerp, the leading port of the southern Netherlands, lost half its population. The city gradually regained its position as Flanders's commercial and artistic capital, although Brussels was the seat of government. Because Flanders continued to be ruled by Spanish regents, who viewed themselves as the defenders of the true faith, its artists relied on commissions from Church and State, but the aristocracy and wealthy merchants were also important patrons.

Holland, in contrast, was proud of its hard-won freedom. Although the official religion was Reformed, the Dutch were notable for their religious tolerance. Even Catholicism continued to flourish, and included many artists among its ranks; Jews found a haven from persecution. Although the cultural links with Flanders remained strong, several factors encouraged the quick development of Dutch artistic traditions. Unlike Flanders, where all artistic activity radiated from Antwerp, Holland had a number of local schools of painting. Besides Amsterdam, the commercial capital, there were important artists in Haarlem, Utrecht, Leiden, Delft, and other towns that frequently established local styles centered on the teachers of the community. Thus Holland produced an almost bewildering variety of masters and styles.

The new nation was one of merchants, farmers, and seafarers, and its religion was Reformed Protestant, which was iconoclastic. Hence Dutch artists rarely had the large-scale commissions sponsored by State and Church that were available throughout the Catholic world. Although city governments and civic bodies such as militias provided a certain amount of art patronage, their demands were limited. As a result, private collectors became the painter's chief source of support. This condition had already existed to some extent before (see page 347), but its full effect can be seen only after 1600. There was no shrinkage of output. On the contrary, the public developed such an appetite for pictures that the whole country became gripped by a kind of collectors'

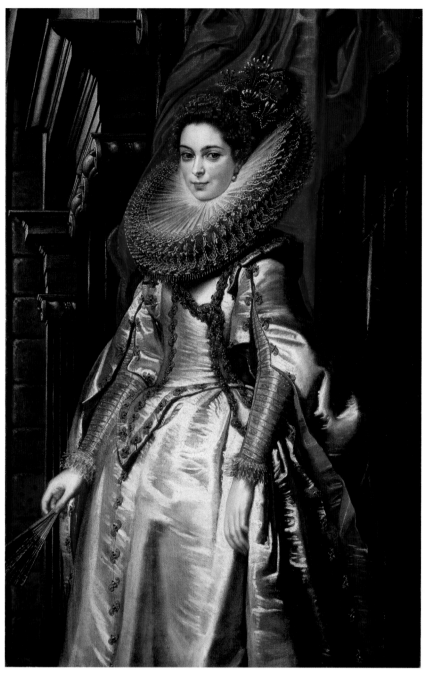

18-1 Peter Paul Rubens. *Marchesa Brigida Spinola Doria.* 1606. Oil on canvas, 5′ × 3′2⅞″ (152.2 × 98.7 cm). The National Gallery of Art, Washington, D.C., inv. 1612

trade followed the law of supply and demand. Many artists produced for the market rather than for individual patrons. They were lured into becoming painters by hopes of success that often failed to materialize, and even the greatest masters were sometimes hard-pressed. (It was not unusual for an artist to keep an inn or run a small business on the side.) Yet they survived—less secure, but freer.

Flanders

Peter Paul Rubens Although it was born in Rome, the Baroque style soon became international. The great Flemish painter Peter Paul Rubens (1577–1640) played a role of unique importance in this process. He finished what Dürer had started a hundred years earlier: the breakdown of the artistic barriers between north and south. Rubens's father was a prominent Antwerp Protestant who fled to Germany to escape Spanish persecution during the war of independence (see page 347). The family returned to Antwerp after his death, when Peter Paul was ten years old, and the boy grew up a devout Catholic. Trained by local painters, Rubens became a master in 1598, but developed a personal style only when he went to Italy two years later.

During his eight years in the south, he absorbed the Italian tradition far more thoroughly than had any Northerner before him. He eagerly studied ancient sculpture, the masterpieces of the High Renaissance, and the work of Caravaggio and Annibale Carracci. In fact, Rubens competed on even terms with the best Italians of his day and could well have made his career in Italy as he had major commissions for altarpieces and portraits. Rubens was one of the greatest and most influential portraitists of the seventeenth century, recording the vast wealth and stature of his often noble patrons. He painted several portraits while in Italy and maintained contacts with his Genoese patrons for years after he left. His resplendent portrait of *Marchesa Brigida Spinola Doria* (fig. 18-1), a member of the ruling class of Genoese banking families, who invested in trade from Africa and the East to Western Europe, was probably executed in celebration of her wedding in 1606 at age 22.

mania. During a visit to Holland in 1641, the English traveler John Evelyn noted in his diary that "it is an ordinary thing to find a common farmer lay out two or three thousand pounds in this commodity. Their houses are full of them, and they vend them at their fairs to very great gain."

The collectors' mania caused an outpouring of artistic talent that can only be compared to that of Early Renaissance Florence. Pictures became a commodity, and their

Although a large painting, it was even more monumental in the seventeenth century—perhaps nine feet high—before it was cut down on all four sides. A nineteenth-century lithograph of the painting tells us that the Marchesa was originally full length and was shown striding from the terrace of her palazzo. She is sumptuously dressed in white satin, with a matching cape, bejeweled with a rope of gold set with gems of onyx and rubies. Her huge, multilayered ruff, typical of her time and class, frames her face, and her red hair is arranged with decorative combs of pearls and feathers. The vast flowing red cloth, which unfurls behind her, sets the color contrast with her dress and heightens the color of her face. The diagonal movement of this drapery also suggests her forward stride. The size, full-length view, elements of movement, and color against her face are just a few of the aspects that will influence Rubens's student and assistant Anthony Van Dyck (see figs. 18-5, 18-6) in his portraits and in later portraits of the eighteenth and nineteenth centuries.

When Rubens returned to Flanders in 1608 because of his mother's illness, he meant the visit to be brief. His plans changed when he received a special appointment as court painter to the Spanish regent, which allowed him to set up a workshop in Antwerp that was exempt from local taxes and guild regulations. Rubens had the best of both worlds. Like Jan van Eyck (see page 323), he was valued at court not only as an artist, but also as an adviser and emissary. Diplomatic errands gave him entry to the royal households of the major powers, where he received numerous commissions. Aided by a growing number of assistants, he was also free to carry out a huge volume of work for the city of Antwerp, for the Church, and for private patrons.

Rubens epitomized the Baroque ideal of the virtuoso for whom the entire universe is a stage. On the one hand, he was devoutly religious. On the other, he was a man of the world who succeeded in every arena by virtue of his character and ability. Rubens resolved the contradictions of the era through humanism, the union of faith and learning that was attacked by both the Reformation and the Counter-Reformation. In his paintings as well, Rubens reconciled seemingly incompatible forces. His enormous intellect and vitality enabled him to unite the natural and supernatural, reality and fantasy, learning and spirituality. Thus his epic canvases defined the scope and the style of High Baroque painting. They possess a seemingly boundless energy and inventiveness, which, like his heroic nudes, express life at its fullest. The presentation of this heightened existence required the expanded arena that only Baroque theatricality could provide. Rubens's sense of drama was as highly developed as Bernini's. At the same time, he could be the most human of artists.

The Raising of the Cross (fig. 18-2), whose very subject speaks to the dynamism

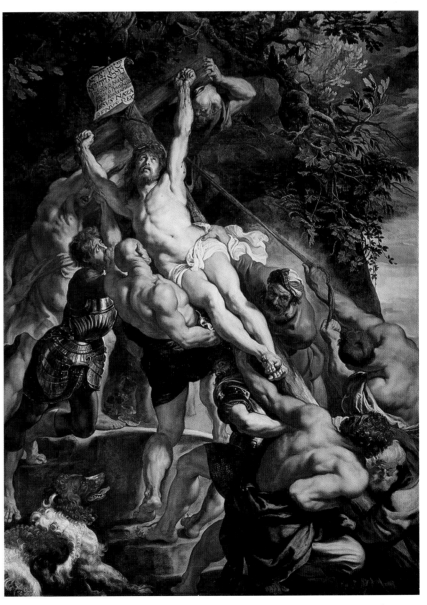

18-2 Peter Paul Rubens. *The Raising of the Cross.* 1609–10. Center panel of a triptych, oil on panel, 15'1" × 11'9⅝" (4.57 × 3.60 m). Antwerp Cathedral

of the Baroque, was the first major altarpiece Rubens painted after his return to Antwerp. In it, we can see how much he was indebted to Italian art. The muscular figures, modeled to show their physical power and passionate feeling, recall those of the Sistine ceiling and the Farnese Gallery, whereas the lighting resembles Caravaggio's (see figs. 13-10, 17-1, and 17-5). The color recalls Titian's (compare fig. 13-20). The panel nevertheless owes much of its success to Rubens's ability to combine Italian influences with Netherlandish ideas, which he updated in the process. The painting is more heroic in scale and conception than any previous Northern work, yet it is unthinkable without Rogier van der Weyden's *Descent from the Cross* (see fig. 15-7). Rubens is also a Flemish realist in such details as the foliage, the armor of the soldier, and the curly-haired dog in the foreground. These varied elements, integrated with total mastery, form a composition of tremendous dramatic force. The unstable pyramid of bodies, swaying precariously under the strain of the dramatic action, bursts the limits of the frame in a typically Baroque way, making the viewer feel like a participant in the action.

In the 1620s, Rubens's style reached its climax in his huge decorative schemes for churches and palaces. The most famous is the CYCLE of 21 paintings, each at least 15 feet high and some 28 feet wide, in the Luxembourg Palace in Paris, glorifying the life and career of Marie de' Medici, the widow of Henry IV and mother of Louis XIII. Our illustration shows the artist's oil sketch for one episode: the young queen landing in Marseilles (fig. 18-3). This is hardly an exciting subject, yet Rubens has turned it into a spectacle of unparalleled splendor. As Marie de' Medici walks down the gangplank to enter France, having already married Henry IV (by proxy in Florence; she had not yet met her husband), Fame flies overhead sounding a triumphant blast on two trumpets. Neptune rises from the sea with his fish-tailed crew; having guarded the queen's journey, they rejoice at her arrival. Everything flows together here in swirling movement: heaven and earth, history and allegory. Even drawing and painting come together, for Rubens used oil sketches like this one to prepare his compositions. Unlike earlier artists, he preferred to design his pictures in terms of light and color from the start. (Most of his drawings are figure studies or portrait sketches.) This unified vision, which had been explored but never fully achieved by the great Venetians, was Rubens's most precious legacy to later painters.

Around 1630, the drama of Rubens's earlier work changed to a late style of lyrical tenderness inspired by Titian, whose work Rubens discovered anew in the royal palace while he visited Madrid in 1628

18-3 Peter Paul Rubens. *Marie de' Medici, Queen of France, Landing in Marseilles.* 1622–23. Oil on panel, 25 × 19³/₄" (63.5 × 50.3 cm). Alte Pinakothek, Munich

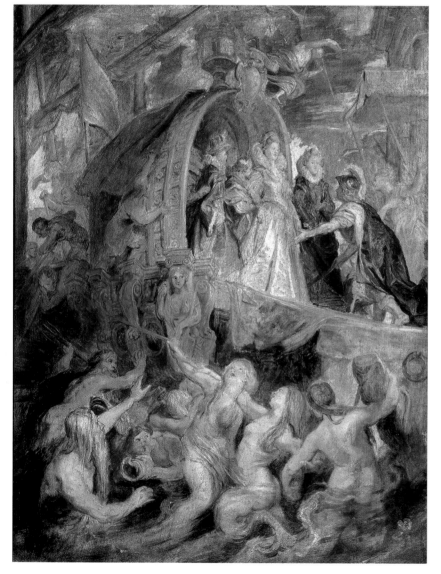

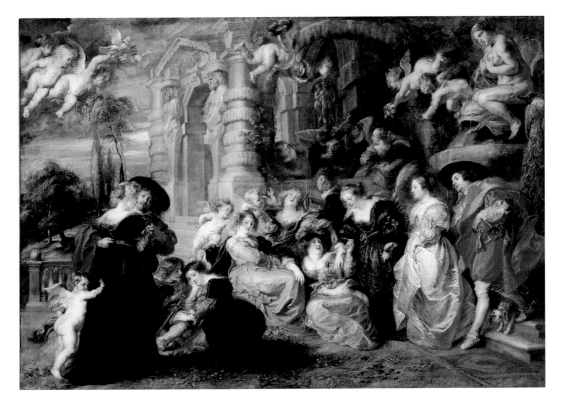

18-4 Peter Paul Rubens. *The Garden of Love.* c. 1638. Oil on canvas, 6'6" × 9'3½" (1.98 × 2.83 m). Museo del Prado, Madrid

(see also page 374). *The Garden of Love* (fig. 18-4) is as glowing a tribute to life's pleasures as Titian's *Bacchanal* (see fig. 13-20). But these fashionable couples belong to the present, not to a golden age of the past, although they are playfully assaulted by swarms of cupids. The picture must have had special meaning for the artist, since, at the age of 53, he had just married a beautiful girl of 16. (His first wife died in 1626.) The Garden of Love had been a feature of Northern painting ever since the courtly style of the International Gothic. The early versions, however, were genre scenes showing groups of young lovers in a garden. By merging this tradition with Titian's classical mythologies, Rubens has created an enchanted realm where myth and reality become one.

Anthony Van Dyck Besides Rubens, only one Flemish Baroque artist won international stature. Anthony van Dyck (1599–1641) was that rarity among painters, a child prodigy. Before he was 20 he had become Rubens's most valued assistant. And, like Rubens, he developed his mature style only after a stay in Italy.

As a history painter, Van Dyck was at his best in lyrical scenes of mythological love. *Rinaldo and Armida* (fig. 18-5) is taken from Torquato Tasso's immensely popular poem *Jerusalem Freed* (1581) about the Crusades, which gave rise to a new courtly ideal throughout Europe and inspired numerous operas as well as paintings. Van Dyck shows the sorceress falling in love with the Christian knight she had intended to slay. The canvas reflects the conception of the English monarchy, for whom it was painted. Charles I, a Protestant, had married the Catholic Henrietta Maria, sister of his rival, the king of France. Charles found parallels in Tasso's epic. He saw himself as the virtuous ruler of a peaceful realm much like the Fortunate Isle where Armida brought Rinaldo. The artist tells his story of ideal love in the pictorial language of Titian and Veronese, but with an expressiveness and opulence that would have been the envy of any Venetian painter. The picture was so successful that it helped Van Dyck gain appointment to the English court two years later.

Van Dyck's fame rests mainly on the portraits he painted in London between 1632

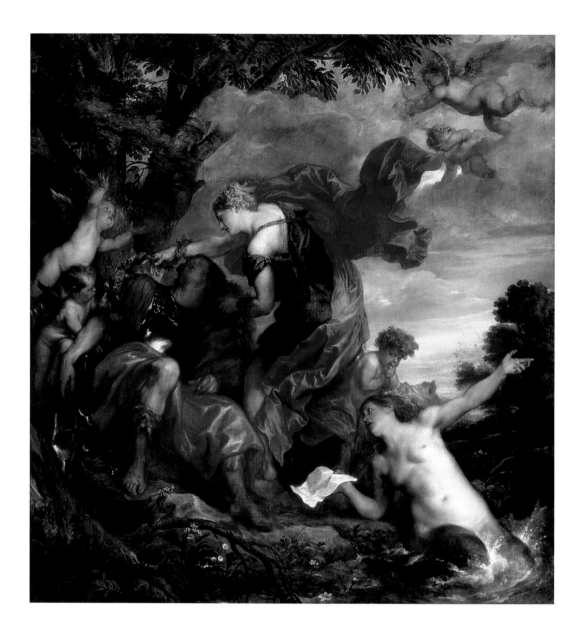

18-5 Anthony van Dyck. *Rinaldo and Armida.* 1629. Oil on canvas, 7′9″ × 7′6″ (2.36 × 2.24 m). The Baltimore Museum of Art

and 1641. *Portrait of Charles I Hunting* (fig. 18-6) shows the king standing near a horse and two grooms against a landscape backdrop. Representing the sovereign at ease, the painting might be called a "dismounted equestrian portrait" and is vastly different in effect from Holbein's portrait of *Henry VIII* (fig. 16-9). It is less rigid than a formal state portrait, but hardly less grand, for the king remains in full command of the state, symbolized by the horse, which bows its head toward its master. The fluid movement of the setting complements the self-conscious elegance of the king's pose. His position, however, was less secure than his confidence suggests.

Charles I's reign ended in civil war, and he was beheaded in 1649. Charles was succeeded by the Puritan leader Oliver Cromwell, referred to with his followers as "round heads" in deference to their short-cropped hair. In contrast, note that Charles I's tresses drop below his shoulder in the French (Catholic) manner. However, Charles's son, Charles II, assumed the throne in the period known as "The Restoration." Van Dyck has brought the court portrait up to date, using Rubens and Titian as his points of departure. He died eight years before the beheading and so never worked for the subsequent courts. But, he created a new aristocratic portrait tradition that

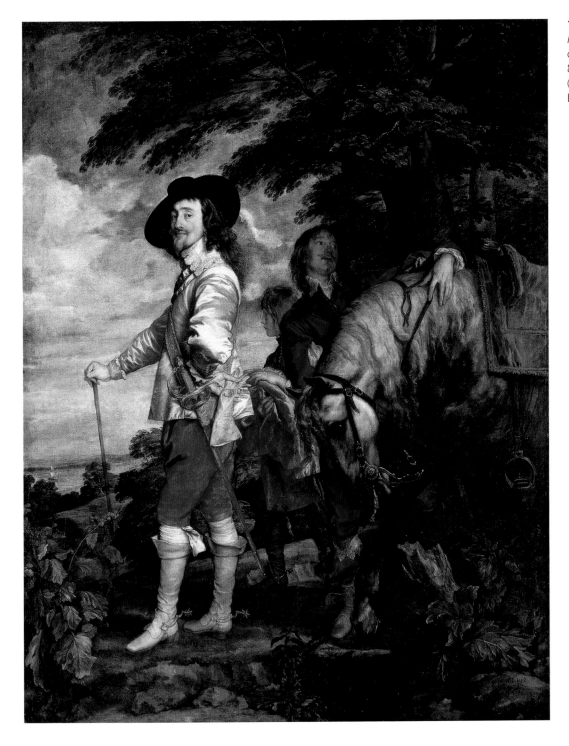

18-6 Anthony van Dyck. *Portrait of Charles I Hunting.* c. 1635. Oil on canvas, 8′11⅛″ × 6′11½″ (2.72 × 2.12 m). Musée du Louvre, Paris

continued in England until the late eighteenth century and had considerable influence on the Continent as well.

Jacob Jordaens Jacob Jordaens (1593–1678) was the successor to Rubens and Van Dyck as the leading artist in Flanders. Although he was never a member of

Rubens's studio, he turned to Rubens for inspiration throughout his career. His most characteristic subjects are mythological themes depicting the revels of NYMPHS and satyrs. Like his eating and drinking scenes, which illustrate popular sayings, they reveal him to be a close observer of people. The dwellers of the woods in *Homage to*

NYMPHS were female divinities in Greek mythology who were identified with nature, natural objects, and sites. The Greeks had many classes of nymphs—most of them gentle and beautiful but some of them wild companions of satyrs—which numbered in the thousands.

of a race against time is, of course, deceptive. Hals spent hours on this life-size canvas, but he maintains the illusion of having done it all in the wink of an eye.

Judith Leyster The most important follower of Hals was Judith Leyster (1609–1660), who was responsible for a number of works that once passed as Hals's own, although she also painted works most unlike his: candlelight scenes and paintings that explored the relationship between men and women. She painted portraits and still lifes, but mostly genre paintings. Her *Self-Portrait* (fig. I-7 in Introduction) shows Leyster as both a portrait and genre painter and was executed no doubt to exhibit her mastery of both. She shows us her technical skill in wielding numerous brushes and a palette as she sits in her studio casually conversing with us.

Leyster became a master in the Guild in 1633 and had her own students. She did not come from a family of artists, but married into one, when she married a fellow student of Hals's, Jan Miense Molenaer (c. 1610–1668), who also excelled in genre and portrait painting and together moved from Haarlem to Amsterdam. Leyster's *Young Flute Player* (fig. 18-10) is her masterpiece, signed on the mouth of the flute with her monogram, a conjoined J, L, and star, punning on her name meaning "leading star." Indeed, she was referred to during her lifetime as a "leading star" in art. Her rapt musician, possibly representing the Sense of Hearing, is a memorable expression of lyrical mood. To convey this spirit, Leyster explored the poetic quality of light pouring in from the left with an intensity that anticipates the work of Jan Vermeer a generation later (see figs. 18-18, 18-19).

18-10 Judith Leyster. *Young Flute Player.* 1630–35. Oil on canvas, 28⅜ × 24⅜″ (72.1 × 61.9 cm). Nationalmuseum, Stockholm

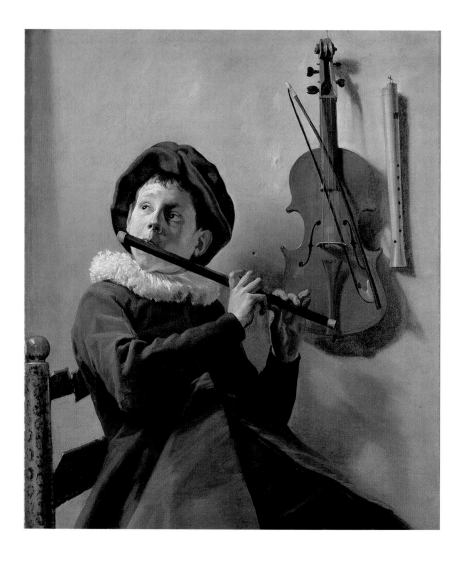

Rembrandt van Rijn Like Hals and Leyster, Rembrandt van Rijn (1606–1669), the greatest genius of Dutch art, was influenced indirectly by Caravaggio through the Utrecht School. His earliest pictures, painted in his native Leiden, are small, sharply lit, and intensely realistic. Many deal with Old Testament subjects, a lifelong preference. They show both his greater realism and his new emotional attitude. Since the beginning of Christian art, episodes from the Old Testament had often been represented for the light they shed on Christian doctrine, rather than for their own sake. (The Sacrifice of Isaac, for example, "prefigured" the sacrificial death of Christ.) This perspective not only limited the choice of subjects, it also colored their interpretation. Rembrandt, by contrast, viewed the stories of the Old Testament in much the same lay Christian spirit that governed Caravaggio's approach to the New Testament: as direct accounts of God's ways with his human creations. Thus his religious images are personal, not doctrinal, statements.

How strongly these stories affected him is clear in *The Blinding of Samson* (fig. 18-11). Painted in the High Baroque style he developed in the 1630s after moving to Amsterdam, it shows Rembrandt as a master storyteller. The artist depicts the Biblical world as full of oriental splendor and violence. The theatrical light pouring into the dark tent heightens the drama to the pitch of *The Raising of the Cross* by Rubens (see fig. 18-2), whose work Rembrandt sought to rival.

Rembrandt was at this time an avid collector of Near Eastern objects, which served as props in these pictures. Thanks not only to his great ability but also to family and congregational connections, which were critical to gaining commissions in seventeenth-century Holland, he was now Amsterdam's most sought-after portrait painter, and a man of considerable wealth. His famous group portrait known as *The Night Watch* (fig. 18-12), painted in 1642, shows a military company, in the tradition of Frans Hals's Civic Guard groups, assembling for the visit of Marie de' Medici to Amsterdam. Although its members

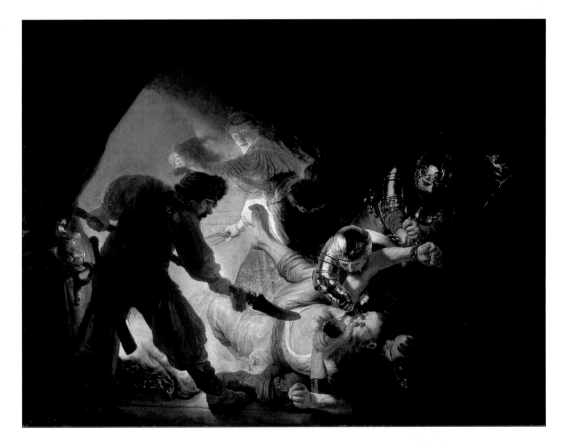

18-11 Rembrandt van Rijn. *The Blinding of Samson.* 1636. Oil on canvas, 7'9" × 9'11" (2.36 × 3.02 m). Städelsches Kunst-institut, Frankfurt

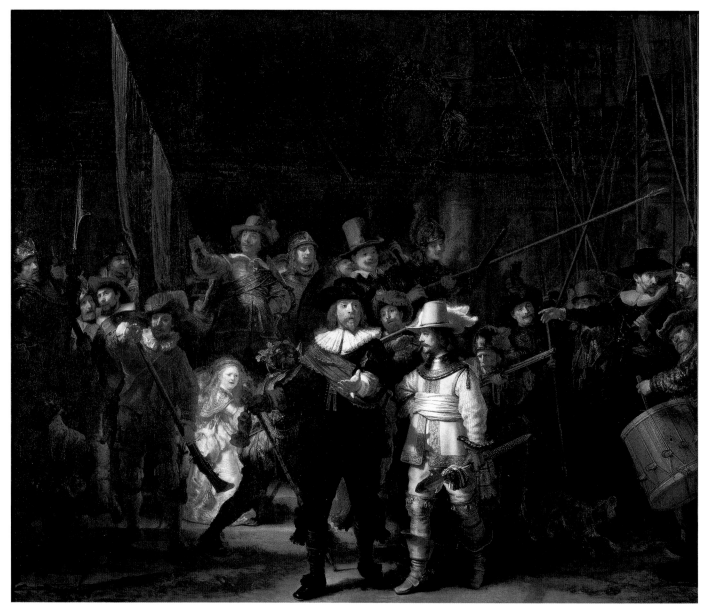

18-12 Rembrandt van Rijn. *The Night Watch (The Company of Captain Frans Banning Cocq)*. 1642. Oil on canvas, 12′2″ × 14′7″ (3.71 × 4.45 m). Rijksmuseum, Amsterdam

had each contributed toward the cost of the huge canvas (originally it was much larger), Rembrandt did not give them equal weight. He wanted to avoid the mechanically regular designs of earlier group portraits—a problem only Hals had solved successfully (see fig. 18-8). Instead, he made the picture a virtuoso performance filled with Baroque movement and lighting, which captures the excitement of the moment and gives the scene unprecedented drama. Some of the figures were

plunged into shadow, and others were hidden by overlapping. Legend has it that the people whose portraits he had obscured were not satisfied with the painting, but there is no evidence for this claim. On the contrary, we know that the painting was much admired in its time.

Like Michelangelo and, later, Van Gogh, Rembrandt has been the subject (one might say, the victim) of many fictionalized biographies. In these, the artist's fall

from public favor is usually explained by the "catastrophe" of *The Night Watch*. It is true that his prosperity petered out in the 1640s, as he was replaced by other, more fashionable artists, including some of his own pupils. Yet his fortunes declined less suddenly and completely than his romantic admirers would have us believe. A number of important people in Amsterdam continued to be his friends and supporters, and he received some major public commissions in the 1650s and 1660s. Actually, his financial problems were due largely to poor management and his own stubbornness, which alienated his patrons. Still, the 1640s were a time of inner uncertainty and external troubles, especially his wife's death. As a result, Rembrandt's outlook changed profoundly. After about 1650, his style is marked by lyric subtlety and pictorial breadth. Some exotic trappings from the earlier years remain, but they no longer create an alien world.

In the many self-portraits Rembrandt painted over his long career, his view of himself reflects every stage of his inner development. It is experimental in the early Leiden years, theatrically disguised in the 1630s, and frank toward the end of his life. While our late example (fig. 18-13) is

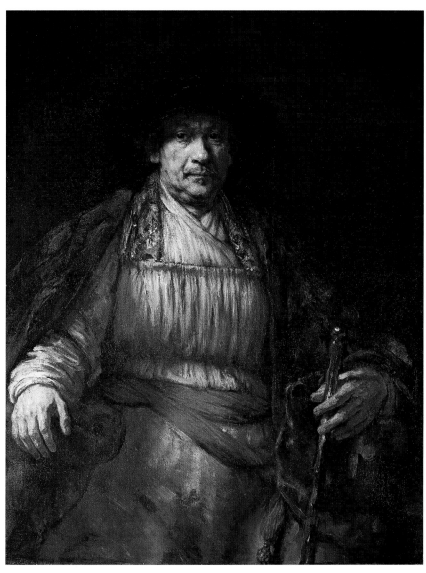

18-13 Rembrandt van Rijn. *Self-Portrait*. 1658. Oil on canvas, 52⅝ × 40⅞" (133.6 × 103.8 cm). The Frick Collection, New York

partially indebted to Titian's portraits, Rembrandt scrutinizes himself with a typically Northern candor. The bold pose and penetrating look bespeak a resigned but firm resolve in the face of adversity. This approach helps to account for the dignity we see in the religious scenes that play so large a part in Rembrandt's work in his later years.

Rembrandt's etchings, such as his famed *One Hundred Guilder Print* (fig. 18-14), show this new depth of feeling. The etching, which has been interpreted as a depiction of the entire nineteenth chapter of the Gospel of St. Matthew, combines various aspects of Christ's preachings, including the healing of multitudes, the gathering of children, and those who had forsaken all to come to Him. This is crystallized in the phrase, "The Son of God in a world of sorrow . . ." (from a contemporary poem). The print is poignant and filled with pathos, revealing a humble world of bare feet and ragged clothes. The scene is full of the artist's compassion for the poor and outcast who make up Christ's audience. Rembrandt had a special sympathy for the Jews as heirs of the biblical past and as victims of persecution, and they were often his models. This print strongly suggests some corner in Amsterdam where the Jews found a haven, and it surely incorporates observations of life from the drawings he made throughout his career; several have been identified as studies for this work. Here, as in Caravaggio's *Calling of St. Matthew* (see fig. 17-1), it is the magic of light that endows the scene with spiritual significance.

The print is a virtuoso combination of etching and drypoint (see Materials and Techniques: Early Printmaking, page 334). It achieved its name from a story that Rembrandt traded it for several others amounting to one hundred guilders—a great

18-14 Rembrandt van Rijn. *One Hundred Guilder Print.* c. 1647. Etching, and drypoint, 11″ × 15½″ (28 × 39.4 cm). The Metropolitan Museum of Art, New York

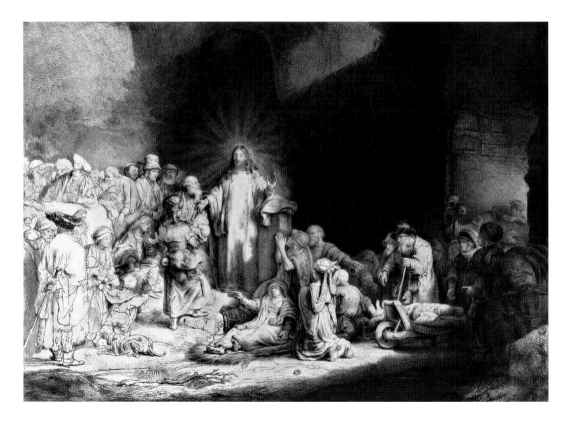

deal of money in 1647. Rembrandt's importance as a graphic artist is second only to Dürer's, although we get no more than a hint of this from our single example. Like other creative printmakers of the day, he preferred etching, often combined with drypoint, to the techniques of woodcut and engraving, which were employed mainly to reproduce other works.

LANDSCAPE, STILL-LIFE, AND GENRE PAINTERS

Rembrandt's religious pictures demand an insight that was beyond the capacity of all but a few collectors. Most art buyers in Holland preferred subjects within their own experience: landscapes, architectural views, **still lifes**, everyday (genre) scenes. These types, we recall, emerged in the latter half of the sixteenth century (see page 347). As they became fully defined, artists began to specialize. The trend was not confined to Holland. We find it everywhere to some degree, but Dutch painting was its fountainhead, in both volume and variety. Art collectors could commission works, but art could also be purchased on the "open market"—from dealers, fairs, stores, and lotteries. Art was made for general consumption and available to those of the middle class.

Jacob van Ruisdael The richest of the newly developed "specialties" was landscape, both as a portrayal of familiar views and as an imaginative vision of nature. Near portraits of cities and their outlying countryside, with low horizon lines, dunes, and wide vistas, mark Dutch landscape painting. Nature was enjoyed for its own sake, but it could also serve as a means of divine revelation through contemplation of God's work. In *The Jewish Cemetery* (fig. 18-15) by Jacob van Ruisdael (1628/29–1682), the greatest

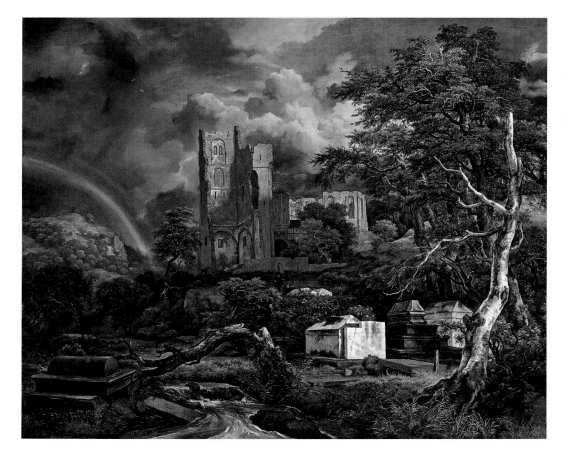

18-15 Jacob van Ruisdael. *The Jewish Cemetery.* 1655–60. Oil on canvas, 4'6" × 6'2½" (1.37 × 1.89 m). The Detroit Institute of Arts

Gift of Julius H. Haass in memory of his brother, Dr. Ernest W. Haass

Dutch landscape painter, natural forces dominate the scene, which is imaginary except for the tombs, depicting a Jewish cemetery near Amsterdam. The thunderclouds passing over a wild, deserted mountain valley, the medieval ruin, the torrent that has forced its way between ancient graves, all create a mood of melancholy. Nothing endures on this earth, the artist tells us: time, wind, and water grind all to dust—trees and rocks as well as the works of human hands. Even the elaborate tombs offer no protection from the same forces that destroy the church built in God's glory. In the context of this extended allegory, the rainbow may be understood as a sign of the promise of redemption through faith. Ruisdael's vision of nature harks back to Giorgione's tragic vision (see fig. 13-19). *The Jewish Cemetery* inspires that awe on which the Romantics, 150 years later, based their concept of the Sublime. The difference is that for Ruisdael, God remains separate from his creation, instead of a part of it.

Willem Claesz. Heda Still lifes are meant above all to delight the senses, but even they can be tinged with a melancholy air. As a result of Holland's conversion to Calvinism, these visual feasts became vehicles for teaching moral lessons. Most Dutch Baroque still lifes treat the theme of Vanitas (the vanity of all earthly things). Overtly or implicitly, they preach the virtue of temperance, frugality, and hard work by warning the viewer to contemplate the brevity of life, the inevitability of death, and the passing of all earthly pleasures. The medieval tradition of imbuing everyday objects with religious significance was absorbed into vernacular culture through EMBLEM BOOKS, which, together with other forms of popular literature and prints, encompassed the Dutch ethic in words and pictures. The stern Calvinist sensibility is exemplified by such homilies as "A fool and his money are soon parted" (a saying that goes all the way back to ancient Rome) and is illustrated by flowers, shells, and other exotic luxuries. The very presence in Vanitas still lifes of precious goods, scholarly books, and objects appealing to the senses suggests an ambivalent attitude toward their subject. Such symbols usually take on multiple meanings that, although no longer readily understood today,

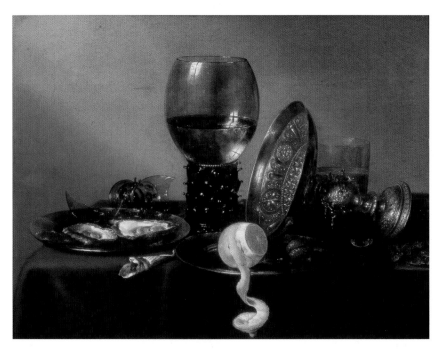

18-16 Willem Claesz. Heda. *Still Life*. 1634. Oil on panel, 16⅞ × 22⅞" (42.9 × 58.1 cm). Museum Boymans–van Beuningen, Rotterdam

were widely recognized at the time. In their most elaborate form, these moral allegories become visual riddles that rely on the very learning they sometimes ridicule.

The **banquet** (or **breakfast**) **piece**, showing the remnants of a meal, had Vanitas connotations almost from the beginning. The message may lie in such symbols as death's-heads and extinguished candles, or be conveyed by less direct means. *Still Life* (fig. 18-16) by Willem Claesz. Heda (1594–1680) belongs to this widespread type. Food and drink are less emphasized here than luxury objects, such as crystal goblets and silver dishes, which are carefully chosen for their contrasting shapes, colors, and textures. How different this seems from the piled-up foods of Aertsen's *Meat Stall* (see fig. 16-11)! But virtuosity was not Heda's only aim. He reminds us that all is

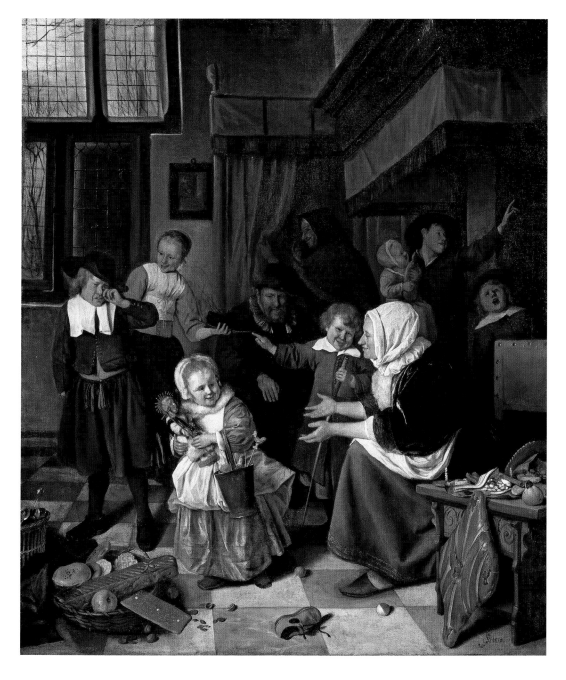

18-17 Jan Steen. *The Feast of St. Nicholas.* c. 1660–65. Oil on canvas, 32¼ × 27¾" (81.9 × 70.5 cm). Rijksmuseum, Amsterdam

vanity. His "story," the human context of these grouped objects, is suggested by the broken glass, the half-peeled lemon, the overturned silver dish. The unstable composition, with its signs of a hasty departure, suggests transience. Whoever sat at this table was suddenly forced to leave the meal. The curtain that time has lowered on the scene, as it were, gives the objects a strange pathos. The disguised symbolism of "Late Gothic" painting lives on here in a new form.

Jan Steen Genre scenes are as varied as landscapes and still lifes. They range from the single figures of Hals and Leyster (figs. 18-9 and 18-10) to tavern brawls or to refined domestic interiors. In *The Feast of St. Nicholas* (fig. 18-17) by Jan Steen (1625/6–1679), St. Nicholas has just paid his pre-Christmas visit to the household and left toys, candy, and cake for the children. The little girl and boy are delighted with their presents. She holds a doll of St. John the Baptist and a bucket filled with sweets, while

18-18 Jan Vermeer. *Woman with a Balance.* c. 1664. Oil on canvas, 16¾ × 15″ (42.5 × 38.1 cm). The National Gallery of Art, Washington, D.C., Widener Collection, 1942

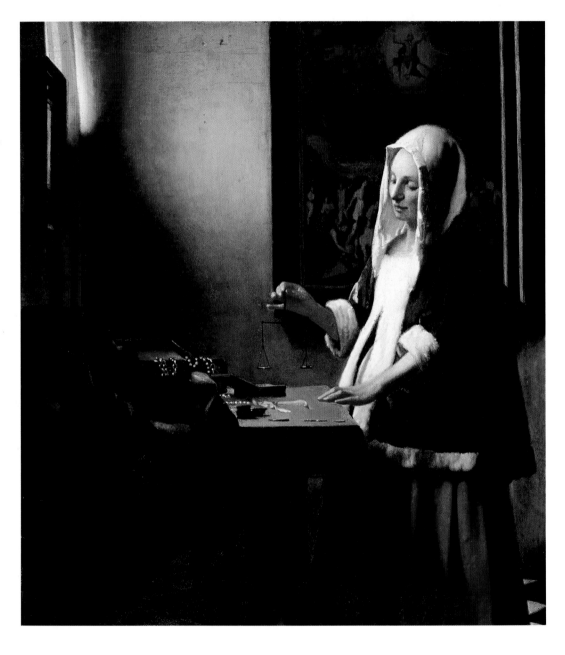

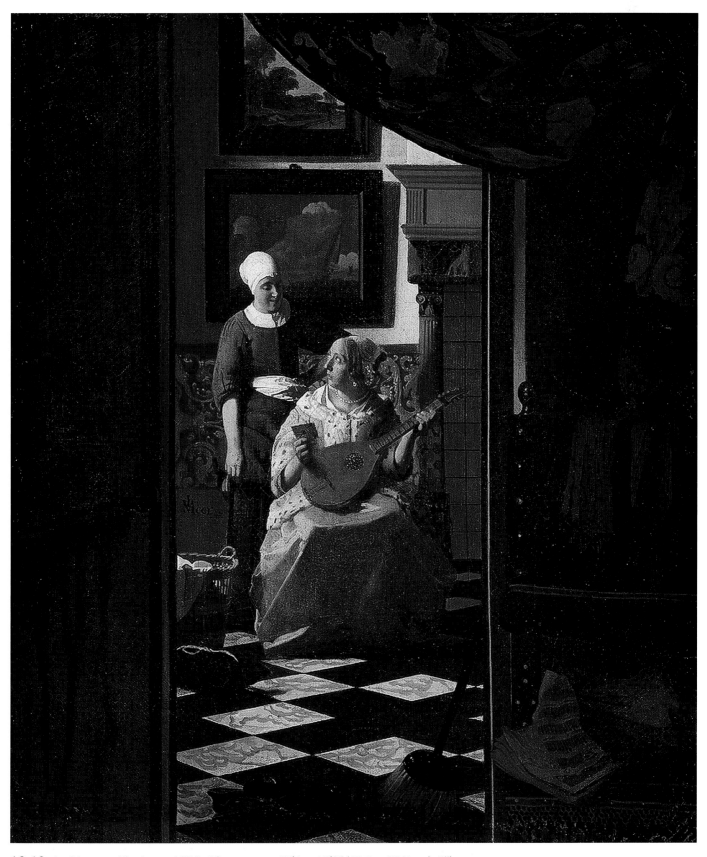

18-19 Jan Vermeer. *The Letter.* 1666. Oil on canvas, 17¼ × 15¼" (43.8 × 38.7 cm). Rijksmuseum, Amsterdam

he plays with a golf club and ball. Everybody is jolly except their brother, on the left, who has received only a birch rod (held by the maidservant) for caning naughty children. Soon his tears will turn to joy, however: his grandmother, in the background, beckons to the bed, where a toy is hidden.

Steen tells the story with relish, embroidering it with many delightful details. Of all the Dutch painters of daily life, he was the sharpest and the most good-humored observer. To supplement his earnings he kept an inn, which may explain his keen insight into human behavior. His sense of timing and his characterization often remind us of Frans Hals (compare fig. 18-9), whereas his storytelling stems from the tradition of Pieter Bruegel the Elder (compare fig. 16-13). Steen was also a gifted history painter, and although his pictures often contain parodies of well-known works by Italian artists, they usually convey a serious message as well. *The Feast of St. Nicholas*, for example, has such a content: the doll of St. John is meant as a reminder of the importance of spiritual matters over worldly possessions, no matter how delightful.

Jan Vermeer In the genre scenes of Jan Vermeer (1632–1675), by contrast, there is hardly any narrative. Single figures, usually women, are seemingly engaged in everyday tasks. They exist in a timeless "still life" world. His *Woman with a Balance* (fig. 18-18) gives a view into such a still-life world—with pearls and gold, paintings and fur all magically created to provide an eternal, yet momentary, glance into a private world where in fact our view is not acknowledged. It is a woman contemplating the future of her unborn child. It is intensely private, quiet, yet also highly sensual, created with optical effects that make the surface shimmer.

Vermeer may have used a *camera obscura*, an optical device (a forerunner of the photographic camera), which may have helped him indicate items "in focus" or "out of focus." The *camera obscura* was demonstrated in England in 1622 (and written about thereafter), and considerable evidence suggests that it was used by Dutch artists.

In *The Letter* (fig. 18-19), the two women do no more than exchange glances. The painting nonetheless does tell a story, but with unmatched subtlety. The "staged" entrance serves to establish our relation to the scene. We are more than bystanders: we become the bearer of the letter that has just been delivered to the young woman. Dressed in sumptuous clothing, she has been playing the lute, as if awaiting our visit. This instrument, filled with erotic meaning, traditionally signifies the harmony between lovers, who play each other's heartstrings. The lover in Dutch art and literature is often compared to a ship at sea, whose calm waters shown in the painting on the wall indicate smooth sailing or that the lover is far away and the letter sent by sea. As usual with Vermeer, however, the picture refuses to yield a final answer, since the artist has depicted the moment before the letter is opened.

Vermeer, unlike earlier artists, perceives reality as a mosaic of colored surfaces—more accurately, he translates reality into a mosaic as he puts it on canvas. We see *The Letter* not only as a perspective "window," but also as a "field" made up of smaller fields. Rectangles predominate, carefully aligned with the picture surface; there are no "holes," no undefined empty spaces. The interlocking shapes give Vermeer's work a uniquely modern quality. How did he acquire it? Although there is considerable documentary evidence relating to his life, we know very little about his training. Some of his works show the influence of Carel Fabritius (1622–1654), the most brilliant of Rembrandt's pupils. Others suggest his contact with the Utrecht School. But none of these sources really explain the origin of his style, which is so original that his genius was not recognized until the mid nineteenth century.

Vermeer's real interest centers on the role of light. The cool daylight that filters in from the left in *The Letter* is the only active element, working its miracles upon all the objects in its path. As we look at the painting, we feel as if a veil has been pulled from our eyes. The everyday world shines with jewel-like freshness, more beautiful than we have ever seen it before. No painter since Jan van Eyck saw as intensely as this. Nor shall we meet his equal again until the Rococo artist Chardin (see fig. 20-6).

The Baroque in France and England

U NDER HENRY IV (1553–1610), LOUIS XIII (1601–1643), AND
Louis XIV (1638–1715), France became the most powerful nation in Europe, both
militarily and culturally. These monarchs were aided by a succession of extremely
able ministers and advisers: the duc de Sully, Cardinal Richelieu, Cardinal Mazarin, and
Jean-Baptiste Colbert. By the late seventeenth century, Paris was vying with Rome as the
world capital of the major and minor arts. How did this change come about? Because of the
Palace of Versailles and other vast projects glorifying the king of France, we are tempted to
think of French art in the age of Louis XIV as the expression of absolute rule. This is true of
the climactic phase of Louis's reign, from 1661 to 1685, but by that time seventeenth-
century French art had already attained its distinctive style.

The French are reluctant to call this style
Baroque. To them, it is the Style of Louis
XIV. Often they also describe the art and lit-
erature of the period as classic. In this con-
text, the word has three meanings. It is a
synonym for "highest achievement," which
implies that the Style of Louis XIV corre-
sponds to the High Renaissance in Italy or
the age of Perikles in ancient Greece. It also
refers to the desire to imitate the forms and
subject matter of classical antiquity. Finally,
it suggests qualities of balance and restraint
shared by ancient art and the Renaissance.
The last two meanings describe what could
more accurately be called classicism. Since
the Style of Louis XIV reflects Italian
Baroque art, however modified, we may label
it "Baroque classicism."

Painting in France

Georges de La Tour Many of the early
French Baroque painters were influenced by
Caravaggio, although it is not clear how they
absorbed his style. Most were minor artists
toiling in the provinces, but a few developed
highly original styles. The finest of them was
Georges de La Tour (1593–1652), whose

importance was recognized only in the nine-
teenth century. Although he spent his career
in Lorraine in northeastern France, he was
by no means a simple provincial artist.
Besides being named a painter to the king,
he received important commissions from the
governor of Lorraine.

La Tour is best noted for his mature reli-
gious pictures, which possess both serious-
ness and grandeur. *Joseph the Carpenter*
(fig. 19-1) might easily be mistaken for a
genre scene, but its devotional spirit has the
power of Caravaggio's *Calling of St. Matthew*
(see fig. 17-1). La Tour's intensity of vision
lends each gesture and each expression its
maximum significance within this spellbind-
ing composition. The boy Jesus holds a can-
dle, a favorite device of the artist, which
lights the scene with intimacy and tender-
ness. La Tour reduces his forms to a geometric
simplicity that raises them above the every-
day world, despite their apparent realism.

Nicholas Poussin Why was La Tour so
quickly forgotten? The reason is simply that
classicism was supreme in France after the
1640s. The clarity, balance, and restraint
of La Tour's art might be termed classical,
especially when measured against other

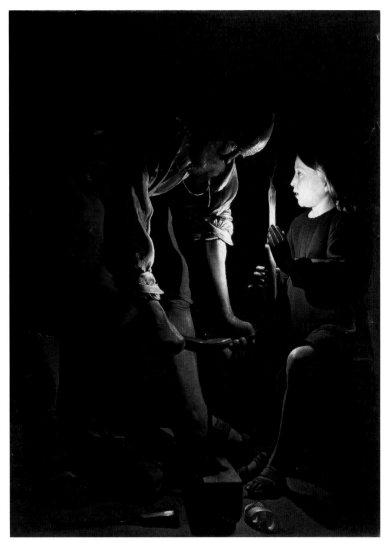

19-1 Georges de La Tour. *Joseph the Carpenter.* c. 1645. Oil on canvas, 51⅛ × 39¾″ (130 × 100 cm). Musée du Louvre, Paris

◻ Titus Livius, called LIVY (59 B.C.–A.D. 17), was a Roman historian whose *History of Rome* is a classic. He wrote 45 books, publishing them five at a time. The first ten books are semilegendary accounts of Rome's founding and early history; the rest are more factual, although colored by Livy's intention to show, through its history, that Rome was destined for greatness.

PLUTARCH (A.D. 46?–120), Greek essayist, moral philosopher, and biographer, is especially appreciated for his *Parallel Lives.* Composed of biographies of illustrious Greeks and Romans, the *Lives* are regarded as historically valid and were, in fact, the source that Shakespeare used for his Roman-history plays, among them *Antony and Cleopatra* and *Julius Caesar.*

Caravaggesque painters, but he was certainly not a classicist. The artist who did the most to bring about the rise of classicism was Nicolas Poussin (1593/4–1665), the greatest French painter of the century and the first French painter in history to win international fame. He nevertheless spent almost his entire career in Rome. There he developed the style that was to become the model for French painters of the second half of the century. At first Poussin was inspired by Titian's warm, rich colors and by his approach to classical mythology. Soon he fell under the spell of antiquity and Raphael. *The Abduction of the Sabine Women* (fig. 19-2) shows his allegiance to classicism. The painting exhibits the severe discipline of Poussin's intellectual style, which developed in response to

what he regarded as the excesses of the High Baroque (see pages 361-63). The strongly modeled figures are "frozen in action," like statues. Many are, in fact, taken from Hellenistic sculpture, but the main group is derived from Giovanni Bologna's *Abduction of the Sabine Woman* (see fig. 14-12). Poussin has placed them before reconstructions of Roman architecture that he believed to be archaeologically correct. The scene has a theatrical air, and with good reason. It was worked out by moving wax figurines around a miniature stagelike setting until it looked right to the artist. Emotion is abundantly displayed, but it is so lacking in spontaneity that it fails to touch us. The attitude reflected here is clearly Raphael's (see figs. 13-16 and 17). More accurately, it is Raphael as filtered through Annibale Carracci and his school (compare figs. 17-5 and 17-6). The Venetian qualities of his early career have been consciously suppressed.

Poussin now strikes us as an artist who knew his own mind only too well. This impression is confirmed by the numerous letters in which he stated his views to friends and patrons. The highest aim of painting, he believed, is to represent noble and serious human actions. This is true even in *The Abduction of the Sabine Women*, which depicts a subject that, ironically, was admired as an act of patriotism ensuring the future of Rome. (According to the accounts of LIVY and PLUTARCH, the SABINES were young women abducted as wives by the Romans who later became peacemakers between the two sides.) It is clear they do not go willingly as swords are drawn, babies are abandoned, and old people suffer. But Poussin's apparent coolness and lack of sympathy has labeled the work heroic (rather than crass). Poussin appealed to the mind rather than the senses, to suppress color and instead stress form and composition. He believed that, in a good picture, the viewer must be able to "read" the emotions of each figure and relate them to the story.

These ideas were not new. We recall Horace's motto *ut pictura poesis* and Leonardo's statement that the highest aim of painting is to depict "the intention of man's soul" (see page 281). Before Poussin, however, no one made the analogy between painting and literature so closely, or put it

into practice so single-mindedly. His method accounts for the cold rhetoric in *The Abduction of the Sabine Women*, which makes the picture seem so remote.

Claude Lorraine Like Poussin, the great French landscapist Claude Lorraine (1600–1682) spent almost his entire career in Rome. He explored the surrounding countryside, the Campagna, more thoroughly and affectionately than any Italian. Countless drawings made on the spot reveal his powers of observation. He also sketched in oils outdoors, the first artist known to have done so. Sketches, however, were only the raw material for his paintings. Claude's landscapes do not aim at topographic accuracy but evoke the poetic essence of a countryside filled with echoes of antiquity. In *A Pastoral Landscape* (fig. 19-3), the vista expands serenely and is imbued with the hazy, luminous atmosphere of late afternoon to bring out the idyllic aspects of nature. An air of nostalgia hangs over the scene, of past experience enhanced by memory.

Simon Vouet At an early age, Simon Vouet (1590–1649), too, went to Rome,

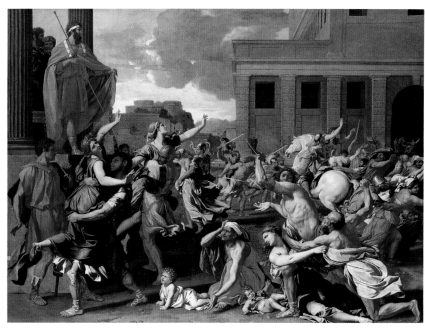

19-2 Nicolas Poussin. *The Abduction of the Sabine Women.* c. 1633–34. Oil on canvas, 5′7⅛″ × 6′10⅝″ (1.54 × 2.09 m). The Metropolitan Museum of Art, New York
Harris Brisbane Dick Fund, 1946

Although the abduction of the SABINE women by early Roman followers of Romulus is regarded as legendary, the Sabines were in fact an Italic people who moved from the mountains east of the Tiber River and settled on the hills that became the early city of Rome (see page 111).

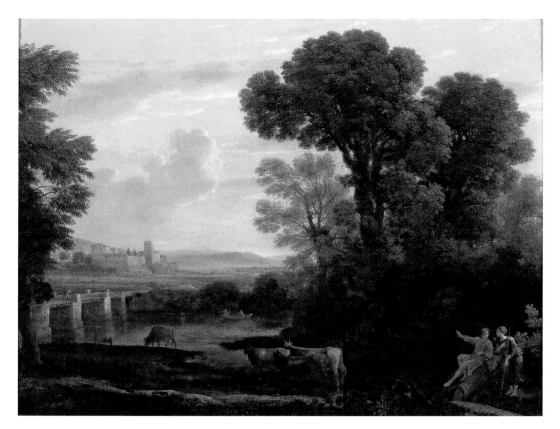

19-3 Claude Lorraine. *A Pastoral Landscape.* c. 1650. Oil on copper, 15½ × 21″ (39.3 × 53.3 cm). Yale University Art Gallery, New Haven, Connecticut
Leo C. Hanna, Jr., Fund

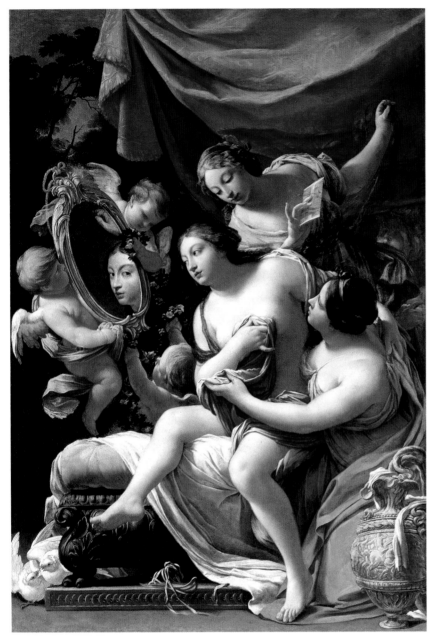

19-4 Simon Vouet. *The Toilet of Venus.* c. 1640. Oil on canvas, 65¼ × 45" (165.7 × 114.3 cm). The Carnegie Museum of Art, Pittsburgh

Gift of Mrs. Horace Binney Hare

fig. 14-7), but without her frank eroticism. Instead, she has been given an elegant sensuousness that is far removed from Poussin's disciplined art.

The Toilet of Venus was painted about 1640, toward the beginning of an ill-fated sojourn taken by Poussin to Paris, where he had gone at the invitation of Louis XIII. He met with no more success than Bernini was to have 20 years later (see pages 401 and 406). After several years Poussin left, deeply disillusioned by his experience at the court, whose taste and politics Vouet understood far better. In one sense, their rivalry was to continue long afterward. Vouet's decorative style was the basis for the Rococo, but it was Poussin's classicism that soon dominated art in France. The two traditions vied with each other through the Romantic era, alternating in succession without either gaining the upper hand for long.

THE ROYAL ACADEMY

When young Louis XIV took over the reins of government in 1661, Jean-Baptiste Colbert, his chief adviser, built the administrative apparatus to support the power of the ABSOLUTE MONARCH. In this system, aimed at subjecting the thoughts and actions of the entire nation to strict control from above, the visual arts had the task of glorifying the king. As in music and theater, which shared the same task, the official "royal style" was classicism. Centralized control over the visual arts was exerted by Colbert and by the artist Charles Lebrun (1619–1690), who became supervisor of all the king's artistic projects. As chief dispenser of royal art patronage, Lebrun had so much power that for all practical purposes he was the dictator of the arts in France. His authority extended beyond the power of the purse. It also included a new system of educating artists in the officially approved style.

Throughout antiquity and the Middle Ages, artists had been trained by apprenticeship, and this practice still prevailed in the Renaissance. As painting, sculpture, and architecture gained the status of liberal arts, artists wished to supplement their "mechanical" training with theoretical knowledge. For this purpose, art academies were founded,

■ The political system that gives rise to an ABSOLUTE MONARCH is absolutism, in which full, unlimited, and unchecked power to rule a nation is in the hands of a single individual (an absolute monarch) or a group of rulers (oligarchs). Absolutism emerged in Europe near the end of the fifteenth century and is most clearly embodied by the reign of Louis XIV of France.

where he became the leader of the French Caravaggesque painters. Unlike Poussin and Claude, who returned to France only briefly, he settled in Paris. There he quickly shed all traces of Caravaggio's manner and developed a colorful style based on Carracci's, which won such acclaim that Vouet was named First Painter to the king. He also brought with him memories of the great North Italian precursors of the Baroque. *The Toilet of Venus* (fig. 19-4) depicts a subject popular in Venice from Titian to Veronese. Vouet's figure also recalls Correggio's Io (see

patterned on the academies of the humanists. (The name *academy* is derived from the Athenian grove, dedicated to the legendary hero Akademos—Academus in Latin—where Plato met with his disciples.) Art academies appeared first in Italy in the later sixteenth century as an outgrowth of literary academies. They seem to have been private associations of artists who met to draw from the model and discuss questions of art theory. These academies later became formal institutions that took over some functions from the guilds, but their teaching was limited and far from systematic.

This was the case as well with the Royal Academy of Painting and Sculpture in Paris, founded in 1648. But when Lebrun became its director in 1663, he established a rigid curriculum of instruction in practice and theory based on a system of rules. This set the pattern for all later academies, including the art schools of today. Much of this doctrine was derived from Poussin, with whom Lebrun had studied for several years in Rome, but it was carried to rationalist extremes. The Academy even devised a method for giving numerical grades to artists past and present in such categories as drawing, expression, and proportion. The ancients received the highest marks, of course, then came Raphael and his school, and Poussin. The Venetians, who "overemphasized" color, ranked low, the Flemish and Dutch even lower. Subjects were also classified, from "history" (that is, narrative subjects, be they classical, biblical, or mythological) at the top to still life at the bottom.

Architecture in France

The foundations of Baroque classicism in architecture were laid by a group of designers who form a continuous tradition with the sixteenth century that is unique in the history of architecture. The classicism introduced by Lescot at the Louvre (see fig. 16-16) reached its height around the middle of the sixteenth century. The central position was occupied by the Du Cerceau family, which worked on the Louvre and other royal projects through the middle of the seventeenth century. However, the first French architect

of genius since Lescot was François Mansart (1598–1666). Apparently Mansart never visited Italy, but other French architects had already imported and adapted some aspects of the early Baroque. Chief among them was his rival, Jacques Lemercier (c. 1585–1654), whose works for Cardinal Richelieu, including the enlargement of the Square Court of the Louvre in 1624, are uninspired adaptations of earlier designs by Lescot and the Du Cerceaus. Mansart eventually lost ground to Lemercier in commissions for church architecture because of his difficult personality. Toward the end of his career, he was also supplanted in the field of hôtels (elegant town houses) and châteaux by the younger and more adaptable Louis Le Vau (1612–1670). Le Vau was part of a team, including Charles Lebrun and the landscape architect André Le Nôtre (1613–1700), that was called to the court by the king's minister Colbert in 1661.

The Louvre The climactic phase of French Baroque classicism, which may be compared with the heroic classicism of Poussin and the playwright Pierre Corneille, began with the first great project Colbert directed, the completion of the Louvre. Work on the palace had proceeded intermittently for over a century, along the lines of Lescot's design (see fig. 16-16). What remained to be done was to close the Square Court on the east side with an impressive facade. Colbert, however, was dissatisfied with the proposals of French architects, including Mansart, who submitted various designs not long before his death. He therefore invited Bernini to Paris in the hope that the most famous master of the Roman Baroque would do for the French king what he had already done for the Church. Bernini spent several months in Paris in 1665 and submitted three designs, all of them on a scale that would have dwarfed the existing palace. After much argument, Louis XIV rejected these plans and turned over the problem to a committee of three: Charles Lebrun, his court painter; Louis Le Vau, his court architect, who had already done much work on the Louvre; and Claude Perrault (1613–1688), who was an anatomist and student of ancient architecture, not a professional architect. All three were responsible for the structure that was

actually built (fig. 19-5), although Perrault is rightly credited with the major share. Certainly his supporters and detractors thought so at the time, and he was often called upon to defend its design.

The center pavilion is based on a Roman temple front, and the wings look like the flanks of that temple folded outward. The temple theme required a single order of free-standing columns, but the Louvre had three stories. This problem was solved by treating the ground story as the **podium** of the temple and recessing the upper two behind the screen of the colonnade. The colonnade itself was controversial in its use of paired columns, even though they were not needed for support.

The east front of the Louvre signaled the victory of French classicism over the Italian Baroque as the royal style. It further proclaimed France the new Rome, both politically and culturally, by linking Louis XIV with the glory of the Caesars. The design combines grandeur and elegance in a way that fully justifies its fame. In some ways it suggests the mind of an archaeologist, but one who knew how to choose those features of classical architecture that would be compatible with the older parts of the palace. This antiquarian approach was Perrault's main contribution.

Perrault owed his position to his brother, Charles Perrault (1628–1703), who, as Colbert's Master of Buildings under Louis XIV, had helped to undermine Bernini during his stay at the French court. It is likely that Claude shared the views set forth some 20 years later in Charles's *Parallels between the Ancients and Moderns*, which claimed "that Homer and Virgil made countless mistakes which the moderns no longer make [because] the ancients did not have all our rules." Thus the east front of the Louvre presents not simply a classical revival but a vigorous distillation of what Claude Perrault considered the eternal ideals of beauty, intended to surpass anything by the Romans themselves. Ironically, this great example proved to be too pure, and Perrault soon faded from favor.

The Palace of Versailles The king's largest enterprise was the Palace of Versailles, located 11 miles from the center of Paris. It was built by Louis XIV to prevent a repeat of the civil rebellion known as the Fronde, which occurred in 1648–53 during his

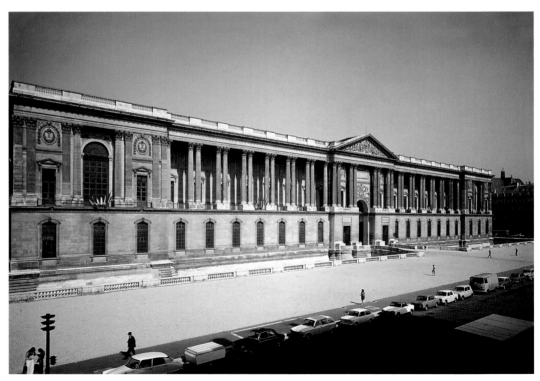

19-5 Claude Perrault. East front of the Louvre, Paris. 1667–70

minority, by forcing the aristocracy to live under royal control outside of Paris. Versailles was begun in 1669 by Le Vau, who designed the elevation of the garden front (fig. 19-6), but he died within a year. Under Jules Hardouin-Mansart (1646–1708), a great-nephew and pupil of François Mansart (see page 401), the project was greatly expanded to accommodate the ever-growing royal household. The garden front, intended by Le Vau to be the main view of the palace, was stretched to an enormous length with no change in the architectural elements. As a result, his original facade design, a less severe variant of the east front of the Louvre, looks repetitious and out of scale. The whole center block contains a single room, the famous Galerie des Glaces (Hall of Mirrors). At either end are the Salon de la Guerre (War) (fig. 19-7) and its counterpart, the Salon de la Paix (Peace).

Baroque features, although not officially acknowledged, reappeared inside the Palace of Versailles. This shift reflected the king's own taste. Louis XIV was interested less in architectural theory and monumental exteriors than in the lavish interiors that would make suitable settings for himself and his court. Thus the man to whom he really listened was not an architect but the painter Lebrun. Lebrun's goal was in itself Baroque: to subordinate all the arts to the glorification of Louis XIV. To achieve it, he drew freely on his memories of Rome. The great decorative schemes of the Baroque that he saw there must also have impressed him. They stood him in good stead 20 years later, both in the Louvre and at Versailles. Although a disciple of Poussin, he had studied first with Vouet and became a superb decorator. Lebrun employed architects, sculptors, painters, and decorators to create ensembles of unprecedented splendor. The Salon de la Guerre at Versailles (fig. 19-7) is close in many ways to the Cornaro Chapel (compare fig. 17-17), although Lebrun obviously emphasized surface decoration far more than did Bernini. As in so many Italian Baroque interiors, the separate components are less impressive than the effect of the whole.

Apart from the magnificent interior, the most impressive aspect of Versailles is the park extending west of the garden front for

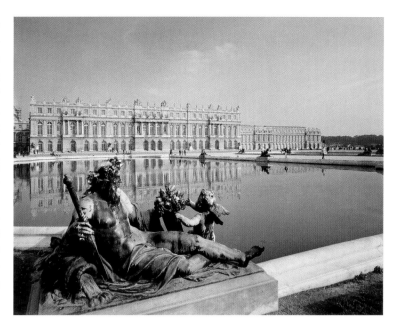

19-6 Louis Le Vau and Jules Hardouin-Mansart. Garden front of the center block of the Palace of Versailles. 1669–85

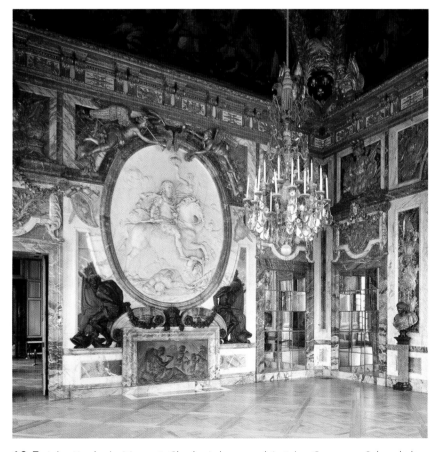

19-7 Jules Hardouin-Mansart, Charles Lebrun, and Antoine Coysevox. Salon de la Guerre, Palace of Versailles. Begun 1678

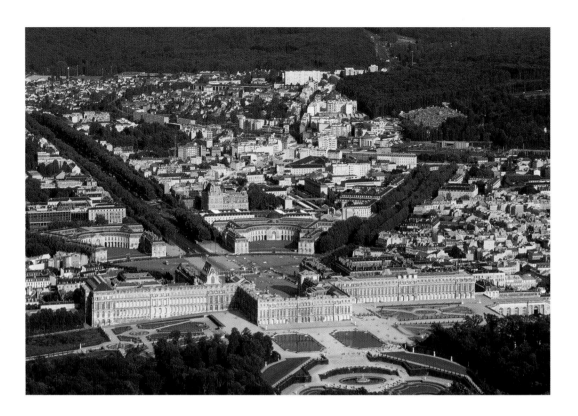

19-8 Aerial view of palace at Versailles, France

several miles (fig. 19-8). The design by Le Nôtre is so strictly correlated with the plan of the palace that it continues the architectural space. Like the interiors, these formal gardens, with their terraces, basins, clipped hedges, and statuary, were meant to provide a suitable setting for the king's appearances in public. They form a series of "outdoor rooms" for the splendid fêtes and spectacles that Louis XIV so enjoyed. The spirit of absolutism is even more striking in this geometric regularity imposed upon an entire countryside than it is in the palace itself. This kind of formal garden had its beginnings in Renaissance Florence but had never been used on the scale achieved by Le Nôtre at Versailles and elsewhere.

Jules Hardouin-Mansart At Versailles, Hardouin-Mansart worked as a member of a team, constrained by the design of Le Vau. His own style can be better seen in the Church of the Invalides (figs. 19-9, 19-10), named after the institution for disabled soldiers of which it was a part. The building combines Italian Renaissance and Baroque features, but they have been interpreted in a distinctly French manner that stretches back to the middle of the sixteenth century. The Invalides may be seen as Hardouin-Mansart's comment on seventeenth-century churches in Paris by Lemercier, Mansart, and Le Vau.

However, Hardouin-Mansart incorporated features found in his granduncle's design of 1665 for the Bourbon dynasty chapel at St-Denis. It may well be that the Invalides was intended to serve a similar purpose as Louis XIV's burial place.

In plan the Invalides consists of a Greek cross with four corner chapels. It is based (with various French intermediaries) on Michelangelo's plan for St. Peter's. The only Baroque element is the oval choir. The dome, too, reflects the influence of Michelangelo (see fig. 13-14), but it consists of three shells, not the usual two, and the classicistic facade recalls the east front of the Louvre. Nevertheless, the exterior as a whole is unmistakably Baroque. It breaks forward repeatedly in the crescendo effect introduced by Maderno (see fig. 17-9). And, as in Borromini's Sta. Agnese in Piazza Navona (see fig. 17-13), the facade and dome are closely linked.

The dome itself is the most original, as well as the most Baroque, feature of Hardouin-Mansart's design. Tall and slender, it rises in one continuous curve from the base of the drum to the spire atop the lantern. On the first drum rests a second, narrower drum. Its windows provide light for the painting inside the dome. The windows themselves are hidden behind a "pseudo-shell" with a large opening at the top, so that the vision of heavenly

19-9 Jules Hardouin-Mansart. Church of the Invalides, Paris. 1680–91

19-10 Plan of the Church of the Invalides, both elevation and floor plan

glory seems to be mysteriously illuminated and suspended in space. The bold "theatrical" lighting of the Invalides would do honor to any Italian Baroque architect.

Sculpture in France

Sculpture arrived at the official royal style in much the same way as architecture. While in Paris, Bernini carved a marble bust of Louis XIV. He was also commissioned to do an equestrian statue of the king, for which he made a terra-cotta model. However, the project shared the fate of Bernini's Louvre designs. Although he portrayed the king in classical military garb, the statue was rejected. Apparently the rearing horse, derived from Leonardo, was too dynamic to safeguard the dignity of Louis XIV. This decision was far-reaching. Equestrian statues of the king were later set up throughout France as symbols of royal authority. Bernini's design, had it succeeded, might have set the pattern for these monuments. Adopted instead was a timid variation on the equestrian portrait of Marcus Aurelius (see fig. 7-13) executed in the 1680s by François Girardon (1628–1715), which was destroyed during the French Revolution.

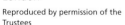
19-11 Antoine Coysevox. *Charles Lebrun.* 1676. Terracotta, height 26" (66 cm). The Wallace Collection, London

Antoine Coysevox Bernini's influence can nevertheless be felt in the work of Antoine Coysevox (1640–1720), one of the sculptors Lebrun employed at Versailles. The victorious Louis XIV in Coysevox's large stucco relief for the Salon de la Guerre (see fig. 19-7) retains the pose of Bernini's equestrian statue, although with a certain restraint. Coysevox is the first of a long line of distinguished French portrait sculptors. His vivacious terra-cotta portrait of Lebrun (fig. 19-11) with open-mouth, head turned to the side and drapery folded over itself below the shoulder line repeats the general outlines of Bernini's bust of Louis XIV. The face, however, shows a realism and subtlety of characterization that are Coysevox's own.

Pierre Puget Coysevox approached the Baroque in sculpture as closely as Lebrun would permit. Pierre-Paul Puget (1620–1694), the most talented and most Baroque of seventeenth-century French sculptors, had no success at court until after Colbert's death, when Lebrun's power was on the decline. *Milo of Crotona* (fig. 19-12), Puget's finest statue, can be compared to Bernini's *David* (see fig. 17-15). Puget's composition is more contained than Bernini's, but the agony of the hero attacked by a lion, while his hand is trapped in a tree stump has such force that its impact is almost physical. The lion's paw digs deep into the thigh of Milo as he cries out in agony and twists in space as the creature claws him from behind. The internal tension fills the statue with an intense life that also recalls Hellenistic sculpture (see fig. 5-27). That, one suspects, is what made it acceptable to Louis XIV.

England

The English contributed little to the development of Baroque painting and sculpture. Their achievement in architecture, however, was of genuine importance. This accomplishment is all the more surprising in light of the fact that the Late Gothic Perpendicular style (see fig. 11-11) proved extraordinarily durable in England, which did not produce any buildings of note until Elizabethan times.

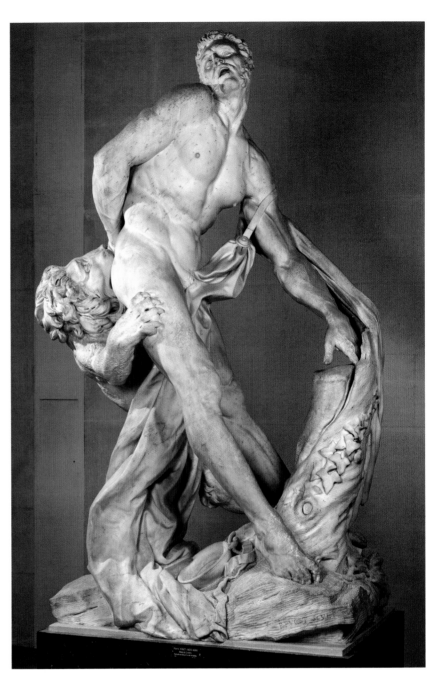

19-12 Pierre-Paul Puget. *Milo of Crotona.* 1671–83. Marble, height 8′10¹/₂″ (2.71 m). Musée du Louvre, Paris

Inigo Jones The first English architect of genius was Inigo Jones (1573–1652), also the leading English theatrical designer of the day. When he went to Italy about 1600 and again in 1613, he was influenced by the Baroque stage designs of Giulio Parigi; surprisingly, he returned a disciple of Palladio. In 1615 Jones was appointed Surveyor of the King's Works, a post he held until 1643. The Banqueting House he built at Whitehall Palace in London (fig. 19-13) for the masques (forms of dance, pantomime, theater, and music-making) and other entertainments he presented at the court conforms in every way to the principles in Palladio's treatise, although it does not copy any specific design. It is essentially a Vitruvian "basilica" (a double-cube with an **apse** for the king's throne) treated as a Palladian villa. Symmetrical and self-sufficient, it is more like a Renaissance palazzo than any other building north of the Alps designed at that time. Jones's spare style, supported by Palladio's authority as a theorist, stood as a beacon of classicist orthodoxy in England for 200 years.

Christopher Wren This classicism can be seen in some parts of St. Paul's Cathedral (fig. 19-14) by Sir Christopher Wren (1632–1723), who was the great English architect of the late seventeenth century. St. Paul's is in other ways an up-to-date Baroque design that reflects a thorough knowledge of the Italian and French architecture of the day. Wren came close to being a Baroque counterpart of the Renaissance artist-scientist. An intellectual prodigy, he first studied anatomy, then physics, mathematics, and astronomy, and was highly esteemed by Sir Isaac Newton. His serious interest in architecture did not begin until he was about 30. Yet it is typical of the Baroque as opposed to the Renaissance that there seems to be no

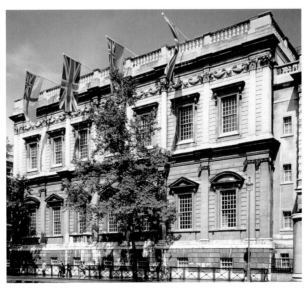

19-13 Inigo Jones. West front of the Banqueting House, Whitehall Palace, London. 1619–22

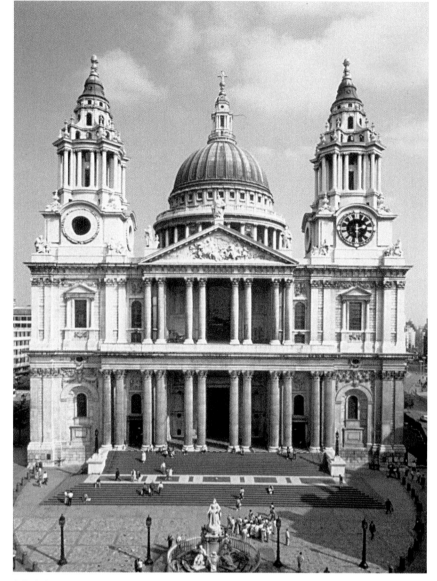

19-14 Sir Christopher Wren. Facade of St. Paul's Cathedral, London. 1675–1710

plan churches and originally conceived St. Paul's in the shape of a Greek cross, based on Michelangelo's plan of St. Peter's, with a huge domed crossing. This idea was evidently inspired by a design by Inigo Jones, who had been involved with the restoration of the Gothic St. Paul's earlier in the century. Wren's proposal was nevertheless rejected by church authorities as "papist" in favor of a conventional basilica, which was deemed more suitable for a Protestant structure.

The tradition of Inigo Jones provided no more than a starting point for Wren. On his only trip abroad in 1665–66, Wren had visited Paris at the time of the dispute over the completion of the Louvre. He must have sided with Perrault, whose design for the east front is clearly reflected in the facade of St. Paul's. St. Paul's also bears a striking resemblance to Hardouin-Mansart's Church of the Invalides (see figs. 19-9 and 19-10), which inspired the tripartite construction of the dome. Despite his belief that Paris provided "the best school of architecture in Europe," Wren was affected by the Roman Baroque. He must have wanted the new St. Paul's to be the St. Peter's of the Church of England: soberer and not so large, but just as impressive. His dome, like that of St. Peter's, has a diameter as wide as the nave and aisles combined, but it rises high above the rest of the structure and dominates even our close view of the facade. Wren ingeniously hid the buttresses supporting the dome behind a thick wall, which further helps to brace them. The lantern and the upper part of the clock towers suggest that he knew Borromini's Sta. Agnese in Piazza Navona (see fig. 17-13), probably from drawings or engravings. It is ironic that St. Paul's, certainly reminiscent of St. Peter's down to the Latin-cross plan, missed the opportunity to display a new Protestant architecture. The final result reflects not only the complex evolution of the design but also some needless changes made late in the construction by the commission overseeing it, which dismissed Wren in 1718.

The GREAT LONDON FIRE OF 1666 lasted for five days in September and destroyed four-fifths of the city, although miraculously only 16 people lost their lives. The noted English writer Samuel Pepys gives a graphic eyewitness account of the disaster in his diary. To help rebuild London, Sir Christopher Wren designed more than 51 new churches, including St. Paul's Cathedral.

direct link between his scientific and artistic ideas. It is hard to determine whether his technological knowledge affected the shape of his buildings.

If the GREAT LONDON FIRE OF 1666 had not destroyed the Gothic cathedral of St. Paul and many lesser churches, Wren might have remained an amateur architect. But after that catastrophe, he was named to the short-lived royal commission for rebuilding the city, and a few years later began his designs for St. Paul's. Wren favored **central-**

The Rococo

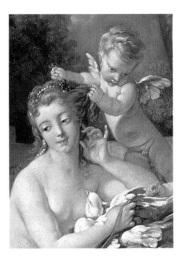

MUCH AS THE BAROQUE IS OFTEN CONSIDERED THE FINAL phase of the Renaissance, so the Rococo has been treated as the end of the Baroque: a long twilight, delicious but decadent, that was cleaned away by the Enlightenment and neoclassicism. In France the Rococo is linked with Louis XV because it roughly corresponds to his life span (1710–1774). However, it cannot be identified with the State or the Church any more than can the Baroque, even though they continued to provide the main patronage. The essential characteristics of Rococo style were defined largely during the regency phase of Louis XV's reign (1715–23), though, its first signs appeared as much as 50 years earlier, during the Late Baroque. Hence the view of the Rococo as the final phase of the Baroque is well founded. As Louis XV's contemporary, the philosopher Voltaire pointed out, the eighteenth century lived in debt to the past. In art Poussin and Rubens cast their long shadows over the period. The controversy between their partisans, in turn, goes back much further to the debate between the supporters of Michelangelo and of Titian over the merits of design versus color. In this sense, the Rococo, like the Baroque, still belongs to the Renaissance world.

Nevertheless a fundamental difference exists between the Rococo and the Baroque. What is it? In a word, it is fantasy. If the Baroque presents theater on a grand scale, the Rococo stage is smaller and more intimate. At the same time, the Rococo is both more lighthearted and tender-minded, marked equally by playful whimsy and wistful nostalgia. Its artifice evokes an enchanted realm that presents a diversion from real life. Because the modern age is the product of the Enlightenment, the Rococo is still often criticized for its unabashed escapism and eroticism. To its credit, however, the Rococo celebrated the world of love and broadened the range of human emotion in art to include the family as a major theme.

France

The Rise of the Rococo After the death of Louis XIV in 1715, the administrative machine that Colbert had created ground to a stop (see page 400). The nobility, formerly attached to the court at Versailles, were now freer from royal control. Many of them chose not to return to their châteaux in the provinces but to live in Paris, where they built elegant town houses, known as hôtels. Hôtels had been used as city residences by the landed aristocracy since about 1350, but during the seventeenth century they developed into social centers. As state-sponsored building activity was declining, the field of "design for private living" took on new importance. These city sites were usually cramped and irregular, so that they offered few opportunities for impressive exteriors. Hence the layout and decor of the rooms became the architects' main concern. The hôtels demanded an intimate style of interior decoration that would give full scope to individual fancy, uninhibited by the classicistic rules seen at Versailles. To meet this need, French designers created the Rococo from Italian gardens and interiors. The name fits

PAINTING

"Poussinistes" versus "Rubénistes"

It is hardly surprising that the strict system of the French Academy did not produce any major artists. Even Charles Lebrun, as we have seen, was far more Baroque in practice than we would expect from his classicistic theory. The rigidity of the official doctrine gave rise to a reaction that vented itself as soon as Lebrun's authority began to wane. Toward the end of the century, the members of the Academy formed two factions: the "Poussinistes" against the "Rubénistes." Neither Poussin nor Rubens was still alive during this dispute, which focused on the issue of drawing versus color. The French knew Poussin's paintings that had been sent from Rome to Paris through his life and knew Rubens's work from the Marie de Medici cycle in the Luxembourg Palace. The conservatives defended Poussin's view that drawing, which appealed to the mind, was superior to color, which appealed to the senses. The Rubénistes (many of whom were of Flemish descent) favored color, rather than drawing, as being more true to nature. They also pointed out that drawing, admittedly based on reason, appeals only to the expert few, whereas color appeals to everyone. This argument had important implications. It claimed that the layperson should be the judge of artistic values and challenged the Renaissance notion that painting, as a liberal art, could be appreciated only by the educated mind.

Antoine Watteau

By the time Louis XIV died, the power of the Academy had long been overcome, and the influence of Rubens and the great Venetians was everywhere. The greatest of the Rubénistes was Jean-Antoine Watteau (1684–1721), the only painter of the Rococo who can be considered a genius without reservation. His paintings broke many academic rules, and his subjects did not conform to any established category. To make room for Watteau, the Academy invented the new category of *fêtes galantes* (elegant fêtes or entertainments). The term refers to the fact that his work mainly shows scenes of fashionable people or COMMEDIA DELL'ARTE actors in park-like settings. His pictures often interweave theater and real life, so that no clear distinction can be made between the two.

A Pilgrimage to Cythera, (Fig. 20-3) painted as Watteau's reception piece for the Academy, is an evocation of love that includes elements of classical mythology. Accompanied by swarms of cupids, young couples have come to Cythera, the island of love, to

20-3 Jean-Antoine Watteau. *A Pilgrimage to Cythera.* 1717. Oil on canvas, 4'3" × 6'4½" (1.29 × 1.94 m). Musée du Louvre, Paris

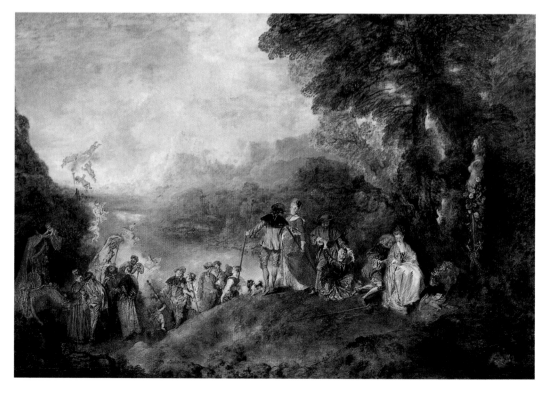

pay homage to Venus, whose garlanded image appears on the far right. The action unfolds in the foreground from right to left, like a continuous narrative, which tells us that they are about to board the boat. Two lovers are still engaged in their amorous tryst; behind them, another couple rises to follow a third pair down the hill as the reluctant young woman casts a longing look back at the goddess's sacred grove.

As a fashionable conversation piece, the scene recalls Rubens's *Garden of Love* (compare fig. 18-4), but Watteau has added a touch of poignancy that lends it a poetic subtlety reminiscent of Giorgione and Titian (see figs. 13-19 and 13-20). Slim and graceful, they move with the assurance of actors who play their roles so well that they touch us more than reality ever could. They recapture an earlier ideal of mannered elegance.

François Boucher The work of Watteau signals the decisive shift in French art to the Rococo. Although the term originally applied to the decorative arts, it suits the playful character of French painting before 1765 equally well. By about 1720 even HISTORY PAINTING became intimate in scale and ebullient in style and subject. The finest painter in this vein was François Boucher (1703–1770), who epitomized the age of MADAME DE POMPADOUR, the mistress of Louis XV. *The Toilet of Venus* (fig. 20-4), which was painted for her private retreat, is full of silk and perfume. Compared with Vouet's sensuous goddess (see fig. 19-4), from which she is descended, Boucher's Venus has been transformed into a coquette of enchanting beauty. In this cosmetic never-never land, she is an eternally youthful goddess with the same rosy skin as the cherubs who attend her. If Watteau elevated human love to the level of mythology, Boucher raised playful eroticism to the realm of the divine. What Boucher lacks in the emotional depth of Watteau, he makes up for in his understanding of the fantasies that enrich people's lives.

Jean-Honoré Fragonard Making fantasy become reality in paint was the great strength of Jean-Honoré Fragonard (1732–1806)—or certainly that was the reputation of Boucher's star pupil. Fantasy, flirtation, and sexual abandon—the spirit of Rococo—all come together in the painting *The Swing*

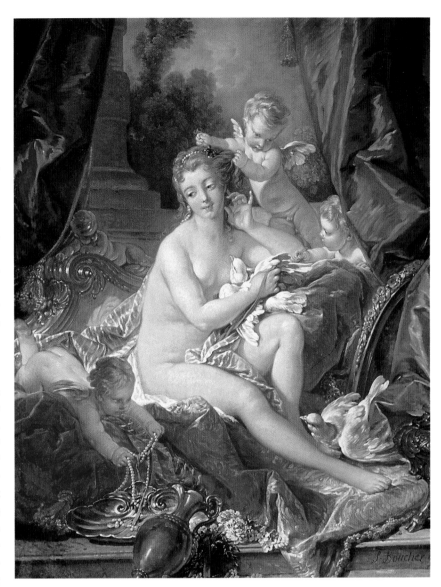

20-4 François Boucher. *The Toilet of Venus.* 1751. Oil on canvas, 43 × 33½" (109.2 × 85.1 cm). The Metropolitan Museum of Art, New York
Bequest of William K. Vanderbilt

(fig. 20-5) and the anecdote about it that has come down to us. Another artist, Gabriel-François Dogin, was approached by the Baron de Saint-Julien to paint his mistress "on a swing which a bishop is setting in motion. You will place me in a position in which I can see the legs of the lovely child. . . ." Dogin suggests that he make the slippers fly off her feet, but also declined the commission and directed it to Fragonard.

The painting suggests an alliance between aristocracy and clergy in secrets and erotic fantasy. This painting of sexual suggestion—not unlike Boucher's *Toilet of Venus* (fig. 20-4) in type, but with all the thrill of sexual openness, is set outdoors. The innocence of the public arena would only

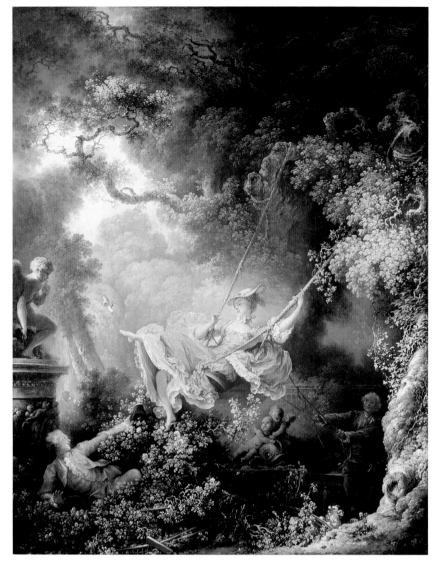

20-5 Jean-Honoré Fragonard. *The Swing.* c. 1768. Oil on canvas, 32²/₃″ × 26″ (82.9 × 66.0 cm.), Wallace Collection, London

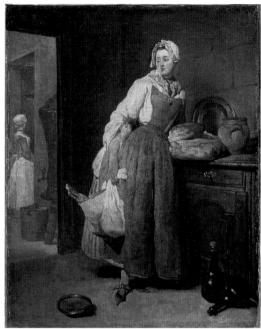

20-6 Jean-Baptiste-Siméon Chardin. *Back from the Market.* 1739. Oil on canvas, 18½ × 14³/₄″ (47 × 37.5 cm). Musée du Louvre, Paris

heighten the teasing quality of the motion of the swing, which would approach and withdraw from the patron-viewer. The painted sculpture of a cupid to the left with a finger to his lips, suggests the conspiracy of all parties to the erotic escapade. Fragonard used painted sculpture in many of his works to echo or heighten their themes.

Fragonard's paintings range from such erotic fantasies to intimate studies and pastoral landscapes, but all marked by the extraordinary virtuosity that made him the finest painter of his generation. He had the misfortune to outlive his era. His pictures became outdated as the French Revolution approached, and he was reduced to poverty after 1789. Later, he was supported only by a curatorship to which he was appointed in 1793 by Jacques-Louis David, who recognized his achievement, although their styles were diametrically opposed. He died virtually forgotten, in the heyday of the Napoleonic era.

Jean Chardin The Rubénistes had cleared the way for a renewed interest in still-life and genre paintings by Dutch and Flemish masters. This revival was spurred by the presence of numerous artists from the Netherlands (and especially from Flanders), who settled in France in growing numbers after about 1550 but maintained ties to their native lands, and by the sale of Dutch paintings in French auction houses. Jean-Baptiste-Siméon Chardin (1699– 1779) is the finest French painter in this vein. Yet he is far removed in spirit and style, if not in subject matter, from any Dutch or Flemish painter. His paintings act as moral lessons, not by conveying symbolic messages as Baroque art often does but by affirming the rightness of the existing social order and its values. To the rising middle class who were the artist's patrons, his genre scenes and kitchen still lifes proclaimed the virtues of hard work, frugality, honesty, and devotion to family.

Back from the Market (fig. 20-6) shows life in a Parisian middle-class household. Here we find such feeling for the beauty hidden in everyday life, and so clear a sense of spatial order, that we can compare him only to Vermeer (see fig. 18-19). However, Chardin's technique is quite unlike any Dutch artist's. His brushwork renders the light on colored surfaces with a creamy touch that is both analytical and lyrical. To reveal the inner nature of things, he summarizes forms, and subtly alters their appearance and texture, rather than describing them in detail. Chardin's genius discovered a hidden poetry in even the most humble objects and endowed them with timeless dignity. His many still lifes avoid the sensuous appeal of their Dutch predecessors. In *Back from the Market*, he treats the platter, bottles, and earthenware pot with a respect close to reverence. Beyond their shapes, colors, and textures, they are to him symbols of the life of common people.

His *Blowing Bubbles* (fig. 20-7) is very much an outgrowth of Dutch genre painting and the vanitas symbols frequently seen in still life. The bubble, only alive for a moment, will burst, and this symbol of the brevity of life is its underlying theme. The triangular shape of the boy leaning on the ledge gives stability to the painting as the lines of sight of both figures engage the viewer in the watching the bubble and awaiting its pop. And the glass of soap at the left is given prominence by the crack in the stone ledge, which separates it from the boy. The endearing way in which this story is told to us—two children, one showing the other (and the smaller one barely able to peer over the window sill to see this magical creation) is frequently a theme in Chardin's work. Children, really young adolescents, are frequently seen at play—in cards or ball. The subject of blowing bubbles must have been popular as there are three known versions and an engraving after it.

England

Across the English Channel, the Venetians were the dominant artists for more than a half-century (see page 421). However, the French Rococo had a major, though unacknowledged, effect. In fact, it helped to bring about the first school of English painting since the Middle Ages that had more than local importance.

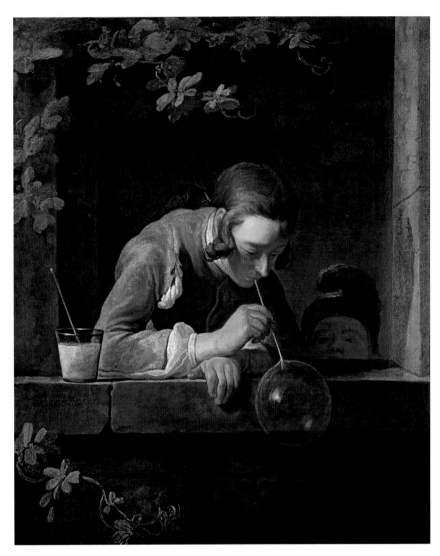

20-7 Jean-Baptiste-Siméon Chardin. *Blowing Bubbles.* c. 1745. Oil on canvas, 36⅝ × 29⅜″ (93 × 74.6 cm.). The National Gallery of Art, Washington, D.C.
Gift of Mrs. John Simpson

William Hogarth The earliest of these painters, William Hogarth (1697–1764), a natural-born satirist, began as an engraver and soon took up painting. Although he must have learned something about color and brushwork from Venetian and French examples, as well as Van Dyck, his work is so original that it has no real precedent. He made his mark in the 1730s with a new kind of picture, which he described as "modern moral subjects . . . similar to representations on the stage." It follows the vogue for sentimental comedies, such as those by Richard Steele, which sought to teach moral lessons through satire. In the same vein is John Gay's *Beggar's Opera* of 1728, a social and political satire that Hogarth illustrated in one of his paintings. Hogarth wished to be judged as a dramatist, he said, even though

his "actors" could only "exhibit a dumb show." These pictures, and the prints he made from them for sale to the public, came in sets, with certain details repeated in each scene to unify the sequence. Hogarth's "morality plays" teach, by bad example, the solid middle-class virtues. They show a country girl who succumbs to the temptations of fashionable London; the evils of corrupt elections; and aristocratic rakes who live only for pleasure and marry wealthy women of lower status for their fortunes, which they soon dissipate. Hogarth is probably the first artist in history to become a social critic in his own right.

In *The Orgy* (fig. 20-8), from *The Rake's Progress*, the young wastrel is overindulging in wine and women. It is set in a famous London brothel, The Rose Tavern. The girl adjusting her shoe in the foreground is preparing for a vulgar dance involving the silver plate and candle behind her; to the left a chamber pot spills its contents over a chicken dish; and in the background a singer holds sheet music for a coarse song of the day. (The rogue is later arrested for debt, enters into a marriage of convenience, turns to gambling, goes to debtor's prison, and dies in an insane asylum.) The scene is so full of visual clues that a full account would take pages, as well as constant references to other plates in the series. However literal-minded, the picture has great appeal. Hogarth combines some of Watteau's sparkle with Jan Steen's narrative gusto (compare figs. 20-3 and 18-17) and entertains us so well that we enjoy his sermon without being overwhelmed by its message.

Thomas Gainsborough Portraiture remained the only constant source of income for English painters. Hogarth was a pioneer in this field as well. The greatest master, however, was Thomas Gainsborough (1727–1788), who began by painting landscapes but ended as the favorite portraitist of British high society. He spent most of his career working in the provinces, first in his native Suffolk, then in the resort town of Bath. Toward the end of his career, Gainsborough moved to London, where his work

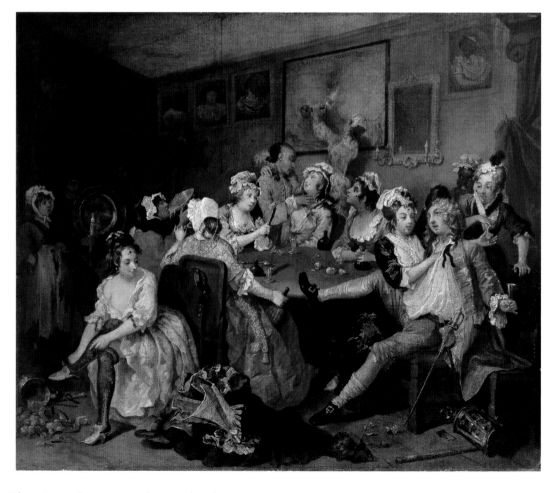

20-8 William Hogarth. *The Orgy, Scene III of The Rake's Progress.* c. 1734. Oil on canvas, 24½ × 29½" (62.2 × 74.9 cm). Sir John Soane's Museum, London

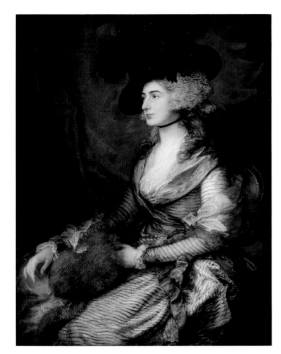

20-9 Thomas Gainsborough. *Mrs. Siddons* 1785. Oil on canvas, 49½ × 39" (125.7 × 99.1 cm). The National Gallery, London

underwent a major change. The splendid portrait of the famous actress Mrs. (Sarah) Siddons (1755–1831, fig. 20-9) has the virtues of the artist's late style: a cool elegance that translates Van Dyck's aristocratic poses into late-eighteenth-century terms, and a fluid, translucent technique reminiscent of Rubens's that renders the glamorous sitter, with her fashionable attire and coiffure, to ravishing effect.

Joshua Reynolds Gainsborough painted Mrs. Siddons to outdo his great rival on the London scene, Sir Joshua Reynolds (1723–1792), who had portrayed her as the Tragic Muse (fig. 20-10).

A less able painter, Reynolds had to rely on pose and expression to suggest the aura of character that Gainsborough was able to convey through color and brushwork alone. Reynolds, who had been president of the Royal Academy since its founding in 1768, championed the academic approach to art, which he had acquired during two years in Rome. In his *Discourses*, delivered at the Academy, he set forth what he considered necessary rules and theories. His views were essentially those of Lebrun, tempered by

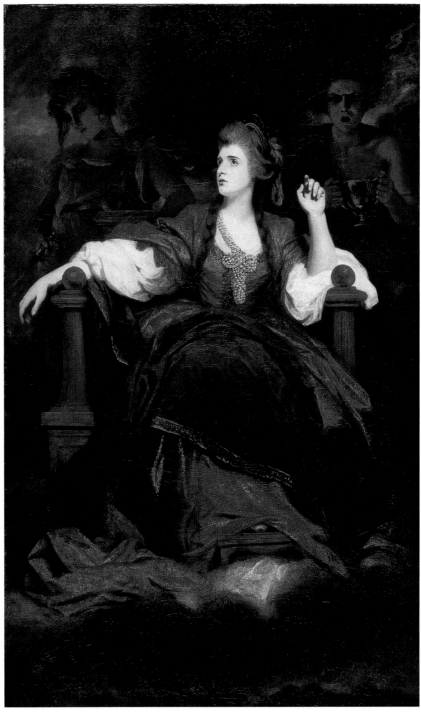

20-10 Sir Joshua Reynolds. *Mrs. Siddons as the Tragic Muse.* 1784. Oil on canvas, 7'9" × 4'9½" (2.36 × 1.46 m). Henry E. Huntington Library and Art Gallery, San Marino, California

British common sense, and like Lebrun, he found it difficult to live up to his theories in practice. Although he preferred history painting in the grand style, most of his works are portraits ennobled by allegorical additions or disguises like those in his picture of Mrs. Siddons. His style owed a good deal more to the Venetians, the Flemish Baroque, and even

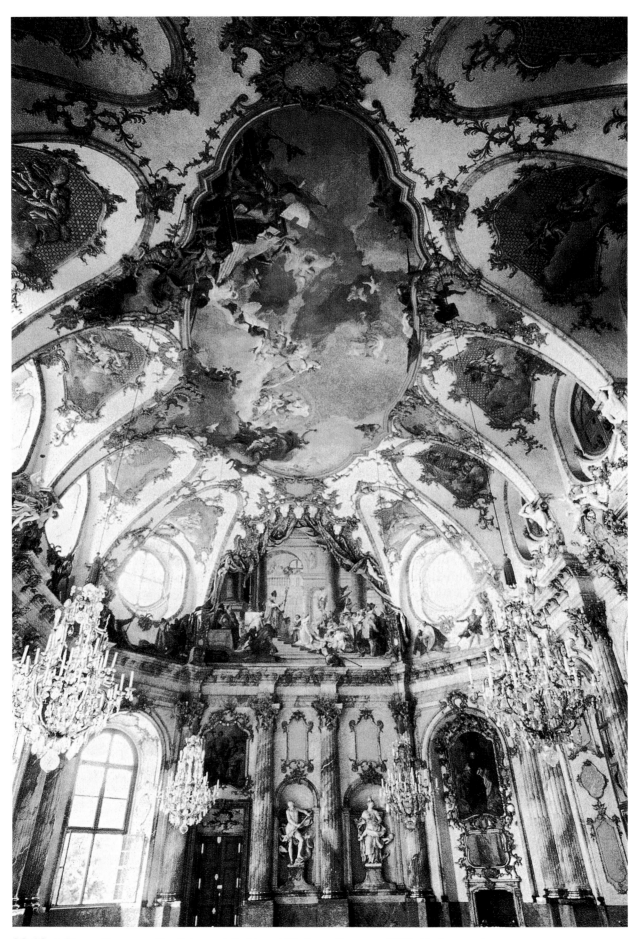

20-12 Balthasar Neumann. The Kaisersaal, Residenz, Würzburg, Germany. 1719–44. Frescoes by Giovanni Battista Tiepolo, 1751

grace of the stucco sculpture give the Kaisersaal an airy lightness far removed from the Roman Baroque. The vaults and walls seem thin and pliable, like membranes easily punctured by the expansive power of space.

Italy

Just as the style of architecture invented in Italy achieved its climax north of the Alps, much of the Italian Rococo took place in other countries. The timid style of the Late Baroque in Italy was transformed during the first decade of the eighteenth century by the rise of the Rococo in Venice, which had been an artistic backwater for a hundred years. The Italian Rococo is distinguished from the Baroque by a revived appreciation of Veronese's colorism and pageantry, but with an airy sensibility that is new. The first artist to formulate this style was Sebastiano Ricci (1659–1734), who began his career as a stage painter and became an important artist only in midcareer. His skill at blending a Venetian painterly manner with High Baroque illusionism made Ricci and his later followers the leading decorative painters in Europe between 1710 and 1760. The Venetians were active in every major center throughout Europe, especially London and Madrid. They were not alone: many artists from Rome and other parts of Italy also worked abroad.

Giovanni Battista Tiepolo The last and most refined stage of Italian illusionistic ceiling decoration can be seen in the works of Giovanni Battista Tiepolo (1696–1770). In his command of light and color, his grace and masterful touch, and his power of invention, Tiepolo easily surpassed his fellow Venetians. These qualities made him famous far beyond his home territory. When Tiepolo painted the Würzburg frescoes (see fig. 20-12), his powers were at their height. The tissuelike ceiling so often gives way to illusionistic openings, both painted and sculpted, that we no longer feel it to be a spatial boundary. These openings do not, however, reveal avalanches of figures propelled by dramatic bursts of light, like those of Roman ceilings (compare fig. 17-8). Rather, we see blue sky and sunlit clouds, and an occasional winged creature soaring in this limitless expanse. Only along the edges of the ceiling are there solid clusters of figures.

At one end, replacing a window, is *The Marriage of Frederick Barbarossa*. As a public spectacle, it is as festive as *Christ in the House of Levi* (see fig. 14-8) by Veronese. The artist has followed Veronese's example by putting the event (which took place in the twelfth century) in a contemporary setting. Its allegorical fantasy is literally revealed by the carved putti opening a gilt-stucco curtain onto the wedding ceremony. The result is a display of theatrical illusionism worthy of Bernini. Unexpected in this lively procession is the element of classicism, which gives an air of noble restraint to the main figures in keeping with the solemnity of the occasion.

Tiepolo later became the last in the line of Italian artists who were invited to work at the Royal Palace in Madrid. There he encountered the German painter Anton Raphael Mengs, a champion of the classical revival whose presence signaled the end of the Rococo.

Canaletto During the eighteenth century, landscape in Italy evolved a new form in keeping with the character of the Rococo: **veduta** (view) painting. Its beginnings can be traced back to the seventeenth century with the many foreigners, such as Claude Lorraine (see fig. 19-3), who specialized in depicting Rome's environs. After 1720, however, it took on a specifically urban identity. The most famous of the vedutists was Canaletto (Giovanni Antonio Canal, 1697–1768) of Venice. His pictures were great favorites with the British, who brought them home as souvenirs from "The Grand Tour" often taken by young men following their schooling. Canaletto himself became one of several Venetian artists to spend long sojourns in London. *The Bucintoro at the Molo* (fig. 20-13) was one of a series of paintings commissioned by Joseph Smith, an English entrepreneur living in Venice. It shows a favorite subject: the doge returning on his magnificent barge to the Piazza San Marco from the Lido (the city's island beach) on Ascension Day after celebrating the Marriage of the Sea. Canaletto has captured the festive air surrounding this great public celebration, which is presented as a brilliant theatrical display.

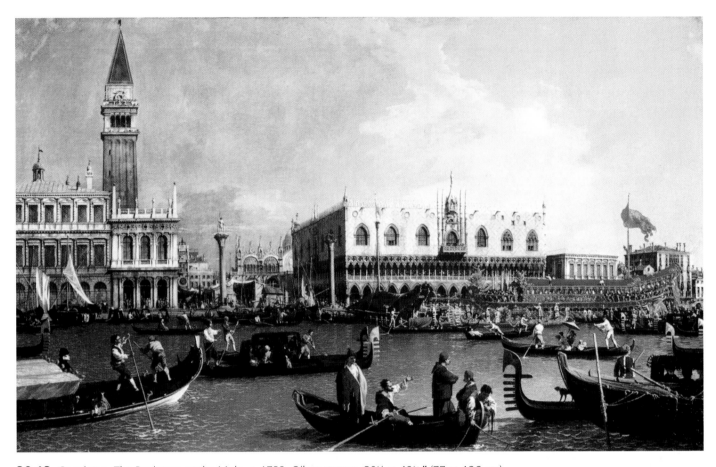

20-13 Canaletto. *The Bucintoro at the Molo.* c. 1732. Oil on canvas, 30¼ × 49½" (77 × 126 cm).
The Royal Collection
©1993 Her Majesty Queen Elizabeth II

Canaletto's landscapes are, for the most part, topographically accurate. Yet he was not above tampering with the truth. While he usually made only slight adjustments for the sake of the composition, he would sometimes treat scenes with considerable freedom or create composite views. He may have used a mechanical or optical device (perhaps a **camera obscura**, a forerunner of the photographic camera) to render some of his views, although he was a skilled draftsman who hardly needed such aids. However, the liveliness and sparkle of his pictures, as well as his sure sense of composition, sprang in large part from his training as a scenographer (stage set designer). As in *The Bucintoro at the Molo,* he often included vignettes of daily life in Venice that lend a human interest to his scenes and make them fascinating cultural documents.

Giovanni Battista Piranesi Canaletto shared his background as a designer of stage sets with Ricci (see above) and with Giovanni Paolo Panini (1691–1765), his fellow vedutist in Rome who had a passion for classical antiquity (see fig. 7-7). They, in turn, are the forerunners of another Roman artist, Giovanni Battista Piranesi (1720–1778), whose *Prison Caprices* (fig. 20-14) are rooted in contemporary designs for theater and opera. Unlike the prints after Canaletto's paintings, these masterly etchings were conceived as original works of art from the beginning, so that they have a gripping power. In Piranesi's imagery, the play between reality and fantasy, so fundamental to the theatrical Rococo, has been transformed into a romanticized vision of despair as terrifying as any nightmare. His bold imagination appealed greatly to many artists of the next generation, on whom he exercised a decisive influence.

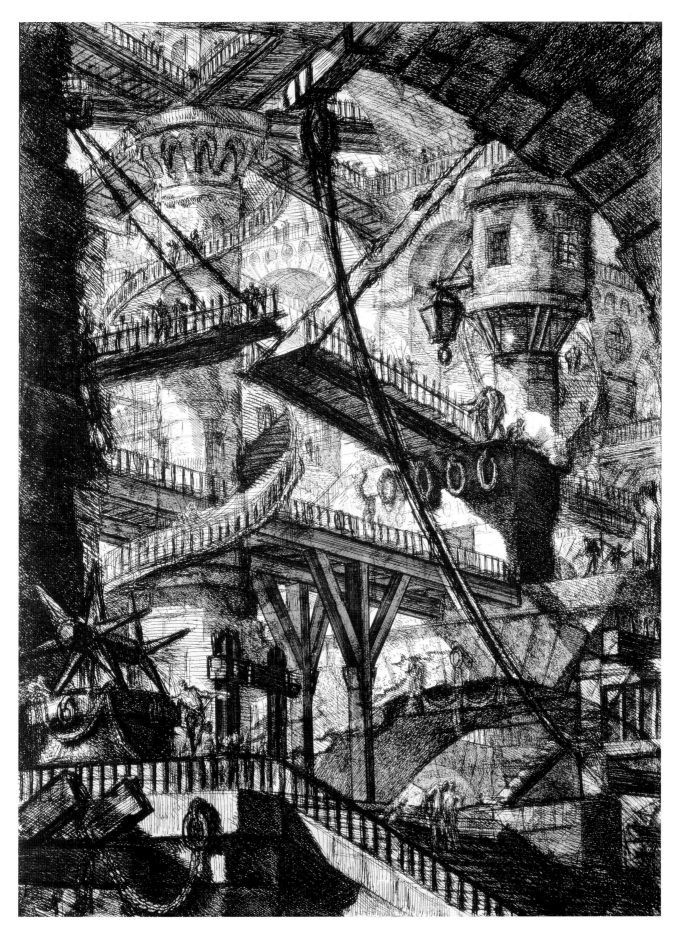

20-14 Giovanni Battista Piranesi. *Tower with Bridges, from Prison Caprices.* 1760–61. Etching, 21¾ × 16⅜″ (55.2 × 41.6 cm). The Metropolitan Museum of Art, New York

Rogers Fund

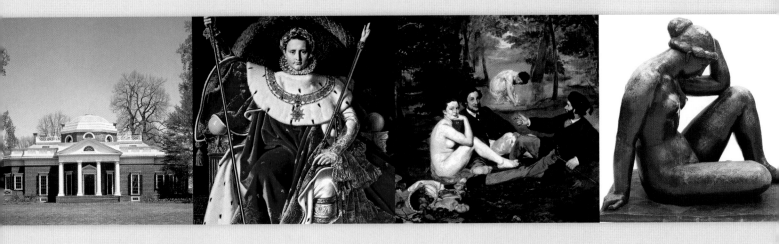

The Modern World

Art history, according to the classical model of Johann Winckelmann, unfolds in an orderly progression in which one phase follows another as inevitably as night follows day. In addition, the concept of period style implies that the arts march in lockstep, sharing the same characteristics and developing according to the same inner necessity. The thoughtful reader will already suspect, however, that any attempt to synthesize the history of art and place it into a broader context must inevitably mask a welter of facts that do not conform to such a systematic model and may, indeed, call it into question. So far as the art of the distant past is concerned, we may indeed have little choice but to see it in larger terms, since so many facts have been erased that we cannot possibly hope to reconstruct a full and accurate historical record. Hence it is arguably the case that any reading is an artificial construct inherently open to question. As we approach the art of our times, these become more than theoretical issues. They take on a new urgency as we try, perhaps vainly, to understand modern civilization and how it came to be this way.

It is suggestive of the difficulties facing the historian that the period which began 250 years ago has not acquired a name of its own. Perhaps this does not strike us as peculiar at first. We are, after all, still in its midst. Considering how promptly the Renaissance coined a name for itself, however, we may well wonder why no key concept comparable to the "rebirth of antiquity" has yet to emerge. It is tempting to call this "The Age of Revolution," for it has been characterized by rapid and violent change. It began with revolutions of two kinds: the Industrial Revolution, symbolized by the invention of the steam engine; and a political revolution, under the banner of democracy, inaugurated in America and France.

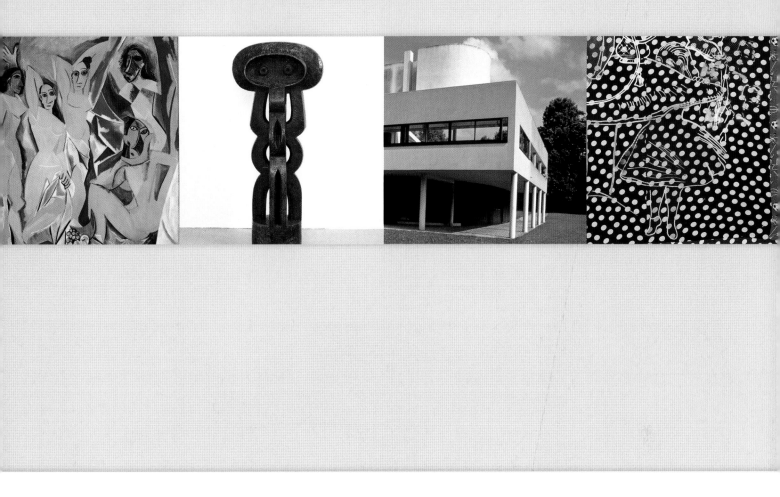

Both of these revolutions are still going on. Industrialization and democracy are sought over much of the world. Western science and Western political thought (and, in their wake, all the other products of modern civilization: food, dress, art, music, literature) will eventually belong to all peoples, although they have been challenged by other ideologies that command allegiance—nationalism, religion, even tribalism. Thus industrialization and democracy are so closely linked today that we tend to think of them as different aspects of one process, with effects more far-reaching than any basic shift since the Neolithic Revolution 10,000 years ago. Still, the twin revolutions are not the same. Indeed, we cannot discern a common impulse behind these developments, despite attempts to relate them to the rise of capitalism. The more we try to explain their relationship and trace their historic roots, the more paradoxical they seem.

Both are founded on the idea of progress. But whereas progress in science and technology during the past two centuries has been more or less continuous and measurable, we can hardly make this claim for our pursuit of happiness, however we choose to define it. Here, then, is a fundamental conflict that continues to this very day. If we nevertheless accept "The Age of Revolution" as a convenient name for the era as a whole, we must still make a distinction for the era since 1900. For lack of a better word, we shall call it modernity. It is a problematic term, *modernity*. What is it? When did it begin? These questions are similar to those posed by the Renaissance, and so perhaps is the answer. No matter how many different opinions there may be about the nature of the beast—and scholars remain deeply divided over the issues—the modern era clearly began when people acquired "modern consciousness." Around 1900 the Western world

became aware that the character of the new age was defined by the machine, which brought with it a different sense of time and space, as well as the promise of a new kind of humanity and society.

It is difficult for us to appreciate from our vantage point just how radical the technological revolution seemed to people of the time, for it has since become commonplace and been outstripped by even more far-reaching changes. The advances that took place in science, mathematics, engineering, and psychol-ogy during the 1880s and 1890s laid the foundation for the Machine Age. The diesel and turbine engines, electric motor, tire, automobile, light bulb, phonograph, radio, box camera: all these were invented before 1900, and the airplane shortly thereafter. They forever transformed the quality of life—its very feel—but it was not until these changes reached a "critical mass" in the opening years of the twenti-eth century that their sweeping magni-tude was fully realized. Of course, this was by no means the first time that people

have felt modern, which simply means contemporary. Yet modern consciousness has been so fundamental to our identity that we can hardly hope to understand civilization for the past 100 years without it.

While this quality of feeling modern can be traced back to the beginning of the last century, the roots of today are grounded in the mid-eighteenth century, when the Enlightenment, using logic and science, shattered the authoritarian supremacy of church and royalty. Having cast off the framework of traditional authority which confined and sustained civilization before, we today can act with a latitude both frightening and exhilarating. The consequences of this freedom to question all values are everywhere around us. Our knowledge about ourselves is now vastly greater, but this has not reassured us as we had hoped. In a world without fixed reference points, we search constantly for our own identity and for the meaning of human existence, individual and collective.

The Modern World 1750–2004

	1750–1775	1775–1800	1800–1825
POLITICAL HISTORY	Seven Years' War (1756–63); French and Indian War, French defeated in Battle of Quebec 1759 Catherine the Great (ruled 1762–96) extends Russian power to Black Sea	American Revolution 1775–85; Constitution adopted 1789 French Revolution 1789–97; Reign of Terror under Maximillen Robespierre 1793 Consulate of Napoleon 1799	Louisiana Purchase 1803 Napoleon crowns himself emperor 1804; exiled to St. Helena 1815 War of 1812 Greeks declare independence 1822
RELIGION AND LITERATURE	Thomas Gray's *Elegy* 1750 Denis Diderot's *Encyclopédie* 1751–72 Jean-Jacques Rousseau (1712–1778), French philosopher and writer	Edward Gibbon's *Decline and Fall of the Roman Empire* 1776–87 Thomas Paine's *The Rights of Man* 1790 William Wordsworth and Samuel Taylor Coleridge, *Lyrical Ballads*, 1798	Johann Wolfgang von Goethe's *Faust* (part I) 1808 George Gordon Byron's *Childe Harold's Pilgrimage* 1812–18 John Keats (1795–1821), English poet Jane Austen (1775–1817), English novelist Walter Scott's Waverly novels (1814–25)
SCIENCE AND TECHNOLOGY	Benjamin Franklin's experiments with electricity c. 1750 James Watt patents steam engine 1769 Coke-fed blast furnaces for iron smelting perfected c. 1760–75	Power loom 1785; cotton gin 1792 Edward Jenner's smallpox vaccine c. 1798	Lewis and Clark expedition to Pacific 1803–6 First voyage of Fulton's steamship 1807 George Stephenson's first locomotive 1814 Michael Faraday discovers principle of electric dynamo 1821
PAINTING	Greuze, *The Village Bride* (21-1) West, *The Death of General Wolfe* (21-5) 21-1	Copley, *Watson and the Shark* (21-6) David, *The Oath of the Horatii* (21-2); *The Death of Marat* (21-3) Gros, *Napoleon in the Pesthouse at Jaffa, 11 March 1799* (22-5)	Goya, *The Family of Charles IV* (22-1) Ingres, *Odalisque with a Slave* (22-4) Goya, *The Third of May, 1808* (22-2) Géricault, *The Raft of the "Medusa"* (22-6) Constable, *The Haywain* (22-17) Friedrich, *Abbey in an Oak Forest* (22-19) 22-4
SCULPTURE		Houdon, *Voltaire* (21-8)	Canova, *Tomb of the Archduchess Maria Christina* (22-22)
ARCHITECTURE	Walpole, Strawberry Hill, Twickenham (22-27) Soufflot, The Panthéon, Paris (21-12) 21-12	Jefferson, Monticello, Charlottesville (21-11) 21-11	
PHOTOGRAPHY			

1825–1850	1850–1875	1875–1890
Queen Victoria crowned 1837 U.S. treaty with China opens ports 1844 Famine in Ireland, mass emigration 1845 U.S. annexes western land areas 1845–60 Revolution of 1848; fails in Germany, Hungary, Austria, Italy; France sets up Second Republic (Louis Napoleon)	Louis Napoleon takes title of emperor 1852 Russia abolishes serfdom 1861 U.S. Civil War (1861–65) ends slavery; Abraham Lincoln assassinated 1865 Franco-Prussian War 1870–71 Benjamin Disraeli British prime minister 1874–80	Peak of colonialism worldwide 1876–1914 First pogroms in Russia 1881–82
Aleksandr Pushkin (1799–1837), Russian writer Victor Hugo (1802–1885), French writer Ralph Waldo Emerson (1803–1882), American essayist Charles Dickens's *Oliver Twist* 1838 George Eliot (1819–1880), English novelist Karl Marx's *Communist Manifesto* 1848 Edgar Allan Poe (1809–1849), American poet	Herman Melville's *Moby-Dick* 1851 Harriet Beecher Stowe's *Unde Tom's Cabin* 1851 Walt Whitman's *Leaves of Grass* 1855 Gustave Flaubert's *Madame Bovary* 1856 Charles Baudelaire (1821–1867), French poet Fyodor Dostoyevsky's *Crime and Punishment* 1866 Karl Marx's *Das Kapital* 1867–94	Mark Twain's *Tom Sawyer* 1876 Henrik Ibsen (1828–1906), Norwegian dramatist Émile Zola (1840–1902), French novelist Oscar Wilde (1854–1900), Irish writer Henry James (1843–1916), American novelist
Erie Canal opened 1825 First railway completed (England) 1825 Cyrus Hall McCormick invents reaper 1831 Daguerreotype process of photography introduced 1839 Samuel F. B. Morse perfects telegraph 1844	Charles Darwin publishes *On the Origin of Species* 1859 Henry Bessemer patents tilting converter for turning iron into steel 1860 Louis Pasteur develops germ theory 1864 Gregor Mendel publishes experiments in genetics 1865 Nobel invents dynamite 1867 First transcontinental railroad in America 1869 Suez Canal opened 1869	Alexander Graham Bell patents telephone 1876 Thomas Alva Edison invents phonograph 1877; invents electric light bulb 1879 First internal combustion engines for gasoline 1885
Delacroix, *The Death of Sardanapalus* (22-7) Corot, *View of Rome* (22-12) Ingres, *Portrait of Napoleon on His Imperial Throne* (22-3) Turner, *The Slave Ship* (22-18) Bingham, *Fur Traders Descending the Missouri* (22-21) Bonheur, *Plowing in the Nivemais* (22-14) Courbet, *Burial at Ornans* (23-1) 23-1	Millet, *The Sower* (22-11) Daumier, *The Third-Class Carriage* (22-10) Manet, *Luncheon on the Grass* (23-3) Homer, *Snap the Whip* (23-19) Monet, *On the Bank of the Seine, Bennecourt* (23-8) Whistler, *Arrangement in Black and Gray: The Artist's Mother* (23-17); *Nocturne in Black and Gold* (23-17)	Renoir, *Le Moulin de la Galette* (23-10) Degas, *The Glass of Absinthe* (23-11) Cézanne, *Still Life with Apples* (24-1) Seurat, *Sunday Afternoon on the Island of La Grande Jatte* (24-3) Degas, *The Tub* (23-12) Morisot, *Summer's Day* (23-13) Gauguin, *Vision after the Sermon (Jacob Wrestling with the Angel)* (24-6) Van Gogh, *Self-Portrait* (24-5); *Wheat Field and Cypress Trees* (24-4)
Rude, *La Marseillaise*, Arc de Triomphe, Paris (22-23)	Carpeaux, *The Dance* (22-24)	Degas, *The Little Fourteen-Year-Old Dancer* (23-24) Rodin, *The Thinker* (23-22) 23-24
Barry and Pugin, The Houses of Parliament, London (22-28) Labrouste, Bibliothèque Ste-Geneviève, Paris (23-25)	Paxton, The Crystal Palace, London (23-27) Garnier, The Opéra, Paris (22-29)	
Niépce, *View from His Window at Le Gras* (22-30)	Nadar, *Sarah Bernhardt* (22-31) Gardner, *Home of a Rebel Sharpshooter, Gettysburg* (22-35) Cameron, *Sister Spirits* (22-34)	Muybridge, *Female Semi-Nude in Motion* (24-25) Riis, *Bandits' Roost* (24-24)

	1890–1910	**1910–1925**	**1925–1950**
POLITICAL HISTORY	First Zionist Congress called by Theodor Hertzl 1897 Spanish-American War 1898; U.S. gains Phillippines, Guam, Puerto Rico, annexes Hawaii President Theodore Roosevelt (1901–9) proclaims Open Door policy; 8,800,000 immigrate to U.S. 1901–10 Internal strife, reforms in Russia 1905	Revolution in China, republic established 1911 First World War 1914–18; U.S. enters 1917 Bolshevik Revolution 1917 Mahatma Gandhi agitates for Indian independence, starting in 1919 Woman Suffrage enacted in U.S. 1920; in England 1928; in France 1945 Benito Mussolini's Fascists seize Italian government 1922	Adolf Hitler seizes power in Germany 1933 Spanish Civil War 1936–39; won by Franco Hitler annexes Austria 1938; invades Poland 1939 Second World War 1939–45 Atomic bomb dropped on Hiroshima 1945 Israel gains independence 1948 Communists under Mao win in China 1949 India gains independence 1949
RELIGION AND LITERATURE	G. B. Shaw (1856–1950), British writer Emily Dickinson (1830–1886), poetry published 1890, 1891 Marcel Proust (1871–1922), French novelist W. B. Yeats (1865–1939), Irish poet Gertrude Stein (1874–1946), American writer	T. S. Eliot (1888–1964), British poet James Joyce (1882–1941), Irish writer Eugene O'Neill (1888–1953), American dramatist D. H. Lawrence (1885–1930), English novelist	Virginia Woolf (1882–1941), English author William Faulkner (1897–1962), American novelist Ernest Hemingway (1898–1961), American writer Jean-Paul Sartre (1905–1980), French philosopher Albert Camus (1913–1960), French novelist
SCIENCE AND TECHNOLOGY	Marie and Pierre Curie discover radium 1898 Max Planck formulates quantum theory 1900 Sigmund Freud's *Interpretation of Dreams* 1900 Wright brothers' first flight with power-driven airplane 1903 Albert Einstein's Special Theory of Relativity 1905 Henry Ford begins assembly-line automobile production 1909	First radio station begins regularly scheduled broadcasts 1920	First regularly scheduled TV broadcasts in U.S. 1928 Motion pictures with sound appear in theaters 1928 Atomic fission demonstrated on laboratory scale 1942 Penicillin discovered 1943 Computer technology developed 1944
PAINTING	Cassatt, *The Bath* (23-14) Toulouse-Lautrec, *At the Moulin Rouge* (24-8) Beardsley, *Salomé* (24-11) Munch, *The Scream* (24-12) Tanner, *The Banjo Lesson* (23-21) Cézanne, *Mont Ste-Victoire Seen from Bibémus Quarry* (24-2) Matisse, *The Joy of Life* (25-1) Picasso, *Les Demoiselles d'Avignon* (25-7)	Matisse, *The Red Studio* (25-2) Duchamp, *The Bride* (25-17) Braque, *The Portuguese* (25-8) Boccioni, *Dynamism of a Cyclist* (25-10) Kandinsky, *Sketch I for "Composition VII"* (25-5) De Chirico, *Mystery and Melancholy of a Street* (25-16) Léger, *Three Women* (26-28) Picasso, *Three Musicians* (26-9) Klee, *Twittering Machine* (26-13)	Picasso, *Three Dancers* (26-10) Hopper, *Early Sunday Morning* (26-36) Mondrian, *Composition with Red, Blue, and Yellow* (26-26) Beckmann, *Departure* (26-40) Miró, *Composition* (26-14) Ernst, *La Toilette de la Mariée* (26-15) O'Keeffe, *Black Iris III* (26-32) 26-10
SCULPTURE	Rodin, *Monument to Balzac* (23-23) Maillol, *Seated Woman (La Méditerranée)* (24-15) Brancusi, *The Kiss* (25-20) 25-20	Boccioni, *Unique Forms of Continuity in Space* (25-12) Duchamp-Villon, *The Great Horse* (25-18) Tatlin, *Project for "Monument to the Third International"* (26-25) Brancusi, *Bird in Space* (25-21)	Moore, *Recumbent Figure* (26-19) Calder, *Lobster Trap and Fish Tail* (26-18) Picasso, *Head of a Woman* (26-12) Hepworth, *Sculpture with Color (Deep Blue and Red)* (26-20)
ARCHITECTURE	Sullivan, Wainwright Building, St. Louis (24-21) Gaudí, Casa Milá, Barcelona (24-18) Wright, Robie House, Chicago (28-1)	Van de Velde, Theater, Werkbund Exhibition, Cologne (24-20) Rietveld, Schröder House, Utrecht (28-6)	Gropius, The Bauhaus, Dessau (28-7) Le Corbusier, Villa Savoye, Poissy-sur-Seine (28-10) 28-10
PHOTOGRAPHY	Kasebier, *The Magic Crystal* (24-22) Steichen, *Rodin with His Sculptures "Victor Hugo" and "The Thinker"* (24-23)	Atget, *Pool, Versailles* (26-23) Man Ray, *Champs délicieux* (26-8)	Sander, *Pastry Cook, Cologne* (26-39) Stieglitz, *Equivalent* (26-35) Lange, *Migrant Mother, California* (26-38)

1950–1965	1965–1980	1980–2004
Korean War 1950–53	Great Proletarian Cultural Revolution in China 1965–68	Mikhail Gorbachev begins implementing reform policy in U.S.S.R. 1985
African colonies gain independence after 1957	Russia invades Czechoslovakia 1968	Tiananmen Square massacre 1989
Fidel Castro takes over Cuba 1959	Massacre of student demonstrators at Kent State University, 1970	Breakup of Soviet Union into independent states 1989–90
Sit-ins protest racial discrimination in U.S. 1960	Civil war in Pakistan gains independence for People's Republic of Bangladesh 1972–73	Berlin Wall demolished; reunification of Germany 1990
Berlin Wall built 1961	Vietnam War ends 1973	Persian Gulf War 1991
John F. Kennedy assassinated 1963	Richard Nixon resigns presidency 1974	South Africa holds first multiracial elections 1994
Lyndon Johnson begins massive U.S. intervention in Vietnam 1965	Iranian Revolution 1979	Clinton impeachment; Panama Canal ceded by U.S. 1999
		World Trade Center towers in New York destroyed in aerial attack 2001
Samuel Beckett (1906–1989), Irish author	Gabriel Garcia Márquez's One Hundred Years of Solitude 1970	Alice Walker's The Color Purple 1982
Jean Genet (1910–1986), French dramatist	First non-Italian pope elected since Adrian VI in 1522—Pope John Paul II (from Poland) 1978	Salman Rushdie's The Satanic Verses 1989; death threats by outraged Islamic fundamentalists force him into hiding
Jack Kerouac's On the Road 1957		Popular acceptance of CD-ROM encyclopedias and reference works
Jorge Luis Borges (1899–1986), Argentinian author		Pope John Paul II visits Sarajevo (1997), Cuba (1998), Nigeria (1998), Mexico City (1999), and Poland (1999)
John Steinbeck awarded Nobel Prize 1962		
Betty Friedan's The Feminine Mystique 1963		
Genetic code cracked 1953	First orbiting laboratory (Skylab) 1973	AIDS virus recognized 1981
First hydrogen bomb (atomic fusion) exploded 1954	Viking I and II space probes land on Mars 1976	New office technology: facsimile machine, modem, rapid development of software programs, fiber-optic technology 1990s
Sputnik, first satellite, launched 1957	Personal computers available 1978	Hubble space telescope launched 1990
First manned space flight 1961	Voyager I space probe orbits Jupiter 1979	Human origins pushed back to 4 million years ago, tool-making to 2½ million years ago 1996
First manned landing on the moon 1969		Cloning of sheep Dolly by scientists at Roslin Institute 1997
Pollock, Autumnal Rhythm: Number 30, 1950 (27-2)		Kiefer, To the Unknown Painter (29-04)
Dubuffet, Le Métafisyx (27-6)		Murray, More Than You Know (29-05)
De Kooning, Woman, II (27-3)		
Rothko, Rust and Blue (Brown, Blue, Brown on Blue) (27-4)	 27-4	 29-8
Johns, Three Flags (27-9)		
Warhol, Gold Marilyn Monroe (27-13)		
Lichtenstein, Drowning Girl (27-12)		
Kelly, Red Blue Green (27-14)		
Stella, Empress of India (27-15)		
Rauschenberg, Odalisk (27-8)	Kienholz, The State Hospital (27-29)	Puryear, The Spell (29-6)
Segal, The Gas Station (27-11)	Smithson, Spiral Jetty, Great Salt Lake, Utah (27-19)	Kabakov, The Man Who Flew into Space from His Apartment (29-9)
Smith, Cubi series (27-5)	Chase-Riboud, Malcolm X #3 (27-27)	Smith, Untitled (29-11)
Kosuth, One and Three Chairs (27-20)		
Mies van der Rohe, Seagram Building, New York (28-14)	Rogers and Piano, Centre National d'Art et de Culture Georges Pompidou, Paris (28-15)	Graves, Public Service Building, Portland (29-1)
Wright, Solomon R. Guggenheim Museum, New York (14, 15)	 29-3	Stirling, Neue Staatsgalerie, Stuttgart (29-2)
		Koolhaus, Netherlands Dance Theater, Amsterdam (28-17)
		Calatrava, TGV Station, Lyon (28-16)
		Gehry, Guggenheim Museum, Bilbao (29-3)
Frank, Drug Store, Detroit (27-23)	Sherman, Untitled Film Still #5 (29-8)	

21 Neoclassicism

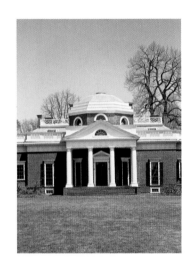

EVER SINCE ITS REVIVAL IN THE RENAISSANCE, CLASSICAL ART continued to interest artists. Undoubtedly the great Rococo master François Boucher, the French painter of frivolous erotic fantasies, thought of himself as working within this tradition, which indeed he was. His favorite subjects, such as Venus, Diana at the Bath, cupids, and satyrs, were all classical motifs. But during the second half of the eighteenth century, a new classicism emerged that was unlike any classicism that preceded it. Neoclassicism (literally, *new* classicism) demanded that the revival of the classical past had to be accurate and logical.

Spurring this attitude was a philosophical movement known as the Enlightenment. Predicated on an intense rationalism, the Enlightenment was rooted in the seventeenth century, but blossomed in the eighteenth. One of the great monuments of the Enlightenment was the *Encyclopédie* (1751–1780), the first encyclopedia, which was designed to accurately document civilization and the natural world, placing knowledge on a scientific and historical footing and removing it from superstition, myth, hearsay, and whimsy. This new temperament resulted in a new approach to antiquity. It had to be presented faithfully, not fancifully.

Facilitating the demand for accurate representations of classical themes and art were the mid-century excavations in Pompeii and Herculaneum. The discoveries of these ancient Italian cities caused great excitement and resulted in the publication of newly discovered ancient artifacts, including costume. Simultaneously, major studies of Greek and Roman architecture appeared. In 1760 the first volume of *The Antiquities of Athens* (1760–1816) was published, authored by two Englishmen, James Stuart and Nicholas Revett. It was followed in 1761 by Giovanni Battista Piranesi's *Della magnificneza ed architettura de' Romani* (*On the Greatness and the Architecture of the Romans*), which was dedicated to proving Roman architecture was every bit as great as its Greek antecedents.

Perhaps the most influential publications came from Johann Joachim Winckelmann (1717–1768), a German scholar and a curator of the antiquities owned by Cardinal Alessandro Albani in Rome. In 1755 he published a pamphlet (*Reflections on the Imitation of Greek Works in Painting and Sculpture*), which was followed by a major study, *The History of Ancient Art* (1764). Winckelmann described individual Greek sculptures, praising them for their "noble simplicity" and "calm grandeur." His observations triggered a resounding response not just from artists and serious collectors but from tourists and the well-educated general public. As suggested by the words *noble* and *grandeur,* morality was an important component of the Greek art that Winckelmann admired, and this emphasis, too, was, in part, a reflection of Enlightenment thought. Turning against the privilege, frivolity, artificiality, and wasteful squandering of the aristocracy, the Enlightenment philosopher's call for reason was also an appeal for morality, sometimes even a stoic morality, which was exemplified by the noble actions of the great Greek and Roman statesmen and military leaders, as well as by the writings of the great thinkers. (See the side bar on Stoicism, p. 122.) Neoclassical themes include an intense devo-

tion, to family and country as well as personal sacrifice.

Neoclassicism is characterized by this twin dedication to morality and logic, couched in an aura of the ancient world. With the demand for logic came the need for intense historical accuracy, which never figured strongly into Renaissance and Baroque classicism. Now, in paintings based on classical themes, artists were expected to recreate ancient settings down to the last detail in order to present a scene of total credibility. This mentality continued into the nineteenth century and prevails to this day in period films, such as those set in ancient Rome or the nineteenth-century American West. In the eighteenth century, and especially the nineteenth century, however, this recreation of the distant past could be tinged with a strong emotional longing for lost worlds and exotic experiences.

As we will see, this need to produce powerful emotions will be a characteristic of the Romantic movement. Neoclassicism, which is largely a *style* based on the look of antiquity, can at moments be put in the service of Romanticism, which was a *concept* rather than a style. (In chapter 22, we'll see that Romanticism was so broad it could sweep into its vast net various styles, such as Neoclassicism, Gothic, Romanesque, and Renaissance.) The style of Neoclassicism itself was rather broad, ranging from frivolous erotic scenes set in the ancient past—a kind of Rococo Neoclassicism—to austere scenes of sacrifice and death—a Stoic Neoclassicism. This was also the era when contemporary history painting was invented. These were paintings of highly significant contemporary events. Enlightenment logic required that the events take place in a modern setting and costume rather than the ancient past, but the look of antiquity was embedded in the gestures and poses, lending a classical aura and morality to a present-day scene.

Neoclassicism was also the perfect style to complement the two republics founded in the late eighteenth century, the United States of America and France. The American Revolution of 1776 and the French of 1789 were expressions of Enlightenment ideals. Hence, both called for rule for the common good. Antiquity was an important symbol for the Enlightenment because it

gave rise to the first rationalist philosophers and because it produced the first democracies, the Greek and Roman republics. What better style to represent these new republics than with that of ancient republics? (Turn over the five, ten, and twenty dollar bills and you will see buildings based on Greek and Roman architecture.) Neoclassicism transformed classicism from a style used to represent the aristocracy and the church into a style of the people, at least in theory. Just as the Rococo epitomized the aristocracy, Neoclassicism could be identified with liberty. Neoclassicism in effect became the nemesis of the Rococo. The ornate, frivolous, fantasy of Rococo painting and architecture was aristocratic, artificial, and immoral, whereas the rational noble world of Neoclassicism was democratic, righteous, and natural. The individual freedom of the Modern World was born simultaneously with Neoclassicism.

Painting

FRANCE

The resurgence of history painting in France can be partly attributed to the efforts of Charles-Claude d'Angiviller, Louis XVI's Director-General of Buildings, who oversaw the FRENCH ACADEMY and the Salon exhibitions as well as commissioning art for royal buildings. After taking office in 1774, he launched an offensive against the Rococo by proclaiming that art's greatest achievement was to promote virtue and condemn vice. Beginning in 1777, he commissioned grand history paintings based on the noble and virtuous deeds of the Greeks and Romans as well as exemplary moments from French history. The resulting paintings are largely forgotten today, but the fruit of d'Angiviller's program appeared in the mid-1780s with the emergence of Jacque-Louis David. David reflected the ideals of the Director-General and established himself as the greatest French history painter since Poussin.

Until the 1780s, however, the Enlightenment emphasis on reason and morality was best presented not by history painting but by the lowly stratum of genre. The field's undisputed leader was Jean-Baptiste Greuze, whose scenes of everyday life were the sensation of the Salons from 1759 into the 1770s,

Strictly speaking, the FRENCH ACADEMY today is the Institut de France, a cluster of five learned societies brought together during the French Revolution. The original L'Académie Français began in secret around 1630 under King Louis XIII and was made official in 1635 at the urging of Louis's chief minister, the powerful Cardinal Richelieu (1585–1642). The Académie Royale de Peinture et de Sculpture (later, the Académie des Beaux-Arts), established in 1648 to encourage French fine artists and to maintain the aesthetic standards favored by those in power, is sometimes referred to by art historians as the French Academy.

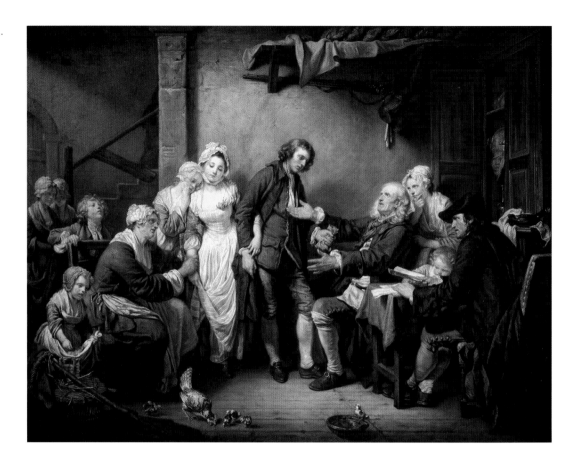

21-1 Jean-Baptiste Greuze. *The Village Bride.* 1761. Oil on canvas, 36 × 46½" (91.4 × 118.1 cm). Musée du Louvre, Paris

helping to pave the way for a demand for images with moral content.

Jean-Baptiste Greuze Greuze's popularity was established at the SALON of 1761 when he submitted *The Village Bride* (fig. 21-1). The picture shows a Protestant wedding the moment after a father has handed his son-in-law a dowry, which has been recorded by a notary seated on the right. Although Greuze's working-class background in the Protestant environs of Lyon may account for some of the morality in his art, the driving force behind his work was Enlightenment philosophy. It especially illustrates the social gospel of Jean-Jacques ROUSSEAU: that the naïve poor, in contrast to the more cultivated yet immoral aristocracy, are closer to nature and thus full of "natural" virtue and honest sentiment. Everything is intended to remind us of this point, from the theatrical gestures and expressions of the actors that reinforce the theme of familial dedication and love to the smallest detail: one of the chicks gathered around the hen in the foreground has left the brood, like the bride who is about to leave her own "brood." Critics were so taken by the emotions that they decreed that they had

even exceeded those of the great Charles Le Brun, the author of the classic treatise on expression and gesture that was still being used in the French Academy.

Greuze was heavily influenced by a second philosopher, Denis DIDEROT, who championed him in his Salon reviews, which appeared anonymously in the *Correspondence littéraire*, a paper circulated privately throughout Europe and Russia. Like Rousseau, Diderot was an apostle of reason, nature, and the common man, and he applauded the narrative of Greuze's pictures as "noble and serious human action" in Poussin's sense. In addition to his many achievements, Diderot advocated a new form of theater, *drame bourgeois*, melodramas focusing on contemporary common folk. As important as the bourgeois settings was his emphasis on the complete logic and naturalism of the play; he wanted the audience to forget the theater and be transported to the world of his drama. Interestingly, the same qualities can be found in Greuze's paintings, like *The Village Bridge*. It has often been noted how stagelike Greuze's paintings are. The gestures are highly theatrical, and the grouping of the figures resembles a *tableau vivant*—when actors freeze as in a painting to portray an important

moment—here the father's poignant speech about marriage.

Largely derived from Dutch and Flemish minor genre painting, the picture is filled with realistic detail, including an attention to texture. Greuze wanted his viewers to forget the gallery they were standing in as they became immersed in the scene he magically painted. Even the figures seem individualized, rather than idealized. They are so real that when he used them again in later paintings, the public felt it was witnessing the continuation of the story of the same family.

Jacques-Louis David Jacques-Louis David studied with the influential classical painter Joseph-Maure Vien at the French Academy in Rome from 1775 to 1781 when he began to develop his Neoclassical style. Upon his return to France, he quickly established himself as the leading Neoclassical painter, overshadowing all others by so far that our conception of the movement is based largely on his work. The painting that endowed him with this indisputable reputation is *The Oath of the Horatii* (fig. 21-2), painted during a second trip to Rome in 1784–85, where it quickly became an inter-

national sensation. Commissioned by King Louis XVI, the theme is taken from a Roman seventh-century B.C. story that appears in both Livy and Plutarch recounting how a border dispute between Rome and neighboring Alba was settled by a sword fight by three soldiers from each side. Representing Rome were the three Horatii brothers, and Alba the three Curiatii brothers.

Complicating the story, a Horatii sister, Camilla, was engaged to a Curiatii brother, while one of the Horatii brothers was married to a Curiatii sister. Only Horatius of the Horatii brothers survived the violent fight, and David was instructed to paint the moment when he returns home and slays his sister Camilla after she curses him for killing her fiancé. Instead David gained permission to paint a scene that does not appear in the literature: the Horatii, led by their father, taking an oath to fight to the death. In contrast to the virile stoic men are the irresolute distressed women, Camilla and the Curiatii wife, who, either way, will lose a brother, husband, or fiancé.

David's invented scene is a *tableau vivant* highlighting the dramatic moment of noble and virtuous action dedicated to the supreme

A genius in many fields, including natural science, and a novelist, dramatist, poet, and art critic, Denis DIDEROT (1713–1784) is still best known as the compiler and editor of the great French *Encyclopédie* (1751–1780), a staggering 28-volume compendium of the natural and physical sciences, law, and what would today be called political science. Fellow *philosophe* Jean-Jacques Rousseau was a contributor to the *Encyclopédie*.

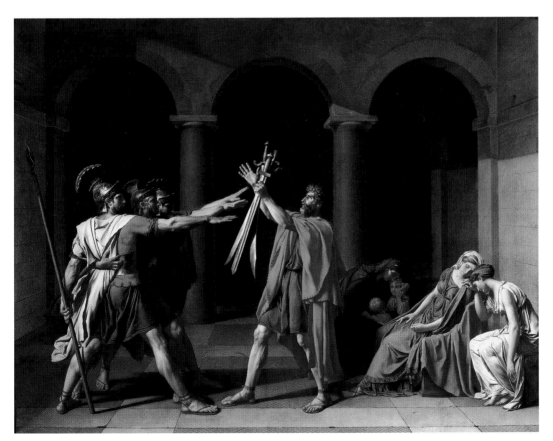

21-2 Jacques-Louis David. *The Oath of the Horatii*. 1784. Oil on canvas, 10′10″ × 13′11″ (3.3 × 4.25 m). Musée du Louvre, Paris

but necessary sacrifice of putting state before family. The severity of the Horatii's dedication is reflected in the severity of the composition. It can be seen in the austerity of the space, and even in David's selection of carefully researched, stark Doric columns for the architecture. David is more "Poussiniste" than Poussin himself in the relentless planarity of the image (notice how the figures and architecture run parallel to the picture plane) and the harsh geometry of the floor tiles, arches, and grouping of men and weapons. The sharp line of the drawing creates hard-edged figures, making them appear as solid and immobile as statues. With the emergence of David, Poussiniste line once again prevails over the hedonistic color and

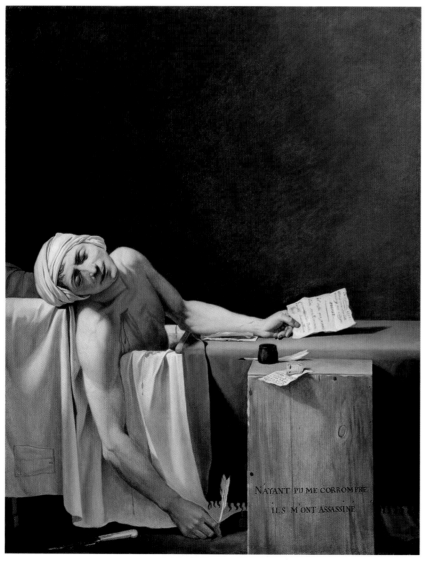

21-3 Jacques-Louis David. *The Death of Marat.* 1793. Oil on canvas, 65 × 50½″ (165.1 × 128.3 cm). Musées Royaux des Beaux-Arts de Belgique, Brussels

brushwork that we saw in the work of Watteau and Boucher (see figs. 20-3 and 20-4).

Sharpening the edge and fueling the drama is a harsh light casting precise shadows, which is derived from Caravaggio (see fig. 17-1). So is the firmly realistic detail. (Note the hands and feet, clothing and weapons, and stone surfaces.) As a result the picture has a lifelike quality and historical accuracy that transports the viewer to seventh-century B.C. Rome to witness this oath of sacrifice and patriotism. Although completed just four years before the French Revolution, we must remember that the picture was commissioned for the king and is about the Enlightenment's emphasis on noble deeds and the prevalence of reason over emotion.

David took an active part in the French Revolution, and in the early 1790s he had controlling power over the artistic affairs of the nation. During this time he painted one of his greatest pictures, *The Death of Marat* (fig. 21-3). What is so exceptional about this painting is its realism and the artist's ability to transform a bathtub setting into a noble monumental icon. Any other artist would have painted an allegorical scene of the slain Revolutionary leader. But David, opting for realism, daringly chose Marat's death place. Marat had a painful skin condition that required immersion in a bath, and he did his work there, with a wooden board serving as his desk. One day a young woman named Charlotte Corday burst in with a personal petition, then plunged a knife into his chest while he read it. David has composed the scene with a stark directness and naturalism that is awe-inspiring.

While closing off the space with a blank wall, he has pushed Marat to the front edge of canvas, allowing, in a Caravaggesque fashion, the tombstone-like writing box, arm and knife to come into the viewer's space. We feel as though we are in Marat's bathroom. But this is no mundane scene. Not only has David created a monumental figure whose well-proportioned body has the calm grandeur of the ancients, but he has transformed him into a saint by giving him the pose of Christ in a Decent from the Cross or a Lamentation scene (see fig. 15-10), a reading reinforced by the shroudlike quality of Marat's bandages and sheets. It is no accident that his *Marat* reminds us so strongly of Zurbarán's *St. Serapion* (see fig. 17-20). While remaining true to Enlightenment logic and morality, David has created

a contemporary history painting worthy of Poussin and Raphael.

Elisabeth-Louise Vigée-Lebrun Vigée-Lebrun (1755–1842) was one of the most accomplished and successful portrait painters of her time. Admired as well for her charm and beauty, she became a court favorite and was portraitist to Marie Antoinette. Fiercely independent, Vigée-Lebrun was also a trend-setter of international renown, establishing taste for hairstyles and clothing that spread throughout Europe.

At the time, Neoclassicism extended well beyond history painting to all of the genres as well as to fashion, as can be seen in Vigée-Lebrun's touching *Self-Portrait with Her Daughter, Julie* (fig. 21-4), made about 1789,

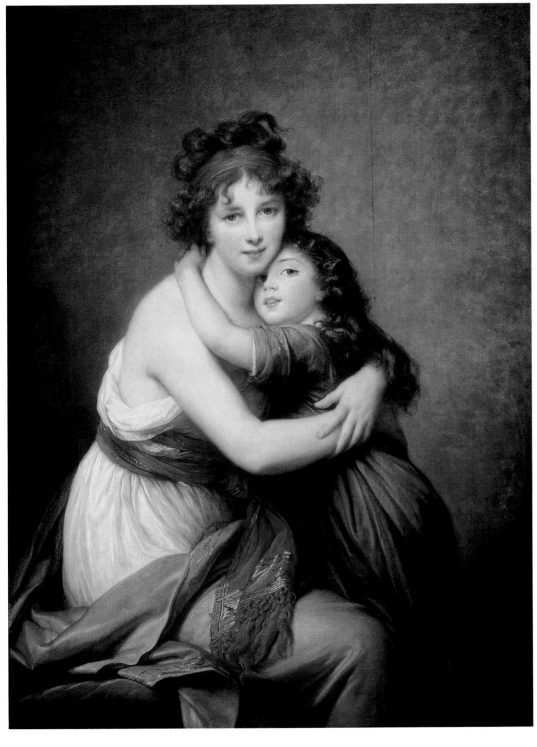

21-4 Elisabeth-Louise Vigée-Lebrun. *Self-Portrait with Her Daughter, Julie.* c. 1789. Oil on canvas, 51³⁄₁₆ × 37″ (130 × 94 cm). Musée du Louvre, Paris

the year of the French Revolution. The sitters are dressed in Neoclassical togas silhouetted against an empty background, devoid of the luxurious trappings we have seen in Rococo portraiture. Vigée-Lebrun sports natural unpowdered hair arranged in an antique style with antique headband. But this is hardly an image of austerity or stoicism. The background may be plain, but it is lusciously painted and subtly colored, whereas the simple togas are adorned with a sensuous red scarf for the artist and gold trim on the sleeve for the daughter. A chiaroscuro softens the contours that would be hard in David, and the remarkable affection displayed by the sitters obviously dominates the picture.

This affection reflects more than maternal love, for starting in the 1780s it was becoming more common for women to be lovingly pictured with their children (Vigée-Lebrun painted quite a few of these images). This taste in mother–child and family portraiture embodied Rousseau's theory about child rearing: He advocated that parents should nurture their children at home, rather than sending them off to wet nurses and nannies until they were adolescents. We have already seen this familial bonding in Greuze's *Village Bride*.

ENGLAND

Contemporary history painting was an English rather than a French invention. Again, it was driven by the Enlightenment demand for logic and morality. And it was combined with the English passion for antiquity, which was political, philosophic, and literary. By the early eighteenth century, every English gentleman, as part of his education, was expected to make the Grand Tour, an extensive trip through Italy to experience first-hand the classical world. (At the time Greece was largely inaccessible because it was controlled by the Ottoman Empire.) Typically, Rome was the culmination of the trip. In 1751 the London Society of Dilettanti, a club for those who had made the tour, underwrote a research expedition by two young architects, James Stuart (1713–1788) and Nicholas Revett (1720–1804), to study

Greek architecture, which they published in a four-volume work entitled *The Antiquities of Athens* (1762–1816). Books like this and those on the excavations at Pompeii and Herculaneum served as important source material for architects, painters, and sculptors alike.

During this same period England was motivated by a new nationalism, and its admiration for ancient art soon turned into a demand that England become "the principal seat of the arts" as well. King George II established the ROYAL ACADEMY OF ARTS as a way of encouraging painting, sculpture, and architecture in Great Britain, and it opened in 1768. Despite the infatuation with antiquity and the preaching of the academicians, nothing approaching the severity of French Neoclassicism appeared in English painting. Portraiture continued to prevail, and neither the monarchy nor the state regularly commissioned history painting, as had been the case in France.

Benjamin West The most important history painter in England was Benjamin West (1738–1820), who succeeded Sir Joshua Reynolds as head of the Royal Academy. Largely self-taught, West was born in the American colony of Pennsylvania. When he went to Rome in 1760, West caused a sensation, because no American-born painter had appeared in Europe before. He relished his role of frontiersman. On being shown a famous Greek statue he reportedly exclaimed, "How like a Mohawk warrior!" He also quickly absorbed the lessons of Neoclassicism, so that he was in command of the most up-to-date style when he left a few years later. West stopped in London for what was intended to be a brief stay on his way home, but decided to remain there, enjoying phenomenal success. His career was thus European rather than American, but he always took pride in his New World background.

The Death of General Wolfe (fig. 21-5) of 1770, West's most famous work, is the first painting to immortalize the martyrdom of a secular hero. Wolfe's death in 1759 occurred in the siege of Quebec during the FRENCH AND INDIAN WAR, and it aroused considerable feeling in London.

The founding in 1768 of Britain's ROYAL ACADEMY OF ARTS was King George II's way of encouraging painting, sculpture, and architecture in Great Britain. (*R.A.* after an artist's name or signature indicates membership in the Academy.) Conservative by nature, the Academy is still under the direct patronage of the Crown, which sponsors a large annual show of works by members and nonmembers.

France and England fought over possession of North America for 150 years. Tension culminated in a nine-year conflict called the FRENCH AND INDIAN WAR. Waged in New York State, New England, and Quebec, it ended in 1763 when Canada was ceded to England.

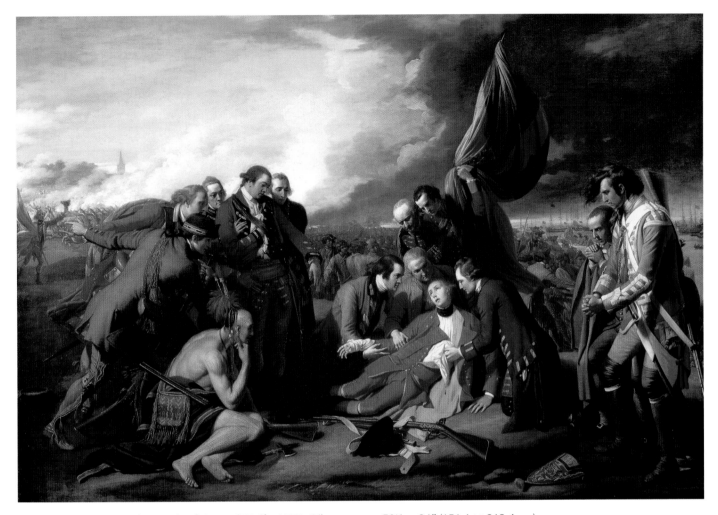

21-5 Benjamin West. *The Death of General Wolfe.* 1770. Oil on canvas, 59½ × 84″ (151.1 × 213.4 cm). The National Gallery of Canada, Ottawa
Gift of the Duke of Westminster

When West decided to represent this event 11 years later, two methods were open to him. He could give a factual account, with the maximum of historical accuracy, or he could use "the grand manner," based on Poussin's ideal of history painting (see pages 397–399), with figures in "timeless" classical costume. Instead, he merged the two approaches. His figures wear contemporary dress, and the figure of the Indian places the scene in the New World. Yet all the attitudes and expressions are "noble" and "heroic." The composition, in fact, recalls the lamentation over the dead Christ (see fig. 11-31). The artist has dramatized it with Baroque lighting, drama, and brushwork (see fig. 18-2), and grouped the figures in classical poses and profile. West thus endowed the death of a modern military hero with both the classical pathos of "noble and serious human actions," as defined by academic theory, and the trappings of a real event. He created an image that expresses an attitude basic to modern times: the shift of allegiance from religion to nationalism. No wonder his picture had countless successors during the nineteenth century.

John Singleton Copley West's gifted countryman, John Singleton Copley of Boston (1738–1815), moved to London just two years before the American Revolution. As New England's outstanding portrait painter, he had adapted the formulas of the British portrait tradition (see figs. 20-9, 20-10, and pages 416–418) to the cultural climate of his hometown (see

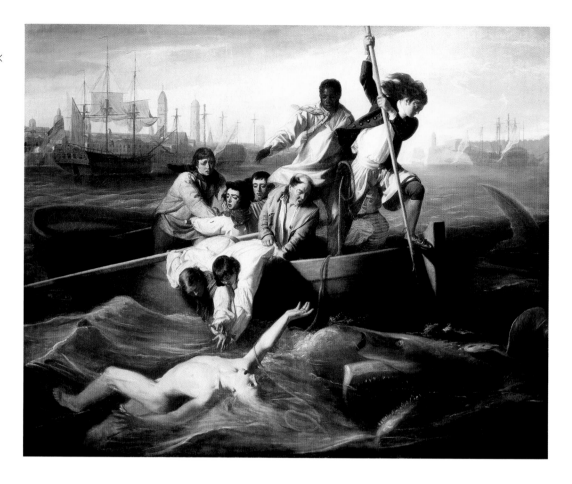

21-6 John Singleton Copley. *Watson and the Shark.* 1778. Oil on canvas, 6'1½" × 7'6¼" (1.84 × 2.29 m). Museum of Fine Arts, Boston

Gift of Mrs. George von Lengerke Meyer, 89.481/Photograph ©2004 Museum of Fine Arts, Boston

Mrs. Joseph Scott, fig. I-1, and the accompanying discussion on pages 1–2). As we noted in the Introduction, Copley left for England partly because he was a Tory, but also because he aspired to become a member of the Royal Academy. Such stature gave him the opportunity to escape the intellectual prison of portraiture and make grand history paintings in the manner of West.

Copley's most memorable work is *Watson and the Shark* (fig. 21-6). As a young man, Watson had been dramatically rescued from a shark attack while swimming in Havana harbor, but not until he met Copley did he decide to have this gruesome experience memorialized. Perhaps he thought that only a painter newly arrived from America would do full justice to the exotic flavor of the incident. Copley, in turn, must have been fascinated by the task of translating the story into pictorial terms. Following West's example, he made every

detail as authentic as possible (here the black man has the same purpose as the Indian in *The Death of General Wolfe,* [fig. 21-5]) and utilized all the expressive resources of Baroque painting to invite the viewer's participation.

Copley may have remembered representations of Jonah and the Whale, which include the elements of his scene. The shark becomes a monstrous embodiment of evil; the man with the boat hook recalls the Archangel Michael fighting Satan; and the nude youth, resembling a fallen gladiator, flounders helplessly between the forces of doom and salvation. This kind of moral allegory is typical of Neoclassicism as a whole, and despite its charged emotion, the picture has the same logic and clarity found in David's *Oath of the Horatii* (fig. 21-2).

Angelica Kauffmann One of the leading Neoclassicists in England was the Swiss-born painter Angelica Kauffmann (1741–1807).

She spent 15 years in London and was a founding member of the Royal Academy. Her circle included Reynolds and West, whom she had met in Rome. From the antique she developed a delicate decorative style admirably suited to the interiors of Robert Adam (see page 446), which she was often commissioned to adorn. Her paintings rarely contained heroic moral content, and the themes, even when set in antiquity, were generally frivolous, even erotic, as suggested by the title of her *Zeuxis Selecting Models for his Painting of Helen of Troy.*

Which is not to say that Kauffmann did not make Neoclassical works of ancient scenes with austere settings and strong moral content. *Cornelia Presenting Her Children as Her Treasures (Mother of the Gracchi)* (fig. 21-7) of c. 1785 elevates child rearing and family over materialism. In this second-century B.C. story from Roman history, a visiting friend has just shown off her jewelry to Cornelia Gracchus. Instead of displaying her own jewelry, Gracchus presents her children, two of whom, Tiberius and Gaius, would become great politicians. To prepare her sons to be brilliant leaders, Cornelia acquired the finest tutors in the world, and it was said that she weaned them on conversation, not her breasts. She remained an ally and advisor to both sons, and in addition to her reputation for virtue and intelligence, she was perhaps the most powerful woman in the history of the Roman Republic, even having public statues erected in her honor. Kauffmann, a woman artist struggling successfully in a field basically restricted to men, must have identified with the savvy Cornelia, whose features resemble the artist's. Despite a Rococo grace in the gestures and the elegant proportions of the figures, Kauffmann has created an austere and monumental painting: the floor and walls are relatively barren, and the composition is anchored by a strong solid triangle, which culminates in Cornelia.

Sculpture

When Winckelmann published his essay advocating the imitation of Greek works

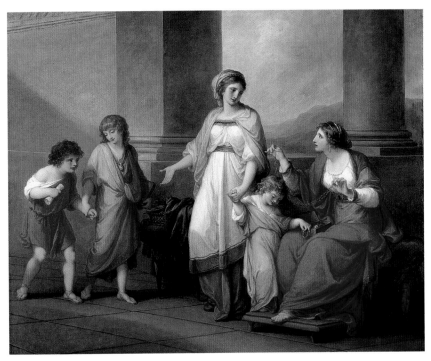

21-7 Angelica Kauffmann. *Cornelia Presenting Her Children as Her Treasures (Mother of the Gracchi).* c. 1785. Oil on canvas. 3′4″ × 4′2″ (101.6 × 127cm). Virginia Museum of Fine Arts, Richmond.

(see page 434), enthusiasm for classical antiquity was already well established among the intellectuals of the Enlightenment. In Rome from 1760 on, restoring ancient sculpture and then selling it to wealthy visitors from abroad was a flourishing business. For these buyers, classical statues belonged to a different world: They embodied an aesthetic ideal, undisturbed by the demands of time and place. To enter this world—and to sell their work—modern sculptors set out to create "modern classics"—sculpture that would be judged against its ancient predecessors. This went far beyond style and subject matter, which was often based on antiquity. Sculptors hoped that critical acclaim would establish their works as classics in their own right and attract buyers.

If Paris was the artistic capital of the Western world during the second half of the eighteenth century, Rome became the birthplace and spiritual home of Neoclassicism. As we have noted, the new style was pioneered by the resident foreigners from north of the Alps, not Italians. That Rome should

21-8 Jean-Antoine Houdon. *Voltaire Seated.* 1781. Terra-cotta model from original plaster, height 47" (119.4 cm). Musée Lambinet, Versailles, France

ture at the Salons, the exhibitions sponsored by the French Academy, where success was crucial for young artists. The original plaster facilitated the Neoclassical revolution in sculpture.

Jean-Antoine Houdon Jean-Antoine Houdon (1741–1828), unlike most of his contemporaries, built his career on portrait sculpture. Not only was there a great demand for such works, but how else could artists attempt to equal the quality of the Greek and Roman classics? Although Houdon's portraits retain the keen sense of individual character introduced by Coysevox (see fig. 19-11), they established entirely new standards of physical and psychological realism. Houdon, more than any other artist of his time, knew how to give visible form to Enlightenment ideals while still relying on Rococo devices. His portraits have an apparent lack of style that is deceptive. Houdon had an uncanny ability to make all his sitters into challenging and questioning Enlightenment personalities while remaining faithful to their individual features.

These qualities can be readily seen in *Voltaire Seated* (fig. 21-8). Houdon modeled the great *philosphe* from life a few weeks before his death in May 1778, and then made a death mask as well. The original plaster has not survived, but a terra-cotta cast from it, retouched by Houdon, offers a close approximation. As contemporary critics quickly pointed out, the *Voltaire Seated* was a "heroicized" likeness. The sculptor enveloped the frail old man in a Roman toga and even added some hair he no longer had so as to justify the classical headband. Yet the effect is not disturbing, for Voltaire wears the toga as casually as a dressing gown. His facial expression and the turn of his head, so reminiscent of Rococo portraiture (compare fig. 20-9, of about the same time), suggest the atmosphere of an intimate conversation. Thus Voltaire is not merely cast in the role of classical philosopher—he becomes the modern counterpart of one, a modern classic in his own right! In him, we recognize ourselves. Voltaire is the image of modern life: unheroic, skeptical, with his own idiosyncratic mixture of rationality and emotion. That is surely why

have been an even stronger magnet for sculptors than for painters is hardly surprising. The city offered an abundance of sculptural monuments but only a meager choice of ancient painting. In the shadow of these monuments, Northern sculptors trained in the Baroque tradition awakened to a new conception of what sculpture ought to be. It also had many skilled artisans in both marble and bronze, who often executed the works that the sculptors designed in plaster. The ORIGINAL PLASTER was an eighteenth-century invention. It allowed sculptors to present major works to the prospective buyers and the public without investing in expensive marble or bronze. In also allowed them to sell several copies of the same work, which often was made available in different sizes, depending on what the client could afford. Plaster sculpture thus became a fea-

One meaning of the word *original* is that an artist (or writer or musician) created the work in question. An ORIGINAL PLASTER is a three-dimensional work made by an artist from plaster of Paris, a hard-drying substance traditionally carved or cast as sculpture.

Voltaire strikes us as so "natural." We are, after all, the heirs of the Enlightenment, which coined this ideal type.

Architecture

Just as Neoclassical painters rejected the artificiality and decorative flamboyance of the Rococo when they instead portrayed a more moralistic natural world, Neoclassical architects did the same. They turned away from asymmetry, pompous display, and emotion to evoke instead the harmonious, calm clarity of antiquity, which they even perceived as a natural architecture. Neoclassicism became the ideal architecture for the new democratic nations founded by revolution, the United States of America in 1776 and France in 1789, for Greek and Roman architecture when associated with republics became symbols of democracy, placing the new governments in a noble and esteemed tradition. The style also became popular in England with those holding more liberal political views.

ENGLAND: THE PALLADIAN REVIVAL

England was the birthplace of Neoclassicism in architecture. It emerged with the revival of the architecture of Antonio Palladio, whose palaces in the outskirts of Vicenza and Venice became icons of the Renaissance classical style (see pages 317–18). The Palladian revival was sparked by the publication of Colin Campbell's treatise *Vitruvius Brittanicus* (1715–17 and 1725), which advocated a return to the stolid antiquity-based stylistic premises of Palladio and Inigo Jones while rejecting the Baroque bravura of Christopher Wren's buildings (see page 408).

Palladio appealed to the English partly because his designs for villas were well suited to English country houses, which were not meant to be pompous and grand, like Versailles, but modest, intimate, and tasteful. Many were surrounded by natural-looking picturesque landscaping rather than geometric formal gardens, in which nature is tamed. The Palladian style also caught on because it accorded with the Rule of Taste promoted by the Enlightenment philosopher Anthony Ashley Cooper, Third Earl of Shaftesbury.

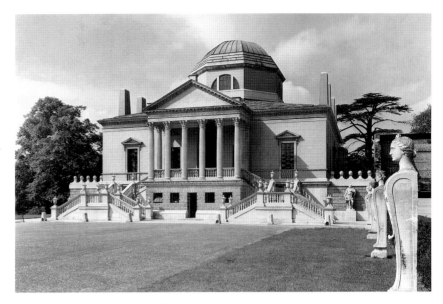

21-9 Lord Burlington and William Kent. Chiswick House, near London. Begun 1725

What distinguishes the Palladian revival from earlier classicisms, however, is less its external appearance than its motivation. Instead of merely reasserting the superior authority of the ancients, it claimed to satisfy the demands of reason, and thus to be more "natural" than the Baroque. At the time, the Baroque style was identified with papist Rome by English Protestants, with absolutist France by George I, and with TORY policies by the WHIG opposition. Thus began an association between Neoclassicism and liberal politics that was to continue through the French Revolution. The appeal to reason found support in Palladio himself, who decried abuses "contrary to natural reason" on the grounds that "architecture, as well as all other arts, being an imitation of nature, can suffer nothing that either alienates or deviates from that which is agreeable to nature."

This rationalism helps to explain the abstract, segmented look of Chiswick House on Burlington's estate (fig. 21-9). Adapted by Burlington and Kent from the Villa Rotonda (see fig. 14-14), as well as other Italian sources, it is compact, simple, and geometric—the antithesis of the Baroque pomp (compare with fig. 19-13). The exterior surfaces of Chiswick are flat and unbroken, the ornament is meager, and the temple **portico** juts out abruptly from the blocklike

TORY and WHIG are the terms applied, since the seventeenth century, to Britain's two chief political parties. *Tory* was originally a name for Irish outlaws. Later, it became associated with the political supporters of James II (1603–1701), the Roman Catholic Stuart king. The name *Whig* was used for those who opposed James II's succession to the Crown. Today's Conservative party members are called Tories; Liberal party followers are Whigs.

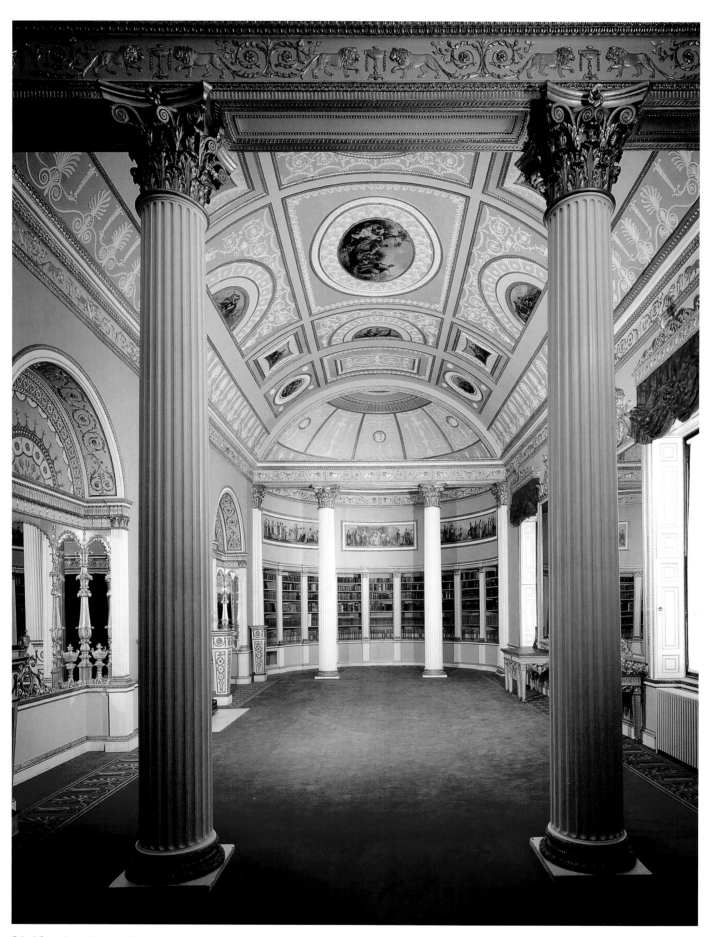

21-10 Robert Adam. The Library, Kenwood, London. 1767–69

body of the structure. The interior, probably by Kent, is more luxurious, in the manner of Jones, and reflects the whimsical application of principles in eighteenth-century England. Just as Rococo strains filter into the Neoclassical painting of Angelica Kauffmann, Rococo elegance and playfulness will dramatically temper Neoclassical interiors, especially those of their most famous practitioner, Robert Adam.

Robert Adam The English Neoclassical interior was epitomized by the work of Robert Adam (1728–1792). His friendship with Piranesi in Rome reinforced Adam's goal of arriving at a personal style based on the antique without slavishly imitating it. His genius is seen most fully in the interiors he designed in the 1760s for palatial homes, which take the style of Lord Burlington and William Kent as their point of departure (see fig. 21-9). Most are remodelings of or additions to existing homes. The library wing he added to Kenwood (fig. 21-10) shows Adam at his finest. It is covered with a barrel vault connected at either end to an apse that is separated by a screen of Corinthian columns. The basic scheme, though Roman in origin, comes from Palladio (see pages 317–18). Amazingly, it had been anticipated more than 40 years earlier by Johann Fischer von Erlach (see pages 418–19), who no doubt used the same source.

But the library is hardly a quiet austere classical interior. On the one hand, it is symmetrical, geometric, planar, and carefully balanced. But on the other, it is filled with movement, largely because of the wealth of details and shapes that forces the eye to jump from one design element to the next. It is a busy and animated interior rather than a tranquil room. Furthermore, Adam's palette is pastel and light: light blues, bright white, and gold. Curving circles, delicate plant forms, graceful fluted columns with ornate Corinthian capitals set a festive, elegant, and refined tone that is closer to the Rococo playfulness than Neoclassical morality. No wonder Adam on occasion commissioned Angelica Kauffmann to make paintings to adorn his interior decoration. Credit for the stucco decoration, the raised white plaster ornament,

goes to Joseph Rose, which was adapted from newly discovered Roman examples.

THE ENGLISH COLONIES IN AMERICA: THOMAS JEFFERSON

Meanwhile, the Palladianism launched by Lord Burlington spread overseas to the American Colonies, where it became known as the Georgian style, after King George III of England. An outstanding example is Thomas Jefferson's (1743–1826) house, Monticello (fig. 21-11). Built of brick with wood trim, it is less doctrinaire in design than Chiswick House (fig. 21-9). (Note the numerous windows.) Nevertheless, it stands as a monument to the Enlightenment ideals of order and harmony, with which Jefferson fully agreed. Jefferson adapted the original plan from a book of English designs, then he gradually modified it as he was exposed to other treatises. In its final form Monticello has a facade inspired by Palladio (compare fig. 14-14). Instead of using the Corinthian order favored by Lord Burlington, Jefferson chose the Roman Doric, which Adam had helped to legitimize, although the late eighteenth century came to favor the heavier and more austere Greek Doric.

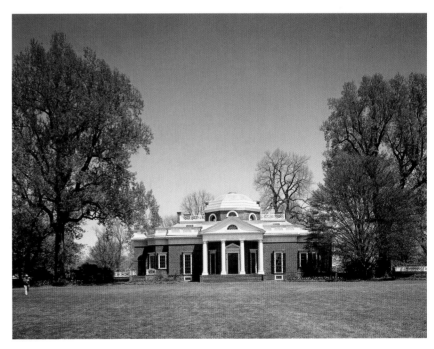

21-11 Thomas Jefferson. Monticello, Charlottesville, Virginia. 1770–84; 1796–1806

22-1 Francisco Goya. *The Family of Charles IV.* 1800. Oil on canvas, 9'2" × 11' (2.79 × 3.35 m). Museo del Prado, Madrid

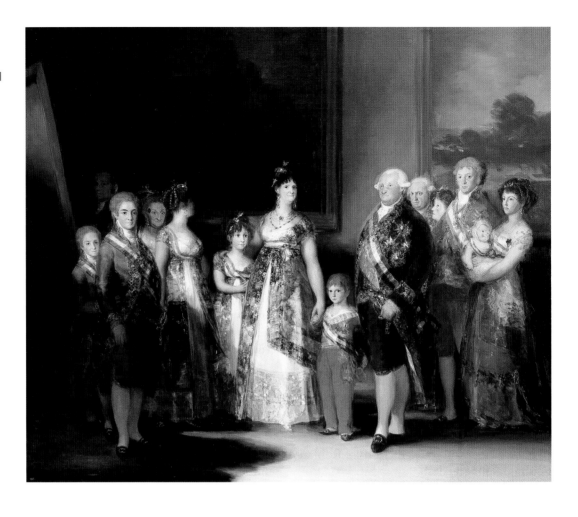

haughty pose of Van Dyck's *Charles I*, fig. 18-6). Unlike traditional group portraiture, there is little hierarchy of importance, no rational order. Nor do the characters interact; everyone seems individually consumed by whom they are. They appear lonely, isolated, even afraid. Each is an individual, plagued by the same doubts about the meaning of existence and the same sense of alienation that haunt all humans. Existence is now unknowable and beyond comprehension, and this shockingly modern psychology casts a dark shadow over the room.

An even more powerful mood of futility pervades Goya's *The Third of May, 1808* (fig. 22-2), one of many paintings, drawings, and prints made from 1810 to 1815 in response to the French occupation of Spain in 1808. Like many Spaniards, Goya hoped the occupation would result in the liberalization of his backward repressive country. Instead NAPOLEON'S forces crushed that dream with barbaric acts that led to a popular resistance of equal savagery. *The Third of May, 1808*, one of a pair of paintings commissioned in 1814 by the newly restored

king, Ferdinand VII, represents the execution of rioters who rebelled against the French troops. A stable lantern illuminates the mechanical process of the slaughter: the line of men cowering at their fate, those being executed as they futilely plead for their lives, and the lifeless bodies littering the foreground. The anonymous rioter with raised arms, dressed in the yellow and white canonical colors of the Catholic Church, has the pose of Christ in the Garden of Gethsemane, where he was surprised by Roman soldiers. His right hand has a stigmata, a wound suggesting Christ's crucifixion. But ironically Goya denies the rioters status as martyrs. They are consumed by a fear of death, not the ecstasy of sacrifice. No divine light materializes to resurrect them, and to the contrary, the church in this imaginary scene remains dark. When the human-made lantern is extinguished, there will only be eternal night, as symbolized by the inert foreground body, abandoned by God, whose face is reduced to a chaotic gory mass of paint. The faceless executioners are indifferent to their victims' defiance and despair.

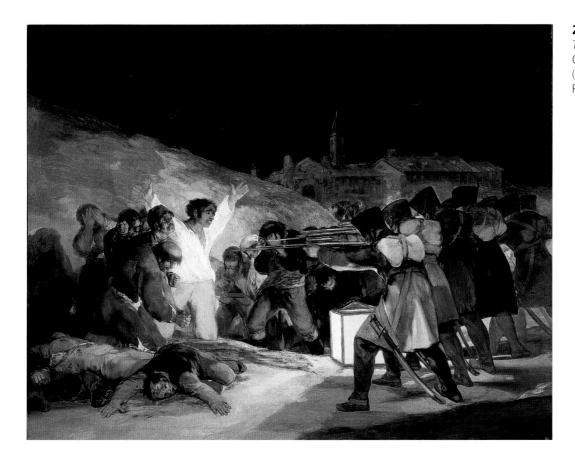

22-2 Francisco Goya. *The Third of May, 1808.* 1814. Oil on canvas, 8'9" × 13'4" (2.67 × 4.06 m). Museo del Prado, Madrid

Although the rioters can be seen as martyrs dying for liberty and the executioners the agents of political tyranny, the real power of the picture lies in the intense sense of terror it instills in us and our own sense of mortality. It is about the specifically modern condition of the anonymity of death, the senseless killing of millions. Reinforcing the drama and hysteria of the image is Goya's bold, even crude, brushwork and blazing color. His importance for the Baroque Romantic painters of France was affirmed by Delacroix, one of the greatest of them all (see pages 458–60), who said that the ideal style would be a combination of Michelangelo's and Goya's art.

FRANCE

By 1795 Neoclassicism in France had largely lost its purity and rigor and was consumed by Romanticism. Weary of and disillusioned by the turmoil and executions of the Revolution, artists began to turn away from heroic themes of sacrifice. Indeed, Napoleon's reign (1799–1815) fueled the rise of Romanticism. Instead of modeling his government on the noble simplicity of republican Greece, as had the short-lived French Republic of the 1790s, Napoleon aspired to the exotic sumptuousness of Imperial Rome. In 1804, he had himself crowned emperor, and during the decade he conquered most of Europe and expanded French colonies around the globe. The exciting glamour and adventurous conquests of his campaigns provided ideal material for artists looking for wondrous new subjects.

Paradoxically, the Romantic movement began to emerge among a group of students in the Primitif faction of Jacques-Louis David's studio (see fig. 21-2). These rebellious students simplified his severe Neoclassicism still further by turning to the linear designs of Greek and Etruscan vase painting and to the unadorned style of the Italian Early Renaissance (see figs. 5-3 and 12-21). At the same time, they undermined it by preferring subjects whose appeal was primarily emotional rather than intellectual. Their sources were not moralistic tales by such classical authors as Horace or Ovid but wild and fanciful scenes from the Bible, Homer, Ossian (the legendary Gaelic bard whose poems were forged by James Macpherson in the eighteenth century), and Romantic literature—anything that excited the imagination and provoked awe or wonder in the

viewer. The Neoclassical style was too confining for most of David's students, who instead fostered a Baroque revival to capture the excitement of their age.

Jean-Auguste-Dominque Ingres One of the Primitifs in David's studio, Jean-Auguste-Dominque Ingres (1780–1867), took over leadership of his school. Because he went to Italy in 1806 and remained for 18

years, he largely missed out on the formation of Romantic painting in France. After returning, he became the high priest of the Davidian linear tradition, which he defended from the attacks of younger painterly artists. What had been a revolutionary style only a half century earlier now became rigid dogma, endorsed by the government and backed by the weight of conservative opinion.

Consequently Ingres is usually labeled a Neoclassicist, and his painterly Baroque opponents Romantics. Actually, both factions stood for aspects of Romanticism after 1800: the Neoclassical phase, with Ingres as the last important survivor, and the Baroque-revival artists, announced in France by Antoine-Jean Gros, whom we will soon meet. On the surface, it would seem as though Neoclassicism and the Baroque revival were worlds apart, an interpretation supported by the resurrection by these two camps of the old quarrel between Poussinistes and Rubénistes (see page 412), i.e., the quarrel of line versus color. But in fact the two styles seem so interrelated that we should prefer a single name for both if a suitable one could be found.

The evolution of Neoclassicism into a Romantic phase can be seen Ingres's *Portrait of Napoleon on His Imperial Throne* (fig. 22-3), painted in 1806 before the artist left for Italy. If David's *Oath of the Horatii* represents a stoic moral stage of Neoclassicism, then Ingres's depiction of Napoleon is an indulgent imperial one. Ingres retains David's emphasis on line (note the beautiful rhythm of the edge of the robe falling from Napoleon's right arm, or descending from his left hand) as well as his teacher's severe planarity, for he aligns everything with the picture plane and compresses it in a relatively shallow space. But here the comparison ends. Every square inch of Ingres's painting is filled with opulence—gold, gems, ermine, marble, tapestries, rare objects. In one hand Napoleon holds the golden scepter of King Charlemagne, and in the other, the ivory hand of justice of the French Medieval kings. The elaborate gild throne looks like it is from Imperial Rome. Its curved back forms a halo around the emperor's head, which contemporaries recognized as a reference to *God the Father* on the central panel of Jan and Hubert Van Eycks' *Ghent Altarpiece* (fig. 15-2), then

22-3 Jean-Dominique Ingres. *Portrait of Napoleon on His Imperial Throne.* 1806. Oil on canvas, 8′9″ × 5′3″ (2.66 × 1.6 m). Musée de l'Armée, Palais des Invalides, Paris

installed in the Napoleon Museum in Paris and part of the immense wealth of Napoleon's conquests. Napoleon even strikes the same pose as God, which when combined with his iconic frontal position suggests he is endowed with the same qualities, or at least is sanctioned by God. This frozen larger-than-life image presents Napoleon as aloof and divine, but its wondrously exotic content had to have fascinated, even awed, the audience at the Salon of 1806.

Ingres's color is virtually as opulent as the objects in his portrait of Napoleon, and it even has the same jewel-like luster found in the Van Eyck's *Ghent Altarpiece*. Ingres always held that drawing was superior to painting, yet his paintings reveal an exquisite sense of color. This can be seen in *Odalisque with a Slave* (fig. 22-4) from 1839–40. Instead of merely tinting his design, Ingres sets off the petal-smooth limbs of his oriental Venus (*odalisque* is a Turkish word for a harem slave girl) with a dazzling array of transparent tones and rich textures. The painting has a poetic mood, filled with the enchantment of the *Thousand and One Nights*. The exotic subject is characteristic of the Romantic movement. Despite Ingres's professed worship of Raphael, this nude hardly embodies a classical ideal of beauty. Her elongated proportions, languid grace, and strange mixture of coolness and voluptuousness remind us of Parmigianino's figures (compare fig. 14-3). In Ingres's hands, line has a life all its own, and its purpose is more to seduce the eye through gentle sensuous contours than it is to define the perimeter of an object. Whether he admitted it or not, Ingres was just as Romantic as his great rival, Eugène Delacroix (compare fig. 22-7 and 22-8).

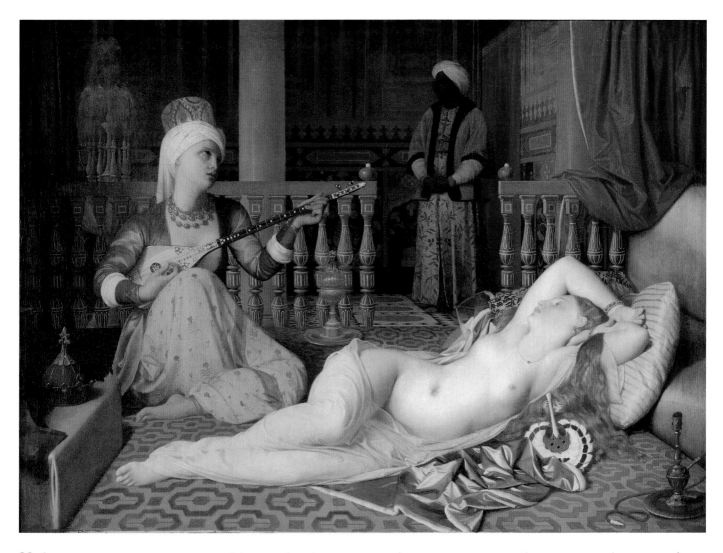

22-4 Jean-Auguste-Dominique Ingres. *Odalisque with a Slave*. 1839–40. Oil on canvas, 28⅜ × 39½" (72.1 × 100.3 cm). Courtesy of Fogg Art Museum, Harvard University Art Museums, Cambridge, Bequest of Grenville L. Winthrop, 1943.251

Antoine-Jean Gros Antoine-Jean Gros (1771–1835) was David's favorite pupil. While David became an ardent admirer of Napoleon and painted several large pictures glorifying the emperor, he was partially eclipsed by his students, especially Gros, who became Napoleon's artist of choice for mythologizing his military triumphs. Napoleon was as brilliant at propaganda as he was at military strategies, and he relied heavily on art to reinforce his political position, as did the Roman emperors (see figs. 7-17 and 7-20). He commissioned large pictures that glorified him and was sure to have them shown at the Salons, where they would be seen by everyone and reported in the press.

Gros's *Napoleon in the Pesthouse at Jaffa, 11 March 1799* (fig. 22-5), one of the hits at the Salon of 1804, was designed to promote the emperor's humanitarian side. Such a display would have seemed essential to Napoleon in the face of the enormous human loss tallied in his battles. To accomplish this, Gros casts Napoleon as a Christ-like leader and healer. In 1799 during the siege of Jaffa, then under the rule of the Ottoman Empire, the bubonic plague broke out. To calm the panic that followed, the general entered the pesthouse and walked fearlessly among the patients—an event that soon became legendary. This is the moment Gros paints. The focus is on the general's courage in touching the sick and the dying, even inserting his finger in an infected wound while the weaker officer behind him recoils from the stench of disease, covering his face with a kerchief. The composition of the central group is a play on the Doubting of Thomas (see fig. 12-8), but now the roles are reversed, as Napoleon becomes Christ and the sick solider the mortal Thomas. This simple but ingenious device raises Napoleon to a godlike status even before he became emperor toward the end of 1804, the year the picture was painted.

What makes this picture so Romantic are its exotic motifs, turbulent drama, and gruesome depiction of death and suffering. Napoleon's conquests opened up Egypt and the Near East for the first time in centuries and led to the European colonization of North Africa. This picture is one of the first manifestations of Orientalism, the Romantic fascination with the Arab world that preoccupied European artists and writers throughout most of the nineteenth century. Gros could not resist dwelling on the foreign costumes and architecture (the three dramatically silhouetted arches curiously paraphrase the arches in David's *Oath of the Horatii* [see fig. 21-2]). But it is the sense of doom and gloom,

22-5 Antoine-Jean Gros. *Napoleon in the Pesthouse at Jaffa, 11 March 1799.* 1804. Oil on canvas, 17'5½" × 23'7½" (5.32 × 7.2 m). Musée du Louvre, Paris

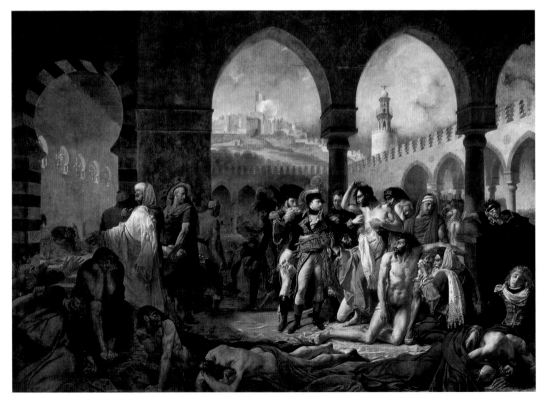

of the horrific, of experiences far from the ordinary that catapult this scene into a highly Romantic work. The sick exhibit a grotesque pallor, and their horrid fate is announced by the dark, oppressive arches and foreground shadow, which in turn is reinforced by the apocalyptic aura of the burning buildings in the background. Buried in the foreground shadow is a cast of tormented figures, some taken directly from Michelangelo's ceiling frescoes in the Sistine Chapel. The dominant feeling in this piece of Napoleonic propaganda is not bravery but repugnance. The crystalline clarity of David has given way to the murky uncertainty of uncontrollable fate favored by the Romantic artists.

Théodore Géricault The Romantic trend initiated in France by Gros aroused the imagination of many talented younger artists. One of the most outstanding was Théodore Géricault (1791–1824), whose promising career was cut short by an early death. Apart from Gros, Géricault's chief heroes were Michelangelo and the great Baroque masters. In 1818 he painted his most ambitious work, *The Raft of the "Medusa"* (fig. 22-6), which was made in response to a political scandal and a modern tragedy of epic proportions. In 1816 the Medusa, a government vessel, foundered off the West African coast with hundreds of people on board. Only a handful were rescued, after thirteen days on a makeshift raft that had been set adrift by the ship's heartless captain, officers, and soldiers, who, as government officials, had commandeered the six lifeboats for themselves. The captain was incompetent, an aristocrat appointed for political reasons by the government of Louis XVIII, who was crowned with the restoration of the monarchy after the fall of Napoleon in 1815. The disaster thus became a symbol of government corruption, and a ripe subject for the liberal Géricault.

Initially, Géricault was undecided about this subject, and it was only after exploring

22-6 Théodore Géricault. *The Raft of the "Medusa."* 1818–19. Oil on canvas, 16′1″ × 23′6″ (4.9 × 7.16 m). Musée du Louvre, Paris

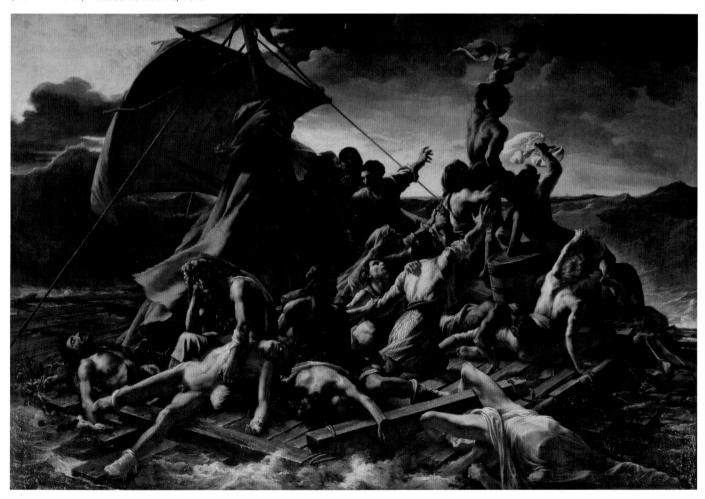

numerous possibilities that he selected the moment when a ship is first sighted. From the bodies of the dead and dying in the foreground, the composition recedes in a dramatic Baroque diagonal (see fig. 18-2) to climax in the group supporting the frantically waving black man. As our eye follows this line of writhing, twisting bodies, we move from death to hope. But this is not a painting about hope. There are no heroes, no exemplary moral fortitude. Rather the theme is man against nature, and Géricault's goal is to make us feel the physical and emotional suffering experienced by the castaways. The classically proportioned Michelangelesque figures are a catalogue of human misery, reflecting the death, cannibalism, fighting, insanity, sickness, exhaustion, hunger, and thirst that tormented the victims. Géricault's stark realism heightens our visceral connection to the dramatically lit event; we are on the crude wood raft, pitched about in the high sea, and aimlessly buffeted by the wind.

Eugène Delacroix The year 1824 was crucial for French painting. Géricault died after a riding accident. The first showing in Paris

of works by the English Romantic painters, especially John Constable, was a revelation to many French artists (see pages 467–68). Ingres returned to France from Italy and had his first public success. And Eugène Delacroix (1798–1863) established himself as the foremost Romantic painter. For the next quarter-century he and Ingres were bitter rivals, and their polarity, fostered by supporters, dominated the artistic scene in Paris.

To critics, who had recently begun to struggle with the problem of defining Romanticism in art, Delacroix seemed the first indisputably Romantic painter, and his work helped to crystallize the issues. As a result, Romanticism now became synonymous with modernism. Delacroix occupied a position at its artistic center comparable to that of Hector Berlioz in music and Victor Hugo and Stendhal in literature. Delacroix, like his model Rubens, is an extremely challenging artist.

One of the first works to show him as a mature master is *The Death of Sardanapalus* (fig. 22-7), inspired by Lord Byron's drama in free verse of 1821. Delacroix was above all a literary painter. (He also became one of the

22-7 Eugène Delacroix. *The Death of Sardanapalus.* 1827. Oil on canvas, 12'1½" × 16'2⅞" (3.69 × 4.95 m). Musée du Louvre, Paris

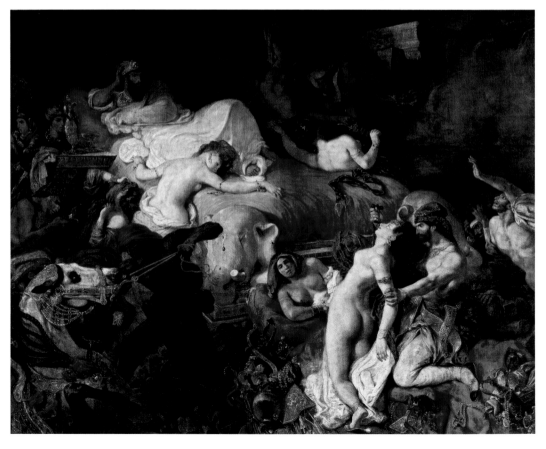

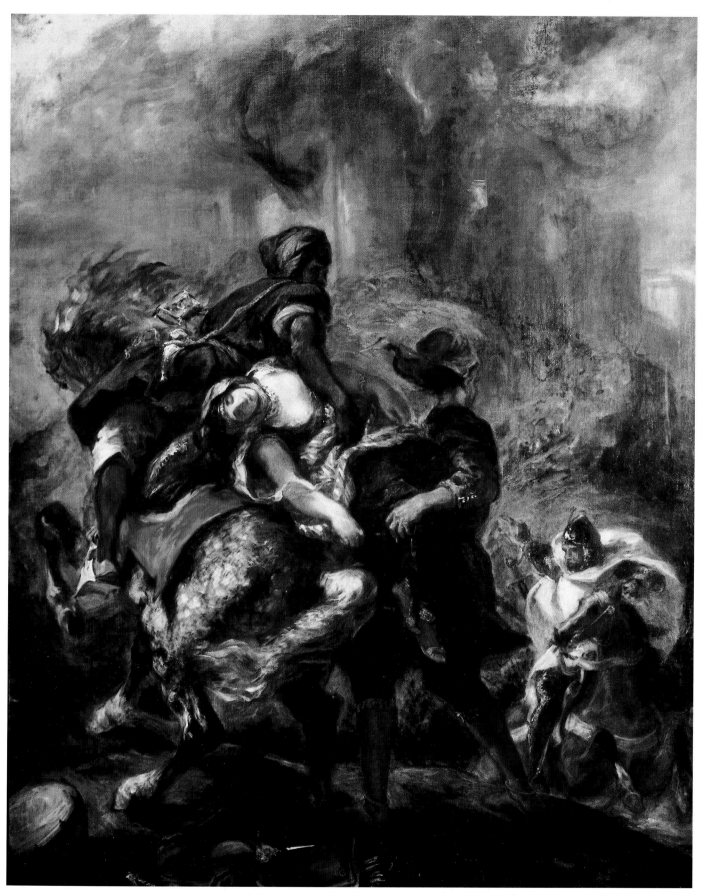

22-9 Eugène Delacroix. *The Abduction of Rebecca.* 1846. Oil on canvas, 39½ × 32¼″ (100.3 × 81.9 cm)
The Metropolitan Museum of Art, New York

Catherine Lorillard Wolfe Collection, Wolfe Fund, 1903 (03.30)

policy ended censorship of the press. This, along with innovations in printing, sparked a proliferation of newspapers that anticipate those of today. One of these innovations was lithography and woodblock engraving, permitting pictures to now appear in the papers, thus increasing their popularity. More than any other artist of his day, Daumier took advantage of this new press to relentlessly expose the corrupt and repressive activities of the government, as well as the avarice and vanity of the nouveaux riche. No social injustice escaped Daumier's sharp eye and caustic draftsmanship.

The extent of Daumier's concern for the working class shows clearly in his paintings, which he started making in the 1840s but virtually never exhibited. The urban life of his cartoons is now viewed through a painter's eye, with compassion replacing satire. We can see this in one of his most famous oils, *The Third-Class Carriage*, c. 1862 (fig. 22-10). Here Daumier's concern is not for the visible surface of reality but for the emotional meaning behind it. The picture captures a peculiarly modern condition: "the lonely crowd." Daumier was especially captivated by the experience of the throngs of workers who crowded into third-class rail-

way cars for a daily commute, consigned to hard benches in contrast to wide plush seats of first class (the first railway to open in France was the Paris–Orléans line in 1843). The artist tells us *nothing* about these people; we do not know who they are, what they do, or where they come from. They are anonymous, part of the growing urban masses, who although packed together on a train, take no notice of one another. Silent and tired, they seem imprisoned in a turgid Rembrandtesque gloom, and struggle to emerge from a Baroque sketchiness to take on an identity. Nonetheless Daumier presents his workers with dignity, for the family on the front bench are large massive forms, which have a monumentality reserved for the Holy Family. This emblematic presentation was the hallmark of Daumier's contemporary Jean-François Millet, who unlike Daumier was widely exhibited and influential.

Jean-François Millet Jean-François Millet (1814–1875) was the advocate of the peasant, just as Daumier championed the urban poor. Millet was born into a family of well-off farmers in Normandy, where he was steeped in the land and the timeless seasonal cycle of rural life. Well educated and well

22-10 Honoré Daumier. *The Third-Class Carriage*. c. 1862. Oil on canvas, 25¾ × 35½" (65.4 × 90.2 cm). The Metropolitan Museum of Art, New York

Bequest of Mrs. H. O. Havemeyer, 1929. The H. O. Havemeyer Collection (29.100.129)

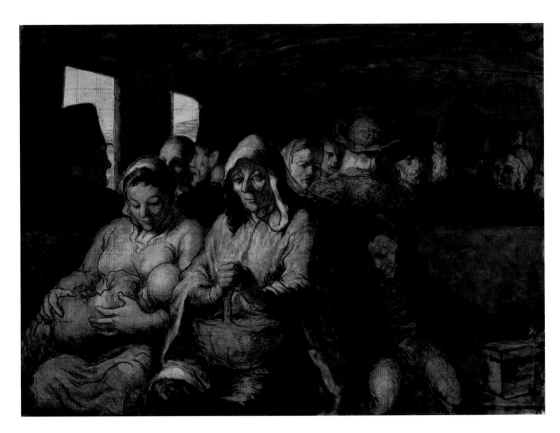

read, he came to Paris to study art in 1845, in time to experience the growing unrest of the lower and middle classes, which demanded social reforms and a voice in the government. This agitating climaxed with the short but bloody REVOLUTION OF 1848. Louis-Philippe abdicated and a Second Republic was established. His nephew Louis Napoleon was elected president, and after a military coup in 1852 he crowned himself emperor, Napoleon III. In 1849 Millet left Paris for the wooded environs of Barbizon, located 30 miles southeast of Paris.

It was only after his arrival in Paris and witnessing urban social turmoil that Millet began to focus on the peasant in his art. As we see in *The Sower* of c. 1850 (fig. 22-11), his peasants are clearly poor and downtrodden, wearing tattered clothing and consigned to a backbreaking life of endlessly working the soil. But they are also ennobled. His sower is anonymous and monumental; he has a Poussiniste dignity that transforms him into an emblem of all sowers. Using a Rembrandtesque gloom, Millet creates a laborer who is dark and shadowy, like the soil from which he seems to emerge. He is the embodiment of the earth, a reading enhanced by the gritty Baroque coarseness of Millet's paint. The dramatic sweep of his gesture and undulating contours of the body endow him with an energy that seems to harness the eternal forces of nature itself.

This powerful figure had to have been threatening to the well-to-do urban audience at the Salon, especially in the wake of the Revolution of 1848. It would only be in the following decade that Millet's pictures would be viewed nostalgically, as representing a rural way of life and involvement with nature that was quickly becoming extinct due to industrialization and urbanization. We should not underestimate the importance of nature as a theme in Millet's work, for his pictures do indeed embrace the Romantics' belief in the primacy of nature. At this point, we must turn our attention to landscape painting, which because of the nineteenth-century cult of nature became the most characteristic form of Romantic art.

FRENCH LANDSCAPE PAINTING

The Romantics believed that God's laws could be seen written in nature, that nature

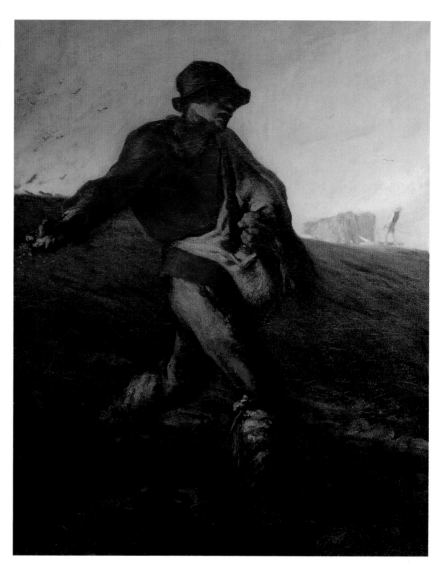

22-11 François Millet. *The Sower.* c. 1850. Oil on canvas, 40 × 32½″ (101.6 × 82.6 cm). Museum of Fine Arts, Boston
Gift of Quincy Adams Shaw through Quincy A. Shaw, Jr., and Mrs. Marion Shaw Haughton, 17.1485

was a manifestation of God, and he was present within it. Where they differed strongly from the Enlightenment mentality is that their faith, known as PANTHEISM, was based on subjective experience, not on rational thought. The appeal to the emotions rather than the intellect made those experiences all the more compelling. To express the feelings inspired by nature, the Romantics transcribed landscape as faithfully as possible, in contrast to the Neoclassicists, who idealized it by forcing it to conform to prescribed ideas of beauty and linking it to historical subjects. At the same time, the Romantics felt free to modify nature's appearance as a means of evoking heightened states of mind in accordance with the dictates of the imagination, the only

PANTHEISM (from the Greek *pan*, "all," and *theos*, "god") is the belief that God and the universe are ultimately identical, and that everything that exists is therefore a divine unity. Although the term itself was first used in 1705 by the British author John Toland, the idea has an ancient, wide-ranging history. Two of the world's major religions, Hinduism and Buddhism, draw upon the pantheistic view, as does the work of many philosophers (among them, Lao-tzu, Plato, Baruch Spinoza, and Paul Tillich) and authors (including Ralph Waldo Emerson, Walt Whitman, and D. H. Lawrence).

standard they ultimately recognized. Landscape inspired the Romantics with powerful passions, and it is interesting that these varied tremendously from one nation to the next. In France, Romantic landscape was largely poetic and serene.

Camille Corot The first French Romantic landscape painter was Camille Corot (1796–1875). In 1825 he went to Italy for two years and explored the countryside around Rome, like a latter-day Claude Lorraine. What Claude recorded in his drawings—the quality of a particular place at a particular time—Corot made into paintings, small canvases done on the spot in an hour or so. He, too, insists on "the truth of the moment," and in a picture like *View of Rome* (fig. 22-12), painted in 1826–27, we can see this. We are convinced we are indeed looking at the Castel Sant'Angelo and St. Peter's, and can feel the sun's heat bouncing off of stone and the clear late afternoon light crisply delineating the buildings and bridge. Without idealizing his landscape, Corot displays an instinct for architectural clarity and stability that recalls Poussin and Claude, a comparison further reinforced by the picture's lack of details. Landscape inspired Corot to project a poetic mood, which he evoked through the harmony of color and tonality and the architectural structure of the composition. But his starting point was nature itself and his desire to capture its

essence. His willingness to accept these small sketches as independent works of art further marks him as a Romantic.

Théodore Rousseau The center for French landscape was the peaceful village of Barbizon and the nearby Forest of Fontainebleau, where Corot spent considerable time and Millet settled. Easily accessible from Paris, it miraculously offered nature in a relatively pristine unspoiled state, undisturbed by the Industrial Revolution smoldering just 30 miles away. Instead of the Neoclassical tradition, Barbizon artists turned to the Northern Baroque, particularly to artists like Ruisdael (see fig. 18-15). While they learned from the Dutch how to replicate many of dramatic properties of nature, especially atmospheric qualities, they generally avoided many of their artificial compositional structures.

The best known of these landscapists was Théodore Rousseau (1812–1867), who moved to Barbizon in the 1830s. His *Under the Birches* (fig. 22-13), painted in 1842–43 when staying in Southern France, shares with Corot's *View of Rome* a fidelity to nature. Each tree, rock, and cloud seems carefully studied and unique. We sense the time of day from the dimming quality of the light and feel the heavy atmosphere of late autumn in the damp ground and rust-colored leaves. Reflecting the omnipotence of nature is the small figure of a curate dwarfed by the

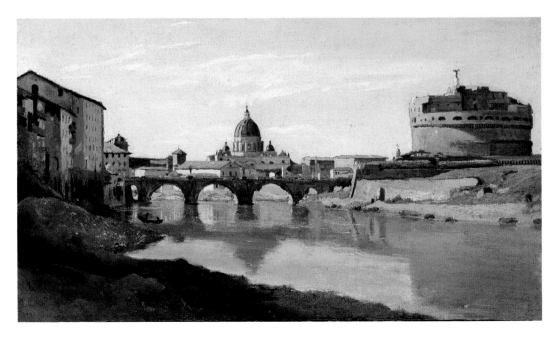

22-12 Camille Corot. *View of Rome: The Bridge and Castel Sant'Angelo with the Cupola of St. Peter's.* 1826–27. Oil on paper mounted on canvas, 10½ × 17" (26.7 × 43.2 cm). Fine Arts Museums of San Francisco

Museum Purchase, Archer M. Huntington Fund, 1932.2

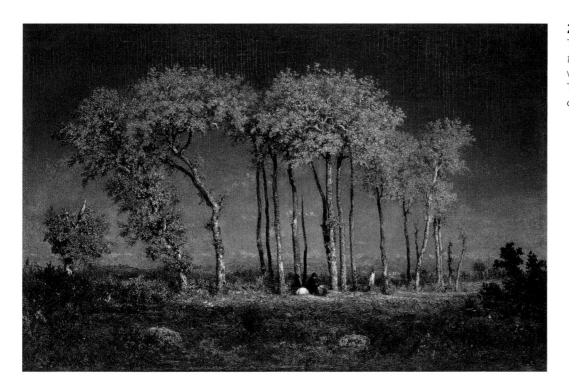

22-13 Pierre-Étienne-Théodore Rousseau. *Under the Birches.* 1842–43. Oil on wood panel, 16⅝ × 25⅜". Toledo Museum of Art, Ohio

Gift of Arthur J. Secor

towering stand of trees. Rousseau has filled his landscape with a simple reverence that admirably reflects the rallying cry of the Romantics—sincerity.

Rosa Bonheur In 1848 the new Second Republic commissioned the young Rosa Bonheur (1822–1899) to paint an agricultural scene. The commission reflects the increasing nostalgic interest that urbanites had in French rural life and the desire to faithfully document the agricultural variations of the different regions. Bonheur responded with *Plowing in the Nivernais* (fig. 22-14), which was a huge success at the Salon of 1850, where Millet's *Sower* was shown as well. Most likely, Bonheur's selection of subject matter was inspired by George Sand's 1846 novel, *The Devil's Pool*, which portrayed the harmonious relationship of humanity and nature. Bonheur went to Nivernais to study the peculiarities of the land, animals, farm tools, and regional dress, all of which her public could recognize in her highly detailed painting.

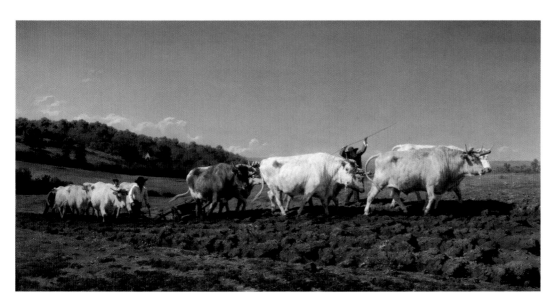

22-14 Rosa Bonheur. *Plowing in the Nivernais.* 1849. Oil on canvas, 5'9" × 8'8" (1.75 × 2.64 m). Musée d'Orsay, Paris

But for all of the realism and the earthiness of her subject matter, the picture seems sanitized compared to Millet's *Sower*. Bonheur keeps the essence of farm life at arm's length. We may feel the ponderous weight of the enormous Nivernais oxen, but we get no sense of toil and no smell of earth. Instead the scene is idyllic and grand, reassuring Parisians that rural life was bucolic not oppressive. Unlike Millet's *Sower*, this is an objective picture that anticipated the neutrality of the positivist painting of the second half of the century (e.g., Courbet and Impressionism) and documentary photography. It appealed to conservative taste that generally preferred pretentious history painting. Bonheur went on to specialize in animal pictures, becoming the most famous woman artist of the nineteenth century, and, in 1894, the first woman officer in the Legion of Honor.

ENGLAND

England was as precocious in fostering Romanticism as it had been in promoting Neoclassicism. In a sense it anticipated if not even invented the genre when Edmund Burke wrote about the sublime as generating more powerful emotions than beauty in his treatise *A Philosophical Enquiry into the Origin of Our Ideas of the Sublime and Beautiful* (1757). More passionately than the French, whose Romanticism tended to be more poetic, the English embraced the most awesome, horrific moments of existence, with entire careers as opposed to isolated paintings based on such frightening apocalyptic imagery. After all, it was England that produced the wild imaginations of Byron and Shelley in addition to the poetic reveries of Wordsworth.

John Henry Fuseli John Henry Fuseli (1741–1825) was a contemporary of West and Copley, which indicates how early Romanticism appeared in England. This Swiss-born painter had an extraordinary impact on his time, more perhaps because of his adventurous and forceful personality than the quality of his work. Ordained a minister at 20, he left the Church by 1764 and went to London in search of freedom. Encouraged by Reynolds, he spent the 1770s in Rome, where he studied classical art. Fuseli, however, based his style on Michelangelo and the Mannerists, not on Poussin and the antique. A German acquaintance of those years described him as "extreme in everything, Shakespeare's painter." Shakespeare and Michelangelo were indeed his twin gods. He even envisioned a Sistine Chapel with Michelangelo's figures transformed into Shakespearean characters. The Sublime would be the common denominator for "classic" and "Gothic" Romanticism (see page 468). This concept marks Fuseli as a transitional figure. He espoused many of the same Neoclassical theories as Reynolds, West, and Kauffmann (he translated Winckelmann's writings into English) but bent their rules virtually to the breaking point. We see this mixture in *The Nightmare* (fig. 22-15). The sleeping woman, more Mannerist than Michelangelesque in proportions, is Neoclassical in style. The grinning devil and the luminescent horse, however, come from the demon-ridden world of medieval folklore, whereas the Rembrandtesque lighting reminds us of Reynolds (compare fig. 20-10). Here the Romantic quest for terrifying experiences leads not to physical violence but to the dark recesses of the mind.

What was the genesis of *The Nightmare?* Nightmares often have strong sexual overtones, sometimes openly expressed, at other times disguised. We know that Fuseli originally conceived the subject not long after his return from Italy. He had fallen violently in love with a friend's niece who soon married a merchant, much to the artist's distress. We

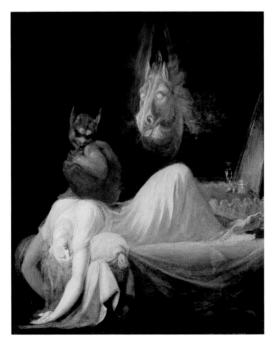

22-15 John Henry Fuseli. *The Nightmare*. c. 1790. Oil on canvas, 29½ × 25¼" (74.9 × 64.1 cm). Freies Deutsches Hochstift-Frankfurter Goethe-Museum, Frankfurt

may see in the picture a projection of his "dream girl," with the demon taking the artist's place while the impassioned horse, a well-known erotic symbol, looks on.

William Blake Fuseli later befriended the poet-painter William Blake (1757–1827), who had an even greater creativity and stranger personality than his own. Blake despised the materialism of contemporary England and the Enlightenment rationalism that produced it. He was a recluse and visionary, who, through poems published with engraved text and hand-colored illustrations, created his own spiritual cosmology. His books were meant to be the successors of medieval illuminated manuscripts, for his intense spirituality led him to admire the Middle Ages. Although he never left England, he also acquired a large repertory of Michelangelesque and Mannerist motifs from engravings, as well as through the influence of Fuseli.

These elements are all present in Blake's memorable image *The Ancient of Days* (fig. 22-16), the frontispiece for his 1794 book *Europe, A Prophesy.* The muscular figure, radically foreshortened and fitted into a circle of light, is taken from Mannerist sources, whereas the symbolic compass comes from medieval representations of the Lord as Architect of the Universe. We might therefore expect the Ancient of Days to signify Almighty God. In Blake's esoteric mythology, however, he stands for the power of reason, which the poet regarded as destructive, because it stifles vision and inspiration. To Blake, the "inner eye" was all-important; he felt no need to observe the visible world around him.

John Constable It was in landscape rather than in narrative scenes that English Romantic painting reached its fullest expression. During the eighteenth century, landscape paintings consisted largely of imaginary scenes conforming to Northern and Italian Baroque examples. John Constable (1776–1837) admired both Ruisdael and Claude, yet he opposed all flights of fancy. Landscape painting, he believed, must be based on observable facts and aim at "embodying a pure apprehension of natural effect." Toward that end, he painted countless oil sketches outdoors. They were not the

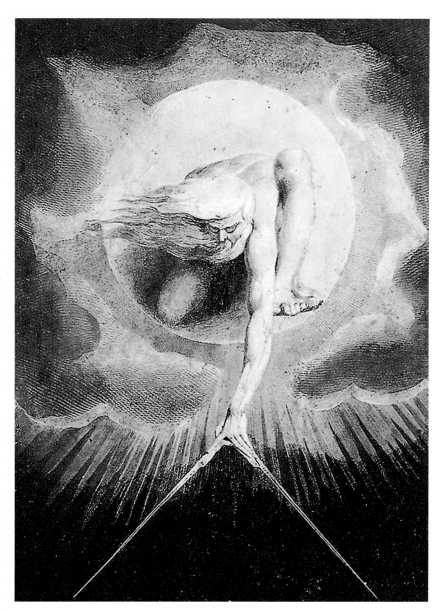

22-16 William Blake. *The Ancient of Days,* frontispiece to *Europe, A Prophesy.* 1794. Metal relief etching, hand-colored, 9⅛ × 6⅝" (23.3 × 16.9 cm). Library of Congress, Washington, D.C.
Lessing J. Rosenwald Collection

first such studies. However, Constable was more concerned than his predecessors with the intangible qualities—sky, light, and atmosphere—rather than the concrete details of the scene. Often the land serves as no more than a foil for the ever-changing drama overhead, which he studied with a meteorologist's accuracy. The sky, to him, was a mirror of those sweeping forces so dear to the Romantic view of nature. It remained "the key note, standard scale, and the chief organ of sentiment."

All of Constable's pictures show familiar views of the English countryside, often around his native Stour Valley. In *The Haywain*

22-17 John Constable. *The Haywain.* 1821. Oil on canvas, 51¼ × 73" (130.2 × 185.4 cm). The National Gallery, London

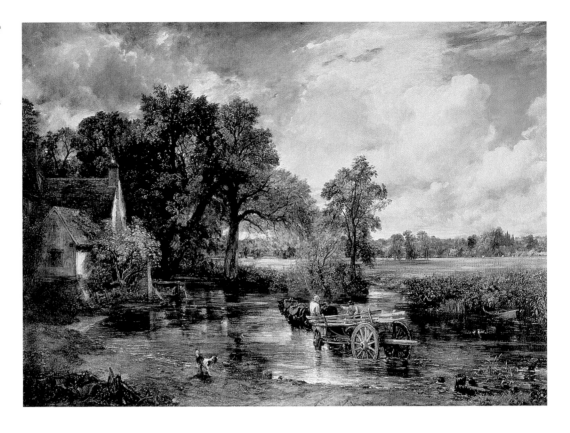

(fig. 22-17), he has caught a particularly splendid moment. A great expanse of wind, sunlight, and clouds plays over the spacious landscape. We sense a blue sky moving in after a noonday storm, for an ambiance of moisture pervades the scene. Constable has magically created this naturalistic image using vibrant flecks of paint and color that seem to dissolve the material world and its detail into one of flickering atmosphere. The earth and sky have become vehicles of sentiment imbued with the artist's poetic attitude. The small scale of the brushwork also gives this monumental composition an intimacy. But it is the detail, including such anecdotes as the dog watching the wagon and the man mooring a boat, that reveals Constable's deep love of the countryside. This new, personal note is characteristically Romantic and gives the painting such conviction that we see the scene through the artist's eyes, just as we feel it through his emotions. *The Haywain* and two other Constable paintings were exhibited in the Salon of 1824 in Paris, where their remarkable brushwork had a dramatic impact on the French artists, particularly Delacroix and the Barbizon landscapists.

J. M. W. Turner Joseph Mallord William Turner (1775–1851) arrived at a style that

Constable disdainfully but accurately described as "airy visions, painted with tinted steam." Turner began as a watercolorist, and the use of translucent tints on white paper may help to explain his obsession with colored light. Like Constable, he made extensive studies from nature (though not in oils), but the scenery he selected satisfied the Romantic taste for the PICTURESQUE and the SUBLIME—mountains, the sea, or places linked with historic events. In his full-scale pictures he often changed these views so freely that they became unrecognizable.

Many of Turner's landscapes are linked with literary themes and bear such titles as *The Destruction of Sodom* or *Snowstorm: Hannibal Crossing the Alps*, or *Childe Harold's Pilgrimage: Italy*. When they were exhibited, he would add appropriate quotations from ancient or modern authors to the catalogue. Sometimes he would make up some lines himself and claim to be "citing" his own unpublished poem "Fallacies of Hope." These canvases are nevertheless the opposite of history painting as defined by Poussin. The titles indeed indicate "noble and serious human actions," but the tiny figures, who are lost in the seething violence of nature, suggest the ultimate defeat of all endeavor— "the fallacies of hope."

THE PICTURESQUE and THE SUBLIME are both aesthetic concepts developed in the eighteenth century. The former was employed to describe landscape scenes that were less idealized than those of the previous century. Such views, often showing dreamy vistas intended to evoke pleasant bucolic memories, were quite often used as models by landscape designers of the period. Conversely, works calling upon the Sublime often inspired awe, for they depicted all that was grand, wild, and extraordinary in nature. The Romantics in particular appreciated how such works could fire the imagination.

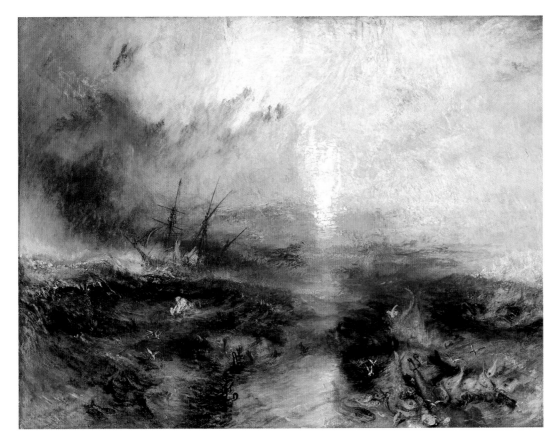

22-18 Joseph Mallord William Turner. *The Slave Ship, (Slavers Throwing Overboard the Dead and Dying Typhoon Coming On)*. 1840. Oil on canvas, 35¾ × 48¼" (90.8 × 122.6 cm). Museum of Fine Arts, Boston. Henry Lillie Pierce Fund, 99.22

Photograph ©2004 Museum of Fine Arts, Boston

The Slave Ship (fig. 22-18) is one of Turner's most spectacular visions and illustrates how he translated his literary sources into "tinted steam." First entitled *Slavers Throwing Overboard the Dead and Dying—Typhoon Coming On*, it has to do, in part, with a specific incident that Turner had recently read about. When an epidemic broke out on a ship hauling captured Africans to be sold as slaves, the captain threw his human cargo overboard because he was insured against the loss of slaves at sea, but not by disease. Turner also thought of a relevant passage from James Thomson's poem *The Seasons* that describes how sharks follow a slave ship during a typhoon, "lured by the scent of steaming crowds, or rank disease, and death." Of the many storms at sea that Turner painted, none has quite this apocalyptic quality. A cosmic catastrophe seems about to engulf everything, not merely the "guilty" slaver but the sea itself, with its crowds of fantastic and oddly harmless-looking fish.

GERMANY

Romanticism had strong roots in Germany, dating to the 1774 publication of Johann Wolfgang von Goethe's *The Sorrows of Young Werther*. The short novel rejected reason in favor of emotion, which as unfettered nature, was elevated as the basis for all morality and human action. The book was an international sensation, and in Germany, it gave rise to the literary movement called "Storm and Stress" ("*Sturm and Drang*"), which in addition to celebrating unrestrained passion advocated a return to the spirituality of the Middle Ages. The Gothic cathedral was the embodiment of this spirituality; it was viewed both as a Christian and a German architecture. German writers believed it was built not by calculation but by intuition. Like a tree, it just grew, and its towering scale was compared to the grandeur of the German forests. The Gothic cathedral was a metaphor for emotion, and nature, religion, and spirituality—all were manifestations of the same mysterious divine force. This Romantic spirit in Germany was no better represented than in landscape.

Caspar David Friedrich The most important German Romantic artist was Caspar David Friedrich (1774–1840), who endowed landscape with a melancholy spirituality while raising frightening questions about the

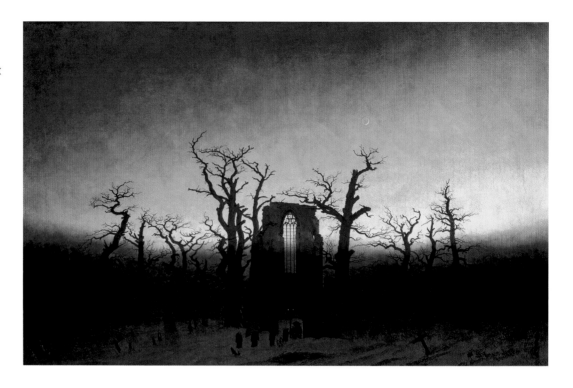

22-19 Caspar David Friedrich. *Abbey in an Oak Forest*. 1809–10. Oil on canvas, 44 × 68½″ (111.8 × 174 cm). Nationalgalerie, Staatliche Museen Zu Berlin

meaning of life and death. In *Abbey in an Oak Forest* (fig. 22-19) of 1809–10, he presents us with a image of death: a snow-covered cemetery, barren trees, a procession of monks carrying a coffin, a ruined church, and a somber winter sky at twilight. The trees and Gothic abbey are like skeletons forming a barrier. On one side is a concrete world of death, and on the far side is the intangible ethereal glow of the sinking sun. Or are the trees and abbey a gate? And is the light divine? The procession of monks approaches a crucifixion at the door, and barely visible is a crescent moon above, both suggesting rebirth and renewal. But it is a mood of gloom that prevails, leaving in doubt the possibility of resurrection and making this picture of loneliness and uncertainty a psychological portrait of the modern condition.

UNITED STATES

As in England and Germany, Romanticism in America was dominated by landscape. It emerged in the 1820s when Americans realized the wilderness was the most distinctive feature of the New World and the basis for its emerging culture. The forests and mountains became the emblems for the young nation. But because it was pristine, untouched by civilization, the wilderness was not just landscape; it was perceived as a manifestation of God. Led by such transcendental poets and writers as Henry Thoreau and Ralph Waldo Emerson,

pantheism virtually became a national religion during the Romantic era. Landscapists were not just painting magnificent views, they were portraying the sublime presence of God.

Thomas Cole The father of American landscape is Thomas Cole (1801–1848), who founded the Hudson River School, which flourished from 1825 to the 1870s. After an 1825 summer sketching tour up the Hudson River, Cole invented the means of expressing the elemental power of the country's primitive landscape by transforming the formulas of the English picturesque into Romantic hymns based on the direct observation of nature. Because he also wrote poetry, he was uniquely able to create a visual counterpart to the literary ideas of the day. His painting *View of Schroon Mountain, Essex County, New York, after a Storm* (fig. 22-20) shows the peak rising majestically like a pyramid from the forest below. It is treated as a symbol of permanence surrounded by death and decay, signified by the autumnal foliage, passing storm, and dead trees. Stirred by sublime emotion, the artist has heightened the dramatic lighting behind the mountain, so that the broad landscape becomes a revelation of God's eternal laws.

George Caleb Bingham *Fur Traders Descending the Missouri* (fig. 22-21) by George Caleb Bingham (1811–1879) sshows this

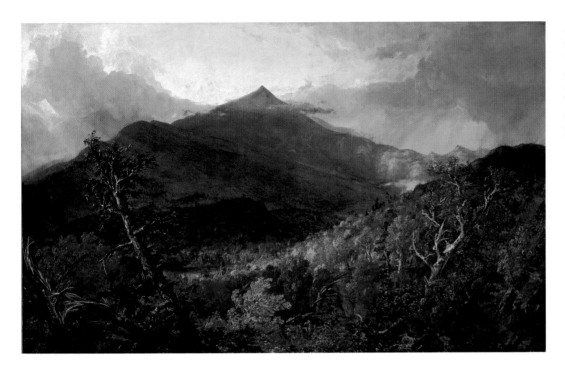

22-20 Thomas Cole. *View of Schroon Mountain, Essex County, New York, after a Storm.* 1838. Oil on canvas, 39⅜ × 63" (100 × 160 cm). The Cleveland Museum of Art

Hinman B. Hurlbut Collection

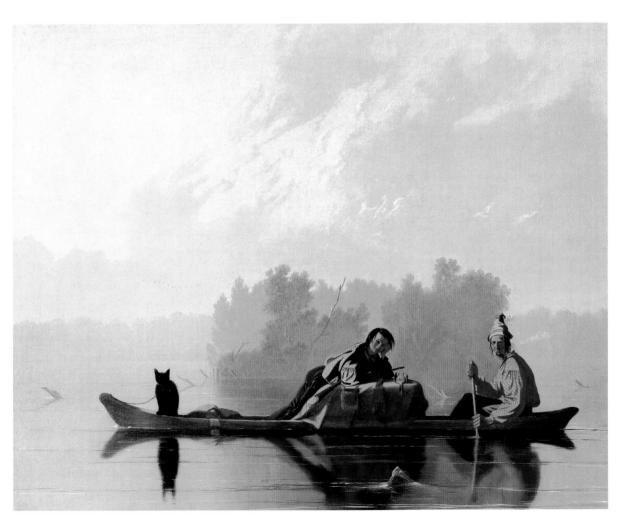

22-21 George Caleb Bingham. *Fur Traders Descending the Missouri.* c. 1845. Oil on canvas, 29 × 36½" (73.7 × 92.7 cm). The Metropolitan Museum of Art, New York

Morris K. Jesup Fund, 1933 (33.61)

close identification with the land in a different way. The picture, both a landscape and a **genre** scene, is full of the vastness and silence of the wide-open spaces. The two trappers in their dugout canoe, gliding downstream in the misty sunlight, are entirely at home in this idyllic setting. Bingham portrays the United States as a benevolent Eden in which settlers assume their rightful place. Rather than being dwarfed by a vast and often hostile continent, these hardy pioneers live in an ideal state of harmony with nature, symbolized by the waning daylight. The picture carries us back to the innocent era of Mark Twain's Tom Sawyer and Huckleberry Finn. It reminds us of how much Romantic adventurousness went into the westward expansion of the United States. The scene owes much of its haunting charm to the silhouette of the black cub chained to the prow and its reflection in the water. This masterstroke adds a note of primitive mystery that we shall not meet again until the work of Henri Rousseau (see page 523).

22-22 Antonio Canova. *Tomb of the Archduchess Maria Christina.* 1798–1805. Marble, life-size. Augustinerkirche, Vienna

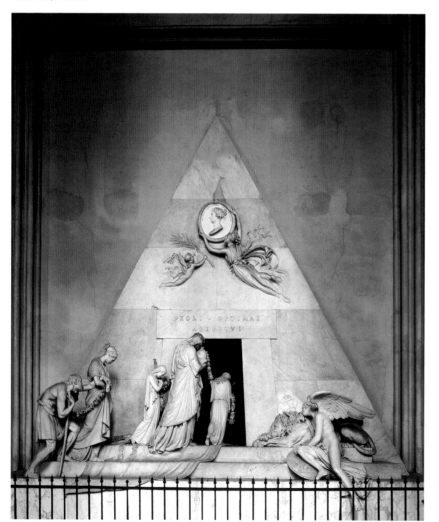

Sculpture

The powerful legacy of antiquity and the Renaissance put virtual blinders on sculptors and patrons. The human figure seemed the only fit subject, and one that was essentially "classical" in style at that. Just as we described Ingres as not just Neoclassical but as a Neoclassical Romantic painter, most nineteenth-century sculpture is essentially Neoclassical, but had elements unique to its time, relating to Romantic notions. Not until the end of the century, when Rodin introduces fragmentary and unfinished sculpture, does the medium begin to break the stranglehold of classical art.

ITALY

Antonio Canova At the beginning of the Romantic era, sculptors adapted the conventions of the Neoclassical style. They were led by Antonio Canova (1757–1822), the most famous artist of the Western world from the 1790s until long after his death, but also a model in both his work and his personality for virtually every sculptor during those years. In the tomb of Maria Christina, archduchess of Austria, in the Church of the Augustinians in Vienna (fig. 22-22), we can see how Canova used a Neoclassical style of classically draped figures. Canova must have known Pigalle's tomb for the maréchal de Saxe (see fig. 20-2), because of the many similarities. The differences are equally striking, however, and quite revealing. Canova's design looks surprisingly like a very high relief. Most of the figures appear in strict profile, so they seem to hug the plane of the wall despite the deep space. Gestures are kept to a minimum, and the dramatic allegorical trappings that clutter Pigalle's monument have been removed, so that nothing distracts us from the solemn ritual being acted out before us. It is this intense concentration and gently melancholy sentiment that distinguishes Canova's Romantic classicism from the Baroque classicism of Pigalle. Actually, Canova's monument is filled with symbolism and allegory, but it is mostly incorporated into a realistic scene, and therefore is not obvious. This ensemble, in contrast to the tombs of earlier times (such as fig. 12-6), does not include the real burial place. The deceased appears only in a portrait medallion framed by a snake biting its own tail (a sym-

bol of eternity) and sustained by two floating genii. Presumably, but not actually, the urn carried by the woman in the center contains her ashes. This is an ideal burial service performed by mostly allegorical figures: a mourning winged genius on the right, and the group about to enter the tomb on the left, who represent the Three Ages of Life. The slow procession, directed away from the beholder, stands for "eternal remembrance." All references to Christianity are conspicuously absent.

FRANCE

It was in France that the main development of Romantic sculpture took place. Although the doctrine of the Academy came to be broadened and modified in the course of time, it lasted until Rodin late in the century. Its core belief was that the human body is nature's noblest creation and hence the sculptor's noblest subject. Translated into practice, this idea meant that every student of sculpture received a rigorous classical training. The course of study was especially demanding at the Paris École des Beaux-Arts, which opened in 1819 and was the most prestigious art school of its time. More than painters, sculptors relied heavily on public commissions for their livelihood, which dictated their themes and restricted their creative freedom.

Françoise Rude François Rude (1784–1855) enthusiastically took Napoleon's side after the emperor's return in 1815 from exile on the island of Elba and was forced to seek refuge in Brussels from Bourbon rule, as had David, whom he knew and revered. After returning to Paris in 1827, he must have felt that artistically he had reached a dead end and struck out in fresh directions, which were distinctly Romantic. With a nationalistic zeal we associate with the Romantic era, he resurrected an interest in French sculptural history, first studying the French Renaissance tradition of the School of Fontainebleau and Giovanni Bologna (see pages 315–16), and then moving back even further into the French past by looking at Claus Sluter (see pages 222–23).

Rude's nationalistic fervor explodes out at us in his masterpiece, *The Departure of the Volunteers of 1792*, commonly called *La Mar-*

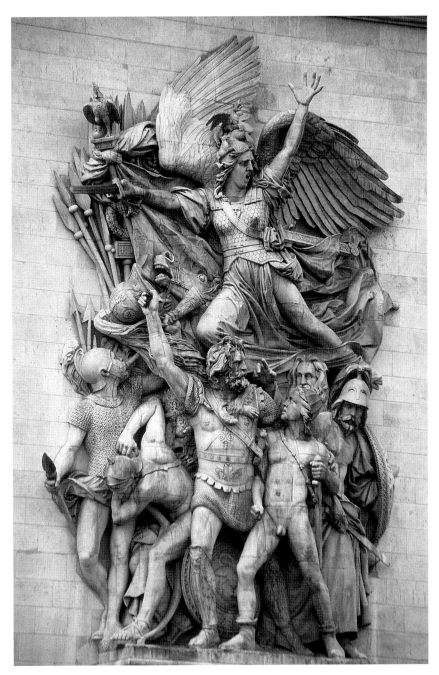

22-23 François Rude. *La Marseillaise*. 1833–36. Stone, approx. 42 × 26′ (12.8 × 7.93 m). Arc de Triomphe, Paris

seillaise (fig. 22-23). It was carved between 1833 and 1836 for Napoleon's Arc de Triomphe on the Place de l'Étoile, which was left unfinished when the emperor was exiled in 1815. The new king, Louis-Philippe, and his energetic minister of the interior, Adolphe Thiers, saw the triumphal arch's completion as an opportunity to demonstrate that his government was one of national reconciliation. Hence the sculptural program, which consisted of four works by different artists, each surrounding the opening, and offering something to every segment of the French

political spectrum. Rude's scene honors the volunteers who rallied to defend the new French Republic from an Austro-Prussian threat in 1792. Led from above by a sword-wielding, winged allegorical figure representing both Liberty and France, we see a collection of soldiers from different periods of France's past. Rude's scene does not represent a specific event; instead it evokes an eternal, all-powerful nationalistic spirit that emanates from the people and arises as need requires. The figures have a classical anatomy and hence feeling about them, and they are aligned parallel to the picture plane in shallow relief.

But we are far from the calm grandeur advocated by Winckelmann (see page 434) and the gentle melancholy of Canova. Instead, Rude's dynamic, virtually chaotic, composition has the Baroque drama of a Delacroix painting, and his figures the tension and emotional intensity of a Géricault. Despite tremendous acclaim, Rude did not receive a flurry of commissions, as he expected. And unlike the effect Canova had, other sculptors were not inspired by the intensity of his Romantic spirit. Poignantly,

22-24 Jean-Baptiste Carpeaux. *The Dance*. 1867–69. Plaster model, approx. 15′ × 8′6″ (4.57 × 2.64 m). Musée d'Orsay, Paris

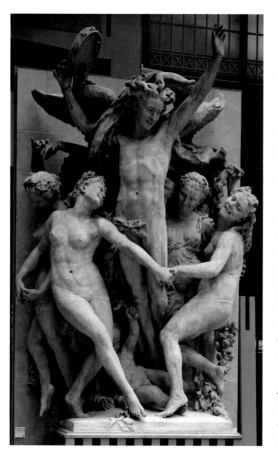

La Marseillaise stands more as an anomaly than representative of nineteenth-century Romantic sculpture.

Jean-Baptiste Carpeaux Several important sculptors were born during the third decade of the nineteenth century. Of these, the best known was Jean-Baptiste Carpeaux (1827–1875). Carpeaux's masterpiece came at the end of the SECOND EMPIRE, which succeeded the short-lived SECOND REPUBLIC in 1852. In 1861 Carpeaux's old friend, the architect Charles Garnier, began the Paris Opéra (see pages 478–79) and entrusted him with one of the four sculptural groups across the façade, *The Dance*, here represented by the more lively plaster model that is closer to the artist's intentions.

In the drama of its composition and its sensuousness, *The Dance* (fig. 22-24) perfectly matches Garnier's opulent Baroque revival architecture. But the group created a scandal after its unveiling in 1869. The nude bacchantes dancing around the winged male in the center were denounced as drunk, vulgar, and indecent—and small wonder. They appear to be real people rather than idealized types from Greek and Roman sculpture. Because of their naturalism, Carpeaux's enormous figures (they are 15 feet tall) look undressed rather than classically nude, so that we do not accept them as inhabiting the enchanted perfect realm of mythology. Instead of being morally uplifting, as expected of public monuments, *The Dance*, one of the four components of the esteemed opera, is portrayed as immoral and licentious. The Baroque drama of Carpeaux's magnificent sculpture, which so brilliantly suggests the rhythm of dance, was undoubtedly perceived as a drunken sensuous delirium. After the war with Germany ended in 1871, the old complaints were forgotten and *The Dance* was recognized as a masterpiece. *The Dance*, which was far superior to the other four Opéra groups, established the Beaux-Arts style in sculpture for the rest of the century, much as the Garnier's Opéra did in architecture.

Auguste Bartholdi The nationalism of the late nineteenth century offered enormous opportunities for official commissions to sculptors, and among the most ambitious of these

was the Statue of Liberty (or, to use its official title, *Liberty Enlightening the World*) by Auguste Bartholdi (1834–1904). This monument (fig. 22-25) was encouraged by French Republicans in conjunction with the American centennial and was meant to dedicate the memory of French support for the American struggle for freedom during the War of Independence. It was a gift of the French people, not of the government, for its enormous cost was raised by public subscription, which took ten years. The sculpture was placed on a tall pedestal designed by an American and built with funds raised by the American public.

Bartholdi developed the Statue of Liberty from a previous concept for a gigantic lighthouse in the form of a woman holding a lamp that was intended to be erected at the northern entry to the Suez Canal. All he had to do was exchange the Egyptian headdress for a radiant crown and the lantern for a torch. None of the three major attributes of the Statue of Liberty—a helmet with sunrays, torch, and tablet—is associated with the traditional allegorical figure of liberty, and all three were inventions that Bartholdi created for this specific occasion. Bartholdi sited the monument on Bedloe's Island (today Liberty Island), at the entrance to New York harbor and facing Europe, where it would greet refugees and visitors as a symbol of freedom. He conceived of the monument as a beacon, hence the light to welcome and attract, as opposed to the normal lighthouse function to warn away. The light of the torch and the rays from the helmet symbolize enlightenment and freedom, and the tablet contains the laws upholding America's liberties. With her left foot, Liberty crushes the shackles of tyranny. Her contrapposto pose, drapery, and austere idealized face place this powerful statue squarely in a Neoclassical tradition. But *Liberty Enlightening the World* operates on a scale that is probably unprecedented, and this scale is not limited to its staggering 150-foot height. It has to include the entire harbor, New York City, the entire nation behind it, and, most important, the millions of passengers on the endless column of steamships and ocean liners that passed by it. The vast majority of people coming to America before 1920 came in through New York City. From 1886, when the statue was placed on its pedestal, until 1920, literally

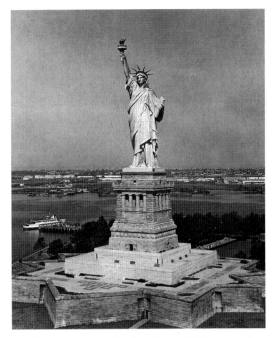

22-25 Auguste Barthodi. *Liberty Enlightening the World*. 1875–84. Copper sheeting over metal armature, height of figure 151'6" (46 m). Liberty Island, New York Harbor

millions of immigrants slowly steamed past the statue on their way to processing at nearby Ellis Island. Because of its symbolism and most immigrants' plight, Liberty had to have brought tears to their eyes. Undoubtedly many visitors to the United States were moved as well, as they still are today. This Neoclassical statue is sited with a Romantic drama that transforms a mere allegorical figure into a powerful emotional statement, one so powerful it has become a symbol of the United States.

Architecture

Just as painters sought to evoke intense emotional responses by creating images set in the long lost past or in equally exotic far-away places, architects as well felt compelled to design buildings that stirred up similar emotions. A hallmark of nineteenth-century Romantic architecture is the revival style, which fostered an attitude that resulted in the plundering of architectural styles from the distant past to create structures that transported contemporaries back to the imperial opulence of ancient Rome, for example, or the intense devoutness of the

Middle Ages. Egyptian, Greek, Roman, Romanesque, Gothic, Renaissance, Moorish, Indian, and Asian architecture were resurrected and applied to contemporary buildings, as well as to interior design. The deeper we go into the century, the more revival styles we see at any given time, and as the century drew to a close, the attitude had yet to burn itself out.

THE CLASSICAL REVIVAL

The "Greek revival" phase of Neoclassicism was pioneered on a small scale in England, but was quickly taken up everywhere. The Greek Doric was believed to embody more of the "noble simplicity and calm grandeur" of classical Greece than did the later, less "masculine" orders. However, the Greek Doric was also the least flexible order and the most difficult to adapt to modern purposes. Hence, only rarely could Greek Doric architecture furnish a direct model for Neoclassical structures. We instead find variations of

it combined with elements taken from the other Greek orders.

Karl Friedrich Schinkel The Altes Museum (Old Museum; fig. 22-26) by Karl Friedrich Schinkel (1781–1841) is a spectacular example of the Greek revival. The main entrance resembles a Doric temple seen from the side (see fig. 5-8), but with Ionic columns strung across a Corinthian order (compare fig. 5-10). The building is notable for its bold, unified design and refined proportions.

Schinkel began as a painter in the style of Caspar David Friedrich (see pages 469–70). He then worked as a stage designer before being appointed to the Berlin public-works office, which he later headed. Thus he knew how to instill architecture with Romantic associations and a theatrical flair worthy of Piranesi. Schinkel's first love was the Gothic, but although most of his public buildings are in a Neoclassical style, they retain a strong element of picturesque variety. (Note the rectangular attic above.) He

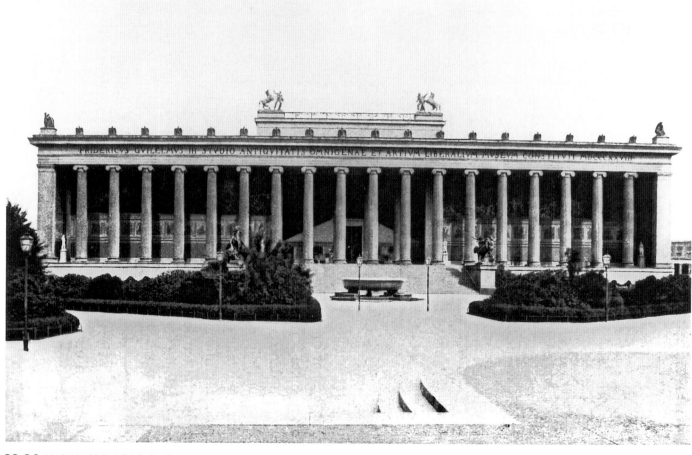

22-26 Karl Friedrich Schinkel. Altes Museum, Berlin. 1824–28

could admire both styles because he shared the Enlightenment belief in the moral and educational functions of architecture.

Here the measured rhythm of the monumental facade establishes a contemplative mood appropriate to viewing the art of antiquity. The Altes Museum expresses the veneration of ancient Greece in the land of Winckelmann. To the poet Goethe, Greece remained the peak of civilization. The Altes Museum would serve as model for countless other museums on both sides of the Atlantic. At the same time, the Greek style served the imperial ambitions of Prussia, which emerged as a major power at the Congress of Vienna in 1815 following the defeat of Napoleon. The imposing grandeur of the Altes Museum proclaims Berlin as the new Athens, with Kaiser Wilhelm III as a modern Perikles.

THE GOTHIC REVIVAL

It is characteristic of Romanticism that at the time architects launched the classical revival, they also started a Gothic revival. The appeal of the Gothic was chiefly as a means for creating picturesque effects and expressing Romantic feeling, especially a nostalgia for a lost past. After 1800, the choice between classical and Gothic modes was often resolved in favor of Gothic. Nationalist sentiments, strengthened by the Napoleonic wars, became important factors. England, France, and Germany each believed that Gothic expressed its national genius, because the Gothic style originated in the North, unlike Greek, Roman, and Renaissance architecture.

Horace Walpole England was central to the Gothic revival, as it was to the development of Romantic literature and painting. Gothic forms had never wholly disappeared in England. They were used on occasion for special purposes, even by Sir Christopher Wren (see pages 407–08, fig. 19-14), but these were survivals of an authentic, if outmoded, tradition. The conscious revival was begun by William Kent in the 1730s, partly at the prompting of Robert Walpole, one of the most important politicians of the day. It soon became linked with the cult of the picturesque and with the vogue for medieval (and pseudomedieval) romances.

Horace Walpole (1717–1797), Robert's son, started the medieval craze with the publication in 1764 of his novel *The Castle of Otranto: A Gothic Story*. It was in this spirit that he enlarged and "gothicized" Strawberry Hill, his country house outside London (fig. 22-27). The process, which began midway in the eighteenth century, took over 25 years and involved Walpole's circle of friends. (Robert Adam was responsible for the round tower.) The rambling structure has a studied irregularity that is decidedly picturesque, providing plenty of variety to entertain the eye. Inside, however, most of the elements were faithfully copied or adapted from authentic Gothic sources. Although Walpole associated the Gothic with the pathos of the sublime, he acknowledged that the house was "pretty and gay." This playfulness, so free of dogma, gives Strawberry Hill its special charm. Gothic here is still an "exotic" style. It appeals because it is strange. But for that very reason it must be "translated," like a medieval romance, or like the Chinese motifs that crop up in Rococo decoration.

Charles Barry and A. N. Welby Pugin
The largest monument of the Gothic revival is the Houses of Parliament in London

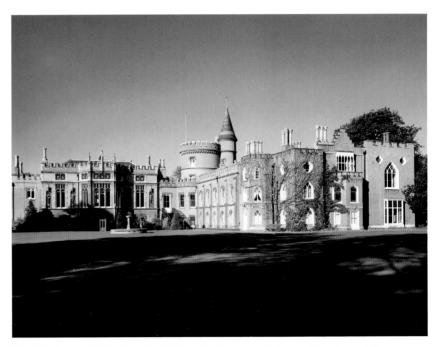

22-27 Horace Walpole, with William Robinson and others. Strawberry Hill, Twickenham, England. 1749–77

22-28 Sir Charles Barry and A. N. Welby Pugin. The Houses of Parliament, London. Begun 1836

(fig. 22-28), designed by Sir Charles Barry (1795–1860) and A. N. Welby Pugin (1812–1852). As the seat of government and a focus of patriotic feeling, it presents a curious mixture: repetitious symmetry governs the main body of the structure and picturesque irregularity its silhouette. The building is a contradiction in terms. It imposes Pugin's Gothic vocabulary, inspired by the English Perpendicular style (compare fig. 11-11), onto the classically conceived structure by Barry, with results that satisfied neither. Nevertheless, the Houses of Parliament admirably convey the grandeur of Victorian England at the height of its power.

RENAISSANCE AND BAROQUE REVIVALS

Charles Garnier Other historical revivals continued to increase the stylistic alternatives available to architects. When the Renaissance, then the Baroque, returned to favor by midcentury, the revival movement had come full circle: Renaissance and Baroque joined the Classical revival. This final phase of Romantic historicism dominated French architecture during the years 1850–75 and lingered through 1900. It is epitomized in the Paris Opéra (fig. 22-29), designed by Charles Garnier (1825–1898). He had graduated from the École des Beaux-Arts and won the Prix de Rome, which enabled him to spend six years studying in Italy and Greece. The Opéra was the culmination of Baron Georges-Eugène HAUSSMANN'S plan to modernize Paris under Napoleon III. It is the focal point for a series of main avenues that converge on it from all sides. Although the building was not completed until after the fall of the Second

22-29 Charles Garnier. The Opéra, Paris. 1861–74

Empire, its extravagance typified the Beaux-Arts style of the new Paris at its height.

The building is a masterpiece of eclecticism. The massing of the main entrance for those arriving on foot is reminiscent of Lescot's Square Court of the Louvre (see fig. 16-16). But the paired columns of the facade, "quoted" from Perrault's east front of the Louvre (see fig. 19-5), are combined with a smaller order in a fashion first suggested by Michelangelo. The rear entrance consists of a temple front. On the east side is the emperor's entrance with a sweeping staircase, and on the west side a carriage entrance. The Opéra used the latest building materials and techniques, including iron (see Materials and Techniques: The Materials of Modern Architecture, page 509). The stagecraft, too, was state-of-the-art. Garnier nevertheless went to great lengths to conceal the technology, which for him remained a means, not a principle.

The Opéra consciously suggests a palace of the arts combined with a temple of the arts. The theatrical effect captures the festive air of a crowd gathering before the opening curtain. Its Baroque quality derives more from the abundance of sculpture—including Carpeaux's *Dance* (see fig. 22-24)—and ornament than from its architectural vocabulary. Critics found the whole building "overdressed," exhibiting a luxurious vulgarity. It reflects the taste of the capitalist tycoons, newly rich and powerful, who saw themselves as the heirs of the old aristocracy and thus found the styles predating the French Revolution more appealing than Neoclassical or Neo-Gothic.

Photography

Although many today consider photography, along with film and video, to be more vital than painting and sculpture, until 25 years ago, it was a second-class citizen in the art world. Its status suffered because it was a mechanical process, and while it initially appeared on glass and tin as well as paper, it was viewed as a work on paper, like drawing and prints, and assigned a low rung in the media hierarchy. Like drawing and prints, it was perceived as a handmaiden to painting. In the nineteenth century, artists generally treated the photograph as a preliminary sketch; a convenient source of ideas or record

of motifs to be fleshed out and incorporated into a finished work. Academic painters found the detail provided by photographs to be in keeping with their own precise naturalism. Other artists, especially the avant-garde as we will see, were influenced by the new look of photography, although they never admitted it. Photography was in turn heavily influenced by the painter's mediums, and well into the twentieth century, photographs were often judged according to how well they imitated paintings and drawings. To understand photography's place in the history of art, we must recognize the medium's particular strengths and inherent limitations.

INVENTING PHOTOGRAPHY

In 1822 the French inventor Joseph-Nicéphore Niépce (1765–1833) made the first permanent photographic image, *View from His Window at Le Gras* (fig. 22–30). He then joined forces with a younger man, Louis-Jacques-Mandé Daguerre (1789–1851), who had invented an improved camera. After ten more years of chemical and mechanical research, the **daguerreotype** was unveiled publicly in 1839, and the age of photography was born. This process generated a positive exposure, which was a unique image on glass. The announcement of the daguerreotype spurred the Englishman William Henry Fox Talbot (1800–1877) to complete his own photographic process, involving a paper negative from which many positives could be made, which he had been pursuing independently since 1833.

What motivated the earliest photographers? They were searching for an artistic medium, not for a practical device. Daguerre was a skilled painter, and he probably turned to the camera to heighten the illusionism of

22-30 Joseph-Nicéphore Niépce. *View from His Window at Le Gras.* 1826. Heliograph, 6½ × 7⅞" (16.5 × 20 cm). Gernsheim Collection, Harry Ransom Research Center, University of Texas at Austin

glass
light
mirror
lens
object

paper
on glass

drawn
image

camera obscura

his huge painted **dioramas**, which were the sensation of Paris during the 1820s and 1830s. Daguerre's first photograph, for example, imitated a type of still life originated by Chardin.

That the new medium should have a mechanical aspect was particularly appropriate. It was as if the Industrial Revolution, having forever altered civilization's way of life, now had to invent its own method for recording itself. The basic mechanics and chemistry of photography had been known for a long time. The **camera obscura,** a box with a small hole in one end, dates back to antiquity. In the sixteenth century, it was widely used for visual demonstrations. The camera was fitted with a mirror and then a lens in the Baroque period, which saw major advances in optical science culminating in Newtonian physics. By the 1720s it had become an aid in drawing architectural scenes. At the same time, silver salts were discovered to be light-sensitive.

Why, then, did it take another hundred years for someone to put this knowledge together? Photography was neither inevitable in the history of technology, nor necessary to the history of art; yet it was an idea whose time clearly had come. Its invention was a response to the artistic urges and historical forces that underlie Romanticism. Much of the impulse came from a quest for the True and the Natural. The desire for "images made by Nature" can already be seen in the late-eighteenth-century vogue for silhouette

portraits (traced from the shadow of the sitter's profile), which led to attempts to record such shadows on light-sensitive materials. David's harsh realism in *The Death of Marat* (see fig. 21-3) had already proclaimed the cause of unvarnished truth.

PORTRAITURE

Like lithography, which was invented in 1797, photography met the growing demand for images of all kinds. By 1850, large numbers of the middle class were having their likenesses painted, and it was in portraiture that photography was most widely accepted. Soon after the daguerreotype was introduced, photographic studios sprang up everywhere, especially in America, and multi-image *cartes de visites* (visiting cards left by visitors with different portraits of themselves) invented in 1854 by Adolphe-Eugène Disdéri, were very popular. Anyone could have a portrait taken cheaply and easily. In the process, the average person became memorable. Photography thus became an outgrowth of the democratic values fostered by the American and French revolutions. There was keen competition among photographers to get the famous to pose for portraits.

Nadar Gaspard-Félix Tournachon (1820–1910), better known as Nadar, managed to attract most of France's leading personalities to his studio. Like many early photographers, he started out as a painter but came to prefer the lens to the brush. He took up the camera in 1853 to capture the likenesses of the 280 sitters whom he caricatured in an enormous lithograph, *Le Panthéon Nadar,* published the following year. By this time, the daguerreotype, which allowed for only one positive image, was being replaced by the albumen salt print, which consisted of a negative from which an endless number of prints could be made. Nadar gave up lithography for photography, and cashed in on the public infatuation with celebrities by making prints of the most famous people of his day, particularly specializing in the writers, actors, performers, and artists of bohemian Paris. His skills as a caricaturist proved invaluable in setting up his shots, allowing him to create incisive portraits that captured the essence of his sitter's mystique. The actress Sarah Bernhardt posed for him several times, and his photographs of her (fig. 22-31) are the direct

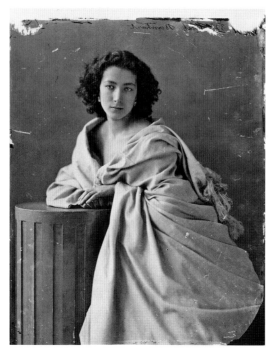

22-31 Nadar. *Sarah Bernhardt.* 1859. Gelatin silverprint from original negative, 24.8 × 20.5 cm. George Eastman House, Rochester, New York

ancestors of modern glamour photography. With her romantic pose and expression, she is a counterpart to the soulful maidens found throughout nineteenth-century painting.

Nadar's counterpart in America was Mathew Brady in New York. He started his career in 1844 by making daguerreotypes of famous figures, which were reproduced as lithographs and published in 1850 as *The Gallery of Illustrious Americans*. In the 1850s and 1860s Brady, like Nadar, graduated to salt paper and albumen prints, which allowed him to print countless images that saturated the American market. Lincoln sat for him over 30 times, and the president credited Brady's flattering 1860 portrait for helping him win the November presidential election.

Augustus Washington The daguerreotype remained popular in America far longer than it did in France and England—well into the 1860s. Its appeal seems to have been due to its powerful realism. Put a daguerreotype under a magnifying glass, and the result is more detail, not a blurry image. This can be readily seen in Augustus Washington's c. 1846–47 portrait of the abolitionist John Brown (fig. 22-32). We can count every hair on Brown's head and trace every wrinkle on his face and hands. Magnify his coat buttons, and we could inspect the thread holding them on! But this beautiful hand-painted image is far from just an objective presentation of arbitrary fact. American portraitists encouraged their clients to project a personality, real or not, for their sitting, and undoubtedly this stern, determined and almost confrontational pose was a collaboration between Brown and Washington.

Brown is taking a vow and holding what is believed to be a flag for the Subterranean Pass Way, which was the name he gave to an underground railroad he was planning. Washington was a free African American, and the most successful photographer in Hartford, Connecticut, a major center for the abolitionist movement. Convinced his race would never achieve equality during this lifetime, Washington sold his business and immigrated to Liberia before the Civil War.

THE RESTLESS SPIRIT AND STEREOPHOTOGRAPHY

Early photography reflected the outlook and temperament of Romanticism as well as an abiding nineteenth-century belief that everything could be discovered. Although this fascination sometimes showed a serious interest in science—witness Charles Darwin's voyage on the *Beagle* from 1831 to 1836—it typically took the form of a restless quest for new experiences and places. Photography had a remarkable impact on the imagination of the period by making the rest of the world widely available in visual form, or by simply revealing it in a new way. Sometimes the search for new subjects was close to home. Nadar, for example, took aerial photographs of Paris from a hot-air balloon.

A love of the exotic was fundamental to Romantic escapism, and by 1850 photographers began to cart their equipment to faraway places. The unquenchable thirst for vicarious experiences accounts for the great popularity of stereoscopic photographs. Invented in 1849, the two-lens camera produced two photographs comparable to the slightly different images perceived by our two eyes. When seen through a special viewer called a stereoscope, stereoptic photographs fuse to create a remarkable illusion of three-dimensional depth. Two years later, stereoscopes became the rage at the Crystal Palace exposition in London (see fig. 23-27). Millions of double-views, the vast majority of little artistic merit (often due to the inferior printing), were taken over the next 50 years. Their importance came not from their aesthetic quality but from the fact that virtually every corner of the earth became

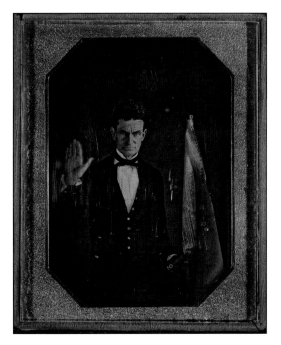

22-32 Augustus Washington. *John Brown.* c. 1846–47. Quarter-plate daguerreotype, 10 × 8.2 cm. National Portrait Gallery, Smithsonian Institution, Washington, D.C.

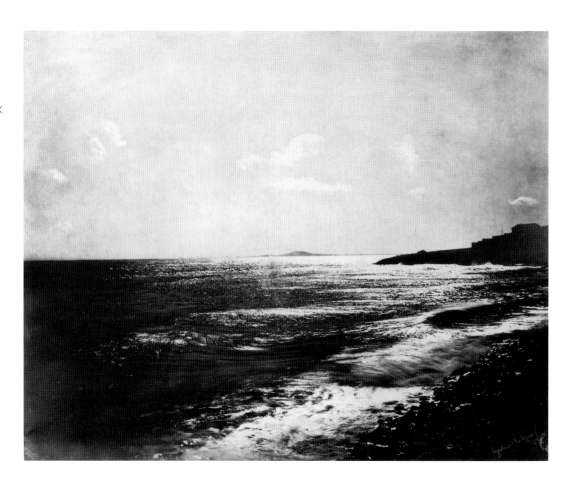

22-33 Gustave Le Gray. *Mediterranean with Mount Agde.* 1857. Albumen print from two wet collodion on glass negatives, from the Vistas del Mar album, 32.5 × 40.8 cm., The Art Institute of Chicago, Hugh Edwards Fund, 1971. 577.6

accessible to practically any household, with a vividness second only to being there.

PHOTOGRAPHY AS ART: GUSTAVE LE GRAY AND JULIA MARGARET CAMERON

Stereographs were churned out for mass consumption. Many photographers from the period, however, considered their work art and carefully labored over their prints. These works were framed and exhibited, where they could challenge the superiority of painting. Many of the great early photographers were explorers, especially in America. Accompanying survey teams to new frontiers to record such natural wonders as Yosemite, photographers framed their images with an eye formed by the Hudson River painters (see fig. 22-20).

But photographers also transformed ordinary nature into spectacular moments, as Rousseau had done in painting (see fig. 22-13). An outspoken advocate of the artistic merit of photography was the Frenchman Gustave Le Gray (1820–1882), who developed a painterly approach to the medium designed to erase detail and create mood. He invented processes that produced extremely fine tones, and another that allowed him to develop a print for up to two weeks after it was exposed. During this time he could manipulate the image in the darkroom, as a painter would on a canvas. Le Gray also combined two negatives to form a single image, and he touched up negatives with a brush to alter the tonality and remove objects. This bag of tricks can be seen in *Mediterranean with Mount Agde* (fig. 22-33), an extremely lush albumen silver print from 1857. The image was made from two negatives, one for sky and a second for sea, with in-painting where the negatives met. Darkening some clouds and waves as well as the border of the image to create a vignette or framing effect, Le Gray transformed a simple, even empty, composition into a powerful transcendental seascape where the drama of clouds, light, and sea embody the elemental forces of nature, even announcing the presence of God.

Le Gray was in part catering to French taste, for in contrast to Americans who were fascinated with the concrete reality of things, Europeans much preferred the drama of painterly photography, blurring

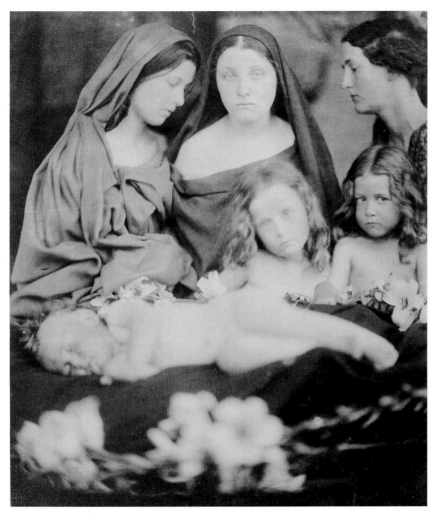

22-34 Julia Margaret Cameron. *Sister Spirits.* c. 1865. Albumen print, (31.6 × 26.6 cm). George Eastman House, Rochester, New York

images and contrasting broad areas of light and dark. Photographers also emulated painting by making images inspired by literature and history. Perhaps the most famous is the Victorian, Julia Margaret Cameron (1815–1879), an intimate of leading poets and scientists, whose reputation was based on allegorical and narrative pictures. Shakespeare, Tennyson, and the Bible provided her with a stock of psychologically tortured scenes for her soft-focused camera. Her c. 1865 albumen print, *Sister Spirits* (fig. 22-34), appears to be an invented scene set in a spiritual early-Renaissance past, which along with the medieval period was so revered by the Romantics. The robed women look like they stepped out of a Raphael painting (see chapter 13) and suggest any number of saints—Mary, Ann, Mary Magdalene—while the sleeping baby recalls the Christ Child. Do the troubling looks of saints and angels refer to Christ's fate? Or are the women the Three Graces and the baby female, as strongly implied by the title and her physical appearance? Are the quiet disturbing looks therefore a concern for the child's future as a woman? Cameron's themes generally focus on women, since, as a female photographer in a repressive sexist society, she found it difficult getting men to pose for her. She was criticized for exhibiting, which was a rare event for Victorian women, and admonished for selling her photographs with a major London print dealer because it was inappropriate for women to earn money. The parallel between children and women in *Sister Spirits* suggests feminist protest, albeit understated to the point of being disguised.

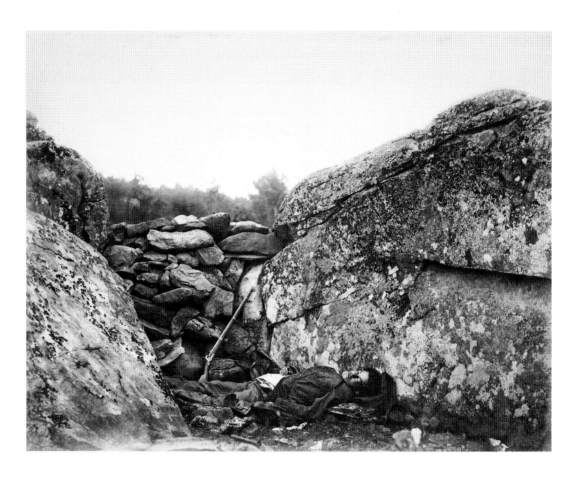

22-35 Alexander Gardner. *Home of a Rebel Sharpshooter, Gettysburg.* July 1863. Wet-plate photograph, Chicago Historical Society

PHOTOJOURNALISM

Fundamental to the rise of photography was the nineteenth-century sense that the present was already history in the making. Only with the advent of the Romantic hero did great acts become popular subjects for contemporary painters and sculptors. This outlook encouraged the development of photography and in particular photojournalism.

Alexander Gardner Photojournalism's first great representative was Mathew Brady (1823–1896), who covered the Civil War in the United States. Other wars had already been photographed, but Brady and his 20 assistants were able to bring home the horrors of that war with unprecedented directness, despite using cameras too slow and cumbersome to show actual combat. *Home of a Rebel Sharpshooter, Gettysburg* (fig. 22-35) by Alexander Gardner (1821–1882), a former assistant of Brady who formed his own photographic team in 1863, is one of the landmarks

in the history of art. Never before had both the grim reality and, above all, the significance of death on the battlefield been conveyed so fully in a single image. The realistic still body is reduced to an annihilating insignificance, having no more prominence than the equally realistic rocks—the head becomes just another rock—while the fortification becomes a horrifying deep grave that swallows him up. Compared with the heroic act celebrated by Benjamin West (see fig. 21-5), this tragedy is as anonymous as the slain soldier himself. The photograph is all the more convincing for having the same harsh realism found in David's *Death of Marat* (see fig. 21-3), and the limp figure, hardly visible between the rocks framing the scene, is no less moving. In contrast, the paintings and engravings by the artists—such as Winslow Homer (see fig. 23-19)—who illustrated the Civil War for magazines and newspapers were mostly genre scenes of camp life that kept the brutality of combat out of sight.

Realism and Impressionism

"**C**AN JUPITER SURVIVE THE LIGHTNING ROD?" ASKED KARL Marx, not long after the middle of the nineteenth century. The question suggests that the ancient god of thunder and lightning was now threatened by science. In 1846 the French poet and art critic Charles Baudelaire addressed the same problem when he called for paintings that expressed "the heroism of modern life":

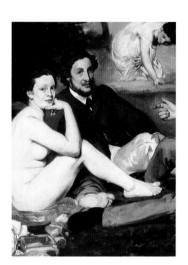

To prove that our age is no less fertile in sublime themes than past ages, we may assert that since all centuries and all peoples have had their own form of beauty, so inevitably we have ours . . . just as we have our own particular emotions, so we have our own beauty.

The pageant of fashionable life and the thousands of floating existences—criminals and kept women—which drift about in the underworld of a great city . . . all prove to us that we have only to open our eyes to recognize our heroism. . . .

The life of our city is rich in poetic and marvellous subjects. We are enveloped and steeped as though in an atmosphere of the marvellous; but we do not notice it.

The *nude*—that darling of the artists, that necessary element of success—is just as frequent and necessary today as it was in the life of the ancients; in bed, for example, or in the bath, or in the anatomy theater. The themes and resources of painting are equally abundant and varied; but there is a new element—modern beauty.

Spurred in part by Baudelaire, avant-garde artists turned their back on the classical past as they instead sought to create an emblem of modernity. The new leisure activities of the middle class and nouveau riche quickly arose as the most popular theme for the period, with the exciting fashionable dance halls and cafés of Paris becoming especially favorite subjects. Boating and boulevard scenes also became icons. While industry was largely ignored, trains and trains stations—the new symbols of technology, speed, and sophistication—cropped up occasionally.

An essential part of this quest for an emblem of the era was the issue of freedom, that distinguishing characteristic of the modern world that set it apart from the past. The Romantic era of the first half of the century, with its emphasis on the cult of the individual, was a first step in this direction. In the second half of the century, this freedom was not just accorded to artists because of their innate genius, but as a universal right. Artists now declared that they had the freedom to paint whatever seemed relevant and appropriate. Freedom of artistic expression was born.

Along with this freedom came the undermining of the old hierarchies, such as the hierarchy of the genres that placed history painting at the pinnacle of art, with still life and landscape dwelling at the bottom. Also dethroned was the academy as the principal arbiter of aesthetic values and taste. In the last quarter of the nineteenth century, avant-garde artists increasingly relied on art dealers and commercial galleries to present their art and establish their reputations. The period also saw the rise of artists' cooperatives, setting the stage for the twentieth century, when artists' organizations played a major role in promoting the new art.

By the end of the nineteenth century, monarchies and the aristocracy were being supplanted throughout Europe by nationalism, increased democracy, and a middle class, including nouveau riche industrialists and

financiers, whose money placed them in an upper crust category, but below that of the decaying aristocracy. Kings, queens, and their official representatives no longer pulled the art-world's strings.

Painting in France

COURBET AND REALISM

At that time only one painter was willing to make an artistic doctrine of Baudelaire's demand to find beauty in the ordinary: his friend Gustave Courbet (1819–1877). Courbet was born in Ornans, a village near the French-Swiss border, and remained proud of his rural background. He had begun as a Neo-Baroque Romantic in the early 1840s. By 1848, under the impact of the revolutionary upheavals then sweeping through Europe, he had come to believe that the Romantic emphasis on feeling and imagination was merely an escape from the realities of the time. An objective truth and sincerity became the rallying cry of the Realists, their motto Baudelaire's motto, "It is necessary to be of one's time." Modern artists must rely on direct experience—they must be Realists. "I cannot paint an angel because I have never seen one," Courbet wrote.

As a descriptive term, *realism* is not very precise. For Courbet, it meant something akin to the realism of Caravaggio (see pages 355–57). As an admirer of Rembrandt, Courbet had, in fact, strong links with the Caravaggesque tradition. Moreover, his work, like Caravaggio's, was denounced for its supposed vulgarity and lack of spiritual content. What ultimately defines Courbet's Realism, however, and distinguishes it from Romanticism, is his devotion to radical (as against merely liberal) politics. His SOCIALIST views were the result of his close friendship with the theorist Pierre-Joseph Proudhon, ten years his senior, who was from the same region in southern France, and they colored his entire outlook. Although Socialism did not determine the specific content or appearance of Courbet's pictures, it does help to explain his unconventional choice of subject matter and style.

Burial at Ornans (fig. 23-1), from 1849, fully embodies Courbet's style of Realism. Here is a picture that disregards the academic hierarchy by treating a common genre scene with the same seriousness and monumentality as a noble, moralistic history painting. (Recall that under the old hierarchies of the academy, paintings of scenes from everyday life were considered inferior.) In addition it was executed with a heavy

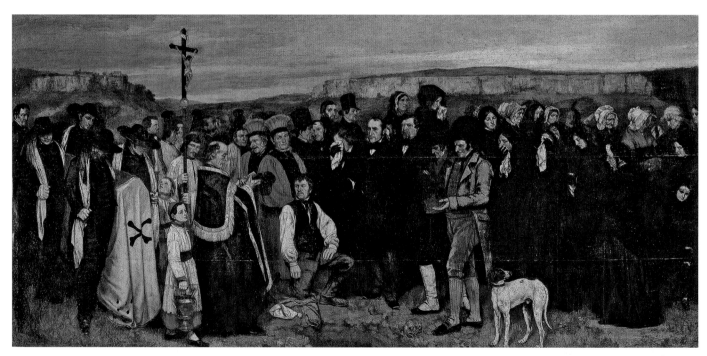

23-1 Gustave Courbet. *Burial at Ornans.* 1849. Oil on canvas, 10′3¹/₂″ × 21′9¹/₂″ (3.13 × 6.64 m). Musée d'Orsay, Paris

impasto that violated accepted standards of finish, so that it had a hostile reception from the public and most critics. Courbet asked 50 people to pose for him in his studio. He painted them life-size, solidly and matter-of-factly, with no attempt to ennoble them by idealizing their faces or poses, or by grouping them in a composition reminiscent of Renaissance painting or Greek pediment sculpture (compare to Benjamin West, fig. 21-5)). The canvas is much larger than anything by Millet, and with none of his overt pathos or sentiment (compare fig. 22-11). Its nearest relatives are Dutch group portraits of the seventeenth century. *Burial at Ornans* rivals Rembrandt's *The Night Watch* (fig. 18-12) in scale and ambition. Courbet has adopted the Dutch master's dark palette and thick brushwork as well. The picture, however, consciously avoids any trace of Baroque dynamism, and is so uncomposed and unstructured the procession of figures simply spills off either end. It has instead a classical gravity worthy of Masaccio and Raphael (see fig. 12-14 and fig. 13-16), but without establishing a hierarchy of importance for the figures—the dog is as significant as the priest or the mayor in this democratic portrait.

In contrast to other funerary scenes, such as El Greco's *The Burial of Count Orgaz* (see fig. 14-10), this is not the apotheosis of a great man or woman. In fact, the identity of

the deceased is never revealed—nor is it important—although the painting is sometimes said to have been inspired by the funeral of Courbet's grandfather. It is not even a religious scene, let alone one about death. The real subject is the gathering as social ritual, to which the burial itself seems almost incidental. The composition is divided into three groups—clergy, men, and women—accurately reflecting social distinctions of gender and profession. Many of the figures are carefully observed and can be identified.

Courbet was mainly interested in recording the dress and customs of his hometown. By rigorously excluding anything that might distract our attention, he prevents us from reading any further significance into the painting. Yet, strangely enough, it has a grandeur and solemnity that are deeply moving, precisely because of the factual presentation. In this way, *Burial at Ornans* fulfills Baudelaire's "heroism of modern life."

During the 1855 PARIS EXPOSITION, where works by Ingres and Delacroix were prominently displayed, Courbet showed his disdain for officially sanctioned painting by organizing a private exhibition of his work in a large shed off the Champs-Elysées, boldly titling it "Du Realisme" ("About Realism") and selling a "manifesto of Realism." The show, which included *Burial at Ornans*, centered on another huge canvas, titled *Studio of*

The Exposition Universelle (PARIS EXPOSITION) of 1855 was the first of a long series of French international expositions, but not the first such world's fair. In 1851 Queen Victoria and Prince Albert of England had inaugurated the very first international exhibition in the newly built Crystal Palace in London (see fig. 23-27). The Paris expositions were showcases for, among other goods and products, the work of officially favored French painters and sculptors.

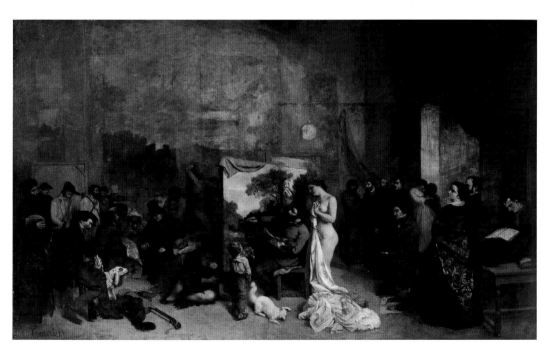

23-2 Gustave Courbet. *Studio of a Painter: A Real Allegory Summarizing My Seven Years of Life as an Artist.* 1854–55. Oil on canvas, 11'10" × 19'7" (3.6 × 6 m). Musée d'Orsay, Paris

a Painter: A Real Allegory Summarizing My Seven Years of Life as an Artist (fig. 23-2). "Real allegory" is something of a teaser. Allegories, after all, are unreal by definition. Courbet meant either an allegory couched in the terms of his particular Realism, or one that did not conflict with the "real" identity of the figures or objects embodying it.

The framework is familiar. Courbet's composition clearly belongs to the type seen in Velázquez's *Maids of Honor* (see fig. 17-21) and Goya's *Family of Charles IV* (see fig. 22-1). But now the artist has moved to the center, and the visitors here are his guests, not royal patrons who enter whenever they wish. He has invited them specially for a purpose that becomes evident only on further thought. The picture does not yield its full meaning unless we take the title seriously and consider Courbet's relation to this assembly.

There are two main groups. On the left are "the people." They are types rather than individuals, drawn largely from the artist's hometown: hunters, peasants, workers, a bearded Jew he had met on a trip to London, a priest, a young mother with her baby. On the right we see groups of portraits representing the Parisian side of Courbet's life: collectors, crit-

ics, intellectuals. (The man reading is Baudelaire.) All of these people are strangely passive, as if they are waiting for something to happen. Some are quietly conversing among themselves, others seem lost in thought. Yet hardly anyone looks at Courbet. They are not his audience, but a representative sampling of his social environment.

Only two people watch the artist at work: a small boy, intended to suggest "the innocent eye," and the nude model. What is her role? In a more conventional picture, we would identify her as Inspiration, or Courbet's Muse, but she is no less "real" than the others here. Courbet probably meant her to be Nature, or that undisguised Truth, which he proclaimed to be the guiding principle of his art. Significantly enough, the center group is lighted by clear, sharp daylight, but the background and the side figures are veiled in semidarkness. This device underlines the contrast between the artist—the active creator—and the world around him that waits to be brought to life. Regardless of the specific interpretations we give to the various figures and objects, this enormous painting was undoubtedly intended as a proclamation of his right to artistic free-

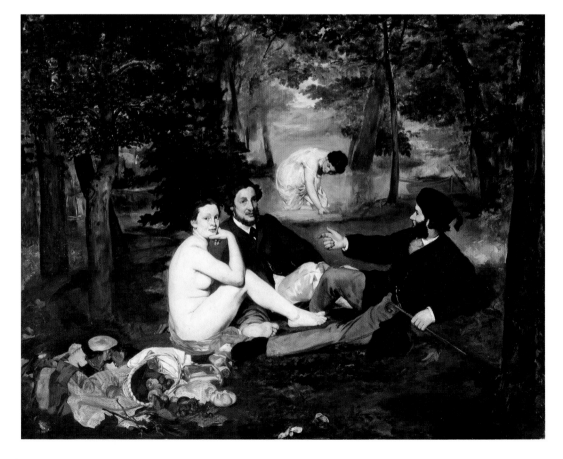

23-3 Édouard Manet. *Luncheon on the Grass (Le Déjeuner sur l'Herbe).* 1863. Oil on canvas, 7' × 8'10" (2.13 × 2.6 m). Musée d'Orsay, Paris

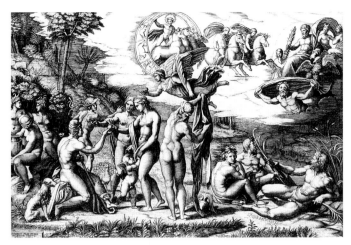

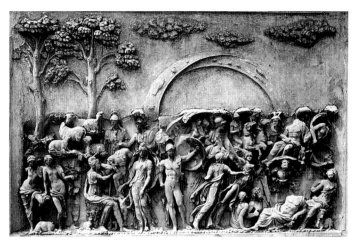

23-4 Marcantonio Raimondi, after Raphael. *The Judgment of Paris*. c. 1520. Engraving, 11⅝ × 17¼″ (29.5 × 43.8 cm). The Metropolitan Museum of Art, New York

23-5 *River Gods*. Detail of Roman sarcophagus. 3rd century A.D. Villa Medici, Rome

dom, which he could not have stated more clearly in his manifesto: "To be in a position to translate the customs, the ideas, the appearance of my epoch according to my own estimation; to be not only a painter, but a man as well, in short to create living art—this is my goal."

ÉDOUARD MANET

Courbet's *Studio* helps us to understand a picture that shocked the public even more: *Luncheon on the Grass* (*Le Déjeuner sur l'Herbe*) (fig. 23-3), showing a nude young woman next to two gentlemen in frock coats, painted by Édouard Manet (1832–1883) in 1863. Manet was perhaps the first artist to grasp Courbet's full importance, and his *Luncheon*, among other things, is a tribute to the older artist.

A long tradition of outdoor picnic scenes stretches back to Titian's *Fête Champetre* in the Louvre, a work that Manet copied when an art student. But this picture is *not a fête champetre* (literally, a rural fete or party). In fact, it lacks any allegorical intent or elevating message that would justify painting a contemporary scene of a nude woman seated with two nattily dressed men. Paintings of nudes plastered the walls at the biannual Salon exhibitions, but they were Venus, Diana, bacchantes, or nymphs, that is, superior beings whose noble stature was established in the heroic age of Greek civilization. These paintings were not only acceptable, they were among the favored themes of Sec-

ond Empire society, appealing to its love of pretension and hedonistic opulence. But Manet's nude woman is just that, a nude woman. The title of the painting offers no clue as to her identity or why she has taken off her clothes, unlike Courbet's nude in his studio, who has disrobed because she is a model. Manet's *Luncheon* is clearly a response to Courbet's *Studio*, for in both paintings discarded clothes appear prominently in the foreground. Although Courbet's egotistical painting may have been hard for the public to swallow, Manet's, because of its licentiousness, was an affront, and literally caused a scandal. Manet was simultaneously acting on Courbet's proclamation to paint contemporary life while attacking the hypocritical taste for nudes displayed by Parisian high society.

Unknown at the time, however, Manet secretly "elevated" his scene. The foreground group is based on a configuration of classical deities from an engraving after Raphael that was in turn derived from a Roman sarcophagus (see figs. 23-4 and 23-5). In both we see *The Judgment of Paris* to the left, and to the right Mars accompanying Venus to Olympia, where they are greeted by Zeus holding his thunderbolt. Manet's bather was inspired by a second source, Watteau's *Diana Bathing*, and initially Manet was going to title his picture *The Bath*. But doing so would have emphasized this theme and figure, and perhaps revealed the picture's parallels with the great art of the past.

But the last thing Manet wanted was to endow his contemporary scene with an aura of moral justification. Nor are the unembarrassed gaze and frank realism of the nude simply a witty parody of classical art. Far more than Courbet's *Studio*, *Luncheon on the Grass* fulfills all the conditions set down by Baudelaire. By borrowing freely from the past and clothing his figures in modern urban dress, Manet both updated tradition and gave fresh meaning to the nude. These, he seems to say, are the gods and goddesses of today, and they are no less worthy of our attention and respect than those of the past.

The public not only was offended by the content of Manet's *Luncheon*, but also found the artist's style completely unacceptable, to the point of being laughable. Even Courbet could not comprehend Manet's spatial disjunctions and cardboard figures, going so far as to describe a nude in another Manet painting as looking "like the Queen of Spades after getting out of the bath." Manet created his figures and objects using broad lush brushstrokes; instead of carefully modeling a fold on the man's trousers, he merely lays down a

stroke of black paint. Space is no more comprehensible. The scale of the background bather is so large she is telescoped into the foreground group, virtually appearing to hover over it so that her hand could touch the man's. The still life of shed clothes and food basket is as much a cutout as the group is, and the entire composition, including trees, water, and patches of sky, appears to be a collage of flat elements pasted onto the canvas. We feel as though we could move these flat elements around to rearrange the composition.

By rejecting conventional modeling and space, Manet challenged six centuries of pictorial conventions that go back to Giotto and the early Renaissance. Replacing them is a new order, one that acknowledges the inherent flatness of painting. Holding the picture together is a visual feast of rich lush paint covering the entire surface and the optical snap of slablike planes of contrasting value, that is, the play of light and dark. Our eye jumps from one bright area to another, from a pale hand to a white collar to the creamy nude. Manet heightens the intensity of these splashes of light tones by pitting them against deep darks. His inclination toward flatness is epitomized in *The Fifer* (fig. 23-6), made three years later in 1866. The picture has little modeling, no depth, and hardly any shadows. The undifferentiated light gray background seems as near to us as the figure, and just as solid. If the fifer stepped out of the picture, he would leave a hole, like the cutout shape of a stencil.

With *Luncheon on the Grass*, Manet redefined the canvas. It is no longer a Renaissance "window" that we look through but an impenetrable screen made up of flat patches of color like a child's jigsaw puzzle. Its structure resembles a Cubist painting like Picasso's *Three Dancers* of 1925 (see fig. 26-10) more than it does Delacroix's *Death of Sardanapalus* (see fig. 22-7). In his last great masterpiece, *The Bar at the Folies-Bergères* (fig. 23-7), completed in 1882 one year before his tragic early death, Manet almost seems to be declaring that his painting exists as paint on a flat surface, since most the image takes place on a mirror, which indeed is flat. Here is Baudelaire's modern world: We see the boisterous gaiety of a crowded Parisian theater club, but the faces of the barmaid and

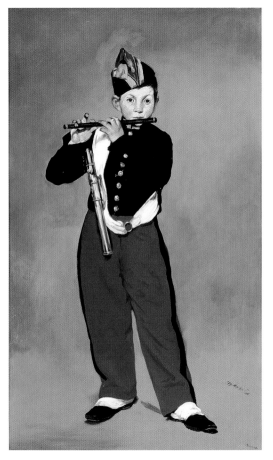

23-6 Édouard Manet. *The Fifer*. 1866. Oil on canvas, 63 × 38¼" (160 × 97.2 cm). Musée d'Orsay, Paris

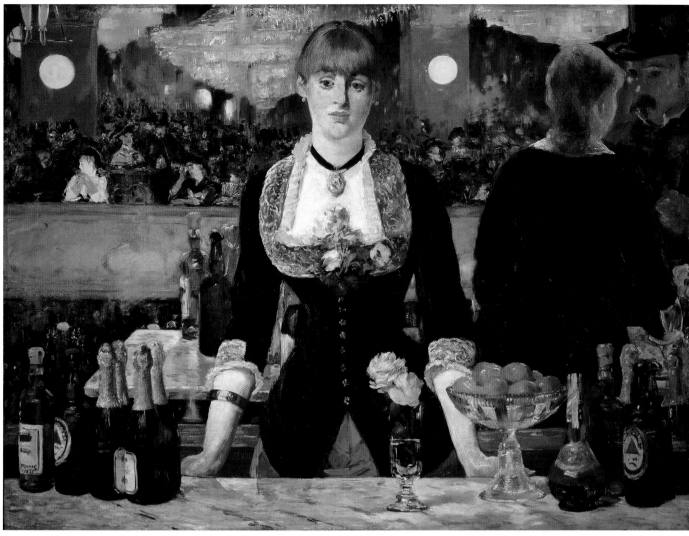

23-7 Édouard Manet. *The Bar at the Folies Bergère.* 1881–82. Oil on canvas, 37¹³⁄₁₆ × 51″ (96 cm × 1.3 m). Courtauld Institute Galleries, London

her client (shown in the mirror behind her) are anything but gay. The festive mood of the scene is a contrast to the urban alienation expressed on their faces. Manet is now using the dazzling color and flickering brushwork of the Impressionists (see page 492), which animates and dissolves the fleeting festivities. But the space of the painting is largely the space we are standing in—the space *in front* of the painting—for behind the barmaid is a mirror, and it is on this flat surface that the image takes place. Once again, we see Velázquez's *Las Meninas* challenging a great nineteenth-century artist, not only in the motif of the mirror but also in the style. Manet's lush brushwork, the silvery tonality, and rich blacks all remind us of Velázquez.

Like *Luncheon on the Grass*, the work is a visual manifesto of artistic freedom. It asserts the painter's privilege to combine whatever elements he pleases for aesthetic effect alone. To put it another way, the world of painting has "natural laws" that are different from those of everyday reality, and the painter's first loyalty is to his canvas, not to the outside world. Here begins an attitude that would be debated by progressives and conservatives for the rest of the century. It was later summed up in the doctrine of "art for art's sake" (see page 525). Manet refrained from such controversies, but his work nevertheless attests to his lifelong devotion to "pure paintings": to the belief that the brushstrokes and color patches themselves—not what they stand for—are the artist's primary reality. Among the painters of the past, he found that Hals, Velázquez, and Goya had come closest to this ideal. He admired their

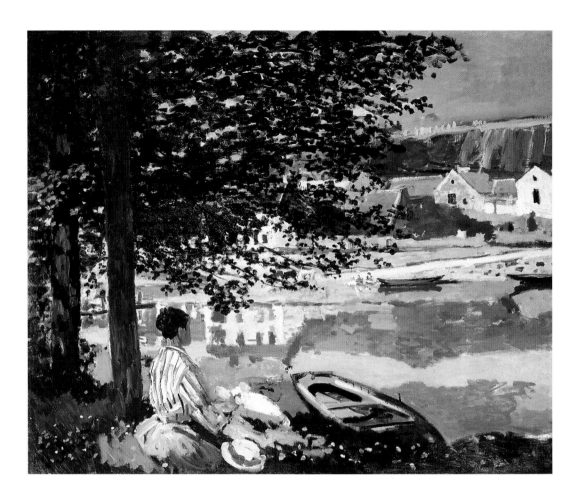

23-8 Claude Monet. *On the Bank of the Seine, Bennecourt.* 1868. Oil on canvas, 32⅛ × 39⅝″ (81.6 × 100.7 cm). The Art Institute of Chicago

Mr. and Mrs. Potter Palmer Collection

broad, open technique and their preoccupation with light and color values. Many of his canvases are, in fact, "pictures of pictures": they translate into modern terms those older works that particularly fascinated him. Yet he always played down the expressiveness or symbolism of his models to keep the viewer focused on the pictorial structure. His paintings invariably have an emotional reserve that can easily be mistaken for emptiness unless we understand its purpose.

MONET AND IMPRESSIONISM

The word *Impressionism* was coined in 1874, after a hostile critic looked at a picture entitled *Impression: Sunrise* by Claude Monet (1840–1926) and, like most of his contemporaries, found it frustrating to decipher anything in the blurry image. The young Monet had grasped almost immediately the implications of the artistic revolution of Manet's *Luncheon in the Grass,* and applied them to landscape, his favored

genre. Monet worked outdoors, carefully observing how light bounced off of objects. This, along with the publication of new scientific theories about color, brought him to introduce intense hues to painting, as can be readily seen in his 1868 painting, *On the Bank of the Seine, Bennecourt* (fig. 23-8). Here Monet has restricted his palette mostly to primary and secondary colors. Even the browns have color, for they are tinged with orange, green, and yellow, while the dark greens are still green, not black. As a result the painting is flooded with sunlight so bright that conservative critics claimed it made their eyes hurt. This sensation was also the result of the flickering quality of Monet's network of flat color patches, shaped like mosaic **tesserae**, which uniformly cover the surface, where they stay as opposed to receding into illusionistic depth. The tree's green leaves are a two-dimensional silhouette, while the blue sky behind it is as planar as a window shade. The reflections on the water seem to run up and down the

picture plane, flattening the river and strengthening the unity of the actual painted surface. This abstract inner coherence sets the painting apart from Romantic "impressions" such as Constable's *Haywain* (see fig. 22-17) or Corot's *View of Rome* (see fig. 22-12), even though all three share the same on-the-spot immediacy.

Although never abandoning a realistic premise for his art, Monet's paintings became increasingly abstract, especially in the early 1890s when he began working in a series format, painting the same subject over and over. His subjects for these series included haystacks, Rouen cathedral, and a line of poplar trees. The haystacks came first, and he painted thirty, beginning in 1890. His premise was to show the same subject at different times of the day and year, and under different weather conditions. Working in a series format meant that the composition remained largely the same from one picture to the next. The intense sun, fog, or snow in these scenes dissolved all detail into an abstract haze of color. Again and again Monet painted a two-dimensional triangular haystack (occasionally he painted two) on top of two successive horizontal bands, the first a row of trees at the edge of the field, and the second distant hills.

With composition out of the way, Monet concentrated on color, his first love, which he changed from one painting to the next. In *Haystack, Sun in the Mist* (fig. 23-9), Monet made a basically orange painting, which is laced with blue. The two hues are complements, and when placed next to one other they are intensified and vibrate. Monet's flickering brushstroke, now short dashes of varying length and direction, increases this shimmering effect. The intense sun and mist may have been Monet's pretext for the picture, but in reality atmospheric conditions simply provided him with an excuse to eliminate detail and pursue the abstract qualities of his medium, as suggested by his endlessly reworking the paintings in his studio. Unlike Constable and Turner, Monet's primary goal was not to transform color into atmosphere. The essence of Impressionism and its great contribution to the development of art was its bright primary and secondary colors, which began to be liberated from the objects that they represented, although Impressionism was always fundamentally representational.

AUGUSTE RENOIR

Although he helped to create the Impressionist landscape style, Auguste Renoir (1841–1919) began as a figure painter who took his lead from Manet. After 1875, his finest works are figural. An outstanding example is *Luncheon of the Boating Party*,

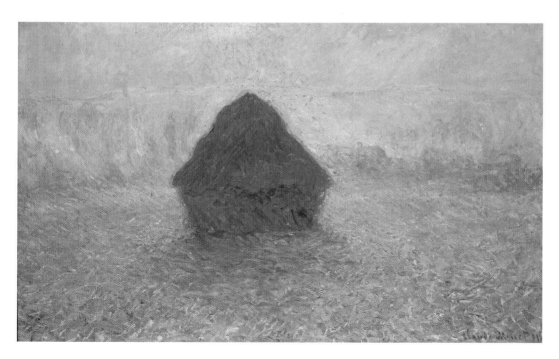

23-9 Claude Monet. *Haystack, Sun in the Mist.* 1891. Oil on canvas, 25⅝ × 39³/₈" (65 cm × 1 m). Minneapolis Institute of Arts

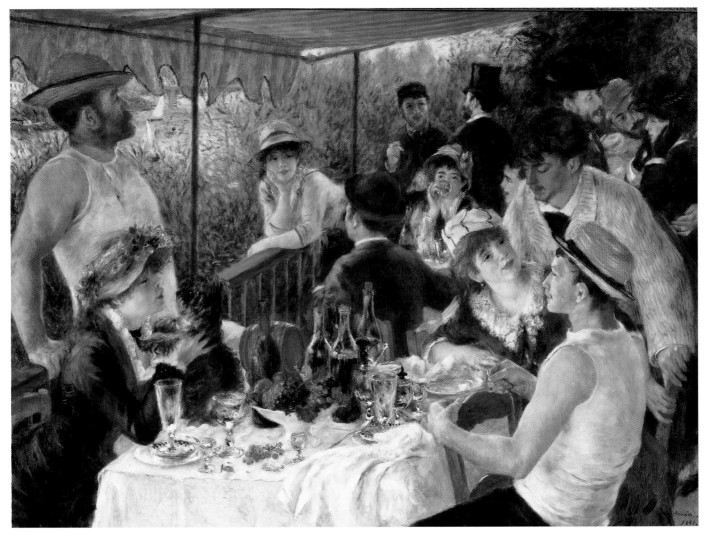

23-10 Auguste Renoir. *Luncheon of the Boating Party, Bougival.* 1881. Oil on canvas, 51 × 68″ (129.5 × 172.7 cm). The Phillips Collection, Washington, D.C.

Bougival of 1881 (fig. 23-10), which reflects the Impressionist response to Baudelaire's challenge to artists to capture the "heroism of modern life." Their favorite themes were dance halls, cafés, concerts, and the theater that recorded the new leisure activities of bourgeoisie, which increasingly defined Parisian life. The painting is classic Impressionism, constructed by a flurry of feathery brushstrokes and intense color (note the juxtaposition of the complements, such as yellow and purple) that make the painting flicker, and give us the feeling that Renoir has captured a fleeting moment. Spontaneity also stems from the dynamic recession of the railing and table and the cropping of the figures to the left and right, which endows the picture with a snapshot quality, a device

learned from fellow Impressionist Edgar Degas, who in turn was influenced by the compositions of Japanese prints.

But the most surprising feature of the painting is its conservativeness, which announces a crisis in Impressionism that set in about 1880. In contrast to Monet, Renoir has suggested a coherent deep space. Furthermore, his figures are not flat (see figs. 23-3 and 23-8) but modeled and three-dimensional, almost sculptural. Renoir is even drawing, giving a strong contour to things. The Impressionists had been attacked for not being able to draw and classically structure a picture. Filled with self-doubt, Renoir and others as we shall see, responded by returning to the values of classical art.

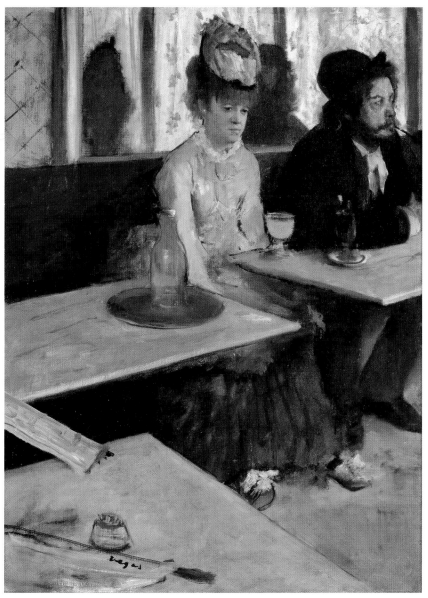

23-11 Edgar *Degas. The Glass of Absinthe.* 1876. Oil on canvas, 36 × 27″ (91.3 × 68.7 cm). Musée d'Orsay, Paris

EDGAR DEGAS

Edgar Degas (1834–1917) was a wealthy aristocrat by birth. His deep understanding of human character pervades his Impressionist pictures, as we see in *The Glass of Absinthe* (fig. 23-11). Absinthe was a popular but potent drink in nineteenth-century France that debilitated drinkers, even causing death. Degas's subject has obviously succumbed to the alcohol in front of her, as suggested by her blank sadness, slumped shoulders, and spread feet listlessly anchoring her to the floor. Her over-the-top hat appears about to slowly slide down her face, while the terrifying dark shadow lurking behind her has more energy than she. Degas's ingenious composition of zigzagging tables imprisons both the figures, reinforcing their alienation. At the same time, this composition creates a sense of spontaneity and immediacy. We feel as though we are seated at the foreground table. Having the tables run out of the composition to the left and shoving the protagonists to the far right to the point of cropping the man, are compositional strategies that Degas learned from Japanese prints, which with the opening up of Japan by America's Commodore Matthew C. Perry in 1854, flooded

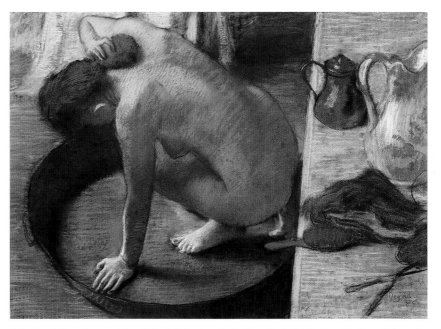

23-12 Edgar Degas. *The Tub.* 1886. Pastel, 23½ × 32⅜" (59.7 × 82.3 cm). Musée d'Orsay, Paris

the Parisian art world. (See Cultural Context: Japonisme, page 498.)

Degas's composition becomes even more radical in *The Tub* of 1886 (fig. 23-12), an updating of the classical theme of the bath. Now we voyeuristically look down over a shelf or table at a woman bathing. The two spaces are conflated, allowing for the juxtaposition of the curvilinear forms of the tub and nude with those of the pitcher and teapot on the shelf. Degas's abstraction includes an interaction of line—such as the black line that forms the curve of the nude's back—with broad free brushwork—such as the multiple streaks we see across her back. Degas studied with a student of Ingres, and retained drawing as a feature of his paintings. In *The Tub*, the abstract qualities of line and gesture—now pastel marks—are even more pronounced, since both appear to sit on the surface of the paper.

Degas's development in the 1880s toward abstraction paralleled that of Impressionism into Post-Impressionism, as we will see, and the abstraction that appeared in Monet's series of the 1890s (see fig. 23-9). Although Degas exhibited with the Impressionists, he renounced its name and stood outside the group. He adopted Impressionist brushwork, but

rarely displayed the interest in intense color that Monet and Renoir did.

MORISOT, CASSATT, AND THE IMPRESSIONIST GROUP

Locked out of the Salons because of the subject matter and style of their paintings, Manet, Monet, Degas, Renoir, and the others in their circle needed a venue for exhibiting their work. Necessity led to invention, and in 1873, 33 artists, who came to be called the Impressionists, formed a cooperative, the Private Company of Artists. From 1874 to 1886 the cooperative organized eight group shows, the first taking place in Nadar's studio. While not long-lived, this artists' cooperative signaled a very important event: the beginning of the end of the École des Beaux-Arts, and actually all academies, as the arbiters of art. Many nineteenth-century academies still exist today, but by the early twentieth century, their influence was gone, turned over to commercial galleries, museums, the press, and private collectors. As we shall see, a continuous succession of artists' groups will play a major role in directing the course of modern art.

In an era when women were discouraged from having professions and independence of any kind, two managed to show with the

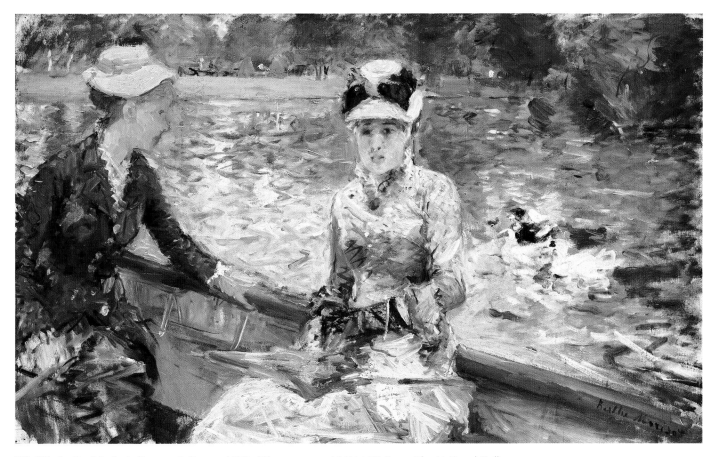

23-13 Berthe Morisot. *Summer's Day.* c. 1879. Oil on canvas, 45.7 × 75.2 cm. The National Gallery, London

Private Company of Artists and today are recognized among the most prominent artists in the Impressionist circle: Berthe Morisot (1841–1895) and Mary Cassatt (1845–1926).

Morisot participated in the very first exhibition, for which she played a major organizational role. She studied with Camille Corot from 1862 to 1868, when she was introduced to Manet, whom she viewed as a symbol of freedom and modernity. The two became very close, with Morisot appearing in ten of Manet's paintings. Their informal relationship, however, was a two-way street. Morisot encouraged Manet to adopt Impressionist color and make etchings. Meanwhile, her style was heavily influenced by his as she embraced the bravura of his brushwork, which by the late 1870s she developed into her own distinctively bold markmaking. This can be seen in *Summer's Day* of 1879 (fig. 23-13),

in which she combines the spectacular explosion of her zigzag brushwork with the energy generated by a composition inspired by the asymmetry and dramatic cropping of Japanese prints and Degas's paintings (see figs. 23-11 and 23-12).

Both Morisot and Cassatt are generally discussed in the context of their paintings of women and of women and children. When in public, women were expected to be accompanied by a man (most likely one is rowing the boat in *Summer's Day*). Such a restriction meant they were not free to move about and thus paint a man's world. (Rosa Bonheur had to blend in with the men when painting the Parisian horse market and was required to obtain a city permit just to wear pants.)

Cassatt especially specialized in themes of maternity, although she never married or had children. An independently wealthy American, she trained in Philadel-

IN 1853 AMERICAN COMMODORE MATTHEW PERRY STEAMED INTO EDO (TOKYO) BAY WITH four war ships. Within a year, Perry extracted a trading and diplomatic treaty from Japan that resulted in the great and powerful Asian nation opening its doors to the West after two centuries of isolation. American and European markets were soon saturated with Japanese goods, which the public found fascinating and ravishing. By the 1860s, everything Japanese was in vogue. Fans, vases, kimonos, lacquer cabinets, folding screens, jewelry, and tea services were found in any fashionable home. The French were especially taken by Japanese culture, and their infatuation was called *japonisme*, a term also used in English. The Japanese pavilion was by the far the most popular at the 1867 Universal Exposition in Paris.

During the last third of the nineteenth century, Japanese design strongly influenced Western interior design and the decorative arts. As important was the effect Japanese prints had on avant-garde artists, in particular Manet, Degas, Cassatt, Whistler, and Van Gogh. Interestingly, the prints did not arrive in France as art, but rather as packing material. Such fragile objects as vases were wrapped in these prints, which, in Japan, were considered common, mass-produced media images. Once viewed, they were discarded like newspaper is today. To Parisian artists, these Japanese pictures were astonishing; never before had they seen such flat images. They were made with woodblocks (see box, page 334). This meant the image was constructed out of flat planes of color since they were produced with blocks of wood inked with a single color. Nor had the Western artists seen compositions like these, which were dynamic and unusual as figures were pushed so far to one side they began to disappear out of the picture field.

Kitagawa Utamaro. Somenosuke of Matsuhaya (house) from the series Toji zensei bijin-zoroe (Parade of Popular Present-day Beauties), ink and color on paper, Oban, published by Wakasaya Yoichi, c.1797, (37.8 × 25.4 cm). The Art Institute of Chicago, Clarence Buckingham Collection, 1925.3041.

phia and settled in Paris in 1865. In its oblique viewpoint and emphasis on drawing, *The Bath* of 1891–92 (fig. 23-14) reflects the powerful hold that Degas had over her style as well as her study of Japanese prints. But instead of the voyeurism or alienation we saw in Degas's work (see figs. 23-11 and 23-12), Cassatt's painting projects a tender intimacy while avoiding sentimentality.

Painting in England

French Impressionism did not have a strong counterpart across the Channel in England. Home of the Industrial Revolution, the country could not escape its defining influence. It accounted for the poverty and countless other social ills described in Charles Dickens's serial novels set in a cruel, corrupt London suffocated by grime and soot.

Materialism and its sister, greed, were perceived by many to be the new religion. This crassness was reinforced by an insensitive palette for cheap, inferior mass-produced objects, which replaced a refined taste for the handmade and exquisite. Almost single-handedly, John Ruskin (1819–1900) attempted to arrest this decline into industrial hell, and after Queen Victoria, he ranks as one of the greatest forces of the Victorian era, his influence expanding beyond Great Britain to mold American taste as well. He was a philosopher, artist, educator, writer, art critic, and environmentalist, and his most powerful tenet was a need for a return to nature. His teaching stints included the Working Men's College in London, where he advocated art education with the intention of generating fine design (based on natural forms, like vines and leaves), since the workers were also industrial designers. This concept of the need to bring fine art to the working class in order to improve contemporary design would be one of the justifications for establishing museums, which, for example, was the case of the Metropolitan Museum of Art in New York, which opened in 1870.

While Ruskin preached nature as the new religion, others sought new moral values by returning to the Middle Ages. England was home to the great Romantic writers, Lord Byron, the Shelleys, Keats, Coleridge, and Wordsworth, and Romanticism did not die easily. (Recall that in France, Realism and Impressionism lacked sentiment and emotion, as artists attempted to present the world objectively.) Turner may have been out of favor by the 1840s, but a love of the exotic and a strong interest in revival styles continued in England almost to the close of the century. The Middle Ages, which at the time included fifteenth-century Italy, was especially important because it was perceived as a deeply religious period. Furthermore, it was viewed as the era of the anonymous artisan, who out of devotion to God, dedicated his life to making beautiful sacred objects.

THE PRE-RAPHAELITES

By the time Monet came to admire his work, Turner's reputation was at a low in his own country. In 1848 the painter and poet

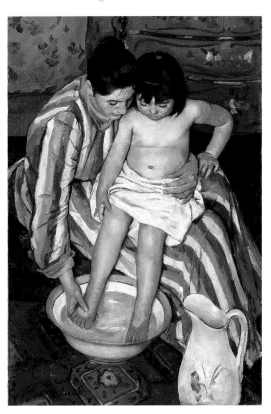

Dante Gabriel Rossetti (1828–1882) helped found an artists' society called the Pre-Raphaelite Brotherhood. The Pre-Raphaelites' basic aim was to do battle against the frivolous art of the day by producing "pure transcripts . . . from nature" and by having "genuine ideas to express." As the name of the society proclaims, its members took their inspiration from the fifteenth-century "primitive" masters of the Renaissance. They were called "primitive" because their simpler, less-sophisticated work predates the perfection and complexity of the High Renaissance of Raphael, Leonardo, and Michelangelo. To that extent, they belong to the Gothic revival, which had long been an important aspect of the Romantic movement. What set the Pre-Raphaelites apart from the Romantics was an urge to reform the ills of modern civilization through their art. In this desire they were aroused by Chartism, a democratic working-class movement that reached its peak in the revolutionary year 1848.

Rossetti himself was not concerned with social problems, however; he thought of himself as a reformer of aesthetic sensibility. The vast majority of his work consists of watercolors or pastels showing

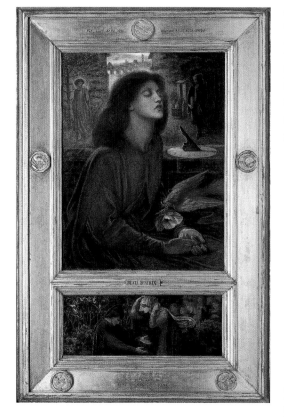

23-15 Dante Gabriel Rossetti. *Beata Beatrix.* 1872. Oil on canvas, 34½" × 27¼" (87.5 × 69.3 cm); predella 10½ × 27¼" (26.5 × 69.3 cm). The Art Institute of Chicago, Charles L. Hutchinson Collection

women taken from literary sources, but all bear a striking resemblance to his wife, Elizabeth Siddal. *Beata Beatrix* (fig. 23-15), created as a memorial to Siddal, imposes her features on the beloved of his namesake, the Italian poet Dante. Dante's account of Beatrice's death inspired Rossetti's painting. Rossetti explained:

"The picture illustrates the 'Vita Nuova,' embodying symbolically the death of Beatrice as treated in that work. The picture is not intended at all to represent death, but to render it under the semblance of a trance. . . . I have introduced . . . the figures of Dante and Love passing through the street and gazing ominously on one another, conscious of the event; while the bird, a messenger of death, drops the poppy between the hands of Beatrice. She, through her shut lids, is conscious of a new world."

In this version, the artist has expressed the hope of seeing his beloved Elizabeth again by adding a second panel showing Dante and Beatrice meeting in Paradise and inscribing the dates of their deaths on the frame. For all its apparent spirituality, the painting has an aura of repressed eroticism that is the hallmark of Rossetti's work as well as a thread running through the paintings of other Pre-Raphaelites.

WILLIAM MORRIS: A REVOLUTION IN INTERIOR DESIGN

William Morris (1834–1896) started out as a Pre-Raphaelite painter but soon shifted his interest to "art for use": domestic architecture and interior decoration such as furniture, tapestries, and wallpapers. He wanted to displace the shoddy machine-made products of the Industrial Revolution by reviving the handicrafts of the distant past, an art "made by the people, and for the people, as a happiness to the maker and the user."

Morris was an apostle of simplicity. Architecture and furniture ought to be designed in accordance with the nature of their materials and working processes. Surface decoration likewise must be flat rather than illusionistic. He often used motifs

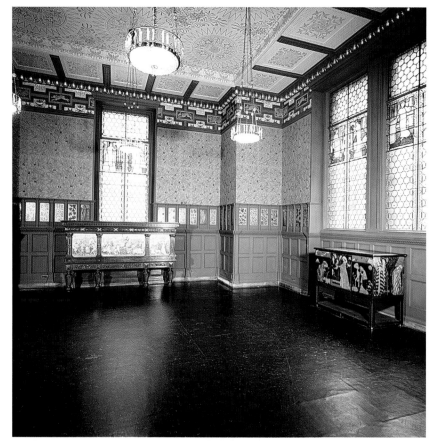

23-16 William Morris (Morris & Co.). Green Dining Room. 1867. Victoria & Albert Museum, London

from nature and an earthy palette of greens and browns, but simple geometric patterns and stronger color appear in his designs as well. His interiors (fig. 23-16) are total environments that create an effect of quiet intimacy. Despite Morris's self-proclaimed championship of the medieval tradition, he did not imitate its forms directly. His achievement was to invent the first original system of ornament since the Rococo.

Through the many enterprises he sponsored, as well as his skill as a writer and publicist, Morris became a tastemaker without peer in his day. Toward the end of the century, his influence had spread throughout Europe and the United States. Nor was he content to reform the arts of design alone. He saw them, rather, as a lever by which to reform modern society as a whole. As a result, he played an important part in the early history of Fabianism, a gradualist variety of socialism invented in England as an alternative to the revolutionary socialism of the Continent.

Painting in the United States

After the Civil War, the United States underwent unprecedented industrial growth, immigration, and westward expansion. These changes led to a new range of social and economic problems as well as to a different outlook and taste particularly among the upper classes. The era was labeled the Gilded Age by writer Mark Twain in his book of the same name. Twain was referring to the massive wealth accumulated by the industrialists, financiers, and oil and railroad men, commonly known as the robber barons because of their cut-throat avaricious practices. This new class of Americans traveled abroad in growing numbers and found their cultural models in Europe, particularly France, which led to a new cosmopolitanism in art. Instead of simple Federal-style houses articulated with Greek motifs that recalled the great republics of antiquity, they aspired to build ornate French chateaus and Italian palazzos, which they then filled with European furniture and paintings.

Simultaneously, there was an equally dramatic shift in the attitude toward nature. The uneasy balance between civilization and nature that came down on the side of nature, as we saw in the sublime landscapes of the Hudson River School, shifted once and for all in favor of progress by the end of the Centennial Celebration in 1876. Instead of American-based landscape and genre, a large contingent of American artists sought to make paintings that looked distinctly European and would appeal to the new American audience that aspired to Old World culture.

JAMES ABBOTT MCNEILL WHISTLER

James Abbott McNeill Whistler (1834–1903) was an American who went to Paris in 1855 to study painting. Four years later he moved to London, where he spent the rest of his life, but he visited France during the 1860s and was in close touch with the rising Impressionist movement. *Arrangement in Black and Gray: The Artist's Mother* (fig. 23-17), his best-known painting, reflects the influence of Manet in its emphasis on flat areas, while the likeness has the austere precision of Degas. Its fame as a symbol of today's "mother cult" would have horrified Whistler, who wanted the canvas to be appreciated for its formal qualities alone.

A witty, sharp-tongued advocate of "art for art's sake," he thought of his pictures as comparable to pieces of music and often called them "symphonies" or "nocturnes." The boldest example, painted about 1874, is *Nocturne in Black and Gold: The Falling Rocket*

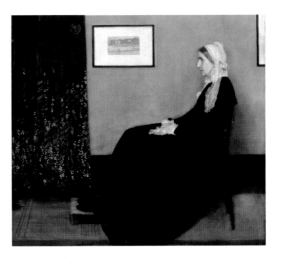

23-17 James Abbott McNeill Whistler. *Arrangement in Black and Gray: The Artist's Mother.* 1871. Oil on canvas, 57 × 64¹/₂″ (144.8 × 163.8 cm). Musée d'Orsay, Paris

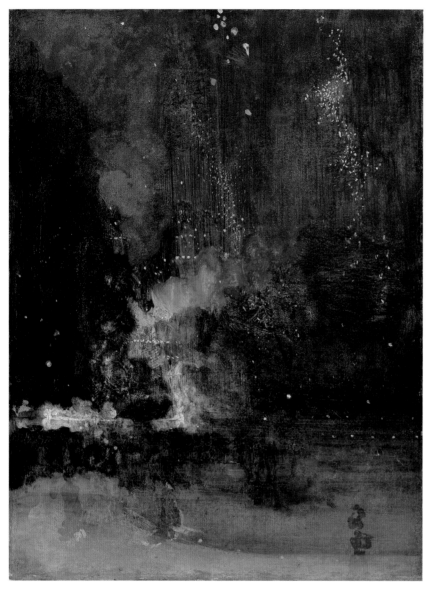

23-18 James Abbott McNeill Whistler. *Nocturne in Black and Gold: The Falling Rocket.* c. 1874. Oil on panel, 23¾ × 18⅜" (60.2 × 46.8 cm). The Detroit Institute of Arts

Gift of Dexter M. Ferry, Jr.

of his aims that seems particularly relevant to *The Falling Rocket:* "I have perhaps meant rather to indicate an artistic interest alone in my work, divesting the picture from any outside sort of interest. . . . It is an arrangement of line, form, and color, first, and I make use of any incident of it which shall bring about a symmetrical result." The last phrase has special significance, since Whistler acknowledges that in using chance effects, he does not look for resemblances but for a purely formal harmony. While he rarely practiced what he preached to quite the same extent as he did in *The Falling Rocket,* his statement reads like a prophecy of American abstract painting (see fig. 27-2).

WINSLOW HOMER

Winslow Homer (1836–1910) did not need Baudelaire's theory that heroism existed in the ordinary in order to portray the modern world. He began his career as a magazine illustrator with assignments to do just that. Homer covered the Civil War, and for the women's journals he recorded the latest fashions and social activities. In 1866 he went to Paris, but left too soon to feel the full impact of Impressionism, which he never fully developed. He painted plenty of outdoor scenes of the middle-class engaged in leisure activities, such as playing croquet, swimming on the beach at the newest shore resorts, and taking horseback tours while vacationing in the White Mountains of New Hampshire. But his color was never as intense as the Impressionists' and his brushwork as loose. Nor were his pictures objective, for unlike the Impressionists he had an agenda: instead of capturing a fleeting moment, he was creating iconic images, as had Millet (see fig. 22-11).

This can be seen in *Snap the Whip* of 1872. (fig. 23-19), a sun-filled picture with fairly strong color and flashy passages of brushwork. But ultimately this is a stop-action picture. The figures are carefully outlined and become monumental, with their solidity reinforced by the geometry of the one-room schoolhouse and the bold backdrop of the mountain, which dramatically parallels the direction of the boys' movement. The bare-foot children in their plain country clothes are transformed into emblems of simplicity and robust

(fig. 23-18). Without an explanatory subtitle, we would have real difficulty making out the subject. No French painter had yet dared to produce a picture so "nonrepresentational," so reminiscent of Turner's "tinted steam" (see fig. 22-18). It was this canvas, more than any other, that prompted the English critic John Ruskin to accuse Whistler of "flinging a pot of paint in the public's face." (Since Ruskin had highly praised Turner's *Slave Ship,* we must conclude that what Ruskin admired was not the tinted steam itself but the Romantic feeling behind it.) During Whistler's successful suit for libel, he offered a definition

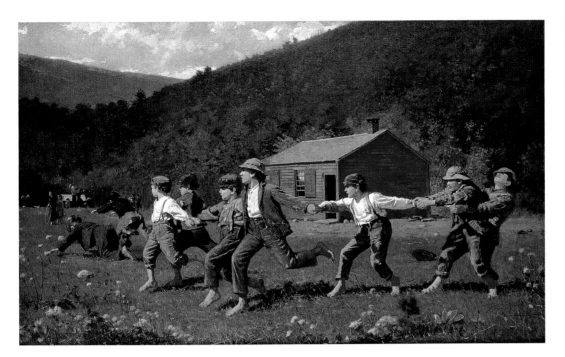

23-19 Winslow Homer. *Snap the Whip.* 1872. Oil on canvas, 22¼ × 36½″ (56.5 × 92.7). The Butler Institute of Art, Youngstown, Ohio

wholesomeness, their youth symbolizing innocence and future hope. At a time when the nation was staggering under the weight of the disillusionment brought on by the Civil War and the turmoil of rampant industrialization, *Snap the Whip* embodies the country's lost innocence. It is a nostalgic appeal for values that were quickly fading into memory.

THOMAS EAKINS

Thomas Eakins (1844–1916) arrived in Paris from Philadelphia about the same time as Homer. He went home four years later, after receiving conventional academic training, but very much aware of the rebellious issues being raised by the radical artists of the day. *The Champion Single Sculls (Max Schmitt in a Single Scull)* (fig. 23-20), made in 1871, the

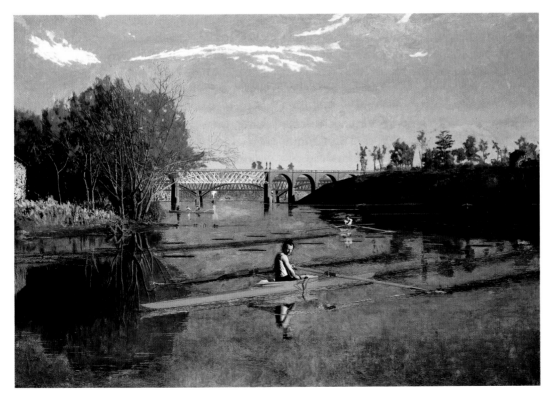

23-20 Thomas Eakins. *The Champion Single Sculls (Max Schmitt in a Single Scull).* 1871. Oil on canvas, 32¼ × 46¼″. The Metropolitan Museum of Art, New York

Alfred N. Punnett Endowment Fund and George D. Pratt Gift, 1934 (34.92)

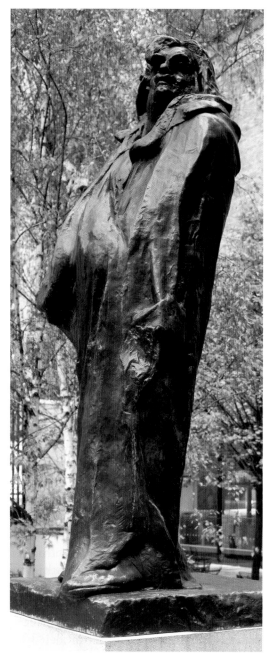

23-23 Auguste Rodin. *Monument to Balzac.* 1897–98. Bronze (cast 1954), height 9'3" (2.82 m). The Museum of Modern Art, New York

Presented in Memory of Curt Valentin by his Friends

creation (fig. 23-23). The sculpture was rejected by the writers' association that had commissioned it, and remained in plaster for many years. He had been asked at the insistence of the author Émile Zola to take over the project when the first sculptor died after producing only a sketch. Rodin declared it to be "the sum of my whole life. . . . From the day of its conception, I was a changed man." Outward appearance did not pose a problem (Balzac's features were well known). But Rodin wanted far more than that. He was searching for a way to cast Balzac's whole personality into visible form, without the addition of allegorical figures, which were the

usual props of monuments to genius. The final version gives no hint of the many alternative solutions he tried. (More than 40 have survived.) The element common to them all is that Balzac is standing, in order to express the virile energy Rodin saw in his subject.

The final sculpture shows the writer clothed in a long dressing gown—described by his contemporaries as a "monk's robe"—which he liked to wear while working at night. Here was a "timeless" costume that permitted Rodin to conceal and simplify the contours of the body. Seized by a sudden creative impulse, Balzac awakens in the middle of the night. Before he settles down to record his thoughts on paper, he hastily throws the robe over his shoulders without putting his arms through the sleeves. But, of course, Balzac is not about to write. He looms before us with the awesome power of a phantom, completely unaware of his surroundings. The entire figure leans backward to stress its isolation from the viewer. The statue is larger than life, physically and spiritually: it has an overpowering presence. Like a huge monolith, the man of genius towers above the crowd. He shares "the sublime egotism of the gods" (as the Romantics put it). From a distance we see only the great bulk of the figure. The head thrusts upward—one is tempted to say, erupts—with elemental force from the mass formed by the shroudlike cloak. When we are close enough to make out the features clearly, we sense beneath the disdain an inner agony that stamps *Balzac* as the kin of *The Thinker*.

EDGAR DEGAS

Among the Impressionists, only Degas produced sculpture. He made dozens of small-scale wax figurines that explore the same themes as his paintings and drawings. (Renoir's late sculptures were actually done by an assistant according to his instructions and thus do not qualify.) They are private works made for his own interest. Few of them were exhibited during the artist's lifetime, and none were cast until after his death in this century.

During the 1870s there was a growing taste for casts made from artists' working models. It reflected the same appreciation for spontaneity and inspiration found in drawings and oil sketches, which had long appealed to collectors. This preference, which dates back to Rodin's ideal, Michelan-

gelo, was essentially an outgrowth of the Romantic cult of originality, not of Impressionism. It was felt that quick, unfinished, even fragmentary works conveyed the force of the artist's vision more directly than any finished piece could. For the first time sculptors felt free to violate time-honored standards of naturalism and craftsmanship for statuettes, and to leave the impress of their fingers on the soft material as they molded it. Nevertheless, when Degas showed the wax original of *The Little Fourteen-Year-Old Dancer* at the Impressionist exhibitions of 1880 and 1881, the public was scandalized by its lack of traditional finish and uncompromising observance of unvarnished truth. (The response from critics was less harsh.) The sculpture, reproduced here in a posthumous cast (fig. 23-24), is nearly as rough in texture as the slightly smaller nude study from life on which it is based.

Instead of sculpting her costume, Degas used real cotton and silk, a revolutionary idea for the time but something the Romantics, with their insistent naturalism, must often have felt tempted to do. Degas was intrigued by the tension between the concrete surface and the abstract but powerfully directional forces beneath it. The ungainliness of the young adolescent's body is subtly emphasized by her pose, that of a dancer at "stage rest." In Degas's hands it becomes an extremely stressful one, so full of sharply contrasting angles that no dancer could maintain it for more than a few moments. Yet, rather than awkwardness, the statuette conveys a simple dignity and grace that are irresistible. The openness of the stance, with hands clasped behind the back and legs pointing in opposite directions, demands that we walk around the dancer to arrive at a complete image of it. As we view the sculpture from different angles, the surface provides a constantly shifting impression of light akin to that in Degas's numerous paintings and pastels of the ballet.

Architecture

For more than a century, from the mideighteenth to the late nineteenth, architecture had been dominated by a succession of "revival styles" (see pages 475–79). This term, we will recall, does not mean that ear-

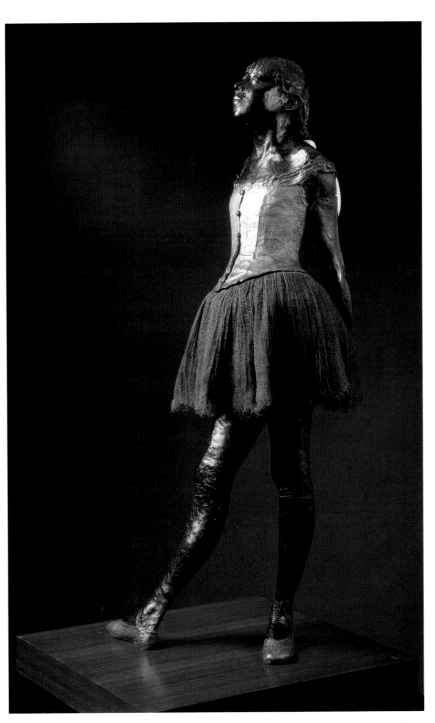

23-24 Edgar Degas. *The Little Fourteen-Year-Old Dancer.* 1878–80. Bronze with gauze tutu and satin hair ribbon, height 38" (96.5 cm). Norton Simon Art Foundation, Pasadena, California

lier forms were slavish copies. The best work of the time has both individuality and high distinction. Moreover, as we have seen, each successive phase of revivalism mirrored a different facet of Neoclassical and Romantic thought. Yet the architecture of the past, however freely interpreted, proved in the long run to be inadequate to the practical demands of the Industrial Age (see Materials and Techniques: The Materials of Modern

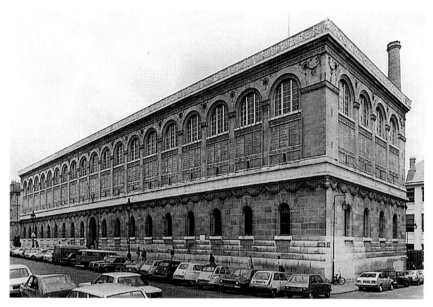

23-25 Henri Labrouste. Bibliothèque Ste-Geneviève, Paris. 1843–50

Architecture, page 509). The problem became one not simply of how to utilize a host of new materials and techniques, including cast iron, in the most utilitarian of structures such as factories and warehouses, but also how to apply them to stores, apartments, libraries, and other city buildings that formed the bulk of construction.

HENRI LABROUSTE

A famous early example is the Bibliothèque Ste-Geneviève in Paris by Henri Labrouste (1801–1875), the architect's first important commission, and the one that made his reputation. The exterior (fig. 23-25) represents the early Beaux-Arts style at its finest. It conforms to the historicism prevalent at mid-century. The facade is drawn chiefly from Italian Renaissance banks, libraries, and churches, but the two-tiered elevation also looks back to

23-26 Henri Labrouste. Reading Room, Bibliothèque Ste-Geneviève

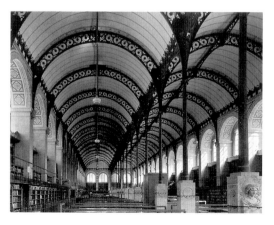

Perrault's east front of the Louvre (see fig. 19-5). At the last minute, Labrouste hit on the brilliant idea of inscribing the names of great writers around the facade to identify the building as a library, adding to the building's aura of authority. (The letters were originally painted red for legibility.) What led him to use this simple but ingenious device was the library's location just behind Soufflot's church of Ste-Geneviève, which, it will be recalled, had been secularized during the French Revolution and renamed the Panthéon (see fig. 21-12). Labrouste, in effect, has turned his library into a pantheon as well—but one dedicated to literary and intellectual, not national, heroes.

The reading room (fig. 23-26), by contrast, recalls the nave of a French Gothic cathedral (compare fig. 11-7). The combination of the classical and the Gothic again pays homage to Soufflot, whose goal was to combine them. Barrel vaults supported by columns, although derived from Romanesque churches, had been introduced into Renaissance libraries and soon became a common feature of reading rooms. Barrel-vaulted libraries enjoyed renewed popularity in England and on the Continent during the 1830s. To Labrouste, barrel vaults undoubtedly looked "Gothic," which at the time included the Romanesque, a term not yet invented. They had the further advantage of acquiring literary associations through the addition of the classical columns. In this way he united the two main systems of Western architecture, thereby fulfilling the program of Soufflot and the Structural Rationalists.

Labrouste's enthusiasm for the Gothic arose from his contact with the writer Victor Hugo, who consulted him on technical questions for his novel *Notre-Dame de Paris* (*The Hunchback of Notre-Dame*). Hugo believed that architecture was originally a form of writing, which had reached its zenith in the Greek and Gothic eras. In a similar vein, Labrouste once wrote that the Temple of Hera at Paestum (see fig. 5-8) had been "covered with painted notices, serving as a book." Hugo, and most likely Labrouste himself, was strongly influenced by the Socialist followers of the Comte de Saint-Simon. They regarded Greek and Gothic architecture as ideal "organic" phases in the development of architecture, to be succeeded by a third one expressing a new social philosophy, moral values, and religious beliefs. These new ideas, further shaped by

MATERIALS AND TECHNIQUES

■ THE MATERIALS OF MODERN ARCHITECTURE ■

Beginning in the late eighteenth century, new materials and techniques began to be used in commercial and public structures that would have a profound effect on architectural style by 1900. The most important new material was iron, which appeared as early as the fourth millennium B.C., but was not used on a large scale until the fourteenth century. When poured into a mold, the iron is called cast iron. A soft, malleable iron, called wrought iron, was introduced around 1820, and during the same period the first steel was invented. It lacked the alloys found in twentieth-century steel, and therefore was not as strong. Nevertheless, it had more strength than iron and also was more corrosion-resistant.

Cast iron was first mass-produced in England in 1767, where it was used for rails. The first iron structure was a bridge built in Coalbrookdale between 1776 and 1779. By the 1780s, iron was replacing fire-prone wood pillars in England's textile mills. Soon cast-iron columns were appearing in Britain's churches, and gradually almost all of the major structural elements of churches were made of iron, as seen St. George's Church in Liverpool, built in 1812–13. The appearance of the railroad in the 1820s brought about a demand for structures that could span enormous spaces. In 1830, the first railroad shed was built using straight iron beams. By the 1840s, the arch was introduced into railroad station architecture, where it would continue to be a prominent motif.

By the mid-1860s, steel mills sprung up everywhere, largely to provide rails

Thomas Rickman and John Cragg. Interior, St. George's Church, Everton, Liverpool, England. 1812–13

for the rapidly expanding railroads. In turn, the long, rolled-steel beams created in the 1880s made steel-frame construction—and the skyscraper—possible. Equally important was the invention of the elevator by Elisha Otis in 1857 and electricity in 1880s. The last major ingredient for the skyscraper was the invention of plate glass, which occurred in the 1820s, which in turn was followed by the far less expensive sheet glass around 1835. Used in conjunction with cast iron, ever larger panes of glass gave rise to the modern storefront, which became ubiquitous after midcentury. Massive windows, used serially, were

also incorporated first into department stores and eventually skyscrapers from the late 1870s onward.

Iron and steel did have a serious drawback. They can rust and be damaged by fire. To overcome these limitations, steel rods, and sometimes steel plates, were embedded in concrete, to make ferroconcrete, which is fire- and water-resistant and can resist the downward forces of gravity and weight far better than brittle concrete alone can. (*Ferrum* is Latin for "iron.") Concrete had been used by the Romans, but was not rediscovered until 1774 in England. Concrete was soon supplanted by the stronger and more durable Portland cement, invented in 1824 by an Englishman. A concrete house was built as early as 1837, but it only became widely adopted in the 1850s and 1860s, and to make sewer systems, not houses.

Iron, steel, and ferroconcrete architecture resulted in the development of new structural systems that in turn required sophisticated engineering skills. Because architecture became increasingly dependent on engineering, the tradition of artists and gifted amateurs dallying in architecture was largely over by 1880. The triumph of the iron age and the new technological sophistication was symbolized by the grand Hall of Machines at the 1889 Paris World's Fair (the building is seen behind the Eiffel Tower in fig. 23-28). It was designed by Charles Dutert. But credit is generally given as well to the engineering team of Contamin, Pierron, and Charton, which helped erect this mammoth structure that dwarfed all of the surrounding buildings.

Charles Fourier, were more egalitarian, and were appropriate to the library, which was for use by the general public. But why did Labrouste choose cast-iron columns and arches? Cast iron was not necessary to provide support for the two barrel roofs—this function could have been filled using other materials. Rather, it was essential to the completion of the building's symbolic program. With the Bibliothèque Ste-Geneviève he announced that technology would provide the new tradition to succeed the Classical and the Gothic.

Labrouste boldly left the interior iron skeleton uncovered, rather than disguising it. His solution does not fully integrate the two systems but lets them coexist. The iron supports, shaped like **Corinthian columns**, are as slender as the new material permits. Their collective effect is that of a space-dividing screen that denies their structural importance. To make them appear weightier, Labrouste has placed them on tall pedestals of solid masonry, instead of directly on the floor. Aesthetically the arches presented greater difficulty, since there was no way to make them look as powerful as their masonry ancestors. Here Labrouste has gone to the other extreme, perforating them with lacy scrolls as if they were pure ornament, so that the vaulting has a fanciful and delicate quality. This daring architectural (as against merely structural) use of exposed iron members created a sensation and placed Labrouste in the forefront of French architecture, although it had already been tried 30 years earlier in England. The reading room featured another innovation as well. It was the first of its kind to be lit by gas, making it usable at night. Although iron was later replaced by structural steel and ferroconcrete (see Methods and Materials box),

Labrouste's wedding of historicism and engineering proved so satisfying that most libraries, railroad stations, and the like were indebted to the Bibliothèque Ste-Geneviève, directly or indirectly, for the remainder of the century.

The authority of historical modes nevertheless had to be broken if the industrial era was to produce a truly contemporary style. It proved extraordinarily persistent, however. Labrouste, pioneer though he was of cast-iron construction, could not think of architectural supports as anything but columns having proper capitals and bases, rather than as metal rods or pipes. The "architecture of conspicuous display" practiced by Garnier (see pages 478–79) was divorced, even more than were the previous revival styles, from the needs of the present. It was only in structures that were not considered architecture at all that new building materials and techniques could be explored without these restrictions.

SIR JOSEPH PAXTON AND GUSTAVE EIFFEL

Within a year of the completion of the Bibliothèque Ste-Geneviève, the Crystal Palace (fig. 23-27) was built in London. A pioneering

23-27 Sir Joseph Paxton. The Crystal Palace, London, 1850–1. Iron, glass, and wood.

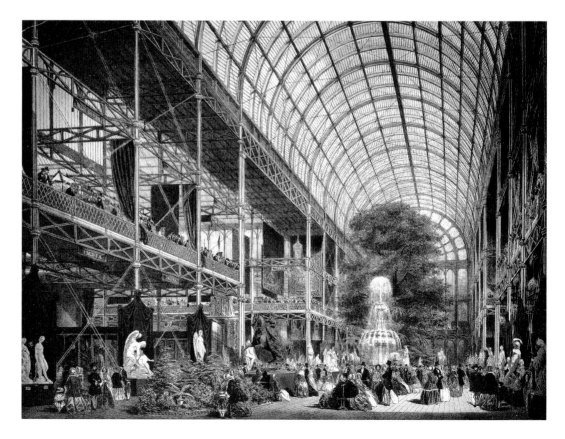

achievement far bolder in conception than Labrouste's library, the Crystal Palace was designed to house the first of the great international expositions that continue in our day. Its designer, Sir Joseph Paxton (1801–1865), was an engineer and builder of greenhouses. The Crystal Palace was, in fact, a gigantic greenhouse—so large that it enclosed some old trees growing on the site—with its iron skeleton freely on display. In exhibition buildings, ease and cost of construction were paramount, because they were not intended to stay up for very long. Paxton's design was such a success that it set off a wave of similar buildings for commercial purposes, such as public markets. However, the notion that products of engineering might have beauty, not just utility, made very slow headway, even though it found supporters from the mid-nineteenth century on. Hence most such buildings were adorned with decorations that follow the eclectic taste of the period.

Only rarely could an engineering feat express the spirit of the times. What was needed for products of engineering to be accepted as architecture was a structure that would capture the world's imagination through its bold conception. The breakthrough came with the Eiffel Tower, named after its designer, Gustave Eiffel (1832–1923). As shown in a contemporary photograph (fig. 23-28), it was erected at the entrance to the Paris World's Fair of 1889, where it served as a triumphal arch of science and industry. It has become such a visual cliché beloved of tourists—much like the Statue of Liberty, which also involved Eiffel (see fig. 22-25)—that we can hardly appreciate what a revolutionary impact it had at the time. The tower, with its frankly technological aesthetic, so dominated the city's skyline that it provoked a storm of protest by the leading intellectuals of the day. Eiffel used the same principles of structural engineering that he had already applied successfully to bridges. Yet the tower is so novel in appearance and so daring in construction that nothing quite like it has ever been built, before or since.

The Eiffel Tower owed much of its success to the fact that for a small sum anyone could take its elevators to see a view of Paris that had previously been reserved for the privileged few able to afford hot-air balloon rides. It thus helped to define a distinctive

23-28 Gustave Eiffel. The Eiffel Tower, Paris. 1887–89

feature of modern architecture, one that it shares with modern technology as a whole: it acts on large masses of people, without regard to social or economic class. Although this capacity, which was shared only by the largest churches and public buildings of the past, has also served the aims of extremists at both ends of the political spectrum, modern architecture has tended by its very nature to function as a vehicle of democracy. We can readily understand, then, why the Eiffel Tower quickly became a popular symbol of Paris itself. It could do so, however, precisely because it serves no practical purpose other than to be an observation tower.

Post-Impressionism, Symbolism, and Art Nouveau

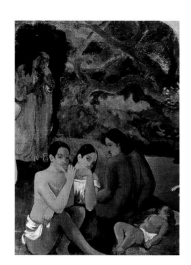

THE THREE MOVEMENTS THAT CAME TO THE FORE AFTER 1884—Post-Impressionism, Symbolism, and Art Nouveau—bore a complex, shifting relationship to each other. At face value, they had little in common other than the time span they shared between the mid- 1880s and 1910. Post-Impressionism encompassed a wide range of styles, from the analytical to the highly expressive. Symbolism was not a style at all but an intensely private worldview based on the literary movement of the same name. It was free to adopt any style that suited its purposes, including Post-Impressionism. Art Nouveau, by contrast, was both a style and an attitude toward life and art, intimately linked to the Aesthetic Movement and the Arts and Crafts Movement. What united Post-Impressionism, Symbolism, and Art Nouveau were a desire to be new and the profound social and economic changes brought on by the Industrial Revolution, no matter how diverse their responses.

Painting

POST-IMPRESSIONISM

In 1882, just before his death, Manet was made a chevalier of the Legion of Honor by the French government. This event marks the turn of the tide: Impressionism had gained wide acceptance among artists and the public—but, by the same token, it was no longer a pioneering movement. When the Impressionists held their last group show four years later, the future already belonged to the "Post-Impressionists." This colorless label designates a group of artists who passed through an Impressionist phase in the 1880s but became dissatisfied with the style and pursued a variety of directions. Because they did not have a common goal, it is difficult to find a more descriptive term for them than Post-Impressionists. They certainly were not "anti-Impressionists." Far from trying to undo the effects of the "Manet revolution," they wanted to carry it further. Thus Post-Impressionism is in essence just a later stage, though a very important one, of the development that had begun in the 1860s with such pictures as Manet's *Luncheon on the Grass*.

Paul Cézanne Paul Cézanne (1839–1906), the oldest of the Post-Impressionists, was born in Aix-en-Provence, near the Mediterranean coast. A man of intensely emotional temperament, he went to Paris in 1861 imbued with enthusiasm for the Romantics—Delacroix was his first love among painters. Cézanne quickly grasped the nature of the Manet revolution as well. After passing through a dark Baroque phase, he began to paint bright outdoor scenes, but he did not share his fellow Impressionists' interest in "slice-of-life" subjects, in movement, and in change. Instead, his goal was "to make of Impressionism something solid and durable, like the art of the museums."

This quest for the "solid and durable" can be seen in Cézanne's **still lifes**, such as *Still Life with Apples* (fig. 24-1). Not since Chardin have simple everyday objects assumed such importance in a painter's eye. The leaf pattern of the ornamental wallpaper is integrated with the three-dimensional

shapes (note the relationship of leaves to tablecloth folds), and the uniform brush-strokes have a constant rhythmic pattern that not only gives the canvas its shimmering texture but holds the image together on the surface. We also notice another aspect of Cézanne's style that may puzzle us at first. The forms are deliberately simplified and outlined with dark colors, and the perspective is incorrect for both the fruit bowl and the horizontal surfaces, which seem to tilt upward. Yet the longer we study the picture, the more we realize the rightness of these apparently arbitrary distortions. When Cézanne took these liberties with reality, his purpose was to uncover the permanent qualities beneath the accidents of appearance. All forms in nature, he believed, are based on abstractions such as the cone, the sphere, and the cylinder. This order underlying the external world was the true subject of his pictures, but he had to interpret it to fit the separate, closed world of the canvas, that is, to make his simple forms lock together to create a solid surface pattern.

To apply this method to landscape became the greatest challenge of Cézanne's career. From 1882 on, he lived in isolation near Aix-en-Provence, exploring its environs as Claude Lorraine and Corot had explored the Roman countryside. One motif seemed almost to obsess him: the distinctive powerful shape of the mountain called Mont Ste-Victoire. Its craggy profile looming against the blue Mediterranean sky appears in a long series of compositions culminating in the monumental late works such as that in figure 24-2. The entire painting is covered with flat planes of color made of brushstrokes mostly running parallel to one another. Cézanne's line is equally flat and likewise sits on the surface of the canvas. There is no attempt to create real space, which can be seen in the way the artist integrates the foreground tree in the upper right corner into the distant blue sky. The only space is the space of one patch of color appearing to sit on a neighboring patch, but this is abstract, not illusionistic, depth. While the brushwork creates a pulsating quality we have seen in Impressionism, Cézanne has stabilized it by the uniformity of his strokes and the repetition of the shapes of his flat planes. Despite its energy, the picture has an equilibrium and monumentality that not only updates the classical tradition but

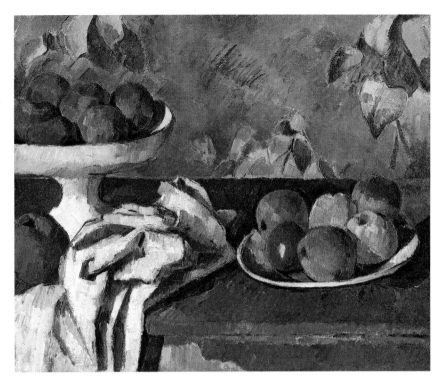

24-1 Paul Cézanne. *Still Life with Apples.* 1879–82. Oil on canvas, 17⅛ × 21¼″ (43.5 × 54 cm). Ny Carlsberg Glyptotek, Copenhagen

also suggests that a powerful order underlies the world of things.

Georges Seurat Georges Seurat (1859–1891) shared Cézanne's aim to make Impressionism "solid and durable," but he went about it very differently. Although he participated in the last Impressionist show, it is an indication of the Post-Impressionist revolution that thereafter he exhibited with an entirely new group, the SOCIETY OF INDEPENDENTS.

Seurat carefully constructed his paintings, even applying a scientific approach. He devoted his main efforts to a few very large canvases, spending a year or more on each of them and making endless series of preliminary studies. *A Sunday Afternoon on the Island of La Grande Jatte* of 1884–86 (fig. 24-3) had its genesis in this painstaking method. The subject, brilliant colors, and the effect of intense sunlight are all Impressionistic. Otherwise, the picture is the very opposite of a quick "impression." The firm, simple contours and the relaxed, immobile figures give the scene a timeless stability that recalls Piero della Francesca (see fig. 12-18). Even the brushwork demonstrates Seurat's passion for order and permanence: the

The SOCIETY OF INDEPEN-DENTS (Société des Artistes Indépendents) was formed in 1884 to organize exhibitions (Salons des Indépendents) open to any artist who paid the required fee. Besides Seurat, founding members included Paul Signac (1863–1935) and Odilon Redon (1840–1916); all three were opposed to the aims of academic art.

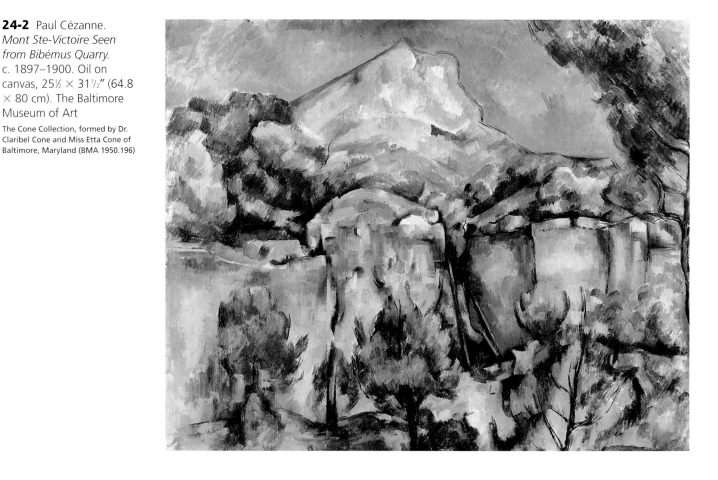

24-2 Paul Cézanne. *Mont Ste-Victoire Seen from Bibémus Quarry.* c. 1897–1900. Oil on canvas, 25½ × 31½" (64.8 × 80 cm). The Baltimore Museum of Art

The Cone Collection, formed by Dr. Claribel Cone and Miss Etta Cone of Baltimore, Maryland (BMA 1950.196)

canvas surface is covered with systematic, impersonal dots of brilliant color that were supposed to merge in the beholder's eye and produce intermediary tints more luminous than anything obtainable from pigments mixed on the palette. This procedure was variously known as Neo-Impressionism, Pointillism, or Divisionism (the term preferred by Seurat). The actual result, however, did not conform to the theory. Looking at the painting from a comfortable distance, we find that the mixing of colors in the eye remains incomplete. The dots do not disappear but are as clearly visible as the **tesserae** of a mosaic (compare figs. 8-9 and 8-10). Seurat himself must have liked this unexpected effect, which gives the canvas the quality of a shimmering, translucent screen. Otherwise, he would have reduced the size of the dots.

The painting has a dignity and simplicity suggesting a new classicism, but it is a distinctly modern classicism based on scientific theory. Seurat adapted the laws of color that were recently discovered by scientists as part of a comprehensive approach to art. These laws included the optical mixing of color, which encompassed the understanding of complementary colors. He came to believe that art must be based on a system. With the help of his friend Charles Henry, he formulated a series of artistic "laws" based on early experiments in the psychology of visual perception. These principles—a line rising from a horizontal is a joyous line and a descending line a sad one—helped him to control every aesthetic and expressive aspect of his paintings.

Color was almost as important as form in Seurat's work, although form was his primary concern. Bodies have little weight or bulk. Modeling and foreshortening are reduced to a minimum, and the figures appear mostly in either strict profile or frontal views, as if Seurat had adopted the rules of ancient Egyptian art. Moreover, he has fitted the forms together within the composition as tightly as the pieces of a jigsaw puzzle. They seem frozen in time and space, acting out their roles with ritualized gravity, in contrast to the joyous abandon of the relaxed figures in Renoir's *Luncheon of the Boating Party* (see fig. 23-10). We read Seurat's cross section of contemporary Parisian society as timeless.

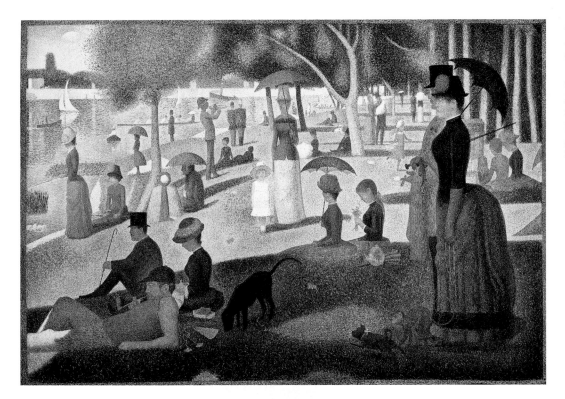

The machine-like quality of Seurat's forms is the first expression of a peculiarly modern outlook that we'll discuss further in chapter 26. Seurat's systematic approach to art is related to modern engineering and a powerful belief in science, which he and his followers hoped would transform and improve society.

Vincent Van Gogh While Cézanne and Seurat were converting Impressionism into a more severe, classical style, Vincent van Gogh (1853–1890) moved in the opposite direction, toward Expressionism. He believed that Impressionism did not provide artists with enough freedom to express their emotions. Van Gogh did not become an artist until 1880; he died only ten years later, so his career was even briefer than Seurat's, who died in 1891. His early interests were in literature and religion. Profoundly dissatisfied with the values of industrial society and imbued with a strong sense of mission, he worked for a while as a lay preacher among poverty-stricken coal miners in Belgium. This intense compassion for the poor dominates the dark Rembrandtesque paintings of his pre-Impressionist period, 1880–85, gloomy pictures of toiling peasants in part inspired by Millet that nonetheless undulate with energy and a respect for life.

In 1886 Van Gogh went to Paris, where his brother, Theo, an art dealer devoted to modern art, introduced him to Degas, Seurat, and other leading French artists. Their effect on him was electrifying: his pictures now blazed with color, and he even experimented briefly with the Divisionist technique of Seurat. This Impressionist phase, however, lasted less than two years. Although it was vitally important for his development, he had to integrate it with the emotional style of his earlier years before his genius could fully unfold. To develop this spiritual reality with the new means at his command, he went to Arles, in the south of France. There, between 1888 and 1890, he produced his greatest pictures.

Like Cézanne, Van Gogh now devoted his main energies to landscape painting, but the sun-drenched Mediterranean countryside evoked a very different response in him. He saw it filled with ecstatic movement reflecting the most elemental forces of life and an exuberant celebration of growth, and not architectural stability and permanence. In *Wheat Field and Cypress Trees* (fig. 24-4), both earth and sky pulsate with an overpowering turbulence. The wheat field resembles a stormy sea, the trees spring flamelike from the ground, and the hills and clouds heave with the same

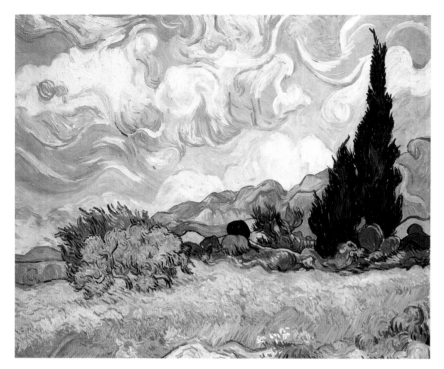

24-4 Vincent van Gogh. *Wheat Field and Cypress Trees.* 1889. Oil on canvas, 28½ × 36" (72.4 × 91.4 cm). The National Gallery, London

undulating motion. The energy in every brushstroke also reflects Van Gogh's spiritual exhilaration before this landscape that for him was a joyous dance of life. To Van Gogh himself, however, it was the color, not the powerful form, that determined the expressive content of his pictures. The letters he wrote to his brother include many eloquent descriptions of his choice of hues and the emotional

meanings he attached to them. He had learned about Impressionist color, but his personal color symbolism probably stemmed from discussions with Paul Gauguin (see below), who stayed with Van Gogh at Arles for several months. (Yellow, for example, meant faith or triumph or love to Van Gogh, whereas carmine was spiritual, cobalt divine; red and green, on the other hand, stood for the terrible human passions.) Although he acknowledged that his desire "to exaggerate the essential and to leave the obvious vague" made his colors look arbitrary by Impressionist standards, he nevertheless remained deeply committed to the visible world.

The colors of *Wheat Field and Cypress Trees* are stronger and simpler than those of Monet (see fig. 23-8) but in no sense "unnatural." They speak to us of that "kingdom of light" Van Gogh had found in the South and of his mystic faith in a creative force animating all forms of life—a faith no less ardent than the sectarian Christianity of his early years. His *Self-Portrait* (fig. 24-5) will remind us of Dürer's (fig. 16-4), and with good reason: The missionary had now become a prophet. His luminous head, with its emaciated features and burning eyes, is set off against a whirlpool of darkness. "I want to paint men and women with that something of the eternal which the halo used to symbolize," Van Gogh had written, groping to define for his brother the human essence that was his aim in pictures such as this. At the time of the *Self-Portrait*, he had already begun to suffer fits of a mental illness that made painting increasingly difficult for him. Despairing of a cure, he committed suicide a year later, for he felt very deeply that art alone made his life worth living.

Paul Gauguin and Symbolism The quest for religious experience also played an important part in the work, if not in the life, of another great Post-Impressionist, Paul Gauguin (1848–1903). He began as a prosperous stockbroker in Paris and an amateur painter and collector of modern pictures. At the age of 35, he became convinced that he must devote himself entirely to art. Gauguin abandoned his business career, separated from his family, and by 1889 was the central figure of a new movement called Synthetism or Symbolism.

Gauguin was originally a follower of Cézanne and once owned one of his still lifes.

24-5 Vincent van Gogh. *Self-Portrait.* 1889. Oil on canvas, 22½ × 17" (57.2 × 43.2 cm). National Gallery of Art, Washington, D.C., collection of Mrs. John Hay Whitney, New York

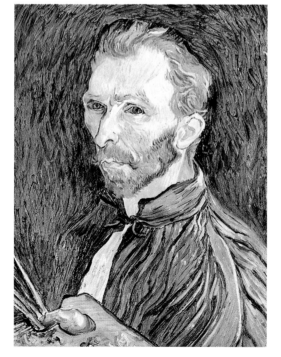

He then developed a style that, though less intensely personal than Van Gogh's, was in some ways an even bolder advance beyond Impressionism. Gauguin believed that Western civilization was spiritually bankrupt because industrial society had forced people into an incomplete life dedicated to material gain while their emotions lay neglected. To rediscover for himself this hidden world of feeling, Gauguin left Paris in 1886 to live among the peasants of Brittany at Pont-Aven in western France. There, two years later, he met the young painters Émile Bernard (1868–1941) and Louis Anquetin (1861–1932), who had rejected Impressionism and began to evolve a new style, which they called Cloisonism because its strong outlines and brilliant color resembled an enamel technique called cloisonné. Gauguin incorporated their approach into his own and emerged as the most forceful member of the Pont-Aven group, which quickly came to center on him.

The Pont-Aven style was first developed fully in the works Gauguin and Bernard painted at Pont-Aven during the summer of 1888. Gauguin noticed particularly that religion was still part of the everyday life of the country people, and in pictures such as *The Vision after the Sermon (Jacob Wrestling with the Angel)* (fig. 24-6), he tried to depict their simple, direct faith. Here at last is what no Romantic artist had achieved: a style based on pre-Renaissance sources. Modeling and perspective have given way to flat, simplified shapes outlined heavily in black, and the brilliant colors are equally unnatural. This style, inspired by folk art and medieval stained glass, is meant to re-create both the imagined reality of the vision and the trancelike rapture of the peasant women, who upon seeing a cow believe they are witnessing Jacob wrestling an angel.

Two years later, Gauguin's search for the unspoiled life led him even farther afield. He went to Tahiti as a sort of missionary in reverse, to learn from the natives instead of teaching them. Although he spent most of the rest of his life in the South Pacific, he never found the unspoiled Eden he was seeking. Indeed, he often had to rely on the writings and photographs of those who had recorded its culture before him. Nevertheless, his Tahitian canvases conjure up an ideal world filled with the beauty and meaning he sought so futilely in real life.

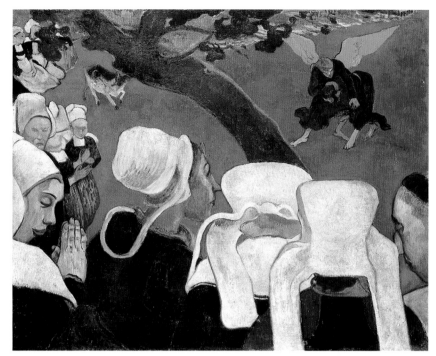

His greatest work in this vein is *Where Do We Come From? What Are We? Where Are We Going?* (fig. 24-7), painted as a summation of his art shortly before he was driven by despair to attempt suicide. Even without the suggestive title, we would recognize the painting's allegorical purpose from its monumental scale, the carefully thought-out poses and placement of the figures within the tapestry-like landscape, and their pensive air. Although Gauguin intended the surface to be the sole conveyer of meaning, we know from his letters that the huge canvas represents an epic cycle of life. The scene unfolds from right to left, beginning with the sleeping girl, continuing with the beautiful young woman (a Tahitian Eve) in the center picking fruit, and ending with "an old woman approaching death who seems reconciled and resigned to her thoughts." In effect, the picture constitutes a variation on the Three Ages of Man. The enigmatic Maori god overseeing everything acts as a figure of death. The real secret to the central mystery of life, Gauguin tell us, lies in this primitive Eden, not in some mythical past.

The renewal of Western art and Western civilization as a whole, Gauguin believed, must come from outside its traditions. He advised other Symbolists to shun Graeco-Roman forms and to turn instead to Persia, the Far East, and ancient Egypt for inspiration. This idea itself was not new. It stems from the Romantic myth of the NOBLE SAVAGE, propagated by the

24-6 Paul Gauguin. *The Vision after the Sermon (Jacob Wrestling with the Angel).* 1888. Oil on canvas, 28¾ × 36½" (73 × 92.7cm). The National Galleries of Scotland, Edinburgh

The idea of the NOBLE SAVAGE goes back to the seventeenth century, but came into its own in the Romantic era, especially in the philosophical writings of Jean-Jacques Rousseau (1712–1778). Essentially an expression of longing for simpler times, the concept of the noble savage refers to peoples uncorrupted by civilization whose outlook was simple, pure, and emotionally direct and who chose to live under just and reasonable laws.

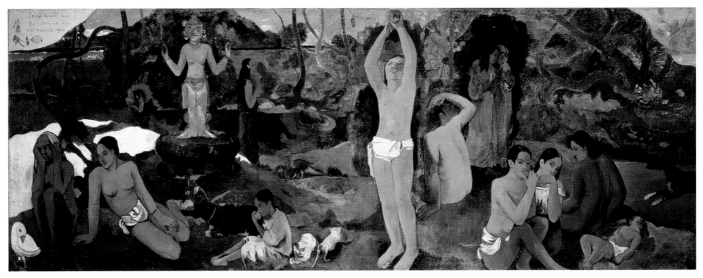

24-7 Paul Gauguin. *Where Do We Come From? What Are We? Where Are We Going?* 1897. Oil on canvas, 4'6¾" × 12'3½". Museum of Fine Arts, Boston

thinkers of the Enlightenment more than a century earlier, and its ultimate source is the age-old belief in an earthly paradise where people once lived, and might one day live again, in a state of nature and innocence. No artist before Gauguin had gone as far to put this doctrine of "primitivism"—as it was called—into practice. His pilgrimage to the South Pacific had more than a purely private meaning: it symbolized the end of the 400 years of expansion that had brought most of the globe under Western domination. Colonialism, once so cheerfully—and ruthlessly—pursued by the empire builders, was, for many, becoming unbearable.

Toulouse-Lautrec The decadent world Gauguin sought to escape provided the subject matter for Henri Marie Raymond de Toulouse-Lautrec (1864–1901), an artist who led a dissolute life in the night spots and brothels of Paris and died of alcoholism. He was a great admirer of Degas, and indeed, his painting *At the Moulin Rouge* (fig. 24-8) recalls the zigzag pattern of Degas's *The Glass of Absinthe* (see fig. 23-11); yet this view of the well-known nightclub is no Impressionist "slice of life." Toulouse-Lautrec sees through the cheerful surface of the scene, viewing performers and customers with a pitilessly sharp eye for character—including his own: he is the tiny bearded man next to the very tall one in the back of the room. The large areas of flat color, however, and the emphatic, smoothly curving outlines reflect the influence of Gauguin. The Moulin Rouge that Toulouse-Lautrec shows here has an atmosphere so joyless and oppressive that we may wonder if the artist did not regard it as a place of evil.

24-8 Henri Marie Raymond de Toulouse-Lautrec. *At the Moulin Rouge.* 1893–95. Oil on canvas, 48⅜ × 55½" (122.9 × 141 cm). The Art Institute of Chicago, the Helen Birch Bartlett Memorial Collection

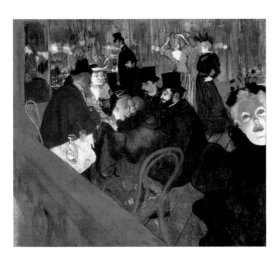

SYMBOLISM

Van Gogh's and Gauguin's discontent with Western civilization was part of a sentiment widely shared at the end of the nineteenth century. It reflected an intellectual and moral upheaval that rejected the modern world and its rational materialism in favor of irrational states of mind. Artists and writers were preoccupied with decadence, evil, and darkness. Even those who saw no escape from the problems of modern life analyzed their predicament in fascinated horror. Yet, this very awareness proved to be a source of

strength, for it gave rise to the remarkable movement known as Symbolism.

Symbolism in art was at first an outgrowth of a literary movement that arose in 1885–86. Reacting against the naturalism (the matter-of-fact observation of life) of the great French novelist Émile ZOLA, they favored, instead, subjective ideas and championed the so-called doomed poets Stéphane Mallarmé and Paul Verlaine. There was a natural sympathy between the Pont-Aven painters (who centered around Gauguin) and the Symbolist poets. Nevertheless, unlike Post-Impressionism, which embodies several stylistic tendencies, Symbolism was a general outlook, one that allowed for a wide variety of styles—whatever would embody its peculiar frame of mind.

Édouard Vuillard and the Nabis Another group of Symbolist artists was known as the Nabis, from the Hebrew word for "prophet." One of them, Maurice Denis, made the statement that was to become the first article of faith for modernist painters of the twentieth century: "A picture—before being a warhorse, a female nude, or some anecdote—is essentially a flat surface covered with colors in a particular order." For these painters, art was a language, and color, line, and composition, for example, were part of the artist's "vocabulary." The Nabis felt the selection of "words" was based on the artist's sensibility, and they were put together to reflect this sensibility. In other words, art was by its very nature abstract, just like language, and while it could be used to create illusionistic images, it could just as easily be used to undermine a sense of illusion in order to create a poetic world of beauty that captured the sensibility of the artist.

Perhaps the most gifted artist to come out of the Nabis was Édouard Vuillard (1868–1940). Vuillard's pictures of the 1890s combine the flat planes and emphatic contours of Gauguin (see fig. 24-6) with the shimmering Divisionist "color mosaic" and the geometric surface organization of Seurat (see fig. 24-3). Most of them are domestic scenes, small in scale and intimate in effect, such as *Interior with Work Table (The Suitor)* (fig. 24-9) of 1893. This seemingly casual view of his mother's corset-shop workroom has a delicate balance of two-dimensional and three-dimensional effects, probably

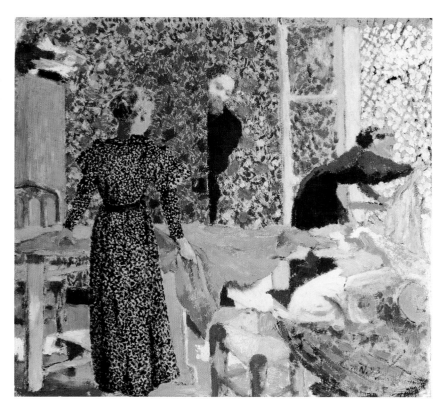

24-9 Édouard Vuillard. *Interior with Work Table* (also known as *the Suitor).* 1893. Oil on millboard panel, 12½ × 14″ (31.8 × 35.6 cm). Smith College Museum of Art, Northampton, Massachusetts. Purchased, Drayton hillyer Fund, 1938 SCI 1938:15
© 2004 Artists Rights Society (ARS), NY/ADAGP, Paris

derived from the flat patterns of the wallpaper and the fabrics themselves.

The picture's quiet magic makes us think of Vermeer and Chardin (compare figs. 18-19 and 20-6), whose subject matter, too, was the snug life of the middle class. In both subject and treatment, the painting has counterparts as well in Symbolist literature and theater: the poetry of Paul Verlaine, the novels of Stéphane Mallarmé, and the productions of Aurélian Lugné-Poë, for whom Vuillard designed stage sets. Like these Symbolists, Vuillard sought to dissolve the materiality of the real world, but by using the poetry of color and paint. Here he creates a peaceful sensuous mood through dappled brushwork and a subdued palette in which the figures, especially the women, become part of the larger composition, melting into it. Table, chairs, women, and bolts of fabric are two-dimensional ghosts floating in an enchanting sea of paint, color, and form that captures the intimate sweetness and languid pace of bourgeois domesticity. The Nabis established an important precedent for the works painted by Henri Matisse a decade later (see fig. 25-2). By then, however, the

After establishing himself as a journalist in Paris, Émile-Édouard-Charles-Antoine ZOLA (1840–1902) turned to writing what he called naturalist fiction. In most of his novels, he explored the hard side of people's lives, especially the social ills afflicting the lower classes. Zola was an outspoken critic on issues ranging from art to politics. In one famous published letter addressed to the president of France, known as J'accuse (I Accuse, 1898), Zola defended Alfred Dreyfus, a Jewish captain in the French army who had been falsely accused and convicted of divulging military secrets.

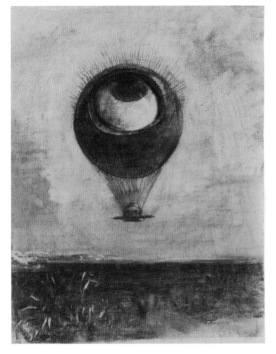

24-10 Odilon Redon. *The Eye like a Strange Balloon Mounts toward Infinity,* from the series *Edgar A. Poe.* 1882. Lithograph, 10¼ × 7¹¹/₁₆″ (25.9 × 19.6 cm). The Museum of Modern Art, New York

Gift of Peter H. Deitsch

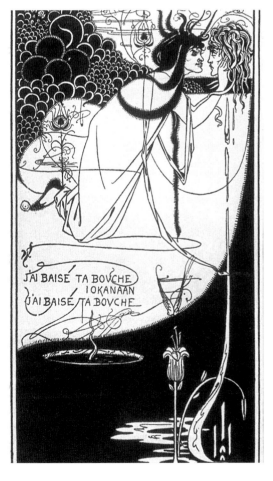

24-11 Aubrey Beardsley. *The Climax.* 1893. Illustration for Oscar Wilde's *Salomé,* 1894 edition. Pen drawing, 10¹⁵/₁₆ × 5¹³/₁₆″ (27.8 × 14.8 cm). Aubrey Beardsley Collection, Manuscripts Division, Department of Rare Books and Special Collections, Princeton University Library, New Jersey

movement had disintegrated as its members became more conservative.

Odilon Redon Another solitary artist whom the Symbolists discovered and claimed as one of their own was Odilon Redon (1840–1916). He had a haunted imagination, but his imagery was even more personal and disturbing. Outstanding at etching and lithography, he drew inspiration from Goya as well as Romantic literature. The lithograph shown in figure 24-10 is one of a set Redon issued in 1882 and dedicated to Edgar Allan Poe, the American poet who had been dead for 33 years. His tormented life and his equally tortured imagination made him the very model of the "doomed poets." Translated into French by Baudelaire and Mallarmé, Poe's works were greatly admired in France. Redon's lithographs do not illustrate Poe. They are, rather, "visual poems" in their own right, evoking the macabre, hallucinatory world of Poe's imagination. In our example, the artist has revived an ancient device, the single eye representing the all-seeing mind of God. But, in contrast to the traditional form of the symbol, Redon shows the whole eyeball removed from its socket and converted into a balloon that drifts aimlessly in the sky. Disquieting visual paradoxes of this kind were to be exploited on a large scale by the Dadaists and Surrealists in the following century (see figs. 25-17 and 26-7).

Aubrey Beardsley Aubrey Beardsley (1872–1898) was a gifted young English artist whose black-and-white drawings were the very epitome of late nineteenth century (fin-de-siècle) decadence. They include an illustration titled *The Climax* for Oscar Wilde's popular French play *Salomé* (fig. 24-11). Salomé has taken up John's severed head and triumphantly kisses it. Beardsley's erotic meaning is plain: Salomé is passionately in love with John and has asked for his head because she could not have him in any other way. Beardsley's drawing explores the frighteningly grotesque femme fatale threat of the female gender, the same theme as Wilde's play. The heads of Salomé and John confront each other with irreconcilable disdain, the hair transforming each into a horrific irrational Medusa. John's blood drips into a black pool of sexuality breeding phallic plants that, like an insidious vine, slither

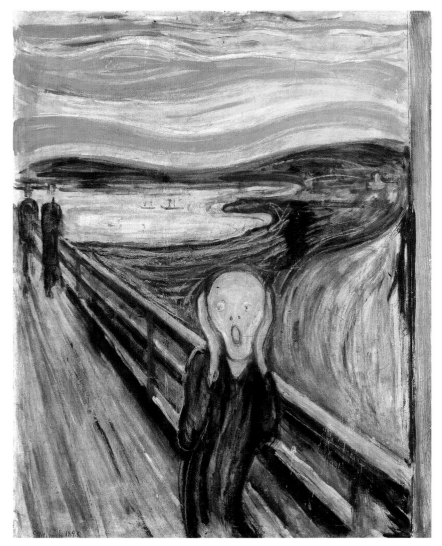

24-12 Edvard Munch. *The Scream.* 1893. Tempera and casein on cardboard, 36 × 29″ (91.4 × 73.7 cm). Nasjonalgalleriet, Oslo

around Salomé. This nightmarish confrontation, dripping with sexual conflict, takes place in a two-dimensional world of curvilinear elegance, so precious that line virtually disappears at times as it twists in a sultry rhythm. Beardsley's abstraction embraces the direction of late-nineteenth-century art, whereas his organic forms share the plantlike, tendril quality of Art Nouveau (see fig. 24-17) which, as we will see momentarily, emerges as a major international style at this time.

Edvard Munch The Symbolist use of abstraction to explore the primordial forces underlying human psychology perhaps reaches its peak in the work of the Edvard Munch (1863–1944), a Norwegian artist who went to Paris in 1889. There Munch adapted the simple curvilinear forms of Gau-

guin and the intense brushwork of Van Gogh to create an abstract expressive style needed to deal with his subject matter. Munch's themes, which he shared with the Scandinavian playwrights Henrik Ibsen and August Strindberg, were the elemental themes of life, death, and sexuality.

The Scream (fig. 24-12) is classic Munch. Painted in 1893 after he moved to Berlin, the picture is based on an experience the artist had some ten years earlier in Christiania (now Oslo) when the sky turned an eerie blood red after the eruption of the Indonesian volcano Krakatoa. (At the time, the cause was unknown.) Already feeling melancholy, Munch noted the following in his diary: ". . . looking out across the flaming clouds that hung like blood and a sword over the blue-black fjord . . ., I sensed a great, infinite scream

The German poet Rainer Maria RILKE (1875–1926) produced a body of introspective, often rapturous poetry and prose that pushed the German language beyond its earlier limits of nuance and has influenced poets and writers ever since. His two most famous works of poetry are *The Duino Elegies* and *The Sonnets to Orpheus* (both 1923, after he had met and worked with Rodin). His much-studied novel *The Notebooks of Malte Laurids Brigge* (1910) is a symbolic recasting of the Old Testament story of the Prodigal Son.

pass through nature." Clasping hands to its skull-like head, the grotesquely squeezed figure reels with a base fear that seems channeled to it from the undulating landscape, life itself. The psychological intensity is elevated to a feverish pitch by the railing, streaking back and out of the picture.

Paula Modersohn-Becker In the opening decade of the twentieth century, Paula Modersohn-Becker (1876–1907) was probably the German artist who was most sensitive to the new radical art coming out of Paris. With her artist husband, she lived in the small village of Worpswede, near her family home in Bremen, Germany. Among the artists and writers who congregated there was the Symbolist lyric poet Rainer Maria RILKE, Rodin's friend and briefly his personal secre-

tary. Rilke had visited Russia and had been deeply impressed with what he viewed as the purity of Russian peasant life. Modersohn-Becker not only absorbed Rilke's views, but from 1901 on she regularly went to Paris to keep abreast of modern art. In her last trips in 1905 and 1906, she was especially affected by the work of Gauguin, Cézanne, Van Gogh, and Matisse. In 1906 she became pregnant and tragically died the following year shortly after giving birth. Despite her short career, her late work represents an important transition from the Symbolism of Gauguin to German Expressionism (see chapter 25).

In her 1906 *Self-Portrait* (fig. 24-13) Modersohn-Becker presents herself as an emblem of fertility, and it undoubtedly was painted once she knew she was pregnant. This iconic figure is simplified to curving

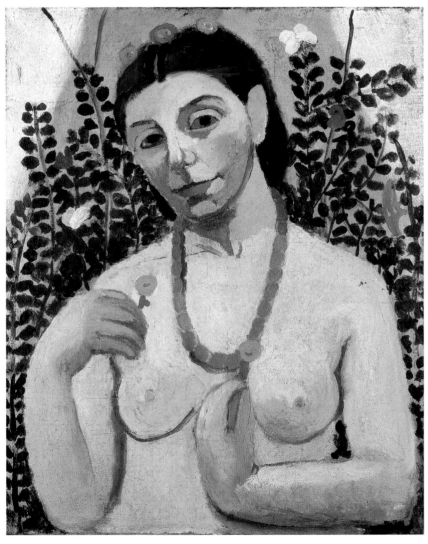

24-13 Paula Modersohn-Becker. *Self-Portrait*. 1906. Oil on canvas, 24 × 19³/₄″ (61 × 50.2 cm). Öffentliche Kunstsammlung Basel, Kunstmuseum, Switzerland

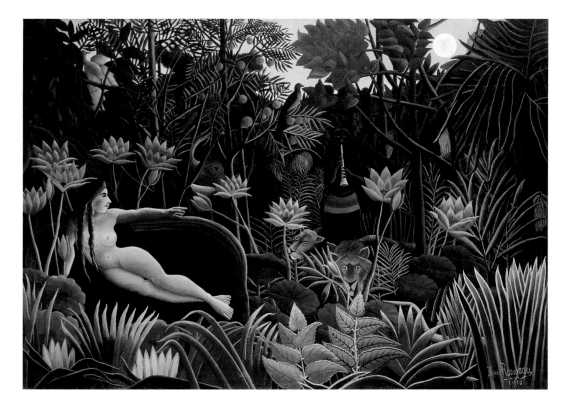

24-14 Henri Rousseau. *The Dream.* 1910. Oil on canvas, 6'8½" × 9'9½" (2.05 × 2.96 m). The Museum of Modern Art, New York, gift of Nelson A. Rockefeller

Licensed by Scala/Art Resource, NY/ © ARS, NY

Gauguinesque forms and strikes an awkward although charming pose that suggests the primitive, recalling Gauguin's Tahitian women (her necklace resembles a lei). This earth goddess poignantly displays two petit flowers, symbols of fertility (note they are the same color as her nipples), as is the garden, in which she is firmly planted. A celestial halo deifies this elemental figure, and her flesh glows from strong pure color which is laced throughout. The effect reflects not only Van Gogh but also the Fauvism of Matisse, who was the sensation of Paris in 1905 (see pages 532–35).

Henri Rousseau The Symbolist preoccupation with portraying the most fundamental human urges through symbols can be seen in the work of the French primitive painter, Henri Rousseau (1844–1910). A retired customs collector who started painting later in life, Rousseau took as his ideal the hard-edged academic style of Ingres's followers (see chapter 22). In his 1910 masterpiece, *The Dream* (fig. 24-14), Rousseau presents woman not as femme fatale or fertility goddess but as enchantress, sexually fascinating and alluring to the male, represented by the hypnotized lion and other animals—but perhaps unattainable. Steeped in a luxuriant

primitive jungle and with the elemental power of the moon, the luscious siren— seated on a contemporary sofa, which establishes her as modern woman—awakens animal instincts in the male sex, as symbolized by the snake focused directly on her.

Here at last, in the work of a primitive folk artist, was the innocent directness of feeling that Gauguin thought was so necessary for the age. Rousseau gained no official recognition during his lifetime, but in 1905 he was discovered by Pablo Picasso and his friends, who were the first to recognize the primordial quality in Rousseau's work. They revered him as the godfather of twentieth-century painting.

Sculpture

Aristide Maillol No tendencies equal to Post-Impressionism appear in sculpture until about 1900. Sculptors in France of a younger generation had by then been trained under the dominant influence of Rodin and were ready to go their own ways. The finest of these, Aristide Maillol (1861–1944), began as a Symbolist painter, although he did not share Gauguin's anti-Greek attitude. Maillol might be called a classical primitivist. Admiring the simplified strength of early Greek

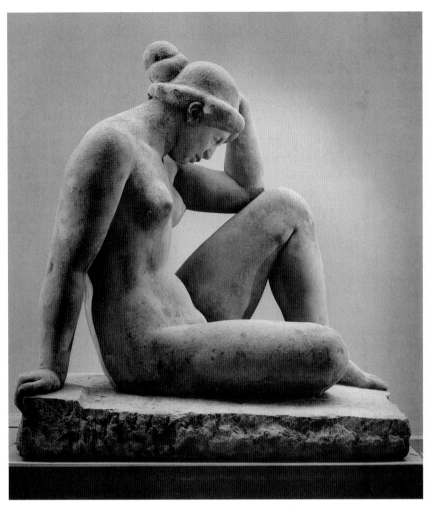

24-15 Aristide Maillol. *Seated Woman (La Méditerranée).* c. 1901. Stone, height 41″ (104.1 cm). Collection Oskar Reinhart, Winterthur, Switzerland

© 2004 Artists Rights Society (ARS), New York/ADAGP, Paris

24-16 Ernst Barlach. *Man Drawing a Sword.* 1911. Wood, height 31″ (78.7 cm). Private Collection

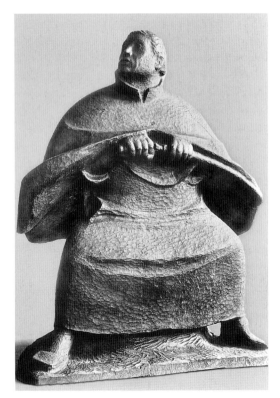

sculpture, he rejected its later phases. The *Seated Woman* (fig. 24-15) evokes memories of the Archaic and Severe styles (compare figs. 5-12 and 5-17) rather than of Praxiteles. The solid forms and clearly defined volumes also recall Cézanne's statement that all natural forms are based on abstractions such as the cone, the sphere, and the cylinder. But the most notable quality of the figure is its harmonious, self-sufficient repose, which the outside world cannot disturb. A statue, Maillol thought, must above all be "static," structurally balanced like a piece of architecture. It must further represent a state of being that is detached from the stress of circumstance, with none of the restless, thrusting energy of Rodin's work. In this respect, the *Seated Woman* is the exact opposite of *The Thinker* (see fig. 23-22). Maillol later gave it the title *La Méditerranée (The Mediterranean)* to suggest the source from which he drew the timeless serenity of his figure.

Ernst Barlach Ernst Barlach (1870–1938), an important German sculptor who reached maturity in the years before World War I, is the very opposite of Maillol: he is a "Gothic primitivist." What Gauguin had experienced in Brittany and the tropics—the simple humanity of a preindustrial age—Barlach found by going to Russia. His figures, such as *Man Drawing a Sword* (fig. 24-16), embody elementary emotions—wrath, fear, grief— that seem imposed upon them by invisible presences. When they act, they appear to be sleepwalkers, unaware of their own impulses. To Barlach human beings are humble creatures at the mercy of outside forces, never in control of their fate. Characteristically, these figures do not fully emerge from the material substance (often, as here, a massive block of wood) of which they are made. Their clothing is like a hard chrysalis that hides the body, as in medieval sculpture. Barlach's figures nevertheless communicate an unforgettable mute intensity.

Architecture

ART NOUVEAU

During the 1890s and early 1900s, a movement now usually known as Art Nouveau (New Art) arose throughout Europe and the

United States. It takes its name from a shop opened in Paris in 1895 by the entrepreneur Siegfried Bing, who employed most of the leading designers of the day and helped to spread their work everywhere. By that time, however, the movement had already been in full force across Europe for several years. In Germany and Austria it was called Jugendstil (literally, "Youth Style"); Italians knew it as Stile Liberty (after the well-known London store that helped to launch it), and in Spain, it was Modernista.

Like Post-Impressionism and Symbolism, Art Nouveau is not easy to characterize. It was primarily a new style of decoration based on sinuous curves, nominally inspired by Rococo forms, that often suggest organic shapes. Its favorite pattern was the whiplash line, its typical shape the lily. Yet there was also a severely geometric side as well that in the long run proved of even greater significance. The ancestor of Art Nouveau was the ornament of William Morris, but the movement was also related to the styles of Whistler, Gauguin, Beardsley, and Munch, among others. (Munch exhibited at Siegfried Bing's gallery L'Art nouveau.) In turn, it was allied to such diverse outlooks as AESTHETICISM, ART FOR ART'S SAKE, socialism, and Symbolism.

The avowed goal of Art Nouveau was to raise the crafts to the level of the fine arts, thereby abolishing the distinction between them. It meant to be a "popular" art, available to everyone. Yet it often became so extravagant as to be affordable only by the wealthy. Art Nouveau had a profound impact on public taste, and its influence on the applied arts can be seen in wrought-iron work, furniture, jewelry, glass, typography, and even women's fashions. Historically, Art Nouveau may be regarded as a prelude to modernism, but its excessive refinement was perhaps a symptom of the malaise that afflicted the Western world at the end of the nineteenth century.

As a style of decoration, Art Nouveau did not lend itself easily to architectural designs on a large scale. Indeed, critics aptly called it book-decoration architecture, after the origin of its designs, which were best suited to two-dimensional surface effects. But in the hands of a few great architects, Art Nouveau buildings could be extraordinary, and significantly, they undermined the authority of the revival styles once and for all.

Victor Horta The first architect to explore the full potential of Art Nouveau was Victor Horta (1861–1947), the founder of the movement in Brussels. After studying in Paris, Horta brought the latest ideas back to Belgium. There he gained the patronage of wealthy industrialists who were surprisingly liberal in their political and cultural views. The stairwell in Tassel House (fig. 24-17), built in 1892–93 for a mathematics professor, has an amazingly fluid grace. Horta has made maximum use of wrought iron, which could be drawn out into almost any shape. While the supporting role of the column is frankly acknowledged, it has been made as slender as possible. If we look back at classical columns (see fig. 5-11 for example), we can see that Horta has designed something quite new. In a charming play on the Corinthian capital, it

AESTHETICISM, which was a movement—and almost a cult by the end of the nineteenth century—took the position that seeking beauty should be the highest aim of art and literature, and that no artist should create with moral or instructive purposes. Aestheticism is thus very close to ART FOR ART'S SAKE, the European and American doctrine that holds that art's only goal and justification is its creation and the perfection of its technical execution. Aestheticism was influenced by the German Romantics, especially Johann Wilhelm von Goethe (1749–1832). Art for art's sake has been a fairly constant intention since the last decades of the nineteenth century.

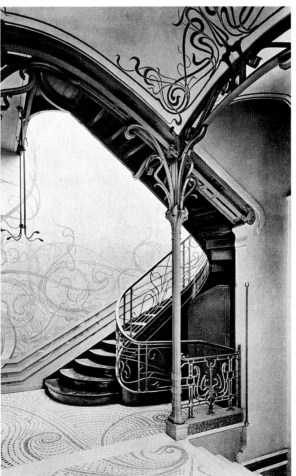

24-17 Victor Horta. Interior Stairwell of the Tassel House, Brussels, 1892–93

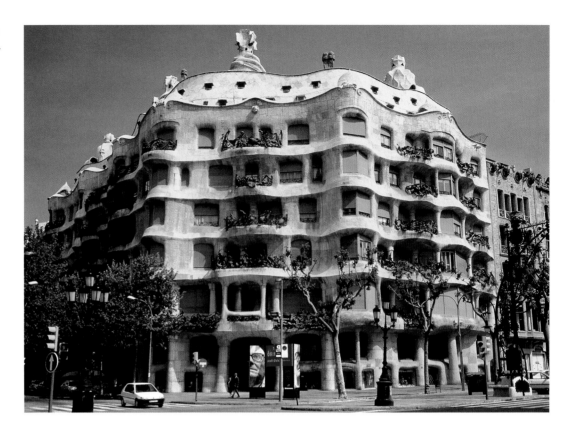

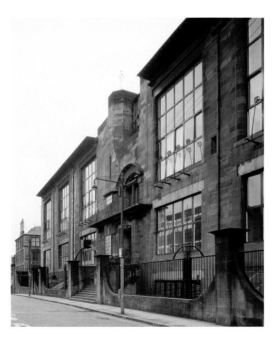

sprouts ribbonlike tendrils that dissolve the arches. This effect is enhanced by continuing the vegetal motif in the vault above. Similarly the banister, which is light and supple, uncoils with taut springiness. The linear patterns extend to the floor and walls, which further integrate the space visually. The ensemble has a litheness and airiness that makes Beaux-Arts architecture seem heavy and vulgar (see fig. 22-29).

Antoni Gaudí The most remarkable instance of Art Nouveau in architecture is the Casa Milá in Barcelona (fig. 24-18), a large apartment house by Antoní Gaudí (1852–1926). It shows a devoted avoidance of all flat surfaces, straight lines, and symmetry of any kind, so that the building looks as if it had been freely modeled of some malleable substance, although it is in fact made of cut stone. The roof and softly rounded openings have the rhythmic motion of a wave, and the chimneys seem to have been squeezed from a pastry tube. The Casa Milá expresses one person's fanatical devotion to the ideal of "natural" form, one quite different from Horta's plantlike designs. Gaudí's style was difficult for other architects to develop further. It is a tour de force of old-fashioned artisanship and stands as an attempt at architectural reform through aesthetics rather than engineering.

Charles Rennie Mackintosh Gaudí represents one extreme of Art Nouveau architecture. The Scot Charles Rennie Mackintosh (1868–1928) represents another. Although they stood at opposite poles, both strove for the same goal—a contemporary style independent of the past. Mackintosh's basic outlook is so pragmatic that at first

glance his work hardly seems to belong to Art Nouveau at all. The north facade of the Glasgow School of Art (fig. 24-19) was designed as early as 1896 but might be mistaken for a building done 30 years later. Huge, deeply recessed studio windows have replaced the walls, leaving only a framework of massive, unadorned cut-stone surfaces except in the center bay. This bay, however, is "sculptured" in a style not unrelated to Gaudí's, despite its preference for angles over curves. Another Art Nouveau feature is the spare wrought-iron grillwork.

Henri van de Velde One of the founders of Art Nouveau was the Belgian Henri van de Velde (1863–1957). Trained as a painter, Van de Velde fell under the influence of William Morris. He became a designer of posters, furniture, silverware, and glass, then after 1900 worked mainly as an architect. It was he who founded the Weimar School of Arts and Crafts in Germany, which became famous after World War I as the Bauhaus (see pages 627–28). His most ambitious building, the theater he designed in Cologne for an exhibition sponsored by the Werkbund (arts and crafts association) in 1914 (fig. 24-20), makes a telling contrast to the Paris Opéra (see fig. 22-29), completed only 40 years earlier. Whereas the older building tries to evoke the splendors of the Louvre Palace, Van de Velde's exterior is a tautly stretched "skin" that both covers and reveals the individual units of which the internal space is composed.

The Werkbund Exhibition was a watershed in the development of modern architecture. It provided a showcase for a whole generation of young German architects who were to achieve prominence after World War I (see chapter 27). Many of the buildings they designed for the fairgrounds anticipate ideas of the 1920s.

THE UNITED STATES

The search for a modern architecture began in earnest around 1880. It required wedding the ideas of William Morris and a new machine aesthetic, tentatively explored some 15 years earlier in the decorative arts, to new construction materials and techniques. The process itself took several decades, during which architects experimented with a variety of styles. It is significant that the symbol of their quest was the

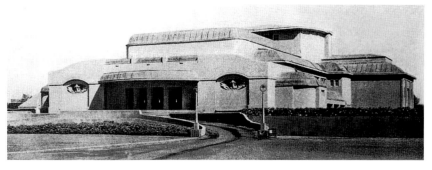

24-20 Henri van de Velde. Theater, Werkbund Exhibition, Cologne. 1914. Destroyed

SKYSCRAPER. It first arose in Chicago, which had been destroyed by the fire of 1871, creating enormous opportunities for architects, who because the core of the city had been wiped out, were unencumbered by an allegiance to the styles of the past.

Louis Sullivan Chicago was home to Louis Sullivan (1856–1924), although his first skyscraper, the Wainwright Building, was erected in St. Louis (fig. 24-21) in 1890–91. The building is **monumental**, but in a very untraditional way. Its exterior—in the slender, continuous brick **piers** that rise between the windows from the base to the attic—both reflects and expresses the internal steel skeleton. The collective effect is that of a vertical grating encased by the corner piers and by the emphatic horizontals

The SKYSCRAPER was developed in the United States in the last quarter of the nineteenth century: the Home Insurance Building in Chicago (William Le Baron Jenney, 1883) was the first to possess the steel-skeleton construction characteristic of the form. Early in the twentieth century, New York eclipsed Chicago as the skyscraper capital of the world, with such structures as the Flatiron Building (D. H. Burnham, 1902), the Woolworth Building (Cass Gilbert, 1913), and the Empire State Building (Shreve, Lamb and Harmon, 1931).

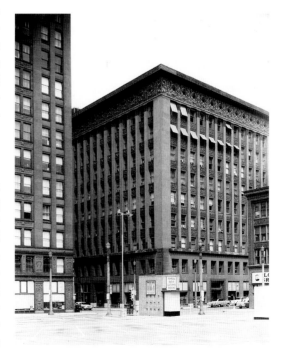

24-21 Louis Sullivan. Wainwright Building, St. Louis, Missouri. 1890–91. Destroyed

of attic and mezzanine. Although many possible "skins" could be stretched over the structural frame, what is important aesthetically is that we immediately feel that this wall is derived from the skeleton underneath and that it is not self-sustaining. *Skin* is perhaps too weak a term to describe this brick sheathing. To Sullivan, who often thought of buildings as analogous to the human body, it was more like the "flesh" and "muscle" that are attached to the "bone," and like them is capable of a variety of expressive effects. When he insisted that "form follows function," he understood the relationship as flexible rather than rigid.

Paradoxically, Sullivan's buildings are based on a lofty idealism and are adorned with a type of ornamentation that remain firmly rooted in the nineteenth century, even as they point the way toward twentieth-century architecture. From the beginning, Sullivan's geometry carried a spiritual meaning that centered on birth, flowering, decay, and regeneration. It was tied to a highly original style of decoration in accordance with his theory that ornament must give expression to structure—not by reflecting it literally but by interpreting the same concepts through organic abstraction. The soaring verticality of the Wainwright Building, for example, stands for growth, which is elaborated by the vegetative motifs of the moldings along the cornice and between the windows.

Photography

PHOTO-SECESSION

The issue of whether photography could be art came to a head in the early 1890s with the Secession movement, which was spearheaded in 1893 by the founding in London of the Linked Ring, a rival group to the Royal Photographic Society of Great Britain. In seeking a pictorialism independent of science and technology, the Secessionists steered a course between idealism and naturalism by imitating every form of late Romantic art that did not involve narrative. Equally antithetical to their aims were Realist and Post-Impressionist painting, then at their zenith. In the group's art-for-art's-sake approach to photography, the Secession had much in common with Whistler's aestheticism.

To resolve the dilemma between art and mechanics, the Secessionists tried to make their photographs look as much like paintings as possible. Rather than resorting to composite or multiple images, however, they exercised total control over the printing process, chiefly by adding special materials to their printing paper to create different effects. Pigmented gum brushed on coarse drawing paper yielded a warm-tone, highly textured print that in its way approximated Impressionist painting. Paper impregnated with platinum salts was especially popular among the Secessionists for the clear grays it produced. The subtlety and depth of the platinum print lend a remarkable ethereality to *The Magic Crystal* (fig. 24-22) by the American photographer Gertrude Käsebier (1852–1934), in which spiritual forces almost visibly sweep across the photograph. Reacting to the social turmoil of the new industrial world and its preoccupation with materialism, Käsebier, like the Symbolists, turned her back on modernity in search of higher fundamental truths.

Edward Steichen Through Käsebier and another American photographer, Alfred Stieglitz, the Linked Ring had close ties with the United States, where Stieglitz opened his Photo-Secession gallery in New York in 1905. Among his protégés was the young Edward Steichen (1879–1973), whose photograph of Rodin in his sculpture studio

24-22 Gertrude Käsebier. *The Magic Crystal.* c. 1904. Platinum print. Royal Photographic Society, Bath

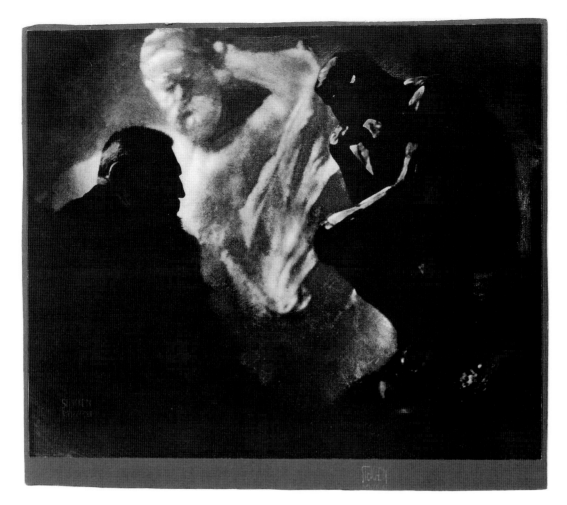

24-23 Edward Steichen. *Rodin with His Sculptures "Victor Hugo" and "The Thinker."* 1902. Gum print, 14¼" × 12¾" (36.3 × 32.4 cm). The J. Paul Getty Museum, Los Angeles

(fig. 24-23) is one of the finest achievements of the entire Photo-Secession movement. The head in profile contemplating *The Thinker* expresses the essence of the confrontation between the sculptor and his work of art. His brooding introspection hides the inner turmoil evoked by the ghostlike monument to Victor Hugo, which rises dramatically like a **genius** in the background. Not since *The Creation of Adam* by Michelangelo (see fig. 13-10), who was Rodin's ideal artist, have we seen a more telling use of space or an image that penetrates the mystery of creativity so deeply.

DOCUMENTARY PHOTOGRAPHY

During the second half of the nineteenth century, the press played a leading role in the social movement that brought the harsh realities of poverty to the public's attention. While photographs did not routinely appear in newspapers until the twentieth century, the camera became an important instrument of reform through the photodocumentary, which tells the story of people's lives in a pic-

torial essay. The press reacted to the same conditions that had stirred Courbet, and its factual reportage likewise fell within the Realist tradition—only its response came a quarter-century later. Hitherto, photographers had been content to present a romanticized image of the poor like that in genre paintings of the day. The first photodocumentary was John Thomson's illustrated sociological study *Street Life in London*, published in 1877. To take his pictures, however, Thomson had to pose his figures.

Jacob Riis The invention of gunpowder flash ten years later allowed Jacob Riis (1849–1914) to rely for the most part on the element of surprise. Riis was a police reporter in New York City, where he learned at first hand about the crime-infested slums and their appalling living conditions. He kept up a steady campaign of illustrated newspaper exposés, books, and lectures that in some cases led to major revisions of the city's housing codes and labor laws. The unflinching realism of his photographs has lost none of its force. In his nightmarish scene, *Bandits'*

24-24 Jacob Riis. *Bandits' Roost.* c. 1888. Glass lantern slide. Museum of the City of New York

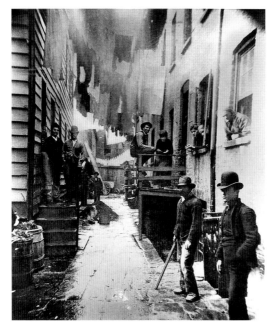

Roost (fig. 24-24), we sense a pervasive air of danger in the eerie light, for the notorious gangs of New York City's Lower East Side sought their victims by night, killing them without hesitation. The motionless figures seem to look us over with the practiced casualness of hunters coldly sizing up potential prey.

MOTION PHOTOGRAPHY

An entirely new direction was charted by the Englishman Eadweard Muybridge (1830–1904), the father of motion photography who spent his entire career in America. He wedded two different technologies, devising a set of cameras capable of photographing action at successive points. Photography had grown from such marriages; another instance had occurred earlier when Nadar used a hot-air balloon to take aerial shots of Paris.

After some trial efforts, Muybridge managed in 1877 to produce a set of pictures of a trotting horse that forever changed artistic depictions of the horse in movement. Of the 100,000 photographs he devoted to the study of animal and human locomotion, the most remarkable were those taken from several vantage points at once (fig. 24-25). The idea was surely in the air, for the art of the period occasionally shows similar experiments, but Muybridge's photographs must nevertheless have come as a revelation to artists. The simultaneous views present an entirely new treatment of motion across time and space that challenges the imagination. Like a complex visual puzzle, they can be combined in any number of ways that are endlessly fascinating, and Muybridge did indeed edit, crop, and arrange his prints to create what he considered works of art, not just scientific documents. His photographs convey a peculiarly modern sense of dynamics, reflecting the new tempo of life in the machine age. However, because the gap was then so great between scientific fact on the one hand and visual perception and artistic representation on the other, their far-reaching aesthetic implications were to be realized only later.

24-25 Eadweard Muybridge. *Sitting Down on the Ground,* from *Animal Locomotion,* Philadelphia, 1887. Collotype print. 19.5 x 37.8 cm. George Eastman House, Rochester, New York

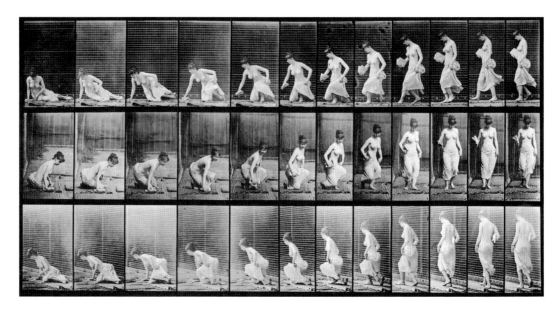

Toward Abstraction: The Modernist Revolution, 1904–1914

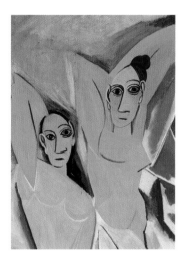

T HE WESTERN WORLD WAS A RADICALLY DIFFERENT PLACE at the opening of the twentieth century than it had been just 20 years before. Electricity, automobiles, airplanes, ocean liners, subways, moving pictures, and the proliferation of the telephone were just a few of the innovations that were announcing the modern era. Machines were everywhere, and they were not only making life easier but rapidly replacing human beings.

The social structure of this faster, more mechanized world was also dramatically changing. Cities were flooded with workers coming from towns, villages, and farms. By 1920, America, for the first time, had more people living in cities than in the country. American demographics were radically realigned as millions of immigrants left Eastern and Southern Europe for the United States from 1880 to 1920, and hundreds of thousands of African Americans migrated from the rural South to Northern cities in the opening decades of the century.

In both Europe and America, the conflict between oppressed labor and management grew increasingly tense and openly hostile, with unionists, socialists, and eventually communists vociferously demanding better rights, hours, wages, and working conditions for workers. The advent of corporations even changed the work environment for white-collar workers, who were now part of a system that was as rote, structured, and predictable as the assembly line would be for the blue-collar worker. Even the European aristocracy was not immune to the new world-structure, which prized the meritocracy of capitalism and gradually ignored the antiquated codes and privileges associated with nobility. Women's status began to change as well. In the closing decades of the old century, they gained a modicum of independence as they could now leave the home unaccompanied by a man, attend college, have their own

money, and enter the workforce, albeit in a positions in which they were generally subservient to men, such as nurses, teachers, secretaries, clerks, and sweatshop laborers. Women, many moving to the city, now lived alone, outside the family, and circulated freely in public places. In 1920, American men granted universal suffrage to women.

The old world order was further shattered by new perceptions of space, time, and the mind. The staid Victorian West was still reeling from Darwin's claim of some 40 years earlier that humans and apes shared common ancestors, when Albert Einstein published his theory on relativity in 1905, describing the existence of an unseen fourth dimension—time. In 1900, Sigmund Freud's *Interpretations of Dreams* appeared. Freud described a repressed world deep in the unconscious that was directly linked to elemental human needs and urges. Nearly forgotten today is the Parisian philosopher Henri Bergson, who was so popular and influential that his Sorbonne University lectures were attended by society ladies and Cubist painters. Bergson argued that we experience life not as a series of continuous rational moments, but as intuited random memories and perceptions. In his view, the world was complex and fractured, or as expressed by the great American philosopher William James, a "booming buzzing confusion." Many artists responded to this new world order by embracing the new. Their art captured the mechanization,

THEOSOPHY (from the Greek *theos,* "divine," and *sophos,* "wisdom") is any religious and philosophical system that seeks knowledge of God and of the universe in relation to God.

speed, and chaotic movement of modernity. In their paintings, they pulled the image even closer to the surface than had the Impressionists and Post-Impressionists, allowing it to speak with an even greater immediacy and urgency.

But not everyone embraced modernity. Many rejected the materialism and blind worship of science and technology that characterized the opening decades of the twentieth century. Instead they sought the spiritual in contemporary life, looking for a higher reality that lay beneath the surface of things, a reality linked to universal forces. Especially influential were the writings of recently deceased German philosopher Friedrich Nietzsche (1844–1900), who viewed reality as an invisible force lying beneath the physical appearance of the visual world. But perhaps the most popular lay spiritual program at the time was THEOSOPHY as promulgated by Madame (Helena Petrovna) Blavatsky (1831–1891), a Russian-born medium, mystic, and occultist who founded the Theosophical Society in New York in 1875. Its worldwide program was largely based on Eastern religions, especially Zen Buddhism, and offered believers a way of looking at life and the world as a mystical interpenetration of all things. For many artists attempting to visualize the spiritual, the essence of which is abstract, the new stripped down vocabulary of art was the perfect vehicle for capturing the spiritual essence of life itself.

Expressionism and the Painterly Tradition

THE FRENCH FAUVES ("WILD BEASTS")

The twentieth century may be said to have begun five years late so far as painting is concerned. Between 1901 and 1906, several comprehensive exhibitions of the work of Van Gogh, Gauguin, and Cézanne were held in Paris and Germany. For the first time the achievements of these masters became available to a broad public. The young French painters who had grown up in the "decadent," morbid mood of the 1890s were deeply impressed by what they saw. Several of them formulated a radical style, full of the

intense color of Van Gogh and the bold patterns of Gauguin, which they manipulated freely, redefining the function of color and the structure of pictorial space. Their work was so revolutionary that when it first appeared in 1905 at an annual exhibition of independent artists called the Autumn Salon, it so shocked the conservative critic Louis Vauxcelles that he dubbed these artists Fauves (wild beasts), a label they wore with pride. What brought this group together was a shared sense of liberation and experimentation largely focusing on color. As a movement, Fauvism lasted only a few years. Most of its members—with the exception of Henri Matisse—were unable to sustain their inspiration or to adapt successfully to the challenges posed by Cubism, which emerged toward 1909. Fauvism was nevertheless a decisive breakthrough: It constituted the first modern movement of the twentieth century in both style and attitude, one to which every important painter before World War I admitted a debt.

Henri Matisse The leader of the Fauves was Henri Matisse (1869–1954), the oldest of the founders of twentieth-century painting. *The Joy of Life* (fig. 25-1), probably the most important picture of his long career, sums up the spirit of Fauvism better than any other single work. It obviously derives its flat planes of color, the heavy, undulating outlines, and the "primitive" flavor of its forms from Gauguin (see fig. 24-7). Even its subject suggests the vision of humanity in a state of nature that Gauguin had sought in Tahiti. But we soon realize that Matisse's figures are not "Noble Savages" under the spell of a native god. The subject is a pagan scene in the classical sense: a bacchanal like Titian's (compare fig. 13-20). The poses of the figures have a classical origin for the most part, and behind the apparently careless draftsmanship lies a profound knowledge of the human body, reflecting Matisse's academic training. What makes the picture so revolutionary is its radical simplicity, its "genius of omission." Everything that possibly can be has been left out or stated only indirectly. The scene nevertheless retains the essentials of three-dimensional form and spatial depth. What holds the painting together is its firm underlying structure, which reflects Matisse's admiration for Cézanne.

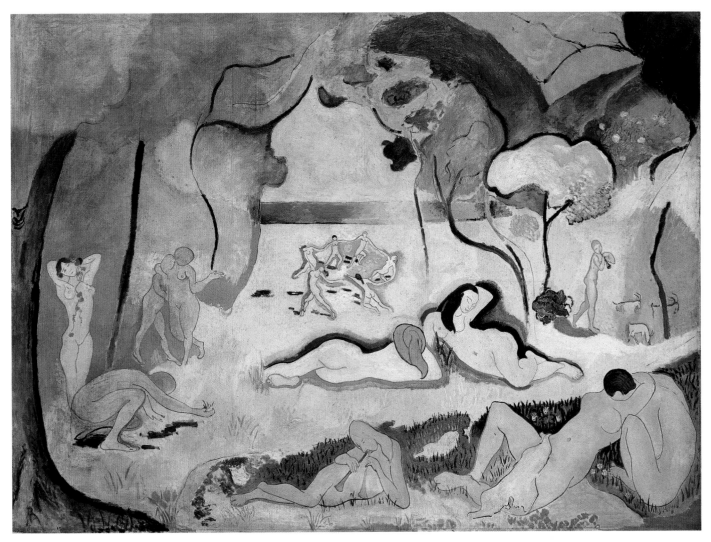

25-1 Henri Matisse. *The Joy of Life*. 1905–6. Oil on canvas, 5'8" × 7'9¾" (1.74 × 2.38 m). The Barnes Foundation, Merion, Pennsylvania

Painting, Matisse seems to say, is not a representation of observed reality but the rhythmic arrangement of line and color on a flat plane. He explores how far the image of nature can be pared down without destroying its basic properties and thus reducing it to mere surface ornament. "What I am after, above all," Matisse once explained, "is expression. . . . [But] . . . expression does not consist of the passion mirrored upon a human face. . . . The whole arrangement of my picture is expressive. The placement of figures or objects, the empty spaces around them, the proportions, everything plays a part." What, then, does *The Joy of Life* express? Exactly what its title says. Whatever his debt to Gauguin, Matisse was never stirred by the same discontent with the decadence of Western civilization. He instead shared the untroubled outlook of the Nabis, with whom he had previously associated, and the canvas owes its decorative quality to their work (compare fig. 24-9). Matisse was concerned above all with the act of painting. This to him was an experience so joyous that he wanted to transmit it to the beholder.

Matisse's "genius of omission" is seen again in *The Red Studio* (fig. 25-2), a buoyant self-portrait as represented by his sensuous-looking studio. By making red so prominent, he makes color an independent structural element. The result is to emphasize the radical new balance he struck between the two-dimensional and three-dimensional aspects of painting. Matisse uses the same plane of red color to define the tablecloth, wall, and floor. If that is not enough to flatten the image, most of the lines are not painted on.

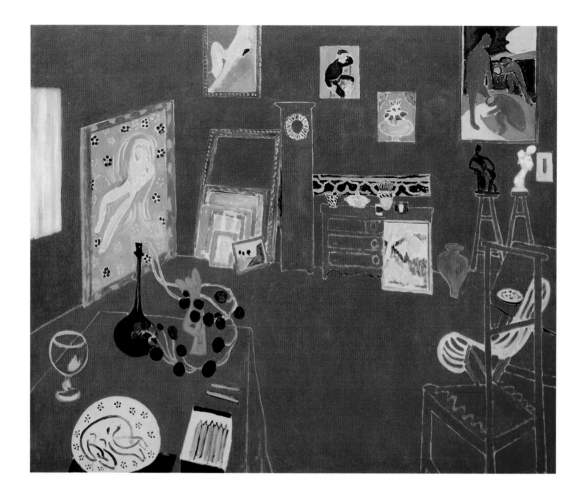

25-2 Henri Matisse. *The Red Studio.* 1911. Oil on canvas, 5′11¼″ × 7′2¼″ (1.81 × 2.19 m). The Museum of Modern Art, New York, Mrs. Simon Guggenheim Fund.

Instead, Matisse has allowed the flat surface of the canvas to show through his "sheet" of red. This preoccupation with denying space by acknowledging the canvas is in part Matisse's response to the Cubism of Picasso and Braque, which had emerged three years earlier (see pages 540-43). As we shall see, the wonderful rhythm of horizontal and vertical lines also comes from the challenge of Cubism, but used in a brilliantly new way by Matisse. Equally bold is Matisse's use of pattern, seemingly casual yet perfectly calculated. He harmonizes the relation of each element with the rest of the picture by repeating a few basic shapes, hues, and decorative motifs around the edges of the canvas. Cézanne had pioneered this integration of surface ornament into the design of a picture (see fig. 24-1), but here Matisse makes it a mainstay of his composition.

It may come as a surprise to learn that Matisse made sculpture, since it does not involve color. But we shall see that many great painters in the twentieth century were also outstanding sculptors as well as photographers, and many great sculptors painted

and used the camera. In the modern era, all of these media go very much hand in hand. For Matisse, sculpture was a natural complement to his pictures, for it allowed him to investigate problems of form that provided important lessons for his canvases. We can see this in *Reclining Nude I* (fig. 25-3) (which has the uneven light-reflecting surface of Rodin's sculptures). Here he explored what he called **arabesque**, the rhythmic contours of his nude, which are similar to the outlines of his figures in his earlier *The Joy of Life*. What we notice most about *Reclining Nude I*, however, are the distortions of the figure, which is twisted and turned to create an abstract undulation of simplified organic forms.

Matisse's inspiration for this liberal manipulation of the figure probably came in part from his discovery of African and Oceanic sculpture displayed in Paris's Trocadero Museum, which was dedicated to ethnographic art. Gauguin and the Nabis (see chapter 24) had laid the groundwork for an interest in the so-called primitive, simpler cultures. The Fauves's discovery of the

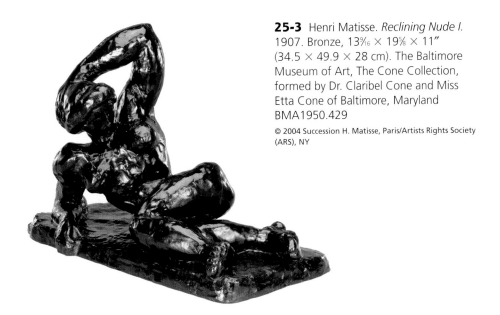

25-3 Henri Matisse. *Reclining Nude I.* 1907. Bronze, 13⁹⁄₁₆ × 19⅝ × 11" (34.5 × 49.9 × 28 cm). The Baltimore Museum of Art, The Cone Collection, formed by Dr. Claribel Cone and Miss Etta Cone of Baltimore, Maryland BMA1950.429

Trocadero's treasures reinforced this incipient interest in societies still steeped in nature and therefore closer to God and cosmic forces. The ritualistic abstract work of these simple cultures embodied a spirituality that would serve as a model in their own search for meaning in an increasingly materialistic, technological world.

GERMAN EXPRESSIONISM

Fauvism had a decisive influence on the Expressionist movement, which arose at the same time in Germany. Because Expressionism had deep historical roots in German art it was especially appealing to the Northern mind, and it had a far greater impact and lasted far longer there than in France. For these reasons, Expressionism is generally applied to German art alone, which minimizes its close ties to Fauvism and the numerous similarities between them. But German Expressionism is different. It is characterized by greater emotional extremes, especially by disturbing states of mind, and by a more spontaneous approach, as opposed to the rational and structured approach of the French. Expressionism in Germany sought to reunite people with the elemental force of nature, and consequently it has a spirituality and primitivism generally not found in France, or is far more intense. Class conflict and urban dislocation were much stronger factors in the recently united Germany—Germany had been an association of self-governing states and city-states until 1871—and German Expressionism reflects this troubling psychology of alienation.

Kirchner and Die Brücke Because Germany was united so late into the nineteenth century, it did not have a national artistic center, as Paris and London were for France and England. Expressionism in Germany began in 1905 in Dresden, where a group of radical artists led by Ernst Ludwig Kirchner (1880–1938) formed Die Brücke, meaning The Bridge, a title wishfully claiming their art would be a bridge to the future. Their first exhibition in 1906 was in an old chandelier factory, and it went largely unnoticed and unattended. Through its bohemian lifestyle, Die Brücke cultivated the sense of imminent disaster that we will see is one of the hallmarks of the modern avant-garde. Like so many young radical artists, The Bridge was jolted by the revolutionary work of Van Gogh and Gauguin when it was finally shown in Germany. But equally important for them was Munch, who, since 1892, had been living off and on in Berlin, where he had a tremendous presence. But it was an exhibition of Matisse that proved decisive.

Matisse's free use of the intense color and surface tension of his Fauve period can be seen in Kirchner's *Street, Dresden* (fig. 25-4)

Gogh's work in 1906, he began a series of what he called "black portraits," expressionistic pictures of troubled sitters that earned him the reputation as the "Freud of painting." People said of him, "He paints the dirt of one's soul." But the sitters all project the same neuroses, which has led many historians to say the pictures reflect Kokoschka's inner soul, not the sitters'. What the portraits reflect is the neurosis of the time, the anxiety that existed under what passed for normalcy in Vienna and the modern world.

The Bride of the Wind (fig. 25-6), painted in 1914, captures a dual quality of psychological turmoil and inner peace. The painting is a self-portrait with his lover, Alma Mahler, the widow of the great composer Gustave Mahler, and it celebrates the power of their bond. Based on Romantic paintings of Dante's tragic lovers Paolo and Francesca, it was originally conceived as *Tristan and Isolde*, after Wagner's opera of an equally doomed couple. Its final title, however, came from the poet Georg Trakl. In a letter to Alma Mahler, Kokoschka described the emotion

he tried to put into this image: "Despite all the turmoil in the world, to know that one person can put eternal trust in another, that two people can be committed to themselves and other people by an act of faith." The painting captures the solace and strength of the couple's eternal love, while simultaneously presenting the psychological and physical "turmoil of the world."

The Linear Tradition: Cubism and Its Impact

PICASSO'S *LES DEMOISELLES D'AVIGNON*

The birth of modern art is inconceivable without Pablo Picasso, a Spaniard who spent his long career in Paris. Picasso would do for line what Matisse did for color, liberating it from representing the real world so that it would have a pictorial life all its own. Picasso and Matisse are two of the major pillars of modern art, Duchamp being the third. For almost 50 years they both painted in Paris,

25-6 Oskar Kokoschka. *The Bride of the Wind.* 1914. Oil on canvas, 5'11¼" × 7'2⅝" (1.81 × 2.20m). Kunstmuseum, Öffentliche Kunstsammlung Basel, Switzerland

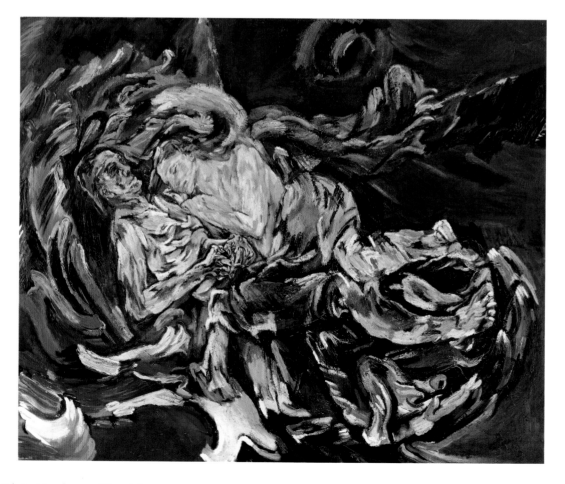

very much aware of each other's work, competing as friendly rivals, each watching the next aesthetic move of the other.

In 1907 Picasso produced his own counterpart to Matisse's *The Joy of Life*, a monumental canvas called *Les Demoiselles d'Avignon (The Young Ladies of Avignon)* (fig. 25-7). It was so challenging that it outraged even Matisse, but once understood provided inspiration for untold artists. The painting's title refers to the red-light district in Barcelona near where Picasso grew up. Early studies for the picture show a sailor in a brothel, seated before a table with a plate of fruit, being tempted by prostitutes. Thematically the picture began as a typical Symbolist painting about male lust and castrating women, which is a reminder of Picasso's roots as a fin-de siècle artist. The sailor is

now gone, but the theme is the same, for we, the viewers, are seated with the sailor at the table with its symbol of lust, the fruit. Coming through the curtains and staring at us are five of the most savage confrontational nudes that anyone may have painted up to that time!

Instead of anecdotally telling his tale of female domination, Picasso turned to the abstract qualities of the medium to do his talking. All the formal qualities are threatening and violent. The space is incoherent and jarring, virtually unreadable, even when compared to Matisse's radical *Joy of Life* (fig. 25-1) of two years earlier. Not just the women, but the entire image is composed of what looks like enormous shards of glass that overlap one another in no comprehensible way. Instead of receding, they simply hover

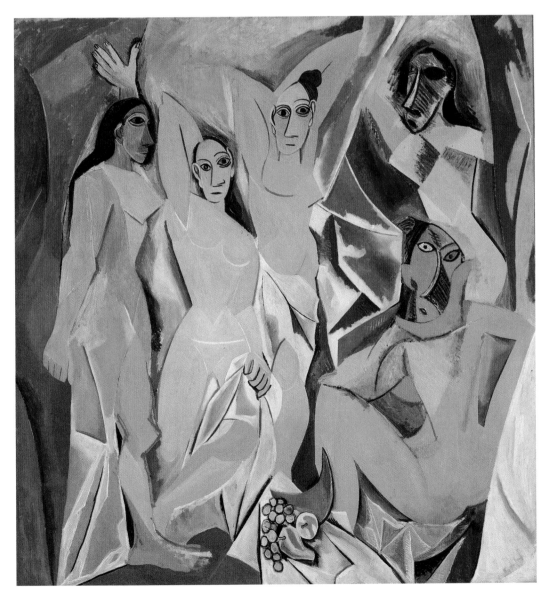

25-7 Pablo Picasso. *Les Demoiselles d'Avignon.* 1907. Oil on canvas, 8′ × 7′8″ (2.44 × 2.34 m). The Museum of Modern Art, New York, Acquired through the Lillie P. Bliss Bequest.

at the surface of the painting. Sometimes the facets are shaded, as is the case with the diamond-shaped breast of the harlot on the right parting the curtain, but Picasso has reversed the shading, in effect, detaching the breast from the body. Even more incomprehensible is the seated figure below her, who has her back to us yet simultaneously faces us!

The table with fruit is tilted at such a raking angle it would shock even Cézanne. The menacing pointed melon sets the shrill tone for the entire picture and through its phallic quality announces the sexual theme, as though it were not obvious.

The disjointed, jarring quality of Picasso's style in this painting has to be added to our list of disturbing items. The three nudes to the left with their almond-shaped eyes and severe facial features were inspired by crude ancient Iberian sculptures, which Picasso himself collected. But the frightening ladies of the night on the right are entirely different. At this point in the painting, or so the story goes, Picasso's Fauve friends took him to the Trocadero museum of ethnographic art, and there he saw African masks, inspiring the ski-jump noses, facial scarifications, and lopsided eyes. The story seems logical enough, since direct sources can be found in African sculpture and the abstraction and "barbarism" of the masks had to have appealed to the artist's sensibility. But Picasso adamantly denied the influence of *art negre,* as the art was then called. And sure enough, in the early 1990s, it was discovered that his source was doodles in his sketchbooks. The striations, for example, were notational marks for shadow. The head of the crouching demoiselle was actually the result of the witty transformation of a female torso into a face (visual double-entendres are a mainstay of Picasso's art). Picasso would soon collect African art, but considering his friendship with the Fauves, it is hard to imagine that he not heard about the Trocadero Museum before and visited. Regardless of the source, the moral of this story is the artist's willingness to look anywhere for inspiration, from the lowly source of his own caricaturing, to African masks that were then considered artifacts and not art, and to the highest achievements of classical Greek sculpture, reflected here by the tradition of the monumental nude. But most important about *Les Demoiselles* is the new freedom it announces for painting, for now line, plane, color, mass, and void have all been released from their representational roles and freed to take on a life all their own. This freedom lays the groundwork for Analytic Cubism.

ANALYTIC CUBISM: PICASSO AND BRAQUE

That *Les Demoiselles* owes anything to Cézanne may at first seem incredible. However, Picasso had studied Cézanne's late work (such as fig. 24-2) with great care, and found in Cézanne's abstract treatment of volume and space the structural units from which to derive the faceted shapes of what came to be called Analytic (or Facet) Cubism. But Picasso did not arrive at Analytic Cubism on his own, and even seemed creatively stalled after making *Les Demoiselles.* The fiery Spaniard needed a methodical French artist steeped in a more decorative rational tradition to help him get beyond this point. That artist was Georges Braque (1882–1963). From 1908 to 1910 the two fed off of one another, their styles developing in what in hindsight seems like steamroller inevitability—from a representational picture of fractured forms and space (fig. 25-07) to a shimmering evanescent mirage of abstract lines and brushwork (fig. 25-08) so obscure its starting point in the real world would remain unknown if the artists had not included hidden clues. Braque and Picasso were so intertwined that their styles began to merge by 1910.

Braque's *The Portuguese* (fig. 25-8) of 1911 is a classic example of the Analytic Cubism that emerged the year before. Gone is the emotional terror and chaos of *Les Demoiselles.* Now a grid of lines follows the rectangular shape of the canvas and moves parallel to the picture plane. Diagonal lines are arranged in an orderly geometric pattern, as are the circular curves, all recalling Cézanne's vision of a structured world made up of circles, cones, and cubes. While abstract, however, these curves are also signs. The circle at the lower center is the sound hole of a guitar and the horizontal lines the strings. The letters D BAL, CO, and numbers 10,40 are fragments from a poster, and probably say Grand Bal and the price of admission. The lines and shadows suggest arms, fingers, and the frontal pose of a figure tapering at the head. What Braque has painted is a Portuguese guitar player in a Marseilles bar, on the wall of which is a poster,

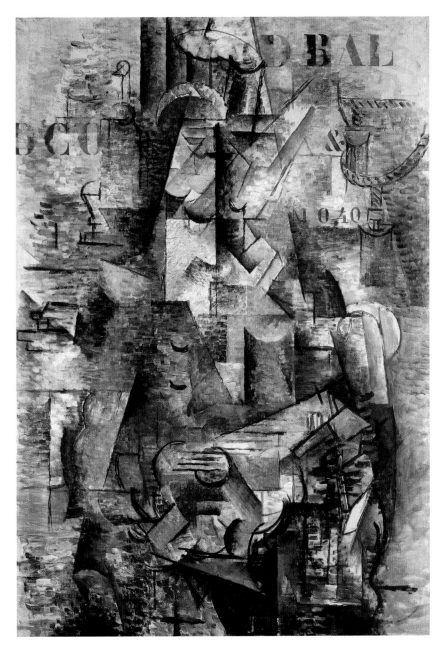

25-8 Georges Braque. *The Portuguese.* 1911. Oil on canvas, 45⅞ × 32⅛″. Kunstmuseum, Basel, Gift of Raoul LaRoche 1952. Photograph by Martin Buhler

and beyond, in the upper right, the harbor. But these objects are no more real or illusionistic than the atmosphere and light that floods the picture, falling on individual facets. The only reality is the pictorial world of line and paint. At a loss to describe Braque's work in a 1909 exhibition, Louis Vauxcelles, who had named Fauvism, labeled the paintings Cubism, because Matisse described them to him as being made of little cubes.

SYNTHETIC CUBISM

To focus on structure and line, Picasso and Braque removed the problem of color in their Analytic Cubism, painting monochrome images instead. But this changed in 1912 when they began working in collage, which is the pasting of flat objects, generally paper, on the canvas. The earliest known example is by Picasso in May 1912, when he glued on the surface of his painting a sheet of imitation chair canning (a photograph-like image of real chair canning that would be mounted on wood as an inexpensive way to repair broken chair caning). This device allowed him to pun on the real and the illusionistic in art, since the fake chair-caning was indeed real. But Picasso and Braque realized immediately the broader implication of

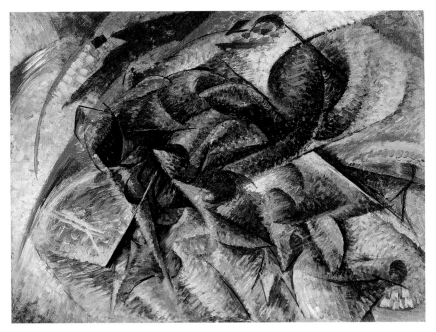

25-11 Umberto Boccioni. *Dynamism of a Cyclist.* 1913. Oil on canvas, 27⅝ × 37⅜″ (70 × 95 cm). Collection Gianni Mattioli, Milan, (on long-term loan to the Peggy Guggenheim Collection, Venice) 1967

© The Artist Rights Society (ARS), New York

gave him the tools to make the figure as mechanical as the machines that the Futurists were praising, if not always depicting.

Boccioni's goal of unifying a moving solid figure with surrounding environment can be clearly seen in his sculpture, such as his 1913 *Unique Forms of Continuity in Space* (fig. 25-12). His running figure is breathtaking in its complexity, as Boccioni uses what he called "forcelines" to create an "arabesque of directional curves." Boccioni dissolves his figure in air. We see not the figure, but the air it displaces, which the figure wears as if it were a garment.

Unfortunately, Boccioni's career, like that of many of the Futurists, was short. Futurism died out in World War I, when its leading artists, particularly Boccioni, were killed by the same vehicles of destruction they had glorified only a few years earlier in their revolutionary manifestos. But their legacy was soon taken up in France, the United States, and, above all, Russia.

Pointillist background of most of the Futurists, further adds to the dynamic motion. But the bike in 1913 was hardly an icon of modernity, which leaves the subject as the energy of moving through space and the figure's becoming an extension of space, to the point of being virtually indistinguishable from it. Not only did Cubism allow Boccioni to create this movement, but its geometry

RUSSIAN CUBO-FUTURISM

Russia was the least industrialized major country in Europe, yet it became a major center for avant-garde art in the 1910s. It was populated by oppressed serfs, ruled by an indifferent Czar, and dominated by a zealously mystical Catholic Church. Despite a dramatic rush to modernize the country, in some respects, Russia was still in the Middle Ages. In such a culture, still dominated by folk art and Christian icons (see, for example, fig. 8.13), how did avant-garde artists emerge? Part of the reason for the appearance of radical art may have been the frantic need for change itself. When it occurred in 1917 with the October Revolution, change was more radical than it had been in America and France. The Russian concept of transformation was so revolutionary that it embraced equality for women, who played a major role in developing radical art. In effect, the need for change was so desperate it called for visionary responses, which is what it got in every respect of the word.

The Russian avant-garde had close ties with its counterparts throughout Europe, with many of the artists, such as Kandinsky, Kazimir Malevich, Lyubov Popova, and Natalia Gontcharova, traveling to Paris and Munich. Two of the greatest collectors of

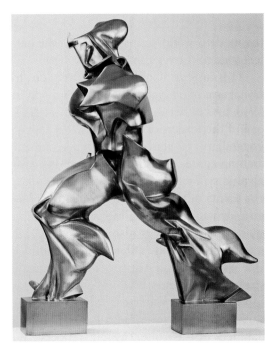

25-12 Umberto Boccioni. *Unique Forms of Continuity in Space.* 1913 (cast 1931). Bronze, 43⅞ × 34⅞ × 15¾″ (111.4 × 88.6 × 40 cm). The Museum of Modern Art, New York, Acquired through the Lillie P. Bliss Bequest

© 2004 Artists Rights Society (ARS), New York

contemporary art, Sergey Shchukin and Ivan Morozov, were in Moscow. By 1910 an avant-garde artists association, the Jack of Diamonds, was formed, and two years later it was followed by a splinter group, The Donkey's Tail. Both were modeled on the Futurists and held landmark exhibitions in Moscow. Like the Futurists, they embraced the modern, including the machine and industry, critical to bringing Russia into the twentieth century. The key figure in the formation of both groups was Gontcharova, and that a woman was permitted such a leadership role tells us how startlingly revolutionary the Russian avant-garde was.

One of the finest painters in this circle was Popova, who studied in Paris in 1912 and Italy in 1914. *The Traveler* (fig. 25-13) of 1915 reflects her absorption of Cubism and Futurism, and the two were merged to create a style that is distinctively Russian. The treatment of forms remains essentially Cubist, but the painting shares the Futurist obsession with representing dynamic motion in time and space. The jumble of image fragments creates the impression of objects seen in rapid succession, with the tumultuous interaction of forms with their environment threatening to extend the painting into the surrounding space.

MALEVICH AND SUPREMATISM

By 1913 many of the Russian artists were calling themselves Cubo-Futurists, a term coined by Kazimir Malevich (1878–1935) that reflects the origins of the style. Malevich had shown with both the Jack of Diamonds in 1910 and The Donkey's Tail in 1912. In 1913 he designed Cubo-Futurist costumes and sets for what was hyped as the "First Futurist Opera" and titled *Victory over the Sun*. Presented in St. Petersburg, this radical "opera" embraced the principle of *zaum*, a term invented by Russian poets. In essence, *zaum* was a language based on invented words and syntax whose meaning was implicit in the basic sounds and patterns of speech. The intent was to return to the nonrational and primitive base of language, which unencumbered by conventional meaning, expressed the essence of human experience. In *Victory over the Sun*, people read, sometimes simultaneously, from nonnarrative texts, often consisting of non-

words, while accompanied by the clatter of an out-of-tune piano. Malevich's costumes were basically geometric. For example, a stack of triangles ran up and down the pants legs of one figure, while the backdrop for one scene was a square divided into two triangles, one white, the other black. Words, music, and art were all abstract, with the idea that communication was "transreal," that is, it would be extracted by simply feeling its essence.

However, it took Malevich two years to realize the implications of *zaum* for his art. In 1915, after working in a Cubo-Futurist style similar to Popova's, Malevich presented 39 nonobjective geometric paintings in a St. Petersburg's exhibition titled *0–10: The Last Futurist Exhibition*. The highlight of the show was *Black Square*, a black quadrilateral on a white ground that was hung, like Russian icons, high across the corner of a room, straddling two walls. In his 1920s Suprematist treatise, *The Nonobjective World*, he explained this and his other Suprematist paintings:

> "But a blissful sense of liberating nonobjectivity drew me forth into the "desert' [of the black square], where nothing is real except feeling. . . . This was no 'empty square' which I had exhibited but rather the feeling of nonobjectivity. . . . Suprematism is the rediscovery of pure art,

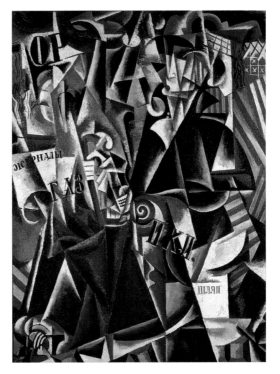

25-13 Lyubov Popova. *The Traveler*. 1915. Oil on canvas, 56 × 41½″ (142.2 × 105.4 cm). Norton Simon Art Foundation, Pasadena, California

that, in the course of time, had become obscured by the accumulation of 'things'.... The Suprematist square and the forms proceeding out of it can be likened to the primitive mask (symbols) of aboriginal man which represented in their combination, *not ornament*, but a *feeling of rhythm*."

Suprematism is the supremacy of feeling. But this feeling is not personal feeling, or emotion, but one of revelation, in which the abstract essence of the world is felt or intuited and translated into painting. Like his fellow Russian, Kandinsky, he was a mystic, searching for cosmic unity, even a utopian world, as would the Russian Revolution. We sense in this painting the legacy of simple, otherworldly Russian icons and the mysticism of peasant folk art.

Malevich did not just paint the square. He worked with rectangles, circles, and crosses, sometimes in combination with one another and using different elementary colors—orange, green, black, and white. In his last phase in 1917–18, at which point he had exhausted and quit Suprematism, his work became increasingly mystical as he painted a white square on white (fig. 25-14). For Malevich white represented the "real concept of infinity," and with this renunciation of the material world, he entered into a truly mystical, ideal world. Seen in person, this painting is surprisingly persuasive; the shapes, created by two subtly different shades of white, each of which has the feeling of being hand-painted, have a visionary purity that makes other paintings seem needlessly complex.

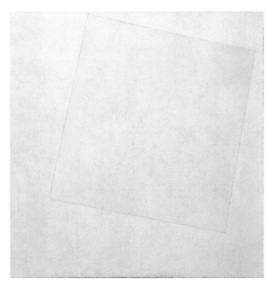

25-14 Kazimir Malevich. *Suprematist Composition: White on White.* Oil on canvas, 31¼ × 31¼" (79.4 × 79.4 cm). The Museum of Modern Art, New York

CUBISM AND FANTASY: CHAGALL AND DE CHIRICO

With the twentieth century we see a dramatic increase in fantasy in art, and Cubism was a wonderful tool for creating the imaginary world much fantasy required. "Fantasy," as used in Freud's psychoanalytic theory in the early twentieth century, was thought of as something mysterious and profound, not lighthearted whimsy. One thing these painters have in common is the belief that imagination, "the inner eye," is more important than the outside world. The major cause of artists' interest in fantasy was surely the emergence of modern day psychology. Freud's writings first appeared in Vienna in the 1890s, and they would come to dominate Western thought in the opening decades of the century. In art and literature, Freud's radically new ideas about dreams and unconscious desires gave the rise to Surrealism in the 1920s. Looking back further, the Romantic cult of emotion played a role in prompting the artist to seek out subjective experience and to accept its validity. This process took considerable time, however. We saw the trend beginning in the art of Goya and Fuseli (see figs. 22-2 and 22-15), but by 1900 it had become a major one, thanks to Symbolism on the one hand and the naïve vision of artists such as Henri Rousseau on the other.

Marc Chagall Despite the tremendous pull to become part of the modern world, many Russian artists sought to reveal the mystical forces that lay beneath the chaos of the twentieth century. We've seen this in the works of Kandinsky and Malevich, and it was true too of Marc Chagall (1887–1985), a Russian Jew from Vitebsk. Chagall was a memory painter whose images recalled the simple peasant routine of his native village. In 1910, after transferring his teaching post at the art school in Vitebsk to Malevich, he moved to Paris, where he immediately embraced Cubism, as can be seen in *I and the Village* (fig. 25-15) of 1911. But this dreamlike image, rendered in the deep-saturated colors of a stained-glass window and using the simple even naïve forms of Russian folk art, is clearly about the most elemental issues of life. Man and animal are equated in their almost mirrorlike symmetry, and the circular

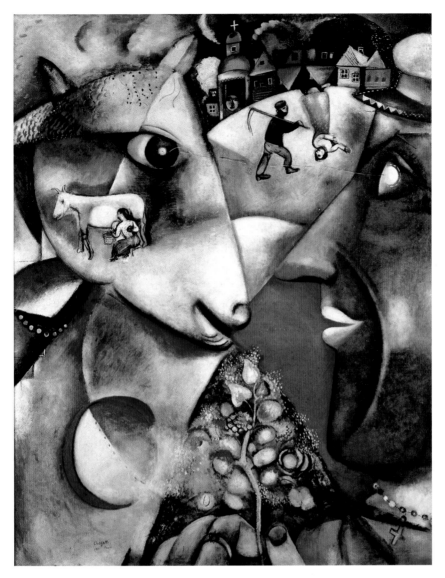

25-15 Marc Chagall. *I and the Village*. 1911. Oil on canvas, 6′3⁵⁄₈″ × 4′11½″ (1.92 × 1.51 m). The Museum of Modern Art, New York, Mrs. Simon Guggenheim Fund

composition presents the cycle of life, with birth as the blooming bush, and death as the farmer who resembles a grim reaper. Chagall ardently disavowed any links to storytelling or fairy tales in his paintings. Instead, Chagall's dream world is a Cubist kaleidoscope of objects and incidents that he considered of elemental significance, capturing something essential about life itself.

Giorgio de Chirico The paintings of the fantasy painter Giorgio de Chirico (1888–1978) do not embrace Cubism or reflect any of its principles of pictorial space and abstraction. Yet, they have a linear, blocklike quality that vaguely echoes Cubism. De Chirico, an

Italian, had studied in Munich from 1905 to 1909, where he was heavily influenced by German Romantic and Symbolist artists and the philosophy of the German Friedrich Nietzsche, who described life as a "foreboding that underneath this reality in which we live and have our being, another and altogether different reality lies concealed." Like Kandinsky, de Chirico was steeped in the theosophy swirling through Munich and preoccupying the cultural community.

After arriving in Paris in 1911, de Chirico abandoned his painterly style and started making crisply drawn scenes with multiple vanishing points set in an empty Italian town square that resemble a stage set. A classic

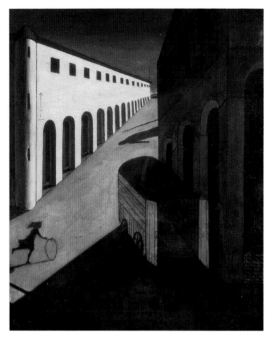

subverted by the frightening eeriness of the scene: the ominous shadows, the inexplicable intense light, the skewered perspective, and the studied emptiness. Railroad tracks, darkened windows and arches, the empty moving van, and the girl with the hoop seem like symbols, but we are given no clue as to their meaning, and de Chirico insisted none existed. On one level, this scene can be perceived as normal. On another, time has stopped and we are trapped in a nightmare where the mind has taken over, casting into doubt the validity of the appearance of things. De Chirico described his pictures as metaphysical painting, and despite his ultraconservative realist style, his poetic reveries, along with those of Rousseau, would serve as a springboard for representational Surrealism in the following decade.

example is *Mystery and Melancholy of a Street* (fig. 25-16) of 1914, made in Ferrara after he returned to Italy. The reliance on diagonal line and disjointed space has the vaguest echoes of Cubism. Unlike his Futurist compatriots, de Chirico idolized rather than rejected the old. But the austere authority of the classical past is

Marcel Duchamp and the Birth of Conceptual Art

Along with Picasso and Matisse, Marcel Duchamp (1887–1968) is the third great pillar of modern art. His monumental contribution is conceptual art, a term that is not applied to art until the 1960s, but nonetheless accurately describes Duchamp's emphasis on the ideas associated with a work of art as being as if not more important than its visual qualities. While Matisse and Picasso were working within the restrictions of painting and sculpture and giving color, space, and form new meaning, Duchamp completely stepped outside of these boundaries and philosophically turned art upside down and inside out to discover what was truly the essence of art, ultimately proclaiming *anything* was art that was declared art. Something not even visible—idea—could be art.

Working in Paris in the opening decade of the century, Duchamp quickly digested Impressionism and Post-Impressionism, and then toward 1911 took on Cubism, as seen in his 1912, *The Bride* (fig. 25-17). At this point, however, Duchamp was rejecting several basic components of the style. The most obvious is flatness, which was giving way to more readable space and forms (even if we are not sure what they are). But the picture is shocking in its irreverent attitude toward the female figure. This strange accumulation of tubes, funnels, and gears that makes this form part

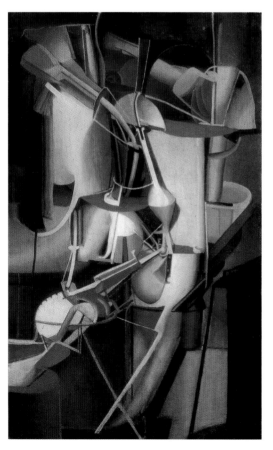

motor, part distilling apparatus is a bride, and in a radical move, Duchamp painted the title in the lower left corner of the painting, making his painting resemble an engineer's blueprint for a new machine. Duchamp has taken one of the most revered images in Western art, the female figure, and transformed it into a complicated piece of plumbing.

By 1912, transforming the figure into a mechanical figure was commonplace, part of the period's worship of the machine, which was a symbol of modernity and the ability of science to produce a better world. This reverence can be seen in *The Great Horse* (fig. 25-18), a 1914 sculpture made by Raymond Duchamp-Villon (1876–1918), Duchamp's older brother. Initial drawings show an actual horse, but the final product is a monument to horsepower, with the body a coiled spring, and the legs, piston rods, giving the animal a powerful torqued dynamism. Duchamp-Villon took his inspiration from Cubism, convincingly translating Picasso's and Braque's facets into three-dimensions to create Cubist sculpture. Tragically, the artist died in World War I.

Duchamp-Villon, like most contemporaries, disparaged his brother's sacrilegious bride. This was a sex machine, which became clear to any doubters when the figure reappeared in a 1915–23 work titled *The Bride Stripped Bare by Her Bachelors, Even (The Large Glass)*, an enormous diagram of oil paint, tinfoil, and wire on glass framed like a double hung window and seen from both sides. In effect, *The Bride* is a radical, clinical updating of the Symbolist preoccupation with sexuality as a elemental force.

The following year, Duchamp's humorous attack on artistic standards culminated in a revolution as monumental as Picasso's in *Les Demoiselles d'Avignon:* he placed a bicycle wheel upside down on a stool (fig. 25-19) and called it art. Duchamp later labeled his sculpture an "assisted readymade," because it consisted of two found readymade objects that he brought together. Here he wittily challenged the notion that art was about technical skill, and the fact that the stool recalls a pedestal and the wheel a head, underscores the extent to which this is a clever satire of artistic tradition. Duchamp also challenged the notion of how a work of art takes on meaning, since he gives no clues to the interpretation of his sculpture, leaving

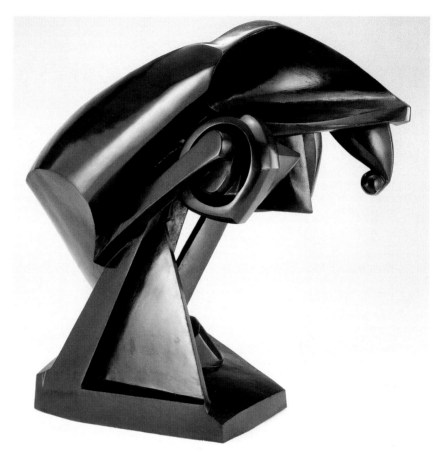

25-18 Raymond Duchamp-Villon. *The Great Horse.* 1914. Bronze, height 39¼" (99.7 cm). The Art Institute of Chicago, Gift of Miss Margaret Fisher in memory of her parents, Mr. and Mrs. Walter L. Fisher

© The Art Institute of Chicago/Robert Hashimoto/2004 Artists Rights Society (ARS), New York

it to the viewer to determine the work's content. Art is no longer about what is seen, and Duchamp was adamant about his objects having no aesthetic value whatsoever. His sculpture was about the ideas. The gesture of combining a stool and wheel is more important that what they look like together. Duchamp's claims notwithstanding, his assisted readymade has a magical beauty and mystery, as though he wants to bring to our attention the haunting comeliness of common objects that generally goes unnoticed.

Modern Sculpture: Brancusi

With the exception of Picasso's constructions, which were few and not exhibited, no revolutionary sculpture was being produced—except by Constantin Brancusi (1876–1957). Brancusi's work is so minimal and stripped down to a bare-bones essence, it has come to represent modern sculpture

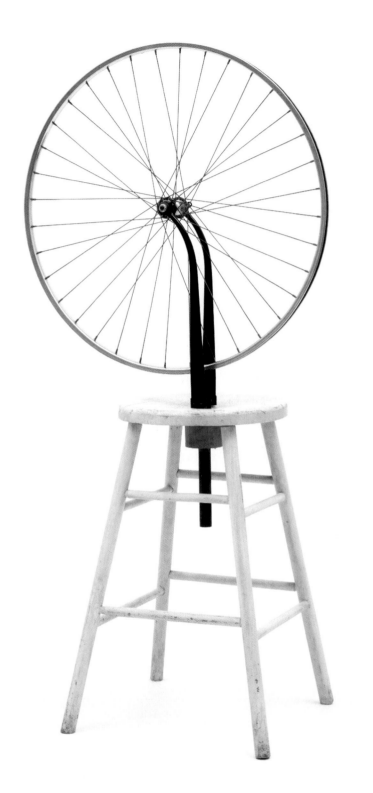

25-19 Marcel Duchamp. *Bicycle Wheel.* New York, 1951. (Third version, after lost original of 1913). Assemblage: metal wheel mounted on painted wood stool, 50½ × 25½ × 16⅝″ (128.3 × 64.8 × 42.2). The Museum of Modern Art, New York
© 2004 Artists Rights Society (ARS), New York/ADAGP, Paris/Succession Marcel Duchamp

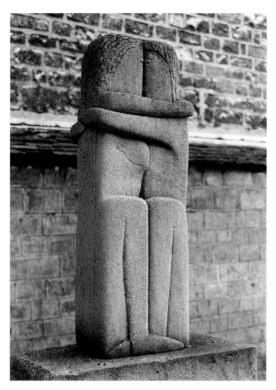

25-20 Constantin Brancusi. *The Kiss.* 1909. Stone, height 35¼″ (89.5 cm). Tomb of T. Rachevaskaia, Montparnasse Cemetery, Paris
© 2004 Artists Rights Society (ARS), New York/ADAGP, Paris

The Kiss (see fig. 25-20, a 1909 version), which thematically was derived from Rodin's famous statue of the same title but stylistically could not be more different.

The Kiss is a primordial block, with minimal markings either etched or in low relief to depict a nude man and woman eternally locked together as one. Instead of the uncontrollable organic passion of Rodin, Brancusi creates a frozen icon to external bonding and procreation. Its geometric severity reminds us of prehistoric monuments, such as Stonehenge or austere Egyptian sculpture. Brancusi was close friends with the Fauves, who had introduced him to so-called primitive art (see pages 534-35) as well as Cycladic art. The impact of this exposure was to give him license to abstract form to a minimum in order to capture the essence of the experience. And probably just as attractive was the commonly held belief going back to the philosopher Rousseau that primitive cultures are much closer to nature and elemental life forces, and thus are more spiritual. Looking primitive meant being spiritual.

Brancusi, throughout his long life, repeated a mere handful of elemental motifs over and over, refining them slightly, execut-

itself. Brancusi was the son of Romanian peasants, and after studying art in Bucharest, he went to Paris in 1904. In 1907 he became an assistant to Rodin, but left after a few months. Later that year, Brancusi executed

ing them in different media (stone, bronze, wood), and changing the bases, which were an integral part of the work meant in part to provide a buffer between the ideal world of the object and the reality of the room. By the early 1910s his work had become virtually abstract, as can be seen in *Bird in Space* (fig. 25-21), a motif that first appeared in the 1920s and was repeated through the 1940s. There is now no bird, just the essence of flight, as suggested by the elegantly stream-lined form weightlessly balanced on a short tapering column.

In this purity of form, Brancusi invested his work with mystical truths. From his Romanian peasant experience, he was steeped in folklore, superstition, and myth, and like so many intellectuals in the early twentieth century, he believed in theosophy and Eastern mysticism. Brancusi's first bird, *Maiastra* (made in 1910 and derived from Romanian folk tales), was a magical golden bird whose song held miraculous powers. This quest for the spiritual is a familiar tale of modernism. It drove the abstraction of Kandinsky and Malevich, Brancusi's contemporaries, and now we see it leading Brancusi to create original sculpture that breaks the powerful grip that Rodin held over the medium.

American Art

Modernism did not come to America until the second decade of the century. It first appeared in New York at a progressive art gallery owned by photographer Alfred Stieglitz. He opened his space in 1902 and called it the Little Galleries of the Photo Succession, although it was known as "291" after its Fifth Avenue address. Initially, Stieglitz showed just photography. But beginning in 1909, he started to feature such seminal modernists as Picasso, Matisse, Henri Rousseau, Rodin, and Brancusi as well as African and children's art. He also published a journal titled *Camera Work*, which started as an avant-garde photography magazine but gradually included the same radical painting, sculpture, and drawings shown in the gallery, as well as articles and criticism on philosophy and modern art, including passages from Kandinsky's *Concerning the Spiritual in Art*.

The momentous modernist event in New York was the 1913 International Exhibition

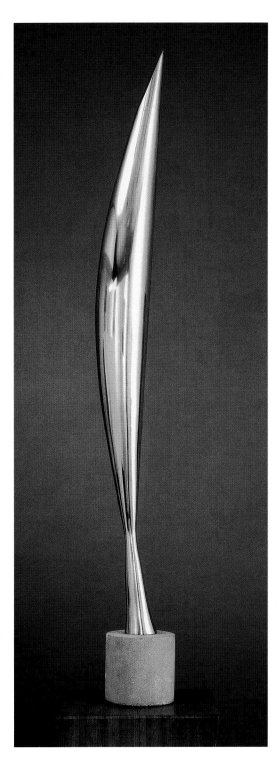

25-21 Constantin Brancusi. *Bird in Space.* 1928 (unique cast). Bronze, 54 × 8½ × 6½" (137.2 × 21.6 × 16.5 cm). The Museum of Modern Art, New York, Given anonymously (153–1934)

© 2004 Artists Rights Society (ARS), New York/ADAGP, Paris

of Modern Art, known as the Armory Show after the 26th Street armory where it was held. Over 400 European works, mostly French, were selected, beginning with Delacroix, and running through Courbet, Monet, Gauguin, Van Gogh, and Cézanne up to the present day with Picasso, Brancusi, and Matisse. Americans were represented by three times as much work, but in comparison it looked provincial and was largely ignored.

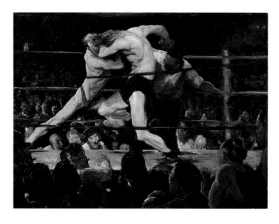

25-22 George Bellows. *Stag at Sharkey's.* 1909. Oil on canvas, 36¼ × 48¼" (92.1 × 122.6 cm). The Cleveland Museum of Art

Hinman B. Hurlbut Collection

Ruthless newspaper reviews lambasted the radical contemporary French art and brought the public out in droves, with 75,000 people attending the four-week show. They especially came to ridicule Marcel Duchamp's 1912 painting *Nude Descending a Staircase*, a cubist abstraction that one reviewer claimed looked like an "explosion in a shingle factory." The slogan for the exhibition was "The New Spirit," and its symbol the pine tree flag of Revolutionary Massachusetts. The American organizers of the show intentionally set out to create their own revolution, designed to jolt conventional bourgeois taste and bring about an awareness and appreciation for contemporary art. Despite the derision from the general public, the show spawned several modern art galleries and collectors adventurous enough to dedicate themselves to supporting radical art.

THE ASHCAN SCHOOL

American art opened the century with a movement unique to the United States, the Ashcan School, which was centered on the gritty urban realism of New York City. These artists found beauty in the commonplace and the ordinary, hence their title. The group centered on Robert Henri, who had studied painting with a pupil of the realist Thomas Eakins (see pages 503-4) at the Pennsylvania Academy in Philadelphia. They were all newspaper illustrators, whom Henri convinced to become artists. Gradually they moved to New York, and by 1905, they were painting the energy of the street, parks, and places of entertainment, capturing the rapidly changing social mores and styles. They especially documented the new demographics resulting from the waves of immigrants coming from Eastern and Southern

Europe as well the African Americans migrating from the South. They depicted the new working-class woman and the mixing of the classes in such public spaces as parks, vaudeville halls, and nickelodeons, where the first movies were shown.

To capture this modern urban energy, they used a Manet-like brushstroke and emphasis on surface, which lent their oils a sense of spontaneity and directness. We can see this in *Stag at Sharkey's* (fig. 25-22) a 1909 painting by George Bellows (1882–1925), the youngest of the Ashcan circle and not an original member. The artist presents one of the city's favorite entertainment spots, Tom Sharkey's Athletic Club, which was a bar located across from Bellows's studio. Bellows places us directly in the scene by using a viewpoint located in the seats, causing the lunging fighters with their rippling muscles to hover over us like monumental gladiators. We sense the sweat, strain, and flesh of the boxers and the enthusiasm and involvement of the audience. A Manet flicker of darks and lights and intense creamy brushwork animate the surface of the image. This along with the bright light, rhythmic undulation of curved heads, and the flailing arms and legs of the fighters causes everything to pulsate with a powerful dynamism that captures the raw, crude tenor of New York City. While most of the Ashcan School painters were socialists and deeply concerned for the welfare of the poor, they tended not to incorporate overt social commentary into their pictures or portray the underclass as oppressed and wretched. This mission was left to photography, which we have already seen in the work of Jacobs Riis (see fig. 24-24).

AMERICA'S FIRST MODERNISTS: ARTHUR DOVE AND MARSDEN HARTLEY

Americans digested European modernism almost as quickly as it was made, but it was largely Americans in Europe, mostly in Paris, who absorbed the new movements like Cubism and Fauvism, not those who remained at home in New York, Philadelphia, Boston, and Chicago, where the largest art schools were located. The young Arthur Dove (1880–1946) was in Paris in 1908, where he saw work by Matisse and the

Fauves. When he returned to New York, he met Alfred Stieglitz and began showing at "291."

While remaining involved in the New York art world throughout his life, Dove lived in rural areas in New York and Connecticut, even spending several years on a houseboat based on Long Island. By 1910 he was painting complete abstractions, two years before Kandinsky made his. Reproduced here is *Plant Forms* (fig. 25-23), from a series of pastels titled *The Ten Commandments* and made about 1912. The work bears little resemblance to the vertical and horizontal geometry of Cubism from this period, and instead has an organic feeling, largely due to the elliptical, oval, and round forms and the plant and treelike shapes. As with Cubism, the composition is made up of abstract components, although they tend to overlap each other in a logical, consistent fashion to suggest a continuous recession back into space. Dove has given us all of the components of nature without painting it illusionistically. The painting has light and atmosphere, which can be seen on each abstract form. We associate green, ochre, and brown with earth and vegetation, and the white and yellow with light. The white and yellow curved forms evoke suns, moons,

and hills. The sharp frondlike shapes suggest plants and trees but also are symbols of an unidentifiable burst of energy. We feel the powerful surge of nature and an elemental life force, and because each form suggests so many different objects, Dove is able to suggest the universal interconnectedness of all things. The picture is cosmic in its scope, although it equally suggests a very intimate view of nature. Dove's preoccupation with portraying the potent force of nature would become a major theme in twentieth-century American art, and as we will see one of the major issues for the artists surrounding Alfred Stieglitz.

The Stieglitz circle also included Marsden Hartley (1887–1943), a Maine artist who was making Pointillist paintings of the New England woods when he met Stieglitz in 1909. In 1912 he went to Paris, where he was infatuated with the so-called primitive art he saw at the Trocadero Museum, declaring that one "can no longer remain the same in the presence of these mighty children who get so close to the universal idea in their mud-baking." He declared art had to be "created out of spiritual necessity," and finding French art superficial and lacking soul, he went to Berlin in 1913 to steep himself in the mystical and spiritual ideas of Kandinsky

25-23 Arthur Dove. *Plant Forms.* c. 1912. Pastel on canvas, 17¼ × 23⅞" (43.8 × 60.6 cm). Whitney Museum of American Art, New York

and Der Blaue Reiter. There he also read the writings of the great German mystics, such as Jakob Boehme. He created a unique form of Synthetic Cubism, which he combined with Fauve and German Expressionist color to produce paintings filled with spiritual content, as can be seen in *Portrait of a German Officer* (fig. 25-24), later bought by Stieglitz. This large picture is one in a series dedicated to the memory of Lt. Karl von Freyburg, Hartley's lover who was among the first German soldiers killed in World War I. Embedded in the paintings are such German military paraphernalia as iron crosses, regimental insignia, heraldic markings, helmets, dress boots, bunting, service stripes, badges, imperial flags, spurs, and tassels. In a sense, this abstraction is a still life that in spirit recalls a Victorian keepsake box made for a deceased beloved and containing photographs, clothing, hair, and memorabilia of the departed, all pressed under glass. Executed with a childlike wobbly drawing that gives the work a primitive folk quality, the painting is filled with circles and diamonds and dominated by a triangle. These forms recall Kandinsky's belief in the spirituality of geometry. Kandinsky wrote, "Form has its own inner sound, is a spiritual being possessing qualities that are identical to that form. . . . A triangle is one such being, with its own particular spiritual perfume." In its jumble of color and form, *Portrait of a German Officer* has a cosmic force similar to Kandinsky's *Compositions* (see fig. 25-5) from this same period, and at moments, the abstraction of this picture seems to suggest landscape almost as readily as it does still life.

25-24 Marsden Hartley. *Portrait of a German Officer.* 1914. Oil on canvas, 68¼ × 41⅜" (173.4 × 105.1 cm). The Metropolitan Museum of Art, New York
The Alfred Stieglitz Collection, 1949 (49.70.42)

Art between the Wars, 1914–1940

P hysically and psychologically, World War I devastated Western civilization. The destruction and loss of life were staggering, with hundreds of thousands of soldiers dying in single battles. The logic, science, and technology that many thought would bring a better world had gone horribly awry. Instead of a better world, they produced such high-tech killing machines as machine guns, long-range artillery, tanks, submarines, fighter planes, and mustard gas.

To many now, the very concept of nationalism seemed destructive, and the rise of the first Communist government in Russia in 1917 offered the hope of salvation. Around the world, Communist parties sprang up, with the goal of creating a nationless world united by the proletariat. Others maintained that a new world order could not be attained without first destroying the old; they advocated anarchy, which remained a constant threat in the postwar decades. Despite this drive to create a nationless, classless world, it was fascism that gained the upper hand by the 1930s, with Germany, Italy, and Japan, armed with new technological tools of destruction, plunging the world into another great war by 1939.

While fascism, communism, anarchy, and democracy jockeyed for dominance in Europe, America enjoyed unprecedented prosperity. Historians have called the economic and cultural exuberance of the postwar years the Roaring Twenties; it was a time of jazz, speakeasies, radio, and silent films. The twenties also saw the rise of the city as the emblem of nation. Technology and machines were king in America, where the world's largest skyscrapers could be erected in a year. This exhilaration came to screeching halt with the stock market crash of October, 1929, which sent the entire world into a downward economic spiral known as the Great Depression that lasted throughout the 1930s. A reactionary backlash set in in both Europe and America: fascism in the former,

and a conservative regionalism and isolationism in the later.

Most artists fell into two primary camps in the period between the wars. One group sought to capture a higher reality that they believed was underlying the superficial appearance of things. Rejecting materialism, they sought to portray the spiritual or universal forces—the essence of life itself. Many were theosophists, a philosophy that continued to thrive into the 1930s (see page 532). A major force behind much contemporary thinking was the writings of the great Viennese physician, Sigmund Freud. His theories about the meaning of dreams and the unconscious mind claimed that the conventions of civilization had repressed the elemental needs and desires that are common to all humanity. This suppressed, invisible world constituted the basic building blocks of life itself. For many, his theory of the unconscious confirmed the existence of higher realities, unseen by the eye or perceived by the conscious mind.

A second group continued to embrace modernity. They viewed technology as a new universal religion and politics that could create a utopian society. Many of these artists, especially the Europeans, equated modernity with pure geometric abstraction. Because their art and architecture virtually had no references other than machines, engineering, and the technology of industrial materials, it was seen as nationless and classless. These artists strove to create an art that

expressed a harmony and machinelike efficiency, which ultimately would create a better world, a utopia.

Dada

The Great War halted much art making as many artists were enlisted in their country's service; some of the finest were killed. But the conflict also produced one art movement: Dada. Its name was chosen at random, the story goes, when two poets (Richard Huelsenbeck and Hugo Ball) plunged a knife into a French-German dictionary and it landed on "dada," French for "hobbyhorse." Its childish association fit the spirit of the movement perfectly. Dada produced two major concepts that would provide the foundation for future art. The first was the use of chance and spontaneity to create art; the second, the fantasy worlds resulting from their pursuit of the nonsensical and the absurd as they sought to jolt their audience out of their bourgeois complacence and conventional thinking. Both were great tools for escaping the controlling hand of civilization. Dada began in 1916 in neutral Zurich, where a large number of writers and artists sought refuge.

ZURICH DADA

In Zurich, Hugo Ball, a German poet, philosopher, and mystic who had fled Berlin, founded the Cabaret Voltaire as a performance center where writers and artists could protest the absurdity and wastefulness of the war. He was soon joined by the Romanian poet Tristan Tzara, who took over the helm of the movement in late 1916 and was its most vociferous proponent until its demise in Paris in the mid 1920s, when it was supplanted by Surrealism. The focus of the Dada attacks at the Cabaret Voltaire was the rational thinking that produced the depraved civilization responsible for the senseless conflagration consuming Europe. Their target was all established values—political, moral, and aesthetic—and their goal was to level the old bourgeois order through a nihilistic "nonsense" and anarchy. In the end, they hoped to produce a *tabula rasa*, a clean slate that would provide a new understanding of the world.

The Cabaret Voltaire group, which included the Alsatian painter and poet Jean (Hans) Arp, mounted boisterous performances. Wearing fanciful costumes, including primitive cardboard masks, they recited abstract phonetic poems of nonwords and nonverses ("zimzim urallala zimzim urallala zimzim zanzibar zimazall zam" went one line in Hugo Ball's *O Gadji Beri Bimba*). The readings were virtually drowned out by an accompanying "music," a cacophony of sounds, often the arrhythmic beating of a drum. The performers' chaos whipped the audience into a frenzy of catcalls, whistles, and shouts. Some evenings Tzara harangued the audience with rambling, virtually incomprehensible Dada Manifestos. And, just as chance had named the Dada movement, it was used to create works themselves. Dada poems were "written" by pulling words out of a hat. Or one poem was read simultaneously in different languages or different verses of the same poem were read simultaneously in one language. The resulting chance weaving of words together in a new way created a new unpredictable poetic fabric, both in sound and meaning. Some performances included *dances nègres* and *chantes nègres*, as African dance and music were called, reflecting the group's interest in so-called primitive cultures. The Dada artists believed that the directness and simplicity of African cultures were in touch with the primal essence of nature itself.

Perhaps the most far-reaching influence of Dada performances was that they tore down the boundaries that had separated the arts. Dada performances brought together artists, musicians, poets, and writers, effectively breaking down the distinctions between their respective media. As we will see in chapter 27, this tradition will become especially important for the visual arts in the 1950s with the birth of Performance Art.

Jean (Hans) Arp The Zurich Dadaists exhibited a broad range of avant-garde art, such as paintings by de Chirico (see pages 547-48), as long as it undermined bourgeois taste and standards. Most of the art presented at the Cabaret Voltaire and its successor, the Galerie Dada, was abstract. The strongest representative of Zurich Dada was Jean (Hans) Arp (1887–1966), whose abstract collages hung on the walls of the Cabaret Voltaire opening night. Arp's cubist collages were made by dropping pieces of torn rectangular paper on the floor, which then determined the composition. Although he claimed that

chance alone arranged the papers, Arp probably manipulated the paper, reserving the role of chance for spurring his imagination rather than creating the image, which resembled a spare or simplified version of Synthetic Cubism.

Arp believed that chance itself replicated nature. For him, life itself, despite the best-laid plans, was pure chance. Arp had been in Munich with Kandinsky and there adopted a mystical view of the world that envisioned a life force running through all things, binding them together in no particular order. This spiritual outlook can be seen in the low relief sculptures he began making about this time, such as *The Entombment of the Birds and Butterflies (Head of Tzara)* (fig. 26-1). The different shapes were determined by doodling on paper. He then gave his doodles to a carpenter, who cut them out in wood, which Arp then painted and assembled into abstract compositions evoking plant and animal forms as well as clouds, cosmic gasses, and celestial bodies. The title came last, suggested by image. Like Kandinsky, Arp's goal was to capture abstract universal forces.

Cabaret Voltaire closed by summer of 1916 and was replaced by a succession of other venues. Meanwhile, Tzara's magazine, *Dada*, spread the word of the movement worldwide. By the end of the war in late 1918, Zurich had been abandoned by many of the major artists. By early 1919, Zurich Dada drew to a close. Only after the war was over did Tzara hear that there was a New York Dada movement happening simultaneously, if not in name, at least in spirit.

NEW YORK DADA: MARCEL DUCHAMP

New York Dada was centered on Marcel Duchamp, who fled Paris and the war in 1915, and the Frenchman Francis Picabia, who arrived the same year. Picabia was notorious for making portraits in which the subject is satirized by being represented by a machine. Obviously, Picabia was inspired by the absurdity of Duchamp's mechanized figure in *The Bride* (see fig. 25-17). The New York artists had no Cabaret Voltaire, no manifestos, and no performances, although they held a weekly salon at the home of the wealthy writer and his wife, Walter and Louise Arensberg, and from 1915 to 1916 published their avant-garde art and ideas in a magazine titled *291*,

26-1 Jean (Hans) Arp. *The Entombment of the Birds and Butterflies (Head of Tzara)*. 1916–17. Painted wooden relief, 15¾ × 12¾" (40 × 32.5 cm). Kunsthaus, Zurich

© 2004 Artists Rights Society (ARS), New York/VG Bild-Kunst, Bonn

which was sponsored by the art dealer Alfred Stieglitz (see page 551). The word Dada was never used at the time to describe their art; it was only applied in retrospect because their spirit was similar to that in Zurich.

Perhaps the highlight of New York Dada is Duchamp's *Fountain* (fig. 26-2). Duchamp submitted this sculpture to the 1917 exhibition of the Society of Independent Artists, an organization begun several decades earlier to provide exhibition opportunities for artists who did not conform to the conservative standards of New York's National Academy of Design, until then the primary exhibition venue. Duchamp labeled his *Fountain*

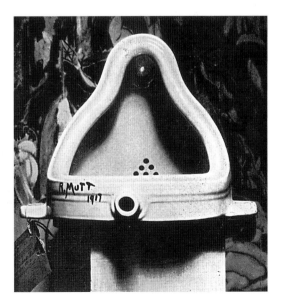

26-2 Marcel Duchamp. *Fountain*. 1917, photograph by Alfred Stieglitz, reproduced in *The Blind Man, No. 2* (May 1917), page 4. Philadelphia Museum of Art, Louise and Walter Arensberg Collection.

© 2004 Artists Rights Society (ARS), New York/ADAGP, Paris/Succession Marcel Duchamp

a "readymade," a term he took from American readymade clothing (today we say "off the rack"), and applied it to all of his sculptures based on a single found object. As we saw in the last chapter, Duchamp began working with found objects when he made his *Bicycle Wheel* in 1913 (see fig. 25-19), although he did not exhibit his readymades and coin the term until he was in New York. *Fountain* was a urinal manufactured by the J. L. Mott Iron Works in New York. All Duchamp did was turn the urinal ninety degrees, set it on a pedestal, and crudely sign it with the fictitious name of R. Mutt, a reference not only to the manufacturer but also to Mutt in the popular Mutt and Jeff comic strip. The work was submitted to the Society's exhibition under Mutt's name, not Duchamp's. According to the Society's rules, anyone paying the $6 admission fee would have their work accepted. Duchamp knew the hanging committee would not allow *Fountain* to go on view, and when it was removed at the opening, he had his friends prepared to take it out in a rowdy procession that drew attention to its rejection. Duchamp continued the hoax of R. Mutt's authorship of the work when he wrote an article about the piece in a small newspaper he published, *The Blind Man*, that only made it through two issues, but was widely circulated in the art world. The article defended Mutt's right to create a readymade: "Whether Mr. Mutt with his own hands made the fountain or not has no importance. He chose. He took an ordinary article of life, placed it so that its useful significance disappeared under a new title and point of view . . . [creating] a new thought for that object."

Like many of Duchamp's works, *Fountain* is rich in ideas, and it stands as one of the monuments of twentieth-century art, although the original has disappeared. The work is all about idea. (Recall our discussion in the Introduction, page 7.) We can even ask ourselves, What is the work of art?: The urinal, the provocation of submitting it to the exhibition, the flamboyant parade when it was removed from the show floor, or the article in *The Blind Man*? Obviously, all of these things. Even the title is essential to the work, since it allows Duchamp to make it clear that he is attacking one of the most revered of all art forms, the fountain, the centerpiece for most European town and city

squares and in some respects a symbol for the tradition of fine art. Duchamp challenges the notion of what is art, the importance of technique or craft as well as the artist's signature, and how a work of art takes on meaning. He even allows the viewer to assign meaning to the work of art, not just reserving it as an artist's right.

Because the work is industrially manufactured and can be easily replaced if broken or lost, Duchamp also questions the significance attached to the uniqueness of artwork. As we will see, in the second half of the century, Duchamp will become the dominant figure in art as artists worldwide make **conceptual art**. Conceptual art is a term coined in the 1960s to describe the work of artists for whom an idea or conceptual premise was an important component of their visual work, often the most important component.

In contrast to Zurich Dada, New York Dada was very quiet. In Manhattan, the group was removed from the war, and it did not have a political agenda. Its focus was largely on defining art, following Duchamp's lead. More important, New York Dada was lighthearted and witty, as in Picabia's humanlike machines and Duchamp's *Fountain*. It attacked bourgeois artistic values through punning, teasing, irony, pranks, and intellectual games of the highest order. In its most rabid form, Dada had a social mission, and this took place in war-torn Germany, not complacent New York.

BERLIN DADA: RAOUL HAUSMANN, GEORG GROSZ, AND HANNAH HÖCH

With the end of the war, the Dada poet Richard Huelsenbeck left Zurich for Berlin in 1918. There he found a moribund city, which like all of Germany was without food, money, medicine, or a future. Germans, especially the working class, loathed the military-industrial machine, which they felt had betrayed their interests by leading them into war. With the surrender, conditions worsened as Germany was punished by harsh and unrealistic reparation demands. Inflation was rampant, and the value of German currency plunged. Open class conflict resulted in bloody Communist-led worker uprisings in Berlin and Munich in 1919. The government

of the Weimar Republic, Germany's first experiment in democracy, failed to revive the country's economy, and its refusal to pay reparations in 1923 only resulted in further humiliation: The French occupied the Ruhr Valley and seized German assets.

For many, hope lay to the East in Russia, where the Bolshevik Revolution established the prospect for a nationless planet governed by the proletariat, and Berlin Dada looked to international worker solidarity as Germany's salvation. Here was a situation where Dada anarchy and nihilism could be put to practical use, and almost without exception the Berlin contingent made political art and were political activists, with some members, such as George Grosz and John Heartfield, joining the Communist Party.

After returning to Berlin from Zurich, the poet Huelsenbeck employed the usual Dada devices: He created an organization, Club Dada, and published manifestos calling for the overthrow of the bourgeois establishment and for the need to create a level playing field where the separation of power, money, and nationalism would be dissolved. The principal members of the Berlin group included Raoul Hausmann (1886–1971), Hannah Höch (1889–1978), Georg Grosz (1893–1959), and John Heartfield (1891–1968) (whose work we discuss later in the chapter). In 1920 they organized the First Dada International Fair, which featured Dada art from everywhere. In the center of the fair, hanging from the ceiling, was an army-uniformed dummy with the head of a pig and wearing a sign saying "Hanged by the Revolution." The work, a collaboration by Hausmann and Grosz, epitomized Dada's abhorrence of the establishment.

Raoul Hausmann Hausmann quickly became the leader of Berlin Dada, and visually was perhaps the most inventive, as can be seen in his assemblage *Mechanical Head (Spirit of Our Time)* (fig. 26-3) of 1919. He uses found objects, which at the time were so foreign to the art world they were considered junk:

a mannequin's head, a collapsible cup, a purse, labels, nails, and rulers. But now we see a new approach to making sculpture, since the objects are assembled together (Duchamp only used two objects in *The Bicycle Wheel*). As important, they are arranged to make a bold statement condemning materialism and loss of individuality and personal identity.

Hausmann, however, is best known for his use of language and collage. Like Ball in Zurich, he wrote and performed phonetic poems made according to the laws of chance. His interest in words, letters, and sound led him to innovative experiments with typography, in which he used different typefaces and sizes for individual letters cut from magazines and newspaper, the shifts in scale indicating how the letter should be emphasized when sounded.

These words were incorporated into ingenious collages made from material cut from different printed sources and rearranged in new contexts. This allowed for vicious satire as a head became too large for a body, for example. Collage itself of course was not new at this point, but previously it had been used in a refined manner, as by the Cubists,

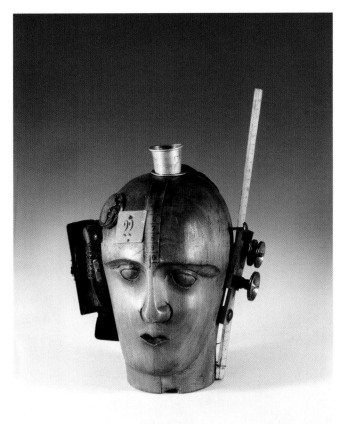

26-3 Raoul Hausmann. *Mechanical Head (Spirit of the Age).* c. 1920. Assemblage, h. 12¾" (32.5 cm). Musée National d'Art Moderne, Centre Georges Pompidou, Paris

© CNAC/MNAM/Dist. Reunion des Musees Natiouaux/Artists Rights Society (ARS), New York/ADAGP, Paris

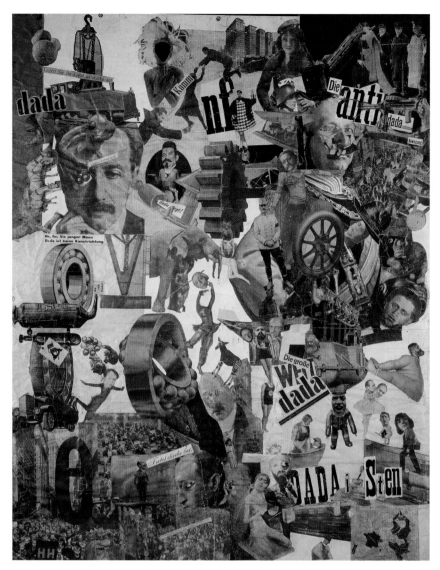

26-4 Hannah Höch. *Cut with the Kitchen Knife Dada Through the Last Weimar Beer Belly Cultural Epoch of Germany.* c. 1919. Collage, 44⅞ × 35⅜". Staatliche Museen, Berlin.

that transformed the materials into high art (see fig. 25-9). With Hausmann, collage retained the look and feeling of popular culture, crass media communication, and the flotsam and jetsam of the street. It looked like it was made with trash, and it looked like anti-art!

Hannah Höch Hannah Höch, Hausmann's partner at the time, adopted these elements from his style in one of the grandest Dada collages from the period, *Cut with the Kitchen Knife Dada Through the Last Weimar Beer Belly Cultural Epoch of Germany* (fig. 26-4) made in 1919–20. The title itself speaks volumes and is an integral part of the work (much as it is for Duchamp, whose *Fountain* only takes

on meaning with the title). Using a chaotic, cramped Cubist composition of crowds, words, machinery, and lettering of different sizes and styles, Höch captures the hectic social, political, and economic intensity of the Weimar Republic, while condemning its new leaders, who are collaged in the upper right corner and villainously labeled just below as "*die anti-dada*" (the anti-dada).

George Grosz George Grosz claimed to have been the inventor of Hausmann's collaging technique, and he certainly worked in the medium at the same time. Grosz was seriously wounded twice in the war and was especially bitter about the disastrous course charted by German leaders. Upon convalescing and

returning to Berlin, he was stylistically inspired by the militant Cubism of the Futurists and worked in this style at the same time as his more technically radical photocollages. A fine example of his Cubist style is *Germany, A Winter's Tale* (fig. 26-5) of 1918. Here, in a claustrophobic composition resembling Höch's *Cut with the Kitchen Knife Dada* of the following year, he presents a chaotic cityscape of office buildings, churches, and factories. The image is dominated by an obedient overfed bourgeois capitalist seated at a well-stocked table (flanked by faithful dog and mistress), and militaristically holding fork and razor-sharp knife as though they were weapons. Anchoring this chaos are the evil forces Grosz holds responsible for molding it: the church, military, and education.

Käthe Kollwitz Käthe Kollwitz (1867–1945) was a powerful independent during this period, whose political sympathies coincide with those of the Dada circle. (She is pictured on the floating head in the center of Höch's collage *Cut with Kitchen Knife Dada*.) Höch's imagery generally contains more women than that of her male counterparts. We can assume this reflects her socialist vision of women playing an equal role in the ideal Germany of the future. But Kollwitz was important as a role model, and although far too conservative stylistically and conceptually to become a member of Berlin Dada, her poignant condemnations of social injustice made her an important predecessor of the group. In 1920, along with George Grosz, she joined the International Workers Aid, for which she produced several posters, including *Help Russia* and *Vienna is Dying! Save Her Children*. A generation older than Höch, she was denied admission to the Berlin Academy because she was a woman. She studied at a women's art school, and after marrying a doctor, settled in a working-class neighborhood in Berlin. There, her husband treated the poor, who became the subject of her art. She shunned painting as an elitist medium of the Academy and the bourgeois, and instead made drawings and prints, which could be mass produced and circulated to wide audiences. Typical of her expressionistic style of strident marks, strong value contrasts, and powerful emotions is *Never Again War!* (fig. 26-6), a lithograph published in 1924.

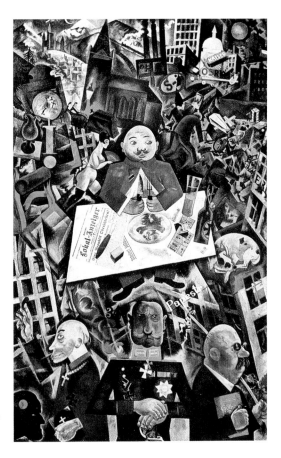

26-5 George Grosz. *Germany, A Winter's Tale.* 1918. Formerly Collection Garvens, Hannover, Germany. Whereabouts unknown

Art © Estate of George Grosz/Licensed by VAGA, New York, NY

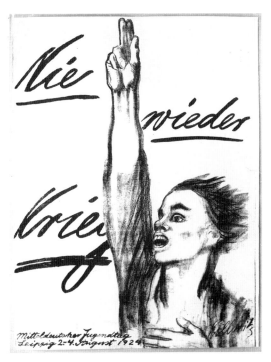

26-6 Käthe Kollwitz. *Never Again War!* 1924. Lithograph, 37 × 27½" (94 × 70 cm). Courtesy Galerie St. Étienne, New York

© 2004 Artists Rights Society (ARS), New York/VG Bild-Kunst, Bonn

COLOGNE DADA

In the city of Cologne, Dada took its lead from Berlin, but it was never as political. Dada artists here were intrigued by Freud's theory of the unconscious and favored the mechanomorphic (machinelike) figures of Duchamp and Picabia. The key artists were Max Ernst (1891–1976) and Johannes Baargeld (a pseudonym meaning "money bags"), both of whom appropriated Berlin's collage technique for themselves. Ernst and Baargeld were iconoclasts, not social evangelists, who delighted in submitting their witty low-end collages to the staid Cologne Kunstverein exhibition in 1919, creating a scandal. When prohibited from showing there the following year, Ernst mounted a solo exhibition at a nearby brewery, forcing visitors to walk past the bathroom to get to the "gallery," where the central work was a sculpture that visitors were instructed to destroy with an axe he provided.

Typical of Ernst's work from this very productive period is *1 Copper Plate 1 Zinc Plate 1 Rubber Cloth 2 Calipers 1 Drainpipe Telescope 1 Piping Man* (fig. 26-7), a gouache, ink and pencil drawing on an illustration from a 1914 book about chemistry equipment. With a line here and a dab of paint there, Ernst transformed the picture of laboratory utensils into bizarre robotic figures set in a stark symbol-filled landscape. Perhaps we should say dreamscape, for the glazed-over stares and skewered de Chirico-like perspective, which culminates in a mystifying square, give this little collage a primitive power that suggests some otherworldly sphere—one of the imagination. Ernst was influenced by others who made dream imagery, primarily the turn-of-century Symbolist Max Klinger, but he also knew about de Chirico, whose work he would have been introduced to by his friend Jean Arp, who visited him in Cologne in 1920. The dreamlike quality of Ernst's image endows his figures with heavy psychological overtones. Indeed, Ernst was infatuated with Sigmund Freud and his theories about the unconscious and the importance of dreams.

Through Arp, Ernst was put in contact with two leaders of the Paris Dada movement, poets André Breton and Paul Éluard, both of whom worshiped Freud as well. In 1921 they arranged for Ernst to show his Dada collages at the avant-garde Galerie Au Sans Pareil in Paris, where they made such a sensation he was hailed as the "Einstein of painting." The following year, Ernst immigrated to Paris. In 1924 Breton and Éluard issued their Surrealist Manifesto, anointing Ernst's 1921 show as the first Surrealist exhibition. Dada was dead, and Surrealism was born.

PARIS DADA: MAN RAY

The transition from Dada to Surrealism was well on its way by 1922, and it occurred in Paris. Dada had established a foothold in the French capital with the return of Duchamp at the end of 1918 and with the arrival of Picabia from Barcelona in 1919. As in Zurich, the thrust behind Paris Dada came from the literary contingent. Inspired by Tzara's *Dada* magazine, three young poets—Louis Aragon, André Breton, and Phillipe Soupault—founded a journal called *Littérature*. It was so avant-garde that there was hardly anything in it that the literary establishment would consider literature. In addition to phonetic poems by Tzara, it included Breton's and Soupault's collaborative poem *Les Champs magnétiques* (*Magnetic Fields*, 1919), which was written as stream-of-consciousness writing in sessions lasting up to ten hours.

26-7 Max Ernst. *1 Copper Plate 1 Zinc Plate 1 Rubber Cloth 2 Calipers 1 Drainpipe Telescope 1 Piping Man.* 1920. Collage, 12 × 9" (30.5 × 22.9 cm). Estate of Hans Arp

© 2004 Artists Rights Society (ARS), New York/ADAGP, Paris

Encouraged by Breton and Éluard, Tzara left Zurich for Paris in 1920, and immediately instituted his riotous performances, his first consisting of a straight-faced reading of a dreary parliamentary speech by an ultra-conservative politician. But the French were not attracted to nihilism and anarchy; they had won the war and, despite identification with the cause of labor against capitalism and with International Communism, were, unlike their German counterparts, complacent and comfortable, solidly led by a far right government. The positive, constructive views of Breton and his colleagues, who were interested in automatism and dreams, were far more attractive and by 1923 the group prevailed.

One of the artists who moved in and out of Breton's circle, was the independent American Man Ray, whose name was originally Emmanuel Rudnitsky (1890–1976). He had befriended Duchamp in New York and came to Paris in 1921, shortly after his mentor. Best known as a photographer, Man Ray was extraordinarily inventive and worked in many media, even introducing some to fine art. In New York, he painted innovative abstractions with an airbrush, a tool previously used only by commercial artists. He also made drawings using *cliché verre*, a technique that involved drawing directly on a glass negative, from which a photograph was then made.

Most important, Man Ray was the first artist to consistently use photography within a Dada context, often using the same conceptual components found in Duchamp's work and thus freeing the medium from the merely representational restrictions placed on it by fine art photographers. As significant, Man Ray helped establish photography as a medium that was viewed on a par with painting and sculpture, and one of the important contributions of Dada was its rejection of the hierarchy of media.

In 1922, Man Ray had a major impact on the development of photography, as well as on Dada and abstract art, when he popularized the photogram—a one-of-a-kind cameraless photograph made by putting objects directly on photographic paper and then exposing it to light (see fig. 26-8). Solid objects block light from hitting the white paper, so they appear white in the image, while the voids are black, since there is

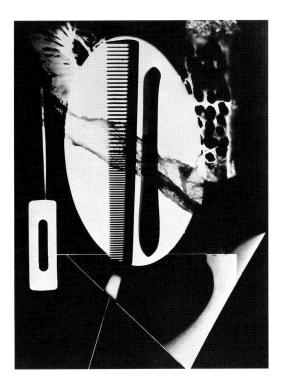

26-8 Man Ray. *Champs délicieux*. 1922. Gelatin silver print.

Rayograph © Man Ray Trust/Artists Rights Society (ARS), New York/ADAGP, Paris

nothing to prevent the light from exposing the paper. Tzara dubbed Man Ray's print a "rayograph," and that year, using cover prints (photographic copies of the unique print) made by Man Ray, he published a limited edition book containing twelve of them.

Reproduced here is one of these untitled rayographs, which appears to have been made with an object that allowed for a silhouette of a brush and comb, a sewing pin, a coil of paper, and a strip of fabric, among the identifiable sources. The objects appear ghostlike and mysterious in their strange atmospheric environment where darks and lights have been reversed and where a haunting darkness prevails. Shapes and lines move in and out of the dark shadows, sometimes vibrating, like the comb and brush, other times crisply stated, like the center oval. Because Man Ray exposed the paper with a light bulb that he moved several times during the process, he created multiple light sources, which caused the edges of some objects to shimmer and allowed other forms to recede back in space instead of just existing as flat silhouettes. His pictures have a magical blend of the real and the nonreal. We feel the presence of a real comb and pin, and yet they seem to exist in some other dream world, not ours. Just as unexplainable is the relationship of these objects and shapes to one another. The

strange juxtapositions spark our imaginations to weave a narrative for this image, although there is none.

Man Ray used this same chance process to make films. At Tzara's invitation, Man Ray participated in what turned out to be the final major Dada event in Paris, la Soirée de la Coeur de la Barbe (The Bearded Heart Soirée) in 1923. Using sand, nails, and pins sprinkled randomly on unexposed cinematic film, he created a short abstract movie titled *The Return to Reason*, an ironic title because the hallucinatory flickering of white objects floating in dark blackness created a sense of chaos that was far from rational, but nonetheless represented a new reality and way to see the world. This was the first time film was included in a Dada soirée. It not only marked the introduction of film into the fine art world, but also help spawn a flurry of experimental films by artists. Shortly after Man Ray's film was screened that evening, the program unexpectedly drew to a close with the arrival of the police, who were called because a riot broke out when Breton, Éluard, and Soupault, all uninvited, stormed the stage screaming that Dada was dead.

Surrealism

Dada ended, replaced by Surrealism as formally launched by poet André Breton in his 1924 *Surrealist Manifesto*. In it, he defined the movement using a dictionary format:

> SURREALISM, n. Pure psychic automatism, by which it is intended to express, either verbally, or in writing, or in any other way, the true functioning of thought. *Thought expressed in the absence of any control exerted by reason, and outside all moral and aesthetic considerations.* [Editor's italics] . . . Surrealism rests on the belief in the superior reality of certain forms of association . . ., in the omnipotence of the dream, and in the disinterested play of thought.

Gone was the Neoclassical god of reason, the sureness of logic, and the artist's calling to depict observable reality. Surrealists argued that we see only a surface reality. More important was uncovering the deepseated secrets and desires of the unconscious mind. Indeed, those desires, repressed by civilization's conventions and demands consti-

tute the most elemental human needs and wants. These ideas originated with Sigmund Freud (see page 555) and influenced Breton and the Surrealists. Freud's *The Interpretation of Dreams* (1900) appeared in English in 1911 and in French in the early 1920s. This treatise and others were dedicated to exposing the repression of forbidden desires. Dreams, said Freud, were clues to these elemental desires residing in the unconscious.

Breton, in his manifesto, called for ". . . the future resolution of these two states, dream and reality, which are seemingly so contradictory, into a kind of absolute reality, a surreality." He emphasized the concept of creating "the marvelous," images, either verbal or visual, that were otherworldly and poetic and swept the audience to a new, unknown plane of reality. He encouraged the use of dreamlike images, the juxtaposition of unrelated objects, and stream-of-consciousness writing as ways to tap in to the unconscious and release greater realities and higher truths.

Surrealism was first a literary style. Breton traced its roots to several sources, including Comte de Lautréamont's 1869 novel *Chants de Maldoror*, which page after page, included wonderous passages of surreal images, the most famous perhaps being ". . . as beautiful as a chance encounter of a sewing machine and an umbrella on an operating table." Breton's literary circle delighted in creating "chance encounters" of words. They devised a verbal game in which each participant provided words for a sentence, not knowing what had already been written. During one game, they produced the sentence, "The exquisite corpse will drink the new wine," and Exquisite Corpse became the game's name. Surrealist artists played Exquisite Corpse as well, folding a piece of paper, and each artist drawing on his or her segment. The result was a provocative image of unrelated objects or a strange form. But visual art had little place in Breton's *Surrealist Manifesto*, and artists were only mentioned as a footnote. Among those listed in a single sentence were Ernst, Man Ray, de Chirico, and Picasso.

PICASSO AND SURREALISM

Perhaps the most surprising name on Breton's list is Picasso's. The Dada artists found little of interest in the analytic logical thinking of the Cubists. But Picasso's painting had

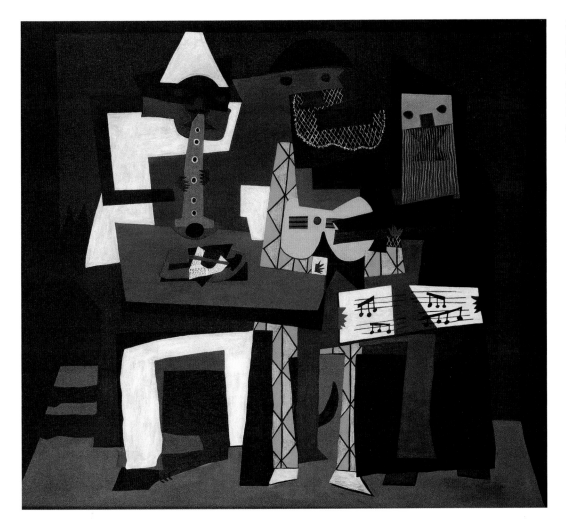

26-9 Pablo Picasso. *Three Musicians*. Summer 1921. Oil on canvas, 6'7" × 7'3¾" (2 × 2.23 m). The Museum of Modern Art, New York, Mrs. Simon Guggenheim Fund

© 2004 Estate of Pablo Picasso/Artist Rights Society (ARS), New York

changed dramatically during the course of the 1910s, and this, along with the fact that he was the most famous contemporary artist, made Breton want him on his Surrealist "team." During the course of the 1910s, Picasso began creating mystifying dreamlike images of sex and death, as can be seen in his *Three Musicians* (fig. 26-9) of 1921. The picture is a traditional *commedia dell'arte*, or Italian Comedy, subject. (Italian Comedy was improvisational theater dealing with jilted love and played by stock actors.) But we instantly sense that this is no longer a witty Synthetic Cubist painting of ingenious interlocking flat planes, although it is not without humor, as suggested by bright colors and the playful patterning.

Ultimately it is the black that prevails, as well as the frightening masks of the musicians, and the jarring, even abrasive, rhythm of the composition that has more in common with the brutal *Les Demoiselles d'Avignon* (fig. 25-7) of 1907 than the with refined *Guitar, Sheet Music, and Wine Glass* of 1912. (Note the disjointedness of the black right arm of the clarinet player.) And what is the dog doing lurking under the table, his head demonically silhouetted against the barren corner of the room, his body sliced up by the legs of the table and intertwined with the musician's legs? These are not just jovial music-making figures, but pathetic lusting lovers, in keeping with the commedia dell'arte theme. The woodwind player on the left, compositionally the major figure, resembles Rousseau's snake charmer in his lustful painting *The Dream* (see fig. 24-14), which Picasso knew as intimately as he did the artist himself. Picasso has transformed this scene into a primitive rite, as further suggested by the masks, which are more mysterious than comic, as is more traditional for Italian comedy players. The painting even has spiritual overtones, implied by the monklike, and therefore celibate, vocalist on the right. The dark silhouetted head of the dog expresses deep-seated animalistic urges, the

libido, which drives the music making, while the austere boxlike room becomes a claustrophobic container—a room of the mind. Picasso has created a psychologically loaded dream world.

We should not be surprised to see Picasso creating such an unsettling and haunting image, for the passionate Spaniard began his career making symbolic works about sexual conflict, and as we have seen, his 1907 *Les Demoiselles d'Avignon* is nothing less than a horrific, disjointed scene of sexual terror. With the advent of Surrealism in 1924, the

primal forces seething beneath the surface in the *Three Musicians* became even more powerful in Picasso's work, as seen in *Three Dancers* (fig. 26-10) of 1925, painted less than a year after Breton published his *Surrealist Manifesto*. Although not prostitutes, the figures are descendents of the sexually charged women in *Les Demoiselles d'Avignon*. (Not only Cubism, but Surrealism came out of this seminal picture that provided inspiration for so many artists, including Picasso, throughout the twentieth century.) They are not the Three Graces, but rather disquieting nudes engaged in a terrifying ritualistic ceremony. The figure in the center appears to be youthful innocence mysteriously crucified on the cross of the window. The horrific contorted figure to the left is a mature sexually aggressive woman with erect nipple. She has been reduced to an assemblage of abstruse hieroglyphic forms, which reinforces her primitive dervish state. Her head is shaped like a quarter moon, and it has been placed against a backdrop of a night sky filled with stars as represented by the fleur-de-lis of the wallpaper. We sense the universal pull of sexual desire.

The figure on the right is multilayered and controlled, reflecting a psychological complexity and maturity that comes with age. Her sex is merely stated, not quivering as in the figure on the left, and can be seen as mere fact in the pointed white breast and black oval. Her black profile—which is said to resemble the head of Picasso's close artist friend who had just died—sets a moribund tone. Securely tucked into the figure's armpit is the head of the dog from the *Three Musicians*, now in red. What Picasso appears to be presenting is a version of the three stages of female sexuality, couching it in primitive, ritualistic, and mythical terms that reveal the elemental psychological and physical impact of sexual yearning.

In addition to the Surrealists, Picasso was taking on his old rival Matisse in *The Three Dancers*! The tall windows opening up onto a black railing and blue sky is immediately recognizable as a take-off on Matisse's many paintings of delightful views from his room in Southern France. The fleur-de-lis patterning of the wallpaper apes Matisse as well. We need but compare Picasso's picture to Matisse's *Decorative Figure against an Orna-*

26-10 Pablo Picasso. *Three Dancers*. 1925. Oil on canvas, 7½″ × 4′8¼″ (2.15 × 1⅓ m). The Tate Gallery, London

© 2004 Estate of Pablo Picasso/The Artists Rights Society (ARS), New York

mental Background (fig. 26-11) of 1927 to see the similarity and the degree to which Picasso's brightly colored decorative patterning relates to Matisse, although it is entirely different in both feeling and intention. Matisse throughout his life never varied from his stated goal of making paintings that were like a comfortable armchair, that is, pleasing to look at. *Decorative Figure* is classic Matisse: a luscious display of beautiful color, rich paint, and curvilinear patterning, which saturates every square inch of the surface with virtually equal stress while simultaneously focusing on a classical nude reminiscent of Ingres's odalisques (see fig. 22-4). Despite the receding perspective of the carpet, the image stays on the surface, as in the *Red Studio* (see fig. 25-2), mainly because of the pattern of the wallpaper, which stays flat, never receding. Unlike Picasso, there is here no symbolism, higher meanings, or grand statements about life. Representational subject matter is essentially an armature for abstract beauty, which is reinforced by themes that are always sensual and depict a cloistered world sheltered from the harsh realities of life. While never convening a major movement, with manifestos, organizations, and group exhibitions, legions of independent painters, especially Americans, would quietly follow in Matisse's footsteps throughout the twentieth century to the present day.

As would be expected, Picasso turned to sculpture as well to express his urge to portray unseen elemental forces and deep-seated psychological passions, and it led him to revolutionize sculpture for a second time (the first in 1912 when he made his constructions, see pages 541-42). By late 1928 Picasso was welding metal, which he experimented with for the next five years, starting a trend that by the 1940s established welded steel as a major sculptural process rivaling cast bronze and chiseled stone. Picasso turned to welding metal when he decided to make sculpture based on the linear drawing of the figures in his current paintings. The resulting three-dimensional sculpture was made up of metal rods that represented the painted lines, and it looked like a drawing in space. The work *Head of a Woman* (fig. 26-12) from 1930–31, shows Picasso two years later and now welding a variety of objects of different sizes and shapes together, including found objects like a colander and

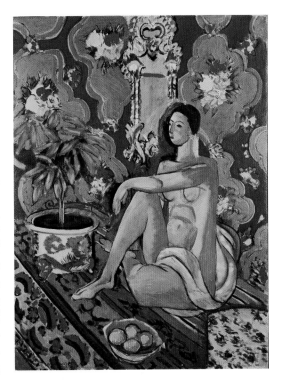

26-11 Henri Matisse. *Decorative Figure against an Ornamental Background.* 51⅛ × 38½" (129.9 × 97.8 cm). Musée National d'Art Moderne, Paris, Centre Georges Pompidou, Paris

© 2004 Succession H. Matisse, Paris/Artists Rights Society (ARS), New York

scraps of metal. But despite the large colander, he is still mostly drawing in space, as seen in the hair, face, skull, and body. The motivation is obvious: the process allowed him to pare his figure down to a bare-bones essence, as though he has peeled off the superficial layers to reveal the psychological core of the woman that lay beneath. The sculpture's overall resemblance to African masks and Picasso's use of what looks like hieroglyphic notations for different parts of the body (note the shape of the legs) reinforces its elemental primeval emotion. Again we feel as though we are in the presence a harpy from *Les Demoiselles d'Avignon,* a sexually driven predatory female.

SURREALISM IN PARIS: PAUL KLEE, JOAN MIRÓ, MAX ERNST, JEAN ARP

Picasso's work from the mid 1920s paralleled that of Surrealism, and he shared many of the same symbols and myths dear to the Surrealists, including the female praying mantis, which eats its male partner upon mating, and the minotaur.

But in 1924, Breton like everyone had doubts about the possibility that there could even be Surrealist painting or sculpture. Many argued that the visual arts unlike writing, did not allow for a stream of conscious, since artists always had the work in front of

26-12 Pablo Picasso. *Head of a Woman*. 1930–31. Painted iron, sheet metal, springs, and colanders, 39⅜ × 14½ × 23¼" (100 × 37 × 59 cm). Musée Picasso, Paris

them and, while creating, could see where they have gone and think about where they are at that moment. The imagery could be Surrealist, but the method was not. Ultimately, Surrealist art was art based on one or more of three qualities, the same that had applied to literature: chance and automatism, dream imagery, and the juxtaposition of unrelated objects. In defense of Surrealist painting, Breton organized the first Surrealist art exhibition in late 1925. Among the artists dominating the show were Ernst, Picasso, and Joan Miró, but also included were de Chirico, Paul Klee, Man Ray, and Arp, who had just settled in Paris. Two of these artists are new to us: Klee and Miró.

Paul Klee Paul Klee (1879–1940) was hardly an emerging artist. Born in Bern, Switzerland, he was already exhibiting in the first decade of the century, and after moving to Munich in 1906, he befriended Kandinsky and the other artists in his group, known as Der Blaue Reiter, showing with them once in 1912. From his contact with these artists, Klee acquired his life-long belief in the need to create a spiritual art, a commitment so

intense he went so far as to label himself "a cosmic point of reference." Klee never identified with any group of artists, and remained quietly independent throughout his career.

Nonetheless, he was included in the first two Galerie Dada exhibitions in Zurich in 1917, and given a one-person show soon after. Klee's work impressed the sculptor Marcel Janco as the best exhibition ever held at the gallery, embodying many of the essential concerns of the Dadaists: "In his beautiful work we saw the reflection of all our efforts to interpret the soul of primitive man, to plunge into the unconscious and the instinctive power of creation, to discover the child's pure and direct sources of creativity." Ernst included Klee in a 1919 Dada exhibition, where his paintings hung along side African and children's art. Looking at Klee's 1922 *Twittering Machine* (fig. 26-13), it's easy to see why Klee appealed to the Dada artists and Breton: He has presented a nonsensical, childlike dream world that magically captures elemental human emotions. The wiry, playful drawing looks like children's drawing, and the asymmetry and emptiness of the image reflects the way in which a child is willing to put a figure or house anywhere on a page and not worry about surrounding details.

But this is a very sophisticated image, in which Klee has allowed the formal qualities to tell much of his story. The nervous black line creates both an unsettling frenetic quality as well as a joyous whimsical quality. The bleeding of the watercolor as it radiates out in an oval around the "twittering machine" simultaneously evokes a moribund atmospheric quality, as though it were a stain, as well as a spiritual essence, like a halo or mandorla. The open rectangular box at the base of the machine is a spooky void, but from it a divine light seems to emanate. The silly machine of mechanical birds suggests a world gone insane. But the birds also appear threatening, looking like flesh-ripping lures. Using a limited, primitive, even childlike vocabulary, Klee portrays an intimate yet cosmic world that encapsulates a wealth of human emotions, ranging from joy to fear.

Joan Miró The other new artist in Breton's first Surrealist exhibition is Miró (1893–1983). Breton, who functioned as the Pope of Surreal-

26-13 Paul Klee. *Twittering Machine*. 1922. Watercolor and pen and ink on oil-transfer drawing on paper, mounted on cardboard, 25¼ × 19″ (64.1 × 48.3 cm). The Museum of Modern Art, New York

ism, sanctioning who was a Surrealist and who was not, dropped Klee after this show, never mentioning his name again. But Miró was a keeper, remaining in the Surrealist Pantheon for many years. Miró was a Catalan from Barcelona, who in 1920 came to Paris and took a studio next to that of the French artist André Masson. He soon met Breton, whom Masson described as "the future."

Within a short time, Miró abandoned Cubism and began working from his imagination. (Actually, Miró claimed he was working from hallucinations, brought on by starvation—"I was living on a few dry figs a day.")

He also adopted the wiry line and atmospheric quality found in Klee's paintings. Miró's pictures became abstractions of biomorphic (animal- and plantlike) and geometric forms, playing off of occasional straight lines, all set against a minimal color field suggesting a landscape. Like Klee and Ernst, he used bizarre evocative titles that complemented the forms, lending a lyrical primal quality to images that were already poetic: *Dog Barking at the Moon, Person Throwing a Stone at a Bird*, and *Birth of the World*.

Miró's paintings became increasingly abstract in the 1920s and 1930s, as seen in

Composition (fig. 26-14), a 1933 oil. This picture was one in a series based on collages on cardboard that he had made of miscellaneous objects and figures cut out of magazines, with the idea that the shape and even details of the objects would fire his imagination. The setting is a hazy atmospheric environment of washes, suggesting a primordial landscape. Strange curvilinear floating forms populate this eerie world. They simultaneously suggest primeval and microscopic creatures, as well as spirits, ghosts, or souls. We can even find a story in places, such as two figures playing with or fighting over a ball in the upper left corner. Or are they? And are they even figures? Regardless, they suggest play or fighting, as others express sex, frolic, struggle, and fear. Miró has used a minimal vocabulary, which includes color as well as form, to create a mythic image expressing primal conditions, conditions that have existed since the beginning of life and run through all life forms, from those invisible to the naked eye to the human being.

Max Ernst Spurred by the Surrealist quest to tap in to the unconscious, Ernst in 1925 developed a new device to spark his imagi-

nation—frottage. Frottage consisted of rubbing graphite over paper placed on an object, like floor boards, chair canning, and pressed flowers, and then divining in the irregular pattern of wood grain or botanic geometry an image, which often turned out to be a primeval forests, birds, animals, and creatures. More than any other Surrealist, with the exception perhaps of Man Ray, Ernst worked in a range of styles. In the late 1930s, for example, Ernst started working with decalcomania, a technique that uses pressure to transfer diluted oil paint to canvas from some other surface, creating a highly suggestive irregular texture, which Ernst then developed into an illusionistic picture. In *L'habillment de l'epousee (de la mariee)*, *(Attirement of the Bride)* (fig. 26-15) of 1940, he used this technique to create hair and robe, its bizarre texture disconcertingly contrasting with the illusionistic style used in the rest of the image, as seen in the seventeenth-century Dutch floor (see fig. 18-19), and the skewered de Chirico perspective (see fig. 25-16). The phallic spear, monstrous bird and bride, four-breasted pot-bellied indescribable thing on the floor, and mirroring picture on the wall make this real

scene unreal, and charge it with a disconcerting psychology of violence and sex.

SURREALISTIC SCULPTURE IN PARIS

By 1930, the terms for Surrealist art had pretty much been firmed up, with the work falling between two poles. One is represented by the biomorphic abstraction of Miró, which exposes the elemental forces residing behind appearance. At the other pole was the representational dream imagery of Ernst, which combined disassociated objects to create new realities.

Jacques Lipchitz The pull of Surrealism was so great that even a classical Cubist sculptor like Jacques Lipchitz could be pulled into its orbit momentarily, although he never exhibited with the Surrealists or was associated with them in the 1920s. In his *Figure* (fig. 26-16), begun in 1926 but not finished until 1930, we can see a residue of the artist's Cubism from the previous decade, for the figure is analyzed in terms of simple geometric forms. But now, influenced by the Surrealist's interpretations of tribal art, Lipchitz strives to create a primitive figure. The work is frozen and totemlike, the face is a tribal mask, and almost every form seems hieroglyphic, including the vaginal oval, pierced from below by a phallic spear-shaped cavity. The body's openings, which would be appropriate to indicate arms and legs but simultaneously define torso, give the figure an intangible quality (compare to Picasso's *Head of a Woman*, fig. 26-12), suggesting we are witnessing some unseen human essence as opposed to outward appearances. The work has a sense of ritual and of capturing timeless primordial urges.

Jean (Hans) Arp The sculptor who comes closest to reflecting the Miró's abstract animal- and plantlike forms was Jean (Hans) Arp (see above, Zurich Dada). In the early 1930s Arp began making what he called his *Human Concretions* (fig. 26-17), a term that he used to indicate that the sculptures were not abstractions of real forms but real forms *in themselves* that in a long careful process he shaped in plaster. The organic quality and simplicity of the sculptures reminds us of Brancusi (see figs. 25-20 and 25-21), but with a difference. Unlike Brancusi's minimized

26-15 Max Ernst. *L'habillment de l'epousee (de la mariee), (Attirement of the Bride).* 1940. Oil on canvas, 51 × 37⅞" (129.6 × 96.3 cm). The Solomon R. Guggenheim Foundation, New York, Peggy Guggenheim Collection, Venice, 1976. 76.2553.78

© 2004 Artists Rights Society (ARS), New York/ADAGP, Paris

26-16 Jacques Lipchitz. *Figure.* 1926–30 (cast 1937). Bronze, height 7'1¼" (2.17 m). The Museum of Modern Art, New York, Van Gogh Purchase Fund

Art © Jacques Lipchitz/Licensed by VAGA,New York, NY

26-20 Barbara Hepworth. *Sculpture with Color (Deep Blue and Red)*. 1940–42. Wood, painted white and blue, with red strings, on a wooden base, 11 × 10 × 145″ (27.9 × 26 cm). Collection Bowness, Hepworth Estate, London

cottage overlooking St. Ives Bay in Cornwall with the outbreak of war in 1939. Her sculpture was a personal response to nature, as can be seen in *Sculpture with Color (Deep Blue and Red)*, (fig. 26-20) of 1940–42. The ovate form, reminiscent of Brancusi's heads and newborns, is an elemental shape, obviously suggesting an egg, which in turn brings to mind fertility and birth. The carving of the wood is miraculously perfect, giving it a purity reinforced by the sanctity of the white paint. The bright white of the shell heightens the mystery of the dark cavity, which harbors a sky or water of deep blue. The stretched red strings have the intensity of the sun's rays and perpetual energy of life forces. Or in another reading as Hepworth herself said, "the tension" she felt between herself and nature.

REPRESENTATIONAL SURREALISM

The other pole of Surrealism is the representational pole, as seen in Ernst's *La Toilette de la Mariée*. Perhaps the best-known representational Surrealist today is René Magritte, a Belgium artist working in Paris in the late 1920s. In his 1928 oil *The False Mirror* (fig. 26-21), he presents us with an uncanny close-up of an eye, in which we see the reflection of a sky. The iris is transformed into an eerie eclipsed sun. Behind it we sense lies the unconscious, which perceives the reality of things, as opposed to the eye, which only sees their false appearance. Many artists went back and forth between the two poles of Surrealism, like Man Ray, who one day could make representational work and the next abstract. Even Miró practiced both, for he made a body of sculpture that consisted of representational assemblages of unrelated found objects, poetically juxtaposed in order to trigger the imagination to find new and higher meanings in them. Some representational Surrealists transformed common objects to endow them with what Breton called the marvelous. Meret Oppenheim, a young Swiss artist in Paris, did exactly that.

Meret Oppenheim Meret Oppenheim's *Object (Luncheon in Fur)* (fig. 26-22) of 1936 has virtually become an emblem for Surrealism. Here we see the perfect marriage of the real and the dream world to create the surreal. Oppenheim (1913–1985) was a Swiss artist

the stone), composed of the same universal forces. Adding to the mystical aura is Moore's brilliant play of solid and void, each having the same weight in the composition. The sculpture evokes the womblike mystery of caves and tidal pools in seashore rocks. The hole at the feet or pelvis is not just symbolically sexual but magical, suggesting a mystical rite of passage. Without overt symbolism, Moore, in this sculpture that looks like it dates to the time of Stonehenge, has given us one of the most extraordinary earth goddess or fertility figures in the history of art. Like the Surrealists, he believed in the marvelous residing in the ordinary, submerged below the appearance of things.

Barbara Hepworth traveled to Paris in the 1930s, visiting the studios of Arp and Brancusi and meeting Picasso and Mondrian in 1932. Like Moore, who was at the Leeds School of Art when she was and a life-long friend, she was interested in investing her abstract forms with a sense of the unseen forces of nature. She began investigating the mysterious resonance of the hole in her representational sculpture in the late 1920s, influencing Moore. But after marrying the abstract painter Ben Nicholson, her shapes became abstract and by the mid 1930s were geometric, not organic. Nonetheless, they are filled with mystery, which became even more intensified after she moved to a rural

26-21 René Magritte. *The False Mirror*. 1928. Oil on canvas, 21¼ × 31⅞″ (54 × 81 cm). The Museum of Modern Art, New York

who went to Paris as a 19-year-old in 1932, where her lively personality and boyish beauty quickly endeared her to the Surrealists.

Object deals with Freudian issues of repression, but Oppenheim's genius is in her use of minimal means, covering a cup, saucer, and spoon with gazelle fur to create an object full of sexual references. It is obviously a fetish, filled with eroticism offered and eroticism denied. Individually fur and beverage can be sensual, but juxtaposed as they are here, they become provocatively disquieting, virtually canceling out their individual appeal. The cup receptacle and phallic spoon are simultaneously arousing and repulsive, hard and soft. The gazelle fur makes inert porcelain animalistic and organic, while also suggesting pubic hair. This work of psychological poetry was so perfect Oppenheim could not top it, and suffered a creative block. She returned to Switzerland and took almost two decades to start making art again.

SURREALISM AND PHOTOGRAPHY

Film and photography, which could manipulate reality and create dreamlike sequences, were perfect vehicles for representational Surrealism, although Bréton initially had reservations that a mechanical process capturing the look of the physical world could unlock higher realities.

Eugène Atget In photography (and painting and sculpture as well), Surrealism did not always have to be consciously produced; it could just happen, confirming the Surrealist belief in the marvelous residing behind the appearance of things. Eugène Atget (1857–1927) was a photographer who just happened to make Surrealism happen when he had an entirely different agenda. He was a self-taught commercial photographer, who began specializing in images of Paris and its environs about 1897. His self-proclaimed mission was to document old Paris, which was quickly disappearing with twentieth-century modernization. With blind dedication to his project, he produced some ten thousand prints, despite the lack of a market for them and living in abject poverty.

26-22 Meret Oppenheim. *Object*. 1936. Fur-covered teacup, saucer and spoon; diameter of cup 4¾″ (12.1 cm); diameter of saucer 9⅜″ (23.8 cm); length of spoon 8″ (20.3 cm). The Museum of Modern Art, New York

26-23 Eugène Atget. *Pool, Versailles*. 1924. Albumen-silver print, 7 × 9¾″ (17.8 × 23.9 cm). The Museum of Modern Art, New York

Abbott-Levy Collection. Partial gift of Shirley C. Burden

Atget shot his photographs when no one was present, giving the image a desolate quality. The craftsmanship in his prints was extraordinary, and he was able to obtain lush rich textures and the most remarkable range of tones and play of light and shadow. As we can see in *Pool, Versailles* (fig. 26-23) of 1924, his images are dreamlike and magical. Time has stopped, and in the hushed stillness, we can feel the figures in the fountain come alive. The plunging dark tunnel of the trees in the center, the flickering v-pattern of light in the leaves above, and the dramatic curve of the pool subtly animate this still image and give the objects a possessed quality. A strange unexplainable dialogue exists among the statue, the wire fence, brightly lit tree trunks, and the ally. Atget's powerful images, which seem to burrow deep into a distant timeless past, went unnoticed until the 1920s, when Man Ray, among others, became entranced by their otherworldliness and praised their surreal quality.

Henri Cartier-Bresson Surrealism had an enormous impact on many of the major photographers of the period, although most were not members of Breton's circle. In this group is the Frenchman, Henri Cartier-Bresson (1908-2004), who made some of the most extraordinary images of the twentieth century. Cartier-

Bresson is the master of what he termed "the decisive moment": the instant recognition and visual organization of an event at the most intense moment of action and emotion in order to reveal its inner meaning. Using the new hand-held 35mm Leica camera, he accomplished this vision, as can be seen in *Behind the Gare Saint-Lazare* (fig. 26-24) of 1932. Cartier-Bresson made photograph after photograph that miraculously captures the same supernatural magic we see in this fleeting image of a silhouetted man unexplainably suspended in midair. A master of strong value contrasts, he is able to coax strange hieroglyphic shapes to materialize out of the pool of water and, like Atget, establish a powerful eerie dialogue between the various shapes and objects throughout the composition.

Creating Utopias: Geometric Abstraction, Russian Constructivism, Dutch De Stijl, the German Bauhaus, and Purism

While Dada and Surrealism constituted a major force for the period between the wars, there were others major issues. One was the commitment of twentieth-century artists to geometric abstraction. As we have seen, many of the artists in the Surrealist circle worked in an abstract style, and some, like Hepworth, were more involved in organizations dedicated to promoting abstraction. Then there is an artist like Arp, who renounced Surrealism in 1931 and declared himself an abstract artist instead. The label changed, but the essence of the work did not.

Surrealists and abstract artists shared similar social goals: Both groups sought individual freedom, and to accomplish this they advocated undermining bourgeois values, eradicating nationalism, and destroying capitalism and personal privilege to create a classless society. Many, if not most, Dadaists and Surrealists were socialists, with many participating in Communist Party activities if not actually joining the party itself. Abstract artists viewed abstraction as a vehicle for creating a utopian society, and like their Surreal and Dada counterparts, they too were politically to the far left.

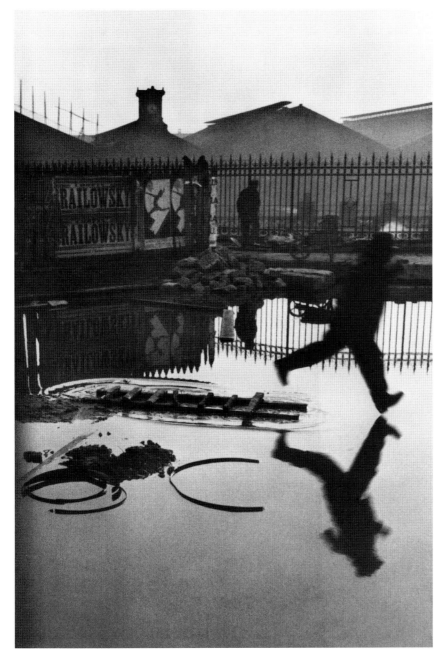

26-24 Henri Cartier-Bresson. *Behind the Gare Saint-Lazare*. 1932. Gelatin silver print

© Henri Cartier-Bresson/Magnum Photos

Two bastions of geometric abstraction emerged simultaneously: Constructivism, which sprang up with the Russian Revolution in 1917, and De Stijl (The Style), which appeared in Amsterdam. A third major center was the Bauhaus in Germany, an art school that emerged in the following decade and was often dominated by Constructivist refugees from Russia, or heavily influenced by it, and by de Stijl. There was a fair amount of cross-fertilization among all three as the principal figures communicated regularly.

RUSSIAN CONSTRUCTIVISM

Vladimir Tatlin As Malevich was developing his Suprematist painting (see page 546), a fellow Russian, Vladimir Tatlin (1885–1953), was in Berlin and Paris. In Paris, he visited Picasso's studio and saw his constructions (see page 543). Upon returning to Russia, he made his own constructed reliefs, using cardboard, wood, and metal covered with a variety of materials, including glazes, glass, and plaster. Unlike Picasso's constructions, which were musical instruments, Tatlin's were entirely nonobjective. Tatlin's constructions spawned

an entire movement in Russia, which in 1922 was formally called Constructivism.

In part, Tatlin's abstraction was based on what he called a "truth to materials," a belief that each material dictates forms that are inherent to it and that these laws must be followed if the work of art is to be valid according to the laws of life itself. He believed, for example, that wood structurally lent itself to flat planes, glass to curves, and metal to cylinders and cones. In 1915 he made what he called Counter-Reliefs, some of which, like Malevich's *Black Square on White* (see pages 545-46), were installed high across a corner of a room, like a Russian icon (Tatlin began his career as an icon painter). Running from one wall to the next, the sculptures began to become environmental, coming out into the room, as opposed to merely reliefs on a single wall. Unlike Malevich, however, there was no spiritual content intended in the sculpture. Because of the ephemeral nature of his material, virtually none of this early works exists.

With the October Revolution, Tatlin, like almost all of the avant-garde artists, avidly embraced Communism and focused his efforts on supporting the party's goal of creating a utopian society. He worked for the Soviet Education Commisariate and turned his attention to architecture and

engineering. One of the most important aspects of his teachings is his complete acceptance of the functionalism of machinery, the quality of mass-produced objects, and the efficiency of industrial materials. Technological modernity was the future and new religion. Tatlin believed that industrial efficiency and materials should be incorporated into art, design, and architecture, where they would produce a new and better world, one that was classless. This new aesthetic called for art, objects, and buildings to be machinelike and streamlined, with form following function and objects stripped of all ornamentation, which was associated with bourgeois and aristocratic ostentation. The social revolution had to be complemented with an aesthetic revolution, that similarly established a utopian classless society.

Tatlin's one famous project was his *Project for "Monument to the Third International"* (fig. 26-25), begun in 1919 and exhibited in Petrograd (St. Petersburg) and Moscow in December 1920. Had the full-scale project been built, it would have been approximately 1,300 feet high, much taller than the Eiffel Tower and the biggest sculptural form ever conceived at that time. It was to have been a metal spiral frame tilted at an angle and encompassing a glass cylinder, cube, and cone. These glass units, housing conferences and meetings, were to revolve, making a complete revolution once a year, once a month, and once a day, respectively. The industrial materials of iron and glass and the dynamic, kinetic nature of the work symbolized the new machine age. The tower was to function as a propaganda center for the Communist Third International, an organization devoted to the support of world revolution, and its rotating, ascending spiral form was a symbol of the aspirations of communism and, more generally, of the new era. It anticipated, and in scale transcended, all subsequent developments in constructed sculpture encompassing space, environment, and motion, and has come to embody the ideals of Constructivism. And because the monument was designed for a building associated with the Bolshevik government, Constructivism was perceived by the Western world as the official style of Communism.

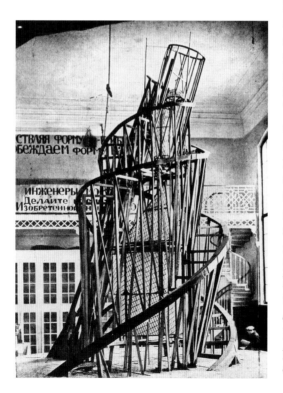

26-25 Vladimir Tatlin. *Project for "Monument to the Third International."* 1919–20. Wood, iron, and glass, height 20′ (6.10 m). Destroyed; contemporary photograph

Art © Vladimir Tatlin/Licensed by VAGA, NY

DE STIJL IN AMSTERDAM

In 1917 in Amsterdam, Piet Mondrian (1872-1944) founded a movement called De Stijl with painter Theo van Doesburg, architect Gerrit Rietveld, and several other artists and architects. They did not have the backing of a revolutionary government like the Constructivists, yet their goal was every bit as radical and utopian, for the De Stijl artists sought to create, through abstraction, total environments that were so perfect they embodied a universal harmony. Unlike their Russian counterparts, their mission was literally spiritual, for it was driven by Mondrian's and van Doesburg's intense commitment to theosophy, the belief in a spiritual force underlying the universe and uniting all things (see page 532). For them, De Stijl was not art but religion. Like the communists, they sought a universal order that would make nationalism obsolete, and hence referred to their style as the International Style. (As we'll see in chapter 28, in 1932 this term would be applied to a new architecture of glass and steel that was modern, pure, and universal. It had no national identification.)

Mondrian published his theory in a series of articles in the group's magazine, also called *De Stijl*. His philosophy was predicated on his deep belief in theosophy, which predates his move to Paris in 1910. After returning to neutral Amsterdam during the war, he was further influenced by the ideas of M. H. J. Schoemaeker. Schoemaeker argued that the structure of the universe was based on the geometry of the rectangle, which united all natural forms. His theory, which he called Neo-Plasticism, assigned specific meanings to primary colors: yellow symbolized the vertical movement of the sun's rays, blue was the horizontal line of the earth's orbit around the sun, and red embodied the union of both.

Following Shoemaeker's lead, Mondrian called his painting Neo-Plasticism, meaning new plasticism. By "plastic" in painting, Mondrian meant that the world of the painting had a plastic, or three-dimensional, reality of its own that was identical to the harmonious plastic reality of the universe. In other words, he sought to replicate in his art the same underlying structure of the universe. Beginning in 1917, Mondrian struggled to achieve this, and only succeeded upon returning to Paris in 1920. Once

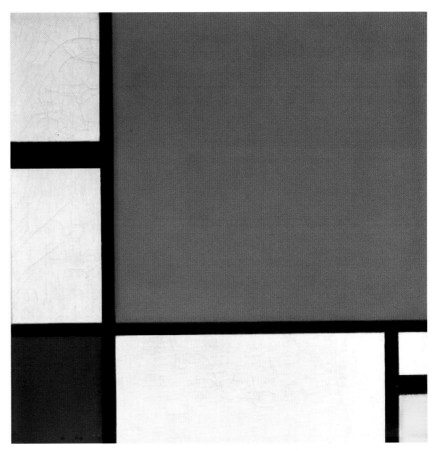

26-26 Piet Mondrian. *Composition with Red, Blue, and Yellow*. 1930. Oil on canvas, 20 × 20″ (50.8 × 50.8 cm). Private Collection
Courtesy of the Mondrian Estate/Holtzman Trust/MBI NY

establishing his style, he pretty much retained it for the rest of his life, as seen in *Composition with Red, Blue, and Yellow* (fig. 26-26) of 1930. His paintings are remarkable for their perfect harmony, which he intuited and carefully hand-painted so that they feel organic, rather than hard-edge and geometric, as they appear in reproductions. Mondrian has very precisely given every element in the painting equal weight. Every line and every rectangle in his perfectly square canvas is given its own identity. Even line exists in its own right, not as a means of defining the color rectangles. (The thickness of the lines often varies in his paintings, a function of having individual identity.) Every component of the painting sits on the same plane on the surface; there is no foreground or background, no one object sitting on top of another. Despite this perfectly interlocking surface, the painting has a feeling of tremendous space, of infinity even, largely due to the rectangles expanding beyond the edge of the

canvas. Space and mass have merged into a harmonious whole. Miraculously, Mondrian has suggested the complexity of the universe, the individuality of all of its infinite components, and the harmony that unites all of these disparate elements.

Mondrian did endless variations of these motifs. Even the color did not change, since these elementary colors were symbolic of the building blocks of the universe, which Calder immediately recognized upon stepping into Mondrian's studio. But in principle, painting was not the end product of Mondrian's aesthetic program. It was, he thought, just a stop-gap measure until perfect abstract environments of architecture, furniture, and objects embodying all of these same principles could be achieved. But until then, the world needed his painting.

THE BAUHAUS

Most Dadaists, Surrealists, and Geometric Abstract painters were socialists or communists who looked to Russian communism to save the world from bourgeois

26-27 László Moholy-Nagy. *Light-Space Modulator*. 1922–30. Kinetic sculpture of steel, plastic, wood, and other materials with electric motor, 59½ × 27½ × 27½" (151.1 × 69.9 × 69.9 cm). Busch-Reisinger Museum, Harvard University Art Museums, Cambridge, Massachusetts

decadence and establish a worldwide utopian society. They flocked to Berlin in 1922 to see the First Russian Art Exhibition, which presented the Constructivists for the first time in the West. Twice more that year, the avant-garde met in Germany, attempting to commit to a social program that would put art at the service of reconstructing society. All of these attempts came to naught. Instead, it was a design school in Weimar, Germany, called the Bauhaus that gradually emerged as the strongest center for bringing about social progress through art.

Founded in Weimar, Germany, in 1919 by the architect Walter Gropius (see pages 627-28), the Bauhaus was dedicated to creating the "new man" through the marriage of art and technology. Its goals were to combine the fine, decorative, and applied arts, giving them equal weight. The artists themselves were called artisan/craftspeople, and their mission was to create a total abstract environment of the most progressive modernity. Gropius and others on the faculty based the design ethic of the Bauhaus on "the living environment of machines and vehicles." Only "primary forms and colours" could be used, all in the service of creating "standard types for all practical commodities of everyday use as a social necessity." Like De Stijl, this was a philosophy oriented toward environments, not painting and sculpture, and the Bauhaus is more associated with the aluminum tubular chairs of architect Marcel Breuer and the abstract textiles of Anni Albers than the paintings of Klee, Kandinsky, and Josef Albers, who also taught at the school. In fact, Gropius saw the painters as providing a spiritual component for the school.

One of the most powerful figures at the Bauhaus was László Moholy-Nagy, a Hungarian, and dedicated Constructivist. Working with high-tech materials or materials that seemed high-tech, he was especially interested in studying light and space, as can be seen in his kinetic Constructivist sculpture *Light-Space Modulator* (fig. 26-27). Made of plastic and reflective metals and propelled by an electric motor, the work projected an ever-changing light onto the environment. It has no strong social program, other than a religious dedication to science and machines. In some respects, the *Light-Space Modulator* was less an end in its own right

than a way to observe and learn about new uses of light and space, which could then be applied to environmental and stage lighting. With the closing of the Bauhaus and the rise of Hitler's Third Reich, Moholy-Nagy immigrated to the United States, establishing the New Bauhaus in Chicago, which became one of the most advanced centers for design in the world.

FERNAND LÉGER AND PURISM

The passionate belief in the superiority of the machine and technology had an impact on the development of Cubism as well. In a manifesto, *After Cubism* (1918), two Paris-based painters, Amédée Ozenfant and Charles-Édouard Jeanneret (who, as an architect, used the name Le Corbusier) faulted the style for being empty and decorative; they called, instead, for an art that embraced the functional precision of machinery. They developed a style, which they called Purism, that reduced objects to hard-edge, geometric forms. Fernand Léger was a well-established Cubist whose painting became increasingly machinelike in the early 1920s, paralleling the emergence of Purism. Léger had no affiliation with Purism, but Purist theories must have interested him, for he was a rabid socialist, who supported utopian visions of the world.

Léger's *Three Women (Le Grand Déjeuner)* (fig. 26-28) of 1921 reflects the period's increasing interest in embracing the machine-made as a symbol of harmony and perfection. This enormous painting presents an emotionless, frozen image. A powerful geometry dominates the painting, aligning all of the forms within a vertical and horizontal grid. The organic figures are constructions of circles, cylinders, and ovals. Their hair looks like machine-stamped sheets of rubber or felt, its shape echoing the undulating geometric pattern found in the curtains in the background. Léger has used mainly primary and secondary colors, reinforcing the simple building-block composition of the image. This reduced palette, along with the asymmetrical play of horizontals and verticals and the use of black lines, gives *Three Women* the look of being a representational Mondrian. Here Léger has created a painting of monumental classical nudes, but instead of being organic, they look more like the machine-made products designed at the Bauhaus while existing in a harmonious world of a Mondrian painting.

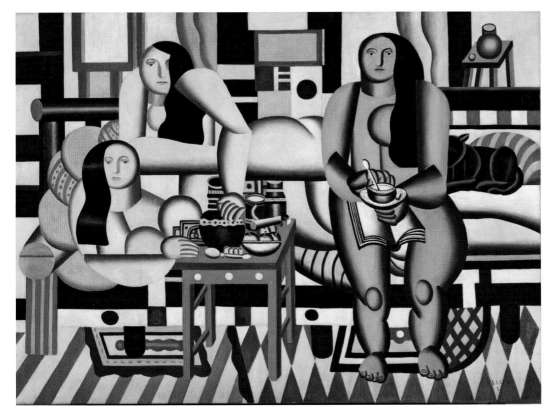

26-28 Fernand Léger. *Three Women (Le Grand Déjeuner).* 1921. Oil on canvas, 6'1¼" × 8'3" (1.8 × 2.5 m). The Museum of Modern Art, New York

Art In America

THE MACHINE AGE

Arriving in New York harbor for the first time in 1915, Marcel Duchamp marveled at the towering skyscrapers and pronounced them the epitome of modernity and America the future of art. The skyscraper and industry

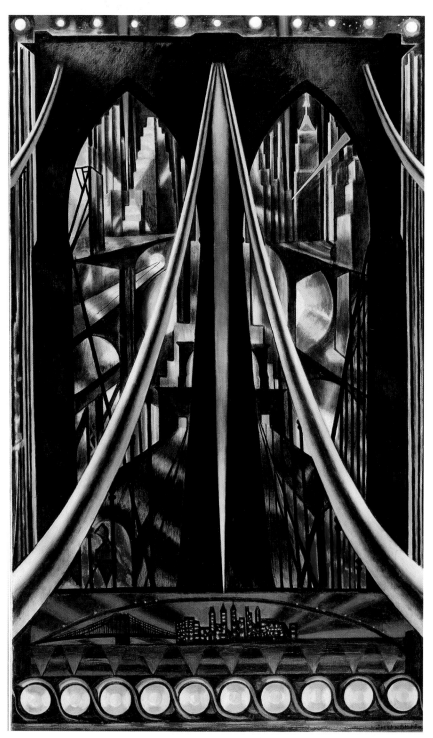

26-29 Joseph Stella. *The Brooklyn Bridge: Variation on an Old Theme.* 1939. Oil on canvas, 70 × 42″ (177.8 × 106.68 cm). Whitney Museum of American Art, New York. Purchase 42.15. Photograph by Geoffrey Clements

did indeed become the emblems of America, replacing landscape, which had dominated painting in the nineteenth century. They represented America's technological and financial superiority, for the United States entered the twentieth century as the wealthiest and most modern country in the world. By the end of World War I, it was the most powerful nation as well. The war fueled the economy, ushering in an era of unprecedented consumerism and materialism. Known as the Roaring Twenties and the Jazz Age, it was dominated by the culture of the city, for by 1920 more people lived in cities than in the countryside.

A more revealing statistic of America's prosperity and technological superiority was that in 1930 more cars were registered in New York City than in all of Europe. The symbol of the nation was New York, and the symbol of the city was the skyscraper. Beginning in the late teens, these cathedrals of capitalism became the favorite subject for painters and photographers (even some sculptors, designers, and furniture makers), who presented the icon in all its technological splendor. Skyscrapers were shown soaring toward the heavens without a hint of the streets or humanity below. Bridges, factories, dams, refineries, anything that demonstrated America's advanced modernity, were transformed into monuments as grand as the pyramids of Egypt and as sacred as the Gothic cathedrals of France.

Joseph Stella (1877–1946) This new subject in American art can be seen in Joseph Stella's *Brooklyn Bridge* (fig. 26-29) of 1939, a theme this Italian immigrant painted time and time again, beginning in the 1910s. The picture pays homage to what then was considered the eighth wonder of the world, for no one ever imagined that a bridge could be built to span the East River, especially one with two railroad tracks in addition to roadways and a grand pedestrian walkway. Some 30 years after its opening, the modern world was still awed by this magnificent structure, which was a major tourist attraction. Stella had returned to his native Italy in the early 1910s, just in time to meet the Futurists, and clearly he has adopted their fractured Cubism to energize his image, which consists of a set of twin-arched piers, suspension cables, railroad cars, and fragments of the structure

supporting the tracks and walkways. The dominating silhouette of the twin Gothic arches, however, gives the picture a monumentality that is foreign to Futurism, even Cubism.

By depicting the bridge at night, Stella was able to show another attribute of American superiority, the pervasiveness of electricity, which illuminated New York as no other city in the world. Here, lights mounted on Manhattan's glorious skyscrapers illuminate the night sky, while the buildings seem to glow from within. One powerful beacon light dramatically divides the grand silhouetted arches from the skyline below. Stella also used the night setting because it gave him an opportunity to play with the green and red reflections of the train signals and lights. It also allowed him to work with dark saturated colors, which when combined with his black line drawing, transformed the painting into a medieval stained-glass window. The religious reference is reinforced by the predella (see page 241), which includes a futuristic bridge spanning the row of train lights at the bottom. Stella is proclaiming technology the new religion.

Paul Strand Photography was especially well suited for capturing the triumphs of the machine age. However, the first photographs of modern New York from the 1890s and 1910s romanticized the city by immersing it in a soft pictorialist mist. A breakthrough occurred when the young Paul Strand (1890–1976) from 1915 to 1917 made a brilliant body of work of crisp hard-edged photographs. Stieglitz immediately recognized their importance and showed a selection at his gallery, "291." A fine example is *Wire Wheel* (fig. 26-30) of 1917, which is a detail of a Model A Ford, an icon of the machine age since it marked the advent of the assembly line. It not only reflects a new aesthetic in photography, but also is remarkable for its skewered perspective and tight cropping. The image becomes just a close-up, making it difficult to read. Its flattening and complicated space resemble Cubist painting. Strand had been a regular visitor to Stieglitz's "291" since 1907, and was quite familiar with Picasso's work; we can assume that he was challenged by the space and composition of his works.

Margaret Bourke-White The impact of Strand's aesthetic was far reaching, trans-

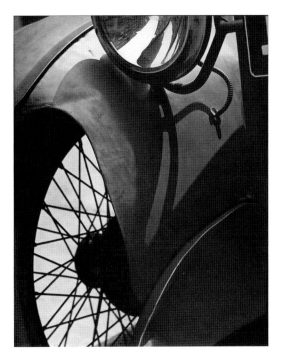

26-30 Paul Strand. *Wire Wheel*. 1917. Platinum print from enlarged negative, 12⅜ × 10¼" (23.2 × 16.5 cm). George Eastman House

forming photography not only in America, but worldwide. It was especially appropriate for technological and industrial images, reinforcing the machine-made precision of the subject. Because it could capture minute detail, it was great for social realism and was adopted by photojournalists, such as Margaret Bourke-White (1904–1971). Her *Fort Peck Dam, Montana* (fig. 26-31) became the cover image for the very first issue of *Life*, November 23, 1936. Bourke-White's photograph, like Strand's of the Model A Ford, presents an icon of American technology.

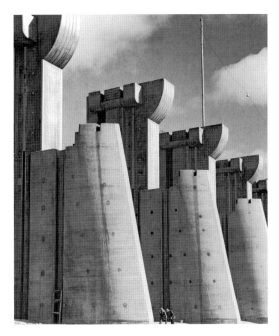

26-31 Margaret Bourke-White. *Fort Peck Dam, Montana*. 1936. Time-Life, Inc.

But it was also a social photograph, for it illustrated an article about how the projects of President Franklin Roosevelt's New Deal administration were providing jobs for the masses of unemployed. (Notice the workers in the foreground of the photo.) But the power of the image lies in the gargantuan austere mass of the unfinished dam, a towering monument to American ingenuity.

THE SEARCH FOR SPIRITUALITY

In the 1910s, much of the American cultural community turned its attention to creating an American art. Writers, musicians, artists, and poets all felt that American culture was derived from Europe; now they would seek to discover what was unique about the American experience and how to express it in an indigenous way. For some artists, like Stella in the *Brooklyn Bridge*, the answer could be found in American modernity. Others looked to nature. Stieglitz became preoccupied with this issue of an American art, deciding in the 1920s to represent only American artists and naming his last gallery, which he opened in 1928, An American Place. Stieglitz himself became increasingly intolerant of modernity, not buying a radio or a car, and like so many at the time shunning materialism to seek a spirituality in modern-day America. Stieglitz had published sections of Kandinsky's *Concerning the Spiritual in Art* in *Camera Work*, and the essay had a tremendous impact on American artists, although most, including Stieglitz, did not become theosophists.

Georgia O'Keeffe The artists that Stieglitz showed from the early 1920s until his death in 1946 generally, but not always, preoccupied themselves with this issue of seeking, in the modern world, the higher meaning of life. One was Georgia O'Keeffe (1887–1986), whom he became romantically involved with in 1918 and later married. When Stieglitz first showed her in 1916, she was painting abstract watercolors that evoked landscape. In the early 1920s, her presentation of nature evolved into close-ups of flowers, as seen in *Black Iris III* (fig. 26-32) of 1926, where the image is so magnified it becomes abstract. The flower is redolent of female sexuality, as the forms morph into parts of a woman's body. The petals ethereally dissipate into their surroundings, becoming one with the rest of nature.

Partly because of Stieglitz's marketing, critics described her as woman artist who was painting the womb and emotions only a woman could feel. (Flowers, of course, have always been an attribute of women.) This, in their view, accounted for her overt presentation of sex, which the new loose morality of the Roaring Twenties could accommodate. This patronizing interpretation outraged O'Keeffe, who claimed her flower pictures were not about sexuality per se. And they are not. Like the banned sexually explicit novels of her friend the English author D. H. Lawrence, with whom she and Stieglitz had regular correspondence, her paintings were not about lust but the surg-

26-32 Georgia O'Keeffe. *Black Iris III*. 1926. Oil on canvas, 36 × 29⅞" (91.4 × 75.9 cm). The Metropolitan Museum of Art, New York, The Alfred Stieglitz Collection, 1949

ing uncontainable force of nature, which includes procreation. Sexuality was portrayed as being as natural, beautiful, and essential as a flowering blossoming, disseminating pollen, and procreating. And if her wonderful organic flower begins to take on the quality of other objects, such as clouds, smoke, buttocks, and flesh, it only increases the sense of the universal equivalence that she believed ran through all things. In this microcosm of a close-up of an iris, O'Keeffe has given us a macrocosm so large it encompasses the entire universe.

Edward Weston We do not have to look far to find the pictorial source for O'Keeffe: Paul Strand. O'Keeffe briefly loved the young and handsome Strand in 1917 and was amazed by the power of his photography, especially the close-ups. Due to both Strand and O'Keeffe, the close-up became a popular device with both painters and photographers in the 1920s, and in the hands of most artists it had the same spiritual dimensions found in O'Keeffe's paintings. Edward Weston's (1886–1958) *Pepper* (fig. 26-33) of 1930 falls into this category, as the rippling gnarled vegetable is transformed through lighting and cropping to resemble in some places a curled up figure (the back facing the upper right corner, buttocks to the lower right) and in other places breasts, arms, and so on.

Ansel Adams Weston worked primarily in California, but any serious artist, especially a photographer, followed Stieglitz and his circle and was familiar with the issues they were raising. Most were in direct contact with him and O'Keeffe, as was the case with the Californian Ansel Adams. Adams had discovered the majesty of Yosemite National Park on his own in the 1920s, where he was guide and custodian. But the preoccupation of so many artists to uncover something spiritual in the modern world where the skyscraper, electricity, and money were king certainly had to have reinforced his interest in photographing Yosemite. His many close-up abstract photographs of rock, cliff, and ice formations or of tree bark and branches reflect his understanding of O'Keeffe's work, which he so much admired.

Adams' most famous photograph, *Moonrise, Hernandez, New Mexico* (fig. 26-34) of 1941, clearly states his belief in the spiritual. Here he has set up a powerful symbolic scene by juxtaposing on the one hand, a cemetery, village, and church perilously isolated in a desert, and on the other, distant beckoning mountain peaks surmounted by angelic whips of clouds and a mystical pull of a full moon. Adams had a great eye that allowed him to visualize his finished product through the lens. He knew,

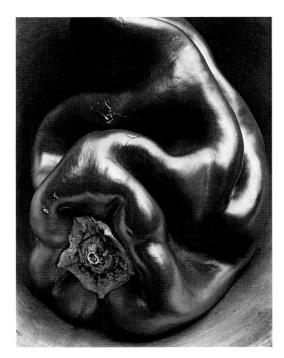

26-33 Edward Weston. *Pepper*. 1930. Gelatin silver print. Center for Creative Photograph, Tucson, Arizona

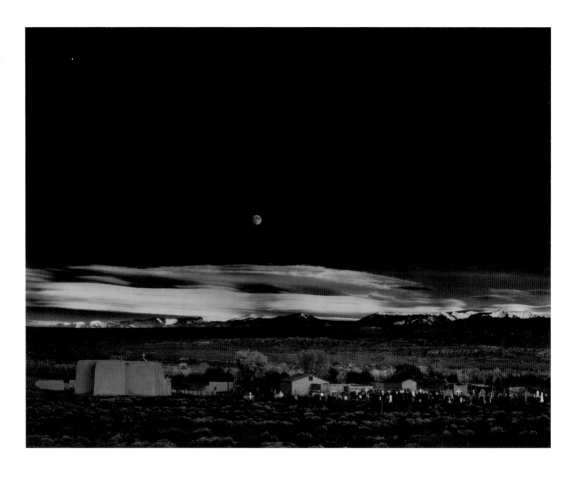

26-34 Ansel Adams. *Moonrise, Hernandez, New Mexico.* 1941. Gelatin silver print, 15 × 18½" (38.1 × 47 cm). Center for Creative Photography, Tucson, Arizona

almost instinctively which aperture and exposure time would generate his magnificent darks and lights, which make his images so spiritual.

Alfred Stieglitz In 1922, influenced by O'Keeffe's spiritual magnifications of flowers and landscapes, Stieglitz began a series of photographs of the night sky, which he called *Equivalent* (fig. 26-35). The title is a reference to nature embodying a spirituality that Stieglitz himself could feel that in turn transcended through him and into the photograph. The images are abstract the way that emotion and spirituality are abstract. And of course, it is no accident that the motif that Stieglitz selected to represent the spiritual is the sky, since traditionally it has been a symbol of infinity and transcendence. Part of the impact of these prints is their scale: they are 4⅝ × 3⅝ inches. Their diminutive size allows for an intense richness of darks, and since the entire series is set at night with moonlight filtering through clouds, the prints are predominantly dark. The magic of these tiny images is their density: we feel as though the entire universe has been concentrated into mere few square inches.

The Eve of War: The 1930s

The 1930s are generally portrayed as a bleak period of conservatism. The decade seems to have begun in October 1929 when the stock market crashed, ushering in the Great Depression that soon fanned out around the globe. The depravation it inflicted lasted an excruciating 16 years. In Europe and Asia, fascists rose to power—Mussolini in Italy, Hitler in Germany, and Franco in Spain. In a sense, even Russia had become totalitarian with the emergence of Stalin in the late 1920s. In 1931 Japan invaded continental Asia. The utopian dream of Dada, Surrealism, De Stijl, Constructivism, and the Bauhaus was just that, a dream. Hitler closed the Bauhaus in 1933, and in 1937, the Nazis staged a *Degenerate Art Exhibition* in Munich, denigrating German avant-garde artists in full public view. In America, social realism and representational regional art gained at the expense of the avant-garde. While the regionalists, like Grant Wood (see fig. I-5) and Thomas Hart Benton, painted stoic or energized scenes glori-

fying America's rural life and history, others focused on urban problems.

THE UNITED STATES: THE FAILURE OF MODERNITY

Edward Hopper Perhaps the most powerful realist painter from the period was Edward Hopper (1882–1967), who worked in New York. His pictures are saturated with the alienation associated with life in the big city, and more generally with modern America. A classic Hopper is *Early Sunday Morning* (fig. 26-36) of 1930. The image is frightening in its quietude and desolation, qualities reinforced by the severe frozen geometry of the composition. The second-floor windows suggest a different story for each apartment, but none is forthcoming as their inhabitants remain secreted behind curtains and shades. A strange relationship exists among fire hydrant, barbershop pole, and the void of the square awning-framed window between them. The harsh morning light has a theatrical intensity. Hopper's only love outside of art was film and the theater, and his paintings have a cinematic and staged quality that intimates that something is about to happen. His pictures are shrouded in mystery, and because their settings are distinctly American, the dreary psychology he portrays within them becomes distinctly American as well.

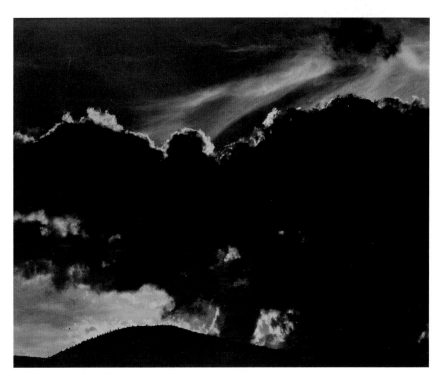

26-35 Alfred Stieglitz. *Equivalent*. 1926. Chloride print, 4¾ × 3¾" (11.6 × 9.2 cm). The Art Institute of Chicago, Alfred Stieglitz Collection

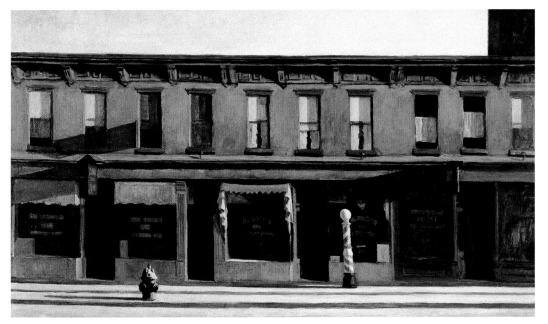

26-36 Edward Hopper. *Early Sunday Morning*. 1930. Oil on canvas, 35 × 60" (88.9 × 152.4 cm). Whitney Museum of American Art. Purchase with funds from Gertrude Vanderbilt Whitney 31.426

Walker Evans The biggest art patron during the Depression was the United States Government, which through the Works Project Administrations and Federal Art Project put tens of thousands of unemployed artists to work. What was so remarkable about these programs was their lack of discrimination, which resulted in support for women and minorities. One especially important project was designed to document the suffering and poverty of both rural and urban Americans. The Farm Security Administration (FSA) hired about 20 photographers to record the desperate conditions and then distributed the photographs to the media.

One of the first photographers hired in 1935 was Walker Evans (1903–1975), who was fired two years later because he was stubbornly difficult and did not make images that *dramatically* portrayed how wretched the conditions were in America. Instead his subtle images focus on the nation's psychology, like Hopper's, showing its gloom and alienation. This can be readily seen in *View of Two-Family Houses and Steel Mill from St. Michael's Graveyard, with*

Cross Headstone in Foreground, Bethlehem, Pennsylvania (fig. 26-37) of 1935, a view of an unpopulated Bethlehem, Pennsylvania, where the crosses in the cemetery, workers' row houses, and treeless industrial landscape of smokestacks and telephone poles conveys the meaningless, rote, empty life of the American worker. In addition to creating a tragic mood, Evans' genius lies in the brilliant formal play of his detailed compositions that subtly pit light against dark and vertical against horizontal.

Dorothea Lange One of the most famous images from the FSA project is Dorothea Lange's *Migrant Mother, California* (fig. 26-38) of 1936. Using the sharp-focus photography innovated by Strand and that had become commonplace by this time, Lange created a powerful image that in its details captures the sitter's destitution, and in its complex composition of hands, arms, and turned heads, their emotional poverty. Because of this photograph and an accompanying news story, the government rushed food to California, and eventually opened relief camps for migrant workers. No paint-

26-37 Walker Evans. *View of Two-Family Houses and Steel Mill from St. Michael's Graveyard, with Cross Headstone in Foreground, Bethlehem, Pennsylvania*, 1935. Film negative 8 × 10 inches. © Walker Evans Archive, The Metropolitan Museum of Art, 1994. (1994.258.753)

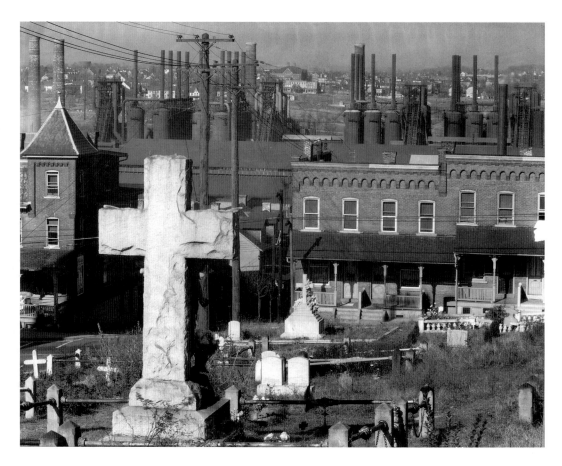

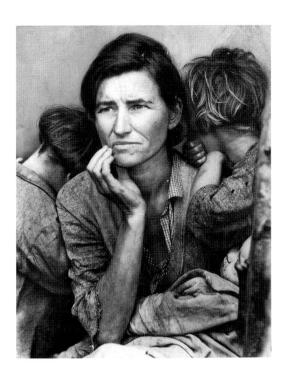

26-38 Dorothea Lange. *Migrant Mother, California.* 1936. Gelatin silver print, Library of Congress, Washington, D.C.

ing or sculpture could match the immediate power of this poignant photograph. It stands as evidence of the undeniable credibility that the medium projects, which in the hands of a great photographer can send a potent message.

EUROPE: ART AND THE RISE OF FASCISM

August Sander Qualitatively, Europe had no parallel to Lange and the other American documentary photographers of the 1930s. But if we want to force an interesting comparison it would have to be with the German, August Sander (1876–1964). In the 1920s, encouraged in part by contact with Johannes Baargeld and Max Ernst (see page 562), he personally set for himself an enormous project of making a portrait of Germany by photographing the different classes of society in their own environments, as opposed to in his commercial portrait studio in Cologne. The presentation of the sitter, and thus the portrait of the nation, was meant to be entirely objective. From his native village of Westerwald near Cologne, he set off on his bicycle with his tripod and enormous box camera finding people willing to pose for him, always allowing them to present themselves as they wished. There was no fancy camerawork, just a straight-on detailed impartial image, as can be seen in *Pastry Cook,*

Cologne (fig. 26-39) of 1928. He then intended to catalogue his images by type, for example, baker, lawyer, factory worker, farm wife, and so on, with the final product being called *People of the 20th Century.* Although he made thousands of prints from his glass negatives, he never finished this ambitious undertaking and only published a

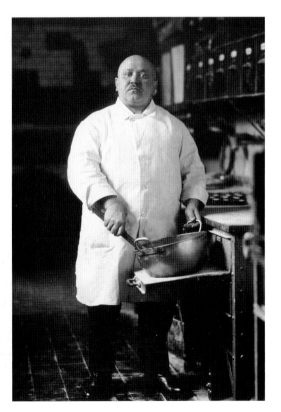

26-39 August Sander. *Pastry Cook, Cologne.* 1928. Gelatin silver print, August Sander Archiv/SK-Stiftung Kultur, Cologne, Germany

© 2004 Die Photographische Sammlung/SK Stiftung Kultur–August Sander Archiv, Cologne, Artists Rights Society (ARS), New York

single book of sixty photographs called *Antlitz der Zeit* (*Face of the Time*) (1929).

Despite his claim to being impartial, he hoped to establish sociological archetypes and probably had the agenda of demonstrating the superiority of the intellectual class, which appears most at-ease and confident in his photographs (and would include him as well). For us, operating from hindsight, the photographs are especially fascinating as a mirror of Germany reconciling itself to the defeat of World War I and gravitating toward fascism. The photographs give no hint of these social issues, as seen in *Pastry Cook*. Here the chef, who obviously likes to indulge in his product, appears uncomfortable posing for the camera; this is something he is not used to doing. He presents himself as humorless, an attitude reinforced by the pristine severity of his white coat, pressed pants, and polished shoes. His soccer-ball head, rotund bulk, huge hands, and stubby legs convey an image of a mindless worker. This honest photograph, like the vast majority of Sander's portraits, does not present the young, trim, blue-eyed and blond Aryan that Hitler believed was going to lead Germany into the future and provide the foundation for the master race. As a result the Nazis

destroyed Sander's glass negatives and the plates for the *Face of Time*.

Max Beckmann Max Beckmann (1884–1950), like George Grosz (fig. 26-5) and many other German artists, are compelling because they reflect the disturbing tenor of Germany in the late twenties and thirties during the rise of fascism. World War I had filled Beckmann with such despair at the state of modern civilization that he became an Expressionist in order to "reproach God for his errors." In the early thirties, he began working in his final style, seen in *Departure* (fig. 26-40) of 1932, which is one of nine enormous triptychs the artist made in the last 20 years of his life. The complex symbolism in the flanking panels represents life itself as seen as an endless misery filled with all kinds of physical and spiritual pain. The bright-colored center panel represents "the King and Queen hav[ing] freed themselves of the torture of life. . . ." Beckmann assigned specific meaning to each action and figure: The woman trying to make her way in the dark with the aid of the lamp is carrying the corpse of her memories, evil deeds, and failures, from which no one can ever be free so long as life beats its drum. But Beckmann

26-40 Max Beckmann. *Departure*. 1932–33. Oil on canvas, The Museum of Modern Art, New York, Given Anonymously (by exchange)

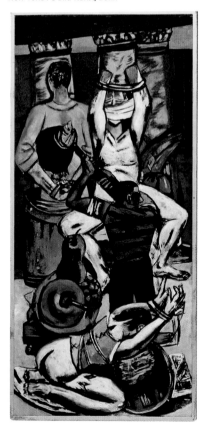
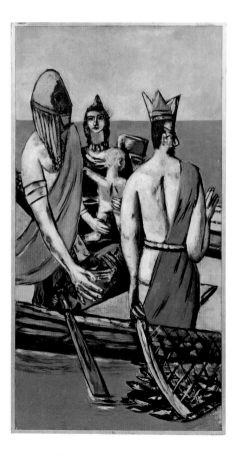
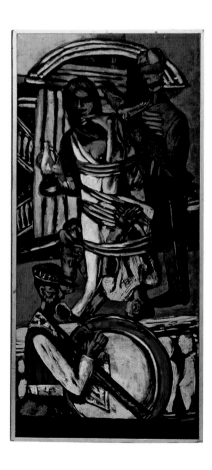

believed that viewers did not have to know his iconography; any interpretation would inevitably be similar to his, at least in spirit, if not in the details.

The triptych's rich allegory and symbolism reflects Beckmann's early study of the old masters and his deep appreciation for the grim disturbing imagery of Grünewald and Bosch (see pages 330-31). But a narrative of mythic proportions also reflects Beckmann's familiarity with Parisian Surrealism. The Frankfurt-based Beckmann was a regular visitor to Paris, and his palette in *Departure* is similar to Picasso's and Matisse's from this period. Beckmann took home more than just color from his visits, for his hell-on-earth nightmare of bizarre and sadistic events relies on disjointed puzzling motifs that parallel the devices found in the dream imagery of the Surrealists (see figs. 26-10 and 26-15).

Not long after Beckmann finished his painting, life itself had become surreal in Germany, for Hitler became chancellor in 1933 when his National Socialist Party won the election. Now, the Nazis turned from bullying and threats to overt violence toward Jews, avant-garde artists, writers and filmmakers, intellectuals, homosexuals—anyone whom they perceived as at odds with the Aryan ideals of the Third Reich. A repressive environment of imprisonment and torture became a fact of daily life, spurring many artists, including Beckmann, to flee to Paris, London, and Amsterdam, and eventually to the United States.

John Heartfield John Heartfield, the Berlin Dadaist who along with Grosz, Hausmann, and Höch, played a seminal role in the development of collage satires about 1920, now took aim at the Nazis, creating some of his best work. *As in the Middle Ages, So in the Third Reich* (fig. 26-41) of 1934 is a wonderful example of his montage technique, which consisted of collaging disparate images together and then photographing them. In this poster he juxtaposes a Nazi victim crucified on a swastika with a Gothic image of the figure of humanity punished for its sins on the wheel of divine judgment. Heartfield was not interested in the original meaning of the Gothic motif; he used it to imply that the Nazis had ruthlessly transported the nation back to the dark barbaric past of the Middle Ages.

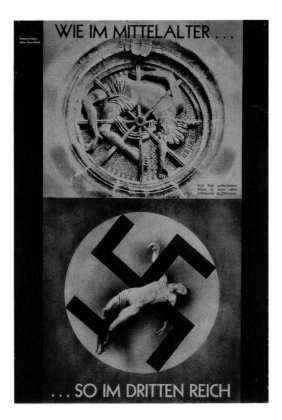

26-41 John Heartfield. *As in the Middle Ages, So in the Third Reich*. 1934. Poster, photomontage. Akademie der Künste, John Heartfield Archiv, Berlin

© 2004 Artists Rights Society (ARS), New York/VG Bild-Kunst, Bonn

Pablo Picasso In 1936 civil war broke out in Spain when conservatives loyal to the king (the Nationalists) tried to overthrow the popularly elected leftist, republican government (the Loyalists). In some ways, it was a rehearsal for World War II. Hitler and Mussolini provided support for the Nationalists, which included monarchists, fascists, and Catholics. The Loyalists consisted of Communists, socialists, and Catalan and Basque separatists as well as the International Brigade, which were volunteers from all over the world. On April 26, 1937, Nazi pilots used saturation bombing to attack the undefended Basque town of Guernica, killing thousands of civilians. Picasso, like most of the free world, was outraged, and responded by painting *Guernica* (fig. 26-42), an enormous black-white-and-gray mural that he exhibited as a protest at the Spanish Republican Pavilion of the 1937 Paris International Exposition. He pulled every artistic device out of his Cubist and Surrealist arsenal to create a nightmarish scene of pain, suffering, and grief. We see no airplanes and no bombs, and the electric light is the only sign of the modernity that made the bombing possible.

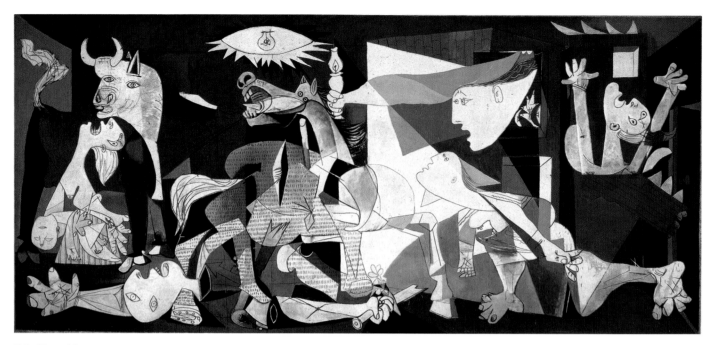

26-42 Pablo Picasso. *Guernica*. 1937. Oil on canvas, 11′6″ × 25′8″ (3.51 × 7.82 m). Museo Nacional Centro de Arte Reina Sofía, Madrid. On permanent loan from the Museo del Prado, Madrid

Photograph by John Bigelow Taylor/© Estate of Pablo Picasso/Artists Rights Society (ARS), New York

The symbolism of the scene resists exact interpretation, despite several traditional elements: the mother and her dead child are descendants of the Pietà (see fig. 11-22), the woman with the lamp vaguely recalls the Statue of Liberty, and the dead fighter's clutching a broken sword is a familiar emblem of heroic resistance (compare fig. 22-23). We also sense the contrast between the menacing, human-faced bull, which we know Picasso intended to represent the forces of brutality and darkness, and the dying horse, which stands for the people.

Picasso insisted, however, that the mural was not a political statement about fascism, and it is interesting that many of the figures were used quite differently in Picasso's earlier work. The horse and bull are motifs from the bullfight, which Picasso had been using since the early thirties as a metaphor for sexual conflict. The huge vulva shaped tear on the side of the horse is certainly not coincidence. Nor is the same sexual orifice on the inside of the sword-holding arm broken off of the classical statue of a soldier. Nor is it coincidence that the flames on the back of the supplicating woman on the right remind us of the sawtooth groin of the sexually aggressive dancer in *Three Dancers* (see fig. 26-10), or that the quarter moon silhouetted against a rooster's

head just beyond her huge flailing breast reminds us of the same dancer's moon-shaped head. And is it coincidence that this figure, who resembles a Mary Magdalene at the cross, also brings to mind Goya's supplicating rebel in the *Third of May* (see fig. 22-02)? Picasso denied that the picture was a political statement about fascism, and if it were not for the title, there is not much to indicate this is not another of his images about the agonizing psychology of sexual conflict that we saw as far back as *Les Demoiselles d'Avignon* (see fig. 25-07) of 1907. As with the *Three Musicians* (see fig. 26-9) of 1921, the scene is even set in a box-shaped room, again suggesting the room of the mind.

But the title cannot be ignored, nor the fallen solider, suffering women and children, and political use of the painting at the International Exposition. When Picasso denied this was an anti-fascist picture, he probably meant in part that this monumental mural was more than just mundane propaganda against Franco, Hitler, and Mussolini. Like Beckmann's *Departure*, we cannot help but feel that this horrifying image is meant to portray the psychology of a world in perpetual conflict and misery, albeit using sexual imagery, but this is what Picasso knew best. In *Guernica*, however, there is no boat to take us away to safety.

Postwar to Postmodern, 1945–1980

T RADITIONALLY, WORLD WAR II IS VIEWED AS A TURNING point for the art world, the time when its focus shifted from Paris to New York. But in fact, the years following the war—the 1950s, were the watershed for the second half of the century. Duchamp's preoccupation with exploring art and how it functions became a driving force as the decade progressed. Many artists became obsessed with the concept that art and image-making were a form of language, and they dedicated their work to revealing the structure of this visual language and the complex ways it can be used to present ideas and opinions, even deceive and manipulate.

Artists also realized that art did not have to be limited to the traditional media, such as oil on canvas or cast bronze or chiseled marble. It did not have to hang on a wall or sit on a pedestal. Anything could be used to make art, and by the late 1950s and 1960s, everything was. Art was made with television sets, film, junk, earth, fluorescent lights, steel tiles, Rhoplex, entire environments, postcards, and words. Performance Art, Earth Art, Conceptual Art, Mail Art, Happenings, and Video Art are just a handful of the movements that appeared from the mid-1950s through the 1970s.

In part, this burst of new media reflects the spirit of liberation that characterized the period, especially in America. World War II ended 16 years of repressive financial depression and deprivation in America, and by the 1950s, the United States had become a nation of consumers. Returning soldiers, eager to resume their lives, married and had children in record numbers, creating the baby-boom generation. They moved from cities to new, affordable suburban tract houses. And, as never before, Americans shopped—for cars, television sets, new labor-saving household appliances, boats, and movie cameras. The period was also characterized by a love of new technology. Nuclear energy and the arms and space races symbolized it on an international level, and Tupperware, stay-pressed synthetic

shirts, Formica, TV dinners, and Naugahyde on the domestic. If it was artificial, and if it was fast, it was good.

The new American lifestyle, however, was not equally available to all. Magazines, newspapers, and television depicted a distinct hierarchy within American democracy, with white males heading up a patriarchal society that viewed women and people of color as less equal. Beatniks, Zen Buddhists, underground improvisational jazz musicians, bikers, and urban gangs of juvenile delinquents established alternative lifestyles in the late 1940s and 1950s. But it was the civil rights movement that first seriously challenged the status quo in the second half of the 1950s, gaining tremendous momentum in the 1960s. Spurred also by the Vietnam War, which many perceived as the misguided concoction of the white-male-led military-industrial complex, the mid-1960s began a period of social upheaval that witnessed the rise of the feminist movement, Gay Pride, Black Power, Gray Power, and such environmental groups as Greenpeace. It was the Age of Aquarius—of flower children, drugs, and free love. It was an age of liberation aimed at shattering the status quo and questioning the validity of any claim to superiority or fixed truth. And in the forefront was art. Conventional painting and sculpture were stripped of their exalted status, freeing art from any

fixed values and allowing it to take on any form artists needed to give it.

But before this artistic revolution occurred, the center of the art world had to be transferred from Paris to New York. This *coup,* often referred to as the "Triumph of New York Painting," occurred with the rise of Abstract Expressionism in the late 1940s.

Existentialism in New York: Abstract Expressionism

Abstract Expressionism evolved out of Surrealism, which traces its roots to Dada of the 1910s (see chapters 25, 26). Like the Surrealists, the Abstract Expressionists were preoccupied with a quest to uncover higher universal truths. In this sense its heritage can be traced back to Kandinsky and Malevich as well (see chapter 25). In many respects, Abstract Expressionism is the culmination of the concerns of the artists of the first half of the century. But they were also driven by a deep-seated belief in Existentialism, a philosophy that came to the fore with the devastation of World War II. The war shattered the faith that had been placed in science, logic, and even the very concept of progress to create a better world. Clearly, these absolute truths had failed. EXISTENTIALISM maintained that there were no absolute truths— no ultimate knowledge, explanations, or answers—and that life was a continuous series of subjective experiences from which each individual learned and correspondingly responded. There were no correct responses, but individuals were nonetheless held responsible for their personal decisions and corresponding actions. Essential to this learning process was facing the most dire aspects of human existence: fear of death, the absurdity of life, and alienation from individuals, society, and even nature. The only way to overcome the anxiety of contemporary life was to confront it. The Abstract Expressionists, like so many intellectuals after the war, embraced this subjective approach to accounting for and experiencing the world. Their art was a personal confrontation with the moment, reflecting both their physical and psychological being.

Although its roots reach back to the nineteenth century, EXISTENTIALISM is regarded as a characteristically mid-twentieth-century response to modern life. An existentialist believes that human beings are not born with an essential nature or a God-within who determines the choices people make; rather, all are painfully free to choose, and each person becomes the sum of his or her choices. Surrounding this existential condition is the inevitability of death, or not-being. Having life at all is a random, absurd fact, and making decisions is all there is to life.

ARSHILE GORKY: THE BRIDGE FROM SURREALISM TO ABSTRACT EXPRESSIONISM

Surrealism dominated New York art in the early 1940s. In late 1936 the seven-year-old Museum of Modern Art mounted a block-buster exhibition *Fantastic Art, Dada, and Surrealism,* which was an eye-opener for New York artists. Those artists not converted then were swayed by the dramatic influx of European artists who fled Europe shortly before and during World War II. André Breton, Marcel Duchamp, André Masson, and Max Ernst were just a few of the legions of artists and intellectuals who sought the safety of Manhattan and were a powerful presence in the art world. Peggy Guggenheim, a flamboyant American mining heiress who had been living in Europe, returned to New York and opened a gallery, Art of This Century. Not only did the gallery feature the Surrealists, it *was* Surrealist: Designed by the German émigré architect Frederick Kiesler, it had dramatic concave walls with the art hung on bizarre devices consisting of flat panels projecting from the wall on baseball-bat-like extensions. The floor was turquoise. Surrealism was everywhere, and New York artists, if they had not been doing so already, began making Miróesque landscapes filled with primeval forms, abstractions filled with primitive-looking hieroglyphic signs, and Picasso-inspired images of psychologically disturbed women.

Just as Dada developed into Surrealism, New York Surrealism seamlessly evolved into Abstract Expressionism. The transformation occurred when all of the symbols and suggestions of myths and primordial conditions disappeared, and images dissolved into a complete abstraction containing no obvious references. We can see the beginning of this process in the paintings of Arshile Gorky (1904–1948), an Armenian immigrant, whose family fled their country to escape the genocide of the ruling Ottoman Empire. Gorky's mother died of starvation in his arms in a Russian refugee camp. By the 1930s, Gorky was in New York, where, over the next decade his Cubist style began to evolve toward complete abstraction. At his wife's farm in Connecticut, he would dash off minimal abstract line drawings inspired by nature. In the studio, he would then develop

these linear patterns into paintings, as seen in his 1944 masterpiece surrealistically titled *The Liver Is the Cock's Comb* (fig. 27-1).

Wiry black-line drawing and washes of predominantly red, blue, yellow, and black play off of one another and give a sense of how the composition developed as a series of psychological reactions of one mark and color triggering the next, and so on. While the painting has hints of Miró's biomorphic forms and airy line as well as Kandinsky's color and cosmic chaos (see figs. 26-14, 25-5), it is somewhat more abstract than abstract Surrealism and flatter than Kandinsky's spacious universes. The title may allow us to think that we see a rooster perched at top center, and we may sense there are suggestions of male and female genitals throughout the picture.

Unlike Miró's images, we cannot safely read much into the image other than a feeling of a landscape filled with some kind of organic animation, much of which seems hostile. In fact, many scholars have suggested that Gorky's abstractions have references to the living hell he experienced when the Turks slaughtered Armenians, but again, the picture is too abstract to substantiate such speculation. What stands out as a prominent theme in the picture is its *process*, our sense of how the picture was made.

ABSTRACT EXPRESSIONISM: GESTURAL ABSTRACTION

Jackson Pollock Three years later, Jackson Pollock (1912–1956) made the physical act of painting the undisputed focus of painting. Which is not to say that is all his paintings are about, because the process is now a metaphor for the human condition, which previously had been represented through hieroglyphs and biomorphic forms. Through the thirties, Pollock was a minor hanger-on in the art world, a marginal figure who worked odd jobs, including being a gallery attendant at what is today called the Solomon R. Guggenheim Museum. In the early forties, just when he started Jungian psychoanalysis, he became a hard-core Surrealist, making crude but powerful paintings filled with slap-dash hieroglyphs, totems, and primitive myth, whipped about in a swirling sea of paint. His big break came in 1943 when Peggy Guggenheim showed him at Art for This Century and gave him a stipend to paint.

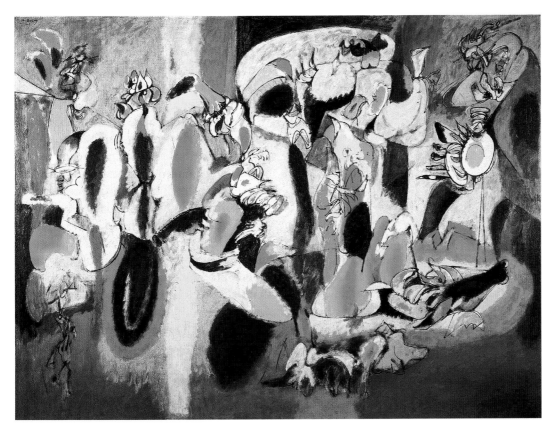

27-1 Arshile Gorky. *The Liver Is the Cock's Comb.* 1944. Oil on canvas, 6′1¼″ × 8′2″ (1.86 × 2.49 m). Albright-Knox Art Gallery, Buffalo, New York

©2004 Artists Rights Society (ARS), New York

paint, they used large planes of color to express their innermost primal qualities linking them to universal forces. Like their counterparts, their objective was to project the sublime human condition as they themselves felt it. The principal color-field painters were Mark Rothko (1903–1970), Barnett Newman, and Clifford Still, all of whom started out by making myth-inspired Abstract-Surrealist paintings in the 1940s and were close friends until 1952. Rothko's paintings from the period drew heavily from Greek tragedy, such as Aeschylus's Agamemnon Trilogy, and from Christ's passion cycle and death—scenes with a harrowing psychology where the lone individual is facing ultimate truths about existence, death, and spirituality. But all suggestion of figuration disappeared in

27-4 Mark Rothko. *No. 61 (Rust and Blue)[Brown Blue, Brown on Blue]*. 1953. Oil on canvas, 115¾ × 91¼". The Museum of Contemporary Art, Los Angeles, The Panza Collection

1947, after Rothko was influenced by Still's emphasis on the concept of painting with only abstract planes of color. In 1949, he arrived at his mature style, from which he did not deviate for the remainder of his life.

Now his paintings consisted of flat planes of color stacked directly on top of one another and sitting on a monochrome ground, as seen in the almost ten-foot-high 1953 work *No. 61 (Rust and Blue)* (fig. 27-4). There is no longer any storytelling, hieroglyphics, or symbols, not even in the title. The artist has painted himself confronting the inevitable void of our common future of death and our sense of a mystical oneness with unseen cosmic forces, a theme similar to Caspar David Friedrich's in his *Abbey in an Oak Forest* (see fig. 22-19). His ethereal planes are so thin, color glimmers through from behind and below, creating a shimmering spiritual light. Their edges are ragged, and like clouds dissipating in the sky, they seem precariously fragile. Although the painting is not about process, we feel Rothko's hand building up the planes with individual marks, giving the work a poignant organic quality. Space is paradoxically claustrophobic and infinite: On the one hand, the planes laterally crowd the picture to the edges and in depth hover at the very front of the picture plane, while on the other the pervasive blue ground seems to continue forever, uncontained by the frame. Enormous shifts in scale give a sense of the sublime, such as the tiny thin wisp of soft white on top of the middle plane, which seems so insignificant in comparison to the enormous planes and the vast size of the canvas. Regardless of the palette, whether bright yellows and oranges or the more moody blues and browns in *No. 61*, the colors in a Rothko painting have a smoldering resonance that makes the image seem to glow from within. Rothko wanted viewers to stand close to his enormous iconic images, which would tower over them, and where they would be immersed in this mystical void of the unknown future, in effect, standing on the precipice of infinity and death. After making a series of predominantly black paintings, Rothko committed suicide in 1970.

NEW YORK SCULPTURE: DAVID SMITH

Along with Alexander Calder, David Smith (1906–1965) was perhaps the most impor-

tant American sculptor at the mid-century mark. He began as a painter, but upon seeing illustrations of welded steel sculpture by Picasso (see page 543) and another Spaniard, Julio González in 1932, he adopted the blow torch and metal as his medium, which he used throughout his career. He was very close with the Abstract Expressionist painters, and even after moving to a farm in Bolton's Landing in upstate New York in 1940, he periodically came to the city for long periods to hang out with his friends in Greenwich Village.

Smith was steeped in the Existential philosophy of his circle, and his work was dedicated to expressing his physical and psychological being. His career follows a path similar to Rothko's, moving from Surrealist sculptures that were basically drawings in space of suggestive Miróesque organic forms to totally abstract iconic forms. An example of his late style is his *Cubi* series (fig. 27-5), begun in 1961 and consisting of 18 works. Beginning in the mid-forties, Smith constructed his sculptures from large reserves of metal that he always had on hand, working not so much from preliminary sketches and preconceived notions of a finished product, but like de Kooning and Pollock, by a continuous chain of reactions to each gesture, which in his case would be a welded material. Despite his working method, which would allow him to work and think in the round, his sculptures generally were conceived like paintings, to be seen almost two-dimensionally from a single viewpoint.

Because of their severe geometry, the *Cubi* series is unusual for Smith. He did not have equipment to cut stainless steel, and consequently he was forced to order it from the manufacturer in pre-cut rectangular shapes, which he assembled into boxes of different sizes that he welded together based on intuition and personal emotion. Despite their relentless geometry, these nine-and-a-half-foot-high sculptures are hardly mechanical and unemotional. They are both anthropomorphic and totemic, evoking giant figures and ritualistic structures. They have the sublime presence of a Stonehenge monument and embrace a powerful spirituality. It is as though the elemental forms, placed on a table-top altar, are the very building blocks of the universe itself, their sense of movement and solidity reflecting the essence of

life, their fragile composition the inevitable impermanence of all things. Smith finished by burnishing the steel, giving it a textured finish. Because we can feel his touch here, the work takes on an organic quality.

Existentialism in Europe: Two Loners

The immense scale of Abstract Expressionism and its powerful sense of the sublime had little direct counterpart in Europe. The movement was identified with the United States, even being exported in exhibitions organized by the federal government in the 1950s, ostensibly for the sake of good international public relations but also to strut the country's artistic superiority, which complemented its military, financial, and technological superiority. In Europe, as in the United States, Existentialism played a major role in the development of Expressionism. Two of the artists most identified with mid 1950s European art are Jean Dubuffet and Francis Bacon, artists who had no affiliations with groups or movements and artistically kept to themselves.

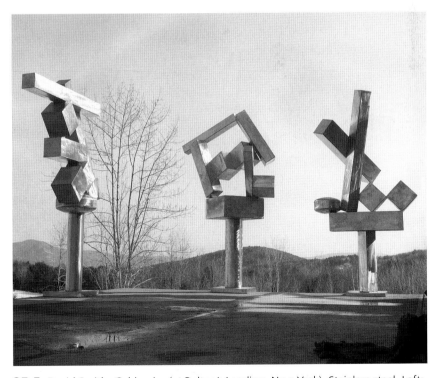

27-5 David Smith. *Cubi* series (at Bolton's Landing, New York). Stainless steel. Left: *Cubi XVIII.* 1964. Height 9'8" (2.95 m). Museum of Fine Arts, Boston. Center: *Cubi XVII.* 1963. Height 9' (2.74 m). Dallas Museum of Art. Right: *Cubi XIX.* 1964. Height 9'5" (2.87 m). The Tate Gallery, London

Art ©Estate of David Smith/Licensed by VAGA, New York, NY

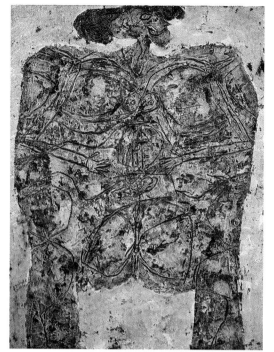

27-6 Jean Dubuffet. *Le Métafisyx,* from the *Corps de Dames* series. 1950. Oil on canvas, 45¾ × 35¼" (116.2 × 89.5 cm). Private Collection

JEAN DUBUFFET

As a young man, the Frenchman, Jean Dubuffet (1901–1985) was an unlikely candidate for fame as an artist. Until the early 1940s his commitment to, and even his belief in, art was intermittent, and he often worked in a family wine business. Many of his attitudes paralleled Dada: He was anti-art and anti-bourgeois. What interested him most was finding a way to see beyond the blinders of civilization, with its limited concepts of beauty and reality, to perceive higher truths. For Dubuffet, as for Kandinsky, Malevich, and Mondrian, those higher truths were the interconnectedness of all things in the universe, both inert and living.

His moment of realization and thus of liberation came in the 1940s when he became enthralled in the art of the insane, called *art brut.* Dubuffet came to believe that the insane were uninhibited by the superego—that part of personality, according to Freud, that restrained the id, the source of our most primitive urges and desires. Consequently their art expressed the deepest urges and fantasies. So primal were these desires, they were connected directly to universal forces. Graffiti, children's art, anything equally uninhibited and spontaneously produced fell into the same category. Dubuffet adopted these primitive styles in his own art because he believed they represented a uni-

versal language that anyone could understand and appreciate.

Another important ingredient in Dubuffet's worldview is the concept that all things are equally consecrated because everything was composed of the same matter and energy. In *Le Métafisyx* (fig. 27-6) of 1950, he literally etches his woman into a deep bed of paint, which is crude, rough, and dirt-brown, suggesting earth, ancient plaster walls, and stone. Not only is this comic-repulsive soil-encrusted women identified with mineral matter, she is also timeless, for she resembles an archeological find excavated from a remote prehistoric site. Reinforcing her universal status is her anatomy, which is depicted through a primitive rock-drawing style. The style becomes so abstract and generalized that it can be read in endless ways, even as a ubiquitous energy that courses through all things. There is even the suggestion of the body dissolving back into elemental matter.

Métafisyx was part of a series called *Corps de femmes,* which in its crude drawing and grating texture was meant to be shocking, challenging the art world's conventional notions of beauty. Putting more emphasis on the pelvis than the head had to have been jolting to unsuspecting viewers. But along with the picture's other attributes, it forced them to rethink the meaning of existence and their relationship to the universe.

FRANCIS BACON

Across the English Channel, a second loner was stirring up the art world pot by expressing his own existential angst: Francis Bacon (1909–1992). One look at his *Head Surrounded by Sides of Beef* (fig. 27-7) of 1954, and we realize we are in the presence of one of the more frightening images of the twentieth century. Bacon emerged as a force on the London art scene right after World War II, and it is tempting to view his horrific pictures as a statement about the senseless brutal savagery he had just witnessed. But Bacon's themes were already in place well before the war, and presumably they stem largely from his own horrible circumstances.

Raised in post–World War I Ireland by well-to-do English parents during the turmoil of the Sinn Fein rebellion for Irish independence, he was a sickly child who had to be tutored at home. His militaristic father periodically had him whipped by the family

grooms, whom he then secretly had sex with later the same day. In London as an adult, this shy man led a dissolute lifestyle dominated by the classic vices of alcohol, gambling, and promiscuous sex, with many of his closest lovers dying from drink.

Whether these experiences account for Bacon's art cannot be known for sure, for unlike Dubuffet and the Abstract Expressionists, for example, he did not pontificate about art, issue manifestos, or declare painting had to fill any social voids. But like his Existentialist contemporaries, he painted from his gut, claiming when he started a picture he had no idea where he would end up. His first painting based on Velazquez's *Pope Innocent* X (there are forty-five), which is the source for the central figure in *Head Surrounded by Sides of Beef*, supposedly began as a garden scene. Our painting not only incorporates the Velázquez painting, but includes a contemporary photograph of Pope Pius XII (whose bespectacled head we see), Rembrandt's painting of a flayed ox, and a still photograph of a nurse screaming in Sergei Eisenstein's 1925 classic silent film *Battleship Potemkin*. In most of Bacon's paintings based on *Pope Innocent* X, the focal point is the primal scream of the sitter, the wide dark pit of the opened mouth. In our picture, however, this motif is balanced by the crucified slab of beef, which frames the sitter. Add the black void, the claustrophobic compression of the glass cage, and the gritty quality of sections of the paint surface, and we are looking at a house of horror, obviously the chamber housing the artist's grim psyche. Nor can we get back from the scene, which seems thrown in our faces by the bold brushwork that prominently sits on the surface of the canvas, pulling the image along with it and toward us. Bacon said of his paintings, "You can't be more horrific than life itself."

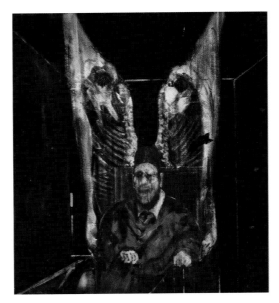

owed. The 1950s ushered in a cultural revolution, resulting in a freedom of expression that virtually required the invention of radically new art forms. It is doubtful that anyone could have imagined their existence before the beginning of the period, except perhaps Duchamp. Now living in New York, his ideas of 40 years earlier helped pave the way for this remarkable period. The art of the fifties was so seminal for the art of the remainder of the century that it still looks fresh today.

ROBERT RAUSCHENBERG

No one person or event triggered the dramatic change that occurred in art in the 1950s, but Robert Rauschenberg (b. 1925) perhaps spoke for many when he explained why he rejected Abstract Expressionism: "It was all about suffering and self-expression and the State of Things. I just wasn't interested in that, and I certainly did not have any interest in trying to improve the world through painting."

Rauschenberg was a Texan from a middle-class Galveston family who ended up in New York studying painting by 1947. A critical component of his development was attending the avant-garde Black Mountain College in North Carolina in the fall of 1948. The small liberal arts school was headed by Josef Albers, who had taught at the Bauhaus along side of Paul Klee and Wassily Kandinsky (see pages 580-81 and 627-28). At Black Mountain, Rauschenberg

American Art of the 1950s: Breaking Down the Barrier Between Art and Life

Abstract Expressionism emerged in 1947–1948 with the first mature work of Pollock and de Kooning, and by the mid-1950s it was already beginning to be overshad-

adopted its program of experimentation and exploration. In New York in 1950, he painted his White Paintings. These were large canvases painted a solid white, with no evidence of brushwork. What were viewers supposed to see? Themselves! Their shadows were cast on the canvases, which also caught reflected colored light and accumulated dust and dirt. These enormous white canvases captured real life, which was presented without comment or meaning. Viewers were expected to read anything into it that they wanted. Like Duchamp, Rauschenberg was making a conceptual art, determined by chance, and aimed at re-presenting the world without attaching any firm meaning. In their objective neutrality, these extraordinary paintings were the antithesis of the intensely personal new-born Abstract Expressionism.

The paintings quickly established Rauschenberg as the bad boy prankster of the art world, although his work was quite serious. One of the people who thoroughly understood the White Paintings was avant-garde composer John Cage. The paintings inspired him to write *4' 3"*, a piano piece first performed in Woodstock, New York, in 1952. The work was played by pianist David Tudor, who sat down and opened the keyboard for 4 minutes and 33 seconds. During this time the audience listened to the sounds of the real world: the shuffling, coughing, and whispering of the audience and the falling rain and chirping birds coming in through an open window. The last sound was the keyboard case being shut, signaling the end of the piece.

Rauschenberg returned to Black Mountain several times and was present in 1952 to participate in the "Event," as the first Happening and the birth of Performance Art is often referred to. It took place in John Cage's composition class, where the students improvised "music" using anything but musical instruments to make sounds, while others simultaneously made visual art, recited literature or poems, and danced. While operating within a few predetermined parameters and a time limit, this combination music, theater, and visual-art work was largely made via chance. Back in New York, Rauschenberg continued his Duchampian experiments. In 1953, in collaboration with de Kooning, he erased a de Kooning drawing to create a new

work of art. The following year he made a print by having Cage drive one tire of his Model A Ford through ink and then onto a lengthy scroll of paper, recording the imprint of the tire. In 1958 he made two identical "Abstract Expressionist" paintings, *Factum I* and *Factum II*, an act that challenged the validity of the emotional content of Abstract Expressionism.

These and many other of his conceptual works from this period raise fundamental questions about art: How does it function? How does it take on meaning? Who is the artist? In his conceptual approach, Rauschenberg picked up where Duchamp left off. But unlike the Dada artists—and perhaps the highly philosophical Duchamp should not be included in their number—Rauschenberg was never intent on destroying. To the contrary, his attitude and approach are positive. He is a presenter, not a nihilist. He is a collector of life, which he gathers up and energetically presents for us to think about and interpret for ourselves. Furthermore, he was not interested in painting life, but *re-presenting* it, in effect, breaking down the barrier between art in life. "I don't want a picture to look like something it isn't. I want it to look like something it is. And I think a picture is more like the real world when it's made out of the real world."

In 1955 Rauschenberg incorporated the real world into his art when he began making his "combines," innovative works that combine painting and sculpture, generally found objects, as seen in *Odalisk* (fig. 27-8), a work begun in 1955 but finished three years later. This four-sided "lamp"—there is an electric light inside—is crowded with collaged material culled from contemporary magazines and newspapers as well as detritus from the street, thrift shops, and his loft. Even the title is part of this busy collage, for it has to be considered when we try to construct a narrative for the work. But is there a narrative in this poetic collage of disparate material? Obviously, *Odalisk* has a subject, for it is filled with sexual innuendo: the phallic pole jammed into the pillow on the bottom, the cock mounted above the nude pinup while the dog howls at her from below, the comic strip of a woman in bed being surprised by a man (not pictured here), and even the title, which is a pun on odalisque and obelisk, a word combining both female

and male—everything can be interpreted sexually. But no value is placed on this material, no interpretation is suggested, no grand statement is being made. It just is. It is our materials, it is our time, it is our life. Rauschenberg re-presents it with extraordinary formal powers and a poetry of paint and collage. In its energy and fragmentation, the work powerfully captures the spirit of the constantly changing world and the fractured way we experience it.

Where did Rauschenberg's philosophy come from? Clearly, he was influenced by Duchamp whose work he would have known through John Cage, who admired him tremendously. But for his perspective on life, he looked to Cage. Cage was deeply committed to Zen Buddhism, which teaches that the universe is composed of objects of no hierarchical significance that are constantly interacting and that this interaction—life—is based on chance. Every moment is therefore unique, and the only validity to life is experiencing the moment, not placing any value on it, since it has none. Because a belief in chance precludes a belief in cause and effect, there are no explanations for what happens. Unlike Cage, Rauschenberg is neither philosophical nor religious, but his worldview of experiencing life free of values and judgments reflected a growing need in the 1950s for liberation from the straightjacket of the status quo, which was becoming increasingly bureaucratic, corporate, and judgmental.

JASPER JOHNS

In 1954 Rauschenberg met Jasper Johns, and he moved into a loft in the same run-down building on Pearl Street at the Seaport in lower Manhattan. While Johns incorporated objects into his paintings before Rauschenberg made his combines, he was primarily a painter, and his works were about painting. This can be seen in *Three Flags* (fig. 27-9) of 1958. Because of the Americana theme, many writers talk about this painting as Pop Art, a style that in New York emerges in the early 1960s and derives its imagery from vernacular culture. American pride surged in the postwar period as the United States emerged as the most powerful nation in the world. More than ever before, images of the flag were everywhere and an integral part of popular culture. *Three Flags* is part of a series in which the artist repeatedly painted flat

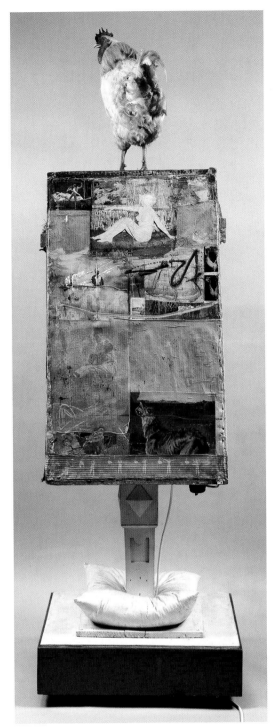

27-8 Robert Rauschenberg. *Odalisk.* 1955–58. Mixed media, 6′9″ × 2′1″ × 2′1″ (205.7 × 63.5 × 63.5 cm). Museum Ludwig, Cologne

Art ©Robert Rauschenberg/Licensed by VAGA, New York, NY

objects such as numbers, targets, and maps with the intention of eliminating the need to paint illusionistic depth of any kind. He has painted a flat object (a flag) on a flat object (the canvas), so we are not tempted to read a white star as sitting on top of a blue field because we know the flag is flat. When we look at *Three Flags* we know immediately we are not looking at an illusion of flags. We *know* it is a painting. Nor do we have to deal with the iconography of the flag, since it is

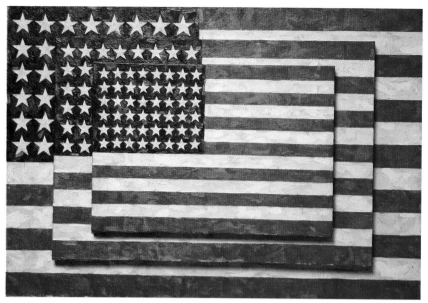

27-9 Jasper Johns. *Three Flags.* 1958. Encaustic on canvas. 30⅞ × 45½ × 5″ (78.4 × 115.6 × 12.7 cm). Whitney Museum of American Art, New York

placed in absolutely no context that would allow us to read anything into it. We digest the image instantly, and what we are left to look at is *how* it was made. We look at Johns's very beautiful and methodical application of wax-based encaustic paint, reminding us that a painting consists of paint on canvas, and one option of the use of paint is

27-10 Allan Kaprow. *Yard.* 1961. Environment of used tires, tar paper, and barrels, as installed at the Martha Jackson Gallery, New York. Life size. Destroyed

to make an image. And of course painting can be about color, which here declares itself with patriotic force. Lest we forget a painting is a three-dimensional object, Johns has stacked the paintings one atop another. We see their sides and hence their depth. Although the intellectual gymnastics in Johns's paintings are complex and rigorous, the works themselves are largely objective, much like Rauschenberg's.

ENVIRONMENTS AND HAPPENINGS

Rauschenberg's combine paintings set off a chain-reaction that caused an explosion of art-making that entirely redefined art. In 1956, months after Pollock's death in a car crash, a Rutgers University painter, Allan Kaprow, published an article in *Art News* titled "The Legacy of Jackson Pollock" that described how Pollock's action paintings, because of their enormous scale, started to become environmental. The next step he claimed was to make environmental art: "Pollock, as I see him, left us at the point were we must become preoccupied with and even dazzled by the space and objects of our everyday life, either our bodies, clothes, rooms, or, if need be, the vastness of Forty-second Street." Kaprow knew Rauschenberg's work (he was awe-struck by the White Paintings, which he grasped immediately), and this pronouncement about incorporating everyday life into art sounds like a description of the Texan's combines.

In 1958, Kaprow took the next step toward making art about life when he built his first Environment. Installed in a New York gallery, it was filled with highly textured, Rauschenberg-like screens of collages and assemblages hanging from the ceiling that the viewer walked through. Kaprow's most famous Environment was *Yard* (fig. 27-10) made in 1961. Filled mostly with used tires, but tar paper mounds and barrels as well, the work had the all-over look and energy of a Jackson Pollock painting. But visitors to the townhouse garden where it was installed were expected to walk through it, experiencing it physically, not just visually. Like Rauschenberg in his combines, Kaprow attached no firm meaning or message to his works, although the strewn synthetic materials suggest a modern industrial,

27-11 George Segal. *The Gas Station.* 1963. Plaster figures, Coca-Cola machine, Coca-Cola bottles, wooden Coca-Cola crates, metal stand, rubber tires, tire rack, oil cans, electric clock, concrete blocks, windows of wood and plate glass, 2.59 × 7.32 × 1.22 m. National Gallery of Canada, Ottawa

Art ©George and Helen Segal Foundation/Licensed by VAGA, New York, NY

even urban environment, as well as a sense of waste, even death.

In 1959, Kaprow added the live human figure to his environment when he presented *18 Happenings in 6 Parts* at a New York gallery. Spectators sat in Kaprow's collaged environment, which was divided into three rooms, watching, listening, and smelling as performers carried out such tasks as painting (Rauschenberg and Johns participated), playing records, squeezing orange juice, and speaking fragments of sentences. In a sense the work was like a Rauschenberg combine that took place in time and space and with human activity. It was equally fragmentary and objective as it merely re-presented life, which could be interpreted as the audience saw fit. Performance Art was born, and it would be one of the most popular media through the 1960s.

Living down the road from Kaprow in New Jersey was George Segal (1924–2000), who responded to his friend's Environments and Happenings by creating environments out of real objects and populated by plaster figures, as seen in *The Gas Station* (fig. 27-11) of 1963. Now the performers are frozen, reduced to ghost-white figures. Segal uses real people to make them, and casts them with plaster medical bandages. Like Rauschenberg and Kaprow, Segal was breaking down the

barrier between art and life. But his art is far from objective, for it is a statement condemning the alienation of contemporary living. His figures are left white, as though drained of life, and generally they are lethargic, exhausted, and alone. They seemed locked in by the harsh geometry of the horizontals and verticals of the objects. Here, the work is dominated by a Bulova clock, which looms in a ten-foot expanse of darkness in the center of the composition and mysteriously echoes the shape of the tire leaning against the window. The vending machine, tires, cans of high-performance oil, and the gas station itself suggest modernity, technology, and fast and efficient living. But missing from this materiality is something meaningful—human interaction and spirituality. The sense of alienation is so strong we feel as though we are looking at a three-dimensional Edward Hopper painting (see fig. 26-36).

Segal retains the existential angst of his Abstract Expressionist background as he questions the meaning of modern existence. He used contemporary branded objects, such as Coca-Cola bottles, in his quest to suggest a real environment, but he is not celebrating or commenting on the design or art of these products. Others, most famously, Roy Lichtenstein and Andy Warhol, would.

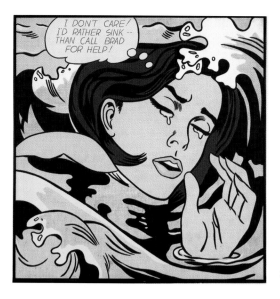

27-12 Roy Lichtenstein. *Drowning Girl.* 1963. Oil and synthetic polymer paint on canvas, 5′7⅝″ × 5′6¾″ (1.72 × 1.69 m). The Museum of Modern Art, New York, Philip Johnson Fund and Gift of Mr. and Mrs. Bagley Wright

POP ART: ROY LICHTENSTEIN AND ANDY WARHOL

Another close friend of Kaprow's, Roy Lichtenstein (1923–1997), arrived at Rutgers University in 1960. Within a year he was transformed from an unknown Abstract Expressionist to a famous artist. He and another New York artist, Andy Warhol, would pioneer a new style that would soon be called Pop Art. The term expressed the group's reliance on popular imagery, such as comic books, advertising, and product packaging.

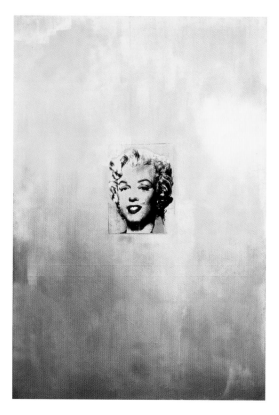

27-13 Andy Warhol. *Gold Marilyn Monroe.* 1962. Synthetic polymer paint, silk-screened, and oil on canvas, 6′11¼″ × 4′7″ (2.12 × 1.39 m). The Museum of Modern Art, New York, Gift of Philip Johnson

© 2004 Andy Warhol Foundation for the Visual Arts/ARS, New York

The contemporary life that Lichtenstein scavenged and re-presented was not the urban streets, as was the case with Kaprow, Rauschenberg, and Segal, but the crude black-and-white advertisements in telephone books and newspapers and clumsily drawn comic strips. These he cropped and adjusted into visually riveting images, as seen in *Drowning Girl* (fig. 27-12) of 1963.

Traditionally, Lichtenstein is celebrated for seeing the beauty of low art and elevating it to high art, in effect celebrating popular culture and in particular American culture. But his work is much more complicated. Like Johns, whose *Flag* had a profound impact on him, Lichtenstein was interested in the language of art, and in particular issues of perception. He does not just imitate the comic strip, he employs the genre's technique of making an image out of ben-day dots, that is, small dots massed together to create lines and shading. He was intrigued by how a three-dimensional spatial image could be made using flat dots and flat black lines, so that when viewed from close up these large images dissolve into a flat abstract pattern, virtually becoming an Abstract Expressionist composition.

But there is more to Lichtenstein's paintings. When viewed together, we see a distinct pattern to the images that the artist has selected: Men are shown as strong, virile soldiers and fighter pilots, whereas women are shown as emotionally distraught, dependent on men, and chained to the house. With deadpan brilliance, Lichtenstein made his paintings a mirror of contemporary society, revealing the stereotyping deeply embedded in the media. But the paintings themselves are objective and unemotional, giving no hint of any polemical agenda nor sense of the artist's presence, whether his hand or emotions. Like Rauschenberg, he makes no judgment.

As a young man in the 1950s, Andy Warhol (1928–1987) arrived in New York from Pittsburgh and built a successful career as an illustrator of women's shoes. As a commercial artist, he was all too familiar with the insidiously deceiving and manipulative role of advertising and product packaging. In 1961 he began silk-screening onto canvas newspaper photographs he found in a dumpster. His imagery includes car crashes, electric chairs, and images of such celebrities as Marilyn Monroe, as seen in *Gold Marilyn Monroe* (fig. 27-13) of 1962. (See discussion

of this work in the Introduction, page 2.) His style replicates the cheap, impersonal presentation of newspapers and magazines. Here he uses the lurid off-register color we associate with the poor printing of the period. Marilyn's head floats on a vast gold backdrop, transforming her into a Byzantine icon while simultaneously swallowing her up and distancing her. Like the media and using their own technique, Warhol glorifies and depersonalizes the celebrity.

Gold Marilyn Monroe was produced in Warhol's midtown "Factory," as he called his studio, which was a beehive of activity with many assistants. He did not necessarily touch this painting (and probably did not), and instead simply gave detailed instructions to his workers and then anointed the final product by signing it on the back. With this Duchamp-like act, Warhol raises the issue of the meaning and importance of authorship. Mimicking the American public's insatiable consumerism, whether for clothing, cars, or glossy magazines, Warhol's factory was churning out a product, and his factory silkscreened thousands of Marilyns, both on canvas and paper. This feverish mass production is perhaps best seen in his famous soup cans series, which glorifies Campbell's design while ignoring the content within the package.

Geometric Abstraction

MOVING TOWARD GROUND ZERO: ELLSWORTH KELLY

The most powerful art critic in the 1940s and well into the 1960s was Clement Greenburg, who wrote art reviews for *The Nation* and *The Partisan Review*. He began by championing Pollock, but as the forties progressed he increasingly promoted an art that was totally abstract and limited to dealing with just those qualities inherent to the medium, that is, color, texture, shape of field, and composition. The work could make no reference beyond itself, and as abstract as Pollock's action paintings were, they were still about him, Jackson Pollock. Consequently, Greenburg deserted Pollock. His theories had an enormous impact on artists, although those he hyped as the new wave never rose above the second tier.

Ellsworth Kelly (b. 1923) developed a distinctly American brand of abstract painting in Paris from 1948 to 1954. During those years, Kelly began to reduce painting to a bare-bones simplicity, which some critics eventually would call "Ground Zero." To free his mind from earlier art, he based his abstractions on shapes he saw in the world around him, especially negative spaces, such as the opening under a bridge, a shadow, or a window. His paintings are limited to a handful of geometric shapes in solid primary and binary colors that explore how forms move through space, colors interact, and figure relates to ground. In a 1963 work, *Red Blue Green* (fig. 27-14), Kelly plays a red rectangle and a blue curved shape off of a green ground. The left side of the painting appears fixed, whereas the right has movement. When standing in front of this enormous work, the viewer can feel at one moment the green ground consuming the blue and the next moment the blue plunging down into the green. But never to be forgotten is the sheer intensity of the color, especially as presented on such a large scale. Kelly's genius is his simple gesture: he stripped everything else away, including any sense of himself, to make a painting that was about red, blue, and green.

MINIMAL PAINTING: FRANK STELLA

Just as Kelly was returning from Europe, a young Frank Stella (b. 1936) began his studies at Princeton University, opting for an art education at a university rather than an art

27-14 Ellsworth Kelly. *Red Blue Green*. 1963. Oil on canvas, 7′8″ × 11′4″ (2.34 × 3.45 m). Museum of Contemporary Art, San Diego, La Jolla, California, Gift of Jack and Carolyn Farris
© Ellsworth Kelly 1963

school, which became commonplace after the war. Within a year of graduating he was in New York and the talk of the town because of his "black paintings," included in a 1959 Museum of Modern Art exhibition *Sixteen Americans*. These were total abstractions of black parallel bands created by the white pinstripe lines of canvas showing through. He soon began working in color, as seen in *Empress of India* (fig. 27-15) of 1965, and on an enormous scale, here over 18 feet across. Inspired by the inherent flatness of Johns's Flag paintings, Stella made entirely flat works as well. There is no figure-ground relationship, as we saw in Kelley's painting, and there is certainly no push-pull of Cubist and Abstract-Expressionist space. There is no hierarchy to the composition at all, as the shape of the canvas, a V, determines the composition, which gets replicated. Stella said of his work that "What you see is what you see." In other words, the painting has nothing that you do not see—no hidden meanings, symbols, or references. It is just an object. Fellow artists and critics evaluated this kind of abstract art on its ability to invent new formalist devices (for example, critics marveled at Stella's ability to create spaceless painting), but the power of such work lies in the sheer force of its scale and dramatic sense of movement, just as we saw in Kelly's *Red Blue Green*. Stella is often described as a Minimal artist, and certainly the term seems appropriate, but Minimalism in the strictest sense is sometimes reserved for sculpture.

MINIMAL SCULPTURE: DONALD JUDD

The sculptors who emerged in the early sixties generally composed their work using a mathematical or conceptual premise. Before the term *Minimalism* was settled on, their work was called a variety of names that reflected the conceptual underpinning of their sculpture, names such as ABC Art, Primary Structures, Serial Art, and System Art. Their art is so conceptual and impersonal, they generally did not even make it themselves. Instead they just sent specifications to an artisan, or more likely, a factory, for production. Like the Pop paintings being produced at exactly the same time, the sculpture looks objective, emotionless, and mass produced. There was no sign of the artist at all. This mentality paralleled the nation's love of synthetic products. Everywhere, plastics and human-made fibers were replacing natural materials. At the same time, architects were designing impersonal glass box towers, replacing the ornate turn-of-the-century skyscrapers that were being bulldozed in the name of urban renewal.

All of these qualities can be seen in the untitled 1969 sculpture of copper boxes (fig. 27-16) by Donald Judd (1928–1994). The shape and spacing of the boxes was determined by mathematical premise (each box is 9 × 40 × 31 inches, with 9 inches between each box), not by intuition or artistic sensitivity, as David Smith operated. Like Stella's paintings, Judd's work was constructed by serial repetitive compositions that have no hierarchy of composition, and no emotional presence. His composition is readily understood and can be taken in in a glance. Judd also designed boxes for the floor. In both instances, the sculpture was a real object, or as Judd called it, a "specific object." This hermetic object is to be admired for its shape, color, texture, and scale.

The Minimalist who was perhaps most severely limited to mathematical formula is the light sculptor Dan Flavin (1922–96), renowned for "painting" with fluorescent light. Flavin used tubes that could be bought at a local hardware store and which came in two-, four-, six- and eight-foot lengths, as seen in *a nominal three (to William of Ockham)* (fig. 27-17) of 1963. Although difficult to tell from reproductions, Flavin's deceivingly simple works are spectacularly beautiful, even when using just white light. The magical quality of the light as it radiates through the surrounding space is mesmerizing, even calming, often projecting a classical serenity. For some viewers, it even embodies a spirituality. Flavin's work could be extremely simple, consisting of a single tube of white light, sometimes placed vertically on the floor, other times coming off a corner at a forty-five degree angle. With Minimalism, art reached "Ground Zero." Reduced to bare essentials, it virtually seemed to have no place left to go.

Postminimalism: Many Voices, Many Media

By the mid 1960s, the unemotional objectivity of Minimalism, Geometric Abstract Painting, and Pop dominated contemporary art, overshadowing styles that focused on subjectivity and the individual. But as the sixties progressed, so did an interest in returning to an art based on emotion, the body, and referential subject matter. In effect, artists began to put the human back into art. The responses were diverse and no leaders were identified with this swelling undercurrent, generally referred to as "Post-Minimalism." The term is generally applied to work made in the late sixties and seventies in reaction to the suffocating limitations of Minimalism. Pluralism is another word often used to describe the heterogeneity of the period, when every kind of art imaginable was produced as the social liberation of the 1960s fueled a demand for broad artistic freedom and expression.

27-17 Dan Flavin. *a nominal three (to William of Ockham),* 1963. Fluorescent light fixtures with daylight lamps. Edition 2 of 3. 6 feet. Fixtures: dimensions vary with installation. The Solomon R. Guggenheim Museum, New York. Panza Collection, 1991 (91.3698)

© Estate of Dan Flavin/Artists Rights Society (ARS), New York

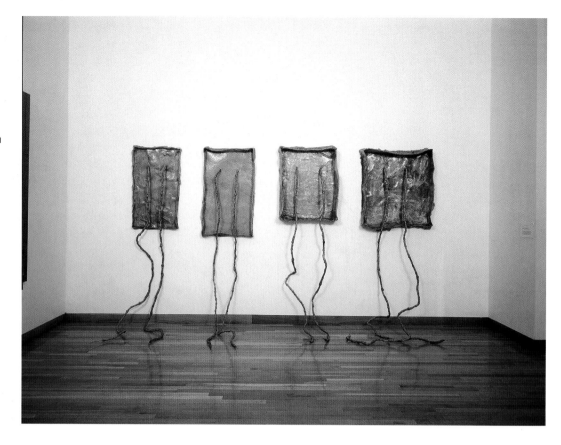

27-18 Eva Hesse. *Untitled.* 1970. Fiberglass over wire mesh, latex over cloth and wire (four units), 7'6⅞" × 12'3⅝" × 3'6½" (2.31 × 3.75 × 1.08) overall. Des Moines Art Center. Purchased with funds from the Coffin Fine Arts Trust, Nathan Emory Coffin, Collection of the Des Moines Art Center, 1988

Purchased with funds from the Coffin Fine Arts Trust; Nathan Emory Coffin. Collection of the Des Moines Art Center. 1988.6.a-.d

Eva Hesse (1936–1970) is one of the outstanding Post-Minimalists in the mid 1960s, and her career is even more astonishing when we discover it was cut short when she died of a brain tumor at age 34. Working with a variety of very unusual materials, such as acrylic paint on papier-mâché over balloons, she made abstract work that had a geometric base, but because it was slightly distorted and rough, it became organic and suggestive of exotic plant forms and fruit. The work was entirely abstract, but suggested growth and sexuality. In 1968 she began working with fiberglass, which became her trademark material and was perhaps responsible for her cancer. A classic work is *Untitled* (fig. 27-18) of 1970, which has as its starting point the geometric form of Minimalism. The units imply boxes or framed paintings because of their curled edges. Contradicting their geometry is the uneven rippling surfaces and sides, which transform the fiberglass into an organic substance, especially recalling skin. The strange ropelike latex appendages eccentrically flopping from either side of center suggest arms or legs, although they ultimately are nothing more than abstract elements, like the rectangular units. The work is full of con-

tradictions: It is simultaneously funny and morbid, geometric and organic, erotic and repulsive, and abstract and referential. Perhaps the most powerful quality in Hesse's sculptures is the sense of frailty, wear, and aging, as best expressed in the wobbly "legs" of our 1970 untitled piece. With Hesse, what you see is not what you get, and what you get is continually being revised.

EARTH ART: ROBERT SMITHSON

By the late 1960s, the Post-minimal aesthetic operated on an enormous scale, not only far beyond the confines of the gallery but far away from the art world, and in many instances in uninhabited remote areas. Several artists began sculpting with earth, snow, volcanoes, lightning, and deep sea sites, their work often temporary and existing today only in photographs and drawings. When the urban-oriented Allan Kaprow in his article "The Legacy of Jackson Pollock" (see page 589) wrote about artists using new materials that incorporated the real world into art, he probably did not envision artists operating at such an enormous scale and with such sublime materials.

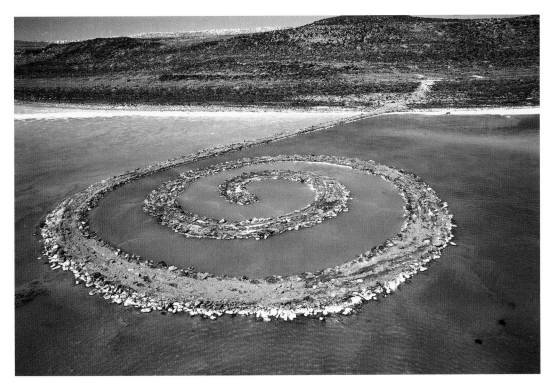

27-19 Robert Smithson. *Spiral Jetty.* 1970. Total length 1,500' (457.2 m); width of jetty 15' (4.57 m). Great Salt Lake, Utah

Art©Estate of Robert Smithson/ Licensed by VAGA, New York, NY

One of the most famous earthworks is *Spiral Jetty* (fig. 27-19), made by Robert Smithson in 1970. He became a prominent figure in the New York art world in the mid-to late 1960s because of his articles on art, which often took an environmental approach to discussing land and nature. He also became known for his Non-site sculptures, which were "landscapes" consisting of rocks and stones from specific sites (often in New Jersey) that were put into geometrically shaped bins or mirrored boxes on a gallery floor. A map or aerial photographs show the actual site of the "landscape." Instead of painting a landscape, Smithson was re-presenting the real thing in what looks like a Minimal sculpture. What the viewer was witnessing was the entropy of the land as it was removed from one site and taken to another.

Like Hesse's sculpture, Smithson's minimal-looking sculpture is full of references and issues, which can be seen in *Spiral Jetty.* The work is 1,500 feet long, 15 feet wide, and involved moving 6,650 tons of mud, black basalt, and salt crystal, the last lining the jetty to either side. It is located at Rozel Point, a remote area of Utah's Great Salt Lake that looks like an industrial wasteland because of the rusting, discarded mining equipment littering the site. Just as time consumes civilization, and all things for that matter, so too will the jetty disappear as it erodes into the lake. The hieroglyphic symbol of the spiral as it wraps around itself, going nowhere, and trapping micro-organisms that turn the water red, seems like the relic of a prehistoric civilization, much like the 3,000-year-old *Great Serpent Mound* (see fig. 1-7) in Ohio. Rather than just a minimal geometric shape to be admired for its own sake, Smithson created a powerful sculpture that utilizes time as a major component to speak about the entropy of all things.

CONCEPTUAL ART: ART AS IDEA

We have discussed Marcel Duchamp as one of the pillars of twentieth-century art because of his invention of what, in the second half of the century, would be called Conceptual Art. For Duchamp, art was not a vehicle for aesthetics but for presenting ideas, as we saw in his *Fountain* of 1917 and his *Mona Lisa (L.H.O.O.Q)* of 1919 (see Introduction, page 8). Of course, ideas appear in all art, but the ideas are closely tied to the formal qualities and cannot exist without them. In Conceptual Art, the art can exist solely as an idea, with no visual manifestation other than words. Or the idea or information can appear as a graph, chart, map, or documentation photograph. In addition to works that are entirely conceptual,

we can also talk about art that is basically visual and aesthetic but has a conceptual component as well. For example, Smithson's *Spiral Jetty* has such an element for we *know* that the work is going to very slowly disappear, which is something not visible when it was made in 1970.

American Conceptual Art first appeared in the late 1950s, a product of John Cage's New School musical composition class. Attending the class was George Brecht, who responded to Cage's ideas by typing performances on 3 × 4-inch cards and mailing them to friends. The cards with instructions got increasingly minimal, so by 1960 the work *Three Aqueous Events* consisted merely of the title, under which were three words, each proceeded by a bullet: water, ice, and steam. The recipients could respond any way they wanted. Allan Kaprow, for example, thought of making iced tea. What is the work of art in *Three Aqueous Events*? The idea? The card itself? The execution of the suggested instructions?

Joseph Kosuth By the late 1960s, more and more artists were making art based on ideas, and in 1970, the Museum of Modern Art in New York mounted an exhibition titled *Information*, which was dedicated to Conceptual Art and the fact that the thrust of art was providing information and ideas and not aesthetics. Co-curator for the show was Joseph Kosuth (b. 1945). Characteristic of his work is *One and Three Chairs* (fig. 27-20) of 1965, in which he combined a large gelatin silver print of a folding chair with the real chair itself and a photograph of a dictionary definition of a chair. By using words instead of just an image, Kosuth tells us how cerebral and nonaesthetic his intentions are. The work appears to be a textbook study in semiotics—the science of signs—a popular topic in universities and the art community at the time. In the language of semiotics, the real chair is the "signified," the photograph is the "signifier," signifying that particular chair, and the dictionary definition is the idealized nonspecific chair. Why is this interesting? By arranging three versions of a chair in this particular way, Kosuth has determined their context, which influences how we think about each. In other words, *context* determines meaning. Reading the definition, we tend to

27-20 Joseph Kosuth. *One and Three Chairs.* 1965. Wooden folding chair, photographic copy of chair, and photograph enlargement of dictionary definition of chair; chair, 32⅜ × 14⅞ × 20⅞ (82.2 × 37.8 × 53 cm); photo panel, 36 × 24⅛ (91.5 × 6.1 cm); text panel, 24 × 24⅛" (61 × 62.2 cm). The Museum of Modern Art, New York, Larry Aldrich Foundation Fund

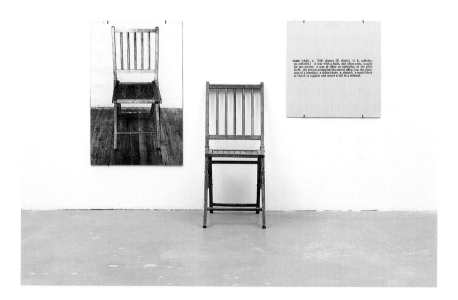

think of the real chair next to it. If it were not present, we would probably think of some other chair from our own experience. If we look only at the photograph of a chair, we may even think the subject of the photograph is not necessarily the chair but the absence of a person sitting in the chair. The title is an important part of the work, for it too provides context, suggesting we can view the chairs as the same chair (one chair) or as three different chairs with very different stories.

In other words, this work is about ideas as much as it is about the aesthetics of the visual presentation, which is as unemotional and straightforward as Minimalism. Ultimately, meaning is handed over to the viewer. Soon after, Kosuth began making works that were just photostats of dictionary definitions of art terms, such as "painting." The series was called *Art as Idea as Idea,* and it forced viewers to imagine the work of art in their minds. Or was the work the photostat of words?

One and Three Chairs reflects a new approach to photography that appeared in the mid 1960s and would prevail for the remainder of the century: The medium was no longer the sacred preserve of photographers, who worked on an 8 × 10-inch or 11 × 14-inch scale and carefully took their own photographs and often slaved over their printing. Now photography was used by Installation, Earth, Performance, and Conceptual artists, who in their primary media often worked on a large scale and made photographs that functioned at a similar scale, even rivaling painting. Generally, they did not take their own pictures, and few if any did their own printing. Most shocking to traditional photographers, they often integrated photography into other media, as Kosuth did in *One and Three Chairs,* thus violating the time-honored integrity of the medium.

Joseph Beuys Joseph Beuys (1921–1986) is a German Conceptual artist whose work is so complex and rich in ideas it is nearly impossible to pin down exactly what the art is. He made objects, diagrams, photographs, and performances, all of which are so interrelated no one piece can comfortably stand on its own. To fully comprehend, each requires a lengthy explanation and knowledge of Beuys's

other work, ideas, and even his life. His mysterious sculptures can almost be considered more relics of his activities and experiences than stand-alone objects to be appreciated aesthetically, although they are. His performances were rituals aimed at bringing about a spiritual transformation, generally in himself. In effect, he is one of the most difficult artists in the entire history of art to understand, and yet one of the most important artists of his time. He was based in Düsseldorf, where he taught at the Art Academy. By the 1970s, the city was home to many of the world's greatest artists, with its art scene perhaps second only to New York's. Beuys played a major role in developing this artistic climate. His impact included spurring German artists to confront their Nazi past, to rediscover their German romantic tradition, and to invest their art with a spirituality.

Two key factors in Beuys's development were his experience in World War II as a fighter pilot in Hitler's airforce and the 1963 arrival in Düsseldorf of a group of Conceptual artists, many of whom, like George Brecht, had attended John Cage's New School composition class. This group, called Fluxus, transformed their teacher's radical principles of musical composition, especially the goal to make art out of life, into an art movement that had performance as a major component. Due to the Fluxus artists, Performance and Conceptual Art became a staple of Beuys's work, which was derived from his World War II experience. Beuys propagated a myth that his plane was shot down in 1943 in a snowstorm over Crimea, and that nomadic Tartars saved him from freezing to death by covering him in animal fat and layers of felt. Whatever Beuys's war experience actually was, it was traumatic. After attending the Düsseldorf Art Academy in the late 1940s, he disappeared into the German countryside to work as a farmhand and purge himself of his guilt and anxiety. He sought a spirituality in nature that would unite him with universal forces, much as animals instinctively were.

By 1961, he was teaching at the Art Academy, and two years later, he was introduced to Fluxus, joining them for a segment of their European tour. The following year he performed *How to Explain Pictures to a*

Dead Hare (fig. 27-21). For three hours he moved his lips as if silently lecturing a dead hare cradled in his arm about the pictures surrounding him on the walls. Felt was attached to his left sole, and steel to his right, the one representing "spiritual warmth," the other "hard reason." Beuys's head was coated in honey and gold paint, transforming him into a shaman. The honey represented a life force. This mysterious ritualistic performance was about the meaningless of conventional picture-making, art that had to be explained, and the need to replace it with a more spiritual and natural form of communication, an art that could be felt, just as animals instinctively interact with nature. The performance was designed to create a magical art that would cause people to invest their own lives with spirituality.

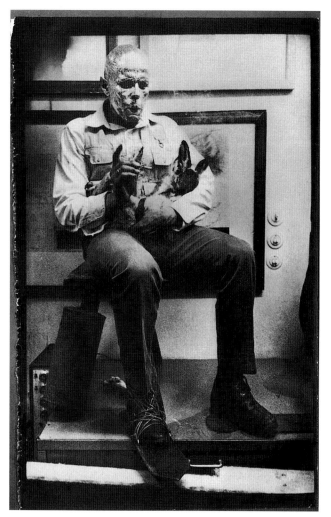

27-21 Joseph Beuys. *How to Explain Pictures to a Dead Hare.* 1965. Performed at Galerie Schmela, Düsseldorf.
© 2004 Artists Rights Society (ARS), New York/VG /Bild-Kunst, Bonn

Despite sharing Performance Art with the Fluxus artists, Beuys could not be further from them in spirit, since their work was light-hearted, fun-filled, objective, and unemotional. Beuys, on the other hand, was a modern-day shaman, bent on proselytizing. He was tapping into the German Romantic tradition of the sublime that we saw in paintings of Caspar David Friedrich (fig. 22-19) and the philosophy of Nietzsche and Arthur Schopenhauer (see page 532). The countless ideas swirling around his work and the esoteric meanings attached to his objects make it difficult to understand his intentions without lengthy explanation. But anyone who watches his performances or views his objects, such as a worn wooden chair with a pile of fat on its seat, is powerfully moved. Many find them riveting and unforgettable, their spiritual ritualistic intentions sensed if not understood.

TELEVISION ART: NAM JUNE PAIK

The radical attitude toward art-making of the 1960s and 1970s led artists not only to transform photography, but also to appropriate television as a vital artistic medium. The Korean-born artist, Nam June Paik (b. 1932) was the leader in this field. Paik passionately believed that television was the most powerful form of communication to influence contemporary society since World War II.

Paik's background was in music, but shortly after studying composition with John Cage in Darmstadt, Germany, in 1958, he became a radical performance artist, exploring unconventional media. Living in Düsseldorf in 1963 and performing in the Fluxus program that had an enormous impact on Beuys, he began making art using television monitors. He called television the "electronic superhighway" and declared it the medium of the future, dedicating his life to working with it. The following year he moved to New York, and with the launch of the first affordable video camera by Sony, he often used video as well.

With success, his work in the 1970s became increasingly grand and complex. Typical of the more elaborate structure of the later work is a piece from 1995, *Electronic Superhighway: Continental U.S.* (fig. 27-22). Fed by numerous computer-controlled video

channels, this installation consists of dozens of monitors inserted in a neon map of the 48 continental states. The rapidly changing images generally relate to the respective states, except for New York, which is fed from a live camera in the New York City gallery where the work was shown and presents viewers looking at the monitors. In the *Electronic Superhighway*, Paik reaffirms the prevalence of television in American society, presenting it with the same fast-paced continuous stream of information found on broadcast television. The work is a celebration of American vernacular culture, both in the use of the neon and television media as well as in the Americana presented in the videos. Paik is telling us television *is* America. It is, in effect, real life, because this is how most Americans experience the world. Paik is not condemning television, but declaring its power to define contemporary life.

27-22 Nam June Paik. *Electronic Superhighway: Continental U.S.* 1995. Installation: multiple television monitors, laser disk images, and neon, 15 × 32′ (4.57 × 9.75 m).
© Nam June Paik

Art with a Social Conscience

Most of the avant-garde artists of the 1950s and 1960s did not have a social agenda. Even those who did, such as Lichtenstein and Warhol, embedded their message in the work so that it was not readily visible, especially to the groups being criticized. The artists who made environments, installations, performances, and conceptual and earth art were art world rebels in their adventurous approach to materials and, in many instances, in their indifference to producing a marketable product from which they could earn a living. Many of these anti-materialistic artists lived in raw illegal lofts in Soho or the neighborhood just south of it, Tribeca, keeping their windows covered at night to avoid detection by the police. Their world was dominated by an atmosphere of counterculture that paralleled the social revolution occurring not only in America but also worldwide by the late 1960s. Large numbers of artists did not begin to make work that dealt with social issues until the late 1960s, when a trickle swelled into a torrent. So great was its influence that we think of social issues playing a major role in avant-garde art for the last 35 years or so. An art with a conscious was a key component of 1970s pluralism.

PHOTOGRAPHY

Not everyone was caught up in the economic boom and technological euphoria of the 1950s. Some observers, including many outstanding photographers, perceived serious problems within American society. In part inspired by the powerful photographs of Walker Evans, they trained their cameras on the injustices smoldering beneath the placid surface of society. In addition, photography was not handcuffed by the modernist aesthetics of painting and sculpture that demanded an increasingly abstract non-referential art.

Perhaps the greatest of the postwar "street photographers," as these socially conscious photographers are often called, is Robert Frank, who emigrated from Switzerland in the 1940s. In 1955, Frank crisscrossed the nation, taking photographs that he published in a book called *The Americans* (1958). His view of America was so grim, Frank had to go to France to find a publisher. An American edition came out in 1959 with an introduction by Jack Kerouac, author of *On the Road* (1957).

Like his friend, George Segal, Frank's work reflects his concern about the alienation and lack of spirituality endemic to

27-23 Robert Frank. *Drug Store, Detroit.* 1955. Gelatin silver print, 11 × 14".
© Robert Frank, from "The Americans." Courtesy Pace/MacGill Gallery, New York

twentieth-century America (see fig. 27-11). *Drug Store, Detroit* (fig. 27-23) is characteristic of the series' national portrait of emptiness, alienation, and despair. Under a barrage of crass advertising, which hangs like festive banners deceitfully offering fresh orange juice (reminding us of Andy Warhol's images of Campbell's Soup cans of ten years later), some 15 men order among other items artificial orange whips, each patron seemingly unaware of the others. Symbolizing their iso-

lation and boredom are the clasped hands in the foreground. On the other side of the counter dutifully serving the men at an undoubtedly minimum-wage rate are African American women. Just as the cake is suffocated in the foreground case, the waitresses are trapped behind the counter in the drudgery of their rote jobs and daily existence. The glare of bare fluorescent bulbs bouncing off of linoleum, Formica, and plastic is a reminder of period's deadening aes-

thetic of efficiency and modernity, while the monotonous lineup of jukeboxes opposite the patrons declares the sell, sell, sell mentality of American business.

Unlike Evans, Lange, and Bourke-White, Frank avoids refinement in his photographs. His prints are blurry and gritty, with grimy blacks violently contrasting with whites. Their harsh crudeness projects an undercurrent of unease and disquiet in the image. We sense the speed with which Frank operated, wielding his 35-mm single-lens reflect camera spontaneously as his instinct dictated. Upon looking at this photograph, it should come as no surprise to learn that downtown Detroit was largely destroyed during the social upheavals of the 1960s.

The New Yorkers Lee Friedlander (see fig. I-11), Gary Winogrand, William Klein, Louis Faurer, and Diane Arbus similarly portrayed an unsettling picture of America during this period. A generation later is William Eggleston (b. 1939), originally from the Louisiana Delta and now living in Memphis, who initially specialized in pictures of the South. Eggleston's use of color is so powerful, it would seem he invented it, although color photography had been around intermittently since the turn of the century. While technological advances brought about a rise of color photography in the late 1960s and 1970s, Eggleston was one of the first to understand how color influenced the meaning of an image, and his work spawned an entire generation of color work. Among his many series and styles, Eggleston is characterized by the large number of close-up photographs in his oeuvre, which have an unsettling, disturbing psychology.

In *Greenwood, Mississippi* (fig. 27-24) of 1970, Eggleston focused his lens on the blood red ceiling of a restaurant, the searing color endowing the image with a violent, strident tenor, which is echoed by the tension of the electrical wires, the brutal cropping of the door, and the starkness of the bare light bulb and what we can see of the room. The mood of the picture is so grim the instructional figures on the life-saving Heimlich maneuver chart are transformed into struggling opponents.

AFRICAN-AMERICAN ART

Another group of artists soon joined the street photographers and began doing what had been unthinkable in the art world of the

27-24 William Eggleston. *Greenwood, Mississippi.* 1970. The J. Paul Getty Museum, Los Angeles, California

© Eggleston Artistic Trust

sixties. These artists turned away from both Minimalism and abstraction: They began making art about the nation's problems and about issues centering on gender, race, ethnic background, and sexual orientation. Because of the civil rights movement, African-American artists were especially pressured to make art about their heritage. At the university, they were trained like everyone else to make abstract art. From their community, they were asked to do the exact opposite, make narrative art and take up the black cause.

Romare Bearden In New York in 1963, a number of African American artists formed a loose group called Spiral dedicated to supporting the civil rights movement. They met at the studio of Romare Bearden (1911–1988), a New York University-educated mathematician and philosopher who in the 1940s increasingly became a committed artist. Influenced by Martin Luther King's 1963 March on Washington, Bearden suggested a collaborative project for Spiral that involved the members all contributing to a large photo collage about black identity. When no one turned up, Bearden by himself cut up newspapers and magazines and began making collages, for which he became famous.

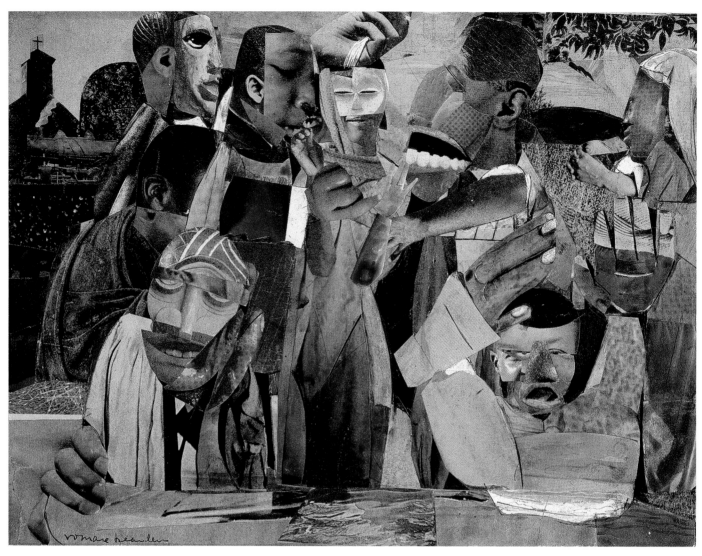

27-25 Romare Bearden. *The Prevalence of Ritual: Baptism.* 1964. Collage of photo-chemical reproduction, synthetic polymer, and pencil on paperboard, 9⅛ × 12" (23.2 × 30.5 cm). Hirshhorn Museum and Sculpture Garden, Smithsonian Institution, Washington, D.C., Gift of Joseph H. Hirshhorn, 1966

The composition of *The Prevalence of Ritual: Baptism* (fig. 27-25) of 1964 is Cubist, but the subject matter is distinctly African-American. Bearden grew up in Charlotte, North Carolina before moving to Harlem, and the fractured image shows a baptism, reflecting the importance of religion in black culture. The faces not only express the African physiognomy but in some instances also suggest African masks. This work has the effect of tracing American culture back to African roots and reinforcing the continuous importance of ritual and community. The collage has a wild syncopation and even a sense of improvisation that seems to relate to the black jazz musicians of the period, such as Charlie Parker or John Coltrane. This is a difficult point to

prove, but these qualities nonetheless distinguish Bearden's collages from other photocollages (compare to fig. 26-4). The power of Bearden's works lies in its compactness, his ability to pack so much information and energy into a single image so that it overflows with the vitality and essence of African-American experience.

Melvin Edwards Melvin Edwards (born 1937) took an entirely different approach to reflecting his racial background. Raised in Houston and studying welded-steel sculpture at the University of Southern California in Los Angeles, Edwards was outraged at the lynchings in the South, which were increasing as the Ku Klux Klan responded to the civil rights movement. As can be seen in

Lynch Fragment: Afro Phoenix 2 (fig. 27-26), he began in 1963 to make relief sculptures incorporating chains and spikes as well as other metal fragments, all of which had a brown tonality when oiled to prevent rusting. While there is no set reading of these works—which he continues to make today as a New York resident—they evoke oppression, bondage, violence, and anger as well as skin color, African masks (which the artist denies is present), ritual, and, in their frontality, a sense of confrontation and dignity. These basically abstract works are so open to interpretation, we can view them as autobiographical as well. The horseshoe, for example, is perhaps a reminiscence of visits to his uncle's ranch outside of Houston. Ironically, Edwards was making Post-Minimal art just as Minimal Art was being established.

Barbara Chase-Riboud Like Edwards, Barbara Chase-Riboud (b. 1939) is a formalist working in an abstract mode, but one filled with ethnic and gender references. Today best

27-26 Melvin Edwards. *Lynch Fragment: Afro Phoenix No. 2.* 1964. Welded steel, 35.6 × 22.9 × 12.1 cm. Collection of Jayne Cortez, New York
Courtesy of the artist and CDS Gallery, New York

27-27 Barbara Chase-Riboud. *Malcolm X #3*. 1970. Polished bronze and silk, 9'10" × 3'11¼ × 9⅞" (3 × 1.2 × .25 m). Philadelphia Museum of Art: Purchased with funds to be raised in honor of the 125th Anniversary of the Museum and in celebration of Aftrican American Art, 2001 (2001-92-1)

Photo by Gradon Wood. Philadelphia Museum of Art: Purchased with funds to be raised in honor of the 125th Anniversary of the Museum and in celebration of African American Art, 2001

known as a novelist and poet, Chase-Riboud made landmark sculptures in the late 1960s and early 1970s, such as the bronze and silk *Malcolm X #3* (fig. 27-27). On one level, the work is a beautiful abstraction, and innovative in its use of fiber, here silk, a medium associated with women and smartly contrasted with the reverential and traditional bronze. Besides the feminist reference, the sculpture is subtly loaded with her African heritage. In the draped fiber there is the suggestion of braided hair as well as African sculpture, such as masks that have raffia hanging below. The bronze patina evokes African skin. And of course the title of the work pays tribute to a dynamic black leader.

David Hammons Also emerging in the late 1960s is David Hammons (b. 1943), a quirky Conceptual artist who is at his best when stealthily operating within the community itself, rather than in museums and art galleries. His Duchamp-like humor can be seen in a later work, *Higher Goals* (fig. 27-28) of 1982, originally installed in his neighborhood in Harlem and here photographed at a Brooklyn site. The work was provoked by neighborhood teenagers playing basketball when they should have been attending school. They told the artist that the road to success lay in sports, not education. *Higher Goals* consists of 40-foot-high basketball hoops decorated with wind chimes, which look like spirit catchers, and bottle caps arranged in colorful geometric patterns suggesting African motifs and designs. As the title states, the work is about setting realistic higher goals, such as getting an education, as opposed to unattainable goals, such as becoming a professional basketball player. These bizarre, zany objects have a ritualistic quality and are even totemic. They raise the issue of what is to be revered and where is ancestral spirit to be placed. While clearly humorous, Hammons' works are thought-provoking. They communicate at a "cool" level with the neighborhood in the neighborhood, while at the same time satisfying the highest demands of the art world (although the latter is a secondary concern for the artist).

EDWARD KIENHOLZ

Some of the most powerful social statements came from the West Coast, which our New-York-centric discussion has so far ignored. Edward Kienholz (1927–1994) was one of the few avant-garde artists from his generation who overtly made art with a social conscience. Kienholz's work ranged from championing individual liberty and rights, including abortion rights, to attacking the nation's callous and corrupt involvement in the Vietnam War. By the early 1960s, the scale of his assemblages increased to the point of becoming environmental, like George Segal's. But while he used real found materials, he combined them in unreal, even surreal, situations, which give his installation-size sculptures powerful symbolic and metaphorical meanings designed to support his passionate political statements.

In intensity and ardor, Kienholz's works rivaled those of Daumier a century earlier (see pages 460 and 462). But there is no humor in

his depressing, generally grotesque works, which leave no doubt to the extent of his repulsion at the horrors he saw in contemporary society. With its bare single lightbulb, rusted bunk bed of stacked tethered inmates with fishtank heads, filthy decaying mattresses, and bodies decomposing into a disgusting gelatinous ooze, *The State Hospital* (fig. 27-29) of 1966 is a damning condemnation of the revolting conditions of state mental hospitals. What is not seen in our reproduction is the door with a small window with bars that is the only way for the viewer to see the claustrophobic space hiding this horrid scene. Kienholz, who among the many menial jobs he had before becoming a self-taught artist was as an orderly in a mental institution, makes it clear that the patient on the lower bunk is fully aware of his denigrating imprisonment. Coming out of his head is a cartoon-like neon thought bubble, in which he sees himself rotting away.

FEMINIST ART

Betty Friedan's 1963 book *The Feminine Mystique* signaled the start of the feminist movement, and almost simultaneously a number of women artists began making work that dealt with women's issues. Nancy Spero made simple but powerful painterly drawings depicting violence toward woman, whereas Mimi Smith made what is now recognized as the first clothing art, objects like a minimalist *Girdle* (1966) made out of rubber bathmats that capture the discomfort of women's clothing. Carolee Schneemann did such outrageous performances as *Interior Scroll* (1975). Naked and crouching, she pulled from her vagina a long scroll, from which she read a fictitious conversation between a woman and a man who failed to recognize the woman as an artist, not just a wife and mother.

Judy Chicago The great monument to the women's movement, however, is Judy Chicago's (b. 1939) controversial *The Dinner Table* (fig. 27-30), made by over 400 women between 1974 and 1979. By the late 1960s, Chicago was a dedicated feminist, who in the early 1970s established a Feminist Art Program, the first of its kind, at California State University at Fresno and then shortly thereafter with artist Miriam Schapiro a second similar program at the California Institute of the Arts in Valencia. The thrust of the courses was to encourage women to deal with gender

27-28 David Hammons. *Higher Goals.* 1982. Wood poles, basketball hoops, bottle caps, and other objects. Height 40' (12.19 m). Shown installed in Brooklyn, New York, 1986
Photograph by Dawoud Bey

identity and cultivate a female sensibility. The projects in Valencia included *Womanhouse* (1972) a suburban house near the campus that was used by female faculty and students for the creation of gender-related installations and performances, especially dealing with oppression and stereotyping of women.

27-29 Edward Kienholz. *The State Hospital.* 1966. Mixed media, 8 × 12 × 10' (2.44 × 3.66 × 305 m). Moderna Museet, Stockholm
© 2004 Artists Rights Society (ARS), New York

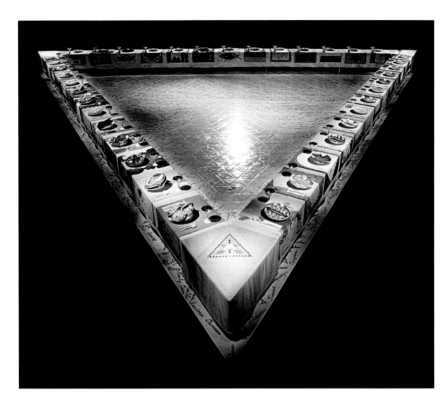

27-30 Judy Chicago. *The Dinner Party.* 1979. Mixed media, 3 × 48 × 42' (.9 × 17.6 × 12.8 m). Brooklyn Museum of Art

© 2004 Judy Chicago/Artists Rights Society (ARS), New York

The Dinner Party reflects Chicago's shift from a maker of abstract minimal objects and paintings to working in installation on environmental scale. It pays homage to the many women who Chicago felt were ignored, underrecognized, or outright omitted from the history books. Chicago first laboriously researched these forgotten figures. She then designed a triangular table with 39 place settings, 13 to a side, each honoring a significant woman, ranging from ancient goddesses to such twentieth-century icons as Georgia O'Keeffe. Hundreds of other names are inscribed on white floor tiles lying in the triangular intersection of the tables. Each place setting included a hand-painted ceramic plate that pictured a vagina executed in a period style—Emily Dickinson's sex, for example, is surrounded by lace, and French queen Eleanor of Aquitaine is encased in a fleur-de-lis. Under each place setting is an embroidered runner, often elaborate and again in period style. Instead of using bull-dozers, chain saws, hoists, and welding equipment as the men did for their environments and installations, Chicago intentionally turned to a media associated with women—china painting, ceramics, and embroidery. Although the work evokes a male ritual, Christ's Last Supper, it is transformed into a feminist ceremony. She collaborated with hundreds of women to produce the highly refined components of her elegant but complicated sculpture.

The Dinner Party was first shown at the San Francisco Museum of Modern Art in 1979, after which it was scheduled to tour the nation. But because of its overt sexuality and what was then perceived as confrontational feminist politics, most major institutions canceled the show (without specifying their reasons). Instead it was shown in alternative spaces, which began to proliferate in the late 1970s. Traditional museums had not adequately represented women and minorities, and now, these alternative spaces exhibited works that reflected the multifaceted pluralistic art that characterized the period. Today it is difficult to see what the fuss was all about. This exquisite setting for a spiritual last supper embraces many of the characteristics we associate with the new artistic freedoms of the period. It stands as a powerful icon for women's liberation and independence. Additionally, its gender politics, commentary on contemporary society, and use of so many different styles and periods announces the art of the 1980s, an art that still prevails today and has come to be called Post-Modernism.

Twentieth-Century Architecture

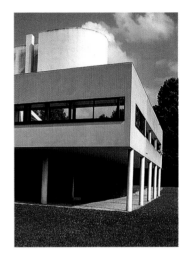

MODERNISM IN TWENTIETH-CENTURY ARCHITECTURE HAS meant first and foremost an aversion to historicism and to decoration for its own sake. Instead it favors a clean functionalism that expresses the Machine Age, with its insistent rationalism. In this regard, it can be considered the successor to classicism and, more specifically, the tradition of Structural Rationalism (see page 448). Yet modern architecture demanded far more than a reform of architectural vocabulary and grammar. A new philosophy was needed to take full advantage of the new building techniques and materials that the engineer had made available to the architect. The leaders of modern architecture have been vigorous and eloquent thinkers, in whose minds architectural theory is closely linked with ideas of social reform to meet the challenges posed by industrial civilization. To them architecture's ability to shape human experience brings with it the responsibility to play an active role in molding modern society for the better. However, modernism has created as many problems as it has solved, from faulty structures caused by engineering errors to inhuman buildings based on abstract ideals.

Architecture before World War I

EARLY MODERNISM

Frank Lloyd Wright The first modern architect was Frank Lloyd Wright (1867–1959), Louis Sullivan's great disciple. If Sullivan, Gaudí, Mackintosh, and Van de Velde could be called the Post-Impressionists of architecture, Wright took architecture to its Cubist phase. This is certainly true of his brilliant early style, which he developed between 1900 and 1910 and which had broad international influence. In the beginning Wright's main activity was the design of suburban homes in the upper Midwest. These were known as Prairie Style houses because their low, horizontal lines were meant to blend with the flat landscape around them.

The last, and most successful, residence in this series is the Robie House of 1909 (figs. 28-1, 28-2). The exterior, so unlike anything seen before, instantly proclaims the building's modernity. However, its "Cubism" is a matter not merely of the clean-cut rectangular elements composing the structure, but also of Wright's handling of space. Robie House is designed as a number of "space blocks," similar to the building blocks the architect played with as a child, arranged around a central core, the chimney. Some of the blocks are closed and others are open, but all are defined with equal precision. Thus the space that has been architecturally shaped includes the balconies, terrace, court, and garden, as well as the house itself. As in Analytic Cubism, voids and solids are regarded as equivalents, and the entire complex enters into an active and dramatic relationship with its surroundings. Wright did

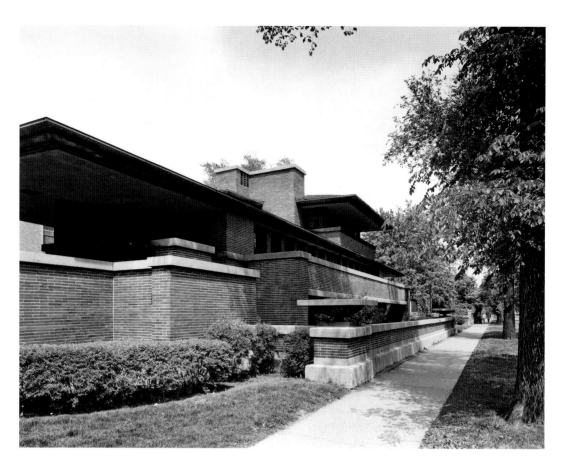

not aim simply to design a house but to create a complete environment. He even took command of the details of the interior. Wright acted out of a conviction that buildings have a profound influence on those who live, work, or worship in them, thus making the architect, consciously or unconsciously, a molder of people.

Deutscher Werkbund In Europe modern architecture developed more slowly and unevenly, and it came to maturity only on the eve of World War I, which effectively halted its further growth for nearly a decade. Central to the early development of modernism in Germany was the Deutscher Werkbund (Artisans Community). This alliance of "the best representatives of art, industry, crafts and trades" was founded in 1907 to upgrade the quality and value of German goods to the level of England's. The leader was Hermann Muthesius (1861–1927), whose mission was to translate the Arts and Crafts Movement into a machine style using the most advanced techniques of industrial design and manufacturing. Its membership consisted of 12 leading industrial firms and a like number of artists, designers, and architects from Germany and Austria. The way was led by Peter Behrens (1869–1940), the chief architect and designer for the electrical firm A.E.G., whose three disciples became the founders of modern architecture: Walter Gropius, Ludwig Mies van der Rohe, and Le Corbusier.

Walter Gropius The first to cross that threshold fully was Walter Gropius (1883–1969), who came from a well-known family of architects. The Fagus Shoe Factory (fig. 28-3), designed in 1911 with his partner Adolf Meyer (1881–1929), represents the critical

28-2 Plan of the Robie House

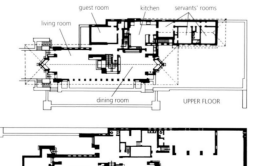

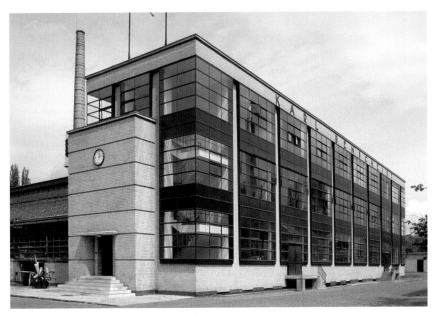

28-3 Walter Gropius and Adolf Meyer. Fagus Shoe Factory, Alfeld, Germany. 1911–14

step toward modernism in European architecture. The most dramatic feature is the walls, which are a nearly continuous surface of glass. This radical innovation had been possible ever since the introduction of the structural-steel skeleton several decades before, which relieved the wall of any load-bearing function. Sullivan had approached it, but he could not yet free himself from the traditional notion of the window as a "hole in the wall." Far more radically than Sullivan or Behrens, Gropius frankly acknowledged, at last, that in modern architecture the wall is no more than a curtain or climate barrier, which may consist entirely of glass if maximum daylight is wanted. Only in the classical entrance did he give a nod to the past.

EXPRESSIONISM

Bruno Taut The Werkbund exhibition of 1914, which featured Van de Velde's theater (see fig. 24-20), was a showcase for a whole generation of young German architects who were to achieve prominence after World War I. Many of the buildings they designed for the fairgrounds anticipate ideas of the 1920s. Among the most adventurous is the staircase of the "Glass House" (fig. 28-4) by Bruno Taut (1880–1938). It was made magically translucent by the use of glass bricks, then a novel material. The structural-steel skeleton was as thin and unobtrusive as the

great strength of the metal permits. The use of glass was inspired, oddly enough, not by technology but by the widespread mystical interest in crystal. This enthusiasm was started by the poet Paul Scheerbart, whose aphorisms, such as "Colored glass destroys hatred," ring the Glass House.

Taut's mysticism was shared by the Expressionist movement. After the war he

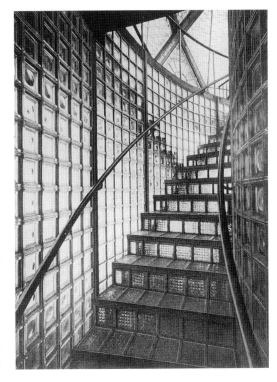

28-4 Bruno Taut. Staircase of the "Glass House," Werkbund Exhibition, Cologne. 1914

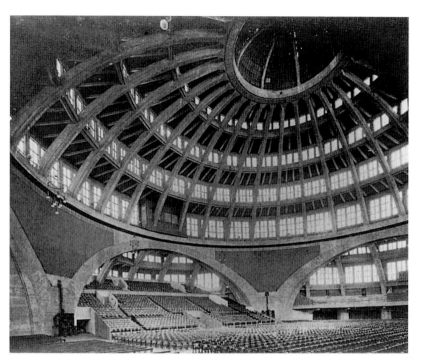

28-5 Max Berg. Interior of the Centennial Hall, Breslau, Germany. 1912–13

helped to establish the short-lived Workers' Council for Art, whose members included painters of Die Brücke (see pages 535-36). Its purpose was to unite all the arts under the umbrella of architecture. Through his journals *The Glass Chain* and *Early Light*, Taut became the center of a loose network of architects, including Behrens, Gropius, Erich Mendelsohn (1887–1953), and even Mies van der Rohe, who had the same fascination with crystalline glass. To Taut, architecture "consists exclusively of powerful emotions and addresses itself exclusively to the emotions." We may call this approach Expressionism, because it stresses the artist's feelings toward himself and the world.

Max Berg The romantic side of Expressionist architecture is best seen in the Centennial Hall (fig. 28-5) built by Max Berg (1870–1948) in Breslau to celebrate Germany's liberation from Napoleon in 1812. Berg, for the first time, has taken full advantage of reinforced concrete's incredible flexibility and strength. The vast scale is not simply an engineering marvel but a visionary space. Ultimately the interior looks back to the Pantheon (see fig. 7-6), but with the solids and voids reversed, so that we are reminded of nothing so much as the interior of Hagia Sophia (see fig. 8-12). That Cen-

tennial Hall further recalls the soaring spirituality of a Gothic cathedral (such as fig. 11-3) is not a coincidence. Berg had an intense Christian religiosity, and he later abandoned his profession.

Architecture between the Wars

By the onset of World War I, the stage was set for a modern architecture. But which way would it go? Would it follow the impersonal standard of the machine aesthetic advocated by Muthesius or the artistic creativity espoused by Van de Velde? Ironically, the issue was decided by Van de Velde's choice of Behrens's disciple Walter Gropius as his successor at Weimar in 1915, when Van de Velde was forced to resign because he was not a German. However, the war effectively postponed the evolution of modern architecture for nearly a decade. When this development resumed in the 1920s, the outcome of the issues posed at the Cologne Werkbund exhibition in 1914 was no longer clear-cut. Rather than a simple linear progression, we find a complex give-and-take between modernism and competing tendencies representing traditional voices and alternative visions.

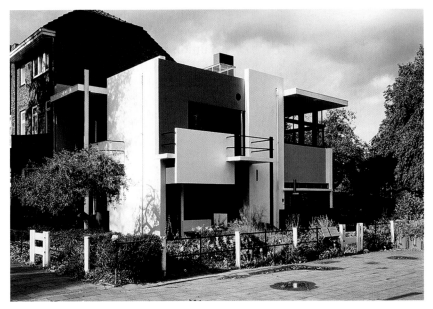

28-6 Gerrit Rietveld. Schröder House, Utrecht, the Netherlands. 1924

DE STIJL

Gerrit Rietveld The work of Frank Lloyd Wright attracted much attention in Europe through German publications of 1910 and 1911 featuring his buildings. Among the first to recognize its importance were some young Dutch architects who, a few years later, joined forces with Mondrian in the De Stijl movement (see page 579). Among their most important experiments is Schröder House (fig. 28-6), which was tacked on to an existing apartment house in 1924 by Gerrit Rietveld (1888–1964). The facade looks like a Mondrian painting transposed into three dimensions, for Rietveld has used the same rigorous abstraction and refined geometry (compare fig. 26-26). The arrangement of floating panels and intersecting planes is based on Mondrian's principle of dynamic equilibrium: the balance of unequal but equivalent oppositions, which expresses the mystical harmony of humanity with the universe. Steel beams, rails, and other elements are painted in bright primary colors to define the composition.

Unlike the elements of a painting by Mondrian, the exterior parts of Schröder House look as if they can be shifted at will, although in fact they fit as tightly as the interlocking pieces of a jigsaw puzzle. Not a single element could be moved without destroying the delicate balance of the whole. Inside, however, the living quarters can be reconfigured through a system of sliding partitions that fit neatly together when moved out of the way. This flexible treatment of the living quarters was devised with the owner, Truss Schröder, herself an artist, to suit her individual lifestyle. The decentralized plan also incorporates a continuous, "universal" space, which is given a linear structure by the network of panel dividers.

Schröder House proclaims a utopian ideal widely held in the early twentieth century. The machine would hasten humanity's spiritual development by liberating us from nature, with its conflict and imperfection, and by leading us to the higher order of beauty reflected in the architect's clean, abstract forms. The harmonious design of Schröder House owes its success to the insistent logic of this aesthetic, which we respond to even without being aware of its ideology.

THE INTERNATIONAL STYLE

The Bauhaus Schröder House was recognized immediately as one of the classic statements of modern architecture. The De Stijl architects represented the most advanced ideas in European architecture in the early 1920s. They had a decisive influence on so many architects abroad that the movement soon became international. The largest and most complete example of this International Style of the 1920s is the group of buildings created in 1925–26 by

become vast expanses of glass, like the stained-glass windows of Gothic cathedrals (see fig. 11-1). In this way, Perret created a modern-day counterpart to Soufflot's Panthéon (see fig. 21-12). This feat is not important in itself. It could, after all, readily be dismissed as mere historicism. Yet Perret has brilliantly solved one of the most difficult problems facing the modern architect: how to express traditional spirituality in our secular Machine Age using a twentieth-century vocabulary. Le Raincy is so pivotal that nearly all later church architecture in the West is indebted to its example, no matter how different the results.

Architecture since 1945

HIGH MODERNISM

Following the rise of the Nazis, the best German architects, whose work Hitler condemned as "un-German," came to the United States and greatly encouraged the development of American architecture. Gropius was appointed chairman of the architecture department at Harvard University, where he had an important educational influence. Mies van der Rohe, his former colleague at Dessau, settled in Chicago as a practicing architect. Following the war, they were to realize the dream of modern architecture, contained in germinal form in their buildings

of the 1930s but never fully implemented. We may call the style that dominated architecture for 25 years after World War II High Modernism. It was indeed the culmination of the developments that had taken place during the first half of the twentieth century.

Even at its zenith High Modernism never arrived at a single, universal style. Nevertheless, its unified spaces embodied a harmonious vision that developed in a consistent way as the style was used in countless buildings throughout the world. Like the International Style before it, High Modernism permitted considerable local variation within established guidelines, although this development led almost inevitably to its decline.

Ludwig Mies van der Rohe The crowning achievement of American architecture in the postwar era was the modern skyscraper, defined largely by Mies van der Rohe. The Seagram Building in New York (fig. 28-14), designed with his disciple Philip Johnson (b. 1906), carries the principles announced in Gropius's design for the Bauhaus to their ultimate conclusion. It uses the techniques developed by Sullivan and Wright, Mies van der Rohe's great predecessors in Chicago, to extend the structure to an enormous height. Yet the building looks like nothing before it. Although not quite a pure box, it illustrates Mies van der Rohe's famous saying that "less is more." This alone does not explain the difference, however. Mies van der Rohe discovered the perfect means to articulate the skyscraper in the I-beam, its basic structural member, which rises continuously along nearly the entire height of the facade. (The actual skeleton of the structure remains completely hidden from view.) The effect is as soaring as the **responds** inside a Gothic cathedral (compare fig. 11-3)—and with good reason, for Mies van der Rohe believed that "structure is spiritual." He achieved it through the lithe proportions, which create a perfect balance between the play of horizontal and vertical forces. This harmony expresses the idealism, social as well as aesthetic, that underlies High Modernism in architecture.

LATE MODERNISM

Since 1970 architecture has been obsessed with breaking the tyranny of the cube—and the High Modernism it stands for. Consequently a wide range of tendencies has arisen,

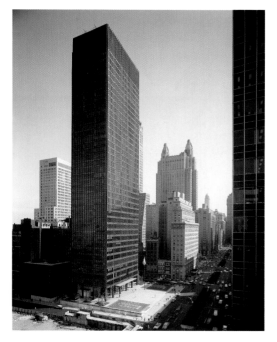

28-14 Ludwig Mies van der Rohe and Philip Johnson. Seagram Building, New York. 1954–58

© 2004 Artists Rights Society (ARS), New York/VG Bild-Kunst, Bonn

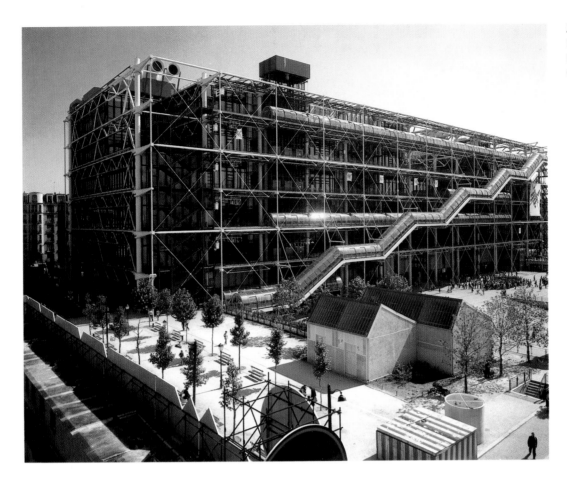

representing almost every conceivable point of view. Like so much else in contemporary art, architecture has become theory-bound. Yet once the dust has settled, we may simplify its bewildering categories, with their equally confusing terminology, into Late Modernism and Post-Modernism (see chapter 29). They are separated only by the degree to which they challenge the basic principles of High Modernism.

Rogers and Piano Late Modernism began innocently enough as an attempt to introduce greater variety of form and material, but it ended in the segmentation of space and use of "high-tech" finishes that are the hallmarks of late-twentieth-century buildings. Among the freshest results of Late Modernism is the Centre Georges Pompidou, the national arts and cultural center in Paris, which rejects the formal beauty of the International Style without abandoning its functionalism (fig. 28-15). Selected in an international competition, the design by the Anglo-Italian team of Richard Rogers (b. 1933) and Renzo Piano (b. 1937) looks like a building turned inside-out. The archi-

tects have eliminated any trace of Mies van der Rohe's elegant facades (see fig. 28-14) by exposing the building's inner mechanics while disguising the underlying structure. The interior itself has no fixed walls, so that temporary dividers can be arranged to meet any need. This stark utilitarianism, sometimes termed Productivism, expresses a populist sentiment widespread in France. The exterior is enlivened by eye-catching colors, each keyed to a different function.

NEO-EXPRESSIONISM

It can be argued that Late Modernism fulfills the agenda mapped at the beginning of the century, when architecture pursued not one but several paths. There is a certain truth to this ironic notion. Since 1985 architecture has also seen the rise of Neo-Expressionism and Neo-Modernism, which can be regarded as counterparts of the similarly named movements in painting (see page 640). They have helped to make architecture the most vibrant and innovative of all art forms on the scene today, in contrast to painting and sculpture, which seem adrift. Indeed, the architecture of the past 15 years is among the

richest in variety and quality of any period since the Baroque. There are at present more than two dozen great architects at work around the world. (See also Post-Modern Architecture, pages 637–39.)

Santiago Calatrava Neo-Expressionism utilizes the same hi-tech materials and techniques as Late Modernism but creates fantasies that are more sculptural than architectural. Thus architecture has replaced sculpture as the giver of contemporary form. Santiago Calatrava (b. 1951), Spanish-born but Swiss-based, has created literally a flight of fancy for the futuristic TGV (the French high speed train) Station at Satolas, Lyons (fig. 28-16), which suggests some sort of mechanized prehistoric creature out of a science-fiction movie.

The entrance to the central hall gives the appearance of the Concorde supersonic plane constructed on a bird-like skeleton but with a tail echoing the French Super Train. Through this seemingly mixed metaphor, the structure helps to link the railroad station with a nearby airport.

NEO-MODERNISM

Neo-Modernism looks back consciously to the modernist tradition created by Gropius, Mies van der Rohe, and Le Corbusier. Within it we may discern three separate, yet closely related, strands. The first is a revival of Structural Rationalism that is especially characteristic of Italian architects, such as Mario Botta (b. 1943) and Aldo Rossi (1931–1997), as well as the Frenchman Jean Nouvel (b. 1945). The

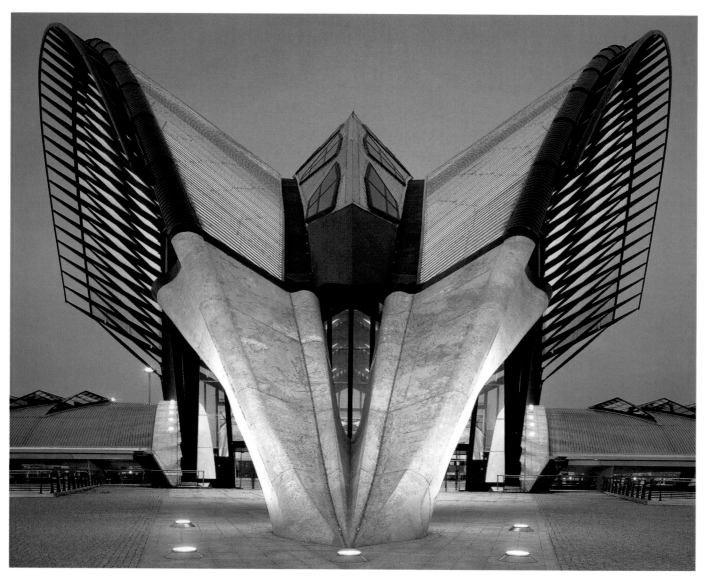

28-16 Santiago Calatrava. TGV (Très Grande Vitesse) Super Train Station, Satolas, Lyons. 1988–94

second is a conscious return on the part of certain English architects, most notably Nicholas Grimshaw (b. 1939), to the functional engineering of Paxton's Crystal Palace (see fig. 23-27). And the third, taken up by a new school of Dutch architects, among whom Rem Koolhaas (b. 1944) is the best known, questions the legacy of High Modernism and tries to give it new life by reconsidering its potential in light of present-day realities. The theories and approaches of these three overlap not only with each other, but also with those of the Post-Modernists, so that in recent years there has been a gradual merging of previously separate tendencies.

Rem Koolhaas An issue that concerns all schools is how to deal with the problem of unplanned urban growth and its attendant blight, although each has faced it somewhat differently. Unlike earlier architects, they have generally avoided attempting to cure social ills, since the utopian schemes put forward by the High Modernists were generally failures. Instead, they have been interested primarily in making significant architectural statements under the difficult conditions imposed by the sites themselves.

Koolhaas and his OMA group have focused on modern chaos theory and the "culture of congestion" epitomized by New York City, which has led to a recent preoccupation with size. For him, it is the architect's role to resist chaos and instead find a new modernism reflecting urban existence in our time, which is full of paradoxes and contradictions. For that reason, Koolhaas combines "architectural specificity with programmatic instability," in which goals are treated in terms of strategy. Far from rejecting modernism, Koolhaas builds on it, while discarding many of its underlying assumptions.

What all this theorizing in effect means is a new functionalism in which the facade is no more than an envelope that coexists with its surroundings, thereby disguising the purposes and spaces it encloses. In fact, Koolhaas's exteriors are deceptively bland. The real action takes place inside. If the Neo-Expressionists and the Sculptural Architects (see pages 639–40) are masters of form, Koolhaas is the master of interior space. The facade of the Netherlands Dance Theater, which is grafted onto an existing concert hall, is extremely modest. However, the foyer (fig. 28-17) is that rarity in modern architecture: a genuinely engaging interior, although it deliberately breaks no new ground as such. Despite Koolhaas's importance as a theorist, his design refrains from the didacticism that made High Modernism seem so cold and barren. He instead rescues modernism from itself and invests it with a new humanism—the feature it most conspicuously lacked—through the use of festive colors and dynamic space strikingly reminiscent of Léger's paintings (compare fig. 26-28). It is this kind of thoughtful reappraisal of the modernist legacy that offers perhaps the best hope for its continued vitality.

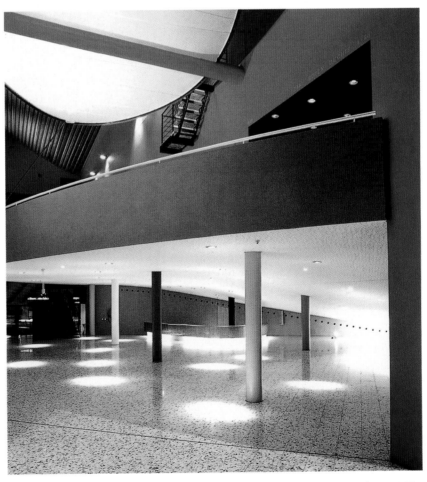

28-17 Rem Koolhaas. Foyer of the Netherlands Dance Theater, Amsterdam, 1987

CHAPTER

29

The Postmodern Era: Art since 1980

POSTMODERNISM IS THE TERM OFTEN USED TO DESCRIBE THE art that became fashionable toward 1980. The word first came into common use in the mid 1960s, when it was adopted by European literary critics and applied mainly to literature. By the late 1970s, artists and critics had digested their theory and pushed it into the forefront of art. What was this theory? Put most simply it was largely based on **semiotics**, the study of signs, and its most fundamental premises include the claim that all art is an elaborate construction of signs and the meaning of these signs is determined by context. In effect, there is no fixed meaning in art because context can change. Therefore there are no fixed truths.

Of course, these ideas didn't just spring up in the 1980s. Marcel Duchamp (see page 548) made similar statements in the 1910s, and Conceptual Artists, such as Joseph Kosuth (see pages 606–7) in the 1960s, and Rauschenberg, Warhol, and Lichtenstein were all interested in similar issues. As we discussed, Warhol and Lichtenstein wanted to expose the powerful hidden meaning of images—the crass commercialism of the press in Warhol and the sexism of comic books in Lichtenstein (see page 600). This **deconstruction** of an image to expose its covert meaning is a concept that is fundamental to Postmodernism.

As we saw in the last chapter, the 1950s and early 1960s were a watershed for the remainder of the century. Even as they criticized American culture, Warhol made his political statements subversively, and Lichtenstein's subtle comments on gender stereotyping comprised only a small portion of his work. But in the 1980s, the concerns of earlier artists solidified into concrete theory, and it was backed up by highly political rhetoric. Now, more overtly and persistently, the Postmodern artists asked, How do signs acquire public meaning? What is the message? Who originates it? What and whose purpose does it serve? Who is the audience?

What are the means of spreading the idea? Who controls the media—and for whom?

Postmodernism also marked a new view of the history of modern art itself. That history could no longer be seen as a linear progression of one style building upon a preceding style, continuously moving art forward toward the "new." The tearing down of all art barriers in the 1950s and 1960s and the proliferation of styles and media in the pluralistic 1970s meant there was nothing "new" to be done. The search for the "new" was a mandate of the 1950s and 1960s, as we saw in the art of the Frank Stella and Donald Judd, for example (see pages 601–603). By the 1980s, artists had license *not* to be new. Now they could appropriate art in every imaginable style and media from the entire history of civilization and combine it as they saw fit. Many of the finest artists do not even concern themselves with cultivating a distinguishable style as they jump from one medium to the next, with theme rather than a look tying their work together.

Finally, the Postmodern era redefined the nature of the art world itself. Its circle widened to embrace artists from all over the world, sponsoring all kinds of art, styles, and issues without prioritizing one as more important than another. In part, this attitude

reflects the restructuring of the world in the last 25 years. Politically and economically it was realigned as first the U.S.S.R. and then China abandoned their strict adherence to communism, experimented with capitalism, and opened their doors to foreign trade and investment. In the 1990s Europe formed the European Economic Community, and the United States, Mexico, and Canada signed the North American Free Trade Agreement. Barriers were falling everywhere with people crossing borders more readily than ever before. But it was perhaps the communication field more than anything else that created the "Global Village." Television, cellular telephones, computers, and the Internet linked the world together, creating a glut of information that was instantly available to almost anyone anywhere. The Post-Industrial era was also the Information Age.

Today, New York may still be the capital of the art world, but not by much. Vibrant art scenes can be found worldwide, and the world's leading artists are Australian, Brazilian, British, Chinese, Cuban, German, Icelandic, Iranian, Israeli, Italian, Japanese, Lebanese, South African, and Thai, to mention but a few of the nationalities that dominate world art. New York *may* provide the best marketplace, but it does not monopolize the talent.

Architecture

POSTMODERNISM

Postmodernism in art was first coined to denote an eclectic style of architecture that arose around 1980. Postmodernism represents a broad rejection of mainstream twentieth-century architecture. Although it uses the same construction techniques, Postmodernism rejects not only the vocabulary of Gropius and his followers but also the social and ethical ideals implicit in their architecture. (See the Bauhaus discussion, pages 627–28.) Looking at the Seagram Building (see fig. 28-14), we can understand why. As a statement, it is so overwhelming in its authority that it prohibits deviation, and so cold that it looks forbidding. The Postmodernist critique was, then, essentially correct. In its search for universal ideals, the International Style failed to communicate with people, who

neither understood nor liked it. Postmodernism is an attempt to reinvest architecture with the human meaning so clearly absent from High Modernism. It does so by appropriating premodernist architecture.

The chief means of introducing greater expressiveness has been to adopt elements from historical styles rich with association. All traditions are assumed to have equal validity, so that they can be combined at will. This eclectic **historicism** is nevertheless highly selective in its sources. They are restricted mainly to various forms of classicism (notably Palladianism; see pages 317–18) and some of the more exotic strains of Art Deco, which provided a genuine alternative to modernism during the 1920s and 1930s. Architects have repeatedly searched the past for fresh ideas. What counts is the originality of the final result.

Michael Graves The Public Services Building in Portland, Oregon (fig. 29-1), by Michael Graves (b. 1934), has many characteristics of Postmodernism. Elevated on a pedestal, it mixes classical, Egyptian, and assorted other motifs in a whimsical building-block paraphrase of Art Deco (see chapter 28). In this way, Graves relieves the building of the monotony imposed by the tyranny of the cube that afflicts so much modern architecture. Although the lavish sculptural decoration intended for it was never added, the exterior has a warmth that continues inside. At first glance, it is tempting to dismiss the Public Services Building as mere historicism, designed to evoke earlier styles. However, no earlier structure looks at all like it. What holds this historical mix together is the architect's style. It is based on a mastery of abstraction that is as systematic and personal as Mondrian's. Indeed, Graves first earned recognition in 1969 as a skilled Late Modernist.

Today Postmodern buildings are found everywhere. They are instantly recognizable by their keyhole arches, round "Palladian" windows, and other relics from the architectural past. They are also marked by their luxuriance. Postmodernism may be characterized as architecture for the rich that has since been translated downward to the middle class. Its aura of wealth suggests the egocentricity and hedonism that spawned the "me" generation of the 1980s, one of the most prosperous and extravagant decades in

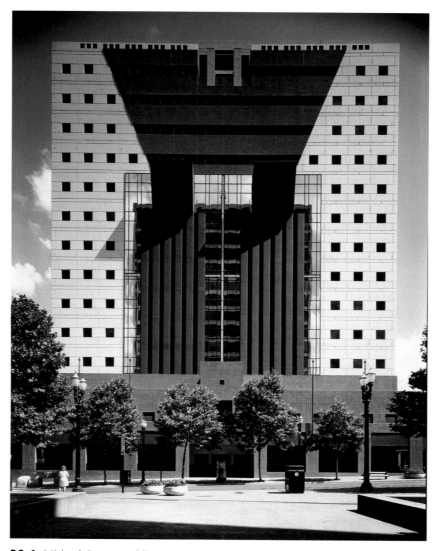

29-1 Michael Graves. Public Services Building. Portland, Oregon. 1980–82

recent history. Nevertheless, the retrospective eclecticism of Postmodernism soon became dated through the repetitious quotation of standard devices that were reduced to self-parodies lacking both wit and purpose. In a larger sense, however, this quick passage reflects the restless quest for novelty and, more important, a new modernism that has yet to emerge to replace the old.

James Stirling Postmodernists criticize Late Modernism for its commitment to the "tradition of the new." Paradoxically, that tradition *excluded* the new. Late Modernist architecture, said the critics, was a monotonous retelling of itself. It was not only repetitive, but also lacked a meaningful relationship to the architecture of the past.

We can test this proposition for ourselves by comparing the Pompidou Center (see fig. 28-15) with the Neue Staatsgalerie in

Stuttgart (fig. 29-2), which was immediately recognized as a classic example of Postmodernism. The latter has the grandiose scale befitting a "palace" of the arts, but instead of the monolithic cube of the Pompidou Center, English architect James Stirling (1926–1992) incorporates a greater variety of shapes within more complex spatial relationships. There is also an openly decorative quality that reminds us of Garnier's Paris Opéra (see fig. 22-29). But Stirling's historical references are far more subtle than Garnier's opulent revivalism. The prim neoclassical masonry facade, for example, is punctured by a narrow arched window recalling Italian Renaissance forms (compare fig. 12-12). At the same time, Stirling evokes modernism by using "high-tech" materials, such as painted metal.

This eclecticism lies at the heart of the building's success. The site, centering on a circular sculpture court, is designed along the

lines of ancient temple complexes from Egypt through Rome, complete with a monumental entrance stairway. This plan enables Stirling to solve a wide range of practical problems with ingenuity and to provide a stream of changing views that fascinate and delight the visitor. The results have been compared to the Altes Museum of Karl Friedrich Schinkel (see fig. 22-26), among the most classical structures of the nineteenth century. By comparison, the Pompidou Center is a far more radical building.

AFTER POSTMODERNISM: SCULPTURAL ARCHITECTURE

An extraordinary variety has characterized architecture around the world over the past decade or so. One trend that has gained tremendous attention is Sculptural Architecture. It is as if contemporary architects urgently need to create sculpture on a scale that surpasses even the grandiose dreams of environmental sculptors. Moreover, the architects who are pursuing this direction are a different breed from their predecessors. Not that they are youngsters. Most were born between 1943 and 1953. But although they are very conscious of everything that has come before them, they think—and even talk—differently.

Frank Gehry The oldest and most radical of these sculptural Postmodernists is Frank Gehry (b. 1929), a Los Angeles architect who has always been a maverick in his sense of design and choice of materials. Gehry's recent buildings can be described as assemblages of miscellaneous parts. His most famous achievement is the Guggenheim Museum in Bilbao, Spain, which opened in 1997 (fig. 29-3). Situated strategically on a bend of the river that runs through the city, it is part cultural institution and part urban renewal project. (It replaced an abandoned lumber mill.) Responding to the director's wishes, Gehry varied the shape of the galleries to provide different viewing experiences appropriate to the various kinds of art they hold. Once the main functional requirements had been determined, the building was conceived in a series of drawings. Often resembling abstract doodles, they were then translated into usable form by employing the latest computer-aided design programs. Throughout the long develop-

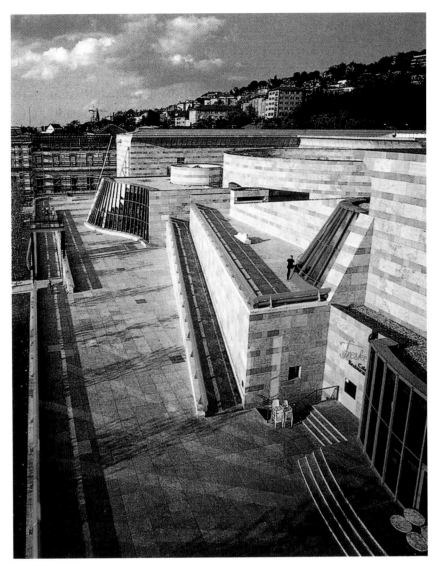

29-2 James Stirling, Michael Wilford and Associates, Neue Staatsgalerie, Stuttgart, Germany. Completed 1984

ment process, Gehry experimented with a number of shapes, many of which were incorporated into the final design.

The result is certainly as innovative and controversial as Frank Lloyd Wright's original Guggenheim Museum in New York (see figs. I-14 and I-15). The Bilbao Guggenheim is a structure of such dazzling complexity that no single photograph can begin to suggest its ever-changing views. As one critic observed, from head-on it looks like a collision between two ships. Seen from above, the museum appears to unfold like a flower, but it also includes fish, snake, boot, and sail forms. Indeed, the main body is clad in a skin of specially fabricated, ultra-thin titanium tiles suggesting the scales of a serpent or denizen of the deep. It has such organic vitality that it almost seems to take on a life of its own,

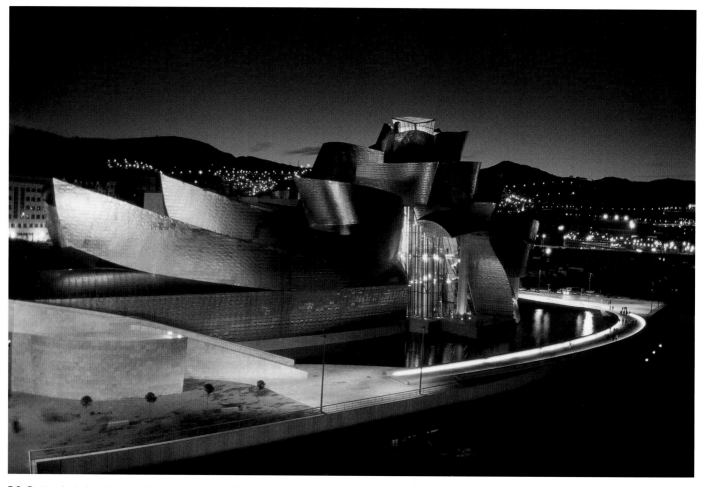

29-3 Frank Gehry. Guggenheim Museum, Bilbao, Spain. 1992–97

especially when viewed from the side, as in our illustration. The building ends in a tower that is actually architectural sculpture rather than a functional piece of architecture. All told, the Bilbao Guggenheim is possibly the most exciting building of the 1990s. It became an instant classic, defining the spirit of the decade much as the Pompidou Center (see fig. 28-15) did for the 1980s.

The Visual Arts

THE RETURN OF PAINTING: NEO-EXPRESSIONISM AND NEW IMAGE PAINTING

Painting was back by 1980. Not that it had disappeared. But it had been overshadowed in the late 1960s and 1970s by Conceptual, Video, Performance, and Environmental art. The art world talked about the "death of painting," which had been supplanted by these new media. But show after show featuring painting opened in London, New York, Germany, and Italy in the late 1970s and 1980s. Critic Achille Bonito Oliva in his 1982 book about this new painting wrote in the introduction that "The dematerialisation of the work and the impersonality of execution which characterised the art of the seventies, along strictly Duchampian lines, are being overcome by the re-establishment of manual skill through a pleasure of execution which brings the tradition of painting back into art."

This new painting came to be known as Neo-Expressionism, an appropriate label for works that are both painterly and expressionistic. Neo-Expressionism appeared first in Germany and Italy and then migrated to New York. In Germany, painting was very self-consciously German, recalling Northern romanticism (see Friedrich, page 470) and Expressionism (see Kokoschka, page 538) so deeply entrenched in nation's culture. Joseph Beuys, through his mystical performances, was the catalyst for this resurrection of the German past. Among the themes he and oth-

ers began to explore were the atrocities of Hitler's Third Reich, which the nation had repressed following World War II.

Anselm Kiefer Among Beuys's students at the Düsseldorf Art Academy were two painters, Anselm Kiefer (b. 1945) and Jorg Immendorf, both of whom created images of mythical and epic scope and power that evoke centuries of German history. Kiefer's enormous painting *To the Unknown Painter* (fig. 29-4) explodes with the energy of flailed paint and the dramatic perspective of crop furrows rushing back toward an eerie monumental tomb, which almost seems to pull them like a powerful magnet. Cold, bleak, and lifeless, the black, white, and earth-colored image oozes death. Or does it? Crops lying fallow in the winter will be reborn in the spring. The cycle of life will go on. The restless drama of paint and composition is virtually a metaphor for the constant movement of nature. Kiefer has not just painted with oil but has used real straw as well, which is embedded in the paint. Viewers could smell it for years after the picture was made. Nature is not just represented, it is actually present. Inspired by the symbolic and spiritual real objects that Beuys used in his installations and sculptures, Kiefer incorporated real materials into his work (he often used lead as well as straw), giving the paintings a similar ritualistic magic. The real straw, however, does not rejuvenate like the illusionistic crop in the field; instead it will gradually disintegrate.

How does the tomb fit into this image? As the title suggests, the mausoleum is for painters, and they are German. We know this because the tomb is not painted, but rendered in a large woodcut. We associate the woodcut with German artists, because it was widely used by Germans during the Renaissance and

29-4 Anselm Kiefer. *To the Unknown Painter.* 1983. Oil, emulsions, woodcut, shellac, latex, and straw on canvas, 9′ 2″ × 9′ 2″ (2.79 × 2.79). The Carnegie Museum of Art, Pittsburgh

Richard M. Scaife Fund; A. W. Mellon Acquisition Endowment Fund

again by the Expressionists in the early twentieth century. The powerful shifting forces of nature swirling around the isolated but well-anchored monument represent the Teutonic mythical past and romantic spirit that has fueled German artists for centuries, providing a continuous tradition. The bunker-like mausoleum also suggests a shelter, protecting the painters from the tumultuous forces without. We know from other works by Kiefer that these destructive forces are also meant to represent Hitler's perversion of the German romantic tradition, which he manipulated to serve his racist politics and his cultural agenda. During Hitler's rule, every avant-garde German artist, even those who supported the Nazi party, was suppressed.

In a painting that deals with national identity, Kiefer, through his expressionistic style and romantic themes, proclaims his own place within the Northern Romantic tradition. He assures us that this tradition is once again in safe hands. Kiefer has loaded his picture with a wealth of meanings, symbols, and metaphors, even assigning different meanings to the same object. With its many layers of overlapping and interlocking meaning, the resulting image is extremely complex, a reflection of the epic scale Kiefer covers and the mythic themes he evokes.

Elizabeth Murray In 1978, the Whitney Museum of American Art in New York mounted an exhibition of American artists titled *New Image Painting*. The show not only claimed that painting was alive and well, but declared that there was a new kind of painting. Embedded within paintings that looked abstract were representational objects. One moment the painting appears totally abstract, and the next representational. Elizabeth Murray (b. 1940) was working in total abstraction at the time and was not included in the show. But within a few years, her abstraction, which served as a metaphor for a psychological state, developed representational components and evolved into New Image Painting. This can be seen in the 1983 oil *More than You Know* (fig. 29-5). At a quick glance, it appears to consist of entirely abstract shapes. But we soon recognize that the sweeping orange curve playing off of a blue-gray Constructivist rectangle is the back of a spindle-back chair. We then recognize the rectangle as a painting hanging on a yellow wall of a room. Finally we can convince ourselves that the green anthropomorphic shape hovering near the surface is a table with collapsed legs. Sitting on the table is a white form that suggests a piece of paper and a disturbing biomorphic shape that recalls the skull in Munch's *Scream* (see fig. 24-12). Tension, symbolized by the collapsed table dominates the entire image. We see it in the strident colors, the raspy unfinished-looking paint-handling, the violent tilt of the floor, and the jarring disruption as the drawing of an object, such as the letter, suddenly drops from one canvas to the next. Even the shape of the painting is frenzied. Murray combines ten different canvases, giving the outer edge of the picture a ragged, hectic profile that transforms it into a wildly spinning pinwheel. Nothing seems to be anchored in this composition, as everything shifts wildly about like detritus adrift in a stormy sea. In picture after picture, Murray focuses on the psychological tension of daily domestic life, the reality that lies beneath the facade of family harmony.

29-5 Elizabeth Murray. *More than You Know.* 1983. Oil on ten canvases, 9′ 3″ × 9″ × 8″ (2.82 m × 2.74 m × 20.3 cm). The Edward R. Broida Collection
Courtesy PaceWildenstein Gallery, New York

POSTMINIMALISM AND PLURALISM IN THE 1980s: MARTIN PURYEAR

The variety of the 1970s continued into the closing decades of the twentieth century. Of the many outstanding sculptors making objects, as opposed to the more popular installations, is Martin Puryear (b. 1941). Puryear fulfills in sculpture what the critic Oliva said about painting when he spoke of "the re-establishment of manual skill through a pleasure of execution. . . ." After serving in the Peace Corp in Sierra Leone, studying printmaking and woodworking in Sweden, and visiting Japan, Puryear settled in Brooklyn in 1973, where he soon emerged as a leading sculptor of his generation.

Perhaps the first thing we notice in his 1985 wood and steel sculpture titled *The Spell* (fig. 29-6) is the craftsmanship. We wonder at the beauty of the curved shapes, elegant tapering of the cone, the playful variety of the rectangular openings in the cone, and the sensuous texture of the flat striated wood strips that make up the "webbing" of what looks like a basket. The allusion to a basket suggests crafts and craftsmanship, which in turn suggests a human presence—we sense the hand that carefully constructed this object. We also sense Puryear's background in Africa, where he would have seen magnificently crafted utilitarian and ceremonial wooden objects, and in Sweden, where he

trained in woodworking. It would be a mistake, however, to interpret Puryear's references to African art as an acknowledgment of his African American background. His sculpture is not about ethnic identity and politics, but instead reflects his experience, which in addition to Africa includes the Swedish and Japanese love and use of wood.

So, if not a basket, then what is this rather enigmatic large inert "thing" that just lies on the floor? There really is no answer. It looks somewhat utilitarian but is not. Despite the shamanistic title, *The Spell*, which evokes mystery and sorcery, there is nothing ritualistic about it. Because we sense the essence of the wood itself, the work evokes nature, but as stated, it is the humanmade component that first prevails. We can even say there is something anthropomorphic about the sculpture as it vaguely suggests a recumbent figure, but this is a stretch of the imagination. Like Eva Hesse, but working in a very different style, Puryear transforms the austerity of Minimalist geometry into an enigmatic but warm organic object loaded with potent human allusions, but no definitive statements.

POSTMODERNIST PAINTING: SIGMAR POLKE

During the 1960s and 1970s, the art world was so focused on New York that other art centers, especially in Europe, were all but ignored. In Germany, Düsseldorf in particular

29-6 Martin Puryear. *The Spell.* 1985. Pine, cedar, and steel, 4' 8" × 7' × 5' 5" (1.42 × 2.13 × 1.65 m). Collection of the artist. McKee Gallery, New York

was producing some of the most important work of the period, but only Joseph Beuys (see page 607–8) was well known internationally. It was not until the late 1980s that the art world discovered Sigmar Polke (b. 1941), Gerhard Richter, and the photography team of Bernhard and Hilla Becher, despite the fact that Polke and Richter had been working since the early 1960s and the Bechers from the end of the decade. Along with Kiefer, and a handful of other Düsseldorf artists, they conquered New York, London, and Paris in the closing decades of the century.

The paintings of Polke and his good friend Richter were such eye-openers partly because they powerfully embraced a Postmodern attitude. Yet they were produced so early, by the mid-1960s, some 15 years before Postmodernism came to the fore worldwide. The Düsseldorf artists were heavily influenced by Rauschenberg and Pop Art, especially that of Roy Lichtenstein and Andy Warhol, which they knew from magazines. And they were well versed in Dada (the first postwar Dada exhibition took place in Düsseldorf in 1958) and Fluxus, which literally came to town in 1963 (see page 607). The last ingredient in the mix was the spirituality of Beuys, who taught at the Art Academy, which they attended.

Armed with this background, Polke made paintings that appropriated images, patterns, and designs from a variety of sources and crashed them together in a single work, as seen in *Alice in Wonderland* (fig. 29-7) of 1971. On top of a fabric design of soccer players and another of polka dots, Polke mechanically reproduced the white image of a basketball player and others of Alice and the caterpillar with water-pipe from *Alice in Wonderland*. Hard to see in our reproduction are the 1950s-styled outlined heads of a man and woman, hand-stamped repeatedly in yellow and red. All of this imagery is appropriated from popular culture and re-presented in this enormous 10 1/2 × 6 1/2-foot work, which is not on canvas but store-bought printed fabric. Viewed separately and in a different context, each of these images would be read quite differently than they are when seen together in this work. In other words, their relationship here creates a context that influences and changes their meaning. Polke avoids assigning a fixed meaning; instead he allows us to weave any story we like from his kaleidoscope of imagery. In effect, Polke has created his image employing the ideas that we saw Joseph Kosuth presenting as theory in his conceptual work *One and Three Chairs* (see page 606).

Although Kosuth's work is *about* theory, Polke's is not. But what is it about? Polke's concern is with how popular imagery, the imagery we confront daily, structures our world: What we see is what we know and what we believe in; images structure our thinking, feeling, and attitudes. Polke selects a host of motifs and presents them objectively, that is, without revealing his own attitudes toward them. Here, he presents us with the pollyannna vision of childhood— the naive innocence that believes in perfect romance, wholesome sports, and charming fairytales— all propagated by the mass media, including interior design. But Polke's painting is hardly without feeling, like the paintings of the American Pop artists. The ghost-white silhouettes hovering over the fabric and the stamped 1950s heads immersed in the pattern of dots and soccer players give the work an ethereal feeling and even a romantic quality. There is a sense of absence and loss, of the fleeting nature of life and things that lends Polke's paintings a strange spiritual quality.

POSTMODERN PHOTOGRAPHY: CINDY SHERMAN

The excitement over painting lasted through the 1980s, but the same period saw the rise of photography, video, and Installation Art as the principal art forms. The first to challenge the painters were the Postmodern photographers, Cindy Sherman, Laurie Simmons, Louise Lawler, Barbara Kruger, and Richard Prince. They unsuccessfully rivaled the painters for attention in the early 1980s, but dethroned them by the time the decade was out. Their art seemed more relevant than the painters', for it presented *Real Life*, to use the name of a short-lived art magazine. It presented the world as we know it, which is not through first-hand experience, but through the lens of a camera, whether a television, video, film, or 35 mm reflex. In other words, our information comes from television, magazine and newspaper photographs, and movies, for example, and this has become the real world.

All of these Postmodern photographers fall into the category of artist-photographer or conceptual-photographer. None of them

29-7 Sigmar Polke. *Alice in Wonderland.* 1971. Mixed media on fabric strips, 10′ 6″ × 8′ 6¾″ (3.2 × 2.6 m). Private collection, Cologne

is interested in the mechanics of taking and processing pictures; some do not handle the camera themselves, and almost all do not do their own printing. What interests them most is revealing how the context of an image determines its meaning and how the mass media subversively structures content to manipulate viewers.

Cindy Sherman's *Untitled Film Still #15* (fig. 29-8) from 1978 is one example of how

this group revealed the difficulty of attaching a fixed meaning to an image and how meaning gets assigned. Beginning in 1977, Sherman (b. 1954) began a series called *Film Stills,* in which she photographed herself in situations that resemble a still from a grade B movie. For each, she created a set and a female character, which she herself always played, donning different clothes, wigs, and accoutrements so that

29-8 Cindy Sherman. *Untitled Film Still #15.* 1978. Gelatin silver print, 10 × 8″. Courtesy of Metro Pictures, New York

concern could be for something that has occurred on the street below her window. Innumerable stories can be spun about this image, taking into account such details as her cross pendent or the old-fashioned spindle-back chair, exposed-brick wall, and turn-of-the-century window, which seem at odds with her youth and the contemporary lifestyle her clothing suggests. Through what seems a simple strategy, Sherman brilliantly reveals the complex ways in which images get invested with meaning. By adding such motifs as the religious cross, the innocent looking bobby socks, and old-fashioned nineteenth-century chair, she demonstrates how images can be used to manipulate society's attitudes and conscience. Take away any one of these motifs, and we will spin a different story.

Sherman made these first stills on an 8 × 10-inch scale, the size of publicity photos and stills used by the film industry for advertising. By the early 1980s, she gradually increased the size of her prints to the same scale as painting.

THE POWER AND POPULARITY OF INSTALLATION ART: ILYA KABAKOV

While Installation Art had been around since the late 1950s (see pages 598–99), it underwent a dramatic surge in popularity in the 1980s, becoming, like photography, a featured medium. By 1993 Installation Art was considered so important that the Whitney Museum of American Art in New York virtually dedicated its *Biennial* exhibition—a survey of what is important in American art—to the medium. Installation shares with photography the semblance of being real, although they go about suggesting reality in very different ways and often for very different reasons. As Kiefer's incorporation of straw into his canvases suggests, a thirst for the real figures prominently in much art since the 1980s.

Of the legions of Installation artists who emerged in the 1980s, one of the most interesting is the Russian Ilya Kabakov (b. 1933), who left Moscow for New York in 1988. From 1981 to 1988 he made a series of rooms he called *Ten Characters*. Each replicates the seedy communal apartment assigned by the state under the Communist regime. Each is inhabited by an imaginary

she is virtually unrecognizable as the same person from one still to the next. The fact that she is always the actress is conceptually quite important, for her transformation represents the transformation women are forced to undergo in order to conform to the stereotypes of society, stereotypes reinforced if not actually determined by the mass media. In *Film Still #15*, we see her playing the "sexy babe" who anxiously awaits the arrival of a date or lover. But is this really what is happening? Sherman may suggest narrative, but there is never enough information to firmly determine one. In effect, the story that each one of us comes up with tells us more about ourselves, our backgrounds, training, and attitudes, than it does about the picture itself, which always remains ambiguous. Our "babe" could very well be dressed for a costume party instead of a date, and her look of

person with an "unusual idea, one all-absorbing passion belonging to him alone." One spectacular cubicle is *The Man Who Flew into Space from His Apartment* (fig. 29-9) made in Moscow in the mid-1980s. We see the room after its occupant achieved his dream of flying into space by being hurled from a catapult suspended by springs while the ceiling and roof were blown off at the precise moment of the launch. Like the other rooms, it was accompanied by a dark text worthy of Fyodor Dostoyevsky, reflecting the Russian talent for storytelling. After reading the text and looking at the collapsed ceiling, limp sling, and clutter, we are transported to Kafkaesque Communist Russia, where living in austere claustrophobic squalor has brought about a hopeless delusional state, and flights of fantasy were the only escape from the reality of the drudgery of daily life. The ruin we are witnessing in *The Man who Flew into Space* is not just the ruin of one man's life, but rather the shattered dream of the utopia that Tatlin, the Constructivists, the Dadaists, and the Communist world in general had so firmly believed in. Kabakov's text and room are so convincing we swallow his fiction whole, as though it were all true. It is as though the apartment had been shipped to a museum and we were standing in front of the real thing. The installation is like a relic of the actual event, and like any relic, it possesses a powerful aura, an aura that painting cannot have.

MANY STYLES, ONE ARTIST: FELIX GONZALEZ-TORRES

By rejecting traditional hierarchies in media, style, and content, Postmodern artists gained the freedom to work in a variety of media and styles. Cultivating an easily recognizable "look" or identity was not important. Felix Gonzalez-Torres (1957–1996) is a classic example of this aesthetic. Working in a wide range of media, and covering a broad range of social issues, Gonzalez-Torres focuses on the psychological impact of AIDS and attitudes toward this plague. Gonzalez-Torres, who was born in Cuba and came to America in the 1981 Mariel boat lift, can best be described as a Conceptual artist who works in a Minimalist mode. He takes an idea and presents it as simply as possible. Despite his

spare vocabulary, the impact is tremendous and the content and implications rich and far-reaching.

Gonzalez-Torres's media stretches from jigsaw puzzles to mirrors to strings of electric lights to live male go-go dancers. His medium is candy for *Untitled (Portrait of Ross in L. A.)* of 1991. The work is a Minimalist-looking pyramid of multicolored candies wedged into the corner of a gallery. The candies weigh 175 pounds, the weight of his lover of the title, who had died of AIDS. Visitors were instructed they could take the candy away with them, the attrition of the pile reflecting Ross's gradually wasting away toward death. The disappearance of the

29-9 Ilya Kabakov. *The Man Who Flew into Space from His Apartment,* from *Ten Characters,* 1981–88. Mixed-media installation

© 2004 Artists Rights Society (ARS), New York/VG Bild-Kunst, Bonn

brightly colored festive candies reflects the transition from the lively and joyous experience of life to eternal nothingness. By encouraging the museum visitor to participate in the work, Gonzalez-Torres raises public awareness of the many issues swirling around AIDS, including lack of public funding to fight the disease as well as the frightening emotional toll it was taking on the victim and loved ones alike.

Like so many artists beginning in the 1980s, Gonzalez-Torres took his art into the

29-10 Felix Gonzalez-Torres. *Untitled.* 1991. Billboard, overall dimensions vary with Installation, ARG GF 1991-84

public domain, even using billboards. In 1991, in conjunction with an exhibition of the same work at the Museum of Modern Art in New York, he used 24 enormous billboards around the city to present a black-and-white photograph of an empty unmade bed. This untitled work (fig. 29-10) was seen throughout New York City. Unlike a traditional advertising billboard, this image was enigmatic. It was a stopper, one that promoted thinking and questioning. The quintessential Postmodern picture, it was highly suggestive and subject to broad interpretation. Unlike most artists with a political agenda, Gonzalez-Torres was not a proselytizer or sloganeerer. He simply presents us with a vacant slept-in bed, conjuring an image of sex and love. And of loss and absence. And ultimately of death. The work was not just about the hundreds of thousands of gay men who had died from AIDS, but heterosexuals and children as well. It was about the tragic suffering and loss, about the end of love and pleasure. It was about the lack of public awareness of this disease. This was a work that forced people to ask who made this billboard and why. This very simple statement, this little piece of poetry focusing on an unmade bed, got people involved without telling them to. And it emotionally moved them without suggesting they were supposed to be affected. Most viewers never even knew it was art. Gonzalez-Torres died of AIDS in 1996 at the age of 38.

KIKI SMITH

The AIDS crisis that began in the early 1980s contributed to artists' preoccupation with the body and the ephemeralness of life. These themes characterize much of the art of the 1980s up to the present. New York artist Kiki Smith (b. 1954) emerged in the early 1980s making work about body fluids and parts. One work consisted of eight jars of blood, and another of water coolers etched with the names of body fluids, such as tears, milk, saliva, vomit, blood, and semen. Because they repeated the same form, these works had the look of Minimal Art, but the conceptual component—the thoughts we have when confronting the real blood or body fluids—packs the emotional punch of Baroque art or German Expressionism. Toward 1990 Smith began making entire fig-

29-11 Kiki Smith. *Untitled.* 1990. Beeswax and microcrystalline wax figures on metal stand. Collection of Whitney Museum of American Art, New York

Purchase, with funds from the Painting and Sculpture Committee. 91.13 a–d. Photograph by Jerry J. Thompson.

ures. Generally, she constructed them out of such impermanent materials as paper, paper maché, and wax, which served as a metaphor for the fragility of the body and the transience of life.

In the 1990 untitled work reproduced here (fig. 29-11), Smith cleverly revives the classical tradition of the nude figure. But we are not looking at Greek gods and goddesses, nor heroic athletes and military leaders. Smith gives us mere flesh-and-blood mortals. The woman oozes milk from her breast and the man semen from his penis, attributes of procreation, nourishment, and life. But death dominates the work in the form of the limp figures slumped on their poles and the jarring discoloration of the skin. Smith presents the entire life cycle, but it is the sadness of deterioration and death that prevails.

WORLD ART: CAI GUO-QIANG

The closing decades of the twentieth century marked the rise of a world art, for want of a better term. Everyone was now speaking a similar visual language, which allowed for a breadth of expression unimaginable in the opening decade of the century. Tremendous differences exist, but a thirst to learn about other cultures and values made the work even more acceptable, if not outright exciting. Differences were embraced and admired rather than rejected as inferior.

It seems only fitting to end this book with Cai Guo-Qiang (b. 1957), a Chinese artist who has been living in New York since 1995 and ranks as one of the most visible artists working today. *A Basic History of Western Art* has been restricted to Western

art, largely because space does not allow for a similar treatment of Eastern art. The fact that the interaction between East and West has been minimal, at least into the eighteenth century, allows for this approach. But this separation will no longer work. Now East meets West; Europe meets Africa; Latin America meets North America. Now, artists worldwide use the same art language, deal with similar issues, and avidly follow each other's work. Cai brings to this new world of art his Chinese background and perspective, which enriches the world's visual language.

Like Gonzalez-Torres, Cai is basically a Conceptual artist who works in a broad range of media. Nonetheless, his work is dominated by Installation Art and explosives, namely fireworks. The latter is his signature style. Explosives, including fireworks, are a Chinese invention, and his use of this medium is certainly a way for him to retain his cultural identity in a world arena. But his use of explosives is motivated by other aesthetic and conceptual concerns, as Cai explains: "Explosions make you feel something intense at the very core of your being because, while you can arrange explosives as you please, you cannot control the explosion itself. And this fills you with a great feeling of freedom." In a sense, Cai uses explosives to draw, and like the work of the Abstract Expressionists, his drawing is filled with sublime references, or is an attempt to tap into universal forces. He even talks about the Yin and Yang of his explosions, the way the work in a split second simultaneously presents creation and destruction.

In 2003, Cai was commissioned by the City of New York and the Central Park Conservancy to do an explosion piece in Central Park. Titled *Light Cycle* (fig. 29-12) and lasting four minutes, the work was divided into three parts: "Signal Towers" (pillars of light), "The Light Cycle" (a series of halos), and "White Night" (small shell explosion of brilliant white light). It is remarkable the degree to which Cai is able to control his explosions and literally draw and paint with the medium, sometimes even evoking Chinese calligraphy. In keeping with his quest to capture a spiritual essence and tap into a cosmic order, the artist talks about making his work for extraterrestrials, even subtitling many of explosion pieces Project for Extraterrestrials. Just when the art world has become worldwide, Cai is looking beyond Earth and making art to be seen by a higher intelligence residing elsewhere in the universe.

29-12 Cai Guo-Qiang. *Light Cycle: Explosion Project for Central Park.* 2003. Tiger tails, titanium solutes fitted with computer chips, shells with descending stars.

Glossary

Cross-references are indicated by words in SMALL CAPITALS.

ABACUS. The uppermost element of a CAPITAL, often a flat, square slab.

ABSTRACT. Having little or no reference to the appearance of natural objects; pertaining to the nonrepresentational art styles since 1900; also the reduction of figures and objects to geometric shapes.

ACRYLIC. Plastic binder MEDIUM for PIGMENTS that is soluble in water, developed about 1960.

AISLE. A side passageway of a BILSILICA or church, separated from the central NAVE by a row of COLUMNS or PIERS.

ALTARPIECE. A painted or carved work of art placed behind and above the altar of a Christian church. It may be a single panel or a DIPTYCH, TRIPTYCH, or polyptych (with more than three panels) having hinged wings.

AMBULATORY. A passageway to the outside of the NAVE that forms a walkway around the APSE of a church.

AMPHORA. Greek vase having an egg-shaped body, a narrow, cylindrical neck, and two curving handles joined to the body at the shoulder and neck.

ANDACHTSBILD. German for "devotional image." A late medieval image, either painted, engraved, or carved, that was designed to inspire pious feelings in the viewer as he or she contemplated it.

ANIMAL STYLE. A type of artistic design, popular in western Asia and Europe in the ancient and medieval periods, characterized by animal-like forms in intricate linear patterns.

APSE. A large architectural niche facing the NAVE of a BASILICA or church, usually at the east end. In a church with a TRANSEPT, the apse begins beyond the CROSSING.

ARABESQUE. A type of linear ornamentation characterized by flowing, organic shapes, often in the form of interlaced vegetal, floral, and animal MOTIFS.

ARCADE. A series of ARCHES and their supports.

ARCH. A structural member, often semicircular, used to span an opening; it requires support from walls, PIERS or COLUMNS, and sometimes BUTTRESSING.

ARCHAIC. A relatively early style, such as Greek sculpture of the seventh and sixth centuries B.C.; or any style adopting characteristics of an earlier period.

ARCHITRAVE. The main horizontal beam, and the lowest part, of an ENTABLATURE .

ARCHIVOLT. The molding framing the face of an ARCH, often highly decorated.

ARTS AND CRAFTS MOVEMENT. A late-nineteenth-century design movement centered in England that developed in reaction to the influence of industrialization. Its supporters promoted a return to handcraftsmanship.

ASSEMBLAGE. Two or more "found" objects put together as a construction. See READYMADE.

ATMOSPHERIC PERSPECTIVE. Means of showing distance or depth in a painting by lightening the tones of objects that are far

away from the PICTURE PLANE and by reducing in gradual stages the contrast between lights and darks.

ATRIUM. In ancient architecture, a room or courtyard with an open roof; or the vestibule, usually roofed, in an Early Christian church.

ATTIC. A low upper story place above the main CORNICE or ENTABLATURE of a building and often decorated with windows and PILASTERS.

BALDACCHINO. A canopy-like structure often placed over an altar.

BANQUET PIECE. See BREAKFAST PIECE.

BAPTISTERY. A building or part of a church, often round or octagonal, in which the sacrament of baptism is administered. It contains a baptismal font, a receptacle of stone or metal for water used in the rite.

BARREL VAULT. A semicylindrical VAULT.

BASE. The lowest element of a COLUMN, PIER, wall, or DOME.

BASILICA. During the Roman period, a large meeting hall, its exact form varying according to its specific use as an official public building. The term was used by the Early Christians to refer to their churches. An Early Christian basilica had an oblong PLAN, a flat timber ceiling, a trussed roof, a NAVE, and an APSE. The entrance was on one short side, and the apse projected from the opposite side, at the far end of the building.

BAYS. Compartments into which a building may be subdivided, usually formed by the space between consecutive architectural supports.

BELVEDERE. Italian for "beautiful view." Any towerlike structure, whether FREESTANDING or attached to a building, constructed to command a view; also a building situated on a hill for the same purpose.

BLACK-FIGURE. A type of Greek vase painting, practiced in the seventh and sixth centuries B.C., in which the design was painted mainly in black against a lighter-colored background, usually the natural clay.

BLIND ARCADE. An arcade in which the arches and supports are attached to a wall and have only a decorative purpose.

BOOK OF HOURS. A book for individual private devotions with prayers for different hours of the day; often elaborately ILLUMINATED.

BREAKFAST PIECE. A STILL LIFE depicting food, drink, and table settings in disorder, as after a meal. This was a popular subject among seventeenth-century Dutch painters and may have been related to the Vanitas tradition.

BURIN. An ENGRAVING tool made of a pointed steel rod and a wooden handle.

BUTTRESS. A masonry support that counteracts the THRUST exerted by an ARCH or a VAULT. See FLYING BUTTRESS, PIER BUTTRESS.

CAMERA OBSCURA. Latin for "dark room." A darkened enclosure or box with a small opening or lens on one wall through which light enters to form an inverted image on the

opposite wall. The principle had long been known but was not used as an aid in picture making until the sixteenth century.

CAMPANILE. Italian for "bell tower." A FREESTANDING tower erected adjacent to a church; a common element in late medieval and Renaissance church building.

CAPITAL. The crowning member of a COLUMN, PIER, or PILASTER on which the lowest element of the ENTABLATURE rests.

CARTOON. From the Italian cartone, meaning "heavy paper." A preliminary SKETCH or DRAWING made to be transferred to a wall, panel, or canvas as a guide in painting a finished work.

CARVING. The cutting of a figure or design out of a solid material such as stone or wood, as contrasted to the additive technique of MODELING; also a work executed in this technique.

CARYATIDS. Greek for "priestess at Caryae." A carved and draped figure, generally a woman, used in place of a COLUMN as an architectural support.

CASTING. A method of reproducing a three-dimensional object or RELIEF. Casting in bronze or other metal is often the final stage in the creation of a piece of SCULPTURE; casting in plaster is a convenient and inexpensive way of making a copy of an original.

CATACOMB. An underground place of burial consisting of tunnels and niches for tombs; most common during Early Christian times.

CATHEDRAL. The principal church of a territory, presided over by a bishop, usually in the leading city of his jurisdiction; known as the bishop's "see."

CELLA. The main chamber of a temple that housed the cult image in Near Eastern, Greek, and Roman temples.

CENTRAL-PLAN CHURCH. The standard design used for churches in Eastern Orthodox Christianity, in which symmetrical chambers radiate from a central primary space.

CHANCEL. See CHOIR.

CHAPEL. A compartment in a church containing an altar dedicated to a saint.

CHEVET. In Gothic architecture, the entire eastern end of a church, including the CHOIR, APSE, AMBULATORY, and radiating CHAPELS.

CHIAROSCURO. Italian for "light and dark." In painting, a method of MODELING form primarily by the use of light and shade.

CHOIR. In a church, the space reserved for the clergy and singers, set off from the NAVE by steps and occasionally by a screen.

CHOIR SCREEN. An element of church architecture, often decorated with sculpture, that is used to separate the CHOIR from the NAVE or TRANSEPT.

CLASSICAL. Used generally to refer to the art of the Greeks and the Romans.

CLASSICAL ORDERS. The three most common Greek and Roman ORDERS are the DORIC, IONIC, and CORINTHIAN.

CLERESTORY. A row of windows piercing the NAVE walls of a BASILICA or church above the level of the side AISLES.

PERISTYLE. COLONNADE (or ARCADE) around a building or open court.

PERSPECTIVE. See ATMOSPHERIC PERSPECTIVE and SCIENTIFIC PERSPECTIVE.

PHOTOGRAM. A shadowlike picture made by placing opaque, translucent, or transparent objects between light-sensitive paper and a light source and developing the latent photographic image.

PHOTOMONTAGE. A photograph in which prints in whole or in part are combined to form a new image. A technique much practiced by the Dada group in the 1920s.

PICTURE. A portable, self-contained painting or drawing (as opposed to a wall- or vase-painting) that is intended to be displayed on an easel or hung on a wall.

PICTORIAL SPACE. In pictures or RELIEFS, the ILLUSION of depth created by devices such as multiple GROUNDLINES and PERSPECTIVE.

PICTURE PLANE. The imaginary plane suggested by the actual surface of a painting, drawing, or relief.

PIER. A vertical architectural element, usually rectangular in section; if used with an ORDER, often has a BASE and CAPITAL of the same design.

PIER BUTTRESS. An exterior PIER in Romanesque and Gothic architecture, buttressing the THRUST of the VAULTS within.

PIETÀ. In painting or SCULPTURE, a representation of the Virgin Mary mourning the dead Jesus, whom she holds.

PIGMENT. A dry, powdered substance that, when mixed with a suitable liquid, or vehicle, gives COLOR to paint. See ACRYLIC, ENCAUSTIC, FRESCO, OIL PAINTING, TEMPERA, and WATERCOLOR.

PILASTER. A flat, vertical attached element having a CAPITAL and BASE, projecting slightly from a wall. Has a decorative rather than a structural purpose.

PLAN. The schematic representation of a three-dimensional structure, such as a building or monument, on a two-dimensional plane.

PLASTIC. Describes a form that is molded or modeled.

PODIUM. The tall base upon which an Etruscan or Roman temple rests; also, in later structures, a ground floor made to resemble such a base.

POLYCHROMY. The decoration of architecture or sculpture in multiple colors.

PORTAL. A doorway, gate, or entrance of imposing size. In Romanesque and Gothic churches, portals may be elaborately decorated.

PORTICO. A roofed porch supported by COLUMNS.

POST AND BEAM. A system or unit of construction consisting solely of vertical and horizontal elements. See LINTEL.

POST-AND-LINTEL CONSTRUCTION. A space-spanning technique in which two or more vertical beams (posts) support a horizontal beam (LINTEL).

PREDELLA. The long and narrow horizontal panel beneath the main scene on an ALTARPIECE. The panel is often painted or sculpted to correspond with the altarpiece's overall theme.

PROGRAM. In art history, the conceptual theme of the subject matter and symbolism behind a complex work of painting and sculpture, such as the Sistine Chapel ceiling, or Gauguin's *Where Do We Come From? What Are We? Where Are We Going?*

PROPORTION. The relation of the size of any part of a figure or object to the size of the whole. For architecture, see ORDER.

PYLON. In Egyptian architecture, the entranceway set between two broad, oblong towers with sloping sides.

QUATREFOIL. A decorative MOTIF composed of four lobes; often used in Gothic art and architecture.

QIBLA. The direction Muslims face when praying. A wall in each mosque marks this direction (toward Mecca).

READYMADE. A manufactured object exhibited as being aesthetically pleasing. When two or more accidentally "found" objects are place together as a construction, the piece is called an ASSEMBLAGE.

RED-FIGURE. A type of Greek vase painting in which the design is outlined in black and the background painted in black, leaving the figures and the reddish color of the baked clay after firing. This style replaced the BLACK-FIGURE style toward the end of the sixth century B.C.

RELIEF. Forms in SCULPTURE that are carved from a background block, to which they remain attached. Relief may be hollowed to create sunken relief, modeled shallowly to produce low relief, or modeled deeply to produce high relief; in very high relief, the sculpture will project almost entirely from its background.

REPRESENTATIONAL. As opposed to ABSTRACT, a portrayal of an object in recognizable form.

RESPOND. A projecting and supporting architectural element, often a PIER, that is bonded with another support, usually a wall, to carry one end of an ARCH.

RHYTHM. The regular repetition of a particular form; also, the suggestion of motion by recurrent forms.

RIB. A projecting arched member of a VAULT.

RIBBED VAULT. A compound masonry vault, the GROINS of which are marked by projecting stone RIBS.

ROSE WINDOW. Round windows decorated with STAINED GLASS and TRACERY, frequently incorporated into FACADES and TRANSEPTS of Gothic churches.

SACRISTY. A room near the main altar of a church where the vessels and vestments required for services are kept.

SARCOPHAGUS. (pl. sarcophagi). A coffin made of stone, marble or TERRA-COTTA, and less frequently, of metal. Sarcophagi are often decorated with paintings or RELIEFS.

SCALE. Generally, the relative size of any object in a work of art, often used with reference to human scale.

SCHIACCIATO. Squashed, flattened; used to describe relief sculpture; first used by Donatello.

SCIENTIFIC PERSPECTIVE. A mathematical system for representing three-dimensional objects and space on a two-dimensional surface. All objects are represented as seen from a single viewpoint.

SCULPTURE. A three-dimensional form, usually in a solid material. Traditionally, two basic techniques have been used: subtractive— CARVING in a hard material such as marble; and additive—MODELING in a soft material such as clay or wax. See FREESTANDING and RELIEF.

SCULPTURE IN THE ROUND. See FREE-STANDING.

SECTION. Architectural drawing representing the vertical arrangement of a building's interior.

SEMIOTICS. The study of signs and symbols— language being foremost among them—in an effort to deduce the underlying nature and bias of the message being conveyed.

SFUMATO. The gentle gradation from light to dark TONES, which softens the appearance of painted images.

SHAFT. A cylindrical form; in architecture, the part of a COLUMN or PIER intervening between the BASE and the CAPITAL. Also, a vertical enclosed space.

SKETCH. A rough DRAWING representing the main features of a composition; often used as a preliminary study.

SPANDREL. The triangular surface formed by the outer curve of an ARCH and its rectangular frame.

STAINED GLASS. The technique of filling architectural openings with glass colored by fused metallic oxides; pieces of this glass are held in a design by strips of lead.

STELA. (pl. stelae). A vertical stone slab decorated with a combination of images in RELIEF and inscriptions; often used as a grave marker.

STILL LIFE. A painting or drawing of an arrangement of inanimate objects.

STUCCO. A mixture of lime, sand, and other materials that can be used as a general ground in FRESCO painting or as a final covering for a wall surface. The mixture can also be manipulated for use as decorative MOLDING.

SUNKEN RELIEF. See RELIEF.

TEMPERA. A painting process in which PIGMENT is mixed with an emulsion of egg yolk and water or egg and oil. Tempera, the basic technique of medieval and Early Renaissance painters, dries quickly, permitting almost immediate application of the next layer of paint.

TENEBRISM. Dramatic contrast of lights and darks, as in the use of a strong, focused light in a dark painting (as in the work of Caravaggio).

TERRA-COTTA. Clay, MODELED or molded and baked until very hard. Used in architecture for functional and decorative purposes, as well as in pottery and SCULPTURE. Terra-cotta may have a painted or glazed surface.

TESSERA. (pl. tesserae). A small piece of colored glass or stone used to create a MOSAIC.

THRUST. The downward and outward pressure exerted by an ARCH or VAULT and requiring BUTTRESSING.

TONALITY. The soft or garish impression given by a COLOR or range of colors.

TONE. A reference to the COLOR, darkness, depth, or brightness of a PIGMENT.

TRACERY. Ornamental stonework in elaborate intersecting patterns, used either in windows or on wall surfaces.

TRANSEPT. In a cross-shaped church, the arm forming a right angle with the NAVE, usually inserted between the latter and the CHOIR or APSE.

TRANSUBSTANTIATION. In the Eucharistic rite, the changing of the bread and wine

into the body and blood of Christ, while their outward appearances remain the same.

TREFOIL. A decorative motif composed of three lobes.

TRIFORIUM. An ARCADE running along the walls of a church above the NAVE, and usually pierced by three openings per BAY.

TRIGLYPH. A vertical block with V-cut channels. It is located specifically on the FRIEZE between the METOPES.

TRIPTYCH. A painting or RELIEF executed on three panels that are often hinged so that the two outer panels fold like doors in front of the central panel.

TRIUMPHAL ARCH. A massive, FREE-STANDING ornamental gateway; originally developed by the ancient Romans to honor a military victory. Also, a MONUMENTAL arch inside a structure.

TRUMEAU. A central post supporting the LINTEL of a large doorway, as in a Romanesque or Gothic PORTAL, where it was frequently decorated with sculpture.

TYMPANUM. The semicircular panel between the LINTEL and ARCH of a medieval PORTAL or doorway; a church tympanum frequently contains RELIEF sculpture.

VANISHING POINT. In PERSPECTIVE, the point at which parallel lines seem to meet and disappear.

VANITAS. A STILL LIFE in which the objects represent the transience of life. A popular subject in seventeenth-century Dutch painting.

VAULT. An arched architectural covering made of brick, stone, or concrete.

VEDUTA. A painting, drawing, or print of an actual city.

VELLUM. Thin, bleached calfskin that can be written, printed, or painted upon.

VOLUTE. A decorative spiral scroll, seen most commonly in IONIC CAPITALS.

VOTIVE. An object created as an offering to a god or spirit.

VOUSSOIRS. Wedge-shaped stones forming an ARCH.

WATERCOLOR. PIGMENTS mixed with water instead of oil or another medium; also, a picture painted with watercolor, often on paper.

WESTWORK. The elaborate west entrance of Carolingian, Ottonian, and Romanesque churches, composed of exteriors with towers and multiple stories and an interior with an entrance vestibule, a CHAPEL, and GALLERIES overlooking a NAVE.

WOODCUT. A printing process in which a design or lettering is carved in RELIEF on a wooden block; the areas intended not to print are hollowed out.

ZIGGURAT. An elevated platform, varying in height from several feet to the size of an artificial mountain, built by the Sumerians to support their shrines.

Books for Further Reading

This list includes standard works and the most recent and comprehensive books in English. Books with material relevant to several chapters are cited only under the first heading.

INTRODUCTION

Broude, Norma, and Mary D. Garrard, eds. *Feminism and Art History: Questioning the Litany.* Harper & Row, New York, 1982.

Holt, Elizabeth Gilmore, ed. *A Documentary History of Art.* 3 vols. Vols. 1–2, Princeton University Press, Princeton, 1981–86; vol. 3, Yale University Press, New Haven, 1986.

Kostof, Spiro. *A History of Architecture: Settings and Rituals.* 2nd ed. Oxford University Press, New York, 1995.

Panofsky, Erwin. *Meaning in the Visual Arts.* Reprint of 1955 ed. University of Chicago Press, Chicago, 1982.

Taylor, Joshua C. *Learning to Look: A Handbook for the Visual Arts.* 2nd ed. University of Chicago Press, Chicago, 1981.

Trachtenberg, Marvin, and Isabelle Hyman. *Architecture: From Prehistory to Post-Modernism.* Harry N. Abrams, New York, 1986.

Part One THE ANCIENT WORLD

1 PREHISTORIC ART IN EUROPE AND NORTH AMERICA

Sandars, Nancy K. *Prehistoric Art in Europe.* Reprint of 1985 2nd integrated ed. Pelican History of Art. Yale University Press, New Haven, 1992.

2 EGYPTIAN ART

Malek, Jaromir. *Egyptian Art.* Phaidon, London, 1999.

Panofsky, Erwin. *Tomb Sculpture: Four Lectures on Its Changing Aspects from Ancient Egypt to Bernini.* Reprint of 1969 ed. Harry N. Abrams, New York, 1992.

Smith, William S., and William K. Simpson. *The Art and Architecture of Ancient Egypt.* Rev. ed. Pelican History of Art. Yale University Press, New Haven, 1999.

3 ANCIENT NEAR EASTERN ART

Frankfort, Henri. *The Art and Architecture of the Ancient Orient.* 5th ed. Pelican History of Art. Yale University Press, New Haven, 1997.

4 AEGEAN ART

Graham, James. *The Palaces of Crete.* Rev. ed. Princeton University Press, Princeton, 1987.

Hampe, Roland, and Erika Simon. *The Birth of Greek Art: From the Mycenaean to the Archaic Period.* Oxford University Press, New York, 1981.

5 GREEK ART

Boardman, John, ed. *The Oxford History of Classical Art.* Oxford University Press, New York, 1993.

Lawrence, Arnold W. *Greek Architecture.* 5th ed., rev. Pelican History of Art. Yale University Press, New Haven, 1996.

Osborne, Robin. *Archaic and Classical Greek Art.* Oxford History of Art. Oxford University Press, New York, 1998.

Pollitt, Jerome. *Art and Experience in Classical Greece.* Cambridge University Press, New York, 1989.

———. *Art in the Hellenistic Age.* Cambridge University Press, New York, 1986.

———, ed. *Art of Greece, 1400–31 B.C.: Sources and Documents.* 2nd ed. Prentice Hall, Englewood Cliffs, N.J., 1990.

Richter, Gisela M. A. *A Handbook of Greek Art.* 9th ed. Da Capo, New York, 1987.

Stewart, Andrew F. *Greek Sculpture: An Exploration.* 2 vols. Yale University Press, New Haven, 1990.

6 ETRUSCAN ART

Brendel, Otto J. *Etruscan Art.* 2nd ed. Pelican History of Art. Yale University Press, New Haven, 1995.

Spivey, Nigel. *Etruscan Art.* World of Art. Thames and Hudson, London, 1997.

7 ROMAN ART

Brilliant, Richard. *Roman Art from the Republic to Constantine.* Phaidon, London, 1974.

Elsner, Jaś. *Imperial Rome and Christian Triumph.* Oxford History of Art. Oxford University Press, 1998.

Kleiner, Diana. *Roman Sculpture.* Yale University Press, New Haven, 1992.

Ling, R. *Roman Painting.* Cambridge University Press, New York, 1991.

Macdonald, William L. *The Architecture of the Roman Empire.* Rev. ed. 2 vols. Yale University Press, New Haven, vol. 1, 1982; vol. 2, 1987.

Pollitt, Jerome. *The Art of Rome and Late Antiquity: Sources and Documents.* Prentice Hall, Englewood Cliffs, N.J., 1983.

Strong, Donald E. *Roman Art.* 2nd ed. Pelican History of Art. Yale University Press, New Haven, 1992.

Part Two THE MIDDLE AGES

Calkins, Robert G. *Monuments of Medieval Art.* Reprint of 1979 ed. Cornell University Press, Ithaca, 1985.

8 EARLY CHRISTIAN AND BYZANTINE ART

Beckwith, John. *Early Christian and Byzantine Art.* 2nd (integrated) ed. Pelican History of Art. Penguin, New York, 1979.

Cormack, Robin. *Byzantine Art.* Oxford History of Art. Oxford University Press, New York, 2000.

Demus, Otto. *Byzantine Art and the West.* New York University Press, New York, 1970.

Kitzinger, Ernst. *Byzantine Art in the Making: Main Lines of Stylistic Development in Mediterranean Art, 3rd–7th Century.* Harvard University Press, Cambridge, 1995.

Krautheimer, Richard, and Slobodan Curcic. *Early Christian and Byzantine Architecture.* 4th ed. Pelican History of Art. Yale University Press, New Haven, 1992.

Lowden, John. *Early Christian and Byzantine Art.* Phaidon, London, 1997.

Macdonald, William L. *Early Christian and Byzantine Architecture.* The Great Ages of World Architecture. Braziller, New York, 1965.

Mango, Cyril. *The Art of the Byzantine Empire, 312–1453: Sources and Documents.* Reprint of 1972 ed. University of Toronto Press, Toronto, 1986.

Mathews, Thomas F. *Byzantium from Antiquity to the Renaissance.* Perspectives. Harry N. Abrams, New York, 1998.

Snyder, James. *Medieval Art: Painting, Sculpture, Architecture, 4th–14th Century.* Harry N. Abrams, New York, 1989.

9 EARLY MEDIEVAL ART

Conant, Kenneth J. *Carolingian and Romanesque Architecture, 800–1200.* 4th ed. Pelican History of Art. Yale University Press, New Haven, 1993.

Davis-Weyer, Caecilia, ed. *Early Medieval Art, 300–1150: Sources and Documents.* Reprint of 1971 ed. University of Toronto, Toronto, 1986.

Dodwell, C. R. *The Pictorial Arts of the West, 800–1200.* New ed. Pelican History of Art. Yale University Press, New Haven, 1993.

Mayr-Harting, Henry. *Ottonian Book Illumination: An Historical Study.* 2 vols. Oxford University Press, New York, 1991–93.

Pevsner, Nikolaus. *An Outline of European Architecture.* Reprint of 1972 ed. Penguin, London, 1990.

Sekules, Veronica. *Medieval Art.* Oxford History of Art. Oxford University Press, New York, 2001.

10 ROMANESQUE ART

Bowie, Fiona, and Oliver Davies, eds. *Hildegard of Bingen: Mystical Writings.* Crossroad, New York, 1990.

Focillon, Henri. *The Art of the West in the Middle Ages.* Ed. Jean Bony. 2 vols. Reprint of 1963 ed. Cornell University Press, Ithaca, 1980.

Hearn, M. F. *Romanesque Sculpture: The Revival of Monumental Stone Sculpture in the Eleventh and Twelfth Centuries.* Cornell University Press, Ithaca, 1981.

Schapiro, Meyer. *Romanesque Art.* Braziller, New York, 1993.

Stoddard, Whitney S. *Art and Architecture in Medieval France: Medieval Architecture, Sculpture, Stained Glass, Manuscripts, the Art of the Church Treasuries.* Harper & Row, New York, 1972.

11 GOTHIC ART

Bony, Jean. *French Gothic Architecture of the Twelfth and Thirteenth Centuries.* California Studies in the History of Art. University of California Press, Berkeley, 1983.

Frisch, Teresa G. *Gothic Art, 1140–c. 1450: Sources and Documents.* Reprint of 1971 ed. University of Toronto Press, Toronto, 1987.

Krautheimer, Richard, and Trude Krautheimer-Hess. *Lorenzo Ghiberti.* Princeton University Press, Princeton, 1982.

Meiss, Millard. *Painting in Florence and Siena after the Black Death: The Arts, Religion, and Society in the Mid-Fourteenth Century.* Princeton University Press, Princeton, 1978.

Pope-Hennessy, John. *Italian Gothic Sculpture.* 3rd ed. Oxford University Press, New York, 1986.

Simson, Otto Georg von. *The Gothic Cathedral: Origins of Gothic Architecture and the Medieval Concept of Order.* 3rd ed. Bollingen Series. Princeton University Press, Princeton, 1988.

White, John. *Art and Architecture in Italy, 1250–1400.* 3rd ed. Pelican History of Art. Yale University Press, New Haven, 1993.

Part Three THE RENAISSANCE THROUGH THE ROCOCO

12 THE EARLY RENAISSANCE IN ITALY

Borsook, Eve. *The Mural Painters of Tuscany: From Cimabue to Andrea del Sarto.* 2nd ed., rev. and enl. Oxford University Press, New York, 1980.

Burckhardt, Jacob C. *The Civilization of the Renaissance in Italy.* Penguin Classics. Penguin, Harmondsworth, England, 1990.

Gilbert, Creighton E. *Italian Art, 1400–1500: Sources and Documents.* Reprint of 1980 ed. Northwestern University Press, Evanston, Ill., 1992.

Gombrich, E. H. *Norm and Form.* 4th ed. Studies in the Art of the Renaissance. University of Chicago Press, Chicago, 1985.

Hartt, Frederick and David G. Wilkins. *History of Italian Renaissance Art: Painting, Sculpture, Architecture.* 5th ed. Harry N. Abrams, New York, 2003.

Heydenreich, Ludwig Heinrich and Wolfgang Lotz. *Architecture in Italy, 1400–1500.* Rev. ed. Pelican History of Art. Yale University Press, New Haven, 1996.

Huse, Norbert, and W. Wolters. *The Art of Renaissance Venice: Architecture, Sculpture, and Painting, 1460–1590.* University of Chicago Press, Chicago, 1990.

Janson, H. W. *The Sculpture of Donatello.* 2 vols. Princeton University Press, Princeton, 1979.

Pope-Hennessy, John. *Donatello, Sculptor.* Abbeville Press, New York, 1993.

———. *Italian Renaissance Sculpture.* 3rd ed. Oxford University Press, New York, 1986.

Seymour, Charles, Jr. *Sculpture in Italy, 1400–1500.* Pelican History of Art. Penguin, Harmondsworth, England, 1966.

Wilde, Johannes. *Venetian Art from Bellini to Titian.* Clarendon Press, Oxford, 1981.

13 THE HIGH RENAISSANCE IN ITALY

Clark, Kenneth. *Leonardo da Vinci.* Rev. and introduced by Martin Kemp. Penguin, New York, 1993.

Freedberg, Sydney J. *Painting in Italy, 1500–1600.* 3rd ed. Pelican History of Art. Yale University Press, New Haven, 1993.

———. *Painting of the High Renaissance in Rome and Florence.* New rev. ed. 2 vols. Hacker Art Books, New York, 1985.

Hibbard, Howard. *Michelangelo.* 2nd ed. Harper & Row, New York, 1985.

Klein, R., and H. Zerner. *Italian Art, 1500–1600: Sources and Documents.* Reprint of 1966 ed. Northwestern University Press, Evanston, Ill., 1989.

Pope-Hennessy, John. *Italian High Renaissance and Baroque Sculpture.* 3 vols. 3rd ed. Oxford University Press, New York, 1986.

———. *Raphael.* New York University Press, New York, 1970.

Rosand, David. *Painting in Sixteenth-Century Venice: Titian, Veronese, Tintoretto.* Cambridge University Press, New York, 1997.

14 THE LATE RENAISSANCE IN ITALY

Shearman, John K. G. *Mannerism.* Reprint of 1967 ed. Style and Civilization. Penguin, Harmondsworth, England, 1986.

15 "LATE GOTHIC" PAINTING, SCULPTURE, AND THE GRAPHIC ARTS

Cuttler, Charles D. *Northern Painting from Pucelle to Bruegel: Fourteenth, Fifteenth, and Sixteenth Centuries.* Rev. and updated printing. Holt, Rinehart, and Winston, New York, 1972.

Hind, Arthur M. *A History of Engraving and Etching from the Fifteenth Century to the Year 1914.* Reprint of 3rd rev. ed. Dover, New York, 1963.

———. *An Introduction to a History of Woodcut.* 2 vols. Houghton Mifflin, Boston, 1935.

Ivins, W. M., Jr. *How Prints Look: Photographs with Commentary.* Rev. and exp. ed. Beacon Press, Boston, 1987.

Panofsky, Erwin. *Early Netherlandish Painting.* 2 vols. Harvard University Press, Cambridge, 1971.

Snyder, James. *Northern Renaissance Art: Painting, Sculpture, the Graphic Arts, from 1350 to 1575.* Harry N. Abrams, New York, 1985.

16 THE RENAISSANCE IN THE NORTH

Blunt, Anthony. *Art and Architecture in France, 1500 to 1700.* 4th ed. Pelican History of Art. Penguin, Harmondsworth, England, 1980.

Osten, Gert von der and Horst Vey. *Painting and Sculpture in Germany and the Netherlands, 1500–1600.* Pelican History of Art. Penguin, Harmondsworth, England, 1969.

Panofsky, Erwin. *The Life and Art of Albrecht Dürer.* 4th ed. Princeton University Press, Princeton, 1971.

Stechow, W. *Northern Renaissance Art, 1400–1600: Sources and Documents.* Northwestern University Press, Evanston, Ill., 1989.

17 THE BAROQUE IN ITALY AND SPAIN

Brown, Jonathan. *The Golden Age of Painting in Spain.* Yale University Press, New Haven, 1991.

Enggass, Robert, and Jonathan Brown. *Italy and Spain, 1600–1750: Sources and Documents.* Reprint of 1970 ed. Northwestern University Press, Evanston, Ill., 1992.

Held, Julius, and Donald Posner. *Seventeenth and Eighteenth Century: Baroque Painting, Sculpture, Architecture.* Harry N. Abrams, New York, 1971.

Hibbard, Howard. *Bernini.* Reprint of 1965 ed. Penguin, Harmondsworth, England, 1982.

Wittkower, Rudolf. *Art and Architecture in Italy, 1600–1750.* 4th ed. Pelican History of Art. Yale University Press, New Haven, 2000.

18 THE BAROQUE IN FLANDERS AND HOLLAND

Brown, Christopher. *Van Dyck.* Cornell University Press, Ithaca, 1983.

Haak, B. *The Golden Age: Dutch Painters of the Seventeenth Century.* Harry N. Abrams, New York, 1984.

Hulst, Roger-Adolf d'. *Jacob Jordaens.* Cornell University Press, Ithaca, 1982.

Rosenberg, Jakob, Seymour Slive, and E. H. ter Kuile. *Dutch Art and Architecture, 1600–1800.* 3rd ed. Pelican History of Art. Yale University Press, New Haven, 1997.

Schama, Simon. *The Embarrassment of Riches: An Interpretation of Dutch Culture in the Golden Age.* University of California Press, Berkeley, 1988.

Schwartz, Gary. *Rembrandt: His Life, His Paintings.* Penguin, New York, 1991.

Scribner, Charles, III. *Peter Paul Rubens.* Masters of Art. Harry N. Abrams, New York, 1989.

Stechow, Wolfgang. *Dutch Landscape Painting of the Seventeenth Century.* Reprint of 1966 ed. Cornell University Press, Ithaca, 1991.

White, Christopher. *Peter Paul Rubens: Man and Artist*. Yale University Press, New Haven, 1987.

19 THE BAROQUE IN FRANCE AND ENGLAND

Blunt, Anthony. *Art and Architecture in France, 1500–1700*. 5th ed. Pelican History of Art. Yale University Press, New Haven, 1999.

*———. *Nicolas Poussin*. 2 vols. Princeton University Press, Princeton, 1967.

*Waterhouse, Ellis Kirkham. *Painting in Britain, 1530 to 1790*. 5th ed. Pelican History of Art. Penguin, Harmondsworth, England, 1994.

20 ROCOCO

Conisbee, Philip. *Chardin*. Bucknell University Press, Lewisburg, Pa., 1986.

———. *Painting in Eighteenth-Century France*. Cornell University Press, Ithaca, 1981.

Levey, Michael. *Painting and Sculpture in France, 1700–1789*. New ed. Pelican History of Art. Yale University Press, New Haven, 1993.

———. *Rococo to Revolution: Major Trends in Eighteenth-Century Painting*. Reprint of 1966 ed. The World of Art. Thames and Hudson, New York, 1985.

Part Four THE MODERN WORLD

Arnason, H. H., and Marla Prather. *History of Modern Art*. 4th ed., rev. and enl. Harry N. Abrams, New York, 1998.

Brown, Milton W., et al. *American Art: Painting, Sculpture, Architecture, Decorative Arts, Photography*. Prentice Hall, Englewood Cliffs, N.J., 1979.

Chipp, Herschel B., ed. *Theories of Modern Art: A Source Book by Artists and Critics*. University of California Press, Berkeley, 1968.

Fineberg, Jonathan. *Art since 1940: Strategies of Being*. 2nd ed. Harry N. Abrams, New York, 1999.

Janson, H. W. *Nineteenth-Century Sculpture*. Harry N. Abrams, New York, 1985.

Rosenblum, Naomi. *A World History of Photography*. Rev. ed. Abbeville Press, New York, 1989.

Taylor, Joshua. *The Fine Arts in America*. University of Chicago Press, Chicago, 1979.

21 NEOCLASSICISM

Boime, Albert. *The Academy and French Painting in the Nineteenth Century*. New ed. Yale University Press, New Haven, 1986.

Honour, Hugh. *Neoclassicism*. Reprint of 1968 ed. Penguin, London, 1991.

———. *Romanticism*. Harper & Row, New York, 1979.

Rosenblum, Robert. *Transformations in Late Eighteenth Century Art*. Princeton University Press, Princeton, 1967.

Vaughan, William. *German Romantic Painting*. 2nd ed. Yale University Press, New Haven, 1994.

22 ROMANTICISM

Clark, Kenneth. *The Romantic Rebellion: Romantic versus Classic Art*. Harper & Row, New York, 1973.

Daval, Jean-Luc. *Photography: History of an Art*. Skira and Rizzoli, New York, 1982.

Licht, Fred. *Goya: The Origins of the Modern Temper in Art*. Harper & Row, New York, 1983.

23 REALISM AND IMPRESSIONISM

Clark, T. J. *The Painting of Modern Life: Paris in the Art of Manet and His Followers*. Reprint of 1984 ed. Princeton University Press, Princeton, 1989.

Fried, Michael. *Courbet's Realism*. University of Chicago Press, Chicago, 1990.

Herbert, Robert L. *Impressionism: Art, Leisure, and Parisian Society*. Reprint of 1988 ed. Yale University Press, New Haven, 1995.

Nochlin, Linda. *Impressionism and Post-Impressionism, 1874–1904: Sources and Documents*. Prentice Hall, Englewood Cliffs, N.J., 1966.

———. *Realism and Tradition in Art, 1848–1900: Sources and Documents*. Prentice Hall, Englewood Cliffs, N.J., 1966.

Pool, Phoebe. *Impressionism*. World of Art. Thames and Hudson, London, 1985.

Rewald, John. *The History of Impressionism*. 4th rev. ed. New York Graphic Society, Greenwich, Conn., 1973.

24 POST-IMPRESSIONISM, SYMBOLISM, AND ART NOUVEAU

Hamilton, George Heard. *Painting and Sculpture in Europe, 1880–1940*. 6th ed. Pelican History of Art. Yale University Press, New Haven, 1993.

Rewald, John. *Post-Impressionism: From Van Gogh to Gauguin*. 3rd ed. Museum of Modern Art, New York, 1978.

Sutter, Jean, ed. *The Neo-Impressionists*. New York Graphic Society, Greenwich, Conn., 1970.

25 TWENTIETH-CENTURY PAINTING

Gray, Camilla. *The Russian Experiment in Art, 1863–1922*. Rev. and enl. by Marian Burleigh-Motley. World of Art. Thames and Hudson, New York, 1986.

Livingstone, Marco. *Pop Art: A Continuing History*. Harry N. Abrams, New York, 1990.

Rosenblum, Robert. *Cubism and Twentieth-Century Art*. Rev. ed. Harry N. Abrams, New York, 1976.

Sandler, Irving. *The Triumph of American Painting: A History of Abstract Expressionism*. Harper & Row, New York, 1979.

26 TWENTIETH-CENTURY SCULPTURE

Elsen, A. *Origins of Modern Sculpture*. Braziller, New York, 1974.

Lucie-Smith, E. *Sculpture since 1945*. Universe Books, New York, 1987.

Read, Herbert. *Modern Sculpture: A Concise History*. The World of Art. Reprint of 1964 ed. Thames and Hudson, London, 1987.

27 TWENTIETH-CENTURY ARCHITECTURE

Curtis, William J. R. *Modern Architecture since 1900*. 2nd ed. Prentice Hall, Englewood Cliffs, N.J., 1987.

Kultermann, Udo. *Architecture in the Twentieth Century*. Van Nostrand Reinhold, New York, 1993.

28 TWENTIETH-CENTURY ARCHITECTURE

Coke, V.D. *The Painter and the Photograph: From Delacroix to Warhol*. Rev. ed. University of New Mexico Press, Albuquerque, 1972.

Green, J. American *Photography: A Critical History, 1945 to the Present*. Harry N. Abrams, New York, 1984.

Krauss, R. *L'Amour Fou: Photography and Surrealism*. Abbeville Press, New York, 1985.

Sontag, S. *On Photography*. Farrar, Strauss & Giroux, New York, 1973.

29 POSTMODERNISM

Jencks, Charles. *Architecture Today*. 2nd ed. Academy Editions, London, 1993.

———. *Post-Modernism: The New Classicism in Art and Architecture*. Rizzoli, New York, 1987.

———. *What Is Post-Modernism?* 3rd ed. St. Martin's Press, New York, 1989.

Norris, Christopher, and Andrew Benjamin. *What Is Deconstruction?* St. Martin's Press, New York, 1988.

Rosenau, Pauline Marie. *Post-Modernism and the Social Sciences: Insights, Inroads, and Intrusions*. Princeton University Press, Princeton, 1992.

Index

Tournachon, Gaspard-Félix. *See* Nadar
Tower of Babel, 49, 56
Tracery, 207
Trajan, Column of, 126–127, *126, 127*
Transepts, 145
Traveler, The (Popova), 545, *545*
Treasury of Atreus, Mycenae, 65, 66
Treasury of the Siphnians, Delphi, 89–90, *89*
Très Riches Heures du Duc de Berry, Les (Limbourg Brothers), 239–241, *239*
Tribute Money (Masaccio), 266–267, *267*
Triforium, 186
Triglyphs, 81, 317
Triptych, 330–331, *330*
 See also Altarpieces
Triumphal arch, 263
Trojan War, 65
Trumeau, 193
Tub, The (Degas), 496, *496*
Tudor, David, 596
Turner, Joseph Mallord William
 Childe Harold's Pilgrimage: Italy, 468
 Destruction of Sodom, The, 468
 Slave Ship, The, 469, *469*
 Snowstorm: Hannibal and His Army Crossing the Alps, 468
Tuscan order, 108
Tutankhamun, 44, *45,* 46, 54
Twittering Machine (Klee), 568, *568*
Tzara, Tristan, 556, *557,* 562, *563*

U

Under the Birches (Rousseau), 464–465, *464*
Unique Forms of Continuity in Space (Boccioni), 544, *544*
United States. *See* American art
Untitled (Hesse), 610, *610*
Untitled (Judd), 608, *608*
Untitled Film Still #15 (Sherman), 645–646, *645*
Untitled (Portrait of Ross in L.A.) (Gonzalez-Torres), 647–649, *648*
Ur, 52–53
Urban VIII, pope, 362–363, *362*
Urnammu, king, 52
Uruk, 49, 50
Utamaro, Kitagawa, *Courtesan, The,* 498

V

Van de Velde, Henri, Theater, Werkbund Exhibition, Cologne, 527, *527*
Van Doesburg, Theo, 579, 628
Van Dyck, Anthony
 Charles I at the Hunt, 382–383, *383*
 Rinaldo and Armida, 381, *382*
Van Eyck, Hubert, *Ghent Altarpiece (Adoration of the Lamb),* 323–325, *324, 325*
Van Eyck, Jan
 Ghent Altarpiece (Adoration of the Lamb), 323–325, *324, 325*
 Portrait of Giovanni Arnolfini and His Wife Giovanna Cenami, 326, 327–328
Van Gogh, Vincent
 Self-Portrait, 516, *516*
 Wheat Field and Cypress Trees, 515–516, *516*
Vanishing point, 272
Vasari, Giorgio, 228, 279, 294, 307
Vases and vessels
 Etruscan, 104, *104*
 Greek forms for, *71*
 Greek painted, Archaic, 72–74, *75,* 76–77, *76*
 Greek painted, Geometric, 69–71, *70*
 Greek painted, Orientalizing, 71–72, *71, 72*
Vatican
 Old Saint Peter's basilica, Rome, 144–145, *144*
 Saint Peter's basilica (Bernini), 364–366, *364, 365*
 Saint Peter's basilica (Bramante), 284–285, *284, 285*
 Saint Peter's basilica (Maderno), 363, *364*

Saint Peter's basilica (Michelangelo) 293–294, *293*
 Stanza della Segnatura, 294–297
Vatican, Sistine Chapel
 Delivery of the Keys to Saint Peter (Perugino), 275–276, *276*
 Last Judgment, 289, 291, *291*
 Libyan Sibyl, 289, *290*
 Michelanglo's work on, 288–291, *288–291*
Vaults
 barrel, 113, *113,* 265
 corbel, 65, *65*
 groin, 113, *113,* 170
Vauxcelles, Louis, 532, 541
Veduta, 421
Velázquez, Diego, *Maids of Honor, The,* 374–375, *375*
Vellum, 150
Vendramin, Gabriele, 299
Veneziano, Domenico, *Madonna and Child with Saints,* 269–270, *269*
Venice, Renaissance oil painting, 311–315, *311, 313–315*
Venus, 73
Venus of Willendorf, 27, *27,* 597
Venus with a Mirror (Titian), 301–302, *301*
Vermeer, Jan
 Love Letter, The, 395, *396*
 Woman Holding a Balance, 394, *396*
Veronese (Paolo Caliari), *Feast in the House of Levi,* 311–312, *311*
Verrocchio, Andrea del, 258, 280, 281
 Doubting of Thomas, The, 259, *259*
Versailles, palace of, 402–404, *403*
 aerial view, *404*
 garden front, 403, *403*
 Hall of Mirrors, 403
 Salon de la Guerre, 403, *403*
Vespucci, Simonetta, 273
Victory over the Sun (Malevich), 545
Vien, Joseph-Maure, 437
Vienna Genesis, 150–151, *150*
View from His Window at Le Gras (Niépce), 479, *479*
View of Rome (Corot), 464, *464*
View of Schroon Mountain, Essex County, New York, after a Storm (Cole), 470, *471*
Vigée-Lebrun, Marie-Louise-Élisabeth, 7
Vignola, Giacomo, 319
Vikings, 177, 184
Village Bride, The (Greuze), 436–437, *436*
Villa Mairea (Aalto), Finland, 630, *630*
Villani, Filippo, 251
Villa of the Mysteries, Pompeii, 130–131, *131*
Villa Rotunda (Palladio), 318, *318*
Villa Savoye (Le Corbusier), France, 630, *630*
Violin (Picasso), 542, *543*
Virgin and Child (Fouquet), 331–332, *331*
Virgin and Child (Murillo), 376, *376*
Virgin of Paris, Notre-Dame, Paris, 220, *220*
Virgin of the Rocks, The (Leonardo da Vinci), 280–281, *280*
Visigoths, 168
Vision after the Sermon (Jacob Wrestling with the Angel) (Gauguin), 517, *517*
Visitation, Reims Cathedral, 218–220, *219*
Vitruvius, 80, 84, 85, 86, 98, 111, 128, 130, 131, 173, 264
Vitruvius Brittanicus (Campbell), 445
Voltaire Seated (Houdon), 444–445, *444*
Votive statues, 51
Vouet, Simon, 399
 Toilet of Venus, The, 400, *400*
Voussoirs, 113, *113*
Vuillard, Édouard, *Suitor (Interior at l'Étang-la-Ville), The,* 519, *519*
Vulcan, 73

W

Wainwright Building (Sullivan), St. Louis, Missouri, 527–528, *527*

Wall painting
 defined, 128
 Roman, 127–131, *129–131*
Walpole, Horace, Strawberry Hill, England, 477, *477*
Walpole, Robert, 477
Warhol, Andy, *Gold Marilyn Monroe, 2–3, 3, 7, 606–607, 606*
Washington, Augustus, *John Brown,* 481, *481*
Watson and the Shark (Copley), 442, *442*
Watteau, Jean-Antoine
 Diana Bathing, 489
 A Pilgrimage to Cythera, 412–413, *412*
Weimar School of Arts and Crafts, 527
Well of Moses (Sluter), 222–223, *222*
Werkbund Exhibition, Cologne, 527, *527*
West, Benjamin, *Death of General Wolfe,* 440–441, *441*
Weston, Edward, *Pepper,* 585, *585*
Westwork, 173
Wheat Field and Cypress Trees (Van Gogh), 515–516, *516*
Where Do We Come From? What Are We? Where Are We Going? (Gauguin), 517, *518*
Whistler, James Abbott McNeill
 Arrangement in Black and Gray: The Artist's Mother, 501, *501*
 Nocturne: Black and Gold: The Falling Rocket, 502, *502*
Whitehall Palace, Banqueting House, London, 407, *407*
White Temple, Uruk, 49–50, *49, 50*
Willem Claesz, Heda, *Still Life,* 392–394, *392*
William the Conqueror, 177, 187, 198
William the Silent, 377
Winckelmann, Johann Joachim, 424, 434
Winogrand, Gary, 617
Wire Wheel (Strand), 583, *583*
Woman, Neolithic, 27, *28*
Woman Holding a Balance (Vermeer), 394, *396*
Woman I (De Kooning), 597, *597*
Women
 Etruscan, 105
 feminist art, 615–616, *615*
 feminist movement, role of, 5–6, 615
 in guilds, 173
 nunneries for, 190
 Postmodern depiction of, 591, *591,* 594, *594*
 Renaissance portrayal of, 343
 Renaissance profile portraits of, 273–274, *273*
 Roman, 122, *123*
 Romanesque artists and patrons, 200
Women artists
 Bonheur, Rosa, 465–466, *465*
 Bourke-White, Margaret, 583–584, *583*
 Cameron, Julia Margaret, 483, *483*
 Cassatt, Mary, 497–498, *499*
 Chase-Riboud, Barbara, 612–613, *613*
 Chicago, Judy, 615–616, *615*
 Gentileschi, Artemisia, 7, 357, 358–359, *359*
 Goncharova, Natalia, 544, 545
 Hepworth, Barbara, 572, 574, *574*
 Hesse, Eva, 603–604, *604*
 Hildegard of Bingen, 200
 Höch, Hannah, 559, 560, *560*
 Käsebier, Gertrude, 528, *528*
 Kauffmann, Angelica, 442–443, *443*
 Kollwitz, Käthe, 561, *561*
 Lange, Dorothea, 588–589, *589*
 Leyster, Judith, 5–7, *6,* 386, *386*
 Magritte, René, 574, *574*
 Morisot, Berthe, 497, *497*
 Murray, Elizabeth, 642, *642*
 O'Keeffe, Georgia, 584–585, *584*
 Oppenheim, Meret, 574–575, *575*
 Popova, Lyubov, 545, *545*
 Schneemann, Carolee, 615
 Sherman, Cindy, 645–646, *645*
 Smith, Kiki, 649, *649*

List of Credits

Introduction

I-1 The Newark Museum/Art Resource, NY; I-2 ©The Andy Warhol Foundation, Inc./Art Resource, NY; I-3 Alinari; I-4 ©Free Agents Limited/CORBIS; I-5 ©The Art Institute of Chicago, All Rights Reserved; I-6 AP Photo/Diane Bondareff; I-7 ©Board of Trustees, National Gallery of Art, Washington, DC; I-8 Photograph by Lynn Rosenthal, 1998, I-9 ©Photograph John Bigelow Taylor/Art Resource, NY; I-10 O'Hara Gallery, NY; I-11 Courtesy Fraenkel Gallery, San Francisco; I-12 IKONA; I-13 ©Reunion des Musées Nationaux/Art Resource, NY; I-14 David Heald ©The Solomon Guggenheim Foundation, NY; I-15 Robert Mates, The Solomon Guggenheim R. Foundation, NY; I-16 ©2004 Board of Trustees, National Gallery of Art, Washington, DC; I-17 Peter Willi/Superstock

Chapter 1

Part Opener, Chapter Opener, and 1-1 Cliche Philippe Berthe/©CMN, Paris; 1-2 Hans Hinz/Colorfoto Hinz; 1-3 ©Erich Lessing/Art Resource, NY; 1-4 The Czech Museum of Fine Arts; 1-5 Simmons Aerofilms, Ltd.; 1-6 English Heritage Photograph Library; 1-7 Tony Linck

Chapter 2

Part Opener Bildarchiv Preussischer Kulturbesitz/Art Resource, NY; Chapter Opener Bridgeman Art Library; 2-1 ©Scala/Art Resource, NY; 2-2 ©Scala/Art Resource, NY; 2-3 Yvonne Vertut; page 35 side bar Henri Stierlin, *The Pharaohs, Master Builders*, Terrail, 1995; 2-4 ©2004 Museum of Fine Arts, Boston; 2-5 ©Ancient Art & Architecture/Danita Delimont Stock Photography; 2-6 Peter A. Clayton; 2-7 Norbert Schiller/The Image Works; 2-9 Roger Wood, London, Corbis/Bettman; 2-10 Peter A. Clayton; 2-11 Peter A. Clayton; 2-12 Bildarchiv Preussischer Kulturbesitz/ Art Resource, NY; 2-13 Bildarchiv Preussischer Kulturbesitz/Art Resource, NY; 2-14 Bridgeman Art Library; 2-15 © Gian Berto Vanni/CORBIS

Chapter 3

Part Opener Photograph by D. Arnaudet, Reunion des Musées Nationaux/Art Resource, NY; Chapter Opener Photograph by D. Arnaudet, Reunion des Musées Nationaux/Art Resource, NY; 3-1 DAI, Baghdad; 3-2 H. Frankfurt, *The Art and Architecture of the Ancient Orient*; 3-3 Photographed by Victor J. Boswell, Jr., National Geographic Society; 3-4 University of Pennsylvania Museum; Side bar illustration ©The Trustees of the British Museum 3-5 University of Pennsylvania Museum of Archaeology and Anthropology; 3-6 Photograph by D. Arnaudet, Reunion des Musées Nationaux/Art Resource, NY; 3-7 Photograph by Herve Lewandowki, Reunion des Musées Nationaux/Art Resource, NY; 3-8 HIP/Art Resource, NY; 3-9 Art Resource/Bildarchiv Preussischer Kulturbesitz; 3-10 ©The Trustees of The British Museum; 3-11 Corbis/Bettmann

Chapter 4

Part Opener Ashmolean Museum, Oxford; Chapter Opener Ashmolean Museum, Oxford; 4-1 Ashmolean Museum, Oxford; 4-2 Roger Wood, Corbis; 4-3 Photostock/Studio Kontos; 4-4 Photostock/Studio Kontos; 4-5 Picture Desk Inc./Kobal Collection/ Dagll Orti; 4-6 Corbis/Bettmann

Chapter 5

Part Opener Canali Photobank; Second Part Opener Werner Forman Archive/Art Resource, NY; Chapter Opener Nimatallah/Art Resource, NY; 5-1 Photograph ©1996 The Metropolitan Museum of Art; 5-2 Photostock/Studio Kontos; 5-3 Canali Photobank; 5-4 Photograph Herve Lewandowski, Reunion des Musées Nationaux/Art Resource, NY; 5-5 ©Scala/Art Resource, NY; 5-8 ©John Heseltine / CORBIS. 5-9 Werner Forman Archiv/Art Resource, NY; 5-10 Photostock/Studio Kontos; 5-12 The Metropolitan Museum of Art, NY; 5-13 Nimatallah/Art Resource, NY; 5-14 Hirmer Photoarchiv; 5-15 Hirmer Verlag Munchen; 5-16 Nimatallah/Art Resource, NY; 5-17 Spiros Tselentis/SuperStock; 5-18 ©Foto Marburg/Art Resource, NY; 5-19 Photostock/Studio Kontos; 5-20 ©Erich Lessing/Art Resource, NY; 5-21 ©The Trustees of The British Museum/Superstock; 5-22 Culver Pictures; 5-23 ©The Trustees of The British Museum; 5-24 Canali Photobank; 5-25 Alinari/Art Resource, NY; 5-27 Bildarchiv Preussischer Kulturbesitz/Art Resource, NY; 5-28 © Reunion des Musées Nationaux/Art Resource, NY; 5-29 National Archaeological Museum, Athens/Art Resource, NY

Chapter 6

Part Opener Canali Photobank; Chapter Opener Canali Photobank; 6-1 Villa Giulia; 6-2 SuperStock, Inc.; 6-3 ©Scala/Art Resource, NY; 6-4 Soprintendenza Alle Antichita' Firenze; 6-5 D Canali Photobank; 06-06 ©Scala/Art Resource, NY

Chapter 7

Part Opener Canali Photobank; Chapter Opener Canali Photobank; 7-1 Embassy of Italy; 7-2 American Academy, Rome; 7-3 ©Deutschen Archaeologischen Instituts – Rome; 7-4 Canali Photobank; 07-05 Jean Pragen, Getty Images Inc.; 7-6 Canali Photobank; 7-7 ©2004 Board of Trustees, National Gallery of Art, Washington; 7-8 H. N. Abrams Archives; 7-9 IKONA; 7-11 ©Scala/Art Resource, NY; 7-12 Superstock; 7-13 Canali Photobank; 7-14 ©Araldo de Luca, Cobis/Bettmann; 7-15 ©Scala/Art Resource, NY; 7-16 Canali Photobank; 7-17 © Erich Lessing/Art Resource, NY; 7-18 Laurie Platt Winfrey, Inc.; 7-19 Woodfin Camp and Associates; 7-20 Siegfried Tauquer/eStock Photography LLC; 7-21 Canali Photobank; 7-22 Superstock; 7-23 Canali Photobank; 7-24 Canali Photoban; 7-25 Photograph ©1998 The Metropolitan Museum of Art

Chapter 8

Part Opener Canali Photobank; Second Part Opener Canali Photobank; Chapter Opener Canali Photobank; 8-1 Canali Photobank; 8-2 ©Scala/Art Resource, NY; 8-3 Canali Photobank; 8-4 ©Scala/Art Resource, NY; 8-5 Bildarchiv d. ONB, Wien; 8-6 Hirmer Verlag Munchen; 8-7 Canali Photobank; 8-8 ©Scala/Art Resource, NY; 8-9 Canali Photobank; 8-10 Canali Photobank; 8-11 Achim Bednorz; 8-12 Marvin Trachtenbeg; 8-13 Photostock/Studio Kontos; 8-14 ©The Trustees of The British Museum; 8-15 ©Erich Lessing/Art Resource, NY; 8-16 Photostock/Studio Kontos; 8-17 ©Erich Lessing/Art Resource, NY; 8-18 ©2004 Board of Trustees, National Gallery of Art, Washington,DC; 8-19 Malak/SuperStock

Chapter 9

Part Opener The Pierpont Morgan Library/Art Resource; Second Part Opener Art Resource, NY; Chapter Opener The Pierpont Morgan Library/Art Resource; 9-1 ©The Trustees of The British Museum/The Bridgeman Art Library; 9-2 The British Library, London; 9-3 Photo: National Museum of Ireland; 9-4 Ann Munchow Fotografin; 9-5 ©Erich Lessing/Art Resource, NY; 9-6 Kunsthistorisches Museum Wien; 9-7 Art Resource, NY; 9-8 The Pierpont Morgan Library/Art Resource, NY; 9-10 Scala/Art Resource, NY; 9-11 H. N. Abrams Archive; 9-12 ©Erich Lessing/Art Resource, NY; 9-13 Bayerische Staatsbibliothek; 09-14 Werner Forman Archive/Art Resource, NY

Chapter 10

Part Opener Photo by David Jacobs/Robert Harding World Imagery; Chapter Opener Société Archéologique et Historique, Avesnes-sur-Helpe, France; 10-3 ©Scala/Art Resource, NY; 10-4 Caisse Nationale des Monuments Historique et des Sites; 10-5 Foto Marburg/Art Resource, NY; 10-6 A. F. Kersting; 10-9 Photo by David Jacobs/Robert Harding World Imagery; 10-10 ©Scala/Art Resource, NY; 10-11 Jean Feuillie ©Centre des Monuments Nationaux, Paris. 10-12 Arch. Phot. ©CMN, Paris; 10-13 H. N. Abrams Archive; 10-14 ©Scala/Art Resource, NY; 10-15 ©Scala/Art Resource, NY; 10-16 ©Alinari/Art Resource, NY; 10-17 Société Archéologique et Historique, Avesnes-sur-Helpe, France; 10-18 Foto Marburg/Art Resource; 10-19 Lauros/Giraudon/Bridgeman Art Library; 10-20 ©Erich Lessing/Art Resource, NY

Chapter 11

Part Opener Canali Photobank; Second Part Opener ©Topham/THE IMAGE WORKS; Third Part Opener ©Photo Josse, Paris; Chapter Opener ©Photo Josse, Paris; 11-1 Marvin Trachtenberg; 11-2 Clarence Ward, Oberlin; 11-3 ©Alinari/Art Resource, NY; 11-4 CORBIS; 11-6 ©Scala/Art Resource, NY; 11-7 Roger Moss Photography; 11-8 Jean Bernard Photographe/Bordas Publication; 11-9 ©Scala/Art Resource, NY; 11-10 ©Topham/THE IMAGE WORKS; 11-12 AKG; 11-13 Vanni/Art Resource, NY; 11-14 © Scala/Art Resource, NY; 11-15 Vanni/Art Resource, NY; 11-16 ©Giraudon/Art Resource, NY; 11-17 ©Erich Lessing/Art Resource, NY; 11-18 Foto Marburg/Art Resource; 11-19 Foto Marburg/Art Resource, NY; 11-20 Giraudon/Art Resource, NY; 11-21 Foto Marburg/ Art Resource, NY; 11-22 Rheinischen Landesmuseum Bonn; 11-23 ©Photograph by Erich Lessing/Art Resource, NY; 11-24 ©Scala/Art Resource, NY; 11-25 ©Scala/Art Resource, NY; 11-26 ©Photograph by Erich Lessing/Art Resource, NY; 11-27 ©Photo Josse, Paris; 11-28 Bibliothèque Nationale de France.11-29 Canali Photobank; 11-30 Alinari/Art Resource, NY; 11-31 Canali Photobank; 11-32 ©Erich Lessing/Art Resource, NY; 11-33 Canali Photobank; 11-34 Canali Photobank; 11-35 ©Scala/Art Resource, NY; 11-36 Photograph ©2004 Museum of Fine Arts, Boston; 11-37 ©Erich Lessing/Art Resource, NY; 11-38 ©Reunion des Musées Nationaux/Art Resource, NY; 11-39 ©Scala/Art Resource, NY

Chapter 12

Part Opener ©Erich Lessing/Art Resource, NY; Chapter Opener ©Erich Lessing/Art Resource, NY; 12-1 Canali Photobank; 12-2 Nimatallah/Art Resource, NY; 12-3 ©Scala/Art Resource, NY; 12-4 Codato/Canali Photobank; 12-5 Bridgeman Art Library; 12-6 Dorling Kindersley Media Library; 12-7 Alinari/Art

Resource, NY; 12-8 Canali Photobank 12-9 Vanni/Art Resource NY; 12-10 ©Scala/Art Resource, NY; 12-11 H. N. Abrams Archive; 12-12 ©Scala/Art Resource, NY; 12-13 Canali Photobank; 12-14 Canali Photobank; 12-15 Studio Mario Quattrone; 12-16 Canali Photobank. 12-17 ©Scala/Art Resource, NY; 12-18 ©Scala/Art Resource, NY; 12-19 ©The National Gallery, London; 12-20 Artothek; 12-21©Erich Lessing/Art Resource, NY; 12-22 Canali Photobank; 12-23 ©Erich Lessing/Art Resource, NY

Chapter 13

Part Opener Canali Photobank; Chapter Opener Canali Photobank; 13-1 ©Scala/Art Resource, NY; 13-2 Canali Photobank; 13-3 ©Reunion des Musées Nationaux/Art Resource, NY; 13-4 ©Reunion des Musees Nationaux/Art Resource, NY; 13-6 The British Museum Great Court Ltd; 13-7 Canali Photobank; 13-8 Galleria dell'Accademia/Art Resource; 13-9 IKONA; 13-10 Canali Photobank; 13-11 Canali Photobank; 13-11 IKONA; 13-12 Archivo Musei Vatican 13-13 ©Scala/Art Resource, NY; 13-14 Canali Photobank; 13-15 ©2004 Board of Trustees, National Gallery of Art, Washington; 13-16 The Bridgeman Art Library; 13-17 Canali Photobank; 13-18 ©Reunion des Musées Nationaux/Art Resource, NY; 13-19 Cameraphoto/Art Resource, NY; 13-20 ©Scala/Art Resource, NY; 13-21Canali Photobank; 13-22 ©2004 Board of Trustees, National Gallery of Art, Washington; 13-23 Artothek

Chapter 14

Part Opener Canali Photobank; Chapter Opener Canali Photobank; 14-1 Canali Photobank; 14-2 Canali Photobank; 14-3 Canali Photobank; 14-4 Canali Photobank; 14-6 Scala/Art Resource, NY; 14-7 The Bridgeman Art Library; 14-8 ©Scala/Art Resource, NY; 14-9 Canali Photobank; 14-10 ©Scala/Art Resource, NY; 14-12 Canali Photobank; 14-13 Superstock; 14-14 Canali Photobank; 14-15 ©Scala/Art Resource, NY

Chapter 15

Part Opener ©Erich Lessing/Art Resource, NY; Chapter Opener ©Erich Lessing/Art Resource, NY; 15-1 Photograph ©1996 The Metropolitan Museum of Art; 15-2 ©Photograph by Erich Lessing/Art Resource, NY; 15-3 ©Archivo Iconografico, S.A./CORBIS; 15-4 Lotte Brand Philip from Snyder, Northern Renaissance Art; 15-5 ©Erich Lessing/Art Resource, NY; 15-6 ©Erich Lessing/Art Resource, NY; 15-7 Prado, Madrid; 15-8 Canali Photobank; 15-9 Oronoz, Madrid; 15-10 Bildarchiv Preussischer Kulturbesitz/Art Resource, NY; 15-11 Koninklijk Museum voor SchoneKunsten (Musée Royal des Beaux-Arts), Antwerp; 15-12 ©Erich Lessing/Art Resource, NY; 15-13 Laurie Platt Winfrey, Inc.

Chapter 16

Part Opener ©Erich Lessing/Art Resource, NY; Chapter Opener ©Erich Lessing/Art Resource,NY; 16-1 Musee d'Unterlinden; 16-2 Musee d'Unterlinden; 16-3 Laurie Platt Winfrey, Inc.; 16-4 ©Scala/Art Resource, NY; 16-5 Culver Pictures; 16-6 Photograph; ©1990 The Metropolitan Museum of Art; 16-7 ©Scala/Art Resource, NY; 16-8 Photograph by Herve Lewandowki, Reunion des Musées Nationaux/Art Resource, NY; 16-9 Canali Photobank; 16-10 Oronoz, Madrid; 16-11 Bo Gyllander; 16-12 ©Erich Lessing/Art Resource, NY; 16-13 ©Erich Lessing/Art Resource, NY; 16-14 Art Resource/Reunion des Musees Nationaux; 16-15 Kunsthistorisches Museum Wien; 16-16 ©Erich Lessing/Art Resource, NY

Chapter 17

Chapter Opener Canali Photobank; 17-1 Canali Photobank; 17-2 Canali Photobank; 17-3 Photograph © 1983 The Metropolitan Museum of Art; 17-4 Detroit Institute of Arts; 17-5 Canali Photobank; 17-6 Canali Photobank; 17-7 Canali Photobank; 17-8 Canali Photobank; 17-9 IKONA; 17-10 Gianalberto Cigolini Art Resource, NY; 17-11 Canali Photobank; 17-12 Aliinari/Art Resouce, NY; 17-13 Alinari Art Resource, NY; 17-14 Alinari/Art Resource, NY; 17-15 Canali Photobank; 17-16 Canali Photobank; 17-17 ©Photograph by Erich Lessing/Art Resource, NY; 17-18 ©Scala/Art Resource, NY; 17-19 ©Scala/Art Resource, NY; 17-21© Erich Lessing/Art Resource, NY; 17-22 Photograph © The Metropolitan Museum of Art

Chapter 18

Part Opener ©Rijksmuseum, Amsterdam; Chapter Opener ©Rijksmuseum, Amsterdam; 18-1 ©2004 Board of Trustees, National Gallery of Art, Washington; 18-2 Peter Willi / Super Stock; 18-3 Alte Pinakothek; 18-4 Giraudon/Bridgeman Art Library; 18-5 The Baltimore Museum of Art; 18-6 © Reunion des Musées Nationaux; 18-7 Musees Royaux des Beaux-Arts de Belgique; 18-8 Artothek; 18-9 ©Rijksmuseum Amsterdam; 18-10 © Erich Lessing/Art Resource, NY; 18-11 Stadelsches Kunstinstitut und Stadtische Galerie; 18-12 ©Rijksmuseum Amsterdam; 18-13 ©The Frick Collection, NY; 18-14 Cincinnati Art Museum; 18-15 Detroit Institute of Arts; 18-17 ©Rijksmuseum Amsterdam; 18-18 Bob Grove/Image © Board of Trustees, National Gallery of Art, Washington, D.C.; 18-19 ©Rijksmuseum, Amsterdam

Chapter 19

Part Opener ©Werner Otto/AGE Fotostock; Chapter Opener © Werner Otto/AGE Fotostock; 19-1 © Reunion des Musees Nationaux/Art Resource, NY; 19-2 The Metropolitan Museum of Art; 19-4 Carnegie Museum of Art; 19-5 Art Resource/Musee du Louvre; 19-6 The Getty Research Institute for the History of Art and the Humanities; 19-7 Giraudon/Art Resource, NY; 19-8 © Stephane Compoint; 19-9 © Werner Otto/AGE Fotostock; 19-12 Giraudon/Art Resource, NY; 19-13 The Art Archive/John Webb; 19-14 Bridgeman Art Library

Chapter 20

Part Opener Superstock; Chapter Opener Superstock; 20-1 Photograph ©1995 The Metropolitan Museum of Art; 20-2 Lauros/Giraudon/Bridgeman Art Library; 20-3 ©Reunion des Musées Nationaux/Art Resource, NY; 20-4 ©Superstock Inc.; 20-5 AKG-Images; 20-6 ©Reunion des Musées Nationaux/Art Resource, NY; 20-7 ©2004 Board of Trustees, National Gallery of Art, Washington; 20-8 The Art Archive; 20-9 ©The National Gallery, London; 20-10 Courtesy of the Huntington Library, Art Collections, and Botanical Gardens, San Marino, California; 20-11 ©Richard Klune/CORBIS; 20-12 AKG-Images; 20-13 The Royal Collection © 2004 Her Majesty Queen Elizabeth II

Chapter 21

Part Opener Lautman Photography, Washington, D.C.; Chapter Opener Lautman Photography, Washington, D.C.; 21-1 ©Photograph by Erich Lessing/Art Resource, NY; 21-2 ©Reunion des Musées Nationaux/Art Resource, NY; 21-3 ©Reunion des Musees Nationaux/Art Resource, NY; 21-4 ©Reunion des Musées Nationaux/Art Resource, NY; 21-5 Photo © National Gallery of Canada, Ottawa Transfer from the Canadian War Memorials, 1921 (Gift of the 2nd Duke of Westminster, Eaton Hall, Chesire, 1918); 21-6 Photograph © 2004 Museum of Fine Arts, Boston; 21-07 Photo by Katherine Wetzel; 21-8 Bridgeman/Giraudon/Art Resource, NY; 21-9 British Department of the Environment; 21-10 ©English Heritage/HIP/The Image Works; 21-11 Lautman Photography, Washington, D.C.

Chapter 22

Part Opener ©Erich Lessing/Art Resource, NY; Chapter Opener ©Erich Lessing/Art Resource, NY; 22-1 ©Erich Lessing/Art Resource, NY; 22-2 Bridgeman Art Library; 22-3 ©Erich Lessing/Art Resource, NY; 22-4 Photo by Katya Kallsen; 22-5 ©Reunion des Musées Nationaux/Art Resource, NY; 22-6 ©Reunion des Musées Nationaux/Art Resource, NY; 22-7 © Reunion des Musées Nationaux/Art Resource NY; 22-8 ©Reunion des Musées Nationaux/Art Resource NY; 22-9 Photograph ©1990 The Metropolitan Museum of Art; 22-10 Photograph ©1992 The Metropolitan Museum of Art; 22-11 Photograph ©2004 Museum of Fine Arts, Boston; 22-12 The Fine Arts Museums of San Francisco; 22-13 The Toledo Museum of Art; 22-14 Photograph by Gerard Blot. Reunion des Musées Nationaux/Art Resource, NY; 22-15 Snark/Freies Deutsches Hochsift-Frankfurter Goethe-Museum/Art Resource, NY; 22-16 Peter Willi / SuperStock; 22-17 Bridgeman Art Library; 22-18 Photograph ©2004 Museum of Fine Arts, Boston; 22-19 Photograph: Joerg P. Anders, Bildarchiv Preussischer Kulturbesitz/Art Resource, New York; 22-21 Photograph © 1992 The Metropolitan Museum of Art; 22-22 © Erich Lessing/Art Resource, NY; 22-23 Bernard Boitrit/ Woodfin Camp & Associates; 22-24 ©Erich Lessing/Art Resource, NY; 22-25 ©Foto Marburg/Art Resource, NY; 22-26 Foto Marburg/Art Resource, NY; 22-27 English Heritage/National Monuments Record; 22-28 English Heritage/National Monuments Record; 22-29 French Government Tourist Office; 22-30 University of Texas at Austin News and Information Service; 22-31 National Portrait Gallery, Smithsonian Institution/Art Resource, NY; 22-32 Art Resource, N.Y.; 22-33 Image ©The Art Institute of Chicago; 22-34 Chicago Historical Society

Chapter 23

Part Opener ©Reunion des Musees Nationaux/Art Resource, NY; Chapter Opener ©Reunion des Musees Nationaux/Art Resource, NY; 23-1 ©Reunion des Musées Nationaux/Art Resource, NY; 23-2 ©Reunion des Musées Nationaux/Art Resource, NY; 23-3 ©Reunion des Musées Nationaux/ArtResource, NY; 23-4 Photograph, all rights reserved, The Metropolitan Museum of Art; 23-5 IKONA; 23-6 ©Reunion des Musées Nationaux/Art Resource, NY; 23-7 AKG-Images; 23-8 ©Art Institute of Chicago, All Rights Reserved; 23-10 Oronoz, Madrid; 23-11 ©Reunion des Musées Nationaux/Art Resource, NY; 23-12 ©Reunion des Musees Nationaux/Art Resource, NY; 23-13 The National Gallery Company Ltd.; BOX UNFIG Photograph © 2000, The Art Institute of Chicago, All Rights Reserved; 23-14 ©Art Institute of Chicago, All Rights Reserved; 23-15 ©Art Instiute of Chicago, All Rights Reserved; 23-16 Victoria & Albert Museum, London/Art Resource, NY; 23-17 ©Reunion des Musées Nationaux/ Art Resource, NY; 23-18 Bridgeman Art Library; 23-19 Bridgeman Art Library; 23-20 Photograph ©1994 Metropolitan Museum of Art; 23-21 Hampton University Museum; 23-22 Christie's Images/SuperStock; 23-23 ©Museum of Modern Art/SCALA/Art Resource, NY; 23-24 The Norton Simon Foundation; 23-25 ©Roger Viollet; 23-26 © Erich Lessing/Art Resource, NY; 23-27 British Embassy; 23-28 Culver Pictures

Chapter 24

Part Opener Scala/Art Resource, NY/©ARS, NY; Chapter Opener SuperStock, Inc.; 24-1 NY Carlsberg Glyptotek; 24-3 ©Art Institute of Chicago, All Rights Reserved; 24-4 ©Erich Lessing/Art Resource, NY; 24-5 Photo by Lorene Emerson. ©Board of Trustees, National Gallery of Art, Washington, DC; 24-6 SuperStock, Inc.; 24-7 SuperStock, Inc.; 24-8 ©The Art Institute of Chicago, All Rights Reserved; 24-9 The Art Institute of Chicago; 24-10 ©Museum of Modern Art/ Scala/Art Resource, NY; 24-11 AKG-Images; 24-12 The Art Archive/Nasjonal Galleriet, Oslo/Joseph Martin; 24-13 Oeffentliche Kunstsammlung Basel (Kupferstichkabinett); 24-14 Scala/Art Resource NY/©ARS, NY; 24-15 Scala/Art Resource,NY/©ARS, NY; 24-16 ©Ernst Barlach Lizenzverwaltung Ratzeburg; 24-17 The Museum of Modern Art/Art Resource, NY; 24-18 Robert

Harding; 24-19 Bridgeman Art Library; 24-21 St. Louis Convention & Visitors Commission; 24-22 NMPFT/Royal Photographic Society; 24-23 The J. Paul Getty Museum; 24-24 Laurie Platt Winfrey, Inc.

Chapter 25

Part Opener Scala/Art Resource, NY/©ARS,NY; Chapter Opener Scala/Art Resource, NY/©ARS, NY; 25-1 Photograph ©Reproduced with the Permission of The Barnes Foundation; 25-2 Licensed by Scala/Art Resource, NY/©ARS; 25-3 The Baltimore Museum of Art; 25-4 ©The Museum of Modern Art/Licensed by SCALA/Art Resource, NY; 25-5 Kunstmuseum Bern, Paul-Klee-Stiftung; 25-6 Artothek; 25-7 Scala/Art Resource NY/©ARS,NY; 25-8 Photograph by Martin Buhler, 25-9 Marion Koogler McNay Art Museum; 25-10 The Solomon R. Guggenheim Museum; 25-11 © Reunion des Musées Nationaux/ Art Resource, NY; 25-12 Scala/Art Resource NY; 25-13 The Norton Simon Foundation; 25-14 ©The Museum of Modern Art/Licensed by SCALA/Art Resource, NY; 25-15 Scala/Art Resource, NY; 25-16 The Bridgeman Art Library; 25-17 Philadelphia Museum of Art; 25-18 ©The Art Institute of Chicago/Robert Hashimoto; 25-19 ©The Museum of Modern Art/Licensed by SCALA/Art Resource, NY; 25-20 ©B. Huet/Tutti; 25-21 Digital image ©The Museum of Modern Art/Licensed by SCALA/Art Resource, NY; 25-23 Photograph by Geoffrey Clements; 25-24 Photograph ©1986 The Metropolitan Museum of Art

Chapter 26

Part Opener ©Museum of Modern Art/Scala/Art Resource, NY Chapter Opener ©Museum of Modern Art/Scala/Art Resource, NY; 26-1 Kunsthaus, Zurich. ARS, NY; 26-2 Philadelphia Museum of Art: The Louise and Walter Arensberg Archives/©ARS, NY; 26-3 ©CNAC/MNAM/Dist. Reunion des Musées Nationaux/Art Resource, NY; 26-4 ©Erich Lessing/Art Resource, NY; 26-6 The Galerie St. Etienne; 26-8 Telimage, 2004; 26-9 Scala/Art Resource, NY, ©ARS, NY; 26-10 Art Resource, NY/© ARS; 26-11 Musée National d'Art Moderne, Centre Georges Pompidou, Paris/Art Resource, NY; 26-12 ©Reunion des Musée Nationaux/Art Resource, NY; 26-13 ©The Museum of Modern Art/Licensed by SCALA/Art Resource, NY; 26-14 Wadsworth Atheneum; 26-15 The Solomon R. Guggenheim Museum; 26-16 The Museum of Modern Art/Licensed by SCALA/Art Resource, NY; 26-17 ©The Museum of Modern Art/Licensed by SCALA/Art Resource, NY; 26-18 ©The Museum of Modern Art/Licensed by SCALA/Art Resource, NY; 26-19 ©Henry Moore Foundation/Art Resource, NY; 26-20 Collection Bowness, Hepworth Estate, London; 26-21 Scala/Art Resource, NY/© ARS, NY; 26-22 Scala/Art Resource, NY/© ARS NY; 26-23 ©Museum of Modern Art/Art Resource, NY; 26-24 ©Henri Cartier-Bresson/Magnum Photos; 26-25 Moderna Museet; 26-26 Art Resource, NY; 26-27 Photographic Services ©2004 President and Fellows of Harvard College; 26-28 ©Museum of Modern Art/Licensed by SCALA/Art Resource, NY; 26-29 Photograph Geoffrey Clements; 26-30 George Eastman House; 26-31 Margaret Bourke-White/Time Life Pictures/Getty Images; 26-32 Photograph ©1983 Metropolitan Museum of Art; 26-33 Center for Creative Photography; 26-34 Photograph by Ansel Adams, Copyright 1997 by the Trustees of the Ansel Adams Trust. All Rights Reserved; 26-35 ©Art Institute of Chicago, All Rights Reserved; 26-36 Photograph Geoffrey Clements 26-37 Walker Evans Archive, The Metropolitan Museum of Art; 26-38 Culver Pictures; 26-39 ©Die Photographische Sammlung/SK Stiftung Kultur-August Sander Archiv, Cologne; ARS, New York 2004; 26-40 ©Museum of Modern Art/ SCALA/Art Resource, NY; 26-42 ©Photograph John Bigelow Taylor/Art Resource, NY

Chapter 27

Chapter Opener Museum Ludwig, Rheinisches Bildarchiv Koln; 27-1 Albright-Knox Art Gallery; 27-2 Photograph ©1998 Metropolitan Museum of Art; 27-3 Scala/Art Resource, NY/© ARS, NY; 27-4 Museum of Contemporary Art; 27-5 Smithsonian Institution/Office of Imaging, Printing, and Photographic Services; 27-6 ©Peter Willi/Superstock; 27-7 ©Art Institute of Chicago, All Rights Reserved; 27-8 Museum Ludwig, Rheinisches Bildarchiv Koln; 27-9 Photograph Geoffrey Clements; 27-10 Photograph: Robert McElroy; 27-12 ©Museum of Modern Art/Scala/ Art Resource, NY; 27-13 ©The Andy Warhol Foundation/Art Resource, NY; 27-14 Photograph Philipp Scholz Ritterman; 27-15©Museum of Modern Art/Scala/Art Resource, NY; 27-16 Photograph David Heald; 27-17 Photograph by David Heald©SRGF, NY/©Estate of Dan Flavin/Artists Rights Society (ARS), New York; 27-18 Des Moines Art Center; 27-19 Courtesy James Cohan Gallery, NY. Collection: DIA Center for the Arts, NY. Photograph Gianfranco Gorgoni; 27-20 Scala/Art Resource, NY/©ARS, NY; 27-21 ©1974 Photograph Ute Klophaus, Dusseldorf; 27-23 Pace McGill Gallery, NY; 27-24 The J. Paul Getty Museum, Los Angeles. ©Eggleston Artistic Trust. 27-25 Hirshhorn Museum and Sculpture Garden/Smithsonian Institution; 27-26 Courtesy the artist and CDS Gallery, NY; 27-27 Photograph: Gradon Wood; 27-28 Courtesy Jack Tilton Gallery, NY; 27-29 Jack Tilton/Anna Kustera Gallery; 27-30 Photograph ©Donald Woodman

Chapter 28

Part Opener Art Resource, NY; Chapter Opener Art Resource, NY; 28-1 Ezra Stoller/EST0; 28-3 ©Vanni/Art Resource, NY; 28-6 Artur Architekturbilder Agentur GmbH; 28-7 ©Vanni/Art Resource, NY; 28-10 Art Resource, NY; 28-11 ©Rauno Traskelin; 28-12 Corbis/Bettmann; 28-13 Paul Maeyaert/Bridgeman Art Library; 28-14 Ezra Stoller/ESTO; 28-16 Ralph Richter/ESTO; 28-17 Photo by Hans Werlemann/Hectic Pictures OMA (Office of Metropolitan Architecture) 28-18 Netherlands Board of Tourism

Chapter 29

Part Opener Courtesy Galerie Michael Werner; Chapter Opener Courtesy Galerie Michael Werner 29-1 ©Peter Aaron/Esto; 29-3 SuperStock; 29-7 Courtesy Galerie Michael Werner; 29-8 Courtesy Cindy Sherman and Metro Pictures; 29-9 Ronald Feldman Fine Arts, Inc.; 29-10 ©The Felix Gonzalez-Torres Foundation. Courtesy Andrea Rosen Gallery, New York and Museum of Modern Art, New York. Photograph: Peter Muscato, 29-11 Photograph Jerry L. Thompson; 29-12 Photograph Charlie Samuels, Courtesy Creative Time